Matte Paint

Its history and technology,

analysis, properties,

and conservation treatment

with special emphasis

on ethnographic objects

A Bibliographic Supplement to

Art and Archaeology Technical Abstracts

Volume 30, 1993

Editors

Eric F. Hansen, Sue Walston, Mitchell Hearns Bishop

Matte paint

) is published semiannually
~~by the Getty Conservation Institute in association~~tion with the International
Institute for Conservation of Historic and Artistic Works (IIC), London.
Formerly *IIC Abstracts*. From 1966 through 1983, AATA was published at
the Institute of Fine Arts of New York University for the IIC.

Prior to 1955, abstracts of the technical literature of art and archaeology
appeared in various publications. The Subject Index to *Technical Studies in
the Field of Fine Arts*, by Bertha M. Usilton, is a key to the more than 160
articles and 450 abstracts that appeared in Technical Studies during 1932-
1942. Copies may be purchased for US $2.50, postage paid, from the pub-
lisher, Tamworth Press, P.O. Box 8211, Pittsburgh, Pennsylvania, 15217,
USA. (Residents of Pennsylvania add appropriate sales tax.)

Abstracts of Technical Studies in Art and Archaeology, 1943-1952, by R.J. Get-
tens and B.M. Usilton, *Freer Gallery of Art Occasional Papers*, Volume 2,
Number 2 (1955), contains 1,399 abstracts of papers that appeared in the 10
years prior to 1955. Abstracts of Technical Studies may be ordered from
the Freer Gallery of Art, Smithsonian Institution, Washington, DC 20560,
USA for US $6.00, postage paid, in the United States and Canada, and US
$6.25, postage included, in other areas.

AATA is available online through the bibliographic database (BCIN) of the
Conservation Information Network, a joint project of the Getty Conserva-
tion Institute and the Department of Canadian Heritage. Currently partici-
pating institutions include the International Centre for the Study of the
Preservation and Restoration of Cultural Property (ICCROM), the Cana-
dian Conservation Institute (CCI), the Canadian Heritage Information Net-
work (CHIN), the International Council of Museums (ICOM), and the
Smithsonian Institution's Conservation Analytical Laboratory (CAL). For
more information, contact: User Services, Conservation Information Net-
work, Canadian Heritage Information Network, 365 Laurier Avenue West,
Ottawa, Ontario K1A OC8, Canada.

ISBN: 0-89236-262-2

Art and Archaeology Technical Abstracts

Editors

Barbara Appelbaum
Appelbaum & Himmelstein, New York

Curt W. Beck
Vassar College

Helen D. Burgess
Canadian Conservation Institute

W.T. Chase
*Freer Gallery of Art/
Arthur M. Sackler Gallery*

David W. Grattan
Canadian Conservation Institute

Judith Hofenk de Graaff
Central Research Laboratory, Amsterdam

Heather Lechtman
Massachusetts Institute of Technology

Joyce Hill Stoner
*University of Delaware/
Winterthur Art Conservation Program*

Norman H. Tennent
University of Strathclyde, Glasgow

Jonathan Thornton
Buffalo State College

George Segan Wheeler
Metropolitan Museum of Art

Managing Editor

Jessica S. Brown

Research Assistant

C. Hamilton Arnold

Production Assistant

Gwynne Garfinkle

Editorial Office

AATA
The Getty Conservation Institute
4503 Glencoe Avenue
Marina del Rey,
California 90292 USA
telephone: (310) 822-2299
fax: (310) 301-4931

Subscription Office

J. Paul Getty Trust
Book Distribution Center
P.O. Box 2112
Santa Monica, California 90407
telephone: (310) 453-5352
fax: (310) 453-7966

Contents

Language Abbreviations

The following abbreviations have been used for the names of languages in the original texts as well as the published summaries.

Alb.	Albanian	Ita.	Italian
Ara.	Arabic	Jpn.	Japanese
Bul.	Bulgarian	Lat.	Latin
Cat.	Catalan	Lav.	Latvian
Chi.	Chinese	Lit.	Lithuanian
Cze.	Czech	Mac.	Macedonian
Dan.	Danish	Nor.	Norwegian
Dut.	Dutch	Pol.	Polish
Eng.	English	Por.	Portuguese
Est.	Estonian	Rum.	Romanian
Far.	Farsi	Rus.	Russian
Fin.	Finnish	Scc.	Serbo-Croatian
Fre.	French	Slo.	Slovak
Ger.	German	Slv.	Slovene
Grk.	Greek	Spa.	Spanish
Heb.	Hebrew	Swe.	Swedish
Hin.	Hindi	Tur.	Turkish
Hun.	Hungarian	Vie.	Vietnamese

Preface

This bibliography is an especially important and groundbreaking AATA compilation. Its publication grew out of a scientific research project, as well as a training course, at the Getty Conservation Institute to study and disseminate information on the consolidation of ethnographic painted objects. Research into the problem began with a literature search, which revealed that there was much relevant information available from the perspectives of numerous related disciplines. In considering the interdisciplinary nature of the problem, the Editors proposed a special supplement to AATA, since material in areas such as anthropology, ethnobotany, art history (with an emphasis on artists' notes, interviews, or descriptions of materials and techniques), and coatings science had not been previously abstracted in the regular volumes of AATA.

Like earlier AATA supplements, this bibliography is presented as a focused view of a unique problem, that of consolidating paint containing little or no binder, often, but not exclusively, found on ethnographic objects. The aims of this bibliography are two-fold: 1) to provide a variety of information from disciplines not directly relevant to the broader scope of AATA; and 2) to compile abstracts previously published in AATA on the topic.

This supplement provides other original material. The Editors' "Introduction: A Topical Review" (page xi) serves as a useful guide to the development of each of the four major subject areas covered: "History and Technology," "Analysis and Examination," "Properties," and "Treatment." A commentary on the material and its significance is provided. The organization of the abstracts is also unique to this supplement; within each major chapter the abstracts are grouped first according to the original date of publication, then by author. The Editors proposed this scheme as a visual way to scan the chronologic development of the literature in each of the four major areas.

A glossary has been compiled by the Editors as a guide to the ever-changing language of paint technology (see Appendix V). Each abstract, whether previously published or not, was reindexed for the supplemental subject index (see Appendix IV).

The Managing Editor
May 1994

Guide to the Use of AATA

I. Types of literature abstracted

This supplement provides 1,125 abstracts of periodical articles, articles and chapters in books, books as a whole, theses and dissertations, films and videos, and unpublished available works. Some of the literature is historic, some contemporary. Publication dates range from the mid-19th century to 1993. The "History and Technology" chapter contains numerous references from early anthropological sources. There are many studies in ethnobotany abstracted as well. Abstracts of literature from the coatings industry, and from the disciplines of chemistry and optics, can be found. Because of the chronological arrangement of the material, the "Treatment" chapter provides numerous references in the history of conservation. (See "Introduction: A Topical Review," page xiii, for a fuller description of all disciplines surveyed for this supplement.)

II. Style of the abstracts

Within each of the four chapters, the abstracts are sorted first according to the date of publication. Within each unique publication date grouping, the abstracts are sorted alphabetically in order of first authors; abstracts of audiovisual sources precede the authored publications.

Each abstract begins with the abstract number, which consists of the AATA volume number joined by a hyphen to a unique sequential number for each abstract. For this supplement, each abstract number is preceded by "S." The abstract number is followed by the name(s) of the author(s).

The following examples demonstrate the formats for the different types of literature abstracted:

A. Periodical Article
Abstracts of periodical articles appear as follows:

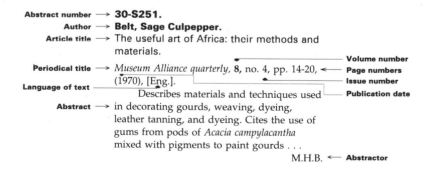

Abstract number —→ **30-S251.**
Author —→ **Belt, Sage Culpepper.**
Article title —→ The useful art of Africa: their methods and materials.
Volume number
Periodical title —→ *Museum Alliance quarterly,* **8,** no. 4, pp. 14-20, ←— Page numbers
(1970), [Eng.]. Issue number
Language of text
Describes materials and techniques used Publication date
Abstract —→ in decorating gourds, weaving, dyeing, leather tanning, and dyeing. Cites the use of gums from pods of *Acacia campylacantha* mixed with pigments to paint gourds . . .
M.H.B. ←— Abstractor

B. Book

Some 300-500 monographic publications and collections of essays, conference proceedings, bibliographies, textbooks, and other books are abstracted in each regular number of AATA. Patent documents, technical reports, masters' theses, doctoral dissertations, and other "gray" literature that can be obtained from an institutional sponsor are also abstracted as whole works. When the content of those works is directly applicable to the scope of AATA, relevant individual essays are abstracted. When the topic is more peripheral or the book is a general textbook, it may be abstracted as a single work. Abstracts of book chapters appear in the following style:

Abstract number —→ **30-S258.**

Author —→ **Cummings, Abbott Lowell.**

Title in original language —→ Decorative painters and house painting at Massachusetts Bay, 1630-1725.

Source type (chapter in book) —→ In book. *American painting to 1776: a reappraisal*, Quimby, Ian M.G., Editor (1971), pp. 71-89, [Eng.].

— Book title
— Editor of book
— Language of text

Discusses whitewashing and decorative painting in New England during the period in question. . . . Whitewash was used or a ←— Abstract glue size or egg white with a colored pigment for the decorative painting done before this date. . . . M.H.B. ←— Abstractor

An abstract for a whole book appears in the following style:

Abstract number —→ **30-S252.**

Author —→ **Eibner, Alexander.**
Entwicklung und Werkstoffe der

Book title in original language —→ Wandmalerei vom Altertum bis zur Neuzeit.

Book title translated into English —→ (Development and materials of wall paintings from antiquity to recent times.)

— Publication date

Document type (book) —→ Book. Elmar Sändig, 1970, Reprint of the Munich ed. 1926. [Ger.]. xvi, 618 p.; 28 cm, bibliog.
Publisher —

— Reprint edition statement
— Bibliographic information
— Number of pages

This reprint of Eibner's 1926 book about the history of mural painting presents his examination of the deterioration of mural paint- ←— Abstract ings from the 18th and 19th centuries.

Staff ←— Abstractor's initials (staff-prepared abstract)

C. Audiovisual Source

Films, videos, and slide sets are abstracted in Section H. The citations are sorted alphabetically according to the title of the source. The bibliographic style for these abstracts is as follows:

Abstract number ⟶ **30-S250.**

Media description — Gelede: a Yoruba masquerade. ⟵———— Title of audiovisual

(motion picture) ⟶ Motion picture. University of California, Los ——— Distributor
Angeles. Instructional Media Library, Los An-

Type of motion picture — geles; Boston University. African Studies Cen-

(film reel) — ter, Boston, 1970, 1 film reel (23 min.), sd.,

col., 16 mm. [Eng.]. Speed, Francis (Director); ⟵— Director(s) of audiovisual

Harper, Peggy (Director); University of Ife, ⌐—— Language of videocassette

Nigeria (Producing Agency). ⟵———— Producing agency

Abstract ⟶ Study of a festival and related dances
of the Gelede society of the Yoruba people
in Nigeria through which the community
reaffirms ties with spirits and ances-
tors. . . . Shows preparations for the festival:
carving the masks, making paints from local
materials . . . PFAOF ⟵— Abstractor's initials

III. Appendices

Appendix I provides an index listing for all authors, including second and subsequent authors of articles, book editors, translators, and compilers. Appendix II is a listing of the audiovisual titles included in this bibliography, arranged alphabetically by title.

Although many of the publications abstracted are no longer in print, Appendix III provides a complete directory of the publishers of periodicals and monographs and distributors of audiovisual sources; Appendix III also provides the International Standard Serial Number (ISSN) or the International Standard Book Number (ISBN), when available, as well as an index to the abstracts for each source cited.

The Subject Index found in Appendix IV utilizes the new AATA format, providing original English language titles or English title translations, for each term listed. The introduction to Appendix IV provides a brief guide to the use of the subject index.

Appendix V is a glossary containing over 200 unique concepts. In this compilation, every attempt was made to use consistent language, despite the fact that the abstracts cover literature published during the course of two centuries. This glossary presents the terms and their commonly accepted definitions, and sources for those definitions, as used in this work.

Introduction: A Topical Review

The literature references assembled in this supplemental bibliography are relevant to the conservation of painted surfaces that are matte in appearance and that require stabilization to prevent loss of material. Because the problem is so widespread amongst ethnographic collections, special emphasis is given to these objects. Preventive conservation, such as environmental control and physical support and protective systems, although normally the first line of defense, will not be addressed, as it has been extensively dealt with in the literature. This bibliography focuses on the factors affecting interventive conservation where stabilization is achieved through the introduction of a consolidant.

In a preliminary review of the literature and in wide-ranging discussions with conservators about the problems and treatment of matte paint, a number of issues stood out that had a bearing on the direction this project took. Firstly, there appeared to be a considerable discrepancy between the knowledge and skills of conservators relating to the stabilization of matte paint and the rather small amount of information that has actually been published. There is a wide variety of methods and materials that are routinely and successfully used to consolidate unstable matte paint. While many of these treatments achieve the desired outcome, not all have been developed with a complete understanding of the deterioration and treatment mechanisms involved; nor is there widespread awareness of them in the conservation community. In addition, although there are many excellent studies in the scientific literature of the physical, chemical, and optical phenomena associated with the properties of paint and potential treatment materials, there are still very few published case histories where theoretical concepts have been translated into practical trials or actual treatments of objects. This shortage of applied literature makes it difficult to construct basic models on which to develop treatment strategies for particular problems. It also inhibits critical appraisal of the existing literature and increases the risk of reinventing treatment systems each time the same problem is encountered. It is hoped that this introductory review to the present bibliography will prove useful in bridging this gap, making the range of literature cited more easily accessible than was previously the case.

Accordingly, this introductory review has several objectives. The first is to provide a guide to the range of literature included in the bibliography, pointing out references of special interest, particularly with respect to the first three chapters, "History and Technology," "Analysis," and

"Properties," which may be outside the mainstream literature commonly used by conservators, such as literature from the fields of anthropology, ethnobiology, and coatings science.

Other aims are to point out those articles, among the wide range of references included in this supplement, which are particular landmarks in their field; those which are most relevant to conservation; and the reasons for including some apparently peripheral articles whose relevance might not be readily apparent. A further aim is to make the literature abstracted in this supplement more accessible through a discussion of the interrelationship of the four chapters. This is most apparent in the last chapter, "Treatment," where, in contrast to the earlier chapters, the coverage has been as inclusive as possible. In the text, illustrations, and schema, a general framework is suggested through which to pursue appropriate responses to the wide variety of paint problems and treatment requirements.

It should be pointed out that, in order to publish this bibliography in a single volume, this work does not include a number of subjects of vital concern to conservators which are also relevant to the treatment of matte paint. Specifically, it does not directly address the ethical issues of treatment; the relationship of the substrate to the deterioration of the paint; the ways that the composition, structure, or behavior of support materials may influence the choice of treatment methods and materials; and, environmentally-induced deterioration of paint and treatment materials and preventive conservation measures. Each of these important subjects would deserve an equal, if not greater, number of abstracts as included in this supplement to provide more than a cursory coverage. An exception is made in regard to the discussion of the stability of conservation treatment materials in the introductory text, because the treatment methods could not be meaningfully discussed without comment on the choice of materials.

The first chapter of the bibliography traces the history, technology, and use of matte paint applied to objects in various cultural and historical contexts. Because confirmation of observations or conclusions relating to the technology are often subject to verification, methods for determining or verifying the composition of paint, its condition, and causes of deterioration are included in the second chapter. The third chapter, on physical and optical properties of high pigment volume paint, explains why matte, porous paint is characteristically light in color and prone to instability. The fourth and final chapter on treatment focuses primarily on painted ethnographic objects, the materials and systems used in their treatment, and the effectiveness of those treatments. A large number of articles that describe treatments for painted archaeological, historical, and modern or contemporary art objects are also included, where the methods or materials have applica-

tion for ethnographic objects, or where the treatment approach provides a useful model for the study and treatment of matte paint in general. The citations are arranged chronologically and, within each year, alphabetically by the authors' names.

Matte paint

Paints with low amounts of binder have a high ratio of pigment volume to binder volume, a condition referred to in the coatings literature as a high pigment volume concentration (high PVC). These paints may have poor cohesive and adhesive properties. They normally have a matte appearance and are often in a powdery, friable, and flaking condition. Their treatment requirements differ from paints containing higher proportions of binder (such as commonly encountered linseed oil or acrylic paints) in that consolidants are easily absorbed into the paint and fill voids between the pigment particles. However, although cohesion of the paint and adhesion to the substrate are promoted by added amounts of resin, filling void spaces between pigment particles may cause changes in the appearance of the paint by a treatment that is practically irreversible. The aim therefore, when consolidating porous, matte paint is to use a consolidation system that distributes the consolidant in a manner that minimizes changes in appearance, introduces the minimum quantity necessary to achieve effective cohesion of the paint and adhesion of the paint to the substrate, and is compatible with the paint and support materials in the long term.

Note: References identified with footnotes in the text are references that are helpful in explaining concepts or issues but do not necessarily belong in a strict subject category for a specific section of the supplement, or references that could not yet be included in AATA because they are in press and not yet available, but worth bringing to the attention of the interested reader.

Chapter I
The History and Technology of Matte Paint

Commentary

This chapter explores the historical and cultural settings that have produced artifacts painted with matte paint. It is primarily concerned with material culture and thus focuses not only on objects that people made but also on the context in which objects were or are created and the materials and techniques chosen for their fabrication. The processes by which materials and techniques are chosen tell us something about materials available in the environment and add to an understanding of the cultural criteria that contributed to those choices.

While emphasis is given to ethnographic objects throughout the bibliography because of the frequency with which their paint problems are reported in the literature, similar problems are also found with matte paints used in architecture, contemporary art, folk art, and many other forms of applied art. Thus the literature cited in this chapter encompasses paint technologies used for the widest range of objects, buildings, monuments, and sites and is not limited to any specific time period, cultural setting, or geographic location. In spite of the variety of objects and cultures in which these surfaces are found, the basic physical nature of the problem is the same. Similarly, the possible conservation treatments are closely related.

Definitions

There is a wide variation in the terminology used to describe coatings on objects in both the abstracts and in the literature cited in this bibliography. To avoid any confusion in this introductory text, the following definitions of matte, gloss, paint, vehicle, and binder are used.

The definition of a matte finish given in the *Pigment Handbook* (1973) is "A dull finish without luster," which would apply to a large number of surfaces. A more specific definition used in the Glossary of this work is from the *Paint/Coatings Dictionary* (1978): "**Matte Finish,** A coating surface which displays no gloss when observed at any angle; a perfectly diffusely reflecting surface. In practice, such perfect surfaces are extremely difficult to prepare. Hence, the term is applied to finishes which closely approach this ideal. Matte is also spelled 'mat'...." The definition of "gloss" in the Glossary (also from the *Paint/Coatings Dictionary* (1978)) should be taken into account to understand the way in which "matte" surfaces are considered in this work: "**Gloss,** Subjective term used to describe the relative amount and nature of mirror-like (specular) reflection. Different types of gloss are frequently arbitrarily differentiated, such as sheen, distinctness-of-image gloss, etc. Trade practice recognizes the following stages, in increasing order of gloss: Flat (or matte)—practically free from sheen, even when viewed from oblique angles...; Eggshell...; Semigloss... ; Full gloss—smooth and almost mirror-like surface when viewed from all angles...." A matte surface can then be considered a low stage of gloss. As discussed below, in order to consolidate matte paint with minimal changes in appearance, great attention must be paid to maintaining the same

amount of specular reflection in addition to avoiding the darkening that can result from the filling of void spaces in a porous paint.

Paint, as defined in the Glossary, is both 1) a "Verb. To apply a thin layer of a coating to a substrate by brush, spray, roller, immersion, or any other suitable means"; and, 2) a "Noun. Any pigmented liquid, liquefiable, or mastic composition designed for application to a substrate in a thin layer which is converted to an opaque solid film after application." Two other useful definitions of paint components, consistently adhered to in this review, are: 1) "**Vehicle**, The liquid portion of paint, in which the pigment is dispersed; it is composed of binder (q.v.) and thinner"; 2) "**Binder**, Non-volatile portion of the liquid vehicle of a coating. It binds or cements the pigment particles together and the paint film as a whole to the material to which it is applied."

However, this definition of "paint" has at times little relevance to many of the coatings or colorant systems that are the subject of this bibliography. When Europeans first made contact with peoples in the Americas, Australia, Oceania, Africa, and Asia they found many of the objects in these societies interesting; they collected examples that were later described in museums' documentation as "painted." In some cases these coatings were related closely to paint encountered on European and North American objects, thereby conforming to the definition of "paint" in the glossary, but in many instances they were different. This misunderstanding survives in contemporary conservation practice, sometimes creating considerable obstacles to an understanding of how to care for or treat a painted (or in some cases more aptly designated "colored") surface.

A wide variety of organic and inorganic materials have been applied to the surfaces of objects to fulfill various practical, aesthetic, ritual, and other purposes. They occur as thin or thick coatings, or multiple combinations of these, in which color, patterns, or designs may or may not be present.

In the context of ethnographic collections, a "painted" surface may not correspond to accepted definitions. Henry Hodges (1964) described the confusion about "painted" objects in the following way: "Many artifacts that have never been given a coat of paint are often described as 'painted' and the reader may be left to discover, if he can, what precisely is meant. Thus a wooden artifact may be colored by applying dyes to different areas with a brush. Such an object would be better described as 'stained,' or even 'dyed' rather than 'painted,' unless a complete account of the method of colouring is given." For example, Murdoch's Point Barrow Expedition account (1892) gives a description of "painting" in a very basic form. An Eskimo working on a sled was observed to color the surface by licking "...the freshly scraped wood with his tongue, so as to moisten it with saliva and then rub...it with a lump of red ocher."

**Observation methods
and cultural bias of observers**
Relatively few anthropological or historical studies are concerned primarily with the materials, manufacture and use of painted artifacts, much less with matte paint in particular. Mention of painting technology in the literature is

rare and observations are normally peripheral to the main subject of the study. Accounts in the literature usually lack the certainty bestowed in those rare instances where the entire process of material procurement and processing and the fabrication of an object is observed and documented, and the object subsequently housed in a museum. Thus, there is a range of credibility. Some accounts are rigorous and appear reliable (Bascom 1973; Mead 1963) with careful investigators observing an entire process; others are those of a casual and not very well informed observer. This uncertainty raises the fundamental question of how useful literature is in ascertaining the physical nature of an object for the purposes of analysis and conservation (Bolton 1979). Some accounts in the literature can only be taken as likely scenarios as to the techniques and materials used.

For example, products of human and animal origin have often been used as vehicles or binders. Milk is often cited as a binder used in the American Southwest (White 1932; Dunn 1955), but the precise source of the milk (domesticated animal or human) is not mentioned. This is quite problematic since no milk-giving domesticated animals were present in the area until they were introduced by Europeans. Consequently, we must conclude that these accounts either date after the period of the introduction of domestic animals or they refer to the use of human milk.

Additionally, observations or conclusions may have been biased by the cultural constraints of the investigator. There are occasional references to the use of urine as a binder (Watson 1967, 1969); however, these are quite rare and it is not clear to what extent the cultural bias of Western investigators, particularly in regard to the use of human bodily fluids, has resulted in an inaccurate picture of the use of such materials as vehicles or binders. There are, in contrast, extensive accounts of the use of blood as a vehicle and binder ranging from 1897 (Roth) to 1990 (Bunney). Since various bodily fluids are available in any group of humans, and often have ritual significance, the patchy nature of references to their use in coatings casts doubt on the reliability and thoroughness of descriptions in the literature.

Material culture studies

There are several considerations that may be useful in studying the material culture of the various artifact-producing societies, both living and extinct, that are represented in this bibliography. For example, the routine use of non-local materials is a recent phenomenon, although there are obvious exceptions for many highly prized materials. Nevertheless, most materials used (especially organic materials used as binders) were those locally available, so it becomes important to look to ethnobiological sources to aid our understanding of the resources available in a given location and how they were likely to have been used. Accounts in the ethnobotanical literature have potential for expanding an understanding of the materials and technologies available in a given geographic location. Climatic alteration over periods of time and the widespread introduction of non-native plants and animals must also be considered as a part of the ethnobiological context[1].

For an extinct culture, one might look to the descendants of the people who created the artifact; even after many generations, cultural practices may survive intact or virtually intact. Through ethnoarchaeology (the study of contemporary peoples to determine relationships that may aid in unraveling the archaeological record of their predecessors), or by reference to ethnohistorical accounts (evidence from documentary sources) and to oral traditions, valuable data can be assembled on the materials and practices of past societies.

For example, understanding the technology used to produce an early 15th-century Netherlandish painting, where detailed contemporaneous accounts of painting methods and materials exist (Wolfthal 1989), is a great deal easier than ascertaining the technology used to produce a painted wooden artifact from the 12th century that was excavated at Chetro Ketl in Chaco Canyon, New Mexico (Vivian et al. 1978). The inhabitants of Chetro Ketl left no written material describing their methods. However, early anthropological accounts described the methods used by Pueblo Indians in the Southwest for the gathering of pigments and the preparation of paint (Bunzel 1932); an investigation of the painted wood artifacts from Chetro Ketl suggest that very similar methods may have been used. Within certain limitations these concepts can be used by conservators to place a painted artifact in its cultural context and to gain insights into the materials and technology used to fabricate it.

Contemporary art in the developing world

Contemporary works acquired for ethnographic museums and other collections frequently contain mixtures of indigenous and introduced materials that are often applied using new painting techniques. There are some references that describe the adoption of modern artists' materials for African art (Bascom 1973) and a number relating to Australian Aboriginal bark painting.

Scientific nomenclature

Botanical names in the abstracts have been given in the forms that appear in the texts. No attempt has been made to provide current taxonomy. As a result some of the scientific nomenclature that appears for plants may reflect antiquated usage.

General survey of the chapter

In the literature of the History and Technology chapter of this bibliography, a number of subject areas are worth noting. This material can be split into three broad categories: historical appearance, geographic location, or special topics. Following the brief description below, specific references are discussed separately.

The earliest references, in "19th-century developments," encompass certain types of studies and the manner in which information was presented based upon the social and intellectual climate of the period. "Historical references for conservation" are also found in this period, and relate to the emergence of restoration as a specialized occupation prior to the development of the conservation profession. "European colonialism" covers a body of literature describing voyages

of discovery and the collecting of objects. "Ethnobotany and economic botany" were disciplines that emerged in the 19th century partly as a result of the commercial exploitation of raw materials by the colonial powers. The disappearance of indigenous cultures in colonized areas led to attempts to study and describe them, e.g., the publications of "The Bureau of American Ethnology" of the United States of America at the end of the 19th century. The working methods of some of these early ethnographers present a number of "Ethical problems."

The largest body of literature cited refers to the geographic areas where matte paint on ethnographic objects is most frequently encountered: "Oceania," "The Pacific Northwest," "The American Southwest," "South America and Mesoamerica," and to a lesser extent "Asia." A great number of references was evaluated for "Africa"; however, most of these only addressed visual styles or social aspects of painting, with few actually mentioning the materials or techniques involved in painting objects.

Within the European painting tradition, including easel paintings and decorative arts, there are several types of objects, colored by various techniques, that have matte, friable surfaces in need of consolidation. "Pastels, drawings, and illuminated manuscripts" include references to poorly bound friable pigments used in pastels and drawings (although they are not painted per se), and to the consolidation problems associated with illuminated manuscripts that are aggravated by the mechanical action of the substrate. References to "Distemper, Tüchlein painting, and re-lated techniques" describe matte friable surfaces that result from the materials used in these painting techniques; similar problems result from the techniques used to produce "Folk art and architectural and decorative finishes" and "Wall paintings." Problems associated with "Contemporary art" often result from experimentation with materials and techniques, including revivals of older techniques and the introduction of new materials.

Special topics of interest are: "Rock art, Paleolithic European painting"; "Paint industry literature," which deals with publications generated within that industry to describe the history and technology of commercial coatings; and, finally, "Conservation science."

19th-century developments
Early references reflect several characteristic aspects of 19th-century thinking. One of these is the development of archaeology as a methodical and scientific activity. This can be seen in the early scientific study of Roman pigments by Davy (1815, reprint 1984). Ultimately Davy's history was presented in a compilation by Augusti (1967) and a review of accounts in the literature of pigment analysis by color (Frizot 1982). Davy's study was a part of the antiquarian interests of the period stimulated by discoveries in Pompeii and Herculaneum and in Egypt (Spurrell 1895). Another characteristic aspect was the attempt to codify practical knowledge in an accessible form for the general public. For example, a house painters' manual (Vanherman 1829) gave recipes and methods used in house painting. The 19th century marked a transition from recipe books or books of secrets

to practically oriented manuals on house painting, wood graining, marbling, gilding, and decorative painting. These books are valuable aids in determining the methods and materials used in architectural finishes and furniture from the period. Similar books exist for amateur and professional artists. Gardner (1887) published a painters' encyclopedia that includes an entry for kalsomine paint, typically used on plaster surfaces.

Historical references for conservation
Practical restoration manuals also began to appear in the 19th century replacing the "books of secrets" that preceded them. Examples are Welsch (1834), Horsin-Déon (1851), and Forni (1866). Methods used to fix pastels and drawings and for consolidation are of particular relevance.

European colonialism
Imperialism brought about a systematic investigation into commercial products useful to the imperial powers of the period. Some of these reports were couched in scholarly terms, such as Crawfurd's (1869) paper to the Ethnological Society regarding "tinctorial plants." Others are the diaries of the explorers themselves such as Captain Cook and his crew (Cook and Beaglehole reprint 1988). Joseph Banks' collection of specimens from his voyage with Cook ultimately resulted in the collection now housed in the recently opened Joseph Banks Building at Kew Gardens (Pain 1990). It houses Kew's extensive collection of plant materials and artifacts made of plant materials assembled over the years.

One of the best later examples is a compilation by Isaac Burkill (1935). This book, *A Dictionary of the Eco-*nomic Products of the Malay Peninsula, is a comprehensive compendium of plants, minerals, and animals that might have potential for commercial use. Later ethnobotanical studies on resins of the area are also a valuable addition (Gianno 1986).

Film from the colonial period is another potential source of information on ethnographic objects, e.g., films in the catalog of the Quex Museum House (Barton et al. 1990). The original owner, P.H.G. Powell-Cotton, traveled widely in Asia and Africa, collecting artifacts and recording human activities on film.

In North America, investigations of the indigenous inhabitants and the plants and animals were undertaken. The discipline of ethnobotany has its origins in this period. European immigrants were greatly interested in the medicinal plants used in the Americas. Examples are the notes of the botanist Gambold on the uses of plants by the Cherokee of Northwestern Georgia from 1805 to 1825 (Witthoft 1947) and the work of Palmer (1878).

Ethnobotany and economic botany
A number of ethnobotany and economic botany references have been included. This is an area that has seen scant coverage in previous editions of *AATA*. A basic reference on ethnobotany and economic botany for a lay audience by Lewington (1990) has been included, along with a basic text on economic botany by Schery (1952). Even in areas where plants are relatively restricted, such as within the Arctic circle, plants play an important role in material culture, food, and medicine (Oswalt 1957; Holloway 1990).

While ethnobotanical literature may not always provide answers in regard to the use of specific materials, it gives an idea of the range of plant materials and technologies that may have been used. Chesnut (1902) studied plants used in Mendocino County in California; in some instances specific materials and technologies were mentioned and the process of manufacture described. Densmore (1974) studied plant usage by the Chippewa. Other examples are accounts found in Bunzel (1932), Stevenson's ethnobotany of the Zuñi (1909), and Robbins and Harrington's Tewa ethnobotany (1916).

Harrington's (1933) comments on a translation of an early 19th-century account of Indians in California by the missionary Geronimo Boscana includes information about painting and paint materials, much of which is recapitulated by Hudson and Blackburn (1986, 1987). Some of Harrington's information is based on Sparkman's (1908-10) account, particularly his discussion of the use of Chilicothe seeds as a binder for paints used in rock art and "turpentine" from pine pitch. Harrington even identified the use of a pigment derived from iron fixing bacteria (*Leptothrix ochracea*), that has been observed in other parts of the world, including Africa (Portell 1988). Another work on California ethnobotany by Mead (1972) can be used to form a picture of possible plant usage. Recent trends in ethnobotany have resulted in a more well rounded approach to plant use in the societies studied. Felger and Moser's (1971) study of the Seri Indians of Baja California discusses the use of plants as colorants and sources of resins for various uses. Ebeling (1986) gives a useful summary of the indigenous foods and fibers for the entire arid Southwest.

Oils and resins from palms have been incorporated in paints in many societies. The proceedings of a symposium on the palm family has been included as a point of entry into this body of literature (Society of Economic Botany and Balick 1988). Orchid bulbs, tubers, and roots are often cited as a source of binders in many areas, particularly Australia (Ravenscroft 1985; Isaacs 1987). Bulbs were usually lightly mashed, then rubbed directly onto a surface to be painted. The orchid juice provided a tacky surface which helped bind the paint. In the 19th century, salep, a form of powdered orchid root, was used as an easily portable food and as a substitute for gum arabic (Miller 1959). The use of orchids for the same purpose is also cited for Mesoamerica by Castello Yturbide (1988). Uses of poison oak and poison ivy *(anacardiaceae)* by Native Americans are described by Sweet and Berkley (1936; 1937). Ebeling (1986) cites the use of the juice of poison oak as a black dye for basketry.

The Bureau of American Ethnology
One of the many publications in the bibliography by the Bureau of American Ethnology is Mallery's (1883) early work on the *Pictographs* of the North American Indians. This work is important not only because the author cites the use of specific binders, such as a binder prepared by the Arikara from beaver tails, but also because Mallery attempted systematically to address painting as a whole in North America. Although the account contains many errors it also includes valuable early illustrations of Chumash rock art in California.

Mindeleff's (1891) work on Pueblo architecture describes the decorated plasters of the Pueblos in the Southwest. Fewkes' (1892) accounts of various Pueblo ceremonies describe the preparation of paints by chewing melon seeds and grinding the pigment with the saliva and masticated seeds. Later works by White (1932) and Bunzel (1932) are more detailed and useful, as is Stephen's *Hopi Journal* (1936).

An unusual later product of the Bureau is *The mining of gems and ornamental stones by American Indians* (Ball 1941). This overview of indigenous American mining activities provides interesting insights into possible pigment sources. An article by Parezo (1987), in addition to giving the history of collecting in the Southwest by the Bureau and a chronological listing of expeditions, also lists materials collected from various groups during these trips.

Ethical problems
Stevenson (1904, 1909) was an investigator of the Bureau of American Ethnology who had a forceful, intrusive approach that has now come into disrepute. In addition to being an example of gaining information in a manner now considered unethical, the extent to which she may have been misled by her reluctant informants is unknown.

Because threats and trickery have sometimes been used to obtain information in the past, ethical problems with the use of some information still exists. Certain literature describes sacred activities and it is unlikely that access would be given to this information today. These are important considerations for those involved in anthropological and conservation activities.

Oceania
The Hawaiian Islands are well represented in this bibliography because there is a comparatively large body of literature that examines the cultural use of plant materials in the region. Part of the reason for this extensive use of plant materials is that the original inhabitants of these islands had no metals and produced no pottery, and thus depended heavily on plants and stone (Krauss 1993). Polynesian voyagers brought useful plants with them, and these were introduced to the islands and used in manufacturing objects. An important early account is provided in the work of David Malo (d. 1853) (reprint ed. 1951), who was familiar with the oral tradition of the royal court.

Little is known about Hawaiian dyes, stains, or paints (Cox and Davenport 1988) with the exception of canoe paints (Holmes 1981) and tapa (bark cloth) dyes. The term "dye" is troubling in relation to tapa because the colorants were often applied by painting and stamping (Brigham 1911; Bishop 1940; Kooijman 1963, 1972; Krauss 1981). As previously discussed, the term "dyeing" is not an accurate description of the practices employed in some cultural milieus, even though the materials that were used have been described as "dyes" by observers. Thus, although explicit in meaning in modern technology, in many descriptions dyeing is an imprecise description of the technology (Bühler 1948; Hodges 1964). Stenciling and painting on tapa is quite similar to African painted textiles in that it is regarded as a dyeing process in literature but is really more closely akin to painting (Picton 1979).

The links between the conservation of paintings and painted textiles has been discussed by Lewis (1984).

Two books on Hawaiian ethnobotany by Abbott (1992) and Krauss (1993) have recently been published. Abbott's study draws on the rich historical collections of the Bishop Museum to illustrate the cultural context of plant use and relate the discussion to specific artifacts.

Turmeric is an important colorant, food, and medicinal plant throughout Oceania and Asia (McClatchey 1993). A publication relating to the cultivation of turmeric has been included since it gives extensive information about the chemistry of the plant, its cultivation, and taxonomy (Randhawa 1985).

In Australia, Roth (1897, 1901, 1904) published a number of studies on the ethnology of North Queensland including an important study (1904) which investigated the materials and techniques used to manufacture artifacts. Roth's (1901) work on food acquisition and preparation may be useful for its insight into the processes of food preparation that may be related to materials and processes used in the production of objects. Clay has a long history of medicinal use and Roth (1901) cites the use of white clay both as a pigment and as a medicine. A book by Isaacs (1987) describing the indigenous foods of Australia provides information on food processing and substances that were not only eaten but also used in artifact manufacture. Akerman's article (1979) on honey usage among the Kimberly Aborigines is another example. Binford's work (1984) provides unique insights into the gathering and processing of

spinifex resin. Ravenscroft (1985) describes the methods and materials of bark painting practice.

Hamilton's book on Maori art (1896, reprint 1977), originally published in installments from 1896 to 1901, gives some idea of the pigments and binders used by Maoris. More recent publications in the conservation literature supplement Hamilton's work (Barton 1984; Barton and Weik 1984; Bacon 1985).

In Papua New Guinea, Mead (1963) observed a group of Mountain Arapesh men painting on Sago palm spathes. This account is particularly interesting since it describes the materials, the process used, and the behavior of the men making the painting. A book on Asmat woodcarvers in New Guinea by Gerbrands (1967) describes the carving technique and, to some extent, paint application.

The Pacific Northwest
The Pacific Northwest, like the American Southwest, is extensively cited. Captain Cook's crew has left its account of some of these cultures (Cook and Beaglehole reprint 1988). Other accounts have been compiled by Gunther (1972) in which large-scale painted house fronts are described. Leechman's (1932, 1937) work on indigenous Canadian paints and dyes is still remarkable for its detail and quality. It represents the beginning of a tradition of extensive studies of the material culture of the Pacific Northwest (Barrow 1942).

Several ethnobotanical works by Turner (1983, 1990, 1992) are quite unusual in terms of the width of their scope and scholarship. With studies such as these, the interest of ethnobot-

any seems to be expanding beyond the realm of food and medicinal plants into a more balanced study of plant usage.

The American Southwest

The importance of the Southwest to American archaeology has resulted in a large body of literature, including discussions of painted objects such as Kiva murals, decorated plasters and painted wooden objects. (Brody 1991). Another study of Kiva murals is the publication on the murals of Awatovi and Kawaika-a by Smith (1952).

Vivian's (1978) analysis and discussion of painted wooden objects found in a room at Chetro Ketl, a Chacoan pueblo dating from the 12th century, indicates that some of the methods and materials of the Anasazi may have been perpetuated by the Pueblo peoples who succeeded them. Work by Gettens (1951) on *retablos* in the Southwest shows the continued use of some indigenous colorants such as the yellow flowers of Chamisa, although Mexican practice and imported materials were predominant.

Dunn, founder of the Indian Painting Studio in the United States Indian School at Santa Fe in 1932, promulgated indigenous painting traditions in the area during a time when assimilation was government policy. Dunn's book on American Indian Painting (1968) contains an account of painting on skin among the plains Indians as well as an extensive bibliography. Other works include a description of a Naskapi painted skin shirt (Douglas 1969) and a substantial book on painted rawhide (Morrow 1974). Mails' book (1972) also contains detailed descriptions of Plains Indian painting techniques and materials.

The desert areas of Northern Mexico and the American Southwest are also represented in the bibliography. Felger (1971) focused on the use of an individual plant, the mesquite, used as a source of food, resin, and colorants; Nabhan (1985) considered the desert environment and plant use more generally.

South America and Mesoamerica

Some years after his work in Australia, Roth (1916-17) did similar work in Guiana where he describes the use of gums, waxes, oils, and pigments by the Indians of the area. Works by De Andrade (1924) and Levi-Strauss (1950) also contributed information on plant-based colorants in South America. A recent ethnobotanical study of the classification and use of resins in the Amazon by Balée and Daly (1990) continues the work of Roth and Levi-Strauss.

Anderson's study of Mesoamerican colorants (1948) provided insights into the uses of various raw materials. Mesoamerican buildings, as well as pottery, were often decorated with elaborately painted stucco. Margival (1955) describes the tradition of illustrated manuscripts where conventions for the use of color were highly developed. Margival also cites the use of rabbit hair for brushes and milk as a binder, although the source of milk is not given.

Works by Littmann (1959, 1960) on Mesoamerican plasters and stuccos have been included for several reasons, the primary one being that many painted plasters and stuccos in the area have friable matte surfaces that require consolidation. A secondary reason is that they contain information relating to the addition of bark extracts to the plaster to improve working

properties, inhibit cracking, and resist moisture.

Bibliographies on archaeological plant remains and an ethnobotany of pre-Columbian Peru have also been included as a resource for pre-Columbian plant usage (Smith 1966; Towle 1962; Bonavia 1990). Similarly, a study of the natural colorants of Mexico mentioned earlier traces the origins of colorant use using Sahagun's descriptions and other ethnohistorical sources (Castello Yturbide 1988). Lemassier (1957) suggests that, as in Southwestern North America, some of the techniques used early in South America and Mesoamerica survived into modern times.

Asia

Studies of Asian paints include: Yue's (1988) *Chinese Painting Colors* which discusses traditional Chinese methods; Uyemura's (1931) study on early Japanese pigments; and, Yamasaki's (1979) history of Japanese pigments. A more recent publication also discusses traditional Japanese pigments (Nishio 1987). Other works on the materials of early buildings and architecture (see Yamasaki 1947) are concerned with the analysis of paintings in caves and temples, e.g., Tanjore (Paramasivan 1937) and Kizil (Gettens 1938) in India. Lal (1967) gives a detailed account of the composition, deterioration, and history of the preservation of the Ajanta cave paintings, including the removal of unstable consolidation materials used in the early 1920s. Riederer discusses Central Asian wall painting techniques.

Some studies reveal the use of unusual materials. An example is Yamasaki's analysis (1957) of the pigments used in the 12th-century wall paintings of the Hoodo temple near Kyoto. A blue pigment made by dyeing yellow ocher with indigo to form an azurite substitute was found. Particularly notable is the extensive use of adhesives derived from plants and animals as binders and the variety of methods and materials used in their formulation (Morita 1984; Winter 1984).

An area of continuing confusion is the botanical identification of red woods and resins used in the Far East. Schafer's article (1957) is an aid to clarifying the identity of various substances cited in literature. A more comprehensive treatment of wood-based colorants is given by Puth (1962).

Agrawal's (1969, 1971) publications on the techniques of Indian polychrome sculpture have been included to represent the Indian tradition of wooden polychrome. Nishikawa (1977) discusses the methods of Japanese polychrome.

Africa

Published accounts of the materials and working methods of African craftsmen, and the context in which they work, are notably scarce although there are exceptions. Bascom's (1973) description of a Yoruba master carver is particularly noteworthy. The carver used both traditional and commercial sources of paint. African red pigments are discussed by Portell (1988) in an article included in the "Analysis" chapter of the bibliography.

The French and Belgian colonial influence has left a legacy of publications such as Raponda-Walker's (1961) book on the uses of plant materials in Gabon, a work on plants of economic importance in Malawi (Williamson 1964), and an article by Pauvels (1952) cit-

ing the use of blood-filled cattle ticks as a source of red colorant. The British influence is represented with an early article by Joyce in *Man* (1910) on the preparation and uses of camwood blocks in the Belgian Congo.

Another interesting source for Africa is missionaries' accounts, represented here by the records of the Swedish missionary Laman (1953; 1968), whose observations in the Congo from 1891 to 1919 constitute a valuable record of observations of the Sundi.

Bascom (1954) in his studies of artifact manufacture in West Africa, discusses wood selection for carving, camwood as a colorant, and the use of palm oil in finishes. Several bibliographies on African art have been cited as a resource (Jolly 1960; Gaskin 1965, Dull 1988).

The fabrication and painting of masks are shown in a film of a festival of the Gelede Society of the Yoruba people (1970). Pemberton (1976) discusses the ritual application of substances such as blood, kola nut, and palm oil to figures associated with the worship of the Yoruba trickster god, Eshu-Elegba. While this article is primarily concerned with the cult itself, the descriptions of substances applied during rituals help to identify the nature of the resulting surfaces. Labi (1993) describes the practices associated with wooden stools that were symbols of chieftainship among the Akan of Ghana. A mixture of sheep's blood, gunpowder, eggs, and soot is used to blacken the stool, which is also treated to ritual pouring on of blood and alcohol.

Abbiw's (1990) book on the useful plants of Ghana provides a comprehensive review of plant use in Ghana

including those used for construction and other ordinarily neglected categories. In some African adobe buildings organic materials were added to waterproof the adobe and impart handling properties. Many of these buildings were also painted (Blier 1981; Bourgeois 1989).

Abstracts on ancient Egyptian paint technology have been included because of the frequent occurrence of matte paint in need of stabilization on Egyptian artifacts. Mekhitarian (1959) and Manuelli (1991) give an idea of the methods and materials used in Egyptian wall paintings. Terrace (1968) discusses painted wooden objects and figures. The technique of Coptic icons is described by Skalova (1990). Lucas (discussed further below) is perhaps the best known source for the technology of ancient Egypt (1922, 1934) as well as being the author of an influential early work on conservation[3].

Pastels, drawings and illuminated manuscripts
Bontinck (1944) gives a history of the manufacture of pastels and provides a bibliography that begins in 1587. Fixing the friable surfaces of pastels has been a long-standing problem. At one point a cash award was offered for the best solution (Monnier 1984). Many secret recipes for fixing pastels have been developed over the years. The techniques of Rosalba Carriera, who is generally credited with the invention of pastel paintings, are described by Burns (1992). Degas was one of the master practitioners of the medium; Maheux (1986, 1988) and Cowart (1975) have described his working methods and materials in detail. A history of pastels by Monnier (1984) includes translations from

16th-century treatises on the manufacture of pastels. Nelson (1984) discusses the pastel technique of Jean François Millet. A book on American pastels with a section on materials and techniques by Shelley (1989) describes the making of pastels and their use by American artists.

Drawings, particularly charcoal drawings, share some of the same conservation problems as pastels (Jirat-Wasiutynski 1980, 1990). Watrous (1957) related the techniques and materials of drawings to relevant conservation problems. Cohn's (1977) exhibition catalog on wash and gouache at the Fogg Art Museum, Harvard University, has been included as a resource for the history of these materials.

A selection of literature has been cited to provide a background to the history and technology of illuminated manuscripts including those on parchment, palm leaf, and paper. These references (Radosavljevic 1976, 1981; Watters 1980; Agrawal 1981) also serve as an introduction to a highly specialized body of literature.

Distemper, Tüchlein painting, and related techniques
A number of publications relating to techniques that involve the use of a glue medium directly onto a fabric support has been included. Among these is an article by Bomford et al. (1986) comparing the technique of Dirck Bouts on a Tüchlein painting on linen to one by the same artist on a wooden panel. Another by Roy (1988) deals with Quentin Massys' Tüchlein technique. Of particular importance is Wolfthal's (1989) monograph on Early Netherlandish painting. A chapter by Rothe (1992) from a monograph on Andrea Mantegna has been included

for its discussion of Mantegna's distemper paintings.

Folk Art and architectural and decorative finishes
Some references are provided on European, Scandinavian, and American folk art, including an article by Schreiber (1979) that describes the methods and materials used in Austria.

Innes (1990) provides a very thorough account of Scandinavian folk painting technology and the range of materials used by Nordic painters. These include rye flour with casein (usually in the form of buttermilk) for exterior and interior paints, beer and vinegar for glazes and marbling, and animal blood and the juice of loganberries and blueberries as tinting agents. The wide range of colorants, vehicles, and binders derived from animal and plant products used to make distempers, gouaches, and temperas are also described in detail.

Blood serum was used in Colonial America as a binder (Candee 1965). Early American paints often had to make do with local materials because of import taxes, blockades, or simple frugality. This has created a situation in historic buildings where large areas of wall surface and painted or stenciled wallpaper are matte and highly friable. A report by Phillips (1989) on the Morse Libby Mansion in Portland, Maine, gives an idea of the nature and extent of the problem faced by architectural conservators.

Information about early American architectural finishes has been discovered during the dismantling or restoration of period structures (Cummings 1971). Mussey (1982) described

the materials and techniques used on furniture. Considerable confusion about materials and nomenclature as well as widespread adulteration and substitution made it quite difficult to compound the same coating twice.

Recently, a great deal of interest in the original finishes of structures has arisen. For example, Bonet (1990) outlines the history and styles of architectural painting in Catalonia. This trend toward historical and technological studies of architectural finishes is represented in this chapter by a range of other studies (Mora 1984, 1986; Brochard 1990; Lavalle 1990; Moulin 1990; Prevost-Marcilhacy 1990). Wallpapers present an especially difficult problem with friability. Lynne (1980, 1980-81) provides information on the history and conservation of American wallpapers.

Wall paintings

Abstracts referring to wall paintings are presented more as a selective introduction to particularly seminal works rather than as a comprehensive survey. Some discussion of early wall painting has been included (Immerwahr 1990) but for the most part readers are directed to the definitive work of Mora et al. (1984); recent conference proceedings can give the reader an idea of developments in the last decade.

Contemporary art

Many modern and contemporary artists began to incorporate unusual materials and working methods into their painting styles. Ed Ruscha used substances such as emulsified raspberries, gunpowder, or Pepto-Bismol in his silkscreens. These comprised both pigment and binder (Morgan 1981). Willem de Kooning apparently incorporated ingredients such as safflower oil and mayonnaise (Russell 1978); Jackson Pollock (1947) added sand and broken glass. Ernst Ludwig Kirchner's painting technique is described by Miesel (1970).

Some artists patented the paints they formulated, such as "Yves Klein Blue"; this paint, which dries to a matte and very delicate surface, was developed by Yves Klein to fulfill requirements he could not meet with commercial paints. Mancusi-Ungaro (1982) described the composition of this paint in a technical note to a catalog of Klein's work. Franz Kline is cited as leaching the binder from black commercial paint with turpentine to achieve a matte effect (Goodnough 1952).

There are resources available to help in understanding the bewildering array of materials introduced in the 20th century. Articles by Mayer (1950, 1951, 1954) and Longo (1956) from the technical columns of *Art Digest* and *Arts* describe working methods and materials used by artists during the period. Collins (1983) gives an excellent overview of twentieth century techniques and materials. French (1989) also discusses art materials currently in use. "Painters Painting," a 1972 film with an associated book published in 1984 (De Antonio), contains statements by Robert Rauschenberg about the random buying of unlabeled surplus paint for use in his paintings. The aims and attitudes of the artists, as well as the technology they employed may be uncovered using this type of documentation.

Several accounts of damage to Mark Rothko's paintings appear as case

studies of the disasters that can befall contemporary works of art (Cranmer 1987; Cohn 1988). Rothko's surfaces were created to be viewed at a certain distance and the artist took great pains to create certain types of matte surfaces. Otto Dix used a mixture of tempera and oil glazing in some of his paintings. Dix's technique is described in an article by Baudisch (1989). Willi Baumeister's techniques, which apparently incorporated undercoatings of buttermilk, are described in an article by Beerhorst (1992). Other artists are represented primarily as examples of the types of literature that can be useful, such as an interview with Joel Shapiro discussing his drawing techniques (Cummings 1990). Particularly interesting is Barnett Newman's (1990) comparison of his paint surfaces to Rothko's. A series of interviews by Götz (1992) elucidates the methods of a number of contemporary artists.

Rock art, Paleolithic European painting

The techniques used to create the cave paintings at Lascaux and Altamira have been the source of speculation since their discovery. Lorblanchet (1991) addresses this subject in some detail. The use of binders and the working methods have been the subject of a great deal of debate. Because of the common use of ocher, especially iron oxide red, general references to ocher are included in the bibliography.

Rudner's article (1983) on the methods and materials of Khoisan rock art provides a literature review and uses ethnoarchaeological methods to ascertain the use of blood and serum as binders. An earlier article in a paint industry journal also addresses these issues (Bryson 1952). Watson (1967, 1969) discusses the composition of paints in prehistoric North America. Dart (1953) describes pigment mining activities in Zimbabwe in the fifth millennium BC.

Another article cites ocher mining in Hungary (Meszaros 1955). Parts of France were, and continue to be, particularly well known for ochers. Defarges (1968) and Aillaud (1986) recount the history of ocher mining in France and the associated geology. Natale (1988) describes the stability of various earth pigments and their use by the paint industry.

The role of ocher, particularly red ocher, in human prehistory has been much discussed in the literature. A work by Rosenfield (1971) discusses ocher residues on Magdalenian scrapers and suggests that this may be the result of scraping pigmented hides. Published descriptions of red ocher in archaeological deposits may in fact be hasty or incorrect (Wreschner 1980) because the term ocher has been used in a generic sense for red, and the actual colorant could be an organic substance.

Lhote (1959) speculates that milk and acacia gum were used as binders in paintings in the Tassili-n-Ajjer area of North Africa. A recent article by Cole (1992) discusses the analysis and remains of fibers and other microscopic remains to identify binders and fibrous materials used as paint in Australian Aboriginal rock art. Analyzing the remains of fibers and other microscopic remains may be a way to identify binders and fibrous materials used in paint application.

Paint industry literature

Works from the paint industry have been included in the history section when they address the history of paint. Particularly noteworthy are the works of Margival (1950, 1954, 1955, 1959, 1960, 1961, 1965) that include a series of articles for the French paint industry journal *Peintures, Pigments, Vernis* dealing with the history of paints. Scholz (1953) discusses the history of water-based paints.

Some works on the history of natural resins used as binders in the paint industry have been included, as well as literature on the historical development of paint as a whole, to provide background information on the sources of binders and on the general properties and composition of paints (Mantell 1938, 1941, 1942; Seymour 1981; Hadert 1954).

Conservation science

Conservation science as a distinct discipline has its origins in the work of researchers such as Lucas and Leechman. Lucas' work *Ancient Egyptian Materials and Industries* remains a classic of its type, although the enormous advancements made in analytical science have revealed weaknesses in his work. Several editions have been included in this work, since the later editions are considerably revised (Lucas 1934). A recent publication on the plant materials from Tutankhamun's tomb is included as well (Hepper 1990).

The launching of the journal *Technical Studies in the Field of Fine Arts* was a critical moment in the history of the conservation profession. Early versions of Gettens and Stout's encyclopedia appeared in the journal in 1937. Ultimately, the compilation was is-

sued in encyclopedia form in 1942 and a Dover paperback edition in 1966 (Gettens and Stout 1966). Literature on the conservation and restoration of Western paintings, particularly easel paintings, has been referenced extensively elsewhere; however, some of the major sources have been included such as Mayer's handbook (1938) and other literature dealing with tempera paints (Borradaile 1942; Brummer 1942).

A number of articles discussing the analysis of plant gums will be found in Chapter 2, "Analysis." However, an article by Brochwicz (1963) looking at gums cited in old treatises and their identification in works of art is included in this chapter.

Chapter 2
Analysis

Commentary

This chapter is concerned with analytical methods that can be used to identify binders and help verify historical accounts. It focuses on the identification of rare, water-soluble materials of plant or animal origin, which may degrade or have insufficient adhesive properties. Another focus of the "Analysis" chapter is the identification of both inorganic and organic pigments through the use of relatively straightforward and widely accessible techniques such as polarized light microscopy.

Because of recent advances and developments in the analysis of binders, reference is made to thin layer chromatography, high performance liquid chromatography, pyrolysis gas chromatography, pyrolysis mass spectrometry, infrared spectroscopy (Cousins 1988), colorimetry and visible light spectroscopy (Johnston-Feller 1994[5]), and microspectrophotometry (using both visible reflectance and infrared spectroscopy (Derrick 1994[6] in press)).

Stoner (1994[7]) has pointed out that, in the early years of conservation (prior to World War II), "the history of paintings conservation and the history of conservation were essentially one and the same." For example, in *Technical Studies in the Field of Fine Arts* (published 1943-52), 70% of the articles were about paintings, and most of these primarily about easel paintings. From 1977 to 1989, 30% of the articles published in the *Journal of the American Institute for Conservation* were about paintings. Moreover, the analysis of paintings has until recently focused more on the identification and characterization of pigments than on the paint binder.

Painted objects in general have not aroused the same level of interest as those objects that fall within the field of fine art, and as a result, comparatively little is known about their composition. In addition to this problem, two additional difficulties were encountered in the historical development of the analysis of their paint. One was the lack of the instrumental and microchemical methods of analysis that might allow identification of small amounts of binder present in the small samples that can be ethically removed from an object; another difficulty was the availability of reference collections of organic and inorganic materials to aid in identification (Gettens 1969, 1972). Today, both these issues are actively being addressed by the conservation community.

Because funds and instrumentation available are often quite limited, "low-tech" methods of analysis are of fundamental importance. Arguably, the most useful of these are the optical microscope and microchemical or spot tests. New methods of characterization are being explored, such as the identification of organic binders based upon tests developed for the medical industry to identify broad classes of compounds such as proteins, sugars, oils, etc. (Stulik and Florsheim 1992). Additionally, the practical possibilities of applying thin layer chromatography to these problems are increasingly becoming recognized (Striegel and Hill 1994).

The ubiquitous presence of iron oxide as a red colorant has sometimes lead to the untested and erroneous conclusion that a red pigment is iron oxide. Portell (1988), primarily using polarized light microscopy and some microchemical tests, was able to identify iron oxide, one example of red lead, and a variety of powdered wood pigments in 40 samples of African red pigments. These red pigments, friable and matte in appearance, were indistinguishable with the unaided eye but readily differentiated with the microscope. Because solvent tests produced a variety of color bleeding and staining, she concludes that "All African objects painted red should have the pigments examined prior to using solvents to clean, to readhere fragments with adhesive, or to consolidate very powdery paint."

The opposite end of the spectrum of analytical difficulty from the successful resolution of problems with simple microscopic observation can also be found in archaeological and ethnographic objects. North American blue pigments such as "Maya blue" and "Seri blue" were manufactured from indigo or other colorants applied to clay; in the case of Maya blue, this resulted in a colorant that was stable in hot concentrated mineral acids and to heating to 250°C (Van Olphen 1966). It thus had characteristics of both organic and inorganic compounds, presenting a unique difficulty in the types of analysis employed and the interpretation of the results (see De Henau et al. 1966; Kleber et al. 1967; Cabrera Garrido 1969; Shepard and Pollock 1977; Littman 1980, 1982; Torres 1988).

In addition to the paint layer itself, consolidation problems of matte paint are also often associated with disintegration of the ground, as often seen in frescos or painted architectural sculpture. Methods of analysis of plaster are included for Mesoamerica (Hyman 1970) and India (Paramasivan 1975).

The process of identifying pigments using microscopy and microchemical tests has been described by McCrone (1979, 1982; McCrone et al. 1984) and Feller and Bayard (Feller 1986). McCrone's (1980, 1980, 1981, 1986, 1987-1988) exceptional work on the identification of the pigments (red iron oxide and vermilion) and binder (glue) in the Shroud of Turin is included as an example of how both pigment and binder may be identified through the use of polarized light microscopy and microchemical tests in conjunction with reconstruction of possible painting processes. McCrone (1994[8] in press) has recently discussed the general utility of microscopy to the field of art conservation.

Most references referring to colorimetry and visible light spectroscopy are included in Chapter 3, "Properties," because they are related to the discussion of why changes in appearance (gloss, discoloration, or darkening) occur. However, the review of colorimetry and spectrophotometry for the analysis of museum objects by Johnston-Feller (1994[5]) should be pointed out because of the great potential utility of this method of analysis, in particular the analysis of reflectance curves, for identifying organic and inorganic pigments without taking a sample.

General survey of the chapter

General reviews

The content of reviews on the identification and characterization of organic binders in paint changes considerably as new advances are made in analytical techniques or as yet unused techniques are applied. Reviews included in the bibliography are those for general classes of organic materials used as vehicles and binders (Masschelein-Kleiner 1963, 1986; Masschelein-Kleiner and Tricot Markx 1965; Masschelein-Kleiner et al. 1968; Masschelein-Kleiner and Taets 1981; Pickova and Zelinger 1981; White 1981). Specific reviews cover the pigments and binders used in illuminated manuscripts (Flieder 1968), and in 15th- and 16th-century Italian paintings (Johnson and Packard 1971).

Mills and White's (1987) survey of the structures and chemistry of organic materials found in objects in museums and art galleries provides a useful, complementary reference and also discusses analytical methods for organic materials.

Spot tests and microchemical tests

The standard reference works on spot tests are *Spot Tests in Organic Analysis* (Feigl and Oesper 1966) and *Spot Tests in Inorganic Analysis* (Feigl et al. 1972). When these or similar tests are observed with the aid of a microscope they are termed microchemical tests (see also McCrone 1971 and Schramm 1985-86 on ultramicrominiaturization of microchemical tests).

Examples of the use of spots tests and microchemical examinations include the differentiation of types of paint on archaeological pottery in the Southwest (Hawley 1938), the analysis of adhesives and dyes (Bontinck 1941), artists' pigments (Malissa 1950), gums and gelatin (Ewart and Chapman 1952), pigments in Mesoamerican mural paintings (Littman 1975), and American Colonial house paint (Welsh 1990).

Staining techniques

Martin (1975) described the identification of proteins in paint media by coloration of thin layers with black amide. Mills and White (1978) described staining tests carried out on prepared sections as supplementary tests to gas chromatography for organic analysis. More recently Wolbers and Landrey (1987) reviewed current methods and materials for media characterization on small cross-sectioned samples, including the performance of stains and fluorescent reactive dyes. Derrick et al. (1993) have recently pointed out problems in the staining of cross sections due to the porosity of some types of paint and subsequent infiltration of the embedding media during the preparation of cross sections.

Instrumental analysis (including chromatography)

Infrared spectroscopy
Second only to optical microscopy, infrared (IR) spectroscopy is arguably the most useful and versatile analytical technique used in the field of conservation. Feller (1954, 1958) pointed out the utility of IR analysis for the examination of dammar and mastic both in regard to grades of resin and in regard to artificially aged samples.

The analysis of ochers is of obvious importance to painted ethnographic objects; Riederer (1969) used IR spectroscopy to characterize yellow and red iron oxide pigments (*see also* Da

Costa et al. 1991 for the identification of hematite and goethite by Mossbauer spectroscopy). The nondestructive uses of IR and x-ray diffraction analysis of paints were compared to microchemical tests by Heilman (1960).

Birstein (1975; Birstein and Tul'chinsky 1976) has published a number of studies using IR spectroscopy on the organic components of ancient middle Asian and Crimean wall paintings. Orna et al. (1989) identified colorants and proteinaceous materials found in Byzantine manuscripts by Fourier transform infrared spectroscopy (FT-IR). Gianno et al. (1987) analyzed over 100 botanically identified resins from Southeast Asia along with archaeological resins, adhesives, and coatings from ethnographic objects using FT-IR. Well-defined samples of aged paint binders have been analyzed by FT-IR in order to study the aging products, the modifying effects of artists' pigments on the binder, and the utility of the findings in the characterization of unknown media (Meilunas et al. 1990).

Over the past 10 years there has been an increased use of infrared microspectrometry in the analysis of cultural artifacts, a method which allows mapping of functional groups and other characteristics identifiable by IR absorption in microscopic cross sections (Derrick et al. 1991).

Chromatography
The potential of paper chromatography for the analysis of organic materials was discussed by Feller for resins (1958) and by Hey for paint media in general (1958).

General reviews of analytical procedures involving liquid or gas chromatography (GC) have been included for the identification of polysaccharides (Matousova and Bucifalova 1989), resin acid methyl esters (Zinkel and Rowe 1964), carbohydrates (Petrovic and Canic 1969), dyestuffs and resins (Rolofs 1972), sugars (Ghebregzabher et al. 1979), proteinaceous media (Zelninskaia 1981; White 1984), plant gums (Twilley 1984), and organic binders in general (Smith and Montgomery 1959; Mills and White 1985).

Thin-layer chromatography (TLC) has been used for the identification of proteins in tempera paintings (Masschelein-Kleiner 1974), wax seals (Baggi and Murty 1982), resins and waxes in ethnographic objects (Bowden and Reynolds 1982), and fats or oils used in the production of Australian Aboriginal objects (Gatenby 1993).

High performance liquid chromatography is a powerful chromatographic technique which has recently been applied to the identification of paint binders: mammal glues and rice paste in Buddhist polychrome sculpture and casein in Buddhist paintings (Sinkai and Sugisita 1990; Sinkai et al. 1992); and amino-acid analysis of the proteins in a 15th-century Italian panel painting (Halpine 1992).

A particularly interesting and potentially significant use of gas chromatography was the study of Skans and Michelsen (1986) (*see also* Skans 1989) who found that fatty acids can be used as a "fingerprint" indicating from which animal or tissue a glue came.

Gas chromatography has been used for the identification of paint binders, particularly drying oils, and the

changes in the films of drying oils as they age (Stolow 1965; Mills and White 1972, 1976, 1978, 1979); proteinaceous binders (Masschelein-Kleiner 1976; Kenndler et al. 1992); conifer resins (Mills and White 1977); tempera (Maue 1979); and ancient pine resin (Shackley 1982).

Pyrolysis gas chromatography has proved to be a sensitive method for the analysis of drying oils, gums, or natural resins (Kiyoshi et al. 1973; Rogers 1976; Matteini et al. 1986; Shedrinsky et al. 1987-88; Shedrinsky et al. 1988; Derrick and Stulik 1990), synthetic resins (Breek and Froentjes 1975; Sonoda and Rioux 1990), commercial waxes (Lawrence et al. 1982), modern synthetic paint binders (Challinor 1983; Stringari and Pratt 1991), and ancient Egyptian mummy cases (Wright and Wheals 1987).

Mass spectrometry
Another analytical technique that is particularly useful for the differentiation of paint binders (Weiss and Biemann 1976) and that is seeing increased use is mass spectrometry (MS). Gas chromatography combined with mass spectrometry has been used to analyze tannin hydrolysates from the ink of ancient manuscripts (Arpino et al. 1977), mixtures of organic binders (Mills and White 1982), oils in Hawaiian oiled tapa (Erhardt and Firnhaber 1987), and aged pine tar (Reunanen et al. 1989; Hayek et al. 1990; Hayek et al. 1991). The degradation products of 18th-century anatomical beeswax models were identified by combined GC/FT-IR/MS (Kenndler and Mairinger 1990).

Pyrolysis gas chromatography mass spectrometry is both more sensitive than mass spectrometry alone and is applicable to a wider range of materials (Wupper 1979). This technique has been used to study organic residues of archaeological origin (Evershed 1990; Chiavari et al. 1991) and organic media in paintings (Chiavari et al. 1992; Chiavari et al. 1993).

Thermal methods
Differential thermal analysis has been used to characterize the binder and to provide an indication of the age of a painting (Odlyha and Burmester 1987; Burmester 1992).

The problem of degradation and mixtures of binders
Problems associated with microanalytical techniques for the identification of organic materials have been discussed in general (Sturman 1980), and specifically for proteins (Jones 1961). Birstein and Tul'chinsky (1981) discussed changes in the IR spectra that are the result of structural alterations due to natural aging of gelatin and collagen in glue used as a binder. Lalli et al. (1987) have prepared a reference collection of organic materials, alone and in mixtures, in order to age them and determine not only changes in composition but also changes from possible interactions between them (which will be followed by IR spectroscopy). Derrick (1989) discusses the potential and limitations of FTIR spectroscopy for the characterization of mixtures of natural organic materials and aged natural materials.

Delbourgo and Gay (1968) discuss the problems encountered in a variety of analytical techniques for the examination of organic remains on archaeological objects. Loy and Nelson (1986) study sophisticated techniques such as isoelectric focusing and radio-immuno assay to complement

microscopic and biochemical methods used to detect residues and to identify species of origin of plant and animal remains on prehistoric tools thousands of years old. De Silva (1963) discusses problems in the interpretation of tests used for the analysis of binders in wall paintings due to impurities in the binder or mixtures of several binders.

Forensic examination of paint
A number of useful analytical techniques for the analysis of paint pigments and binders have been assessed by forensic chemists (Cousins 1988; Nielson 1984). Micromethods used in forensic science which have potential uses in the analysis of cultural objects include: microspectrophotometry (Laing et al. 1980; Cousins et al. 1984) to identify the pigments in paint samples from the visible reflectance spectra; complementary benefits of pyrolysis gas chromatography, pyrolysis mass spectrophotometry, and infrared spectroscopy (Burke et al. 1985); and the reflectance spectra of colored thin layer chromatography spots by microspectrophotometry (Fuller 1985).

Chapter 3
Properties

Commentary

Some physical and optical properties of matte porous paint are considered in this chapter in order to lay a broad foundation for the discussion of possible reasons for successful or unsuccessful treatment strategies presented in Chapter 4, "Treatment."

Applying a consolidant to the surface of a powdering matte paint may cause darkening or an increase in gloss resulting in a marked change in appearance. A noticeable "tide line" (a dark outline defining the extent to which the consolidant solution has spread) may appear if the surface is not fully covered. An adhesive solution, applied at the interface of a substrate and a porous flake, may wick into the flake resulting in similar changes in appearance. Two of the major difficulties encountered in the consolidation of this type of paint are: 1) imparting sufficient consolidation to the paint and adhesion of the paint to the substrate; and, 2) determining how to measure or quantify the effect that the application of different materials by various methods has on the physical and optical properties.

Changes in lightness and chroma are often due to changes in the pigment volume concentration (PVC), defined as the ratio of the pigment volume to the pigment and binder volume:

$$PVC = (\text{pigment volume})/(\text{pigment volume} + \text{binder volume})$$

The coatings industry has long been aware of the importance of an understanding of PVC, especially the property of critical pigment volume concentration (CPVC), because PVC affects the manufacture, application, performance, and appearance of coatings (Asbeck 1992). It is just as imperative for conservators working with painted surfaces as for coatings manufacturers to be aware of what PVC and CPVC are and how they affect paint properties. For the conservator, this understanding is an important consideration in the selection of suitable treatments for high PVC coatings.

Since the late 1920s (Stieg 1973), it has been recognized by the coatings industry that the formulation of paint needed to be approached on the basis of volume relationships rather than weight relationships. The reason for this is illustrated in Figure 1, the pigment volume "ladder" (Asbeck 1992). The ladder shown is a schematic of a paint system where all pigments have the same size and refractive index. It illustrates a 10% increase in each "step" from 0% pigment, totally comprised of binder, to 100% pigment (highest PVC). As the percentage of binder is decreased, the void space between pigment particles increases past the CPVC.

The CPVC is the point when all the air between pigment particles has been replaced with binder. In practice, CPVC must be experimentally determined for each pigment and binder system; CPVC generally falls in between 30% and 65% PVC (Feller and Kunz 1981).

Below the CPVC, with excess binder, the surface becomes smoother and glossier. Many coating properties change radically at CPVC, because this is the idealized point where the coating changes from being a porous

system to a solid system. This can be demonstrated by plotting properties, such as gloss and permeability, against the PVC ladder. Representative curves are illustrated in Figure 2.

Both the physical and optical properties of a paint depend upon the PVC. A matte, porous paint is at a PVC above the CPVC. Because little binder is present, extendability and strength decrease at higher PVCs. The lack of physical integrity is one reason why porous paint often needs consolidation.

The general reason why darkening occurs is due to the way diffusely reflected light is perceived. Below the CPVC, pigment particles protrude minimally above the binder, and in the case of a smooth surface the specularly reflected light will be perceived as glossy or shiny. When the amount of binder is reduced and pigment particles increasingly protrude above the surface of the binder, the surface becomes rougher (less mirror-like) and the light hitting the surface is more scattered or diffusely reflected. The scattered light will be additively mixed as the "white light" of the illuminant to the reflectance spectrum of the object surface, and the net effect will be the perception of a lighter color.

Thus, differences in the surface structures of materials must be avoided if colors are to match, as in the case of before-and-after consolidation treatment. This problem has long been recognized in the coatings industry, where two colors which appear identical at one angle, but which no longer match if the viewing angle is changed, are called "geometric

metamers." The diagram of geometric metamerism reproduced in Figure 3, showing the effect of the amount of pigment protruding from a film, was originally prepared (Johnston 1967) to emphasize the critical effect PVC has on the appearance of matte paint.

Scattering is also affected by the amount of air/pigment interfaces in a paint film, as well as by the refractive index of the pigment particles involved. At higher PVCs , there are increased amounts of void spaces which scatter larger amounts of light that will be further additively mixed as white. This was illustrated by Feller and Kunz (1981) who measured the surface reflectance at 440 nm of ultramarine blue paint formulated at various PVCs (440 nm is the wavelength at which the maximum reflectance will occur when the paint is saturated with binder). Figure 4 shows how, for ultramarine blue in dammar, with increasing PVC (and therefore increasing void space which results in greater scattering at air/pigment interfaces) the amount of reflected, diffusely scattered light increases and the color becomes lighter.

Feller and Kunz (1981) initiated their study in part to demonstrate the fact that the darkening phenomenon associated with high PVC paint was primarily a result of the filling of void spaces, and not primarily due to differences in the refractive indices of the pigment and the binder. They found a series of polymers of different refractive indices were similar in their darkening effects for ultramarine blue paint formulated at different PVCs. The conclusion that individual refractive indices of pigment and resin are relatively unimportant in the darkening that occurs when

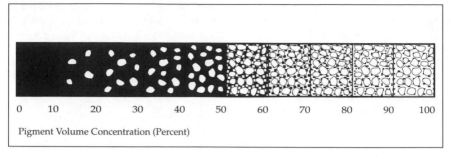

0 10 20 30 40 50 60 70 80 90 100

Pigment Volume Concentration (Percent)

Figure 1. The Pigment Volume Concentration Ladder (after *Asbeck 1992*).

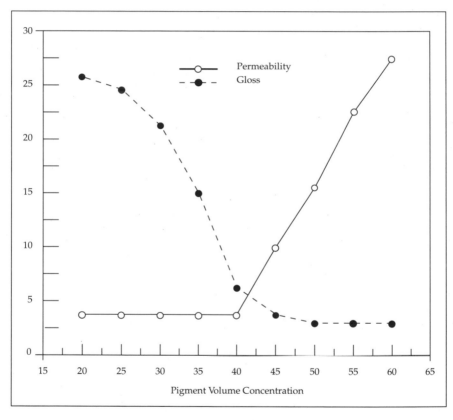

Figure 2. Representative graphs of changes in some paint properties plotted versus the PVC (after *Asbeck and Van Loo 1949*).

impregnating porous paint (at a very high PVC) is an important one when trying to determine the materials and methods that might be useful for consolidation treatments.

Factors affecting the deterioration of high PVC coatings are related to increased porosity and permeability and decreased strength and flexibility. Porous paint is more open to the effects of oxygen and water or humidity, and may degrade relatively faster than a less permeable coating through environmentally-induced deterioration and biodeterioration. Similarly, protective effects with respect to the ground or substrate may be lessened. Other factors affecting deterioration are: the size, shape, and distribution of pigments; binder/pigment interactions; solvent systems of the vehicle; and the physics of drying, including the development of internal stress (also related to the thickness) in an applied wet coating.

Abstracts of articles on the theories of leveling of coatings and conformational coating of rough surfaces have also been included in this chapter. In the conservation literature, the most influential has been Feller's (Feller et al. 1984) discussion of control of the appearance of freshly applied varnish on paintings. Feller used a diagram similar to Figure 5 to show that, if a solvent-type varnish forms an immobile gel at a point when considerable solvent still remains, it will tend to form a surface which follows the irregularities of the paint underneath the varnish. Similarly, polymers of high viscosity grade (highly viscous at low solids content) will stop flowing over a surface sooner than resins with a low viscosity grade (less viscous at a similar solids content). Because a coating that is not able to level itself tends to form a nonglossy surface, factors that inhibit the length of time allowable for a solution to flow over a rough surface (such as a rapid loss of a highly volatile solvent) promote a matte finish.

General survey of the chapter

The discussion that follows briefly comments on literature in the chapter other than that mentioned above. Some references to causes of paint deterioration due to other considerations than high PVC are included.

Historical development

In his review on the influence of PVC on paint properties, Stieg (1973) states that the true value of the concept of PVC in paint technology is "its use to predict the performance of paint systems in such diverse areas as viscosity, exterior durability, film porosity, hiding power, and color uniformity over adjacent sealed and unsealed substrates." This conclusion is the result of many years of study of the durability of paints in relation to the nature of their formulas in the wet state, until the concepts of PVC (Asbeck and Van Loo 1949) in the dry state became recognized and established.

The first papers to recognize explicitly that paint properties were more properly understood by considering volume relationships than weight relationships appeared in 1926 (Calbeck; Rhodes and Fonda). See Stieg (1973) for an overview of the historical development of these concepts, in which for many years investigators "naively" assumed a relationship between paint viscosity and exterior durability (Klumpp 1927; Wolff 1930,

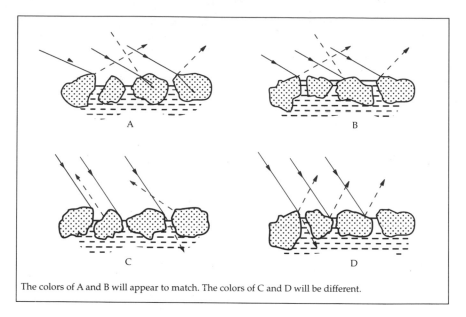

The colors of A and B will appear to match. The colors of C and D will be different.

Figure 3. Geometric metamerism (after *Johnston 1967*).

Figure 4. Graph of the percent reflectance at 400 nm plotted versus the PVC of ultramarine pigment in dammar (after *Feller and Kunz 1981*).

Figure 5. Leveling of solutions of high and low viscosity grade polymers (after *Feller 1985*). 1a. Level of solution of low viscosity grade polymer when applied (wet). 1b. Level of solution of low viscosity grade polymer which continues to flow at high solids concentration while drying. 2a. Level of solution of high viscosity grade polymer when applied. 2b. Dry film of high viscosity grade polymer which ceases to flow at high solids concentration while drying and follows the irregularities of the surface.

1932, 1933; Wolff and Zeidler 1933, 1935, 1936; Elm 1934).

General reviews
Physical principles of paint properties, including deterioration and appearance, were discussed early on by Bontinck (1943) and Van Loo (1956). Stieg considers PVC and CPVC in a discussion stressing the relationship of coating performance to particle size in the *Pigment Handbook* (1973). Patton's (1979) practical guide to the concepts relating to paint flow, pigment dispersion, and related technology for the paint industry includes a thorough discussion of PVC and paint properties. Paint deterioration relating to many factors besides pigment volume concentration are discussed by Hess (Hess et al. 1979) in *Paint Film Defects: Their Causes and Cure.*

Bierwagen and Rich (1983), Bierwagen (1984), and Floyd and Holsworth (1990) reviewed the literature on the concept of the critical pigment volume concentration in relation to latex coatings. Bierwagen reviewed the effect of PVC of a coating on its service lifetime or durability (1987), and on the performance of coatings in general (1990). Asbeck (1992) and Bierwagen (1992) have more recently reviewed the concept of CPVC and how it influences the behavior of coating systems. Weaver (1992) discussed CPVC both as a theoretical and a practical concept.

Pigment volume concentration and critical pigment volume concentration
Discussions of PVC and CPVC often center around measurement techniques for their determination (Asbeck and Van Loo 1949; Stieg 1958;

Cole 1962; Pierce and Holsworth 1965; Schaller 1968; Rudolph 1976; Castells et al. 1983; Culhane et al. 1983; Stieg 1983; Gibson et al. 1988; Braunhausen et al. 1992).

References to the relationship of pigment volume concentration to various properties include particle size and hiding power (Piper 1939); penetration, color, and sheen uniformity (Stieg and Burns 1954); film thickness and optical properties (Craker and Robinson 1967); ultimate tensile properties of films (Evans 1967); opacity and the rate of fading of organic pigments (Camina 1968; Johnston-Feller 1986); film density (Eissler and Baker 1969); luster and organic pigments (Funke and Zorll 1973); mechanical properties of paint films (Toussaint 1974; Zorll and Hyde 1975); adhesion (Montreal Society for Coatings Technology 1976; Kannan et al. 1990); matting performance of silica gel in clear coatings (Algieri et al. 1978); color matching (Marcus and Welder 1978); tinting strength and degradation (Kaempf 1979); calcium carbonate in paper coatings (Zeller 1980); and, coating durability (Boxall 1981; Rutherford and Simpson 1987).

CPVC has been discussed in reference to color (Stieg 1956; Ghisolfi 1984); opacity (James 1957); particle size, film shrinkage, porosity, and hiding power (Stieg 1959); hiding power (Adams 1961); bond strength of pigmented films (Reddy 1972); as a function of vehicle systems as well as pigment composition (Wiita 1973); internal stress in pigmented thermoplastic coatings (Perera and Eynde 1981); Young's Modulus, magnetic moment, abrasive wear, and gloss (Schaake et al. 1988); solvent systems and Young's Modulus (Huisman et al.

1989); density fluctuations and void formation (Fishman et al. 1992; Floyd and Holsworth 1992); and, corrosion resistance of organic paint films (Skerry et al. 1992). Hegedus and Eng (1988) describe a method to obtain optimum coating compositions of multipigment systems by integrating CPVC predictions with statistical formulation design.

The reduced pigment volume concentration (the PVC/CPVC ratio, Λ) has also been shown to be an important consideration for optimizing paint formulations to control paint properties (Bierwagen and Hay 1975).

Pigment size, shape, and particle-size distribution
The size, shape, and particle-size distribution of pigment particles have been discussed in relation to durability, gloss, hiding, and chemical activity (Elm 1959); general optical properties (Ferrigno 1959); reflectance, hiding power, tinting strength, and color uniformity (Hall 1959; Morgan 1959); viscosity, penetration, and hiding power (Stieg 1967); packing efficiency (Bierwagen and Saunders 1974); porosity and optical properties in paper coatings (Alince and Lepoutre 1980); opaque polymer beads or microvoids (Hook and Harren 1984; Fasano et al. 1987; Fasano 1987; Grange et al. 1987) oil absorption of pigments and determination of CPVC (Huisman 1984); hiding during latex film formation (Anwari et al. 1991); and, gloss of paint films (Braun and Fields 1994).

Gloss: definition and measurement
Harrison (1949), Morse (1973), Zorll (1973), Simpson (1978), Billmeyer (1985), and Hare (1990) have re-

viewed the literature on gloss or luster. Types of gloss and the connection between gloss and color were discussed by Judd (1952). Cermak and Verma (1985), using statistical analysis, concluded that subjective judgments of the appeal of paint samples were best predicted by color and gloss, and to a lesser extent by distinctness-of-image gloss. An excellent summary was recently presented by Seve (1993) with specific attention to the problems raised by the evaluation of perceived gloss with physical quantities.

Goniophotometric analysis (Johnston 1967; Baba 1969; Hemmendinger and Johnston 1969; Johnston and Stanziola 1969; Osmer 1979) is of particular importance, as noted above in reference to geometric metamerism, because color can be characterized as a function of both illumination and viewing angles.

The examination of spectral reflectance curves offers a wide range of qualitative and quantitative information (Johnston and Feller 1963; Johnston 1966). Particularly important is the differentiation between chalking or fading, which may be discerned by reference to the specular and diffuse reflectance (Johnston and Feller 1965; Johnston-Feller and Osmer 1977).

Factors affecting leveling of coatings
Bruxelles and Mahlmann (1954) discussed the gloss of nitrocellulose lacquer coatings in regard to the viscosity and leveling of the coating as it dried. Feller incorporated these ideas into a discussion of factors affecting the glossiness of picture varnishes (Feller et al. 1985). Smith et al. (1961) outlined a mathematical model for the leveling process of simple liquids

and applied this to residual stress in brushmarks and brushmark formation on a surface. Overdiep (1962, 1986) expanded this work by also considering solvent volatility and surface tension; Orchard (1963) considered surface tension to be the dominant factor. The importance of surface tension and leveling to the optical properties of picture varnish has also been the subject of some debate (*see* De La Rie 1987, 1989).

References from the conservation literature
In perhaps the earliest spectrophotometric measurements of artists' materials, Barnes (1939) investigated the color of 51 matte artists' pigments in conjunction with the Department of Conservation and Research of the Fogg Art Museum, Harvard University. Bontinck (1944) described the difficulties in fixing pastel without causing a change in appearance, and gives a historical survey of the materials used to fix pastels.

Cadorin and Veillon (1978) gave a definition of matte paintings in relation to painting media, techniques, and surface coatings; similarly, Parra (1975) discussed matness in terms of standard physical parameters for the conservation field. *In Light: Its Interaction with Art and Antiquities*, Brill (1980) reviewed many factors relating to object appearance.

In the field of conservation, the influence of PVC on the chalking tendency of films was understood early on (Feller and Matous 1964; Hours et al. 1967). Ghisolfi (1983) examined the physical structure of watercolor films having a high PVC.

Deterioration (including nomenclature)

Stout attempted to describe paint as a material using a limited terminology (1938) and developed a scheme for describing degradation (types of laminal disruption of a paint film (1977)). Callegari (1983) attempted the codification and classification of different types of craquelure in a thesis on the formation of craquelure (including internal causes).

Brachert (1956) discussed the problems of rapid deterioration, severe cracking, and loss of both the ground and oil paint itself in paintings. Problems in contemporary works which are the result of improper preparation of paintings and the use of incompatible materials by the artists have been noted (Keck 1960, *see also* the discussion of contemporary art in the previous introduction to the "History and Technology" chapter). Causes of deterioration in general to works of art including plasterwork, stucco, and mural paintings have been reviewed by Gebessler and Eberl (1980).

The effect of pigment and binder interaction on the characteristics of paint, including mechanical strength, was studied through microscopic examination of pigment/vehicle interaction during film formation (Jettmar 1969). Perera and Eynde (1981) discussed the origins and measurement of internal stress in organic coatings and the influence of the nature of binder, pigments, solvents, temperature, and relative humidity. Braun (1991) has discussed the mechanism of pigment involvement in the loss of gloss of films, in relation to surface tension and the shrinkage of a drying paint film. Michalski (1991) modeled the interparticle bond in gesso as a function of the gesso recipe, and predicted the mechanical properties of gesso based upon that of glue alone. Michalski has also investigated the effect of thickness of an applied layer and the degree of adhesion to the substrate in relation to cracking.

Chapter IV
*Treatment**

Commentary

In this chapter, treatment methods and materials are discussed with reference both to the general properties of matte paint and to consolidation treatment and testing programs reported in the conservation literature. The aim is to explore as many options as possible for the treatment of matte paint. Particular emphasis is given to treatment strategies that are most likely to achieve minimum change in appearance with the required degree of consolidation. The way that this can be achieved in any given instance depends on an understanding of the relationship between the physical characteristics of the paint and the variety of treatment systems that might be suitable for use.

In order to visualize this relationship, the schematic representation shown in Figure 6 was developed. It is not intended as a guide to selecting particular materials or methods but rather as an aid to developing relevant treatment strategies. It indicates, for example, that the treatment strategy required to consolidate crumbling or flaking paint could be different from the one required to consolidate powdering paint. Even for powdering paint the strategy might vary depending on whether the paint was applied as a thick or as a thin coating. In

practice, object surfaces occur in a variety of conditions ranging from flaking to crumbling or powdering within the same area; high PVC paint may be adjacent to, or layered over, paint with a high resin content; several overlaid areas of paint may each exhibit different problems, such as flaking paint on a powdering ground.

Nature of the problems and implications for treatment

Progress in the development of satisfactory treatments for matte paint has been slow, due to the complex and conflicting nature of the problem: the need to convert highly porous, loosely bound matte paint into a coherent layer that can be safely adhered to a support without damaging the paint, or changing its color or reflectance characteristics. The tendency in the past has been to concentrate mainly on the specific properties of treatment materials to achieve the desired outcome rather than on the treatment system as a whole. This somewhat restricted approach has often been accompanied by unconfirmed or highly speculative theories to account for discoloration or the behavior of solutions, and confusing and sometimes conflicting conclusions about the stability of consolidants, their function and suitability for use on particular objects.

Discoloration is a common side effect of consolidation, usually as a result of the way that the consolidant is

*Throughout this bibliography and this introductory "topical review," reference is made to literature that states certain polymers were used, or certain methods were found useful, to consolidate paint on objects. However, these treatments often have not been tested or monitored over time. The authors wish to emphasize they are reporting, and in some instances commenting on, what has been published; they are not assessing the suitability of a procedure nor the "success" of a treatment for specific objects.

Figure 6. Schematic Representation of Paint
Properties and Possible Treament Options.

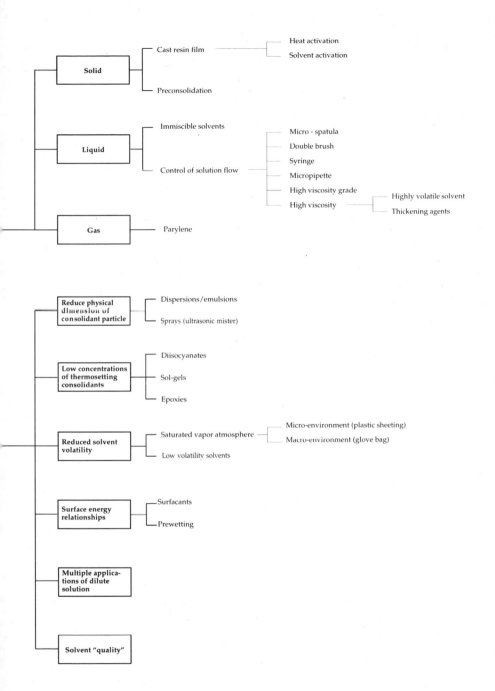

Solid
— Cast resin film
 — Heat activation
 — Solvent activation
— Preconsolidation

Liquid
— Immiscible solvents
— Control of solution flow
 — Micro - spatula
 — Double brush
 — Syringe
 — Micropipette
 — High viscosity grade
 — High viscosity
 — Highly volatile solvent
 — Thickening agents

Gas
— Parylene

Reduce physical dimension of consolidant particle
— Dispersions/emulsions
— Sprays (ultrasonic mister)

Low concentrations of thermosetting consolidants
— Diisocyanates
— Sol-gels
— Epoxies

Reduced solvent volatility
— Saturated vapor atmosphere
 — Micro-environment (plastic sheeting)
 — Macro-environment (glove bag)
— Low volatility solvents

Surface energy relationships
— Surfacants
— Prewetting

Multiple applications of dilute solution

Solvent "quality"

distributed in the paint layer. It may, however, also be due to solvent interactions or phenomena completely unrelated to appearance changes that are the result of the consolidant distribution: solubility of colorants or binders; solubility of dirt, fungus, and bacteria, or products of biodeterioration; and soluble components in the substrate. Schiessl (1989) has commented on the formation of tidelines from the physical redistribution of small particles in a paint that has a wide range of particle size. The flow of a solution moves the smaller particles, but leaves the larger particles in place.

Problems in evaluating treatments
When specific conclusions about materials and methods are desired from an evaluation, explicit testing criteria must be established as a basis for quantifying effects for comparison. The variables being compared must be sufficiently isolated to allow confidence that a change in a specific variable will have a quantifiable effect. In previous comparative studies (listed in the bibliography), this may not be clear. For example, Acryloid B-72 as a 5% solids solution in toluene may be compared with a 1% aqueous gelatin solution. If the stated result is that the gelatin solution causes comparatively less change in appearance following brush application, is this due to the difference in the optical properties of the two consolidants, or to the difference in the concentrations of the two solutions, or to the difference in the polarity or volatility of the two solvents used to make the solutions? Furthermore, what differences in consolidative strength resulted from the different treatments?

For example, Feller and Kunz (1981) suggested that when very little darkening results from the addition of a consolidant, analysis of the paint will show that it is still at a high PVC and subsequently there will be little improvement in the paint cohesion. Hansen et al. (1990) reviewed practical and theoretical information and concluded that treatment parameters, specifically solution properties (such as volatility, viscosity, and surface tension), were more important considerations than individual resin properties.

In addition to the difficulty in designing and carrying out comparative testing, and evaluating the results, there is the added difficulty of designing future testing when the reasons for the behavior of materials are not well understood. For example, two of the many possible explanations for the discoloration or darkening of porous powdering paint resulting from consolidation are: 1) the differences in the refractive indices of pigment and medium; and 2) reverse migration of resin from the interior to the surface with solvent evaporation.

Where interactions with resins are important and the PVC is comparatively low, there may be some concern for the effects of different refractive indices. As previously discussed, Feller (Hansen et al. 1990) believes that the refractive index rarely needs to be considered in high PVC systems.

Hansen et al. (1993), concurring with Domaslowski (1987-88) that the migration process is insufficiently known and understood by both scientists and conservators, used a different working assumption than "re-

verse migration" to account for higher resin concentrations at or near the surface of a porous paint that had been treated with a consolidant solution. Penetration of the consolidant solution into the paint was considered to be inhibited by a rise in the viscosity of the consolidant solution due to loss of solvent from evaporation, as opposed to resins first penetrating a system and then returning to the surface with solvent evaporation (reverse migration). Because suppression of solvent evaporation would diminish both a rise in viscosity as a solution flows into a system and reverse migration with solvent evaporation, the actual mechanism remains unclear.

Factors affecting the choice of materials
A wide range of issues need to be addressed in addition to the chemical stability and physical properties of consolidants. The situation is even further complicated by the fact that many of the physical properties of thermoplastic polymers used in conservation, including tensile strength, extendability, and the glass transition temperature, may be dependent upon the solvent or solvent systems used to make the solution that delivers the resin (*see* the discussion of solvent "thermodynamic quality" below).

Walston et al. (1987) suggested that desirable properties of resins for the consolidation of crumbling and flaking paint on ethnographic objects, in addition to causing minimal change in appearance, were those that promoted: suitable working properties for the particular application techniques to be used; physical and chemical compatibility with the paint layer and support; compatibility with the range of environmental conditions that might apply after use in treatments of objects; the formation of a sufficiently flexible bond between the paint and support to ensure good adhesion between materials with different levels of expansion and contraction; and long term chemical and physical stability. In a continuation of this study, Horton-James et al. (1991) examined a wide variety of tests that could be used to evaluate the stability, appearance, and performance of resins for the conservation of porous flaking paint on ethnographic objects. They concluded that the most useful information resulted from those tests that most closely simulated the object and its environment. They also emphasized the importance of determining the aging characteristics of consolidants since it is doubtful whether they could ever be removed if, in the future, they were found to be damaging.

Articles dating from 1935 in the literature survey indicate that the range of materials used in the consolidation of fragile surfaces vary widely and that their stability and properties are equally varied. These include natural products (beeswax, dammar, gelatin, funori, etc.), synthetic polymers (poly-(vinyl acetate)s, acrylics, soluble nylon, poly(vinyl butyral), epoxies, etc.), and inorganics (sol-gels). Resistance to chemical changes in the consolidant that would affect the color stability (darkening or yellowing), strength of adhesive bond, and solubility in the future are desirable qualities. References to environmentally induced chemical modifications of objects and conservation materials are not dealt with directly in this bibliography. However, the following discussion, which is concerned only with

materials that have been considered for the consolidation of paint, is included in this introductory text because the choice of materials is an important factor in treatment.

Feller (1978[9]) suggested standards for the evaluation of thermoplastic resins for use in conservation by developing a classification scheme. The divisions were made with the following considerations: Class A materials are expected to last in excess of 100 years with less than 20% change in the properties of interest; Class B 20 to 100 years; and Class C fewer than 20 years (materials in this class are generally considered unsuitable for use on museum objects). The initial laboratory-based criterion was the photochemical stability of resins and polymers in relation to loss of solubility; subsequent criteria included thermal discoloration and loss of molecular weight (Feller and Wilt 1990[10]). Materials used for the consolidation of painted ethnographic objects which may be class A, but still remain to be fully tested and reported on in the conservation literature, were placed in class B by Hansen et al. (1990) (this particular consideration was not used by Feller in 1978[9]). Although this classification scheme may be quite useful for assessing the suitability of chemical classes of resins, the problems still remain of assessing the aging characteristics of materials which vary according to manufacturer, or even from year to year by the same manufacturer, particularly in regard to emulsions which contain a wide range of additives.

A further complication is that aging characteristics vary according to treatment circumstance. Consolidants tested under controlled conditions in a laboratory may have very different characteristics when compared to those in a treatment situation. Aging properties can be affected by interaction with paint and object materials, as well as with the environment.

On the above basis, materials which may be given a class A rating at this date are some acrylic resins, poly (methyl methacrylate) (PMMA) and Acryloid B-72; poly(vinyl acetate) resins (in their supplied form as opposed to being a component of an emulsion or dispersion formula); and some water-soluble cellulose ethers (see Feller and Wilt 1990[10]). Poly(n-butyl methacrylate) (PnBMA) is a component of many emulsions, but is more prone to crosslinking than PMMA or Acryloid B-72. On this basis, PnBMA based emulsions would have a stability classification of B or C. Poly(vinyl butyral) (PVB) and ethylene vinyl acetate (EVA), also widely used, may be stable enough to be rated Class A; however, a definitive series of testing to elucidate the stability of these polymers is not known to the authors.

Poly(vinyl alcohol) (PVOH) may be given a Class C rating based upon the field observations of a number of conservators and tests indicating unacceptable performance in accelerated thermal aging tests (Feller and Wilt 1990[10]). However, it is unclear in what way PVOH has been used, i.e., whether as a resin dissolved in water or as an emulsion (a formulated commercial product). Recent testing (Bicchieri et al. 1993[11]) has suggested that PVOH is not a particularly unstable resin. (See Feller n.d.[12] for a more in-depth discussion of these issues).

I

A final comment on materials concerns the stability of gelatin. Gelatin was classified as a Class B material by Hansen et al. (1990) because, although under the right climatic conditions (low, stable relative humidity) the material may last in excess of several hundred years, it may also readily degrade if subjected to high humidities, fluctuating temperatures, and intense light levels (note the references to powdering distemper (glue-based) paint in the "History" chapter). The stability may also be influenced by the nature of the pigments (Kenjo 1974).

Laboratory-produced object facsimiles
The use of facsimiles to help model deterioration processes or treatment systems has not been widely reported in the literature although views about their advantages and disadvantages abound. If facsimiles are to be used, it is clearly important to determine the specific properties in the paint or treated paint system that are to be simulated and to keep variables to a minimum. Simulating old and complex paint is particularly difficult when the aim is to assess the effects of proposed treatment prior to carrying out work on objects. The nature and distribution of binders within the paint layer, interaction of binder and vehicle with the substrate, pigment particle size, quantity and distribution of dirt within the paint, multiple paint layers, and the effects of variation in color and properties must all be considered.

Walston and Gatenby (1987) used facsimiles in a study aimed at selecting a treatment material for the adhesion of flaking paint on an old and very rare Australian Aboriginal painted shield.

Even using the most promising materials, they found that appearance differences between treated facsimiles and a preliminary spot test on the object were very pronounced. For this reason, together with concerns about the stability of emulsions, further attempts at treating the object were abandoned. The variables of paint composition, thickness, dirt, and substrate had not been well enough reproduced in the facsimile to obtain a realistic picture of the effect that treatment materials would have on the object.

Horton-James et al. (1991) made extensive use of facsimiles in tests on the properties of materials for the adhesion of flaking paint and concluded that greater use of facsimiles would have been an advantage for many of the tests, provided improvements were made in their manufacture. In this instance, there was no direct comparison between treated facsimiles and treated objects.

Facsimiles can also provide useful practice surfaces for the development or refinement of treatment techniques. This is particularly significant for porous paint where treatment materials cannot be removed and the effects of treatment need to be assessed before tests on the object, since even small spot tests can cause appearance problems.

Treatment methods
The schema illustrated in Figure 6 is intended as a guide to help categorize paint problems and relate these problems to potentially useful treatment options. It is not intended to suggest any particular application method or material. It should be considered with the understanding that the

schematicized relationships remain subject to change or reinterpretation as more data becomes available. For example, it may prove desirable to break down further the categories of paint, perhaps into groupings based upon physical properties of pigments (particle size, refractive index, etc.) or the chemical composition of the binders.

The different treatment methods in the schema have been categorized in relation to the problems characteristic of the paints (flaking and porous, or powdering) and in relation to delivering a consolidant in a desired distribution (internally or at the surface). Because consolidants are usually delivered by brush or spray application of a solution, the factors affecting solution flow, particularly viscosity, are of primary interest.

The simplest definition of viscosity, found in most dictionaries, is "the resistance of a solution to flow" (*see also* the technical definition in the glossary). Of greatest importance to this discussion is the dependence of viscosity on the amount of polymer dissolved in the solvent; as the concentration increases, the viscosity becomes greater. When a polymer solution reaches a certain concentration through solvent evaporation it will essentially cease to flow. It is at this point that the distribution of the consolidant becomes fixed.

Therefore, highly volatile solvents and high-viscosity-grade resins can be used to form concentrated solutions that can be put to use either to promote the retention of surface roughness by inhibiting leveling or by decreasing penetration of the consolidant solution and the filling of void spaces by the addition of a consolidant. Conversely, by using an initially very low concentration solution, a low volatility solvent, or a means of slowing or inhibiting solvent evaporation, the flow and spreading or penetration of consolidants will be promoted.

A model of how inhibition of solvent evaporation may reduce darkening and the formation of tidelines outlining the extent to which a consolidant solution has flowed through a paint layer is shown in Figures 7, 8, and 9. Figure 7 shows the flow of a solution (in cross section) while solvent is simultaneously evaporating from the surface. The concentration (and therefore the viscosity) is increasing with time due to solvent evaporation as the solution flows both into the porous paint and spreads outward. This results in higher concentrations of consolidant at the surface and at the front of solution flow, causing increased gloss and darkening, depicted in Figure 8. Figure 9 shows the contrasting situation where solvent loss is suppressed by maintaining a vapor-saturated atmosphere. The solution flows into and throughout the porous paint layer with little final differentiation in the concentration of resin.

Referring again to the schema shown in Figure 6, porous paint is categorized into two subcategories: porous and powdering; and porous and flaking. Although strategies for promoting or inhibiting solution flow can be applicable to both categories, in general those that promote the penetration and distribution of the consolidant are most often considered in relation to powdering paint; and those that inhibit penetration or minimize leveling of a surface coating are

Figure 7. Schematic of resin solution applied to a porous paint surface in an open atmosphere. (after *Hansen et al. 1993*).

Figure 8. Schematic of resin solution applied to a porous paint surface in a vapor-saturated atmosphere (after *Hansen et al. 1993*).

Figure 9. Possible concentration profiles of resin in a consolidated paint layer, shown in cross section, which result from application in an open atmosphere which allows solvent evaporation (darker areas indicate higher concentrations of resin) (after *Hansen et al. 1993*).

considered in relation to porous, flaking paint.

It has often been observed by conservators that exposure to solvents or solvent vapors alone seems to "reform" and possibly "reactivate" the binder already present in either flaking or powdering paint (e.g., when an object is placed in a humid atmosphere for some time to relax flaking paint prior to readhering the flakes, this seems to promote adherence of the flakes). It is important to include this phenomenon because many field observations to this effect made by conservators are known to the authors. However, because there are also no known systematic studies relating types of binders, pigments, and solvents to this phenomenon in porous paint, the ramifications and veracity of the "reforming" of resins remains open and subject to debate.

Referring to Figure 6, it can be seen that the widest variety of methods that may be useful for the consolidation of powdering paint (reported in the literature to date) are related to the penetration of an applied solution and the final distribution of the consolidant throughout the paint layer. Three of these are based upon the control of solvent volatility: 1) solutions prepared with low volatility solvents (such as diethyl benzene) described by Welsh (1980); 2) evaporation inhibition through saturating the working environment with solvent vapors (Hansen et al. 1993); and, 3) multiple applications of dilute solutions which penetrate to a greater depth due to their initial low viscosity.

Increased penetration may also occur if the particle size of emulsions is reduced, allowing them to flow into small

pores. Koob (1981) has suggested that using those dispersions of polymers that have an effectively smaller size than an emulsion of the same material will promote this penetration. Michalski (Anon. 1990) has suggested using an ultrasonic humidifier to produce a spray of a solution with a very small droplet size. This spray could penetrate to a greater extent and deliver a smaller amount of solution to a surface in a controlled manner, thus reducing the concentration of the consolidant delivered to the paint in each individual application.

Another technique employed to minimize the concentration of resin in both the vehicle and the solid state is the use of thermosetting polymers which polymerize or set in situ. These materials, although not soluble, form a strong bond if they react chemically with the pigment particles or substrate. In general, greater consolidative strength would result with a lesser amount of material in comparison to soluble but nonreactive thermoplastic resins which mechanically adhere pigment particles together (Hansen and Agnew 1990[13]). Both organic materials (such as epoxies, Weintraub and Greenland 1984) and inorganic materials (such as sol-gels, Romich et al. 1990) in low concentrations have been suggested for fixing powdering paint.

Another factor which reduces penetration is improper wetting (*see* Patton 1979 for a discussion of surface energy). Two methods have been suggested to improve wetting: 1) prewetting with a solvent; and 2) using surfactants. Surfactants modify the interfacial surface tension of a liquid; in this case, the energy at the interface of the liquid and solid pigment particles is reduced.

The use of solvents of different thermodynamic "quality" has also been investigated to control the distribution of a resin within a porous system. "Good" solvents for a particular polymer can dissolve larger amounts of a material in comparison to "poor" solvents. Thus, polymers precipitate out at lower concentrations in poor solvents than in good solvents, so that with solvent evaporation they also precipitate sooner. Gerassimova et al. (1975) found that impregnation of loess plaster with a 10% PBMA solution in xylene-ethyl alcohol (a comparatively poor solvent mixture) in comparison to a xylene solution of the same concentration (a comparatively better solvent) gives more regular resin distribution inside the porous material and considerably less change in appearance. This agrees with Domaslowki's findings (1987-88) that poorer solvents promoted less surface concentrations of acrylic resins in porous stones, although the effect of resin migration depended not only on the quality of the solvent but also on the dimensions of resin molecules, solution viscosity, stone structure, and the conditions of drying after impregnation. Gerassimova and Melnikova (1978) subsequently found that, although the resin was distributed more evenly, the physical properties (porosity, water vapor absorption, bending strength) were unaffected by using solvents of different quality to deliver the PBMA.

Because possibilities for improving compatibility with a substrate, such as manipulating flexibility and strength, have been demonstrated in relation to solvent quality for some poly-

mers used in conservation (Hansen et al. 1991[14], Hansen 1994[15] in press), further investigation of these phenomena in a system such as porous paint may result in even more available techniques for consolidation. For example, tensile testing of solution cast films (subsequent to nearly full solvent release) has shown that films of Acryloid B-72 cast from acetone solutions have low extendability (under 10% strain-to-break) in contrast to films cast from toluene solutions (over 100% strain-to-break). Thus, application of Acryloid B-72 from a toluene solution may be more suitable than an acetone solution if the paint being consolidated is on a flexible substrate such as a textile.

Strategies based upon minimizing leveling (suggested by a number of field observations made by conservators known to the authors) include multiple spraying of the surfaces of pastels with extremely viscous solutions in high volatility solvents. Presumably, there is little penetration but enough resin is delivered to the surface to hold particles together without forming a smooth film. Spray application of a viscous polymer solution made with a highly volatile solvent has been successfully used for flaking paint, and may be particularly applicable to large areas of flaking paint on objects (Mibach 1990[16]). However, there is still some concern that the adhesion to the substrate may be unaffected or negatively affected by the fixing of a paint film only on the surface. Because there is yet to be published information relating solvents, resins, pigments, paint thickness, and adhesion to the substrate, little comment can be made other than to point out the necessity for confirmative testing of spray techniques for the consolidation of powdering paint.

The second category is paint characterized by the lifting of porous flakes. Because adhesive solutions applied under a porous flake may wick into the flake causing discoloration, methods that discourage penetration of the consolidant have been considered, along with consolidants that conformally coat a flake and retain the matte appearance.

Reactivation of a solid (cast resin film) placed under a flake by heat or wetting with a solvent to make the film tacky, but not enough to induce flow, is often used. Hatchfield (1988) reported some success in maintaining the appearance of water-soluble paints by using a preconsolidant of a cellulose ether in ethanol to strengthen flaking paint and then adhering the flakes with an aqueous solution of methyl cellulose.

Common techniques focusing on the control of solution flow or the application of minimal amounts of solution that can only flow to a limited extent are: 1) double brush techniques, involving removal of excess solution applied from a wet brush by a dry brush; 2) delivering small amounts of solution with a microspatula positioned under a flake (Walston et al. 1987); and 3) using a micropipette or a syringe to control the amount of solution deposited. All these methods may benefit from the use of highly concentrated and viscous solutions or the addition of thickening agents. However, highly concentrated and viscous solutions might be difficult to deliver using a micropipette or syringe; and, in the case of a microspatula, might cause

sticking and possible dislodging of flakes.

Another technique for paints that interact negatively with either water or organic solvents, is saturation of the porous flakes with a solvent immiscible with the solvent used to make the consolidant solution. For example, water-sensitive flaking paint has been successfully adhered with acrylic emulsions while the paint was saturated with toluene (which did not allow wicking of the emulsions into the paint layer) and then the toluene was allowed to dry, leaving the flaking paints still porous but adhered (Futernick 1990[17], personal communication).

Methods that promote penetration may have some use in adhering porous flakes, particularly if enough resin is delivered to the interface of the flake and substrate to adhere the flake. Application of a consolidant solution in a vapor-saturated atmosphere has been used with some success on ethnographic objects with extensive flaking over a large area. However, Hansen and Volent (1994[18] in press) have pointed out some practical limitations to this procedure in a cautionary note on solvent sensitivity testing.

A novel method is the application of a conformal coating, Parylene, (Humprey 1984; Grattan 1989) that polymerizes from the gaseous state onto the surface of a paint layer, thus in theory conforming almost completely to the surface roughness. The practical benefits and limitations of using this material in this manner have yet to be fully demonstrated.

Lastly, another method mentioned by many conservators is the use of matting agents. Silica or other inert, low-refractive-index "fillers" are mixed with the consolidant to reduce gloss. However, matting agents tend to lighten or alter the color of the treated surface compared to the untreated surface, thus making it difficult to match the original color (especially if spot treatments are required).

The subject of retreatment of unsuccessful treatments deserves some additional comment. As stated above, because the reasons for changes in appearance may be related to the distribution of a consolidant in a porous paint system, these changes can be minimized by further treatment based upon an understanding of the same principles. For example, localized surface concentrations of consolidants may be reduced and the consolidant redistributed (by using several techniques mentioned in the schema); however, this would only be possible when soluble consolidants were originally used.

General survey of the chapter

Comments on other literature in the chapter in addition to the work mentioned earlier follow. The materials mentioned include both brand names and chemical designations of polymers, depending upon how the consolidants were described in the article being abstracted.

Materials
Materials that have been used or evaluated for use in the consolidation of matte paint and other fragile surfaces are listed. It should be emphasized that the literature and comments included in this bibliography do not reflect the full range of consolidation materials used in conservation or when and how they were first used.

Natural products

Rosen (1950-51) mentions the use of wax and beeswax plus 25% gum elemi as a consolidant for polychrome sculpture. Based upon the recommendation that adhesives chosen for fixing flaking paint on illuminated parchment should be insoluble in water, microcrystalline wax, and an almost equal mixture of beeswax to dammar resin were suggested by Marconi (1961).

Poorly adhering pigments on carvings from Oceania and Africa were stabilized through treatment with aqueous solutions of gelatin and gum tragacanth (Bauer and Koller 1965). Gelatin has often been described as a consolidant for weak grounds and flaking paint (Wodzinska 1971). Problems with glue and relative humidity, temperature, biodeterioration, etc. were discussed by Kenjo (1974). Von Reventlow (1991) discussed the use of rabbit-skin glue as an adhesive for consolidation of gesso. Isinglass (Petukhova 1993), a fish gelatin product whose best grade is prepared from sturgeon, is mentioned as a superior animal glue adhesive.

Schmitzer (1980) discusses reattachment of paint to parchment on South and East Asian shadow puppets with egg white applied with a hot spatula; crumbling paint was sprayed with starch size and pressed flat (Schmitzer 1984). At the State Hermitage, tempera paintings (Russian, Byzantine, and Italian) were consolidated with sturgeon glue and water, egg emulsions, and natural and synthetic resins by various methods (Chizova 1981).

Synthetic polymers

Early references to materials used for consolidation are the use of "polyvinyl resin" and cellosolve acetate to impregnate painted clay (Stout 1935) and mural paintings (Ullah 1940). Bedacryl 122 X (solution of poly(n-butyl methacrylate) in xylene) was reported to be very successful for fixing the paint design without creating undue gloss on Australian Aboriginal bark paintings (Boustead 1966).

Poly(methyl methacrylate) was recommended for the prevention of flaking of pigments (Sakurai 1951) and painted textiles (Gairola 1957). Watercolors were treated with low concentrations (under 1%) of poly(methyl methacrylate) in toluene (Bhowmik 1969).

As previously mentioned, soluble nylon is no longer extensively used in conservation, but is mentioned as a consolidant in some earlier references. Gowers (1968) consolidated both colorants and brittle cedar fibers in a Tlingit blanket with soluble nylon. Paint was fixed on a 16th-century manuscript with 5% soluble nylon in ethyl alcohol (Drayman 1968). Soluble nylon was also used to consolidate paint on wall paintings in Thailand (Agrawal 1974).

Riederer (1979) mentions the use of synthetic resins in the preservation of cultural property in Japan since 1942, and the use of acrylic resins and poly(vinyl acetate) for consolidation of flaking paint layers. An emulsion of acrylic resin was found more suitable than an aqueous solution of poly(vinyl alcohol) (PVOH) for treating flaking paint (Higuchi 1974). Higuchi and Nakasato (1978) found that wall paintings on a paper base, which

were consolidated in 1957 with PVOH, continued to flake or chalk; the paint was retreated with a water-soluble acrylic resin (ethyl alcohol was added to lower the surface tension). PVOH was used to fix pigment layers in Japanese paintings (Iwasaki 1974). Lal suggested PVOH as a fixative for loose pigments and grounds needing consolidation in Indian murals (1974). Chalking pigments on 17th-century Edo screens were treated with water-soluble acrylic resin with the addition of acetone to lower the surface tension of the resin solution (Higuchi and Katsuhiko 1976).

Higuchi (1985) discusses the benefits of a mixture of p-xylene and alcohol (25-30%) as a solvent for B-72 over p-xylene alone for the consolidation of thick undercoats of shell white in animal glue which coats many polychrome wooden sculptures from the Edo period. The solution became tacky more rapidly than the same solution in a nonpolar solvent; several minutes after injection it was tacky enough for reattaching thick paint and the shell white layer. Masuda and Higuchi (1985) described the reattaching of severely detached fragile color layers on a mural painting on a wooden wall; they wet the color layers with water and then injected them with a 20% solution of Paraloid B-72.

Adobe wall paintings in Peru were treated with polyacrylates or polystyrene (procurable as cheap industrial waste) (Szabo 1978). Chiari (1980) treated painted and unpainted adobe friezes by consolidation of the mud layer underlying the surface with sprayed ethyl silicate and fixing of the paint layer with Paraloid B-72. Cedillo Alvarez (1987, 1991) reviewed the problems associated with consoli-

dation of ubiquitous lime-plaster (stucco) coating on many Mesoamerican archaeological structures. All consolidant systems to date have failed, causing either biodeterioration or detachment of consolidated areas. Marxen-Wolska (1991) reviewed the use of poly(vinyl acetate) in the conservation of wall paintings, and found that it has been used successfully in Poland and elsewhere.

In addition to the introduction of organic consolidants, wall paintings have also been treated with inorganic reagents, such as ammonium carbonate and barium hydroxide (Matteini 1991). Inorganic gels, prepared by sol-gel techniques, seem to offer a promising new method for the consolidation of paint layers on historic stained glass windows (stable, good adhesion, minimal effect on appearance) (Romich et al. 1990).

Additional methods

An early treatment for the fixing of paint was total immersion in wax (Rosen 1951).

Schaffer (1972, 1974) described the consolidation of painted wooden artifacts by monomer vacuum impregnation (methacrylate monomer) and initiation of polymerization by either gamma radiation or an activator at 45°C (noting that the reaction causes excessive warming). Blyth suggested noninterventive, antistatic stabilization of pastels (1978).

Comparative studies of treatment materials and methods

Ghillis (1985) reviewed the evaluation of both synthetic and natural adhesive systems utilized in the consolidation of paints. Ghillis commented on the detrimental effects of aqueous ve-

hicles on cellulose materials and the inefficient wetting of hydrophobic painted surfaces, seeing them as a major consideration in selecting an adhesive system.

Ivanova (1975) compared synthetic polymers for the consolidation of paint layers of Medieval parchment.

Bansa (1980) mentioned a wide variety of materials in use by various conservation centers for fixing flaking or powdery paint color in Medieval miniatures: gelatin, parchment glue, beeswax, dammar, methyl cellulose, ethyl cellulose, carboxymethyl cellulose, benzyl cellulose, alkyd resin, mineral wax, and poly(vinyl acetate).

Guillemard (1987) tested six synthetic resins (a ketone resin, Laropal K80; two vinyl derivatives, Rhodopas B and Elvax 150; two acrylic resins, Paraloid B-72 and Plexisol P 550; and a cellulose ether, Klucel G). All caused a change in color; the worst results were found with Laropal and the best with B-72.

Daly (1978) found through microscopic examination of films and their interaction with pastel pigments (exposed to ultraviolet aging) that different pigments as well as different papers affected the ease of fixing and the degree of visual alteration.

Flieder et al. (1981) conducted comparative tests on a wide variety of materials for fixing powdering pigments. In subsequent testing, natural resins were found unsatisfactory for fixing powdery media on paper; three synthetic resins were found to work well for charcoal, black lead, and carbon: Klucel G, Plexisol P550, and Elvamide 8061 (R. Talbot et al. 1984). Richardin and Bonnassies (1987)

found Plexigum P24, a poly(butyl methacrylate), to be superior to Plexisol 550 as a fixative.

Fox (1983) compared B-72 in toluene, EM Ethulose 400 in water, gelatin, and a poly(vinyl acetate) emulsion for treatment of Abelam yam masks.

Plossi and Crisostomi (1981) tested synthetic polymers and solvents for consolidation of the pictorial layer on illuminated parchment, finding the best aesthetic result with dilute methyl cellulose and the worst with cellulose acetate, which formed a white coat without penetration. Tests included flexibility measurements.

I'ons (1983) compared the performance of Paraloid B-72 and Beva 331 in different solvents, with and without adding ethyl acetoacetate, in causing changes in the color of friable ocher surfaces. She concluded consolidation procedures were related to the chemical and physical structures of the clay-mineral layers, the difference in refractive index of the resin and the ochers, and the surface wetting and evaporation rate of the solvents.

Zeskoski and Smith (1984) tested and compared the effectiveness of five different consolidants for the consolidation of friable frescoes: calcium hydroxide, calcium bicarbonate, barium ethyl sulfate, methyl triethoxysilane (MTEOS) and tetraethyl orthosilicate (TEOS). MTEOS gave the best performance based upon abrasion tests and changes in appearance.

A comparison of consolidants for *eglomise* (a special type of glass painting) included Paraloid B-72, Plexisol P550, Mowilith and Vinnapas (poly(vinyl acetate)s, isinglass, gelatin, albumen,

dammar, and naturally bleached beeswax containing 5% larch turpentine (Schott 1988). The last named mixture was chosen for use.

Schiessl (1989) described in great detail a series of experiments for consolidating powdering paint layers on wood. Calcium carbonate, gypsum, iron oxide, chalk, and artificial ultramarine were applied to wood without any binder. Consolidant solutions included gelatin in water, caseinate in water/alcohol, hydroxypropylcellulose in water, hydroxypropal cellulose in propanol, poly(vinyl alcohol) in water, poly(vinyl acetate) in organic solvents, ethyl methacrylate in organic solvents, and acrylic emulsions and dispersions. The solutions were prepared in various dilutions. Changes in appearance were considered from both a theoretical and practical viewpoint, aided by observing film formation and resin distribution microscopically.

Seven kinds of adhesives were tested for use in consolidation and reattachment of paint on a Buddhist polychrome sculpture from the Edo period (Okabe et al. 1989), including funori (a seaweed glue), an animal glue, Binder-18, and Paraloid B-72 in xylene. Funori gave the best results and Paraloid B-72 the worst.

Other related references
Newton (1982) presented a bibliography on deterioration and conservation of painted glass (a supplement to AATA Volume 10, No. 2).

Hanna and Lee (1988) reviewed the performance of adhesives and consolidants used on stone objects in the British Museum during this century (consolidants were nitrocellulose, wa-

ter-glass, soluble nylon, poly(ethylene glycol), wax, and vinyl acetate).

Van Strydonk et al. (1992) pointed out the problems in carbon dating of museum objects resulting from the application of organic consolidants.

Another consideration is the possibility of increasing degradation by using synthetic consolidants in mural paintings which serve to promote the growth of microorganisms (Petersen et al. 1993).

Acknowledgements

We would like to acknowledge gratefully the following individuals for their help in this project, emphasizing that all errors, omissions, or inconsistencies are entirely the responsibility of the editors.

For suggestions and comments on the topical review, we would like to thank Michele Derrick, Robert Feller, John Griswold, Pamela Hatchfield, Ruth Johnston-Feller, Heather Lechtman, and Chandra Reedy.

For their generosity in pointing out relevant citations for the supplement we would like to thank Gordon Bierwagen for allowing us the use of his personal bibliography on high PVC coatings, Michele Derrick, Robert Feller, Ruth Johnston-Feller, Sue Gatenby, Jo Hill, Kevin Mulroy, Joyce Hill Stoner, Nancy Turner, Paula Volent, and John Winter.

For their assistance in many phases of the supplement we would like to thank Carol Anne Garrison, Blanche Kim, Marie Labidnis, Kristin Lang-Green, and Carole Sussman.

We are especially grateful for the help provided by the Getty Conservation Institute Library's staff, in particular Shannon O'Neill and Marlene Wholihan for their assistance with a large number of interlibrary loans; and the AATA production staff, including C. Hamilton Arnold, Michèle Buchholz, Barbara Friedenberg, Gwynne Garfinkle, Kathleen Louw, and Jacki Redeker.

[1] An extended discussion can be found in Alfred W. Crosby's *Ecological Imperialism, The Biological Expansion of Europe, 900-1900* (Cambridge: Cambridge University Press, 1986).

[2] See also Karl G. Heider's *Ethnographic Film* (Austin: University of Texas, Austin, 1986).

[3] Lucas, Alfred, *Antiques, Their Restoration and Preservation* (London: F. Arnold and Co., 1924).

[4] Cather, Sharon; Park, David; and Paul Williamson, eds., *Early Medieval Wall Painting and Painted Sculpture in England: based on the proceedings of a symposium at the Courtauld Institute of Art, February, 1985* (Oxford, England: B.A.R., 1990); b) Sharon Cather, ed., *The Conservation of Wall Paintings: proceedings of a symposium organized by the Courtauld Institute of Art and the Getty Conservation Institute, London, July 13-16, 1987* (Marina del Rey: The Getty Conservation Institute, 1990).

[5] Johnston-Feller, Ruth, *The Science of Colorimetry and Spectrophotometry in the Examination of Museum Objects* (Santa Monica: The J. Paul Getty Trust, *forthcoming*).

[6] Derrick, Michele; Doehne, Eric; Parker, Andrew; and Dusan Stulik, "New analytical techniques for use in conservation," in *Journal of the American Institute for Conservation* (In press, Summer 1994).

[7] Stoner, Joyce Hill. "An overview of the impact of research on the lining and cleaning of easel paintings" in *Journal of the American Institute for Conservation* (In press, Summer 1994).

[8] McCrone, Walter C. "The use of microscopy in conservation" in *Journal of the American Institute for Conservation* (In press, Summer 1994).

[9] Feller, Robert L. "Standards in the evaluation of thermoplastic resins." Paper 78/167/4 ICOM Committee for Conservation, Zagreb Meeting (1978).

[10] Feller, Robert L. and M. Wilt, *Evaluation of Cellulose Ethers for Conservation* (Marina del Rey: The Getty Conservation Institute, 1990).

[11] Bicchieri, M.; Bortolani, M.; and E. Veca, "Characterization of low-molecular-weight polyvinyl alcohol for restoration purposes," in *Restaurator* **14**:1, pp. 11-29 (1993).

[12] Feller, Robert L. *Accelerated Aging: Photochemical and Thermal Aspects* (Santa Monica: The J. Paul Getty Trust, forthcoming).

[13] Hansen, Eric F. and Neville Agnew, "Consolidation with moisture-curable isocyanates: polyureas and polyurethanes," *Preprints, ICOM Committee for Conservation 9th Triennial Meeting, Dresden, GDr ed., K Grimstad, (Los Angeles: ICOM Committee for Conservation, 1990), pp. 567-572.

[14] Hansen, Eric F.; Derrick, Michele R.; Schilling, Michael R. and Raphael Garcia, "The effects of solution application on some mechanical and physical properties of thermoplastic amorphous polymers used in conservation: poly(vinylacetate)s," in *Journal of the American Institute for Conservation*, **30**: pp. 203-213 (1991).

[15] Hansen, Eric, "The effects of solvent quality on some properties of polymers used in conservation" in *Postprints of Materials Issues in Art and Archaeology IV, Cancun, Mexico,* 1994; Druzik, Vandiver, and Wheeler, eds. (in press).

[16] Mibach, Lisa , personal communication, 1990.

[17] Futernick, Robert, personal communication, 1990.

[18] Hansen, Eric F. and Paula Volent, "Technical note on solvent sensitivity testing of objects for treatment in a vapor saturated atmosphere," in *Journal of the American Institute for Conservation,* (In press, Autumn 1994).

A. History & Technology

This section contains abstracts that pertain to certain practices or materials whose use, intentionally or unintentionally, result in a matte surface or coating. These include direct observations or descriptions of techniques from a wide variety of time periods and cultures (both art historical and anthropological); and ethnobiological and archaeological literature that may be useful in ascertaining materials used in different geographic areas. (Please note: the citations are organized chronologically by publication year and alphabetically by author within each year.)

30-S1.
Davy, Humphry.
Some experiments and observations on the colours used in painting by the ancients.
Philosophical transactions of the Royal Society of London, 105, pp. 97-124, (1815), [Eng.].
A description of the experiments that Sir Humphry Davy carried out on samples obtained from the Baths of Titus, Baths of Livia, and other palaces and ruins of ancient Rome and Pompeii. He discusses the colors (reds, yellows, blues, greens, purple, blacks, browns, whites), then the techniques employed, with references to Pliny and Vitruvius. He concludes with some general observations: Greek and Roman painters had all the colors available to Renaissance painters, and, in addition, Egyptian blue and Tyrian purple, the former apparently being easy to make (recipe given). Among "modern" pigments he cites patent yellow and chrome yellow as better than the old ones. Scheele's green, sulphate of baryta, also receives praise. Davy ends with a lament that the materials on which paintings were carried out (wood, canvas) were unfortunately less durable than the pigments used. ICCROM(03644800)

30-S2.
Vanherman, T.H.
Every man his own house-painter and colourman: the whole forming a complete system for the amelioration of the noxious quality of common paint. A number of invaluable inventions, discoveries and improvements...and a variety of other particulars that relate to house painting in general.

Book. I.F. Setchel, London, 1829, [Eng.]. xxiv, 111 p.; 24 cm.
Graining was done in water and in oil. Vanherman suggests the use of beer as a binder for a number of his graining techniques. Pigment is ground with beer and painted on the prepared surface. When dry a varnish is applied. M.H.B.

30-S3.
Welsch, Fr.
Vollständige Anweisung zur Restauration der Gemälde in Oel-, Wachs-, Tempera-, Wasser-, Miniatur-, und Pastellfarben: nebst Belehrungen über die Bereitung der vorzüglichsten Firnisse für Gemälde, Basreliefs und Gypsstatuen, getrocknete Insecten und Pflanzen, Kupferstiche und Landkarten, sowie über das Reinigen, Bleichen, Aufziehen und Einrahmen der Kupferstiche, Steinabdrücke und Holzschnitte; für Kunstliebhaber, Maler, Bronzierer, Tapezirer etc.
(Complete guide for the restoration of oil, wax, tempera, watercolor, miniature, and pastel paintings, together with instructions for preparing excellent varnishes for paintings, bas-reliefs and plaster casts, dried insects and plants, prints and maps, as well as the cleaning, bleaching, mounting, and framing of copper engravings, lithographs, and woodcuts; for the art lover, painter, bronzer, decorator, etc.)

Book. Bauverlag GmbH, 1834, Reprint (1984); originally published in Quedlinburg und Leipzig by Druck und Verlag von Gottfr. Basse [Ger.]. viii, 111, 3 p.; 18 x 11 cm. [ISBN 3-7625-2671-0].

This reprinted booklet reveals restoration practice in the first half of the 19th century. Some of the guidelines for restoration of paintings in oil, wax, tempera, watercolors, miniatures, and pastels are still applicable, while others are outdated; the book is mainly of historical interest. ICCROM(04276800)

30-S4.
Horsin-Déon, Simon.
De la conservation et de la restauration des tableaux: éléments de l'art du restaurateur: historique de la partie mécanique de la peinture, depuis sa renaissance jusqu'a nos jours: classification de toutes les écoles: recherches et notices sur quelques grands maîtres.
(On the conservation and restoration of panel paintings: elements of the restorer's art. History of the mechanical part of the painter's work from its renaissance until our times: classification of all of the schools; research and information on some of the great masters.)

Book. Chez Hector Bossange, Paris, 1851, [Fre.]. viii, 234 p.; 19 cm.

Early treatises on restoration can provide valuable insights into the techniques and materials used by restorers before the use of modern materials and techniques. The author describes restoration techniques, the nature of materials both good and bad, and the working methods of artists. Of particular interest are sections describing consolidation and in-painting. M.H.B.

30-S5.
Forni, Ulisse.
Manuale del pittore restauratore.
(Manual of the painter restorer.)

Book. Successori Le Monnier, Florence, 1866, [Ita.]. 455 p.; 19 cm., bibliog.

A systematic description of restoration treatments for fresco, tempera, and oil painting: transfer, fixative consolidation, cleaning, filling, lacuna treatment, retouch, support consolidation, relining of canvas, biodeterioration, and protective glazing. The action of light and atmosphere on oils and resins is explained. Recipes for grounds, gums, glues, resins, oils, pigments, and various retouch media are provided. ICCROM(00126000)

30-S6.
Crawfurd, John.
On the history and migration of textile and tinctorial plants in reference to ethnology.
Transactions of the Ethnological Society of London, **7,** pp. 1-15, (1869), [Eng.].

Discusses "tinctorial plants," giving descriptions of the history of the use of indigo, madder, woad, safflower, crocus (saffron), turmeric, and anatto and views as to the countries of their origin. Also discusses fiber plants and, although the context is dyes, many of these plants are used directly as stains or paints. An interesting perspective on the history of these colorants is provided. M.H.B.

30-S7.
Palmer, Edward.
Plants used by the Indians of the United States.
The American naturalist, **12,** no. 10, pp. 646-655, (1878), [Eng.].

Describes the preparation and utilization of plants by the Indians of southern Utah, Arizona, California, New Mexico, and Mexico, during the 19th century, for food, beverages, medicine, poisons, clothing, dyes, objects (e.g., rope, nets, soap, etc.). CCI

30-S8.
Mallery, Garrick.
On the pictographs of the North American Indians.
Annual report (United States. Bureau of American Ethnology), **4,** pp. 13-256, (1883), [Eng.].

An important early work on Native American art. Discusses and illustrates examples from rock art to the Dakota winter counts. Discusses technique in a section on colors and methods of application. Describes the mixing of blood and charcoal by the Inuit for a black pigment. Also describes a binder prepared by the Arikara from the tail of the beaver which is boiled to obtain a viscous fluid to which pigment is added. The use of cinnabar in California is also mentioned, as are trade pigments that were available at the time. Contains an early depiction of Chumash rock art in Santa Barbara County. M.H.B.

30-S9.
Mindeleff, Victor.
A study of Pueblo architecture: Tusayan and Cibola.

Annual report (United States. Bureau of American Ethnology), **8,** no. 1, (1886-1887 issued in 1891), [Eng.].

Describes the use of whitewash to decorate buildings at Zuñi and the use of colored clays to create decorated plasters. Lumps of clayey gypsum were dissolved in hot water and applied with a sort of skin mitten with the hair side out. The author doubts the antiquity of the practice but subsequent archaeological evidence has found decorated plaster in Chacoan outliers. This publication contains a wealth of technological information on pueblo masonry and structures. M.H.B.

30-S10.
Gardner, Franklin B.
The painters' encyclopaedia.

Book. M.T. Richardson, New York, 1887, [Eng.]. 427 p.: ill.; 29 cm.

A late 19th-century reference book for painters. The entry for kalsomine defines the term and gives a recipe. Six pounds of zinc white or Paris white is mixed with one-half pound of dry glue. The mixture is heated with water and applied in a gelatinous state. Bluing is added for a whiter appearance and pigments to give a tone. Describes the proper brushing technique for applying the kalsomine. M.H.B.

30-S11.
Fewkes, Jesse Walter; and Stephen, A.M.
The mamzrauti: a Tusayan ceremony.

American anthropologist, **5,** no. 3, pp. 217-245, (1892), [Eng.].

Describes the ceremony in detail with illustrations of painted ritual objects and their use in the ceremony. A few references are made to pigments used to paint the bodies of the participants using a lump of "black shale" which is ground and applied. "Copper carbonate" is also described as a green pigment used. Of particular interest is a statement made by a priest in one of the ceremonies that leads Fewkes to remark "the reason why the painted designs looked so dauby was because they only renewed the paint from time to time and only in the places nec-

essary" (p. 227). The object referred to is a bundle of painted wooden strips that were lashed together using yucca fiber for the ritual. This is a tantalizing insight into possible attitudes toward the use and care of painted objects by the Tusayan. Also describes how a paint brush from a strip of yucca is made and used. M.H.B.

30-S12.
Fewkes, Jesse Walter; and Stephen, A.M.
The Na-ac-nai-ya: a Tusayan initiation ceremony.

Journal of American folklore, **5,** no. 18, pp. 189-221, (1892), [Eng.].

Describes the painting of ritual objects for the ceremony. Melon seeds were chewed by six individuals engaged in the work and the masticated seeds and saliva spat into a mortar containing ground shale (also unspecified). This was mixed and used for painting the objects. The article is primarily concerned with a description of the ritual and information about the preparation of ritual objects is incidental. M.H.B.

30-S13.
Murdoch, John.
Ethnological results of the Point Barrow expedition.

Annual report (United States. Bureau of American Ethnology), **9,** pp. 3-441, (1892 issued in 1887-1888), [Eng.].

Discusses the use of red ocher by the Eskimos. Also mentions the use of a green pigment derived from a fungus. Black from soot is used and black lead. Of particular interest is a description of an Eskimo painting a sled. Captain E.P. Herendeen, the interpreter of the expedition, observed this man at work. He describes it as follows: "He licked the freshly scraped wood with his tongue, so as to moisten it with saliva and then rubbed it with a lump of red ocher." This is painting in its most basic form. Also refers to painting on a variety of objects such as arrow shafts, paddles, boxes, dishes, and other objects.
 M.H.B.

30-S14.
Turner, Lucien M.
Ethnology of the Ungava District, Hudson Bay Territory.

Annual report (United States. Bureau of American Ethnology), **11**, no. 1, pp. 161-350, (1894 issued in 1889-1890), [Eng.].

Describes paint sticks used by the Indians to apply paint to leather. Containers for the paint are also described and illustrated, as is the method used to apply the paint. The use of mineral pigments and of indigo and washing blue obtained from traders are cited. The favorite paint vehicle was prepared roe from a sucker (*Catastomus*) that is found in the area in abundance. The roe is removed from the fish, crushed, and strained through a cloth. The fluid obtained is allowed to dry and water is added when it is used, producing a paint with a rich glaze (pp. 296-298).
M.H.B.

30-S15.
Laurie, Arthur Pillans.
Facts about processes, pigments and vehicles: a manual for art students.

Book. Macmillan Publishers Ltd., London, 1895, [Eng.]. x, 131 p.: ill.; 19 cm., index.

Discusses techniques for grinding pigments and the durability of various pigments, and proposes means of testing this durability. Includes a description of tempera paints and mentions the use of fig tree juice (a milky latex) as an additive to egg tempera. Watercolor and fresco painting are also discussed.
ICCROM(00490200) and M.H.B.

30-S16.
Spurrell, F.C.J.
Notes on Egyptian colours.

The archaeological journal, **52**, pp. 222-239, (1895), [Eng.]. bibliog. refs.

These notes are a combination of several articles contributed to the Royal Archaeological Institute during the last few years. They are mainly the consequence of opportunities offered by Professor Flinders Petrie's kindness in permitting an examination of specimens found by him; but many other collections have also been studied. Mr. Petrie's specimens have the special value of being correctly dated. The chief of the notes are devoted to three periods in ancient Egyptian history: the Fourth, the Twelfth, and the Eighteenth Dynasties. Though this involves some repetition, the examination of each series separately helps to mark chronological changes.
CCI(5827)

30-S17.
Fewkes, Jesse Walter.
Archaeological expedition to Arizona in 1895.

Annual report (United States. Bureau of American Ethnology), **17**, no. 2, pp. 527-752, (1895-1896 issued in 1898), [Eng.].

On pp. 728-729, the author describes pigments found stored in bowls and deposited as grave goods at Sikyatki. The author found red ocher, yellow ocher, a green pigment described as a carbonate of copper, and disks of kaolin, which in one instance was placed on the head of an individual in a burial. Also described is a micaceous hematite that was being used at the time and described as yayala by the Tusayan Indians. On pp. 736-739 illustrations and descriptions of a number of painted wooden prayer sticks can be found.
M.H.B.

30-S18.
Hamilton, Augustus.
Maori art.

Book. Harmer Johnson Books Ltd., New York, 1896, Reprint (1977) of the 1896-1901 ed. (published in parts) by the New Zealand Institute, Wellington. [Eng.]. v, 438 p.: ill. (some col.); 32 cm., refs. and index.

Painting was widely practiced by the Maori. Red ocher or *kokowai* was gathered in volcanic areas and either mined from seams exposed by erosion or gathered in more novel forms. Bundles of fern fronds were placed in certain creeks and a fine deposit of red iron oxide would form on them. They were then dried, the iron oxide shaken off and formed into balls and roasted in a fire. This was highly esteemed and mixed with shark oil or the oil of certain seeds (*Electryon* or *Passiflora* are cited) and used for body painting. Oil was also obtained from *miro* (*Podocarpus ferruginea*) and *tangeo* (*Tetranthera calycaris*). A yellow pigment was obtained from rotting wood, and a blue pigment from vivianite or iron phosphate deposits was also used. The text cites this as being from decom-

posing moa bones. Four types of red pigment are cited, *kokowai, taupo, tareha,* and *taramea.* Houses and objects were commonly painted and it is safe to assume that only the binder was changed for this purpose. Elaborate preparation of pigments for tattooing is discussed. Kauri and white pine resin was burned and the soot gathered. The soot was mixed with bird fat and fed to a dog who was prepared for the purpose by fasting. The excrement of the dog was subsequently gathered, mixed with water and oil, and made into dried cakes which were buried for storage and future use. [Editor's remark: this work was originally published in parts from 1896-1901 by the New Zealand Institute.]

M.H.B.

30-S19.
Roth, Walter Edmund.
Ethnological studies among the northwest-central Queensland Aborigines.

Book. E. Gregory, Government Printer, Brisbane, 1897, [Eng.]. xvi, 199 p.: ill. (some col.), plates, map; 26 cm., Bibliog.

Describes body painting with blood, feathers, and ocher. "Cementing" substances such as Spinifex resin are described as well as other resins. An important early account of the area that was followed by more detailed publications. In this work the author makes some preliminary descriptions that are elaborated in later works. M.H.B.

30-S20.
Roth, Walter Edmund.
Food: its search, capture, and preparation.

Book. North Queensland ethnography bulletin, no. 3, G.A. Vaughn, Government Printer, Brisbane; Queensland. Home Secretary's Department, Brisbane, 1901, [Eng.]. 31 p., 3 plates; 34 cm.

An early description of the plant, animal, and mineral material used as food by Aborigines in Queensland. Cooking techniques and food processing are also described. The preparation of white clay, which was made into cakes for eating and painting, is described. Provides useful insights into the technology of processing. M.H.B.

30-S21.
Chesnut, V.K.
Plants used by the Indians of Mendocino County, California.

Contributions from the United States National Herbarium, **7,** no. 3, pp. 295-403, (1902), [Eng.]. classified list of economic plants.

Describes the utilization of plants by the Yuki, Yokia, and Pomo Indians of Mendocino County, California during the late 19th century. A list of plants under the following functions is attached: food, clothing, housing, furniture, utensils, fuel, tools, weapons (hunting, fishing, trapping, warfare), travel and transportation, games, dancing, medicine, poisons, and art (paint, dyes, tattoos), etc. This article is a useful reference for ethnobotany in the western United States, and was reprinted by the Mendocino County Historical Society in 1974. CCI(3076)

30-S22.
Fewkes, Jesse Walter.
Two summers' work in Pueblo ruins.

Annual report (United States. Bureau of American Ethnology), **22,** no. 1, pp. 3-195, (1904), [Eng.].

Describes pigments found in the Little Colorado Ruins as "red paint (sesquioxide of iron), blue paint (azurite), green paint (carbonate of copper), and white paint (kaolin)." Some of these were formed into lumps or cylinders or disks. A mortar shaped object of kaolin is described. The author also mentions that the contemporary Indians in the area asked him for fragments of the green paint to use on ceremonial objects. M.H.B.

30-S23.
Roth, Walter Edmund.
Domestic implements, arts, and manufactures.

Book. North Queensland ethnography bulletin, no. 7, G.A. Vaughn, Government Printer, Brisbane; Queensland. Department of Public Lands, Brisbane, 1904, [Eng.]. 34 p., 26 plates; 34 cm.

Contains a description of sources of vegetable and animal adhesives as well as pigments and dyes. Roth states that the most used media for paint is the most readily available, in most cases saliva. He describes the practice of applying adhesive to a surface

and then rubbing on the pigments. He describes a number of substances used for this purpose such as human blood, candlenut oil (*Aleurites moluccana*), snake and iguana fat, and honey. Plants used as stains or dyes are also described. The means used to manufacture various items of material culture is described by the author as well. This account is an important early description of the material culture of the area from a good source. The author sent botanical material to a botanist for proper identification. M.H.B.

30-S24.
Stevenson, Matilda Coxe.
The Zuni Indians, their mythology, esoteric fraternities, and ceremonies.

Annual report (United States. Bureau of American Ethnology), **23,** (1904), [Eng.].

This important early account of the Zuñi primarily concerns itself with mythology and ritual observed by the author at the end of the 19th century. It provides information about the ritual production of objects used in ceremonies. An example on page 221 describes the preparation of paint from dry cakes of green pigment made of copper ore and Piñon gum. The pigment is ground with water and squash seeds prior to application. The paint was applied to dancers' moccasins by placing it in the mouth and spraying it onto the surface. M.H.B.

30-S25.
Hodge, Frederick Webb, Editor.
Handbook of American Indians north of Mexico.

Book. Bulletin (United States. Bureau of American Ethnology), no. 30, United States Government Printing Office, Washington, 1907 and 1910, [Eng.]. 2 v. (2193 p.): ill., fold. map; 24 cm.

The section on dyes and pigments describes the use of various dyes and states that binding media varied according to the substrate. Face paint was mixed with grease or saliva but body paint and paint for wood was grease or glue. [Abstractor's note: What exactly is meant by "glue" is not explained.] In the Pacific Northwest grease is applied before applying the paint. In the Southwest an emulsion of fatty seeds is mixed with the pigment. The section on painting describes

the widespread nature of the practice throughout North America. Pigments were derived from iron oxides and copper carbonates primarily. Face and body painting were widespread for purposes of ornament, ritual, camouflage, and protection from the sun. Oil and water are cited as the mediums used. An extensive knowledge of organic pigments from plant sources is hinted at. References to various publications by the Bureau of American Ethnology that deal with the subject are given. M.H.B.

30-S26.
Sparkman, Philip Steadman.
The culture of the Luiseno Indians.

Book. University of California publications in American archaeology and ethnology, no. v. 8, no. 4, University Press of Berkeley, Berkeley, 1908-1910, [Eng.]. 234 p.; 24 cm.

Contains a brief section on "Gums, Dyes and Paints" which describes the use of bitumen, pitch from various pines, and the wax from a scale insect as adhesives. Cites the use of "turpentine" obtained from pine trees, ground kernels of the chilicothe (*Marah macrocarpus*), and iron oxide in formulating a red paint used in making rock art. Information about the use of plants and the material culture of the Luiseños is also given. This source was frequently cited by later authors on the subject of rock art. [A 1964 edition is available as a Kraus reprint.] M.H.B.

30-S27.
Stevenson, Matilda Coxe.
Ethnobotany of the Zuni Indians.

Annual report (United States. Bureau of American Ethnology), **30,** pp. 35-102, (1909), [Eng.].

Describes the plants used by the Zuñi for food, medicine, material culture, and religious ceremonies. The use of "leaf mouse" (*Psilostrophe tagetina*) in making a yellow paint is described. The blossoms are ground with yellow ocher for painting ritual objects and application to the human body. Some dye plants are described, although the fact that native dyes are being supplanted by trade dyes at time of writing is mentioned. Includes an excellent description of the gathering and processing of Datil, or yucca fruit (*Yucca baccata*), into dried form that was stored for future use. Small portions of this

would be rehydrated with water to make yucca syrup which was used as a binder.

M.H.B.

30-S28.
Joyce, T.A.
Note on the pigment blocks of the Bushongo, Kasai District, Belgian Congo.

Man, **10,** no. 46, pp. 81-82, (1910), [Eng.].

Describes how blocks of *Tukula,* a red pigment made from the wood of various species of trees, are made. Women rub moistened blocks of the wood together to create a paste. This paste is formed into lumps which are shaped and carved prior to hardening. Scrapings from the blocks are mixed with water or palm oil and applied either to the human body or to any other surface which is to be decorated. When the owner dies the heirs distribute the blocks to friends of the deceased as commemorative gifts. M.H.B.

30-S29.
Laurie, Arthur Pillans.
Greek and Roman methods of painting: some comments on the statements made by Pliny and Vitruvius about wall and panel painting.

Book. Cambridge University Press, Cambridge, 1910, [Eng.]. vi, 124 p.: col. front., plates (part col.); 19 cm.

Comments on statements by Pliny and Vitruvius about wall and panel painting. Pigments, egg, wax, oil media, varnish, and wall rendering are discussed. The use of various resins and their sources are discussed, as are ancient accounts of the use of glues derived from hide and fish glue. The uses of drying oils and distillates from resins are examined on the basis of documentary sources.

ICCROM(00088200) and M.H.B.

30-S30.
Wissler, Clark.
Material culture of the Blackfoot Indians.

Book. Anthropological papers of the American Museum of Natural History, no. 5/1, American Museum of Natural History, New York, 1910, [Eng.]. 175 p.: ill., 8 plates; 25 cm., bibliog.

Includes particularly detailed descriptions of Blackfoot quillwork and leather manufacture, both rawhide and soft-tan, the latter

with a mixture of brains, fat, and often liver, or a mixture of flour, lard, and warm water. Leather working tools are described and pictured. A section lists the local pigments used in painting. Other aspects of Blackfoot culture, food habits, transportation, shelter, dress, and warfare are described. Staff

30-S31.
Brigham, William T.
Ka hana kapa: the making of bark-cloth in Hawaii.

Book. Memoirs of the Bernice Pauahi Bishop Museum of Polynesian Ethnology and Natural History, no. 3, Bishop Museum Press, Honolulu, 1911, [Eng.]. iv, 273 p., 48 leaves of plates: ill. (some col.); 32 cm., refs. and index.

Surveys the manufacture of bark cloth throughout Oceania with an emphasis on Hawaii. Plants used in the process are listed with complete botanical information. Photographs illustrate the plants described. Early accounts of bark cloth are reviewed. Beaters in the collection of the Bishop Museum are listed and illustrated. Includes color illustrations for a number of cloth examples in collections from all over the world. The author briefly recounts his experiments in trying to recreate the colorants of ancient Hawaii. M.H.B.

30-S32.
Gilmore, Melvin R.
Uses of plants by the Indians of the Missouri River region.

Annual report (United States. Bureau of American Ethnology), **33,** pp. 43-154, (1911-1912), [Eng.].

Describes plants used by the indigenous inhabitants of the area for food, medicine, and material culture. Plants used for dyes, colorants, and fibers are also described. Includes photographs of plants and the terms used for the plants in the Indian languages of the area. M.H.B.

30-S33.
Robbins, Wilfred William; Harrington, John Peabody; and Freire-Marreco, Barbara.
Ethnobotany of the Tewa Indians.

Book. Bulletin (United States. Bureau of American Ethnology), no. 55, United States Government Printing Office, Washington,

1916, [Eng.]. xii, 124 p.: ill., plates, map; 24 cm., bibliog.

An early landmark in ethnobotany, this publication describes techniques for conducting field work to study the use of plants (ethnobotanical research) by aboriginal Indian peoples in an effort to understand their culture (food, medicine, religion, ceremonies, material culture, etc.) The practice of venturing into the field with several elder Indian informants to see plants in their habitat is recommended as an excellent way of obtaining accurate information. Standards for the collection and display of ethnobotanical specimens are proposed. The authors recommend the inclusion of artifacts made from the plant with the display. While primarily dealing with food, medicinal plants, and associated terms in the Tewa language, this study also explains concepts relating to color and the parts and properties of plants. Of particular interest is an account of the preparation of paint for decorating pottery. Pigment is ground and a syrup prepared from the fruit of the yucca (*Yucca baccata*) is added. The paint is then applied with a brush made of yucca needles. CCI and M.H.B.

30-S34.
Roth, Walter Edmund.
An introductory study of the arts, crafts, and customs of the Guiana Indians.

Annual report (United States. Bureau of American Ethnology), **38**, pp. 80-91, (1916-1917 issued in 1924), [Eng.].

A study of the material culture of the Guiana Indians. Includes all aspects of material culture of the Indians of the area. This follows an earlier work by Roth on the "animism and folklore of the Indians." Roth was working at a critical time in the area. Subsequent works draw heavily on his information. Of particular interest is his section on gums, wax, oils, and pigments. He describes the gathering, use, and processing of these materials. The gathering of rubber from various species of trees is described, as are the ways it was processed and cast in molds. Various pigments of mineral and botanical origin are also described. M.H.B.

30-S35.
Lucas, Alfred.
The inks of ancient and modern Egypt.

Analyst, **47**, pp. 9-15, (1922), [Eng.].

Presents general information on inks and pens used in ancient Egypt for writing. Specific analytical information is given on ink found in an ancient inkstand (16th century BC) and a number of other samples, some as recent as the early 19th century. Examines also inks on sale in Egypt at the time of writing. Colored inks in ancient Egypt were apparently used for illustration. Red ink derived from iron oxides was used in texts and blue and green inks derived from copper compounds used for pictorial purposes. The pigment was finely ground and suspended in solution with gum. Several traditional recipes for ink are discussed. M.H.B.

30-S36.
Smith, H.H.
Ethnobotany of the Minomini Indians.

Bulletin of the Public Museum of the City of Milwaukee, no. 4, pp. 1-174, (1923), [Eng.].

Cites the use of various plants as colorants by the Menomini. Latin names for plants are given with the names in the Menomini language. Photographs of some of the plants and processing methods illustrate the text.
 M.H.B.

30-S37.
De Andrade, Alfredo Antonio.
Estudo das materias corantes de origem vegetal em uso entre os indios do Brasil e das plantas de que procedem.
(A study of plant-based colorants used by the Indians of Brazil and the plants from which they are derived.)

In book. *Annaes do XX Congresso internacional de americanistas, realizado no Rio de Janeiro, de 20 a 30 de agosto de 1922*, (1924), pp. 185-201, [Por.]. 33 notes.

Describes the various sources of plant pigments used by the indigenous inhabitants of Brazil. Names are given in several languages and cited in scientific nomenclature. Extensively referenced to the works of earlier investigators. M.H.B.

30-S38.
Gardner, G.A.
On the nature of the colouring matter employed in primitive and rock-paintings.

Man, **24**, p. 142, (1924), [Eng.].

The paintings examined were in the northwest of Cordoba Province, Argentina. The pigments included slaked lime, earth pigments, and manganese dioxide (pyrolusite). Bird excrement was also used.
C.A.L.(21071) and M.H.B.

30-S39.
Vanderwalker, Fred N.
Interior wall decoration: practical working methods for plain and decorative finishes, new and standard treatments.

Book. Frederick J. Drake & Co., Chicago, 1924, [Eng.]. 451 p.: ill.; 19 cm., index.

Contains a discussion of calcimine paints beginning on page 118. Pigments are described with reference to the whiting or zinc that makes up the bulk of the pigment. White glue in dry form is described as the binder, although it is noted that casein is sometimes used as the binder in prepared calcimine paints. A description is then given of materials used to impart color taken from supply catalogs of the day and listed by color. Calcimine (or Kalsomine) paints were generally white paints or tinted washes used on plaster surfaces.
M.H.B.

30-S40.
Germann, F.E.E.
Ceramic pigments of the Indians of the Southwest.

Science, **58**, pp. 480-482, (1926), [Eng.].

Describes accounts of various authors on the use of plants such as the bee plant (*Cleome serrulata*) as a black pigment in pottery. A juice was prepared and boiled to a thick viscous liquid which was applied to the pottery. He also cites Nordenskjöld's discovery of a stick at step house in Mesa Verde with a mixture of pitch and red ocher. Nordenskjöld believed that when applied to pottery the pitch reduced the red oxide to a black oxide. This author feels that the use of the processes of oxidation and reduction represent a considerable achievement. It is rea-
sonable to assume that similar methods were used in the preparation of other types of paint as well.
M.H.B.

30-S41.
Densmore, Frances.
Uses of plants by the Chippewa Indians.

Annual report (United States. Bureau of American Ethnology), **44**, pp. 277-397, (1926-1927), [Eng.].

In the section on dyes the author gives a number of recipes used for coloring various materials. Mineral colorants are discussed briefly and something is said about techniques. Mats and textiles were dyed by repeated immersion. Some colorants were directly applied to wooden objects. This text was reprinted in 1974 by Dover as *How Indians Use Wild Plants for Food, Medicine and Crafts.*
M.H.B.

30-S42.
Eibner, Alexander.
Entwicklung und Werkstoffe der Tafelmalerei.
(Development and materials of easel painting.)

Book. Elmar Sändig, 1928, Reprint (1974) of the 1928 ed. published by B. Heller, Munich. [Ger.]. vi, 194 p.: ill., graphs; 22 cm., bibliog. [ISBN 3-500-29540-1].

The reprint of Eibner's 1928 book about easel painting discusses many of the common types of deterioration found in oil paintings. Suggestions for avoiding these problems are given.
Staff

30-S43.
Smith, H.H.
Ethnobotany of the Meskwaki Indians.

Bulletin of the Public Museum of the City of Milwaukee, no. 4, pp. 175-326, (1928), [Eng.].

Cites various plants used by the Meskwaki. Only four plants are cited by the author as colorants, most are common to tribes in the area.
M.H.B.

30-S44.
Smith, Harlan I.
Restoration of totem poles in British Columbia.

In book. *Annual report for 1926: National Museum of Canada,* (1928), p. 126, [Eng.].

Contains a very interesting account of repainting totem poles during the restoration of totem poles in the village of Kitwanga. The author was particularly sensitive to the inappropriateness of using modern colors. Unfortunately, only the oldest members of the village could remember the original appearance. Indians were employed to repaint the poles but the author still found the toned down paints "gaudy" although he was aware the original colors were quite bright. Apparently, no attempt was made to use traditional materials. The project stimulated a revival of interest in the indigenous art of the area. M.H.B.

30-S45.
Steedman, Elsie Viault.
Ethnobotany of the Thompson Indians of British Columbia, based on field notes by James A. Teit.

Annual report (United States. Bureau of American Ethnology), **45,** pp. 447-522, (1928), [Eng.].

Divided by the various uses of plants this contains a section on "Plants Used in Making Dyes and Paints." Steedman says that pigments or colorants were mixed with deer fat and heated prior to application. This would seem to be useful only for body painting since it would not dry, but no variant is cited for use on objects. A list of plants used as colorants is given. Mentions the use of Strawberry blite (*Blitum capitatum*) to dye wood and clothing. The calyx and fruit were pressed to obtain a red colorant that would fade fairly quickly to a dark purple. Colorants were probably applied in the same manner regardless of their source, although the use of mordants was known. M.H.B.

30-S46.
Hawley, Florence May.
Prehistoric pottery pigments in the Southwest.

American anthropologist, **31,** pp. 731-754, (1929), [Eng.].

An extensive discussion of painted pottery in the Southwest. Describes techniques of forming vessels, the composition of coloring matter applied to the pottery, and techniques of firing. Black pigments derived from various plant materials and minerals are discussed. Analytical methods and findings for the painted surfaces of the pottery are given. M.H.B.

30-S47.
Reagan, Albert.
Plants used by the White Mountain Apache Indians of Arizona.

The Wisconsin archaeologist, **8,** no. 4, pp. 143-161, (1929), [Eng.].

Describes the plants used by the Apache for food, material culture, and medicine. Mentions the use of the leaves of a gourd (*Curcubita perennis*) as a source of a green paint used in sand paintings. A number of other colorants are also mentioned. This article apparently dates from field work done in 1901-02. Interesting descriptions are given of plant processing and the preparation of intoxicating beverages containing both alcohol and hallucinogens which were apparently being used abusively at the time to the author's dismay. Methods of food preparation are described as well. M.H.B.

30-S48.
Smith, Harlan I.
Materia medica of the Bella Coola and neighbouring tribes of British Columbia.

In book. *National Museum, Ottawa: annual report for 1927,* (1929), pp. 47-68, [Eng.].

Although this is concerned with the medical uses of plants by the Bella Coola and their neighbors, it describes extensive and sophisticated use of plant gums, waxes, and oils. Gum from the Douglas fir was mixed with shark oil and warm water and taken as an emetic or purgative. Similar materials were used in formulating paints. M.H.B.

30-S49.
Coomaraswamy, Amanda.
One hundred references to Indian painting.

Artibus Asiae, **4,** no. 1, pp. 41-129, (1930), [Eng.].

These literature references about Indian painting, arranged in chronological order, throw light on techniques, terminology, and application. They refer mostly to wall paint-

ings; some discuss painted cloth and painted wood panels. ICCROM(00308800)

30-S50.
Te Rangi Hiroa (Peter H. Buck).
Samoan material culture.

Book. Bernice P. Bishop Museum bulletin, no. 75, Bernice Pauahi Bishop Museum, Honolulu, 1930, [Eng.]. xi, 724 p., 56 p. of plates: ill., map; 26 cm., bibliog., index.

The description of materials used for dyeing and painting bark cloth is of particular interest. This account describes the use of an overripe breadfruit (*Artocarpus spp.*) as a glue pot. The top is removed and the overripe flesh is painted out as an adhesive for joining sheets of bark cloth. The use of arrowroot (*Tacca leontopetaloides*), fausonga (*Pipturus argenteus*), and berries of (*Cordia aspera*) were also used as adhesives. An especially detailed account is given of the use and preparation of turmeric (*Curcuma longa*). A number of other dyes are described as well as brushes and painting techniques for tapa.
M.H.B.

30-S51.
Roys, Ralph L.
The ethnobotany of the Maya.

Book. Middle American research series, no. no. 2, Tulane University. Middle American Research Institute, New Orleans, 1931, [Eng.]. xxiv, 359 p.; 28 cm., bibliog.

Concerned almost exclusively with medicinal uses of the plants, this book does contain an annotated list of Maya plant names. An example of a useful reference is one to *Chacah*, a tree used as a source of resin (*Bursera simaruba*) for medicinal uses and for burning. Some dye plants are mentioned and other plants used in material culture. M.H.B.

30-S52.
Uyemura, Rokuro.
Studies on the ancient pigments in Japan.

Eastern art, **3**, pp. 47-60, (1931), [Eng.].

Describes about 20 ancient pigments in use in Japan citing sources, preparation, and a brief history of each pigment. Japanese and Chinese names in characters, romanized and with variant names, are given. Of particular interest is the use of materials such as glue in compounding pigments. In the case of lamp-

black derived from rosin, glue is added to one and the juice of the bark of *Fraxinus pubinervis* is added for another type. Organic pigments such as safflower were prepared with ashes to extract the pigment and then precipitated with an acid. Preparation of pigments is an important factor in understanding their durability and their tolerance to materials used in treatment. M.H.B.

30-S53.
Bunzel, Ruth L.
Zuni Katcinas.

Annual report (United States. Bureau of American Ethnology), **47**, no. 6, pp. 837-1086, (1932), [Eng.].

This publication includes an invaluable description of the pigments used by the Zuñi and their preparation for use as body paint and for use in painting Kachina masks. Most of the pigments are gathered according to a prescribed ritual and ritually ground. Binding media are also described when used. Of particular interest are some organic colorants such as a corn fungus called Hekwitola which is mixed with yucca syrup for a shiny black pigment when used on masks. Corn pollen is used as a yellow pigment when mixed with yucca juice. Various seeds are masticated ritually and applied as a first layer on masks. This serves an important ritual function but may also be a preparatory layer for subsequent paint layers. The gathering and composition of mineral pigments is described. M.H.B.

30-S54.
Leechman, Douglas.
Aboriginal paints and dyes in Canada.

Proceedings and transactions of the Royal Society of Canada = Délibérations et mémoires de la Société royale du Canada, **26**, no. 2, pp. 37-42, (1932), [Eng.].

Documents native pigments and dyes and describes methods of application. Describes East Coast, Haida, and Tsimshian painting techniques and Great Lake region dyeing practices. Proficiency in these crafts was related to the degree of cultural sophistication of the tribe. East Coast painting was supported by a complex school of art. Artists were often supported by patronage. Permanent settlements allowed for the

establishment of studios. Cedar house fronts, canoes, boxes, and masks served as supports. Pigments were of natural origin, charcoal black, red and yellow ocher, diatomaceous earth white, green and blue from copper carbonates. Media vary, that reserved for fine work being salmon roe chewed with cedar bark. A limited dye technology existed for the decorating of Chilkat blankets. Forest dwellers of the Great Lakes were proficient dyers utilizing a large number of available plants. Until Europeans introduced alum and copperas, fruit juices served as mordants. Goods to be dyed were boiled with the dye plant. Some native pigments that originate from animal sources are yellow derived from buffalo gall bladder, calcined bones, and shell. Paint was applied with brushes, fingers, animal teeth, stamps, and bones. CCI

30-S55.
Parsons, Elsie Clews.
Isleta, New Mexico.

Annual report (United States. Bureau of American Ethnology), **47**, no. 2, pp. 193-466, (1932), [Eng.].

A detailed ethnography of the pueblo. At the time of writing, the Isletans had managed to keep most of the details of their belief systems and accompanying rituals private. Charles Lummis published a volume of folk tales which incorporated some of the information and led to the holding of a council in 1927 to punish members of the pueblo who had acted as informants. In spite of this, the author obtained an enormous amount of information, although she seems to have had few illusions about the reliability of her informants. The painting of prayer sticks and other ritual objects is described; as in other pueblo groups, the preparation of the paint is part of the ritual. The author refers to a number of mineral pigments of various colors including a dark blue she thought might be malachite. A process for gathering a red pigment from a spring is described (p. 320) which is interesting since the pigment apparently is taken from the water. M.H.B.

30-S56.
Smith, H.H.
Ethnobotany of the Ojibwa Indians.

Bulletin of the Public Museum of the City of Milwaukee, no. 4, pp. 327-525, (1932), [Eng.].

Includes a section on dyes used by the Ojibwa. Although trade pigments were supplanting traditional methods, older Ojibwas still preferred traditional colorants for personal items. This book also covers plants used as sources of fibers, food, and medicine. Photographs of plants and some processing are included. M.H.B.

30-S57.
White, Leslie A.
The Acoma Indians.

Annual report (United States. Bureau of American Ethnology), **47**, no. 1, pp. 17-192, (1932), [Eng.].

Pigments formulated for painting Kachina masks and other ritual objects are described. A blue green called *mo ock* (believed by the author to be copper ore) is gathered in the mountains west of Acoma and ground and boiled in pitch. It is then formed into balls for storage. When used it is chewed and sprayed with the mouth onto the surface to be painted. Cow's milk is then sprayed with the mouth to give a glossy appearance (obviously this practice dates to a period after the introduction of domestic cattle). Black is from chimney soot and is sometimes mixed with egg yolk. For yellow, a rock of that color is ground and washed with water to obtain the finest sediment. It is then mixed with egg yolk. A red clay is used for a red pigment and blue is obtained from a trader's store. This seems to represent a mixture of the traditional and various phases of the adaptation to modern materials. M.H.B.

30-S58.
Boscana, Geronimo; Robinson, Alfred; and Harrington, John P.
Chinigchinich: a revised and annotated version of Alfred Robinson's translation of Father Geronimo Boscana's historical account of the belief, usages, customs and extravagancies of the Indians of this mission of San Juan Capistrano called the Acagchemem Tribe.

Book. Fine Arts Press, Santa Ana, California, 1933, [Eng.]. 247 p.: ill. (some col.); 37 cm., bibliog.

Harrington's extensive notes and comments for this publication contain several informative pages describing the making of paints and the materials used. He cites the use of three ingredients in making the paint used in rock art. The first of these is iron oxide, the second, "turpentine" (meaning pitch from the pine *Pseudotsuga macrocarpa*) and the third, the ground kernels of chilicothe (*Marah macrocarpus*). The chilicothe seeds were parched and ground and evidently added an oiliness to the paint. Harrington gives the terminology for the different types of paint and for the various pigments and their sources. Iron-depositing bacteria (*Leptothrix ochracea*) were gathered from ponds and roasted with oak bark to obtain a red pigment. M.H.B.

30-S59.
Douglas, Frederic Huntington.
Colors in Indian arts: their sources and uses.

Special issue. *Indian leaflet series*, no. 56, 1933, 2nd, rev. ed.: July, 1968 [Eng.]. 4 p., refs.

This leaflet gives an outline of the principal kinds of colors used in North American Indian crafts, and their distribution. The sources of colors are given as: natural colors (materials which are naturally colored); vegetable dyes; mineral dyes and paints; aniline dyes and dyed cloth. Plants and other materials used to create natural or dyed colors on basketry and weaving are given, following their geographical distribution. The origins of colors on beadwork are listed as colored glass beads (mostly European), wampum, turquoise, shell, coral, or seeds. Colors found on painted objects, dyed quillwork, pottery, and sand painting are also briefly described. The author compiled this information from referenced sources dating between 1902 and 1931. C.D.

30-S60.
Gilmore, Melvin R.
Some Chippewa uses of plants.

Papers of the Michigan Academy of Science, Arts, and Letters, **17**, pp. 119-143, (1933), [Eng.].

Discusses the uses of plants in all aspects of Chippewa life. The process of maple sugar production is described as is the harvesting of wild rice. Of particular interest is a section on dyeing that describes the technology and gives recipes commonly used. The use of bloodroot (*Sanguinaria canadensis*) for coloring wooden objects is described. The fresh root is simply rubbed onto wood to impart an orange color. Red and black pigments were gathered from the surface "scum" of certain springs. It was collected, dried, and baked in a fire for use as a pigment. Grease was added for body painting. M.H.B.

30-S61.
Smith, H.H.
Ethnobotany of the forest Potawatomi Indians.

Bulletin of the Public Museum of the City of Milwaukee, no. 7, pp. 1-230, (1933), [Eng.].

The author lists colorants under "miscellaneous uses of plants." States that traditional materials are used for sacred and ceremonial purposes and that they last longer than trade dyes available to them for purchase. Some plants are illustrated with photographs. M.H.B.

30-S62.
Boscana, Geronimo; Harrington, John P., Translator.
A new original version of Boscana's historical account of the San Juan Capistrano Indians of Southern California.

Book. Smithsonian Institution, Washington, 1934, [Eng.]. 62 p.: ill.; 25 cm.

Father Jerónimo Boscana's (1776-1831) account is one of the rare records of Native American culture in California before it was destroyed. Boscana believed that it was impossible to convert the Indians without understanding their beliefs and customs. John Peabody Harrington found a second manuscript version of his narrative and is the translator for this version. Boscana describes body paint without specifically mentioning sources of pigments or how they were applied. Boscana mentions one village named Tobe after a white pigment found there which he describes as being like white lead and was used by the women for body paint. He describes women painted for a first menstruation ceremony as being painted with a "black glue or bitumen" and also refers to glossy body paint in other areas of the text but does not go into detail. Ritual painting is described in a vague and tantalizing manner. Boscana found the paintings absurd and does not describe them. He seems to indicate that they were highly abstract rather than

representational. [Editor's remark: The 1933 Fine Arts Press edition of this publication includes an important commentary by Harrington regarding paint and pigments. This edition does not but is more widely available.] M.H.B.

30-S63.
Lucas, Alfred.
Ancient Egyptian materials & industries.

Book. Edward Arnold Publishers Ltd., London, 1934 and 1962, 2d ed., rev.; 4th ed., rev. and enl. by J.R. Harris [Eng.]. 2nd ed.: xii, 447 p.; 22 cm.; 4th ed.: xvi, 523 p.; 25 cm., refs., index.

This is a comprehensive examination of the materials and the technologies of the ancient Egyptians. The author discusses a variety of topics in great depth and with extensive referral to other literature. Among the materials he covers are: adhesives (resin, starch, beeswax, glue, gum); animal products (bone, feathers, gut, hair); building materials (bricks, stone, plaster, wood); fibers; metals and alloys; and oils, fats, and waxes. Egyptian methods of basketry, glass manufacture, pottery making, mummification, glazed ware, and painting are all described at length.
Staff

30-S64.
Branzani, Luigi.
Le tecniche, la conservazione, il restauro delle pitture murali.
(The techniques, conservation, and restoration of mural paintings.)

Book. Società anonima tipografica "Leonardo da Vinci," Città di Castello, 1935, [Ita.]. xii, 133 p.; 20 cm., refs.

A history of mural painting techniques from antiquity to the 20th century, with chapters on ancient and modern colors, causes of deterioration, gum and resin media, glue and the Etruscan technique, wax painting, medieval lime painting, Renaissance fresco, tempera, oil and sgraffito techniques, gilding, stacco and strappo transfer, and cleaning. ICCROM(00319400)

30-S65.
Burkill, Isaac H.
A dictionary of the economic products of the Malay Peninsula.

Book. "Published on behalf of the governments of the Straits Settlements and Federated Malay States by the Crown agents for the colonies," London, 1935, [Eng.]. 2 v.; 24 cm.

While this work is primarily concerned with the uses of plant materials, the author also lists minerals and animals of economic importance. For instance an entry for "rhinocerus" describes the history of rhinocerus horn drinking cups and the present state of the various species of Malaysian rhinocerus. Listings are alphabetical by substance or plant. Terms in the local languages are also given. The listing for the *Garcinia* family describes *G. hanburyi* as the source of gamboge and gives its history. Margin notes highlighting the use of the plants with notes such as "timber" of "Gum kino" for the source of this material make the book particularly easy to use. This geographic area is particularly rich in plant based colorants, gums, and resins. This book is a very valuable historical reference for the area. M.H.B.

30-S66.
Segal, R.
A possible base for "Bushman" paint.

Bantu studies: a journal devoted to the scientific study of Bantu, Hottentot, and Bushman, **9,** pp. 49-51, (1935), [Eng.].

Analyzes limonite concretions found in sandstone. These were known locally as "Bushman paint." It was found that the inclusions mixed well with drying oils to form a paint. Variations in color could be obtained by roasting and mixing with red ocher. After roasting, grinding, and mixing with tallow and water, the paint exhibited good covering power. M.H.B.

30-S67.
Burrows, Edwin Grant.
Ethnology of Futuna.

Book. Bernice P. Bishop Museum bulletin, no. 138, Bernice Pauahi Bishop Museum, Honolulu, 1936, [Eng.]. iv, 239 p., 11 p. of plates: ill., map, music; 26 cm., bibliog., index.

Burrows mentions the use of anatto (*Bixa orellana*) and turmeric (*Curcuma longa*)

as colorants. The use of anatto for body painting is described, as is the cultivation and preparation of turmeric. Turmeric was used as a pigment and as a dye. Lime burning was also practiced for producing mortar, for dressing the hair, and presumably also as a white pigment. For the most part the book is concerned with general ethnological matters. It provides useful information on material culture. M.H.B.

30-S68.
McClintock, Walter.
The Blackfoot tipi.

Masterkey, **10,** no. 3, pp. 85-96, (1936), [Eng.].
The preparation of hides, and the manufacture, erection, and decoration of tepees by the women are described. There are descriptions of the furnishings, transportation, and length of use, and of obtaining pigments for paint. Staff

30-S69.
McClintock, Walter.
Painted tipis and picture-writing of the Blackfoot Indians.

Masterkey, **10,** no. 4, pp. 121-133, (1936), [Eng.].
Describes the construction and use of tepees by the Blackfoot as well as the types of decoration and the associated iconography. Includes a description of the technique used in painting a tepee. First an underdrawing is done, then pigment is mixed with water and fat in a clam shell and applied to the design. Pigments used include various colored earths, charcoal, and a yellow pigment from buffalo gallstones. Some pigments are transformed by heating. M.H.B.

30-S70.
Stephen, Alexander M.; Parsons, Elsie Clews, Editor.
Hopi journal of Alexander M. Stephen.

Book. Contributions to anthropology (Columbia University), no. 23, pt. 1-2, Columbia University Press, New York, 1936, [Eng.]. 2 v. (1417 p.): ill., 25 col. plates, 12 fold. maps; 25 cm., bibliog., glossary.
Extensive descriptions of various Hopi ceremonies include the Winter Solstice, Powa'mû, and Kachina Return. Most references to pigments concern painting Kachina masks and

prayer sticks, some wall paintings in kivas, and body paint. Sections on paint technology/painting techniques include descriptions of minerals used to produce specific colors (i.e., specular iron for red, shale for black), chewing different nonspecified seeds to produce saliva to mix with pigments to make paint, the rubbing of pigment on prayer feathers, how minerals are processed to make pigments, and combinations of organic and mineral substances to produce paints. C-A.G.

30-S71.
Sweet, Herman R.; and Barkley, Fred A.
A most useful plant family, the Anacardiaceae.

Missouri Botanical Garden bulletin, **24,** pp. 216-229, (1936), [Eng.].
This plant family includes among its members the mango, pistachio, cashew, poison oak, poison ivy, and the lacquer tree of Asia. A number of plants are also used as sources for colorants. This article presents an overview of the plants in the family and their uses. M.H.B.

30-S72.
Berkley, F.A.; and Sweet, H.R.
The use of the sumacs by the American Indian.

Missouri Botanical Garden bulletin, **25,** pp. 154-158, (1937), [Eng.].
Sumacs of various species were used extensively by the indigenous Americans. This article cites the use of the gum of the American pistachio (*Pistacia mexicana*) by the Indians of Mexico. Other species are used as colorants. The wood of sumacs is used extensively in material culture. This article states that poison ivy is little used. However, on the West Coast, poison oak was used in basketry and the use of the sap is also cited. Many sumacs were used medicinally. M.H.B.

30-S73.
Britton, Roswell S.
Oracle-bone color pigments.

Harvard journal of Asiatic studies, no. 2, pp. 1-3, (1937), [Eng.].
Describes oracle bones in the Princeton collection. Microchemical analyses by Benedetti Pichler analyzed two pigments perceived as various reds and a black pigment.

The red proved to be cinnabar. The black was not positively identified but suspected to be blood in a highly decomposed state.

M.H.B.

30-S74.
Burrows, Edwin G.
Ethnology of Uvea (Wallis Island).

Book. Bernice P. Bishop Museum bulletin, no. 145, Bernice Pauahi Bishop Museum, Honolulu, 1937, [Eng.]. iii, 176 p., 8 p. of plates: ill., map; 26 cm., bibliog., index.

A portion of this text describes colorants used for matting and bark cloth. A reddish brown from koka (*Bischoffia javanica*) predominates followed by a black from candlenut soot. A purple compounded from loa (*Bixa orellana*) and pou muli (*Xylosma*) is also in use. A red earth was formerly in use and turmeric is cited as being scarce.

M.H.B.

30-S75.
Leechman, Douglas.
Native paints in the Canadian West Coast.

Technical studies in the field of the fine arts, 5, no. 4, pp. 203-208, (1937), [Eng.].

This article is based on notes accumulated by the author on the arts of painting and dyeing as practiced by the Indians of Canada. The palette of the West Coast artists was a severely restricted one. The eggs of various species of salmon were used as a medium. Brushes and other types of painting equipment are described.

ICCROM(01117700)

30-S76.
Paramasivan, S.
The mural paintings in the Brihadisvara Temple at Tanjore: an investigation into the method.

Technical studies in the field of the fine arts, 5, no. 4, pp. 221-240, (1937), [Eng.].

The mural paintings of the 11th-12th centuries in the Brihadisvara Temple at Tanjore are examined. Over the early Chola paintings is a second layer of paint executed during the 17th century. The painting grounds, pigments, media, and execution techniques are analyzed.

ICCROM(01117702)

30-S77.
Stout, George; and Gettens Rutherford, John.
Trial data on painting materials - mediums, adhesives, and film substances.

Technical studies in the field of the fine arts, 6, no. 1, pp. 26-68, (1937), [Eng.].

The second part of an extensive work on painting materials. The first portion discusses supports. This section is devoted to paint mediums and related adhesives. It is in the form of an alphabetical compendium that begins with "Acrylic Resins" and ends with "Oils, yellowing." A definition of the material cited and the history of its use are given for each entry. The authors intended this as a preliminary compendium of information gathered from other sources. Further sections continue to address pigments and other materials. Modern (to 1937) and historic materials are covered. [Abstractor's note: this was a preliminary work for *Painting Materials; a short encyclopedia* by Gettens and Stout.]

M.H.B.

30-S78.
Stout, George; and Gettens Rutherford, John.
Trial data on painting materials - mediums, adhesives, and film substances (continued).

Technical studies in the field of the fine arts, 6, no. 2, pp. 110-152, (1937), [Eng.]. bibliog.

Continues the work by the same title in the July issue. Alphabetical entries from "Oleo-Resin" to "Zanzibar Copal." Includes an extensive bibliography covering both the first and second parts.

M.H.B.

30-S79.
Wall, William E.; Vanderwalker, Fred N., Editor.
Graining: ancient and modern.

Book. Frederick J. Drake & Co., Chicago, 1937, 3rd. ed., rev. and enl. [Eng.]. iv, 155 p.: ill. (some col.); 24 cm.

Cites the use of whiting or corn starch as an additive to the medium for oil graining so the medium will better hold the marks made by the graining tool.

M.H.B.

30-S80.
Daniel, F.
Yoruba pattern dyeing.

Nigeria, no. 14, pp. 125-129, (1938), [Eng.].

Concerned primarily with the techniques used to achieve the dyed patterns of the textiles, this article also mentions the use of a shrub called Elu (*Lonchocarpus cyanescens Dalziel*) as a blue dye. This is used in preference to indigo which is used by the Hausa.

M.H.B.

30-S81.
Gettens, Rutherford J.
The materials in the wall paintings from Kizil in Chinese Turkestan.

Technical studies in the field of the fine arts, **6,** no. 4, pp. 281-294, (1938), [Eng.].

A few fragments of wall paintings from Kizil were analyzed. The paintings were executed on a clay wall support prepared with a gypsum ground. The pigments seem to have been applied with a glue medium. With regard to the use of pigments, there is a greater similarity between paintings of Kizil and Bamiyan than there is between paintings of Kizil and the Far East. ICCROM(01118103)

30-S82.
Mantell, C.L.
Natural resins.

Book. American Gum Importers Association, Brooklyn, 1938, [Eng.]. 64 p.: ill.; 28 cm., bibliog.

Primarily a compilation of information about the properties of natural resins used in the paint industry during this time period. A useful compendium of information about the properties of natural resins and the sources of resins used in commercial paints of the period. M.H.B.

30-S83.
Mayer, Ralph.
The artist's handbook of materials and techniques.

Book. Dial Press, Garden City, 1938, [Eng.]. 676 p.: ill., bibliog., index.

The revised and expanded edition of this well-known work covers oils, tempera, mural painting, pigments, mediums, grounds, watercolor, pastel, encaustic, and solvents and thinners. A new chapter deals with

"New Materials," including synthetic resins, polymer colors, and straight acrylic colors; also synthetic organic pigments and luminescent pigments. There is a section on modern printmaking trends including color woodcuts and relief prints. Collagraphs, collage, and rubbings are also dealt with. A special chapter on "Chemistry" covers, first, fundamental theories that relate to art materials and, secondly, the chemistry that is involved with the various painting processes discussed. In a special chapter on the "Conservation of paintings," the common agents of decay are reviewed and modern methods of treatment to combat them described. The next chapter deals with the important matter of tools and equipment including paint brushes, knives, palettes, and gilding tools. There are notes on the graphic arts, covering lithography, etching, woodblock printing, and serigraphy. Chapter 17 is an extensive annotated bibliography. The abundant section headings and the thorough index make it easy to use. This is probably the most complete treatise on artists' materials published in this period.

Staff

30-S84.
Paramasivan, S.
Technique of the painting process in the Kailasanatha and Vaikunthaperumal temples at Kanchipuram.

Nature, no. 3599, p. 757, (1938), [Eng.].

Examination of Indian mural paintings: plasterwork, paint layer, pigments, medium, and fresco technique. ICCROM(00468800)

30-S85.
Paramasivan, S.
The Pallava paintings at Conjeevaram: an investigation into the methods.

Proceedings of the Indian Academy of Sciences, **10,** pp. 77-84, (1939), [Eng.].

An investigation into the chemical composition and technique of execution of the "painted stuccoes." Characterizes the particle size of the two coats of the underlying plaster and their chemical composition. No trace of binding media could be found in any color other than black which appears to be bound with a gum. The author concludes that "lime medium" was used in all portions of the paintings except for the black which required

History

the use of a binder because of wetting problems with the black pigments.
ICCROM(00469300) and M.H.B.

30-S86.
Paramasivan, S.
Technique of the painting process in the rock-cut temples at Badami.
Proceedings of the Indian Academy of Sciences, **10,** pp. 145-149, (1939), [Eng.]. 2 plates, bibliog.

Discusses microchemical examination of the paint layer of the mural paintings: plasterwork, pigments, and binding medium. Describes the technique of laying the ground.
ICCROM(00474500)

30-S87.
Paramasivan, S.
The wall paintings in the Bagh caves: an investigation into their methods.
Proceedings of the Indian Academy of Sciences, **10,** pp. 85-95, (1939), [Eng.]. 2 plates, bibliog.

Describes the caves and their wall paintings, with analysis of the plaster substrate and the pigments. The pigments are colored earths and lapis lazuli for the blue. Analytical results indicate that the paintings were done in a tempera technique with glue as the binder. ICCROM(00474600)

30-S88.
Anon.
The Botanical Museum of Harvard University has recently received the Economic Herbarium of Oakes Ames.
Chronica botanica, **4,** no. 4, pp. 90-91, (1940), [Eng.].

A collection of material formed by Ames and his associates after 30 years of teaching an economic botany course at Harvard is described. The collection includes "plants of importance in agriculture, industry, and the arts" and "plants of use among primitive peoples." It consists of herbarium specimens, plant products, and publications. The notice appeared in 1940 when the collection was donated to the Botanical Museum of Harvard University. Such collections are invaluable reference collections for studying plant materials used in the manufacture of artifacts. M.H.B.

30-S89.
Bishop, Marcia Brown.
Hawaiian life of the pre-European period.
Book. Southworth-Anthoensen Press, Portland, Maine, 1940, [Eng.]. v, 105 p.: ill.; 22 cm.

Published to accompany an exhibition of Hawaiian artifacts from the Marcia Brown Bishop collection at the Peabody Museum in Salem. The book also includes a catalog of the collection. The section on the sources of dyes for tapa describes the various plants used with the Hawaiian names and the scientific nomenclature. Tools used and methods of application of the paint are briefly described. The various uses of tapa from bandaging to clothing are also discussed. The term "dyes" for tapa is somewhat misleading since much of the decoration was applied with stamps or painted on. The catalog includes a full spectrum of items of Hawaiian material culture. M.H.B.

30-S90.
Bontinck, Ed.
(Microchemical analysis of the wall paintings of St. Baafsabtei in Ghent (about 1175).)
Mededelingen van de Koninklijke Vlaamse Academie voor Wetenschappen, Letteren en Schone Kunsten van België, Klasse der Wetenschappen, no. 13, pp. 3-12, (1940), [Dut.].

$CaCO_3$ + $Ca(OH)_2$ in admixture with casein, lapis lazuli, yellow and red ocher, burnt sienna, glauconite, and powdered wood charcoal were identified, but the following pigments were not detected: white lead, cinnabar, and blue and green copper pigments. The method previously given for the determination of lapis lazuli is not applicable in the presence of casein. $Ca(OH)_2$ and casein, and also glue, were used as the principal binding agents for black pigments. The presence of casein is indicated also by its resistance to dilute HCl, by which method the presence of organically bound P, N, and S was determined, particularly of P, for which the silicates were removed with HF and H_2SO_4. The presence of casein was confirmed by testing in ultraviolet light, wherein I causes the fluorescence of casein to disappear. Staff

30-S91.
Stowe, Gerald C.
Plants used by the Chippewa.

The Wisconsin archaeologist, **21,** pp. 8-13, (1940), [Eng.].

Briefly describes the dyes used by the Chippewa and cites the direct application of blood root as a colorant. Some plant processing and preparation is described. M.H.B.

30-S92.
Anon.
Breadfruit.

Field Museum news, **12,** no. 8, p. 5, (1941), [Eng.].

A brief description of the bread fruit and its history. Bread fruit is an important source of food and adhesive in Polynesia.
 M.H.B.

30-S93.
Ball, Sydney Hobart.
The mining of gems and ornamental stones by American Indians.

Book. Bulletin (United States. Bureau of American Ethnology), no. 128, United States Government Printing Office, Washington, 1941, [Eng.]. xiii, 77 p.: front., plates; 24 cm., bibliog.

An overview of mineral exploitation by Native Americans. Particularly interesting is a description of the use of sharp quartz fragments by the Hidatsa of North Dakota to cut pictographs in rock. A section on minerals used as pigments (p. 4) describes the use of galena as a black pigment by the Apache and the Yumas. Hewettite is cited as a pigment used in rock art in Utah. The practice of burning limonite to produce red ocher is noted, as well as the dehydration of gypsum for whitening. Contains two maps of sites being worked by Native Americans for various materials prior to European contact. Extensive bibliography. M.H.B.

30-S94.
Mantell, Charles L.
Natural resins for the paint and varnish industry.

In book. *Protective and decorative coatings: paints, varnishes, lacquers, and inks,* Mattiello,

Joseph J., Editor (1941 and 1946), pp. 213-258, [Eng.].

Gives a brief history of the use of natural resins in coatings with a special mention of the extremely durable properties of urushi (*Rhus vernicifera*). The bulk of the chapter concerns itself with the commercial plant resins of Australasia, the trade in these resins and their properties in reference to the paint industry at the time the book was written. Useful tables describing the resins, their place of origin, and physical properties are given.
 M.H.B.

30-S95.
Barrow, Francis J.
Petroglyphs and pictographs on the British Columbia coast.

Canadian geographical journal, **24,** no. 2, pp. 94-101, (1942), [Eng.]. ill.

This illustrated journal article describes petroglyphs (rock carving) and pictographs (rock painting) of prehistoric Pacific Northwest Coast Indians on the coast of British Columbia and Vancouver Island. Origins, function, and symbolism (e.g., anthropomorphic figures) are unclear. Study and understanding of primitive rock art worldwide (e.g., North America, Europe, Africa, Australia) may lead to links between ancient cultures. Paintings in red ocher or other pigments, possibly in a deer fat or salmon egg binding medium, may depict dreams or important events. CCI(1579)

30-S96.
Borradaile, Viola; and Borradaile, Rosamund.
The student's Cennini: a handbook for tempera painters.

Book. Dolphin Press, Brighton, 1942, [Eng.]. xi p., 2 l., 30 p., 2 l., 49 p., 2 l., 39, xiii-xviii p.; 19 cm.

Contents: Foreword, by P. Tudor-Hart; Preface; How to paint in egg tempera; Grounds for egg tempera; The art of gilding; Supplementary workshop notes; Table of reference to Cennini's *Trattato*. A.A.

History

30-S97.
Brummer, Ernö.
(Tempera adhesives in the history of art.)

Technika, **23**, pp. 78-83, 123-128, (1942), [Ger.].

The physicochemical basis of paint binders in the painting of the Middle Ages.

Staff

30-S98.
Hodge, W.H.
Plants used by the Dominica Caribs.

Journal of the New York Botanical Garden, **43**, no. 512, pp. 189-201, (1942), [Eng.].

Describes plant use by what was the sole surviving community of Island Caribs in 1942. A range of plant usage is described including basketry, canoe making, and some colorants. A native plant *tan (Picramnia pentandra)* and turmeric (*Curcuma longa*) were both in use as colorants, the former giving a mauve color and the latter a yellow.

M.H.B.

30-S99.
Mantell, Charles Letnam; Kopf, C.W.; Curtis, J.L.; and Rogers, E.M.
The technology of natural resins.

Book. Wiley & Sons Ltd., Chichester; Chapman and Hall Ltd., London, 1942, [Eng.]. vii, 506 p.: ill.; 24 cm., bibliogs.

This book is about the exudations of trees of many different genera; it excludes coverage of rosin and shellac. It covers the physical and chemical properties of natural resins, including solubility and compatibility with other materials. There are chapters on the processing and formulations of resins, and their uses in varnishes, lacquer, paints and enamels, and printing ink. Two sections deal with detection and identification, and physical and chemical testing methods. There are tables of: native designations of natural resins; properties of commonly used solvents; characteristics of various petroleum naphthas.

Staff

30-S100.
Brummer, Ernö.
Artistic frescoes.

A Magyar Mernok- es Epitesz-Egylet kozlonye, **77**, pp. 65-71, (1943), [Eng.].

Optical effects depend on the quality of applied binders, the sequence of layers forming the actual picture, and the method of painting. The most durable frescoes are those which contain exclusively inorganic binders (with the exception of casein if it is treated abundantly with lime).

Staff

30-S101.
Heizer, Robert Fleming.
Aboriginal use of bitumen by the California Indians.

Book. Bulletin (California. Division of Mines), no. 118 pt. 1, California State Printing Office, Sacramento, 1943, [Eng.]. [6] + 74 p.: ill., map; 31 cm., bibliog.

Describes how bitumen was used by the California Indians and cites early European accounts that describe uses of bitumen. The Chumash were the most sophisticated users of bitumen, using it as an all-purpose adhesive and with particular skill in the construction of their seagoing plank canoes. Bitumen was used not only as a structural adhesive but was used to apply decorative elements. It was pressed into incised lines to create a sharp black line. A map is given showing important sources in Los Angeles, Santa Barbara, and San Luis Obispo. The author credits the Yokuts of the Southern San Joaquin Valley as being the earliest users of bitumen, exploiting natural tar springs in the area of present-day Bakersfield.

M.H.B.

30-S102.
White, Leslie A.
Keresan Indian color terms.

Papers of the Michigan Academy of Science, Arts, and Letters, **28**, pp. 559-563, (1943), [Eng.].

Provides interesting insights into the cultural associations the author's informants had with colors. The informants were from a number of the Keresan speaking pueblos. Certain colors are associated with dyes such as an orange red color associated with a dye derived from the Mountain Mahogany (*Cercocarpus argenteus*). Blue-green is associated with copper sulfite and malachite which are gathered as pigments.

M.H.B.

30-S103.
Bontinck, Ed.
La fabrication des pastels.
(The manufacture of pastels.)
Chimie des peintures, **7**, pp. 243-256, (1944),
[Fre.]. ill., table, 47 refs.
A history of the manufacture of pastels
with an annotated bibliography that begins
with Armenini's *De Veri Precetti della pittura*
in 1587. Describes the manufacturers of pastels and the ingredients used. M.H.B.

30-S104.
Caley, Earle R.
Ancient Greek pigments from the Agora.
Hesperia, **14**, pp. 152-156, (1945), [Eng.].
In 1937 the author examined and identified a number of specimens of pigments from
the Agora. These were substantial specimens
or small remains of bulk pigments found in the
vessels in which these pigments had been
stored or in which they had been mixed for application. The following pigments were analyzed: blue frit; artificial calcium copper silicate; several forms of red ocher; cinnabar;
natural mercuric sulfide; white lead, artificial
basic lead carbonate; chalk; impure calcium carbonate; and yellow ocher diluted with chalk.
Few pigments were in use, and of these only a
small proportion were prepared by any chemical process. This indicates the primitive state
of chemical technology in ancient Greece. Certain of the pigments used in ancient times
are still among the most widely used and valued of all pigments, notably white lead and
the iron ochers. C.A.L.(14990)

30-S105.
Caley, Earle R.
Ancient Greek pigments.
Journal of chemical education, **23**, pp. 314-316,
(1946), [Eng.].
The author was the staff chemist for the
American excavations at the Athenian Agora;
in this article, he publishes the results of his
analysis of pigment samples from objects
found during these excavations, as well as
analysis of bulk samples of pigments found
in the excavations. Discusses the source of
various pigments and relates this to the writings of Theophrastus of Eresos and Vitruvius.
 M.H.B.

30-S106.
Schnell, Raymond.
Sur quelques plantes à usage religieux de
la région forestière d'Afrique occidentale.
(Plants for religious use from the forest
region of West Africa.)
Journal de la Société des africanistes, **16**, pp. 29-
38, (1946), [Fre.]. bibliog.
Describes the ceremonial uses of some
plants of the area. Iroko wood (*Chlorophora
excelsa*) and camwood (*Baphia nitida*) are mentioned. The former is used for carving ritual
figures; the wood of the latter is one of several species powdered for use as a red colorant. M.H.B.

30-S107.
Shepard, Anna O.
Technological notes on the pottery,
pigments, and stuccoes from the
excavations at Kaminaljuyu, Guatemala.
In book. *Excavations at Kaminaljuyu, Guatemala,* Carnegie Institution of Washington
publication, no. 561, (1946), pp. 261-277,
[Eng.]
Fragments of 60 pottery vessels were
sectioned; 42 contained either volcanic ash or
volcanic sand as temper. (Mineral components are described in detail.) Basalt and sand
and schist temper were observed in occasional pieces. The paste of several fragments
has the texture of untempered clay. Although
the recognized trade ware of the Kaminaljuyu tombs includes a number of distinctive
pastes as observed petrographically, not
enough is yet known about geographic occurrence of the various tempers noted to trace
geographic origin of the pottery. The data
collected raise many questions still to be answered by further archaeological and scientific research. Pigments identified include
samples from stuccoes, pottery, miscellaneous
artifacts, paint pots. They were: reds with
oxide-containing crystals of specular hematite, red ferric oxide, ferruginous clay, cinnabar, pinks, cinnabar and calcite, cinnabar and
diatomaceous earth, ferruginous clay or ferric
oxide and calcite; greens, such as malachite,
unidentified copper mineral, malachite mixed
with unidentified copper mineral, and impure azurite; yellows, ocher with cryptocrystalline calcite; and black, charcoal and white
clay, carbon and calcite. Stuccoes were of two

kinds: argillaceous and calcareous. Examples of the use of clay in place of lime have been found in widely distant regions. The soft opaque calcareous stuccoes are composed of cryptocrystalline calcite and are in all probability made from slaked lime. The hard translucent lime stuccoes seem to have been cemented by calcareous solutions after burial. All painted stucco appears to have been done in secco technique. Staff

30-S108.
Walkabout.

Motion picture. Australian Information Service, New York, 1947, 1 film reel (20 min.), sd., col., 16 mm. [Eng.]. Mountford, C.P. (Cameraman); Chase, G. (Editor); Film Australia (Producing Agency).

Records the University of Adelaide expedition to study the lives and traditions of the Aborigines of central and south Australia. Includes an Aborigine making a cave painting. PFAOF

30-S109.
Bender, Max.
Colors for textiles: ancient and modern.

Journal of chemical education, **24,** pp. 2-10, (1947), [Eng.]. bibliog.

Examines natural and synthetic dyes. Indigo from the leaf of *Indigofera tinctoria* and woad are both ancient blue dyes. Indigo supplanted woad, the inferior dye, in Western Europe at the close of the 18th century. Logwood, still in use, derives from a South American tree, providing purple and black. Madder, known to the ancients, occurs in roots of herbaceous *Rubia tinctorum* or peregrina. Tyrian purple comes from the purpura shell, Kermes, a brilliant scarlet, from several species of shield louse. A Mexican species produces scarlet cochineal. Other natural dyestuffs are enumerated. Indians of the Americas are skilled dyers utilizing a variety of locally occurring plants. Mordants, oxidizing agents, and developers help to fix dyes to fabric. Mordants can alter dye color. Alum, tannin, urine, fatty acids, oils, iron, calcium, aluminum, and chrome compounds are examples of mordants. Some substances facilitate color application; others control dyeing. The first modern synthetic dye appeared in 1856. These are classified as basic, acid, mor-

dant or chrome, direct, sulfur, and vat dyes. Coloring with pigments is regaining popularity. Synthetic resins have replaced traditional gums. This along with vat dyeing is currently the most popular form of textile coloring. This forms a general review of dyes and dye technology. CCI

30-S110.
Kronstein, Max.
Ancient surface technology.

American paint journal, **32,** no. 8, pp. 39, 42-43, 46, 48, 51-52, (1947), [Eng.].

The history of painting by the Egyptians, Italians, etc., before the use of drying oils as vehicles is discussed, particularly as concerns tempera painting and wax vehicles. Staff

30-S111.
Nordmark, Olle.
Fresco painting: modern methods and techniques for painting in fresco and secco.

Book. American Artists Group, New York, NY, 1947, [Eng.]. 126 p.: ill., col. plates; 25 cm.

Contents: Walls; Preparation of mortar materials; Mortar mixing; Plastering the fresco ground; Fresco grounds; Intonaco; Preliminary work to painting the fresco; Painting the fresco; Secco painting in limecolor; Modeling of relief in mortar; Retouching; Preliminary work for plastering; The scaffold; Source of supplies; Index. Staff

30-S112.
Pollock, Jackson.
My painting.

Possibilities, an occasional review, no. 1, p. 79, (1947), [Eng.].

A brief statement by Pollock about his working methods. "I continue to get further away from the usual painter's tools such as easel, palette, brushes, etc. I prefer sticks, trowels, knives and dripping fluid paint or a heavy impasto with sand, broken glass and other foreign matter added." This has of course created some problems with adhesion and flaking in Pollock's paintings. M.H.B.

30-S113.
Rabaté, Henri.
Les pigments jaunes des anciens.
(Yellow pigments used in antiquity.)

Peintures, pigments, vernis, **23,** pp. 358-359, (1947), [Fre.].

Yellow pigments used in antiquity include: yellow ocher, river ocher, litharge and massicot, orpiment, perhaps sulfur, and powdered gold. Yellow ocher, a native mineral pigment, is seen in prehistoric cave paintings. River ocher was gathered from the beds of certain streams rich in iron deposits. Litharge, obtained from plumbiferous sand or as a by-product of silver and lead, was not distinguished from massicot by the ancients. Orpiment is mentioned in Pliny; Cennini called it risalgallo (mineral yellow). The ancients also used yellow vegetable dyes extracted from yellow lake, quercitron, and weld.
C.A.L.(413)

30-S114.
Rabaté, Henri.
Les pigments rouges des anciens.
(Red pigments of antiquity.)

Peintures, pigments, vernis, **23,** p 69, (1947), [Fre.].

An account is given of the red pigments used by the Greeks and Romans. The most commonly used pigments were iron oxide, cuprous oxide, and red lead. Other pigments were cinnabar and realgar.
Staff

30-S115.
Stoppelaëre, Alexandre.
Introduction à la peinture thébaine.
(Introduction to Theban painting.)

Actes (Congrès des Sociétés de philosophie de langue française), no. 7/8, pp. 3-13, (1947), [Fre.]. 4 ill.

Technical data on materials and techniques of ancient Egyptian (Thebes) wall paintings.
Staff

30-S116.
Taylor, Edith S.; and Wallace, William J.
Mohave tatooing and face-painting.

Book. Southwest Museum leaflets, no. 20, Southwest Museum, Los Angeles, 1947, [Eng.]. 13 p.: ill.; 20 cm., bibliog.

The Mojave used charcoal as a pigment for their facial tattooing. The method used is described and some of the more common designs are shown. For body paint, deer fat was used as a binder and kept stored in ceramic containers sealed with "wax from the greasewood bush" (probably a wax from scale insects on creosote). Red pigment was acquired by trade from the Walapai. The Mojave had a mineral source for black pigment used and a source for a white pigment as well. Pumpkins were burned to obtain another black pigment. This was believed to prevent wrinkles and protect the skin from the weather.
M.H.B.

30-S117.
Watrous, James.
Observations on a late Medieval painting medium.

Speculum; a journal of Medieval studies, **22,** pp. 430-434, (1947), [Eng.].

Refers to a paint recipe in a manuscript by Jehan Le Bègue that has been subject to much speculation. The recipe is for a paint medium composed of fish glue, wax, and gum mastic in a solution of lye made with wood ash and lime. The medium supposedly made a paint that was very durable and could even be burnished. Variant translations made the recipe difficult to interpret but the author succeeded in making the medium. The appearance of the medium is said to resemble egg tempera. The author describes it as being "a mat paint surface similar to wax medium, but with less obvious brush work than is typical of egg tempera."
M.H.B.

30-S118.
Witthoft, John.
An early Cherokee ethnobotanical note.

Journal of the Washington Academy of Sciences, **37,** no. 3, pp. 73-75, (1947), [Eng.].

Anna Rosina Gambold, a botanist and the wife of a missionary, lived at Spring Place on the Conasauga River from 1805 to 1825 (present day northwestern Georgia). She collected specimens and kept notes on the use of plants by the Cherokee of the area before they were forcibly resettled. This brief article describes a surviving manuscript by Gambold describing Cherokee ethnobotany. It cites several plants used as colorants.
M.H.B.

30-S119.
Yamasaki, Kazuo; and Shibata, Yuji.
(The chemical studies on the pigments used in the Main Hall and pagoda of Hōryūji temple (Nara, Japan).)

Bijutsu kenkyu = The journal of art studies, no. 144, pp. 225-231, (1947), [Jpn.].

Depictions of the Western paradise painted in the Main Hall of the temple dating from the 10th century were badly damaged in a fire in January of 1949. Analysis and conservation of the paintings show them to be on an earthen wall with a white clay ground. Spectrographic analysis of the pigments revealed yellow and red ocher, red lead, malachite, azurite, and other pigments.

M.H.B.

30-S120.
Anderson, Arthur J.
Pre-Hispanic Aztec colorists.

El Palacio, **55,** pp. 20-27, (1948), [Eng.].

Describes the colorants used by the Aztecs based on surviving historic texts. The Aztecs had a sophisticated palette available that they had developed for illuminating manuscripts, painting, and dyeing fabrics. Vendors specializing in colors and other material which the Aztecs felt to be related sold a variety of colorants and preparations of colorants. Cochineal was sold in a number of different preparations. Other sources of pigments were derived from a number of plants, minerals, and animals. M.H.B.

30-S121.
Buhler, A.
Dyeing among primitive peoples.

Ciba review, no. 68, pp. 2478-2512, (1948), [Eng.]. bibliog.

An entire issue devoted to dyeing among indigenous peoples. Concepts such as "dyeing" or "painting" are completely meaningless in this context. The author explains that the goal is simply to impart color to an object or clothing by the most effective means possible. To artificially separate textile material from an entire cultural panoply of activities that involve the application of colorants is convenient but misleading. In its most basic form plant materials or minerals were simply applied without the use of any binder or medium. Increasingly sophisticated means

were used that involved adding various substances as a medium or carrier, introducing mordants, and heating. Ritual, religion, and magic were an important component of the dyeing process and a number of additives seem to fulfill no practical purpose but were important ingredients according to the belief system of the people dyeing the material. This is also often the case with painting as well as dyeing in indigenous groups. Mentions plants and minerals used with examples from many cultures globally. M.H.B.

30-S122.
Kronstein, Max.
Medieval surface techniques, II.

American paint journal, **32,** no. 34, pp. 92-94, 96, 98, 100, (1948), [Eng.].

Before the period of oil paints and varnishes, there were two groups that embodied the principle of closing the color substance in an organic medium, such as the paint enclosure in glass, the painting of stained glass windows, or the painting of china, and embodied the principle of mixing the pigments with media such as glue, gelatin, or egg white. Around 1750 the basic foundation had been laid from which the industrialized varnish and paint production could get its start as an industry. Staff

30-S123.
Mayer, Ralph.
The painter's craft: an introduction to artists' materials.

Book. Van Nostrand Reinhold Company Inc., New York, 1948, 1st ed. (4th ed.: 1991) [Eng.]. ix, 218 p.: ill.; 24 cm., bibliog. index.

Contents: Introduction; Color; Pigments; Grounds; Oil painting; Tempera painting; Aqueous paints; Pastel; Mural painting; Studio and equipment; Additional reading; Index. Staff

30-S124.
Rabaté, Henri.
Sur l'ocre du Berry.
(French ocher from Berry.)

Peintures, pigments, vernis, **24,** no. 6, pp. 177-178, (1948), [Fre.].

A historical account of the ochers found in the Paris area, with special reference to

Berry. Berry ocher was known to the Romans and was worked up to 1860. C.A.L.(411)

30-S125.
Sweeney, James Johnson.
Joan Miro: comment and interview.

Partisan review, 15, no. 2, pp. 206-212, (1948), [Eng.].

Comments on Miro's primitivism, comparing it to douanier Rousseau's simplicity and directness. Miro's reported remarks discuss both the form and the content of his work: his early need to create realist forms; his learning from Cubism about structure; the influence of Urgell and Pasco on his work; the recurrence of certain forms; the touch-drawing technique; formal inspiration from hunger-induced halllucinations (ca. 1925); his return to realism around 1939 accompanied by a new interest in the materials of his paintings: paper with a surface roughened by rubbing in the heavy burlap series of 1939. He details his production of a group of 22 gouaches done in Palma (Majorca) and shown in New York in 1945, executed slowly with infinitesimal dots of color; later, in Barcelona, he composed and rapidly produced gouaches in pastel colors with violent contrasts, using some spilled jam; he has always painted in three stages; "first, the suggestion, usually from the material; second, the conscious organization of these forms; and third, the compositional arrangement." M.B.

30-S126.
Kahn, Rahim Bux.
Fresco paintings of Ajanta.

Journal of the Oil and Colour Chemists' Association, 32, pp. 24-31, (1949), [Eng.].

Describes the fresco paintings in the Ajanta caves. Analysis of pigments revealed local ochers, siennas, umbers, and terre verte. The black was probably lamp black and lapis lazuli was used as a blue pigment. Analysis was unable to determine what the binder was if any. The paintings are on a plaster containing lime and gypsum with an underlying mud plaster which coats the rock of the cave. A brief discussion at the end concerns itself with preservation measures for the paintings. M.H.B.

30-S127.
Laurie, Arthur Pillans.
The technique of the great painters.

Book. Carroll and Nicholson, London, 1949, [Eng.]. 192 p.: illus. (some col.); 26 cm., index.

A summary, for the student of the history of art, of what is known about pigments, mediums, and methods of painting from Egyptian times to the present day. The following techniques are described: true fresco; Medieval pigments and varnishes; tempera and oil painting; Persian miniatures and emulsions. One chapter deals with forgeries.
ICCROM(00065700)

30-S128.
Lavallée, Pierre.
Les techniques du dessin: leur évolution dans les différentes écoles de l'Europe.
(Drawing techniques: their evolution in different European schools.)

Book. Van Oest, Paris, 1949, 2 éd. rev. et corr. [Fre.]. 110 p., 51 p. of plates: illus.; 23 cm., bibliog.

The author traces the evolution of drawing techniques in various European schools, including the use of liquid and solid colorants, inks and watercolors, the metal point, charcoal, pastels, crayons, pencils, paper, parchment, and cloth.
ICCROM(00230800)

30-S129.
Lawrie, Leslie Gordon.
A bibliography of dyeing and textile printing comprising a list of books from the 16th century to the present time (1946).

Bibliography. Chapman and Hall Ltd., London, 1949, [Eng.]. 143 p.; 23 cm., bibliog.

A list of 816 important books on dyeing of "value to the historian and to the scientific worker as well as to the practical dyer." Emphasis is on the European dyeing tradition with entries chiefly from Great Britain, Germany, and France. Non-European entries are confined to those of the United States, India, and Russia. Titles in Part 1 are arranged alphabetically by author and include title, size and number of pages, place and date of publication, editions, and cross-references to secondary authors, translators, etc. Part 2 is a short-title catalog arranged chronologically. Contains a list of sources (catalogs,

bibliographies) and a classified index. Most trade publications are excluded. Staff

30-S130.
Wulf, Heinrich.
Merkblatt Fresko-Malerei.
(Survey of fresco painting.)

Farben, Lacke, Anstrichstoffe, **3,** no. 4, pp. 113-116, (1949), [Ger.].
 Synopsis about mural painting technique: definitions, materials, methods, selection of pigments and binding media like chalk. Preliminary drawing technique, instruments, retouche, organization of work.
 ICCROM(00363300)

30-S131.
Augusti, Selim.
La tecnica dell'antica pittura parietale pompeiana.
(The technique of antique Pompeian wall painting.)

In book. *Pompeiana: raccolta di studi per il secondo centenario degli scavi di Pompei,* Biblioteca della parola del passato, no. 4, (1950), pp. 1-41, [Ita.].
 Analyzes Pompeian mural painting samples from the excavations of Pompeii, Herculaneum, and from the collections of the National Museum in Naples. He explains how he came to identify the technique as saponified lime. ICCROM(00202000)

30-S132.
Levi-Strauss, Claude.
The use of wild plants in tropical South America.

In book. *Handbook of South American Indians. Volume 6: physical anthropology, linguistics and cultural geography of South American Indians,* Bulletin (United States. Bureau of American Ethnology), no. 143, Steward, Julian Haynes, Editor (1950), [Eng.].
 Describes plants used for food, medicine, and material culture by the indigenous peoples of South America. A huge array of plant material was available for almost any purpose. Rubber and resins were used as adhesives and burnt. Various resins were used to lacquer ceramics and containers to waterproof them. The area was also particularly rich in oils of various kinds and had a large number of plants that were used as colorants.

The most well known is Urucú or *Bixa orellana* which is extensively used for body paint, the painting of weapons, and many other uses. Mentions a number of other plant-based colorants for blue, black, red, and yellow.
 M.H.B.

30-S133.
Margival, F.
Les couleurs et la peinture dans l'antiquité.
(Colors and painting in antiquity.)

Peintures, pigments, vernis, **26,** pp. 467-474, (1950), [Fre.].
 Describes the evolution of painting methods during prehistory, protohistory, and classical antiquity. Techniques and materials used for Magdalenian cave paintings; Chaldean, Assyrian, Mycenaean, and Egyptian mural paintings; and wax and fresco painting are examined. ICCROM(00363700)

30-S134.
Mayer, Ralph.
On the material side: recent trends in painting mediums.

Art digest, **24,** no. 11, p. 22, (1950), [Eng.].
 The author discusses two topics: the introduction of sand, sawdust, and other coarse materials to give paint a granular texture; and the use of casein paints. The first instance of the former cited is in the work of Braque and Lurçat. The author gives his opinion on the effect of various substances on the permanence of the paint film. He states that if the substance is inherently stable it will have little effect on the paint layer except as an inclusion. He does remark that surfaces of this nature will collect dirt and be extremely difficult to clean. The inclusion of unstable materials obviously causes other problems. The author then gives a history of casein paints prompted by the popularity of casein paints in tubes that led to a significant increase in their use at the time the author was writing. He warns that casein forms a particularly brittle paint film. He then briefly describes the use of skim milk paints by Washington Allston and Thomas Sully as underpaints which were then covered with oils. The author also "suspects" John James Audubon of the same practice in some of his small paintings. M.H.B.

30-S135.
Plenderleith, Harold James.
The history of artists' pigments.

Science progress, **150,** pp. 246-256, (1950), [Eng.]. bibliog. refs.

Traces the history of pigments from antiquity to the present. Contents: Egyptian pigments; Roman pigments; Classical dyestuffs; Miniature painting; Buon fresco; Easel painting, egg tempera, and oil; Paint in the chemical era; Advent of artists' colorman; Coal tar dyestuffs; Durability tests; and Recent pigments. ICCROM(03529300)

30-S136.
Wulf, Heinrich.
(Tempera paints.)

Farben, Lacke, Anstrichstoffe, **4,** pp. 298-301, (1950), [Ger.].

A concise summary of composition, preparation, types, properties, technique of application, effect of varnish top coat, etc., is presented. Staff

30-S137.
Wulkan, H.E.
Wat weten wij van de verven der oude Egyptenaren?
(What do we know about the paints of the old Egyptians?)

Verfkroniek, **23,** pp. 41-46, (1950), [Eng.]. 19 refs.

Surveys the pigments and binders used in ancient Egypt. Discusses gum arabic, gum tragacanth, gelatin, sandarac, and myrrh as well as a number of other gums. M.H.B.

30-S138.
Yamasaki, Kazuo.
Chemical studies on ancient pigments in Japan.

Nihon kagaku zasshi, no. 711, pp. 411-412, (1950), [Eng.].

Pigments used in the wall paintings of various temples, such as Hōryūji and Hō-ōdō, were studied chemically. In the wall paintings of Hōryūji, which is of about the end of the 7th century, use was made of cinnabar, red ocher, red lead, yellow ocher, litharge, malachite, azurite, and carbon applied to mud walls coated with china clay. Calcium carbonate does not appear to have come into use as a white pigment until a later date. Staff

30-S139.
Augusti, Selim.
La tecnica del Velasquez nel dipinto 'I bevitori' della Pinacoteca di Napoli.
(The technique of Velasquez in the painting *The Drinkers* at the Picture Gallery of Naples.)

Bollettino dell'Istituto Centrale del Restauro, no. 5-6, pp. 97-101, (1951), [Eng.].

The 1.70 m by 2.32 m painting titled "I Bevitori," also known as "Los Borrachos" (or, the Triumph of Bacchus) of the Pinacoteca of Naples is very similar in composition to the painting by the same name at the Prado in Madrid, but differs in technique of execution, a source of polemics. Its attribution to Velásquez has been negated on the basis of arguments that are refuted here. The support is studied at length. The painting is not on canvas, but on a thick paper coating reduced to a paste by wetting and equivalent to a preparatory layer of intonaco, as ground for a tempera painting. A 1946 physicochemical examination of the painting by this author confirms these observations, stressing again a thickening of the ground where the color impasto is heaviest and on the outlines of the forms. The agglomerant was studied under the microscope and found to be composed of an organic (animal glue) and an inorganic substance (calcium surfate or gesso). The paper is defined as waste paper. Two paint samples were examined. Ceruse was found and a tempera coating. M.B.

30-S140.
Carson, Marian Sadtler.
Early American water color painting.

Antiques, **59,** pp. 54-56, (1951), [Eng.].

A brief account is given of the early history of watercolor painting in America. Staff

30-S141.
Crivelli, E.
The origins of pigment and varnish techniques.

L'industria della vernice, **5,** pp. 134-138, (1951), [Eng.].

A survey of the development of colors, coatings, etc., from ancient times. Staff

30-S142.
**Gettens, Rutherford J.; and Turner,
Evan H.**
The materials and methods of some
religious paintings of early 19th century
New Mexico.

El Palacio, **58,** pp. 3-16, (1951), [Eng.].

Analysis of a number of samples taken
from retables and samples from the wall
paintings at the Church of Old Laguna are
used as a basis for a general description of
the techniques used. The paintings are tem-
pera or distemper with a protein glue binder.
Pigments are from materials available locally
or imported from Mexico or possibly Europe.
Some pigments, such as Prussian blue, argue
for an ultimately more distant origin than
Mexico. Curiously, locally available reds,
blues, and greens are not prevalent and a
preference for imported colors seems evident.
Southwestern sources of cinnabar may have
been used to produce the vermilion present,
but it is more likely to have come from Mex-
ico. Indigenous Native American painting
traditions seem to have been supplanted in
favor of imported techniques and materials
from Mexico. Some local materials, such as
Chamisa flowers for yellow and locally avail-
able water-soluble resins, may be present.
With the analytical techniques available to
the author at the time, it was not possible to
tell. Egg white and yolk may also have been
used, which is consistent with Native Ameri-
can and European usage. M.H.B.

30-S143.
Lal, B.B.
The technique of the paintings at
Sitabhinji.

Artibus Asiae, **14,** no. 1/2, pp. 14-15, (1951),
[Eng.].

The paintings were executed on the
rough surface of the holocrystalline biotite
granite rock of Ravanachhaya and no rhin-
zaffato is present. The rock surface was not
plastered but a thin coating of lime wash (in-
tonaco) was laid before the application of col-
ors. Colors used are: lime for the white; mix-
ture of lime and red ocher for the buff;
yellow ocher for the yellow; and red ocher
for the red. Paintings were damaged due to
the effects of sun and rain and the growth of
insect nests. Chemical analysis shows the
presence of a water-soluble binding medium.

The medium was not being identified; proba-
bly gum or glue was used. Staff

30-S144.
**Malo, David; Emerson, Nathaniel B.,
Translator.**
Hawaiian antiquities (Moolelo Hawaii).

Book. Bernice P. Bishop Museum special pub-
lication, no. 2, Bernice Pauahi Bishop Mu-
seum, Honoiulu, 1951, 2d ed. (1st ed.: 1898)
[+ Eng.]. xxii, 278 p.: ill.; 24 cm., index.
[ISBN 0-910240-15-9].

One of the most important sources for
information about Hawaii before contact with
Europeans. The author was a part of the
royal court so he was familiar with all
sources of Hawaii's rich oral tradition. De-
scribes the use of plants by the Hawaiians for
food and material culture. The making of
tapa and canoes is also described. The pro-
cess of manufacturing canoes and the ingre-
dients for the paint used to finish and deco-
rate the canoe is described. Because the
author became a Christian convert, he makes
many contemptuous references to his former
beliefs and world view. This colors his ac-
count significantly in many areas. M.H.B.

30-S145.
Mayer, Ralph.
The material side.

Art digest, **26,** no. 6, p. 27, (1951), [Eng.].

In response to a question regarding the
best choice of a fixative for pastels the author
briefly reviews the fixatives available at the
time. He cites two varieties, the first a solu-
tion of casein and alcohol, the second, very
weak alcoholic solutions of resins such as
Manilla copal or vinyl butyral. He explains
that for optical reasons, all pastel fixatives
give disappointing results and for that reason
pastel specialists dislike the use of fixatives.
The author suggests using just enough to
slightly lessen the extreme fragility of the
surface and cautions against spoiling the
color relationships and the natural pastel
surface. M.H.B.

30-S146.
Mayer, Ralph.
The material side: tempera painting -
part 1.

Art digest, **25,** no. 19, p. 18, 25, (1951), [Eng.].
 The author gives a brief history of tempera as a paint medium. He defines contemporary tempera as an "oil-in-water" emulsion vehicle on an absorbent gesso panel. Ingredients such as the natural emulsion (pure egg yolk) and artificial tempera emulsions composed of mixtures of whole egg and linseed oil, or of gums or casein, with waxes, oils, or resins are mentioned. Other aqueous mediums are not included in the author's definition. The main characteristic is what the author refers to as the "tempera effect" characterized by a brilliance and luminosity that combines the effects of transparence and opacity. Andrew Wyeth and Ben Shahn are cited as contemporary practitioners.
 M.H.B.

30-S147.
Mayer, Ralph.
On the material side.

Art digest, **25,** no. 12, p. 25, 33, (1951), [Eng.].
 In a column devoted to "Popular Misconceptions about Oil Painting" the author addresses the topic "that it is proper for oil paintings to be matte." He states that oils are naturally somewhat glossy and that it is not possible to simulate the matte effects of gouache, tempera, fresco, or resinous base paints without a sacrifice in permanence or durability. He further states that oil paints were adopted for their gloss and that if a matte surface is desired a technique employing a water-soluble binder should be employed. (In spite of Mayer's advice, oil paints have been tampered with endlessly to achieve a matte surface.) M.H.B.

30-S148.
Mayer, Ralph.
On the material side. Glazes and glazing -
Part 2.

Art digest, **25,** no. 18, pp. 21-22, (1951), [Eng.].
 In a discussion about glazing tempera or casein paints the author recommends sizing the surface with a weak solution of gelatin to reduce absorbency. In cases where the underpaint is too water-soluble for this he recommends the use of an extremely weak solution of shellac. He cautions that the entire surface of the painting must be coated with oil paints or glazes. This is noteworthy in that it probably reflects actual practice during the period. It is interesting to compare with consolidation strategies in the treatment section of this publication. M.H.B.

30-S149.
Simpson, Colin.
Adam in ochre: inside aboriginal Australia.

Book. Angus & Robertson Pty Ltd., North Ryde, 1951, American ed.: New York, Frederick A. Praeger, 1953 [Eng.]. 219 p.: ill.; 24 cm.
 Describes the use of human blood as a binder in certain rituals involving painting. The use of ocher for a variety of purposes and the subject matter and methods of rock art are also described. Animal blood and the juice of plant stalks as a binder is mentioned. The book includes descriptions of the preparation of a number of painted objects. Attitudes in the book are representative of the period and some ritual matters are treated with less sensitivity than they would be today. M.H.B.

30-S150.
Yamasaki, Kazuo.
(Chemical studies on ancient painting
materials.)

Kobunkazai no kagaku, **30,** no. 1, pp. 27-30, (1951), [Jpn.].
 Pigments used in the wall paintings of temples in Japan were chemically studied. Among the existing wall paintings which amount to 68, that of the Hōryūji is oldest. Pigments used in it are china clay, red ocher, cinnabar, red lead, yellow ocher, litharge, azurite, malachite, and carbon. There are no marked differences between the pigments of Hōryūji (end of the 7th century) and wall paintings of the 18th century, except white pigment. Before the Kamakura period, china clay was used, while in and after the Momoyama period, calcium carbonate was used. The time of change is not yet determined with certainty, but it seems to be Muromachi period (15th-16th centuries). Staff

30-S151.
Yamasaki, Kazuo.
(Chemical studies on the pigments of ancient ornamented tombs in Japan.)

Kobunkazai no kagaku, no. 2, pp. 8-14, (1951), [Jpn.].

Colored ornaments of about 40 ancient tombs distributed in northern Kyushu, mainly in Fukuoka and Kumamoto Prefectures, were chemically studied. The ornaments and figures painted in the inner walls of stone chambers are concentric circles, triangles, magical geometrical figures, bird, ship, swords, bow, arrows, quiver, horse, and man. The pigments used are red ocher, yellow ocher, china clay, charcoal, a black mineral containing manganese which is probably pyrolusite, and powders of green rocks containing chlorite. Malachite, azurite, and cinnabar were not found. The most numerous figures are red concentric circles. The date of these ornamented tombs is supposed to be about 500-700 AD.

30-S152.
Bliesener, Paul.
(Artists' paints and their manufacture, and the products.)

Seifen, Öle, Fette, Wachse, **78,** pp. 199-202, (1952), [Ger.].

A review of the production and properties of oil paints, watercolors, pastels, and colored chalks. Staff

30-S153.
Bryson, H. Courtney.
The earliest known paints.

Paint manufacture, **22,** pp. 243-246, 257, (1952), [Eng.].

Paintings on the roof of a cave in Altamira in northern Spain and on the walls of grottoes in the Dordogne in central France are estimated as being 20,000 years old. The materials used in the limestone cave at Altamira include Spanish red oxide, ochers, and charcoal with likely binding media of blood serum, milk, or animal fat. Some of the outlines have a feathered edge. One possible hypothesis is that the dry powder was blown on to the outline by means of tubes, the medium having been previously applied. The use of paintings in sympathetic magic is discussed. Staff

30-S154.
Goodnough, Robert.
Kline paints a picture.

ARTnews, **51,** no. 8, pp. 36-39, (1952), [Eng.].

Franz Kline used commercial paints intended for house painting. He used a black oil paint that was sold for tinting paints. It was thinned with turpentine and was usually matte except where it was more heavily applied. Kline used Behlen's zinc white and mixed it with titanium. The white was thinned less than the black. [Editor's note: in a later interview Kline states that he used whatever black or white paint was available.]

30-S155.
Hadert, Hans.
Neues Rezeptbuch für die Farben- und Lackindustrie.
(New book of recipes for the paint and varnish industry.)

Book. Curt R. Vincentz Verlag, Hanover, 1952, (1st Rezeptbuch 1943) [Ger.]. v.: ill.

Approximately 2,000 recipes are given in this book, embracing a wide variety of paint, varnish, and lacquer types, and drawn mostly from the patent, journal, or manufacturing literature. The recipes are arranged according to principal component, e.g., chlorinated rubber, nitrocellulose, etc., and also according to purpose, e.g., ship-bottom paints, fire-resistant paints, a method which leads to a great deal of overlapping. Each chapter is preceded by a short section on materials and principles of formulation. The viewpoint is not critical. Materials are referred to by their German trade names; though an imperfect glossary of such names is given under cellulose lacquers, the treatment is neither systematic nor comprehensive. A major defect is the absence of mention of many subjects which are at present of considerable interest to the paint technologist. The outstanding example is synthetic resin emulsions, which are barely mentioned, although there is a section on nitrocellulose emulsions. In general the newer synthetic resins are poorly covered. In spite of these defects, the book contains a wealth of information concerning the formulation of a wide range of finishes. Staff

30-S156.
Merrifield, Mary Philadelphia.
The art of fresco painting as practised by the old Italian and Spanish masters, with a preliminary inquiry into the nature of the colours used in fresco painting, with observations and notes.

Book. A. Tiranti, London, 1952, new ill. ed. [Eng.]. 134 p.: ill.; 22 cm.

A description of methods used by Italian and Spanish masters and the nature of colors used in fresco painting. The major literary sources are excerpted, with passages on deterioration, the history of retouch, repair, and cleaning. Giovanni Pietro Bellori's comments on the restoration of the Carracci Gallery in the Farnese Palace and the Loggia of Raphael in the Farnesina, Rome, are included.
ICCROM(00020900)

30-S157.
Monti, Niccola.
Della pittura a fresco.
(Fresco painting.)

Bollettino dell'Istituto Centrale del Restauro, no. 9-10, pp. 106-109, (1952), [Ita.].

Reproduces a letter written by Monti to the *Nuovo Giornale de' Letterati* and published in the September-October issue of 1836. The letter discusses different techniques of fresco painting. The letter is republished as an example of the controversies of the period about the methods and materials used at Pompeii and Herculaneum. M.H.B.

30-S158.
Pauvels, Marcel.
Les couleurs et les dessins au Ruanda.
(Colors and drawings in Rwanda.)

Anthropos, **47,** pp. 474-482, (1952), [Fre.].

Lists the names used to designate colors, their derivations, their absence when the color, such as purple for instance, does not occur in the natural environment. The origin of these colors is discussed, red coming from cow ticks' blood, black from soot, both mixed with a different plant's sap. Another red used to treat cow skin is obtained by reducing a stone to powder. The mystical significance of the colors black and white are elucidated.
M.B.

30-S159.
Schery, Robert W.
Plants for man.

Book. Prentice-Hall plant science series, Prentice-Hall, Englewood Cliffs, 1952, [Eng.]. viii, 564 p.: ill.; 26 cm.

This economic botany textbook contains chapters that discuss latex products, pectins, gums, resins, oleoresins and similar exudates. It also covers plants used for dyes, oils, fats, and waxes. The history of the industries associated with the products is outlined and most plant sources described and discussed. The chemistry of the substances is also described. Provides a complete survey of basic plants for virtually any purpose. M.H.B.

30-S160.
Smith, Watson; Ewing, Louie, Illustrator.
Kiva mural decorations at Awatovi and Kawaika-a, with a survey of other wall paintings in the Pueblo Southwest.

Book. Papers of the Peabody Museum of American Archaeology and Ethnology, Harvard University, no. 37, Peabody Museum of Archaeology and Ethnology, Cambridge, 1952, [Eng.]. xxi, 3;63 p.: ill. (part col.), maps; 28 cm., refs.

The physical and material characteristics of the elements employed in the wall paintings are described. Explanations of methods used for the recovery, presentation, and reproduction of the paintings follow. A survey of other Pueblo wall paintings in the Southwest United States is provided.
ICCROM(00173500)

30-S161.
Dart, Raymond A.
Rhodesian engravers, painters and pigment miners of the fifth millennium B.C.

South African archaeological bulletin, **8,** pp. 91-96, (1953), [Eng.].

Contains a description of the Chowa manganese deposit near the Broken Hill Mine. Psilomalene, a manganese ore, was being mined about 6,000 years BP. Curiously the miners reburied all the workings from the mine. In the process, they left behind tools and other material. Concludes that the miners were removing pyrolusite, a pure crystalline

History

form of manganese dioxide that occurs in a crystalline form and as a soft black mineral. They may also have been after a rose-colored silicate, rhodonite, and a carbonate rhodochrosite that would have occurred in the form of rhombohedral crystals like calcite. These would have been used as gems and pigments. The oxidizing power of manganese modifies the reds and yellows of ochers to lighter hues and the blues and greens of copper pigments into more pastel shades.

M.H.B.

30-S162.
Laman, Karl Edward.
The Kongo I.

Book. Victor Pettersons Bokindustri Aktiebolag, Stockholm, 1953, [Eng.]. 155 p.: ill.; 31 cm.

The author was active as a missionary in the Congo from 1891 until 1919. He returned to Sweden with a large collection of ethnographic material from the area which is now deposited with the State Ethnographical Museum in Sweden. Until his death in 1944, he was engaged in working on a monograph on the Congo primarily concerned with the Sundi tribe. He was a careful observer of the Sundi at a time when European contact was still very limited. This represents the publication of the first part of his monograph. The text concerns itself with all aspects of the Sundi and their material culture. Laman describes the use of chalk, charcoal, *tukula* (camwood) made from coral trees and other colorants derived from plants. Laman states that as a rule water is mixed with the colorants. Blacks are derived from the fruit and bark of *bunzi* and *mbunzi* which are pounded with water and cooked. He also describes the making of incisions in the bark of the *mungyenye* tree and the collection of the resin that oozes out. It is then mixed with charcoal and used for painting doors.

M.H.B.

30-S163.
Scholz, H.A.
History of water-thinned paints.

Industrial and engineering chemistry, **45**, pp. 710-711, (1953), [Eng.].

The first paints used were water-thinned. Their evolution is briefly sketched from the mud daubings of the cavemen through the distemper wall paintings of the Dynasty Egyptians, the frescoes of the ancient Romans and Medieval Italians, and the milk and curd paints of the ancient Hebrews, to the whitewash of Colonial and early United States days. The whitewash developed into bonding Portland cement paints in one branch, and as dry casein became a commercial product, into casein powder paints in another. Casein paints were important until the development about 25 years ago of paste paints with their superior application and hiding qualities. Resin emulsion paints provided improved washing qualities while retaining most of the good qualities of the casein paste paints. The latest in the H_2O-thinned line are latex paints in which polymers and copolymers of styrene, vinyl vinylidine, and other chemicals serve as binders. The products have properties and qualities possessed by no other type of wall coating, and as a result sales have increased greatly in the few years they have been on the market; they now hold a large share of the interior wall decoration market. Staff

30-S164.
Bascom, William Russell; and Gebauer, Paul; Ritzenthaler, Robert E., Editor.
Handbook of West African art.

Book. Popular science handbook series, no. 5, Milwaukee Public Museum, Milwaukee, 1954, [Eng.]. 83 p.: 66 ill., maps; 19 x 21 cm., bibliog.

Describes some of the techniques used in the manufacture of painted wooden artifacts. Contrary to popular belief, various woods are used and not just hard black woods. Masks and figures are often painted with a number of colors. Camwood (*Baphia nitida*) is powdered and mixed with palm oil and applied to carvings during ceremonies. Old pieces acquire a patina from multiple applications of camwood and palm oil. A black finish sometimes used is composed of soot and palm oil. Palm or castor oil are often applied before the figure is used in rituals. Also contains information about the casting techniques used in making metal masks and sculpture.

M.H.B.

30-S165.
Margival, F.
Extenders.

Travaux de peinture, **9**, no. 1, pp. 5-7, (1954), [Eng.].

The use of extenders in paint, putty, etc., is considered. The mineral extenders are usual in paint products; certain organic vegetable materials, e.g., wood flour, dextrin, etc., can also be considered as extenders and find use in putty, plastics, rubber, linoleum, etc. The required properties of extenders are discussed. Extenders are also used in powder driers. Staff

30-S166.
Mayer, Ralph.
The material side.

Art digest, **28**, no. 9, p. 23, 29, (1954), [Eng.].

Discusses the new aesthetic predilection for matte or semimatte surfaces on paintings. Wider appreciation of techniques other than oil painting (including tempera), watercolor, gouache, and pastel is credited to new concerns with minimal surface gloss. The author attributes part of the change to the introduction of the electric light. He notes a growing distaste for very glossy, thickly varnished surfaces and a preference for normal to dull finishes. A cautionary note is made of some techniques used by artists to create a matte effect in oil painting, imitating the effects of watercolors and casein paintings. Techniques such as painting on fully absorbent surfaces or "drowning" paints with excessive additions of turpentine may seriously threaten the permanence of the artwork. The author cites industrial architectural coatings where coatings intended for exterior wear and tear are given glossy surfaces. No product has been developed that will not turn yellow or polish out when rubbed. However, gloss can be added to matte mediums such as tempera or casein. The author expresses the opinion that oil paints should be used with the "age-old techniques." P.V.

30-S167.
Yamasaki, Kazuo.
Technical studies on the pigments used in ancient paintings of Japan.

Proceedings of the Japan Academy, **30**, pp. 781-785, (1954), [Eng.].

Pigments used in the decorated tombs of the 5th-7th centuries in Kyushu are all powdered minerals and stones, i.e., impure red ocher, yellow ocher, green rock, clay, charcoal and pyrolusite. With the introduction of Buddhism, pigments such as vermilion, red lead, litharge, malachite, azurite, and China ink came into use in wall paintings. Calcium carbonate was found in paintings later than in the 15th century. In scroll paintings, white lead, which was more precious than clay, was used. The example of its use goes back as early as the 8th century.

Staff

30-S168.
Dunn, Dorothy.
America's first painters.

National geographic, **107**, no. 3, pp. 349-377, (1955), [Eng.].

Refers to traditional Pueblo painting as a "casein tempera technique" employing earth pigments mixed with milk. Describes the use of chewed yucca leaves as brushes and the use of the mouth for spraying paint. Particularly interesting is the account of the transition from use of traditional materials to use of trade goods and paper substrates. The disappearance of the buffalo deprived the Plains Indians of their favorite substrate and they were forced to find other materials. Prior to the founding of the Indian Painting Studio in the United States Indian School at Santa Fe in 1932, the government's policy was one of cultural assimilation. The author founded the school and was an early advocate for Native American painting. This was a rather remarkable achievement since the atmosphere of cultural assimilation continued for some time. Due to the strong Native American presence in the Southwest, the school has continued to be a force in contemporary Native American art. (Editor's note: the use of milk would have only begun with the introduction of European domestic animals in the historic period.) M.H.B.

30-S169.
Margival, F.
Couleurs et peintures au temps des civilisations mexicaines précortésiennes. (Colors and paint at the time of the pre-Cortés Mexican civilizations.)

Peintures, pigments, vernis, **31**, pp. 1078-1085, (1955), [Fre.]. line drawings, 56 refs.

Describes the importance of color in the lives of the Mexican peoples before the Spanish conquest, for painting themselves, their clothes, for decorating their buildings, for ceramics, mosaics, sculpture, and paintings. There was polychrome decoration on their ceramics, one vase having five colors on it. The minerals used for the mosaic work included jade, turquoise, jet, pyrites, and mother-of-pearl. For painting, there was a large choice of coloring materials. Those used included ochers, malachite, lapis lazuli, bitumen, cochineal, and a purple obtained from snails. The media used are less certain but it is known that some work was carried out using water, and in other cases pigments were mixed with milk, i.e., casein, and plant juices and gums. The brushes were made from the hair of small animals such as rabbits. The techniques used are described, together with the subjects painted, and the significance of these and the various colors used. Ends with a brief description of painted manuscripts. There are not many left, owing to their almost complete destruction by the first missionaries. Staff

30-S170.
Meszaros, Gy.; and Vertes, L.
A paint mine from the early Upper Palaeolithic age near Lovas (Hungary, County Veszprém).

Acta archaeologica Academiae Scientiarum Hungaricae, **5**, no. 1-2, pp. 1-32, (1955), [Eng. w. Rus. summary]. map, photos., refs.

A detailed examination of the excavations at prehistoric Lovas leads the author to conclude that a group of specialists in mining were engaged in producing red ocher paint beyond their own requirements with the purpose of exchanging it with neighboring groups. A description of the archaeological finds is followed by a survey of the use of ocher in prehistoric times.
ICCROM(00307900)

30-S171.
Longo, Vincent.
Studio talk: improvement in tubed casein. Interview with Ted Davis.

Arts, **30**, no. 11, p. 29, (1956), [Eng.].

Improvements in the qualities of casein paint sold in tubes caused a surge in their popularity at the time this was written. A precipitated lactic acid, made from the curd of skim milk with slaked lime was used as the binder. This and the use of distilled water are the improvements cited. Ted Davis was the Secretary of the National Society of Painters in Casein. The author cautions against the danger of the casein surface becoming shiny by rubbing. He advises protecting the surface with a varnish like "Tuffilm" and spraying it at a 90° angle to avoid glossiness and retain the matte quality. This is suggested as a means of avoiding the danger of the casein painting looking like an oil painting as a result of excess varnishing. Spraying in a thin application at a 90° angle is said to enhance the color without spoiling the matte appearance. M.H.B.

30-S172.
Thompson, Daniel Varney; Berenson, Bernard, Preface.
The materials and techniques of Medieval painting.

Book. Dover Publications, Inc., 1956, Unabridged and unaltered republication of 1st ed. (1936) with title: The materials of medieval painting [Eng.]. 239 p.; 21 cm. [ISBN 0-486-20327-1].

An extensive investigation into the techniques used by Medieval painters: miniature painting on parchment and vellum, painting on canvas, walls and structural woodwork, grounds, binding media, pigments and metals. ICCROM(00034300)

30-S173.
Wehlte, Kurt.
Ein Beitrag zur Werkstoffgeschichte. (A contribution on the history of materials.)

Maltechnik, **62**, pp. 45-51, (1956), [Ger.]. ill.

The materials of ancient Roman wall paintings and their application are discussed.
Staff

30-S174.
Augusti, Selim.
La technique de la peinture pompéienne.
(Pompeian painting technique.)

Book. Edizioni tecniche publiedi, Milan, 1957,
[Fre.]. 20 p.; 23 cm.

Pompeiian paintings: technique, physi-
cal examinations, support and ground layers,
Vitruvian tinctorium; study of the composi-
tion of the different layers.

ICCROM(00910800)

30-S175.
Cooke, C.K.
The prehistoric artist of Southern
Matabeleland; his materials and technique
as a basis for dating.

*In proceedings. Third Pan-African Congress on
Prehistory, Livingstone, 1955,* Clark, J. Des-
mond; and Cole, Sonia, Editors (1957), pp.
282-294, [Eng.].

Discusses the probable materials used in
making the rock art of Matabeleland. The use
of plant gums, animal fat, water, and hyrax
urine is suggested as a binder. Evidence from
spilled paint indicates that the paint was liq-
uid when applied. Colors and styles are dis-
cussed as a means of dating. Speculates about
the role of the artists in their society.

M.H.B.

30-S176.
Curtin, Leonora Scott Muse.
*Some plants used by the Yuki Indians of
Round Valley, northern California.*

Book. Southwest Museum leaflets, no. 27,
Southwest Museum, Los Angeles, 1957,
[Eng.]. 24 p.: ill.; 20 cm.

Curtin is well known for ethnobotanical
work with the Pima in Arizona. At the urg-
ing of John P. Harrington and others Curtin
turned her attention to the Yuki. She was
joined in her endeavor by Margaret Irwin of
the Santa Barbara Museum of Natural His-
tory. The Yuki are a unique group since they
are linguistically distinct from their neighbors
and believed by some to be remnants of an
earlier phase of settlement in California. This
pamphlet describes Yuki usage of plants for
various purposes using a number of infor-
mants in Round Valley. Comparisons are
made with Chesnut's well known study of
1902 and indicate a considerable loss of

knowledge about plant usage. Edith V.A.
Murphey, a well known figure in the area,
also assisted Curtin and Irwin with their
work. While this pamphlet includes no dis-
cussion of dyes or paints, it does touch on
basketry, fibers, and other matters of material
culture of the Yuki. It includes a reference to
the use of wormwood (*Artemesia tridentata*) as
the source of a green pigment used in tattoo-
ing the face by Yuki women. Yuki culture
was severely impacted by the forced resettle-
ment of Pomo and Wintun Indians in Round
Valley, traditional Yuki territory. M.H.B.

30-S177.
Hodge, Walter H.; and Taylor, Douglas.
*The ethnobotany of the island Caribs of
Dominica.*

Book. Istituto Botanico dell' Universita di
Firenze, Florence, 1957, [Eng.]. 130 p., 8 p. of
plates: ill., maps; 25 cm., bibliog. and indexes.

Describes plants used for food, fiber, oil,
medicine, and articles of material culture.
Turmeric, an introduction from Asia, was in
use as a condiment and colorant when this
book was published. A portion of the text
lists 10 plants used as a source of dyes, pig-
ments, and tannins. Plants used for basketry
and plaiting, building and construction, ca-
noe construction and cordage are also listed.

M.H.B.

30-S178.
Lemassier, A.
Meubles et bibelots peints mexicains.
(Painted Mexican furniture and trinkets.)

Peintures, pigments, vernis, 33, pp. 231-234,
(1957), [Fre.].

Describes materials, including pigments,
available to and used by Mexican craftsmen
from the 16th century on. The methods used
nowadays to produce articles for the tourist
markets are also described. Pigments listed in
an inventory of 1645 include vermilion, in-
digo, yellow arsenic sulfide, yellow ocher,
madder, cochineal, and a purple obtained
from snails, analogous to Tyrian purple.

Staff

30-S179.
Michel, Paul H.
The frescoes of Tavant (France).

Graphis, **13**, pp. 364-368, (1957), [Eng.]. ill.
The 12th-century murals in the church
of Tavant (Indre-et-Loire Département) are
described and their painting technique dis-
cussed. A thin coat of plaster was allowed to
dry and was moistened again immediately
before painting. The colors come up evenly
on such a ground of whitewash. The range of
pigments used is limited to yellow, red and
brown ocher, and green earth. Staff

30-S180.
Oswalt, W.H.
A Western Eskimo ethnobotany.

*Anthropological papers of the University of
Alaska*, **6**, no. 1, pp. 16-36, (1957), [Eng.]. refs.
The fact that plant products can play a
significant part in Eskimo subsistence pat-
terns is usually ignored. Discusses the botani-
cal knowledge and general range of plant
uses among the residents of Napaskiak, a
western Eskimo village. The names of plants,
utilization of these plants as food, medicines,
ceremonial equipment, or raw material for
artifacts is recorded. CCI

30-S181.
Schafer, Edward R.
Rosewood, dragon's blood and lac.

Journal of the American Oriental Society, **77**, pp.
129-136, (1957), [Eng.].
The purpose is to make plain some
terms in early Chinese literature which refer
to red woods and red resins. The rosewood
of antiquity was *Dalbergia hupeana*; sandal-
wood (*Santalum album*), sanderswood (*Ptero-
carpus indicus*), Hainanese rosewood (*Dal-
bergia hainanensis*), and Indonesian laka-wood
(*Dalbergia parviflora*) are rosewood varieties
used for dyes, incense, and other special pur-
poses. Red resins from different sources were
called dragon's blood. Most important were
Socotran dragon's blood from species of *Dra-
caena*, Indonesian gum-kino from species of
Pterocarpus and Indonesian dragon's blood
from species of *Daemonorops*. Lac dye from
the female lac insect was imported from
southern Asia as early as Han times. Chinese

characters for numerous natural products are
listed, and transliterations are also provided.
 Staff

30-S182.
Watrous, James.
The craft of old-master drawings.

Book. University of Wisconsin Press, Madi-
son, 1957, [Eng.]. xiii, 170 p.: ill.; 26 cm., bib-
liog. and index. [ISBN 0-299-01421-5].
The author aims to supply a critical and
historical study of drawing techniques. Old
master techniques and tools are described for
metalpoint drawing, chiaroscuro drawing,
and pen drawing. There are chapters on inks
for drawing (black carbon, iron gall, bistre,
sepia, and colored inks and washes); chalks,
pastels, and crayons; and charcoal and graph-
ite. Staff

30-S183.
Yamasaki, Kazuo.
(Pigments used in the paintings of
"Hoodo.")

Bukkyo geijutsu, no. 31, pp. 62-64, (1957),
[Jpn.].
Pigments used in the mural paintings of
Hoodo, a temple of the 12th century situated
at Uji near Kyoto, were examined on the oc-
casion of the repairs carried out in 1950-56.
Pigments found were clay, vermilion, red
ocher, red lead, gold, yellow ocher, litharge,
malachite, azurite, and Chinese ink. In addi-
tion to these pigments a hitherto unknown
peculiar pigment was found. It was a blue
pigment prepared by dyeing yellow ocher
with indigo. This was used as a substitute for
azurite in various parts of the paintings prob-
ably because azurite was in short supply and
expensive at the time of the construction of
the temple. This pigment lost its blue color
on exposed surfaces and only the yellow
color of ocher used as the ground material
now remains. Staff

30-S184.
Gettens, Rutherford J.; and Stout, George L.
Un monument de peintures murales byzantines—la méthode de construction.
(A monument of Byzantine wall painting: the method of construction.)
Studies in conservation, **3,** no. 3, pp. 107-119, (1958), [Fre. w. Eng. summary].

This is a study of the painting technique used for a Byzantine wall painting in the Kariye Kamii Church. The plaster was spread in large areas. Indications of the drawing were put in with charcoal in a fluid suspension. The paint then followed; pigment mixed with a milky dilution of lime putty.
ICCROM(01718901)

30-S185.
Augusti, Selim.
Sui colori degli antichi: la chrysocolla.
(On the colors of the ancients: chrysocolla.)
Rendiconti dell'Accademia di archeologia lettere e belle arti, **34,** pp. 7-13, (1959), [Ita.]

Chrysocolla was the most commonly used green pigment in antiquity. Its usage continued through the Middle Ages. It was eventually replaced by more practical and purer colors.
ICCROM(00151100)

30-S186.
Augusti, Selim.
La tecnica della pittura murale di Ercolano.
(Mural painting technique of Herculaneum.)
Rendiconti dell'Accademia di archeologia lettere e belle arti, **34,** pp. 15-19, (1959), [Ita.].

The mural paintings of Pompeii and Herculaneum were painted with the saponified lime technique. The paintings are composed of two layers of rendering, one layer of ground, and one layer of paint. In Herculaneum, finely ground sherds were added to the ground layer.
ICCROM(00151101)

30-S187.
Lhote, Henri; Brodrick, Alan H., Translator.
The search for the Tassili frescoes: the story of the prehistoric rock paintings of the Sahara.
Book. E.P. Dutton, New York, 1959, [Eng.]. 236 p., plates, maps; 22 cm.

The author was the first European to describe the rock art of Tassili-n-Ajjer in any detail. This book describes his trip to the area with a number of companions. He recorded many of the sites using gouache pigments. At one point in the expedition they ran out of paint and experimented with local ochers. They found painting on the sandstone to be easier than painting on paper since the sandstone absorbed the paint readily. He claims that the pieces they made experimentally could be detected as modern because the surface paint was water-soluble. He qualifies this somewhat by saying that thickly applied paints in some of the rock paintings are "not so stable, although they resist water quite well." Analyses he made (not specifically described) led him to believe that the binder for the paintings included casein and/or acacia gum and other unknown substances. Milk would have to date from periods after the domestication of animals in the area unless, of course, the milk used was human. Many ochreous schists which were ground into pigments were found in the area. The climate of the area has undergone severe desiccation since the end of the last ice age and some of the rock art depicts animals driven out of the area by increasing aridity. Human habitation declined for the same reason.
M.H.B.

30-S188.
Lhote, Henri.
The Tassili frescoes.
Graphis, **15,** pp. 510-511, (1959), [Eng.]. ill.

The prehistoric rock paintings in the north of Sefar (Tassili) in the Sahara were examined and copied by the author. The designs were painted on the rock walls without any preparation. As a coloring matter, the ochreous schists of the region were used. They are more or less rich in iron oxide and offer a variety of color ranging from light red to violet, including yellows and greens.
Staff

30-S189.
Littmann, Edwin R.
Ancient Mesoamerican mortars, plasters, and stuccos: Las Flores, Tampico.

American antiquity: a quarterly review of American archaeology, **25,** no. 1, pp. 117-119, (1959), [Eng.]. diagrams, ref.

Examination of Las Flores showed a resemblance to the building method used at Comalcalco, Tabasco (AATA 2-1055), with repetitive building units of lime aggregate and plaster. See also AATA 3-2835, 17-1482, 17-1483, and 17-1485. [Editor's note: Mesoamerican stuccoes and plasters often present consolidation problems similar to matte painted surfaces.] Staff

30-S190.
Littmann, Edwin R.
Ancient Mesoamerican mortars, plasters, and stuccos: Palenque, Chiapas.

American antiquity: a quarterly review of American archaeology, **25,** no. 2, pp. 264-266, (1959), [Eng.].

Shows the use of lime aggregate as a building element at Palenque, which expands the known use of the technique. See also AATA 2-1055, 3-2835, 17-1482, 17-1483, 17-1404, and 17-1486. [Editor's note: Mesoamerican stuccoes and plasters often present consolidation problems similar to matte painted surfaces.] Staff

30-S191.
Margival, F.
Pigments et peintures dans l'antiquité préhistorique.
(Pigments and paints in prehistoric antiquity.)

Peintures, pigments, vernis, **35,** pp. 521-528, 568-574, (1959), [Fre.]. 48 refs.

This article, in two parts, is the first of four providing a history of painting from the technical point of view, as a complement to the very many histories of painting written from the purely aesthetic angle. The first part deals with cave paintings and is subdivided into 1) pigments and media; 2) techniques of application; and 3) the objects painted and their significance. Four colors were available to primitive peoples: a) red—haematite, red ocher; b) yellow—yellow ocher, goethite; c) black—pyrolusite, manganite, graphite; d) and white—chalk, clay. Minerals such as lapis lazuli and malachite, although highly colored, were not suitable for use as pigments because of their loss of tinting power on grinding. (The pigment component forms only about 2-3% of the mineral and has to be extracted.) Materials used as media included honey, animal fat, ox gall, or fish glue, but sometimes none was necessary, as for example, when soot was used. The second part discusses prehistoric art in regional schools, French, Spanish, African, Australian, and briefly, many others. The 48 references and a list of books together form the most valuable part of the articles, with extensive quotations from the authors cited. Staff

30-S192.
Mekhitarian, Arpag.
Unvollendete Darstellungen auf Mauern ägyptischer Tempel und Gräber.
(Unfinished wall paintings in Egyptian tombs and temples.)

Du, **19,** no. 218, pp. 11-13, (1959), [Ger.].

The technique of the unfinished tomb paintings of the Eighteenth and Nineteenth Dynasties was studied by the author. When the plaster had been applied, the surface was divided into squares by means of a string that had been rubbed with a red pigment. The drawing of the figures was emphasized by painting the background, which during the Eighteenth Dynasty shows a bluish grey. The flesh of male figures was painted with red ocher, that of female figures with yellow, rose, or brown ochers. For garments, lime white was used. Finally the whole work was outlined in red. An aqueous medium with a little resin was employed, and the range of pigments covered red and yellow ochers, lime white, Egyptian blue, a copper green, and soot black. The technique is described in detail and the stability of materials discussed. Staff

30-S193.
Miller, Morrison A.
Orchids of economic use.

American Orchid Society bulletin, **28,** no. 3, pp. 157-353, (1959), [Eng.].

The second part of a series on economic uses of orchids, this article deals primarily with medicinal uses of orchids throughout the world. Salep, the powdered root of a number of species of orchids, was used in India in much

the same manner as arrowroot, sago, or tapioca. Although it is believed to come from the Near East, salep became a popular food in 19th-century England and was carried as an emergency food in ships since it was lightweight and easily reconstituted into a nutritious food. It was also used as a substitute for gum arabic. This is particularly interesting in view of the use of orchid bulbs as a binder by indigenous Australians. M.H.B.

30-S194.
Yamasaki, Kazuo.
(The pigments used in the wall paintings.)

In book. *Daigoji goju no to no hekiga,* Takata, Osamu, Editor (1959), pp. 13-14, [Jpn. w. Eng. summary]. Summary only.

The pigments used on the Daigo-ji pagoda wall paintings were examined by means of ultraviolet light, infrared photography, x-ray and microchemical techniques. The following pigments were found: kaolin, lead white, vermilion, red lead, iron oxide red, litharge, malachite, gold, and a special mixture of yellow ocher and indigo. The stability of these pigments is discussed.
ICCROM(00007802)

30-S195.
Jolly, David.
Bibliography and the arts of Africa.

African studies bulletin, **3,** no. 1, pp. 4-9, (1960), [Eng.].

A discussion of bibliographic and visual resources available to researchers in 1960. Dated but useful. M.H.B.

30-S196.
Laurie, Arthur Pillans.
The painter's methods and materials.

Book. Seeley Service & Co., London; Dover Publications, Inc., , 1960 and 1967,"Reprint of 1960 ed. first published in 1926." [Eng.]. 249 p.: ill.; 21 cm.

In a book written for the craftsman painter working in oil, watercolor, tempera, and/or fresco, the author describes methods and properties of the materials used, including paints, oils, varnishes, emulsions, etc. He also discusses early methods, such as those described by Cennino Cennini and Vasari. The book is a reprint of the 1960 edition published by Seeley. Staff

30-S197.
Littmann, Edwin R.
Ancient Mesoamerican mortars, plasters, and stuccos. The use of bark extracts in lime plasters.

American antiquity: a quarterly review of American archaeology, **25,** pp. 593-597, (1960), [Eng.].

Bark extracts have been used in the preparation of lime plaster in Mexico from prehistoric times to the present. Experiments were made to see if the use of these extracts modifies the characteristics of a simple lime plaster. Samples of four woods traditionally used were obtained, and extracts made from the bark. These were then used in the preparation of plasters. Two of the plasters were much glossier than the others, and all were slightly tinted. Less obvious changes were also observed. These were probably due to a stabilization of the system during curing. The experiments are being continued. [Editor's note: Mesoamerican stuccoes and plasters often present consolidation problems similar to matte painted surfaces.] Staff

30-S198.
Littmann, Edwin R.
Ancient Mesoamerican mortars, plasters, and stuccos: the Puuc Area.

American antiquity: a quarterly review of American archaeology, **25,** no. 3, pp. 407-412, (1960), [Eng.].

The author shows a further geographical use of a lime aggregate as a building element. The Puuc sites differ from those at Comalcalco at Las Flores in the use of nonmarine sources of lime, greater strength, and generally smoother composition. See also AATA 2-1055, 3-2835, 17-1482, 17-1483, 17-1404 and 17-1485. [Editor's note: Mesoamerican stuccoes and plasters often present consolidation problems similar to matte painted surfaces.] Staff

30-S199.
Margival, F.
Pigments et peintures au Moyen Age. (Pigments and paints in the Middle Ages.)

Peintures, pigments, vernis, **36,** pp. 545-555, 614-621, (1960), [Fre.].

Gives a general review and highly positive evaluation of the state of the arts during what has been wrongly named the Dark Ages,

describing the advanced arts of manuscript illumination, stained glass windows, fresco paintings in churches, polychromy on statuary, etc. Discusses as well the value of the various sources of information available. Remaining Medieval paintings have left enough traces to motivate admiration not only on aesthetic but on craftsmanship grounds as well. Examines in detail 1) the nature and preparation of pigments and other painting materials; 2) the paint preparation and application techniques; and 3) the particular characteristics of the various schools of painting, dividing these schools into three categories: a) paintings done according to Roman traditions in the new nations of the old Roman Empire (where Latin was the common language of the Church); b) paintings done following Byzantine traditions in Greek or Slav countries; and c) paintings executed in the Moslem civilizations of such areas as Arabic, Persian, or Turkish countries.

ICCROM(00362800) and M.B.

30-S200.
Margival, F.
Pigments et peintures dans l'antiquité classique.
(Pigments and paints in classical antiquity.)

Peintures, pigments, vernis, **36,** pp. 245-251, (1960), [Fre.]. 2 tables, 19 refs.

Based on the abundant legacy left us by the Greek, Roman, and Egyptian civilizations, this text studies in detail the painting materials and techniques used in classical antiquity. It is divided in two parts, 1) pigments, classified according to color; and 2) paint in the generic sense, that includes coatings, varnishes, and encaustics; it also refers the reader to three scholarly bibliographic sources. The natural and artificial pigments and binding media used in antiquity are listed by Latin name and discussed under the headings of whites, blacks and browns, reds and purples, yellows, greens, and binding and fixing media. The second part is titled "What the painters of antiquity painted"; and details the information under these headings: 1) variety of supports; 2) the painting of edifices; 3) painted statues; and 4) easel paintings. The data on techniques used, fresco, distemper, and encaustic painting, are discussed in conclusion.

ICCROM(00362200) and M.B.

30-S201.
Margival, F.
Pigments et peintures dans les techniques primitives exotiques.
(Pigments and paints in primitive exotic techniques.)

Peintures, pigments, vernis, **37,** pp. 41-55, 109-117, (1961), [Fre.]. 46 ill., 53 refs.

This continues the history of painting techniques initiated in the previous issues. The author first provides a list of pigments used classified according to their origin: earthen, plant or animal, and artificial. He then examines the art produced in different parts of the world: the Far East (with a study of the technology of wood oil, or tung-yu oil, from China, and Chinese and Japanese lacquer), Africa, America, and Oceania. For each of these areas, the author discusses the nature of the pigments used and the methods of application of the pigments. As in the preceding articles, the focus remains on technology, and aesthetic discussion of the production is not attempted. Staff

30-S202.
Raponda-Walker, André; and Sillans, Roger.
Les plantes utiles au Gabon: essai d'inventaire et de concordance des noms vernaculaires et scientifiques des plantes spontanées et introduites: description des espèces, propriétés, utilisations économiques, ethnographiques et artistiques.
(The useful plants of Gabon: an inventory and concordance of popular and scientific names of native and nonnative plants. Description of species, properties, and economic, ethnographic, and artistic uses.)

Book. Encyclopédie biologique, no. 56, Editions Lechevalier, Paris, 1961, [Fre.]. x, 614 p.: ill., maps; 28 cm.

An extensive work on plants used in the area for material culture and other purposes. Woods used in the manufacture of sculpture are described, as are oils used and sources of pigments. Sources of this type for Africa are quite rare. Of particular interest are illustrations of sculpture with the woods used and the finish materials described. M.H.B.

30-S203.
Augusti, Selim.
I bianchi nella pittura antica.
(White pigments in ancient painting.)
Rendiconti dell'Accademia di archeologia lettere e belle arti, **37**, pp. 133-141, (1962), [Ita.]. 1 plate, microphotographs.

Describes the nature and composition of white pigments used in ancient painting as coloring materials, as fillers, or in mixtures, as lake bases or in mural painting plasterwork. ICCROM(00151302)

30-S204.
Puth, M.
Die Farbhölzer, ihre Inhaltsstoffe und deren Verwendung. Teil 1: Beschreibung der wichtigsten Farbhölzer.
(Dyewoods, their composition and use. Part 1: Description of the most important dyewoods.)
Holz-Zentralblatt, **88**, no. 43, (1962), [Ger.].

The following woods are described: caliatour wood, Narra, barwood/camwood, Sapan wood (sibukau), Pernambuco (brazilwood), brazilette (redwood), Campeachy wood (logwood), fustic (yellow wood), and fisetin. Staff

30-S205.
Puth, M.
Die Farbhölzer, ihre Inhaltsstoffe und deren Verwendung. Teil 2: Holzfarbstoffe und ihre Anwendungsgebiete.
(Dyewoods, their composition and use. Part 2: Wood dyes and their fields of application.)
Holz-Zentralblatt, **88**, no. 45, (1962), [Ger.].

The use of wood dyes reached its peak toward the end of the 19th century, after which the development of synthetic dyes displaced the natural products. Treats in detail the chemical structure, extraction, and applications of logwood dyes, soluble and insoluble redwood dyes, yellow wood dye, and fisetin dye. Staff

30-S206.
Towle, Margaret A.; Willey, Gordon R., Preface.
The ethnobotany of pre-Columbian Peru.
Book. Aldine Publishing, Chicago, 1962, Subscribers ed. [Eng.]. ix, 180 p.: ill., map; 26 cm., bibliog.

Summarizes the uses of both wild and cultivated plant species in pre-Columbian Peru, and provides information about which types of plants were used to make textiles, basketry, matting, gourd vessels, wooden objects, and other items of material culture. Various plants used as colorants are also described. Examples include the Algarroba (*Prosopis chilensis*) which was used as a source of gum much like gum arabic. Gum from the Algarroba was also used to mend pottery. Annatto (*Bixa orellana*) was used as a colorant and cochineal was raised on the cactus (*Opuntia exaltata*). A small tree (*Myroxylon spp.*) was the source of the widely used resin "Peruvian balsam." K.L. and M.H.B.

30-S207.
Brochwicz, Zbigniew.
Gumy roslinne jako spoiwa malarskie w swietle dawnych traktatow, ich wlasnosci, oraz ich identyfikacja w dawnych polichromiach.
(Plant gums as painting mediums in the light of old treatises, their properties, and their identification in ancient polychromy.)
Materiały zachodniopomorskie (Muzeum Narodowe), **9**, pp. 487-575, (1963), [Pol. w. Ger. summary]. tables, 46 chromatograms and densitograms.

A detailed monographic article on plant gums, their history, occurrence, physical and chemical properties, kinds of trade products, and means of detection by comparative paper chromatography. Experimental techniques, comparative standards, and preparation of samples are fully described. Staff

30-S208.
Himmelheber, Hans.
Personality and technique of African sculptors.
In book. *Technique and personality*, Lecture series / Museum of Primitive Art, no. 3, (1963), pp. 80-110, [Eng.].

Describes the practice of using green wood as carving material, which is then coated with palm oil to prevent cracking during the drying period. Root woods are favored for masks and some other purposes because of their extreme hardness and density and their resistance to termite infestation. Finished carvings are always colored. Certain leaves (not named) are crushed for a black juice and then used to blacken the carving. Resin is burned for a soot that is also used to blacken the wood. Tools and carving techniques are described as is the position of the carver in his society. Attitudes toward the finished products and the function of objects are described. M.H.B.

30-S209.
Kooijman, S.
The technical aspects of ornamented bark-cloth.

In book. *Ornamented bark-cloth in Indonesia,* Mededelingen van het Rijksmuseum voor Volkenkunde, Leiden, no. 16, (1963), pp. 56-69, [Eng.].

Bark cloth in Indonesia was colored by immersion, stamping or freehand painting. A carmine red paint was made from the red wood of the lower part of the *dolo (Morinda bracteata)* tree. The wood was minced, pounded and boiled with betel and lime. The pits of the *alomi (Peristrophe tinctoria)* were also rubbed on directly for a red paint. Repeated applications built up the color. A yellow came from the *kudu* tree (*Morinda citrifolia*), the roots of which were prepared in the same manner as the *dolo* tree only without the betel and lime. The flowers of *lele ngkasa (Papilionacea spp.)* provided a purple paint, and a green paint was made from the leaves of the *Kalamaya (Homalomena alba)* which were pounded and kneaded in water. M.H.B.

30-S210.
Latner, J.
An analysis of paints used in Roman Britain.

Paint technology, **27,** no. 6, pp. 29-30, (1963), [Eng.].

Discusses the chemical analysis of samples of painted Roman wall plaster collected during recent excavations made by the London Museum on the site of the old palace of the Bishops of Winchester in Southwark, London. The method of analysis used for the paint was the fusion of the samples with potassium bisulfate followed by chemical analysis of the acid solution of the resultant flux. Metallic radicals tested were iron, manganese, chromium, arsenic, antimony, copper, nickel, and lead. Sulfide was also tested and silica residues examined. A quantitative estimation of the cement and sand aggregate of the wall plaster is also given. Suggests likely minerals which would fit the color of the pigments present and the radicals contained. As well as familiar materials such as ochers, possible pigments are alabandite (a pink magnesium sulfide mineral), turquoise (as the blue pigment present), manganosite (a green manganese mineral) and stibnite (orange red antimony trisulfide). There is no knowledge of turquoise being used as a pigment in present-day paints. Staff

30-S211.
Mead, Margaret; Bird, Junius B.; and Himmelheber, Hans.
Technique and personality.

Book. Lecture series / Museum of Primitive Art, no. 3, New York Graphic Society Books, Boston, 1963, [Eng.]. 110 p.: ill. (some col.); 22 cm.

Describes painting on sago palm spathes by the Mountain Arapesh of Papua New Guinea. The spathe is first flattened by heating and weighting and prepared with an application of the sap of a branch from the *dimi* tree. If this is not available breadfruit sap is used. This forms a surface that the clay paint will adhere to. A ground of *adag,* or scrapings from a soft stone from the Sulum River is applied in powdered form. The paint is then applied using clays of various colors traded from different locations. No binder is mentioned other than water. A flat stone palette and a shell for scraping pigments is used. Brushes are feathers from the *manyin* or *nauwitep* are preferred but other quill feathers are considered satisfactory. Describes the painting process in detail. Multiple workers are involved with one person as the primary painter. A great deal of discussion is involved and the process seems remarkably communal. M.H.B.

30-S212.
Mora De Jaramillo, Yolanda.
Barniz de Pasto, una artesania colombiana de procedencia aborigen.
(Varnish of Pasto, a Colombian craft of aboriginal origin.)

Revista colombiana de folclor, **3,** no. 8, pp. 11-48, (1963), [Spa.].

The varnish of Pasto is a craft industry carried on in the city of Pasto, consisting in the decoration of furniture and wood vessels with a vegetable lacquer derived from the resin produced by the mopa-mopa tree (*Elaeagia utilis, Wedd*), commonly called varnish. The varnish of Pasto is one of the few craftsmanships in existence in Colombia of an aboriginal origin that has survived and maintained a continuity from Spanish early times until today, with very few innovations, and those, of a secondary character. The careful and systematic study of the fabrication of the varnish and its applications, and some socioeconomic aspects of the craft, constitute the subject of this work. Headings: 1) History and geography of the varnish; 2) Raw material and place of origin; 3) Distribution and conservation; 4) The family workshop; 5) Tools of the craft; 6) Preparation process, steps and applications; 7) Preparation of the objects to be varnished; 8) Function of the decorated objects; 9) The design and its themes; 10) Craftsmen and apprentices; 11) Calendar and production system; sales conditions; 12) Perspectives for the varnish of Pasto. M.B.

30-S213.
Plesters, J.
An analysis of paints used in Roman Britain.

Paint technology, **27,** no. 8, p. 42, (1963), [Eng.].

In a letter commenting on an article by J. Latner in the same journal the writer points out that, although the fusion method of analysis used by J. Latner indicates the metallic ions present in the paint samples, supplementary methods such as microscopical examination of particle characteristics or x-ray diffraction crystallography are necessary for the complete identification of pigments present. The minerals suggested by J. Latner as likely to represent the pigments present in the samples of Roman wall painting examined lie well outside the range of pigments known either from early

literary sources or from other analyses of Roman painted wall plaster. The presence of stibnite (Sb2S3), turquoise, and alabandite for example, is seriously questioned. The writer suggests that the majority of J. Latner's analytical results could be interpreted equally well by assuming the presence of well-known pigments (e.g., Egyptian blue instead of turquoise). Staff

30-S214.
Rice, Tamara Talbot.
The technique of icon painting.

In book. *Russian icons,* (1963), pp. 23-25, [Eng.].

Documents materials and techniques of Medieval Russian icon painting. Wooden panels of lime, birch, alder, oak, or cypress had a thin layer of gesso with powdered alabaster or a canvas added, applied to the face. The gesso was smoothed and polished. The medium consisted of 24 basic colors of tempera made from raw egg yolk diluted in rye beer. Cinnabar was used for outlines, followed by a coat of white lead paint burnt to a greenish tinge. Faces were painted a darkish brown, features outlined in red ocher, and touched up with a lighter brown (*okhreniye* or *ochring*). Highlights (*bliki*) of white lead, occasionally mixed with dark ocher, were applied in tiny curved (*ozhyvki,* "enliveners") or parallel lines (*dvizhki,* "flecks"). Backgrounds of gold leaf over a priming of red (*svet*) or of a bronze and gold blend (*inokop*) represented the radiance of heaven. Throughout various times and regions, silver, red, pale ocher, green, and bright blue backgrounds were popular. In pre-Mongol Kiev, metal halos, jewels, cloisonné enamels and stamped metal sheets adorned icons later encased in costly *rizas* or swathed with elaborately embroidered cloths. Church and processional icon production disappeared under influences of Western art and Soviet anti-religious measures. CCI

30-S215.
Hodges, Henry W.M.
Artifacts: an introduction to early materials and technology.

Book. John Baker Publishers Ltd., London, 1964, [Eng.]. 248 p.: ill.; 26 cm., bibliog. and index.

In the section on painting Hodges gives a definition of exactly what is meant

by "painting." Objects that have never had a coat of paint are often referred to as painted when in fact they may have had a dye or some other colorant applied directly. This provides an important clarification of what exactly is meant by "painted" over a wide range of objects from different cultures and time periods.

M.H.B.

30-S216.
Jenkins, Katharine D.
Aje or Ni-in (the fat of a scale insect): painting medium and unguent.

In book. *XXXV Congreso Internacional de Americanistas, Mexico, 1962: actas y memorias,* (1964), pp. 625-636, [Eng.].

Describes the preparation, use and history of aje. Generally, a powdered white earth with or without colorants is used with a drying oil from the seeds of a Salvia species called Chia or linseed oil. To this is added the fat of a scale insect (*Llaveia axin*) which is extracted by cooking or crushing the insects. The article gives the properties of the material and discusses the gathering of the insects.

M.H.B.

30-S217.
Moser, Mary Beck.
Seri blue.

The kiva, **30,** no. 2, pp. 27-39, (1964), [Eng.].

Describes the making of Seri blue. The author was allowed by an informant to witness the process. The root bark of *Franseria dumosa* is ground with a particular clay found in the area and the sap of *Guaiacum coulteri.* The root bark of *Franseria ambrosioides* or *Stegnospermum halimifoliam* can be substituted for the *Franseria dumosa.* The preparation is an important part of the process. Traditional Seri blue was being supplanted by laundry blueing at the time this was written. M.H.B.

30-S218.
Peirce, H. Wesley.
Seri blue - an explanation.

The kiva, **30,** no. 2, pp. 33-39, (1964), [Eng.].

X-ray diffractometer studies were made of the inorganic, naturally occurring, mineral substance used by the Seri Indians in the preparation of a blue pigment, Seri blue. The main conclusions are: 1) the major part of the inorganic material consists of a random, mixed-layer clay in which expansible or montmoril-

lonitic clay layers predominate, and 2) the process that produces blue coloration results in a detectable change of basal spacing in certain layers of the random-mixed layer clay. A resin from the *Guaiacum coulteri* tree is also used in the preparation of the pigment. This resin was used by the author to stain other clays, and a color plate of the resulting pigments is included. Staff

30-S219.
Williamson, Jessie; Jackson, G., Illustrator.
Useful plants of Malawi.

Book. Malawi Government Printer, 1964, [Eng.]. 168 p.: ill.; 25 cm., bibliog.

A section on p. 155 lists plants by category of use. Categories include "plants used as dyes," "plants used for gum and latex," and "plants used as piscicides and insecticides." Oil producing plants and plants used for fibers and textiles are also covered.

M.H.B.

30-S220.
Augusti, Selim.
Analysis of the material and technique of ancient mural paintings.

In proceedings. *Application of science in examination of works of art: proceedings of the seminar, September 7-16, 1965,* Young, William Jonathan, Editor (1965), pp. 67-70, [Eng.].

The chemical compositions of 240 samples of prepared pigments from shops in ancient Pompeii were determined by microchemical tests and other analytical techniques. Evidence is presented that a mixture of calcium soap and beeswax was the medium for mural paints in ancient Pompeii. The stratigraphic structure of murals in ancient Pompeii is described. Staff

30-S221.
Candee, Richard M.
Materials toward a history of housepaints: the materials and craft of the housepainter in 18th century America.

Master's thesis. State University College at Oneonta, Oneonta, New York, 1965, [Eng.]. viii, 143 leaves; 30 cm., bibliog.

A master's thesis discussing the preparation of paints, pigments, and binders used in 18th-century America. Of particular interest is a description of the use of ox blood se-

rum as a binder. The blood from slaughtered oxen was allowed to settle and the serum separated from the blood cells and used as a binder. Political difficulties made it necessary to improvise with ingredients and many distemper finishes from this period are matte and very friable. The sections on distempers, casein, and milk paints are especially relevant. M.H.B.

30-S222.
Cheng Te'k'un.
The T'u-lu colour-container of the Shang-Chou period.

Bulletin: The Museum of Far Eastern Antiquities (Östasiatiska museet) Stockholm, **37,** pp. 239-250, (1965), [Eng.].

An unusual type of Chinese square vessel with four vertical cylindrical tubes at the corners and an elongated handle is recognized as a color container and may be called a t'u-lu or "drawing pot." Eight specimens in bronze, three in pottery, one in jade, and two in marble are described and pictured. They are sometimes mistaken for lamps. They may have held water and brushes for writing sacred or dynastic records. In one, residues of pigments identified provisionally as chalk, charcoal, hematite, and malachite were found. Color residues have been observed in some of the others. Staff

30-S223.
Gaskin, L.J.P.; and Atkins, Guy, Directors.
A bibliography of African art.

Book. International African Institute, London, 1965, [Eng.]. x, 120 p.; 29 cm.

Arranged geographically with subsections such as "Techniques," "Rock Art," "Clothing and Adornment," and other subject headings. The compiler was trying to provide access to a proliferation of publishing on African art since the second world war and particularly in the early 1960s. M.H.B.

30-S224.
Kupka, Karel; and Ross, John; Breton, André, Preface.
Dawn of art: painting and sculpture of Australian Aborigines.

Book. Penguin Books, Inc., New York, 1965, [Eng.]. x, 180 p.: ill. (some col.), map; 24 cm., bibliog.

Describes the preparation of bark paintings. The bark is flattened and then red ocher is rubbed on the surface with wild orchid stems. The sticky sap from the orchid stems functions as a fixative for the first coat. Other "natural" fixatives are mentioned but not specifically. Colors are red, yellow, black from charcoal or sometimes from mineral sources (magnesium oxides), brown, and a pipe clay white. Ochers are traded from remote locations and some colors are highly prized. Pigment is prepared by soaking shells in water, and hard pigments are ground with water to the desired consistency. Remarks on the difficulty of retouching damaged bark paintings. M.H.B.

30-S225.
Margival, F.
Importance du liant.
(The importance of binders.)

Peintures, pigments, vernis, **41,** pp. 321-324, (1965), [Fre.]. 2 tables.

Reviews the various meanings of the word binder and of its near-synonyms, i.e., medium, matter, gluten, and megilp. The nature and properties of three groups of binders are reviewed: 1) aqueous binders, such as gelatin, casein, gum, silicates, and all sorts of water-soluble substances, or at least those apt to swell in water; 2) organic solvent-based binders, such as fatty materials, resinous materials, or rubber-based materials; and 3) emulsions that can be related to one or the other of the preceding. A table indicates the state of oil paintings using nine kinds of binders after a 20- and 60-day exposure to a warm and humid environment. Staff

30-S226.
Philippot, Paul; and Mora, Paolo.
Technique et conservation des peintures murales. Rapport: réunion mixte de Washington et New York, 17-25 Septembre 1965.
(Technique and conservation of mural paintings: report on the meeting held in Washington and New York, 17-25 September 1965.)

Technical report. International Centre for the Study of the Preservation and the Restoration of Cultural Property, Rome, 1965, [Fre.]. 1 v.; 28 cm., refs.

The authors trace the history of mural painting technique from prehistoric times to the Baroque era. Internal and external causes of deterioration are discussed. Treatments explained include cleaning, fixative consolidation of paint layer, consolidation of plasterwork, transfer, and lacunae treatment. Analysis techniques are discussed. ICCROM(00122900)

30-S227.
Gettens, Rutherford J.; and Stout, George L.
Painting materials: a short encyclopaedia.
Book. Dover Publications, Inc., 1966, [Eng.]. ix, 333 p.: ill.; 22 cm., bibliogs. [ISBN 0-486-21597-0].

Designed as a reference handbook for museum curators and conservators. Explains the chemical and physical properties of mediums, adhesives, film substances, pigments, inert materials, solvents, diluents, and detergents. Supports and tools are discussed. (Originally published as a series of notes in *Technical studies in the field of fine arts*, 1936-41.) ICCROM(00548000)

30-S228.
Smith, C. Earle; Callen, Eric O.; Cutler, Hugh C.; Galinat, Walton C.; Kaplan, Lawrence; Whitaker, Thomas W.; and Yarnell, Richard A.
Bibliography of American archaeological plant remains.
Economic botany, **20,** no. 4, pp. 446-460, (1966), [Eng.]. bibliog.

The authors attempt to list all reports of plant materials in American archaeological sites. An important source for American palaeoethnobotany. M.H.B.

30-S229.
Augusti, Selim.
I colori pompeiani.
(Pompeian colors.)
Book. De Luca Editore, Rome, 1967, [Eng.]. 163 p.: plates; 24 cm., bibliog.

A scientific study of Pompeian colors, with information on literary sources, pigment analysis, deterioration of ancient colors and the price of pigments in antiquity. Includes a systematic catalog of the pigments, with ancient and modern names, and their composition. ICCROM(00257600)

30-S230.
Candee, Richard M.
House paints in Colonial America: their materials, manufacture and application. Part III.
Color engineering, **1967,** no. March-April, pp. 32-42, (1967), [Eng.]. bibliog.

Discusses nomenclature (terminology), manufacture, preparation, and application of the following red, blue, and yellow pigments used in 18th-century house paints in colonial America: vermilion, cinnabar, minium, red lead, orange mineral, iron red oxide, ruddle, red chalk, red ocher (oker), purple red, Indian red, rouge, colcothar, caput mortuum, Venetian red, Spanish red and brown, umber, Terra umber, brown ocher, Turkey umber, red lakes, carmine, drop lake, crimson lake, rose pink, purple lake, ultramarine, blue (Prussia, Prussian, Persian, verditer, Sanders (cendre), bice, smalt, strewing smalts, powder, indigo, fig, stone), yellow ochers (English, French, flat, stone, spruce, brown, terra di Sienna), yellow lakes (Dutch, English, brown and light pinks), asphaltum, yellows (King's, common orpiment (auripigmentum), Naples, princess, patent, Turner's, mineral, Montpellier, chrome), and gamboge. There is an extensive list of references continuing from an earlier article. This article is a reference for early American paints, and for architectural conservation. CCI

30-S231.
Gerbrands, Adrian A.; Seeger, Inez Wolf, Translator.
Wow-Ipits: eight Asmat woodcarvers of New Guinea.
Book. Art in its context: studies in ethno-aesthetics. Field reports, no. 3, Mouton & Cie, Editions, Paris, 1967, [Eng.]. 192 p.: ill.; 26 cm., bibliog.

The author describes the use of chalk and red ocher as colorants. Apparently, pigments are applied dry or mixed with water in paint vessels. The use of red sap from the mangrove (species not described) or *tau* is also mentioned for painting grooves in a carving. A wad of fern leaves is used to apply chalk and a twig to apply red earth to the grooves of another piece. Carving is described in detail through profiles of the woodcarvers and descriptions of them at work and how they use their tools. M.H.B.

30-S232.
Lal, B.B.
Ajanta murals: their composition and technique and preservation.

Memoirs of the Archaeological Survey of India, pp. 53-59, (1967), [Eng.].

Describes the structure of the rock support of the Ajanta caves murals, a compact rock with a rough surface. The three-layered mud-plaster ground is composed of coarse plaster, fine plaster, and pigments. These are all locally available earth colors, except for imported lapis lazuli. The painting technique used was tempera, and the external and internal causes of deterioration are listed as follows: 1) humidity and temperature variations, various kinds of dirt, soot, tar, insect, bird, and bat droppings, water infiltrations, mildew, and vandalism; and 2) bulging and cracking of the paint layer, fading and flaking of pigments, etc. Describes the 1921-22 restoration by Italian experts who used shellac in alcohol and gum dammar in turpentine to fix the pigments, and various cleaning agents such as ammonia and others; a survey carried out 35 years later showed that the intervention had been ineffective, and a new restoration was undertaken. Details the techniques and products used; mentions the photographic documentation kept before, during, and after the conservation treatment.
Staff

30-S233.
Langenheim, Jean H.
Preliminary investigations of Hymenaea courbaril as a resin producer.

Journal of the Arnold Arboretum, **48,** no. 3, pp. 204-229, (1967), [Eng.].

Describes the chemistry of the resin, giving infrared spectra for samples of the resin from different locations in Central and South America. The production of the resin by the tree is discussed with the authors concluding that the tree does not necessarily have to be damaged or diseased to produce large quantities of resin.
M.H.B.

30-S234.
Merrifield, Mary P.
Original treatises on the arts of painting.

Book. Dover Publications, Inc., 1967, [Eng. + Lat.]. 2 v. (cccxii, 918 p.); 22 cm., refs.

The Dover edition is an unabridged republication of Mrs. Merrifield's *Original Treatises* first published in London in 1849, with the addition of a glossary for modern readers. The treatises include: those collected by Jehan le Begue in 1431 (Table of Synonyms, Petrus de St. Audemar's *On making colours,* Eraclius' *On the colours and arts of the Romans,* Archerius' *A treatise on preparing many kinds of colours* and *On colours of different kinds,* with some miscellaneous recipes contributed by Jehan le Begue); The Bologna Manuscript *Secrets for making colours,* 15th-century; The Marciana Manuscript *Divers secrets,* 16th-century; The Paduan Manuscript *Recipes for making all kinds of colours,* 17th-century; The Volpato Manuscript *Mode to be observed in Painting,* 17th-century; The Brussels Manuscript *Collection of essays on the wonders of painting* by P. Lebrun, 17th-century; Extracts from a History of the Academy of Fine Arts at Venice; Extracts from a dissertation read in the Academy of Fine Arts at Venice by P. Edwards on the *Propriety of Restoring the Public Pictures in Venice.* In these treatises, the greatest emphasis is on the preparation of pigments for use in the illumination of manuscripts (mss. of Jehan le Begue); for larger-scale painting on wood (Bologna Ms.); on canvas in oil, with significant recipes on the preparation of varnishes (e.g. Jehan le Begue, Marciana Ms., Volpato Ms.); and for fresco painting (Brussels Ms., Jehan le Begue). But notable sections in all the treatises are devoted to gilding of all types, to the manufacture of inks, and the preparation of adhesives of all kinds. Working with glass and glazes is dealt with in Eraclius, the Bologna Ms., the Marciana Ms., and the Brussels Ms.; dyeing of skins and bones occurs in Eraclius, Jehan le Begue, the Bologna Ms.; and the manufacturing (falsification), polishing, and engraving of precious stones are described in the Bologna Ms. and Eraclius. Throughout the texts are individual recipes on a wide variety of subjects such as: substitute materials for precious metals (Jehan le Begue); tempering and cleaning iron; rust prevention (Jehan le Begue); coloring metals (P. de St. Audemar); the cleaning and cementing of parchment and paper (Jehan le Begue); making tracing paper (Jehan le Begue); making windows from parchment (Bologna Ms.); manufacture of leather (Bologna Ms.); manufacture of gesso

(Jehan le Begue, Bologna Ms.); manufacture of stucco (Marciana Ms.); manufacture of amber beads (substitute) (Bologna Ms.); cleaning wool, velvet, etc. (Jehan le Begue); dyeing silk and other materials (Bologna Ms.); bending ivory (Eraclius); preparation of surfaces such as linen, wood, paper, parchment, stone for various purposes such as gilding, silver-point, and painting (Archerius, Eraclius); the painter's equipment (Brussels Ms.); how to speak of beautiful paintings (Brussels Ms.). The text of each treatise is found in its original language on one side of the page, with an English translation, where feasible, on the opposite page. Also traces the history of each significant material dealt with in the treatises, in an introduction of 312 pages. Staff

30-S235.
Mora, Paolo.
Proposte sulla tecnica della pittura murale romana.
(Proposals on the technique of Roman mural paintings.)

Bollettino dell'Istituto Centrale del Restauro, pp. 63-84, (1967), [Ita.].

Treatise on the Roman techniques for mural paintings based on classical sources and on examinations carried out with scientific methods. ICCROM(16102)

30-S236.
Watson, Editha L.
What did they use for paint?

The artifact, **5**, no. 2, pp. 1-11, (1967), [Eng.]. bibliog.

Describes possible paint and binder materials used by prehistoric North American Indians for kiva murals and rock painting (rock art, pictographs). Most pigments were obtained from metals, mineral oxides, organic and siliceous sources, for example: iron oxide, hematite, ocher, limonite, malachite, serpentine, copper ore, azurite, clay, kaolin, diatomaceous earth, carbon, charcoal, graphite, manganese. Other colors were produced by mixing or heating by baking or roasting. Binding vehicles improved penetration, durability, and adhesion. Possible sources may include milk casein, acacia gum, egg, water, blood, plant and vegetable oils, or animal fats. Further scientific analysis is required. Paints were also used on pottery (ceramics)

and clothing. This article applies to the following disciplines: archaeology, anthropology, ethnology, conservation, and those working with ethnographic artifacts or primitive art. CCI

30-S237.
White clay and ochre.

Motion picture. Australian Museum, Sydney, 1968, 1 film reel (15 min.), sd., col., 16 mm. [Eng.]. Australian Museum (Producing Agency).

Report on study of the Aborigines of western New South Wales highlights on-location work of an Australian Museum field party. One of the few remaining areas where the Aborigines still live as they have for thousands of years is shown. The museum party records cave paintings at an Aboriginal campsite in order to determine their age by radiocarbon dating and study their history and meaning. The techniques of archaeologist, artist, and photographer are intercut with shots of the paintings, which document the hunting, food gathering, warring, and ceremonialism of Aboriginal life. Staff and PFAOF

30-S238.
Defarges, Dom Bénigne.
L'ocre et son industrie en Puisaye, géologie et histoire.
(Ocher and ocher industry in the Puisaye region, geology and history.)

Book. Association d'études et de recherches du Vieux Toucy, 1968, [Fre.]. 101 p.: tables; 23 cm., bibliog.

The first chapter, on ocher in prehistory, includes information on the use of ocher throughout the world in prehistoric times. The second chapter, on the geology of ocher, studies the geology of the Parisian Basin where ocher is found, particularly in the Puisaye area, and the surroundings of the town of Pourrain. Chapter three gives a chemical analysis of the ocher previously defined. Chapter four studies the extraction of ocher, first from a historical point of view, then a geographical one. The processing of the mineral is then considered, and includes a list of mine ownerships, techniques of extraction, applicable laws, and workers' statutes. The last chapter covers the mineral's manufacture and trade, with separate entries

for the preparation of yellow and red ochers. Production levels and prices are indicated. Among the appended documents is a note on an ocher-caused disease, pneumoconiosis.

M.B.

30-S239.
Dunn, Dorothy.
American Indian painting of the Southwest and Plains areas.

Book. University of New Mexico Press, Albuquerque, 1968, 1st ed. [Eng.]. xxvii, 429 p.: ill. (some col.); 29 cm., bibliog.

Summarizes painting materials and techniques beginning on page 107. Describes the pigments used and the sometimes highly ritual processes in which they were gathered and prepared. States that ritual substances were sometimes incorporated into the pigment when it was being ground. Characteristically, these could be eagle feathers, abalone shell, turquoise, or other material. Binders used were Yucca syrup when a glossy surface was desired. With the introduction of new domestic animals, new pratices evolved such as spraying cow's milk onto a surface to make it glossy. Melon seeds, squash seeds, eagle eggs, and piñon gum were also traditionally used as binders. The melon and squash seeds were chewed and the combined seed and saliva mixture ground with the pigment. Piñon gum was boiled and mixed with blue and green copper carbonates. A form of oil paint was made with liquid animal fat or piñon seed oil. Brushes were usually made of yucca fiber. A number of other means were used to apply paint. The text provides a synthesis of a very large body of literature in this brief section.

M.H.B.

30-S240.
Grabowski, Jozef.
Ludowe malarstwo na szkle.
(Folk painting on glass.)

Book. Zaklad Narodowy im. Ossolinskich. Wydawnictwo Polskeij Akademii Nauk, 1968, [Pol. w. Eng. + Ger. summaries]. 377 p.: ill. (some col.); 30 cm., bibliog.

In 19th-century Poland, folk painting on glass evolved from the practice of finishing woodcuts with translucent paints put on the overlying glass rather than on paper. In subsequent stages, the woodcut dwindled until a

small fragment in the center of the picture remained; its sides were occupied by the ever-expanding decorative motifs painted on the glass overlay. Craftsmen used opaque and also translucent paints (green, brown, ocher), against a background of golden tinsel or gold-colored paper.

K.L.

30-S241.
Hendy, Philip; Lucas, A.S.; and Plesters, Joyce.
The ground in pictures.

Museum, **21,** no. 4, pp. 245-276, (1968), [Eng.].

Discusses the nature and function of grounds in paintings. Indicates the materials used and their preparation for grounds at various periods, and classifies grounds as aqueous, emulsions, and drying oils, each of which is discussed. Deterioration problems and treatments are also described. The paint film with grounds of some famous paintings are published in 22 color cross sections with descriptive texts.

Staff

30-S242.
Laman, Karl Edward; Lagercrantz, Sture, Editor.
The Kongo IV.

Book. Berlingska Boktryckeriet, Lund, 1968, [Eng.]. 198 p.: ill.; 31 cm.

Briefly describes colors and the terms associated with them in the section on arts. Sources for pigments are described, as are the objects colorants are applied to. A black derived from the bark of the *mwindu* tree is mixed with water and applied. Refers to it as a dye but states: "This solution is spread over surfaces which readily absorb the dye, such as newly baked earthenware vessels, pipes, etc." This is not a true dye. It is perhaps more correctly described as a paint. The use of colorants is so extensive in all aspects of Sundi life, for instance body painting, that it is difficult to understand it by simply looking at items of material culture.

M.H.B.

30-S243.
Reynolds, Barrie.
The material culture of the peoples of the Gwembe Valley.

Book. Kariba studies, no. 3, Praeger Publishers, New York, 1968, [Eng.]. xiii, 262 p.: ill., map; 25 cm., bibliog.

Building the Kariba dam meant the flooding and displacement of the people living in the Gwembe Valley. A series of studies of the people and their culture were made before the dam displaced them. This text represents the publication of the information about material culture derived from this study. Many objects were collected during the study and deposited in the Livingstone Museum in Zambia. Specific information about materials used in making paint is not provided. One section describes the making of paint for decorating pottery using castor oil as a binder with graphite or red ocher. *Muskili (Trichilia roka)* oil is also cited as a binder. Precise detail is given concerning the making of houses and virtually every other aspect of material culture except painting and dyeing. Scientific nomenclature and the African name of plants are given and the text includes a useful appendix of plants used by category. M.H.B.

30-S244.
Terrace, Edward L.B.
The entourage of an Egyptian governor.

Boston Museum bulletin, **66,** no. 343, pp. 5-27, (1968), [Eng.].

Describes an Egyptian Middle Kingdom wooden object known as the Bersheh Procession. It consists of four figures of offering bearers in the round, mounted on a base (66.5 cm long). The finding and subsequent restoration of the Procession are described, and many technical points are mentioned. Pigments found were: pink (red iron oxide mixed with white calcium carbonate); white (calcium carbonate); charcoal black; red (red ocher); and green (Egyptian blue + atacamite). The last pigment, a rare one, occurs also on the Twelfth Dynasty coffin discovered at Bersheh, suggesting that the two were painted by the same artist. All colors are painted over a white calcium carbonate ground. The objects represented are also of great technical interest. A copper *hes* jar is represented purplish brown, although copper tools on the coffin are represented a dark brown-red. A mirror handle is black, to represent ebony. The mirror case is represented as being made from red leather, with side pieces made from mottled cowhide. Reed baskets are also shown. Also mentions details of construction of the wooden image; joining by dowelling and by mortise-and-tenon both appear. Staff

30-S245.
Terrace, Edward Lee Bockman.
Egyptian paintings of the Middle Kingdom.

Book. Unwin Hyman Ltd., New York, 1968, [Eng.]. 172 p.: ill. (some col.), 2 maps, 3 plans; 32 cm., bibliog. [ISBN 0-04-709007-3].

In the description of the materials used in the coffins of Djehuty-Nekht, a coating is described that appears to be a sort of transparent size. The authors were unable to identify this coating and they were also unable to identify the medium used in the paintings. Brushes are described and a technical appendix identifies the pigments used. The coffins are particularly interesting since the painting is done directly on the wood surface of the coffins with no ground of any kind except the possible clear size suspected by the authors. M.H.B.

30-S246.
Agrawal, Om Prakash.
Notes on the technique of Indian polychrome wooden sculpture.

Book. National Museum. Conservation Laboratory, New Delhi, 1969, [Eng.]. 18 p. and unpaged appendices; 30 cm.

A note on the antiquity of the use of wood in India is followed by brief mentions of important surviving wood sculptures. Various texts give information on technique; there were elaborate rules for the selection of woods, and information on types used is summarized. The carving technique is described, as are the types of decoration found and the painting process. Surface preparation was sometimes used, sometimes not, and the following pigments are reported: malachite, green earth, red ocher, yellow ocher, chrome yellow, ultramarine, kaolin. With lac-work, cinnabar, indigo, and carbon black are also mentioned. Inlay and lac techniques are described briefly. Conservation problems are summarized. The appendices give summary descriptions of four individual pieces. C.A.L.

30-S247.
Douglas, F.H.; Burnham, Harold B., Editor.
A Naskapi painted skin shirt.

In book. *Material culture notes,* (1969), pp. 53-59, rev. ed. [Eng.].

Describes the manufacture of a Naskapi (Montaignais) painted caribou skin (hide) shirt in the American Indian Art Department of the Denver Art Museum. Topics include analysis of paint and binding medium, colors, grub (gadfly larvae) scars, and design style. Ground pigments were mixed with water and dried fish roe. Double curve designs were drawn by means of a tool and template onto the hide. Although the shirt is compared to tailored European garments of the day, the author deduces that the fitted painted coats of Labrador are of Native origin, presumably protohistoric. There is one reference, dated 1894. [Note: The work was completely revised in June 1968 by Harold B. Burnham.]
CCI(2416)

30-S248.
Stolow, N.
Conservation of the contemporary.

Artscanada, **26**, no. 1, pp. 14-18, (1969), [Eng.].

An illustrated discussion on the problems encountered or anticipated in the preservation of contemporary paintings and works of art. Unusual materials used in unconventional ways cause premature failure. The artist should apply spare parts with his work so that obsolete portions may be replaced. Op art, kinetic art, light art, and conceptual art forms will be dealt with in future years by conservators having considerable skills in chemistry, physics, electrical and mechanical engineering, metal welding, plastics fabricating, and illumination. An appeal is made to the artist-technologist to concern himself more with the properties and permanence of materials, even when the work is created in the first instance to have a limited life.
Staff

30-S249.
Watson, Editha L.
The ancients knew their paints.

The artifact, **7**, no. 2, pp. 1-6, (1969), [Eng. w. Eng. summary]. bibliog.

Describes painting materials and techniques of prehistoric rock art (rock painting, pictographs) and Hopi Kiva murals by North American Indians. Pigments from mineral and metallic oxides or from organic sources were obtained locally or through trade. Pigment examples include: iron oxide, ocher, copper ores, hematite, limonite, malachite, azurite, manganese oxide, goethite, clay, kaolin, chalk, gypsum, carbon, charcoal, soot, and graphite. Other colors were produced by mixing or heating. Binders improved penetration, durability, and adhesion. Possible sources may include water, saliva, vegetable and plant oils, animal fats, milk, blood, urine, honey and eggs. References date 1918-67. This information applies to the following disciplines: archaeology, anthropology, ethnology, conservation, and work with ethnographic artifacts or primitive art.
CCI

30-S250.
Gelede: a Yoruba masquerade.

Motion picture. University of California, Los Angeles. Instructional Media Library, Los Angeles; Boston University. African Studies Center, Boston, 1970, 1 film reel (23 min.), sd., col., 16 mm. [Eng.]. Speed, Francis (Director); Harper, Peggy (Director); University of Ife, Nigeria (Producing Agency).

Study of a festival and related dances of the Gelede society of the Yoruba people in Nigeria through which the community reaffirms ties with spirits and ancestors. The Yoruba have a patriarchal society, but women run the market economy. The Gelede festival honors important women of the society and honors the goddess of fertility. Shows preparations for the festival: carving the masks, making paints from local materials. Dances are performed the following day. The ritual song and dance rise to dramatic heights when the masks appear.
PFAOF

30-S251.
Belt, Sage Culpepper.
The useful arts of Africa: their methods and materials.

Museum Alliance quarterly, **8**, no. 4, pp. 14-20, (1970), [Eng.].

Describes materials and techniques used in decorating gourds, weaving, dyeing, leather tanning and dyeing. Cites the use of

gums from pods of *Acacia campylacantha* mixed with pigments to paint gourds. Sorghum is used for a red colorant and millet leaves. Natron added to the sorghum is used to make a black color. A number of plants used for dyes and weaving are described. Recommends the accounts of missionaries and early travelers as a source of information about African folk arts as well as anthropological and botanical literature. M.H.B.

30-S252.
Eibner, Alexander.
Entwicklung und Werkstoffe der Wandmalerei vom Altertum bis zur Neuzeit.
(Development and materials of wall paintings from antiquity to recent times.)
Book. Elmar Sändig, 1970, Reprint of the Munich ed. 1926. [Ger.]. xvi, 618 p.; 28 cm, bibliog.
This reprint of Eibner's 1926 book about the history of mural painting presents his examination of the deterioration of mural paintings from the 18th and 19th centuries.
 Staff

30-S253.
McCarthy, Frederick David, Editor.
Aboriginal antiquities in Australia: their nature and preservation.
Proceedings. Australian Aboriginal studies, no. 22, Australian Institute of Aboriginal and Torres Strait Islander Studies, Canberra, 1970, [Eng.]. xiv, 188 p.: ill., tables; 26 cm., bibliogs.
Contributions presented at a conference in Canberra in 1968, covering the range of antiquities, deterioration and conservation, and protective legislation in force and proposed. Full bibliographies are appended to each section. Maps give locations of sites in each state. Staff

30-S254.
Miesel, Victor H., Editor.
Voices of German Expressionism.
Book. Prentice-Hall, Englewood Cliffs, 1970, [Eng.]. x, 211 p.; 26 cm., refs. [ISBN 0-13-943712-6].
Includes a letter by Kirchner to the archaeologist Botho Graef describing his artistic development. Kirchner makes the following mention in passing, "Technically, I first used thick oil colors, then in order to cover larger surfaces I applied the colors more thinly with a painting knife, and then I used benzine (my secret for the mat finish) with a wax additive." Kirchner is speaking in terms of the development of his technique chronologically. Kirchner was also influenced or certainly interested by the distemper technique of Otto Müller. M.H.B.

30-S255.
Agrawal, O.P.
A study of Indian polychrome wooden sculpture.
Studies in conservation, 16, no. 2, pp. 56-68, (1971), [Eng. w. Fre., Ger., Ita. + Spa. summaries].
There is evidence in the literature that in India wood was used for making sculptures from very early times. Owing to the destructive climate, however, only wooden objects dating from the 7th century are available today, while polychromed wooden sculptures of the period before the 16th century are unobtainable. Sculptures were produced either by carving from one solid block, or by building up from small pieces. The main types of decorating were painting, inlay work, or lac work. Painting was done sometimes without, but mostly with, surface preparation. For this a thin layer of a ground was used. Sometimes a layer of cloth and then paper was used before applying the gesso. Pigments in common use were malachite, terre verte, red ocher, red lead, lac dye, yellow ocher, chrome yellow, ultramarine, kaolin, and chalk. A gold effect was often produced by applying shellac varnish over shining silvery tin paint or foil. Lac work was produced by painting with lac solution or by turnery. Staff

30-S256.
Alliot, Hector.
Prehistoric use of bitumen in Southern California.
Masterkey, 44, no. 3, pp. 96-102, (1971), [Eng.].
Some 10 miles off the coast of California (between Redondo Beach and Santa Catalina Island) small masses of asphaltum are ejected from the sea bottom; these then float to the shore. Formerly Indians gathered the material

and used it as a cementing agent for tools and weapons, for waterproofing basketry, and to mend cracked steatite bowls. The tar was also used to caulk the plank boats of the Channel Islands. [Editor's remarks: Bitumen from ocean seeps and bitumen from land seeps were distinguished by the Indians and used for different purposes and processed differently. Bitumen collected on beaches contains water and possesses different properties, recognized by the Indians. Consequently, the uses cited by this author are debatable.]

Staff

30-S257.
Baur, P.
Bindemittel und Pigmente in der Literatur des Altertums.
(Binding media and pigments in the literature of antiquity.)

Farbe + Lack, pp. 5-10, (1971), [Ger.]. 21 refs.

In the occasional short accounts of the history of paints and pigments only descriptions based on secondary literature are to be found. Based on thorough studies of primary sources, this attempts to give a short survey of the literature in pre-Christian times as far as it contains notes on pigments and paint vehicles. Draws interesting conclusions on the development of pigments and vehicles in the period considered. Staff

30-S258.
Cummings, Abbott Lowell.
Decorative painters and house painting at Massachusetts Bay, 1630-1725.

In book. *American painting to 1776: a reappraisal,* Quimby, Ian M.G., Editor (1971), pp. 71-89, [Eng.].

Discusses whitewashing and decorative painting in New England during the period in question. Before 1725 there is no evidence of oil painting in Massachusetts houses. Whitewash was used or a glue size or egg white with a colored pigment for the decorative painting done before this date. Although there were wealthy homeowners during this period, and descriptions of painted rooms exist, little is known. The evidence discussed here is derived from paint layers revealed during the dismantling of houses of the period. M.H.B.

30-S259.
Felger, Richard S.; and Moser, Mary B.
Seri use of mesquite, *Prospis glandulosa* variety *torreyana.*

The kiva, **31,** no. 1, pp. 53-60, (1971), [Eng.].

The uses to which the Seri put the western honey mesquite are listed. This useful plant yields dye and paint (recipes given) as well as food, building material, etc. Staff

30-S260.
Mead, George R.
The Indians of the Redwood Belt of California: an ethnobotanical approach to culture area.

Dissertation. University Microfilms International. Dissertation Publishing, Ann Arbor, 1971, [Eng.]. ix, 141 p.: ill.; 21 cm., bibliog.

Rejects Kroeber's and Meighan's linguistic and geographical analysis of cultural groups in the area and proposes plant usage as the means of defining cultural areas. Plant usage information for all the groups in the area is derived from an examination of ethnographic and ethnobotanical literature. Includes useful appendices arranged by plant usage. M.H.B.

30-S261.
Mora, Paolo.
Tecniche pittoriche.
(Painting techniques.)

In book. *Artigianato e tecnica nella società dell'alto Medioevo occidentale, 2-8 aprile 1970,* Settimane di studio del Centro italiano di studi sull'alto Medioevo, no. 18, (1971), pp. 633-642, 667-674, [Ita.]. 14 ill., diagrams, photos.

The study of historic painting techniques is approached in two days, through the reading of technical treatises and through the examination of the works themselves. After a survey of the basic terms used in painting technology, the author cites the principal literary sources for the high Middle Ages. Diagrams and photographs of painting.
ICCROM(03222506)

30-S262.
Rosenfeld, Andrée.
The examination of use marks on some Magdalenian end scrapers.

In book. *Prehistoric and Roman studies: commemorating the opening of the Department of Prehistoric and Romano-British Antiquities,* Sieveking, Gale de G., Editor (1971), pp. 176-182, [Eng.]. figs.

Recent study of 34 Late Magdalenian end-scrapers shows additional evidence of wear not discussed by Semenov or Brezillon, including chipping and abrasion of the working edges as two distinct forms of wear, presence of ochreous deposits on the scraper end and sides, and damage to butts. The method and angle of use of the tool can be seen under the binocular microscope as well as the progress of wear (small flake scars beginning to blunt the tool edge, followed by abrasion which rounds them off). It is evident that the scrapers were multipurpose tools of which the ends or sides were used as needed. Some butt ends showed evidence of being hafted, others were apparently used with no more than a protective pad in the hand. The ochreous deposits appear to be due to the scraping of pigmented hides or the like. Staff

30-S263.
Turner, Nancy Chapman; and Bell, Marcus A.M.
The ethnobotany of the Coast Salish Indians of Vancouver Island.

Economic botany, **25,** no. 1, pp. 63-104, (1971), [Eng.]. refs.

The aims of this study are: 1) to indicate what plant species were used, and for what purposes, by this Indian group and to give Coast Salish names along with their English equivalents for as many species as possible; 2) to denote how these plants were collected, stored, and prepared for use; 3) to discuss the importance of these plants to Vancouver Island Salish in terms of their food use, their value in technology and medicine, the role they played in religious tradition and recreation, and the influence they had on linguistics and migration and settlement patterns; and 4) to briefly compare the ethnobotany of Vancouver Island Salish with related Salish and other Northwest Coast Indian groups. CCI

30-S264.
Brochwicz, Zbigniew; and Walkowa, Dymitrowa Mladost.
Budowa techniczna XVII-wiecznych malowidel sciennych w cerkwi Sw. Jerzego w Wielkim Tyrnowie (Bulgaria).
(The structure of the 17th-century mural paintings in the S. George Orthodox church at Veliko Turnovo (Bulgaria).)

Ochrona zabytków, **25,** no. 3, pp. 143-159, (1972), [Pol.].

Detailed investigations and analyses (petrographic, chemical, chromatographic) have provided the following information: the paintings were applied to dry plaster, using a mixture of egg yolk and animal glue as a medium; only a few pigments were used (yellow and red ochers, carbon black, calcium carbonate white, minium, green earth, in one case malachite, no blue), but a large variety of tones was obtained by mixing; the plasters were lime with about 29% of crushed limestone and 4-8% of chopped fibrous materials (straw in the lower layer, cut flax fibers in the upper layer). According to ancient recipes, flour was often added to plasters for wall paintings. This was confirmed in the present case by chemical and chromatographic means. A detailed discussion is included on the mechanisms of carbonization and binding in connection with the investigated murals. Staff

30-S265.
Feller, R.L.
Scientific examination of artistic and decorative colorants.

Journal of paint technology, **44,** no. 566, pp. 51-58, (1972), [Eng.]. ill., tables, 41 refs.

In this lecture the author first reviews the history of commercial paint manufacture in the USA which began seriously in the early 19th century. The Wetherill Company of Philadelphia began to corrode lead for lead white between 1804 and 1809. The records of the early paint industries are unfortunately in danger of becoming lost. Even old technical texts on the subject are disappearing. These often contain the key to the early history of "dating pigments" so important to the architectural historian and the museum curator. Lead white, the key pigment in artist's painting, is fast becoming a dating pigment owing to improvements in analytical

methods which enable the differentiation of lead white manufacture used at various times by different methods. Some of the old stand-by pigments of the paint industry including lead white, ultramarine, and vermilion are slowly becoming obsolete. The newer industrial and artists' pigments include several organics like the quinacridones and phthalocyanines which have surprising light stability. The National Gallery of Art Research Project at the Mellon Institute has been building up a "Pigment bank" which is becoming invaluable in art technical research.

Staff

30-S266.
Gunther, Erna.
Indian life on the northwest coast of North America, as seen by the early explorers and fur traders during the last decades of the 18th century.

Book. University of Chicago Press, Chicago, 1972, [Eng.]. xiv, 277 p.: ill.; 23 cm., bibliog. [ISBN 0-226-31088-4].

Derived from the accounts of explorers in the area during the period in question. Accounts of monumental (5' x 9') painting on plank house fronts at Cloak Bay in the Queen Charlotte Islands are described by Captain Chanal of the *Solide*. The paintings were of human figures in red, black and green. Body painting was widely practiced with red ocher and other pigments. Includes an appendix on technology used by the Indians during this period which does not mention painting but briefly mentions dyeing. M.H.B.

30-S267.
Kooijman, Simon.
Tapa in Polynesia.

Book. Bernice P. Bishop Museum bulletin, no. 234, Bernice Pauahi Bishop Museum, Honolulu, 1972, [Eng.]. xiv, 498 p.: ill.; 26 cm., bibliog. [ISBN 0-910240-13-2].

Compiles information about tapa throughout Polynesia. Particularly useful are the tables that describe adhesives used in pasting tapa together, sources of dyes for the various colors and how they are made, and finally techniques used to apply the colorants. Descriptions include the Polynesian name of plant materials and the scientific name. Techniques include dyeing, freehand

painting, stencilling, and rubbing. The text is arranged by geographical areas within Polynesia and covers all aspects of the manufacture and use of tapa. Includes an extensive bibliography. M.H.B.

30-S268.
Mails, Thomas E.
The mystic warriors of the Plains.

Book. Doubleday & Co., Des Plaines, 1972, [Eng.]. xvii, 618 p.: ill.; 32 cm., bibliog. [ISBN 0-385-04741-X].

Chapter 14 contains a detailed description of the materials and techniques used in painting by the Plains Indians. Colorants were derived primarily from mineral and plant sources. New colorants were eagerly sought and rapidly introduced into the palette of the Plains people. It is possible to date paintings based on the color range present. Paints were ground and mixed with tallow for storage. When used they were mixed with hot water or with glue made by boiling beaver tails or hide scrapings. A variety of brushes were used but the preferred brush was made from the porous bones of buffalo which absorbed a quantity of paint. Paintings were laden with symbolism and functioned both as decoration and as a kind of symbolic language recalling the personal history and exploits of the owner when painted on teepees. Colors were also symbolic and the same vocabulary of symbols was often used in body painting and tattooing as well as painting tepees, buffalo robes, or parfleches.

M.H.B.

30-S269.
Mead, George R.
The ethnobotany of the California Indians: a compendium of the plants, their users, and their uses.

Book. Occasional publications in anthropology: ethnology series, no. 30, University of Northern Colorado. Museum of Anthropology, Greeley, 1972, [Eng.]. v, 138 p.

A two-part alphabetical listing of plants by scientific name. Listings include usage, name in the appropriate Indian language and bibliographic citations where the information was found. Examples would be the use of the sap of milkweed (*Asclepias mexicana*) by the Cahuilla as an adhesive, or the use of the

wild cucumber of Chilicothe (*Marah macrocarpus*) in the manufacture of red paint by the Luiseño. M.H.B.

30-S270.
Radosavljevic, Vera.
Conservation of miniatures.

Technical report. International Centre for the Study of the Preservation and the Restoration of Cultural Property, Rome, 1972, [Eng.]. 8 p., 7 p. of plates.

Some historical data on materials of miniature painting are summarized. The damaging effect of verdigris-based colors on parchment is well-known; experiments were performed to elucidate the reason for this and suggested that it was due to acetic acid in the verdigris. Malachite suspensions had no effect on parchment. Different binding media used in conjunction with verdigris were allowed to age on paper and parchment for four years with and without prior aging with ultraviolet radiation. The results (visual appearance) are tabulated.

ICCROM(00898198)

30-S271.
Yamasaki, Kazuo.
(Coloring materals of the murals in the Main Hall of the Horyuji Temple compared with those of the ornamented tombs.)

Bukkyo geijutsu, no. 87, pp. 23-25, (1972), [Jpn.].

The pigments found in the murals of the Horyuji Temple, Nara, are red lead, vermilion, iron oxide red, yellow ocher, litharge, malachite, azurite, white clay, and Chinese ink. The pigments used in the ornamented tombs in the Kyushu which are older than the Horyuji Temple are primitive, such as: impure hematite, yellow clay, green or greenish blue rock, white clay, carbon, and a black mineral of iron and manganese, while those used in the murals of the Taka-matsuzuka Tomb found in the Nara Prefecture are similar to those of the Horuji murals, and the presence of vermilion, iron oxide red, yellow ocher, malachite, azurite, Chinese ink, gold, and silver was determined. Staff

30-S272.
Yasuda, Hiroyuki.
(Chemical study on the coloring materials of the murals of the Taka-matsuzuka Tomb in Nara Prefecture.)

Bukkyo geijutsu, no. 87, pp. 20-23, (1972), [Jpn.].

The fragments of the lime plaster collected at the time of excavation of the tomb in April, 1972, were examined, and the following ions were detected by paper chromatography: mercury, iron, lead, and copper. The presence of the following pigments was suspected: iron oxide red, vermilion, red lead (?), malachite, azurite, and yellow ocher. (Abstractor's note: The author analyzed very small fragments of the lime plasters bearing coloring materials without seeing the murals. Therefore it is not certain if lead is to be attributed to the presence of red lead or impurities contained in other red pigments.)

Staff

30-S273.
Alvarez De Williams, Anita.
Face and body painting in Baja California: a summary.

Pacific Coast Archaeological Society quarterly, **9,** no. 1, pp. 21-26, (1973), [Eng.]. bibliog.

Cites the use of lard or pumpkin seed oil as a binder for body paint. A black made from carbonized pumpkin juice is also described. White pigment made from burned and pulverized fish bones is also mentioned. A range of colors including white, black, green, blue, red, and yellow was used and described in the accounts of early travelers. Most of these were from mineral sources and some were processed by heating and grinding. M.H.B.

30-S274.
Bascom, William.
A Yoruba master carver: Duga of Meko.

In book. *The traditional artist in African societies,* D'Azevedo, Warren L., Editor (1973), pp. 62-78, 1st Midland book ed. [Eng.].

Describes the tools, techniques, and materials used by the sculptor. Imported oil paints were used as well as traditional pigments. The author requested Duga to only use traditional paints. A palette of nine colors was used. Each color could be made matte or

glossy. The paints were normally matte but would be made glossy by the addition of a gum called *omi sogidoka (Lannea acida)*. Pigments are derived from mineral and plant sources. Scientific nomenclature and the Yoruba name is given for all materials. Some materials could not be identified. The names of the sources for the various woods used are also given. M.H.B.

30-S275.
Dunstan, B.
The distemper technique of Edouard Vuillard.

American artist, **37,** no. 367, pp. 44-51, (1973), [Eng.].

Describes Vuillard's distemper technique based on methods used in scene painting at the time. Powdered pigment mixed with size was used in a complicated method that involved heating the size. Vuillard also used a technique involving the use of oil and distemper. M.H.B.

30-S276.
Messenger, John C.
The carver in Anang society.

In book. *The traditional artist in African societies,* D'Azevedo, Warren L., Editor (1973), pp. 101-127, 1st Midland book ed. [Eng.].

The section on materials and tools states that traditional paints are being abandoned in favor of imported oil paints. Cites the use of palm oil after the carving is painted to prevent termite damage. Two coats of palm oil are applied for this purpose. The five basic colors and the materials used to compound them are cited briefly. Names of plants are given in the Anang language but not in scientific nomenclature. Informants would not give further information about the mixing of indigenous paints unless the author paid a sum he was unwilling to pay. M.H.B.

30-S277.
Vestal, Paul A.
Ethnobotany of the Ramah Navaho.

Book. Papers of the Peabody Museum of Archaeology and Ethnology, Harvard University, v. 40, no. 4, Kraus Reprint and Periodicals, Milwood, 1973, Reprint of the 1952 ed. [Eng.]. ix, 94 p.; 28 cm., bibliog. and indexes.

Cites the use of *yucca baccata* as a paint medium (juice from the leaves for painting pottery) and piñon resin (*Pinus edulis*). This ethnobotany of the Navajo includes tables listing the uses of plants by the Ramah Navajo. Ceremonial and ritual uses of plant material are also described, as are plants used as dyes and colorants. M.H.B.

30-S278.
Densmore, Frances.
How Indians use wild plants for food, medicine, and crafts.

Book. Dover Publications, Inc., 1974, [Eng.]. 397 p.; illus.; 24 cm., refs. [ISBN 0-486-23019-8].

An important early study of plant use by the Chippewa. Plants used for dyes, food, medicinal purposes, and material culture are described. Beliefs associated with the plants are also discussed. [Editor's note: this was originally published in the *Forty-fourth Annual Report of the Bureau of American Ethnology to the Secretary of the Smithsonian Institution, 1926-1927* as Uses of plants by the Chippewa Indians.] M.H.B.

30-S279.
Huff, Ralph H.
Chemistry of painting surfaces from earliest time to unfathomable future.

Affl: Calitone Chemical Company, Pasadena, CA, USA.

Journal of paint technology, **46,** no. 558, pp. 62-73, (1974), [Eng. w. Eng. summary]. 2 tables, 26 figs., 19 refs., bibliog.

Mr. Huff begins his article with a discussion of some of the most durable paint surfaces known to civilization, the paintings of the cave dwellers. He also mentions early monastery paintings and frescoes as examples of paint surfaces which have endured the test of time. He then goes on to relate the technology of these surfaces to modern coating science, stating the need for a paint layer that can combine with its substrate. This leads to an informative discussion of metal and wood as supports for paint layers. The detailed section on the chemical components of soft wood is especially interesting. Staff

30-S280.
Morrow, Mable.
Indian rawhide: an American folk art.

Book. University of Oklahoma Press, Norman, 1974, 1st ed. [Eng.]. xii, 243 p.: ill. (some col.); 31 cm., bibliog. [ISBN 0-8061-1136-4].

Details techniques used for manufacturing rawhide articles, such as parfleches, boats, cradles, drums, masks, horse trappings, and various types of bags. Each step in the process is described in detail, from skinning the animal to finishing the hide. Usually, buffalo hides were used, but rawhide articles could be manufactured from cow, deer, moose, elk, antelope, or horse hides. It is of interest to note the details about painting a hide. A brush, or more accurately stylus, is made from the cancellous inner part of large bones or joints from large animals, such as buffalo or cattle. When brushes are not used, the dry pigment is rubbed into a wet hide with the craftswoman's fingers. Pigments used were both organic and mineral, and sometimes the two sources were mixed to obtain different colors, producing the full spectrum of colors. The only color that was never used was orange. Sources for different minerals are described. Binding media could be either water, cactus juice, boiled sinew, resin, or salmon roe. Also gives several examples of two methods of paint application (wet and dry) by several craftswomen. Designing the symbolism of parfleches is briefly discussed, and examples of designs from different tribes are shown in color plates.

C-A.G.

30-S281.
Newman, Thelma R.
Contemporary African arts and crafts: on-site working with art forms and processes.

Book. Unwin Hyman Ltd., New York, 1974, [Eng.]. xiv, 306 p.: ill. (some col.); 27 cm., bibliog. and index. [ISBN 0-04-730029-9].

Describes a variety of techniques and materials used in weaving, painting on textiles, and leather, metalwork, carving, etc. Paints used on fabric are described and the technique of application is illustrated. The intent is to present a range of techniques and crafts of sub-Saharan Africa in sufficient detail for replication by those interested. M.H.B.

30-S282.
Watherson, Margaret M.
The cleaning of Color Field paintings.

Book. Museum of Fine Arts, Houston, 1974, [Eng.]. 11 p.: ill.; 28 cm.

Describes the special problems involved in the conservation of the Color-field paintings. The works of Helen Frankenthaler, Morris Louis, and Kenneth Noland are described separately since the techniques used make them exceptions. Color-field paintings were often done on unprimed canvas with very high pigment-volume paint. Large areas of the canvas were left unpainted or very thinly painted. As a result the surfaces tend to be matte and very vulnerable to damage.

M.H.B.

30-S283.
Weaver, Martin E.
The recording of rock art: an illustrated paper presented to the Canadian Conservation Institute trainees and to the Course in the Conservation of Historic Monuments and Sites, Restoration Services Division, Engineering and Architecture Branch, D.I.N.A.

Technical report. Canadian Conservation Institute, Ottawa, 1974, [Eng.]. 15 p.

This presentation discusses the documentation and recording of ancient (prehistoric, Aboriginal) rock art (petroglyphs, pictographs) found on caves, shelters, cliffs, and rock slabs. Pigments (e.g., charcoal, chalk, clay, oxides, ochers) mixed with a binding medium (e.g., blood, fat, grease, gum) were applied (drawn, painted) by finger, brush, stick, or spray. Petroglyph carvings were created by pecking, pounding, or engraving. Types of deterioration and damage include weathering, wear, erosion, abrasion, exfoliation, and fading. Microbiological growth (e.g., microorganisms, lichens, fungi, moss, etc.), sooty and calcareous encrustations, and natural features (e.g., faults, fissures) may obscure paint images but be beneficial for dating purposes. Guidelines: determine location and orientation; record all features, markings, and conditions by means of photogrammetry, photography, drawings (sketches, tracings, molding, rubbings) and written data; use

oblique lighting, not chalking to enhance images. Temperature (e.g., freeze and thaw cycles), humidity, moisture content of rocks and soils, pH of ground water, presence of soluble salts, organic growth, light, wind, rain, etc. will affect the condition of the site. This is a reference for archaeology, archaeometry, conservation science, and primitive rock art.

CCI

30-S284.
Bakuradze, K.N.; and Chelshoyli, G.D.
Restoration of ancient monumental painting in cult buildings.

In book. *ICOM Committee for Conservation, fourth triennial meeting, Venice, 13-18 October 1975: preprints,* (1975), [Eng.].

Wall paintings dating from the 10th to 19th centuries were found in 300 churches in Georgia. Since 1950, systematic cleaning and conservation of these wall paintings has been carried out. Both tempera painting and fresco were used. In some cases, a thin plaster layer was detected under the painting. In others a glue-chalk ground with coal and straw fillers was used. Efflorescent salts were sometimes observed. Red-brown, gray, and ocher pigments were used in one case. Details of restoration work are described in scientific accounts with technical documentation. Staff

30-S285.
Cowart, J.
A sculpture and a pastel by Edgar Degas.

Bulletin—The St. Louis Art Museum, **11,** no. 1, pp. 6-10, (1975), [Eng.].

This bulletin article describes the Steinberg Degas bronze cast *Petite Danseuse de Quatorze Ans,* recently acquired by the St. Louis Art Museum. The work begins with sketches and subsequent tinted wax model, 1879-80, of Louise-Josephine Van Gothem. The model, exhibited at the 1881 Impressionist salon, excited critical acclaim. Twenty-two bronze lost-wax casts were made of all of Degas sculpture after his death in 1917 by the foundry A.A. Hebrard, Paris. *Petite Danseuse de Quatorze Ans* is one of these original casts. A crack in the right arm is due to a break in the original wax model. Examples of chromatic sculpture date to the Greeks and Etruscans, however, the vibrance and presence of this work is unique. Pastels and drawings of

dancers help to perfect form. This culminates in the large pastel *Two Dancers.* Pure color produces striking visual effects. This style is influenced by Japanese prints and the photographic image. Degas' technique, the application of chalk pastels in layers over gouache wash, is seen to advantage in *Two Dancers.* This is a reference for the documentation of works by Edgar Degas. CCI

30-S286.
Edelman, Miriam.
Contemporary artists and their experimental use of historical methods and techniques.

Dissertation. 75-15,755, University Microfilms International. Dissertation Publishing, Ann Arbor, 1975, [Eng.]. vi, 132 leaves: ill.; 29 cm., bibliog. (Ed.D. degree awarded by Columbia University, Teachers College.)

Describes the working methods of a number of artists known for being technically inventive; Edouard Vuillard's distemper technique, Orozco's fresco techniques, and a number of other artists. The relationship between historical methods and materials, and experimentation for specific effects or other reasons are discussed. M.H.B.

30-S287.
Hamel, Paul B.; and Chiltoskey, Mary U.
Cherokee plants and their uses: a 400 year history.

Book. Herald Publishing Co., Sylva, 1975, [Eng.]. 65 p.: ill.; 24 cm., bibliog., index.

A description of plants used by the Cherokee for food, medicine, and material culture. Plants are listed according to a code system to indicate the division between food, dyes, medicine, and other uses. M.H.B.

30-S288.
Krauss, Beatrice H.
Ethnobotany of the Hawaiians.
(Harold L. Lyon Arboretum lecture no. 5.)

Book. University of Hawaii Press, Honolulu, 1975, [Eng.]. 32 p.: ill.; 23 cm., bibliog.

Describes the plants used by the ancient Hawaiians for food, fiber, and material culture. Includes illustrations of plants and items of material culture. Also includes glossaries of Hawaiian names and the corresponding scientific nomenclature. M.H.B.

30-S289.
Birstein, V.ya; Tul'chinsky, V.M.; and Troitsky, A.V.
(A study of organic components of ancient middle Asian and Crimean wall paintings.)
Vestnik Moskovskogo Universiteta. Seriia VI: Biologiia, pochvovedenie, **31**, no. 3, pp. 33-38, (1976), [Rus.].

In wall paintings from the 2nd century BC to the 4th century AD, gelatin and gums of *Prunoidae* (probably apricot and cherry tree) were identified by amino acid and sugar analysis and beeswax was identified by infrared spectroscopy. Staff

30-S290.
Clarke, John.
Two aboriginal rock pigments from Western Australia: their properties, use and durability.
Studies in conservation, **21**, no. 3, pp. 134-142, (1976), [Eng.]. 8 figs., 13 refs.

Naturally occurring pigments used by Aborigines in rock paintings have been collected in Western Australia. They are a red pigment (mainly hematite, Fe_2O_3) (from a red ocher mine worked until historic times by Aborigines, and a white pigment (huntite, $Mg_3Ca(CO_3)_4$) which is still collected and used by Aborigines. Samples were also taken from rock paintings in which these pigments were used or were thought to have been used. The pigment samples were analyzed to establish chemical, mineralogical, and physical properties. The paint samples were examined microscopically and with an electron probe to study their relationship with the rock surface and with other paint layers. The relationship between the pigments' properties and their durability is discussed. A.A.

30-S291.
MacGaffey, Janet.
Two Kongo potters.
African arts, **9**, no. 1, pp. 29-31, 92, (1976), [Eng.].

Describes the working methods of two potters in Zaire, Thérèse Mayivangwa and Esther Wadimbudula from the village of Vunda in the province of lower Zaire. Both potters make a traditional matte black ware. Of particular interest is a description of the use of an infusion of the bark of the *mwindu*

tree (*Bridelia scleroneura*) to blacken the pots. The infusion is a dark red liquid made by pounding the bark and steeping it in water overnight. It is then heated. The potter uses a bamboo whisk to apply it to the pots while they are still hot. An even application creates an even blackening and seals the surface of the pot. It is cited as increasing the strength of the vessel as well. M.H.B.

30-S292.
Pemberton, John.
Eshu-Elegba: the Yoruba trickster god.
African arts, **9**, no. 1, pp. 20-28, (1976), [Eng.].

Describes ritual applications of various substances to figures associated with the worship of Eshu-Elegba. Before a festival the Eshu figure is washed with cool water containing the medicinal herbs *odundun, rinrin, imi, esu, rowowo*, and *aje*. The figure is then painted with black European paint, a substitute for an indigo dye used in the past. Shrine figures are anointed with blood from sacrificed animals, kola, and sometimes palm oil. Provides insights into the use of figures and ritual objects, and substances applied during these rituals. (Latin names for plants are not given.) M.H.B.

30-S293.
Radosavljevic, Vera.
The technique of old writings and miniatures.
In book. *Conservation and restoration of pictorial art*, Brommelle, Norman; and Smith, Perry, Editors (1976), pp. 202-206, [Eng.].

The history of old writings and miniatures with reference to literary sources, the composition of black and brown inks, pigments used for coloring inks, binding media, supports, equipment, and the technique of illumination are considered.
ICCROM(00859327)

30-S294.
Walston, S.; and Dolanski, J.
Two painted and engraved sandstone sites in Australia.
Studies in conservation, **21**, no. 1, pp. 1-17, 49-50, (1976), [Eng. w. Fre. + Ger. summaries]. 7 refs.

Two rock painting sites in New South Wales were examined to determine the na-

ture of the materials used, their state of pres-
ervation, and the types of deteriorative pro-
cesses acting upon them. Steps for the
protection of these sites are described.

ICCROM(01724800)

30-S295.
A calendar of dreamings.

Motion picture. Tasmanian Film Corp., North
Sydney; Sydney Filmmakers Co-operative,
Kings Cross, 1977, 1 film reel (35 min.), sd.,
col., 16 mm. [Eng.]. Bardon, Geoff (Director,
Producer); Bardon, James (Executive Pro-
ducer).

Documents the ancient technique of
sand painting in central Australia. Explains
that the paintings depict the mythological
aspects of the Aboriginal life and culture of
the desert people, and shows their under-
standing of their environment and the spiri-
tual importance of plants and berries. Dis-
cusses the dreamings as a recalling and
reliving of fixed history. Describes the signs
and symbols in the corroboree ritual. Juxta-
poses the European customs imposed by
white settlers with Aboriginal culture.

PFAOF

30-S296.
Cohn, Marjorie B.
*Wash and gouache: a study of the
development of the materials of
watercolor.*

Book. Harvard University Art Museums.
Center for Conservation and Technical Stud-
ies, Cambridge, 1977, [Eng.]. 116 p.: ill. (some
col.); 26 cm., bibliog. and index. [ISBN
0-916724-06-9].

Catalog published on the occasion of an
exhibition of watercolors at the Fogg Art Mu-
seum, May-June 1977. It describes in detail
the materials, tools, and techniques used for
watercolor and gouache. The appendix pre-
sents case studies of artists' materials and
pigment analysis using works in the exhibi-
tion. The catalog of the exhibition is by
Rachel Rosenfield. ICCROM(01012000)

30-S297.
Ford, Richard I., Compiler.
*Systematic research collections in
anthropology: an irreplaceable national
resource. A report of a conference
sponsored by the Council for Museum
Anthropology.*

Book. Peabody Museum of Archaeology and
Ethnology, Cambridge, 1977, [Eng.]. 81 p.; 28
cm.

Describes the various types of system-
atic research collections in anthropology and
problems of access and use. Includes a com-
pilation of various institutions with the types
of collections they hold and their size. This
provides a valuable guide to institutions with
ethnobotanical reference collections and col-
lections of other material useful to a re-
searcher interested in the composition and
fabrication of ethnographic objects.

M.H.B.

30-S298.
Riederer, Josef.
Pigmente und Technik der
frühmittelalterlichen Wandmalerei
Ost-Turkistans.
(Pigments and techniques of the early
Medieval wall paintings of eastern
Turkistan.)

*Veröffentlichungen des Museums für Indische
Kunst,* pp. 353-423, (1977), [Ger.].

Some 80 wall paintings of central Asia
were examined to determine the pigments
and painting techniques. The pigments used
were anhydrite, gypsum, lead white, yellow
and red ocher, orpiment, minium, cinnabar,
atacamite, chrysocolla, malachite, azurite, la-
pis lazuli, indigo, carbon black, and gold leaf.
It could be proved that originally massicot
was used, which had completely transformed
to brownish lead oxide. The results of the
pigment analysis are compared with the texts
of early Buddhist manuscripts. X-ray diffrac-
tion data, infrared absorption spectra, micro-
scopic properties and qualitative emission
spectra are given. The painting techniques
are deduced from analytical observations.

Staff

30-S299.
Bryan, Nonabah G.; Young, Stella,
Compiler.
Navajo native dyes: their preparation and use.

Book. Filter Press, Palmer Lake, 1978 and 1940, Reprint of: Chilocco, Okla.: Chilocco Agricultural School, 1940 [Eng.]. 75 p.; 21 cm. [ISBN 0-910584-57-5 (paper); 0-910584-49-4 (cloth)].

Traditional methods of dyeing are described. Recipes are given for making various colors. Describes the preparation of ochers (by toasting) for incorporation into dyes with plant materials and mordants. The Navajos acquired wool from the Spaniards and the upright loom from the Pueblo peoples but developed their own colors and methods.
M.H.B.

30-S300.
Colton, Mary Russell Ferrell.
Hopi dyes.

Book. Museum of Northern Arizona Press, Flagstaff, 1978, [Eng.]. x, 88 p.: ill. (some col.); 23 cm., bibliog. [ISBN 0-89734-000-0].

Describes the fibers used in Hopi textiles and the dyes used to color them. Recipes are given for the dyes. Provides insights into the organic colorants derived from plant materials used to color textiles. Many of the same colorants were used for coloring objects as well.
M.H.B.

30-S301.
Koller, Manfred.
Monumentales pastell—a forgotten invention in wall painting techniques about 1900.

In proceedings. *ICOM Committee for Conservation, fifth triennial meeting, Zagreb, 1-8 October 1978: preprints*, (1978), [Eng.].

In 1905, in Munich a booklet was edited by Wilhelm Ostwald about "Das monumentale Pastell," a newly invented uncomplicated wall-painting technique. He describes the drawing on dry plaster with self-made thick color sticks bound with casein and fixed with casein solutions. The Beethoven frieze by Gustav Klimt, 30 meters-long and executed in 1902 for an exhibition of the "Secession" in Vienna, seems to be the uniquely important piece of art representing this technique. Similar examples are noted; the restoration was in progress at the time of writing.
ICCROM(01936501)

30-S302.
Larsen, Mogens; and Haastrup, Ulla.
Kalkmalerierne i Fraugde kirke på Fyn. (Mural paintings in the Fraugde church on Funen.)

Nationalmuseets arbejdsmark, pp. 119-130, (1978), [Dan.]. ill.

Describes the restoration of fragments of Romanesque mural paintings dated from the 12th century. Discusses the technique of mortar application, and compares it to Theophilus' *On Diverse Arts*. The mortar has a brownish color due to the addition of ground bricks and charcoal, common additions in Romanesque mural paintings in Denmark. The following colors have been identified: calcium carbonate, charcoal, unburned and burned ocher, lapis lazuli, and copper chloride. (The last mentioned probably identical with Theophilus' "Salt green.") The blue and green color are underpainted with grey. All basic colors contain lime, and protein has also been identified—however, this is not the case with the blue and green colors, where one would expect to find it in accordance with Theophilus' text. Protein is found in the colors which are strongly bound with lime.
Staff

30-S303.
Nishikawa, Kyotaro; and Emoto, Yoshimichi.
Colouring technique and repair methods for wooden cultural properties.

In proceedings. *International symposium on the conservation and restoration of cultural property: conservation of wood: 24-28 November 1977, Tokyo, Nara, and Kyoto, Japan*, (1978), pp. 185-194, [Eng.].

The painting technique of Japanese sculpture is discussed: ground coating, gilding, polychromy, pigments. Restoration materials include both traditional and synthetic materials are described, as is the fixing of paint.
ICCROM(01993116)

30-S304.
Russell, John.
De Kooning: "I see the canvas and I begin."

The New York Times, **1978,** no. February 1, p. Arts and Leisure, 1, (1978), [Eng.].

During this interview with John Russell, some of de Kooning's working methods are briefly described. Of particular interest is Russell's statement that "Oil paint is thinned with water. Safflower oil, kerosene and mayonnaise are pressed into service as binding agents." M.H.B.

30-S305.
Vivian, R. Gwinn; Dodgen, Dulce N.; and Hartmann, Gayle H.
Wooden ritual artifacts from Chaco Canyon, New Mexico: the Chetro Ketl collection.

Book. Anthropological papers of the University of Arizona, no. 32, University of Arizona Press, Tucson, 1978, [Eng.]. viii, 152 p.: ill.; 28 cm., bibliog. [ISBN 0-8165-0576-4].

Some 200 artifacts excavated in 1947 from a room in the Chacoan pueblo, Chetro Ketl (northwestern New Mexico), are thoroughly described and discussed. The people at Chetro Ketl were of the Anasazi culture group, and the objects appear to have been made in approximately the first quarter of the 12th century. The artifacts are mainly fragments of carved and painted wooden objects, but also include cordage, arrow fragments, gourd and rind discs, worked sticks, worked stone, and corn husk packets. Comparison is made between the Chetro Ketl objects and similar archaeological and ethnological material. Interpretation of the functions of the artifacts or their grouping as found in the pueblo is limited; the reasons for this are thoroughly discussed. The objects are photographed and verbally described. Techniques of binding, joinery, and attachment are described and some are diagrammed. Results from semiquantitative spectrographic analysis of 15 paint samples are presented and compared with other archaeological and ethnological data on paint pigments and binders. Beams in both the room where the objects were found and an adjacent room, and the annual rings present in some of the painted wooden artifacts were dated by dendrochronology. The tree species used for a number of the wooden objects and architectural elements are identified, as are the species used for other artifacts of plant origin. Miscellaneous faunal remains, some unaltered, are described and identified. Staff

30-S306.
Akerman, Kim.
Honey in the life of the Aboriginals of the Kimberleys.

Oceania, **49,** no. 3, pp. 169-178, (1979), [Eng.]. 1 fig., refs.

Examines the role of honey in the lives of the northern Kimberley Aboriginals of Australia, including the dietary role of honey, methods of collecting, and myths associated with bees and honey. Of particular interest is a brief description of the processing of beeswax for use in mounting lithic materials, waterproofing containers, and other related uses. M.H.B.

30-S307.
Anton, Ferdinand; Dockstader, Frederick J.; Trowell, Margaret; and Nevermann, Hans.
Primitive art: pre-Columbian, North American Indian, African, Oceanic.

Book. Harry N. Abrams, Inc., New York, 1979, [Eng.]. 526 p.: ill. (some col.); 29 cm., bibliog. and index. [ISBN 0-8109-1459-X].

The art is connected with the archaeology of each area, discussed within its historical and technological context. Staff

30-S308.
Bolton, Lissant.
Pilot study: survey of the literature relating to the material culture of the New Guinea Highlands.

ICCM bulletin, **5,** no. 2, pp. 51-52, (1979), [Eng.].

An important early study on the usefulness of ethnographic literature to conservators. Describes the problematic nature of the literature for conservators. Most material does not concern itself with material culture and often neglects to mention specifics such as scientific nomenclature for materials used and methods of preparation. Concludes that most of the literature provides low quality information with notable exceptions. M.H.B.

History

30-S309.
Danziger, Christine S.; and Hanson, Jim.
The conservation of a Tlingit totem pole.

In book. *Preprints of papers presented at the seventh annual meeting: Toronto, Canada, 30-31 May and 1 June 1979,* (1979), pp. 18-29, [Eng.]. photos., 15 refs.

Describes the different steps in the conservation process: research into the original anthropological literature, differential solubility tests, analysis of pigment samples taken from the pole and, for comparison, from artists' tools of the same tribe and period, and analysis of the method of paint application.
ICCROM(02135203)

30-S310.
Ellis, Margaret Holben.
Charcoal, chalk and pastel drawings: special problems for collectors, Part 1.

Drawing, 1, no. 3, pp. 58-59, (1979), [Eng.]. refs.

A discussion of the so-called broad drawing materials, charcoal, chalk, and pastel, intended for the collector and others involved in the care of drawings. Presents a brief history of these drawing media and explains some of the problems which develop due to careless handling, poor storage conditions, improper framing, and misguided conservation efforts.
Staff

30-S311.
Ellis, Margaret Holben.
Charcoal, chalk and pastel drawings: special problems for collectors, Part 2.

Drawing, 1, no. 4, pp. 79-81, (1979), [Eng.]. refs.

Investigation on traditional drawing techniques: pastels and their conservation problems.
ICCROM(02563500)

30-S312.
Graf, Roy.
Techniques and subsequent deterioration of drawings.

ICCM bulletin, 5, no. 1, pp. 16-19, (1979), [Eng.]. bibliog.

A history of drawing materials and techniques is given, covering metalpoint, graphite, chalks and charcoal, pen and ink drawings, and watercolor.
Staff

30-S313.
Picton, John; and Mack, John.
African textiles: looms, weaving and design.

Book. British Museum Publications Ltd., London, 1979, [Eng.]. 208 p.: ill.; 28 cm., bibliog. and index. [ISBN 0-7141-1552-5].

Discusses traditional dyes and their preparation and direct drawing, painting, and printing onto textiles. While a great deal of attention has been paid to drawing and painting on rock surfaces and calabashes, little attention has been paid to the same drawing and painting on fabrics.
M.H.B.

30-S314.
Schreiber, Hiltigund.
Volkstümliche Malerei auf Holz: Kleister- und Kasein-Techniken.
(The folk art tradition in painting on wood: paste and casein techniques.)

Book. Oberösterreichischer Landesverlag, 1979, [Ger.]. 67 p.: ill.; 24 cm., bibliog.

A textbook aiming at familiarizing students with the traditional techniques used to decorate wooden objects, especially furniture, in the rural areas of Upper Austria. Contents: 1) Materials for painting: nature of wood to be used, necessary qualities; cleaning and staining; plastic wood; priming; brushes; care of brushes; brush techniques; other painting tools; colors; pigments; paint preparation; mixing colors; binding agents; paste; casein glue; egg emulsion. 2) Painting techniques: general painting techniques; sketching. 3) Special painting techniques: paste painting; painting with casein-based colors; painting with egg tempera; techniques with templates; painting on unfinished wood; veneer (imitating wood grain); marbling techniques; summary of work processes; waxing.
M.B.

30-S315.
Yamasaki, Kazuo; and Emoto, Yoshimichi.
Pigments used on Japanese paintings from the protohistoric period through the 17th century.

Ars orientalis, 11, pp. 1-14, (1979), [Eng.]. refs.

Describes the history of pigment use in Japan with examples from a number of sources. Cites the use of oil as a medium as

early as the 8th century. Oil was used as medium on objects made of wood, leather, and Japanese lacquer. It was used either as a medium or applied over a glue tempera painting. The examples for the use of oil are taken from the Shosoin treasure house. Concludes with a listing of colors and the materials used to compound them. M.H.B.

30-S316.
Fleming, Stuart James.
Paintings and pigments: I. The traditional palette.

MASCA journal, **1**, no. 4, pp. 114-117, (1980), [Eng.].

A short history of traditional pigments from ancient Egypt to the 17th century. M.H.B.

30-S317.
Jirat-Wasiutynkski, Vojtech; and Jirat-Wasiutynski, Thea.
The uses of charcoal in drawing.

Arts magazine, **55**, no. 2, pp. 128-135, (1980), [Eng.]. 21 photos.

A brief introduction to the history of the charcoal medium as used in drawings from the perspective of an art historian and a conservator. It establishes the technical characteristics of charcoal as a basis for identifying its presence in a drawing and distinguishing its use from that of other media, such as black chalk and crayon; and it examines the historical uses of charcoal in drawings from 1500 to the present, in order to evaluate some of its aesthetic constants. Staff

30-S318.
Lee, D.J.V.
Report on the collecting visit to the Wosera-Abelam of Sarakim village, and a note on conservation requirements.

Book. British Museum, London, 1980, [Eng.]. 7 p.; 30 cm.

Describes the use of a red pigment made by immersing a timber called *Taun* in water for a period of time. After immersion it is roasted and provides a bright red powder. Other pigments from mineral sources are described. The use of a root called *Tanu* in compounding a yellow mineral-based pigment is also cited. Paint brushes and other pigments are described. Binders are not mentioned.

Discusses the transport of powdery painted material from the field to the British Museum, and related conservation problems. An internal report from the British Museum. M.H.B.

30-S319.
Leonard, Anne; and Terrell, John.
Patterns of paradise: the styles and significance of bark cloth around the world.

Book. Field Museum of Natural History, Chicago, 1980, [Eng.]. 76 p.: ill. (some col.); 27 cm., bibliog. [ISBN 0-914868-05-5].

A catalog to an exhibition of bark cloth organized by the Field Museum of Natural History in 1980. One section describes the decoration of bark cloth. Bark cloth never lasted very long and the nature of the material is not conducive to immersion in dyes. As a consequence, a rich tradition of applied decoration exists worldwide. In Hawaii and tropical South America, this was particularly rich since there was a wealth of material for use as colorants. This text presents the various countries that make bark cloth, the methods and materials used, and how the cloth is used by its makers. M.H.B.

30-S320.
Lynn, Catherine.
Wallpaper in America: from the 17th century to World War I.

Book. W.W. Norton & Co., Inc., New York, 1980, 1st ed. [Eng.]. 533 p.: ill. (some col.); 27 cm., bibliog. and index. [ISBN 0-393-01448-7].

Contains a thorough description of the techniques used to manufacture wallpaper. In the mid-18th century distemper colors began to be used on printing blocks for wallpaper. Earlier, printing ink was used and outlines printed onto wallpaper. Color washes were applied freehand or with stencils. Distempers were made with glue size of various types and frequently whiting and pigment. The result was a matte chalky appearance. Varnishes were also used and were the adhesive for flocked wallpaper. Whiting and size was generally applied as a ground on the unbleached paper support. M.H.B.

30-S321.
Rády, Ferenc.
Die Restaurierung tapetenartiger dekorativer Wandmalereien des 18. Jahrhunderts in Ungarn.
(The restoration of 18th-century decorative wall paintings imitating wallhangings in Hungary.)
Maltechnik-Restauro, **86,** no. 4, pp. 203-209, (1980), [Ger. w. Eng. summary].

A type of 18th-century wall painting, found in the decoration of country castles and town residences in Transdanubia, the western part of Hungary, imitate wall hangings. They reveal distinctive features in their execution and a characteristic technique. Various silk wall hangings from simple ornaments to figures were already known to the artists and craftsmen who adapted to this new technique and its principles with surprising flexibility. The choice of technique indicates its temporary character, and its style, the contemporary taste favoring chinoiserie and motifs from nature; this explains why these pictures were painted al secco.
Staff

30-S322.
Schießl, U.
Probleme der Interpretation kunsttechnischer Quellen und ihrer Bestaetigung durch technologische Untersuchungsbefunde an Kunstwerken, dargestellt am—Beispiel der Fassmalerei im 18. Jahrhundert in Sueddeutschland.
(Problems of the interpretation of historical sources and their confirmation by the results of technical analysis on works of art, shown on the example of painted sculptures from the 18th century in southern Germany.)
Mitteilungen (Deutscher Restauratoren-Verband), pp. 16-28, (1980), [Ger.].

The 18th-century literature on painting techniques (Croler, Watin, etc., books on varnishing) was studied and compared with the results of the technical analysis of polychrome sculpture and painted wooden objects. Many observations on the use of materials and the techniques of decorating the surface become clearer after interpreting the historical citations.
Staff

30-S323.
Schießl, Ulrich.
Die Bestaetigung kunsttechnischer Quellen durch technologische Untersuchungsbefunde.
(The confirmation of literary sources on art technology through scientific examination.)
Maltechnik-Restauro, **86,** no. 1, pp. 9-21, (1980), [Ger.].

There are two methods of gaining access to bygone technologies used in art: to study literary sources and to evaluate the results from scientific examination of the objects of art. The findings of scientific examination can help interpret old art technological terminology. A good deal of printed technical literature, as well as published archive material (bills, contracts, etc.) about individual works of art are available as sources about 18th-century South German decorative painting. Besides German originals there is an increasing number of translations from French, Italian, and English in the second half of the century. With the establishment of technology as a science (at the University of Göttingen in 1772) the literature on painting techniques becomes more precise and more practicable. Archival sources of individual works of art can be compared to findings of scientific examination. The philological problems of the old painting terminology, which sometimes differs from the language in the printed literature, have not yet been examined. Possible changes in meaning of certain 18th-century terms that were already used in the late Middle Ages dialect forms must still be checked. Examples of techniques of applying leaf-metal and such cases where historical literary sources and scientific data are available for the same work of art demonstrate this difficulty.
Staff

30-S324.
Watters, Mark.
Application of traditional Indian techniques in the treatment of a Bundi miniature.
ICA newsletter, **12,** no. 2, pp. 7-8, (1980), [Eng.].

Technical study of Indian miniatures guided the selection and application of Oriental paper fills and inpainting techniques for a damaged miniature.
Staff

30-S325.
Wreschner, Ernst E.
Red ochre and human evolution: a case for discussion.

Current anthropology, **21,** no. 5, pp. 631-644, (1980), [Eng.].

A short article with published discussions by Karl W. Butzer, Tadeusz Malinowski, and others. The text deals with the early use of ocher and its discovery in archaeological contexts. The point is made that ocher is used as a generic term for red minerals found with artifacts and remains. Malinowski makes the point that red vegetable dyes are also found in human burials. The associations with the color red and the nature of human use of colorants are discussed. Descriptions of ocher found in burials may often be hasty or ill-advised. This discussion strikes at the foundation of the use of colorants by humans. M.H.B.

30-S326.
Lynn, Catherine.
Colors and other materials of historic wallpaper.

Journal of the American Institute for Conservation, **20,** no. 1-2, pp. 58-65, (1980-1981), [Eng.].

Examines published 18th- and 19th-century instructions for the making of wallpaper, with emphasis on specific pigments recommended and their application.
ICCROM(02602906)

30-S327.
My country, Djarrakpi.

Motion picture. Narritjin Maymuru, Australian Film Commission/CA, Hollywood, 1981, 1 film reel (16 min.), sd., col. [Eng.]. Dunlop, Ian (Director, Producer); Film Australia (Producing Agency).

Narritjin Maymuru (d. 1981) was a highly respected elder within Yolngu society and one of Australia's best-known traditional Aboriginal artists. At an exhibition of his bark paintings at the Australian National University in Canberra, Narritjin explains the significance of the settlement at Djarrakpi, one of the most sacred sites of the Manggalili clan of northeast Arnhem Land. On location at Djarrakpi itself, the artist describes more elements

of Aboriginal mythology. Narritjin Maymuru series, one of five. (See also following abstracts.)
PFAOF

30-S328.
Narritjin at Djarrakpi: Part 1.

Motion picture. Narritjin Maymuru, Australian Film Commission/CA, Hollywood, 1981, 1 film reel (50 min.), sd., col. [Eng.]. Dunlop, Ian (Director, Producer); Film Australia (Producing Agency).

Shows Narritjin and his family as they leave Yirrkala Mission, where they have spent most of their lives, to establish their own small settlement at Djarrakpi on the northern headland of Blue Mud Bay. They live off the land and sea, producing bark paintings and craft work to sell at Yirrkala. Through bark paintings Narritjin teaches his sons about their clan land and its history. *Narritjin at Djarrakpi,* Part 1 of 2. Narritjin Maymuru series, one of five. PFAOF

30-S329.
Narritjin at Djarrakpi: Part 2.

Motion picture. Narritjin Maymuru, Australian Film Commission/CA, Hollywood, 1981, 1 film reel (39 min.), sd., col. [Eng.]. Dunlop, Ian (Director, Producer); Film Australia (Producing Agency).

Shows Narritjin and his family at his clan settlement at Djarrakpi in northeast Arnhem Land. Narritjin continues to create bark paintings, while his son makes a yidaki, or drone pipe, for the tourist trade. *Narritjin at Djarrakpi,* Part 2 of 2. Narritjin Maymuru series, one of five. PFAOF

30-S330.
Narritjin in Canberra.

Motion picture. Narritjin Maymuru, Australian Film Commission/CA, Hollywood, 1981, 1 film reel (40 min.), sd., col. [Eng.]. Dunlop, Ian (Director, Producer); Film Australia (Producing Agency).

Shows Narritjin and his son Banapana in 1978, when they were awarded Creative Arts Fellowships at the Australian National University in Canberra. Observes them and their families at work in their University studio, both painting and giving a seminar to anthropology students. Shows an exhibition

of the work they produced during their three-months' stay in Canberra. Narritjin Maymuru series, one of five.

PFAOF

30-S331.
Agrawal, O.P.
Problems of preservation of palm-leaf manuscripts.

In proceedings. *ICOM Committee for Conservation, sixth triennial meeting, Ottawa, 21-25 September 1981: preprints*, (1981), pp. 81.14.17:1-7, [Eng.].

Palm leaf has long been a popular writing material in Asian countries. A study was undertaken to identify the varieties of palm leaves used. The results of a survey of processes used for making the palm leaf fit for writing are mentioned. In some countries such as Thailand, palm leaf was decorated before being written upon. Deterioration of palm leaf is discussed and a program of future research mentioned.

ICCROM(02438706)

30-S332.
Blier, Suzanne Preston.
Architecture of the Tamberma (Togo).

Dissertation. University Microfilms International. Dissertation Publishing, Ann Arbor, 1981, [Eng.]. xiv, 512 p.: ill., maps, bibliog.

Describes the plastering and staining of Tamberma adobe houses. The plaster is made with river silt, dung, and the dried fruit of the *neré* tree. The procedure for applying these materials to the structure is described. Areas more exposed to the rain receive heavier applications with higher proportions of dung and *neré*. A final staining is applied using a solution of dung and powdered *neré* seeds or the dregs remaining from the preparation of shea butter. The *neré* solution acts as a hardener and sealant and the shea (*Butyrospermum parkii*) has a very high oil content. Shea causes the walls to take on a reddish color considered more desirable. The *neré* gives a dark brown. The shea stain lasts longer and is considered more beautiful.

M.H.B.

30-S333.
Gunn, Michael.
The material composition of Malanggans - a preliminary approach toward a non-destructive analysis.

COMA: bulletin of the Conference of Museum Anthropologists, no. 8, pp. 17-21, (1981), [Eng.].

The author is interested in finding alternative, nondestructive methods of discerning the materials used on Malanggan artifacts from New Ireland. He approached the problem from a social anthropological view, using a structuralism paradigm to determine what the artifact expresses for the people as they see themselves (i.e., leaves from a tree with specific meaning used on a mask would take that meaning with them and associate it with the mask). So by looking at the materials making up the artifacts, and assuming they represent a structured, symbolic language, the author has a way of finding out what materials were used and the local names of the materials. Eventually, he would be able to track down the raw materials with an ethnobotanist, and find the best method of conserving each material, without destroying any part of the artifact. However, the author notes that the method produced conflicting results, and states that ethnobotanical field work is necessary before this approach can proceed further.

C-A.G.

30-S334.
Holmes, Tommy.
The Hawaiian canoe.

Book. Editions Limited, 1981, [Eng.]. viii, 191 p.: ill. (some col.); 29 cm., bibliog. and index.

Describes the manufacture and use of canoes in Hawaii before European contact and up to the present day. The paint used to coat the canoes is described as are the ingredients used. The paint (*pa'ele*) was compounded of the buds and twigs of a species of Euphorbia, the flower and buds of banana, the juice from the inner bark of the *kukui* and the juice of the root of the *ti* plant. Variations on the recipe were used and red earth was added for the canoes of chiefs. The paint was noted for its remarkable powers of waterproofing and preservation.

M.H.B.

30-S335.
Krauss, Beatrice.
Ancient Hawaiian tapa dyes for coloring paper.

In book. *Tapa, washi and western handmade paper: papers prepared for a symposium held at the Honolulu Academy of Arts, 4-11 June 1980,* (1981), pp. 21-23, [Eng.].
Deals with the use of traditional Hawaiian tapa colorants to dye paper. Provides some insights into the colorants used by the ancient Hawaiians. M.H.B.

30-S336.
Mancusi-Ungaro, Carol C.
Preliminary studies for the conservation of the Rothko Chapel paintings: an investigative approach.

In proceedings. *Preprints of papers presented at the ninth annual meeting, Philadelphia, 27-31 May 1981,* Preprints of papers presented at the annual meeting (American Institute for Conservation of Historic and Artistic Works), (1981), pp. 109-113, [Eng.].
Examines Mark Rothko's murals for Houston's Rothko Chapel with respect to their deteriorating condition and departure from traditional technique. Observations made from simulation of the technique suggest that the cause of the current state of the paintings originates in the artist's choice of materials. ICCROM(02467713)

30-S337.
Morgan, Robert C.
Pastel, juice and gunpowder: the Pico iconography of Ed Ruscha.

Journal: a contemporary art magazine, no. 30, pp. 26-31, (1981), [Eng.]. 5 ill.
Study of Ruscha's books, comparing the early artist-books with recent commercial publications, and of his drawings examines the interplay between verbal and visual, and notes his use of unusual media (gun powder, Pepto-Bismol, and vegetable extracts).
 Staff

30-S338.
Radosavljevic, Vera.
La technique d'écriture et d'enluminures des manuscrits anciens serbes.
(Writing technique and illumination of ancient Serbian manuscripts.)

In proceedings. *ICOM Committee for Conservation, sixth triennial meeting, Ottawa, 21-25 September 1981: preprints,* (1981), [Fre.].
Understanding of the diverse techniques of illumination aids conservators and restorers in devising appropriate methods of treatment. A part of this report summarizes the completed work in the identification of components that have been utilized in the production of black ink of ancient manuscripts while the other part is exclusively dedicated to pigments and their utilization in the pictorial layers of illuminations of Serbian manuscripts. Various techniques of identification were utilized: microscopy, microchemical analysis, infrared spectrophotometry, cross sections, gas phase chromatography, and x-ray fluorescence. ICCROM(02550191)

30-S339.
Schießl, Ulrich.
Ochsenblut: ein Farbbindemittel und ein Farbname.
(Ox-blood: a color binding media and a color name.)

Denkmalpflege in Baden-Württemberg, no. 3, pp. 122-126, (1981), [Ger.].
Overview on the properties of ox-blood and its utilization in mural and wooden paintings, miniature painting, etc.
 ICCROM(02366202)

30-S340.
Seymour, Raymond B.
Development and growth of resins for the coating industry.

Paintindia, pp. 11-13, (1981), [Eng.]. 25 refs.
A brief survey of the history of coatings. Cites the use of animal blood and egg white in the Stone Age and the use of gum arabic, gelatin, and beeswax later. Primarily concerned with the history of synthetics such as cellulosic derivatives, amino resins, and vinyl coatings. M.H.B.

30-S341.
Vestal, Paul A.; and Schultes, Richard E.
The economic botany of the Kiowa Indians as it relates to the history of the tribe.

Book. AMS Press, New York, 1981, Reprint of 1939 ed. published by Botanical Museum, Cambridge, Massachusetts [Eng.]. xiii, 110 p., 4 leaves of plates: ill.; 23 cm., bibliog. and index. [ISBN 0-404-15740-8].

Describes the use of plants by the Kiowa for all purposes. Cites eight plants used for dyes and tannins. When this book was written the Kiowa were based on a reservation in Oklahoma. Originally they were based farther north where they would have had very different plants available to them. The authors take pains to try to establish which plants would have been familiar to the Kiowa in their traditional home and which ones they would have become acquainted with during their move south. The plants used by the Kiowa in the peyote ritual are also described. M.H.B.

30-S342.
Delamare, F.; Darque-Ceretti, E.; and Dietrich, J.E.
Etude physico-chimique des couches picturales des peintures murales romaines de l'Acropole de Léro.
(Physico-chemical study of the painting layers of the Roman mural paintings from the Acropolis of Lero.)

Revue d'archéométrie: bulletin de liaison du Groupe des méthodes physiques et chimiques de l'archéologie, **6,** pp. 71-86, (1982), [Fre. w. Eng. summary]. tables, diagrams, refs.

The color thickness, hardness, and roughness of samples of the pictorial layers of Roman mural paintings from the Acropolis of Lero (Alpes-Maritimes, France) were studied. The average and surface composition of the paint layers and of the intonaco were also determined by means of electron microprobe analysis and x-ray diffraction. The materials used seem to conform with Vitruvius' specifications except for the use of pure hematite instead of red ocher and the systematic addition of clay wherever the pigment does not contain any. Roughness and texture of the material seem to be linked to the practice of a nonabrasive polishing of some paint layers.
ICCROM(03982002)

30-S343.
Frizot, Michel.
L'analyse des pigments de peintures murales antiques. Etat de la question et bibliographie.
(The analysis of pigments from ancient mural paintings. The state of the problem and a bibliography.)

Revue d'archéométrie: bulletin de liaison du Groupe des méthodes physiques et chimiques de l'archéologie, **6,** pp. 47-59, (1982), [Fre. w. Fre. summary]. bibliog.

Based on a bibliography of analyses of pigments in ancient mural paintings, reviews the results achieved with the various types of analyses conducted since the 19th century. A summary is provided for each color— white, black, yellow, red, green, and blue. Little information has been obtained from these analyses because of the small variety of materials used (predominantly ocher, terre verte, and Egyptian blue) and because the questions raised from an archaeological viewpoint are hard to solve as far as physicochemical analysis (origin, natural or artificial material, etc.) is concerned.
ICCROM(156029)

30-S344.
Hudson, Travis; and Blackburn, Thomas C.
The material culture of the Chumash interaction sphere. Volume IV: Ceremonial paraphernalia, games, and amusements.

Book. Ballena Press, Menlo Park; Santa Barbara Museum of Natural History, Santa Barbara, 1986 [Eng.] 460 p., index. [ISBN 0-87919-108-2 (hbk); 0-87919-107-4].

Contains a general description of ceremonial painting. The Chumash painted grave markers, canoes, bowls, and other wooden objects. Ritual connected with the winter solstice seems to have been the purpose for painting rock art. A tradition of ground painting also existed although there are no surviving examples for obvious reasons. Gives examples of movable painted rocks and pebbles. M.H.B.

30-S345.
Hudson, Travis; and Blackburn, Thomas C.
The material culture of the Chumash interaction sphere. Volume V: Manufacturing processes, metrology, and trade.

Book. Ballena Press, Menlo Park; Santa Barbara Museum of Natural History, Santa Barbara, 1987 [Eng.] 364 p., index. [ISBN 0-87919-101-5 (hdbk–series].

Describes pigments and their sources as well as glue, adhesives, brushes, and related paraphernalia. This series directly relates to objects in various museums and the uses they were put to. The Chumash used pine pitch, tar seeps on land, and tar gathered on beaches from oceanic seeps as adhesives. Adhesives were sometimes mixed with pigment and bits of shell as decorative coating. Various sources of pigments, both local and traded, are described. Many are mineral sources but the Chumash also made use of a red pigment from the octopus and the sea hare. Many objects were painted as well as the body. M.H.B.

30-S346.
Kockaert, Leopold.
(Structure, composition, and technique of the paintings.)

In book. *Maria van Bourgondie: de tragiek van een vorstin,* (1982), pp. 137-138, [Dut. w. Eng. summary].

Samples of tomb paintings found inside and outside Our Lady's Church, in S. Donatian Church in Bruges, and also from Hannekenswerve, all dating from the 14th century, were examined microchemically and the results were compared. The wall paintings from Hannekenswerve are very similar to those from the Bruges churches, except for the pigments from the latter, which are mixed with sand. Red and yellow ochers and charcoal were found; the white was probably S. John's white. These paintings are to be considered as tempera paintings, but some doubt exists, as they contain some proteins but react like frescoes, because a layer of calcium carbonate has covered them. Generally one pigmented layer has been applied on a white ground of lime and sand. Rests of shells in the whites from Hannekenswerve show that sea shells were used as a source of calcium carbonate. See also *AATA* **21-131** for reference to book. Staff

30-S347.
Mancusi-Ungaro, C.C.
A technical note on IKB (International Klein Blue).

In book. *Yves Klein, 1928-1962: a retrospective,* (1982), [Eng.].

Yves Klein formulated and patented his own blue paint which he named International Klein Blue (IKB). Klein was anxious to achieve a matte surface in which the binder did not interfere with perception of the individual paint particles. He settled on an artificial ultramarine blue and used a poly(vinyl acetate) medium (Rhodopas M). He mixed the pigment with 95% pure ethyl alcohol and ethyl acetate in which pellets of Rhodopas M had been dissolved. The recipe apparently varied somewhat depending on what Klein was using it for. Consolidation of these surfaces has proven to be incredibly difficult to achieve without marring the surface characteristics. The problem is made more difficult by an imperfect understanding of the material. This note explains in full the nature of the paint. M.H.B.

30-S348.
Mussey, Robert D.
Early varnishes. The 18th century's search for the perfect film finish.

Fine woodworking, no. 35, pp. 54-57, (1982), [Eng.].

Describes the materials and techniques used in varnishing in the 18th century. Confusion about terminology for the ingredients and variation from country to country has created a number of misunderstandings about the subject. This article includes recipes and descriptions of standard varnishes from the period. Varnished surfaces usually do not become matte or friable but this article is interesting for its insights into materials and techniques used in coatings in this time period. M.H.B.

30-S349.
Burk, William R.
Puffball usages among North American Indians.

Journal of ethnobiology, 3, no. 1, pp. 55-62, (1983), [Eng.]. bibliog.

Provides an informative review of ethnobotanical and ethnographic literature

regarding the use of puffballs by Native Americans. Fungal spores were sometimes used as pigment although this article does not specifically cite their use for this purpose. A substantial bibliography is included.

M.H.B.

30-S350.
Collins, Judith; Welchman, John; Chandler, David; and Anfam, David A.
Techniques of modern artists.

Book. Macdonald & Co. Ltd., London, 1983, [Eng.]. 192 p.: ill.; 31 cm., bibliog. and index. [ISBN 0-356-09802-8].

Discusses the development of new materials and techniques, styles of painting, and the achievements of individual artists, 1900 to the present. Key paintings are given detailed technical analysis in the context of the contemporary artistic climate, and their influence is described in background essays on each artist. Staff

30-S351.
De Vos, Ashley.
A survey of the painted mud *Viharas* of Sri Lanka.

In proceedings. *El Adobe: Simposio Internacional y Curso-taller sobre Conservación del Adobe: informe final y ponencias principales: Lima-Curso (Peru) 10-22 sept. 1983,* (1983), pp. 91-95, [Eng.].

Discusses construction techniques, typology, and decoration of the *viharas,* typical adobe temple structures of Sri Lanka with painted walls. Describes the mural painting technique, with a note on deterioration factors and conservation problems.

ICOMOS

30-S352.
Delamare, François.
Etude physico-chimique et colorimétrique des rouges et des violets d'hématite, à propos des peintures murales de l'Acropole de Léro, ou "histoires d'ocre"
(Physico-chemical and colorimetric study of haemitite reds and purples, with reference to the mural paintings of the Acropolis of Lero, or "histories of ochre".)

In proceedings. *Caractérisation, datation, technique de la peinture antique: IIIe rencontres internationales d'archéologie et d'histoire d'Antibes,* *12-14 octobre 1982,* (1983), pp. 9-43, [Fre. w. Fre. + Eng. summaries]. charts, photos., bibliog.

Three paint layers from Roman wall paintings colored with hematite are described. Sections were analyzed with an electron microprobe. The study of the pigments showed that the coloration of the paint layer depends on the granulometry and the hematite concentration. ICCROM(03240701)

30-S353.
Hamsik, Mojmir; and Tomek, Jindrich.
Technicke paralely deskove a nastenne malby 14. stoleti.
(Technical parallels between panel and wall painting of the 14th century.)

Uměni, **31,** no. 4, pp. 308-316, (1983), [Cze. w. Eng. summary].

Bohemian painters used the same procedures and materials for both these techniques. Coincidences in the stratigraphy, binding media, pigments, and underdrawing are documented on the wall paintings in the Emaus Monastery and St. Vitus Cathedral in Prague and panel paintings by the Master Theodoric and the Master of Trebon. Characteristic is the ground siliceous layer bound with starch and an addition of glue and oil, followed by an ocher also containing oil. Occasionally a white lead in oil seals the surface just beneath the paint layers. Gilding was applied over an oil film or ocher in oil film.

Staff

30-S354.
Lee, John.
Collecting wooden ethnographic carvings in the tropics.

In proceedings. *Biodeterioration 5: papers presented at the fifth international biodeterioration symposium, Aberdeen, September 1981,* Oxle, Thomas Alan; and Barry, Sheila M., Editors (1983), pp. 404-408, [Eng.].

A large collection of ocher-painted ancestor carvings were brought from Papua New Guinea to the British Museum in 1980. They had suffered damage not only to the timber but also to the friable painted surfaces. Termites had eaten the bases of the carvings, and the mechanical strength of the timber was much reduced. During the sea trip back to the United Kingdom the damp carvings had been further damaged by mold;

on return the carvings were fumigated with ethylene oxide gas in a vacuum chamber; the paint was then cleaned and consolidated with a spray application of Paraloid B-72 in xylene 2% solution. The damaged bases were consolidated with Paraloid B-72, and strengthened with B.P.K. setting dough (Butvar B98, paper dust, and kaolin). Staff

30-S355.
Rudner, I.
Paints of the Khoisan rock artists.

In book. *New approaches to southern African rock art*, Goodwin series, no. 4, Lewis-Williams, J. David, Editor (1983), pp. 14-20, [Eng.].
Ethno-archaeological methods are used to ascertain the ingredients used for rock paints. Past theories, statements, and experiments are examined and evaluated; information on traditional paints obtained from historical and contemporary literature and from ethnographical and archaeological fieldwork is examined and correlated. Much of the recorded information, particularly in regard to binders, is found to have been based on plagiarism and speculation. The most likely binders would have been fat and perhaps water. Mainly earth pigments would have been used and possibly plant pigments, which might not have lasted. A.A.

30-S356.
Turner, Nancy J.
Ethnobotany of the Nitinaht Indians of Vancouver Island.

Book. Occasional papers of the British Columbia Provincial Museum, no. 24, Royal British Columbia Museum, Victoria, 1983, [Eng.]. x, 165 p.: ill.; 27 cm., bibliog. [ISBN 0-7718-8375-7].
Cites six plants used as dyes, stains, and paints by the Nitinaht. The bark of red alder (*Alnus rubra*) is used for a reddish dye. Salal leaves (*Gaultheria shallon*) are used as a yellowish pigment or dye. Various types of Oregon grape (*Mahonia spp.*) are used to provide a yellow dye from the stems and roots. Wood charcoal from Devil's-club (*Olopanax horridus*) is used as a face paint and colorant. The bud resin of black cottonwood (*Populus balsamifera* spp. *trichocarpa*) is used as a paint base. The bark of the Western hemlock (*Tsuga hetero-*

phylla) provides varying dyes that range from a light brown to black. This book includes a thorough description of plants used in material culture, food, and medicine. It also includes photographs of many of the plants discussed and of objects made from plant materials. M.H.B.

30-S357.
Vandiver, Pamela.
Paleolithic pigments and processing.

Master's thesis. Massachusetts Institute of Technology, Cambridge, 1983, [Eng.]. 258 p.
A study of the nature and technology of Palaeolithic pigments employed at three French caves is presented. The Palaeolithic caves are the following: Arcy-sur-Cure, ca. 35,000-25,000 years B.P., Lascaux, ca. 14,000 years B.P., and Mas d'Azil, ca. 11,000 years B.P. From Arcy-sur-Cure are a diverse selection of minerals and rocks only some of which are suitable as pigments. At Lascaux a group of pigments were used which display a finer particle-size range and more diverse composition than are found in local deposits. Mixing and milling are shown to be responsible for the differences. The murals of Lascaux are believed to be drawings employing a different technology for the red and black colors. Evidence that the red pigments from Mas d'Azil and surrounding sites are from three different sources is presented. The fine particle size of Palaeolithic pigments has made necessary the characterization of microstructure and composition which has been carried out by optical microscopy, scanning electron microscopy with simultaneous energy dispersive x-ray analysis and x-ray diffraction. Emission spectroscopy, Auger and differential thermal analysis have been employed in supplementary analyses as required. Establishment of a geological reference collection of naturally occurring pigment minerals has been an important requirement for this study. The fine scale microstructures and compositions of palaeolithic pigments have been compared with those of geological and other archaeological samples in order to determine the nature and extent of processing employed. The reference collection is quite extensive and includes minerals collected in a 15-km. radius of these three cave sites, minerals and pigments from other sites in the southwest of France, and from museum col-

lections. At Lascaux, investigation of colorants in various stages of processing, together with analysis of pigment fragments from the ceiling, have yielded detailed evidence about the preparation and use of pigments, including observations on the methods of grinding and mixing. Heat treatment was not found to have been employed in the preparation of pigments. Investigation of the use of such methods of purification as sedimentation or levitation are inconclusive, as it is not possible to differentiate natural from man-induced processing. Replication studies of pigment application to limestone have been compared with application to paper in order to explain relationships between composition, microstructure, and color. A.A.

30-S358.
Althöfer, Heinz.
Die "schnellen" Blider der Neuen Wilden. (The "fast" paintings of the Neuen Wilden.)

Maltechnik-Restauro, **90,** no. 1, pp. 45-50, (1984), [Ger.].

The way paintings of the Neuen Wilden (i.e., the "New Savages," a contemporary group of artists) are constructed makes an early occurrence of damage highly probable. A separation of paint layers, the appearance of cracks, peeling of emulsion paints, bulging of the heavy canvases, and a rapid decay of the cotton support are to be expected. Prophylactic lining is advisable in many cases. Staff

30-S359.
Barton, Gerry.
Conservation considerations on four Maori carvings at Auckland Museum, New Zealand.

Studies in conservation, **29,** no. 4, pp. 181-186, (1984), [Eng. w. Eng., Fre. + Ger. summaries]. ill., 6 refs.

Since the late 19th century, museums in New Zealand have intermittently painted Maori wood sculpture matte red in the mistaken belief that they were continuing a tradition of red colored carving predating the arrival of the Europeans in New Zealand. Conservation work at Auckland Museum has restored some of these back to their original surfaces. Described are the history of the

carvings under discussion, the conservation carried out, and some of the ramifications of the results achieved. See also AATA 21-1638 for related paper. Staff

30-S360.
Barton, Gerry; and Weik, Sabine.
Maori carvings in Auckland Museum, New Zealand. Ethical considerations in their restoration.

In proceedings. *ICOM Committee for Conservation, seventh triennial meeting, Copenhagen, 10-14 September 1984: preprints,* De Guichen, Gael; and Gai, Vinicio, Editors (1984), pp. 84.3.7-84.3.9, [Eng.].

Recent conservation work on Maori wood sculpture has shown the variety of surface finishes with which the artists completed their carvings. However, up until 1953, the Auckland Museum overpainted the majority of its carvings with matte red paint. This article discusses the reasons for this overpainting. A.A.

30-S361.
Binford, Lewis R.
An Alyawara day: flour, Spinifex gum, and shifting perspectives.

Journal of anthropological research, **40,** no. 1, pp. 157-182, (1984), [Eng.].

Details the harvesting and production of Spinifex gum from wild Spinifex grass by Alyawara-speaking Australian Aborigines. Explains each step: cutting winnowing trays from a "ghost bark" tree, picking out a large flat rock to act as the threshing floor, pulling up grasses and forming them into a very large haystack-like piles about three-feet high, cutting a small tree into a flail to beat the grass and extract the dry, gray resin, winnowing out the grass particles from the resin dust, heating the dust to make small, gray balls of gum, and refining the balls into black, tar-like tablets. It is these gum tablets that are used as an adhesive. Concludes with an anthropological reflection on the entire day's events. C-A.G.

30-S362.
De Antonio, Emile; and Tuchman, Mitch, Compilers.
Painters painting: a candid history of the modern art scene, 1940-1970.

Book. Abbeville Press, New York, 1984, 1st ed. [Eng.]. 192 p.: ill.; 24 cm., index. [ISBN 0-89659-418-1].

Based on the transcripts of a film by the same name done in 1972, this book has a number of important statements by contemporary artists about their working methods. An example is this statement by Robert Rauschenberg: "At that time surplus paint fit my budget very well. It was like 10 cents for a quart can downtown, because nobody knew what color it was. I would just go and buy a whole mass of paint, and the only organization, choice, or discipline was that I had to use some of all of it and I wouldn't buy any more paint until I'd used that up." Other artists covered are Frank Stella who discusses his techniques, Jules Olitski, Jasper Johns, and others. The use of industrial paints, painting directly onto unprimed canvas and other materials and techniques have created considerable conservation problems for works by these artists. Statements by artists contained in books like this are very revealing of the intent of the artist and the circumstances involved in the creation of a given work. M.H.B.

30-S363.
Lewis, Gillian M.; Muir, Nanette T.; and Yates, Nicolas S.
The link between the treatments for paintings and the treatments for painted textiles.

In proceedings. *Fourth international restorer seminar: Veszprém, Hungary, 2-10 July 1983 = Viertes internationales Seminar für Restauratoren = Quatriéme cours international pour restaurateurs,* Tim ar-Balazsy, Agnes, Editor (1984), pp. 169-182, [Eng.].

The different treatments for painting and for textile restoration are compared and discussed with due regard to painted flags and banners which fall between the above two fields of conservation. A comparative listing of adhesives and consolidants used in the treatment of textiles and paintings is attached. See also AATA 21-490. Staff

30-S364.
Monnier, Geneviève.
Pastel, a technique of yesterday and today.

In book. *Pastels: from the 16th to the 20th century,* (1984), pp. 107-121, [Eng.].

Selected translations from a number of books from 1583 to 1983 on the manufacture and fixing of pastels. Part of a general work on pastels with a bibliography on the subject. M.H.B.

30-S365.
Mora, Laura.
Il colore delle superfici architettoniche. (The color of architectural surfaces.)

In book. *Facciate dipinte: conservazione e restauro: atti del convegno di studi, Genova, 15-17 aprile 1982,* Rotondi Terminiello, Giovanna; and Simonetti, Farida, Editors (1984), pp. 151-152, [Ita.].

Surface treatments in the history of architecture: function and character of color. Notes on historical development of painted surfaces. ICCROM(02980313)

30-S366.
Mora, Paolo; Mora, Laura; and Philippot, Paul.
Conservation of wall paintings.

Book. Butterworths series in conservation and museology, Butterworth & Co., Sevenoaks, 1984, [Eng.]. 494 p., 148 p. of plates: ill. (some col.); 26 cm., bibliog. and indexes. [ISBN 0-408-10812-6].

Revised and enlarged from the original French edition (see also AATA 15-1480), this volume provides a history of wall painting techniques and advanced guidelines for conservation. The chapters dealing with the history of mural painting techniques have been extensively revised; the section on Gothic mural paintings has been updated in light of recent technological examinations. An appendix by Bernard Feilden on scaffolding and safety has been added. Chapters cover: Examination and Documentation; Technology of the Constituents of Renderings; Pigments; The History of Techniques from the Prehistoric Period to Classical Antiquity; The History of Techniques in the Middle Ages; The History of Techniques from the Renaissance to the Present; Causes of Alteration in Wall Paintings; Fixation and Consolidation; De-

tachment; Application to the New Support; Cleaning and Disinfection; Problems of Presentation. Staff

30-S367.
Morita, Tsuneyuki.
"Nikawa": traditional production of animal glue in Japan.

In proceedings. *Adhesives and consolidants: preprints of the contributions to the Paris Congress, 2-8 September 1984*, Brommelle, N.S., Editor (1984), pp. 121-122, [Eng.].

The complete process of animal glue production by hand is described in detail. Some historical background is provided.
ICCROM(02981326)

30-S368.
Nelson, Jerri Reynolds.
On the technical study of thirty pastel works on paper by Jean-François Millet.

In book. *Papers presented at the art conservation training programs conference: 2-4 May 1984, Center for Conservation and Technical Studies, Harvard University Art Museums, Cambridge, Massachusetts*, (1984), pp. 2-13, [Eng.]. table of pigment colors, pigment analyses, refs., bibliog.

Thirty pastel works by Millet were examined using magnification, normal and raking light, ultraviolet and infrared radiation, and analysis of pigments and fibers from six characteristic works. The aim was to investigate the working techniques and materials used, then compare them with the recommendations in contemporary pastel manuals. The color of the papers used was often found to have been discolored by light. Pentimenti, although visible to the naked eye, were more clearly seen with infrared radiation. Analysis was by means of x-ray fluorescence, x-ray diffraction, and spot tests on mounted samples. The pigments found were the standard 19th-century ones—what was remarkable was their extremely fine grain. Examination report on painting "Noonday rest."
ICCROM(03530002)

30-S369.
Schwartz, Catherine; Guineau, Bernard; Flieder, Françoise; Laroque, Claude; and Flieder, Nathalie.
Les pastels.
(Pastels.)

In book. *Analyse et conservation des documents graphiques et sonores: travaux du Centre de re cherches sur la conservation des documents graphiques, 1982-1983*, (1984), pp. 121-178, [Fre.]. 68 refs.

Literature review and experimental study led to the following conclusions: the pigment influences the stability of the pastel to a great extent. Certain colors—for example, white, brown, green, and yellow—are very stable to light, while purples and violets are not. Ethylene oxide does not have a darkening effect on the pastels. Finally, the resin most adaptable for fixing pastels was found to be Elvamide 8061, a 0.5% solution in ethanol and water in proportion of 90 to 1.
Staff

30-S370.
Stretch, Bonnie Barrett.
The conservation of contemporary paintings.

Art and auction, **271**, pp. 70-74, (1984), [Eng.].

Discusses the deterioration of contemporary paintings caused by experimentation in painting techniques and materials in the 20th century, with specific examples of various artists' techniques and resulting problems—structural, aesthetic, and philosophical. Conservators consulted cite examples of problems and the issues inherent in specific treatments. There is some information on new technologies and materials being developed to meet the requirements of contemporary paintings.
Staff

30-S371.
Whitley, David S.; and Dorn, Ronald I.
Chemical and micromorphological analysis of rock art pigments from the western Great Basin.

Journal of New World archaeology, **6**, no. 3, pp. 48-51, (1984), [Eng.].

Pigment samples were collected from three pictograph sites in the western Great Basin of eastern California and from the Coso Hot Springs mineral deposits. These samples

were chemically analyzed by x-ray fluorescence, and the micromorphology studied with a scanning electron microscope. The purpose of the study was to determine how much variation exists among the different pigments, and to see how closely the Coso Hot Springs minerals match the pigments used in the site closest to the springs. This study is also intended to be a beginning in the establishment of a database of California pictograph pigments and their sources. For dating of these petroglyphs, see also AATA 20-2062, and 22-61. Staff

30-S372.
Winter, John.
Natural adhesives in East Asian paintings.

In proceedings. *Adhesives and consolidants: preprints of the contributions to the Paris Congress, 2-8 September 1984*, Brommelle, N.S., Editor (1984), pp. 117-120, [Eng.].

The three types of natural adhesives used in East Asian (Chinese, Japanese, and Korean) painting and calligraphy are animal glues, starch pastes, and seaweed mucilage (funoran). Animal glue is the traditional binding medium for inorganic pigments. Starch paste is used to mount scrolls. Seaweed mucilage is used in certain painting techniques and to reattach loose paint. The preparation of these adhesives and their chemical characteristics are described.
 Staff

30-S373.
Bacon, Louise.
The examination, analysis and conservation of a Maori model canoe.

The conservator, no. 9, pp. 26-32, (1985), [Eng.]. 4 photos., 4 ill., 22 refs.

Describes comprehensively the style, condition, and composition of the canoe, providing a useful reference point for conservation purposes since the relevant literature is thoroughly surveyed. The analytical work reported does not include x-ray diffraction analysis as only the metals in the paints have been identified. Staff

30-S374.
Burkill, H.M.
The useful plants of west tropical Africa.

Book. Royal Botanic Gardens (Kew), Richmond, 1985, 2nd ed. rev. [Eng.]. v.: ill. (some col.), maps; 26 cm., bibliog. and indexes. [ISBN 0-947643-01-X].

This book was originally published as a supplement to Dalziel's *Flora of West Tropical Africa* in 1937. It has been considerably revised to reflect changes in taxonomy and the growth of knowledge about the use of plants in the area. The book is arranged alphabetically by families. It also contains an index of "Plant species by usage" that is quite comprehensive. Categories include "dyes, stains, ink, tattoos, and mordants"; "mucilage"; "insecticides, arachnicides"; and a number of other categories interesting to the conservator. Names for plants in the relevant African language are also given. "Useful" is defined by the authors in the broadest sense to include ritual usage and material culture. The authors acknowledge the concept as an "anthropinism" and address it directly in the introduction. This is one of the few truly systematic works of this type. M.H.B.

30-S375.
Carrington, Tim.
Why modern art may never become old masterpieces.

The Wall Street journal, **112**, p. 1, 8, (1985), [Eng.].

Modern artists have experimented with media which tend to deteriorate rapidly: mixing mayonnaise with the pigments, or mixing oil and acrylic paints with raw eggs. Various conservators comment on their treatments of some of these works: finding the right size of pickle jar at the supermarket for a Rauschenberg sculpture, smoking a Camel cigarette and bending the butt to the right shape for a Jackson Pollock picture. The most serious problem is, however, cleaning or treating paintings that have not been primed; traditional treatments will cause the colors to run. Varnish cannot be used if it violates the artist's original intent; thus many surfaces crack or become smudged without this protective finish. The current "ignorance" of materials displayed by contemporary artists has led to disastrous results for the permanence of the

History

art work and occasionally for the health of the artist. Staff

30-S376.
Felger, Richard Stephen; and Moser, Mary Beck.
People of the desert and sea: ethnobotany of the Seri Indians.

Book. University of Arizona Press, Tucson, 1985, [Eng.]. xv, 435 p.: ill.; 28 cm., bibliog. and index. [ISBN 0-8165-0818-6].

A complete study of the use of plants by the Seri for all purposes. A section devoted to paints and dyes describes the plants used by the Seri both for colorants and for binders. Another section on adhesives and sealants describes the use of lac from the creosote bush and plant resins for various purposes. One of the authors is an ethnobotanist and the other a linguist, so this book includes the relevant Seri words. M.H.B.

30-S377.
Masschelein-Kleiner, Liliane; Bridgland, Janet, Walston, Sue, and Werner, A.E., Translators.
Ancient binding media, varnishes and adhesives.

Book. Notes techniques de l'ICCROM = IC-CROM technical notes, International Centre for the Study of the Preservation and the Restoration of Cultural Property, Rome, 1985, [Eng.]. xi, 115 p.: ill.; 24 cm., bibliog.

Discusses the physical and chemical properties of film forming materials; surface phenomena, wetting, and rheology; optical and mechanical properties; lipids, oils, waxes, polysaccharides, proteins; distemper and tempera; emulsion mediums; terpenes and resins. Originally published in Belgium under the title *Liants, vernis et adhésifs anciens* in 1978 (revised edition 1983). ICCROM(03082700)

30-S378.
Nabhan, Gary Paul; Mirocha, Paul, Illustrator.
Gathering the desert.

Book. University of Arizona Press, Tucson, 1985, [Eng.]. ix, 209 p.: ill.; 24 cm., bibliog. and index. [ISBN 0-8165-0935-2].

Discusses the use of plants by the indigenous peoples of the arid Southwest and the Hispanic settlers. Nabhan gives a particularly

interesting account of the use of the resins in the creosote bush and the gumlike lac formed by a scale insect that live on creosote. This book illustrates the relationship between people and the plant resources available to them and how they are used for food, medicine, and material culture. M.H.B.

30-S379.
Randhawa, G.S.; and Mahey, R.K.
Advances in the agronomy and production of turmeric in India.

In book. *Herbs, spices, and medicinal plants: recent advances in botany, horticulture, and pharmacology,* Craker, Lyle E.; and Simon, James E., Editors (1985), pp. 71-101, [Eng.].

The different varieties of turmeric are described (*Curcuma amada, C. angustifolia, C. aromatica, C. caesia,* and *C. zedoaria*) in the context of commercial production of turmeric in India. In reality there are about 70 species in Asia and Oceania. The five named are those primarily used commercially. The origins of turmeric are unknown. The Persians did bring the plant to China sometime before AD 572 and to France and Italy in the 16th century. Turmeric has been used extensively as a colorant and a spice. The exact chemical constituents of turmeric and its cultivation are described. M.H.B.

30-S380.
Ravenscroft, Marion.
Methods and materials used in Australian Aboriginal art.

ICCM bulletin, **11,** no. 3, pp. 93-109, (1985), [Eng.].

Discusses two modern styles of Australian Aboriginal painting, Arnhem Land in northern Australia and the Papunya-Tula School in central Australia, and their origins and methods. Covers the harvesting of raw bark and its preparation, pigments used, binding media, and the manufacture of traditional brushes. Notes that many Aborigines have switched to a poly(vinyl acetate) adhesive (PVA Aquadhere) as a binding medium, rather than use the traditional tree resins, vegetable gums, wax, and orchid sap. The Papunya-Tula style of painting is transposing traditional ground paintings (usually only seen by initiated men) to a canvas background and altering the traditional elements

to an acceptable degree for sale on the international art market. Discusses the construction and symbolism of the traditional ground paintings, and the style changes, methods, and materials used in the Papunya-Tula paintings. C-A.G.

30-S381.
Siqueiros, David Alfaro.
Como se pinta un mural.
(How to paint a mural.)

Book. Editorial Arte y Literatura, Havana, 1985, [Spa.]. 234 p.: numerous ill., photos; 23 cm., bibliog., chronological table.

Theoretical and practical discussion of mural painting by one of its foremost practitioners in Mexico. Contains historical reviews and stylistic comparisons as well as practical information on how to organize a team of mural painters and to teach them the craft in a series of well-defined steps, including taking photographic documentation of their work; setting up the compositional framework; outlining and painting from a movable scaffolding; what materials and tools to use in what order. The appendix gives technical details on the preparation of coatings (lime or cement) before painting, of an encaustic paint, of an anti-saltpeter formula, an ethyl silicate paint, and vinyl acetate paints.
M.B.

30-S382.
Van Der Post, Laurens; and Taylor, Jane.
Testament to the Bushmen.

Book. Penguin Books, Inc., New York, 1985, [Eng.]. 176 p., 48 p. of plates: ill. (some col.); 26 cm., bibliog. [ISBN 0-14-007579-8].

Rock art in southern Africa that can be ascribed to the group of people described as "Bushmen" dates from about 6,000 years ago. Most of this rock art probably dates to a more recent period, about 2,000 years BP. The text reports the various historical accounts in European literature relating to the methods and materials used in creating the paintings. The use of Eland blood as medium is cited as well as the use of the juice of *Asclepia gibba* mixed with a white pigment. The authors cite the use of reeds, feathers, and hair as brushes. Discusses the gathering and processing of pigments and the use of so-called stones with soft centers filled with pigment.
M.H.B.

30-S383.
Yamazaki, Shojiro.
Reproduction of colored patterns in temples and shrines.

In proceedings. *International symposium on the conservation and restoration of cultural property: conservation and restoration of mural paintings II: 18-21 November 1985, Tokyo, Japan,* (1985), pp. 175-183, [Eng.]. 2 tables.

Describes a method of documenting wall or cave paintings prior to restoration, and how to avoid damaging the original painting. The documentation includes the original pattern of the painting, the coloring techniques, the condition of the paint layer, and the restorer's personal notes. The author describes this method of reproducing colored patterns on the wooden structural members of Japanese buildings. The materials required for tracing and copying existing decorations include eight different types of papers, drawing materials, colors, lighting, and photographic equipment. Preparation of glue-alum size is described, then of the oyster shell ground (gofun). Drawing an outline sketch and coloring are the next steps. A list of pigments is given; a useful paragraph describes pigment mixtures known to have been used and known also to have changed in color across the centuries: substitute azurite (thought to have been yellow ocher, indigo, and oyster shell white); a mixture of gamboge and indigo, usually applied on top of malachite to make a deeper green, and a mixture of indigo and oyster shell white. The procedure for preparing this documentation is outlined; the final step is recording the conservation work via a monochromatic drawing. ICCROM and K.M.G.W.

30-S384.
Aillaud, Georges J.; Bec, Serge, Editor.
Ocres: ocres et ocriers du pays d'Apt.
(Ochers and ocher workers and manufacturers around Apt, Provence, France.)

Book. Luberon, images et signes, no. 1, Edisud, Aix-en-Provence, 1986, [Fre.]. 71, xiv p.: 86 ill. (some col.); 23 cm., refs. [ISBN 2-85744-253-X].

The table of contents indicates the topics treated, following introductory remarks on ocher in France and in the rest of the world: 1) The landscape where ocher is found, the nature of ocher, geological formations, shapes, colors, and vegetation relating to its presence; 2) From the mine to the barrel: open pit quarries, mines, laws and regulations, the manufacture of ocher (washing, decanting, drying, processing, conditioning), sales promotion, pollution and legal problems; 3) The romance of ocher as centered in Apt, in the Provence, from family enterprise to industrial production, a description of everyday life, the conquest of world markets, the decline; 4) The uses of ocher: traditions, current uses, the future of ocher. Research and experiments are underway to help this industry regain its former importance. The material could be used to give color to concrete, either as an admixture or as a coating.
M.B.

30-S385.
Binford, Lewis R.
An Alyawara day: making men's knives and beyond.

Affl: University of New Mexico. Department of Anthropology, Albuquerque, NM, USA.

American antiquity: a quarterly review of American archaeology, **51**, no. 3, pp. 547-562, (1986), [Eng. w. Eng. summary]. 14 figs., refs.

Discusses the manufacture of men's knives by Alyawara-speaking Australian Aborigines. The setting is a men's camp at the site of Bendaijerum near MacDonald Downs in central Australia. Obtaining the raw material, the lithic blanks, and the Spinifex resin used in manufacture has already been described (Binford 1984; Binford and O'Connell 1984). This essay treats the social context and the technical process of tool production as it was observed among the Alyawara during the winter of 1974. These experiences then serve as the basis for a discussion of the concept of style and for an analysis of some common views regarding settlement typology. [Note: Spinifex resin is used in this article to attach handles to the stone blades. This resin was widely used by indigenous Australians for many purposes.] A.A.

30-S386.
Bomford, David; Roy, Ashok; and Smith, Alistair.
The techniques of Dieric Bouts: two paintings contrasted.

National Gallery technical bulletin, **10**, pp. 38-57, (1986), [Eng.]. photos., refs.

The comparison of two paintings done in different techniques by the same artist demonstrates the significance of using different materials to achieve particular effects. Broadly similar pigments were found in both the oil on oak panel and glue tempera *tüchlein* on linen by Dieric Bouts. Technical examinations of both pictures gave information on their supports, grounds, underdrawings, media, and paint layers. ICCROM

30-S387.
Boulton, Anne.
The examination, treatment and analysis of a pair of boots from the Aleutian Islands including a note about possible pesticide contamination.

Journal of the American Institute for Conservation, **25**, no. 1, pp. 1-13, (1986), [Eng.]. ill., bibliog.

During the course of the examination and treatment of a pair of boots from the Aleutian Islands, the author was confronted with problems regarding materials identification. Lack of suitable hair identification keys and possible contamination of pigments by pesticides are discussed. Identification of hair and pigments is reported. Use of cast paper pulp as a filling material for seal skin is described in the treatment section. C.A.L.

30-S388.
Cather, Sharon; and Howard, Helen.
The use of wax and wax-resin preservatives on English Medieval wall paintings: rationale and consequences.

In book. *Case studies in the conservation of stone and wall paintings: preprints of the contributions to the Bologna Congress, 21-26 September 1986*, Brommelle, N.S.; and Smith, Perry, Editors (1986), pp. 48-53, [Eng.]. 7 photos., 17 refs.

The removal of wax preservatives applied as a matter of policy in the 19th century to Medieval wall paintings, the repair of the rendering, and the sympathetic reintegration of the murals within their architectural con-

text are the most widespread problems in their conservation. Typical examples are given and illustrated. An appendix contains 10 recipes for wax preservatives and the text indicates that they included instructions for their application, information which may prove relevant to their current conservation. The products were supposed not only to act as consolidants, but also to enhance colors and control the glossiness of the surface. Ease of cleaning was one of the virtues claimed. But wax is damaging in ways spelled out in this paper; moreover, it is not reversible. The practice of applying it ceased in the 1950s.

Staff

30-S389.
Ebeling, Walter.
Handbook of Indian foods and fibers of arid America.

Book. University of California Press, Berkeley, 1986, [Eng.]. xxviii, 971 p.: ill.; 24 cm., bibliog. and index. [ISBN 0-520-05436-9].

Ebeling's book is unique in that it includes insects which are ordinarily overlooked or mentioned only in passing. This is hardly surprising since Ebeling is an entomologist. This rather unique perspective makes for a more rounded ethnobiology of the arid Southwest. The use of certain plants as insecticides by Native Americans is mentioned as well. Dyes are discussed for the cultures in the area covered. Strictly speaking most of these were simply colorants applied in a number of ways and not necessarily true dyes. Of particular interest is a description of the use of the juice from poison oak (*Toxicodendron diversilobum*) as a black dye for basket material. Stems were also used in basketry and other items of material culture. Native Americans apparently were more or less unaffected by the irritants that cause those of European descent so much difficulty. Individuals working with collections of ethnographic material from California should be aware of this. Although little is said about painting materials, this book provides a particularly valuable and well balanced view of the materials available to the indigenous inhabitants of arid America.

M.H.B.

30-S390.
Faulstich, Paul.
Pictures of the dreaming: Aboriginal rock art of Australia.

Archaeology, **39,** no. 4, pp. 18-25, (1986), [Eng.]. 10 color plates, map.

Reviews the various types of rock art and identifies sites. Techniques as well as subject matter are described. Local pigments and brush materials are identified. Conservation of paintings up until the last 25 years had been a prescribed part of the Aborigines' rituals, and now rapid deterioration is evident at many sites. The rock art is endangered by weather, livestock, vandals, and greed.

K.M.G.W.

30-S391.
Gianno, Rosemary.
The exploitation of resinous products in a lowland Malayan forest.

Affl: Smithsonian Institution. Conservation Analytical Laboratory, Washington, DC, USA.

Wallaceana, **43,** pp. 3-6, (1986), [Eng.]. refs.

Presents some of the results of an anthropological investigation into resin collection, technology, and trade among the Semelai of Tasek Bera. The investigation focused on the relationship between these substances and a representative culture that could provide clues for the interpretation of resin technology in prehistoric, protohistoric, and historic Malaya. It cannot be assumed that past Malayan peoples evinced a pattern of resin use and trade identical to, or even similar to, the Semelai, but this type of work can generate hypotheses useful for future research. An added benefit of the project was the retrieval of data relevant to current problems of tropical ecology and forest management. Discussion of these is divided into three sections: the tapping of *Dipterocarpus kerrii* oleo resin, the collecting of hard resins, and the extraction of gharu wood.

C.A.L.

30-S392.
Gianno, Rosemary.
Resin classification among the Semelai of Tasek Bera, Pahang, Malaysia.

Economic botany, **40,** no. 2, pp. 186-200, (1986), [Eng.]. tables, bibliog.

Resins are an abundant and varied resource in the wet tropical forests of Southeast

Asia. These exudates have been found archaeologically in Malaysia and are still exploited extensively by indigenous peoples. This article analyzes the system of plant classification used by the Semelai of Tasek Bera who still exploit in many traditional ways their local forest resources. Two types of English terminological usage are presented in order to facilitate description of the Semelai classification system. Their complex and interlocking categories reflect the large range of useful natural substances found in their local environment. It is concluded that an understanding of their classification of plant fluids, which is largely based upon gross morphological features, also requires a knowledge of Semelai torch technology. C.A.L.

30-S393.
Maheux, Anne; and Zegers, Peter.
Degas pastel research project: a progress report.

In proceedings. *Preprints of papers presented at the fourteenth annual meeting: Chicago, Illinois, 21-25 May 1986,* (1986), pp. 66-76, [Eng.]. ill., 7 notes.

In 1983 an in-depth research project on some 150 (out of 680) Degas's pastels was undertaken by the National Gallery of Canada with the aims of determining how he used the medium and why it appealed to him. A number of related aims for this study are listed as well and treated in the text. The investigation is not yet complete. Certain conclusions on his technique already emerge. Some causes of alteration are explored. This study led the authors to new levels of appreciation for Degas's pastels, not only as consummate works of art but as telling reflections of the artist's personality; they often show the conflict between his awesome manual dexterity and his even greater intellectual capacities. Staff

30-S394.
Minunno, Gabriella.
Azzurri.
(Blues.)

In book. *La fabbrica dei colori: pigmenti e coloranti nella pittura e nella tintoria,* (1986), pp. 327-382, [Ita.]. refs.

Blue pigments from the earliest times to the 18th century include azurite, smalt, Egyp-

tian blue, Mayan blue, and blue verditer. The blue dyes considered include woad, logwood, and litmus. Pigments and dyes of the industrial period include Prussian blue, cobalt blue, and cerulean blue, as well as many dyes. ICCROM(03696907)

30-S395.
Mora, Laura; Mora, Paolo; and Zander, Giuseppe.
Coloriture e intonaci nel mondo antico.
(Colorings and renderings in the ancient world.)

Bollettino d'arte, pp. 11-16, (1986), [Ita.]. ill., refs.

Techniques of building rendering and painting in the Roman world. A comparison of literary sources (Vitruvius and Pliny) and direct examination of ruins and buildings in Rome and Pompeii. Techniques of surface finishing in Roman architecture: the "Roman stucco." The Roman technique of mural painting: interpretation of Vitruvius' text.
 ICCROM(03569501)

30-S396.
Petropaoli, Rita; and Milaneschi, Annamaria.
Gialli.
(Yellows.)

In book. *La fabbrica dei colori: pigmenti e coloranti nella pittura e nella tintoria,* (1986), pp. 195-252, [Ita.]. refs.

The first section considers the origins, manufacture, and use of yellows from the time of their appearance in history until Greek and Roman times. These yellows were gamboge, yellow ocher, orpiment, yellow lead oxide, antimony yellow, saffron, and turmeric. Yellows in Medieval and Renaissance times included lead-tin yellow, gold, tin yellow, yellow lake, weld, aloe. Yellows of the industrial period (after 1700) include mars yellow, chrome yellow, cadmium yellow, zinc yellow, cobalt yellow, barium yellow, mineral yellows, and Indian yellow.
 ICCROM(03696904)

30-S397.
Quartullo, Giuliana.
Rossi.
(Reds.)

In book. *La fabbrica dei colori: pigmenti e coloranti nella pittura e nella tintoria*, (1986), pp. 79-136, [Ita.]. refs.

The reds covered are vermilion, red lead, realgar, red ocher, carmine, madder, red lake, archil, dragon's blood, litmus, and sappan wood. The use of red colors in dyeing and painting during the 1550 to 1700 period is described, followed by a section on synthetic reds of the industrial age.

ICCROM(03696902)

30-S398.
Roche, Alain.
Notes sur les origines du vieillissement prématuré des peintures contemporaines. (Notes on the causes of premature aging of contemporary paintings.)

Conservation restauration, no. 7/8, pp. 22-24, (1986), [Fre.].

The causes of premature aging of modern paintings are numerous and varied. The author considers economic factors influencing painters in their selection of canvas, stretchers, pigments, and binding agents, warning against the use of low-cost or defective materials. Under the heading of erroneous applications of painting materials, he considers in turn the misapplication of a product (not conforming to its intended use), the abuse of additives, the use of incompatible materials, and the lack of respect for the principle "fat over lean." A better knowledge of material properties is the best way to prevent premature aging of paintings.

A.A. and M.B.(transl.)

30-S399.
Cranmer, Dana.
Ephemeral paintings on "permanent view": the accelerated ageing of Mark Rothko's paintings.

Affl: The Mark Rothko Foundation, Inc., New York, NY, USA.

In book. *ICOM Committee for Conservation, eighth triennial meeting, Sydney, Australia, 6-11 September, 1987: preprints*, Grimstad, Kirsten, Editor (1987), pp. 283-285, [Eng.]. 2 ill., 2 notes.

The paintings of the New York School painter, Mark Rothko, are aging at an accelerated rate. The combination of his experimental techniques and materials, and the vulnerability of the paintings to environmental degradation have contributed to this deteriorating process. By briefly assessing the three mural projects that Rothko painted between 1958-1965, including their formulation and specific histories, factors which have precipitated the changes in the paintings can be established. Ultimately this information can be applied to Rothko's paintings in general, emphasizing preventive measures for their maintenance and treatment. Staff

30-S400.
Innes, Jocasta.
Paint magic: the home decorator's guide to painted finishes.

Book. Pantheon Books, New York, 1987, Rev. ed. [Eng.]. 239 p.: ill. (some col.); 28 cm., bibliog. and index. [ISBN 0-394-75434-4].

A comprehensive guide to the art of painted finishes. Techniques for the home decorator are explained and illustrated in detail. Painting walls: special paint finishes and decorative painting. Woodwork: simple decorative treatments and fantasy finishes. Floors: transparent and painted finishes. Furniture: paint finishes and decorative flourishes. A useful appendix provides background knowledge on materials and technologies.

ICCROM(03150700)

30-S401.
Isaacs, Jennifer.
Bush food: Aboriginal food and herbal medicine.

Book. Weldons Pty Ltd, McMahons Point, 1987, [Eng.]. 256 p.: col. ill., map; 31 cm., bibliog. and index. [ISBN 0-949708-33-X].

Describes the entire range of wild foods used by the indigenous Australians. Medicinal materials are also discussed and one section describes cooking techniques. Of particular interest is a description of orchid tubers that are eaten. Orchid tubers are often cited as the source of a binder used in formulating paints. The Queensland tree orchid (*Cymbidium canaliculatum*) is eaten raw or boiled. The author states "the thick starch gives this food the common nickname of native arrowroot."

**83**

Another noteworthy section describes "Honey, gum and nectar." A wide range of edible gums are gathered as a delicacy. Foodstuffs are probably often the same materials used as binders and adhesives. Processing methods are also probably similar. This book gives a good understanding of the materials available, the seasonal round, and the technology used in processing foods and medicines. M.H.B.

30-S402.
Karsten, Erich; Lückert, Olaf, Editor.
Lackrohstoff-Tabellen.
(Lists of raw materials for lacquer.)

Book. Curt R. Vincentz Verlag, Hanover, 1987, 8th ed. [Ger.]. 748 p., index. [ISBN 3-87870-340-6].

Lists all raw materials available for use by the European paint industry. Pigments, however, are covered in a separate volume. Sections include natural binders, solvents, plasticizers, and additives. Materials are listed by trade name with information on the physical properties of the substance, its composition, and recommended uses. Indices and chapter headings are given in English, French, German, and Italian. A standard reference for European paint chemists.
M.H.B.

30-S403.
Lincoln, Louise.
Assemblage of spirits: idea and image in New Ireland.

Book. George Braziller, Inc., New York; Minneapolis Institute of Arts, Minneapolis, 1987, 1st ed. [Eng.]. 168 p.: ill.; 29 cm., bibliog. [ISBN 0-8076-1187-5].

Malangan sculpture is usually made of the wood of *Alstonia villosa*, described as being like the European linden in texture. Traditionally, the wood is carefully worked to prevent cracking. A tool kit of sharpened pieces of shell and sharks' teeth is used for shaping and carving. Finish work is done with the skin of sharks and rays. The valve of the sea snail *Turbo petholatus* is used for eyes. For pigments, a white made from lime powder, red ocher, black from ashes, charcoal, or burnt *Calophyllum* nuts are employed. Yellows and blues are derived from plant sources (not specified). Brushes are made

from *Alpinia* leaves. Hair is suggested by making a paste of the fruit of the *parinarium* into which is pressed the fruit of the pandanus to give an effect of coarse hair. Other fibrous material is often adhered as well. Introduced paints and tools have supplanted many of the traditional materials. M.H.B.

30-S404.
Murphey, Edith Van Allen.
Indian uses of native plants.

Book. Mendocino County Historical Society, Mendocino, 1987, 3rd ed. [Eng.]. 81 p.: ill.

Describes plants used by Native Americans primarily in Northern California and the West but in other areas as well. Discusses plant dyes and mordants as well as mineral pigments used for paint. There is also a reference to slashing pines and gathering the gum the following year after the piñon harvest. The gum is then picked over to clean it and softened for use. Refers to the use of a fungus called conk (*Fomes laricus*) as a source of red pigment. Also cites the use of the roots of snowdrops (*Plagiobothrys campestris*) as source of a red coloring matter. M.H.B.

30-S405.
Nishio, Yoshiyuki.
Pigments used in Japanese paintings.

The paper conservator: journal of the Institute of Paper Conservation, **11**, pp. 39-45, (1987), [Eng. w. Fre. summary]. photos., refs.

An introduction from an artist's point of view, to some of the basic techniques concerning traditional Japanese preparation of pigments. Describes the two painting techniques, sumie and nihonga, and considers the pigments in detail: oyster shell white, kincha, shinsha (cinnabar), rokusho (malachite) and gunjo (azurite), indigo, vermilion, red lead, iron oxide brown, yellow ocher, gamboge, obsidian, white lead, and china clay. Illustrates preparation of pigments (both regular and alternative/special methods) and painting techniques used to obtain special effects.
ICCROM(03988106)

30-S406.
Parezo, Nancy J.
The formation of ethnographic collections: the Smithsonian Institution in the American Southwest.

Advances in archaeological method and theory, **10,** pp. 1-47, (1987), [Eng.].

The material collected by Bureau of American Ethnology investigators in the Southwest—such as Matilda Coxe Stevenson, James Stevenson and Frank Hamilton Cushing—was shipped to what became the Smithsonian. This article describes the formation of these collections and the rationale behind the collecting. An appendix gives a chronological listing of expeditions and lists material collected from various groups in the Southwest. The material collected represents a complete spectrum of indigenous Southwestern material culture of the period. M.H.B.

30-S407.
Smith, Ray.
The artist's handbook.

Book. Alfred A. Knopf, Inc., New York, 1987, 1st American ed. [Eng.]. 352 p.: ill. (some col.); 25 cm., bibliog. and index. [ISBN 0-394-55585-6].

Provides an introduction to artists' materials (pigments, binders, adhesives, and supports) and overviews of techniques of drawing, painting, and printmaking. Discusses color and perspective, as well as conservation and framing. Provides brief histories of techniques and provides color "how-to" illustrations. S.Q.L.

30-S408.
Dreamings: the art of Aboriginal Australia.

Videorecording. Film Australia, Lindfield, 1988, Videocassette VHS (30 min.), sd., col. [Eng.]. Riley, Michael (Director); Bell, Janet (Producer); Film Australia (Producing Agency).

Discusses myths of Australian Aboriginal culture and the concept of "the dreaming." Explores the symbolism of Aboriginal art, from the acrylic dot paintings of the Central Desert to cross-hatched bark paintings and burial poles from the Northern Territory. Interviews Australian Aboriginal painter Michael Nelson Jakamarra (b. 1946) and shows him at work on a canvas. A ceremonial dance by the women of the Great Western Desert at a sacred waterhole is depicted. Made in conjunction with the 1988-90 touring exhibit "Dreamings: The Art of Aboriginal Australia" organized by the Asia Society Galleries, New York City, and the South Australian Museum, Adelaide. PFAOF

30-S409.
Albano, Albert.
Art in transition.

Affl: The Museum of Modern Art, New York, NY, USA.

In book. *Preprints of papers presented at the sixteenth annual meeting, New Orleans, Louisiana, 1-5 June 1988,* (1988), pp. 195-204, [Eng.].

The intent is to assess current criticism of faulty materials and techniques used in 20th-century art by reviewing some of this criticism within a historical context. This will encourage conservators to draw conclusions which will be more broad-minded and sympathetic towards the material nature of modern and contemporary art. Staff

30-S410.
Bethell, John T.
Damaged goods.

Harvard magazine, **1988,** no. July-August, pp. 24-31, (1988), [Eng.]. 11 photos.

Mark Rothko painted a suite of five paintings for Harvard's Holyoke Center penthouse. He painted only two other ensembles (one now at the Tate and the other in the Houston Rothko Chapel). Tests carried out recently at the Center for Conservation and Technical Studies in Cambridge, Massachusetts, indicated that Rothko had made up his crimson background by mixing synthetic ultramarine and lithol red, a fugitive organic colorant. The distressed reactions to the changed paintings, the unfortunate choice of the high light level display area in 1962-63, the subsequent physical damages, and removal from display are chronicled. The paintings will be displayed again for a limited time in 1988 accompanied by a detailed monograph, *Mark Rothko's Harvard Murals.* (See also S413 and S418, following). Staff

30-S411.
Burt, Eugene C., Compiler.
Ethnoart: Africa, Oceania, and the Americas: a bibliography of theses and dissertations.

Book. Garland reference library of the humanities, no. 840, Garland Publishing, New York, 1988, [Eng.]. xix, 191 p.; 23 cm., indexes. [ISBN 0-8240-7545-5].

A bibliography of dissertations and theses about the visual arts, architecture, material culture, or archaeology of indigenous peoples of Africa, the Americas, and Oceania. Entries date from the late 19th century to 1987. It is divided into five chapters, each covering one of the geographic areas; the first chapter is devoted to general items that cover more than one area. Each chapter is further divided by geography, culture groupings, historical periods, and other factors. At the end are three indices arranged by author, institution, and subject.　　　　　C-A.G.

30-S412.
Castello Yturbide, Teresa.
Colorantes naturales de México.
(Natural dyes of Mexico.)

Book. Industrias Resistol, S.A., Mexico City, 1988, [Spa.]. 172 p. [ISBN 968-6318-00-3].

Describes the art of dyestuffs of the ancient Mexicans, using natural colors, and explains the sources, including plants, animals, minerals, etc. Discusses also how the Mexicans still use the ancient methods. Contains samples obtained from the use of such colorants. Of great utility for paper and textile restoration, this work suggests that natural colors be used again instead of chemical ones in daily life.　　　　　M.D.L.V.

30-S413.
Cohn, Marjorie B.
Mark Rothko's Harvard murals.

Book. Harvard University Art Museums. Center for Conservation and Technical Studies, Cambridge, 1988, [Eng.]. 62 p.: ill. (some col.); 28 cm., refs. [ISBN 0-916724-69-7].

Murals by Rothko installed in the dining room of the Holyoke Center of Harvard University were painted using unstable colors which caused them to fade dramatically. The building was designed by Lluis Sert and the paintings done by Rothko specifically for the space. He used lithol red, a pigment very susceptible to fading, and a technique of painting that involved a very lean glue medium applied directly to the canvas. Subsequent surfaces painted on this first "stain" layer are also painted quite thinly. The canvas is described as being still supple and the paint layer uncracked except in some of the more thickly painted white layers in one of the paintings. Flaking and delamination were not a problem at the time of this publication. A bureaucratic muddle over who was responsible for the care of the paintings resulted in their being irreparably damaged by severe fading. A number of interested parties tried to prevent further damage and save the paintings but to no avail. Today the paintings are permanently stored. Rothko wanted the paintings to be viewed from a distance of 18 inches which placed them in an impossible proximity to diners. The sheer scale of the paintings and the function of the room created a situation where the paintings were vandalized and subject to accidental damage. The arrangement of the windows created a situation where the light levels were impossibly high. Rothko intended the viewer to look at the paintings from 18 inches away so that they filled the entire field of vision, both frontal and peripheral. The matte luminous qualities of the surface were of the greatest importance to the artist who intended the viewer to perceive certain effects.　　　　　M.H.B.

30-S414.
Cook, James; Beaglehole, John Cawte, Editor.
The journals of Captain James Cook on his voyages of discovery.

Book. Kraus Reprint and Periodicals, Milwood, 1988, [Eng.]. 3 v.: ill., maps (some col.); 24 cm., bibliog. and index. [ISBN 0-8115-3861-3].

Reproduces the diaries of Cook and those kept by his crew members on his Pacific voyages. These diaries and the diaries of Joseph Banks are important sources of information about the material culture of the indigenous peoples they encountered. Descriptions of painted canoes and caulking adhesives in the Pacific Northwest and in Polynesia are of particular interest. The index in volume 3, number 4 lists flora and fauna referred to by scientific nomenclature. Species

used for fiber, dyes, and adhesives in the making and decorating of tapa are described with notes by the editor discussing proper nomenclature and referring to other sources.
M.H.B.

30-S415.
Cox, J. Halley; and Davenport, William H.
Hawaiian sculpture.

Book. University of Hawaii Press, Honolulu, 1988, [Eng.]. xxvi, 213 p.: ill.; 28 cm., bibliog. [ISBN 0-8248-1069-4].

The section on technology describes the woods used and the methods of seasoning the wood. The authors state that wooden figures were rarely painted but sometimes stained or finished with plant juices or oils. The only plant specifically mentioned is *kukui* (*Aleurites moluccana*). Tools used for carving and methods are described.
M.H.B.

30-S416.
De Plaen, G.
Étude de la patine.
(The study of patina.)

In proceedings. *Symposium '86: the care and preservation of ethnological materials: proceedings = L'entretien et la sauvegarde de matériaux ethnologiques: actes,* Barclay, R.; Gilberg, M.; McCawley, J.C.; and Stone, T., Editors (1988), pp. 223-226, [Fre. w. Eng. + Fre. summaries]. 2 figs.

The patina in Zairian art is the work of the sculptor, and not merely the result of time or use. It is tied to the distinctive cultural characteristics of each style. The complex work of the sculptor may include up to 10 successive operations with complementary functions. Some are designed to preserve the wood, while others give the artifact its cultural character. Knowledge of these techniques is essential in order to distinguish genuine artifacts from fakes; however, it is also important for determining restoration procedures which respect this important aspect of style. For example, various techniques characteristic of specific ethnic groups are examined: Luba, Tabwa, and Kuba. References are made to the various intended uses for the sculpture, for example: domestic use, musical instruments, and religious objects. A true appreciation of the value of the patina

leads to an accurate definition of authentic art and appropriate conservation procedures.
A.A.

30-S417.
Howatt-Krahn, A.
Field research in the conservation of ethnographical collections: an ecological approach applied to polychrome monumental sculpture.

In proceedings. *Symposium '86: the care and preservation of ethnological materials: proceedings = L'entretien et la sauvegarde de matériaux ethnologiques: actes,* Barclay, R.; Gilberg, M.; McCawley, J.C.; and Stone, T., Editors (1988), pp. 156-169, [Eng. w. Eng. + Fre. summaries]. 5 figs., 24 refs., bibliog.

Methods for field research and analysis of ethnological collections are discussed. Preparatory research for the reproduction of the 19th-century Kwakiutl totem pole, the objective was to produce a reproduction which would accurately represent the technology and aesthetics of the original decoration. Investigation included: examination of photographs, consultation with curators, paint analysis, research on sources and types of paint available from 1880 to 1890 in British Columbia, interviews and collection reviews. Concludes with the results and the broader implications for the evolution of Native art and artifacts in response to the influences of industry, technology, and museums. The author discusses the methodology of field research in conservation and suggests further applications for investigative conservation for Native North American collections.
Staff

30-S418.
Kimmelman, Michael.
Mark Rothko's Harvard murals are irreparably faded by sun.

The New York Times, **1988,** no. August 8, p. 11, (1988), [Eng.].

The "lush crimson toned paintings" have faded, due largely to the artist's use of lithol red as his dominant color. The murals have also been ripped, spattered with food, and marred by graffiti. The Chief Conservator of the Harvard Center for Conservation and Technical Studies has organized an exhibition which opened 6 August 1988, for only

two months, bringing focus to the fragility of 20th-century materials. After the exhibition, the paintings (carefully treated yet permanently discolored) will be returned to dark storage. Staff

30-S419.
Maheux, Anne F.
Degas pastels.

Book. National Gallery of Canada, Ottawa, 1988, [Eng.]. Can.$14.95. 93 p.: 43 ill. (20 col.), ports.; 23 cm., bibliog. [ISBN 0-88884-547-2].

Study of the techniques used by Degas in executing his pastels, from the late 1850s until about 1900. The evolution of his technique from the classic methods emulating oil paintings, e.g., Jacopo Bassano (1517-92), or preliminary sketches or studies, to his use of pastels over ink monotypes and heavily built-up layers of color using dry pastel, *pastel à l'eau* applied with a brush, distemper (powdered pigment mixed with heated solution of water and glue), *peinture à l'essence* (soaking oil out of paint and diluting it with turpentine), gouache and pastel paste in his later works, are described. Degas's technique of blending the colors, stamping, cross-hatching, striping (*zébrures*), steaming, burnishing, and using fixatives (especially in his later work) are all discussed. There is a chapter on pastel supports. The book has an appendix by Anne F. Maheux, Judi Miller, and Ian N.M. Wainwright entitled: "Technical analysis of the Degas pastels at the National Gallery of Canada." Close examination of pastels using infrared challenges the question of fragility and perishability of the medium. In his use and combination of traditional techniques, Degas has transformed them to an innovative and new artistic vehicle, reflecting the artist's technical skill and creative capacity. N.S.

30-S420.
Marxen, Ingegerd; and Moltke, Erik.
The Jelling Man and other paintings from the Viking age.

Mediaeval Scandinavia, **12**, pp. 107-121, (1988), [Eng.]. plates (some col.), figs., refs.

The Jelling Man is a painted wooden figure found in the grave chamber of King Gorm and Queen Thyre when a mound at Jelling was excavated in 1820. Dating from

ca. 955-985, this figure of a man was analyzed by Professor Zeise, a highly respected chemist at the time, in the 1820s. He concluded that the paint was oil paint and analyzed the pigments. The authors are of the opinion that it was more probably egg tempera. The significance of the Jelling Man is that it is the earliest surviving example of a rich tradition of painted wood in Scandinavia. The piece was lightly cleaned under a microscope to remove dirt and earlier conservation materials. A detailed pigment analysis follows that shows that the figure was first painted blue (actually a black of plant origin and chalk that appears blue). No consolidation is mentioned. A drawing done in 1875 indicates that the piece has suffered severe pigment loss and overall shrinkage since that time. M.H.B.

30-S421.
Natale, Pietro; and Scarzella, Paolo.
Terre coloranti e loro colori.
(Earth pigments and their colors.)

In book. *Le scienze, le istituzioni, gli operatori alla soglia degli anni '90*, (1988), pp. 175-183, [Ita. w. Eng. summary]. 1 graph.

Natural mineral pigments—ochers, siennas, umbers, etc.—were traditionally employed for manufacturing paints until the second world war. They were later replaced by synthetic-based "washable" products which have both bad weathering properties and an undesirable appearance. A research program on the natural pigments commonly used in Piedmont, Italy, started in 1986; its initial results are reported and discussed.
 ICCROM(03949644)

30-S422.
Rosenfeld, Andrée.
Rock art conservation in Australia.

Book. Special Australian Heritage publication series, no. 2, Australian Government Publishing Service, New York, 1988, 2nd ed. [Eng.]. 79 p., bibliog. [ISBN 0-644-07197-4].

Describes the types of rock art in Australia and the techniques employed in making it. The deterioration and conservation of rock art is discussed with strategies employed to protect sites and the often delicate friable surfaces of rock art. Contends that there is no evidence for organic binders used

in rock art (recent findings by Loy contradict this). Organic binders were used in body painting and bark painting and are well documented but no such evidence exists for rock art. The author believes that water only was used in formulating paint for rock art. Binders may not have been used or are so deteriorated that a battery of analytical techniques have not provided a body of conclusive analytical evidence for organic binders until recently. This book's audience is not necessarily restricted to rock art conservators, as it is a summation of information concerned with the techniques of rock art, its weathering processes, and conservation strategies for archaeologists and other interested parties.

M.H.B.

30-S423.
Roy, Ashok.
The technique of a *Tüchlein* by Quinten Massys.

National Gallery technical bulletin, **12**, pp. 36-43, (1988), [Eng.]. photos., refs.

Tüchlein, a glue tempera medium on linen, is an early Netherlandish technique used for *The Virgin and Child Saints Barbara and Catherine* attributed to Quentin Massys. Technical examinations disclosed an animal glue medium, linen fiber, and lack of a conventional ground. Infrared photographs showed an underdrawing and black underpaint. The painting is compared to a Dieric Bouts *Entombment* executed in the same technique.

ICCROM

30-S424.
Society For Economic Botany; Balick, Michael J., Editor.
The palm, tree of life: biology, utilization, and conservation. Proceedings of a symposium at the 1986 annual meeting of the Society for Economic Botany held at the New York Botanical Garden, Bronx, New York, 13-14 June 1986.

Book. Advances in economic botany, no. 6, New York Botanical Garden. Scientific Publications Department, Bronx, 1988, [Eng.]. 282 p.: ill.; 26 cm., refs., indexes. [ISBN 0-89327-326-0].

Palms are an important source of a large number of useful products. Among these are oil, sugar, fiber, building materials, and a number of other products. They have

been used extensively by indigenous peoples in the manufacture of artifacts. The oils and resins from palms have frequently been used as binding media in paint. This book is the published proceedings of a symposium held at the New York Botanical Garden by the Society for Economic Botany in 1986.

M.H.B.

30-S425.
Sutton, Peter, Editor.
Dreamings: the art of aboriginal Australia.

Book. George Braziller, Inc., New York, 1988, [Eng.]. 266 p., bibliog. and index. [ISBN 0-8076-1201-4].

The catalog for a travelling exhibition organized by the Asia Society Galleries in New York and The South Australian Museum in Adelaide. It describes the history and traditional techniques of Australian Aboriginal art and how it was perceived by Europeans coming to Australia. Contemporary Aboriginal artists are the true focus of the text and modern methods of painting using acrylics and other commercial materials are also described. Religious and spiritual beliefs concerned with the art are explained. Particularly interesting is Philip Jones' chapter on the reaction to Aboriginal art in the European art world and the early collectors and ethnographers interested in Australian Aboriginal art. Biographies of the artists in the show are given.

M.I.I.B.

30-S426.
Turner, N.J.
Ethnobotany of coniferous trees in Thompson and Lillooet Interior Salish of British Columbia.

Economic botany, **42**, no. 2, pp. 177-194, (1988), [Eng. + Fre.]. 23 refs.

All 17 species of conifers (and one taxad) occurring within the traditional territories of the Thompson and Lillooet Interior Salish of British Columbia are known to these peoples and named by them at a restricted level. Of moderate to high cultural significance, most were used many ways of traditional life. Uses included: food—seeds, inner bark, sugar, pitch (for chewing), and boughs (for making beverages); technology—wood for construction and fuel, bark for construction, fibrous materials for weaving, resins for

glue and caulking, and, of prime significance, boughs as scents and cleansing agents; and medicine—primarily as tonics, and as remedies for respiratory ailments, stomach and digestive disorders, eye problems, and dermatological complaints. The use of boughs as scents and agents for cleanliness also made conifers very important in religious and spiritual rituals. Some were also featured in mythology. Thompson and Lillooet people continue to use conifers, but to a more limited extent than in the past.

F.P.A.(12:869) and A.A.

30-S427.
Yue, Fei-An; Silbergeld, Jerome, and McNair, Amy, Translators.
Chinese painting colors: studies of their preparation and application in traditional and modern times.
(Chinese title: Chung-kuo hua yen se ti yen chiu.)

Book. Hong Kong University Press, Hong Kong; University of Washington Press, Seattle, 1988, English [Eng.]. xiv, 93 p.: ill. (some col.); 29 cm., bibliog. and index. [ISBN 962-209-222-5; 0-295-96356-5].

Describes the pigments used in Chinese painting and the methods used to prepare them. Glue is used as a binder and alum is often used as a size. Substrates are often prepared with a size of glue and alum. The alum solution serves the purpose of fixing the colors. A number of plant pigments are used in traditional painting. Log woods are used, gardenia seeds for a yellow, gamboge (*Garcinia hamburyi*), the sap from a rattan is another yellow, and a number of plants for blues including indigo. M.H.B.

30-S428.
Agrawal, O.P.; and Tiwari, Rashmi.
Analysis of pigments and plaster of the paintings in the Sheesh Mahal, Nagaur.

In book. *Examination and conservation of wall paintings of Sheesh Mahal, Nagaur: a programme under National Project on Wall Paintings,* (1989), pp. 30-36, [Eng.]. 2 figs., 15 refs.

The pigments used for the wall paintings in the Sheesh Mahal, Nagaur, were identified by x-ray diffraction and microchemical techniques. The support of the painting was a wall made of red sandstone blocks. The plaster was composed of a mixture of lime and

an inert material. The technique of preparing the plaster was the Rajasthani technique in which burnishing and reburnishing the surface plaster plays a very important role. The various pigments were identified as follows: red pigments were of three types: red lead, red ocher and cinnabar; blue: indigo; green: malachite; yellow: orpiment; white: chalk, zinc white; gold. Staff

30-S429.
Antúnez De Mayolo, K.K.
Peruvian natural dye plants.

Economic botany, **43,** no. 2, pp. 181-191, (1989), [Eng. w. Eng. summary]. 60 refs.

The use of natural dyes to color textiles and other objects has a long history in Andean South America, but has for the most part become a lost technology with the introduction of synthetic dyes. A literature and field survey to recover information about the traditional use of dye plants in Peru, from pre-Hispanic to recent times, was accompanied by taxonomic identification of collected dye plant materials. Lists 56 dye plants from Peruvian sources.

F.P.A.(12:1834) and D.W.G.

30-S430.
Baudisch, Jens.
Studien zur Maltechnik von Otto Dix in der Schaffenszeit von 1933-1969.
(Studies on the painting technique of Otto Dix during the period 1933-1969.)

Zeitschrift für Kunsttechnologie und Konservierung, **3,** no. 2, pp. 321-362, (1989), [Ger.]. 43 ill. (10 col.), 227 refs., bibliog.

Describes the development of the painting methods of the German realist painter Otto Dix (1891-1969) from 1933 to 1969. The study is based on the visual examination of 37 paintings. Stereo microscope, ultraviolet fluorescence, and (for pigment analysis) x-ray diffraction analysis (XRD) and optical emission spectroscopy (OES) were used in a few cases. Written and oral sources by the artist and his contemporaries complement the information. The evolution of the artist's style with changes of technique is observed, as well as the use of preliminary drawings and compositions incorporating the Golden Section. Frame molding profiles designed by the artist are shown. After his dismissal from the Dresden Academy in 1933, Dix adapted the

Mischtechnik (tempera and oil glazing technique) to landscape painting. A change to a more opaque combination of tempera and oil started in 1943, but the artist continued to underpaint, occasionally taking to pure oil painting. (See also AATA 30-1143.) U.D.

30-S431.
Bourgeois, Jean-Louis.
Spectacular vernacular: the adobe tradition.

Book. Aperture Foundation, New York, 1989, [Eng.]. 191 p.: col. photos.; 32 cm., refs. [ISBN 0-89381-391-5].

Documents, discusses, and defends adobe architecture of the desert and savanna in West Africa, Southwest Asia, and the American Southwest. This vernacular tradition of architecture has given rise to a remarkable range of styles and forms in the severe desert climates of these areas. This striking form of architecture should be protected against the ideology and march of progress. Considers mud architecture; townscapes; household construction techniques; decorated walls; shrines; West African mosques; Afghan Muslim *Ziarats*; and Western preconceptions (political and ideological) about adobe in these areas. Most of the architecture is from Islamic regions. Countries studied include Afghanistan, Pakistan, India, Mauritania, Burkina Faso, Mali, Senegal, Guinea, and Ivory Coast. A special appendix provides a critical overview of adobe building codes concerning plaster repairs in the US Southwest. This outlaws the use of mud plaster and instead requires the application of a cement plaster veneer, which often leads to structural damage and problems. These regulations involve procedures more dangerous than those they forbid.
ICCROM(04403300)

30-S432.
Brochwicz, Zbigniew; Górzyńska, Małgorzata; Domasłowski, Jerzy; and Wiklendt, Janusz.
Materiały i techniki malarskie malowideł ściennych w nawie głównej kościoła p.w.NMP w Toruniu.
(Materials and painting techniques of the wall paintings of the main nave of S. Mary's Church in Toruń.)

Zabytkoznawstwo i konserwatorstwo, **14,** pp. 3-21, (1989), [Pol. w. Eng. summary]. 6 tables, 18 refs.

Technological and chemical analyses allowed the determination of materials and the technical structure of two wall paintings in the main nave of the church. Initially, stratigraphy of mortars, whitewash, and paint film was determined. Three- (mortar, whitewash, paint) or four-layer (mortar, two whitewash layers, paint film) structures were found. The mortars examined show a variable binder-to-filler ratio, the binder being of basal, or, locally, of porous type. Natural aggregate of fluvial origin is the main filler component. Chalk whitewash containing carbohydrates, presents a good adhesion to mortars, which indicates that it was applied to wet mortar. The color scale of the examined paintings includes the following: chalk, ocher, red lead, iron red, azurite, malachite, raw umber, carbon black. The binder of the paint film contains corn glue with an admixture of an unidentified protein-like substance.
A.A. and ICCROM

30-S433.
Cook, N.D.J.; Davidson, I.; and Sutton, S.
Seeing red in Queensland.

Nature, 342, no. 6249, p. 487, (1989), [Eng.].

A brief letter describing the mechanism by which goethite, a yellow brown pigment used in rock art, converts to hematite under certain weather conditions. This may account for the seeming predominance of red observed in older rock art in Australia. Yellows may convert to hematite except in low-temperature, humid caves.
M.H.B.

30-S434.
De Keijzer, M.
The colourful twentieth century.

In proceedings. *Modern art: the restoration and techniques of modern paper and paints: proceedings of a conference jointly organised by UKIC and the Museum of London, 22 May 1989,* Fairbrass, Sheila; and Hermans, Johan, Editors (1989), pp. 13-20, [Eng.].

The Standard Specification of Artists' Oil and Artists' Acrylic Emulsion Paints gives a survey of compounds used as artists' pigments, which is recommended by the ASTM Committee. The pigment lists of manufactur-

ers indicate which modern organics and inorganics are used. This article describes the blue, violet, and green modern 20th-century synthetic organic and inorganic artists' pigments. The history and development of these pigments have been studied from the literature, especially patent literature, because the invention and the start of the industrial production can be ascertained from patents. The chemical identification can be done by microchemical color reactions, laser-microspectral analysis, x-ray diffraction, infrared spectrophotometry and micro-crystallizations. These methods of analysis together with the discovery dates of the individual modern synthetic organic and inorganic artists' pigments enable dating modern works of art and detection of forgeries. M. de K.(A.A.)

30-S435.
De Keyzer, M.; and Karreman, M.F.S.
Een vroeg-twintigste-eeuwse pigmentcollectie: De pigmentcollectie van het Missiemuseum te Steyl-Tegelen. (An early 20th-century pigment collection: the pigment collection in the Missiemuseum at Steyl-Tegelen.)

Mededelingenblad (IIC Nederland), **6**, no. 2, pp. 7-24, (1989), [Dut. w. Eng. summary].

A collection of pigments was found in 1986, during the restoration of the dioramas in the Missiemuseum at Steyl-Tegelen (Limburg, Netherlands). The pigments had been used in 1929 for decorating the dioramas. The collection was analyzed microscopically, by microanalytical methods, laser microprobe, x-ray diffraction, and Fourier transform infrared spectroscopy (FTIR). Mainly common 19th-century and earlier pigments were found: yellow ocher, chalk, zinc white, barium sulfate, lithopone, artificial ultramarine, lead chromate, and cobalt green. Some rather rare pigments were identified, e.g. artificial posnjakite, Indian yellow, ultramarine red, and a modern synthetic organic pigment, chlorinated-p-nitroaniline red (PR 4, 12085). FTIR spectra were made of 10 more synthetic organic pigments. For the major part these were discovered in the last quarter of the 19th century. This study gives a good idea of what pigments were used in 1929 and what synthetic organic pigments were commercially available at that time.

M. de K.(A.A.)

30-S436.
Fairbrass, Sheila; and Hermans, Johan, Editors.
Modern art: the restoration and techniques of modern paper and paints. Proceedings of a conference jointly organised by UKIC and the Museum of London, 22 May 1989.

Proceedings. United Kingdom Institute for Conservation, London, 1989, [Eng.]. 36 p.: ill.; 30 cm., refs. [ISBN 1-87-1656-04-4].

Proceedings of a conference jointly organized by UKIC (United Kingdom Institute of Conservation) and the Museum of London held 22 May 1989, at the Museum of London in England. Contributions covered the following subjects: modern paper, pigment-coated papers, the colorful 20th century, modern-day artists' colors, collage and other novel uses of paper, screen printing, and the conservation of a paper banner. ICCROM(04347100)

30-S437.
French, Alan.
Modern day artists colours.

In proceedings. *Modern art: the restoration and techniques of modern paper and paints: proceedings of a conference jointly organised by UKIC and the Museum of London, 22 May 1989*, Fairbrass, Sheila; and Hermans, Johan, Editors (1989), pp. 21-22, [Eng.]. refs.

All artist color manufacturers offer an exhaustive range of artists' color, some which could be classified modern and others, traditional. Oils, watercolors, and egg tempera constitute the latter category, while there have only been two important innovations in more modern times: the alkyd and acrylic media. This contribution aims at outlining the history and development of these two media and at highlighting their respective merits. Concludes that both media, but especially acrylic, will gain more acceptance over the next 30 years. ICCROM(04347104)

30-S438.
Fünders, W.
Aktuelle Befunde zur Verwendung
"vergessener" Pigmente in
niedersächsischen Raumfassungen.
(Topical observations on the use of
forgotten pigments used for painting
rooms in Lower Saxony.)

In book. *Restaurierung von Kulturdenkmalen: Beispiele aus der niedersächsischen Denkmalpflege,* Berichte zur Denkmalpflege in Niedersachsen, no. 2, Moller, Hans, Editor (1989), pp. 44-48, [Ger.]. 9 figs., 17 refs.

Restorations of historical buildings in Lower Saxony, Germany, are accompanied by the analysis of pigments used for painting rooms. It was found that powdered crystals of gypsum were frequently used together with other pigments, such as nontronite, ocher, hematite, pyrite, and vivianite. For white paints, mixtures of gypsum, lime, and a magnesia-containing carbonate were used. Besides these powdered minerals (which were used together with powdered crystals of gypsum), galena, antimonite, and calcined glass were used. It seems possible that pharmacies, where these materials were common products, also provided products which could be used as pigments. J.R.

30-S439.
Idiceanu, Dorina.
Forme de degradare specifice si cauzele producerii lor la pictura in tempera, pepanou de lemn.
(Specific forms of degradation and their causes in wood panel tempera paintings.)

Revista muzeelor si monumentelor: Muzee, 3, no. 3, pp. 30-38, (1989), [Rum. w. Fre. summary]. 20 photos., bibliog.

About 2,000 Romanian wood panel tempera paintings from the 15th to the 18th centuries were examined to study the causes of their deterioration. These may be divided in two categories: those of natural origin including temperature, humidity, wood and painting technologies used by the artists, and those of human origin including overcleaning and inappropriate handling. C.A.L.

30-S440.
Matteini, M.; and Moles, A.
Tecniche della pittura antica: la preparazione del supporto.
(Techniques of ancient painting: the preparation of the support.)

Kermes, 2, no. 4, p. 13, (1989), [Ita.]. 10 photos.

After an introduction explaining that, from the attention paid to working technique by early painters, it could almost be called a science, the article is in the following sections: the need for a prepared support layer; the gesso preparation of wooden panels; priming layers; oil-based preparation layers; preparation of metal leaf. Cross sections, in color, illustrating the text show layer composition for fresco, panel, canvas, and polychrome paint. ICCROM(03974208)

30-S441.
Phillips, Morgan.
Historic finishes analysis.

In technical report. *Historic structure report, Morse Libby Mansion, Portland, Maine, National Park Service, Washington, DC,* 1989, pp. 117-216, [Eng.].

Discusses the condition of the painted surfaces in the Morse Libby Mansion. Painted surfaces in historic houses suffer from lack of cohesion. Considerable difficulties arise when trying to deal with large areas of friable, flaking paint. In this structure the painted surfaces are described by the author as being of considerable historic importance. Many of these paints are water-based or distemper. The author notes that "Distempers are extremely vulnerable to staining by adhesives" and remarks that while consolidation without discoloration has been done on art objects successfully, the question in architecture is how to do this in a cost-effective manner for large areas. A pilot program to investigate this is suggested. M.H.B.

30-S442.
Shelley, Marjorie.
American pastels of the late nineteenth & early twentieth centuries: materials and techniques.

In book. *American pastels in the Metropolitan Museum of Art,* (1989), pp. 33-45, [Eng.].

Discussion of the fabrication of pastels and their use by late 19th- and early

20th-century American artists. Techniques of individual artists are discussed, e.g., James McNeill Whistler, John Twachtman, Everett Shinn, Mary Cassatt, Robert Blum, Arthur B. Davies, etc. Subheadings are: Medium: pigments, fillers and binders; Pigments; Fillers; Binders; Fabricating the crayon; Handling; Supports; and Fixatives. Some of the possible conservation problems are touched upon, as are methods of controlling them by appropriate environmental conditions. N.S.

30-S443.
Tworek-Matuszkiewicz, Beata.
Bark paintings: techniques and conservation.

In book. *Windows on the dreaming: Aboriginal paintings in the Australian National Gallery,* Caruana, Wally, Editor (1989), pp. 176-180, [Eng.].

An account of the techniques and history of bark painting. Preparation of the bark is described as well as the types of pigments, binders, and painting techniques used in traditional bark painting. Traditional pigments are iron ochers, pipe clay, gypsum, manganese ores, and charcoal. Traditional binders depended on local tradition and the availability of materials. Typically these are orchid juice, honey and beeswax, eggs of various species, tree and plant gums, and resins. For some contemporary artists, this has been supplanted by the use of poly(vinyl acetate) (PVA) and commercial paints. The author feels that the primary problem in conserving bark paintings is securing unstable paint and maintaining stable environmental conditions to minimize dimensional changes and prevent biodeterioration and the damaging effects of excessive light levels. M.H.B.

30-S444.
Willis, Liz.
Uli painting and Igbo world view.

African arts, **23,** no. 1, pp. 62-67, 104, (1989), [Eng.].

Uli painting, the art of body embellishment and wall decoration, has not completely disappeared from southeastern Nigeria where it was traditionally practiced by Igbo girls and women. Uli is a common Ibo prefix applied to shrubs and small trees with the botanical names *Rothmania whitfieldi* and *Cremas-*

pora triflora. The liquid obtained from their crushed seeds is traced onto the skin with a sliver of wood or a pointed metal knife; oxidation turns the curvilinear designs black for about eight days. Similar designs are also painted with earth pigments on the walls of shrines to celebrate religious festivals. The methods of application, the designs, and the ritualistic significance of both forms of this art are discussed and illustrated, along with their geographical variations. M.B.

30-S445.
Wolfthal, Diane.
The beginnings of Netherlandish canvas painting, 1400-1530.

Book. Cambridge University Press, Cambridge, 1989, [Eng.]. xiv, 252 p.: ill.; 27 cm., refs. [ISBN 0-521-34259-7].

Describes the tradition of painting on linen with a glue medium in the Netherlands from 1400 to 1530. This old technique embraces *Tüchlein* painting and a number of related techniques. Large works such as the gigantic thanka paintings still used in religious celebrations in the Himalayas give an idea of their large size and public role. Flags and religious artifacts are examples of earlier works of this type. The Shroud of Turin has been shown to be an example of this technique. Their light weight made them ideal for organ doors and other applications where weight was problematic. The history of the technique is discussed. Some 135 works from this period are described. Few paintings of this type survive because of their fragility. Jehan le Begue and Cennini both cite the sizing of the canvas. Cennini cites *gesso sottile* with a little starch and sugar. Le Begue gives two methods, the first is immersion of the linen in a pot of boiling parchment, the second, sizing the canvas with gum arabic. Grounds seem to have been very thin or nonexistent, and in the same material as the paint film. The paintings all have a matte, powdery, and thin appearance. Some have been ruined by subsequent varnishing. It seems that some areas were occasionally painted in oil or glazed with oil-base paint. Generally, the medium is tempera and certain pigments such as azurite are used as they are more effective with tempera. The unique characteristics of the tempera medium and the matte surface were deliberately cultivated. M.H.B.

30-S446.
Aboriginal art.

Videorecording. RM Associates/NY, New York, 198?, Videocasette (53 min.), sd., col. [Eng.]. Featherstone, Don (Producer, Director); Don Featherstone Films (Producing Agency).

Explores the work of four contemporary Australian Aboriginal artists who demonstrate the visual and oral traditions of their culture. Features Banduk Marika, a traditional painter and carver from the community of Yirrkala in Arnhem Land; Trevor Nickolis, a painter trained in the European style but who now draws on Aboriginal legends and techniques; Archie Weller, a novelist who writes about the life of the urban Aboriginal; and Kath Walker, the first Aboriginal poet to be published in English. Shows their work in the context of Aboriginal life in various cities, along the Australian coast, and in the outback.
PFAOF

30-S447.
Abbiw, Daniel K.
Useful plants of Ghana: West African uses of wild and cultivated plants.

Book. Intermediate Technology Publications Ltd., London, 1990, [Eng.]. xii, 337 p., [16] p. of plates; 23 cm., refs., index. [ISBN 1-85339-080-1].

Describes the useful plants of Ghana by category of use. Categories include "Tools and Crafts" and "Poisons, Tannin Dyes, etc." What makes this book particularly useful is the association of the full scientific name with the species used for something like camwood as a red dye. This provides an opportunity to know exactly what plant is used to make a drum and what plants might be used as an organic colorant that would be applied to the drum.
M.H.B.

30-S448.
Alcaraz González, Francisco.
Los nuevos materiales en el arte contemporáneo.
(New materials in contemporary art.)

In proceedings. *VIII Congrés de Conservació de Béns Culturals: València, 20, 21, 22 i 23 de setembre de 1990 = Congreso de Conservación de Bienes Culturales: Valencia, 20, 21, 22 y 23 de setiembre de 1990,* Roig Picazo, Pilar, Editor (1990), pp. 129-130, 1a ed. [Spa.].

Outlines some of the new materials used in contemporary art. The liberty to choose different materials and adopt different techniques is considered to be above all a product of the 20th century. This can be witnessed by the growth of abstract styles such as Cubism. The concerns for conservation and restoration of these works are outlined.
ICCROM

30-S449.
Anderson, Catherine.
Conservation applied to historic preservation.

In book. *Papers presented by trainees at the fifteenth annual art conservation training programs conference: 28 April 1989, Center for Conservation and Technical Studies, Harvard University Art Museums, Cambridge, Massachusetts,* (1990), [Eng.]. ill., bibliog.

Art conservation and architectural preservation are complementary professions with the same goal: the protection and preservation of our cultural heritage. The concerns for both professions include the strength, appearance, and stability of a variety of materials, and the ways in which they interact with the environment. Conservators can learn a great deal from preservationists, much of which will be of value in helping the professions work together. Conservators can offer preservationists their knowledge of the physical and chemical properties of building materials; the processes, agents, and treatments of materials deterioration; and the scientific equipment or services necessary for research, testing, and identification of building materials. Following a brief introduction to the history of preservation, three examples of the ways in which conservators can contribute to preservation will be presented. The first is an environmental monitoring and assessment survey at the Rockwood Museum, an historic house in Wilmington, Delaware. The second involves an analysis of structural materials used in two black powder roll mills at the Hagley Museum in Wilmington, Delaware. The third is a study of architectural paint from historic paint sample books and an historic room at the Winterthur Museum. The last two examples are drawn from research projects completed during the author's

second year in the Art Conservation Program at Winterthur/University of Delaware.
C.A.L.

30-S450.
Anon.
Architecture et décors peints: Amiens, Octobre 1989.
(Painted surfaces in architecture: Amiens, October 1989.)

Book. Direction du patrimoine (France), Paris, 1990, [Fre.]. 271 p.: photos.; 30 cm., refs.

Proceedings of a symposium on cultural heritage held in Amiens, France, in October 1989. The symposium was organized by the French Ministry of Culture on the theme of polychromy and decorated surfaces in architecture. Six countries were represented and approximately 200 people attended the symposium. Contributions covered the following: specific problems of polychromy; polychromy in the Middle Ages; the Classical era; and polychromy in the 19th and 20th centuries. The concluding reports of the discussions are also provided. ICCROM(04415500)

30-S451.
Balée, William; and Daly, Douglas C.
Resin classification by the Ka'apor Indians.

In book. *New directions in the study of plants and people: research contributions from the Institute of Economic Botany*, Advances in economic botany, no. 8, Prance, Ghillean T.; and Balick, Michael J., Editors (1990), pp. 24-34, [Eng.].

Primarily a study of the language and system of description used by the Ka'apor Indians of Amazonian Brazil in classifying and identifying the resins, saps, and latexes they use. The Ka'apor speak a Tupi-Guarani language and the terms used to describe resins do not correspond to the actual descriptions of the plants themselves. Aside from the insights provided about the way they think about plants, it provides concrete botanical information about the species used and what they use the products for. M.H.B.

30-S452.
Barton, L.R.; Howlett, D.R.; Howlett, S.G.; Nicklin, K.W.; and Pinfold, W.F.
Quex Museum House and Gardens.

Book. Powell-Cotton Museum,; Jarrold Colour Publications, Norwich, 1990, [Eng.]. 30

p.: ill. (some col.); 24 cm. [ISBN 0-9513915-1-8].

A guide to a museum founded by P.H.G. Powell-Cotton, a traveler, collector, hunter, and naturalist who traveled widely in Asia and Africa between 1887 and 1939. Powell-Cotton collected specimens, artifacts, and filmed wherever he went. The museum retains these films and some of them document Africans engaged in manufacturing items of material culture. These films are an important document of African material culture at a critical time period. The collection contains Asian material as well. The museum is also a traditional English country house with extensive grounds. M.H.B.

30-S453.
Bhat, R.B.; Etejere, E.O.; and Oladipo, V.T.
Ethnobotanical studies from central Nigeria.

Economic botany, **44,** no. 3, pp. 382-390, (1990), [Eng.].

The people of Kwara State, central Nigeria, depend on natural plant resources of their forests for food, medicine, pastoral, domestic, and other cultural and religious needs. This area, one of multiethnic status, has remained ethnobotanically unexplored until recently. This survey among herbalists, herb sellers, tribal priests, and local people recorded medical and other uses of 52 species of plants. This first-hand information points out the importance of plants to people in central Nigeria. A.A.

30-S454.
Boatwright, Joseph H.
Worldwide history of paint.

In proceedings. *Organic coatings: their origin and development: proceedings of the international symposium on the history of organic coatings, held 11-15 September 1989, Miami Beach, Florida, USA,* Seymour, Raymond B.; and Mark, Herman F., Editors (1990), pp. 9-13, [Eng.].

A history of paint from the earliest times to the present. Cites the first inhabitants of Australia and the European cave painters as being the originators of the earliest paints. The binders used are cited as animal fats, blood, egg whites and yolks, etc. The survey continues discussing ancient Egypt, the Far East, and Central America.

[Editor's note: While the technical information in this article is useful, there are some statements that are not generally accepted in anthropology, an example being the author's belief that a race of Caucasians inhabited the area west of the Pecos river 9,000 years ago.]
M.H.B.

30-S455.
Bonavia, Duccio; and Kaplan, Lawrence.
Bibliography of American archaeological plant remains (II).

Economic botany, **44,** no. 1, pp. 114-128, (1990), [Eng.].

Data relating to archaeological botany are often omitted or difficult to locate in the standard bibliographic sources of archaeology because the botanical component may be secondary to the principal intent of archaeological publications. Similarly, bibliographic abstracting and indexing services in the natural sciences do not include archaeological journals and monographs. This bibliography is an effort to deal with this shortcoming, especially for sources concerned with South America and primarily for the period from 1966 through 1983. The first installment of this bibliography was published by C.E. Smith in *Economic botany* Volume 20, 1966 on pages 446-460. Archaeological plant remains provide important insights into the use of plants by the groups concerned.
A.A. and M.H.B.

30-S456.
Bonet, Jordi.
L'architecture et les décors peints, en Catalogne.
(Architecture and decorated surfaces in Catalonia.)

In book. *Architecture et décors peints: Amiens, Octobre 1989,* (1990), pp. 220-221, [Fre.].

Outlines the history, conservation, and problems of architectural mural paintings in Catalonia, Spain. Considers frescoes, floral decorations of church arches, polychromed stone altarpieces at churches around Catalonia. Consolidation, cleaning, and conservation of these mural paintings are briefly reviewed. Stucco works and sgraffiti are also described.
ICCROM(04415552)

30-S457.
Brochard, Bernard.
La château d'Oiron et ses décors peints.
(The Château of Oiron and its decorated surfaces.)

In book. *Architecture et décors peints: Amiens, Octobre 1989,* (1990), pp. 160-164, [Fre.]. ill.

Describes the history and types of decorated surfaces that adorn the Renaissance castle of Oiron in Deux-Sèvres, France. There are: mural paintings; painted woodwork, i.e., ceilings and chimneys; some paneling and door frames; and some canvases strengthened with marouflage. Examples of decorations with some details of restoration work are provided for the Renaissance, the beginning of the 17th century, and the second half of the 17th century.
ICCROM(04415535)

30-S458.
Bunney, Sarah.
Ancient artists painted with human blood.

New scientist, **125,** no. 1710, p. 31, (1990), [Eng.]. 1 photo.

Reports on the finding of blood on rock paintings from two sites in Australia (Laurie Creek, Northern Territory, and Judds Cavern, Tasmania) and the dating of the paintings through accelerator mass spectrometry (AMS) to obtain the radiocarbon dates of 20,000 years for the former and between 10,000 and 11,000 years for the latter site. Discusses the evidence for the use of human blood in ritual ceremonies in modern times and the development of this evidence to the use of the same material in the preparation of rock paintings. The use of immunological detection techniques pioneered by Thomas Loy are reviewed, as is archaeological evidence for the age of occupation of Tasmanian and mainland sites.
D.R.W.T.

30-S459.
Cather, Sharon; Park, David; and Williamson, Paul, Editors.
Early Medieval wall painting and painted sculpture in England: based on the proceedings of a symposium at the Courtauld Institute of Art, February 1985.

Proceedings. BAR British series, no. 216, British Archaeological Reports, Oxford, 1990, [Eng.]. xxii, 262 p.: b/w ill.; 30 cm., refs., index. [ISBN 0-86054-719-1].

Examines the techniques of wall painting and painted sculpture from the Anglo-Saxon and Romanesque periods, providing needed information for assessing the intent and process of technology in the artistic traditions of these periods, and for relating the artwork to an historical continuum.

K.M.G.W.

30-S460.
Cummings, Paul.
Interview with Joel Shapiro.

Drawing, **12**, no. 2, pp. 31-35, (1990), [Eng.].

In an interview with Paul Cummings, the artist Joel Shapiro talks about his painting/drawing techniques and the changes which have occurred across the years—changes from enamels to chalk, charcoal; the importance of the right type of paper. Black and white photographs of works, all called "untitled" and dating from 1968 to 1985.

ICCROM(04202400)

30-S461.
De Friedmann, Nina S.
Mopa-mopa o barníz de Pasto: los marcos de la iglesia bogotana de Egipto.
(Mopa-mopa or Pasto varnish: the frames of the Church of Egypt, in Bogotá.)

In book. *Lecciones barrocas: pinturas sobre la vida de la Virgen de la Ermita de Egipto,* (1990), pp. 40-53, [Spa.]. 14 col. photos.

An anthropologist describes the history and technique of the Andean plant resin preparation known by native peoples as *mopa-mopa* and since colonial times also called *barníz de Pasto* (Pasto varnish) because of its association with that Colombian city. The author illustrates several wooden decorative art objects dating from the 17th to the 20th century that are coated with this polychromed layer. The author suggests that this technique may derive from the late Inca period resinous paint decorations that were applied to wooden kero cups (*queros*). In 1963, the botanist Luis Eduardo Mora Osejo identified the source of true *mopa-mopa* as the shrub *Elaeagia pastoensis* rather than *Elaeasia utilis* as previously believed. (See also *AATA* **30-1030.**

J.D.P.

30-S462.
Garcia, Pierre.
Le métier du peintre.
(The painter's craft.)

Book. Dessain & Tolra, Paris, 1990, [Fre.]. 512 p.: ill. (some col.), facsims.; 27 cm., refs. [ISBN 2-249-27795-8].

An exhaustive manual on the materials and techniques of paintings, divided into the following chapters: supports, glues, marouflages, grounds, impressions, preparatory drawings, media, solvents and diluents, siccatives, pigments, grinding of colors, varnishes, tools, techniques of execution, and toxic materials.

ICCROM(04469100)

30-S463.
Hepper, F. Nigel; and Royal Botanic Gardens, Kew.
Pharaoh's flowers: the botanical treasures of Tutankhamun.

Book. Her Majesty's Stationary Office, London, 1990, [Eng.]. xi, 80 p., 18 p. of plates: ill., map; 25 cm., bibliog. and index. [ISBN 0-11-250040-4].

A comprehensive description of all the plant materials found in Tutankhamun's tomb. Colorants, oils, resins, and the various woods used in wooden objects in the tomb are botanically described. An introduction gives the historical context. Tutankhamun's tomb contained a wealth of plant material in excellent condition in the form of food, liquid and cosmetic offerings, and artifacts.

M.H.B.

30-S464.
Holloway, Patricia S.; and Alexander, Ginny.
Ethnobotany of the Fort Yukon Region, Alaska.

Economic botany, **44**, no. 2, pp. 214-225, (1990), [Eng.].

Native plants of the Fort Yukon region, Alaska, were identified as to their medicinal, edible, and material uses by the Gwich'in Athabaskan and Caucasian residents. Forty-eight species or groups of native plants were identified as having some use predominantly as medicines (40%) and as food or beverages (56%). Their value in past and present Gwich'in culture is discussed.

A.A.

30-S465.
Hughes, Sylvia.
Blues for the chemist.

New scientist, no. 1748-1749, pp. 21-24, (1990), [Eng.].

Describes the use of Raman spectroscopy to analyze pigments from Haymon's *Commentary on Ezekiel*, a late-10th-century manuscript from Auxerre Abbey, as a part of an interdisciplinary research project on the Abbey undertaken by the CNRS (Centre National de la Recherche Scientifique) in Paris. Claude Coupry, the analytical chemist from the project, was able to identify lapis lazuli as a blue pigment. Previously the earliest known example of lapis in manuscripts was from a manuscript dating from the 13th century. The investigators hope that advances in the technology associated with Raman spectroscopy will allow for the use of infrared instead of laser radiation. This would make it possible to analyze organics as well as inorganics. A blue pigment that was identified as indigo could be further identified as to its plant origin. Sampling techniques are also described. M.H.B.

30-S466.
Immerwahr, Sara A.
Aegean painting in the Bronze Age.

Book. Pennsylvania State University Press, University Park, 1990, [Eng.]. xxiv, 240 p., 45 p. of plates: ill., maps; 29 cm., bibliog. and index. [ISBN 0-271-00628-5].

This book is concerned with Aegean wall paintings found in archaeological sites. Chapter two describes painting techniques and the history of controversies as to whether or not wall paintings in the Aegean are in the true fresco technique. The author states that there is no scholarly consensus as to exactly what technique was used, whether it was *buon fresco*, *fresco secco*, or a tempera technique. There is also no consensus as to whether or not binders were used. The author states that there is clear evidence of overpainting done while the plaster was dry and sensibly points out that it is pointless to expect the painters to use exactly the techniques of the Medieval-Renaissance painters of *buon fresco* since Minoan painting represents this technique in its infancy. Pigments are described as well as plastering and con-

struction techniques but not in great detail. Primarily an art historical text. M.H.B.

30-S467.
Innes, Jocasta.
Scandinavian painted decor.

Book. Rizzoli International Publications, New York, 1990, [Eng.]. 256 p.: col. ill.; 29 cm., bibliog. and index. [ISBN 0-8478-1235-9].

Describes the materials and techniques used by Scandinavian painters to decorate houses, churches, and artifacts from Medieval times to the present. Detailed information is provided on pigments and binding media and the many color combinations and application techniques used to achieve the wide range of effects sought by painters. S.W.

30-S468.
Jirat-Wasiutynski, Thea.
Tonal drawing and the use of charcoal in nineteenth century France.

Drawing, **11**, no. 6, pp. 121-134, (1990), [Eng.]. 7 ill.

Discusses the emergence of charcoal as a major medium in French landscape, genre, and portrait drawings, ca. 1850, with illustrations from the works of Odilon Redon, Karl Robert, Auguste Allongé, Adolphe Appian, Gustave Courbet, and Maxime Lalanne. The importance of the backing paper in the overall appearance of the drawing is stressed, as well as that of the mounting. Refers to the application of a fixative to secure the charcoal after completion of the drawing.
ICCROM(04169300) and R.A.R.

30-S469.
Larson, John.
The treatment and examination of painted surfaces on eighteenth-century terracotta sculptures.

In proceedings. *Cleaning, retouching and coatings: technology and practice for easel paintings and polychrome sculpture: preprints of the contributions to the Brussels Congress, 3-7 September 1990*, Mills, John S.; and Smith, Perry, Editors (1990), pp. 28-32, [Eng. w. Eng. summary]. list of materials, 9 refs.

Original pigmented surfaces are often removed from terracotta sculptures in the erroneous belief that they are later restorations, or a result of cleaning methods which

are too harsh and abrasive. During the 18th century, pigmentation was generally monochromatic, and the reasons for these coatings are outlined. The types of painted surface commonly found in European 18th-century terracottas are discussed, and a range of available cleaning methods is assessed.

A.A.

30-S470.
Lavalle, Denis.
Étude et conservation des décors de quadratura aux voûtes des édifices français du XVIIème siècle.
(Study and conservation of quadratura decoration on the vaults of 17th-century French buildings.)

In book. *Architecture et décors peints: Amiens, Octobre 1989,* (1990), pp. 119-124, [Fre.]. photos., refs.

Presents a study of the history, techniques, and conservation perspectives for quadratura paintings and decoration on the vaults and arches of 17th-century buildings in France. The techniques used for quadratura were introduced by artists from Bologna, Italy: Ange-Michele Colonna, Enrico Haffner, Domenico Canuti. Also examines the evolution of a *quadratura à la française.* Examples from Paris, Tanlay, and Nevers are outlined. Most of the quadratura mural paintings, either frescoes or oil, are badly deteriorated because of improper methods of application and of successive restoration treatments. Proposes general advice for adequate restoration measures. ICCROM(04415525)

30-S471.
Lewington, Anna.
Plants for people.

Book. Oxford University Press, Inc., New York, 1990, [Eng.]. vii, 232 p.: ill. (some col.); 29 cm., index. [ISBN 0-19-520840-4].

Presents an overview of how plants have been used historically and how they are used in present day applications. Sections cover the use of plants in art materials and colorants used by indigenous people. Designed as an illustrated general reference book on economic botany and ethnobotany.

M.H.B.

30-S472.
Marconi, Paolo.
La restauration des enduits de façades en Italie.
(The restoration of facade plasterwork in Italy.)

In book. *Architecture et décors peints: Amiens, Octobre 1989,* (1990), pp. 203-205, [Fre.].

Considers the restoration of polychromy and decorated architectural surfaces of building facades in Italy. Declares that the problem of color in architecture and, as a result, the restoration of plasterwork, stucco, and even historical mural paintings, has become very popular in Italy. The restoration of plasterwork, stuccoes, and lime-based colors must remain faithful to the original techniques and materials. ICCROM(04415547)

30-S473.
Miller, Judi; Moffatt, Elizabeth; and Sirois, Jane.
CCI Native Materials Project: final report.

Technical report. Canadian Conservation Institute, Ottawa, 1990, [Eng.]. 53 p., bibliog.

Pigments and binding media from 1,346 samples from historic Native objects were analyzed at the Canadian Conservation Institute by Fourier transform infrared (FTIR) spectroscopy, x-ray energy spectrometry combined with scanning electron microscopy, and, when required, by x-ray diffraction or polarized light microscopy. The frequency and, where possible, the period of occurrence of each pigment was assessed by region or by tribe, mainly from the Plains, Naskapi, Haida, Kwakiutl, Tsimshian, and the group of tribes from the Northwest Coast. Fillers, extenders, and media were also identified. A database was compiled with artifact documentation (accession number, description, tribe, collector), analytical information (elements, medium, pigments), date the artifact was collected, date the artifact was acquired, and date attributed to the artifact by a curator. It is hoped that information from the Native materials database will be used by others to elicit information for their specific requirements. The report gives 22 references to the data presented, 36 literature references to ethnographic pigments, and 36 other general references. C.D.

30-S474.
Moulin, Jacques.
Eglise de Lourps, à Longueville:
restauration du décor peint.
(The Church of Lourps in Longueville:
restoration of the painted surfaces.)

In book. *Architecture et décors peints: Amiens,
Octobre 1989*, (1990), pp. 94-97, [Fre.].

Studies the nature, state of conservation,
and colors of the painted surfaces and mural
paintings that decorate the interior of the
12th to 13th-century Church of Lourps in
Longueville, Seine-et-Marne, France. Declares
that studies carried out so far identify the
different stages of the decoration's evolution
and propose a restoration project for the
paintings. The question of which of the paint
layers, 13th-century, end-of-the-Middle-Ages,
or later decoration, to restore is discussed in
detail. ICCROM(04415519)

30-S475.
**Newman, Barnett; O'Neill, John P.,
Editor.**
*Barnett Newman: selected writings and
interviews.*

Book. Alfred A. Knopf, Inc., New York, 1990,
1st ed. [Eng.]. xxxi, 331 p., 16 p. of plates: ill.;
25 cm., index. [ISBN 0-394-58038-9].

Newman was a prolific writer, theorist,
and explainer of his own work. On pages 202
to 204 a letter to Clement Greenberg is pub-
lished in which Newman takes exception to
Greenberg's description of his paint surface
being like Rothko's. Greenberg described
Rothko's and Newman's paint surface in the
following manner; "like Newman, he
[Rothko] soaks his pigment into the canvas,
getting a dyer's effect." Newman says that
this may be a fair description of Rothko's
paint surface but insists that his "paint qual-
ity is heavy, solid, direct, the opposite of a
stain." Newman was particularly anxious in
1955 to set the record straight on this matter.
This is a particularly interesting example of
the importance of surface qualities to the art-
ists of this period. Apparently, lumping to-
gether artists who paint directly onto the can-
vas is by no means fair to their original
conception of the paint surface. M.H.B.

30-S476.
Pain, Stephanie.
Sir Joseph's buried treasure.
New scientist, **125,** no. 1708, pp. 57-60, (1990),
[Eng.].

Discusses the rehousing of Kew's eco-
nomic botany collection in a new structure
built for the purpose and named the Joseph
Banks' Building. Banks began the tradition of
returning from voyages of discovery with
plant specimens and useful products made
from them. In addition to the high scientific
value of the collections, their rehousing in a
state-of-the-art building with a new storage
system is of the first importance. Reference
collections of plant materials and products
made from them can provide critical informa-
tion about the composition of artifacts and
their deterioration. Specimens in the collec-
tions range from material gathered in the lat-
ter half of the 18th century to specimens of
plant material from Tutankhamun's tomb,
and, of course, more recent additions.
 M.H.B.

30-S477.
Prasartset, Chompunut.
The investigation of pigments and paint
layer structures of mural paintings at
Maitepnimit Temple.

*Warasan Samnakngan Khana Kammakan Wichai
hang Chat = Journal of the National Research
Council of Thailand,* **22,** no. 1, pp. 73-86, (1990),
[Eng. w. Eng. summary]. 4 photos., 10 refs.

Studies 25 samples covering all the col-
ors taken from mural paintings at Maitep-
nimit Temple. Methods of investigation in-
volved microscopical examination of the
pigments and cross-sections of the samples.
The inorganic pigments were analyzed by
microscopical chemical tests or by scanning
electron microscope with energy-dispersive
x-ray spectrometry and further identified by
x-ray diffraction with the help of a Guinier-
Hagg type of focusing powder camera. The
organic pigments were identified by thin-
layer chromatography, high-pressure liquid
chromatography, and mass spectroscopy
methods. The analyses revealed that the
painting technique was tempera. Before
painting, the plaster of the wall was primed
with a ground layer that consisted of
white pigment of calcite. However, the white

pigment used in the white patterns was hydrocerussite. In addition, gypsum and kaolinite were found as white pigments mixed as fillers in other paint layers of various color samples. The red pigments found were cinnabar, minium, and hematite. The blue pigments were indigo and cumengeite. The green pigment found was malachite. Carbon was found as black pigment. Gamboge was found as yellow pigment under the gold layer in the gold sample and also found mixed in the paint layer of the leaf green sample. Ch.P(A.A.)

30-S478.
Prevost-Marcilhacy, Christian.
Ancienne collégiale Saint-Barnard de Romans: décor du choeur et du transept. (Ancient Collegiate Church of Saint Barnard de Romans: decorated surfaces of the choir and transept.)

In book. *Architecture et décors peints: Amiens, Octobre 1989,* (1990), pp. 73-74, [Fre.].

Examines the state of conservation and form of the decorated surfaces of the choir and transept in the church of Saint Barnard de Romans, the founder of the town of Romans-sur-Isère, Isère, France. The 9th-century church was damaged by fire several times and was also subject to various restoration efforts; the choir and the transept were rebuilt in 1238. The decorated surfaces, of a geometrical character, are divided between the walls and the columns of the choir and transept. The technique used was distemper paint on a thin layer of plasterwork; thick deposits of dirt and dust covered the paintings. Treatment included cleaning, consolidation of the renderings by injection, refixing parts using acrylic resins, and restoration and harmonization of the lacunae.
ICCROM(04415512)

30-S479.
Skálová, Zuzana.
Conservation problems in Egypt: some remarks on the technology of postmediaeval Coptic icons.

Bulletin (Société d'Archéologie Copte), 29, pp. 55-62, (1990), [Eng.]. 3 plates.

Considers the problems of conserving post-Medieval Coptic icons in Egypt. Most of the existing icons there date from the second half of the 18th century. The author identifies characteristics that distinguish Coptic icons from holy pictures of the same period: lack of stylistic and technical unity; rusticity; lack of theological perspective; use of local tempera techniques. These techniques and other technical questions form the main subject of this survey. The implications for any restoration treatment are reviewed: suitability, fragility, etc. Concludes that more in-depth research is needed. ICCROM(04489800)

30-S480.
Skolnik, Herman.
The history of naval stores in coatings.

In proceedings. *Organic coatings: their origin and development: proceedings of the international symposium on the history of organic coatings, held 11-15 September 1989, Miami Beach, Florida, USA,* Seymour, Raymond B.; and Mark, Herman F., Editors (1990), pp. 15-20, [Eng.].

Oleoresins, their turpentine and rosin components, and their fossilized resins, e.g., amber and copal, have played an important role in the evolving history of coatings from the Palaeolithic period to the present. Over most of this history, the manufacture of coatings was an art and they were used primarily for decorative purposes. Coatings emerged slowly as a technology and industry in England in the 18th century and in Europe and the United States in the early 19th century. With the blossoming of chemistry as a science in the 19th century, constituents of oleoresins were separated and identified, and in the 20th century, based on extensive research and development, converted to a stable of products that made possible the coatings industry of today. A.A.

30-S481.
Sutton, Mark Q.
Notes on creosote lac scale insect resin as a mastic and sealant in the Southwestern Great Basin.

Journal of California and Great Basin anthropology, 12, no. 2, pp. 262-268, (1990), [Eng.]. 2 figs., 34 refs.

A general discussion of mastics and sealants in the Southwest is followed by a detailed discussion of the biology, properties, and ethnographic accounts of cresote lac. The author cites the use of glue prepared from

horn and hides. Several other lac insects are described, notably oak wax scale (*Cerococcus quercus*) found on oaks in arid mountain areas of Arizona and California, and irregular wax scale found on species on saltbush (*Atriplex spp.*) in California, Arizona, and New Mexico. Archaeological examples are also described. The author concludes that many accounts describing "greasewood gum" or "creosote gum" are probably references to creosote lac. M.H.B.

30-S482.
Timbrook, Jan.
Ethnobotany of Chumash Indians, California, based on collections by John P. Harrington.

Economic botany, **44,** no. 2, pp. 236-253, (1990), [Eng.].

At least 150 plant species were used for food, medicine, material culture, and religious practices by the Chumash Indians of Southern California. A great deal of traditional Chumash plant knowledge survived into the present century, despite massive deculturation. The most significant source of information on Chumash ethnobotany is the extensive, unpublished field notes of John P. Harrington, based on interviews conducted from 1912 into the 1950s. Several hundred voucher specimens collected by some of Harrington's consultants have also been preserved, along with the original notes, at the Smithsonian Institution. Data are presented here on knowledge and uses of plants in this important California Indian culture, as reconstructed from the Harrington material. Changes in plant knowledge resulting from Euro-American contact are also discussed. A.A.

30-S483.
Turner, Nancy J.; Thompson, Laurence C.; Thompson, M. Terry; and York, Annie Z.
Thompson ethnobotany: knowledge and usage of plants by the Thompson Indians of British Columbia.

Book. Memoir, no. 3, Royal British Columbia Museum, Victoria, 1990, [Eng.]. 335 p.: ill.; 28 cm., refs., index. [ISBN 0-7718-8916-X].

A comprehensive ethnobotany of the Thompson Indians of British Columbia. This text includes the work of James Teit (1896-1918) who pioneered Thompson ethnobotani-

cal work. This means that the time span covered by the informants goes back as far as 90 years. Significantly, only 20 plant species are not recognized as usable by contemporary elders. The text takes the form of an inventory of species named or used by the Thompsons. Entries are arranged alphabetically by scientific name; Thompson Salish names are given as well. This is followed by a summary of ethnobiological data. Plants are grouped as food, materials, or medicine. The materials section is of particular interest since it describes plants used for fiber, dyes, stains, paints, and preservatives. Sources of resin and pitch are described as well as plants used as cleaning agents or harvested for their scent. The cultural role of plants and the methods of preparation for consumption or use are described. M.H.B.

30-S484.
Williams, David E.
A review of sources for the study of Náhuatl plant classification.

In book. *New directions in the study of plants and people: research contributions from the Institute of Economic Botany*, Advances in economic botany, no. 8, Prance, Ghillean T.; and Balick, Michael J., Editors (1990), [Eng.].

The broad knowledge of plants attained by the ancient Mexicans is well known, yet this branch of indigenous science has not received the attention it deserves. Few systematic treatments of Náhuatl botany have been undertaken. Náhuatl language and culture were dominant in Mesoamerica for centuries, and books using a pictorial writing system were widespread at the time of the Conquest. A small number of the surviving pictorial manuscripts provide important yet incompletely studied information regarding Aztec plant knowledge. The ethnohistorical sources of actual or potential value to the study of Náhuatl botany are reviewed, as are the modern interpretations of the subject. There is evidence suggesting a Prehispanic system of scientific plant classification based on pictorial representations of the plants and plant groups. The reconstruction of Náhuatl plant classification through ethnohistoric and ethnographic research would facilitate identification of many plants whose uses are now forgotten. A.A.

30-S485.
Brochwicz, Z.; Domasłowski, J.; Górzyńska, M.; Okuszko, E.; and Wiklendt, J.
Materiały i techniki malarskie w średniowiecznych malowidłach ściennych w domu dawnego Bractwa Kupieckiego przy ulicy Żeglarskiej 5 w Toruniu.
(Materials and techniques of Medieval wall paintings from the former House of Merchants' Fraternity at 5 Zeglarska Street in Toruń.)

Book. Rozprawy, Uniwersytet Mikołaja Kopernika w Toruniu, Toruń, 1991, [Pol. w. Eng. summary]. 92 p.: ill., refs. [ISBN 83-231-0117-5].

Examination of the wall paintings, dating from 1380-1400, is described in detail. Analysis of the materials should be accompanied by the technological reconstruction of the plaster and paint layers of the paintings in order to assure proper conservation recommendations. Macroanalysis, microanalysis, liquid chromatography, stereoscopy, polarized light microscopy, microcrystallography, and stratigraphic analysis were used for identification of plaster, pigments, and binding media. Analysis revealed presence of a single layer of lime plaster characterized as fat with the ratio of binder to filler of approximately 1:1. The filler was identified as being mainly natural fluvial aggregate. The palette of pigments in the paintings consists of chalk, yellow ocher, iron red, red lead, vermilion, azurite, malachite, and carbon black. The medium used in paints consists of a combination of egg or egg yolk, barley glue, and supposedly cattle blood serum. The layer of white wash on plaster contains chalk and a combination of egg and barley glue as a binder. Also, Gothic iconography, artistic genesis, and history of the paintings are explained in detail.
J.S.P.

30-S486.
Brochwicz, Zbigniew; and Basiul, Elżbieta.
Fresk tyrolski: próba jego rekonstrukcji i modyfikacji.
(Tyrolean fresco: an attempt to reconstruct and modify the technique.)
Acta Universitatis Nicolai Copernici, **18**, no. 227, pp. 3-33, (1991), [Pol. w. Eng. summary]. 65 refs.

One of the least-known techniques of wall painting is discussed. Based on scarce literature on the subject and laboratory experiments, a possible procedure was recreated. Gypsum plaster combined with skim milk was applied on lime-sand mortar and then polished. A perfectly smooth surface was sized with albumin glue with the addition of lime. Painting started from light tones and continued to dark glazed shadows. A history of the application of gypsum in wall painting is presented.
J.S.P. and J.G.

30-S487.
Brody, J.J.
Anasazi and Pueblo painting.

Book. University of New Mexico Press, Albuquerque, 1991, 1st ed. [Eng.]. xiv, 191 p.: ill. (some col.); 27 cm., bibliog. and index. [ISBN 0-8263-1236-5].

Describes all aspects of painting including rock art, pottery, and kiva murals. Begins with the Archaic period and continues into the 20th century, mostly from the viewpoint of archaeology and art history. Very little is said about pigments or the actual methods of painting. Earlier authors have dealt with this in great detail and this text provides a very useful overview of their research.
M.H.B.

30-S488.
Chavanne, Blandine.
"Un coup de peinture, un coup de jeunesse" ou de la restauration de l'art contemporain.
("A brush stroke, a stroke of youth," or on the restoration of contemporary art.)
Conservation, restauration des biens culturels: revue de l'ARAAFU, **311**, pp. 8-9, (1991), [Fre. w. Fre. summary].

Regarding contemporary art, we must think more in terms of conservation than of restoration. Indeed, the notion of prevention must underlie reflection on contemporary art conservation. This would necessitate a better knowledge of techniques used on the part of the artists, for it seems that for a large number of works, the idea of conservation comes to mind only after reconstitution has been considered. Paying attention to the problem at its source, without waiting for the often unavoidable degradation, would allow us to

transmit contemporary artworks to future generations in better conditions.

A.A. and M.B.(transl.)

30-S489.
Finnigan, Mary; and Broome, Thad T.
Structural painting in early America.

JCT: Journal of coatings technology, **63**, no. 794, pp. 53-57, (1991), [Eng.]. 47 refs., bibliog.

The restoration of American Colonial landmarks has recently caught the attention of historians, architects, and the paint industry. Authentic reproduction has been their utmost concern, with much emphasis being placed on reproducing furnishings and ornaments. In order to obtain a completely realistic effect in a restoration effort, however, thought must be given to the reproduction of the painted surfaces. To achieve a true reproduction, the architect must rely on the paint manufacturer to supply material which accurately represents that used during the period. The paint industry must obtain information from historians concerning raw materials in use during the period in question. This knowledge is necessary for the craftsman to successfully produce the illusion of uninterrupted existence. This article attempts to bridge the gap between the historian and the craftsman by discussing the history of early American painting. The problems encountered in studying the history of paint making are outlined, and the purposes of early American painting are presented. A useful reference section and annotated bibliography are provided.

A.A. and B.A.R.

30-S490.
Hutchens, Alma R.
Indian herbalogy of North America: the definitive guide to native medicinal plants and their uses.

Book. Shambhala Publications, Boston; Random House, New York, 1991, 1st paperback ed. [Eng.]. xxxviii, 382 p.: ill.; 23 cm., bibliog. [ISBN 0-87773-639-1].

Concerned primarily with medicinal plants and their use by the indigenous inhabitants of North America. Also mentions a number of plants used as colorants by indigenous people and in industrial processes by European colonists. The materials are referred to as dyes although their use by American Indians would have been as colorants often applied directly. An example would be the use of larkspur (*Delphinium consolida*) by the Hopi for ritual purposes, or the direct application of golden seal (*Hydrastis canadensis*) root to clothing as a colorant.

M.H.B.

30-S491.
Lorblanchet, Michel.
Spitting images: replicating the spotted horses.

Archaeology, **44**, pp. 26-31, (1991), [Eng.].

Describes the reconstruction of the spotted horse panel at Pech Merle in the Quercy region of southern France using techniques learned from Australian Aboriginal cave painters from Queensland. Using an animal fat lamp as a light source, the author reproduced the panel with a combination of spitting, blowing, and stencilling. Charcoal and red ocher were used as pigments. The ground charcoal was masticated and diluted with saliva and water. No binder was used.

M.H.B.

30-S492.
Manuelli, Neri.
Studio sulle tecniche pittoriche nell'antico Egitto.
(Study of painting techniques in ancient Egypt.)

Kermes, **4**, no. 11, pp. 42-49, (1991), [Ita. w. Eng. summary]. figs.

Examines Egyptian painting techniques from the beginning of Egyptian history to the Roman epoch. In Egyptian culture, the painter is never considered an artist, Egyptian works of art are always anonymous. Hieroglyphic writing and painting are necessarily linked together, both by the same type of execution and by a magic-like correlation. Tempera painting methods and the natural mineral origin of different colors are analyzed. When finished, the painting was sometimes covered by a thin wax layer for protection. In some cases, transparent varnishes of natural origin were used.

ICCROM(04458104)

30-S493.
Rossi-Manaresi, R.; Tucci, A.; and Grillini, G.C.
Le finiture di prospetti architettonici rinascimentali a Ferrara: indagini scientifiche.
(The surface finishing of Renaissance facades in Ferrara, Italy: scientific studies.)

In book. *Superfici dell'architettura: le finiture: atti del convegno di studi, Bressanone, 20-29 giugno 1990,* Biscontin, Guido; and Volpin, Stefano, Editors (1991?), pp. 225-240, [Ita. w. Eng. summary]. 6 photos., 4 figs., 23 refs.

The original features of five Renaissance buildings were reconstructed from the results of the study of their plasters, stuccos, and pigments. The results agree with historical hypotheses and indicate that a scraping of the facades had been carried out in the early 20th century. The facades were faced with limestone, painted plaster of calcite and gypsum, and false stone, a thin layer of calcite and gypsum.　　　　　　　　G.A. and R.B.

30-S494.
Abbott, Isabella Aiona.
Lā'au Hawai'i: traditional Hawaiian uses of plants.

Book. Bishop Museum Press, Honolulu, 1992, [Eng.]. xii, 163 p.: ill., maps; 31 cm., bibliog. and index. [ISBN 0-930897-62-5].

The author describes the traditional uses of plants in Hawaii. The entire range of use is discussed with a particular emphasis on cultural context. Historical photographs, prints and photographs of the plants themselves as well as objects fabricated from them make the book a unique resource. The author is a respected limnologist and brings a unique perspective to this work.　　M.H.B.

30-S495.
Anupam Sah.
The first painting on earth.

The eye, **1,** no. 3, pp. 9-10, (1992), [Eng.]. 2 photos.

Recounts an old legend about the origin of painting, as given in an ancient Indian treatise on painting. The treatise is called *Chitralakshana* and is by Nagnajit. Mention is made of other ancient Indian texts on painting: the *Vishnudharmottara* (ca. 5th-7th centuries), the *Samrangana Sutradhara* (11th cen-

tury), the *Abhilasitartha Chintamani* or *Manasollasa* (12th century), and the *Kashyapasilpa.*　　　　　　　　　　　　N.H.

30-S496.
Beerhorst, Ursula.
Studien zur Maltechnik von Willi Baumeister.
(Studies of the painting techniques of Willi Baumeister.)

Zeitschrift für Kunsttechnologie und Konservierung, **6,** no. 1, pp. 55-80, (1992), [Ger.].

This is a shortened version of the author's dissertation. It deals with the various unorthodox painting techniques employed by the German abstract painter Willi Baumeister between 1920 and 1955 and the materials he used both as undercoating and surface applications. Baumeister painted on canvas, specially prepared wallboard and cardboard; he often eschewed traditional framing. He mixed sand into oil paint, drew steel combs through it for texture, applied spackling materials often mixed with paint, and frequently allowed undercoating (sometimes consisting of buttermilk) and surface to merge. This study of the materials and techniques used is intended to be helpful in dealing with the considerable problems encountered in preserving the work of this painter.　　　　　　　　E.M.B.

30-S497.
Blanchard, William D.; Stern, E. Marianne; and Stodulski, Leon P.
Analysis of materials contained in mid-4th to early 7th-century A.D. Palestinian kohl tubes.

Affl: Detroit Institute of Arts, Detroit, MI, USA.

In book. *Materials issues in art and archaeology III: symposium held 27 April-1 May 1992, San Francisco,* Materials Research Society symposia proceedings, no. 267, Vandiver, Pamela B.; Druzik, James R.; Wheeler, George Segan; and Freestone, Ian C., Editors (1992), pp. 239-254, [Eng. w. Eng. summary]. 14 figs., 1 table, 17 refs.

The powdered contents of 17 Late Roman and Byzantine glass vessels used to hold cosmetic eye paints (kohl) were analyzed. The principal analytical techniques employed were x-ray diffraction, Fourier transform infrared spectroscopy, x-ray fluorescence, and

scanning electron microscopy. The materials detected are described, indicating those which may have been used as kohl. Also reported are analytical results from a solid chunk of material surrounding a fragment of a metal rod, also obtained from a kohl vessel.

A.A.

30-S498.
Burns, Thea.
Rosalba Carriera and the early history of pastel painting.

In proceedings. *The Institute of Paper Conservation: conference papers, Manchester, 1992,* Fairbrass, Sheila, Editor (1992), pp. 35-40, [Eng. w. Fre. + Ger. summaries]. 1 fig., 48 refs.

Discusses the difficulties of definitely attributing any work in a dry, friable colored medium as pastel or as chalk. Gives a general history of the uses and development of pastel as a drawing medium with reference to the technical literature of the time. Finally, examines the role of the Venetian artist Carriera who has been credited with the role of inventor of pastel painting. S.F.

30-S499.
Cole, Noelene; and Watchman, Alan.
Painting with plants: investigating fibres in Aboriginal rock paintings at Laura, north Queensland.

Rock art research, **9,** no. 1, pp. 27-36, (1992), [Eng. w. Eng., Fre., Ger. + Spa. summaries]. 6 plates, 3 figs., 5 tables, refs.

Investigation of paint samples from rock paintings at Laura, north Queensland, has revealed the presence of fibrous material which appears to be derived from plants. Outlines recent research into the nature and source of this material. Ethnobotanical data and the analyses conducted so far suggest that fibers may occur as by-products or as integral components of the painting process. Presents direct evidence in the archaeological record for the physical involvement of plants in the creation of Australian Aboriginal rock paintings. [Editor's note: Contains an extensive discussion of plants used as binders, colorants, and brushes. Species of orchids used are discussed in some detail.]

R.G.B. and A.A.

30-S500.
Götz, Stephan; Bowen, Craigen W., and Olivier, Katherine, Editors.
American artists in their New York studios: conversations about the creation of contemporary art.

Book. Harvard University Art Museums. Center for Conservation and Technical Studies, Cambridge; Daco-Verlag Günter Bläse, Verlag Hanfstaengl Nachfolger, , 1992, [Eng.]. 176 p.: ill. (some col.); 28 cm. [ISBN 3-87135-006-0].

During the author's internship at the Fogg, he conducted a series of interviews with contemporary artists concerning their working methods and attitudes about the permanence and conservation of their work. Some 26 of these are published in this compilation. One of the artists interviewed, Michael David, makes this statement: "One other thing I do in drawing, is I use a very pure powder pigment, no paint, complete powder pigment. Then I mix it with methyl cellulose and then I paint with that and it gives me this incredibly matte finish. As for its stability—It won't flake, but if you touch it, it will still come off on you." This type of statement is particularly revealing of how the artist intends the work to appear. Götz also asks about the use of fixatives and other issues relevant to matte paint. M.H.B.

30-S501.
Hunt, Valerie Reich.
Care of folk art: the decorative surface.

In book. *Conservation concerns: a guide for collectors and curators,* Bachmann, Konstanze, Editor (1992), pp. 123-127, [Eng.].

Deals with the conservation of paint found on the surface of folk art objects made of such disparate materials as wood, metal, chalkware, ivory, basketry, and glass. The cultural information contained in this fragile top layer may be as important to conserve as the object itself. The conservation guidelines presented here take this into consideration. Problems affecting paint on wood include poor adhesion of paint on the support and between successive layers, insect infestation, incompatible surface coatings; painted metals are subject to corrosion; gold leaf on metal or wood also presents problems. Incised bone and ivory, and painted glass are fragile. The storage and handling requirements of these

artifacts include environmental control, as well as structural supports, regular cleaning and inspection, and appropriate professional intervention. M.B.

30-S502.
Morton, Julia F.
The ocean-going *noni*, or Indian mulberry (*Morinda citrifolia, Rubiaceae*) and some of its "colorful" relatives.

Economic botany, **46**, no. 3, pp. 241-256, (1992), [Eng.].

The genus Morinda embraces about 80 species, mostly of Old World origin. *M. citrifolia L.* (southern Asia-Australia), noted as a source of dye and edible leaves, has buoyant seeds that float for many months and commonly appear in the Pacific and also in tropical America where *M. royoc L.*, piña de ratón, is indigenous, inhabits inland hummocks and pinelands as well as seacoasts, and is also one of the floating-seed Morindas. There are brief references to its use for dyeing in the Cayman Islands and Yucatán. The dye varies in color depending on the mordant used. In Polynesia alum was used as a mordant to produce a red color. Colors achieved can range from black to yellow or a lilac color. Both *M. citrifolia* and *M. royoc* have sundry folk-remedy uses. *M. parvifolia Bartl.* has antitumor/antileukemic activity. High intake of selenium by *M. reticulata Benth.* has poisoned horses in Australia. In the Philippines, there is new interest in the wood of *M. citrifolia*. It is hard and of beautiful grain.
A.A. and M.H.B.

30-S503.
Plahter, Unn.
Likneskjusmid: fourteenth century instructions for painting from Iceland.

Zeitschrift für Kunsttechnologie und Konservierung, **6**, no. 1, pp. 167-173, (1992), [Eng.].

A 14th-century Icelandic text in the form of a letter was recently scrutinized again by Olafur Halldorsson. The text of this manuscript is presented here along with a translation and an extended commentary on sections of the text and on technical formulations regarding the craft of painting in Norway in the Middle Ages. This letter was apparently intended for a practicing craftsman and indicates the major steps for gilding

wood according to the contemporary tradition practiced in Norway and Iceland. The method for gilding silver is detailed. It involves the use of a yellow glaze obtained from pine resin or mixtures of pine resin, oil, and possibly egg. M.B.

30-S504.
Raft, Adam.
Zu den historischen Quellentexten über bemalte Textilien.
(Written sources about painted textiles.)

Restauratorenblätter, **13**, pp. 33-37, (1992), [Ger. w. Eng. summary]. 20 refs.

Painted textiles are decorative works, such as church banners, hangings, clothes, triumphal arches used to welcome persons of rank, and scenery. Such textiles have to retain their flexibility, unlike the painter's canvas, which is mounted on a stretcher. Often the textile only gets a thin coat of glue to prevent the colors from running, but there are also examples of the use of a very thin ground. At times in the Middle Ages, the colors were applied without a medium, in the proper sense of the word, but they contained a mordant that dyers used to help consolidate the colors on a fabric. A.A. and M.K.

30-S505.
Rothe, Andrea.
Mantegna's paintings in distemper.

In book. *Andrea Mantegna*, Martineau, Jane, Editor (1992), pp. 80-88, [Eng.].

Distemper is the name given to a technique that uses animal glue instead of egg as a medium. Left unvarnished, the colors have an opaque brilliance and precision akin to pastels, enabling the paintings to be viewed in any light without the reflections of a varnished picture. The technique was popular in the Netherlands and Germany. Dürer painted more than 16 distempers, which he refers to as *tüchlein* or linen paintings. Of the thousands of works in this medium that were painted in the Netherlands, fewer than 100 have survived, and in Italy the losses are only slightly less drastic. Unfortunately later applications of varnish or soot accumulations have changed the appearance of many distemper paintings due to their fragile and porous nature. Mantegna may have used casein or gum arabic as a paint medium. The cata-

log contains a list of paintings by or attributed to Mantegna painted in a medium that has either been analyzed as distemper or that shows some of the characteristics of distemper. Only five of the paintings seem never to have received a conventional coat of varnish and, in consequence, retain their original matte surface and brilliant crispness of detail.

J.H.S.

30-S506.
Turner, Nancy J.
Plants in British Columbia Indian technology.

Book. Handbook—British Columbia Provincial Museum, no. 38, Royal British Columbia Museum, Victoria, 1992, [Eng.]. 304 p.: ill.; 19 cm., bibliog. and index.

Describes the use of plant material by the indigenous inhabitants of British Columbia in the manufacture of objects of material culture. Particularly interesting is an account of the use of Indian Paint Fungus (*Echinodontium tinctorium*). Primarily a red pigment for body painting and tattooing, it was used by the Kwakiutl as a general purpose red paint. The fungus was heated on stones and covered with fern until it became a red powder.

M.H.B.

30-S507.
Albano, Al.
Twentieth century painting.

Technical report. Available from the author c/o Winterthur Museum & Gardens, Winterthur, DE, 19735, 1993, [Eng.]. 39 p.; 28 cm., 38 refs.

The author discusses new painting techniques that emerged with the new art movements of the 20th century. These have proven to be particularly problematic for conservators. For instance, the author states "due to their highly porous paint surfaces and ground layers, pictures by German Expressionists, in general, are extremely vulnerable to disfiguration by saturating varnish or penetrating conservation adhesives." Similar problems exist with many other schools of modernism including the Abstract Expressionists and Color Field painters. The author presents an authorative review with particularly valuable references.

M.H.B.

30-S508.
Barclay, Marion H.
Some structural solutions to the question of preventive conservation care for a major travelling exhibition, "The Crisis of Abstraction in Canada: The 1950s."

Affl: National Gallery of Canada, Ottawa, Ontario, Canada.

In book. *ICOM Committee for Conservation tenth triennial meeting, Washington, DC, 22-27 August 1993: preprints*, Bridgland, Janet, Editor (1993), pp. 225-230, [Eng. w. Eng. summary]. ill., refs.

The exhibition, The Crisis of Abstraction in Canada: the 1950s, comprises 158 works of art, 125 of which are paintings. Many of the works are privately owned or belong to small institutions that do not have ready access to conservation facilities. The exceptional decision was made to treat the majority of the physically deteriorated paintings either at the National Gallery of Canada or on contract. Given the large numbers of works requiring treatment and the tight time constraints, it was decided to focus on structural soundness rather than appearance. A number of preventive and remedial care techniques were developed for the paintings requiring treatment. This discussion deals with the preventive care for the works on canvas. The nonintrusive methods of treatment chosen have proven to be extremely effective; these include stretcher-inserts, stretcher-bar linings, and rigid and padded backings.

A.A.

30-S509.
Bøllingtoft, Peder; and Christensen, Mads Chr.
Early Gothic wall paintings: an investigation of painting techniques and materials of 13th-century mural paintings in a Danish village church.

Affl: Nationalmuseet (Denmark), Brede, Denmark.

In book. *ICOM Committee for Conservation tenth triennial meeting, Washington, DC, 22-27 August 1993: preprints*, Bridgland, Janet, Editor (1993), pp. 531-535, [Eng. w. Eng. summary]. ill., bibliog.

Describes investigations carried out by the Danish National Museum in connection with the discovery of Gothic wall paintings in a small Danish village church.

Examinations of the painting technique, structure, and composition of materials were carried out. The results indicate a rapid technique with use of little equipment and few materials. The degradation of red, blue, and green pigments is described. A.A.

30-S510.
Colinart, Sylvie; and Eveno, Myriam.
Etude scientifique du décor de quatre boîtes funéraires en bois provenant de Chine.
(Scientific study of the decoration of four wooden funerary boxes from China.)

Affl: Laboratoire de recherche des musées de France, Paris, France.

In book. *ICOM Committee for Conservation tenth triennial meeting, Washington, DC, 22-27 August 1993: preprints,* Bridgland, Janet, Editor (1993), pp. 9-14, [Fre. w. Fre. summary]. ill., refs.

Deals with the polychromy technique of four 7th-century wooden funerary boxes discovered in China. Describes the polychromy on each box and presents the results of the various types of pigments and binders employed. The examination techniques used are binocular observation, photographic examination, infrared reflectography, and scanning electron microscopy. Materials identification was conducted using microchemistry, x-ray microanalysis, x-ray fluorescence, x-ray diffraction, Fourier transform infrared spectrometry, and gas chromatography. The studies revealed that two different decorating techniques using a limited number of pigments had been employed, and that coatings had been applied on the inside of each box.
 A.A. and M.B.(transl.)

30-S511.
de Tapol, Benoit.
Produits, faits, modes en peinture murale: évolution et répartition des produits de restauration utilisés dans les peintures murales de 1850 à 1992: un premier tri concernant France, Espagne, Angleterre et Pologne.
(Products, facts, modes in mural painting: evolution and distribution of restoration products used in mural paintings from 1850 to 1992. A first sorting concerning France, Spain, England, and Poland.)

In book. *Les anciennes restaurations en peinture murale,* (1993), pp. 273-288, [Fre.]. tables, bibliog.

Part of a didactic project aimed at providing restorers with tools to refine their diagnosis of the state of conservation of wall paintings that have previously undergone interventions. Written information was relied upon to identify synthetic materials for which there are no microchemical tests for identification, to determine how they were used (solution, dispersion, etc.), for what purpose, and for how long. Documentation was found at the ICCROM library in 242 articles published between 1920 and 1992, and in the answers to a questionnaire sent to 450 ICCROM alumni. A Lotus program was used to manage this information. Four tables indicate what products were used in France, Spain, Great Britain, and Poland. Dates of publication of recipes are compared with actual dates of use for wax and natural resins; for gelatin, casein, and cellulosic glues; for barium hydroxide; for silicates; for cellulose nitrates; polyvinyl alcohol, polyvinyl acetate; acrylics, slaked lime, and mortar. There is a regrettable absence of data originating in Italy, and readers are asked to communicate additional relevant information. M.B.

30-S512.
Ekroth-Edebo, Margareta; and Petéus, Thomas.
The study and conservation of glue paintings on textile: 18th and 19th century painted wall hangings from southern Sweden.

Affl: Studio of the Western Sweden Conservators Trust, Gothenburg, Sweden.

In book. *ICOM Committee for Conservation tenth triennial meeting, Washington, DC, 22-27 August 1993: preprints,* Bridgland, Janet, Editor (1993), pp. 135-140, [Eng. w. Eng. summary]. ill., refs.

The technique and state of preservation of a group of traditional painted wall hangings is presented. The paintings have dual importance as objects of art and bearers of cultural and historical information. Earlier conservation treatments have often disregarded their intended character and the way they were used. A new method for treating porous and flaking layers of glue paint on

flexible textile supports is outlined. The method enables treatment without disturbing the original appearance of texture and gloss, or the textile character of the painting. Employing a suction table, the treatment includes moisture softening and consolidation of the paint layers using sturgeon glue, as well as lining of the textile support using Plextol D360 and Hollytex 3257 polyester fabric. A.A.

30-S513.
Grant, Campbell.
The rock paintings of the Chumash: a study of a California Indian culture.

Book. Santa Barbara Museum of Natural History, Santa Barbara, 1993, [Eng.]. xviii, 163 p.: ill. (some col.), maps; 29 cm., bibliog. and index.

In discussing the fabrication of the paint used in rock art the author states that it is unknown what binder was used. He suggests that it was probably the same as the Yokuts who he cites as using the juice of the milkweed (*Asclepias fascicularis*) mixed with oil extracted from the crushed seeds of chilicothe (*Marah macrocarpus*). He also mentions that liquid fat of animal origin and eggs may also have been used. Paint application was done with brushes made of yucca fiber or soap plant (*Chlorogalum pomeridianum*) or by using fingers or drawing directly on the rock with a lump of ocher. This is a well known reference for Chumash rock art. M.H.B.

30-S514.
Howard, Helen.
Workshop practices and identification of hands: Gothic wall paintings at St Albans.

The conservator, no. 17, pp. 34-45, (1993), [Eng. w. Eng. summary]. 2 figs., 6 color plates, 1 table, 33 refs.

Scientific examination of two stylistically indistinguishable early 14th-century wall paintings revealed fundamental differences in technique, indicating that they are by different artists. The relationship between the two wall paintings, the surrounding scheme of decoration, and the polychromy on the shrine of S. Alban is explored. A.A.

30-S515.
Krauss, Beatrice H.; Greig, Thelma F., Illustrator.
Plants in Hawaiian culture.

Book. University of Hawaii Press, Honolulu, 1993, [Eng.]. ix, 345 p.: ill.; 24 cm., bibliog. and index. [ISBN 0-8248-1225-5].

Describes the uses of plants for food, medicine, and material culture by the ancient Hawaiians. The history of the introduction of various plants by Polynesian voyagers is discussed as well as the uses of indigenous Hawaiian plants. Pages 65-67 contain a useful table of plants used as colorants with Hawaiian names and their botanical identification. M.H.B.

30-S516.
Labi, Kwame Amoah.
The theory and practice of conservation among the Akans of Ghana.

Affl: Institute of African Studies, Accra, Ghana.

In book. *ICOM Committee for Conservation tenth triennial meeting, Washington, DC, 22-27 August 1993: preprints*, Bridgland, Janet, Editor (1993), pp. 371-376, [Eng. w. Eng. summary]. bibliog.

Describes beliefs and practices associated with conservation among the Akans of Ghana. Particularly interesting is an account of the "black stool" as a symbol of Akan chieftainship. After the death of a chief his stool is blackened to honor his memory if he is deemed to have deserved this honor. A mixture of eggs, gunpowder, soot, and sheep's blood is used to blacken the stool. The process of coating the stool along with the associated ritual and offerings transform the stool into a sacred object. The author describes the woods used to make the stools and explains that the ingredients used in blackening the stools are viewed as preservatives. Subsequent ritual applications of blood and alcohol are accompanied by inspections of the condition of the stool. Certain officials are charged with the care and handling of the stools. This article provides a very interesting description of an indigenous African tradition that parallels Western conservation. M.H.B.

30-S517.
Macgregor, Colin A.
A support system for flexible palm spathe objects.

Affl: Australian Museum. Materials Conservation Division, Sydney, NSW, Australia.

In book. *ICOM Committee for Conservation tenth triennial meeting, Washington, DC, 22-27 August 1993: preprints*, Bridgland, Janet, Editor (1993), pp. 172-177, [Eng. w. Eng. summary]. ill., refs.

Methods to cast supports for flexible sections of Irian Jaya ceremonial costumes were considered. The sections of costume consist of flat palm spathe, decorated with pigment and seeds embedded in a resinous material with feather and fur attachments. The fragile surface decoration required total support to allow inversion of the objects during casting of their undersides. This was achieved using casting plaster and liquid polyurethane foam. Since some parts of the objects are sensitive to heat, temperatures generated by plaster and polyurethane foam while curing were measured. The final support mounts were made from fiberglass-reinforced polyester resin and covered with fabric. A.A.

30-S518.
McClatchey, Will C.
Traditional use of *Curcuma longa* (Zingiberaceae) in Rotuma.

Affl: Brigham Young University. Department of Botany and Range Science, Provo, UT, USA.

Economic botany, **47**, no. 3, pp. 291-296, (1993), [Eng. w. Eng. + summaries].

The ritual production and usage of the powder produced from the rhizomes of *Curcuma longa L.*, on the tropical Polynesian island of Rotuma, prior to European contact was integral in every aspect of life, from birth to death and possibly held religious significance. The orange powder called "mena" was formerly produced on a large scale involving entire villages and several months of preparation. The mena (dry powder) and a paint (powder mixed with coconut oil) were used medicinally both internally and externally. The powder was sprinkled on the shoulders of dancers while performing the traditional dance called the maka. This usage

is the only tradition involving mena which is still widely practiced, although it has been modified with the substitution of imported Gucci powder from Europe. Possible cultural implications of the substitutions and subsequent loss of this traditional plant product are discussed. A.A.

30-S519.
Scott, David A.; and Hyder, William D.
A study of some Californian Indian rock art pigments.

Studies in conservation, **38**, no. 3, pp. 155-173, (1993), [Eng. w. Eng., Fre. + Ger. summaries]. 11 figs., 3 tables, 38 refs.

A study was made of a number of rock art sites in California to determine which pigments had been used by the Native American Chumash Indians. The study was based on pigment microsamples and rock art fragments excavated from site debris. The techniques of examination employed in the study were polarized light microscopy, environmental scanning electron microscopy, electron microprobe analysis, color recording on site, and x-ray powder diffraction. The pigments identified by this study include yellow ocher, red ocher, wood charcoal, halloysite (a white clay), and a white which is probably shell white. The mineral crusts associated with the rock art surface were also studied, and gypsum was found to be a common component, together with the calcium oxalate, whewellite. The potential alteration of carbonate pigments to gypsum is inferred from the study. Illustrated with examples of deteriorated rock art and with cross sections from the sites discussed, particularly Carneros Rock and Painted Rock. A.A.

30-S520.
Stavisky, B.J.; and Zhukova, N.N.
Parallel progress in restoration and archaeology: discovery and restoration of monumental painting and sculpture on a loess ground.

Affl: State Scientific Research Institute of Conservation, Moscow, Russia.

In book. *ICOM Committee for Conservation tenth triennial meeting, Washington, DC, 22-27 August 1993: preprints*, Bridgland, Janet, Editor (1993), pp. 395-398, [Eng. w. Eng. summary]. bibliog.

The post-World War II years were marked by major archaeological discoveries in Central Asia where many ancient wall paintings, as well as clay and ganch (clay and gypsum) sculpture were found. These finds prompted the development of a new trend in restoration. The Hermitage Museum and the State Scientific Research Institute for Restoration (VNIIR) have played a major role in saving and preserving these discoveries by developing a new conservation method which uses synthetic resins and glue. These methods have been applied by restoration specialists in Moscow, St. Petersburg, and Central Asia. A.A.

30-S521.
Stoll, Anna; and Sander, Jochen.
Ein "Tüchlein" aus der van-der-Goes-Nachfolge. Zur Identifikation, Technik und Restaurierung.
(A Tuchlein from the Van der Goes legacy: identification, technique, and restoration.)
Restauro, **99,** no. 5, pp. 347-353, (1993), [Ger. w. Eng. summary]. 14 figs., 61 refs.

The recent interest in Dutch Tuchlein paintings explains the large number of new discoveries. Intensive investigation of the technique of *The Adoration of the Shepherds,* a canvas painting by Hugo van der Goes, reveals that it is of the highest quality and one of the best-preserved examples of the genre. The restoration succeeded in reconstructing the painted surface to such an extent that its original character and texture came to light. A.A.

30-S522.
Subbaraman, S.
Conservation of mural paintings.
Current science, **64,** no. 10, pp. 736-753, (1993), [Eng.].

Deals with the application of scientific techniques in mural painting conservation, especially in India where there are many such paintings. Discusses different aspects of mural paintings, such as techniques, causes of deterioration, and conservation methods. Recent developments in world conservation techniques on mural paintings are also highlighted. Some case studies of work done on different sites of Indian mural paintings are also described. M.M.K.

30-S523.
Watchman, Alan.
Perspectives and potentials for absolute dating prehistoric rock paintings.
Antiquity, **67,** no. 254, pp. 58-65, (1993), [Eng.].

Absolute dating of prehistoric rock paintings is an exciting archaeological pursuit. Sophisticated sample collection, handling and pretreatment methods, and new analytical equipment and techniques are minimizing contamination and permitting identification of trace amounts of organic substances in prehistoric paints. Radiocarbon dating using accelerator mass spectrometry (AMS) is producing dates for minute residues of blood, charcoal and plant fibers, either accidentally or deliberately incorporated in paintings. Carbon-bearing laminations, such as oxalate-crusts and silica skins, which have accumulated under and over rock art, have also been recently dated. Materials used as binders in rock art throughout the world are briefly reviewed. A.A. and M.H.B.

See also:

The examination and treatment of two wood funerary masks with Negroid features, **30-S990.**

When textiles are paintings, **30-S1060.**

Natural resins of art and archaeology. Their sources, chemistry, and identification, **30-S579.**

The state of preservation of Pueblo Indian mural paintings in the American Southwest: findings of a condition study carried out in 1978-1979, and a proposed pilot project to test materials and methods for conservation, **30-S977.**

Problems in the restoration and preservation of old house paints, **30-S947.**

Documentation bois. VII: conservation du bois et traitement des surfaces. Tome 2: traitement des surfaces [Wood documentation. VII: wood conservation and surface treatment. Volume 2: surface treatment], **30-S897.**

Bemalte Wandbehänge als Restaurierproblem [The restoration of painted tapestry and its problems], **30-S1112.**

Annäherung an die Gemäldeoberfläche der modernen Malerei [An approach to the study of modern paintings surfaces], **30-S1124.**

B. Analysis & Examination

This section contains abstracts, primarily from the conservation literature, that pertain to the identification and characterization of materials used as binders and colorants in ethnographic objects; with a subsequent focus on low-cost methods, including microscopy and microchemical tests. (Please note: the citations are organized chronologically by publication year and alphabetically by author within each year.)

30-S524.
Hawley, Florence May.
Classification of black pottery pigments and paint areas.

Book. University of New Mexico bulletin. Anthropological series, no. 2/4, University of New Mexico Press, Albuquerque, 1938, [Eng.]. 27 p.; 24 cm., bibliog.

Describes the use of four types of black pigment on the painted pottery of the Southwest. Types of pigments used are an organic black probably derived from Rocky Mountain Bee Weed (*Cleome serrulata*), carbon or soot, iron oxide, and manganese. Methods of testing are described. The use of certain pigments comprises a cultural trait and the author relates the use of these to Kidder's classifications. M.H.B.

30-S525.
Bontinck, Ed.
(The examination of mural paintings.)

Natuurwetenschappelijk tijdschrift, 23, pp. 97-109, (1941), [Dut.].

Microchemical reactions are given for the analysis of adhesives and dyes, determination of N, S, and P in adhesives containing N (egg white, egg yellow, and casein), gum arabic, resins, linoxyn (black spots on treatment with 1% aqueous OsO_4 solution; detection of glycerol), wax, starch flour in N-free adesives, and of calcium, lead, zinc, iron, manganese, copper, mercury, and sulfur in dyes. A table shows the scheme of analysis for the examination of adhesives. The necessary apparatus, solvents, and reagents are listed. Staff

30-S526.
Malissa, Hanns.
Mikromethoden zur Gemäldeuntersuchung. (Microscopic methods for research on paintings.)

Mikrochemie vereinigt mit Mikrochimica acta, 35, pp. 34-55, (1950), [Ger. w. Eng. summary].

The essential result of this study is the separation scheme given in Table 2, which permits the detection, in a single analytical procedure, of the 20 most important and most frequent elements used by artists. When not indicated by literature references, other detection reactions were mentioned; the "Feigl" spot reactions were drawn on to the fullest extent. Thus a further proof was given that it is entirely possible to accomplish entire separation procedures on the microscale more rapidly and more simply than by macroanalytical methods. Staff

30-S527.
Ewart, M.H.; and Chapman, R.A.
Identification of stabilizing agents.

Analytical chemistry, 24, pp. 1460-1464, (1952), [Eng.]. tables.

A method is described for the identification of stabilizing and thickening agents used in food products including gum tragacanth, starch, gum arabic, gelatin, and others. The proposed identification scheme is based on precipitation reactions with calcium chloride, sodium hydroxide, barium hydroxide, and lead acetate. (Some of these reactions might be useful in the microchemical identification of the mediums of paintings.) Staff

Analysis

30-S528.
Feller, Robert L.
Dammar and mastic infrared analysis.

Science, **120**, no. 3130, pp. 1069-1070, (1954), [Eng.].

Infrared absorption of dammar and mastic were measured in films cast from resins dissolved in chloroform. The curves of good and poor grades of resin, the poor grades being more intensely colored, were practically identical. Spectra of artificially-aged samples were similar to results from unexposed material.　　ICCROM(00249700)

30-S529.
Feller, Robert L.
Special report on picture varnish.

Book. Carnegie-Mellon University. Mellon Institute, Pittsburgh, 1958, [Eng.]. 132 p.: ill.; 28 cm., refs.

The report is not meant to provide the conservator with specific directions for the analysis of varnish, but considers important literature and current methods of analysis that a conservator should know in order to discuss the problems with a chemist-analyst should a need for analysis or identification arise. These include separation of resin and solvent and identification of the resin (solids content, viscosity grades, brittleness, and color). The importance of infrared analysis and paper chromatography are also discussed. Special problems associated with the aging of resins are also considered.　　E.Ha.

30-S530.
Hey, Margaret.
The analysis of paint media by paper chromatography.

Studies in conservation, **3**, no. 4, pp. 183-193, (1958), [Eng. w. Fre. summary]. 14 refs., 4 figs.

The problem of the analysis of paint media is more difficult to solve than that of pigment analysis mainly because the proportion of medium in a given sample is much smaller than the proportion of pigment, but also because of the physical and chemical changes which the materials used as media undergo with time. Paper chromatography is explained.　　ICCROM(01719003)

30-S531.
Smith, F.; and Montgomery, R.
Analytical procedures.

In book. *The chemistry of plant gums and mucilages and some related polysaccharides,* Monograph series (American Chemical Society), no. 141, (1959), pp. 77-113, [Eng.].

Analytical procedures for the identification and characterization of plant gums, mucilages, and some related polysaccharides are given. These include methods for derivatization and hydrolysis in addition to quantitative analytical procedures. Paper and column chromatography and detection methods are reviewed in detail.　　E.Ha.

30-S532.
Heilman, William R.
Nondestructive infrared and x-ray diffraction analyses of paints and plastics.

Journal of forensic sciences, **5**, no. 3, pp. 338-345, (1960), [Eng.].

The benefits and uses of infrared spectroscopy for pigments, dye and extender examination, and of x-ray diffraction for pigment identification, are discussed in comparison to classic microchemical tests. These methods are simple and rapid in addition to being nondestructive.　　E.Ha.

30-S533.
Jones, Peter Lloyd.
Some observations on methods for identifying proteins in paint media.

Studies in conservation, **7**, no. 1, pp. 10-16, (1961), [Eng. w. Fre. summary]. 13 refs.

No general microanalytic technique exists for identifying paint media. This is because materials used in media are highly complex organic substances, containing the same common elements. Binding materials also undergo considerable degradation over long periods of time. The author outlines the existing identification techniques.
　　ICCROM(01720201)

30-S534.
De Silva, R.H.
The problem of the binding medium particularly in wall painting.

Archaeometry, **6**, pp. 56-64, (1963), [Eng.].

A critique and in-depth study of currently used tests and techniques for the anal-

ysis of binders used in mural paintings. It includes the detection of vegetable gum, proteinaceous binders such as animal glue, egg yolk and egg white, milk, and drying oils. Discusses the errors of interpretation that can be caused by the presence of impurities in the major element of the binder. Describes the precautions to be taken in each case to insure reliable test and technique results.

M.B.

30-S535.
Masschelein-Kleiner, Liliane.
Perspectives de la chimie des liants picturaux anciens.
(Perspectives on the chemistry of old paint binders.)

Bulletin (Institut Royal du Patrimoine Artistique) = Bulletin (Koninklijk Instituut voor het Kunstpatrimonium), **6**, pp. 109-125, (1963), [Fre.].

Natural resins occupy an important place among paint binders. The separation of the components of a diterpenic resin is illustrated by the example of sandarac resin fractioning. The text reviews the present-day identification and characterization methods of the components of resin, i.e., paper-, thin-section, gas chromatography, and visible, infrared, ultraviolet, nuclear magnetic resonance spectroscopy. The various factors, such as acids, air, light, and heat, that influence the aging process of these materials are discussed next, as are the chemical effects they cause. The text concludes with an explanation of metallic resinates formation; the presence of these resinates can play an important role in the interaction between the various paint layers.

A.A. and M.B.(transl.)

30-S536.
Zinkel, Duane F.; and Rowe, John W.
Thin-layer chromatography of resin acid methyl esters.

Journal of chromatography, **13**, pp. 74-77, (1964), [Eng.]. refs.

The problem of separating and identifying resin acids has been the subject of considerable research effort. A partition chromatographic system has been employed but is rather tedious and complete separations are not obtained. Partition paper chromatography has been applied with limited success. Gas chromatography has been used with partial

success; in the Forest Products Laboratory, resin acid methyl esters have been subjected to gas chromatography without isomerization of the sensitive abietadienic acid esters. Mass spectroscopy has been used successfully. However, a much simpler method is desirable. Daniels and Enzell have successfully applied a method, developed by Wickberg, for the separation of unsaturated hydrocarbons by partition of their silver π-complexes between hexadecane and aqueous methanol, to the separation of resin acid methyl esters. It seemed quite possible from this work that a more convenient system could be developed having the silver salt in the stationary phase. Indeed, thin-layer chromatography using silver-nitrate-impregnated silica gel has been successfully applied to some difficult separations of unsaturated fatty acid esters and triglycerides. The acetic-acid-containing solvent system of Barrett, Dallas and Padley was ruled out because of the probability of acid isomerization of the resin acid esters. The ethyl ether-hexane system of Morris, however, offered promise.

CCI

30-S537.
Masschelein-Kleiner, Liliane; and Tricot-Marckx, Frieda.
La détection de polysaccharides dans les matériaux constitutifs des oeuvres.
(The detection of polysaccharides in the constituent materials of works of art.)

Bulletin (Institut Royal du Patrimoine Artistique) = Bulletin (Koninklijk Instituut voor het Kunstpatrimonium), **8**, pp. 180-191, (1965), [Fre. w. Dut. summary].

Some polysaccharides, particularly natural gums, have been used as binding agents for paintings. Infrared absorption spectroscopy examination permits differentiation between carbohydrates and proteins. Sugars and uronic acids are identified by thin layer chromatography.

Staff

30-S538.
Stolow, Nathan.
The application of gas chromatography in the investigation of works of art.

In proceedings. *Application of science in examination of works of art: proceedings of the seminar, September 7-16, 1965*, Young, William Jonathan, Editor (1965), pp. 172-183, [Eng.]. graphs, tables, refs.

Analysis

Reviews some of the principles of gas chromatography and its application to the identification of drying oils in the media of works of art and the study of the properties of such films as they age.

ICCROM(00257815)

30-S539.
De Henau, Pierrik; Kléber, Robert; Masschelein-Kleiner, Liliane; Thissen, Jean; and Tricot-Marckx, Frieda.
Les peintures murales Mayas de Bonampak: analyse des matériaux.
(The Maya mural paintings of Bonampak, materials analysis.)

Bulletin (Institut Royal du Patrimoine Artistique) = Bulletin (Koninklijk Instituut voor het Kunstpatrimonium), **9**, pp. 114-124, (1966), [Fre. w. Dut. summary]. 7 figs., 12 notes.

The various mural materials were analyzed to find out the causes and forms of alteration before determining a definite treatment for this most important evidence of Maya pictorial art. The stones and mortar were examined through microscopy, microchemistry, and infrared spectrometry. The organic constituents of the paint layer were examined using thin layer chromatography and infrared spectrometry; proteins and polysaccharides were determined. Pigments were identified as ochers for reds and yellows and as Maya blue (indigo fixed on attapulgite) for the blues. Staff

30-S540.
Feigl, Fritz; Oesper, Ralph E., Translator.
Spot tests in organic analysis.

Book. Elsevier Science Publishers B.V., Amsterdam, 1966, 7th English ed., completely rev. and enl. [Eng.]. xxiii, 772 p.: ill.; 23 cm., refs. and index. [ISBN 0-444-40209-8].

This is one of the two primary, standard reference works on spot tests (see also Feigl and Anger 1972 for analysis of inorganic elements and compounds). Spot tests are single chemical tests carried out in drops of solution on filter paper or on impermeable surfaces. The seventh edition contains chapters on the development, present state, and prospects of organic spot test analysis; preliminary (exploratory) tests for the indication of elements; detection of characteristic functional groups in organic compounds; detection of structures

and certain types of organic compounds; identification of individual organic compounds; application of spot tests in homologous compounds, and determination of constitutions; and application of spot tests in the testing of materials, examination of purity, and characterization of pharmaceutical products. An appendix serves as a guide to the individual compounds and products examined in the text. [Editor's note: This is a basic reference that every conservator should be aware of in regard to low-cost analytical techniques.] E.Ha.

30-S541.
Gettens, R.J.; and Fitzhugh, E.W.
Identification of materials of paintings: I. Azurite and blue verditer.

Studies in conservation, **11**, no. 2, pp. 54-61, (1966), [Eng.]. 1 photo, 11 photomicrographs, 32 refs.

The sources, history of use, preparation, particle and optical characteristics, chemical properties, and permanence of the blue mineral azurite (basic carbonate of copper), formerly much used as a blue pigment in painting, are outlined. The ferrocyanide, triple nitrite, and potassium mercuric thiocyonate tests for copper in microscopic-sized specimens of paint films bearing azurite are described. Also spot tests for copper using rubeanic acid and ferric thiosulfate can be used. Other methods applied to the identification of copper or the azurite molecule in microscopic specimens are emission spectrometry, x-ray diffraction analysis (spacings and intensities of lines above intensity 20 are listed), and x-ray fluorescence analysis. Blue verditer (artifical basic copper carbonate) is in all respects similar to crushed azurite except in particle characteristics; the particles are fine, rounded and uniform in size. Notable worldwide occurrences of azurite in paintings beginning in ancient times are listed. Staff

30-S542.
Mills, John S.
The gas chromatographic examination of paint media. Part I. Fatty acid composition and identification of dried oil films.

Studies in conservation, **11**, no. 2, pp. 92-107, (1966), [Eng. w. Ita., Ger. + Fre. summaries]. refs.

There is a need for a method to characterize dried oil media dependent upon type, age, and origin. Drying oils are composed of mixtures of triglycerides. These are esters formed by the combination of one molecule of the trihydric alcohol glycerol with three molecules selected from a variety of possible fatty acids. The drying-oil triglycerides contain a large proportion of the unsaturated oleic, linoleic, and linolenic acids. The double bonds of the unsaturated acids allow them to combine with the oxygen of the air and with one another to form a polymeric network. After saponification the free acids can be isolated. These contain unchanged saturated acids, a little oleic acid, and the acids resulting from the decomposition of polyunsaturated acids. These components after conversion into their methyl esters can be easily separated and quantatively determined by gas chromatography. The drying process depends on the nature of the pigment and the conditions. A tentative relation can be established between the composition of fatty acids (in particular between saturated acids and the products of decomposition) and age. However, the relationship between the quantities of two saturated acids, palmitic and stearic, for the sample given remains essentially unchanged by drying and is independent of the pigments present. This differs for the principal drying oils—linseed, walnut, and poppy—and seems to be a means for their identification in paint samples. Fatty acids of dried egg are qualitatively similar to those of dried oils but can be distinguished by the very small proportion of bicarboxylic acid produced by the separation, such as azelaic acid. Staff

30-S543.
Van Olphen, H.
Maya blue: a clay-organic pigment?

Science, 154, no. 3749, pp. 645-646, (1966), [Eng.].

Maya blue, a pigment used by the Mayas in Yucatan, is remarkably stable: the color is not destroyed by hot concentrated mineral acids or by heating to about 250°C. The principal constituent is the colorless mineral attapulgite. It is proposed that the pigment is an adsorption complex of attapulgite and natural indigo; a synthetic equivalent may be prepared from attapulgite and either indoxyl ester or indigo, or by applying the vat dyeing technique, with reduced indigo. The low dye content of the pigment (less than 0.5%) indicates that the dye is absorbed only on the external surfaces of the attapulgite particles and not throughout the channels in their structures. The complex as such is not stable to acids, but the stability displayed by Maya blue is achieved simply by heating the complex from 75° to 150°C for several days. An analogous stable pigment can be prepared from sepiolite and indigo. No stable pigments could be prepared from clays with platelike structures or from zeolotes.
C.A.L.

30-S544.
Kleber, R.; Masschelein-Kleiner, Liliane; and Thissen, J.
Etude et identification du Bleu Maya. (Examination and identification of Maya blue.)

Studies in conservation, 12, no. 2, pp. 41-56, (1967), [Fre. w. Eng., Ita. + Ger. summaries].

The Maya blue was studied by physical and chemical methods: optical microscopy, reflection spectrophotometry, x-ray and electron diffraction, electron microscopy, infrared absorption spectrophotometry, electrophoretic mobility, chemical stability, vat dyeing of attapulgite with indigo and their interaction on heating. A pigment at least similar to Maya blue is found to be produced by heating at 190°C a mixture of attapulgite and indigo. A set of pigments with variable indigo content was prepared in order to determine the limits of detection of the dyestuff. Infrared spectrophotometry was found to be the most suitable method for the identification of indigo. This dyestuff has definitely been identified in authentic samples of Maya blue. The conclusion that the colored principle in Maya blue is indigo is further supported by x-ray diffraction. Pigments similar to Maya blue containing indigo and attapulgite were also found in samples representative of other civilizations of ancient America: Mixtec, Toltec, and Aztec. The mechanism of the interaction of indigo and attapulgite is discussed. Electrophoretic mobility of the pigment indicates that indigo fixed on the clay behaves as a cationic additive on the dispersed electronegative colloidal attapulgite.
ICCROM(01722300)

30-S545.
Delbourgo, Suzy; and Gay, Marie Christine.
La physico-chimie au service de l'archéologie—examen d'une série d'échantillons provenant de fouilles effectuées au Soudan.
(Physico-chemistry at the service of archaeology: examination of a series of samples from excavations done in Sudan.)
Bulletin du Laboratoire du Musée du Louvre, **12,** pp. 20-25, (1968), [Fre.].

Reports on the examination of a series of samples of organic remains or mineral compounds proceeding from excavations in Mirgissa, Sudan. The mineral samples were studied by chemical microanalysis and emission spectrography. The organic compounds were analyzed by chromatography in thin layers and by spectrometry of infrared absorption. For the mineral products, the samples could be classified by those containing impure natron, ferruginous clay, red ocher, fired kaolin, or lead sulfur. For the organic materials, in one of the samples, glucose, xilose, and dextrin (probably cereal remnants) were detected; in the other, honey, proteins and beeswax colored with red ocher. Reservations are stated concerning the exploitation of these results, as they convey the present degraded state of the analyzed samples. Staff

30-S546.
Flieder, Françoise.
Mise au point des techniques d'identification des pigments et des liants inclus dans la couche picturale des enluminures de manuscrits.
(The development of techniques of identification for pigments and binders used in the paint layer of manuscript illuminations.)
Studies in conservation, **13,** no. 2, pp. 49-86, (1968), [Fre. w. Eng., Ger. + Ita. summaries].

A very large number of illustrations on manuscripts are damaged. With a view to restoring them in a more justified way a study has been made of the chemical composition of the paint layer of these illustrations. The problem of the mineral pigments has been solved thanks to microscopic and microchemical examinations. Where the sample was very small micromanipulation was applied. Unfortunately, since these techniques are not suitable for the study of organic pigments, physical methods, such as infrared spectrophotometry, were tried. This examination requires, according to the procedure applied at present, a pure sample of at least 1 mg; because these two conditions can hardly ever be met, it will be necessary to change the procedure or to employ other methods of analysis, such as ultraviolet spectrophotometry or thin layer or gas chromatography. The problem of the mediums has partly been solved, thanks to thin layer chromatography. According to the information from the literature, the media used by illustrators were watery and belonged to the class of glucosides or proteides. By hydrolysis the glucosides release sugars and uronic acids and the proteides amino acids. It is, therefore sufficient to identify the products released by hydrolysis in order to know the nature of the media used. Methods of hydrolyzing media and identifying the hydrolyzed products have been developed. This examination still lacks precision, for if, in certain cases, the nature of the medium can be determined, this is not always possible, because certain sugars and amino acids are sometimes difficult to bring out. Although at present it is possible to identify the nature of mineral pigments and certain media, the problem of organic pigments remains unsolved. Staff

30-S547.
Masschelein-Kleiner, L.; Heylen, J.; and Tricot-Marckx, F.
Contribution à l'analyse des liants, adhésifs et vernis anciens.
(Contributions to the analysis of binders, adhesives and ancient varnishes.)
Studies in conservation, **13,** no. 2, pp. 105-121, (1968), [Fre. w. Eng., Ger., Ita. + Spa. summaries].

An analytical scheme is proposed for the whole of binders, adhesives, and old varnishes. Of special interest is the fraction of the constituents little or not altered by the process of aging. Four analytical methods are used in succession: solubility tests, infrared absorption spectrometry, thin layer chromatography, and gas chromatography. The stages succeed one another in such a way that each type of material can be subjected to an unbiased study. The study details the identification of polysaccharides, proteins,

waxes, resins, tars, and oils that may have been used in ancient times. The separation of the various mixtures, such as wax and resin or oil and resin, is also envisaged. The method has been developed by its application to analyses carried out at the Institut Royal du Patrimoine Artistique, Brussels.

Staff

30-S548.
Cabrera Garrido, José María.
El "Azul Maya"
(Maya blue.)

Special issue. *Informes y trabajos del Instituto de Conservacion y Restauracion de Obras de Arte, Arqueologia y Etnologia,* no. 8, 1969, [Spa.]. 37 p.: ill (some col.).

It is demonstrated that Maya blue is composed of attapulgite and indigo. Maya blue was used profusely in parts of Mexico and Central America, at least since the "classic period of the Maya Culture" to the present, to decorate many varied objects such as beads, mural and easel paintings, and manuscript illumination. The author proposes to isolate indigo by treatment with cold, concentrated acid, washing with alcohol, and extraction of the coloring with slightly heated chloroform.

Staff

30-S549.
Gettens, Rutherford J.
Preliminary report on reference materials: ICOM Committee for Conservation, Amsterdam, 15-19 September, 1969.

Technical report. ICOM Committee for Conservation, Paris, 1969, [Eng.]. 18 p.

The questionnaire elicited 46 replies concerning the various things collected and retained by museum laboratories as "reference materials." They include microscope slide mounts made from samples from objects, thin and opaque sections, various trimmings, detached fragments, etc., bulk pigments and microscope mounts made from them, analytical standards, x-radiographs, and artists' studio leavings. The information collected is discussed rather generally and recommendations made.

ICCROM(00893011)

30-S550.
Petrović, Slobodan M.; and Canić, Velimir D.
Separation of carbohydrates by thin-layer chromatography.

Affl: University of Novi Sad. Department of Chemistry, Novi Sad, Yugoslavia.

Mikrochimica acta, pp. 599-604, (1969), [Eng. w. Eng. + Ger. summaries]. 5 figs., 1 table, 8 refs.

The separation of 13 sugars by means of eight solvents and one- and two-dimensional chromatography on cellulose and starch layers is described. Good results were obtained on cellulose layers.

A.A.

30-S551.
Riederer, J.
Infrarotspektrographische Untersuchung der gelben und roten Eisenoxidpigmente. (Infrared study of the yellow and red iron oxide pigments.)

Deutsche Farben-Zeitschrift, **23**, no. 12, pp. 569-577, (1969), [Ger.].

Yellow, brown, and red iron oxide—pigments of natural or synthetic origin—cannot be determined from the small samples which can be taken from paintings with the same accuracy as is possible with infrared absorption spectrography, using micro samples. The kinds of clay minerals (kaolinite, montmorillionite, nacrite, illite, etc.) which are constituents of earth minerals can be determined, with the aim to classify ochers from different origins used in painting. Some 24 spectra of iron oxide pigments are illustrated and discussed.

Staff

30-S552.
Broekman-Bokstijn, M.; Van Asperen De Boer, J.R.J.; Van 't Hul-Ehrnreich, E.H.; and Verduyn-Groen, C.M.
The scientific examination of the polychromed sculpture in the Herlin altarpiece.

Studies in conservation, **15**, no. 4, pp. 370-400, (1970), [Eng. w. Eng., Fre., Ger., Ita. + Spa. summaries]. 10 figs., 4 tables, 49 refs.

An account is given of the examination of the polychromed sculpture in the Herlin altarpiece (1466) in Rothenburg o/d T. (Germany). Analytical methods used, such as microscopy, wet chemical analysis, infrared

Analysis

spectrophotometry, thin layer chromatography, and gas and liquid chromatography are briefly described. Criteria for identification are summarized. Pigments identified are azurite, indigo, verdigris, green earth, madder, vermilion, red lead, lead white, and carbon black. The binding medium is glue in matte areas. In other parts paintings are mostly based on a resinous medium with varying amounts of oil. The materials identified in the appliqué relief brocades are compared with recipes described in the *Liber Illuministarius* from Tegernsee. Silver foil is used in producing translucent paint. A.A.

30-S553.
Hyman, David S.
Precolumbian cements: a study of the calcareous cements in pre-Hispanic meso-American building construction.

Book. Johns Hopkins University Press, Baltimore, 1970, [Eng.]. v.: ill., maps; 28 cm., bibliog.

This study was made to procure information on the characteristics of pre-Columbian cements manufactured for and used by the building industry in middle America between the 1st and 16th centuries. Samples of stuccos, mortars, and concretes were obtained from 18 sites in Mexico and Central America. Specimens selected were considered representative of various cultures which had occupied the central valley of Mexico and surrounding area, and of both the highland and lowland Maya. Materials obtained were subjected to petrographic, chemical, and x-ray diffraction analyses and, wherever practical, load tests. The assembled and collected data form the basis for interpenetrations stated below. Lime (calcite) cements were used exclusively in the building industry in prehispanic Mesoamerica, and were apparently manufactured only by the process of calcining limestone rock. The study produced no evidence to support postulations that cement had been manufactured from shell, gypsum or uncalcined sascab (lime sand). Also it is apparent that hydraulic cements, either of the pozzolanic or Portland types, were not used in middle America prior to the European invasions. Some concretes and stuccoes indicate the employment of additives prepared from vegetable gums to improve the quality of the finished products. In a few cases, there is evidence

of the use of surface hardeners to make aqueduct linings impervious. American technology in the manufacture of cement, its mixing and placement 2,000 years ago, paralleled that of the Greeks and Romans during the same time period. Subsequently, hydraulic cements largely replaced lime in concretes in Europe and the Mediterranean region but apparently never found their way into America. This study has not been able to uncover clues relative to the origins of American cement manufacturing. The earliest sample, dating probably to the first century AD, is a fully developed product. Its predecessors as yet remain obscure. [Editor's note: Mesoamerican stuccos and plasters often present consolidation problems similar to matte painted surfaces.] A.A.

30-S554.
Johnson, Meryl; and Packard, Elisabeth.
Methods used for the identification of binding media in Italian paintings of the 15th and 16th centuries.

Studies in conservation, **16,** no. 4, pp. 145-164, (1971), [Eng. w. Fre., Ger., Ita. + Spa. summaries]. refs.

For the study of Italian paintings and their techniques, the examination of the binding media (glue, egg, oil) has considerable importance, but with the usual scientific methods of analysis the results have never been conclusive. Each sample may include more than one layer of paint and many constituents: egg yolk alone contains protein, oils, and cholesterol. In the present project, in order to identify these diverse materials and also to eliminate interference from contamination (glue, wax, or oil) used in later restoration processes, it was decided to mount original paint samples, including a bit of the ground, as cross sections in polyester resin embedding material and then to make the constituents visible under the microscope by using selective staining techniques. Only in this way could the foreign materials be distinguished from the original and the structure of the original layers be understood. Finally, other tests such as the fluorescent antibody technique and thin layer chromatography could be applied to confirm the results of the staining. In removing over 500 specimens from paintings in the Walters Art Gallery precautions were taken to assure sample

authenticity, and during the testing at the University of Michigan careful methods of standardization and control were devised, using both fresh and old samples of egg tempera and oil. Two stains, Ponceau S for protein and Sudan Black B for oil, provided the most workable means of identifying the binding media in the majority of the samples studied. A final report will have to await correlation of the material, but certain observations may be made at this stage: a) 14th century, in primarily tempera paintings a limited use of oil was found associated with a specific green pigment, copper resinate; b) 15th century, the majority of the paintings were entirely of egg tempera, but layers containing oil in the underpainting or in the above-mentioned copper green occurred more frequently; c) 16th century, egg tempera was not replaced by oil, but both were used in a complex layering technique, the media varying layer by layer and area by area; d) 17th century, the mixed technique gradually declined, but egg tempera continued to be associated with the painting of flesh and occasional highlights. Staff

30-S555.
McCrone, Walter C.
Ultramicrominiaturization of microchemical tests.

The microscope, **19,** pp. 235-241, (1971), [Eng.].

By controlling the relative humidity in a small cell on the microscope stage, Chamot-type microchemical tests can be carried out in nanogram-size drops. This reduces the sample size in such tests from the microgram to the picogram range. C.A.L.

30-S556.
Feigl, Fritz; Anger, Vinzenz, and Oesper, Ralph E., Translators.
Spot tests in inorganic analysis.

Book. Elsevier Science Publishing Co., Inc., New York, 1972, 6th English ed., completely rev. and enl. [Eng.]. xxix, 669 p.: ill.; 23 cm., refs. [ISBN 0-444-40929-7].

This is one of the two primary, standard reference works on spot tests (see also Feigl 1983 for analysis of organic compounds). Spot tests are single chemical tests carried out in drops of solution on filter paper or on impermeable surfaces. They are useful for the identification of both cations and anions of

elements and compounds. This sixth edition contains chapters on the development, present state and prospects of inorganic spot test analysis; methodology of spot test analysis; preliminary orientational tests; tests for the elements, their ions and compounds; and application of spot reactions in tests of purity, examination of technical materials, and studies of minerals. The last chapter presents a tabular summary of substances that can be identified, reagents or test reactions and limit of identification with reference to the pages of the text which describe the tests. [Editor's note: This is a basic reference that every conservator should be aware of in regard to low-cost analytical techniques.] E.Ha.

30-S557.
Gettens, Rutherford J.
Second report on reference materials incorporating special reports by members of the working group: ICOM Committee for Conservation, Madrid, 2-7 October, 1972.

Technical report. ICOM Committee for Conservation, Paris, 1972, [Eng.] 47 p.

Contains five papers: R.J. Gettens, the reference materials working party; S. Rees Jones, radiographs and infrared photographs of paintings and objects in galleries and other institutions; M. Tabasso Laurenzi, collections of cross sections of paintings in galleries and other institutions; R. Feller, reference standards for pigments, paper fibers, textile fibers, and particulate materials; R.J. Gettens, specimens of ancient materials for technical study. A.A.

30-S558.
Mills, John S.; and White, Raymond.
The gas-chromatographic examination of paint media. Part II. Some examples of medium identification in paintings by fatty acid analysis.

In book. *Conservation of paintings and the graphic arts: preprints of contributions to the Lisbon Congress, 9-14 October 1972,* (1972), pp. 721-728, [Eng.].

Results given were obtained solely by gas-chromatographic analysis (GLC) of the fatty acids present; methods for sampling and discussion are provided. Staff

30-S559.
Rölofs, Wilma G.Th.
Thin layer chromatography: an aid for the analysis of binding materials and natural dyestuffs from works of art.
Book. ICOM report, no. 9/72/3, International Council of Museums, Paris, 1972, [Eng.]. 21 p.: ill., refs.

Basic principles of chromatography are discussed and the experimental technique is described in detail. Methods for determining resins, varnishes, glues, and red and yellow dyestuffs from painting are described.
C.A.L.

30-S560.
Takiura, Kiyoshi; Yamaji, Akira; and Yuki, Hidetaka.
(Analysis of natural resins by pyrolysis gas chromatography. II. Identification of natural resins by pyrograms.)
Affl: Osaka University. Faculty of Pharmaceutical Sciences, Osaka, Japan.
Yakugaku zasshi, **93**, no. 6, pp. 776-781, (1973), [Jpn. w. Eng. summary].

Pyrolysis gas chromatography at 450° was investigated for the identification of natural resins. Each natural resin tested gave different pyrogram, and the characteristic peaks were identified as follows: From copal, *m*- and *p*-xylene and limonene, acetone from rosins, C_9H_{14} and isoprene from gamboge, ethyl acetate from guaiacum, methanol from dragon's blood, toluene and styrene from Storax and Peru balsam, and monoterpene compounds from elemi and Canada balsam. Consequently, it was concluded that natural resins can be identified by their characteristic pyrogram at 450°.
A.A.

30-S561.
Gettens, Rutherford J.; FitzHugh, Elisabeth West; and Feller, Robert L.
Calcium carbonate whites.
Studies in conservation, **19**, no. 3, pp. 157-184, (1974), [Eng. w. Eng., Fre. + Ger. summaries]. refs.

Calcium carbonate in various forms has had from earliest times a wide role in art. The most common natural form of calcium carbonate is calcite. It is ubiquitous in the mineral, animal, and vegetable kingdoms. It occurs mainly in sedimentary rocks like chalk and limestone, but also in metamorphic rocks like marble, and even occasionally in igneous rocks. Calcite (and sometimes its dimorph, aragonite) is the main constituent of some mollusk shells, but living or fossil lower organisms of recent origin are more likely to be composed of aragonite, the less stable form, which is converted to calcite with changes in the environment, particularly heating. Calcite also occurs as the skeletal material of many forms of marine life, such as the *Foraminifera* and *Coccolithophoridae*. It is the main constituent of cave deposits, onyx marble, and other concretionary lime carbonate rocks. Pure calcium carbonate is white; hence it has many uses in powdered as well as in massive forms in arts and industries. The powdered whites are still used as the principal pigment white in some modern paints and as extenders and bulking agents for white hiding and colored paints. The different types of calcium carbonate pigments that have a place in the history of painting materials are calcite, chalk, precipitated chalk, lime white, shell white, and coral. They are differentiated mainly by particle characteristics which are described here for each kind.
A.A.

30-S562.
Masschelein-Kleiner, Liliane.
An improved method for the thin-layer chromatography of media in tempera paintings.
Studies in conservation, **19**, no. 4, pp. 107-111, (1974), [Eng. w. Fre., Ger., Ita. + Spa. summaries].

Thin-layer chromatography of dansyl amino acid derivatives permits the improvement of the limits of detection of protein media in paintings. These derivatives can be detected in very small concentrations by their fluorescence under ultraviolet light. The procedure of identification is described and some examples are given.
ICCROM(01724301)

30-S563.
Birstein, V.J.
On the technology of Central Asian wall paintings: the problem of binding media.
Studies in conservation, **20**, no. 1, pp. 8-19, (1975), [Eng. w. Fre., Ger., Ita. + Spa. summaries].

Analysis

Organic components of paint layers and grounds in specimens of late ancient and early Medieval Central Asian wall paintings were studied. Quantitative analysis of amino acids isolated from specimens of Mansur-Depe wall paintings, 2nd-1st centuries BC, has demonstrated that gelatin was used for the preparation of painting media and grounds; proline, glycine, and alanine were revealed to a high percentage while hydroxyproline was not detected. In other wall paintings of the 2nd-8th centuries, the use of plant gums was inferred since polysaccharides isolated from the specimens had infrared spectra resembling those of polysaccharides from the *Prunoideae* subfamily. The gum used in the Toprak-Kala wall paintings, 3rd-4th centuries, and in a 19th-century painting from Khiva could be identified precisely: it was either apricot or cherry gum. The technique used for the preparation of paints and grounds in Mansur-Depe and Kara-Tepe, 2nd-4th centuries, ressembles those described in Medieval Indian manuscripts. Staff

30-S564.
Birstein, V.J.
A study of organic components of paints and grounds in Central Asian and Crimean wall paintings.

Affl: WCNILKR, Moscow, Russia.

In book. *ICOM Committee for Conservation, fourth triennial meeting, Venice, 13-18 October 1975: preprints*, (1975), pp. 75/1/10-1 -9, [Eng.].

Glue-based paints were apparently used for ancient and early Medieval paintings of central Asia; a mixture of amino acids and polysaccharides was isolated from specimens of 2nd century BC to 7th century AD. Gelatin and gums were employed as binding media for paints and grounds. Both binding media were widely used in medieval Indian art. Analysis of a specimen of monochromatic antique Panticapean painting showed that the paint layer consisted of ocher and $CaCO_3$ implying that the painting was done in fresco technique. Beeswax isolated from the specimen was probably applied to the walls after finishing the painting. Staff

30-S565.
Breek, R.; and Froentjes, W.
Application of pyrolysis gas chromatography on some of Van Meegeren's faked Vermeers and Pieter de Hooghs.

Studies in conservation, **20,** no. 4, pp. 183-189, (1975), [Eng.]. refs.

Comparative pyrolysis gas chromatography of material from the Van Meegeren studio, with samples of five Vermeer and Pieter de Hoogh fakes attributed to Van Meegeren, has confirmed irrevocably that the binding medium in these samples is identical to the synthetic resin Van Meegeren stated he used. Gas chromatographic identification of the substances that caused five of the characteristic peaks in the pyrograms confirmed that this binder and the synthetic resin consist of a polymerized phenol formaldehyde synthetic resin. Staff

30-S566.
Littman, Edwin R.
Short methods for the identification of pigments.

American antiquity: a quarterly review of American archaeology, **40,** no. 3, pp. 349-353, (1975), [Eng.].

Semimicro methods have been devised for the identification of the metallic components comprising the pigments used in Mesoamerican mural paintings. The analyses are performed on individual samples [10-15 mg] for each color, thereby eliminating the need for long and tedious analytical procedures which are difficult to apply to the small amounts of material often available. Staff

30-S567.
Martin, Elisabeth.
Notes sur l'identification des protéines dans les liants de peinture.
(Notes on the identification of proteins in paint binders.)

Annales (Laboratoire de recherche des musées de France), pp. 57-60, (1975), [Fre.].

Describes a new method of identification of proteins in paint mediums by coloration of thin layers; the reaction is called black amide. The technique, its advantages over previous methods (fuschine, ponceau) and new information provided by the use of

Analysis

black amide (distinction of different successive layers of identical color or determination of a mixture of binders) are given. The advantages of this method were evident during a systematic study of madder layers of 14th- and 15th-century Italian paintings in the Campana collection. Staff

30-S568.
Nelson, Fred W., Jr.
A simple method for distinguishing between organic and inorganic paints on black-on-white Anasazi pottery.

American antiquity: a quarterly review of American archaeology, **40,** no. 3, pp. 348-349, (1975), [Eng.].

Testing with potassium ferrocyanide in the presence of hydrochloric acid immediately forms a dark blue precipitate if the paint is inorganic (iron oxide). Staff

30-S569.
Paramasivan, Subrahmanya.
Ajanta and Ellora wall paintings. Scientific research as an aid to their conservation.

Bulletin (Institut Royal du Patrimoine Artistique) = Bulletin (Koninklijk Instituut voor het Kunstpatrimonium), **15,** pp. 302-317, (1975), [Eng.].

The following examinations were carried out on the wall paintings of the rock cut temples of Ajanta and Ellora in India: microsection, size of particles in the rough plaster, analysis of the plaster, technique of laying the ground, pigments and binding medium. The results are listed. Describes the main causes of deterioration of the paintings, cracks in the stone, efflorescences of calcium sulfates, accretions on the paint layer. Suggestions for conservation are given. ICCROM(01027318)

30-S570.
Birstein, V.Ya.; and Tul'chinsky, V.M.
An investigation and identification of polysaccharides isolated from archaeological specimens.

Chemistry of natural compounds, **1,** pp. 12-15, (1976), [Eng.].

Polymeric compounds have been isolated from archaeological specimens (fragments of Central Asian paintings of the 2nd-19th centuries). A comparison of their infrared spectra with the spectra of plant gums has shown that they are polysaccharides which have remained undestroyed for up to 1800 years. In some cases it has been possible from the infrared spectra and composition of the extracted polysaccharides to provisionally identify sour-cherry or apricot gum, of which these polysaccharides were components. A.A.

30-S571.
Kashiwagi, K. Maresuke.
An analytical study of pre-Inca pigments, dyes and fibers.

Bulletin of the Chemical Society of Japan, **49,** no. 5, pp. 1236-1239, (1976), [Eng.]. bibliog.

The total analysis of 800-year-old Peruvian pigments with regard to the inorganic elements was carried out; some typical pigments, like vermilion and iron oxide, were shown. Some characteristic pre-Inca (6th-7th century Tiwanaku and 13th-14th century Chancay) dyes, including cochineal, indigo, and probably logwood, were identified from old fabrics by absorption spectroscopy and chromatographic analysis. Two kinds of fiber constituting those fabrics were also investigated, and a few chemical analyses, including that of the amino acid composition of protein fiber and that of the extent of degradation of old cellulose fiber, were made. Staff

30-S572.
Masschelein-Kleiner, Liliane.
Contribution to the study of aged proteinaceous media.

In book. *Conservation and restoration of pictorial art,* Brommelle, Norman; and Smith, Perry, Editors (1976), pp. 84-87, [Eng.].

The purpose of this study was to improve methods for the identification of the four principal proteinaceous media: animal gelatin, casein emulsion, egg white, and egg yolk. This was achieved by gas chromatography. ICCROM(00859311)

126

30-S573.
Mills, John S.; and White, Raymond.
The gas chromatographic examination of paint media. Some examples of medium identification in paintings by fatty acid analysis.

In book. *Conservation and restoration of pictorial art,* Brommelle, Norman; and Smith, Perry, Editors (1976), pp. 72-77, [Eng.].

Paint media of several paintings of the Italian, French, Spanish, and Flemish schools, of the 15th through the 20th centuries, were identified by gas chromatographic analysis of the fatty acids present.

ICCROM(00859309)

30-S574.
Mills, John S.
The identification of paint media: an introduction.

In book. *Conservation and restoration of pictorial art,* Brommelle, Norman; and Smith, Perry, Editors (1976), pp. 69-71, [Eng.].

The identification of paint media has always been second to the study of paint layer structure and pigments. Several reasons for this are given. The approach to the identification of media is presented by reviewing the various analytical methods and instruments available and their capacities.

ICCROM(00859308)

30-S575.
Rogers, George Dewitt.
An improved pyrolytic technique for the quantitative characterization of the media of works of art.

In book. *Conservation and restoration of pictorial art,* Brommelle, Norman; and Smith, Perry, Editors (1976), pp. 93-100, [Eng.].

Quantitative analysis of art media by the Pyroprobe 100 pyrolysis system is described and judged more accurate than previous systems. (See also AATA 9-706 and 14-1005). Staff

30-S576.
Weiss, Norman R.; and Biemann, K.
Application of mass spectrometric techniques to the differentiation of paint media.

In book. *Conservation and restoration of pictorial art,* Brommelle, Norman; and Smith, Perry, Editors (1976), pp. 88-92, [Eng.].

The experiments performed illustrate four of the most useful mass spectrometric techniques currently available for the differentiation of paint media.

ICCROM(00859312)

30-S577.
Arpino, P.; Moreau, J.-P.; Oruezabal, C.; and Flieder, F.
Gas chromatographic mass spectrometric analysis of tannin hydrolysates from the ink of ancient manuscripts (XIth to XVIth century).

Journal of chromatography, **134,** no. 2, pp. 433-439, (1977), [Eng.]. refs.

A procedure was devised for determination of constituents of ink from ancient handwritten parchments. Tannic acids and sugars from acid hydrolysis of ink were identified at the nanogram level by gas chromatography-mass spectrometry of their trimethylsilyl derivatives. The presence of ferrogallic inks on manuscripts was assumed from the detection of gallic acid and glucose by selective ion monitoring and capillary-column gas chromatography. The method was applied to inks from European manuscripts dating from the 11th to the 16th centuries, and to possible ink precursors (extracts from gall nuts, pods of Tara (*Caesalpinia spinosa*), and gum arabic).

Staff

30-S578.
Mills, J.; and White, R.
Analyses of paint media.

National Gallery technical bulletin, **1,** pp. 57-59, (1977), [Eng.].

Analysis of paint media by gas chromatography on 28 paintings of the National Gallery, London. ICCROM(01843807)

30-S579.
Mills, John S.; and White, Raymond.
Natural resins of art and archaeology. Their sources, chemistry, and identification.

Studies in conservation, **22,** no. 1, pp. 12-31, (1977), [Eng. w. Fre. + Ger. summaries].

Reviews the botanical sources and chemical compositions of natural resins used

in the fabrication of objects of art and archaeology. They fall into two main chemical groups: those containing diterpenoids (from the order Coniferales and from the Leguminosae family), and those containing triterpenoids from several families of broad-leaved trees. Their chemical compositions, although liable to varying degrees of change with time and exposure, permit them to be identified more or less precisely in favorable cases. Examples of such identifications are described, mostly of conifer resins, using gas chromatography. A.A.

30-S580.
Shepard, Anna O.; and Pollock, Harry E.D.
Maya blue: an updated record.

In book. *Notes from a ceramic laboratory*, (1977), [Eng.]. 32 p.: ill., 3 figs., 7 tables.

Summarizes data and outlines problems regarding research on Maya blue. Topics covered are: ceramic materials of contemporary Yucatecan potters; attapulgite in Yucatán; important samples of Maya blue; Seri blue; Montmorillonite blue; historic Mexican records of blue dyes; a chemist's description of the preparation of indigo dye; ethnological records relating to Maya blue; the archaeological significance of Maya blue; and problems for future research. C.A.L.

30-S581.
Mills, John S.; and White, Raymond.
Organic analysis in the arts: some further paint medium analyses.

National Gallery technical bulletin, **2**, pp. 71-76, (1978), [Eng.].

Presents a table of results from current paint media analyses carried out by gas chromatography. Begins with a brief historical survey of methods used for organic analysis of materials used in art objects and, in particular, paint media. Notes to the table include supplementary staining tests carried out on prepared sections. See also AATA 15-579.
 Staff

30-S582.
Butzer, Karl W.; Fock, Gerhard J.; Scott, Louis; and Stucken-Rath, Robert.
Dating and context of rock engravings in South Africa.

Science, **203**, no. 4386, pp. 1201-1214, (1979), [Eng.].

Prehistoric rock engravings are seldom recovered from sealed archaeological contexts and are therefore difficult to date. Multidisciplinary study of technique, thematic variation, faunal content, geoarchaeological patterning, settlement history, and ethnoarchaeological setting can provide information. Paper chromatographic determination of amino acids in paint binder can provide age estimation; binders may include bird-egg albumin, milk casein, animal glue, and animal blood or serum. Radiocarbon dating is not possible because of the small amount of material. Pigments used include charcoal, soot, or ground manganiferous concretions for black; pulverized ferric concretions or ferruginized shales and sandstones, sesquioxide-rich clayey to sandy soils, or animal blood for yellow, orange, brown, or red; marl, gypsum, kaolin, or bird guano for whites. Staff

30-S583.
Ghebregzabher, M.; Rufini, S.; Sapia, G.M.; and Lato, M.
Improved thin-layer chromatographic method for sugar separations.

Affl: Università degli Studi di Perugia. Istituto di Clinica Pediatrica, Perugia, Italy.

Journal of chromatography, **180**, pp. 1-16, (1979), [Eng. w. Eng. summary]. 7 figs., 6 tables, 9 refs.

A method is described for the utilization of precoated, nonimpregnated silica gel thin layers in one- and two-dimensional separations of carbohydrates and related compounds. Boric and phenylboronic acids were added to the organic elution systems in different concentrations and their interactions with the sugar molecules during the chromatographic process were studied. A comparison was made between solvent systems containing boric or phenylboronic acid and systems devoid of both acids as eluents. With boric acid-containing solvents the migration of some sugars was considerably inhibited, whereas phenylboronic acid produced an increase in the R_F values of certain sugars. The combination of these two types of solvent in two-dimensional development resulted in the

clear separation of a group of mono- and disaccharides of bioclinical interest.　　A.A.

30-S584.
Maue, Hermann, Editor.
Johann Georg Rudolphi: 1633-1693. Vol. 1.
(Johann Georg Rudolphi (1633-1693).
Volume 1.)

Book. Ferdinand Schöningh GmbH Verlag, 1979, [Ger.]. 109 p.: ill., map; 25 cm., refs. [ISBN 3-506-76175-7].

Some 37 Rudolphi paintings on canvas and copper that have been restored recently, were exhibited; his work has been influenced by Rubens. 12 of the paintings, dating from 1660 to 1690, are primed with yellow-red ochers with various additions such as quartz, chalk, smalt, and glass-powder. The pigments found include: three different red lakes, lead-tin yellow, azurite, ultramarine, indigo, and smalt. Copper plates have been primed with lead white in oil. Canvas was the cloth generally used, but one altar painting from Hoexter (1670) was done on hemp. Gas chromatography was used to analyze the media; this was identified as linseed and walnut oil mixed with animal glue, occasionally with egg yolk. Walnut oil was used only with white and blue pigments. A mastic resin was used with lead white and lead-tin yellow along with the oil and some protein substance. He is one of the few Baroque painters to have employed tempera in the tradition of Flemish and German Renaissance artists.
　　Staff

30-S585.
McCrone, Walter C.
Application of particle study in art and archaeology.

In book. *The particle atlas: an encyclopedia of techniques for small particle identification*, (1979), pp. 1402-1413, 2nd ed. [Eng.].

An introduction to the field of particle study includes specifications for polarizing microscopes and stereobinocular microscopes and identification of pigments and fibers. A table lists the optical crystallographic properties and characteristic descriptions of 48 common paint pigments. Six dichotomous keys provide an analytical scheme for identifying

pigments by polarized light microscopy. See AATA 13-872, 15-3, 18-842, and 18-843.
　　Staff

30-S586.
McCrone, Walter C.; Delly, John Gustav; and Palenik, Samuel J.
The particle atlas: an encyclopedia of techniques for small particle identification.

Book. Ann Arbor Science Publishers, Ann Arbor, 1979, 2nd ed. [Eng.]. 5 v.: ill.; 32 cm., bibliogs. [ISBN 0-250-40008-1].

The first volume deals with principles and techniques for particle identification. The individual chapters cover the following topics: optics and the microscope, characterization of particles, particle handling techniques, and methods of identification. The second volume, "The Light Microscopy Atlas," describes the procedures for the study of samples. It includes 609 color plates of micrographs with a description of each slide. The third volume is the Electron Microscopy Atlas. There are procedures for study with both the scanning and transmission electron microscopes. There are 609 black and white plates with descriptions. The last volume is the "Particle Analyst's Handbook" which tabulates all the background data. It includes tables, charts, graphs, a glossary, and an extensive bibliography.
　　Staff

30-S587.
Mills, John S.; and White, Raymond.
Analyses of paint media.

National Gallery technical bulletin, **3**, pp. 66-67, (1979), [Eng.]. ill., 1 table, refs.

The authors present further analyses of the paint media of works in the National Gallery, London. Like earlier results they are based on gas-chromatographic examination of the fatty acid content of the samples. In most cases the results are unambiguous and unsurprising and tend to confirm trends noted before, notably the use of walnut oil in the earlier Italian oil painting and its replacement by linseed oil as the 16th century progressed.
　　C.A.L.

Analysis

30-S588.
Wüpper, John L.
Pyrolysis gas chromatographic mass spectrometric identification of intractable materials.

Analytical chemistry, **51,** no. 7, pp. 997-1000, (1979), [Eng.]. 9 figs., 1 table, 11 refs.

Pyrolysis gas chromatography-mass spectrometry with data system is used to provide unequivocal identification of various intractable carbon black filled rubbers and is extended to the identification of paint resin, epithellal tissue, textile fibers, polymers, and gum. A.A.

30-S589.
Laing, D.K.; Dudley, R.J.; and Isaacs, M.D.J.
Colorimetric measurements on small paint fragments using micro-spectrophotometry.

Affl: Home Office Central Research Establishment, UK.

Forensic science international, **16,** pp. 159-171, (1980), [Eng. w. Eng. summary]. 4 figs., 5 tables, 13 refs.

The use of the Nanospec 10S microspectrophotometer (Nanometrics Inc.) as a color-coding instrument for small paint fragments and individual layers within a layer structure is described. The CIE system of color notation is discussed and numerical values for colors within the CIE system are derived from reflectance measurements made with the microspectrophotometer. A.A.

30-S590.
Littmann, E.R.
Maya blue: a new perspective.

American antiquity: a quarterly review of American archaeology, **45,** no. 1, pp. 87-100, (1980), [Eng.]. appendix.

Review of the literature concerning the composition, analyses, experimental preparation, sources, and archaeological significance of Maya blue. Although the presence of indigo is strongly suggested for at least one type of Maya blue, it has not been scientifically confirmed as an integral component; blue montmorillonite may be an alternative pigment. In addition, it appears that minerals other than attapulgite such as palygorskite, sepiolite, and montmorillionite may form a stable pigment with indigo. The appendix contains information on the preparation of samples, analytical procedures, and test results. Staff

30-S591.
MacKenzie, W.S.; and Guilford, C.
Atlas of rock-forming minerals in thin section.

Book. Halstead Press, New York; John Wiley & Sons, Inc., New York, 1980, [Eng.]. v, 98 p.: ill. (some col.); 28 cm., index. [ISBN 0-470-26921-9].

A laboratory handbook containing very good color photomicrographs in plane-polarized light and under crossed polars of 97 minerals. Data on chemical formula, crystal system, optic sign, and refractive indices, as well as a paragraph describing the properties seen in the photographs, are included for each mineral. Staff

30-S592.
McCrone, Walter C.; and Skirius, Christine.
Light microscopical study of the Turin Shroud. I.

The microscope, **28,** no. 3-4, pp. 105-113, (1980), [Eng.].

Thirty-two samples removed on transparent sticky tape from the linen surface of the Holy Shroud of Turin from image, bloodstain, scorch, water stain and control areas were examined by light microscopy. None of the control samples (those with no image) showed pigment particles whereas 19 body image and blood image areas showed significant amounts of a very fine red iron oxide pigment. The examination of 8,000 fibers from both image and non-image areas showed that the image areas had many more fibers uniformly stained from faint yellow to yellow. The Shroud image is made up of uniformly colored fibers (by some yet unknown mechanism) and a red iron earth pigment applied by hand. Staff

30-S593.
McCrone, Walter C.
Light microscopical study of the Turin
Shroud. II.

The microscope, **28**, no. 3-4, pp. 115-128, (1980),
[Eng.].

Numerous pigment particle aggregates
that behave as though held together by an
organic binder were observed on linen fibers
removed from the Holy Shroud of Turin.
These aggregates and fibers from image areas
were tested microscopically with amido black
which confirmed the presence of a tempera
paint. A simple microscopical test for sulfur-
containing amino acid functional groups—the
catalytic release of nitrogen gas from sodium
azide in the presence of iodine—was negative
indicating the tempera was of animal (colla-
gen) origin. An artist has at least enhanced
what would have been a far fainter (authen-
tic) image or he has produced the entire im-
age applied as a red iron earth tempera.
Staff

30-S594.
Mills, John S.; and White, Raymond.
Analyses of paint media.

National Gallery technical bulletin, **4**, pp. 65-68,
(1980), [Eng.].

Identification of linseed, walnut, and
poppy oils in Italian oil paintings in the Na-
tional Gallery, London. Discusses the possible
transition from walnut to linseed oil around
1520. ICCROM(02399904)

30-S595.
Sturman, Lee.
Some problems in analysis of aged
organic materials in art works and
artefacts.

ICCM bulletin, **6**, no. 2, pp. 53-60, (1980),
[Eng.].

A general survey of the problems in-
volved in the analysis of aged organic materi-
als, with emphasis upon problems found
with the analysis of proteins and oils (as
binding media), natural resins, and waxes.
Staff

30-S596.
Birstein, V.Ya; and Tul'chinsky, V.M.
IR-spectroscopic analysis of aged gelatins.

In book. *Preprints: ICOM Committee for Con-
servation, sixth triennial meeting, Ottawa, 21-25
September 1981*, Anon., Editor (1981), pp. 81/
1/9-1-81/1/9-8, [Eng.].

Infrared (IR) spectroscopy was used to
study the samples of fresh soluble, naturally-
aged soluble (a flow of glue taken from a
wooden sculpture of 1483) and insoluble (the
same flow of glue) gelatin before and after
heating the samples to +210°C. The IR spec-
tra of the unheated samples were typical
spectra of collagen or gelatin, with certain
distinctions observed within the 1,460 to
1,380 cm^{-1} region. After heating, the Amide II
band shifted to the range 1,530 cm-1 in the
soluble gelatin spectrum, the band at about
1,400 cm-1 disappeared in the fresh soluble
gelatin spectrum, and its intensity decreased
in the aged soluble gelatin spectrum. The IR
spectra of insoluble gelatin before and after
heating did not differ in the 1,560-1,380 cm^{-1}
region. The changes observed in IR spectra
are discussed in connection with the probable
structural alterations during the natural aging
of gelatins, including the formation of inter-
chain bonds and removal of water molecules.
Staff

30-S597.
**Masschelein-Kleiner, Liliane; and
Taets, P.**
Contribution to the study of natural resins
in the art.

In book. *Preprints: ICOM Committee for Con-
servation, sixth triennial meeting, Ottawa, 21-25
September 1981*, Anon., (1981), pp. 81/16/3-1/
81/16/3-8, [Eng.].

A general method of analysis is pro-
posed for natural resins. It enables the detec-
tion of oils, waxes, and paraffin, as well as
the identification of resinates.
ICCROM(02438723)

Analysis

30-S598.
McCrone, Walter C.; Teetsov, Anna; Andersen, Mark; Hinch, Ralph; Humecki, Howard; Majewski, Betty; and Piper, Deborah.
Microscopical study of the Turin Shroud. III.

The microscope, **29**, no. 1, pp. 19-38, (1981), [Eng.].

Additional microanalyses of yellow to red pigment-medium agglomerates (PMA) from Shroud tape 3-CB,a blood image area, confirm the presence of iron oxide and add the important new information that vermilion (mercuric sulfide), an artist's pigment popular for centuries, is present in significant amounts on the Shroud. The scanning electron microscope shows the paint layer on a typical fiber, and elemental maps of the same fiber show heavier concentrations of iron in the areas showing heaviest paint medium. Analyses of 11 additional PMA particles by electron microprobe show iron and/or mercury (associated with sulfur) in amounts related to the depth of red color. The red pigment particles in one red PMA were identified by electron diffraction as vermilion; a second red PMA yielded x-ray diffraction lines for vermilion, iron oxide (hematite), a calcite. Finally, a highly sensitive microchemical test was successful in finding mercury in a single red PMA from the Shroud. These data support the conclusión of the Bishop of Troyes, Henry of Poitiers, who said in the 1350s that the Shroud had been "cunningly painted, the truth being attested by the artist who had painted it." A radiocarbon date can now best confirm or deny the conclusion reached. C.A.L.

30-S599.
Pickova, Ivana; and Zelinger, Jiří.
Metody identifikace organickych pojir v barevne vrstvc.
(The methods of identifying organic binders in paint layers.)

Sborník Vysoké školy chemicko-technologické v Praze. Polymery: chemie, vlastnosti a zpracování, **S6**, pp. 157-182, (1981), [Slo. w. Eng. + Ger. summaries].

A survey of analytical methods used in the identification of organic binders in paint layers. Thin layer chromatography and infrared spectroscopy can be used for experimen-tal verification. Differentiation of most common polypeptide and polysaccharide binders, resins, waxes, and oils is discussed. Staff

30-S600.
White, R.
A review, with illustrations, of methods applicable to the analysis of resin/oil varnish mixtures.

In book. *Preprints: ICOM Committee for Conservation, sixth triennial meeting, Ottawa, 21-25 September 1981*, Anon., (1981), pp. 81/16/2-1-81/16/2-9, [Eng.].

A review of the analytical procedures currently employed in the laboratory of the scientific department at the National Gallery, London, for the analysis of resin-oil varnish mixtures. Critical comments are offered on techniques which have been examined, but were found to be either partially or totally unsatisfactory. An outline of the application of such methods is given, a fuller treatment, together with specific examples. Emphasis is placed upon gas chromatographic methods and gas chromatography-mass spectrometry.
 A.A.

30-S601.
Zelninskaia, Z.M.
Analiz belkovikh sviazuiusikh metodom ultramikrotonkosloinoi khromatografii.
(Analysis of proteinaceous media by thin layer chromatography.)

Khudozhestvennoe nasledie: Khranenie, issledovanie, restavratsiia, **7**, no. 37, pp. 43-51, (1981), [Rus. w. Eng. summary]. 2 tables, 15 refs.

Describes the comparatively simple and inexpensive method of differential analysis of proteinaceous media using ultra thin layer chromatography of DNS-derivatives of amino acids and then qualitative estimation of chromatic spots with microfluorimetro of two co-ordinates in situ. Shows the possibility of qualitative identification of glutin glues with a set of terminal amino acids.
 ICCROM(02609503) and A.A.

30-S602.
Baggi, T.R.; and Murty, H.R.K.
Forensic examination of wax seals by thin-layer chromatography.

Affl: Ministry of Home Affairs. Bureau of Police Research and Development. Central Forensic Science Laboratory, Hyderabad, India.

Forensic science international, **19**, pp. 259-262, (1982), [Eng. w. Eng. summary].

An attempt has been made to separate some of the constituents of wax seals by thin layer chromatography, and thereby differentiate them. The method is suitable for routine forensic examinations. A.A.

30-S603.
Bowden, Bruce F.; and Reynolds, Barrie.
The chromatographic analysis of ethnographic resins.

Newsletter (Australian Institute of Aboriginal Studies), no. 17, pp. 1-4, (1982), [Eng.].

Reports on chromatography as a possible method for the analysis of resins and waxes used in ethnographic artifacts. Gas-liquid and thin layer chromatography were employed in the identification, dating, and location of these organic materials. This analysis can be used most productively in association with other laboratory methods. ICCROM

30-S604.
Lawrence, J.F.; Iyengar, J.R.; Page, B.D.; and Conacher, H.B.S.
Characterization of commercial waxes by high-temperature gas chromatography.

Journal of chromatography, **236**, no. 2, pp. 403-419, (1982), [Eng. w. Eng. summary].

Some 16 waxes (including two oils) were characterized by temperature-programmed gas chromatography up to 400°C, using flame ionization detection. Chromatographic patterns were obtained for the untreated samples and for samples treated with diazomethane and acetic anhydride. Included with the patterns are physical characteristics, origins of the waxes, and where available, references to gas-liquid chromatographic work done by others. A.A.

30-S605.
Littmann, E.R.
Maya blue: further perspectives and the possible use of indigo as the colorant.

American antiquity: a quarterly review of American archaeology, **47**, no. 2, pp. 404-408, (1982), [Eng.].

A blue pigment having the chemical stability of authentic Maya blue can be prepared from indigo and attapulgite with the raw materials available to the ancient Maya, and by techniques presumably within their knowledge. The procedure possibly used consists of impregnating attapulgite with an extract of indigo plant leaves and stems and subsequently heating the impregnated clay for an extended period of time at the temperature of boiling water. This procedure would obviate the need for transportation of montmorillonite to areas far removed from its source and would account for the existence of the various types of Maya blue noted in a previous report. (Analytical procedures are described in an earlier report. See AATA 17-1349.) Staff

30-S606.
McCrone, Walter C.
The microscopical identification of artists' pigments.

Journal of the International Institute for Conservation-Canadian Group: J. IIC-CG, **7**, no. 1-2, pp. 11-34, (1982), [Eng.]. 2 tables, 24 color plates, 15 figs.

Briefly describes the process of identifying pigments using microscopy. Techniques used in the removal and handling of small pigment samples from paintings are outlined, and the different particle characteristics that are used in distinguishing pigments and identifying them are discussed. The characteristics of traditional artists' pigments are given, and the microanalytical schemes to aid in their identification are presented. Microchemical tests that can be used to confirm the microscopical identifications are also discussed. Staff

30-S607.
Mills, John S.; and White, Raymond.
Organic mass spectrometry of art materials: work in progress.

National Gallery technical bulletin, **6**, pp. 3-18, (1982), [Eng.]. 19 figs., 13 refs.

Mass spectrometry performed on compounds separated using gas chromatography can give precise information on organic mixtures (microanalysis). Describes a detailed method and the instrumentation, as well as applications to dried oil, cholesterol in egg fats, and resin in paint media, varnish, lacquer. ICCROM(02596700)

30-S608.
Shackley, Myra.
Gas chromatographic identification of a resinous deposit from a 6th century storage jar and its possible identification.

Journal of archaeological science, **9**, no. 3, pp. 305-306, (1982), [Eng.].

A deposit representing the original contents of a Byzantine storage jar from the *castellum* of En Boqeq (Israel) was analyzed using gas chromatography and identified as a highly oxidized pine resin. This oleoresin may have been intended for caulking, waterproofing, or for blending with fats and oils to produce an unguent, and the limitations of inference dictated by the use of this technique are discussed. A.A.

30-S609.
Challinor, J.M.
Forensic applications of pyrolysis capillary gas chromatography.

Affl: Government Chemical Laboratories. Forensic Chemistry Division, Perth, Western Australia, Australia.

Forensic science international, **21**, pp. 269-285, (1983), [Eng. w. Eng. summary]. 14 figs., 14 refs.

A simple system of pyrolysis capillary gas chromatography has been used to improve discrimination and long-term reproducibility in the analysis of polymers particularly alkyd based paints typically encountered in forensic casework. This involved the coupling of a Pye Curie-point pyrolyser to the inlet port of a capillary gas chromatograph operated in the splitless mode. Examples of pyrograms demonstrating improved differentiation of alkyd paints, and also examples of other architectural and automotive paints, automobile rubbers, adhesives, polyurethane foams, and fibers are shown.
A.A.

30-S610.
McCrone, Walter C.
Dispersion staining.

American laboratory, **15**, no. 12, pp. 52-55, (1983), [Eng.].

Dispersion staining is a technique for color-coding any given transparent particle based on its refractive index(ices). A microscopist who becomes adept at this technique can solve many of the daily problems encountered much more rapidly and often increase confidence in the result. C.A.L.

30-S611.
Adams, A.E.; MacKenzie, W.S.; and Guilford, C.
Atlas of sedimentary rocks under the microscope.

Book. Halstead Press, New York; John Wiley & Sons, Inc., New York, 1984, [Eng.]. 104 p.: ill. (some col.); 28 cm., refs. and index. [ISBN 0-470-27476-X].

A laboratory handbook to assist in the study of sedimentary rocks in thin section. Part 1 deals with terrigenous clastic rocks, concentrating on sandstone. Part 2 deals with carbonate rocks, the limestones. Part 3 illustrates ironstones, cherts, evaporites, phosphorites, and carbonaceous rocks in thin section. Appendix 1 describes how thin sections may be made, appendix 2 describes a method of staining thin sections of limestones, and appendix 3 contains instructions on how to make acetate peels. ICCROM(02947300)

30-S612.
Banik, Gerhard; and Stachelberger, Herbert.
Mikroanalytische untersuchung von kunstwerken: zwei fallbeispiele von malschicht-untersuchungen.
(Microanalytical examination of works of art: two examples of the examination of paint layers.)

Wiener Berichte über Naturwissenschaft in der Kunst, **1**, pp. 214-225, (1984), [Ger. w. Eng. summary]. ill., 1 plate, 5 figs., 2 tables, refs.

The technical study of the materials used in works of art by means of microchemical analysis leads to an increased understanding of artistic materials, artistic techniques, or of the aging phenomena exhibited by the materials. Advantages and limits of chemical microanalysis especially for characterization of binding media, are discussed and demonstrated by the technological examination of a Fayum portrait in the papyrus collection of the Austrian National Library, Vienna. Several paint samples were analyzed by microchemical methods to determine the character of the paint layer. The identification of the components of the binding medium was limited by the analytical procedure. In other cases the problem under investigation, e.g., the already-mentioned aging phenomena of the materials, requires the use of modern analytical equipment; sometimes development work is necessary for its suitable application. Of critical importance for the analysis is the selection and preparation of samples. The trend to minimize the sample size requires the development of special preparation methods. The described sampling method allows the preparation of single grains from pigments applied in colored etchings and subsequent semiquantitative analysis of definite particles by means of scanning electron microscopy and energy-dispersive spectrometry. Examples of the application of the method and analytical data are given.

C.A.L.

30-S613.
Cousins, D.R.; Platoni, C.R.; and Russell, L.W.
The use of microspectrophotometry for the identification of pigments in small paint samples.

Affl: Metropolitan Police Forensic Science Laboratory, London, UK.

Forensic science international, **24**, pp. 183-196, (1984), [Eng. w. Eng. summary]. 13 figs., 2 tables, 8 refs.

The visible reflectance spectra of a number of common pigments are presented. These were measured between 380 nm and 900 nm in paint films using the Nanospec 10S Microspectrophotometer. This data can be used in combination with a computer program based upon simple Kubelka-Munk the-

ory to identify the pigments in paint samples. The use of this approach in forensic science is illustrated by examples from recent cases.

A.A.

30-S614.
McCrone, Walter C.; McCrone, Lucy B.; and Delly, John Gustav.
Polarized light microscopy.

Book. McCrone Research Institute, Chicago, 1984, [Eng.]. vii, 251 p.: ill. (some col.); 30 cm., bibliogs. and index. [ISBN 0-250-40262-9].

The first hardcover edition of a manual used in microscopy courses taught by the McCrone Research Institute of Chicago, Illinois, covers microscope optics, photomicrography, optical crystallography, thermal microscopy, and microchemical analysis. One illustration is a reproduction of a Michel-Lévy Birefringence chart showing the interrelationship of thickness, birefringence, and interference colors. Chapter headings are: Introduction, Optics, Compound Microscope, Resolving Power and Illumination, Specialized Microscope Illumination, Photomicrography, Micrometry, Crystal Morphology, Crystal Optics, Dispersion Staining, Hot Stage Methods, Microchemical Tests, Morphological Analysis, Laboratory Exercises, Index.

Staff

30-S615.
Nielsen, Hans K.R.
Forensic analysis of coatings.

JCT: Journal of coatings technology, **56**, no. 718, pp. 21-32, (1984), [Eng.]. 5 tables, 17 figs., 9 refs.

The importance of analysis of paint samples during forensic examination is presented. Physical examination includes visual and microscopic examination and solubility tests. Chemical analysis helps to identify binders, pigments, and trace elements. Techniques include: infrared spectroscopy, Fourier transform infrared spectroscopy, pyrolysis gas chromatography, energy dispersive spectroscopy (x-ray analysis), and neutron activation analysis. The importance of close collaboration between the forensic analyst and the coatings industry chemist is stressed.

Staff

Analysis

30-S616.
Twilley, John W.
The analysis of exudate plant gums in their artistic applications: an interim report.

Affl: University of California, Riverside. Department of History, Riverside, CA, USA.

In book. *Archaeological chemistry III*, Advances in chemistry series, no. 205, Lambert, Joseph B., Editor (1984), pp. 357-394, [Eng. w. Eng. summary]. 3 tables, 10 figs., 1 appendix, 47 refs.

The rapid unambiguous identification of plant gums used in artistic and ethnographic artifacts has been demonstrated to be feasible through the use of various chromatographic microtechniques. Determination of the monosaccharide ratios for these gums can be accomplished by gas-liquid chromatography of the trimethylsilyl ether derivatives after the monosaccharides have been liberated by hydrolysis. Analysis of a group of gums by these techniques indicates that the precision of such analysis can be 2-3% and that the genus and species of origin may thereby be determined. The taxonomic and geographic origins of the exudate plant gums are discussed briefly along with a historical perspective upon their collection and utilization. The results are presented for a reference group of gums to which unidentified samples may be compared. Included as well are the results of a literature search for species reported to yield exudate plant gums. A.A.

30-S617.
White, Raymond.
The characterization of proteinaceous binders in art objects.

National Gallery technical bulletin, **8**, pp. 5-14, (1984), [Eng.]. 7 tables, 10 figs., 26 refs.

Deals with the analysis of proteinaceous binders by hydrolysis, and separation of the amino acids liberated by gas chromatography. Staff

30-S618.
Burke, P.; Curry, C.J.; and Davies, L.M.
A comparison of pyrolysis mass spectrometry, pyrolysis gas chromatography and infra-red spectroscopy for the analysis of paint resins.

Forensic science international, **28**, pp. 201-219, (1985), [Eng.].

A series of paint resins of known composition have been analyzed by pyrolysis mass spectrometry, pyrolysis gas chromatography, and infrared spectroscopy. The results show that although all three techniques are able to identify many of the resins used in paints, the information given by the techniques is to a certain extent complementary and there are good arguments for employing more than one technique whenever possible. The implications of this work for the analysis of questioned paint samples is discussed. A.A.

30-S619.
Davies, I.L.
Instrumental analysis in the coatings industry.

Journal of the Oil and Colour Chemists' Association, **68**, no. 5, pp. 109-115, (1985), [Eng.].

Describes the two instrumental techniques, namely infrared spectroscopy (IR) and gas chromatography (GC), commonly used to determine the composition of surface coating materials. The basic theory underlying each technique is explained briefly and several examples are given to show their applications in the coatings industry. The first section deals with the interpretation of infrared spectra and the use of surface techniques in infrared spectroscopy. The second section deals with the identification of paint solvents and the use of pyrolysis and headspace techniques in gas chromatography. A.A.

30-S620.
Fuller, N.A.
Analysis of thin-layer chromatograms of paint pigments and dyes by direct microspectrophotometry.

Affl: Metropolitan Police Forensic Science Laboratory, London, UK.

Forensic science international, **27**, pp. 189-204, (1985), [Eng. w. Eng. summary]. 4 figs., 4 tables, 19 refs.

The Nanospec 10S microspectrophotometer has been used to produce reflectance spectra over the 380-900 nm range from colored thin layer chromatography spots. The method has been applied to extracted paint pigments and to dyes from other materials examined in forensic science. A.A.

30-S621.
Mills, John S.; and White, Raymond.
Organic analysis in the examination of museum objects.

In proceedings. *Application of science in examination of works of art: proceedings of the seminar, 7-9 September 1983*, England, Pamela; and Van Zelst, Lambertus, Editors (1985), pp. 29-34, [Eng.]. 8 figs., 13 refs.

Gas chromatography (GC) has advantages over paper and thin-layer chromatography, which compensate for its cost and time spent in manipulation of the sample. It is the technique of first choice in analyzing organic components in museum objects, followed by gas chromatography-mass spectrometry (GC-MS). Brief comments on identification of proteins and waxes precede discussion of oils and fats, particularly in regard to use in paint media. Several examples illustrate how mass spectrometry is applied to the detection of resins. K.M.G.W.

30-S622.
Schramm, Hans-Peter.
Die Ultramikroanalyse: ein effektives Verfahren zur substantiellen Untersuchung von Kunstwerken.
(Ultramicroanalysis: an effective method for substantial investigation of works of art.)

Wiener Berichte über Naturwissenschaft in der Kunst, 2/3, pp. 14-39, (1985-1986), [Ger. w. Eng. summary]. plates.

The technical study of the materials used in works of art by means of chemical and physical analyses leads to an increased understanding of artistic materials, artistic techniques, and aging and degradation phenomena. The rapid development of analytical methods has introduced a number of sophisticated instrumental analytical techniques with lower sample requirements and low limits of detection. In spite of the advantages of modern analytical instrumentation, the classical micro- and ultramicroanalysis are still valuable although these techniques today are frequently underestimated. The advantages of chemical microanalysis are the small amount of sample required, its simplicity, and low cost. In the case of ultramicroanalysis, detection limits between 10^{-4} and $10^* h^{-9}$g are obtainable. The advantages and methods of chemical micro- and ultramicroanalysis are outlined, with discussion of pyrolytic procedures and of binding media. The limits of these procedures are discussed by presenting results of the investigation of Raphael's Sistine Madonna (Dresden). The results are in good agreement with those obtained from samples taken from Raphael's Madonna in the Meadow (Vienna) by means of instrumental analytical techniques. Additional examples given are the investigations of the original polychromy of an 18th-century musical instrument and the analytical identification of pigments originally used for imitation marbles in the Opera House (Gottfried Semper, architect) in Dresden. Staff

30-S623.
Feller, Robert L., Editor.
Artists' pigments: a handbook of their history and characteristics.

Book. National Gallery of Art, Washington; Cambridge University Press, Cambridge, 1986, [Eng.]. 300 p.: ill. (some col.); 26 cm., refs. [ISBN 0-521-30374-5].

The pigments included in this volume are Indian yellow, cobalt yellow, barium sulfate—natural and synthetic—cadmium yellow, oranges and reds, red lead and minium, green earth, zinc white, chrome yellow and other chromate pigments, lead antimonate yellow, and carmine. Appendices describe the terminology and procedures used in the examination of particles with the polarizing microscope and standard specifications of pigment composition and color. ICCROM(03600000)

30-S624.
Loy, T.H.; and Nelson, D.E.
Potential applications of the organic residues on ancient tools.

In proceedings. *Proceedings of the twenty-fourth international archaeometry symposium*, Smithsonian contributions to anthropology, no. 31, Olin, Jacqueline S.; and Blackman, M. James, Editors (1986), pp. 179-185, [Eng. w. Eng. summary]. 1 fig., refs.

The residues of blood, tissue, hair, feathers, and other animal and plant materials have been found on the surfaces of many prehistoric tools up to several thousand years old. Apparently, this preservation does not depend upon special burial environments.

Research already completed has concentrated on microscopic and biochemical methods to detect residues and to identify the species-of-origin. Continuing studies focus on using more sophisticated techniques such as iso-electric focusing and radioimmuno assay. The quantity of residue on tools may be sufficient for the new radiocarbon dating techniques.

A.A.

30-S625.
Masschelein-Kleiner, Liliane.
Analysis of paint media, varnishes and adhesives.

PACT, **13**, pp. 185-209, (1986), [Eng. w. Fre. summary].

Binding media, varnishes, and adhesives used in old paintings include various film-forming organic substances: polysaccharide gums and mucilages (sugar polymers), proteins (amino acid polymers), drying oils (fatty acid esters), waxes (long-chain hydrocarbons and fatty acid esters, etc.), natural resins (terpenic compounds), etc. In the past several years, their identification has progressed due to the development of new analytical methods and the improvement of older methods such as staining tests. Operating procedures and results obtained in the study of old paintings are reviewed for the main analytical methods used: staining tests, infrared absorption spectrometry, thin layer chromatography, gas chromatography with or without pyrolysis, mass spectrometry combined or not with gas chromatography, high performance liquid chromatography, differential thermal analysis. Even more than in the past, these analyses require the skill of specialized staff as well as expensive equipment. Moreover, it is essential that results be discussed by art historians and restorers and interpreted accordingly. It is always advisable to use more than one analytical method to support conclusions.

A.A. and M.B.(transl.)

30-S626.
Matteini, Mauro; Moles, Arcangelo; Masala, Anastasia; and Parrini, Valerio.
Examination through pyrolysis gas chromatography of binders used in painting.

In book. *Scientific methodologies applied to works of art: proceedings of the symposium, Flo-*rence, Italy, 2-5 May 1984, Parrini, Paolo L., Editor (1986), pp. 41-44, 230, Special ed., not for sale [Eng.]. graphs, tables, refs.

Pyrolysis gas chromatography was only recently applied to research on the nature and modifications of binders used in painting, especially linseed oils. The paper reports investigations of films of boiled linseed oil, alone, in white lead, and in burnt sienna. Analyses provided useful information on the nature of these products and the transformations they undergo during the aging process.

ICCROM(03701009)

30-S627.
McCrone, Walter C.
Microscopical study of the Turin "Shroud," IV.

In proceedings. *Preprints of papers presented at the fourteenth annual meeting: Chicago, Illinois, 21-25 May 1986*, (1986), pp. 77-96, [Eng.]. 23 figs., 1 table, 12 refs.

A detailed description of the microscopical work carried out on the Shroud of Turin. High power (1000x to 2500x) light microscopy was used. Fibers and particles removed from the shroud using adhesive tape were examined and many thousands of photomicrographs taken at every stage of the work. These were compared with standard samples. Blood samples were prepared, analyzed and compared with the spots on the shroud before concluding that the stains were iron oxide and vermilion applied in a collagen-based aqueous adhesive, possibly derived from parchment. Possible reasons for divergence from the Shroud of Turin research project conclusions (i.e., that the shroud is genuine) are given at every stage. The author concludes that the shroud is a painting probably executed in the mid-14th century.

ICCROM(03377207) and A.A.

30-S628.
Skans, Bengt; and Michelsen, Peter.
Die Bedeutung von Fett in Tierleim für Malzwecke.
(The significance of fat in animal glue for painting purposes.)

Maltechnik-Restauro, **92**, no. 2, pp. 63-71, (1986), [Ger. w. Eng. summary]. 4 photos., 21 refs.

Animal glue in all its variations is a very old material in the history of civiliza-

tion. Unfortunately it has almost disappeared since the introduction of "cold glues" which came with the artificial resins in the 1930s. Nevertheless it is still a very useful and important material for several craftsmen, including restorers of old paintings and other artifacts. Old manuscripts on painting from classical antiquity to 1850 were studied, and recipes made from 25 hide glues were made. It was found that the fatty acids can be used as a "fingerprint" indicating which animal or tissue the glue came from. The analysis was carried out by means of chromatography.

Staff

30-S629.
Erhardt, David; and Firnhaber, Natalie.
The analysis and identification of oils in Hawaiian oiled tapa.

In proceedings. *Recent advances in the conservation and analysis of artifacts: Jubilee Conservation Conference papers,* (1987), pp. 223-227, [Eng.]. ill., 2 figs., 1 table, refs.

Tapa, or bark cloth, is a nonwoven felted material prepared from the inner bark of certain plants. Oil was sometimes applied to make tapa waterproof and more flexible. Oiled tapa objects usually become severely degraded. Gas chromatography-mass spectrometry was used to identify the oil as kukui nut oil in six of the seven samples. A consideration of drying oil chemistry suggests that it is the highly unsaturated oil which has oxidized and caused the degradation. Degraded oil contains acid products bound to the oil matrix. Paper conservation methods which work for unoiled tapa are not suitable for oiled tapa. Conservation of oiled tapa should consist mostly of proper storage consisting of low temperature, moderate relative humidity, and good physical support.

C.A.L.

30-S630.
Gianno, Rosemary; Von Endt, David W.; Erhardt, W. David; Kochummen, K.M.; and Hopwood, Walter.
The identification of insular Southeast Asian resins and other plant exudates for archaeological and ethnological application.

In proceedings. *Recent advances in the conservation and analysis of artifacts: Jubilee Conserva-*

tion Conference papers, (1987), pp. 229-238, [Eng. w. Eng. summary].

Resins and other plant exudates such as gums and latexes have long been important materials used and traded by Southeast Asian peoples. The forests there include hundreds of resiniferous species distributed among nine plant families. Many resin specimens have also been found in local archaeological sites. This study presents preliminary results of the analysis of over 100 botanically identified resins from Southeast Asian, mainly Peninsular Malaysian, forests along with archaeological resins, adhesives, and coatings from ethnographic objects using Fourier transform infrared spectrometry (FTIR). A cluster analysis based on a comparison of peak distributions using coefficients of similarity was also developed.

Staff

30-S631.
Lalli, C.; Matteini, M.; Moles, A.; and Nepoti, M.R.
Stesure artificiali di leganti pittorici. Olii, resine, core, colle, uovo, preparati in miscele binarie: caratteristiche analitiche e proprietà.
(Artificial samples of paint binders. Oils, resins, waxes, glues, egg, prepared in binary mixtures: analytical characteristics and properties.)

OPD restauro: quaderni dell'Opificio delle pietre dure e Laboratori di restauro di Firenze, no. 2, pp. 81-86, (1987), [Ita.]. 2 tables, appendix, bibliog.

The majority of present-day analytical methods for the identification of organic materials used in painting require comparison with analogous materials of known composition. However the original materials have aged for centuries while modern samples have not. The intention of this study was to prepare and age samples and determine possible interactions between them, thus giving information of use for historical investigations and also indications for possible restoration use. The materials were egg yolk; casein (ammonium caseinate); animal glue; boiled linseed oil; mastic; shellac; gum arabic; flour paste; and beeswax. Details are provided of sample preparation (without and with an inert filler, zinc white, and chromic oxide). Tables show the mixtures and some optical and

physical properties. Infrared analysis will be used for definition and checking changes.

ICCROM(03774309)

30-S632.
McConnell, Anne.
Pigment analysis for the authentication of the Aboriginal paintings at Bunjils Cave, western Victoria.

In proceedings. *Archaeometry: further Australasian studies*, Ambrose, W.R.; and Mummery, J.M.J., Editors (1987), pp. 43-56, [Eng. w. Eng. summary]. 1 photo., 6 tables, 1 fig., 8 refs.

An analysis of the pigments from paintings in Bunjils Cave, a small granite shelter in the Black Range, western Victoria, was undertaken to determine the Aboriginal authenticity of the paintings. Many analyses, including emission spectroscopy, x-ray fluorescence (XRF), infrared spectroscopy (IRS), x-ray diffraction (XRD), and scanning electron microscopy (SEM and EDS) were conducted. Based on the SEM evidence, the paintings are now believed to have been painted originally by Aborigines using clay-based pigments, with later touching up, and addition to motifs using European pigments. Problems with pigment sampling, inconclusive results from the earlier analyses, and consequences of the project, which included avoidable damage to the paintings, illustrate the importance of choosing the appropriate techniques. Also indicated is the need for wide discussion and information exchange in archaeometry and the fact that archaeometry should not be isolated from archaeology. Staff

30-S633.
Mills, John S.; and White, Raymond.
The organic chemistry of museum objects.

Book. Butterworths series in conservation and museology, Butterworth & Co., Sevenoaks, 1987, [Eng.]. xi, 165 p.: ill.; 26 cm., bibliogs. and index. [ISBN 0-408-11810-5].

Gives a survey of the structures and chemistry of the organic materials which enter into the composition of objects found in museums and art galleries. Covers the fundamental chemistry of the bulk materials (wood, paper, natural fibers, skin) and also paint media, varnishes, adhesives, dyes. Contents: basic organic chemistry; analytical methods; oil and fats; natural waxes; bitumi-

nous materials; carbohydrates (sugars and polysaccharides); proteins; natural resins and lacquers; synthetic materials; dyestuffs and other colored materials; fundamental aspects of deterioration analysis in practice.

ICCROM(03770300)

30-S634.
Odlyha, M.; and Burmester, A.
Preliminary investigations of the binding media of paintings by differential thermal analysis.

Affl: South Australia Institute of Technology. School of Chemical Technology, Australia.

Journal of thermal analysis, 33, no. 4, pp. 1041-1052, (1987 issued in 1988), [Eng.].

Differential thermal analysis (DTA) was used to study the binding media of paintings. To assist in the interpretation of the DTA curves, known organic materials commonly used in paintings such as linseed oil, egg yolk, and their mixtures with pigment (e.g., linseed oil/egg yolk/ZnO) were initially investigated together with paint films (prepared in 1915-1941) containing linseed oil/lead white and some additions of proteinaceous material. DTA or differential scanning calorimetry (DSC) could be used both to characterize the binding media (i.e., to decide whether oil or protein appeared as the main component, and to provide an indication of the age of the painting.

C.A.(110:156125v) and C.W.B.

30-S635.
Wolbers, Richard; and Landrey, Gregory.
The use of direct reactive fluorescent dyes for the characterization of binding media in cross sectional examinations.

Affl: Henry Francis du Pont Winterthur Museum, Winterthur, DE, USA.

In book. *Preprints of papers presented at the fifteenth annual meeting, Vancouver, British Columbia, Canada, 20-24 May 1987*, (1987), pp. 168-204, [Eng.].

A brief review of current methods and materials used for media characterization on small cross-sectioned samples of painted or varnished structures is presented. Both the limitations and advantages of these techniques are discussed, along with general criteria for the successful performance of such stains. Several fluorescent reactive dyes are

currently available to meet these requirements. Their application, and usefulness as microscopic reagents is presented in a case study format. Painted and varnished structures of all types are covered by these examinations. Staff

30-S636.
Wright, M.M.; and Wheals, B.B.
Pyrolysis-mass spectrometry of natural gums, resins, and waxes and its use for detecting such materials in ancient Egyptian mummy cases (cartonnages).
Journal of analytical and applied pyrolysis, **11,** pp. 195-211, (1987), [Eng.].

Pyrolysis-mass spectrometry (Py-MS) has been applied to the study of some ancient Egyptian mummy cases (cartonnages). Samples of organic materials, used in the construction of these objects, have been collected from cartonnages housed in various museums in Europe. Some 50 samples were examined by Py-MS and the pyrograms obtained were compared with those of some 70 modern natural gums, resins, and waxes. The technique permitted a classification of about half of the ancient adhesives; and polysaccharide gums, waxes, and rosins have been detected in samples from objects some 2,000 to 4,000 years old. A.A.

30-S637.
McCrone, W.C.
Microscopical study of the Turin "Shroud."
Wiener Berichte über Naturwissenschaft in der Kunst, **4/5,** pp. 50-61, (1987-1988), [Eng. w. Eng. + Ger. summaries]. 23 figs., 11 refs.

More than 600 years ago a 14-foot length of linen suddenly appeared in the pages of history. Showing full-size back and front images of a crucified man, it was exhibited, and accepted by the general public, as the Shroud of Christ. Some, however, have doubted its authenticity up to the present. In 1978, sticky tapes applied to the Shroud surface removed many fibers from image areas which have been shown by microanalysis to be coated with a watercolor paint. The pigments have been identified by polarized light microscopy as red ocher and vermilion; the medium as a collagen tempera. The author feels that these findings, confirmed by elec-

tron microprobe analyses, prove that the Shroud is a painting. A.A. and M.K.

30-S638.
Shedrinsky, A.M.; Wampler, T.P.; and Baer, N.S.
The identification of dammar, mastic, sandarac and copals by pyrolysis gas chromatography.
Wiener Berichte über Naturwissenschaft in der Kunst, **4/5,** pp. 12-23, (1987-1988), [Eng. w. Eng. + Ger. summaries]. 11 figs., 28 refs.

Since natural resins have variable, complex structures and are polar and nonvolatile, they have resisted direct analysis by gas chromatography-mass spectrometry (GC-MS) and Fourier transform infrared spectroscopy (FTIR). Pyrolysis gas chromatography (PyGC) is a sensitive technique (sample size 10-200 µg) often providing fingerprints that permit one to distinguish among resins with virtually identical ultraviolet and infrared spectra (e.g., dammar and mastic). The optimal temperature for pyrolysis of natural resins was found to be 650°C. Samples of four major resins (dammar, mastic, sandarac, and copal) were pyrolyzed at 650°C (CDS Model 120 Pyroprobe) and capillary chromatography was performed on a 25 m Carbowax 20M column and 50 m nonpolar SE-54 column (Quadrex Corp.). Pyrolysis of five samples each of dammar, mastic, sandarac, and copal from different sources gave pyrograms with both areas of similarity and portions that were sample-specific. These differences suggest it may be possible to identify the sources of individual resins. Experimental details including choice of columns, pyrolysis techniques, and PyGC combined with MS detection are discussed. A.A. and M.K.

30-S639.
Cousins, D.R.
Developments in paint analysis for forensic purposes.
Polymers paint colour journal, **178,** no. 4225, p. 824, 836, (1988), [Eng.].

Analysis of paints for forensic purposes has two objectives: to determine whether paint fragments with similar chemical compositions and microscopic appearances have come from the same painted surface, and to assess the likelihood and accuracy that paint flakes came from the same surface.

Microspectrophotometry (including analysis of the visible reflectance spectra) provides an objective comparison of the colors of layers of paint, as well as enabling the pigment compositions to be compared. Microprobe analysis and x-ray diffraction also yield information about pigments and other inorganic components in a paint sample. For analyzing resin components three techniques are commonly used: pyrolysis gas chromatography (PGC), pyrolysis mass spectrometry (PMS), and infrared spectrometry (IR). E.Ha.

30-S640.
Miller, Judi.
Analysis of paints used by Canadian native cultures: a project at the Canadian Conservation Institute.

In proceedings. *Symposium '86: the care and preservation of ethnological materials: proceedings = L'entretien et la sauvegarde de matériaux ethnologiques: actes,* Barclay, R.; Gilberg, M.; McCawley, J.C.; and Stone, T., Editors (1988), pp. 137-141, [Eng. w. Eng. + Fre. summaries]. 7 refs.

This project was initiated by the Analytical Research Services Laboratory of the Canadian Conservation Institute (CCI) in 1984 in order to document the pigments and binding media used by the various native groups from pre-contact times to the early part of the 20th century. Topics under investigation include the identification of "native" pigments primarily of vegetable or mineral origin, the introduction of trade pigments, the progression of trade pigments available, and the use of synthetic organic pigments starting in the late 19th century. This information will enable CCI to assist curators and conservators in establishing the provenance, date, or degree of previous restoration, in confirming published historical information and in selecting appropriate display and treatment conditions. Such questions have frequently been asked but response has often been hindered by lack of reliable analytical reference data. Staff

30-S641.
Portell, Jean D.
African red pigments.

In proceedings. *Symposium '86: the care and preservation of ethnological materials: proceedings = L'entretien et la sauvegarde de matériaux ethnologiques: actes,* Barclay, R.; Gilberg, M.; McCawley, J.C.; and Stone, T., Editors (1988), pp. 119-129, [Eng. w. Eng. + Fre. summaries]. 14 figs., 8 color photos., 15 notes, bibliog.

Samples of powdery red pigments from various African objects, and several known comparison materials, were examined by polarized light microscopy. In some cases, scanning electron microscopy and microchemical testing were also used to facilitate identification of the unknowns. Several scientists were consulted during this investigation into the probable mineralogical and botanical origins of African red pigments, including a metallurgist who was asked about the possibility that rust powder might be the source of a certain type of iron oxide pigment. Discusses the kinds of red African pigments that have been observed so far, and presents simplified methods for pigment characterization of use to conservators in planning appropriate treatment of African objects. Staff

30-S642.
Riedel, E.
Bibliographie über die Pigmente der Malerei.
(Bibliography on the pigments of painting.)
Berliner Beiträge zur Archäometrie, **10**, pp. 173-192, (1988), [Ger.].

Lists 380 publications on pigments used in paintings. The bibliography is divided into sections such as particular pigments and the use of pigments by different cultures from prehistory to modern times. Staff

30-S643.
Schramm, Hans-Peter; and Herring, Bernd.
Nachweis natürlicher organischer Bindemittel.
(Directory of natural organic binding media.)

In book. *Historische Malmaterialien und ihre Identifizierung,* (1988), pp. 190-231, 1988 [Ger.].

After an introduction into historic painting materials and examination of paints from works of art, a reference-type part of the volume describes properties of and uses for the paint and binding media which, until the 19th century, were commonly employed in artistic techniques. The second part of the volume details microchemical as well as in-

strumental procedures for obtaining evidence of the presence of such materials. Emphasis is put on simple microchemical analytical procedures which can be carried out by restorers with a minimum of chemical knowledge and expertise. The book was written primarily to train restorers but, beyond this, should be of interest to art historians, curators, and experts in monument protection. It came into being and has proved itself over a period of 12 years as teaching material for the education in the principles of natural science for future restorers at the Dresden College of Fine Arts. A.A. and E.M.B.(transl.)

30-S644.
Shedrinsky, Alexander; Wampler, Thomas P.; Indictor, Norman; and Baer, Norbert S.
The use of pyrolysis gas chromatography (PyGC) in the identification of oils and resins found in art and archaeology.

Affl: New York University. Conservation Center, New York, NY, USA.

Conservation of cultural property in India, **21**, pp. 35-41, (1988), [Eng. w. Eng. summary]. 7 figs., 26 refs.

Pyrolysis gas chromatography (PyGC) has become a powerful technique for the characterization of nonvolatile materials. It has been widely used in forensic science and industrial laboratories, but its application to conservation has been limited, due to the compositional complexity and small sample size of the materials available for examination. Further, the absence of a reliable compound reference library for identification of major materials in art works has restricted comparative studies on actual artifacts. The use of PyGC for the general study of materials (e.g., drying oils, amber, natural resins) is reviewed and specific examples are given to provide an introduction to applications of this technique in art and archaeology.
A.A. and M.M.K.

30-S645.
Torres, Luis M.
Maya blue: how the Mayas could have made the pigment.

Affl: Universidad Nacional Autónoma de México. Ciudad Universitaria. Instituto de Investigaciones Antropológicas, Mexico City, Mexico.

In proceedings. *Materials issues in art and archaeology*, Materials Research Society symposia proceedings, no. 123, Sayre, Edward V.; Vandiver, Pamela; Druzik, James; and Stevenson, Christopher, Editors (1988), pp. 123-128, [Eng. w. Eng. summary]. 30 refs.

For over 50 years, Maya blue has been an unsolved problem in the manufacture of ancient pigments. It can be reproduced with several procedures using palygorskite, indigo, and heat; however, we do not know how the Mayans made this pigment. Interpretation of ethnohistoric data allows us to deduce that pre-Hispanic, and even Spanish Colonial, procedures for manufacturing indigo may produce Maya blue if clay is added during the process. Ethnohistoric and archaeological evidence is presented to support this hypothesis, and following the proposed procedures, Maya blue was reproduced in the laboratory. Microscopic examination and chemical microscopy were applied to the synthetic Maya blue to characterize and compare it with original Mayan samples. A.A.

30-S646.
Derrick, Michele.
Fourier transform infrared spectral analysis of natural resins used in furniture finishes.

Journal of the American Institute for Conservation, **28**, no. 1, pp. 43-56, (1989), [Eng. w. Eng. summary]. 4 figs., 3 tables, refs.

Infrared spectroscopy is a method for the detection and identification of organic coatings. The vibrational bands may allow general characterization of the material or even the identification of specific compounds. The analysis of mixtures of natural materials, which are often found in furniture finishes, is almost beyond the capability of conventional infrared spectroscopy. The capabilities and limitations of Fourier transform infrared spectroscopy for the identification of natural resins used in historic furniture finishes is discussed. A.A.

Analysis

30-S647.
Matoušová, Milena; and Bucifalová, Jarmila.
Polysacharidy jako součást barevné vrstvy a metody jejich identifikace.
(Polysaccharides as part of a color layer and methods for their identification.)

Sborník restaurátorských prací, no. 4, pp. 60-74, (1989), [Cze. w. Rus. + Eng. summaries]. Státní restaurátorské ateliéry Praha. 2 tables, 1 fig., 3 photos., 40 refs.

Polysaccharides such as plant gums, starch, honey, and beer used as part of the bonding agents in works of art, and their basic properties are described. Hydrolysis of polysaccharides, analytical methods for their determination, such as gas and thin-layer chromatography, the preparation of derivatives for gas chromatography determination, and infrared spectroscopy are discussed. Selected optimal conditions for the analysis of polysaccharides by thin-layer chromatography are given. Chromatograms of monosaccharides and their mixtures, standard samples of plant gums, such as peach, cherry, and plum gums, Arabic gum, Quar gum, Ghatti and Karaya-tragant, and a sample of an unknown saccharide material are evaluated. J.Č., R.A.R., and A.A.

30-S648.
Orna, Mary Virginia; Lang, Patricia L.; Katon, J.E.; Mathews, Thomas F.; and Nelson, Robert S.
Applications of infrared microspectroscopy to art historical questions about Medieval manuscripts.

Affl: College of New Rochelle, Department of Chemistry, New Rochelle, NY, USA.

In book. *Archaeological chemistry IV,* Advances in chemistry series, no. 220, Allen, Ralph O., Editor (1989), pp. 265-288, [Eng. w. Eng. summary]. 10 figs., 3 tables, 28 refs.

Fourier transform infrared microspectroscopy applied to Byzantine manuscripts in the Special Collections Department of the University of Chicago Library revealed the use of numerous additives to the paint mixture including kaolin, hide glue, egg yolk, and other proteinaceous materials. Some evidence suggests that cochineal was used as a red pigment. A.A.

30-S649.
Poksińska, M.; and Shoeib, A.S.
Identification of medium used in polychrome reliefs in ancient Egyptian limestone tomb dating from the nineteenth dynasty /1350-1200 B.C./ at Saqqara.

Affl: Uniwersytet Mikołaja Kopernika w Toruniu, Toruń, Poland.

In proceedings. *VIth international congress on deterioration and conservation of stone: Torun, 12-14.09.1988. Supplement: list of participants = VIe congrès international sur l'alteration et la conservation de la pierre: Torun, 12-14.09.1988,* (1989), pp. 446-455, [Eng. w. Eng. summary]. 1 fig., 1 table, 19 refs.

In 1984, tombs dating from the Nineteenth Dynasty (1350-1200 BC) were discovered by the Cairo University Mission in Saqqara. The present work reports on binder identification of the paintings found in Imnmint's tomb. Analyses showed the presence of acacia gum, which is another example of application of plant gums in the painting of ancient Egypt. A.A.

30-S650.
Reunanen, Markku; Ekman, Rainer; and Heinonen, Markku.
Analysis of Finnish pine tar and tar from the wreck of frigate St. Nikolai.

Holzforschung, 43, no. 1, pp. 33-39, (1989), [Eng.].

Liquid tar barrels and tarred twine and rope samples from the Russian shipwreck frigate *St. Nikolai* (foundered in 1790) were analyzed for their organic constituents by gas chromatography and gas chromatography-mass spectrometry. A fresh Finnish tar sample, produced by tar-burning of pine wood in a pit, was analyzed for comparative purposes. Tricyclic diterpenoid resin acids originating from pine oleoresin were the major constituents of the Finnish pine tar. Dehydroabietic acid was the main resin acid. Pine oleoresin-derived mono- and sesquiterpenoids were also detected. Tricyclic hydrocarbons such as phenanthrenes and simple phenols represented thermal degradation products of pine oleoresin components and pine wood lignin, respectively. The barrel tar from the wreck closely resembled the Finnish pine tar both by its appearance, i.e., color and odor, and its chemical composition. Combined with

data from the tar-burning history, the barrel was concluded to be pine tar produced by tar-burning in a pit. The twine and rope samples contained resin acid disproportionation products, indicating heated tar to have been used in impregnation as is known to have been common practice at that time.

C.A. and C.W.B.

30-S651.
Skans, Bengt.
Tillverkuing och analys av gamla limmer. (Manufacturing and analyzing ancient animal glues.)

Meddelelser om konservering, **4**, pp. 145-164, (1989), [Swe. w. Eng. + Fin. summaries]. photos., refs.

Animal glue has almost disappeared since the introduction of "cold glues" in the 1930s. Nevertheless it is a very useful and important material for craftsmen and restorers of paintings and other artifacts. Bone glue is practically the only animal glue left on the market and the revival of old animal glues (mostly of hide origin) would be of great interest. Ancient manuscripts and treatises from classical antiquity to about 1850 on the matter have been studied in order to remake glues according to old formulas. More than 25 hide glues and one bone glue, ranging from cattle, sheep, elk, and rabbit, to fish, like eel, and bear, have been manufactured. One important factor which has a great influence on the properties of the various glues is the content of natural fat. The analysis of the fatty acids has been performed by means of gas chromatography and this can also be done when the glue is aged and the unsaturated fatty acids have more or less degraded. Some interesting foaming-tests carried out on hand-made glues are also presented.

ICCROM(04245600)

30-S652.
Derrick, Michele R.; and Stulik, Dusan C.
Identification of natural gums in works of art using pyrolysis-gas chromatography.

Affl: Getty Conservation Institute, Marina del Rey, CA, USA.

In proceedings. *ICOM Committee for Conservation, ninth triennial meeting, Dresden, German Democratic Republic, 26-31 August 1990: pre-* prints, Grimstad, Kirsten, Editor (1990), pp. 9-13, [Eng. w. Eng. summary]. 5 figs., 18 refs.

Pyrolysis-gas chromatography was used for identification of natural gum types (gum, arabic, ghatti, guar, karaya, and tragacanth). Regardless of chemical and structural similarities between different gum types, the identification of gum based on manual or computer-aided pyrogram matching of peak and intensity patterns is possible. Identification of gums is feasible from samples as small as 1 μg. Pyrolysis at lower temperatures (400°C) provide a better match between analytical results obtained from analysis of pure gums and gum-pigment mixtures.

A.A.

30-S653.
Evershed, R.P.
Lipids from samples of skin from seven Dutch bog bodies: preliminary report.

Archaeometry, **32**, no. 2, pp. 139-153, (1990), [Eng.]. figs., tables, refs.

Using a combination of thin layer chromatography, gas chromatography, and combined gas chromatography and mass spectrometry, it was possible (among other results) to distinguish between components originating from the bog body and from the surrounding peat.

B.A.A.(91/159) and K.M.G.W.

30-S654.
Evershed, Richard P.; Heron, Carl; and Goad, L. John.
Analysis of organic residues of archaeological origin by high-temperature gas chromatography and gas chromatography-mass spectrometry.

Affl: University of Liverpool. Department of Biochemistry, Liverpool, UK.

Analyst, **115**, pp. 1339-1342, (1990), [Eng. w. Eng. summary]. 3 figs., 27 refs.

Organic residues are extracted from materials of archaeological interest by solvent extraction and subjected directly to high-temperature gas chromatography (GC) and gas chromatography-mass spectrometry (GC-MS). The use of high-temperature GC allows intact acyl lipids, e.g., triacylglycerols, diacylglycerols, monoacylglycerols, and wax esters, to be analyzed without prior degradation (e.g., saponification) to release constituent fatty acids and alcohols. Trimethylsilylation is employed

to block protic sites in free fatty acids and hydroxylated components. The data obtained from temperature programmed GC and GC-MS analyses, employing immobilized apolar (dimethyl polysiloxane type) stationary phases, provide essential compositional information that would be lost if the more conventional degradative approach to acyl lipid analysis was adopted. A.A.

30-S655.
Hayek, Erich W.H.; Krenmayr, Peter; Lohninger, Hans; Jordis, Ulrich; Moche, Wolfgang; and Sauter, Fritz.
Identification of archaeological and recent wood tar pitches using gas chromatography/mass spectrometry and pattern recognition.

Analytical chemistry, **62,** no. 18, pp. 2038-2043, (1990), [Eng.].

An analytical method has been developed for the assignment of recent and archaeological wood tar pitches to the species of trees used for their preparation. It incorporates the prepurification by Kugelrohr distillation and solid-phase extraction followed by gas chromatography/mass spectrometry analysis. Distribution patterns of volatile, thermostable triterpenoids and steroids characterizing the biological origin of the pitches are evaluated by principal component analysis (PCA) and discriminant component analysis (DCA) of the data. Quantities of 10-100 mg of archaeological material can thus be characterized. By comparison with recent pitches of known origin, 14 archaeological samples have been identified as birch bark pitches. In addition, 28 substances present in recent barks and pitches could be identified.
 A.A. and C.K.S.

30-S656.
Kenndler, E.; and Mairinger, F.
Examination of the diterpenoic resin components of anatomical wax models from the eighteenth century by gas chromatography.

Fresenius' journal of analytical chemistry, **338,** pp. 635-640, (1990), [Eng.].

In literary sources of the 18th century the recipes for modeling wax suggest the addition of various resinous materials which serve as plasticizers and hardeners. The determination of such additives in case of the

anatomical models created by Felice Fontana and Pietro Mascagni, which are displayed at the "Josephinum" in Vienna is presented in this paper. The identification of the resins was accomplished by comparison of the gas chromatographic pattern of diterpenoic resin esters. The addition of Venetian turpentine was verified. The degradation products of aged beeswax were identified by combined GC-FTIR-MS (gas chromatography—Fourier transform infrared spectrometry—mass spectrometry). A.A.

30-S657.
Meilunas, Raymond J.; Bentsen, James G.; and Steinberg, Arthur.
Analysis of aged paint binders by FTIR spectroscopy.

Affl: Northwestern University. Department of Materials Science.

Studies in conservation, **35,** no. 1, pp. 33-51, (1990), [Eng. w. Eng., Fre. + Ger. summaries]. 6 figs., appendix, 52 refs.

In order to distinguish aged paint media by Fourier transform infrared (FTIR) spectroscopy, the authors focus on: 1) the natural aging of well-defined macroscopic samples of paint media; 2) the modifying effects of typical artists' pigments on the aging of these media; and 3) the utility of these findings in the characterization of unknown media samples. The key findings are that samples of linseed oil, egg yolk, and an emulsion of linseed oil and egg yolk, prepared by R.J. Gettens in the 1930s, exhibit diagnostic IR spectral features well resolved from common inorganic pigment absorptions, thus enabling us to distinguish between these materials and also to detect their presence in authentic Renaissance paintings. Moreover, thermally accelerated aging of freshly prepared linseed oil films yields FTIR spectral features that agree closely with those obtained for the naturally aged Gettens samples of similar initial composition. The results further demonstrate that the chemical changes associated with either natural or thermally accelerated aging of oil films vary widely with the choice of the inorganic pigment present. Results presented here serve to provide a spectroscopic characterization of the drastic, pigment-dependent chemical changes that have previously hampered the identifica-

tion of linseed oil on aged paint samples. Successful extension of these results to the spectroscopic analysis of dimensionally resolved layers of paint will be addressed in subsequent publications. A.A.

30-S658.
Palet, Antoni; and Porta, Eduard.
Análisis químico de los pigmentos y aglutinantes empleados en las pinturas murales de la tumba de Nefertari.
(Chemical analyses of pigments and media used in the mural paintings of the tomb of Nefertari.)

In proceedings. *VIII Congrés de Conservació de Béns Culturals: València, 20, 21, 22 i 23 de setembre de 1990 = Congreso de Conservación de Bienes Culturales: Valencia, 20, 21, 22 y 23 de setiembre de 1990*, Roig Picazo, Pilar, Editor (1990), pp. 452-460, 1a ed. [Spa. w. Spa. summary]. figs., bibliog. refs.

Presents a study of the pigments and media used in the mural paintings of the tomb of Nefertari in the Valley of the Kings in Egypt. This study constituted an important part of the overall conservation and restoration program that was carried out by the Egyptian Antiquities Organization and the Getty Conservation Institute. More specific research was carried out on the white pigments which appeared to be composed of calcium carbonate and magnesium, an inorganic product known as huntite. The medium was identified by gas chromatography as gum arabic, and the superficial varnish as egg white. This seems to prove that native materials were used and fills a gap in knowledge about materials and techniques in ancient Egypt. ICCROM

30-S659.
Sinkai, Tetuo; and Sugisita, Ryuitiro.
(Identification of protein containing binding media and adhesives in works of art by amino acid analysis.)

Kobunkazai no kagaku, **35**, pp. 1-12, (1990), [Jpn.]. ill., refs.

Glue, casein, egg yolk, and wheat flour paste used as binding media in art objects contain various kinds of proteins. In this article, quantitative amino acid analyses for such proteinaceous binders in specific art objects, e.g., Buddhist statues or paintings, were car-

ried out by high performance liquid chromatography (HPLC) to obtain knowledge about the differences in amino acid content between each binding medium and to establish the method for identification of each medium. Very small portions of samples were taken from the surfaces of the artistic objects and hydrolyzed with hydrogen chloride. The products were processed to separate the amino acids which were determined by HPLC. From the results of determinations, so-called amino acid similarity for each sample was calculated by using some adhesives like isinglass, bovine skin glue, lime casein, and others available from stationery houses, as controls for calculation. Comparing the pattern similarities between samples taken from the objects and controls, it can be said that mammal glues and rice paste were used for Buddhist statues and casein for paintings examined in this study. C.A.L.

30-S660.
Sonoda, Naoko; and Rioux, Jean-Paul.
Identification des matériaux synthétiques dans les peintures modernes. 1. Vernis et liants polymères.
(Identification of synthetic materials in modern paintings. 1: varnishes and polymer binders.)

Studies in conservation, **35**, no. 4, pp. 189-204, (1990), [Fre. w. Fre., Eng. + Ger. summaries]. 4 figs., 3 tables, 2 appendixes, 26 refs.

An analytical method using pyrolysis and gas chromatography is proposed for the identification of microsamples of varnishes and binding media made with synthetic polymers. Standard conditions of analysis of vinylic, acrylic, methacrylic, and ketonic polymers and copolymers are set up and presented. This study of basic materials is then used for the characterization of some varnishes and binding media developed by specialized manufacturers for painters and restorers. Results show the interest of such analysis; it can give painters and restorers a way of controlling the nature and quality of the products they use. A.A.

Analysis

30-S661.
Welsh, Frank S.
Microchemical analysis of old housepaints with a case study of Monticello.

The microscope, **38**, no. 3, pp. 247-257, (1990), [Eng. w. Eng. summary]. 4 figs.

There are two major reasons for microscopically analyzing paints on historic buildings today. First, knowing the number, the color, and the types of coatings on architectural elements can reveal vital information about the sequence of additions and alterations. Second, analyses using the stereomicroscope and the polarized light microscope are used to identify the original colors and composition of paint films for purposes of authentic restoration. At Monticello, the home of Thomas Jefferson in Charlottesville, Virginia, the author analyzed historic architectural paints with both these purposes in mind. Participation in the analysis of the Dome Room, familiar to most Americans because of its representation on the reverse side of the nickel, enabled the Thomas Jefferson Memorial Foundation to restore and repaint the room according to Jefferson's original architectural and painting schemes.

A.A. and I.N.M.W.

30-S662.
Chiavari, Giuseppe; Ferretti, Silvia; Galletti, Guido C.; and Mazzeo, Rocco.
Analytical pyrolysis as a tool for the characterization of organic substances in artistic and archaeological objects.

Affl: Università di Bologna. Dipartimento di Chimica "G. Ciamician", Bologna, Italy.

Journal of analytical and applied pyrolysis, **20**, pp. 253-261, (1991), [Eng. w. Eng. summary].

The black solid content of a red ceramic bottle (Cyprus, 14th-13th century BC) and the organic patinas on the bronze statue of Neptune (Bologna, 1566) were analyzed by pyrolysis gas chromatography-mass spectrometry (PY-GC/MS) and by GC/MS after extractions with organic solvents, using a capillary gas chromatograph coupled to an Ion Trap Mass Spectrometer. Results show that the supposedly bituminous material of the ceramic bottle is, in fact, a mixture of aliphatic mono- and dicarboxylic acids, palmitic acid being the main peak, probably deriving from a vegetable oil. The patinas on the Neptune statue result in pyrograms containing mainly palmitic acid and minor quantities of other aliphatic acids, which can be attributed to both protective coatings and atmospheric depositions. Pyrolysis works as a thermal desorption injector and is useful for the rapid analysis of small samples.

A.A.

30-S663.
Da Costa, G.M.; Cruz Souza, L.A.; and De Jesus Filho, M.F.
Mossbauer study of rock paintings from Minas Gerais (Brazil).

Hyperfine interactions, **67**, no. 1-4, pp. 459-462, (1991), [Eng.].

Four samples of a wall containing rock paintings have been studied by Mossbauer spectroscopy in combination with optical microscopy analysis and x-ray diffraction. Hematite and goethite were identified as the pigments responsible for the colors, and the mineral tinsleyite as the principal component of a light pink layer that is present in some parts of the wall.

A.A.

30-S664.
Derrick, Michele R.; Landry, James M.; and Stulik, Dusan C.
Methods in scientific examination of works of art: infrared microspectroscopy.

Book. Getty Conservation Institute, Marina del Rey, 1991, [Eng.]. 1 v.: ill.; 30 cm., refs.

Over the past five years there has been an ever-increasing use of infrared microspectrometers in the analysis of cultural artifacts. Since the materials and samples found in art objects are unique and sometimes complex, an infrared microspectroscopy workshop and corresponding textbook were developed by the Getty Conservation Institute to disseminate methods for their analysis. The textbook includes the following chapters: An Introduction to Infrared Spectrometry; IR Instrumentation; Spectral Interpretation; Sample Preparation; Binding Media and Binding Media Library; Cross-Section Analysis; Scientific Examination of Works of Art; Potential for IR Microspectroscopy in Art Conservation; Bibliography, as well as other information pertaining to the workshop. Schematics were introduced for the preliminary identification of synthetic and natural resins commonly found in works of art. Methods for embed-

ding and microtoming multiple layer paint cross-sections were presented.　　　A.A.

30-S665.
Hayek, E.W.H.; Krenmayr, Peter; and Lohninger, Hans.
GC/MS and chemometrics in archaeometry: investigation of glue on Copper-Age arrowheads.

Fresenius' journal of analytical chemistry, **340,** pp. 153-156, (1991), [Eng.].

Glue samples (100 mg) on two Copper Age arrowheads have been investigated by means of gas-chromatography/mass spectrometry and chemometrics. The samples have been identified as birch bark derivatives, but the distribution patterns of triterpenoids and steroids show significant differences to similar samples from younger archaeological periods that can be explained by the use of a different species of birch and a different method of preparation.　　A.A.

30-S666.
Stringari, Carol; and Pratt, Ellen.
The identification and characterization of acrylic emulsion paint media.

Affl: The Museum of Modern Art, New York, NY, USA.

In book. *Symposium '91: saving the 20th century: the degradation and conservation of modern materials: abstracts = Sauvegarder le XXe siècle: la dégradation et la conservation des matériaux modernes: résumés,* (1991), pp. 411-440, [Eng. w. Eng. + Fre. summaries]. 27 figs., 3 tables, refs.

An ongoing project to study the properties of acrylic emulsion paints is underway at The Museum of Modern Art, New York. Approximately 150 paintings in the collection were surveyed to study the medium and assess condition. Routine examination and testing were done in the laboratory and a body of standards was prepared for comparison. Three case studies were chosen to explore more specific methods of identification. These methods included microscopic analysis and staining, Fourier transform infrared spectroscopy (FTIR), and pyrolysis-gas chromatography (Py-GC).　　A.A.

30-S667.
Burmester, A.
Investigation of paint media by differential scanning calorimetry (DSC).

Studies in conservation, **37,** no. 2, pp. 73-81, (1992), [Eng. w. Eng., Fre. + Ger. summaries]. 9 figs., 17 refs.

Evaluates the possibilities and limitations of the investigation of paint media by differential scanning calorimetry (DSC). For the first time, particular care was taken to include a large number of samples and a large range of media, and to examine thoroughly the influence of the pigments present. The investigation was carried out on samples from test panels which date from the beginning of this century. The simple experimental procedure, without any sample preparation, allowed a rough characterization of most paint media. The limitations are discussed in detail. Differential scanning calorimetry shows promise as an addition to common techniques of paint media analysis.　　A.A.

30-S668.
Chiavari, G.; Bocchini, P.; and Galletti, G.C.
Rapid identification of binding media in paintings using simultaneous pyrolysis methylation gas chromatography.

Affl: Università di Bologna. Dipartimento di Chimica "G. Ciamician", Bologna, Italy.

Science and technology for cultural heritage, **1,** pp. 153-158, (1992), [Eng. w. Eng. + Ita. summaries].

Pyrolysis gas chromatography (PY-GC) and pyrolysis gas chromatography mass spectrometry (PY-GC/MS) are proposed as rapid and simple techniques to identify organic binding media in paintings. A methylating agent is used in a procedure called simultaneous pyrolysis methylation (SPM) to improve the response of fatty acids. Diagnostic markers for linseed oil, egg yolk, animal glue, casein, and glair are identified and quantified. Ten samples by Italian artists are analyzed and discussed. Typical programs are shown.　　A.A.

Analysis

30-S669.
Halpine, Susana M.
Amino acid analysis of proteinaceous media from Cosimo Tura's "The Annunciation with Saint Francis and Saint Louis of Toulouse."
Studies in conservation, **37,** no. 1, pp. 22-38, (1992), [Eng.]. 8 figs., 2 tables, 2 appendices, 36 refs.

Very small paint samples from Cosimo Tura's *The Annunciation with Saint Francis and Saint Louis of Toulouse* were submitted to amino acid analysis in order to determine the nature of the binding media. The four panels appeared to have been painted with egg tempera, and showed extensive localized deterioration in the blue areas but not in the other colored areas. Following the Picotag method, the samples were hydrolyzed in an acid vapor, derivatized with iso-thiocyanatobenzene, and analyzed using reversed phase high pressure liquid chromatography (HPLC). Amino acid analysis demonstrated that the red and brown areas were painted using egg yolk as the binding medium, while the blue areas were painted with animal-skin glue (distemper). Analysis of the green paint indicated a mixture of egg yolk and glue. The use of these techniques makes it possible to identify proteinaceous materials in art objects from samples in the microgram range.
A.A.

30-S670.
Kenndler, Ernst; Schmidt-Beiwl, Karin; Mairinger, Franz; and Poehm, Maximilian.
Identification of proteinaceous binding media of easel paintings by gas chromatography of the amino acid derivatives after catalytic hydrolysis by a protonated carbon exchanger.
Affl: University of Vienna. Institute of Analytical Chemistry, Vienna, Austria.
Fresenius' journal of analytical chemistry, **342,** no. 1-2, pp. 135-141, (1992), [Eng.].

A procedure for the hydrolysis of proteins, based on catalysis by the protonated form of a strong cation exchanger, was established for proteinaceous binding media (e.g., casein, egg, animal collagen) used for objects of art. The experimental parameters for the hydrolysis (temperature, time) were optimized, as well as the conditions for sorption

and desorption of the amino acids on the cation exchanger. The results for the identification of proteins by the gas chromatography pattern of the amino acid derivatives after hydrolysis by the ion exchanger and by hydrochloric acid were compared. The former method proved to be more efficient due to the mild conditions, avoiding the formation of humins in the presence of carbohydrates, and reducing the dissolution of pigments. The method was applied to identify the proteinaceous vehicles of samples from priming and paint layers of easel and wall paintings from the 16th and 18th centuries.
C.A.(116:193243b) and C.W.B.

30-S671.
Messinger, John M. II.
Ultraviolet fluorescence microscopy of paint cross sections: cycloheptaamylose-dansyl chloride complex as a protein-selective stain.
Journal of the American Institute for Conservation, **31,** no. 3, pp. 267-274, (1992), [Eng. w. Eng. summary]. 1 table, 13 figs., refs.

Cycloheptaamylose-dansyl chloride complex, a new fluorochrome-specific for proteins, has been investigated as a stain to identify artists' paint media. Its selectivity and limitations are compared to those of the following commonly available fluorescent and nonfluorescent stains: lisamine rhodamine B sulfonyl chloride, 5-fluorescein isothiocyanate, amido black, Sudan black, rhodamine B, and 2′,7′-dichlorofluorescein. The methods used to examine the characteristics of these stains were reflected visible light microscopy and ultraviolet fluorescence microscopy. The known samples of artists' media analyzed with the stains were linseed oil, casein, tempera, glair, gelatin, rabbit-skin glue, and acrylic emulsions.
A.A.

30-S672.
Peek, Marja; and de Boer, Hayo.
Introduction to TINCL: a database system for art technological sources.
Zeitschrift für Kunsttechnologie und Konservierung, **6,** no. 2, pp. 346-352, (1992), [Eng. w. Eng. summary].

The Central Research Laboratory for Objects of Art and Science (CL) in Amsterdam has developed a database system to open

up historical sources in the field of art technology. The system has been operational since September 1990 and is called TINCL. Unlike most bibliographic databases, this database not only contains data such as authors, titles, and abstracts of sources, but also full text transcriptions of relevant passages derived from these sources. In addition, modern publications related to sources and information on research projects are also part of the database. The database system is used by conservators, historians, art historians, conservation scientists, and researchers in this field.　　　K.V. and A.A.

30-S673.
Pröfke, M.L.; Rinehart, K.L.; Raheel, M.; Ambrose, S.H.; and Wisseman, S.U.
Probing the mysteries of ancient Egypt: chemical analysis of a Roman period Egyptian mummy.

Analytical chemistry, **64,** no. 2, pp. 105A-111A, (1992), [Eng.]. 4 photomicrographs, 23 refs.

Discusses the analysis and interpretation of a Roman period mummy from the World Heritage Museum at the University of Illinois at Urbana-Champaign. Small samples of wrapping fabric, wooden board, and crystallized resins were taken from the feet of the mummy. Embalming resins were analyzed and characterized by fast atom bombardment mass spectrometry (FABMS). The resin was found to be based on pine pitch (oxidized forms of abietic acid were identified). The wrapping fabrics were analyzed by macroscopic examination, solubility, and longitudinal and cross-sectional scanning electron microscopy (SEM). Inner wrapping fabrics were found to be woven from flax fiber, but the outer bundle was made from ramie. Bone fragments were collected and characterized by stable isotope analysis. The analysis of the mummy's δcarbon-13 (a measure of the ratio of carbon isotopes 13 and 12) from collagen and carbonate sources were consistent with a C3 type diet (bread and onions) as opposed to a C4 diet.　　　A.A. and C.K.S.

30-S674.
Sinkai, Tetuo; Nagasawa, Ichiro; Shida, Tsukasa; and Sugisita, Ryuitiro.
(Analysis of binding media and adhesives in Buddhist wooden statues.)

Kobunkazai no kagaku, no. 37, pp. 1-11, (1992), [Jpn. w. Eng. summary]. ill.

For the study of art objects and their restoration, the identification of binding media as well as that of pigments is considerably important. Binding media consist of complicated organic compounds but only a small amount of sample can be used for analysis. For this reason analysis of binding media by means of conventional techniques has been difficult. In this paper, identification of protein containing binders such as glue used in Buddhist wooden statues was carried out by sodium dodecylsulfate polyacrylamide gel electrophoresis (SDS-PAGE) and by high performance liquid chromatography (HPLC). By using SDS-PAGE, it was not possible to distinguish mammal glue from fish glue whereas by HPLC these two types of glue were clearly distinguished.　　　C.A.L.

30-S675.
Stulik, Dusan; and Florsheim, Henry.
Binding media identification in painted ethnographic objects.

Journal of the American Institute for Conservation, **31,** no. 3, pp. 275-288, (1992), [Eng. w. Eng. summary]. 2 tables, 8 figs., refs.

Describes a binding media identification procedure for the analysis of 5 mg samples from painted ethnographic objects. It is based on modified medical diagnostic and forensic science tests and is designed to identify vegetable oils, lards, simple sugars, tree gums, starches, animal glues, casein, eggs, and blood in paint layer samples. Flow diagrams for individual tests are described, as well as a binding media identification procedure and a general binding media identification flow chart.　　　A.A.

30-S676.
Sundar Rao, K.; and Sino, D.
Fatty acid composition of 20 lesser-known Western Australian seed oils.

Affl: University of Papua New Guinea. Department of Chemistry, Papua New Guinea.

Journal of the science of food and agriculture, **58,** pp. 585-587, (1992), [Eng. w. Eng. summary]. 1 table, 5 refs.

The fatty acid composition of the seed oils of Compositae (eight species), Proteaceae (four species), Begoniaceae (one), Boraginaceae (one), Euphorbiaceae (one), Liliaceae (one), Meliaceae (one), Rhamnaceae (one),

Analysis

Sapindaceae (one), and Stylidaceae (one) were qualitatively and quantitatively determined by a combination of thin layer chromatography and gas liquid chromatography. The seeds contained oil in the range 1.6-37.7% (on a dry basis). Unusual fatty acids were not found. The major fatty acids were oleic and linoleic in all the species of seed oils except one (*Phyllanthus calycinus*) in which linolenic acid was the major component. A.A.

30-S677.
Tomek, Jindřich; and Pechová, Dorothea.
A note on the thin-layer chromatography of media in paintings.

Studies in conservation, **37**, no. 1, pp. 39-41, (1992), [Eng. w. Eng. summary]. 2 figs., 16 refs.

Proteinaceous media used in paintings were analyzed using thin-layer chromatography (TLC) of the dansyl derivatives of amino acids on micropolyamide. Spots of dansyl amino acids were detected by their fluorescence under ultraviolet light. A.A.

30-S678.
Chiavari, Giuseppe; Galletti, Guido C.; Lanterna, Giancarlo; and Mazzeo, Rocco.
The potential of pyrolysis-gas chromatography/mass spectrometry in the recognition of ancient painting media.

Affl: Università di Bologna. Dipartimento di Chimica "G. Ciamician", Bologna, Italy.

Journal of analytical and applied pyrolysis, **24**, no. 3, pp. 227-242, (1993), [Eng. w. Eng. summary]. figs., tables, refs.

Pyrolysis-gas chromatography mass spectrometry is shown to be a rapid technique, requiring no sample work-up, for the recognition of organic materials, namely animal glue, egg yolk and glair, and linseed oil and casein, commonly used as binding media in ancient paintings. Major compounds originating from the thermal decomposition of proteins are identified by their mass spectra and have been diagnostic for glue, glair, and casein. C-16, C-18, and other lower molecular weight free fatty acids are significant markers for yolk and linseed oil; however, they are not detectable in their free form when present in low quantities or as salts. In this case, the use of simultaneous pyrolysis-methylation (SPM), by addition of an aqueous solution of tetramethylammonium hydroxide to the sample, is recommended. Chromatograms of pyrolysates of binding media and of samples from original paintings are shown. A.A.

30-S679.
Derrick, Michele; Souza, Luiz; Kieslich, Tanya; Florsheim, Henry; and Stulik, Dusan.
Embedding paint cross section samples in polyester resins: problems and solutions.

Technical report. Getty Conservation Institute, Marina del Rey, 1993, [Eng. w. Eng. summary]. 25 p.: ill., bibliog.

Polyester resins have been commonly used in art conservation for embedding paint cross sections prior to analytical studies. These resins set rapidly without heat, are clear, polish readily and microtome easily. However, while they work well in most cases, there are some specific samples for which these resins pose problems. The polyester embedding media have been found to dissolve wax and fresh natural resin layers in cross sections. Additionally, the embedding resin wicks into porous, low binder samples. This infiltration hinders the determination of the type of binder in the sample by producing blotchy, uneven staining results as well as obstructing infrared analysis. Alternate embedding materials and procedures are discussed in this paper. One method to prevent the infiltration of embedding media is also presented in which the samples are precoated with a thixotropic acrylic gel prior to embedding. A.A.

30-S680.
Gatenby, Sue.
An identification method for fat and/or oil binding media used on Australian Aboriginal objects.

Affl: Australian Museum. Materials Conservation Division, Sydney, NSW, Australia.

In book. *ICOM Committee for Conservation tenth triennial meeting, Washington, DC, 22-27 August 1993: preprints*, Bridgland, Janet, Editor (1993), pp. 167-171, [Eng. w. Eng. summary]. ill., refs.

There has been little research carried out on the materials used in the manufacture

of traditionally painted Australian Aboriginal objects. Their significance toward the present condition of the object, as well as the treatment options have not been reported. The anthropological literature has outlined several different types of materials used in combination with pigments to decorate surfaces. These materials have been identified and a procedure developed, which has been based on Bromine-Sudan Black B staining and a biochemical identification method for triglycerides. The following procedure outlined has provided reliable results to warrant further testing on a selected group of objects from the museum's collection. [Editor's note: The author cites fats and oils from kangaroo and goanna, blood (presumably human and other mammals), eggs, plant gums, and sugars such as orchid juices as binders used.]

A.A.

30-S681.
Schulz, H.; and Kropp, B.
Micro spectroscopy FTIR reflectance examination of paint binders on ground chalk.

Affl: Technische Universität Berlin, Berlin, Germany.

Fresenius' journal of analytical chemistry, **346,** pp. 114-122, (1993), [Eng. w. Eng. summary].

A restorer's questions on chemical analysis of paint binders to support his complicated work has always had an exceptional appeal for chemists. Nondestructive surface analysis of rather complex materials such as paint binders is possible. The advantages of vibrational spectroscopy related to the details about chemical structure of organic compounds have been combined with sophisticated methods of multivariate data analysis. Reflectance spectra of several paint binders on ground chalk were measured using a fast, sensitive FTIR spectrometer equipped with an infrared microscope. The initial reflectance spectra include sufficient structural information to allow successful classification by hierarchical cluster analysis (HCA). Similarities between the several binders are plotted as dendrograms which are well structured. Their explanation is discussed in detail. Finally the postulated feature sets are checked

by principal component analysis (PCA) as to their relevance and information content.

A.A.

30-S682.
Striegel, Mary F.; and Stulik, Dusan.
High performance thin-layer chromatography for the identification of binding media: techniques and applications.

Technical report. Getty Conservation Institute, Marina del Rey, 1993, [Eng. w. Eng. summary]. 22 p.: ill. (some col.), bibliog.

While sophisticated analytical methods for the identification of binding media can be used in a research setting, conservators are often limited in the techniques available to them. Thin layer chromatography is an analytical method useful for the analysis of paint binding media. It provides a relatively simple, inexpensive method of identification with high sensitivity and low detection limits for samples ~ 500 µg in size. This paper presents the application of thin layer chromatography to the identification of binding media. Recent advances in the field of thin layer chromatography that can benefit binding media analysis are discussed. The paper details the step-by-step application of thin layer chromatography in the identification of protein, carbohydrate, wax, and natural resin binders.

A.A.

30-S683.
Derrick, Michele; and Gergen, Melena.
Methods in scientific examination of works of art. Volume 3: thin-layer chromatography reference materials binder.

Technical report. Getty Conservation Institute, Marina del Rey, 1994, [Eng.]. 40 p.

This binder is a companion to a binding media reference kit and contains documentary information on 40 types of gums, proteins, waxes, and resins included in the kit. The written documentation includes the source, history of the material, and date that it was obtained. An infrared spectrum of each material and analysis conditions is included.

M.Str.

30-S684.
Striegel, Mary F.; and Hill, Jo.
Methods in scientific examination of works of art. Volume 1: thin-layer chromatography course book.

Technical report. Getty Conservation Institute, Marina del Rey, 1994, [Eng.]. 122 p.

This course book presents a step-by-step guide for the analysis of organic binders, adhesives, and coatings by thin layer chromatography (TLC). Chapters include: an overview, a discussion of technique, methodology, and applications to proteins, carbohydrates, waxes and resins, and a presentation of the interpretation of a TLC plate. Additional articles are collected at the end of the course book which provide detailed information on the chemistry and fundamentals of TLC analysis. M.Str.(A.A.)

30-S685.
Striegel, Mary F.; and Hill, Jo.
Methods in scientific examination of works of art. Volume 2: thin-layer chromatography protocols.

Technical report. Getty Conservation Institute, Marina del Rey, 1994, [Eng.]. 91 p.

This report details 12 laboratory protocols that describe the practical laboratory procedures used in the analysis of proteins, carbohydrates, waxes, and resins by thin layer chromatography (TLC). Procedures that are described include sample preparation (dissolution and hydrolysis), preparation of solvent systems and detection reagents, use of conventional and sandwich development chambers, visualization, written documentation, photographic documentation, and evaluation and interpretation of the TLC plate. M.Str.(A.A.)

See also:

Gumy roslinne jako spoiwa malarskie w swietle dawnych traktatow, ich wlasnosci, oraz ich identyfikacja w dawnych polichromiach [Plant gums as painting mediums in the light of old treatises, their properties, and their identification in ancient polychromy], **30-S207.**

Blues for the chemist, **30-S465.**

Etude physico-chimique et colorimétrique des rouges et des violets d'hématite, à propos des peintures murales de l'Acropole de Léro, ou "histoires d'ocre" [Physico-chemical and colorimetric study of haemitite reds and purples, with reference to the mural paintings of the acropolis of Lero, or 'histories of ochre'], **30-S352.**

Paleolithic pigments and processing, **30-S357.**

Colouring technique and repair methods for wooden cultural properties, **30-S303.**
[Microchemical analysis of the wall paintings of St. Baafsabtei in Ghent (about 1175)], **30-S90.**

Probleme der Interpretation kunsttechnischer Quellen und ihrer Bestaetigung durch technologische Untersuchungsbefunde an Kunstwerken, dargestellt am—Beispiel der Fassmalerei im 18. Jahrhundert in Sueddeutschland [Problems of the interpretation of historical sources and their confirmation by the results of technical analysis on works of art, shown on the example of painted sculptures from the 18th century in southern Germany], **30-S322.**

Die Bestaetigung kunsttechnischer Quellen durch technologische Untersuchungsbefunde [The confirmation of literary sources on art technology through scientific examination], **30-S323.**

C. Properties

This section contains abstracts, primarily from the coatings field, that pertain to the physical and optical properties of matte paint. The majority of citations refer to the appearance and physical integrity of high pigment volume concentration paint. (Please note: the citations are organized chronologically by publication year and alphabetically by author within each year.)

30-S686.
Thompson, G.W.
Scientific preparation and application of paint.

The journal of industrial and engineering chemistry, **2,** no. 87, pp. 87-92, (1910), [Eng.]. 6 figs.

Discusses the use and limitations of science as applied to the preparation and application of paint. The author calls for the use of scientific methodology (accumulating facts, accurate description of facts, studying the interrelation of facts, developing hypotheses, discovering laws arising from the classification and organization of facts, and drawing appropriate conclusions) in the manufacture of paint. Both tests for paint performance and the effect of size and shape of pigment particles on the performance of paint are considered. The importance of volume relationships (pigments, voids and vehicle) is stressed. An apparatus for the classification of simple pigments composed of particles of varying size is described. E.Ha.

30-S687.
Merwin, H.E.
Optical properties and theory of color of pigments and paints.

Proceedings (American Society for Testing and Materials), **17,** no. 2, pp. 494-527, (1917), [Eng.].

The hue, purity, and brightness of light diffused by a pigment or paint depend upon the refractive index, color absorption, size, shape, and texture of the pigment grains; upon the refractive index, color, and continuity of the vehicle; and upon the distribution of the grains in the vehicle. Coloring efficiency must be considered as much from the standpoint of the hue and tone desired as of the absolute quality of color obtained. Thus, although extremely fine division may favor the last factor

mentioned, when the pigment is used in a mixture with a strongly diffusing pigment, under other conditions size and shape of grain and refractive index are of great importance. The optical properties which determine whether a pigment is best suited for producing tints or shades are discussed. Special methods of studying the optical properties of pigments have been used and a considerable number of optical constants determined. These properties can be applied in determinative work or to problems in chromatics. This investigation has been conducted in the Geophysical Laboratory of the Carnegie Institute. CCI

30-S688.
Calbeck, J.H.
Application of the statistical method in testing paints for durability.

Industrial and engineering chemistry, **18,** no. 1220, (1926), [Eng.].

This statistical analysis of the durability of paint exposed for six years in North Dakota was one of the first to emphasize explicitly the role of pigment volume concentration. Instead of considering the weight of the paint, it is more acceptable to speak of the volume ratio, which is defined as the percentage volume of the pigment phase in the dried paint film (the ratio of the volume of the pigment to the volume of paint less the volatile component of the vehicle). 28% pigment by volume is found as the minimum for acceptable durability. E.Ha.

30-S689.
Rhodes, F.H.; and Fonda, J.S.
Factors determining the brightness and opacity of white paints.

Industrial and engineering chemistry, **18,** no. 2, pp. 130-135, (1926), [Eng.]. 2 tables, 5 graphs.

Properties

A formula is developed to express the relation between the brightness of a film of white paint and the thickness of the film, and experimental evidence in support of this formula is advanced. The well-known effect of the addition of a small amount of black pigment in increasing the hiding power of a white paint is explained. Attention is called to the possible effect of the roughness of the surface of a paint film upon the brightness of the film. A.A.

30-S690.
Klumpp, E.
Pigment und Oel.
(Pigment and oil.)

Farben-Zeitung, **32**, no. 2306, pp. 2306-2307, (1927), [Ger.].

An older theory that held that the oil requirement for paint depended on the size of the entire surface of its particles did not stand up to more rigorous testing. The research results cited in this article prove beyond a doubt that the oil requirement of a paint depends rather on the pore space between the particles after the tightest possible packaging and the removal of adsorbed air along the surface. E.M.B.

30-S691.
Wolff, H.
Über die Viskositat von Anstrichfarben.
(On the viscosity of paints used for coatings.)

Farben-Zeitung, **35**, no. 2175, pp. 2175-2176, (1930), [Ger.].

Examinations of paints by means of the Wolff-Hoepke turboviscosimeter have led to certain correlations where the product is relatively constant while weighting and elapsed time for the drop tend to vary inversely one with the other. The observations were made with different types of white paint with different oil contents. E.M.B.

30-S692.
Wolff, H.
(On the viscosity of oil paints, the turboviscosimeter, and the critical oil content.)

Farben-Zeitung, **37**, no. 1512, (1932), [Ger.].

From the speech given at a Congress in Leningrad (now St. Petersburg) by Dr. Hans Wolff on the limitations of Bingham's equation and how best to measure the viscosity of paints used for coatings which always varies between "stiffness" and "mobility" and apparently is subject to physical laws which Dr. Wolff—at the time—was on the verge of discovering. E.M.B.

30-S693.
Wolff, H.; and Zeidler, G.
Die Funktion des Olgehaltes auf die Eigenschaften von Olfarben und Anstrichen.
(Oil content as a determinant of the properties of oil paints and coatings.)

Colloid and polymer science = Kolloid-Zeitschrift & Zietschrift für Polymere, **65**, no. 228, pp. 57-61, (1933), [Ger.].

Various types of oil paints were examined for their viscosity and formulae developed to help in predicting viscosities depending on oil content and the type of oil used. E.M.B.

30-S694.
Wolff, H.
Further experiments on the importance of the critical point.

Paint and varnish production manager, **9**, no. 5, pp. 5-10, (1933), [Eng.].

One of a series of articles based upon the premise that paint viscosity, being related to pigment concentration, is the true source of exterior durability. The concept of the "critical oil content" for each pigmentation which yield both optimum brushing characteristics and paint durability, previously reported for linseed oil paints, is extended to stand oil and mixed oil paints. E.Ha.

30-S695.
Wolff, H.; and Zeidler, G.
Oil requirements and structure of paints.

Paint and varnish production manager, **9**, no. 18, (1933), [Eng.].

A series of experiments are presented to support the conclusions that oil requirements of paste and prepared paints may *a priori* be expected if the pigment volumes per unit of paint volume are compared instead of comparing the oil contents or oil volume. The hypothesis previously held that the critical oil contents are determined by the packing ar-

156

rangement of pigment particles needs modification to consider packing arrangement corresponding to other chief factors such as real spherical packing. E.Ha.

30-S696.
Wolff, Hans.
Über die Viskosität von Ölfarben.
(On the viscosity of oil paints.)
Kolloid Zeitschrift, 65, no. 228, pp. 228-233, (1933), [Ger.]. 1 fig., 6 tables.

An attempt to relate the viscosity relationships of oil paints and their dependence on oil content in such a way that relatively few and simple measurements could furnish a great deal of information with sufficient accuracy to be useful for practical purposes. The article describes how the viscosity relationships of various types of oil paint can be rendered by two, or, at most, three constants which result from the important relationship which holds good, in practice, in the field of oil: $V - V_O = cp^n$ and can be calculated from the determination of two different oil contents. In addition, this gives rise to the possibility of calculating, from these constants, the critical oil content for a paint and any surfaces to be covered by it.
 A.A. and E.M.B.(transl.)

30-S697.
Wolff, Hans.
Über den Einfluß der Korngröße von Farbkörpern auf den Ölbedarf.
(On the influence of grain size of pigment parts on oil requirement.)
Farben-Zeitung, 38, no. 876, pp. 876-878, (1933), [Ger.]. 4 graphs.

An attempt to relate pigment-grain size to critical oil content for paint to fulfill its function. Experiments conducted with different types of paint led to the preliminary conclusion that grain size, and with it, the dispersion of the pigment in the paint, was, indeed, functionally related to critical oil content but that this was not the only determinant because of certain types of pigment having more chemically active surface features that might overcome the influence of grain size alone. E.M.B.

30-S698.
Elm, A.
Fundamental studies of paints. Paint durability as affected by the colloidal properties of the liquid paint.
Industrial and engineering chemistry, 26, no. 1245, pp. 1245-1250, (1934), [Eng.].

A large number of tests extending over a period of two years have shown that the critical point of a specific paint system as determined according to Wolff's method indicates the pigment-binder ratio which gives the best durability on exterior exposure. There is at present no evidence that the critical points of dissimilar paint systems are indicative of their relative durabilities. Wolff's critical point method promises to become a research tool of considerable value to the paint chemist. A.A.

30-S699.
Wolff, H.; and Zeidler, G.
The relationship between oil content, particle size and particle shape.
Paint and varnish production manager, 12, no. 14, pp. 14-20, (1935), [Eng.].

The authors, writing in 1935, state that current conceptions and laws relative to dispersions do not form a sufficiently wide basis for the theoretical solution of the "pigment vehicle problem." The mathematical conception "particle surface," is introduced, showing that the viscosity properties of oil paints are governed by the size and shape of the particles forming the dispersion. For linseed oil- and linseed oil varnish paints, the oil requirement and viscosity relations are dependent on size and shape of particles. E.Ha.

30-S700.
Wolff, H.; and Zeidler, G.
Die Schnellbestimmung des kritischen Oelbedarfs I.
(Rapid determination of the critical oil requirement. 1.)
Farben-Zeitung, 40, no. 375, (1935), [Ger.]. 1 fig.

A simplified process, by means of a turboviscosimeter attached to a wall, to determine the critical oil requirement for oil paint to cover surfaces and exhibit the proper luster. A distinction is made between critical and optimal oil content. The necessary steps

to obtain reliable results are spelled out. This is part 1 of a two-part article. Calculations can be held to a minimum. E.M.B.

30-S701.
Robertson, D.W.; and Jacobsen, E.A.
Physical study of two-coat paint systems.
Industrial and engineering chemistry, **28,** no. 403, pp. 403-407, (1936), [Eng. w. Eng. summary].

A technique is employed which permits the removal of paint films from metal panels after various periods of exposure. By use of a two-coat system and a physical examination of the detached films after exposure, interrelationships between the physical properties of the two films, in terms of exposure results, are shown. Films are tested for distensibility, flexibility, and tensile strength, and the results are tabulated with reference to failure as ordinarily observed in paint testing on panels. Results indicate the desirability of using specialized paints as undercoaters for general house painting and point to some definite formulation principles which promise improvement in results over current general practice. A.A.

30-S702.
Wolff, H.; and Zeidler, G.
Über die Viskosität von Ölfarben als Ausdruck ihrer Struktur.
(On oil-paint viscosity as an expression of paint structure.)
Colloid and polymer science = Kolloid-Zeitschrift & Zietschrift für Polymere, **74,** no. 97, pp. 97-103, (1936), [Eng.].

The structure of oil paint is basically dependent on two factors: arrangement of the pigment particles and the arrangement of the oil in hulls around the particles or as "virtual" hulls where no real hulls have been formed. The key to good coatings seems to be that the paint retains its structure as any subsequent alteration gives rise to insecurity which, in practice, may have serious consequences. E.M.B.

30-S703.
Stout, George L.; and Pease, Murray.
A case of paint cleavage.
Technical studies in the field of the fine arts, **7,** no. 1, pp. 33-45, (1938), [Eng.].

Explains the causes of paint cleavage and describes a fixative consolidation treatment carried out on a highly deteriorated 17th-century Italian painting on stone. This included acetone and diacetone-alcohol vapor impregnation and application of a wax-resin adhesive over the warmed support.
ICCROM(01118200)

30-S704.
Stout, George L.
Classes of simple paint structure.
Technical studies in the field of the fine arts, **6,** no. 4, pp. 221-239, (1938), [Eng.]. 11 figs., 1 diagram, 5 notes.

The author's aim is to describe paint as a material. Rather than offering a complete terminology, the author is attempting to: search for some order in the ways that paint is built and formed, to specify what arrangements of materials compose paint, and to see how differences in arrangement affect the character of its tones and surfaces. K.L.

30-S705.
Barnes, Norman F.
Color characteristics of artists' pigments.
Journal of the Optical Society of America, **29,** no. 5, pp. 208-214, (1939), [Eng.].

An investigation of the color of matte artists' pigments was undertaken with the cooperation of the Department of Conservation and Research of the Fogg Art Museum, Harvard University. A brief synopsis of the results of that investigation are presented in this paper for the 51 pigment samples analyzed. The following characteristics were analyzed or noted: origin; composition; tristimulus values; trichromatic coefficients; dominant wavelength; relative brightness; and excitation purity. C.A.L.

30-S706.
Piper, Henry D.
The influence of variations of barium sulfate extender particle size on the hiding power of titanium dioxide paints.
American paint journal, **24,** pp. 17, 18, 20-21, (1939), [Eng.].

A study was made of the hiding power of paints consisting of 75% boiled linseed oil and 25% solids (TiO_2 and $BaSO_4$) by volume. For each $BaSO_4$ sample of different particle

size, paints were prepared in which 85%, 75%, 65%, and 50% of the total volume of solids present were sulfate. The remainder of solids was TiO_2. The total volume was always 25% of the total volume of the paint. The most general conclusion is that in TiO_2-$BaSO_4$ system paints up to about 35% TiO_2 concentration of pigment volume, there is no indication that variations of $BaSO_4$ particle size have any effect whatsoever on hiding power. Staff

30-S707.
Bontinck, Ed.
Physica en schilderkunst, inleiding tot de studie van physische verschijnselen toegepast op schilderkunst en schildertechniek.
(Physics and painting: introduction to the study of physical phenomena applied to painting and painting techniques.)

Book. Basis, bibliotheek voor wetenschappelijke en actueele vraagstukken, no. 14, A. Manteau, n.v., Brussels, 1943, [Dut.]. 110 p.: ill.; 21 cm.

Contents include: introduction; physical principles; applications based on optics; opaque and translucent painting; the color of dry painting; yellowing of oily binders; problems with varnish and its treatment; migratory pigments; panel painting and its context; physical examination of panels; cracking in panels. A.A.

30-S708.
Bontinck, Ed.
Fixatifs pour le pastel.
(Fixatives for pastels.)

Chimie des peintures, **7**, pp. 151-158, (1944), [Fre.]. bibliog.

Describes the optics of the pastel surface and the difficulties of attempting to fix the pastel without causing a change of appearance. A historical survey of the materials used to fix pastels is given. Recipes are given and the article concludes with a discussion of synthetic resins. Contains a good historical bibliography. M.H.B.

30-S709.
Thynne, A.W.F.
The pigment-binder relationship as a fundamental property of paints.

Paint technology, **11**, no. 131, pp. 423-427, (1946), [Eng.].

Although only 17 years ago that the first study of pigment binder relationship in paint formulation was carried out, it is generally recognized that variations in the gloss of the dry paint film depends upon the proportion of pigment. However, it should be understood that the gloss is completely dependent upon the pigment binder relationship. Important aspects include the oil absorption (of pigments and pigment mixture), the particle size and shape, the packing system, the wetting of pigment by oil, the effect of acid value, and the percent pigment in paint (by volume). E.Ha.

30-S710.
Asbeck, W.K.; and Van Loo, Maurice.
Critical pigment volume relationships.

Industrial and engineering chemistry, **41**, no. 7, pp. 1470-1475, (1949), [Eng.].

The critical pigment volume concentration (CPVC) is a fundamental physical transition point in a pigment-binder system at which the appearance and behavior of paint films change considerably. CPVC is influenced by such factors as fundamental packing characteristics of the pigments, type of binder employed, types and amounts of special agents present, and fineness of grind of the system. Degree of dispersion or agglomeration determines the CPVC of specific paints. New terms are introduced to characterize the physical relationships between pigments and binders, and a new cell is described in which the CPVC of a paint can be determined on a single sample in the wet state. Staff

30-S711.
Harrison, Vernon George Wentworth.
Gloss: its definition and measurement.

Book. Chemical Publishing Co., Inc., New York, 1949, [Eng. w. Eng. summary]. vi, 145 p.: ill.; 22 cm., refs.

This monograph contains no new facts or experimental data, but gives a critical study of the extensive literature on gloss and

luster, and attempts to assess the present state of our knowledge of this subject. Part 1 deals with physical factors influencing our sensations of gloss or luster. Specular reflection from plane surfaces and the scattering of light from optically rough surfaces are discussed. The ideal matte surface is described, and the departures from it occurring in practice are illustrated. Real surfaces are considered in detail, and it is shown that in general it is not possible to explain the optical behavior of such surfaces by assuming that the light scattered from them is a simple mixture of "specularly reflected" and "diffusely reflected" components. Some types of goniophotometric curves are considered with special reference to Barkas's method of analysis. Part 2 deals with physiological and psychological factors which contribute to our sensations of gloss. The different types of gloss recognized by Hunter and Judd are described. There are sections on binocular and monocular luster, metallic and vitreous luster, the "glassy sensation," and various pseudogloss effects. In Part 3 the various attempts at practical gloss measurement are discussed, including the Ostwald-Klughardt method, the "objective" glossmeter, the Goerz and Askania glossmeters, the polarization glossmeter, and the goniophotometer. Other methods of minor importance are also mentioned. Part 4 summarizes the state of knowledge as of 1949 of the whole subject. It deals with the complete range of gloss, which is found to be not a simple sensation, but a complex of at least three simpler sensations, the relative importance of which in any particular case determines the type of gloss. The production or increase of gloss by "non-physical" means, and the complications which this introduces into any system of physical gloss measurement. A.A.

30-S712.
Asbeck, W.K.; Laiderman, D.D.; and Van Loo, M.
Oil absorption and critical pigment volume concentration (CPVC).

Official digest (Federation of Paint and Varnish Production Clubs), **24**, no. 3, pp. 156-171, (1952), [Eng.]. 17 refs.

The relative advantages and disadvantages of oil absorption and pigment packing factors (PPF) tests are examined and the shortcomings of various test methods are discussed. The theory of oil absorption is explained by the concepts of critical pigment volume concentration (CPVC), and a modification of the CPVC test is suggested for the determination of PPF. E.Ha.

30-S713.
Judd, D.B.
Physics and psychophysics of colorant layers.

In book. *Color in business, science, and industry*, (1952), [Eng.].

Layers of compounded colorants represent a large portion of the color problems in industry. Incident light reflected without penetration from the top of a layer has various angular distributions that determine whether the layer appears glossy or matte. The ability of the layer to absorb and diffuse the light flux penetrating it determines whether the underlying color and pattern are visible (known as opacity or hiding power). Gloss, opacity, and hiding power and the Kubleka-Munk analysis are discussed, including types of gloss (specular, sheen, contrast, distinctness of image and absence of bloom) and the connection between gloss and color. E.Ha.

30-S714.
Eckhaus, Sigmund; Wolock, Irvin; and Harris, B.L.
Porosity of paint films.

Industrial and engineering chemistry, **45**, no. 2, pp. 426-428, (1953), [Eng. w. Eng. summary].

The exact nature of the physical structure of paint films is of great interest in determining the mechanism of permeation of water vapor through a film. Recent studies indicated that unpigmented linseed oil films are nonporous, i.e., there is no appreciable quantity of discrete fine pores in these films. An investigation of the nature of pigmented oil films by Asbeck and Van Loo indicated that, for any given pigment-binder system, there is a "critical" pigment volume concentration (CPVC), in the region of which substantial changes are noted in the physical appearance and behavior of a film. They demonstrated that the permeability rises sharply at the critical pigment volume concentration and postulated that at this point there is just sufficient binder completely to fill the voids between the pigment particles in

the film after evaporation of the thinner. Above this point, therefore, a dried film should be physically porous. Such pores should be easily detected by the technique used in previous studies of unpigmented linseed oil films, i.e., measurement of the total surface area of unsupported films of known geometrical area. The transition from a nonporous to a porous film would then be noted by an increase in the total surface area of the film samples. These measurements would logically follow the work on unpigmented films and serve to give a more complete picture of the nature of pigmented oil films. It was believed that comparisons on similar films of the roughness factor (ratio of total surface area to apparent or geometric film area) and of the water vapor permeability would be of interest. The results of such studies are reported here. A.A.

30-S715.
Bruxelles, G.; and Mahlmann, B.
Glossiness of nitrocellulose lacquer coatings.

Official digest (Federation of Paint and Varnish Production Clubs), no. 351, pp. 299-314, (1954), [Eng.]. refs.

Diagnoses some of the factors which affect the glossiness of nitrocellulose lacquer coatings and discusses the control of gloss.
Staff

30-S716.
Stieg, F.B.; and Burns, D.F.
The effect of pigmentation on modern flat wall paints.

Official digest (Federation of Paint and Varnish Production Clubs), 26, no. 81, pp. 81-93, (1954), [Eng.].

The desired properties of modern flat wall paint (nonpenetration, enamel holdout, color uniformity, and sheen uniformity) are shown to be directly related to pigmentation (and the pigment volume concentration). Formulation suggestions are made which will either result in the development of flat wall paints that are highly satisfactory, or clearly demonstrate the unsuitability of the materials selected. Staff

30-S717.
Asbeck, W.K.; Schere, G.A.; and Van Loo, Maurice.
Paint viscosity and ultimate pigment volume concentration.

Industrial and engineering chemistry, 47, p. 1472, (1955), [Eng.].

Mathematical equations (Vand and Braily) relating the viscosity of suspensions to the concentration of pigment are employed in the practical viscosity measurements of paint systems. Methods for determining the ultimate pigment volume concentration (UPVC) from simple modifications of critical pigment volume concentration (CPVC) and pigment packing factors (PPF) techniques are discussed. E.Ha.

30-S718.
Brachert, Thomas.
Rissbildung an Gemälden.
(Cracking on paintings.)

Maltechnik, 62, no. 4, pp. 105-110, (1956), [Ger.]. 8 figs.

This is a survey of the many causes and types of crack formation on oil paintings to be followed by more detailed descriptions as well as a methodology for distinguishing between genuine crack formation and attempts at faking such phenomena. The author stresses that whatever materials were used to paint on, they continue to expand and contract depending on weather conditions. This is especially true for wood, above all, softwood, where different portions will expand and contract at different rates. But beyond this, the grounding, and the paint itself, especially if admixtures were used, as was frequently the case in the 18th and 19th centuries, that were subject to rapid deterioration, could cause severe cracking, and even complete detachment, of portions of the surface. In addition, such damage may be caused by stress during transport, by inexpert transfers of oil paintings from wood panels to canvas, and by inept applications of varnish.

E.M.B.

30-S719.
Stieg, F.B.
Color and CPVC.

Official digest (Federation of Paint and Varnish Production Clubs), **28,** pp. 695-706, (1956), [Eng. w. Eng. summary].

The various problems confronting paint formulators as the result of the present popularity of color "systems" involving deep-colored alkyd flat wall paints are described and their basic causes discussed. The role of CPVC in color problems is illustrated and a "dynamic" concept of CPVC is described in considerable detail. Simplified formulating procedures are outlined by which many of these problems may be avoided. A.A.

30-S720.
Van Loo, Maurice.
Physical chemistry of paint coatings.

Official digest (Federation of Paint and Varnish Production Clubs), **28,** no. 383, pp. 1126-1156, (1956), [Eng.]. 39 refs., bibliog.

A full account of the 1956 Joseph J. Mattiello Memorial Lecture. Three main topics are discussed: vortex action in paint films, critical pigment volume concentration, and durability of paint films and ultraviolet absorption. The first two topics have already been fully reported elsewhere. The third topic describes experimental work designed to relate paint durability with ultraviolet data absorption using clear films. Staff

30-S721.
Feller, Robert L.
Factors affecting the appearance of picture varnish.

Science, **125,** no. 3258, pp. 1143-1144, (1957), [Eng.]. refs.

In picture varnish of the spirit type, variations of the refractive index of the resin used play a negligible part in determining the appearance of the varnish on the surface of paintings. Variations in the appearance of the varnish are due chiefly to differences in the viscosity grade of the resin used. "Viscosity grade" is the viscosity of a 20% mixture by weight of the resin in toluene at 70° F. On this scale dammar, mastic, and resin AW-2 have a viscosity grade between 1.2-1.3, while Lucite 44 has a value about 48. Varnishes prepared with resins of high viscosity grade

apparently do not form an intimate contact with the paint, with the result the color appears light irrespective of the refractive index, and such varnishes tend to be less glossy than varnishes of the dammar type.
 Staff

30-S722.
James, D.M.
On the wet and dry opacity of paints.

Journal of the Oil and Colour Chemists' Association, **40,** pp. 786-789, (1957), [Eng.].

From experiments on paints made from rutile and dolomite in alkyd resins the author concludes that the change (usually loss) in opacity of paints (especially flat paints) on drying is due to the increase in refractive index of the medium when the solvent evaporates. Above the critical pigment (volume) concentration (critical p.(v.)c. is the ratio of pigment to binder at which there is just sufficient binder to wet the particles and fill the voids) the opacity increases because the effect of drying is partially to replace pigment/medium by pigment/air interfaces. Criticism of this paper is made by F.B. Steig (same issue pp. 794-796) on the grounds of a) experimental technique, b) that James assumes that the critical p.(v.)c. has been reached when loss of gloss occurs, whereas the latter may be due to flocculation. Staff

30-S723.
Stieg, Fred B.
The determination of CPVC by the oil absorption test method.

American paint journal, **43,** no. 38, pp. 106-114, (1958), [Eng.].

A test method and calculation of critical pigment volume concentration is described, which eliminates calculating the "oil absorption." Determination of CPVC (the very least amount of oil that will cause the pigment mass to cohere) results in good correlation between the CPVC and the paint performance. E.Ha.

30-S724.
Stieg, Fred B., Jr.
Fundamentals of formulation of interior architectural finishes.

Affl: Titanium Pigment Corporation, New York, NY, USA.

Official digest (Federation of Paint and Varnish Production Clubs), **30,** no. 824, pp. 824-834, (1958), [Eng. w. Eng. summary].

This paper deals with the volume relationships between the essential paint components of pigment, vehicle solids, and volatile solvent. It is pointed out that these relationships follow an orderly pattern from enamel to flat, and from one vehicle system to another. While it is recognized that there must, of necessity, be some overlapping of types due to the wide variations possible in vehicle preparation, it is suggested that the average compositions derived from this pattern are superior to "out-of-the-file" stock formulas as starting points for formulation and testing work. Methods are outlined for arriving at basic formulas for various types of finishes at predetermined hiding power levels. A.A.

30-S725.
Anon.
The Louisville Paint and Varnish Production Club, Fourth Technical Symposium. The effect of physical characteristics of white and extender pigments on paint film properties.

Official digest (Federation of Paint and Varnish Production Clubs), **31,** no. 413, pp. 713-831, (1959), [Eng.].

Ten papers were given in this symposium on subjects ranging from size and shape properties of white pigments to the relationship of critical pigment volume concentration (CPVC) to rheological properties of paint. Good photo micrographs of modern white pigments also are included. Staff

30-S726.
Anon.
Water thinnable coatings, a symposium.

Official digest (Federation of Paint and Varnish Production Clubs), no. 409, pp. 198-302, (1959), [Eng.].

Subjects in this symposium include: determination of average particle size by turbidity measurements, factors affecting the leveling of latex paints, determination of critical pigment volume concentration, and microbiological deterioration of water-thinnable coatings. The latter subject, pp. 276-283, describes the fungi and bacteria isolated from films of emulsion paints in the United States and also

gives experimental evidence that bacteria are able to utilize the resin molecules either as the sole or partial source of their nutritional demand. Staff

30-S727.
Elm, Adolf C.
Size and shape properties of representative white hiding and extender pigments.

Official digest (Federation of Paint and Varnish Production Clubs), **31,** no. 413, pp. 720-735, (1959), [Eng. w. Eng. summary].

From the point of view of particle size and shape the white hiding and extender pigments employed in the paint industry fall into two major classes. One group of pigments, which includes titanium dioxide and zinc oxide among others, is made from fume by condensation or from solution by precipitation. In these cases the pigment particles are grown from the nuclei initially formed to the desired size or shape which are determined by considerations of hiding power, durability, or chemical activity. The second group, which comprises most of the extenders, is derived from natural deposits by grinding. The nature of the natural deposit and the particular grinding methods employed determine the shape and size characteristics of these pigments. Particle size or shape factors can and do affect many paint properties. Consistency, for example, is influenced either by soap formation, which is a function of chemical activity and hence, particle size, or by a pigment stacking effect which can be affected by particle shape. Good initial gloss and gloss retention are dependent not only on appropriate pigment particle size but also on a high degree of deflocculation and freedom from large aggregates or agglomerates. Combinations of pigments differing in particle size and shape may give rise to packing effects which enable the paint formulator to design flat paints possessing a high degree of uniformity of hiding, color, sheen, enamel hold-out, and other related paint properties when applied to surfaces differing widely in porosity. The intelligent utilization of such basic knowledge could greatly ease the paint formulator's task. A.A.

Properties

30-S728.
Ferrigno, Thomas H.
The effect of extenders on the optical properties of air drying alkymul and styrene-butadiene latex paints.

Official digest (Federation of Paint and Varnish Production Clubs), **31**, no. 413, pp. 759-779, (1959), [Eng. w. Eng. summary].

Minimum and maximum particle size extenders were compared in single extender paints at 30 and 70% PVC's and blends were made to obtain certain data at intermediate PVCs. The results indicate that flatting increases with increasing particle size in both systems. Flatting uniformity over porous and nonporous substrates improves as particle size increases in the S/B (styrene-butadiene) paints but the reverse occurred in the alkymul paints. In sheen uniformity the micas were definitely superior and all other extenders were generally poor. According to the TT-P-29 test method, resistance to polishing generally improves with increasing particle size in S/B latex paints, but was generally excellent for all extenders in alkymul paints. Soil removal properties of both systems appear to improve as particle size decreases. Enamel holdout is good for all extenders in both systems but the aluminum silicates are outstanding in S/B, and the micas in alkymul. Fine particle aluminum silicate provides excellent color uniformity over porous and nonporous substrates and finer particle sizes generally produce better color uniformity although great divergencies exist between types. All extenders provide zero or negative yellowness values except calcined aluminum silicate and the medium and fine particle aluminum silicates which contribute low positive values. Coarser extenders generally provide better gloss retention although fine particle barytes are excellent in this property. Fine particle aluminum silicate contributes highest hiding, but in the range of 35 to 55% PVC, calcined aluminum silicate is superior in S/B latex paints. Micas also provide excellent contribution to hiding in S/B paints. Several extenders provide excellent contribution to hiding in alkymul paints. A.A.

30-S729.
Hall, Robert F.
Effect of particle size distribution of pigment and pigment volume concentration on flat wall paint properties (solvent type).

Official digest (Federation of Paint and Varnish Production Clubs), **31**, no. 413, pp. 788-799, (1959), [Eng. w. Eng. summary].

Five calcium carbonate extenders were chosen and a graph shown of the comparison in the particle size distribution of the five as run by a standard method adopted by the Pulverized Limestone Association. Alkyd flat paints were made with each of these at 60, 65, 70, 75 PVC including a constant amount of titanium dioxide and diatomaceous silica in each. The properties of reflectance, hiding power, change in hiding on drying, tinting strength, color uniformity, color change on drying, and stain removal were then examined and plotted versus PVC. It was determined at what PVC each calcium carbonate extender gave a tight film and then these same properties were again run on these five paints. Some work was done on trying to obtain a better packed pigmentation. Rub ups in oil were made of blends of the different calcium carbonate extenders both with and without the titanium dioxide and diatomaceous silica. Paints were made from blends which appeared to have better packing and their properties tested. A.A.

30-S730.
Larson, George P.
The comparisons of two-component extender systems in emulsion paint.

Official digest (Federation of Paint and Varnish Production Clubs), **31**, no. 413, pp. 800-810, (1959), [Eng. w. Eng. summary].

The use of a two-component extender pigment system was investigated for an emulsion paint. A typical latex paint was selected utilizing the butadiene-styrene emulsion. The major types of extender pigments were investigated. These included: hydrated aluminum silicate, calcined aluminum silicate, magnesium silicate, calcium carbonate, silica, and barytes. The effects of these extenders on the properties of the emulsion were determined. This was done for the individual extenders and dual extender systems

in conjunction with the hydrated aluminum silicate at three PVC levels. The properties studied were: reflectance, contrast ratio, yellowness, color uniformity, enamel hold-out, and viscosity. The effects of extender combinations on these properties were correlated in graphic form. Based on these studies, a combination of extenders appeared to give optimum properties. At all PVC levels tested, the use of 75% hydrated aluminum silicate with 25% magnesium silicate appeared to give the optimum over-all properties to the paints.

A.A.

30-S731.
Morgan, Albert R.
Relative flatting efficiency of extenders and effect of these extenders on sheen uniformity, color uniformity, suction spotting, and enamel hold-out in solvent systems.

Official digest (Federation of Paint and Varnish Production Clubs), 31, no. 413, pp. 780-787, (1959), [Eng. w. Eng. summary].

Compares directly 16 extender or extender combinations in alkyd flat systems for flatting, color and sheen uniformity, and enamel holdout. Only six of the pigmentations under investigation produced low sheen flats. Both Non-Fer-Al and Carbium showed excellent flatting efficiency when used as sole extender. Color uniformity from sealed to unsealed surfaces was in general found satisfactory. Diamond Alkali's new Carbium showed outstanding results in a new test designed for obtaining color uniformity upon overlap. This test places under observation the percent tint variation occurring upon overlap after 10 and 30 minute intervals. Also, test results were obtained on sheen uniformity upon recoat. In this test Carbium, Non-Fer-Al, and Surfex were outstanding. By using a combination of calcium carbonate and diatomaceous silica, improved color uniformity from sealed to unsealed surfaces was obtained. However, upon overlap or recoat, adverse effects on color and sheen uniformity were encountered. All of the calcium carbonate extenders investigated showed good enamel holdout. However, the aluminum silicate, calcium silicate, and magnesium silicate were inferior in this test. A.A.

30-S732.
Philadelphia Paint and Varnish Production Club Technical Committee; and Alexander, Richard G.
Predicting the oil absorption and the critical pigment volume concentration of multicomponent pigment systems.

Official digest (Federation of Paint and Varnish Production Clubs), 31, no. 1490, pp. 1490-1530, (1959), [Eng. w. Eng. summary].

The Philadelphia Club has investigated the possibility of calculating the oil absorption and CPVC of pigment mixtures from spatual rub-up oil absorption determinations of the constituent pigments. Ten pigments and all possible binary mixtures were investigated. It was shown that these data can be used to predict with satisfactory accuracy the values for mixtures of more than two components. The data were used further to study the effect of composition on pigment packing. It was found possible to assign characteristic oil contribution factors to each pigment in any mixture in which it occurred. These oil contribution factors can easily be used to predict the oil absorption and CPVC of any pigment mixture. This method may be expanded to include pigments not yet investigated.

A.A.

30-S733.
Stieg, F.B.
The relationship of pigment packing patterns and CPVC to film characteristics and hiding power.

Official digest (Federation of Paint and Varnish Production Clubs), 31, pp. 736-751, (1959), [Eng. w. Eng. summary].

The relationship of pigment distribution in the paint film to hiding power below the "high dry hiding" level, and the relationship of the CPVC of a given pigment to its known particle size, are offered as evidence suggesting the uniform distribution of pigment in paint films in a rhombohedral pattern. New applications of the CPVC concept are presented in the form of mathematical relationships for the prediction of film shrinkage (wet-to-dry), film porosity, the variation of hiding power with film porosity, and the viscosity changes resulting from extender substitutions. It is suggested that CPVC data determined by the spatula rub-up oil absorption method are of greater value to the paint

formulator than average particle size figures or distribution curves. A.A.

30-S734.
Zettlemoyer, Albert C.
The contributions of pigments and extenders to organic coatings.

Official digest (Federation of Paint and Varnish Production Clubs), **31**, no. 413, pp. 713-719, (1959), [Eng. w. Eng. summary].

Surveys the pigment and extender contributions to the properties of initially low solids, relatively liquid dispersions, and to the final applied dry films. Emphasized in the discussion is research in the fields of the wetting of solids, pigment dispersion, flow properties, optical properties of film, and stability of coatings. Some of the areas in which we are now poorly informed are indicated and suggested as fields for potential research. A.A.

30-S735.
Harding, R.H.; Golding, B.; and Morgen, R.A.
Optics of light-scattering films: study of effects of pigment size and concentration.

Journal of the Optical Society of America, **50**, no. 5, pp. 446-455, (1960), [Eng. w. Eng. summary].

Optimization of enamel formulations to achieve desired optical film properties at minimum cost is a subject which has received considerable attention but made little progress in the paint industry. Inquiries have not progressed as far as might be expected because of the cost of the extensive and precise laboratory work presently required. An extension of theory to practice was undertaken in this work. When thoroughly investigated, the new concepts developed should permit computation of film optics rapidly and with low investment. In beginning the project, suitably reproducible laboratory techniques were developed and their precisions were estimated. It was then determined that pigment size distribution, pigment concentration, and distribution of wavelength of light interact to produce situations that have apparently not previously been recognized. Magnitudes of these effects are reported for a system of anatase-pigmented alkyd enamels, and the exploratory experimental procedures are outlined. Further work along these lines

is encouraged, since the mathematical functions involved have not yet been completely defined for the general case. A.A.

30-S736.
Keck, Caroline.
Conservation of contemporary art.

Museum news (American Association of Museums), **38**, no. 5, pp. 34-37, (1960), [Eng.].

Although the improper preparation of paintings and the incompatible materials used contribute to the impermanence of modern art, the author, who has had more experience with preserving contemporary painting than most conservators, questions whether all the blame should be put on the artist. While exhorting the artist to be more careful, she points out the general ignorance concerning the behavior of matter, the vast quantity of new and unfamiliar products, the lack of standards of procedure to guide the painter. The article is illustrated with dramatic enlargements showing the results of using improper mediums or primings, the cracking or wrinkling of paint films caused by undried paint active underneath too rapidly drying surfaces. ICCROM(01734707) and Staff

30-S737.
Adams, P.I.
A method of hiding power determination and its application as an aid to paint formulation.

Journal of the Oil and Colour Chemists' Association, **44**, no. 5, pp. 295-307, (1961), [Eng. w. Eng. summary].

Contrast hiding ratio (CHR) values for differing thicknesses of dry paint are found by taking reflectance measurements on films applied to black and white printed tinplate by a spraying technique. From a knowledge of the formulation and the dry paint weights, values of the volume of pigment present per unit area in the paint films are calculated. A method of plotting the results is described which, when applied, to a series of paints of differing pigmentation of a given pigment in a given medium, demonstrates the variation of CHR with both pigmentation and volume of pigment per unit area. Results are repeatable and reproducible to better than ± 2% on CHR at a given value of the paint film thickness parameter. The critical pigmentation of a

pigment in a medium may be deduced from the hiding power graphs. The critical pigment volume concentration (CPVC) for zinc sulfide in three alkyd media of differing oil length and properties is found to vary between 45 and 51%; oil absorption pigmentation is higher (53%). Calculations based on paint weights, non-volatile and density measurements permit the study of the variation in CHR with pigmentation and wet film thickness. Interpolation and extrapolation of results are discussed with a view to the possible expression of results in terms of spreading rate at given opacity levels. A.A.

30-S738.
Bennett, H.E.; and Porteus, J.O.
Relation between surface roughness and specular reflectance at normal incidence.

Journal of the Optical Society of America, **51,** no. 2, pp. 123-129, (1961), [Eng. w. Eng. summary]. 3 figs., 2 tables, 17 refs.

Expressions relating the roughness of a plane surface to its specular reflectance at normal incidence are presented and are verified experimentally. The expressions are valid for the case when the root mean square surface roughness is small compared to the wavelength of light. If light of a sufficiently long wavelength is used, the decrease in measured specular reflectance due to surface roughness is a function only of the root mean square height of the surface irregularities. Long-wavelength specular reflectance measurements thus provide a simple and sensitive method for accurate measurement of surface finish. This method is particularly useful for surface finishes too fine to be measured accurately by conventional tracing instruments. Surface roughness must also be considered in precise optical measurements. For example, a non-negligible systematic error in specular reflectance measurements will be made even if the root mean square surface roughness is less than 0.01 wavelength. The roughness of even optically polished surfaces may thus be important for measurements in the visible and ultraviolet regions of the spectrum. A.A.

30-S739.
Smith, N.D.P.; Orchard, S.E.; and Rhind-Tutt, A.J.
The physics of brushmarks.

Affl: Imperial Chemical Industries Ltd. Paints Division, Slough, UK.

Journal of the Oil and Colour Chemists' Association, **44,** pp. 618-633, (1961), [Eng. w. Eng. summary].

The role of the bristles in causing brushmarks is discussed and evidence is presented to show that a simple theory of bristle clumping is not entirely adequate. Brushmark formation appears to be partly a dynamic process and shows some similarity to rib formation in the wake of rollers and spreaders. Factors influencing the flow-out of brushmarks are examined, and a mathematical model of the levelling process for simple liquids is outlined. The stresses in residual brushmarks have been calculated, and these are compared with experimental yield values. The conflicting requirements of good flow and sag resistance are discussed. A.A.

30-S740.
Stieg, F.B., Jr.; and Ensminger, R.I.
The production and control of high dry hiding.

Official digest (Federation of Societies for Paint Technology), **33,** pp. 792-806, (1961), [Eng.].

Continued investigations of hiding power have been extended to the present analysis of the increase in white hiding power that occurs when a paint passes from a wet to a dry state (dry hiding). This is shown to be related to the Fresnel reflectance of the pigment in air and to the pigment volume concentration. The amount of hiding is shown to follow an increase in the number of air-pigment interfaces which can be easily estimated from the "porosity index." Staff

30-S741.
Cole, R.J.
Determination of critical pigment volume concentration in dry surface coating films.

Affl: Paint Research Station, Teddington, UK.

Journal of the Oil and Colour Chemists' Association, **45,** no. 11, p. 776, (1962), [Eng. w. Eng. summary].

Critical pigment volume concentration is defined and its importance stated. An

Properties

original dry film method and the principle behind its determination are described, and the results for rutile/alkyd and mica/alkyd paints are given. A.A.

30-S742.
Overdiep, W.S.
Levelling of paints.

In book. *Physiochemical hydrodynamics,* Prentice-Hall international series in the physical and chemical engineering sciences, (1962), [Eng. w. Eng. summary].

According to Smith, Orchard, and Rhindtutt the "driving force" promoting a level smooth surface of the paint after application is the hydrostatic pressure gradient in the film caused by the surface tension and the free boundary of the paint film. Experiments have shown that for solvent-based alkyd paints this theory fails to give even a qualitative description of the leveling process. The evaporation of solvent may give rise to several effects which had not been incorporated in the original theory, one of the most important effects being the development of surface tension gradients. Equating these gradients to the shear stress at the free boundary (Levich-Aris condition) leads to a second order differential equation, which on numerical solution shows a good agreement with experimentally observed leveling processes. It is concluded that the surface tension promotes a smooth surface, whereas its gradient favors a coating film of equal thickness. A.A.

30-S743.
Stieg, Fred B.
The geometry of white hiding power.

Affl: Titanium Pigment Corporation, New York, NY, USA.

Official digest (Federation of Societies for Paint Technology), **34,** no. 1065, pp. 1065-1079, (1962), [Eng. w. Eng. summary].

The title of this paper is intended to convey the impression that physical dimensions and spatial distributions are important considerations in the development of white hiding power. It is to be hoped that it will serve that purpose, for the acceptance of a few simple mechanical concepts will lead to an improved understanding of the behavior of titanium pigments. Much has been written in the past about the relationship of refractive

index to hiding power, and about the high refractive index of titanium dioxide. Yet this is a property that was bestowed upon the crystal of titanium dioxide by the laws of nature—there is nothing that either the pigment manufacturer or the paint formulator can do to change it. It therefore seems far more logical to concentrate on those factors which can be controlled. A.A.

30-S744.
Johnston, Ruth M.; and Feller, Robert L.
The use of differential spectral analysis in the study of museum objects.

Dyestuffs, **44,** no. 9, pp. 1-10, (1963), [Eng.]. bibliog.

The characteristics of the spectral reflectance curves of colored substances can be used in qualitative and quantitative analyses. The method is nondestructive. The absorption bands in the usual curve are not as numerous as those in the typical infrared spectral analysis, but the technique of differential spectral curve analysis, the analysis of the difference between two absorption curves, can provide considerable precision to the interpretation. There are now available computers, such as the Davidson and Hemmdinger "Comic," which greatly facilitate the analysis of curves. (Davidson, H.R.; Hemmendinger, H., and Landry, J.L.R., Jr., *Journal of the Society of Dyers and Colourists,* 79 (1963), pp. 577-589). The authors suggest the use of the method in the analysis of pigments, in studies of fading, and in the verification, during the removal of varnishes, of the presence or absence of glazes. Staff

30-S745.
Orchard, S.E.
On surface levelling in viscous liquids and gels.

Applied scientific research. A. Mechanics, heat, chemical engineering, mathematical methods, **11,** no. 4-6, pp. 451-464, (1963), [Eng. w. Eng. summary].

Surface tension at an irregular boundary of a liquid or gel gives rise to stresses within the material. In the two-dimensional case, for a Newtonian viscous liquid, the resulting flow is analyzed and an expression for the decay of the irregularities derived. Since the stresses do not involve viscosity, they can be

obtained from the viscous flow theory. Stress components obtained for gels in this way are identical with those deduced by means of the elastic theory of plane strain[1] taking Poisson's ratio as 1/2. The maximum shearing stress in the gel, which governs the onset of flow, is obtained from the derived stress distribution. It is assumed that the surface gradient is everywhere small. In the viscous flow case, it is additionally assumed that variations in the depth of the liquid are also relatively small; but failure to observe this restriction closely does not lead to serious error. The effect of gravity can readily be allowed for when the fluid extends in a horizontal direction. Surface tension is the dominant factor for surface profile components with a wavelength less than about one centimeter. A.A.

30-S746.
Feller, R.L.; and Matous, J.
Critical pigment volume concentration and chalking in paints.

Bulletin of the American Group (International Institute for Conservation of Historic and Artistic Works), **5**, no. 1, pp. 25-26, (1964), [Eng.].

The critical pigment volume concentration is an important characteristic of paints that can be related to porosity, gloss, flexibility, and other physical properties. The tendency of a paint to "chalk" upon deterioration is an important phenomenon to consider for it can be mistaken for fading of the colorants in the film. Chalking tendency is also influenced by the pigment volume concentration. Staff

30-S747.
Philadelphia Society For Paint Technology. Technical Committee On C.P.V.C.; and Ramsay, Howard L.
C.P.V.C. of a pigment mixture as a function of vehicle type.

Official digest (Federation of Societies for Paint Technology), **36**, no. 1359, pp. 1359-1367, (1964), [Eng. w. Eng. summary].

In previous studies of critical pigment volume concentration (CPVC) the Philadelphia Society's Technical Committee developed a method for calculating CPVC from oil absorption measurements and showed that the method was accurate for a wide variety of pigment mixtures in one vehicle system.

This paper extends these studies to include CPVC determinations of one pigment combination in a variety of vehicle types. The data indicate that the oil absorption method is as accurate as other methods for determining of CPVC, and that a given pigment combination has the same CPVC in a variety of vehicles. However, other film properties, such as hiding power, vary from vehicle to vehicle. A.A.

30-S748.
Johnston, Ruth M.; and Feller, Robert L.
Optics of paint films: glazes and chalking.

In proceedings. *Application of science in examination of works of art: proceedings of the seminar, September 7-16, 1965*, Young, William Jonathan, Editor (1965), pp. 86-95, [Eng.]. refs.

Reviews the Kubelka-Munk theory and the theories of Debye and Mie, Lamer, and Stearns briefly. Their application is described for two problems encountered in the study of the behavior of colorants in paint. The problems illustrated are: an analysis of the optics of glazes and a description of the phenomenon of chalking. ICCROM(00257807)

30-S749.
Pierce, P.; and Holsworth, D.D.
Determination of critical pigment volume concentration by measurement of the density of dry paint films.

Official digest (Federation of Societies for Paint Technology), **37**, no. 482, pp. 272-283, (1965), [Eng. w. Eng. summary].

The method proposed by Cole for the determination of the CPVC of dry paint films by density measurements is applied to latex paints. The preparation of unsupported latex paint films suitable for physical property measurements is described and a new method for the treatment of the density data is discussed. The results obtained are shown to be in agreement with CPVC determinations made by the tensile strength method and the water vapor permeability method. A critical examination of the density method is made to determine the minimum number of density measurements required to establish the CPVC and it is shown that the method can yield information concerning the structure of the dry film. A.A.

30-S750.
Johnston, R.M.
Spectrophotometry for the analysis and description of color.

Journal of paint technology, pp. 346-354, (1966), [Eng. w. Eng. summary].

A spectrophotometric curve is, in itself, not a description of color. Color depends on the nature of the light incident on the object, on the nature of the object, and on the characteristics of the observer response. Spectrophotometry serves to describe each of these contributing factors in terms of narrow spectral regions, so that changes in the total color can be computed, predicted, or analyzed. This article is concerned only with the spectral curve of the object and how this information can be helpful and useful for solving problems encountered in the paint industry. The application of spectrophotometric curve information is valuable for two purposes: 1) the description of color; and 2) the analysis of the nature of the object. Both are analytical in nature. A series of examples of the application of spectrophotometric techniques to specific problems encountered in the paint industry are given. A.A.

30-S751.
Craker, W.E.; and Robinson, F.D.
Effect of pigment volume concentration and film thickness on the optical properties of surface coatings.

Journal of the Oil and Colour Chemists' Association, **50**, pp. 111-133, (1967), [Eng. w. Eng. summary].

The results obtained from the measurement of the optical properties (transmission and reflectance) of paint films at various thicknesses and PVCs are described and a theoretical interpretation is given. It is shown that there are two extreme regions of scattering behavior, as defined by the product PVC times thickness. For low values of this product, simple scattering predominates and the films exhibit Beer's Law behavior and extinction coefficients may be determined; at the other extreme (high product), the optical phenomena are the results of multiple scattering and the pigment properties may be evaluated in terms of the Kubelka-Munk theory. Those films falling between these limits cannot be adequately dealt with by either treatment. From this work,

it has become possible to determine more precisely the contribution of the white pigment to the hiding power of the film. A.A.

30-S752.
Evans, R.M.
Ultimate tensile properties of paint films.

In book. *Treatise on coatings*, Myers, Raymond R.; and Long, J.S., Editors (1967), pp. 131-190, [Eng. w. Eng. summary]. 37 refs.

Discusses the tensile properties of coatings films which have been strained until they break. The stress-strain curve of a typical coating is explained and a glossary of tensile terms is presented, as are the stress-strain curve and stress-relaxation studies of rubbers. The following are comprehensively discussed: ultimate properties; effect of plasticizers, water, pigments, and pigment-volume concentration on film properties; considerations of internal stresses, internal aging, and weathering in relation to tensile strength; and the prediction of exterior weathering and abrasion resistance from tensile properties. A.A.

30-S753.
Hours, Madeleine; Delbourgo, Suzy; and Stoebner, A.
Altérations physico-chimiques de la couche picturale. 1. Comptes rendus de l'enquête auprès des différents laboratoires: altérations apparentes de la couche picturale et leurs causes probables. 2. Etude experimentale du laboratoire du Musée du Louvre sur la laque de garance. (Physicochemical alterations to the paint layer. 1. Results of a survey of various laboratories: apparent alterations of the paint layer and their probable causes. 2. Experimental study by the Musée du Louvre laboratory on madder varnish.)

Technical report. International Centre for the Study of the Preservation and the Restoration of Cultural Property, Rome, Italy, 1967, [Fre.]. 28 p.

In part 1 it is recalled that the paint layer does not exist in isolation, but is in contact with the ground on one side and a varnish layer on the other. Studies on the binding medium include the effects of lead white, the question of chalking and the influence of pigment concentration, the role of oxidation processes and the influence of ultraviolet radiation, and attack by microorganisms. Alterations in pig-

ments show much variation; various cases are mentioned including lakes, white lead, ultramarine, and azurite. Part 2 is concerned with changes that occur in madder lake, an experimental study having been in progress. Madder diffuses slowly from the substrate of alumina hydrate but may be readsorbed by lead white, if the latter is present. The secondary complex thus formed is susceptible to bleaching by light. Lead white thus appears to be important to the fading mechanism of madder, but further mechanical details remain to be elucidated. ICCROM(00892936)

30-S754.
Johnston, Ruth M.
Geometric metamerism.

Color engineering, **1967**, no. May-June, (1967), [Eng.]. 5 figs., 25 refs.

"Geometric metamers" are two colors which appear identical when viewed at one angle, but which no longer match if the viewing angle is changed. This phenomena is a widely recognized problem in a variety of industries. Causes of geometric metamerism are discussed in reference to differences on the surface of materials (including pigment volume and orientation) and differences inside materials (including embedded particles and the variations in size and orientation of flake pigments). Measurement of geometric metamerism requires a color-measuring instrument with the addition of goniophotometric spectrophotometers. Calculation of the degree of geometric metamerism is discussed: spectral curves measured at various angles are converted to colorimetric terms and differences in the color measured at various angles can then be described by using standard color-difference equations. A helpful measurement in describing geometric metamers is the "isochromatic angle" which is the angle of viewing at which two colors are the same. E.Ha.

30-S755.
Stieg, F.
Particle size as a formulating parameter.

Journal of paint technology, **39**, no. 515, pp. 703-720, (1967), [Eng. w. Eng. summary].

The results of the author's extensive work in the area of critical pigment volume concentration are reviewed and extrapolated to provide, with additional evidence, a justification

for the concept of a paint film as a bed of solid particles (pigment) into which a liquid (the vehicle) has been infused, as distinct from a liquid into which solid particles have been stirred. The control of porosity, viscosity, penetration, and hiding power by deliberate selection of particle size and particle-size combinations is demonstrated. A.A.

30-S756.
Camina, M.
Measurements of the fading of pigments in relation to opacity.

Journal of the Oil and Colour Chemists' Association, **51**, no. 1, pp. 14-26, (1968), [Eng.].

The relationship between loss of opacity, film thickness and pigment volume concentration of a number of organic pigmentations was investigated using an accelerated fading apparatus. The loss of opacity of a number of pigments as measured by the reflectance over a black background was found to vary linearly with the time of exposure and the rate of loss of opacity appeared to vary linearly with the initial reflectance and therefore depended upon the film thickness and the pigment volume concentration. Based upon the equation developed, a tentative method is proposed for quick determination of the relative lightfastness of highly scattering organic pigmentations over a range of concentrations and film thicknesses. The pigments used in this work were Toluidine Red (CI 12120), Rubine Tones Ba (CI 15865), Fast Red FRS (CI 12440), Fast Red GS (CI 12085), Fast Orange (GS CI 21110). These results may be of use in the assessment of modern organic pigments for use in restoration work. Organic pigments only have been tested so the results will probably not be applicable to the inorganic pigments used by artists in the past. Staff

30-S757.
Schaller, E.J.
Critical pigment volume concentration of emulsion based paints.

Journal of paint technology, **40**, no. 525, pp. 433-438, (1968), [Eng. w. Eng. summary].

A technique is presented for determining the binding power of emulsion vehicles by means of contrast ratio measurements. Critical pigment volume concentrations (CPVCs) determined by this method correlate

well with the results of the commonly used, but more tedious, tensile strength, scrub resistance, and enamel holdout methods. The effects of emulsion particle size and polymer hardness on binding power were investigated by this technique. Coalescing agent was found to increase the CPVC of a given paint, but the amount of coalescent required was dependent on particle size and polymer hardness. A.A.

30-S758.
Schmidt, R.N.
Application of Mie scatter theory to the reflectance of paint-type coatings.

In proceedings. *Proceedings of the fourth symposium on thermophysical properties sponsored by the Standing Committee on Thermophysical Properties, Heat Transfer Division, of the American Society of Mechanical Engineers,* Anon. (1968), pp. 256-269, [Eng.]. 15 refs.

The author's mathematical model, which was derived strictly from theory with no empirical inputs, predicts the reflectance of coating geometries as a function of the basic optical properties of paint. This model is based on a combination of the Monte Carlo random walk computation procedure, Mie scattering theory, Fresnel's law, Snell's law, Beer's law, and the free path distribution of kinetic theory. The author has made a single mathematical model representative of the paint matrix possible, by using a high-speed digital computer to combine several basic physical theories. This model computes reflectance as a function of pigment size, size distribution, pigment volume concentration, interface reflectance, surface roughness, indices of refraction of the pigment, binder and substrate, and absorption indices of the pigment, binder, and substrate. K.L.

30-S759.
Baba, Gorow.
Goniophotometric analysis of colored surface.

In book. *Tagungs-Bericht: Internationale Farbtagung Color = Proceedings: international colour meeting, Stockholm, 1969,* (1969), pp. 517-524, [Eng. w. Eng., Ger. + Fre. summaries].

A three-dimensional goniospectrophotometer was devised. With this instrument ordinary and metallized paint, paper, and cloth were measured. From these reflected-light distributions, radiance factors and trichromatic coordinates were calculated for various viewing directions. The color change depending on illuminating and viewing conditions is rather small, but in case of color matching or color difference problems it must not be neglected. A.A.

30-S760.
Eissler, R.L.; and Baker, F.L.
Critical pigment volume concentration in linseed oil films.

Coatings and plastics preprints, **30,** no. 1, pp. 346-355, (1969), [Eng. w. Eng. summary]. 9 refs.

Experimental program is reported in which films prepared from pigmented mixtures that contained a linseed oil, driers, and one of three selected pigments were studied by density measurement and plotted for pigment volume concentration. By inspection with the scanning electron microscope of surfaces formed by tensile fracture it was also possible to relate interior structures of films to pigmentations above and below critical. Smoothness of exteriors appeared to correlate with ion measurements on pigments and did not appear to predict critical pigment volume concentration values of linseed oil films formed from these same materials. A.A.

30-S761.
Hemmendinger, Henry; and Johnston, Ruth M.
A goniospectrophotometer for color measurements.

In book. *Tagungs-Bericht: Internationale Farbtagung Color = Proceedings: international colour meeting, Stockholm, 1969,* (1969), pp. 509-515, [Eng. w. Eng., Ger. + Fre. summaries].

An aspect of the appearance of colored objects which, though important in color matching, has not been amenable to numerical specification, is the change in color as the illumination and viewing angles are changed. The challenge to the color matcher involves matching the geometric appearance attributes in order to achieve an acceptable color match. A new instrument is described which makes possible the measurement of color as a function of illumination and viewing angles. Examples of measurements made with this instrument on three industrially important types of material are presented. A.A.

30-S762.
Jettmar, W.
Microscopic examination of pigment/vehicle interaction during film formation.

Affl: Badische Anilin-& Soda-Fabrik AG, Ludwigshafen am Rhein, Germany.

Journal of paint technology, **41**, no. 537, pp. 559-566, (1969), [Eng. w. Eng. summary]. 13 figs., 22 refs.

The interaction between pigment and binder often has a considerable effect on the characteristics of pigmented systems. Microscopic examination shows that in the liquid state a portion of the binder can be preferentially adsorbed by the pigment. This adsorption results in the formation of relatively immobile flocculates which increase the viscosity of the system and lead to the formation of semisolid zones enriched in pigment. Preferentially adsorbed individual components of the binder lead to a separation of the binder system. This separation is sometimes increased by mechanical effects occurring during the application of the film or by convection currents described by Bénard. A new technique has been developed which distinguishes the vehicle fractions adsorbed on the particles by their swelling behavior. Many inorganic oxides and some organic pigments adsorb mainly low molecular weight fractions of the binder which swell strongly. Other pigments adsorb the higher molecular weight fractions of the binder which do not swell so much. Vehicle separation through differential adsorption causes "floating" and thus changes in tint strength and hue. Microscopic sections and break surfaces of weathered and non-weathered paint films show that the mechanical strength of weathering of pigmented systems may be dependent on the interaction of pigment and binder. A.A.

30-S763.
Johnston, R.M.; and Stanziola, Ralph.
Angular color measurement on automotive materials.

In proceedings. *Society of Automotive Engineers: international automotive engineering congress, Detroit, Michigan, 13-17 January 1969*, (1969), pp. 1-7, [Eng. w. Eng. summary].

The new Thilac goniospectrophotometer, discussed in detail here, offers a valuable measurement dimension for characterizing the optical nature and appearance of materials which reflect light differently when the angles of illumination and viewing are changed. Use of this device is particularly helpful to the stylist who wants to be sure that various automotive trim materials will retain a coordinated appearance when viewed under varying lighting conditions. A.A.

30-S764.
Orr, Clyde, Jr.
Application of mercury penetration to materials analysis.

Powder technology, **3**, pp. 117-123, (1970), [Eng.]. refs.

The technique and apparatus for determining the void spaces and pores in a porous material by use of a penetration porosimeter are described. From the volume of mercury penetrating the porous material as a function of pressure, other characteristics such as the particle size distribution and specific surface can be determined. Information regarding the shape and structure of pores can be obtained from the volume of mercury expelled from the pores as a function of decreasing pressure. ICCROM(00437600)

30-S765.
Stieg, F.
Latex paint opacity: a complex effect.

Journal of the Oil and Colour Chemists' Association, **53**, pp. 469-486, (1970), [Eng. w. Eng. summary].

The factors concerned in the opacity of emulsion paints are considered and reasons for the difference of the ratio of wet to dry hiding in emulsion and solvent-based paints explained, in terms of refractive index, wavelength, and solids concentration. A number of equations are considered from which the hiding power may be calculated, and a method for its determination is discussed. The effects of extenders and of porosity in the film on the hiding power are considered. It is concluded that a prediction of the actual hiding power is not possible for a variety of reasons but that determination of the comparative hiding power is a useful tool in the development of paint formulation. A.A.

30-S766.
Eissler, R.L.; and Baker, F.L.
Critical pigment volume concentration in
linseed oil films.

Affl: United States. Department of Agriculture, Washington, DC, USA.

Applied polymer symposia, **16**, pp. 171-182, (1971), [Eng.].

Photomicrographs taken with a scanning electron microscope appear to demonstrate clearly a relationship between pigment volume concentration (PVC) and structure of linseed oil films. At loadings above the critical pigment volume concentration (CPVC) films seem to form from individual particles, each having its own coating of vehicle. At pigmentations below critical, the particles are embedded in a continuous vehicle matrix. The structure can be most clearly observed in outer (nonsubstrate) surfaces and those formed by fracture. Structure of outer surfaces is influenced by factors other than PVC.
Staff

30-S767.
Anon.
Review of literature relating the effect of binder on coating gloss.

Tappi journal, **36**, (1972), [Eng.]. 50 refs.

A literature-based survey was conducted; the survey was concerned with gloss of coated papers as a function of binder and concentration of binder in a coating formulation. The survey reported that high binder concentrations adversely affect gloss except in one case where an increase in binder content in a cast coating actually improved the gloss of the coating; a second exception is in coatings formulated below the critical pigment volume concentration or at low pigment volume concentrations. In gloss development, natural binders, such as starch, casein, and protein are inferior to latexes. Because of the overwhelming effect of other variables on gloss, the effect of binder on gloss cannot be considered alone.
K.L.

30-S768.
Reddy, J.N.
Role of pigments.

Journal of paint technology, **44**, no. 566, pp. 70-75, (1972), [Eng. w. Eng. summary].

The adhesion of alkyd based paints to mild steel substrate, using titanium dioxide (anatase), zinc oxide, and natural iron oxide as pigments, has been studied in relation to pigment volume concentration (PVC). The bond strength of the paint films as determined by the sandwich pull-off technique and the extent of adhesive failure have been correlated with the internal stresses developed during the drying period. The bond strength and the internal stress increase with increasing PVC and attain a maximum at a definite PVC (critical pigment volume concentration (CPVC)). Failure is mostly adhesive at CPVC but is cohesive at lower and higher levels of pigmentation. The adhesion method could usefully be employed to determine CPVC.
A.A.

30-S769.
Walter, A.
Rasterelektronenmikroskopische Aufnahmen bei verschiedenen Pigmentvolumen-konzentrationen eines Anstrichfilms.
(Scanning electron microscopic pictures of coating films with various pigment concentrations.)

Adhäsion, **6**, pp. 190-194, (1972), [Ger.].

Starting with the results of an earlier investigation the author shows, by means of microelectronic scans of paint coatings, what influence pigment volume concentrations have on the anticorrosive properties of the coatings including corrosion setting in under the surface correlated with pigment volume concentration in the paint.
E.M.B.

30-S770.
Allen, E.
Prediction of optical properties of paints from theory (with special reference to microvoid paints).

Journal of paint technology, **45**, no. 584, pp. 65-72, (1973), [Eng.]. 22 refs.

In considering new paint systems (e.g., systems containing microvoids), one would like to be able to predict reflectivity, tinting strength, and hiding power completely from theory. The Kubelka-Munk theory cannot be used by itself because it relies on experimental measurements for its constants. Mie theory cannot be used by itself because it does

not take multiple scattering into account. But methods based on radiative transfer theory have recently appeared by which Kubelka-Munk constants can be calculated from Mie theory. Alternatively, since Kubelka-Munk theory incorporates some simplifying assumptions and does not always work, radiative transfer theory shows how to use Mie equations to calculate reflectivity and transmissivity directly with more realistic assumptions. Staff

30-S771.
Funke, W.; and Zorll, U.
Untersuchungen über den Zusammenhang zwischen Glanz und Pigment-volumenkonzentration.
(Research on the relationship between luster and pigment volume concentration.)

Defazet-aktuell, **27,** no. 7, pp. 322-328, (1973), [Ger. w. Eng. summary].

The critical pigment volume concentration (CPVC) is often connected to a minimum of gloss that can be used for its determination. This possibility regularly exists for inorganic, but rarely for organic pigments. Electron micrographs of some films, of which gloss was measured, revealed that the thickness of the residual layer of vehicle at the film surface is essentially smaller than the diameter of a pigment particle. The increase of gloss in this range is obviously caused by an interference effect in the layer. Refractive index and particle size of the pigment affect the increase of gloss. A.A.

30-S772.
Morse, Mark P.
Surface appearance (gloss, sheen, and flatness).

In book. *Pigment handbook. Volume 3,* Patton, Temple C., Editor (1973), p. 341, [Eng.].

Glossiness as an important surface appearance property of materials is discussed. Visual and instrumental evaluations of gloss are discussed in regard to types of visual gloss, visual evaluations of glossiness, relationship between visual glossiness and color, physical factors governing gloss of surfaces, specular reflectance characteristics of surfaces, specular gloss measurements with fixed angle glossmeters, calibration of glossmeters, and measurement of distinctness of image gloss.

Because gloss and flatness are highly dependent upon the roughness of the reflecting surfaces, the glossiness is dependent on pigmentation (particle size of pigment, pigment dispersion, pigment concentration). Staff

30-S773.
Stieg, F.B.
The influence of PVC on paint properties.

Progress in organic coatings, **1,** pp. 351-373, (1973), [Eng.]. 69 refs.

The concept of pigment volume concentration, abbreviated as PVC, is explained as a convenient numerical index, useful for the classification of paint systems in terms of their nonvolatile composition. Its true value in paint technology derives, however, from its use to predict the performance of paint systems in such diverse areas as viscosity, exterior durability, film porosity, hiding power, and color uniformity over adjacent sealed and unsealed substrates. Critical PVC (CPVC) is also discussed and its significance in the latex systems indicated. Applications of the PVC and CPVC in paint formulations in reference to effect of air, opacity, penetration and color uniformity, and viscosity. Recommendations for practice are given.
 Staff

30-S774.
Stieg, F.B.
Pigment/binder geometry.

In book. *Pigment handbook. Volume 3,* Patton, Temple C., Editor (1973), pp. 203-217, [Eng.].

A description of the interparticle relationships of pigments which primarily affect the physical characteristics but also affect the optical characteristics of paint. Pigment volume concentration and the critical pigment volume concentration (CPVC) are discussed in relation to particle spacing, the critical pigment volume concentration, pigment packing, adsorbed binder film porosity, hiding power, binder penetration, and viscosity. Relying on CPVC (determined experimentally) allows one to eliminate the need to know exactly what particle sizes and distributions are present, because one is able to understand the relationships of coating performance to relative particle sizes. Staff

Properties

30-S775.
Wiita, R.E.
Vehicle CPVC.

Journal of paint technology, **45**, no. 578, pp. 72-79, (1973), [Eng.]. 6 refs.

Latex, alkyd, and oil paint systems were evaluated for their change in CPVC (critical pigment volume concentration) when prepared with identical, varying, pigment compositions. Traditional oil absorption CPVC values were determined for these pigment compositions as well as actual CPVC values of complete paints using some standard and unique paint tests. Evidence is developed demonstrating that CPVC is not only a function of pigment composition but is also dependent on vehicle systems as well as other variables. Staff

30-S776.
Zorll, Ulrich.
New aspects of gloss of paint film and its measurement.

Progress in organic coatings, **1**, pp. 113-155, (1973), [Eng.].

A review of the general requirements of gloss measurement, which includes both non-technical aspects of gloss, systems of measurement (including aspects of instrumentation), and particular gloss effects. Basic optical characteristics are considered and the main features of systems for measurements of gloss are reviewed for goniophotometers, specular glossmeters, and contrast glossmeters. Special emphasis is placed on the correlation between visual assessment and instrumental evaluation. The effect of surface structure and type of films, effect of pigments on gloss, consideration of scattering effects, and characterization of gloss-haze are discussed. E.Ha.

30-S777.
Bierwagen, G.P.; and Saunders, T.E.
Studies of the effects of particle size distribution on the packing efficiency of particles.

Powder technology, **10**, pp. 111-119, (1974), [Eng. w. Eng. summary].

In the studies of pigment volume effects in paint films, particle packing has been shown to be very important. The effects of particle size distribution on this packing has

been known but has received little quantitative consideration. The authors consider the packing of real and model continuous distributions of particle sizes. An extension of an algorithm for the calculation of random densest packing is given which applies to continuous distributions. Using a log-normal distribution as a model, the effect of the width of a single distribution on packing is considered. Mixtures of distributions are also considered with the calculation of packing efficiency as a function of mean size ratio and distribution widths. Maxima are shown to occur in the packing efficiency of mixtures of distributions as a function of the volume fractions of the individual distributions. The implications of these packing variations in real systems are then discussed. A.A.

30-S778.
Fialkiewicz, A.; and Szandorowski, M.
Radiochemical investigation of ionic penetration into paint films.

Journal of the Oil and Colour Chemists' Association, **57**, no. 8, pp. 259-263, (1974), [Eng.].

The authors carried out an investigation into the ionic penetration of a coating material and its variation with pigment volume concentration (PVC). A radiochemical method was used. Aqueous solutions containing radioisotopes were kept in contact with the paint surface and then removed and the surface dried and abraded under controlled conditions so that layers were removed and the radioactivity present at different depths in the coating could be measured. The coatings used were alkyd paints pigmented with red iron oxide within the range 10-60 PVC and the radioisotopes used were strontium 90 and chlorine 36 ions. Considerable penetration by the strontium cation was found with negligible penetration by chlorine anions. The penetration of strontium ions was considerably affected by the PVC. Approximate values for the diffusion coefficients were also calculated. Staff

30-S779.
Toussaint, A.
Influence of pigmentation on the mechanical properties of paint films.

Progress in organic coatings, **2**, no. 3, pp. 237-267, (1974), [Eng.]. 13 figs., 64 refs.

176

Discusses the effect of pigment volume concentration (PVC) on the mechanical performance of paint film. The first section qualitatively summarizes the modifications undergone by the mechanical properties of binders and polymers in general when finely divided particles are incorporated. The second section discusses the influence of pigmentation on the glass transition temperature. The final section reviews the main theoretical studies attempting to explain and quantify the observed behavior. Staff and C.D.

30-S780.
Tunstall, D.F.; and Hird, M.J.
Effect of particle crowding on scattering power of TiO_2 pigments.

Journal of paint technology, **46,** no. 558, pp. 33-40, (1974), [Eng.].

The effect of pigment volume concentration (PVC) on the scattering power of rutile titanium dioxide pigments in a typical commercial alkyd medium has been examined. Colormaster reflectance data of alkyd paint films have been analyzed in terms of the scattering power of titanium dioxide pigments. The loss in pigment scattering power due to particle crowding is shown to depend on two factors only: the ratio of pigment particle diameter to the wavelength of light; and PVC. Quantitatively the results have been explained by a simple equation that has been derived using sound physical arguments. Finally, the paint film-substrate boundary reflectance is shown to be much greater in magnitude than is normally assumed.
Staff

30-S781.
Bierwagen, G.P.; and Hay, T.K.
Reduced pigment volume concentration as an important parameter in interpreting and predicting the properties of organic coatings.

Progress in organic coatings, **3,** no. 4, pp. 281-303, (1975), [Eng. w. Eng. summary].

Discusses the utilization of the PVC/CPVC ratio, Λ, defined as reduced pigment volume concentration, in optimization of paint formulations. Describes direct guidelines for the formulation of certain classes of paints based on Λ. Λ values or ranges of values for these paint classes were given. These data plus other available information, such as the fact that a certain PVC of titanium dioxide will give one sufficient hiding, the data on use of colored pigments, and guidelines on the optimal PVC for corrosion-inhibiting pigments or fungistats enable quite a bit of pigment formulating to be done numerically with little experimentation necessary. Many steps in the paint formulation can be simplified, based on the knowledge of Λ. Pigmentation needs should be known well before any experimental studies are necessary, i.e., the amount of hiding, corrosion inhibiting, coloring, and extender pigment should be known with the latter values calculated from Λ. Control of Λ is shown to be an excellent starting point for controlling paint properties.
A.A.

30-S782.
De Witte, Eddy.
The influence of light on the gloss of matt varnishes.

In book. *ICOM Committee for Conservation, fourth triennial meeting, Venice, 13-18 October 1975: preprints,* (1975), pp. 75226-1 -9, [Eng.].

The influence of Cosmoloid 80 H on the gloss of four varnishes—Paraloid B-72, AYAT, Ketone Resin N, and dammar—is investigated. The change of smoothness of the film surface is also recorded. Fundamental differences in distribution and particle size of wax in low molecular weight and high molecular weight varnishes are observed.
Staff

30-S783.
Parra, François.
Quelques aspects théoriques des propriétés optiques de la matière: essai de définition de la matité.
(Some theoretical points of view on the optical properties of matter: attempt at defining "matness.")

Affl: Museum National d'Histoire Naturelle, Paris, France.

In book. *ICOM Committee for Conservation, fourth triennial meeting, Venice, 13-18 October 1975: preprints,* (1975), pp. 75161-1-75161-8, [Fre.]. refs.

Diffuse reflection, which gives the psychological impression of "matness," is

Properties

distinguished from specular reflection, and the situation analyzed in terms of standard physical parameters. The practical situation of reflection from a paint layer is considered briefly: an index of specular reflection can be expressed only as a complicated relation to which a simple solution has not yet been found. J.W.

30-S784.
Ramig, A.
Latex paints: CPVC, formulation, and optimization.

Journal of paint technology, **47**, no. 602, pp. 60-67, (1975), [Eng.].

A mathematical model is proposed for the calculation of latex paint CPVC from pigment oil absorption and latex binder index. The concept of binder index is discussed and shown to be a basic latex property. Techniques for determination of binder index and CPVC are defined. Evidence is offered which demonstrates that CPVC is a property of both pigmentation and binder. Application to latex paint formulation is discussed with respect to optimizing the performance-cost balance of a latex paint system. A.A.

30-S785.
Zorll, U.; and Hyde, P.J., and Associates, Translator.
Failure envelopes of paint films as related to pigmentation and swelling: technical translation.
(Translation from the German of "Bruch-Enveloppen von Anstrichfilmen in Abhaengigkeit von Pigmentierung und Quellungszustand" in the proceedings of the XIth FATIPEC Congress, Florence, 11-16 June 1972.)

Technical report. NRC/CNR TT—1787, National Research Council Canada. Canada Institute for Scientific and Technical Information, Ottawa, 1975, [Eng.]. 19 p.: ill.

A suitable presentation of the tensile properties of paint films is obtained by means of T. Smith's failure envelope. The viscoelastic states of material appear distinctly on the failure envelope. Technological properties, such as strength, toughness, and deformability can also be evaluated in this way. Films of linseed alkyd, pigmented with Pb_3O_4, MgO, and ZnO, exhibited a shift to the energy-elastic state with increasing pig-

mentation. In the swollen state, this tendency is markedly reduced by swelling of the binder. The "active" effect of the pigments are diminished at higher pigment volume concentration, since reactive groups in the binder may then be lacking. For systems with inactive pigments, such as urea resin/Fe_2O_3 and PVC-copolymer/TiO_2, failure envelopes in the dry and swollen state were found which indicate no essential change in the viscoelastic character of the films. Measurements of the systems studied could be explained qualitatively on the basis of theoretical ideas derived by T. Smith, Bueche, and Halpin. A.A.

30-S786.
Anon.
Single pigment paints.

JCT: Journal of coatings technology, **48**, no. 614, pp. 38-43, (1976), [Eng.]. 5 refs.

In previous studies of critical pigment volume concentration (CPVC) Philadelphia's Technical Committee developed a method for calculating CPVC from oil absorption measurements and showed that the method was accurate for a wide variety of pigment mixtures in one vehicle system, as well as for one pigment combination in a variety of vehicle types. This article further extends these earlier studies to include exposure of single pigment paints formulated at PVCs related to their CPVCs. The results of these exposures are discussed and illustrated. The value of a balanced pigmentation to the performance of exterior house paints is stressed. Staff

30-S787.
Montreal Society For Coatings Technology.
Adhesion of latex paint: Part 1.

JCT: Journal of coatings technology, **48**, no. 617, pp. 52-60, (1976), [Eng.]. 13 refs.

The cross-hatch adhesion test method was evaluated for its ability to monitor changes in intercoat adhesion of latex paints to alkyd paints when pigment, polymer, pigment volume concentration (PVC), and drying time of the latex systems were varied. It was found that the method has limitations at PVC much higher or lower than the critical pigment volume concentration (CPVC) of the latex test paints. Acicular and platy extenders imparted intercoat adhesion properties far

178

superior to those of nodular and spherical types. Polymers varied widely in performance but intercoat adhesion was generally enhanced by fine particle types. Adhesion improvements on continued air drying varied with the polymer.

30-S788.
Rudolph, J.P.
Determination of CPVC of latex paints using hiding power data.

Coatings and plastics preprints, **36,** no. 1, pp. 110-115, (1976), [Eng.].

Definition and general considerations of critical volume pigment concentration (CPVC) are followed by a description of an experimental investigation in which six series of paints containing seven or eight paints in each series were prepared using a typical masonary paint formula based on a vinyl acrylic latex and a constant concentration of coalescing agent based on latex solids. A different pigmentation (titanium dioxide plus one extender) was studied in each series. Within a series PVC was varied but the ratio of titanium dioxide volume to extender volume was kept constant by preparing a master batch of grind and letting down to different PVCs. The series was chosen so as to cover a wide range of formulation parameters typically used in flat latex paints. A table summarizes the pertinent composition data for each series. The pigmentation and composition data for each paint were used to calculate CPVC values according to the techniques of Bierwagen and Ramig. These values were obtained using the Datacraft 6024 computer. The oil absorption data needed for these calculations were obtained experimentally using the Brabender plastograph procedure described by Hay. Measuring and calculated data are tabulated, plotted, and evaluated in terms of usability of CPVC concept for latex paint characterization.

30-S789.
Anon.
(Defects with old paint surfaces: occurrence, causes, and remedies.)

Die Mappe; Deutsche Maler- und Lackierer-Zeitschrift, no. 7, pp. 437-440, (1977), [Ger.].

The following defects are considered and illustrated pictorially: on masonry fa-cades, flaking, cracking, spotting, chalking; on woodwork, defects due to faulty construction, greening, cracking, efflorescence, and resin exudation; on steel, rusting of galvanized steel, defects from mill scale, edge rusting, and rusting of garden railings. Staff

30-S790.
Johnston-Feller, R.; and Osmer, Dennis.
Exposure evaluation: quantification of changes in appearance of pigmented materials.

JCT: Journal of coatings technology, **49,** no. 625, pp. 25-36, (1977), [Eng.].

A spectrophotometric technique for calculating the type and magnitude of changes in appearance of pigmented materials following exposure is described. The procedure is not intended to replace visual evaluation, but is, instead, designed to: 1) provide analytical data concerning the nature and extent of the changes that have occurred; and 2) provide objective numeric evaluation of changes to augment subjective visual evaluation. While the technique was developed primarily for the evaluation of paint panels exposed outdoors or in a Weather-Ometer, it may be used to evaluate any materials exposed to any conditions expected to alter the appearance of the materials. As applied to paint or plastic materials, the changes specifically determined are changes in pigment color (fading or darkening) or vehicle color (such as yellowing), changes in surface reflectance (such as changes in gloss, occurrence of bronzing, chalking, or dirt accumulation) as well as the changes correlating with total visual evaluation (the integrated differences of all changes). The types of differences may be expressed in color difference terms as well as in color matching terms. This type of objective evaluation has proven to be of great value in aiding the visual evaluation of exposed materials. Qualitatively, visual and instrumental results have agreed very well. Separating the types of changes has been particularly useful in comparing results in different vehicles, different pigment mixtures, and with different concentrations, formulations, and degrees of dispersions.

30-S791.
Lepoutre, Pierre; and Rezanowich, Alex.
Optical properties and structure of clay-latex coatings.

Tappi journal, **60,** no. 11, pp. 86-91, (1977), [Eng. w. Eng. summary].

The dense and fairly ordered aggregate structure that develops upon drying a well-dispersed clay suspension is altered by the presence of a latex, through both colloidal and steric interactions. Two regimes are considered for the consolidation of the structure. Below a critical latex content 5-10%, depending on the latex, the consolidation of the structure is largely determined by the packing of the clay. This packing is affected by the latex mainly through changes in colloidal properties that lead to a less ordered structure. Above this critical range, the consolidation becomes controlled by the ease of coalescence and flow of the latex at the drying temperature, and the orientation of the clay now increases again with increasing proportions of latex. Uncalendered gloss did not reflect the orientation of the clay platelets at the surface, but seemed to be related to the presence of depressions caused by the irregular collapse of the structure that takes place as the latex coalesces. Coating porosity, a function of the mechanical properties and addition level of the latex, is shown to be an important structural parameter, greatly influencing the light-scattering properties of the coating. A mechanism for the consolidation of the coating structure during drying is proposed. A.A.

30-S792.
Stout, George L.
A trial index of laminal disruption.

Journal of the American Institute for Conservation, **17,** no. 1, pp. 17-26, (1977), [Eng.]. ill.

A scheme for describing this kind of degradation is suggested. Laminal disruption is a defect of a film, a thin cutting, or a coating which is an integral part of an artifact—paint, lacquer, marquetry, and enamel are examples. Disruption may lie parallel to the surface plane or contour (cleavage); or it may run perpendicular to the surface (fissurage). Cleavage takes one of two general forms—shell clefts and ridge clefts. Fissurage also follows one of two types—rifts and crevices.

The varied patterns that occur within these types can be described by terms that relate to the facts of their appearance.

ICCROM(01849902)

30-S793.
Thomas, L.W.
Volume considerations in coating evaluations.

In book. *1976 TAPPI coating conference, 15-18 May, Atlanta, Georgia: papers,* Anon., Editor (1977), pp. 109-113, [Eng.]. 5 refs.

Coating properties are largely volume related, but because one usually deals with weight measurements, there is a tendency to overlook the significance of volume. In coating formulation problems, the concept of pigment volume concentration (PVC) and critical pigment volume concentration (CPVC) can be used to evaluate alternatives in coatings and ingredients. The concept is described and examples of its use are given. A.A.

30-S794.
Algieri, S.; Clark, W.E.; and Wackernagel, A.R.
The influence of pore volume and particle size of micronized silica gel on the matting performance in clear coatings.

In proceedings. *14e congrès FATIPEC = 14 FATIPEC Kongress = 14th FATIPEC congress: recent progress in the production, processing and properties of varnishes and paints, Budapest, Hungary, 4-9 June 1978,* Takacs, Vilmos, Editor (1978), pp. 689-695, [Eng.].

Matting agents derived from silica gel can be manufactured to a controlled particle size and a defined porosity. They are therefore eminently suited for an investigation of the influence of these basic physical parameters on matting efficiency. Experimental data are presented to show the effect on matting efficiency of the following parameters: pore volume and particle size of the matting agent, dry film thickness, and solids content of the coating. Of particular interest is the effect of pore volume which can be described quantitatively by means of the concept "Quasi Pigment Volume Concentration."

A.A.

30-S795.
Borch, J.; and Lepoutre, P.
Light reflectance of spherical pigments in paper coatings.

Tappi journal, **61,** no. 2, pp. 45-48, (1978), [Eng. w. Eng. summary].

Variations in the light-scattering coefficients of coatings containing spherical pigments have been calculated on the basis of current scattering theory as a function of pigment size and refractive index. The calculated variations are in general agreement with the experimentally measured values. The spherical size that produced maximum scattering was computed by considering either the closely packed spheres or their void interstices as the scattering bodies. The experimentally observed variation of the light-scattering coefficient with wavelength, namely the ratio of blue to red scattering as a function of pigment size, was also predicted theoretically. These effects were still present when the spherical pigments were mixed with clay, although to different degrees. It is shown that light-scattering coefficents may give indirect information on the structure of paper coatings. A.A.

30-S796.
Cadorin, P.; and Veillon, M.
La peinture mate: définition. Techniques permettant d'obtenir l'effet mat: matériaux, modes d'application, vernis mats. (Matte painting: definition. Techniques that permit you to obtain a matte effect: materials, methods of application, matte varnish.)

In proceedings. *ICOM Committee for Conservation, fifth triennial meeting, Zagreb, 1-8 October 1978: preprints*, (1978), pp. 78/6/5/1-4, [Fre.]. 5 figs., 2 refs.

Gives a definition of matte painting and describes it in relation to painting mediums, techniques, and surface coatings. B.A.B.

30-S797.
Marcus, R.T.; and Welder, J.
Pigment volume concentration effects in color prediction and practice.

JCT: Journal of coatings technology, **50,** no. 642, pp. 78-83, (1978), [Eng.]. 18 refs.

Color control technology, using digital computers, has advanced sufficiently to allow paint batches to be manufactured without physically matching the color standard in the laboratory. Generally, it is assumed that a color match, predicted with pigments characterized at a single pigment volume concentration (PVC), will not be affected when the loading is varied providing that the ratio of colored pigments to the titanium dioxide remains constant. This study explores why a gray industrial enamel violated that assumption and attempts to quantify the color change in order to achieve more usable color predictions.

30-S798.
Simpson, L.A.
Factors controlling gloss of paint films.

Progress in organic coatings, **6,** no. 1, pp. 1-30, (1978), [Eng.].

The origins of gloss are explained in physical terms, while recognizing that a complete understanding of gloss involves the theory of sense perception. Theoretical aspects and instrumentation for the measurement of specular gloss and surface texture are discussed. The effect of titanium dioxide on gloss is described in relation to pigment loading and dispersion; and the effect of binder on gloss is described in relation to refractive index, film formation, and the characteristics of the overlying clear layer. E.Ha.

30-S799.
Hess, Manfred; Hamburg, Herman R.; and Morgans, Wilfred M., Editors.
Hess' paint film defects, their causes and cure.

Book. Chapman and Hall Ltd., London, 1979, 3rd. ed. rev. [Eng.]. xiv, 504 p., 48 p. of plates: ill. (some col.); 24 cm., bibliog. and indexes. [ISBN 0-412-13880-8].

A reference book on the causes and cures of paint film defects, with chapters on the following subjects: faults that develop during application, shortly after application, or during storage; faults associated with the paint and varnish material employed, defects on the finished object when in use. One chapter describes toxic substances. (Translation of *Häufige Anstrichmängel und Anstrichschäden*.) ICCROM

30-S800.
Kaempf, G.
Pigment-polymer interaction and technological properties of pigmented coatings and plastics.

JCT: Journal of coatings technology, **51**, no. 655, pp. 51-64, (1979), [Eng.].

An overview of the use of inorganic pigments in coatings and plastics discusses the important properties of pigments (i.e., optical, protective, and reinforcing) and how they affect the performance of coatings and plastics. The influence of particle size distribution on tinting strength of TiO_2 pigments and on dominant wavelength is examined. Photochemical reactions at the TiO_2 surface and the degradation processes during weathering of TiO_2 pigmented binders (chalking) are presented. After-treated rutile pigments cause an efficient protection against degradation of the organic matrix. Good interaction between pigment and binder brings about a marked improvement in strengthening qualities as well as the overall properties of pigmented plastics. Staff

30-S801.
Osmer, Dennis.
An instrumental technique for assessing the transparency of melt-spun fibers.

Affl: Ciba-Geigy Ltd., Basel, Switzerland.

Fiber producer, **11**, no. 4, pp. 79-81, (1979), [Eng. w. Eng. summary]. 1 fig., 6 tables, 6 refs.

The relative transparency of melt-spun fibers is often difficult to judge visually. Observers frequently do not agree on transparency ratings. Therefore, an instrumental method for transparency assessment would have practical value as a tool for objective relative transparency evaluations. The purpose of this paper is to present results of an investigation into an instrumental method for making relative transparency assessments by using goniospectrophotometric measurements, and to show the correlation of these instrumental rankings with visual evaluations of transparency. A.A.

30-S802.
Patton, Temple C.
Paint flow and pigment dispersion: a rheological approach to coatings and ink technology.

Book. Wiley-Interscience, New York, 1979, 2nd ed. [Eng.]. xxiv, 631 p.: ill.; 24 cm., bibliog. and indexes. [ISBN 0-471-03272-7].

A practical guide to the concepts relating to paint flow, pigment dispersion, and related technology that have developed in the paint industry to date. The book covers viscometers, grinding (dispersion) equipment, dispersion theory, plant piping calculations, solubility parameters, mill base let down, and paint flow relationships. It has been written in terms of ideas, and avoids a highly theoretical or "cook-book" type of treatment. Contents: Viscosity; Viscometers; Theory and reduction to practice; Interconversion of viscosity units; Effect of temperature, resin concentration, solvent, and molecular size on viscosity; Brushing, levelling, sagging, settling, piping, and pump calculations in the paint plant; Oil absorption, critical pigment volume content, dispersion behavior, and fineness of grind; Grinding (dispersion) of pigments into liquid vehicles and dispersion theory; Ball and pebble mills; Sand grinder and Szegvari attritor; Three roll mill; High speed grinding equipment; Solubility and solvent volatility; Mill base let down; Film applicators; Paint flow relationships; Floating, flooding, orange peel, and foaming. Staff

30-S803.
Alince, B.; and Lepoutre, P.
Plastic pigments in paper coatings: the effect of particle size on porosity and optical properties.

Tappi journal, **63**, no. 5, pp. 49-53, (1980), [Eng. w. Eng. summary].

It has been determined that the extent to which plastic pigments affect the structure and optical properties of a paper coating depends on the particle size and amount of the plastic pigment and on the shape of the inorganic pigment particles. Blends of larger synthetic particles (0.5 and 0.2 μm in diameter) with a platelike delaminated clay resulted in porosity and light scattering coefficient values larger than those calculated from additivity. Smaller particles (0.1 and 0.03 μm in diame-

ter) gave lower porosity and scattering efficiency than calculated. In blends with sphere-like calcium carbonate, no expansion of the porous structure or increase in the light scattering coefficient was observed even with the largest synthetic particles (0.5 μm). It was also determined that gloss is a function of the manner in which the packing of the particles affects the smoothness of the surface. A.A.

30-S804.
Bierwagen, G.P.
Studies of film formation in latex coatings.

Organic coatings and plastics chemistry: preprints of papers presented at the meeting of the American Chemical Society, **42,** no. 1, pp. 51-54, (1980), [Eng.]. bibliog.

Describes methods for studying the film formation process in latex coatings, some of the goals of these studies, and initial experimental results. This work began in the laboratory as a study of mud cracking in high pigment volume concentration latex coatings. One of the first persons consulted on this problem was John Vanderhoff, who is honored in this symposium. His advice, encouragement, and the generous sharing of his experience and knowledge in the area of latex systems helped to establish the technical concepts upon which this work was then based. The goals of this work are: 1) Develop a conceptual model for film formation in latex coatings from which one can predict and interpret experimental results; 2) Design and perform experimental studies of latex film formation both to test and improve the model and to generate data for use in latex coating formulation; 3) Analyze experimental data and model predictions to develop conclusions which lead to principles for improved latex coating formulation. The first phase of this work has been completed and work is underway on the second and third goals. The model is being revised as it is tested by experimental results. CCI

30-S805.
Brill, Thomas B.
Light: its interaction with art and antiquities.

Book. Plenum Publishing Corp., New York, 1980, [Eng.]. xi, 287 p.: ill.; 24 cm., bibliogs., index. [ISBN 0-306-40416-8].

An examination of the beneficial effects of light on materials—the effects of producing color and the desired appearance in a work of art—and detrimental effects that result in deterioration and color changes begins with the basic concepts of light itself, i.e., what it is, how it is generated, how it is measured, and how it is manipulated by materials. Why objects appear as they do is discussed. The origin of color and photoreactions are explored in organic materials, such as dyes, fibers, and coatings; and in inorganic materials, such as pigments and glass. Also included is a survey of the use of light to make photographic images. Staff

30-S806.
Gebessler, August; and Eberl, Wolfgang.
Konservierung der Ausstattung von Baudenkmalen.
(Conservation of interior decoration and furniture of monuments.)

In book. *Schutz und Pflege von Baudenkmälern in der Bundesrepublik Deutschland: ein Handbuch,* (1980), pp. 137-170, [Ger.]. diagrams, 300 refs.

Overview on the causes of deterioration or damage referred to the different works of arts, their materials (stone, terracotta, plasterwork, stucco, mural painting, stained glass, wooden furniture and paint, miniatures, paper, parchment, textiles, wax, metals) and on the most current conservation methods.
ICCROM(02298303)

30-S807.
Zeller, R.C.
Optical properties of calcium carbonate in paper coatings.

In book. *1980 coating conference: proceedings of the Technical Association of the Pulp and Paper Industry,* TAPPI proceedings, Anon., Editor (1980), [Eng.]. 5 refs.

The optical properties of calcium carbonate in paper coatings are strongly affected by the particle size distribution (PSD) of the pigment and the pigment volume concentration (PVC) of the coating. These effects have been investigated using a novel experimental approach and Kubelka-Munk mathematics. The results show that the optimum particle size for light scattering varies with the PVC of the coating. For typical commercial

coatings (70-80% PVC), the optimum particle size is 0.4-0.6μm. Gloss is also strongly affected by PVC and particle size; the highest gloss is produced by fine particles and high PVC. The type of particle size distribution which promotes good light scattering is diametrically opposed to the type which promotes good high solids rheology. A narrow PSD is best for high light scattering, but a narrow PSD causes very high viscosity in high-solids coatings.

30-S808.
Boxall, J.
Coating formulation: its effects on the durability of exterior wood finishes.

Journal of the Oil and Colour Chemists' Association, **64**, no. 4, pp. 135-143, (1981), [Eng.].

A range of exterior coatings of known composition have been assessed for durability by natural exposure on redwood timber. Trends are found which suggest that certain aspects of coating durability were dependent upon the formulation variables of pigment volume concentration and binder content. The number of coats applied also affected performance; for some systems the mode of failure changed as film thickness increased.

Staff

30-S809.
Colling, J.H.; and Dunderdale, J.
The durability of paint films containing titanium dioxide—contraction, erosion and clear layer theories.

Progress in organic coatings, **9**, pp. 47-84, (1981), [Eng. w. Eng. summary]. bibliog.

For gloss paint films containing titanium dioxide, evidence fundamental to the development of weathering theories, including weight loss, thickness loss, and electron microscope examination of weathered surfaces, especially for the stages before chalking, is critically reviewed and discussed. It is concluded that the published data, considered as a whole, cannot explain erosion of the surface, but can easily be interpreted in terms of a model based on appreciable degradation beneath the surface, decreasing with depth depending on the penetration of ultraviolet radiation. This results in differential contraction of the surface layers and an increasing surface pigment concentration. Various "clear layer" theories are also discussed and distinguished by the thickness of the clear layer exposed. It is concluded that there is no convincing evidence that distinct uniform pigment-free layers exist in normal air-drying gloss paints. Even if clear layers ~ 0.2-0.5 μm thick were present, durability results could still not be explained by erosion. Effects of pigment volume concentration on the specular gloss of alkyd paints at various wavelengths, which have been interpreted in terms of "clear layers" and optical interference, can be much more satisfactorily explained by alternative theories (based on gloss reduction at particular wavelengths due to surface micro-defects, and gloss enhancement at higher PVC's due to refractive index effects). Some implications of contraction are considered. Because erosion has been assumed in all visualizations of the weathering process previously published, sketches illustrating the effect of a number of variables on the contraction model are included.

CCI and A.A.

30-S810.
Feller, Robert L.; and Kunz, Noel.
The effect on pigment volume concentration on the lightness or darkness of porous paints.

In proceedings. *Preprints of papers presented at the ninth annual meeting, Philadelphia, 27-31 May 1981,* Preprints of papers presented at the annual meeting (American Institute for Conservation of Historic and Artistic Works), (1981), pp. 66-74, [Eng.].

Demonstration of the general principle that the lightness or darkness of a paint varies widely depending on the pigment volume concentration. The change is most noticeable at the critical PVC below which all air pockets in the pigment-vehicle mass are filled with vehicle and the paint is usually in a dark condition, and above which the lightness of the paint increases with PVC, owing largely to the presence of increasing amounts of void space.

ICCROM(02467708)

30-S811.
Perera, D.Y.; and Eynde, D.V.
Internal stress in pigmented thermoplastic coatings.

JCT: Journal of coatings technology, **53,** no. 678, pp. 40-45, (1981), [Eng.]. 23 refs.

The effect of pigmentation on the development of internal stress in thermoplastic coatings is discussed. Three pigments (titanium dioxide, red and yellow iron oxides) and one filler (talc), a thermoplastic binder, and a solvent were used to formulate a range of pigment volume concentration (PVC). A cantilever (beam) method was used to measure the internal stress (S). It was found that, for PVC < CPVC (critical pigment volume concentration), S increases with increasing PVC, while for PVC > CPVC, S decreases with increasing PVC. This variation is mainly due to the dependence of the elastic modulus (one of the S-components) on the PVC. Such behavior indicates that internal stress measurements can also be used to determine the CPVC. The low internal stress values obtained with the talc formulations were related to the lamellar shape of this extender.

30-S812.
Lichtenstein, Joram.
Paint coating pigment volume concentration.

Materials performance, **21,** no. 8, p. 56, (1982), [Eng.].

PVC (pigment volume concentration) is defined as the ratio between the volume of all the pigments (suspended solids) and the volume of the pigment plus the volume of the binder (resins) in the dried film. The CPVC (critical pigment volume concentration) is that combination of the specific pigments and the specific binder which will fill up all the spaces between the pigments without void spaces, pinholes, or craters. Including in specifications the PVC and gloss requirements might be useful to obtain the best coating system available.

30-S813.
Shafey, H.M.
Experimental study on spectral reflective properties of a painted layer.

AIAA journal, **20,** no. 12, pp. 1747-1753, (1982), [Eng.].

A new diffuse reflectometer using a paraboloidal mirror has been developed and employed to measure various reflective properties of painted layers for the case normal incidence. The effects of the pigment volume concentration, the scattering properties of the pigment (titanium dioxide, Fe_2O_3, carbon, and zinc oxide), the thickness of the painted layer, the reflection characteristics of the substrate (specular or diffuse) on the spectral normal-hemispherical reflectance, and the angular distribution of the diffuse reflection are studied. The wavelength dependence of the results is examined over the range of 0.45 ~ 10 µm. The comparison with the analysis indicates that the experimental results, with the exception of the interference effect at large pigment volume concentrations, are in reasonable agreement with the analytical results.

30-S814.
Voelz, Hans G.
(Determination of the brightening power in relation to the pigment volume concentration (PVC) of white pigments. A reasonable quick method.)

Farbe + Lack, **88,** no. 5, pp. 356-360, (1982), [Ger. w. Ger. summary]. 8 figs., 2 appendices, 6 refs.

The power to brighten is the most important property of white pigments; it characterizes their productivity and thus is analogous to color intensity in the sphere of variegated (many-colored) pigments. The development of methods for the determination of values for brightening power began already a few decades ago with visual procedures (DIN 53 191), and the first photogrammetric procedure (DIN 53 192) was an advance over the older methods. A better photogrammetric procedure which corresponds to the state of the art (1982) allows the determination of the value of the brightening power with each desired PVC (DIN 55 982). However, for each PVC, a new amount of pigment/black paste has to be rubbed into the paint; therefore, an attempt was made to arrive at a method of determination that would reduce the number of such rubbings. In the process, the possibility of linearization of a dispersion curve, discovered earlier and confirmed anew, of the dependency on the PVC, was utilized. In the end, a procedure

was perfected that requires no more than one rubbing of the pigment/black paste into the paint and all the same obtains all the brightening values over the entire range of PVCs that might be of interest. The individual steps in the calculation which led to a computer and plotting program are described in detail.

A.A. and E.M.B.(transl.)

30-S815.
Alince, B.; and Lepoutre, P.
Viscosity, packing density and optical properties of pigment blends.

Colloids and surfaces, **6**, pp. 155-165, (1983), [Eng. w. Eng. summary].

The effect of blending particles of different size and shape on the viscosity of aqueous suspensions has been evaluated using polystyrene spheres (plastic pigments) and platelike clay particles. At high solids content a minimum viscosity is observed in mixtures of like particles differing in size but not in mixtures of unlike particles. The viscosity of blends is closely related to the packing density of particles as inferred from the critical solids volume concentration and the porosity of dry coatings formed from the blends. The variation in light-scattering efficiency of the coating is also related to changes in the void structure of dry coatings formed from blends.

A.A.

30-S816.
Bierwagen, G.P.; and Rich, D.C.
Critical pigment volume concentration in latex coatings.

Progress in organic coatings, **11**, no. 4, pp. 339-352, (1983), [Eng.]. 62 refs.

A critical review of the literature on the use of the critical pigment volume concentration (CPVC) concept in the examination of latex coatings and relevant experimental studies. A secondary goal is to present the proper conceptual background for interpretation of latex CPVC results. Further analysis is proposed for the proper consideration of error levels in measurements and curve fitting for the experimental determination of CPVC values.

30-S817.
Callegari, Laurence.
Les craquelures.
(Craquelures.)

Technical report. Institut français de restauration des oeuvres d'art, Paris, 1983, [Fre.]. 76 p.; 30 cm., bibliog.

An end of course thesis on *craquelures*, for the Institut français de restauration, divided into three parts. The first part considers formation mechanisms: formation of an oil film; its rheological behavior; temporary and permanent strains placed on the oil film; its mechanical response to these constraints, with detailed examples of different types of *craquelure*. The second part attempts the codification and classification of *craquelures*. The third part discusses further causes of the formation of *craquelures*: resulting from the nature of the support, or due to defects or deterioration of the support, and *craquelure* produced by poor conservation of the painting. Finally, internal causes for the development of *craquelure* are considered. These include: nature of the medium; nature of the pigments; deterioration of the medium; working technique employed; and conditions of conservation.

ICCROM(04062200)

30-S818.
Castells, Reynaldo; Meda, Jorge; Caprari, Juan; and Damia, Monica.
Particle packing analysis of coatings above the critical pigment volume concentration.

JCT: Journal of coatings technology, **55**, no. 707, pp. 53-59, (1983), [Eng. w. Eng. summary]. 9 refs.

Dry film densities are determined by hydrostatic weighing; the method is rapid, precise, and can be applied on real films. The experimental data for films constituted by zinc, zinc oxide, or aluminum as pigment, and a mixture of chlorinated rubber plus chlorinated paraffin as binder are reported and interpreted by a packing model. This model predicts the existence of two characteristic points in the plots of film properties against PVC; the CPVC, defined in 1949 by Asbeck and Van Loo, and a point of maximum film porosity designated CPVC. There is a nonlinear decrease in film density between the two points. A method for their location is proposed.

A.A.

30-S819.
Culhane, W.J.; Smith, D.T.; and Chaing, C.P.
Characterization of pigment volume concentration effects in latex paints.

JCT: Journal of coatings technology, **55,** no. 698, pp. 53-58, (1983), [Eng.]. 35 refs.

In the reported experiments, the relationship of the pigment volume concentration to the critical pigment volume concentration in latex paint films has been characterized by conventional and new methods. Calculated and empirical critical pigment volume concentration determinations are shown to yield consistent results. Gloss, scrub resistance, staining, and observed T_g of the films are correlated with scanning electron microscope observations for samples formulated over an extreme range of pigment volume concentrations. New insights into the role of the pigment/latex ratio are provided.

30-S820.
Ghisolfi, Giancarlo.
Struttura dei film di idropitture ad alta P.V.C.
(The structure of watercolor films with a high PVC.)

Pitture e vernici, no. 8, pp. 21-30, (1983), [Ita. w. Eng. summary].

The first part examines the physical structure of watercolor films with a high pigment volume concentration (PVC), based on a study of the optical characteristics and of the resistance to abrasion as a function of PVC. In the second part the influence of some binary mixtures is studied: mineral-emulsion burdens on the phenomenon of dry covering and on relative quantification.
A.A.

30-S821.
Monnier, G.; Buiron, P.; and Lorang, R.
Effect of certain physical and chemical properties of titanium dioxides on the optical properties of coatings.

In book. AFTPV, 15th Congress, Cannes, 1983, (1983), pp. 67-76, [Eng.].

The main characteristics studied in this paper include whiteness, color shade, tinting strength, purity of hue, opacity, and efficiency. The assessment of these properties by colorimetric methods is briefly described.

Thereafter, it is shown that the properties of titanium dioxide pigments are not only a function of the chemical composition, the particle size, and the crystal structure, but are also related to the nature of the binder, the pigment volume concentration, and the specific use of the pigment. Both solvent and emulsion paints are considered. See also AATA 21-1358, 21-1386, 21-1418, 21-1862, 21-1891, and 21-1915.
Staff

30-S822.
Stieg, F.B.
Density method for determining the CPVC of flat latex paints.

JCT: Journal of coatings technology, **55,** no. 696, pp. 111-114, (1983), [Eng.].

Results of an experimental study are presented which demonstrate that determination of the air content of a dry latex paint film, derived from density measurements, combined with a graphical analysis of the data, will provide numerical values for both the critical PVC of the tested paint system (CPVC) and its porosity index (I.P.). The additional determination of the pigmentation's volumetric oil absorption (OA_v) permits calculation of the latex vehicle's "binding power index" (x). The need for PVC-ladder preparations is completely eliminated. The values obtained by the described graphical methods are quite easily verified mathematically. The greatest value of the graphical approach is the clear picture that it provides of important volume relationships in a porous latex paint film.

30-S823.
Andrew, Robert W.; and Lestarquit, B.
New additive helps cut the cost of hiding.

Polymers paint colour journal, **174,** no. 4122, pp. 442-446, (1984), [Eng. w. Eng. summary].

Rohm and Haas chemists have developed a unique new hiding additive. This novel product allows the trade sales paint manufacturer to address his most pressing problem, reducing raw material cost without sacrificing paint quality. Designated Ropaque OP-42 opaque polymer, the new additive offers several important benefits. First, it augments the hiding of conventional pigments through the innovative use of microvoids. Second, the opaque polymer reduces titanium

dioxide crowding. Third, it allows the paint manufacturer to formulate at higher PVC without adversely affecting paint film properties. A.A.

30-S824.
Bierwagen, G.P.
Critical pigment volume concentration and its effects in latex coatings.

In proceedings. *Proceedings of the eighth international conference in organic coatings science and technology, Athens, Greece, 12-16 July 1982,* Parfitt, Geoffrey D.; and Patsis, Angelos V., Editors (1984), pp. 407-422, [Eng.]. 62 refs.

This article has the major goal of presenting a critical review of the literature on the use of the critical pigment volume concentration (CPVC) concept in the examination of latex coatings and relevant experimental studies. A secondary goal is to present the proper conceptual background for interpretation of latex CPVC results. Further analysis is proposed for the proper consideration of error levels in measurements and curve-fitting for the experimental determination of CPVC values.

30-S825.
Ghisolfi, G.
La messa in tinta della idropitture a medio e alto P.V.C.
(Coloring of latex paints of medium and high pigment volume concentration.)

Pitture e vernici, **60,** no. 12, pp. 21-36, (1984), [Ita.].

Light scattering is mainly responsible for the color's fading in dry film of latex paint with PVC value above optical CPVC. Setting out the hypothesis that scattering could be expressed as fictitious, titanium dioxide, it was worked out a system of quantitative appraisal for such an effect. The system is based on a special color matching program. Starting from one known and defined recipe of the blend titanium dioxide/colored pigment, the program computes a lot of nominal recipes, the fictitious titanium dioxide content of them, and is a direct function of the following parameters: PVC, type of extenders, scattering power in the dry film of the extender's blend above the specific optical CPVC. As result of previous work an extension of the special color matching program

has been obtained. The input of the aforesaid parameters: PVC, extender's type, etc., allows the attainment of the entire latex paint's recipe, besides a modified recipe of the titanium dioxide/colored pigments blend, which is able to counteract the color fading. A.A.

30-S826.
Hook, J.W. III; and Harren, R.E.
Opaque polymers.

Organic coatings science and technology, **7,** pp. 21-36, (1984), [Eng.]. 11 refs.

Opaque polymer is a unique approach to incorporating microvoid hiding into coatings without the problems associated with unencapsulated air voids. The opaque polymer beads have been designed for optimum light scattering power. Their small, uniform particle size provides gloss potential and reasonably low binder demand. Because of their small particle size, opaque polymer beads do not crowd titanium dioxide. Opaque polymer serves as a partial replacement for titanium dioxide. It cannot replace all of the titanium dioxide in a formulation because it is not as efficient as titanium dioxide on a volume basis. However, titanium dioxide usage can be lowered significantly by reformulating with opaque polymer. In many coatings, careful reformulation with opaque polymer provides significant savings with no compromise of hiding or performance properties.

30-S827.
Huisman, H.F.
Pigment volume concentration and an interpretation of the oil absorption of pigments.

JCT: Journal of coatings technology, **56,** no. 712, pp. 65-79, (1984), [Eng.]. 42 refs.

A new description for the pigment volume concentration (PVC) is given. It is based on the average effective density of the aggregated particles as these particles are present, e.g., in dispersions, in coating layers, and in oil absorption pastes. The average effective particle density can be measured by mercury porosimetry. In this paper, the model is applied to pigment powder packings, e.g., bulk and tap densities, and to oil absorptions, the mathematical description of the OA paste contains three contributions; these are: the average effective particle density; the packing

of the particles; and the wettability of the particles by the oil. This model clarifies why in the past it was not possible to solve the problem of how to adjust exactly the OA-measurements or the powder compaction to give pigments packings that correlate with CPVCs derived from actual paint results.

A.A. and Staff

30-S828.
Perera, D.Y.; and Vanden, E.D.
Effect of pigmentation on internal stress in latex coatings.

JCT: Journal of coatings technology, **56,** no. 717, pp. 47-53, (1984), [Eng.]. 5 tables, 7 figs., 16 refs.

The internal stress in filled latex coatings was studied. The formulations consisted of single filler systems (one binder/one filler) and mixtures of fillers. The experimental results show that the development of internal stress depends on pigmentation (pigment volume concentration and type of filler). Mathematical relationships were established to predict approximately the internal stress and the critical pigment volume concentration for paints containing a mixture of fillers. See also AATA 21-1948, and 22-189. Staff

30-S829.
Werner, R.; Strauch, D.; and Hofer, H.
(Method to follow the degradation by natural weathering of emulsion paint films.)

In book. *XVII. FATIPEC-Kongress: Vorprogramm: Lugano, Schweiz, 23.-28.9.1984 = XVIème Congrès FATIPEC: programme préliminaire: Lugano, Suisse, 23.-28.9.1984 = XVIIth FATIPEC Congress: preliminary programme: Lugano, Switzerland, 23.-28.9.1984,* (1984), pp. 473-484, [Ger.].

A simple method is described in which rainwater falling on the sample is collected and analyzed quantitatively for calcium by atomic absorption spectrometry. Film erosion rose with increased pigment volume concentration, highlighting the fact that pigment volume concentration is of greater critical importance than binder composition. See also AATA 19-517 for more information on weathering. Staff

30-S830.
Billmeyer, Fred W., Jr.
Color and appearance characterization for the coatings industry.

JCT: Journal of coatings technology, **57,** no. 722, pp. 47-53, (1985), [Eng. w. Eng. summary].

It is convenient to separate the overall appearance of a protective and decorative coating into its color, determined by the wavelengths of light incident on and reflected from it, and the remaining effects contributing to its total appearance, determined by the geometry of its illumination and viewing. Color measurement has had great success for over 50 years in predicting whether two colors match, but even today we are less sure of estimates of the difference between two colors, and we can say very little about how a color that is part of a complex scene would look if the illumination or the rest of the scene were changed. The measurement of other aspects of appearance is even less well developed. Only recently, for example, have we begun to understand how to relate measured and perceived gloss. Some of the recent advances and some of the unsolved problems in the measurement of the color and appearance of coatings are discussed. A.A.

30-S831.
Cermak, Gregory W.; and Verma, Monica H.
Objective predictors of paint appeal.

JCT: Journal of coatings technology, **57,** no. 720, pp. 39-47, (1985), [Eng. w. Eng. summary].

Four groups of nonexperts judged the subjective appeal of 40 paint samples which varied in color, gloss, and distinctness of image (DOI). Statistical analysis showed that the subjective judgments were best predicted by color and gloss, while DOI was not an important predictor. These results were observed for both fluorescent lighting and sunlight, for both single and paired presentation of samples, and for two different demographic groups of judges. Large individual differences among judges were observed in color preference. A.A.

30-S832.
Feller, Robert L.; Stolow, Nathan; and Jones, Elizabeth H.
On picture varnishes and their solvents.

Book. National Gallery of Art, Washington, 1985, Rev. and enl. ed. [Eng.]. xxiv, 260 p.: ill.; 23 cm., bibliog. [ISBN 0-89468-084-6].

Originally based on the principal papers of a conference sponsored by the Intermuseum Conservation Association (USA) in 1957, this book has served as a basic text on solvent-based coatings for easel paintings. Contents: 1) solvents; 2) solvent action; 3) resins and the properties of varnishes; 4) the removal of varnish. Four appendixes: early studies on the cross-linking of polymers; solubility and removability of aged polymeric films; studies of the effect of light on protective coatings; polymer emulsions; grades of poly(vinyl acetate) resins with respect to their viscosity in solution; physical, chemical, and toxicological properties of solvents and liquids for conservation. Bibliography. (Revised to 1983). ICCROM(03348500)

30-S833.
Holtzen, D.A.; and Morrison, W.H., Jr.
Statistical model for emulsion paint above the critical PVC.

JCT: Journal of coatings technology, **57,** no. 729, pp. 37-45, (1985), [Eng. w. Eng. summary]. 13 refs.

An empirical model that provides cost-effective starting point formulations for given hiding power and film properties of a paint was developed. This model reduces significantly the number of experiments required using a conventional trial and error approach. The model was developed for emulsion paints between 50 and 70 pigment volume concentration. The effects of different grades of titanium dioxide pigments and various extenders is also predicted for a given paint formulation. A.A.

30-S834.
Parpaillon, M.; Engström, I.; Pettersson, I.; Fineman, I.; Svanson, S.E.; Dellenfalk, B.; and Rigdahl, M.
Mechanical properties of clay coating films containing styrene-butadiene copolymers.

Journal of applied polymer science, **30,** no. 2, pp. 581-592, (1985), [Eng.]. refs.

The mechanical properties of clay-based pigmented coating films bonded with a series of carboxylated styrene-butadiene latex binders have been investigated. The in-plane tensile strength and the elongation at rupture increased with increasing amount of polymeric binder. It is suggested that this is due to an improvement in stress transfer through the structure. The mechanical behavior of the films was furthermore found to be strongly related to the properties of the polymeric binder at the usage temperature. In torsional pendulum experiments an increase in the glass transition temperature of the polymeric binder was observed when it was incorporated in the coating film. This is interpreted as being the result of a decrease in the segmental mobility of the polymer molecules due to the presence of the clay particles, i.e., due to the interaction between the clay pigments and the binder. The interaction was, however, less noticeable in experiments using a nuclear magnetic resonance (NMR) technique. If the clay was replaced by calcium carbonate, a strong interaction, as measured using NMR, was observed between calcium carbonate and the styrene-butadiene polymer, although the in-plane mechanical strength and ductility were reduced. A structural model accounting for some of the observed differences in mechanical behavior betwen clay-based and calcium carbonate-based coating films is suggested. CCI

30-S835.
Perera, D.Y.
(Formulating for better control of internal stress.)

Pitture e vernici, **61,** no. 8, pp. 35-39, (1985), [Ita.].

A certain internal tension develops in most organic coatings, independent of their type and composition, and although its influence on the film's durability is evident, this phenomenon is only occasionally taken into account during formulation. The origins and measurement of internal tension, and the influence of the nature of binder, pigments, and solvents used, temperature, and relative humidity on its development are examined. The interdependence between internal tension, adhesion, and cohesion of coatings is shown. Staff

30-S836.
Stieg, F.B.
Opaque white pigments in coatings.

In book. *Applied polymer science,* ACS symposium series, no. 285, Tess, Roy W.; and Poehlein, Gary W., Editors (1985), pp. 1249-1269, 2nd. ed. [Eng.]. 94 refs.

Subjects covered include: the early history of titanium dioxide manufacture, optical theories and optimum particle size with relevant equations, hiding power and its measurement, exterior durability, rutile titanium dioxide, advances in hiding power theory, chloride-process titanium pigment and optimum particle size, pigmentation of latex paints, high dry hiding of paints, light-scattering studies, composite titanium pigment (calcium-base), microvoids (air bubbles), single-pigment concept, effective pigment volume concentration and dilution efficiency, plastic pigments (cost-reduction aims), and optimum solids.

30-S837.
Chiang, C. Peter; and Rehfeldt, T.K.
Scanning laser acoustic microscopy of latex paint films.

JCT: Journal of coatings technology, **58,** no. 737, pp. 27-32, (1986), [Eng. w. Eng. summary]. 25 refs.

Scanning laser acoustic microscopy (SLAM) has been used to investigate some aspects of the internal structure and pigmentation of latex paint films. As the acoustic wave moves within the latex films, waves are differentially scattered and absorbed at the internal boundaries of pigments, binders, and air voids. The pattern of sound transmission reveals the internal structures of the dried paints. The volume of air voids inside the paint films can be quantitatively determined by an extinction method of SLAM. An inflection point corresponding to the critical pigment volume concentration (CPVC) of the paints is found in the plot of pigment volume concentration vs. acoustic attenuation. Thus, the CPVC of a dry film may be determined. The principles of the technique are discussed and the future utility of the method to coating measurements is demonstrated. A.A.

30-S838.
Cutrone, Luigi.
Influence of fine particle size extenders on the optical properties of latex paints.

JCT: Journal of coatings technology, **58,** no. 736, pp. 83-88, (1986), [Eng. w. Eng. summary]. 29 refs.

The "spacer" theory suggests that coarse extenders crowd titanium dioxide particles together, reducing the ideal spacing at which the pigment affects maximum light scattering. When extender particles of a size closer to that of titanium dioxide are used, they move between the titanium dioxide particles and space or separate them for greater scattering efficiency. This paper gives examples of light scattering phenomena which are better explained by a new model involving air encapsulation. For example, fine-particle size extenders were found not to enhance the scattering ability of titanium dioxide but merely maintain the same level of opacity as binder is removed at low concentration of titanium dioxide (10% PVC), and a reduction in scattering efficiency as the titanium concentration was increased (20 and 30% PVC). A number of fine-particle size extenders were used in the study and none improved the scattering effiency of titanium dioxide. A.A.

30-S839.
Dittrich, K.
(Weight and volume as a basis for formulation.)

Farbe + Lack, **92,** no. 2, pp. 111-114, (1986), [Ger.]. 3 refs.

Although the formulation of coating materials is for practical reasons usually based on weight relations of pigment, binder, and volatile components, there are good reasons to take into account volume ratios and in some cases give them foremost consideration. This applies for instance in the development of products with specific solid volume concentrations or of a specific density. Examples are given to show how to calculate volume ratios from weight relations.

Staff

30-S840.
Ferch, H.; Eisenmenger, E.; and Schafer, H.
Coloristics of grey coatings.

In proceedings. *18 FATIPEC Kongress: die wissenschaftliche und technische Entwicklung in der Farben, Lack und Druckfarbenindustrie an der Schwelle des 21. Jahrhunderts = 18th FATIPEC congress: the scientific and technical developments in the coatings and printing ink industries on the doorway of the 21st century = 18ème congrès FATIPEC: les développements scientifiques et techniques dans l'industrie des peintures, vernis et encres d'inprimerie au seuil du 21ème siecle,* Venice, Italy, 22-26 September 1986, Anon., (1986), pp. 465-508, [Eng.].

As in the mass tone coloring of coatings with pigment blacks, the average primary particle size of the carbon black has a considerable influence on the coloristic behavior in the mixing of white pigments to produce gray coatings. Equally, the characteristics of the white pigment, e.g., grain size and grain size distribution, in conjunction with the individually chosen PVC affect the coloristics of gray coatings. This present piece of work joins coloristic findings made in 1980 on jet black coatings.

30-S841.
Johnston-Feller, Ruth M.
Reflections on the phenomenon of fading.

Affl: Carnegie-Mellon University. Mellon Institute, Pittsburgh, PA, USA.

JCT: Journal of coatings technology, **58,** no. 736, pp. 33-50, (1986), [Eng.].

Evaluation of the degree of fading on exposed paints by visual means alone obscures the underlying physical behavior of the pigments. It is shown that "Mother Nature is logical" and that, when hiding is complete, and the dispersion is uniform, the rate of fading is constant and is not appreciably affected by many of the variables of paint formulation, such as pigment volume concentration. On this basis, the observed visual changes are also predictable. When hiding is incomplete, however, the rate of fading increases and is dependent on the nature of the substrate. Illustrations of these phenomena are presented. 1985 Joseph J. Mattiello Memorial Lecture. Staff

30-S842.
Overdiep, W.S.
The levelling of paints.

Progress in organic coatings, **14,** no. 2, pp. 159-175, (1986), [Eng. w. Eng. summary].

According to Smith, Orchard, and Rhind-Tutt, the "driving force" promoting a level smooth surface for paint after application is the hydrostatic pressure gradient in the film caused by surface tension and the free boundary curvature of the film. However, experiments have shown that for solvent-based alkyd paints this theory fails to give even a qualitative description of the leveling process. The evaporation of the solvent may give rise to several effects which were not incorporated in the original theory, one of the most important of these being the development of surface tension gradients. Equating these gradients to the shear stress at the free boundary (Levich-Aris condition) leads to an integro-differential equation, which on numerical solution shows good agreement with the experimentally observed leveling processes. The technique applied for the measurement of the amplitude of paint ripples during leveling is explained. A.A.

30-S843.
Bierwagen, G.P.
The science of durability of organic coatings: a foreword.

Progress in organic coatings, **15,** pp. 179-195, (1987), [Eng.].

In this overview of organic coatings durability, the author asserts that there is a need for compression of the product development cycle in the area of coating polymers. Since the formulation of a coating is the key to its service lifetime, the pigment volume concentration (PVC) of a coating has a significant effect on durability in that it is a measure of the amount of pigment and polymer present in a unit volume of coating. If the PVC exceeds the critical PVC (CPVC) there are voids in the coating, and durability in exterior exposure is severely decreased by the action of water, etc., in these voids. According to Bierwagen, in a coating that is very close to the CPVC, a small amount of polymer degradation will raise the coating above the CPVC and cause rapid degradation of coating protective properties. K.L.

30-S844.
De La Rie, E. René.
The influence of varnishes on the appearance of paintings.

Studies in conservation, **32,** no. 1, pp. 1-13, (1987), [Eng.].

Despite numerous publications on picture varnishes, little information is available on their optical properties. Varnishes, however, greatly influence the appearance of paintings. Modern synthetic varnishes, used by restorers as replacements for unstable natural resin varnishes, do not produce the same amount of gloss and color saturation as traditional varnishes. Evidence is presented that molecular weight and refractive index are key factors in determining the optical properties of varnishes. Surface tension and hence molecular composition are of minor importance taking into consideration that varnishes of practical interest are all of relatively low polarity. Varnishes for Old Master paintings that aim at imitating the appearance of traditional picture varnishes should have low molecular weight and a relatively high refractive index. Staff

30-S845.
Fasano, David M.; Hook, John W.; Hill, William H.; and Equi, Robert J.
Formulating high-PVC paints with opaque polymer additives.

Resin review, **37,** no. 2, pp. 20-31, (1987), [Eng. w. Eng. summary]. 8 figs., 2 tables.

Rohm and Haas chemists have determined that Ropaque OP-62 opaque polymer can be used successfully in paints formulated above the critical pigment volume concentration (CPVC). By substituting opaque polymer for titanium dioxide pigment and extender, paint manufacturers can produce interior flat paints that match the hiding of conventionally pigmented paint at cost, and with better scrub resistance properties. Converting a conventional formulation to opaque polymer can be a complex process. For that reason, Rohm and Haas chemists have developed a protocol that makes the paint maker's task considerably easier. It eliminates the need to create an experimental model. It reduces the number of test paints one must prepare. And it minimizes work necessary to reformulate conventional high-PVC paints with opaque polymer. A.A.

30-S846.
Fasano, David M.
Use of small polymeric microvoids in formulating high PVC paints.

JCT: Journal of coatings technology, **59,** no. 752, pp. 109-116, (1987), [Eng. w. Eng. summary].

Since the introduction of opaque polymers to the coatings industry, many paint manufacturers have successfully used this small polymeric microvoid technology to lower their total raw material costs, while maintaining the quality of their paint formulation. This trend has recently accelerated due to increased prices for titanium dioxide, improvement in opaque polymer technology, and the move to uniform sales of paint by volume rather than weight. As formulators introduce this new technology across their full line of paints, they must pay particular attention to those properties which are most important for each line. In the highly competitive interior paint market, these key properties include color, hiding, and washability. When formulated carefully, we find that opaque polymers can be used successfully in the interior market. A.A.

30-S847.
Grange, B.; Riemann, S.; and Rademacher, A.
Opaque polymers in paints with high pigment volume concentration.

Farbe + Lack, **93,** no. 10, pp. 808-812, (1987), [Eng.]. 2 refs.

The use of opaque polymers in paint systems is discussed with reference to their effect on paint cost and quality. By means of statistical methods and examples it is shown how such polymers can either reduce paint cost or improve paint quality. Paint hiding power, washing resistance, and porosity are used as quality criteria.

30-S848.
Hesler, K.K.; and Lofstrom, J.R.
Combining mixture and independent variables for coatings research.

JCT: Journal of coatings technology, **59,** no. 750, pp. 29-32, (1987), [Eng. w. Eng. summary]. 4 refs.

A design for combined mixture and independent variable experiments with pigment volume concentration (PVC) and

nonvolatile material (NVM) is presented. A model is proposed providing quadratic mixture component coefficients and linear independent variable coefficients. Experimental data and associated error analysis are discussed and matrix methods are shown for calculation of the model coefficients. A technique for plotting a response surface graphic using the model coefficients is illustrated.

A.A.

30-S849.
Lambourne, Ronald, Editor.
Paint and surface coatings: theory and practice.

Book. Halstead Press, New York, 1987, [Eng.]. 696 p.: ill.; 25 cm., bibliogs. and index. [ISBN 0-470-20809-0].

Contents of this book include: organic film formers; pigments for paints; the physical chemistry of dispersions; coatings for buildings; automotive paints; the rheology of paints; durability testing. The work provides the needed bridge between academia and the applied science and technology of paints with special attention to the physics of paint and the physical chemistry of dispersions. The polymer chemistry of all common paint binders and the "how and why" of pigment selection are reviewed.

Staff

30-S850.
Müller-Sydler, F.
PVK, POK, Packungsdichte und Glanz von Anstrichstotten.
(Pigment volume concentration, pigment surface concentration, packing density, and gloss of paints.)

Farbe + Lack, **93,** no. 11, pp. 877-882, (1987), [Ger. w. Ger. summary]. 16 refs.

Luster/pigment volume concentration (PVC) curves display a marked minimum at the critical pigment volume concentration (CPVC). This fact yields a simple procedure to examine various pigment fixing systems. Neither the PVC nor the pigment-surface concentration (PSC) are relevant parameters to correctly quantify the load (factor) of a fixing agent. The packing factor ϕ serves the purpose best. However, no simple determination is possible as the packing factor of the pure pigment as well as the thickness of

the adsorption layer are not constants. The research is focused on relevant degrees of dependence and connections with proposals for solutions to problems.

A.A. and E.M.B.(transl.)

30-S851.
Rutherford, D.J.; and Simpson, L.A.
Mechanical properties of weathered paint films.

Polymers paint colour journal, **177,** no. 4199, pp. 653-663, (1987), [Eng.]. 25 refs.

A simple fatigue flexing machine was designed, the use of which involved subjecting a paint film, applied to a steel strip, to a repeated flexing movement. Factors influencing the fatigue life of a paint film were determined and, by exposing paints (applied onto wood) to natural weathering, the correlation between cracking and fatigue life was investigated. The influence of certain paint formulation variables, such as pigment volume concentration and pigment composition, on cracking was studied. The cracking behavior of a primer, undercoat, and top coat was examined and an evaluation of several aqueous and nonaqueous white wood stains was carried out.

30-S852.
Gibson, S.H.M.; Rowe, R.; and White, E.F.T.
Determination of the critical pigment volume concentrations of pigmented film coating formulations using gloss measurement.

JCT: Journal of coatings technology, **60,** no. 758, pp. 67-71, (1988), [Eng.].

Considerations of the geometry and the covering power demonstrate that the spacing of rutile particles can slightly improve the covering power of nonporous paint films at high pigment volume concentration. This result can be obtained with the help of a thin coating applied on the rutile particles, which does not affect rheological properties.

30-S853.

Hediger, H.; and Pauli, H.

Messung optischer Konstanten an aufgedampften Pigmentschichten und berechnete Farbe pigmentierter PVC-folien. (Measurement of optical constants of sublimed pigmented layers and calculation of color of pigmented poly(vinyl chloride) films.)

In proceedings. *19 FATIPEC Kongress: Gegenwart und Zukunft von Wissenschaft und Technik der Anstriche und ihrer Komponenten = 19th FATIPEC congress: presence and future in science and technology of coatings and their components = 19ème congrès FATIPEC: la science et la technologie des peintures et de leurs composants à l'heure actuelle et à l'avenir, Aachen, Germany, 1988*, (1988), pp. 503-522, [Ger. w. Eng., Fre. + Ger. summaries].

The coloristic behavior of a pigment depends on the optical constants and the particle geometry. The pigment concentration and the thickness of the pigmented layer are important application parameters, which also influence the color. In order to show the influence of the pigment particle size and concentration, the optical constants of C I Pigment Red 255 have been determined on evaporated layers. On the basis of these data and using the MIE theory, the theory of multiple scattering, and colorimetry, the authors calculate the color of a pigmented PVC foil for different particle sizes and pigment concentrations. A.A.

30-S854.

Hegedus, Charles R.; and Eng, Anthony T.

Coating formulation and development using critical pigment volume concentration prediction and statistical design.

JCT: Journal of coatings technology, **60**, no. 767, pp. 77-87, (1988), [Eng. w. Eng. summary].

A method has been devised to obtain optimum coating compositions of multipigment systems by integrating critical pigment volume concentration (CPVC) predictions with statistical formulation design. Two parameters are used to predict CPVC: pigment packing factor and oil absorption data. Following prediction of CPVC, a statistical formulation design is utilized to "screen" compositions and quickly optimize the coating

formulation. In this manner, a coating with the desired properties is quickly and efficiently obtained. To demonstrate this approach, five binary pigment systems were evaluated in a two component polyurethane resin system. Rutile titanium dioxide was combined separately with diatomaceous silica, antimony oxide, zinc chromate, vesiculated polymer beads, and solid polymer beads, respectively. Each pigment system was systematically formulated with the binder using a statistical design. After application and cure, the coatings were tested and evaluated for gloss and flexibility to experimentally determine the CPVC of the coating systems. The correlation between the predicted and experimental CPVC was either good or fair for the five systems studied. These results indicate that theoretically predicting CPVC along with a statistically designed formulation procedure will yield an optimum pigment system composition and concentration. Although the approach is presented using binary pigment systems, it has been used in other studies for developing multipigment coatings. A.A.

30-S855.

Schaake, R.C.F.; Heifkant, J.A.; and Huisman, H.F.

CPVC relationships. III. The real CPVC and its relationships to Young's modulus, magnetic moment, abrasive wear and gloss.

Progress in organic coatings, **16**, no. 3, pp. 265-276, (1988), [Eng. w. Eng. summary].

The "real" critical pigment volume concentration (CPVC) is defined, in its simplest form, as the pigment concentration at which porosity starts and above which a coating layer is porous. This CPVC, as measured by means of mercury porosimetry, was collated with the CPVCs determined from certain coating properties versus pigment volume concentration plots. In most cases the slope discontinuities, generally identified also as CPVCs, do not coincide with this "real" CPVC. A.A.

30-S856.
De La Rie, E. René.
Old master paintings: a study of the varnish problem.

Affl: National Gallery of Art. Science Department, Washington, DC, USA.

Analytical chemistry, **61,** no. 21, pp. 1228A-1233A,1237A-1240A, (1989), [Eng.].

The use of varnishes on old master paintings is historically traced, and the degradation of varnishes on paintings and their replacement during restoration are examined. The development and use of synthetic varnishes for paintings are discussed, and the importance of refractive index and molecular weight in their design is described. Varnish stabilizers are detailed, and future directions in varnish development are discussed.

C.A.(111:231362w) and C.W.B.

30-S857.
Huisman, H.F.; Pigmans, H.J.M.; and Schaake, R.C.F.
Critical pigment volume concentration of paints. Its measurement and some relationships.

Advances in organic coatings science and technology series, **11,** pp. 75-81, (1989), [Eng.].

A "one point" CPVC measuring method was used to investigate some factors which might affect the CPVC of actual coatings. In this work the influence of different solvent systems on CPVC and on Young's modulus has been investigated. The effect of solvents on the CPVC could qualitatively be explained on the basis of the following factors: a) the type of solvent, good or poor for the binder; b) the evaporation rate; c) the viscosity of concentrated polymer solutions, in combination with the tolerance ratios; d) the surface tension. Young's moduli, plotted as function of the normalized pigment concentration (=PVC/CPVC), follow a kind of master curve. However, if the morphology of the binder system is strongly affected by the solvent, the system deviates from that master curve. MIBK turned out to be such a special solvent, affecting the morphology of the polyurethane binder employed in the experiments. A.A.

30-S858.
Lepoutre, P.; and Hiraharu, T.
Note: on the cohesion of clay and $CaCO_3$ coatings.

Journal of applied polymer science, **37,** no. 7, pp. 2077-2084, (1989), [Eng.]. refs.

Despite its importance in printing, folding, or gluing, surprisingly little work has been reported on the subject of the mechanical strength of a paper coating, no doubt on account of its complexity. A recent publication lists the many factors that influence coating strength, among them: pigment and binder mechanical properties; adhesion between pigment, binder, and fiber; and the structure of the coating. This short communication contributes information regarding the latter, specifically, the effect of the porous structure of the coating on its strength in the transverse direction. The mechanical strength of a material decreases when voids, which are not load-bearing, are introduced. Accordingly, one might expect, at a given binder level, denser coatings to be stronger. Indeed, long ago, Cobb and Willet, and Marchetti, showed that bulk was an important component of coating strength. Ground calcium carbonate coatings, at a given binder level, have a better IGT pick resistance than clay coatings. There are two main differences between clay and calcium carbonate coatings. One is, of course, a difference in particle shape: clay is plate-like, ground calcium carbonate particles are isometric. The other is a difference in density. Even though very few data have been published, one may speculate that calcium carbonate coatings are denser than clay coatings since they can be formulated at higher solids, an indication of better packing ability. Can one separate the effect of coating void fraction from that of particle shape on the z-direction strength? The authors have attempted to do so. CCI

30-S859.
Anon.
Ernittlung der KPVK an Dispersion-
sanstrichen durch Messung der Inneren
Spannung.
(Determination of the CPVC by measuring
the internal stress in paint films.)

Farbe + Lack, **96,** no. 10, pp. 769-772, (1990),
[Ger. w. Ger. summary].

The working group II of the Swiss Federation of Lacquer and Paint Chemists (SV-LFC) (analysis and testing methods), in collaboration with the G. *Zehntner Electronic* firm came up with a simple device to measure internal tension in lacquer films. While searching for other uses for the device, the research here described was carried out. This method for determining the critical pigment volume concentration (CPVC) is simple and yields test results which are good on repetition and, moreover, is in agreement with the classical method for determining the CPVC for the paint's potential for covering surfaces. In contrast to the method for determining the paint's potential for covering areas which is restricted to white paint films, the method here described permits determination of the CPVC of color paint films.

A.A. and E.M.B.(transl.)

30-S860.
Anon.
Properties of high solid systems: ACS talks examine physical and optical characteristics.

American paint & coatings journal, **75,** no. 9, p. 18, 55, (1990), [Eng.].

Ask a paint chemist what the No. 1 formulating challenge is today, and she'll answer, "VOCs." Ask another what's the toughest substrate to paint, and he'll probably say plastic. Then find out what they think of critical pigment volume concentration. Chemists interested in any or all of those formulating concerns learned of new developments at the fall meeting of the American Chemical Society's Division of Polymeric Materials Science and Engineering in Washington, DC. Six sessions were specifically related to paint and were part of the big ACS affair. The six groups of papers looked at four categories of high-solids coatings, as well as coating plastics and critical pigment volume concentration (CPVC). The article focuses on high-solids chemistry, and on new developments that were reported at a session of the ACS meeting. A.A.

30-S861.
Anwari, Freidun; Carlozzo, Ben J.; Chokshi, Kalpesh; Chosa, Mike; Dilorenzo, Mark; Knauss, Carl J.; Mccarthy, Joe; Rozick, Phil; Slifko, Phillip M.; and Weaver, John C.
Changes in hiding during latex film formation.

JCT: Journal of coatings technology, **62,** no. 786, pp. 43-54, (1990), [Eng. w. Eng. summary]. 22 refs.

Changes in hiding during latex film formation were monitored by measuring the reflectance (Y) as a function of dry time for a coating drawn over a black substrate. This was accomplished by placing the wet drawdown against the viewport of a computer interfaced spectrophotometer and measuring the reflectance approximately every six seconds. Pigment volume concentration (PVC) ladders of extenders with different oil absorptions were studied using this technique and compared to dry film properties (i.e., contrast radio, porosity, rewet with mineral oil, etc.). Results suggest that this method may be useful for determining CPVC or, in the absence of a PVC ladder, whether a coating sample is above or below CPVC. A.A.

30-S862.
Asbeck, Walter K.
Critical look at CPVC performance and application properties.

Polymeric materials science and engineering: proceedings of the ACS Division of Polymeric Materials Science and Engineering, **63,** pp. 165-170, (1990), [Eng.]. 10 refs.

The critical pigment volume concentration (CPVC) of a coating system is a ubiquitous property which directly or indirectly affects the manufacture, application, performance, and appearance of all solution resin or latex type coatings. Completely dispersed pigments will pack to their maximum or ultimate pigment volume concentration (UPVC), whereas the more the particles are agglomerated, the lower their CPVC will be. In some instances, this difference may be substantial. Latex paints, because of their

Properties

monodisperse condition, usually have the highest packing density commensurate with the highest CPVC. They are essentially always at the UPVC. The use of the same pigment combination with different latexes may give different CPVC values and different brushing application characteristics.

30-S863.
Balfour, J.G.
Back to basics: opacity and titanium dioxide pigments.

Affl: Tioxide UK Ltd. Central Laboratories, Stockton-on-Tees, UK.

Journal of the Oil and Colour Chemists' Association, **73,** no. 6, pp. 225-231, (1990), [Eng. w. Eng. summary]. 16 figs., 13 refs.

Opacity is a complex subject which has been described in many publications. Often these have been difficult to comprehend by newcomers to the field, because of the mathematical content. This study attempts to describe the basics of opacity in a relatively simple, nonmathematical fashion. It considers factors affecting opacity with particular reference to titanium dioxide pigments in paint systems. A.A.

30-S864.
Bentz, Dale P.; and Nguyen, Tinh.
Simulation of diffusion in pigmented coatings on metal using Monte-Carlo methods.

JCT: Journal of coatings technology, **62,** no. 783, pp. 57-63, (1990), [Eng. w. Eng. summary].

Presents a two-dimensional model for the diffusion of these species through a pigmented coating. The model is implemented via digitized Monte-Carlo simulations of the random walk behavior of individual species within the coating layer. Results are presented for a number of cases which explore the effects of pigment volume concentration, pigment dispersion, pigment shape and orientation, the presence of surface defects, and constant versus cyclic environments. Key features of the digitized simulation model are its flexibility, the visualization it provides the researcher, and the possibility of executing the algorithms on digitized images of cross sections of real coating systems.
A.A.(abridged)

30-S865.
Bierwagen, G.P.
Re-examination of the CPVC as a transition point in the properties of coatings.

Polymeric materials science and engineering: proceedings of the ACS Division of Polymeric Materials Science and Engineering, **63,** pp. 186-193, (1990), [Eng.]. 7 refs.

The critical pigment volume concentration (CPVC) concept has been the basis of much work done on the performance of coatings as affected by variations in the level of pigmentation. It is especially crucial in those coatings in which there is a motivation to have a high pigment volume concentration (PVC) for performance or economic reasons. At PVCs below the CPVC, a dry coating film is polymer continuous, a composite consisting of pigment particles embedded in a continuously connected matrix of polymer. Above the CPVC, there are void structures in the film due to insufficient polymer, but the pigment particles can be thought of as continuously connected.

30-S866.
Floyd, F.L.; and Holsworth, R.M.
CPVC as point of phase inversion in latex paints.

Polymeric materials science and engineering: proceedings of the ACS Division of Polymeric Materials Science and Engineering, **63,** pp. 180-185, (1990), [Eng. w. Eng. summary]. 9 refs.

With his introduction of the seminal concept of critical pigment volume concentration (CPVC) in 1949, Walter Asbeck became one of the pioneers of modern coatings research in the paint industry, taking us from a unique-mixture view to a continuum view of paint films. While the essential concept of CPVC has not changed appreciably in the intervening time, the debate on what is happening on a microscopic scale continues to evolve. Conventionally, CPVC has been viewed as the onset of air voids in an otherwise void-free paint film. We propose the view that CPVC is a phase inversion from one in which the primary matrix is polymer to one with a primary matrix of air. This alternate view is important in explaining anomalies occurring when polymeric fillers are employed, and suggests fertile areas for future investigation. A.A.

198

Properties

30-S867.
Hare, Clive H.
Anatomy of paint.
Journal of protective coatings & linings, **7,** no. 5, pp. 75-81, (1990), [Eng.].

The physics of gloss and opacity are considered, and the selection and optimization of these properties as factors in the formulation of protective coatings, noting the importance of pigment and nonvolatile vehicle. The physics of gloss and opacity, formulating coatings for opacity or gloss, adding pigments to increase hiding, substituting particle size, formulating at or above CPVC, increased hiding through increased film thickness, and increasing volume solids are discussed. E.Ha.

30-S868.
Kannan, M.V.K.; Sathyanarayana, M.N.; Sampathkumaran, P.S.; and Sivasamban, M.A.
Effect of ageing of alkyd-TiO$_2$ paints on adhesion to mild steel: role of pigment volume concentration.
Affl: Regional Research Laboratory. Coatings Division, Hyderabad, India.
Journal of the Oil and Colour Chemists' Association, **73,** no. 3, pp. 108-112, (1990), [Eng. w. Eng. summary]. 9 figs., 13 refs.

Alkyd-based paints are being used for the protection of metals on account of their versatile properties. When the objects painted with them are exposed to different environments, destructive forces affect the paint films resulting in their premature failure. Thus the performance of the coatings over a period of time is difficult to predict from their properties initially measured according to standard specifications, as the paint films do not retain these properties during aging. It has been observed that even for a system consisting of the same binder and pigment, the properties are affected to different degrees during aging depending upon the level of the pigmentation. In the present work, the effect of aging of alkyd-TiO$_2$ paint films of different PVCs (pigment volume concentrations) on their adhesion, tensile strength, and percent elongation has been studied when exposed to ambient indoor and outdoor environments. A.A.

30-S869.
Lothian, Barry.
Very high binding vinyl acetate based dispersions.
Polymers paint colour journal, **180,** no. 4258, pp. 234-235, (1990), [Eng.]. 5 figs.

For some time it has been a generally held view that styrene acrylic copolymers have better binding power than competitive vinyl acetate based systems. This paper describes the results from a program of work aimed at developing a vinyl acetate pressure polymer with equivalent or better scrub resistance than typical styrene acrylics (and includes schematic representations of high PVC paint films). K.L.

30-S870.
Rehacek, K.; and Bradac, C.
(Influence of pigments on properties of emulsion paints.)
Farbe + Lack, **96,** no. 6, pp. 425-428, (1990), [Ger.]. 3 refs.

A study was made of the properties of two acrylate emulsion paints with morphologically different pigments and fillers in the pigment volume concentration range of 0-60%. Properties investigated were mechanical characteristics, adhesion, gloss, and weathering. Results are discussed and evaluated.

30-S871.
Anwari, Freidun; Carlozzo, Ben J.; Chokshi, Kalpesh; Chosa, Mike; Dilorenzo, Mark; Heble, Milind; Knauss, Carl J.; Mccarthy, Joe; Rozick, Phil; Slifko, Phillip M.; Stipkovich, Walter; Weaver, John C.; and Wolfe, Michael.
Changes in hiding during latex film formation. Part II. Particle size and pigment packing effects.
JCT: Journal of coatings technology, **63,** no. 802, pp. 35-46, (1991), [Eng. w. Eng. summary]. 26 refs.

Several latex paints were prepared to study pigment particle size and packing effects. Each paint contained varying ratios of fine to coarse particle size extenders at different pigment volume concentrations (PVC). Using a technique previously reported, changes in hiding were monitored during the drying process and reflectance data acquired for these paints. The reflectance (Y) of each

199

paint, drawn down over a black substrate, was measured as a function of drying time using the long-term drift test of a computer-interfaced spectrophotometer. Using blends containing varying ratios of large to fine extender pigments at constant PVC, changes in hiding due to extender dilution effects could be determined and compared to proposed models offered by other researchers. Additionally, critical pigment volume concentration (CPVC) information for each PVC ladder could be obtained by inspection, with accuracy exceeding that of other classical methods; the presence or absence of a minimum in the drying curves indicating whether a paint is above or below CPVC. In earlier work, correlations of CPVC determined by this method compared to methods using standard dry film properties (contrast ratio, porosity, rewet with mineral oil, etc.) were very good and actually demonstrated the greater sensitivity of this technique. Changes in the reduced PVC, Lambda (where Lambda equals PVC/CPVC), which occur as the ratio of coarse to fine extender varies from blend to blend, were also apparent. A.A.

30-S872.
Braun, Jürgen H.
Gloss of paint films and the mechanism of pigment involvement.

JCT: Journal of coatings technology, **63**, no. 799, pp. 43-51, (1991), [Eng. w. Eng. summary].

The optics and the perceptions of gloss are discussed in terms of *intensity-of-reflected-image* and *distinctness-of-image* and an hypothesis is proposed for the mechanism by which pigment degrades the gloss of paint films. Paint films dry in two stages, separated by what we call a surface critical point. During the first, wetter stage of drying, surface tension dominates and forces the surface of the wet film to remain smooth down to molecular scale. As the film dries, structure develops within. During the second, drier stage, the compressive strength of structure within the drying paint film, its yield stress, exceeds the surface tension, and as the film shrinks, its surface develops the micro roughness that diminishes gloss. The structure within the film is controlled largely, but not exclusively, by flocculation and packing of pigment particles. The proposed mechanism is supported by paint lore and experimental results in op-

tics, rheology, colloid science, paint practice, and pigment technology. A.A.

30-S873.
Lettieri, Thomas R.; Marx, Egon; Jun-Feng Song; and Vorburger, Theodore V.
Light scattering from glossy coatings on paper.

Applied optics, **30**, no. 30, pp. 4439-4447, (1991), [Eng. w. Eng. summary]. 10 figs., 3 tables, 22 refs.

The application of angle-resolved light scattering (ARLS) to the measurement of the surface roughness of glossy coatings on paper was investigated. To this end, ARLS patterns were measured for laser light scattered from several glossy paper samples, and these patterns were compared with those calculated using a theoretical model based on plane-wave scattering from an isotropic rough surface. Mechanical stylus profilometry data for the rms roughnesses and the autocorrelation functions of the coatings were used as input to calculate the patterns. For all the paper samples measured, as well as for all the incidence angles used, there was good agreement between the experimental and the calculated patterns when all the rms roughnesses measured by profilometry were reduced by 30%. The indication from these experiments is that ARLS may be used to determine the roughness parameters of the coatings. As a check on these results, measurements were also performed with a commercial optical surface probe; these data agreed well with both the ARLS and the stylus profilometry results. A.A.

30-S874.
Michalski, Stefan.
Crack mechanisms in gilding.

In book. *Gilded wood: conservation and history,* Bigelow, Deborah; and Hutchins, Catherine E., Editors (1991), [Eng. w. Eng. summary].

Gesso's interparticle bond is modeled as a function of gesso recipe. Mechanical properties of gesso become predictable from that of glue alone. Cracking of gesso perpendicular to the grain on wood results from drying stresses plus wood shrinkage across the grain plus insufficient stress relaxation in the glue at low humidity. A.A.

30-S875.
Asbeck, Walter.
Critical look at CPVC performance and applications properties.

JCT: Journal of coatings technology, **64,** no. 806, pp. 47-58, (1992), [Eng. w. Eng. summary].

Critical pigment volume concentration (CPVC) influences the behavior of coatings systems directly or indirectly. Performance, coating applications, production, and storage characteristics are all affected. Although the principles of the CPVC concepts are identical for solution- and dispersion (latex)-type coatings, the details of their causes are not the same. Thus, the CPVC of solution coatings can respond strongly to the degree of dispersion or agglomeration of the pigment particles as a result of the vehicle which may be used. Agglomerated particles will have lower CPVC than systems of well dispersed particles of the same pigment. With latex coatings, the quantity, size, and size distribution of the latex particles, as well as the type and quantity of the coalescing agents used, can result in different values of the CPVC for the same pigment system. The application properties of coatings are also strongly influenced by relative CPVC. For solution-type coatings, flow and sag can be controlled by lowering of the CPVC from the ultimate pigment volume concentration (UPVC) due to slight agglomeration of the pigment particles. In contrast, for dispersion-type coatings, the pigment system must virtually always be formulated at the UPVC and flow is controlled by the use of thickeners. The reasons for this behavior are explained. A.A.

30-S876.
Bierwagen, G.P.
Critical pigment volume concentration (CPVC) as a transition point in the properties of coatings.

JCT: Journal of coatings technology, **64,** no. 806, pp. 71-75, (1992), [Eng. w. Eng. summary].

Volume concentration effects in organic coatings are very important in the performance and physical properties of such coatings. The volume concentration or volume fraction of dispersed pigmentary solid phase in the polymeric binder of the coating is normally defined as the pigment volume concentration (PVC). There exists a critical PVC

(CPVC) where there is just sufficient polymer matrix to wet and fill the voids between the individual particles. First clearly recognized and characterized in 1949 by Asbeck and Van Loo, the CPVC is a very important transition point in coating performance and properties. A reexamination of the CPVC is presented examining its experimental measurement and error effects in these measurements, the CPVC as a pigment-only determined property vs. system effects on CPVC, and interpretation of experimental data in light of percolation theory as applied to composite materials. A.A.

30-S877.
Braunshausen, R.W.; Baltrus, R.A.; and De Bolt, L.
Review of methods of CPVC determination.

JCT: Journal of coatings technology, **64,** no. 810, pp. 51-54, (1992), [Eng. w. Eng. summary].

Various experimental methods have been used to determine the critical pigment volume concentration (CPVC) of coating systems. All of them involve the making of paints formulated over a range of pigment volume concentrations (PVC) and the examination of changes in the film properties. The authors review some of these methods, survey the development of mathematical models to predict the CPVC, and examine some of the factors affecting the measured CPVC in latex paints. A.A.

30-S878.
Fishman, R.S.; Kurtze, D.A.; and Bierwagen, G.P.
The effects of density fluctuations in organic coatings.

Journal of applied physics, **72,** no. 7, pp. 3116-3124, (1992), [Eng. w. Eng. summary].

It is usually assumed that the pigment and polymer concentrations are homogeneously distributed in an organic coating. This would imply that voids only appear when the pigment volume concentration (PVC) p exceeds the critical pigment volume concentration (CPVC) p_c. However, a great deal of experimental work suggests that voids actually appear even below the CPVC. In this article, we present a phenomenological theory for the effects of density fluctuations on the formation of voids both below and above the CPVC. If the distribution of

the local PVC $p(x)$ is Gaussian, then our theory contains two phenomenological parameters: a coarseness parameter C_p which is proportional to the width of the Gaussian distribution, and the diameter d_0 of the smallest densely packed cluster of pigment particles. When $C_p=0$, the homogeneous model of void formation is recovered; but for any nonzero coarseness, voids will appear even below the CPVC. In agreement with earlier work, we find that optical measurements will underestimate p_c. While bulk properties like the void density depend only on the coarseness parameter C_p, microscopic properties like the distribution of void diameters $d_v(x)$ in the coating also depend in the diameter d_0. Above the void percolation threshold p_v of an organic coating, chains of voids span the sample. If the coarseness parameter of the Gaussian model is larger than about 0.2, then p_v will drop below p_c. As in our earlier work, we find that the peak in the mass density overestimates the CPVC. By formulating a simple theory for the Young's modulus of the coating, we show that the Young's modulus also peaks above p_c for any nonzero C_p, in agreement with recent experiments. A.A.

30-S879.
Floyd, F.L.; and Holsworth, R.M.
CPVC as point of phase inversion in latex paints.

JCT: Journal of coatings technology, **64**, no. 806, pp. 65-69, (1992), [Eng. w. Eng. summary].

In 1949, Asbeck and Van Loo introduced the seminal concept of critical pigment volume concentration (CPVC) as the loading beyond which insufficient polymeric binder existed to encapsulate each filler particle and fill residual interstitial voids in the packed bed. One corollary was that CPVC represented the onset of air voids in filled systems. Subsequent work showed that in latex systems, at least, air voids exist to some extent even down to zero pigment volume concentration. The present work suggests that CPVC might be better thought of as the point at which a phase inversion occurs, from a system in which polymer is the primary phase to one in which air becomes the primary phase. The alternate view explains the anomalies which occur when polymeric fillers are employed, accommodates the porosity which exists below CPVC, explains why properties

change in slope at CPVC rather than going to zero or infinity, and offers a view of why different properties exhibit different apparent CPVCs. A.A.

30-S880.
Murray, Alison; Fortunko, C.M.; Mecklenburg, Marion F.; and Green, Robert E., Jr.
Detection of delaminations in art objects using air-coupled ultrasound.

Affl: Johns Hopkins University. Department of Materials Science and Engineering, Baltimore, MD, USA.

In book. *Materials issues in art and archaeology III: symposium held 27 April-1 May 1992, San Francisco,* Materials Research Society symposia proceedings, no. 267, Vandiver, Pamela B.; Druzik, James R.; Wheeler, George Segan; and Freestone, Ian C., Editors (1992), pp. 371-377, [Eng. w. Eng. summary]. 6 figs., 21 refs.

The possibility of using air-coupled ultrasound to find delaminations between layers in paintings was investigated. Simulations of modern paintings were constructed with hardboard as the support layer, and a layer of gesso, an animal hide glue and chalk, as the upper layer. Delaminations were introduced between the two layers. Scanning the samples using air-coupled ultrasound clearly showed these flaws. A transmitting transducer, which was 25 mm in diameter and had a focal length of 51 mm, was placed 11 mm from the back surface of the sample and an identical receiving transducer was placed 51 mm from the front surface. The transducers were operated in a tone burst mode at a center frequency of 475 kHz. Signal enhancement techniques were used to improve the contrast of the data. A.A.

30-S881.
Oosterbroek, M.; Boerman, A.E.; and Bosma, M.
A quantitative method for determining the adhesion of coatings to plastics.

Journal of the Oil and Colour Chemists' Association, **75**, no. 2, pp. 53-58, (1992), [Eng. w. Eng. summary].

In many applications plastics are rapidly replacing metal parts. The adhesion of coatings to these plastic substrates is optimized in the paint formulation process. In

this paper a method for quantitative adhesion measurements is proposed which may facilitate this optimization. A modified three-point bending test is used to create a stress concentration. The critical energy release rate for delamination is calculated. An analytical solution is presented which is in agreement with finite element approximations. On the basis of an example, the efficiency of adhesion promoters will be demonstrated. The method is applicable to both poorly adhering and well adhering coatings on various substrates. A.A.

30-S882.
Skerry, B.S.; Chen, C.-T.; and Ray, C.J.
Pigment volume concentration and its effect on the corrosion resistance properties of organic paint films.

JCT: Journal of coatings technology, **64,** no. 806, pp. 77-86, (1992), [Eng. w. Eng. summary].

The effect of the pigment volume concentration (PVC) to critical pigment volume concentration (CPVC) ratio (i.e., Λ) on the corrosion resistance properties of paint films has been investigated by AC impedance and electrochemical noise techniques. Painted mild steel electrodes were studied during exposure to 0.6 M NaCl solution for up to 2700 hours. Two series of alkyd paints were prepared containing either zinc chromate or barium metaborate as inhibitors. Paints were prepared from similar pigment blends (15 vol% inhibitive pigment, 19% titanium dioxide, 24% magnesium silicate, 27% calcium carbonate, and 15% barium sulfate) at Λ values 0.0, 0.28, 0.55, 0.83, and 1.1. The results showed that all paints prepared at Λ=1.1 deteriorated quickly. Panels painted with resin only (i.e., Λ=0.0) exhibited underfilm rusting and very poor wet adhesion. Only slight differences in corrosion resistance were observed, during the test, for zinc chromate containing paints at Λ values of 0.28, 0.55, and 0.83. In contrast, all barium metaborate containing paints progressively deteriorated. Performance levels also declined steadily in the sequence Λ=0.28, 0.55, 0.83. In conclusion, for this alkyd resin, corrosion resistance can be affected greatly by the PVC/CPVC ratio. However, the presence of zinc chromate as inhibitor allows considerable flexibility in the PVC/CPVC ratio which can be used. A.A.

30-S883.
Weaver, J.C.
CPVC, critical pigment volume concentration: an overview.

JCT: Journal of coatings technology, **64,** no. 806, pp. 45-46, (1992), [Eng. w. Eng. summary].

Critical pigment volume concentration (CPVC), as a theoretical as well as a practical concept was evolved into a formal statement in 1949 by Asbeck and Van Loo, following evolution of physical chemistry as a formal branch of science a half century earlier. Prior to 1920, Coleman studied oil absorption as a specific measurement of pigment surfaces. This work has been followed by a dozen or more pigment-binder properties which exhibit inflection points at the CPVC. A.A.

30-S884.
Ngo, P.P.; and Cheever, G. Dale.
Development of a predictive model for the changes in roughness that occur during the painting process.

JCT: Journal of coatings technology, **65,** no. 821, pp. 29-37, (1993), [Eng. w. Eng. summary].

A model involving surface and coating parameters was developed to relate their effects on the formation of the paint/air interface. In this investigation, the study included selective changes in coating material properties (molecular weight, percent solids, surface tension, and viscosity) in addition to the changes in substrate roughness (25.4, 50.8, and 76.2 μm grooves) and film thickness. The change in roughness (DELTRT) that occurred with painting was used and is defined as the difference between the initial and the final peak-to-valley roughness, Rt. The change in the topcoat roughness was expressed as a function of initial roughness (RTB), film thickness (FILM), and paint properties. It was found that the initial roughness of the substrate was the main predictor followed by the film thickness. The viscosity (VISLOSHR) was found to be the only material property which influenced the topcoat. The model that best predicts the change in roughness is: DELTRT = 8.48 + 0.81 RTB + 1.87 FILM + 0.001 VISLOSHR. A.A.

30-S885.
Sève, Robert.
Problems connected with the concept of gloss.

Color research and application, **18,** no. 4, pp. 241-252, (1993), [Eng. w. Eng. summary]. 11 figs., 2 plates, 2 tables, 36 refs.

A summary of the most recent ideas about gloss is presented with specific attention to the problems raised by the evaluation of perceived gloss with physical quantities. Research work published on the problem of multidimensionality of gloss, as well as methods using several parameters to characterize gloss, are first mentioned. Then physical phenomena related to gloss are discussed from the points of view of physical optics, geometrical optics, and photometry. Experimental results are related to the theory. It is shown that a mirror element reflects light in such a way that its radiant intensity in the specular direction is independent of its area, contrary to the radiant intensity scattered by an isotropic diffuser. The consequences of this fact for the current measurement of gloss are developed, mainly, the arbitrary choice of any gloss scale. A proposal is made to relate the measured gloss to the luminance factor in the specular direction. Problems raised by the terminology are also discussed: terms are needed for the general phenomenon of gloss, for the perceptual aspect of gloss, and for the most widely measured photometric quantity related to gloss. Proposals for future work are made. A.A.

30-S886.
Braun, Jürgen H.; and Fields, David P.
Gloss of paint films: II. Effects of pigment size.

Affl: DuPont Chemicals. Research and Development Division, Wilmington, DE, USA.

JCT: Journal of coatings technology, **66,** no. 828, pp. 93-98, (1994), [Eng. w. Eng. summary]. 9 figs., 1 table, 9 refs.

A theory that explains the mechanism by which pigments affect the gloss of paint films was strengthened and expanded. Immediately after paint is applied, surface tension of the wet film maintains its surface at molecular smoothness and gloss at perfect distinctness-of-image. While the film dries or cures it shrinks from loss of solvent or condensation products. Pigment particles and, if present, resin droplets, come together, interact and develop structure within the wet film. Eventually, the compressive strength of this structure in the film overcomes the surface forces. As the film continues to shrink, its surface becomes rough, degrading distinctness-of-image gloss. Experimental data and theoretical argument are presented that show that effects are proportional to pigment particle size. A.A.

See also:

Entwicklung und Werkstoffe der Tafelmalerei [Development and materials of easel painting], **30-S42.**

Consolidation of delaminating paintings, **30-S951.**

Treatment of adobe friezes in Peru, **30-S970.**

Treatment on painting of sliding screens and wall panels to prevent exfoliation in Japan, **30-S972.**

A consolidation treatment for powdery matte paint, **30-S979.**

Painting materials: a short encyclopaedia, **30-S227.**

D. Treatment

This section contains abstracts from the conservation literature that pertain to the materials or methods used to consolidate matte paint or similar systems that are physically related. (Please note: the citations are organized chronologically by publication year and alphabetically by author within each year.)

30-S887.
Stout, George L.
Restauration d'un relief d'argile peint.
(Restoration of a relief in painted clay.)
Mouseion: bulletin de l'Office international des musées, **29-30**, no. 1-2, pp. 105-111, (1935), [Fre.]. photos., refs.
Description of consolidation treatment applied to a highly deteriorated Chinese polychrome relief in the Fogg Art Museum (Cambridge, Massachusetts, USA): surface impregnation with polyvinyl resin and cellosolve acetate, application of silk paper and mousseline facing, followed by a layer of plaster of Paris and sawdust mixture. The relief was then turned over and the clay support scraped away leaving one millimeter of clay to support the polychrome paint. The sculpture was consolidated by application of a polyvinyl resin and ground clay backing. The plaster facing was removed. ICCROM(01798007)

30-S888.
Ullah, Mohammad Sana.
Conservation of mural paintings in Central Asia which have been damaged by salt efflorescence.
Mouseion: bulletin de l'Office international des musées, **49/50**, pp. 131-136, (1940), [Eng.].
Mural paintings in the museum of New Delhi, made by mixing ocher, blacking, malachite, green earth, and lapis lazuli with hardened mud plaster applied over a layer of gypsum, were damaged by humidity during certain seasons of the year, which caused an efflorescence of salts out of the plaster. The composition of the base made leaching out by immersion in water impossible. Impregnation with solutions of cellulose or vinyl acetate do not prevent the penetration of moisture. To remove the salts from the plaster layer, a moistening chamber is used which produces a counteracting moisture. In this

chamber humidity is maintained above 85%. The backs of the tablets were provided with a 12-mm thick paper pulp layer. To prevent mold formation 15-30 g of thymene was evaporated in the chamber from time to time and a little phenol was added to the paper paste. The application of the paper paste was repeated until traces of salts were no longer evident. The tablets were finally impregnated with 5% vinyl acetate solution in toluene.

30-S889.
Wete.
Restaurierung alter Gemälde. Unter besonderer Berücksichtigung des Freskos und der Mineralmalerei.
(Restoration of old paintings. With special emphasis on frescoes and murals (alone) in oil paint.)
Farben-Zeitung, **47**, p. 6, (1942), [Ger.].
Emphasizes that this is more of a matter of conservation than restoration, that it requires expertise in recognizing the techniques originally employed which differ so substantially that, if the wrong method is used in the restoration effort, permanent damage may result. The article details the differences between the major painting techniques and points to some of the major mistakes that expert restorers have learned to avoid, especially in view of the fact that assumptions are sometimes made that wall paintings are frescoes when they are not. E.M.B.

30-S890.
Rosen, David.
The preservation of wood sculpture: the wax immersion method.
Journal of the Walters Art Gallery, **13/14**, pp. 45-71, (1950-1951), [Eng.]. 1 plate.
The wax immersion method has been used since 1935 to correct powdery or insect-damaged wood and chalky gesso as they occur in painted wood panels. It has been

adapted to the more complex problems of polychrome wood sculpture. Objects are immersed in a large tank of molten wax until the wax has penetrated all porosities. Beeswax plus 25% gum elemi to improve adhesiveness has generally been used. Without the use of complex surgical techniques, the treatment consolidates the components of objects so that they may be handled safely. Among 30 pieces of polychrome sculpture so treated were two very large altarpieces that were treated disassembled. It is concluded that the method is no longer experimental, but safe, practical, and effective. Staff

30-S891.
Sakurai, Takakage.
(Application of synthetic resins to the preservation of antiques and art crafts.)
Kobunkazai no kagaku, **30,** no. 1, pp. 25-26, (1951), [Jpn. w. Eng. summary].

A study of the application of synthetic resins to wall paintings for the prevention of flaking of pigments and the preservation of burnt wood and wall structures of Hōryūji Temple. Poly(methyl methacrylate) for the first and urea resin for the second and third purposes were used. Poly(vinyl alcohol) was suitable for the preservation of old silks.
K.Y.

30-S892.
Sakurai, Takakage.
(Some problems on the preservation of wall paintings using synthetic resins.)
Kobunkazai no kagaku, no. 2, pp. 29-31, (1951), [Jpn. w. Eng. summary].

The results of application of acrylic resin to the wall paintings of Ryōzenji Temple, Nara, and those of Nijō Castle, Kyoto, in 1942 were examined in 1951. Neither color change nor flaking of pigments were observed. K.Y.

30-S893.
Sakurai, Takakage; and Iwasaki, Tomokichi.
(Scientific treatments made on the main hall of the Hōryūji Monastery after the fire of 1949.)
Bijutsu kenkyu = The journal of art studies, no. 147, pp. 99-107, (1952), [Jpn. w. Eng. summary]. ill., diagrams.

The scorched timbers inside the main hall were treated with urea resin compound to prevent the carbonized part from falling off. Acrylic resin was used to prevent the falling off of the pigments of the wall paintings. The walls themselves were enclosed in frames and removed from the building and their reverse sides were scraped to remove the top layer. The mud layer thus exposed was reinforced with urea resin. Many steel bolts embedded in the back sides of the walls were connected by bars. Walls thus reinforced were enclosed in frames of stainless steel. Staff

30-S894.
Gairola, T.R.
Preservation of two ancient objects.
Ancient India: bulletin of the Archaeological Survey of India, no. 10-11, pp. 192-193, (1954-1955), [Eng.]. ill., 2 plates.

Describes the skillful cleaning and preservation of a Tibetan painting and a bone object found embedded in clay in the excavation at Rupar. Methods are given for the slow drying of the damp object, removal of the clay, cleaning, vacuum impregnation of the pieces, joining them together, and filling the cracks. C.A.L. and Staff

30-S895.
Gairola, T.R.
Preservation of a textile and a miniature painting.
Ancient India: bulletin of the Archaeological Survey of India, no. 13, pp. 143-146, (1957), [Eng.]. 3 plates.

A piece of 8th-century textile from Central Asia was in fragmentary and brittle condition. The fragments were strengthened with 1% methyl methacrylate, flattened, wetted with dilute aqueous Cetavlon, and washed in running water (see apparatus described in *Ancient India* 8 (1952), p. 92), and after drying mounted with starch paste on silk. A Rajasthani miniature painting on paper was torn and had been overpainted with recent watercolors to mask damage. The overpaint was removed, the original pigments fixed with 1% methyl methacrylate, the old paper mount and paste removed, the paper flattened, mounted on Nepalese tissue paper, and given a preservative coating of 1% methyl methacrylate. Staff

30-S896.
Majumdar, P.C.
Birch-bark (bhurjapatra) and clay-coated manuscripts in the Gilgit Collection: their repair and preservation.

Indian archives, **11,** no. 1-2, pp. 77-83, (1957), [Eng.].

Concise description of the nature of inner bark of birch and clay-coated manuscripts. Various suggestions for their preservation are proposed and discussed.
ICCROM

30-S897.
Lignum (Union suisse en faveur du bois).
Documentation bois. VII: conservation du bois et traitement des surfaces. Tome 2: traitement des surfaces.
(Wood documentation. VII: wood conservation and surface treatment. Volume 2: surface treatment.)

Book. Lignum (Union suisse en faveur du bois), Zurich, 1960, [Fre.]. 111 p.; 31 cm.

Finishing techniques: preparation, mordant, bleaching, filling, stains, paints. Maintenance and renovation of exterior paints. Defects of paint, chalking, blistering.
ICCROM(02213500)

30-S898.
Marconi, Bohdan.
Some tests on the use of wax for fixing flaking paint on illuminated parchment.

Studies in conservation, **7,** no. 1, pp. 17-21, (1961), [Eng. w. Fre. summary].

It is the author's experience that the adhesive chosen for fixing flaking paint on illuminated parchment should be insoluble in water. Two adhesives were tested: a microcrystalline wax and a mixture of five parts of beeswax to four parts of dammar resin. Results are given for two 15th-century European manuscripts.
ICCROM(01720202)

30-S899.
Wehlte, K.
Pastelfixative.
(Pastel fixatives.)

Maltechnik, no. 4, pp. 112-115, (1962), [Ger.].

The author describes various pastel fixatives and how to use them.
ICCROM(01634402)

30-S900.
Rosenqvist, Anna M.
New methods for the consolidation of fragile objects.

In book. *Recent advances in conservation: contributions to the IIC Rome Conference, 1961,* Thomson, Gerry, Editor (1963), pp. 14-144, [Eng.]. 1 fig., 1 table.

The basic requirements of a substance to be used for the impregnation of fragile objects are enumerated. The factors which affect the adhesive action of the consolidation are given. The most important consolidant materials are reviewed and classified.
ICCROM(00064829)

30-S901.
Bauer, Wilhelm P.; and Koller, Manfred.
Festigung loser Bemalungen auf ethnographischen Holzobjekten.
(Consolidation of loose paint on ethnographic wooden objects.)

Der Präparator, **2,** no. 4, pp. 235-238, (1965), [Ger.].

The Museum of Ethnology in Vienna possesses many painted objects with very poorly adhering pigment, among them fine valuable carvings from the Oceanic collections and from Africa. The preservation of the colors was up to now an unsolved problem. They had often suffered heavily from rubbing of color, peeling off, and dust. A stabilization of the colors was achieved through treatment with a solution of gelatin tragacanth-cellulose (natural products) without changing the overall aesthetic appearance of the carvings.
C.A.L.

30-S902.
Bhowmik, Swarna Kamal.
Technical study and conservation of an old painted textile (Simhasana).

Studies in museology, **1,** pp. 60-63, (1965), [Eng.].

The late 18th- or early 19th-century painting was on cotton fabric sized with starch paste. The outline was drawn with charcoal. The pigments are zinc white, red ocher, vermilion, indigo blue, yellow ocher, and malachite green. Treatment required was for the removal of creases and folds, strengthening the fibers, fixing the loose ground and pigments, removal of stains and acidity, relining, and steriliza-

tion. After cleaning with isopropyl alcohol and carbon tetrachloride, and deacidification with ammonia fumes, bleaching of the stains was done with chloramine T. Relining was done with terylene cloth and Fevicol as adhesive.

Staff

30-S903.
Torraca, Giorgio; and Mora, Paolo.
Fissativi per pitture murali.
(Fixatives for mural paintings.)
Bollettino dell'Istituto Centrale del Restauro, pp. 109-132, (1965), [Ita.].

Comprehensive report about the use of consolidants, the required characteristics of permanent fixatives in dry and in moist environment, and of fixatives for stacco. Description of fixatives made of natural and synthetic materials. Experiments and their results carried out to select permanent fixatives.

ICCROM(01486109)

30-S904.
Agrawal, O.P.; and Bisht, A.S.
Technical examination and conservation of an Indian painting.
Studies in museology, **2**, pp. 7-14, (1966), [Eng.].

Examination of board, ground, medium, and paint layer colors. The conservation process includes: cleaning, maintaining rough sketch on backside, fixing, and lacuna treatment. ICCROM(00716500)

30-S905.
Boustead, William M.
Conservation of Australian Aboriginal bark paintings with a note on the restoration of a New Ireland wood carving.
Studies in conservation, **11**, no. 4, pp. 197-204, (1966), [Eng.].

Describes the paint technique used by Aboriginal artists. Bark sheets are stripped from one of the local stringy bark trees, *Eucalyptus tedrodonta*, dried over fire or on sand and painted with red, yellow, brown, and black natural pigments plus white clay. The tree orchid bulb sap, *Dendrobium sp.*, is used as a binder. Wild beeswax, honey, and the yolk of the eggs of the seagoing turtle may also be added. One part of Bedracryl 122 X (40% solution in xylene, marketed by I.C.I. Ltd.) to five parts of toluene has proved to be very successful in fixing the paint design without creating undue gloss. One coat is applied in the field; another before storage or exhibition. Mold-infested bark paintings are sprayed with 2.5% solution of Santobrite in alcohol (sodium salt of pentachlorophenol, marketed by Monsanto Ltd.). Vacuum pressure was used to correct and flatten warped back supports slowly. A polythene membrane .004 inch (0.1mm) thick is placed over the warped support and sealed to the vacuum table with packing tape. Pressure is applied very gradually to avoid splitting. The transparent polythene permits observation of the operation. A poly(vinyl acetate) (PVA) copolymer incorporating a plasticizer in its molecular structure when applied to the reverse of the painting helps to flatten. The PVA is brushed on the back of the bark, a sheet of polythene placed on the vacuum table face up. Pressure is gradually applied for two or three hours. The bark is removed from the press and the polythene sheet peeled off. A wax mixture was poured into termite tunnelings in a large Uli hermaphrodite figure. Heat applied by infrared lamps helped the wax maintain its liquid state. Broken portions were glued back using a copolymer PVA adhesive with a high degree of tack. Losses were compensated by modeling missing parts from a wax-resin-kaolin mixture suitably colored. Staff

30-S906.
Goetghebeur, Nicole; Lefève, René; Philippot, Albert; and Thissen, Jean.
Materiële beschrijving, bewaringstoestand en behandeling.
(Material description, state of conservation, and treatment.)
Bulletin (Institut Royal du Patrimoine Artistique) = *Bulletin (Koninklijk Instituut voor het Kunstpatrimonium)*, **9**, pp. 73-88, (1966), [Dut. w. Fre. summary]. figs., refs.

Describes the materials and painting technique of the triptych of the *Lamentation* from the church of Watervliet. Scientific analysis revealed the composition of the paint layer. Conservation treatment included reattaching the wooden support joints and fixative consolidation of the paint layer with animal glue and wax-resin adhesive. The triptych wings were reconstituted.

ICCROM(01026702)

30-S907.
Kirshore, R.
A clay-coated manuscript in the Gilgit collection.

Conservation of cultural property in India, pp. 74-79, (1966), [Eng.].

Describes the examination and conservation of a manuscript in *pothi* form written in Sanskrit (late Gupta Script) on a clay-coated fibrous base at the National Archives of India. The manuscript was laminated by hand using chiffon gauze and cellulose acetate foil. The clay coating was found to be mineral gypsum. The fibers appeared to be similar to flax, *Linum usitatissimum,* and Indian hemp, *Cannabis sativa.* It is difficult to establish precisely where the manuscript might have been produced. Staff

30-S908.
Boustead, William.
Conservation of Aboriginal bark paintings and artifacts.

Kalori: journal of the Museums Association of Australia, no. 35, pp. 46-53, (1968), [Eng.].

Describes Australian bark paintings and the usual conservation treatment required. Deals with the flattening of the support, the fixing of colors, and the retouchings.
ICCROM(00504000)

30-S909.
Gowers, H.J.
The conservation of a Tlingit blanket.

Studies in conservation, **13,** no. 2, pp. 98-101, (1968), [Eng.].

Describes the preservative treatment of a rare finger-woven blanket beaten out of cedar bark produced by the Tlingit people of the Northwest Coast of America. It has been in the collection of the British Museum since the mid-19th century. No analysis of the pigments used in the design was made. The painted design in red and black appears to have been applied with color from red ocher or ground hematite and charcoal mixed with the oily substance obtained from chewed salmon eggs as a binding medium. During the course of cleaning, evidence of a third color appeared which would almost certainly have been a copper green. The blanket was washed in a nonionic soap solution, dried and further spot cleaned using a synthetic

soap solution in industrial methylated spirits (IMS). Remaining color and brittle cedar fibers were consolidated with monomyl soluble nylon in IMS. Staff

30-S910.
Drayman, Terry.
The conservation of a Petrarch manuscript.

Journal of the Walters Art Gallery, pp. 119-123, (1968-1969), [Eng.]. ill., refs.

The illuminations of this early 16th-century manuscript had become disfigured by the darkening of the high values in which white lead had been used. Hydrogen sulfide of the polluted air had combined with dampness to change lead carbonate to lead sulfide. By the application under microscopic magnification of a 1:1 mixture of 30% hydrogen peroxide and anhydrous ether, the black spots were successfully bleached. It was also observed that flaking of the paint of the illuminations had occurred as a result of poor adhesion to the smooth surface of the vellum and the turning of the pages over the centuries. This condition was corrected by introducing with a one-haired brush into the paint cracks a solution of 5% soluble nylon (calaton CB) in ethyl alcohol. Staff

30-S911.
Bhowmik, S.K.
Conservation of Indian miniature paintings in the Baroda Museum.

Bulletin (Museum and Picture Gallery, Baroda (India)), **21,** p. 3, (1969), [Eng.].

Artists' materials, causes of deterioration of watercolor paintings, and nature of deterioration are considered. Standard methods were used for cleaning and preservation. Poly(methyl methacrylate) in toluene (0.7%) was used as preservative. Staff

30-S912.
Boston, D.M.; Williams, G.E.; and Jarvis, G.W.P.
Conservation of a Navajo sand-painting.

Minutes of meeting: UKG-IIC, p. 2, (1969), [Eng.].

A sandpainting made by Navajos at the Horniman Museum, London, in 1966, on a rigid platform was consolidated by spraying with a mist consisting of poly(vinyl acetate) emulsion one part and distilled water three

parts. The sand was "keyed" to the wooden base by a plastic emulsion before the sand-painting was made. Staff

30-S913.
Boustead, William.
Museum conservation of anthropological material.

In proceedings. *Aboriginal antiquities in Australia: their nature and preservation,* Australian Aboriginal studies, no. 22, McCarthy, Frederick David, Editor (1970), pp. 127-134, [Eng.]. 4 plates.

Covers the history of the technique of primitive cave paintings; treatment of conservation problems of Aboriginal cave paintings; selection and application of fixatives, and cleaning of paintings and rock surfaces. Treatment of the surfaces of Aboriginal bark paintings is also discussed and solutions proposed. ICCROM(00501100)

30-S914.
Losos, Ludvik.
Vady barevnych nateru omitek u pamatkovych objektu.
(Defects of color dyes on historic buildings' renderings.)

Pamatkova pece, **30,** no. 1, pp. 9-16, (1970), [Cze. w. Ger. summary].

Traditional lime films are still widely used because they are very inexpensive and well adapted to soft lime plasters. Their inconveniences are pale colors and short durability. If they start chalking, spraying with 10% Akronex or Disapol helps to fix loose pigment. In the past the quality of the binding medium was improved by addition of casein and stand oil, today by latex medium (PVAc) or Akronex or Disopol, always below 10%. To increase resistance to atmospheric corrosion Leukofob L (on the base of methyl silicone varnish) may be applied. Locally manufactured latex dispersal coatings are not very usable. More reliable are Western European products such as Abolin, Silin Fassatex, Dekora, A-c-pon, Brandurin, Brocolor, Dinofan, Reesa, Spridolux, Acryl-latex, Herbol, Siwal, Miropan, Ritex-Nyl, Wielatex, Aquadur, Caparol, Indeko, Herbol-latex. The colors tend to be intense. Silicate films are perhaps most satisfactory as they are compatible with the mortar. Efflorescence tends to appear when the masonry is mixed.

Austria, Yugoslavia, and Germany (KEIM) produce a number of materials.
ICCROM(01390801) and Staff

30-S915.
Brachert, Thomas.
Restaurierung zwischen Gestern und Morgen.
(Restoration between yesterday and tomorrow.)

Maltechnik, **77,** no. 4, pp. 91-103, (1971), [Ger.].

Outlines the development of modern conservation methods. In the past it was felt that a work of art should be appreciated as a whole; obtrusive damages were carefully removed, even deep cracking on a Holbein Madonna was inpainted. The modern conservator often removes just as carefully these "improvements." The influence of science on conservation has recently increased in part because of the lack of well-trained artists as modern art schools no longer teach painting techniques. The trend to surrender artistic problems to scientists is decried while the belief that sound technical craftsmanship should be combined with scientific methods is expressed. Staff

30-S916.
Koller, Manfred.
Gemäldeübertragungen—um jeden Preis?
(Transfer of paintings: at any price?)

Maltechnik, **77,** no. 4, pp. 94-102, (1971), [Ger.]. 5 photos., bibliog.

An overview of the history and practice of transfers of paintings and murals citing case histories, including paintings on both sides of a canvas or wooden altar screens, with special emphasis on technical advances made in the 1960s and stressing pitfalls to be avoided. E.M.B.

30-S917.
Wodzinska, Maria.
Skrzydla kwadryptyku z legenda Sw. Jana Chrzciciela. Zagadnienia i przebieg prac konserwatorskich.
(Wings from a quadriptych with the legend of St. John the Baptist: general problems and conservation treatment.)

Rocznik muzeum narodowego w Warszawie, **15,** no. 2, pp. 281-311, (1971), [Pol. w. Fre. summary].

The two panels (beech, ca. 105 x 22, and 92 x 34 cm, Spanish School) are dated to the first half of 14th century. The ground is gypsum, the medium is water-soluble, and the pigments are: blue (indigo), red (cinnabar and minium at the front side paintings, and iron oxide on the reverse), yellow (ocher), and carbon black. Silver leaf was used as background in the front paintings. The panels have suffered considerably in the past from neglect and climatic conditions. This caused blistering, powdering and flaking of paint, poor adhesion of ground, cracks in boards, losses in paint and ground, and a considerable accumulation of dirt. In the course of treatment poly(vinyl acetate) emulsion was used for deep blisters, gelatin for weak grounds and flaking paint, Vinoflex MP 400 for consolidating wood, thymol for disinfection, DDT-lindane for fumigation. Finally, the whole was infused with molten beeswax. Staff

30-S918.
Boustead, William.
Australian Aboriginal bark paintings: an ICOM report.

Technical report. Canadian Conservation Institute, Ottawa, 1972, [Eng.]. 9 p., 8 refs.

Paintings are done upon *Eucalyptus tedronta* bark using a very limited palette of red and yellow (various iron oxide pigments), white (pipe clay or gypsum) and black (manganese ore, or wood charcoal). The binding medium varies with locality. A major problem is friable paint, which has been fixed with Bedacryl 122X, Calaton CB, and Paraloid B-72. Flattening of the whole work is often necessary, methyl bromide is favored for fumigation, and either a dichloroethyl ether/chlordane/dieldrin mixture or pentachlorophenol as a protective insecticide. Conservation problems with various artifacts, chiefly of wood, from Papua and New Guinea are also described. ICCROM(00898119)

30-S919.
Bykova, G.Z.; Ivanova, A.V.; and Mokretsova, I.P.
Conservation methods for Medieval miniatures on parchment.

Technical report. International Centre for the Study of the Preservation and the Restoration of Cultural Property, Rome, 1972, [Eng.]. 13 p.: ill., 8 refs.

Some technical data on miniature painting are reviewed briefly. The kinds of deterioration encountered are then described. Before miniatures were treated, test pieces were fabricated using materials (parchment, pigments, media) close to the traditional ones, and these used to evaluate synthetic polymers later used for consolidation. Actual examples of treatment are cited and the details of consolidation technique given. ICCROM(00898115)

30-S920.
Bykova, G.Z.; Ivanova, A.V.; and Mokretzova, I.P.
The conservation methods for miniature-painting on parchment.

In book. *Conservation of paintings and the graphic arts,* (1972), pp. 915-917, [Eng.].

Discusses historical parchment preparation in Greece and the West. The Greek method tended to cause lack of adhesion and paint flaking. Damage in manuscript painting is divided into two groups: pulverization of paint layer deprived of the medium, and flaking of the paint layer. In the first case, consolidation is necessary, in the second, gluing to the parchment. Byzantine miniatures and 12th century Greek Gospels were treated. Deformed parts of the parchment were straightened by the so-called distant moisturing process through numerous sheets of filter paper. Staff

30-S921.
Gowers, Harold J.
The problems of treating ethnographical specimens decorated with applied surface paint.

Technical report. International Institute for Conservation of Historic and Artistic Works, London, 1972, [Eng.]. 5 p.

Some 13 ethnographic objects are described very briefly and the type of treatment they needed indicated in summary form. ICCROM(00898159)

Treatment

30-S922.
Hamelin, Bernard.
Maranyl as a fixative for pastel.

In proceedings. *Library and archives conservation: the Boston Athenaeum's 1971 seminar on the application of chemical and physical methods to the conservation of library and archival materials, 17-21 May 1971, Topsfield, Massachusetts,* Cunha, George Martin; and Tucker, Norman P., Editors (1972), pp. 139-140, [Eng.].

Pastel consists of powdered pigments pressed in the shape of sticks, the cohesion being almost entirely mechanical. The fragility of pastel results from the very loose holding to the surface of paper. Use a fixative which is not soluble in water and that is not likely to darken or change the colors since it has a matte finish. ICCROM(00784722)

30-S923.
Paterson, E.T.
Ethnographical wooden objects.

Dissertation. University of London, Institute of Archaeology, London, 1972, [Eng.]. ca. 64 leaves: ill.

Describes structure, properties, and deterioration of wood and concludes with an outline of basic tests used to assess color changes of painted wood treated with nine synthetic resins.

30-S924.
Schaffer, Erika.
Consolidation of painted wooden artifacts: an ICOM report.

Technical report. International Council of Museums, Paris, 1972, [Eng.]. 14 p.

Problems of consolidation by monomer impregnation are discussed in general and three case histories of restoration of painted artifacts described. Polymerization reaction of the methacrylate monomer was initiated by either gamma radiation or 4-t-butylcyclohexyl peroxidicarbonate with pyridine as activator at 45°C. To avoid excessive warming during the reaction, the rate was reduced by diluting the impregnating solution with the polymer. Details of the procedure and the apparatus are given. ICCROM(01923507)

30-S925.
Wawrzenczak, Andrzej.
Oznaczenie wplywu fixatywy "Perfix" na wlasnosci papieru. (Determination of the influence of Rowney's "Perfix" fixative on the properties of paper.)

Materialy konserwatorskie, pp. 75-81, (1972), [Pol.].

The Rowney's fixative "Perfix" for pastels, crayons, and charcoal drawings was tested on three different grades of paper. After artificial aging for 72 hours at 105°C the changes in tear resistance, double folds and brightness were measured. Details are given in a table. Conclusions: "Perfix" does not affect papers of better quality, but it cannot be used to fix colors on lower grade papers, because it reduces the resistance of these papers to aging. The chemical composition of the fixative is not available from the manufacturer. Staff

30-S926.
Kuiper, Luitsen.
Restoration of paintings.

Book. Van Dishoeck,; Unieboek B.V., Houten, 1973, [Eng.]. 40 p., 28 leaves of plates: ill. (some col.); 21 cm., bibliog. [ISBN 90-228-4292-4].

This booklet about conservation and restoration is meant to give a general audience some idea of the actual work of a restorer, according to the foreword. The author is chief restorer of paintings at the Rijksmuseum. Contents include short sections on structure, environment, aging, treatment, training of restorers, and notes on technical vocabulary. Staff

30-S927.
Agrawal, O.P.
Conservation of wall paintings in Thailand.

In proceedings. *Conservation in the tropics: proceedings of the Asia-Pacific Seminar on Conservation of Cultural Property, 7-16 February 1972: held at the Central Conservation Laboratory, National Museum, New Delhi,* Agrawal, O.P., Editor (1974), pp. 20-29, [Eng.].

In Thailand, many buildings were adorned with murals. Many of these wall paintings have now been totally destroyed by climate, vandalism and neglect; a few still remain. The conservation of wall paintings has two important parts: 1) consolidation of

the building or "structural conservation," and 2) conservation of the paintings. The Thai wall paintings were usually done in the tempera technique. This article discusses problems of conservation due to climate and decay of materials, rainwater, capillary water, and biological growth. A problem prevalent in almost all wall paintings is the flaking of the paint from the plaster. A solution of soluble nylon was used to consolidate the paint; this has worked very satisfactorily. Some specific monuments are described which were treated or are in need of treatment. The author suggests treatment methods. See also AATA 12-48. Staff

30-S928.
Higuchi, Seiji.
(Treatment on sliding screen and wall panel paintings to prevent exfoliation with synthetic resins.)
Hozon kagaku, **12**, pp. 57-70, (1974), [Jpn. w. Eng. summary].

Important points are as follows: 1) selection of a suitable resin for each kind of flaking; 2) causes of flaking should be studied more; 3) treatments to prevent flaking should help the pigment layer adhere to the substrate interface without leaving any resin film on the surface of the pigment layer. In many cases, an emulsion of acrylic resin is more suitable than the aqueous solution of poly(vinyl alcohol); and 4) If a sliding door painting previously treated against flaking requires another treatment, the painting is first cleaned by removing the resin film left on its surface as completely as possible, and then it is treated with an emulsion of acrylic resin. Staff

30-S929.
Iwasaki, Tomokichi.
(Preservative treatment on paint layer of screen and wall panel paintings.)
Hozon kagaku, **12**, pp. 55-58, (1974), [Jpn. w. Eng. summary].

The technique for fixing pigment layers of Japanese paintings to the support has been developed and carried out in the field of picture mounting. However, special research for preventing exfoliation has, of course, not been conducted. When the mounting is carried out a minor portion of the pigment layer is sometimes lost. In order to prevent the loss, acrylic

resin was effectively applied to the pigment layer prior to the conventional mounting treatment. Furthermore, the portions of thick multilayered pigments of sliding door paintings were successfully prevented from exfoliating by using poly(vinyl alcohol) which is water-soluble and has the affinity to the glue present in the paint layer. The resins used were of course colorless. However, they tend to give a wet and glossy appearance when they are used in excess. Other synthetic resins possess a strong adhesive property but the author makes it a fundamental policy to avoid the use of those resins which are impossible to be redissolved after curing. The main importance of the utilization of synthetic resins in the treatment for preventing exfoliation is not to deny and replace the conventional and traditional mounting techniques but to improve the conventional techniques by introducing new materials and techniques in order to achieve better results. The author tried to make a sliding door as shown in the figure in order to facilitate the studies on preventing exfoliation and other conditions for the conservation and the restoration. The sliding door was made to be almost the same in structure as conventional ones. However, it is to be noted that there are many kinds of conventional ones now in existence. A.A.

30-S930.
Kenjo, Toshiko.
(Basic experiments concerning deterioration of glue and discoloration of pigments, and discussion on the actual condition of wall panel paintings on the basis of their results.)
Hozon kagaku, **12**, pp. 83-94, (1974), [Jpn. w. Eng. summary].

For one and a half years samples of azurite and malachite, which had been mixed with glue solution, then applied to substrates and finally dried, were kept in three separate desiccators in which the relative humidity (RH) was 75, 55, and 33% respectively. During this period it was observed with both pigments that the higher the humidity, the darker the color became. When they were exposed to ultraviolet rays the discoloration increased and it was also observed in this case that the higher the humidity, the greater the discoloration. Of the two pigments, azurite showed greater discoloration than the

other. Glue is protein which possesses a complicated polypeptide structure consisting of many different amino acids. Therefore, the properties of its film are markedly affected by the environmental humidity (in parallel, by its water content being in equilibrium with the humidity) and by the type and the concentration of coexisting substances. The physical properties of the glue film, such as strength, adhesion to the substrate and flexibility, depend upon its water content. It was found that when irradiated with ultraviolet ray the film lost some of the water and sometimes the molecular structure of the glue was broken. In the case of glue itself, relative humidities ranging from 60~70% were optimum at which point its film showed no cracks nor softening. On the other hand, in the case of pigment layers containing glue as the adhesive, deterioration of the pigments was less when relative humidities were no more than 55%. It was also found that Japanese paper was markedly strengthened when coated with glue and the strengthening effect of glue was by far greater at RH of 75% than at RH of 30 to 40%. The author tried to consider the result of the observation of the wall panel paintings at Nijō-jō, Nanzen-ji temple, Nishihougan-ji temple and Tenkyū-in temple. In these paintings, azurite had generally become darker and deeper in color due to direct sunlight and high humidity, and malachite exfoliated in many of the paintings due presumably to high humidity. Additionally, some of the paintings which were directly struck with the sunlight at every sunrise and sunset showed cracks. Since musah kakushi-no ma room at kuroshoin in Nijō-jō castle is dark in all seasons, it can be assumed that the change in the temperature and the humidity is very small. The author actually found there that malachite and azurite seemed bright green and blue respectively and that exfoliation of pigments such as chalk could scarcely be found. Through the above observation and discussion of the wall panel paintings in the shoinzukuri type rooms, it can be said that it is necessary to stop the sunlight from directly striking the paintings. Furthermore, temperature and humidity must be kept as constant as possible. In such places where the sunlight falls even into the interior of the room, as in Nijō-jō castle and Nanzen-ji temple, as a provisional method for preserving the paintings reed screens and the like should be hung in such a way that the scenery is not impaired and sunlight and air are prevented from entering, so as not to allow the humidity to change. Since the author believes that it is important to keep the wall panel paintings at their present locations, she suggests that as a useful exhibition method display cases are constructed from them containing a zeolite-type substance capable of maintaining a constant humidity. A.A.

30-S931.
Lal, B.B.
Indian murals: techniques and conservation.

In proceedings. *Conservation in the tropics: proceedings of the Asia-Pacific Seminar on Conservation of Cultural Property, 7-16 February 1972: held at the Central Conservation Laboratory, National Museum, New Delhi*, Agrawal, O.P., Editor (1974), pp. 1-19, [Eng.].

The ancient mural paintings of India fall generally into the category of tempera paintings in which some water-soluble adhesive was used as a binding medium for fixing the pigments to the dry plaster. The true fresco technique was not in vogue, although some paintings have been reported executed in lime medium. This article is a brief survey of the extant remains of mural paintings in different parts of India, causes of deterioration, diagnostic procedures and conservation techniques. Methods and materials employed in chemical cleaning and conservation of typical wall paintings from different regions of the subcontinent are described. Structural repairs are very necessary to save many paintings from damage and destruction. Therefore action was taken to stop the entry of rainwater and humidity into the painted monuments so as to keep the walls and ceilings dry. For preservation of wall paintings poly(vinyl acetate) solution has proved satisfactory, not only as a fixative for loose pigments, but also as an impregnant for painted surfaces, and as a consolidant and adhesive for securing loose pigment layers and the plaster to the ground and the support. Staff

30-S932.
Mogi, Akira.
(Preservative treatment of the *Funa-Ema* (votive tablets of boats), important folklore materials at Arakawa Shrine and Hakusanhime Shrine.)
Hozon kagaku, **13,** pp. 5-15, (1974), [Jpn. w. Eng. summary].

Peeled sheets of paper were fixed to the wooden baseboards by application or injection of an approximately 15% solution of an acrylic resin emulsion (Primal AC 34). The treatment for preventing the flaking of pigment layers was carried out with a 24% aqueous solution of poly(vinyl acetate) or a 10% solution of acrylic resin. 85 tablets at *Arakawa* Shrine and 52 tablets at *Hakusanhime* Shrine have been restored. Staff

30-S933.
Nakasato, Toshikatsu.
(Present state of screen and panel paintings in Kyoto.)
Hozon kagaku, **12,** pp. 39-48, (1974), [Jpn. w. Eng. summary].

Research on the present state of screen and panel paintings at six temples and one castle in Kyoto. Scaling was observed on the chalk-painted areas without exception. Some areas painted with vermilion showed network-like cracks which were considered to be in the synthetic resin film previously applied. Also some flaking areas were observed on the part painted with yellow ocher and red ocher. The wood panel painting showed damages attributable to the glue and alum size, and the surface was covered with layers of blackish-brown stains as if it had been burned. The network-like cracks on a painting which were attributable to the restoration treatment made before 1953 were found only on the part painted with pigments of fine particles (vermilion, pale malachite, etc.). Great care should be taken during the restoration treatment in the presence of chalk, vermilion, and yellow ocher. Staff

30-S934.
Schaffer, Erika.
Consolidation of painted wooden artifacts.
Studies in conservation, **19,** no. 4, pp. 212-221, (1974), [Eng. w. Fre., Ger., Ita. + Spa. summaries].

Wood, particularly in the presence of excessive moisture, deteriorates due to action of biological agents and sunlight. Decay manifests itself not only in impairment of physical strength but also in discoloration. Protection of the paint during consolidation by impregnation and polymerization, albeit difficult, is possible. Details of a home-built 23 cm-diameter and 48 cm-long chamber of vacuum impregnation are given. The permeating methylmethacrylate monomer solution used with good results contained bis-4-t-butylcyclohexyl peroxidicarbonate as catalyst, and pyridine as activator in addition to methylmethacrylate polymer, which reduced the rate of heat generation by the reaction. Polymerization induced by gamma irradation also yielded satisfactory results. Case histories of three artifacts are described. A.A.

30-S935.
Vandyke-Lee, David J.
The conservation of a preserved human head.
Studies in conservation, **19,** no. 4, pp. 222-226, (1974), [Eng. w. Fre. summary]. 8 refs.

Large ethnographical collections sometimes contain examples of preserved human heads. There are those from the Maori of New Zealand, the well-known Jivaro Indian shrunken heads, and others from Papua New Guinea. Describes the preservation process as practiced in Western Papua by the tribal craftsman, and the problems of conservation in the museum laboratory. The latter include the cleaning of the skin, and the painted areas of the face, with the nonionic surface-active agent Lissapol N in distilled water, followed by consolidation of the painted surface with an application of 2% soluble nylon in industrial methylated spirit. Clay and fiber within the head were consolidated with a 5% solution of the polymethacrylic ester Bedacryl 122X (I.C.I.) in xylene; and the fiber ear ornaments, after cleaning with Lissapol N, were consolidated with a 5% solution of soluble nylon in industrial methylated spirit. The specimen was fitted with a specially-made polythene cover, and stored in an individual box. Staff

Treatment

30-S936.
Gerassimova, N.G.; Melnikova, E.P.; Vinokurova, M.P.; and Sheinina, E.G.
New possibilities of polybutyl methacrylate as a consolidating agent for glue painting on loess plaster.

Affl: Gosudarstvennyi Ermitazh, St. Petersburg, Russia.

In book. *ICOM Committee for Conservation, fourth triennial meeting, Venice, 13-18 October 1975: preprints,* (1975), pp. 75/1/4-1-75/1/4-10, [Eng. w. Fre. + Eng. summaries]. 1 table, 7 refs.

Poly-n-butyl methacrylate of low viscosity grade "for restoration" of the USSR production (PBMA) proved to be reversible over 25 years and stable to ultraviolet irradiation. New possibilities in the PBMA conservation technique for murals on loess plaster were revealed when using mixtures of "good" and "bad" solvents for PBMA instead of "good" solvents only. Thus impregnation by 10% PBMA solution in xylene-ethyl alcohol mixture in comparison with xylene solution of the same concentration gives more regular resin distribution inside porous material and considerably lesser changes in surface optical properties. Acetone-white spirit and some other solvent mixtures are efficient in cleaning processes and restoring the appearance of murals which were conserved in the field with excess of PBMA. A.A.

30-S937.
Gowers, Harold J.
The conservation of Javanese shadow puppets.

In book. *ICOM Committee for Conservation, fourth triennial meeting, Venice, 13-18 October 1975: preprints,* (1975), pp. 75.3.1:1-5, [Eng.].

Deals with a collection of Javanese animated skin puppets used in shadow play during the first half of the 18th century, but suggests that the text is relevant to a wide variety of similar objects. Reference is made to probable techniques and materials used in manufacture, and a method of restorative treatment which has been developed in the British Museum is discussed. A brief account is also given of a storage method which, allied to the conservation treatment, should eliminate the main sources of deterioration in future years. Staff

30-S938.
Ivanova, A.V.
Primenenie sinteticeckikh polimerov dlia ukrepleniia srednevekovykh miniatur na pergamente.
(The use of synthetic polymers for the consolidation of Medieval miniatures on parchment.)

Soobshcheniia, no. 30, pp. 3-9, (1975), [Rus. w. Eng. summary].

An account of search, choice, and examination of the most effective synthetic polymers used for consolidation of paint layer of Medieval miniatures on parchment.
ICCROM(01712000)

30-S939.
Masuda, Katsuhiko.
(Cleaning treatment on votive tablet in traditional way.)

Hozon kagaku, **14,** pp. 71-76, (1975), [Jpn. w. Eng. summary].

The tablet was painted on a gilded paulownia board about 1814. After being damaged in the fire of the temple housing it in 1966, it was stored at the Tokyo National Museum. The stains were composed mainly of water-soluble substances, and were removed by a traditional method, i.e., applying wet paper (first synthetic fiber paper and then Japanese handmade paper) to the surface in order to soak them off. As an additional treatment, an acrylic resin emulsion was applied to the interface between the pigment layer and the support to prevent flaking. Staff

30-S940.
Mogi, Akira.
(Studies on fixing treatments of color paintings on the ceiling of Sanmon Gate, National Treasure, Tofuku-ji Temple.)

Hozon kagaku, **14,** pp. 93-98, (1975), [Jpn. w. Eng. summary].

The San-mon Gate to the Tofuku-ji Temple in Kyoto is a two-story wooden gate built in the Muromachi Period (1384-87). The interior of the upper story is painted in colors. This San-mon Gate has now been dismantled for overall repair. Concerning treatments to be given to the ceiling, where the probability of the colors flaking or peeling off is particularly high, studies have been conducted by request. The area of the ceiling is about 3 m x

19 m, made up of 44 boards. There are arabesque patterns along the four sides, with Aspara and musical instruments at the center, all painted on pieces of paper and stuck onto the ceiling. At numerous points, either the painted paper is coming off, or colors are scaling off from the paper. Experiments were made to select the best of several conventional methods of treatment with synthetic resins, with comparatively few chances of leaving stains. Consequently, in order to adhere paper and boards, PVA emulsion (Bond PS 210) modified with acrylic resin was spread between the paper and the boards and was made to set by pressing. In order to check the scaling off of pigments from the paper, acrylic emulsion (Primal AC 3444), diluted with water, was injected and made to set by pressing. In both cases, the results obtained were satisfactory. Full-scale treatments are scheduled to be undertaken in 1975, by technicians available locally. A.A.

30-S941.
Mogi, Akira; Nakasato, Toshikatsu; and Emoto, Yoshimichi.
(Conservation treatments with reference to color paintings on the ceiling of the main hall, National Treasure, of Toshodaiji Temple, Nara.)
Hozon kagaku, **14,** pp. 55-69, (1975), [Jpn. w. Eng. summary].

Pigment analysis shows that the blue is a mixture of indigo and yellow ocher and the purple a mixture of indigo and red iron oxide. It indicates the presence of red lead, cinnabar, malachite, lead sulfate, and white clay. Consolidation was carried out with poly(vinyl acetate) and protection with acrylic resin. Aqueous solutions of resins are mentioned but they are probably emulsions.
ICCROM(01792707) and A.A.

30-S942.
Mokretsova, I.P.
Sur quelques particularités technologiques et de la restauration de deux manuscrits enluminés d'Europe occidentale du XIIIe siècle.
(Some details on the technique and of the restoration of two illuminated 13th-century manuscripts from Western Europe.)
In book. *ICOM Committee for Conservation, fourth triennial meeting, Venice, 13-18 October*

1975: preprints, (1975), pp. 75/15/17-1-75/15/17-10, [Fre.]. refs.

The two manuscripts, both in Latin and from the 13th century, are a Bible from France and a psalter, probably from southern Germany. They were subjected to detailed visual examination, and in the case of the Bible, to systematic radiography. The colors are described and pigments suggested but, as sampling was not allowed, could not be confirmed. The miniatures on the psalter were much worse preserved, especially the gilding, which had suffered many losses. Treatments in the case of both manuscripts consisted of fixing the paint layer in place, the parchment being in good condition. Flaking paint was attached with a copolymer of vinyl acetate and either hexyl 2-ethyl acrylate or ethylene. Powdering paint was treated with Fluoroplast 6H. C.A.L.

30-S943.
Bykova, G.Z.; and Mokretzova, I.P.
Conservation methods for miniature paintings on parchment: treatment of the paint layer.
In book. *Conservation and restoration of pictorial art,* Brommelle, Norman; and Smith, Perry, Editors (1976), pp. 207-209, [Eng.].

The technique of Western and Byzantine miniature paintings on parchment, followed by conservation of the paint layers which are flaking or pulverized, is described.
ICCROM(00859328)

30-S944.
Byrne, Allan F.
Conservation of polychrome wood sculpture at the Australian War Memorial.
ICCM bulletin, **2,** no. 3, pp. 5-14, (1976), [Eng.].

A description of the technical examination and treatment of a polychrome wood sculpture held by the Australian War Memorial. The sculpture appeared to be of European origin, ca. 12th century. Analysis by pyrolysis gas chromatography of the surface coating was carried out, and microscopic examination of paint samples was also done. Cleaning and consolidation of the sculpture with poly(vinyl acetate) is described.
Staff

30-S945.
Higuchi, Seiji; and Katsuhiko, Masuda.
(Study on the repair technique of polychrome paintings drawn on sliding screens in the Nagoya Castle.)
Hozon kagaku, **15,** pp. 25-35, (1976), [Jpn. w. Eng. summary].

The 33 sliding screens from Nagoya Castle (which was destroyed by bombing in 1945) are now preserved in the exhibition room of the castle. Both faces of the screens are decorated with polychrome paintings, invaluable examples of the Kano School in the early Edo Period (the 17th century). Since the exfoliation of these paintings was considerable, they were treated in the following way: 1) When the exfoliated pigment layers were thin or chalk-like, water-soluble acrylic resin with the addition of acetone to lower the surface tension of the resin solution was used to fix them; 2) When the exfoliated pigment layers were thick and hard, acrylic resin emulsion was applied after the treatment with the resin mentioned in (1); 3) Pigment particles were bound by the resin mentioned in (1); the same binding agent was used to stick a thin pigment layer to the substratum because of its high permeability; 4) To adhere a thick and hard layer to the substratum, acrylic resin emulsion which is strong enough to bind a large gap between two contiguous surfaces was used. Staff

30-S946.
MacKay, A.I.
The restoration of artefacts in the National Ethnographic Collection.

In proceedings. *Proceedings of the national seminar on the conservation of cultural material, Perth, 1973,* Pearson, Colin; and Pretty, Graeme L., Editors (1976), pp. 215-218, [Eng.].

Describes the restoration of objects in the National Ethnographic Collection with various case studies. Ends with an appeal for curators not to discard so-called rubbish from their ethnographic collections as it could be an invaluable source of materials for restoration purposes. See AATA 13-772. Staff

30-S947.
Phillips, Morgan W.
Problems in the restoration and preservation of old house paints.

In book. *Preservation and conservation: principles and practices: proceedings of the North Amer-*

ican international regional conference, Williamsburg, Virginia, and Philadelphia, Pennsylvania, 10-16 September 1972, Timmons, Sharon, Editor (1976), pp. 273-285, [Eng.]. ill., refs.

Discussion of preservation and restoration of early American oil-based house paints. Discoloration: fading, yellowing, blanching, chalking. Limitations of quantitative analysis. Use of spectrophotometric curve analysis. Choice of pigments in paint restoration, texture, transparency, dispersion of pigments, glazes, and verdigris. Problems in preservation: adhesion, reattachment and inpainting, varnish. ICCROM(00826329)

30-S948.
Atanasov, Atanas.
Restavraci i konservaci na ikona ot Melnik. (Restoration and conservation of an icon from Melnik.)
Muzei i pametnitsi na kulturata, **17,** no. 2, pp. 41-50, 79, (1977), [Bul. w. Fre. summary]. ill., figs., refs.

The restoration and conservation of an icon, dated 16th-17th centuries and coming from the church at Melnik, Bulgaria, is described. The icon is painted on hand-loomed linen canvas, attached to a conifer wood panel of the same dimensions. Two ground layers are present, the first being chalk and glue size, the second chalk and lead white. The painting technique was egg tempera. The following pigments were identified: terre verte, ocher, red earth, indigo, vermilion, burnt umber, lead white, ivory black, blue (sic), transparent resin colors, and metals, gold and silver. Restoration was carried out in accordance with these findings, since the icon had suffered many previous interventions. ICCROM(03559502)

30-S949.
Hittmair, E.
Restaurierung eines japanischen Paravents. (Restoration of a Japanese screen.)
Maltechnik-Restauro, **1977,** pp. 99-102, (1977), [Ger.]. 1 photo.

A six-panel screen by the Japanese painter Sotatsu (17th-century) exhibited fissures and flaking paint. To consolidate the paint, ''Planatol BB'' was used. Old repairs were removed with an ammonia solution. To retouch the gilded parts, small areas were painted with gold in watercolor techniques.

Larger missing parts were covered by gold leaf. The green, blue, and ocher parts were retouched in watercolors, using a Japanese glue medium. Staff

30-S950.
Vandyke-Lee, David J.
The conservation of some carved wooden war shields from the Tifalmin Valley, Papua New Guinea.

The museums journal (Museums Association), 77, no. 2, p. 77, (1977), [Eng.].

Describes conservation problems of carved and painted shields and house boards from Papua New Guinea. Treatment given included consolidation of the wood, and consolidation of the flaking red and white paint; after cleaning and removal of water stains, loose pieces of earth pigment were fixed using poly(vinyl acetate). The consolidants found successful were Paraloid B-72, Bedacryl 122x, Calaton CB, Galva V7, and Elvacite 2013. ICCROM(01756001)

30-S951.
Berger, Gustav A.
Consolidation of delaminating paintings.

In proceedings. *ICOM Committee for Conservation, fifth triennial meeting, Zagreb, 1-8 October 1978: preprints*, (1978), pp. 78/2/1/1-78/2/1/19, [Eng.].

A frequent cause of deterioration in paintings is the loss of adhesion or cohesion in the different parts of the paint films and their supports. The paint mediums, such as casein or drying oil, which are strong adhesives themselves, fail under the tensions generated by dimensional changes in the paint film and the support. Components of the painting are forcibly separated, cracks form in the horizontal direction, and later cleavages in the vertical direction. The treatment of delaminations requires three operations: 1) penetration of the consolidating adhesive between the delaminating layers; 2) release of tensions within them; and 3) reattachment of the paint to its previous support. Low viscosity and good wetting properties make Beva well suited for the treatment of delaminations, both of the adhesive and cohesive type. Beva's chemical stability, strength, and elasticity assure effective, long-lasting bonds. Since Beva is easily reversible and can be reactivated at low tempera-

ture, it will not impede or weaken future consolidation measures. Its flow and elasticity prevent damage caused to the painting by other strong adhesives. Consolidation of two delaminating paintings, one of them severely damaged by fire, is described in detail. A.A.

30-S952.
Blyth, Victoria S.
Electrostatic stabilizing plate (E.S.P.): an alternative method for stabilizing the flaking tendencies of works of art in pastel.

In proceedings. *Preprints of papers presented at the sixth annual meeting of the American Institute for Conservation of Historic and Artistic Works, Fort Worth, Texas, 1-4 June 1978*, (1978), pp. 21-30, [Eng.].

The fragility of works of art in pastel represents a continuing problem for conservators. Several traditional methods of fixing were tested and all were found to alter the original appearance of sample pastels. By creating an electrostatic attraction between the pastel particles and their support through the use of an electrostatic stabilizing plate (E.S.P.), the samples were maintained in their original condition without subjecting them to any irreversible processes. In addition, the E.S.P. may have other practical applications. Staff

30-S953.
Daly, Debra.
An investigation into the use of several substances as fixatives for works of art in pastel.

Master's thesis. Queen's University, Kingston, 1978, [Eng.]. 118 p.: ill.; 28 cm.

Fixed samples on paper and glass slides were subjected to ultraviolet aging. Microscopic examination of the film and its interaction with the pastel pigments was undertaken. Different pastel pigments as well as different papers affect the ease of fixation and the degree of visual alteration. ICCROM(02268422)

30-S954.
Gerassimova, N.G.; and Melnikova, E.P.
The effect of the treatment with polybutyl methacrylate solutions on physical and mechanical properties of loess plaster.

In proceedings. *ICOM Committee for Conservation, fifth triennial meeting, Zagreb, 1-8 October*

Treatment

1978: preprints, (1978), pp. 78/15/13-1-78/15/ 13/11, [Eng. w. Eng. summary]. 3 tables, 2 figs., 1 ref.

Characteristics of loess plaster of Middle Asian mural paintings (8th-century, Pendzhikent), namely, its exposed porosity, mean diameter of pores, water vapor absorption, and bending strength have been estimated. The evaluation of the changes of these characteristics after treatment with 10% poly(butyl methacrylate) solutions in xylene and in xylene-ethyl alcohol mixture under equal laboratory conditions has revealed no difference between the two ways of the treatment. A.A.

30-S955.
Higuchi, Seiji; and Nakasato, Toshikatsu.
(Preservative treatment on the *Shoheki-ga* at the Daiju-ji.)

Hozon kagaku, **17,** pp. 28-41, (1978), [Jpn. w. Eng. summary]. 12 photos., 17 ill., 2 refs.

The Shoheki-ga at the Daiju-ji Temple, painted by Reizei Tamechika (1823-64) in rich bright colors consists of paintings on paper base on walls and sliding doors in six rooms. The pigments have flaked away in layers here and there, or show chalking in part, but missing parts are few. The paintings were repaired in 1957 with poly(vinyl alcohol) but have continued to flake. The reason for this second peeling was judged to have been the poly(vinyl alcohol) used as the adhesive at the first repair which, because of its high viscosity and surface tension, could not penetrate sufficiently into the peeled parts. This time, water-soluble acrylic resin containing some ethyl alcohol (to lower the surface tension) was used. For parts where strong adhesion was needed, acrylic resin emulsion was used. A.A.

30-S956.
Myers, P. Gay.
The technical investigation and conservation treatment of an alleged Ming Dynasty wall painting.

Master's thesis. Oberlin College, Oberlin, 1978, [Eng.]. 103 p.: ill.

A painting on a dried mud and fiber support, believed to be a fragment of a Chinese wall painting, was examined and the materials and techniques analyzed and compared to other transferred Chinese wall paintings. The discovery of emerald green in the design layer, small pieces of modern newspaper embedded in the mud/fiber support, and other evidence suggest that the painting is a modern forgery. Conservation treatment included: consolidation of the flaking paint using dilute solutions of gelatin in warm water and ethyl alcohol, consolidation of the friable mud/fiber layer with repeated applications of 2.5% and 5% Paraloid B-72 in xylene within a vapor chamber, and attachment to an auxiliary support of linen (using poly(vinyl acetate) "heat seal" adhesive) and an aluminum honeycomb panel (using microcrystalline wax and Zonarez B-85). Included is an appendix of materials found in the paint, ground, and support layers of 20 other Chinese wall paintings. Staff

30-S957.
Serck-Dewaide, Myriam.
Disinfestation and consolidation of polychromed wood at the Institut Royal du Patrimoine Artistique, Brussels.

In proceedings. *Conservation of wood in painting and the decorative arts,* Brommelle, Norman; Moncrieff, Anne; and Smith, Perry, Editors (1978), pp. 81-83, [Eng. w. Fre. summary].

Examples are given of different treatments applied to polychromed wood sculpture seriously damaged by insects: fumigation with methyl bromide or Zyklon B, application of Xylamon Combi-Clear, consolidation with Paraloid B-72 (with or without pentachlorophenol) and partial replacement of the wood. These operations are described with the reasons for their choice and the inherent problems in each case. The conclusion warns against the use of mass treatment procedures for polychromed wood. Staff

30-S958.
Szabó, Zoltán.
The conservation of adobe walls decorated with mural paintings and reliefs in Peru.

In proceedings. *ICOM Committee for Conservation, fifth triennial meeting, Zagreb, 1-8 October 1978: preprints,* (1978), p. 7, [Eng.].

The buildings decorated with wall paintings and reliefs were made of adobe on the narrow coastal desert of Peru. Both the excavated original parts of the buildings, and the restored ones are equally deteriorated by

220

the wind and the rare but strong rains. For the building material of the restored parts the author suggests an adobe tempered with 10 v/v% of lime cream, which has become waterproof. The original parts could be protected by polyacrylates or polystyrene procurable as cheap industrial waste. Staff

30-S959.
Walston, S.; and Gill, P.
Conservation of the Australian Museum's collection of Aboriginal bark paintings.
ICCM bulletin, **4,** no. 2-3, pp. 54-59, (1978), [Eng.].

A collection of 330 paintings at the Australian Museum was treated over a period of three and a half years. This discusses their examination, recording, cleaning, color recording by Munsell soil chart, pigment consolidation, bark repairs, reinforced epoxy backing, and mounting.　ICCROM(02259902)

30-S960.
Walston, S.
The preservation and conservation of Aboriginal and Pacific cultural material in Australian Museums.
ICCM bulletin, **4,** no. 4, pp. 9-21, (1978), [Eng.].

Reviews the background and development of conservation in museums housing Aboriginal and Pacific ethnographic collections; discusses ways of upgrading the quality of conservation and areas of deeper involvement of museums in the conservation of indigenous collections.　ICCROM(02260000)

30-S961.
Werner, Anthony E.A.
Consolidation of deteriorated wooden artifacts.
In proceedings. *International symposium on the conservation and restoration of cultural property: conservation of wood: 24-28 November 1977, Tokyo, Nara, and Kyoto, Japan,* (1978), pp. 17-21, [Eng.]. 8 refs.

Discusses basic requirements for a consolidant; use of epoxy and polyester resins with or without solvent; polymerization of monomers by gamma ray irradiation or catalyst; the case of painted wood artifacts; and filling of voids.　ICCROM(01993102)

30-S962.
Savko, Michel.
La fixation des peintures murales à l'alcool polyvinylique (Moviol N-70-98): l'expérience d'un restaurateur.
(The fixing of mural paintings with poly(vinyl alcohol) (Mowiol N-70-98): a restorer's experience.)
Bulletin (Institut Royal du Patrimoine Artistique) = Bulletin (Koninklijk Instituut voor het Kunstpatrimonium), **17,** pp. 175-193, (1978-1979), [Fre. w. Fre., Eng. + Dut. summaries]. 3 photos., appendixes, 41 refs.

Deals with research on methods and treatment products that permit the safeguarding of the character and materials of wall paintings. The fixing of wall paintings with polyvinyl alcohol is discussed from both a theoretical and a practical point of view. Discusses the constancy of materials, a factor that must be taken into account during restoration work. Finally, describes a fixing technique involving prewetting with water-alcohol. Concludes with a brief note on the possibility of using poly(vinyl alcohol) as a vehicle for cleaning products.　A.A.

30-S963.
Eastaugh, Nicholas; Eaton, Linda; and Legg, Sally.
Painted textiles.
In book. *Preprints of papers presented at the seventh annual meeting: Toronto, Canada, 30-31 May and 1 June 1979,* (1979), pp. 84.9.15-84.9.16, [Eng.].

Considers the problems raised by the conservation of painted textiles, and discusses several areas of interest: the cleaning of painted textiles, the choice of consolidants, and the materials and techniques used in painting on textiles.　A.A.

30-S964.
Higuchi, Seiji; and Nakasato, Toshikatsu.
(Conservation treatment of the painting on wooden walls in the oratory of Osakihachiman Shrine.)
Hozon kagaku, **18,** pp. 63-72, (1979), [Jpn. w. Eng. summary].

Osakihachima shrine registered as a national treasure was built in about 1610 by Date Masamune. All members of the building

are lacquered by urushi and painted with colors. The oratory interior except pillars is painted entirely with colors. Especially, 10 wooden walls made of zelkova boards are painted with the motif of Karashishi (mystic lions) with Botan (peony flowers). Before the present treatment, treatments had been performed two times on color parts to prevent further exfoliation. The first treatment was done with poly(vinyl alcohol) in 1956, and the second with acrylic resin emulsion in 1967. However, the expected results were not obtained in both cases. The third treatment under discussion was done on the same walls with another time scaling of color layer after about 10 years aging. The authors tried to apply the nonfluid thixotropic acrylic resin emulsion by use of the syringe with 10-cm-long needle. By this operation, resin is introduced into the space between detached color layer and ground. A.A.

30-S965.
Ramer, Brian.
The technology, examination and conservation of the Fayum portraits in the Petrie Museum.

Studies in conservation, **24,** no. 1, pp. 1-13, (1979), [Eng. w. Fre. + Eng. summaries].

The chronology established for the production of the Fayum portraits is briefly outlined, followed by a review of the encaustic painting technique in which the controversy surrounding the nature of the binding medium used to execute these paintings is discussed. In a technical examination of three Fayum portraits in the Petrie Museum, the wooden support, binding medium and pigments present in each painting were identified. In addition, paint samples mounted as cross sections served to elucidate the paint layer structure and to indicate the presence or absence of ground and/or priming layers. The techniques used to conserve a number of these paintings are outlined under the following headings: cleaning; treatment of the detached paint layer; repair and structural stabilization of the wooden support. Staff

30-S966.
Riederer, Josef.
Restaurierung mit Kunstharzen in Japan. (Restoration with synthetic resins in Japan.)

Maltechnik-Restauro, **85,** pp. 118-125, (1979), [Ger. w. Eng. summary].

In Japan, synthetic resins have been used for the preservation of cultural property since 1942. For the consolidation of flaking paint layers mixtures of acrylic resins and poly(vinyl acetate) have proved to be useful. For the impregnation of decayed wood and all excavated metal objects, acrylic resins are used. Isocyanates have been used for the stabilization of wood. For gluing and molding missing parts of stone, wood, and metal, epoxy resins are used. Stone is consolidated by ethyl silicates with convincing success. Acrylic materials are also useful for stabilization of structures over excavations, and for museum display. Continuous tests on early restorations done with synthetic resins have proved their efficiency. J.R.(A.A.)

30-S967.
Vandyke-Lee, David J.
An ethnographic collecting expedition to Papua New Guinea: field conservation and laboratory treatment.

The conservator, no. 3, pp. 43-46, (1979), [Eng.]. photos., 1 ill., 12 refs.

Describes the treatment in the field and subsequently in the laboratory of ethnographic specimens collected in the Papua New Guinea area. The climatic conditions made the use of chemicals impossible and the methods of storage and protection of the specimens used reflect this. Fumigation, cleaning, and consolidation methods carried out when the specimens were brought to the British Museum are discussed. Staff

30-S968.
Wolscy, Ewa; and Wolscy, Jerzy.
Zagadnienie konserwacji wielkich plaszczyzn malarstwa klejowego na plotnie. (The problem of conservation of very large canvases painted in glue medium.)

Ochrona zabytków, **32,** no. 2, pp. 121-126, (1979), [Pol. w. Eng. summary].

The paintings that decorate interiors of a parish church at Stegna on a Gdańsk sand-

bar were made in ca. 1683 on a canvas which was then sized with a gluten glue and nailed directly onto the entire surface (450 m²) of a wooden pseudoarched ceiling of the church. Apart from normal problems encountered in the conservation and restoration of canvas paintings, in the case of the conservation of polychromy there appeared additional technical difficulties caused by atypical features of the painting, i.e., the gluing technique, the large surface of the canvas, and hardly removable repaintings. Due to the lapsed time, and the climatic conditions of the seaside region, the canvas was badly damaged. After a thorough analysis of the painting and a number of laboratory studies, a program was worked out for a conservation procedure to include the following operations: preliminary cleaning, varnishing of the facing, protection, disassembling, cleaning and varnishing of the reverse, gluing-in patches, strengthening and reinforcement of the canvas, removal of protections, cleaning of the surface, removal of repaintings, puttying, painting, reconstruction, laying down on the ceiling, retouching after assembling, treatment of ceiling beams and prophylactic use of 0.3% solution of Rashit sodium salt on the surface of the painting. Along with the conservation of the painting, building works were carried out in the church (e.g., the exchange of some beams in a ceiling's rafter framing). The described treatment, proved correct in practice as well as substances used in the conservation of the painted ceiling at Stegna, can be employed in the conservation of other works of art whose technique and condition would pose similar problems. ICCROM and A.A.

30-S969.
Bansa, Helmut.
Praxis und praktische Möglichkeiten bei der Restaurierung mittelalterlicher Miniaturen.
(Practice and practical possibilities in the conservation of Medieval miniatures.)
Maltechnik-Restauro, **86,** no. 2, pp. 93-95, (1980), [Ger.]. bibliog.
 Bibliography 1970-78. The main problem is fixing flaking or powdery color. Various methods, gelatin, parchment glue, beeswax, dammar, methyl cellulose, ethyl cellulose, carboxymethyl cellulose, benzyl cellulose, acrylic resin silicone, alkyd resin, mineral

wax, and poly(vinyl acetate), used by the main conservation centers are shortly described. ICCROM(02137400)

30-S970.
Chiari, Giacomo.
Treatment of adobe friezes in Peru.
In proceedings. *Ucuncu uluslararasi kerpic koruma sempozyumu: 29 Eylul-4 Ekim 1980, Ankara = Third international symposium on mudbrick (adobe) preservation: 29 September-4 October 1980, Ankara,* (1980), pp. 39-45, [Eng.].
 Report on chemical treatment experiments carried out in Peru on painted and unpainted adobe friezes. The processes consisted in the consolidation of the mud layer underlaying the surface with sprayed ethyl silicate, strengthening of the inner part of the wall by the injection of Primal, and fixing of the painted layer with Paraloid.
 ICCROM(02292005)

30-S971.
Haner, Paul; Rankin, Quentin; and Vitale, Timothy.
Paintings on paper: a dialogue in five case histories.
In book. *Preprints of papers presented at the eighth annual meeting, San Francisco, California, 22-25 May 1980,* (1980), pp. 26-38, [Eng.].
 Discusses paintings on paper by e.e. cummings, Ben Shahn, Carlos Clemente Lopez, Karl Spitzweg, and David Gardner. Problems with the deterioration of both paint and paper are described and possible conservation treatments given. The medium was either oil or gouache. In general the paintings were flattened and consolidated and then mounted to rigid supports. Staff

30-S972.
Higuchi, Seiji.
Treatment on painting of sliding screens and wall panels to prevent exfoliation in Japan.
In proceedings. *International symposium on the conservation and restoration of cultural property: conservation of Far Eastern art objects: 26-29 November 1979, Tokyo, Japan,* (1980), pp. 69-77, [Eng.].
 The paint layer tends to flake off if it is too rich in glue or to chalk off if the binder is too low. Use of solutions and emulsions for

fixing thixotropic emulsions to fix flaking. The resin must not be left on the surface. Animal and seaweed glue are compared with synthetic glues. Three examples of treatment. Enzymes for removal of glue.

ICCROM(02339107)

30-S973.
Ito, Nobuo.
Conservation within historic buildings in Japan.

In book. *Conservation within historic buildings: preprints of the contributions to the Vienna Congress, 7-13 September 1980*, Brommelle, Norman S.; Thomson, Garry; and Smith, Perry, Editors (1980), pp. 34-36, [Eng.]. 7 refs.

An identification of historic buildings in Japan. A study of shoin-zukuri buildings in Kyoto city documents environmental problems of historic buildings: high humidity, high relative humidity, too much light, some air pollution from sulfur oxides and nitrogen oxides, and high concentrations of microorganisms. Principles of maintenance and restoration within historic buildings, treatment against exfoliation (flaking, or chalking of paint) are discussed. The most effective adhesive is Acrylic Resin Sol from Rohm and Haas Co. Staff

30-S974.
Lyall, J.
Various approaches to the conservation and restoration of Aboriginal artifacts made from bark.

ICCM bulletin, 6, no. 2, pp. 20-32, (1980), [Eng.]. ref.

General coverage of the nature of Australian Aboriginal artifacts made from bark, including bark paintings, their conservation and restoration. The nature of the bark from different trees (e.g., stringy barks, boxes, and peppermints, etc.) is discussed. The deterioration, conservation, and restoration of barks are discussed; descriptions of methods which have been used in Australia for the conservation, display, and storage of bark paintings, and recommendations for future work on the conservation of barks are included. Staff

30-S975.
Mesterházy, Erika.
Uj-irlandi szertartási maszk es Oceániai kettös faszobor restaurálása.
(Restoration of a New-Ireland ceremonial mask and a double wood carving of Oceania.)

Müzeumi mütargyvédelem, no. 6, pp. 125-136, (1980), [Hun. w. Eng. + Ger. summaries].

The first part gives a picture of the society of New Ireland and describes the restoration process of the mask. The mask had to be restored to the original state, a work which consisted of the removal of the old overpainting and the addition of missing parts. The second part gives a detailed description of the double wood carving and explains how the extraction of the old conservation material was carried out and how the new restoration and conservation methods complying with the aesthetic and museological requirements had been applied. A.A.

30-S976.
Schmitzer, Werner.
Restaurierung von Schattenspielfiguren.
(The restoration of shadow puppets.)

Arbeitsblätter für Restauratoren, 13, no. 2, pp. Gruppe 9: 57-67, (1980), [Ger.].

The manufacture of shadow puppets is described. They are made of parchment decorated with different colors of paint and gold leaf. The paint hides damaged parts where they separate from the parchment. To fix small portions of loose paint, egg white is used with a hot spatula. Larger portions are consolidated with a commercial glue. According to the different techniques of manufacture in different regions of south and east Asia, specific techniques of restoration must be applied. Staff

30-S977.
Silver, Constance S.
The state of preservation of Pueblo Indian mural paintings in the American Southwest: findings of a condition study carried out in 1978-1979, and a proposed pilot project to test materials and methods for conservation.

Technical report. International Centre for the Study of the Preservation and the Restoration

of Cultural Property, Rome, 1980, [Eng.]. 42
p.: ill.; 29 cm.

Briefly describes mural paintings in the Southwest and their construction, with emphasis on existing kiva murals and their condition. Conservation problems of the murals are discussed as are the reasons for the survival of so few of the mural paintings that have been excavated. The materials used create highly friable and pulverulent surfaces and of course the substrate is adobe architectural elements. Proposes a pilot study to test conservation strategies for treating the murals. M.H.B.

30-S978.
Stevens, Phillip.
The conservation of Indian and Moghul miniatures.

In book. *Abstracts and preprints: international conference on the conservation of library and archive materials and the graphic arts*, Petherbridge, Guy, Editor (1980), pp. 157-160, [Eng.].

Alternative and conservative approach to the treatment of the miniatures avoiding the use of irreversible surface coatings. The process is described in detail.
 ICCROM(02224838)

30-S979.
Welsh, Elizabeth C.
A consolidation treatment for powdery matte paint.

In book. *Preprints of papers presented at the eighth annual meeting, San Francisco, California, 22-25 May 1980*, (1980), pp. 141-150, [Eng.]. 53 refs.

Powdery matte paint on art objects made of wood or bark frequently needs consolidation to strengthen the paint as a film and to help hold the paint to its substrate. Conservation literature on the subject of consolidating matte paint is reviewed and the recommendations evaluated. A treatment using Acryloid B-72 in diethyl benzene was developed.
 ICCROM(02309216) and Staff

30-S980.
Yusupova, M.V.
Conservation and restoration of manuscripts and bindings on parchment.

Restaurator, **4**, no. 1, pp. 57-69, (1980), [Eng. w. Fre. + Ger. summaries].

Contains short descriptions of the main types of damage that might occur on manuscripts and bindings on parchment. Literature dealing with problems of their conservation and restoration are analyzed. Reasons of increase in transparency of parchments are examined. Materials for the effective removal of different soiling, the fixing of texts, and the elimination of mechanical damages are suggested. ICCROM(02655701)

30-S981.
Masschelein-Kleiner, Liliane; Eyskens, Peter; Kockaert, Leopold; and Vynckier, Jozef.
Examen et traitement d'une détrempe sur toile du XVIe siècle: les Pèlerins d'Emmaüs du Musée des Beaux-Arts de Bruxelles. (Examination and treatment of a tempera on canvas from the 16th century: the *Emmaus Pilgrims* from the Fine Arts Museum of Brussels.)

Bulletin (Institut Royal du Patrimoine Artistique) = Bulletin (Koninklijk Instituut voor het Kunstpatrimonium), **18**, pp. 21-29, (1980-1981), [Fre. w. Dut. summary]. 6 photos., 4 refs.

The cleaning of the painting by immersion allowed the removal of starch and old varnish. The immersion consisted of three baths in a solution of isopropanol and acetone (50/50) and one bath in a solution of isopropanol and acetyl acetone (50/50). The cleaning resulted in noticeable change in aspects of the painting. Reports on pigment analysis, solvent selection, and discusses treatment and results.
 ICCROM(02587601)

30-S982.
Phillips, Morgan.
Wallpaper on walls: problems of climate and substrate.

Affl: Society for the Preservation of New England Antiquities, Boston, MA, USA.

Journal of the American Institute for Conservation, **20**, no. 1-2, pp. 83-90, (1980-1981), [Eng. w. Eng. summary]. 2 notes.

225

Treatment

Destructive condensation in walls and accelerated deposition of dirt on wallpapers can result from attempts to maintain within a historic building climatic conditions too widely different from those outdoors. More testing and experience are needed in selecting temperature and relative humidity levels that represent the best compromise between the needs of artifacts and the structural limitations of buildings that contain them. Crumbly old plaster on which wallpaper is found may merit consolidation, and this can be done practically using a variety of organic and inorganic materials. Temporary removal of the paper is almost surely necessary. Plaster that is merely loose from its support can often be reattached without removing the wallpaper. Making new plaster to match old is not difficult, and modifiers can be used to improve properties. Wallpapers that have been mounted directly on wood are attacked by acids from the wood. A.A.

30-S983.
Pugachenkova, G.A.; and Levushkina, S.B.
Experiments on preservation of adobe structures and restoration of gypsum plaster paintings in Uzbekistan.

Technical report. Uzbek Academy of Sciences. Institute of Archaeology, Samarkand, 1980s, [Eng.]. 4 p.; 30 cm.

The use of polymers and monomers for the consolidation of adobe structures and paintings on plaster walls in the Soviet Central Asian countries is discussed. Research is being conducted at the Institute of Archaeology in Samarkand and the Science of Art Institute in Tashkent. ICCROM(03051200)

30-S984.
Barton, Gerry.
Pigment consolidation on six Pacific artifacts: a CCI internship report.

Student project. Canadian Conservation Institute, Ottawa, 1981, [Eng.].

Describes a series of tests to determine a suitable consolidant for flaking, powdering pigments on artifacts from New Guinea, Australia, and New Britain. In four of the objects, ethanol based solutions caused noticeable color changes and aqueous solutions of gelatin were chosen because they caused the least changes in appearance. For two objects where

ethanol caused no discoloration, poly(vinyl butyral) was chosen as the consolidant.
E.Ha.

30-S985.
Chieffo, Clifford T.
Fixing and flocking.
American artist, **45,** p. 14, (1981), [Eng.].

Replies to the following questions: in what way can pastel be fixed permanently? What kind of product is pastel canvas? What is Venice turpentine? ICCROM(02550705)

30-S986.
Chizhova, T.D.
Methods of egg-tempera panel painting conservation employed in the State Hermitage.

In proceedings. *ICOM Committee for Conservation, sixth triennial meeting, Ottawa, 21-25 September 1981: preprints,* (1981), pp. 81/24/5-1 -7, [Eng. w. Eng. summary].

Reviews methods of conservation of old Russian, Byzantine, and Italian egg-tempera panel painting used in the easel painting restoration studio of the State Hermitage for the last 25-30 years. Describes the methods of consolidation of painting and ground with sturgeon glue and water solutions, egg emulsion, and natural and synthetic resins. The consolidation methods depend upon the character and degree of the destruction of the object. Methods of straightening and stabilization of supports are also given. A.A.

30-S987.
Flieder, Françoise; Talbot, Roseline; Flieder, Catherine; and De Reyer, Dominique.
Etude expérimentale sur les fixatifs des traces pulvérulentes.
(Experimental studies on fixatives for powdery traces.)

In proceedings. *ICOM Committee for Conservation, sixth triennial meeting, Ottawa, 21-25 September 1981: preprints,* (1981), pp. 81/14/8-81/ 14/16, [Fre.]. 4 tables, 2 appendices, 14 refs.

A major concern of paper conservators is to preserve the legibility of text. As protective coatings, the effects of two natural resins, 15 synthetic resins, and 16 commercial fixatives were tested on three papers of different qualities. A.A.

30-S988.
Koob, Stephen P.
Consolidation with acrylic colloidal dispersions.

Affl: American School of Classical Studies at Athens, Athens, Greece.

In proceedings. *Preprints of papers presented at the ninth annual meeting, Philadelphia, 27-31 May 1981,* Preprints of papers presented at the annual meeting (American Institute for Conservation of Historic and Artistic Works), (1981), pp. 86-94, [Eng. w. Eng. summary]. 4 tables, 8 refs.

The application of a polymer in a water medium offers many advantages over true solutions. Difficulties have been encountered with the use of poly(vinyl acetate) and acrylic emulsions. Acrylic colloidal dispersions may be considered hybrids between emulsions and true solutions and exhibit the favorable properties of both. The smaller particle size and lower viscosity ensure better penetration and the near neutral pH's are more suitable for use on organic materials. The hardness and durability (without brittleness), along with greater stability, offer better protection for consolidated objects, especially those stored in adverse climatic conditions. A.A.

30-S989.
Plossi, Mariagrazia Zappala; and Crisostomi, Paolo.
Consolidation de la couche picturale des enluminures avec polymères synthétiques purs.
(Consolidation of the pictorial layer of illuminations with pure synthetic polymers.)

In proceedings. *ICOM Committee for Conservation, sixth triennial meeting, Ottawa, 21-25 September 1981: preprints,* (1981), pp. 81/14/7-1-15, [Fre. w. Fre. + Eng. summaries].

In the framework of a research on the fixing of the pictoral layer of illuminations on parchment, five types of pure synthetic polymers were tried. Samples of painted parchment were tested to observe the practical effect of these pure polymers. The solvent used influences the level of penetration of the polymer. The best aesthetic result is obtained with methyl cellulose diluted in methylene/methanol chloride. Cellulose acetate, on the other hand, gives a negative result, forming a whitish coat without any penetration. Flexibility measurements were also taken on untreated parchment, and on parchment treated with the selected polymers. A.A.

30-S990.
Portell, Jean D.
The examination and treatment of two wood funerary masks with Negroid features.

In proceedings. *Preprints of papers presented at the ninth annual meeting, Philadelphia, 27-31 May 1981,* American Institute for Conservation of Historic and Artistic Works, (1981), pp. 146-152, [Eng.].

Two ancient funerary masks made of wood with applied surface layers and inlays, in very fragile condition, were examined and treated. A sample of wood from the larger mask yielded a radiocarbon date of around 1700 BC. Microscopic study of particles from the surface materials revealed the presence of otherwise indistinguishable retouching in the matte brown layer of the large mask. Treatment was localized and consisted of reattachment of breaking areas and consolidation of friable and flaking surface layers. A storage/display case containing preconditioned silica gel was made for each mask. Staff

30-S991.
Wachter, Otto.
Diagnose und Therapie in der Pergament- und Miniaturenrestaurierung.
(Diagnosis and therapy in parchment and miniature restoration.)

Restaurator, **5,** no. 1-2, pp. 135-150, (1981-1982), [Ger.].

In 1898, a conference held at St. Gall, Switzerland, brought together librarians and curators concerned with the deteriorating state of Medieval manuscripts, especially those that had been exposed to efforts to make them more legible or to reproduce them by photographic means. The more frequent handling and the treatment with chemical solutions often led to the total disappearance of the writing or the deterioration of the support such as parchment. The author describes the various methods that have since been discovered to preserve and to restore, wherever possible, such writing and pictures and the preferred methods for preserving the parchment support. Staff

30-S992.
Agrawal, O.P.
Care and conservation of palm-leaf and paper illustrated manuscripts.

INTACH Indian Conservation Institute, Lucknow, 1982, [Eng.]. 7 p.; 25 cm.

Conservation problems of palm-leaf manuscripts: techniques, deterioration, treatment and storage. Paper manuscripts and paintings: conservation treatments according to their technique. Notes from the experience in south and southeast Asian countries.

ICCROM(03190100)

30-S993.
Eckardt, Helmut.
Ein Porträt des Magisters Sahl (1683-1753). Besonderheiten einer Pastellrestaurierung. (A portrait of Master Sahl (1683-1753). Particularities of a pastel restoration.)

Beiträge zur Erhaltung von Kunstwerken, **1,** pp. 120-128, (1982), [Ger.].

Concerns a pastel drawing cartoon, measuring 415 x 325 mm. Its history; condition before restoration; thoughts on the restoration method; past conservation and restoration operations; and the fitting of the mounting are described and discussed. Staff

30-S994.
Newton, Roy G.
The deterioration and conservation of painted glass: a critical bibliography.

Book. Corpus vitrearum medii aevi, Great Britain: occasional papers, no. 2, Oxford University Press, Oxford, 1982, 2nd. ed. [Eng.]. xxxii, 103 p.; 25 cm. [ISBN 0-19-726017-9].

Revised and expanded version of the *AATA* supplement published in Volume 10, Number 2. Seven sections cover the history of manufacture of Medieval window glass, causes of weathering, ethics of conservation and restoration, cleaning painted glass, conservation, restoration, and preservation. Every section has an initial essay covering the works cited; the references with annotations are grouped together in the same order in the eighth section of the work. 433 references are listed but many more appear in the lively discussions of individual papers.

ICCROM(03654500) and Staff

30-S995.
Silver, Constance S.
1981 report on the development of methods for the conservation of Pueblo Indian mural paintings in the American Southwest.

Technical report. International Centre for the Study of the Preservation and the Restoration of Cultural Property, Rome, 1982, [Eng.]. iv, 52 p., 82 cm.

Report on research and preservation of paintings on adobe walls. Discusses causes of alteration; strappo and stacco techniques adapted to the adobe support; consolidation in situ; and reattachment of plasters.

ICCROM(02670100)

30-S996.
Fox, Judith C.
Consolidation techniques for "yam masks": a practical investigation paper presented to the National Museum Act and the Museum of Cultural History at the University of California at Los Angeles as an advanced internship research project.

Student project. University of California, Los Angeles, Fowler Museum of Cultural History, Los Angeles, 1983, [Eng.]. 10p., 10 refs.

The deterioration and treatment of three painted Abelam rattan yam masks are described in detail. Reasons behind the selection of treatment materials and application techniques are given and both successful and less successful results are documented. Acryloid B-72 in toluene, CM Ethulose 400 in water, gelatin, and poly(vinyl acetate) emulsion were tested for various treatment uses.

Staff

30-S997.
I'ons, Anne.
Friable ochre surfaces: further research into the problems of colour changes associated with synthetic resin consolidation.

ICCM bulletin, **9,** no. 3-4, pp. 13-33, (1983), [Eng.].

Examines some of the structural and chemical components found in ochers, pigments commonly used in ethnographic bark paintings and wooden objects. These pigments are known to become friable with use and age. Detailed information is provided on

the successful use of Paraloid B-72 and Beva 371 to consolidate friable ocher. Concludes that consolidation procedures were related to the chemical and physical structures of the clay-mineral layers; the difference in refractive index of the resin and the ochers; and the surface wetting and evaporation rate of the solvents. ICCROM and E.Ha.

30-S998.
Lee, John.
Collecting wooden ethnographic carvings in the tropics.

In proceedings. *Biodeterioration 5: papers presented at the fifth international biodeterioration symposium, Aberdeen, September 1981,* Oxle, Thomas Alan; and Barry, Sheila M., Editors (1983), pp. 404-408, [Eng.].

A large collection of ocher-painted ancestor carvings were brought from Papua New Guinea to the British Museum in 1980. These had suffered damage not only to the timber but also to the friable painted surfaces. Termites had eaten the bases of the carvings, and the mechanical strength of the timber was much reduced. During the sea trip back to the UK the damp carvings had been further damaged by mold; on return the carvings were fumigated with ethylene oxide gas in a vacuum chamber; the paint was then cleaned and consolidated with a spray application of Paraloid B-72 in 2% xylene solution. The damaged bases were consolidated with Paraloid B-72, and strengthened with B.P.K. setting dough (Butvar B98, paper dust, and kaolin). Staff

30-S999.
Olin, Charles H.; and Riddleberger, Alexandra.
The special problems and treatment of a painting executed in hot glue medium, "The Public Garden" by Edouard Vuillard.

In book. *Preprints of papers presented at the eleventh annual meeting, Baltimore, Maryland, 25-29 May 1983,* (1983), pp. 97-103, [Eng.].

This paper describes the deteriorating condition and subsequent treatment of an unvarnished wall-size painting executed in hot glue medium, an unusual technique favored by Vuillard for large decorative works. It was received for examination in order to determine how best to treat problems of paint loss and active cleavage between the

various layers of paint as well as between ground and fabric that already constituted 50% of the painting. It was soon to leave Washington, DC, but was too fragile to travel. Inherent vice in the artist's method of rapid paint application, surface characteristics, previous restoration and a rigid time constraint all limited rather narrowly how this painting could be treated. The intent was to clean, consolidate, and protect it without altering in any way color or surface characteristics. After testing various materials, the procedures ultimately chosen to care for this painting were quite traditional. A 10% solution of poly(vinyl acetate) emulsion and water was applied to local disruptions to consolidate. Cleaning was accomplished with a single application of a 1% solution of Orvis Liquid in water on a slightly damp swab. Details of the artist's technique, the painting's condition, causes of deterioration, analysis of the multiple problems, testing, and completed treatment are included. Staff

30-S1000.
Tibor, Kováts.
Egy festett matyo lada tisztitasa, konzervalasa es restauralasa.
(The cleaning, conservation, and restoration of a Matyo chest.)

A Miskolci Herman Ottó Muzeum közleményei, no. 21, pp. 176-180, (1983), [Hun.].

The Matyos are the inhabitants of a small region, the so-called Matyond, at the northeastern corner of Hungary. A unique culture formed here during the 18th and 19th centuries dominated by colorful decor even on furniture. This article describes a case study and experimental conservation treatment. The chest itself was made around 1900 and posed special problems because of thick paint layers, special pigments, and binding material. Special consideration was given to the wooden structure and the preservation of damage that may be caused by insects and fungi. Staff

30-S1001.
Ghose, Arun.
Note on the classification of choice of adhesives.

Conservation of cultural property in India, **16-17**, pp. 17-24, (1983-1984), [Eng. w. Eng. summary].

The behavior and setting action of different classes of adhesives used in conservation and restoration of paintings, documents, and other artifacts are discussed. Properties of an adhesive which determine its choice are mentioned to help in restoration practice.
A.A.

30-S1002.
Agrawal, Om Prakash.
Conservation of manuscripts and paintings of Southeast Asia.

Book. Butterworths series in conservation and museology, Butterworth & Co., Sevenoaks, 1984, [Eng.]. 299 p.: ill.; 26 cm., bibliog., index. [ISBN 0-408-10671-9].

The paintings and manuscripts from Southeast and South Asia differ significantly from those found in other parts of the world: birch bark and palm leaves have been the popular materials used for writing and painting; glue, gum, tamarind seed, and similar aqueous media have been used for the fine line and minute detail. In addition to the specialized care and restoration techniques required by such works, information is provided on the proper display of the paintings. The first chapter provides a brief history of painting in the region; the remaining chapters discuss the conservation of birch-bark, palm leaf, cloth paintings, paper paintings, and thankas. Each chapter gives a detailed account of the composition of the material, its deterioration, conservation techniques, and care and storage in museums. Staff

30-S1003.
Barras, Martine; and Balazsy, Agnes T.
Proposal for the consolidation of the painted surface on reverse painted glass.

In proceedings. *Fourth international restorer seminar: Veszprém, Hungary, 2-10 July 1983 = Viertes internationales Seminar für Restauratoren = Quatrième cours international pour restaurateurs*, Tim ar-Balazsy, Agnes, Editor (1984), pp. 167-170, [Eng.].

The traditional consolidant, Paraloid B-72, was not satisfactory for reverse painted glass. The consolidant Howiol poly(vinyl alcohol), sprayed and reactivated with heat over the vacuum table has been tested and has been found to be quite satisfactory. See also AATA 21-490. Staff

30-S1004.
Centre de recherches sur la conservation des documents graphiques.
Analyse et conservation des documents graphiques et sonores: travaux du Centre de recherches sur la conservation des documents graphiques, 1982-1983.
(Analysis and conservation of graphic and sound documents: work by the Centre de recherches sur la conservation des documents graphiques, 1982-1983.)

Book. Editions du CNRS, Paris, 1984, [Fre.]. 257 p.: ill.; 24 cm., bibliogs. [ISBN 2-222-03419-1].

R. Talbot, F. Flieder, and C. Laroque sought the best method for fixing powdery media on paper. Natural resins were not completely satisfactory. Three synthetic resins were found to work particularly well for charcoal, black lead, and carbon, when used prudently: Klucel G, Plexisol P550, and Elvamide 8061. A bibliography of 114 references accompanies this study. C. Schwartz, B. Guineau, F. Flieder, C. Laroque, and N. Flieder discuss the results of their collective work on pastels. Literature review (68 references) and experimental study led to the following conclusions: the pigment influences the stability of the pastel to a great extent. Certain colors—for example, white, brown, green, and yellow—are very stable to light, while purples and violets are not. Ethylene oxide does not have a darkening effect on the pastels. Finally, the resin most adaptable for fixing pastels was found to be Elvamide 8061, a 0.5% solution in ethanol and water in a proportion of 90 to 1. Staff

30-S1005.
Humphrey, B.J.
The application of Parylene conformal coating to archival and artifact conservation.

Studies in conservation, **29,** no. 3, pp. 117-123, (1984), [Eng. w. Fre. + Ger. summaries]. 10 figs., bibliog.

This study concerns the application of Parylene conformal coating technology to the preservation and/or protection of archival materials and museum artifacts. Topics discussed are the properties of the polymer, the process of deposition, stress tests conducted on Parylene-treated paper, encapsulation of entire books, artifact analog studies, as well as the restoration and subsequent treatment of an antique microscope with Parylene.
A.A.

30-S1006.
Larson, John.
Case studies in the treatment of polychrome wood sculptures at the Victoria and Albert Museum.

In proceedings. *The proceedings of the symposium "Decorative Wood"; held at the Burrell Collection, Glasgow, U.K., 31st March 1984,* Carthy, Deborah; and McWilliam, Colin, Editors (1984), pp. 26-38, [Eng.].

Three case histories of wooden sculptures demonstrate special problems facing conservators. A French 15th-century angel was unstable as a result of past treatments. A German 15th-century carving proved to be a fake. A 12th-century Chinese boddhisattva had been repainted in the historical past.
ICCROM(03525003)

30-S1007.
Mora, Paolo.
Conservation of excavated intonaco, stucco, and mosaics.

In book. *Conservation on archaeological excavations: with particular reference to the Mediterranean area,* Stanley Price, N.P., Editor (1984), pp. 97-107, [Eng.]. refs.

Causes of deterioration, initial interventions, cleaning, extraction of soluble salts, consolidation of plasters, stucco, and mosaics are described. A new backfilling method is presented in detail.
ICCROM(02876108)

30-S1008.
Poladian-Moagăr, Alice.
Utilizarea substantei Carboxi-Metil-Celuloza in restaurarea picturilor de sevalet.
(The use of carboxymethylcellulose in the restoration of easel paintings.)

Revista muzeelor si monumentelor: Muzee, **1984,** no. 4, pp. 37-40, (1984), [Rum. w. Fre. summary]. 4 photos.

Henry Catargi, a Romanian contemporary artist, painted Industrial Landscape, a sketch in oil colors on drawing paper, in the collection of Romania's Art Museum-National Gallery. The artist's techniques include sketching with unfixed coal and using ballpoint pen, felt tip pen, and colored pencil to sign the work. He had lined the work with cardboard, using a bone (gelatin) glue which was much too hard and acid. The oil medium was responsible for oxidizing the paper support. A one percent solution of carboxymethylcellulose was used with Japanese tissue to reline the drawing. The traditional method of using fish glue (sturgeon) was deemed inappropriate because the amount of water required would have been detrimental to the charcoal drawing and the signatures. Use of carboxymethylcellulose is reversible. A microscopic film of carboxymethylcellulose remained on the surface like a varnish; but without detracting from the visual intent of the original work.
Staff

30-S1009.
Randolph, Pamela Young
A technical and stylistic analysis of detrempe painting on cardboard by Edouard Vuillard.

ICA newsletter, **15,** no. 1, pp. 3-4, (1984), [Eng.]. ref.

Vuillard's method of painting *à la colle* and his use of cardboard as a support are discussed. The treatment of one example, *La salle à manger au château de Clayes* is discussed. Consolidation of crackle and flaking was accomplished with 1.5-3% solution of cellulose acetate.
ICCROM(02959903)

Treatment

30-S1010.
Randolph, Pamela Young.
History, analysis and treatment of "La salle à manger au château de Clayes," 1938, by Edouard Vuillard.
The Book & Paper Group annual, 3, pp. 112-121, (1984), [Eng.].

A brief history of Vuillard's life, working circle, and painting technique is given. A large painting from the University of Kentucky (USA) was catalogued as pastel, then thought to be gouache, then finally discovered to be distemper. The paint layer was extremely matte, quite brittle, and insensitive to water and most solvents, and tested as glue-positive. There were cupped, cracked, flaking areas and small losses. Some fading of purple and red pigments was obvious, compared with a 1946 reproduction. The paper support, 173 x 134 cm, a mixture of 20% groundwood and 80% bleached softwood fibers was stuck onto a lightweight canvas with a starch-type adhesive. The bond between paper and paint was only fair. Strips of heavier canvas had been used to reinforce edges tacked onto a seven-member wooden stretcher. The support was not good and was leading to paint-layer insecurity. It was decided to loose line onto a panel. This is described in detail. Other treatment was minimal since it was felt that correction of past mistakes could do more harm than good.
ICCROM(03310612)

30-S1011.
Schießl, Ulrich.
Historischer Überblick über die Werkstoffe der schädlingsbekämpfenden und festigkeitserhöhenden Holzkonservierung.
(A historical survey of the materials used for pest control and consolidation in wood.)
Maltechnik-Restauro, **90**, no. 2, pp. 9-40, (1984), [Ger. w. Eng. summary].

Article discussing the materials and processes that are and have been used in the conservation of painted wood. A survey of materials used for fungi and pest control is given as well as those for the consolidation of wood. Today the standard materials for consolidation seem to be acrylic resins. The reversibility of all consolidating and impregnating substances as well as their effect and stability are discussed.
ICCROM(02882600)

30-S1012.
Schmitzer, Werner.
Restoration of Chinese and Indonesian shadow puppets.
In proceedings. *ICOM Committee for Conservation, seventh triennial meeting, Copenhagen, 10-14 September 1984: preprints*, De Guichen, Gael; and Gai, Vinicio, Editors (1984), pp. 84/18/9-84/18/13, [Eng.].

Worn off parchment parts of the puppets are replaced by patches of new parchment, but of the same thickness as the original. Parchment used for the restoration of Chinese puppets is dyed on either side with dyestuff because these puppets are and should remain transparent. The binding medium for these dyes is an alcoholic solution of egg white, ox gall, and sugar. Damaged Indonesian puppets, which are, as a rule, coated with tempera paint and therefore waterproof, are restored by fixing the cracked paint layer with diluted egg white followed by burnishing with a hot spatula. On the other hand, crumbling paint is sprayed with diluted starch size and pressed flat. Staff

30-S1013.
Talbot, Roseline; Flieder, Françoise; and Laroque, Claude.
Etude expérimentale sur les méthodes de fixation des traces pulvérulentes.
(Experimental studies on fixatives for powdery traces.)
In book. *Analyse et conservation des documents graphiques et sonores: travaux du Centre de recherches sur la conservation des documents graphiques, 1982-1983*, (1984), pp. 65-119, [Fre.].

Study discussing fixatives susceptible to permanently fix charcoal, ink, and fragile pigment layers on graphic art. A preliminary study of books or articles is given. The causes of deterioration are discussed. Different products that can be used for the consolidation of fragile paper supports are tested and analyzed. Natural substances and synthetic resins in solution are examined.
ICCROM(02879703)

30-S1014.
Weintraub, Steven; and Greenland, *
Melville.
Field applications of stained glass
conservation techniques.

In proceedings. *Adhesives and consolidants: preprints of the contributions to the Paris Congress, 2-8 September 1984,* Brommelle, N.S., Editor (1984), pp. 199-201, [Eng.].

In Part 1, the authors were commissioned by the New York Landmarks Conservancy to develop a procedure for the consolidation of unstable paint on stained glass windows. The consolidative treatment chosen was a two-part system involving the use of a silane coupling agent (Union Carbide A-1100) and an epoxy resin (Ablebond 342-1). The silane is intended as an adhesion promoter and wetting agent for the epoxy resin that is applied in the second step of the process. In Part 2, the authors discuss the copper foil technique used by the Greenland Studio, Inc., New York, to join breaks in stained glass. The procedure is similar to that used in the late 19th century in the manufacture of stained glass windows and lamps in the United States, particularly by the Tiffany Company. See also AATA 21-1334 for reference to entire proceedings. Staff

30-S1015.
Zeskoski, Srebenska; and Smith, Monica.
The consolidation of friable frescoes.

Master's thesis. Queen's University, Kingston, 1984, [Eng. w. Eng. summary]. x, 94 p.: ill.; 28 cm., refs.

The aim of this experiment was to test and compare the effectiveness of five different consolidants for the consolidation of friable frescoes: calcium hydroxide, calcium bicarbonate, barium ethyl sulfate, methyl triethoxysilane (MTS), and tetraethyl orthosilicate. To test the consolidants, mini fresco samples were created, which imitated as much as possible the true fresco technique and composition. Each sample combined both the fresco buono and fresco secco techniques using a stable yellow ocher pigment. Half of the samples created were through repeated mistings with 5N H_2SO_4. Once degraded, all samples were then consolidated with the various consolidants mentioned above. The effectiveness of the consolidants was then tested by subjecting the samples to two basic

degradative treatments, namely, sulfuric acid mist and salt crystallization cycles using NA_2SO_4. The protective ability of the consolidants through these degradative treatments was noted by using an abrasion test and by changes in visual appearance of the samples. Of all the consolidants tested, MTS gave the best performance. When used in double application, MTS protected both true fresco and fresco secco against salt and sulfuric acid damage. It was also noted that MTS-consolidated samples showed minimal change in visual appearance.
 ICCROM(04441400) and A.A.

30-S1016.
Baldini, U.; and Boni, S.
Restauration d'une miniature de Fra
Angelico à Florence.
(Restoration of a miniature by Fra Angelico in Florence.)

Conservation restauration, no. 3, pp. 10-11, (1985), [Fre.].

Conservation and restoration report on a 15th-century tempera miniature on parchment by Fra Angelico. The removal of the miniature from the wooden support and its consolidation are described.
 ICCROM(03237801)

30-S1017.
de Bournet, Natalie.
Approche théorique du refixage.
(Theoretical approach to refixing.)

Master's thesis. Institut français de restauration des oeuvres d'art, Paris, 1985, [Fre.]. iii, 70 p.: ill.; 30 cm., refs.

Such alterations as powdering, curling up, detachments imply the need for refixing, i.e., a conservation treatment using adhesives to reestablish the degraded mechanical stability of a painting, allowing it to overcome the constraints of its environment, while preserving its specific, matte, rich, flexible, characteristics. There are two basic types of intervention, temporary and permanent fixations. The latter only are the subject of this contribution to the theoretical approach to refixing, intended to better understand the balance of forces and constraints commonly present in the work, and its behavior as well as that of the treatment materials during implementation. The studied paintings' components are

as follows: for the paint layer, drying oils and pigments; for the underlayer, proteinic glue, calcium carbonate, drying oils, loads; for the support, wood or canvas, in a good state of preservation. The permanent fixative consists of an adhesive, its diluent, and necessary adjuvants. The first part analyses the forces that ensure the integrity of the work and the conditions that bring about the degradation of the paint layer and of the support. The second part examines the behavior of the treatment materials and their compatibility with the work's. Three adhesives are used as illustration: polyvinyl alcohol, emulsified polyvinyl acetate, methyl acrylate and ethyl methacrylate copolymer. The third part surveys the general properties required from refixing adhesives, with considerations of temperature, relative humidity, and pressure changes. M.B.

30-S1018.
Friend, Susanne E.
History, technology and conservation of dry media.

Technical report. Smithsonian Institution. Conservation Analytical Laboratory, Washington, DC, 1985, [Eng.]. 25 p., refs.

This seminar deals with dry media, defined as those media with which a drawing or painting may be made without a chemical vehicle. A binder is present primarily to hold the medium in the shape of a drawing tool. Drawings or paintings made with dry media depend upon roughness of the support or ground to file pigment off the drawing tool. The pigment lies on the surface, adhering by mechanical or physical forces. The degree of adhesion depends upon the nature of the support, pigment particle size, and the pressure applied to make the stroke. Therefore dry media are easily smudged and abraded. Though mechanically they are fragile, they are in many ways more stable than media using liquid vehicles since they are not subject to the same chemical alterations. The author discusses these aspects with respect to metal point, pencil, charcoal, chalk, and pastel; the first four are covered briefly with only history and technology and a few points on conservation. Pastels are emphasized, since they pose more problems for conservators and the other media share similar defects.
 C.A.L.

30-S1019.
Ghillis, Alexandru.
Evaluarea unor sisteme adezive utilizate la consolidarea structurii picturilor degradate. Cinetica de consolidare (I). (The evaluation of some adhesive systems utilized in the consolidation of paintings. The kinetics of consolidation (1).)

Revista muzeelor si monumentelor: Muzee, 1985, no. 1, pp. 48-57, (1985), [Rum. w. Fre. summary]. 2 diagrams, 13 refs.

The importance of consolidation in the treatment of paintings is discussed. A classification of adhesive systems, based upon the chemistry of the reactions, is put forth: solvent type systems (natural and synthetic); solvent type heat-activated systems (natural and synthetic); hot-melt systems (natural and synthetic); and thermosetting systems, free of solvents. Criteria for selecting the optimal system of consolidant and adhesive are presented. A.G.(A.A.)

30-S1020.
Ghillis, Alexandru.
Evaluarea unor sisteme adezive utilizate la consolidarea structurii picturilor degradate. Cinetica de consolidare (II). (The evaluation of some adhesive systems utilized in the consolidation of paintings. The kinetics of consolidation (2).)

Revista muzeelor si monumentelor: Muzee, 1985, no. 2, pp. 36-46, (1985), [Rum. w. Fre. summary]. 15 refs.

Specific adhesive systems are evaluated. The solvent-type adhesive systems include egg yolk (or egg yolk and white or a mixture with other natural and synthetic adhesives); casein glues, transparent calcium caseinate; dispersions/emulsions, and solutions of poly-(vinyl acetate), poly(vinyl alcohol), and acrylics, either aqueous or in organic solvents. The gelatin or fish (sturgeon) glue solutions are included in the category of the solvent type heat-activated system (natural) because the adhesive can be applied only as a hot fluid, congealing at room temperature. The advantages and disadvantages of these adhesives are discussed. The detrimental effects of aqueous vehicle on cellulose materials or the inefficiency of wetting hydrophobic painted surfaces are major considerations in selecting an adhesive system. A.G.(A.A.)

30-S1021.
Ghillis, Alexandru.
Evaluarea unor sisteme adezive utilizate la consolidarea structurii picturilor degradate. Cinetica de consolidare (III). (The evaluation of some adhesive systems utilized in the consolidation of paintings. The kinetics of consolidation (3).)

Revista muzeelor si monumentelor: Muzee, 1985, no. 3, pp. 32-42, (1985), [Rum. w. Fre. summary]. 7 refs.

This third part of a series on adhesive systems presents an evaluation of solvent type heat-activated adhesive systems (synthetic), stressing Gustav A. Berger's research on Beva adhesives, particularly Beva 371. Covidez C.P. gold, an equivalent of Beva 371, was formulated for this testing. Hot-melt adhesive systems are also evaluated in terms of their advantages and disadvantages. Thermosetting systems free of solvents are also assessed briefly including adhesives such as polyester resins and epoxy resins, particularly as they are used to consolidate painting supports of glass, wood, and canvas.
A.G.(A.A.)

30-S1022.
Higuchi, Seiji.
Saishiki kibori zo hozon shufuku shori ni tsuite. Jutaku kenkyu hokoku dai 54-go. (Reattaching thick color layer of polychrome wooden sculpture.)

Hozon kagaku, 24, pp. 85-94, (1985), [Jpn. w. Eng. summary].

Many polychrome wooden sculptures in the Edo period are coated with thick undercoats of shell white in animal glue. This type of color layer is not stable and often peels off. It has been a custom to repaint the polychrome sculptures because of the difficulty of consolidation. This study reports a new mixture of solvents for applying Paraloid B-72 in p-xylen (nonpolar solvent). It was diluted to 25-30% by adding ethyl alcohol (polar solvent). The solution becomes tacky more rapidly than the same solution in a nonpolar solvent. Several minutes after injection of the solution, it can be tacky enough for reattaching thick paint and the shell white layer. A wooden sculpture owned by Jokoji temple,

Katsushika, Tokyo, was repaired by this method.
A.A.

30-S1023.
Lee, David J.; Bacon, Louise; and Daniels, Vincent.
Some conservation problems encountered with turmeric on ethnographic objects.

Studies in conservation, 30, no. 4, pp. 184-188, (1985), [Eng. w. Fre. + Ger. summaries].

Turmeric used as a dye or pigment on ethnographic objects turns from yellow to red-brown in alkaline conditions. Great care must be taken with cleaning, consolidation, repair, storage, and display of objects of this nature. Analytical methods to identify the dye were tested and compared.
ICCROM(03218105) and A.A.

30-S1024.
Masuda, Katsuhiko; and Higuchi, Seiji.
(Reattaching color layers on a wooden wall and documenting the distribution of damages.)

Hozon kaguku, 24, pp. 95-103, (1985), [Jpn. w. Eng. summary].

Fixing and reattaching treatment was done for the mural painting on a wooden wall (approximately 5 x 6 m) inside the main hall of Hasedera Temple, Sakurai city, Nara prefecture, after investigation followed by some test treatments on the color layer. The color layer is severely detached, fragile but not curled. On account of the dimension of the wall, the limited time for treatment and the severe environmental conditions, injection of a concentrated Paraloid B-72 solution was employed because of its strong and stable adhesiveness between color layer and wooden support. Fixing the color layer and urushi foundation layer was also expected. The treatment started by spraying water, and thin Japanese paper was applied with a dampened brush to protect and hold the color. A 15-20% solution of Paraloid B-72 in P-xylene was injected to the underside of the color layer by piercing with the needle of the injector through the paper and the color layer. The injected portion was then pressed down with a paper pad which was wetted by a mixture of acetone and diacetone alcohol. The paper was removed by brushing with the mixture. In order to observe the distribution of damages on the wall painting, 100

shots each of raking light photos and flat light photos were necessary to cover the wall, because there was no space in front of it. The photos were synthesized. Threads sectioning the wall are helpful to synthesize the photos. The damages were traced on transparent films from the photos. Three drawings on the films were used (picture, missing parts, detached parts) for making seven kinds of copies by a single, or a combination of, films.

A.A.

30-S1025.
Rainer, Florian.
Restaurierung eines Prunkschildes von den Salomonen.
(Restoration of a ceremonial shield from the Solomon Islands.)

Restauratorenblätter, **8,** pp. 112-120, (1985-1986), [Ger.].

One of about 20 known examples of Oceanic ethnographic shields presumably came in 1858 to Vienna; it now belongs to the Ethnographic Museum. The face of it consists of painted mat work with a mosaic of square mother-of-pearl fragments of nautilus shell stuck into a brownish cement. A preliminary scientific analysis showed that about a 12% loss of mosaic was due to the reduction of protein at the backside of the shell pieces. The cement proved to be made from the black pigmented mass of the local *parinarium* nut. Different glues of low viscosity were tested for fixing and filling losses, with the addition of new mosaics without further retouchings. The materials selected for use were silicone gum (Elastosil A 33), poly(vinyl acetate) emulsion (Planatol BB superior) and hydroxypropyl cellulose (Klucel Hf 10% with isopropanol) for mat fixing of loose pigments.

Staff

30-S1026.
Das, A.C.
Conservation of some non-book material in National Library, Calcutta.

Conservation of cultural property in India, **18-20,** pp. 14-21, (1985-1987), [Eng. w. Eng. summary].

Describes deinfestation, deacidification, and consolidation procedures for paper and for paintings on paper and mica plates, as well as on palm leaf artifacts. Weakened map papers are coated with gelatine, bedacryl, or cellulose acetate in acetone. Poly(vinyl acetate) and poly(methyl acrylate) are used to consolidate flaking paint. Cellulose acetate and citronella oil are used to fix inks and weakened or brittle supports are laminated using nylon gauze adhered with carboxymethyl cellulose. Preventive treatments are also outlined.

A.A.

30-S1027.
Vozil, Iren.
Restoration and display of Egyptian stucco mummy masks from the period of the Roman Empire.

In proceedings. *Fifth international restorer seminar = Fünftes internationales Seminar für Restauratoren: Veszprém, Hungary, 29.6-9.7, 1985,* Eri, Istvan; and Sarkozy, Gabriella, Editors (1985?), pp. 227-236, [Eng.]. 13 refs.

A report on the restoration of stucco masks from the Fayum region, now in the collections of the Hungarian Museum of Fine Arts. The composition of the stucco and the pigments was analyzed, and the fragments were cleaned with alcohol, consolidated with Paraloid B-72 in toluene, and rejoined with poly(butyl methacrylate).

ICCROM(03298930)

30-S1028.
Baker, Robert.
Conservation of English Medieval wallpaintings over the century.

In book. *Conservation of wall paintings: the international scene,* Burman, Peter, Editor (1986), pp. 28-31, [Eng.].

A history of the changes in attitudes towards Medieval mural paintings in England over the past century. They were indiscriminately destroyed first by the Reformation then by post-Reformation architects in an attempt to reveal the structural history of the buildings. Paintings were not appreciated until the 1860s and 1870s. Great damage was also done by modern restorers, through the use of varnish and wax cement and intermittent heating.

ICCROM(03540105)

30-S1029.
Chandler, David.
Edgar Degas in the collection of the Art Institute of Chicago: examination of selected pastels.

The Book & Paper Group annual, **5**, pp. 74-82, (1986), [Eng.]. b/w photos.

Five of Degas's pastels were examined for condition, technique, and possibility of intervening even when the secondary support was original but perhaps damaging the artwork. Describes the conservation solutions adopted for each case. Includes black and white photographs and infrared vidicon images. ICCROM(03979507)

30-S1030.
Di Matteo, Colette.
The conservation of wallpaintings in France.

In book. *Conservation of wall paintings: the international scene,* Burman, Peter, Editor (1986), pp. 43-46, [Eng.].

The author discusses some problems of restoring mural paintings in France, and how the Service des Monuments Historiques tackles them. The work done on Berze-la-Ville church apse paintings, the Chapelle St.-Laurent apse paintings, fresco in the 18th-century church of Cordon, the cathedral of Autun, and the church of Saint Jacques-des-Querets are used as examples. ICCROM(03540109)

30-S1031.
Keene, Suzanne.
Some adhesives and consolidants used in conservation.

The geological curator, **4**, no. 7, pp. 421-425, (1986), [Eng.]. 11 refs.

A general introduction to the nature of adhesives and consolidants for the nonspecialist. What is required of these materials is placed in the context of conservation aims. A short list of adhesives and consolidants used in archaeological conservation is provided together with desirable and undesirable properties and uses.
ICCROM(03618205) and G.St.

30-S1032.
McKay, Gina; and Lodge, Robert.
Removing severe distortions in a pastel on canvas.

The paper conservator: journal of the Institute of Paper Conservation, **10**, pp. 24-26, (1986), [Eng. w. Fre. summary]. 7 ill.

A large pastel portrait on canvas of Marie-Antoinette by Vigée-Lebrun was treated to remove severe distortions. Limitations in handling the delicate surface of the pastel required an interdisciplinary approach involving techniques used in paintings and paper conservation. Mounting onto an oversize strainer using Pellon applied to the tacking edges with a heat-seal adhesive [not described] was carried out prior to humidification on a cold-lining suction table. The so-called Dutch method of applying strips of Kraft or cartridge paper to the edges of the pastel with wheat starch paste, while it was still attached to the stretcher with Pellon, was also tried. Damp felt was applied to the verso to prevent drying out. Much of the cockling was pulled out by these two methods. The remaining distortions were removed by attaching *Okawara* [machine-made Japanese paper] to the reverse of the canvas and the strainer by spray moistening and wheat starch paste. After distortions were removed the *Okawara* was allowed to remain as a lining support for the pastel. D.T.

30-S1033.
Mora, Laura; and Mora, Paolo.
Ispezione sullo stato dell'arte: materiali comunemente disponibili sul mercato ed impiegati per intonaci e colore.
(Inspection of the state of the art: materials commonly available on the market and employed for renderings and paint.)

Bollettino d'arte, pp. 115-118, (1986), [Ita.].

Guidelines for conservation of historic renderings and paints. Diagnosis of rendering deterioration. Consolidation, repair, renewal of building renderings and the requirements of restoration mortars. Fundamentals for the restoration of architectural color, with illustrations of Roman examples. The case of S. Michele is discussed in detail.
ICCROM(03569519)

30-S1034.
Neagoe, Ion.
Specific problems concerning the restoration of wall paintings at Humor.

In book. *Conservation of wall paintings: the international scene,* Burman, Peter, Editor (1986), pp. 72-73, [Eng.].

A report on some aspects of the fixing and cleaning methods used during the pilot workshop at Humor (1972-75), organized by the Directorate of Historic Monuments and ICCROM to undertake research with the aims of establishing a single method of mural painting conservation, beginning restoration work on the wall paintings of Humor Church, and forming a nucleus of Romanian restorers. ICCROM(03540115)

30-S1035.
Cedillo Alvarez, Luciano.
Stucco: a report on the methodology developed in Mexico.

Affl: Instituto Nacional de Antropología e Historia (Mexico), Mexico City, Mexico.

In proceedings. *In situ archaeological conservation: proceedings of meetings, 6-13 April 1986, Mexico,* Hodges, Henry W.M., Editor (1987), pp. 90-97, [Eng.]. 3 figs., 2 notes, refs.

Describes the work done in Mexico in stucco conservation, the term stucco referring to mixtures of lime compounds and sand or other additions. It is an ever-present surface coating of much Mesoamerican archaeological structures. The vast quantity of material that needs preservation is one of the main difficulties in this field. Another is the wet tropical climate. An early measure to preserve stucco was to build shelters for protection against sun and rain. The modern methods include resurfacing and binding; injecting mixtures to fill cavities; consolidation; fixing the polychromy; applying biocides. Their applications are described, and proposals for alternative solutions offered. Staff

30-S1036.
De Witte, Eddy.
Vieillissement naturel et artificiel des produits synthétiques comparé à celui des produits naturels.
(Natural and accelerated aging of synthetic products compared with that of natural products.)

In book. *Kunststoffe in der Konservierung und Restaurierung von Kulturgütern: Seminar 28-30 November 1985 in Bern = Produits synthétiques pour la conservation et la restauration des oeuvres d'art: séminaire 28-30 novembre 1985 à Berne,* (1987), pp. 87-97, [Fre.].

Degradative factors of synthetic materials (homopolymers, copolymers), such as ultraviolet and visible radiation, oxygen, temperature, and mechanical stress are discussed. There is also an explanation of how production changes in Paraloid B-72 were discovered, and their implications for restoration use. ICCROM(03675705)

30-S1037.
Espinosa, Agustín.
Conservation and restoration of the murals of the Temple of the Paintings in Bonampak, Chiapas.

Affl: Instituto Nacional de Antropología e Historia (Mexico), Mexico City, Mexico.

In proceedings. *In situ archaeological conservation: proceedings of meetings, 6-13 April 1986, Mexico,* Hodges, Henry W.M., Editor (1987), pp. 84-89, [Eng.]. fig., ref.

The importance, location, access to, and contents of the Temple of the Paintings at Bonampak are described. An historical account of the discovery of this Mayan temple with completely painted interior walls and vaults is followed by the report of successive interventions supported by UNESCO. When experts assessed the state of deterioration of the true fresco, decisions to transfer the paintings were made but could not be implemented. The adobe walls supporting the paintings were then found to need consolidation. In 1974 an international meeting took place in the Bonampak archaeological zone. The interest of a broad spectrum of specialists was renewed in 1984. The causes of deterioration were assessed; the cleaning and consolidation attempts performed since then are described in detail, and results presented. Staff

30-S1038.
Fuchs, Robert.
Nolite manuscripta cruciare sed conservate potis. Uberlegungen zur Konservierung mittelalterlicher Buchmalerei.
(Nolite manuscripta cruciare sed conservate potis. Considerations on the preservation of Medieval miniatures.)
Maltechnik-Restauro, **93,** no. 2, pp. 39-46, 48-49, (1987), [Ger.]. 5 photos., 1 ill., 18 refs.

To develop efficient techniques for the preservation of miniature paintings, the materials have to be studied in detail. As pigments, for instance, powdered minerals, vegetable material, insects, snails, and artificially prepared products were used and applied with different media. Chemical analysis has to determine the materials and, from the information obtained, new techniques of preservation can be worked out. Staff

30-S1039.
Guillemard, Denis.
Conservation des couches pigmentées pulvérulentes de Mélanésie: choix d'un fixatif.
(Conservation of powdering pigment layers on Melanesian objects: choice of a fixative.)
In proceedings. *Journées sur la conservation, restauration des biens culturels: recherches et techniques actuelles: Paris, 15-16 octobre 1987,* (1987), pp. 132-136, [Fre.]. graphs, refs.

The great variety of materials to be found in Melanesian art is described. The greatest conservation problem is that of consolidating powdery pigment layers. It is not easy to choose a consolidant or to use it. Often different colors will behave differently on the same item, even with respect to the solvent alone. Tests were conducted on six synthetic resins: a ketone resin (Laropal K80); two vinyl derivatives (Rhodopas B and Elvax 150); two acrylic resins (Paraloid B-72 and Plexisol P 550); and a cellulosic ether (Klucel G). None of the resins gave entirely satisfactory results, all causing a modification in color. The worst was Laropal. Although not perfect, the best seemed to be Klucel G in acetone solution, although its high viscosity was a handicap. It is suggested that admixture with Paraloid B-72 would improve matters. A mixture at 2% did seem better. It is

concluded, however, that improvements in conservation storage would be the best answer. ICCROM

30-S1040.
Higuchi, Seiji; and Okabe, Masako.
Fixing agent for chalking color on wood and its laboratory evaluation.
Hozon kagaku, **26,** pp. 15-21, (1987), [Jpn. + Eng. w. Eng. summary].

The following fixing agents were tested in various concentrations for preventing chalked colors on wood from exfoliation: funori or Gloiopeltis, sanzenbon nikawa or cow hide glue, water-soluble acrylic resin Binder 18, acrylic aqueous emulsion Primal AC 34, and acrylic resin Paraloid B-72 in organic solvents. Test pieces of chalked colors on wood were prepared by applying shell white and yellow ocher without adhesive on Japanese cypress. Fixing agents were applied by pipette. A peeling test employed pressure sensitive tape. Test pieces were kept in a weathering chamber for 600 hours. Evaluation criteria were color change, peeling strength, and weathering endurance. Funori was best for color change and peeling tests, but was worst in weathering endurance. Water-soluble acrylic resin (acrylic resin sol), and acrylic emulsion gave good results in the peeling test and weathering endurance, but had greater color changes. In general, aqueous agents showed good results, while agents in organic solvent gave poor results.
 Staff

30-S1041.
Joyce, Sarah.
Chiriquano masks: polychrome wood (treatment and inquiry).
Ethnographic conservation newsletter, no. 3, p. 14, (1987), [Eng.].

Bolivian Chiriquano masks, carved from toboroche tree wood (similar to balsa) are covered with white (gypsum) and black (wood ash or cinders) decoration. Flaking of the surface layers is a serious problem because every movement of the wood causes further loss. Consolidation was needed and gelatin (2.5 g in water) seemed to give the best results, at least on the white areas. The black areas changed color and developed a sheen, so that an alternative to the gelatin is

Treatment

being sought. Black and brown algae (*chryso-phyceae*) were found on the surfaces and brushed off. O-phenol is being tested for use before the gelatin consolidation.

ICCROM(03621403)

30-S1042.
Reeve, B.H.C.
The conservation of an orator's stool from Papua New Guinea.

ICCM bulletin, **13,** no. 3-4, pp. 89-106, (1987), [Eng.]. photos.

Report on the restoration of an orator's stool, a cult figure used during the delivery of ceremonial speeches by the Iatmul people of Papua New Guinea. As the wood's condition was stable, the treatment involved mainly the decorative elements of the figure's mask. Cleaning, readhesion, or consolidation and repair of each element are described in detail; the most complicated treatment was that of the hair. A new grass skirt was made. The treatment illustrates the occasional variances between ideal museum practice and customer satisfaction for the conservator in private practice; in this case, a commercial requirement was achieved.

ICCROM(03739808)

30-S1043.
Richardin, Pascale; and Bonnassies, Sylvette.
Etude du Plexigum P24 utilisé comme fixatif des traces pulvérulentes.
(A study of Plexigum P24 used as a fixative for flaking paint traces.)

Nouvelles de l'ARSAG et du Groupe documents graphiques du Comité de conservation de l'ICOM, no. 3, p. 8, (1987), [Fre.].

Two materials for fixing flaking ink, pigments, etc., on paper were studied: Elvamide 8061 and Plexisol P550. The latter is, unfortunately, dissolved in a solvent (boiling point 100-140° C), and its characteristics and effects on paper are not known. Another acrylic resin, Plexigum P24, a poly-n-butyl-methacrylate, was to prepare known solutions. Testing (four days at 80° C and 60% RH, and exposure to a mercury vapor lamp) allowed the recommendation of the use of this resin for fixing flaking paint.

ICCROM(03697202)

30-S1044.
Sease, Catherine.
A conservation manual for the field archaeologist.

Book. Archaeological research tools, no. 4, University of California, Los Angeles. Institute of Archaeology, Los Angeles, 1987, [Eng.]. xii, 169 p.: ill.; 28 cm., bibliog., index. [ISBN 0-917956-59-1].

A manual aimed at field archaeologists, providing them with the basic conservation techniques necessary to safeguard and protect artifacts from the moment they are excavated until they reach the conservation laboratory. Gives advice on safe use of chemicals and on the supplies and materials required. Describes general treatment techniques, such as record keeping, handling, lifting, bandaging, backing, consolidation, marking, joining, packing, storage, and transport. Outlines techniques for 36 specific materials.

ICCROM

30-S1045.
Walston, S.; Horton-James, D.; and Zounis, S.
Investigation into methods and materials for the adhesion of flaking paint on ethnographic objects: a progress report.

In book. *ICOM Committee for Conservation, eighth triennial meeting, Sydney, Australia, 6-11 September, 1987: preprints,* Grimstad, Kirsten, Editor (1987), pp. 833-841, [Eng. w. Eng. summary]. 22 notes.

A method has been developed for the adhesion of flaking paint on ethnographic artifacts using water-based adhesives. These have a distinct advantage over solvent-based resins in that they cause much less darkening of paint, particularly when used with matte, porous paint typical of Oceanic painted artifacts. Since the formulation of many water-based resins, particularly emulsions and dispersions, is more complex and potentially less stable than pure resins, thorough testing is needed before resins can be selected and used with confidence. Testing and evaluation procedures have been designed to predict the performance, appearance, and aging characteristics of resins being considered for the adhesion of flaking paint. Both quantitative and subjective evaluation procedures are used. Where possible, resins are evaluated in combination with painted wood facsimiles of

artifacts, rather than in isolation, to enable the assessment to be made under conditions that relate more directly to the way resins are actually used in conservation. Resin application, sample preparation, and accelerated aging techniques are described, as well as progress on tests to be used to assess appearance, pH, flexibility, adhesion, stability, and the effect of temperature on the performance of resins. A.A.

30-S1046.
Walston, S.; and Gatenby, S.
A preliminary evaluation of acrylic emulsions for the adhesion of flaking paint on ethnographic objects.

Ethnographic conservation newsletter, no. 4, pp. 12-17, (1987), [Eng.]. 1 table, refs.

Acrylic emulsions were evaluated for the purpose of adhering flaking paint on ethnographic objects. Although a suitable material was not found, it is thought that the sequence of tests carried might be useful for other conservators. The properties investigated were as follows: resin application—working properties; accelerated light aging tests (with solubility and color changes monitored); flexibility and surface tension. The materials tested were Primal AC-22, Primal AC-235, Primal AC-6501, Acronal D-300, with Paraloid B-72 (good) and Neocryl B700 (bad) as the resin controls. ICCROM(03698002)

30-S1047.
Domaslowski, W.
The mechanism of polymer migration in porous stones.

Wiener Berichte über Naturwissenschaft in der Kunst, **4/5**, pp. 402-425, (1987-1988), [Eng. w. Eng. + Ger. summaries]. 12 figs., 10 refs.

Reports the results of investigations on the migration of thermoplastic resins to the surface pores of impregnated stone. The causes of migration were evaluated as well as the conditions which allow to reduce this undesirable effect. It has been stated that the effect of resin migration depends on the quality of solvents, dimensions of resin molecules, solution viscosity, stone structure, and the conditions of drying after impregnation. The best results were obtained for poly(methyl methacrylate) of medium molecular weight. Less promising results were noticed for Para-

loid B-72 which is subjected to partial migration in fine-porous stones (porous limestone) and is not suitable for the consolidation of coarse-porous material (sandstones).
 A.A. and M.K.

30-S1048.
Bourret, Jean-Claude.
Restauration de plafonds peints en Oman: le fort de Jabrin.
(Restoration of painted ceilings in Oman: the Jabrin fortress.)

ICOMOS information, no. 1, pp. 17-25, (1988), [Fre. w. Eng., Spa. + Ita. summaries]. photos., drawings, maps, refs.

Describes the restoration of the painted ceilings in the fort of Jabrin, a late-17th-century building, located in an oasis in a mountainous semidesert area in central Oman. Restoration included repair and consolidation of the beams, treatment of wood against insects and fungi, and restoration of the painted decoration. Preliminary analysis of paint samples allowed the identification of the original painting technique and materials. Similar materials (gum arabic as binder and mineral pigments) were used in the restoration.
 ICCROM(03837103) and A.A.

30-S1049.
Brichzin, Ulrike.
Die Restaurierung indonesischer Wayang-Figuren in Staatlichen Museum für Volkerkunde Dresden.
(Restoration of Indonesian Wayang-figures in the National Ethnographical Museum of Dresden.)

In proceedings. *Conservation, restoration of leather and wood: training of restorers: sixth international restorer seminar, Veszprém, Hungary, 1987*, Eri, Istvan; and Sarkozy, Gabriella, Editors (1988), pp. 241-248, [Ger.].

The Dresden Museum of Ethnography has some 250 silhouette-figures in its collection, mainly obtained in the 19th century. The parchment base of the Wayang figures is painted and gilded. Analysis of the figures identified the binding medium as well as the painting materials. The author describes several methods for the conservation and restoration of the figures. So far, 20 pieces of the collection have been restored. The iconography of the Wayang figures is discussed, as

well as criteria for proper storage and treatment. Staff

30-S1050.
Gesell, B.
Restoration of Shipibo pottery.

In proceedings. *Symposium '86: the care and preservation of ethnological materials: proceedings = L'entretien et la sauvegarde de matériaux ethnologiques: actes*, Barclay, R.; Gilberg, M.; McCawley, J.C.; and Stone, T., Editors (1988), pp. 39-40, [Eng. w. Eng. + Fre. summaries]. 4 b/w photos.

Shipibo pottery presents a number of conservation problems. It is very thin-walled and fired at a low temperature, while to provide waterproofing, the interiors of vessels are coated with natural resin. Techniques are described here for reflowing the resin in areas of loss using ethanol or shellac, reassembling fragmented vessels with a baker's gelatin adhesive, infilling with Keramiplast modeling clay, and inpainting with watercolors. A.A.

30-S1051.
Hanna, Seamus; Lee, Nicholas; and Foster, Geoffrey.
Three Bodhisattvas: the conservation of a fifteenth century Chinese wall painting in the British Museum collection.

In book. *Conservation today: papers presented at the UKIC 30th Anniversary Conference, 1988*, (1988), pp. 130-134, [Eng. w. Eng. summary]. 1 map, 2 tables, 9 figs., list of materials, scientific appendix.

Starts with information on the date and provenance of this large (4.3 x 4 m) wall painting acquired in 1927 by the British Museum. Describes the main characteristics of the technique and its past treatment, involving dismantling at time of acquisition, remounting, and subsequent cleaning with Paraloid B-72 in xylene. When it became necessary to dismantle and relocate the painting, the panels were carefully examined, protected, separated, and enclosed in plywood boxes with removable lids for further, more thorough cleaning. Areas with flaking and cupping paint were treated with Raccanello acrylic silane E55050, and small gaps filled with Vinacryl R40224 acrylic emulsion. The friable areas of the clay straw render were consolidated with a poly(vinyl butyral) solu-

tion, also used to inject into gaps of the underlying render. Assembly and reintegration are detailed as well. The panels are now well preserved, their condition is monitored, and they are accessible to researchers and the public. ICCROM(03975037) and M.B.

30-S1052.
Hanna, Seamus B.; and Lee, Nicholas J.
The consequences of previous adhesives and consolidants used for stone conservation at the British Museum.

Affl: British Museum. Department of Conservation, London, UK.

In book. *Early advances in conservation*, Occasional paper (British Museum), no. 65, Daniels, Vincent, Editor (1988), pp. 89-102, [Eng. w. Eng. summary]. ill., refs.

During this century various adhesives and consolidants have been used on stone objects from the vast collection in the British Museum. Adhesives have included shellac, cement mortars, plaster of Paris, nitrocellulose, epoxies, and polyesters. The consolidants have been nitrocellulose, water-glass, soluble nylon, polyethylene glycol wax, and vinyl acetate. Some of these materials and their methods of application have proved successful, whereas others with the passing of time, have been less satisfactory. Problems of decay have in some cases been exacerbated, resulting in serious deformation of the upper surface and loss of carved detail. Examples of such deterioration and the evidence of previous treatments are illustrated. This paper evaluates the materials used and records the physical effects on various types of stone. Practical methods to remove old adhesives and consolidants and introducing a new consolidant following previous treatment are also described. A.A.

30-S1053.
Hatchfield, Pamela.
The use of cellulose ethers in the treatment of Egyptian polychromed wood.

In proceedings. *Conservation of ancient Egyptian materials: preprints of the conference organised by the United Kingdom Institute for Conservation, Archaeology Section, held at Bristol, 15-16 December 1988*, Watkins, Sarah C.; and Brown, Carol E., Editors (1988), pp. 71-78, [Eng.].

Describes a major investigation into the conservation needs of Egyptian polychromed wooden artifacts in preparation for exhibition which includes: the history of the Egyptian collection of the Museum of Fine Arts in Boston; composition of Egyptian polychromed wooden artifacts; role that the manufacturing technique has in mitigating against dimensional changes; tests that can be used to identify binders; effects that previous conservation treatment methods and materials have had on the condition of objects and their influence on subsequent treatment systems. Following cleaning and partial removal of earlier unsatisfactory treatment materials, two cellulose ethers were selected, Klucel G and Culminal MC3000. Describes in detail why these materials were selected and how they were applied to stabilize powdering and flaking paint.

30-S1054.
Havaux, Cecilia Rangel.
Investigación, conservación y restauración de la técnica pictorica al pastel.
(Investigation, conservation and restoration of the pastel painting technique.)
Book. Instituto Nacional de Antropología e Historia. Escuela Nacional de Conservación, Restauración y Museografía 'Manuel del Castillo Negrete,' Mexico City, 1988, [Spa.]. 229 p., bibliog.

This thesis for the Master's degree in conservation and restoration of movable objects consists of the following section and chapter headings: 1) Historical and aesthetic review. 2) Pastel technique: application technique; manufacture of the sticks; supports; agglutinants; pigments; fixatives; oil pastel; the practice of pastel in Mexico. 3) Interview with six painters who presently work in pastel in Mexico: Fernando Leal Audirac, Martha Orozco, Myra Landau, Perla Krauze Broid, Joy Laville, Oliverio Hinojosa. 4) Intervention processes on a pastel painting: photographic processes; scientific processes. 5) Causes, prevention, and solution to the deterioration of a pastel painting: causes of deterioration and its effect on the paper; on the pictorial layer; prevention; solution; report on the intervention on a pastel work. 6) Lighting and assembly on a support. Conclusions, annexes on pigments and palettes; fixatives; main types of fungus on archive materials. M.B.

30-S1055.
Lee, David J.
Some early examples of the conservation of Maori wood carvings in the collections of the British Museum.
Affl: British Museum. Department of Conservation, London, UK.

In book. *Early advances in conservation,* Occasional paper (British Museum), no. 65, Daniels, Vincent, Editor (1988), pp. 157-166, [Eng.].

Before the formation of the Department of Conservation in 1975, the conservation of objects was carried out by staff attached to the various antiquities departments. In the Department of Ethnography a considerable amount of restoration and cleaning of Maori artifacts was done by museum assistants and technicians even before the formation of the conservation grades within the Museum Service. This text describes early examples of conservation treatments. Some wood carvings had been badly damaged by wood-boring insects, and there were breakages due to the loss of mechanical strength of the wood Other examples had been heavily varnished, possibly during the early years of this century, with a thick brown shellac varnish that now obscures the fine detail of the carving, the ocher-painted surfaces, and the shell inlay. Most early conservation methods are unrecorded and the present visible evidence is the only clue to the treatment given to the objects. Records appear to have been kept from the late 1950s. C.A.L.

30-S1056.
Lee, David John.
The removal and conservation of the painted bark (palm leaf petiole) panels and carved figures from a Papua New Guinea "Haus Tambaran."

In proceedings. *Symposium '86: the care and preservation of ethnological materials: proceedings = L'entretien et la sauvegarde de matériaux ethnologiques: actes,* Barclay, R.; Gilberg, M.; McCawley, J.C.; and Stone, T., Editors (1988), pp. 23-29, [Eng. w. Eng. + Fre. summaries]. 6 figs., 13 refs.

In 1980 the British Museum sent D. Starzecka of the Ethnography Department (Museum of Mankind) and D.J. Lee, of the Conservation Department, to the Wosera-Abelam

area of the Maprik district of the East Sepik province to collect the figures and panels from a Haus Tambaran. These carved and painted figures and the painted panels had been made for an initiation ceremony about 1975. Since that time they had been virtually abandoned to nature; some figures had been damaged by termite attack. Explains the problems of packing the figures and panels, and describes the identification of timbers and fragments, and conservation treatments on return to the conservation laboratory. Also included are a short note on storage, and information for those making ethnographic collecting visits to the Tropics.

A.A.

30-S1057.
Mishra, Mamta.
Restoration of three miniature paintings with a problem of colour change.

In book. *Restoration of Indian art: some case studies. Volume 1,* Agrawal, Om Prakash; and Agrawal, Usha, Editors (1988), pp. 56-62, [Eng.]. 6 figs.

Conservation of three miniature paintings in gouache technique with very fine detailed brushwork, suffering from color changes in body color and some other areas. The pigments were found to be lead oxide-based. An unspecified reduction process was found to change the colors back to the original tones (yellow, red, white, green). Deacidification was carried out using barium hydroxide/methanol. Paper repairs were removed using rectified spirit/water at 80:20. The paintings are now kept wrapped in tissue paper. ICCROM(03946211)

30-S1058.
Neely, James A.; and Storch, Paul S.
Friable pigments and ceramic surfaces: a case study from SW Iran.

Journal of field archaeology, **15,** no. 1, pp. 109-114, (1988), [Eng. w. Eng. summary]. 2 figs., 1 photo., 22 refs.

Describes the analysis, identification, and consolidation of friable pigments on the surface of prehistoric ceramic sherds from the Near East. Light microscopy (polarized), scanning electron microscopy (SEM), and x-ray diffraction (XRD) analysis were used for characterization and identification pur-

poses. A cleaning method using a sequestering agent was developed to allow for clearer XRD analysis results. Several types of thermoplastic resins were tested as consolidants. Acryloid B-72 (Rohm and Haas) was chosen for its fast drying time, ease of application, stability, and adhesive properties in low concentration solutions. Staff

30-S1059.
Schott, Franz Leonhard.
Eglomise—technik und konservierung.
(Eglomise: technique and conservation.)
Restauro, **94,** no. 1, pp. 9-17, (1988), [Ger. w. Eng. summary]. photos., refs.

Eglomise is a special type of glass painting. Three possible variations of the technique are described before considering in detail the conservation of a 17th-century eglomise casket. The choice of a consolidant for the paint layers was particularly difficult, since whatever was applied would, in practice, be irreversible, given the fragility of the paint layer. The consolidants tested were: Paraloid B-72, Plexisol P550, poly(vinyl acetate) (Mowilith and Vinnapas) and isinglas, gelatin, albumen, dammar, and naturally bleached beeswax containing 5% larch turpentine. The last mixture was chosen for use.
ICCROM(03813101) and A.A.

30-S1060.
Smith, Leslie Melville.
When textiles are paintings.

In proceedings. *Symposium '86: the care and preservation of ethnological materials: proceedings = L'entretien et la sauvegarde de matériaux ethnologiques: actes,* Barclay, R.; Gilberg, M.; McCawley, J.C.; and Stone, T., Editors (1988), pp. 57-58, [Eng.].

Pigment-painted patterns are encountered by the textile conservator, especially on ethnographic examples. This text describes interdisciplinary treatments of paper, painting, and object conservation approaches. Case histories include: large South Pacific tapa cloths, torn and sharply folded at an unknown date which were scheduled for a loan exhibition; a series of Peruvian painted textiles analyzed before establishing a conservation program; and the treatment of various Oriental textiles of silk with gilded designs.
A.A.

30-S1061.
Vilar Brumbeck, Beatriz; and Santos Ramos, Juan.
Restauración de tres vidrios pintados.
(The restoration of three paintings on glass.)
Pátina, no. 3, pp. 49-51, (1988), [Spa.]. 5 photos.

The three paintings of the Virgin, two Saints, and a Mary Magdalene, date from the 18th century. They were executed by engraving on paper adhered to the front of the glass and colored from the back. They bore some inscriptions. The glass acts as support for the paper, while providing a protective layer and playing its own aesthetic role. These latter functions were largely lost before the intervention, but a transfer was rejected. A wax frame on a Mylar plate received the paintings, and methyl methacrylate with catalyst was applied to consolidate the cracks and fill in the gaps. Color reintegration was done by the tratteggio technique, using watercolor and varnish-based pigments. M.B.

30-S1062.
Walston, Sue; Coote, Karen; and Horton-James, David.
Ethnographic collections: case studies in the conservation of moisture-sensitive and fragile materials.
Affl: Australian Museum. Materials Conservation Division, Sydney, NSW, Australia.
In proceedings. *The museum conservation of ethnographic objects,* Senri ethnological studies, no. 23, Morita, Tsuneyuki; and Pearson, Colin, Editors (1988), pp. 69-110, [Eng. w. Eng. summary]. 18 figs., refs.

The conservation requirements of ethnographic collections vary owing to the great diversity of cultural material in different countries, and to the range of environments the collections are subjected to, from that of their manufacture and use to the museum storeroom and exhibition. This text discusses the problems of ethnographic objects from Australia and Papua New Guinea, dealing first with the acclimatization of moisture-sensitive materials. Here the advantages of computerized environmental monitoring and consolidation are discussed. Case studies are then given for the mounting of objects for both fixed site and traveling exhibitions, the

movement of large fragile objects, and finally the problems of conserving large nondurable objects. A.A.

30-S1063.
Xarrié Rovira, Josep Maria; and Borell, Angels, Editors.
Memória d'activitats del Centre de Conservació Restauració de Bens Culturals Mobles de la Generalitat de Catalunya: 1982-1988.
(Centre for the Conservation and Restoration of Movable Cultural Property of Catalonia: a record of achievements, 1982-88.)
Book. Generalitat de Catalunya. Departament de Cultura, 1988, 1st ed. [Cat.]. 293 p.: ill. (some col.); 29 cm.

A detailed record of restoration work carried out between 1982 to 1988 at the Center for the conservation and restoration of movable cultural property, Catalonia, Spain. Includes articles on the establishment of the institute, analysis of pigments and metals, documentation, the inclusion of private conservation workshops within the institute. Six separate sections cover specific restorations on painting on wood, sculptures, mural painting, paintings on canvas, archaeological and ethnographical artifacts, paper, textiles, and drawings. The final section contains a list of all works treated, a map of Catalonia, and a 38-page list of restorers. ICCROM(03996600)

30-S1064.
Baines, John; Jaeschke, R.; and Henderson, J.
Techniques of decoration in the Hall of Barques in the Temple of Sethos I at Abydos.
The journal of Egyptian archaeology, 75, pp. 13-30, (1989), [Eng. w. Eng. summary]. 3 photos.

Fragmentary paintings on the south and east walls of the Hall of Barques were studied, cleaned, and photographed in 1983 and 1988. Removal of obscuring accretions permitted study of the technique. A separate conservation report describes briefly the cleaning with EDTA and a nonionic detergent, the use of ammonia solution to remove soot patches, and consolidation using Paraloid B-72 (acrylic copolymer) resin. A separate analysis report summarizes the pigments

Treatment

identified by x-ray fluorescence (XRF), x-ray diffraction (XRD), and energy dispersive spectrophotometry. H.F.J.

30-S1065.
Castiglioni, Alfredo.
Conservazione degli intonaci esterni degradati.
(Conserving deteriorated exterior plaster coatings.)
Arkos, no. 7, pp. 20-25, (1989), [Ita. w. Eng. summary]. figs.

One of the most frequent interventions concerning the existing housing stock is the so-called restoration of the facades. This kind of intervention is often undervalued from the technical and economical point of view, both by buyers (private and public, joint owners) and by planners and plant managers, who are often unprepared to tackle the problem. These instances show the questionable result of several restorations of facades, even shortly after the execution of the work. A good diagnosis of the causes of the degradation must come first; the consolidation of the existing plaster and, if necessary or requested, the preparation of a support for the restoration of the lacunae, second. The graphs show the right and the wrong ways to intervene on the deteriorating plaster. The article is accompanied by some technical index cards concerning the specific cycles set up by Caparol. ICCROM(04430900)

30-S1066.
Duffy, Michael C.
A study of acrylic dispersions used in the treatment of paintings.
Affl: Solomon R. Guggenheim Museum, New York, NY, USA.
Journal of the American Institute for Conservation, 28, no. 2, pp. 67-77, (1989), [Eng. w. Eng. summary]. 3 tables, 15 notes, list of suppliers, 14 refs.

A series of simple tests studied the properties of five acrylic emulsion adhesives: Plextol B500, Rhoplex AC 33 and AC 234, and Lascaux 360 HV and 498 HV. Properties such as peel strength, yellowing, and solubility were investigated to assess the practicality of these products' use in the treatment of paintings with regard to their aging characteristics. A.A.

30-S1067.
Flamm, Verena; Hofmann, Christa; and Banik, Gerhard.
Die Konservierung von Kostümentwürfen zu Broadway-Musicals, 1900-1925: Aus der Theatersammlung der Österreichischen Nationalbiliothek, Wien.
(Conservation of costume designs for Broadway musicals, 1900-1925: from the drama collection, Austrian National Library, Vienna.)
Restauro, 95, no. 4, pp. 306-311, (1989), [Ger. w. Eng. summary]. 7 photos., 15 refs.

Conservation of some early 20th-century costume sketches in gouache. Mounted onto highly acidic wood pulp boards, the paper sketches had to be detached then remounted onto conservation quality board. Moisture-containing systems for remounting had to be avoided given the vulnerability of the paint. The system chosen involved prior preparation of an adhesive film, which was then reactivated using very little moisture. Adhesives used were methyl cellulose MC 400 and Tylose (NaCMC) C 300. Deacidification was carried out with Wei T'o no. 2 (solution) or 10 (spray). A considerable amount of adhesive-impregnated backing paper could be prepared at one time, and attachment, using low pressure, took about 20 minutes per sheet. Includes list of materials used. See also AATA 29-515 for republication in English. ICCROM(04070307)

30-S1068.
Göpfrich, Jutta; and Jägers, Elisabeth.
Das Verhalten von Farben auf Leder/Pergamentobjekten und die daraus resultierenden konservatorischen Probleme.
(The behavior of colors on leather and parchment objects and the resulting problems of conservation.)
In proceedings. *Internationale Leder- und Pergamenttagung = International leather and parchment symposium, vom 8. Mai bis 12. Mai 1989*, (1989), pp. 145-161, [Ger. + Eng.]. 6 photos.

A report is given on the restoration of three objects consisting of painted leather or parchment: a bishop's coat, shadow puppets from Java, and a modern painting. The main methods used were lining, mending using compatible material, and fixing the paint lay-

ers using synthetics, e.g., poly(vinyl acetate) (PVAC), acrylics, and cellulose derivatives.

ICCROM(04311014)

30-S1069.
Grattan, David.
Parylene at CCI = L'emploi du parylène à l'ICC.

Newsletter (Canadian Conservation Institute) = Bulletin (Institut canadien de conservation), no. 3, pp. 16, 18-19, (1989), [Eng. + Fre.].

Describes the use of Parylene made by Union Carbide, for the conservation of natural history specimens too fragile for any other treatment. In the Parylene process, objects to be treated are placed in a vacuum chamber, and the consolidant is heated and applied in the gas phase. The collaborative project between US and Canadian institutions into possible uses for Parylene in conservation is outlined. ICCROM(03991106)

30-S1070.
Grote, R.-J.; and Kummer, W.
Die Wand und Deckenmaloroion in den Kabinetten des Galeriegebäudes in Hannover-Herrenhausen.
(The paintings on walls and ceilings in the cabinets of the gallery building in Hannover-Herrenhausen.)

In book. *Restaurierung von Kulturdenkmalen: Beispiele aus der niedersächsischen Denkmalpflege,* Berichte zur Denkmalpflege in Niedersachsen, no. 2, Moller, Hans, Editor (1989), pp. 228-231, [Ger.]. 7 ill., 2 refs.

The gallery building of the castle of Hannover-Herrenhausen was set up between 1694 and 1700. The interior of the building has been covered by later decorations. In the 19th century, the paintings had to be restored, but soon humidity and a permanent change of temperature again led to a rapid decay. After the first restorations in 1965 and 1966, the wall paintings had to be treated again in 1975. A scientific examination revealed the techniques of the original paintings, which were executed in casein, and the relationship between the original and the overpainted areas could be determined more precisely. It was decided to consolidate the wall paintings and to recover the original decoration. This work became difficult be-

cause polymers had been used for consolidation between 1954 and 1965. J.R.

30-S1071.
Guinand, Jeanne-Laurence.
A la recherche d'une solution aux altérations des peintures mates: un produit à créer.
(Searching for a solution to the problem of altered mat paintings: a new product is needed.)

In book. *Technologie industrielle, conservation, restauration du patrimoine culturel: colloque AFTPV/SFIIC, Nice, 19-22 Septembre 1989,* (1989), pp. 34-35, [Fre.].

The problems encountered when trying to restore matte paintings are explained. The possible ways by which matte effect could be obtained are described, then the requirements of materials for use during their restoration. Certain modern materials were excluded by reason of the change brought about in the appearance (waxes, Paraloid B-72, Rhodopas) of a matte painting. Choice lay between a poly(vinyl alcohol) or an animal glue. The latter was chosen for use on a matte painting by Paul Sérusier, *Bretonne au Bouquet,* 1893. It is accepted that this choice will be criticized but better materials are not available and the question is asked whether new technology could help. ICCROM(04180006)

30-S1072.
Gupta, C.B.
Technique, deterioration and restoration of Thanjavur paintings.

Conservation of cultural property in India, **22,** pp. 36-39, (1989), [Eng.].

Outlines the technique of making Thanjavur paintings and describes the main types of deterioration of these paintings as well as the conservation treatments required. M.M.K.

30-S1073.
Lausmann, M.; and Königfeld, P.
Das romanische Deckenbild der Ev. Pfarrkirche St. Michael in Hildesheim.
(The painted ceiling from the Romanesque period in the Protestant church of Saint Michael at Hildesheim.)

In book. *Restaurierung von Kulturdenkmalen: Beispiele aus der niedersächsischen*

Denkmalpflege, Berichte zur Denkmalpflege in Niedersachsen, no. 2, Moller, Hans, Editor (1989), pp. 197-201, [Ger.]. 10 ill., 9 refs.

The church of Saint Michael at Hildesheim, a former Benedictine abbey, is one of the most important examples of Ottonian architecture in Germany. The wooden ceiling was decorated either in the 12th or in the 13th century with a large painting. In the course of time, the painting was restored several times. In the 19th century, large areas which had faded were repainted. At that time, animal glue was used as a medium; new damage was observed soon after. A thorough restoration followed in 1909. During World War II, the painting was removed for protection and brought back in 1960. In 1984, the painting was restored again. An extensive technological study accompanied this new restoration which focused on the consolidation of the paint layer with Paraloid B-72. J.R.

30-S1074.
Lennard, Frances.
The conservation of the United Tin Plate Workers' Society Banner of 1821.

The conservator, no. 13, pp. 3-7, (1989), [Eng.]. 9 photos (8 col.), diagram, list of materials and suppliers, refs.

Painted banners and their conservation have always presented problems. Banners are generally painted on both sides, each with its own design, but the paint rarely covers the whole of the fabric. At the Textile Conservation Centre at Hampton Court Palace, techniques have been developed for their treatment that owe more to textile conservation methods than to those used in painting conservation. The treatment of the earliest known Trade Union banner with a design taken from the arms of the Worshipful Company of Tin Plate Workers is described. The banner measures 209 cm. by 267 cm. The documentation prior to conservation includes analysis of fabrics and paints and their condition. The description of the conservation begins with the removal of old repairs, including sellotape, and continues with surface cleaning, consolidation of paints, humidification with poultice treatments, heat sealing of weak painted areas, and stitched support of unpainted areas. It ends with a description of the measures taken to protect the banner in transport, future displays, or in storage.
 K.F.

30-S1075.
Okabe, Masako; Higuchi, Seiji; and Masuda, Katsuhiko.
Saitama-ken shitei-bunkazai. Tenkai-zazō no shūfuku shochi.
(Reattaching a thick color layer of polychrome sculpture. Conservation of a seated figure of Rev. Tenkai.)

Hozon kagaku, **28,** pp. 93-108, (1989), [Jpn. w. Eng. summary]. 20 photos., 2 tables.

Seven new kinds of adhesives used in conservation for artistic objects, i.e. funori (a sort of Japanese seaweed glue containing galactane as a major component), an animal glue, HPC90SH9000, AC3444, a mixture of HPC3000 and AC3444, Binder-18, and Paraloid B-72 in xylene, were tested for the conservation treatment of a Buddhist polychrome sculpture of the Edo period, including protection of its surface against flaking and chalking, and reattaching damaged areas. As a preliminary experiment before the practical work, test pieces made of Japanese cypress boards painted with shell white or ocher by means of the above adhesives were studied for their adhesiveness and coloring behavior. Funori and a mixture of HPC3000 and AC3444 gave better results than HPC90-SH9000 and Paraloid B-72. Results from scientific investigations, details of practical procedures, and a trial of new techniques according to the Italian tradition are also described. M.S.

30-S1076.
Petukhova, Tatyana.
Potential applications of isinglass adhesive for paper conservation.

The Book & Paper Group annual, **8,** pp. 58-61, (1989), [Eng.]. bibliog.

In Russia, fish gelatin and isinglass have been used at least since the 17th century as adhesives in painting and icon restoration. Fish glue is prepared from the waste products of fish such as the head, skin, and bones. Isinglass is a superior fish gelatin product, the best grade being prepared from sturgeon. It is reversible, nontoxic, easy to prepare and apply; a thin film produces a strong bond. In collaboration with specialists in Food Science

and Chemistry at Cornell University, the author is working on a project to develop a pure fish gelatin adhesive suitable for conservation with qualities similar to Russian isinglass. This text describes some experimental procedures involving a German-made isinglass applied to archival or tracing papers.
C.C. and M.B.

30-S1077.
Schießl, Ulrich.
Konservierungstechnische Beobachtungen zur Festigung wäßrig gebundener, kreidender Malschichten auf Holz.
(Observations about conservation techniques regarding the consolidation of water-bound chalk paint layers.)
Zeitschrift für Kunsttechnologie und Konservierung, 3, no. 2, pp. 293-320, (1989), [Ger.]. 24 figs., 54 refs.
Describes a series of experiments for consolidating powdering paint layers on wood. Methods for consolidation were sought which do not result in any visual changes of the surface: gloss, stains, margins, or darkening of the color. Chalking paint and plaster result from using water-soluble binders. Calcium carbonate, gypsum, iron oxide and chalk, and artificial ultramarine were applied to wood without any binder. Consolidant solutions included gelatin in water, caseinate in water/alcohol, hydroxypropylcellulose in water, hydroxypropyl cellulose in propanol, poly(vinyl alcohol) in water, poly(vinyl acetate) in organic solvents, ethyl methacrylate in organic solvents, and acrylic emulsions and dispersions. The solutions were prepared in various dilutions. Changes in appearance are considered from both a theoretical and practical viewpoint, aided by observing film formation and resin distribution microscopically (both visual and electron microscope). Factors discussed include: the ability to penetrate the pigment layer and solidify within the layer; oversolidification of a porous, unpolished pigment layer; formation of pore holes in the pigment layer and in the consolidant substance; cavities at the interface of pigment and substate; peeling off of the layer and widespread formation of flakes; reaction to humidity; formation of dark margins (tide marks), relocation of pigment particles during the wet phase of consolidation; and added gloss, darkening, or

transparency. Concludes that the manner of the technique of application plays the most essential role. Stresses the fact that the inhomogenity of an actual multicolor painting reduces the relevance of observations and explanations of the consolidation of homogenous, prepared samples. E.Ha.

30-S1078.
Schleicher, Barbara.
Il restauro della statua lignea di "Nostra Donna" nella pieve di Cercina.
(The restoration of the wooden statue of Our Lady in the parish church of Cercina.)
In book. *Legno e restauro: ricerche e restauri su architetture e manufatti lignei*, Tampone, Gennaro, Editor (1989), pp. 281-284, [Ita. w. Fre., Eng. + Ger. summaries]. photos.
A report of the 1986-89 restoration, carried out by the author, of a Tuscan polychrome wood statue of the madonna from Cercina, Italy. The statue had been heavily repainted, probably in the 18th century, with tempera on a gesso ground. Tests showed traces of the original color which was fixed with Primal AC33. The repainting was removed with scalpels, water, and, in parts, Primal and acetone. Certain lacunae in the wooden structure were reconstructed with Araldite SV427. Elvacite 2044 resin dissolved in Xylamon was used to integrate the uncovered parts of the wood. Gold gesso and rabbit glue were used as putty and turpentine with mastic for the varnish. ICCROM

30-S1079.
Anon.
Ethnographic conservation training at the GCI.
The Getty Conservation Institute newsletter, 5, no. 3, pp. 1-2, (1990), [Eng.]. 1 photo.
Conserving ethnographic objects encompasses the preservation of a wide range of ephemeral materials, often organic in nature. The variety of compositional and manufacturing techniques of these objects reflects local materials and traditions. Collections of ethnographic materials are valuable resources for research—sometimes providing the only information available about the cultures that produced them. Ethnographic conservators strive to find treatments that will not change the nature of the material nor affect its re-

search potential. In the case of stabilizing fragile paints, a common problem in conserving ethnographic collections, applying additional consolidants may not only affect the appearance of objects but may be mistaken for the original binder. As a consequence, conservation treatments often represent a compromise between saving the original material and altering it. Two new techniques were developed and introduced for experimentation. Stefan Michalski presented a modified ultrasonic humidifier that produces a mist, consisting of a 0.5-1% gelatin solution, offering a finer application than is possible from a commercial sprayer and eliminating the problems of rapid evaporation that often occur during spraying. Eric Hansen proposed a second technique, involving applying the solution to the object inside a clear plastic bag to allow complete manipulation of the object in a solvent-saturated atmosphere.

Staff

30-S1080.
Danti, Cristina; Matteini, Mauro; and Moles, Arcangelo, Editors.
Le pitture murali: tecniche, problemi, conservazione.
(Wall paintings: technique, problems, conservation.)
Book. Centro Di della Edifimi s.r.l., Florence, 1990, [Ita.]. 371 p.: ill. (some col.), plans; 29 cm., refs. [ISBN 88-7038-196X].
A collective work on the techniques and conservation of mural paintings. Included are 31 contributions divided in three sections. The first one, materials and techniques, includes: influence of techniques and constituents in the deterioration of mural paintings; composition and techniques of Milanese Renaissance plasterworks; notes on the mural painting by Ghirlandaio; study of the plasters and revestments of the *Colosso dell'Appennino* by Giambologna; materials and techniques of mural paintings in Italy from Middle Ages to the 19th century, and in the 20th century; gilding techniques; polychrome graffiti by Cosimo Daddi (technique and restoration). The second one, deterioration and diagnosis, includes: considerations on the more frequent deterioration processes; analysis (XPS spectroscopic analysis, chemicostratigraphic, ecospectrography, photogrammetry); biodeterioration and vegetation; influence of envi-

ronment and state of conservation of outside murals (Padua). The third one, method and and procedure, includes: comments on the choice of conservation methodologies; history and restoration of the *Trinity* by Masaccio, of the mural paintings of San Marco (Florence), of the Refectory of the SS. Annunziata, of the Chapel of the Assunta in Prato (Paolo Uccello); aspects of the use of barium hydroxide; catalog of detached frescoes in Florence from 1945 to 1980, extensive bibliography in the restoration of mural paintings from 1975 to 1989.

ICCROM(04348100)

30-S1081.
Ericani, Giuliana.
Problemi di restauro di una tempera su carta ottocentesca: la decorazione del Ponga per la balconata del teatro Olimpia di Piove di Sacco.
(Problems in restoring a tempera on 19th-century paper: decoration by Ponga for the balcony of the Olympic Theatre of Piove di Sacco.)
In proceedings. *Conservazione delle opere d'arte su carta e pergamena: atti del convegno Torgiano, 14-16 aprile 1988,* di Serego Alighieri, Flavia, Editor (1990), pp. 51-58, [Ita.]. ill.
Concerns problems involved in the restoration of a tempera painting on 18th-century paper, painted by Giuseppe Ponga, and decorating the balcony of the Olympic Theatre of Piove di Sacco, Italy. The paper had suffered much degradation: peeling off in places; yellowing due to aging and glue; lacunae; insect damage; color abrasion due to people leaning on the balustrade. The fragility of the work made restoration difficult. Treatment involved removing the painting from the balcony, consolidating the colors with Gelowal adhesive, treating lacunae with Japanese paper, cleaning with distilled water and ethyl alcohol, and protecting the color layers with a fixative.

ICCROM(04396906)

30-S1082.
Fassina, V.
Considerazioni sui criteri di scelta del consolidante e la relativa metodologia di applicazione.
(Considerations concerning criteria for the selection of consolidant and the relative methodology of application.)

In book. *Il Prato della Valle e le opere in pietra calcarea collocate all'aperto*, Borsella, S.; Fassina, V.; and Spiazzi, A.M., Editors (1990), pp. 131-145, [Ita.]. 2 photos., 6 figs.

The use of a consolidant product to conserve statues made of decayed, soft limestone, is reported. The product is a silicone resin that provides good waterproofing. Tests were conducted on two application methods, cotton pads and a brush, to evaluate the resin concentration. In order to obtain better results, the vacuum impregnation method was employed for the consolidation. The depth of resin penetration was tested by the energy dispersive x-ray analysis (EDAX) of silicone content of suitable cores sampled from the stone; in one case the consolidant penetrated to a depth of 30 mm. G.A. and R.B.

30-S1083.
Fernández García, Guillermo; García Molina, María José; González Pascual, Margarita; Sanz Crusado, Laura Jack; and Pérez Medina, Diana.
El legado de la Tía Sandalia: Consolidación, arranque y montaje de la obra para el futuro Museo etnográfico local de Villacañas (Toledo).
(The legacy of the Tía Sandalia: consolidation, removal, and mounting of the work in the future Ethnographic Museum of Villacanas (Toledo).)

In proceedings. *VIII Congrés de Conservació de Béns Culturals: València, 20, 21, 22 i 23 de setembre de 1990 = Congreso de Conservación de Bienes Culturales: Valencia, 20, 21, 22 y 23 de setiembre de 1990*, Roig Picazo, Pilar, Editor (1990), pp. 180-192, 1a ed. [Spa. w. Spa. summary]. pl. xvii-xxiv, bibliog. refs.

Considers the conservation and removal of the Spanish collection of Tía Sandalia from the Casa Sandalia to the Ethnographic Museum in Villacañas, Toledo. Provides a brief biography of Sandalia Simón Fernández (1902-87), her work, and surroundings, with a description of the collection, which consists

of 66 sculptures and 40 relief objects, mural paintings, canvas paintings, and polychrome works. Describes the condition of the collection and the treatment, including consolidation, transporting the collection from its architectonic support, and reassembly of the collection in the museum. Also describes the reproductions of Sandalia's house to recreate the atmosphere of the collection fully. The collection, "Legado de la Tía Sandalia," was put on display after conservation work was finished. ICCROM

30-S1084.
Hansen, Eric F.; and Lowinger, Rosa.
Investigations into techniques for the consolidation of high pigment volume concentration paint at the Getty Conservation Institute.

Newsletter (Western Association for Art Conservation), **12**, no. 3, pp. 13-16, (1990), [Eng.]. 12 refs.

The consolidation of powdery matte paint presents many unresolved problems for conservators: darkening and gloss may result, the strength of the consolidation is difficult to measure, and there is some uncertainty about the aging properties of the consolidant once embedded in the artifact's materials. Review of publications about the consolidation of powdery paint showed gaps in prior studies. A survey of ethnographic objects conservators revealed a wide variety of methods and materials are being used for this purpose. Experiments in the consolidation of powdery matte paint at the Getty Conservation Institute with a wide variety of application techniques are described. Solution viscosity and wetting were found to be two important factors in the success of consolidation treatments. Research continues. E.C.W.

30-S1085.
Hansen, Eric F.; Sadoff, Eileen T.; and Lowinger, Rosa.
A review of problems encountered in the consolidation of paint on ethnographic wood objects and potential remedies.

Affl: Getty Conservation Institute, Marina del Rey, CA, USA.

In proceedings. *ICOM Committee for Conservation, ninth triennial meeting, Dresden, German Democratic Republic, 26-31 August 1990: pre-*

prints, Grimstad, Kirsten, Editor (1990), pp. 163-168, [Eng. w. Eng. summary]. 3 tables, 26 refs.

Problems encountered in the consolidation of paint on ethnographic wood objects are reviewed, based upon the literature and surveys of North American ethnographic conservators. Significant consolidation may require a large quantity of resin, which will affect the appearance of the paint. Changes in appearance may be minimized by selecting either particular application procedures or resins that are effective in lower concentrations. The solution properties (volatility, viscosity, surface tension) may be as important as, or more important than, the physical properties of the dried resin. As removal of a resin used to consolidate a fragile deteriorated paint is unlikely, the aging characteristics are of primary importance in the choice of a resin. Insoluble thermosetting resins (diisocyanates, epoxies) are considered due to their high strength in low concentrations, compared to thermoplastic resins.
A.A.

30-S1086.
Heath, Diana.
The conservation of painted and polychromed metal work. Two case studies from the V & A Museum.

In proceedings. *Conservation of metals: problems in the treatment of metal-organic and metal-inorganic composite objects: international restorer seminar, Veszprém, Hungary, 1-10 July 1989,* Jaro, Marta, Editor (1990), pp. 99-103, [Eng.]. 4 refs.

Painted and polychrome metal surfaces are often exposed to the atmosphere where physical and chemical alteration of the surface can take place almost immediately. The author gives examples of possible treatment on two objects in the possession of the Victoria and Albert Museum, London, i.e., the plateau from the Sèvres Egyptian Centre Piece and the sculpture of the Buddhist goddess, Tara, from Nepal.
R.S.C.D.M.

30-S1087.
Hermerén, Karin.
Adhesiver för impregnering av måleri på duk.
(Adhesives for impregnation of painting on canvas.)

Master's thesis. University of Gothenburg. Institute of Conservation, Gothenburg, 1990, [Swe. w. Swe. summary]. 72 p.: ill., figs., refs.

A comparative study of eleven adhesives used for impregnation. Both traditional and synthetic adhesives have been tested. The recipes, concentrations, and solvents are those commonly used by conservators. Acidity, surface tension, penetration, solubility, surface and film properties, stiffness, elasticity, and adhesion power tests have been performed. For each adhesive every test has been performed, both directly after application and activation, and when artificially aged. The adhesives tested were: gelatin, sturgeon glue, beeswax, Klucel GF, Mowilith 50, Cascol, Beva 371, Mowiol VP 3:83, Paraloid B-72, Plexisol P 550, and Acronal 300 D. The first part of the thesis deals with impregnation, definition of terms, meaning, and practical handling. This is followed by a short chapter on the history of impregnation, a chapter on the properties of adhesives and adhesion, and a section with a more thorough presentation of the different types of adhesives used in the tests: natural (glues, beeswax), half natural (klucel), and synthetic (vinyl acetates and acrylics, both as resins and dispersions). The second part starts with a short chapter about testing, followed by the description of the specific adhesives used. Then the preparation, execution, commentary, and results of each test are described. Finally there is a short discussion and a summary. The aim of this work was not to set up rules for determining the best adhesive. It should rather be looked upon as a basis for further discussions about when and how to impregnate. It is also meant to clarify the different working properties of different adhesives under similar circumstances, always bearing in mind the practical needs of the conservator.
A.A. and C.H.

30-S1088.
Jaeschke, Richard L.; and Jaeschke, Helena F.
The cleaning and consolidation of Egyptian encaustic mummy portraits.

In proceedings. *Cleaning, retouching and coatings: technology and practice for easel paintings and polychrome sculpture: preprints of the contributions to the Brussels Congress, 3-7 September 1990*, Mills, John S.; and Smith, Perry, Editors (1990), pp. 16-18, [Eng. w. Eng. summary]. 5 figs., 4 refs.

The Petrie Museum of Egyptian Archaeology (University College, London) contains a large collection of encaustic wax on wood portraits from a Roman-period cemetery at Hawara in Egypt. They received some early conservation treatment during or shortly after excavation, usually consolidation with modern wax, softening the ancient wax with heat or facing with paper. Some of the portraits were cleaned during the 1970s and early 1980s, using solvents such as Shellsol T (a mixture of aliphatic hydrocarbons) or white spirit. Water-soluble dirt was removed with aqueous solutions of Synperonic NDB, a non-ionic detergent, or Vulpex, a potassium oleate soap. Fragmentary areas were consolidated, usually with polyethylene glycol. The authors have found that cleaning the portraits mechanically with a polished scalpel blade removes the early conservation wax and the ancient burial debris which overlie and are sometimes intermixed with the pigmented wax, while avoiding many of the problems associated with solvent cleaning. Consolidation of loose or detached paint with a solution of Paraloid B-72 in acetone has proved satisfactory. A.A.

30-S1089.
Laure, Pierre.
Investigations et sondages préalables. (Investigations and preliminary probes.)

In book. *Architecture et décors peints: Amiens, Octobre 1989*, (1990), pp. 25-29, [Fre.].

Contemplates the importance of investigations and preliminary probes as an absolute prerequisite to the conservation or restoration of decorated surfaces. They provide historical, archaeological, technical, and artistic information on the relationship between the building and the painted surface(s). This information helps determine the type of con-

servation work required. Archives can also provide valuable information on polychromy, information that can make the difference between a good and a poor conservation effort. Gives examples of sites in Brittany, Côte-d'Or, Puy-de-Dôme, Calvados, and Morbihan. ICCROM(04415503)

30-S1090.
Oddy, W.A.O.
The conservation of the Winchester Anglo-Saxon fragment.

In proceedings. *Early Medieval wall painting and painted sculpture in England: based on the proceedings of a symposium at the Courtauld Institute of Art, February 1985*, BAR British series, no. 216, Cather, Sharon; Park, David; and Williamson, Paul, Editors (1990), pp. 65-71, [Eng.]. 3 plates, 14 refs.

Conservation history of the fragment indicates that the stone was subjected to three unrelated conservation treatments. Initially mechanical cleaning was employed to remove the mortar, and methylated spirits were used to soften earth deposits. Limewater treatments were the procedure of choice of the second conservator assigned to the project; the third conservator applied soluble nylon, not having been informed of the limewater treatments. Despite these disparate treatments, the fragment appears to be in stable condition; no problem seems likely so long as storage conditions remain as prescribed: controlled temperature and humidity, and protection from sulfur dioxide. K.M.G.W.

30-S1091.
Römich, H.; Fuchs, D.R.; Popall, M.; and Schmidt, H.
A new fixation method for paint layer conservation.

Affl: Fraunhofer-Institut für Silicatforschung, Würzburg, Germany.

Eingereicht für News Letters, no. 45, pp. 1-9, (1990), [Eng. w. Eng. + Ger. summaries]. 4 figs., 7 refs.

Inorganic gels, prepared by sol-gel techniques, offer a promising new method for the consolidation of endangered paint layers on historic stained glass windows. The fixation material was tailored for good adhesion to glass and long term stability. The stable

fixation of the paint provides the possibility to apply a reversible protective coating later. The development and characterization of the fixation system so far were carried out on test pieces simulating loose paint on noncorrosive glass. First results of adhesion tests confirm the consolidation effect of the material, but further investigations on its efficiency on corrosion-sensitive model glasses and originals have to be carried out before recommending the method for the restorer's workshops.

A.A.

30-S1092.
Sandner, Ingo.
The treatment of cracks in canvas paintings with synthetic adhesives: procedures and possible combinations with the lining process.

Affl: Hochschule für Bildende Kunste Dresden, Dresden, Germany.

In proceedings. *ICOM Committee for Conservation, ninth triennial meeting, Dresden, German Democratic Republic, 26-31 August 1990: preprints*, Grimstad, Kirsten, Editor (1990), pp. 133-138, [Eng. w. Eng. summary]. 5 figs., 2 refs.

As part of the training of restorers, a description is given of various possibilities for the treatment with synthetic adhesives of cracks in pictures. The problem is to check which methods for consolidation can be combined with which adhesives in the case of lining. A series of tests was carried out, and recommendations are given for more or less suited combinations of synthetic adhesives.

A.A.

30-S1093.
Taarnskov, Bodil.
Examples of conservation of painted metal objects.

In proceedings. *Conservation of metals: problems in the treatment of metal-organic and metal-inorganic composite objects: international restorer seminar, Veszprém, Hungary, 1-10 July 1989*, Jaro, Marta, Editor (1990), pp. 105-107, [Eng.]. 3 ill., 5 refs.

An account of current conservation practice at the National Museum of Denmark, Copenhagen. Conservation of iron and copper alloy objects is described. Examples given are an exceptional 1681 coffin from Roskilde,

a sheet-iron box, and a fire screen from the collection of the Museum. R.S.C.D.M.

30-S1094.
Althöfer, Heinz.
Il restauro delle opere d'arte moderne e contemporane.
(The restoration of modern and contemporary works of art.)

Book. Nardini, Florence, 1991, [Ita.]. 197 p.: 35 ill., 264 refs. [ISBN 88-404-4010-0].

Consists of eight chapters of text, an introduction by M. Cristina Mundici and a postscript by Antonio Rava: 1) Between the 18th and 19th century: the loss of craftsmanship starting with the Industrial Revolution is discussed; 2) Present-day painting and the traditions of the academicians in the 19th century; 3) A five-point program for the preservation of contemporary art: paintings are divided into five groups each of which requires a different approach for their preservation and conservation, those made with conventional techniques, monochrome paintings, works made of unstable materials, works made intentionally to decay (so-called Happenings), and kinetic works which need mechanical repairs; 4) What could be and what should be restored, and the contradictions; 5) The techniques of restoration of contemporary art; 6) Fragment and ruin: the questions of art made intentionally to decay or left intentionally incomplete, the importance of correct interpretation of the artist's intentions; 7) The two final limits of restoration: contemporary art is built with two concepts which the conservator has to interpret correctly: everlasting perfection (as with acrylics), and built-in decay. The question becomes how to preserve the pretense of perfection, or when to stop intentionally built-in decay; 8) Illustrations: typical damage and suggested interventions. Includes 35 color plates showing interventions to restore modern art by H. Schinzel and M. Huisgen. G.A.B.

30-S1095.
Cedillo Alvarez, Luciano.
La conservación en zonas arqueológicas: tres decadas de trabajo.
(Conservation in archaeological areas: three decades of work.)

Book. Instituto Nacional de Antropología e Historia. Escuela Nacional de Conservación, Restauración y Museografía "Manuel del Castillo Negrete", Mexico City, 1991, [Spa.]. 371 p.

The thesis presents an in-depth review (with extensive references) of the conservation treatments (from the late 19th century to the present) of plaster in eight archaeological zones of Mexico: Teotihuacán, Palenque, Kohunlich, Cacaxtla, Comalcalco, El Zapotal, Teopantecuanitlan, and Lamitieco. Results of field tests of polymers for the consolidation of lime-plaster stucco are reported along with suggestions for future research into the problems of consolidation of stucco in diverse climatic regions. E.Ha.

30-S1096.
Conti, P.; Emiliani, A.; Torkaman, M.M.; and Tomasi, C.
(The restoration of the wooden painted ceiling in the "Confraternità del Rosario," SS. Filippo and Giacomo Church, Ospedaletto d'Alpinolo.)

In proceedings. *Science, technology, and European cultural heritage: proceedings of the European symposium, Bologna, Italy, 13-16 June 1989,* Baer, N.S.; Sabbioni, C.; and Sors, Andre I., Editors (1991), pp. 704-706, [Ita. w. Eng. summary]. photo., fig.

During the work in the SS. Filippo and Giacomo Church (July-September 1988) a new system of anchors was created which was reversible and quickly collapsible even by nonspecialized personnel and at minimum cost. A system of parquetry composed of aluminum slats running along wooden blocks of various heights necessary for the uneven levels of the painted panels was used. The slats were anchored to a metallic structure (50 cm distance from the panels) by means of adjustable tie-bars and steel wire cables. Such a system allows the natural movement of the panels in all directions, without creating tension. Therefore, the work on the paint film could begin. The ceiling of the oratory, composed of 90 painted panels, was anchored to

the wooden beams of the truss by steel nails and pivots. After the earthquake of 1983, the panels were warped, disconnected, and twisted, and infiltrations of water had damaged the pictorial film which was restored after the parquetry. The painted panels were cleaned of greasy dust. Then the ceiling was disinfected with Xylamon to kill the woodworms. The wooden panels were consolidated using Paraloid B-72 and the paint film was fixed by Primal AC33. At the end, pictorial retouching was done using watercolors.
ICCROM(044964116) and A.A.

30-S1097.
Gänsicke, Susanne.
Die restaurierung einer ptolemäischen Mumienmaske.
(The conservation of a Ptolemaic mummy mask.)

Arbeitsblätter für Restauratoren, **24,** no. 2, pp. Gr. 9, 81-84, (1991), [Ger. w. Ger. + Eng. summaries]. 4 b&w ill.

Egyptian mummy masks, the materials used in their construction and decoration, and the methods of their manufacture are discussed. Specifically, the treatment of a formerly restored and badly damaged Ptolemaic mummy mask made of stucco-covered linen is described as well as its mounting for exhibition and travel. The successful application of conservation methods and materials, recently developed and tested in the research laboratory at the Museum of Fine Arts, Boston, is introduced. A.A.

30-S1098.
Hammer, Ivo.
The conservation in situ of the Romanesque wall paintings of Lambach.

In proceedings. *The conservation of wall paintings: proceedings of a symposium organized by the Courtauld Institute of Art and the Getty Conservation Institute, London, 13-16 July 1987,* Cather, Sharon, Editor (1991), pp. 43-55, [Eng.]. 6 col. plates, 5 drawings, 2 photos., 16 refs., bibliog.

The Romanesque wall paintings in the Benedictine Abbey Church at Lambach, Austria, dating from ca. 1089, were in large part preserved by the 17th-century addition of buttressing walls. Their state at discovery in 1957 varied considerably. This text lists the

Treatment

pre-1966 interventions and gives research on the original fresco technique. Increasing moisture damage was investigated, documented, and monitored during the 1970s. Using electrical conductivity studies, chemical analyses, and physical observations, the author determined the presence of hygroscopic salts concentrated on the wall surfaces to be the main cause of damage, and discusses the reasons for rejecting a proposed treatment involving total or partial detachment of the paintings. The in situ consolidation and desalination treatments are described, giving details on the materials and application techniques used, and stressing climate control as a necessary condition to the prevention of salt crystallization. No negative alterations to the paintings have been observed since the intervention and a 1983 partial follow-up treatment. M.B.

30-S1099.
Hanna, S.B.; and Dinsmore, J.K.
Conservation of Central Asian wall painting fragments from the Stein Collection in the British Museum.

In proceedings. *The conservation of wall paintings: proceedings of a symposium organized by the Courtauld Institute of Art and the Getty Conservation Institute, London, 13-16 July 1987*, Cather, Sharon, Editor (1991), pp. 77-86, [Eng.]. 1 map, 1 col. plate, 11 b&w photos., 2 drawings, bibliog.

A large quantity of wall paintings from Buddhist monasteries and cave temples, discovered in central Asia at the end of the 19th and early 20th centuries during expeditions by Sir Aurel Stein, are kept at the British Museum. The conservation and mounting of this collection is shown in two case studies, namely two painting fragments from Dāndān-Oilik (782-787) and one painting from Ming-Oi (8th or 9th century). This text provides information on the paintings' provenance, method of construction and decoration, iconographical content, condition when entering the collection, and storage method. Their treatment made use of cleaning poultices in equal volumes of acetone and industrial methylated spirits (IMS). The acrylic silane mixture Raccanello E 55050 gave best consolidation results for both Dāndān-Oilik fragments; the composition and technique of application of the reattachment paste are de-

scribed as well as the storage containers adopted. The same informative details are provided concerning the treatment of the Ming-Oi painting, with emphasis on the steps taken for realignment and consolidation.
 M.B.

30-S1100.
Hebrard, Michel, and Small, Sophie; Mauger, Vincent, and Ranier, Leslie, Translators.
Experiments in the use of polyvinyl alcohol as a substitute for animal glues in the conservation of gilded wood.

In book. *Gilded wood: conservation and history*, Bigelow, Deborah; and Hutchins, Catherine E., Editors (1991), pp. 277-290, [Eng. w. Eng. summary]. 2 tables, 1 fig., 11 notes.

This essay relates comparative experiences of using poly(vinyl alcohol) as a substitute for rabbit-skin glue. It gives a chemical description of the product and relates practical experiences using different qualities of poly(vinyl alcohols). All the gilding operations are made with their different qualities, and results are given. A.A.

30-S1101.
Horton-James, David; Walston, Sue; and Zounis, Steven.
Evaluation of the stability, appearance and performance of resins for the adhesion of flaking paint on ethnographic objects.

Studies in conservation, **36**, no. 4, pp. 203-221, (1991), [Eng. w. Eng. summary]. 7 tables, 3 figs., 32 refs.

A series of resins, mainly water-based, was tested to identify suitable materials for the adhesion of flaking, porous paint on ethnographic objects. Tests of tensile strength, color, pH, flexibility, adhesion, dust retention, working properties, and solubility were used to assess the stability, appearance, and performance of unaged and aged resins. Facsimiles of painted objects were used in tests wherever possible to simulate the behavior of resins on museum objects. Of the 19 resins tested, Plextol B500, an acrylic dispersion, performed best and was selected for use in the Australian Museum Conservation Laboratory. A.A.

30-S1102.
Kindl, Silvia; and Brown, Karen.
An investigation of several fixatives for pastel works.

In book. *Papers presented at the sixteenth annual art conservation training programs conference: 26-28 April 1990, University of Delaware/Winterthur Museum Art Conservation Department,* Anon., Editor (1991), pp. 33-47, [Eng.]. bibliog.

The dilemma of whether or not to apply fixatives to works of art in pastel plagues many contemporary artists. They recognize the undesirable effects of commercial fixatives (such as Krylon, Tuffilm), and complain that the sprays dull or saturate their colors, cause some pigments to disappear altogether and yellow or stain paper substrates rendering them shiny or sticky. The large size of many pastels executed today has made the application of a fixative even more important for their safe handling. Artists are concerned about preserving the appearance of their works but feel there is a lack of information from manufacturers on the quality of their products. It should not be surprising, therefore, that conservators frequently receive calls from artists inquiring about appropriate fixatives for their pastels. C.A.L.

30-S1103.
Marxen-Wolska, E.
Polyvinyl acetate in the conservation of the wall paintings.

In proceedings. *Science, technology, and European cultural heritage: proceedings of the European symposium, Bologna, Italy, 13-16 June 1989,* Baer, N.S.; Sabbioni, C.; and Sors, Andre I., Editors (1991), pp. 640-641; [Eng. w. Eng. summary].

Poly(vinyl acetate) was used in painting and conservation before 1935. In the 1950s and 1960s, there were many positive comments about this material used in wall paintings conservation, but there were also some remarks critical of it. In the past 33 years, attention has been applied towards the above problems and this resin has been used successfully in the conservation of wall paintings in Poland and elsewhere.

ICCROM(04496499) and A.A.

30-S1104.
Matteini, Mauro.
In review: an assessment of Florentine methods of wall painting conservation based on the use of mineral treatments.

In proceedings. *The conservation of wall paintings: proceedings of a symposium organized by the Courtauld Institute of Art and the Getty Conservation Institute, London, 13-16 July 1987,* Cather, Sharon, Editor (1991), pp. 137-148, [Eng.]. 6 figs., 1 table, 10 col. plates, bibliog.

The materials that constitute wall paintings have a high and open porosity, which makes them vulnerable to the effects of both liquids and gases either found in their environment or used for their conservation. Therefore, wall painting conservation strategies involving mineral treatments should be preferred for compatibility, thus ensuring good, lasting results. This text examines problems of sulfation, discussing appropriate tests to evaluate and monitor them. It describes a methodology based on the use of ammonium carbonate and barium hydroxide that has been employed in Florence for some 20 years. M.B.

30-S1105.
Moormann, Eric M.
Destruction and restoration of Campanian mural paintings in the eighteenth and nineteenth centuries.

In proceedings. *The conservation of wall paintings: proceedings of a symposium organized by the Courtauld Institute of Art and the Getty Conservation Institute, London, 13-16 July 1987,* Cather, Sharon, Editor (1991), pp. 87-101, [Eng.]. 11 b&w photos., 1 col. plate, 22 refs., bibliog.

Historical survey of first excavations of Herculaneum and Pompeii, starting in 1738, by Charles III, King of Naples. Discussion of early excavation techniques and provisions for storage and documentation, with mention of subsequent transfers from the summer palace at Portici to the National Archaeological Museum at Naples. Wall paintings were found after 1764, when the first open-air excavations started at Pompeii. When detaching them, experimental varnish conservation treatments were attempted. Many fragments were rejected and smashed to pieces, sometimes as a move to prevent their unwanted

acquisition by foreigners. An accurate account of detachment of a complete mural in 1755 has survived. In the 18th century, the murals left in situ were not protected at all and were soon lost. After being inventoried, fragments were often fitted in a bed of gypsum and mortar into wooden frames and then varnished. This unfortunate practice is discussed here at some length, with indication that a precise formula for the varnish has been documented. Another conservation treatment was done using slate as a support, and yet another using hot wax, with unsatisfactory results. Urgent cooperative efforts on an international scale are advocated.

M.B.

30-S1106.
Torraca, Giorgio; Mora, Paolo; and Rossi, Pier Paolo.
Sperimentazione di un consolidante per smalti di maioliche e tessere vitree di mosaico.
(Experiments on the consolidation of glazes on majolica and glass tesserae from mosaics.)
Materiali e strutture, **1,** no. 2, p. 59, (1991), [Ita. w. Eng. summary].

Reports on the use of BS-44 (Wacker Chemie GmbH), a mixture of monomeric alkoxysilanes with some prepolymerized polysiloxane, to solve the problem of consolidating semidetached glazes in the faience decoration in the Cloister of Santa Chiara in Naples, Italy, endangered by the combined attack of salts and algae. The encouraging results of these tests suggested the use of BS-44 to consolidate some completely shattered glass tesserae in the mosaic of the Church of the Saints Cosma and Damian in Rome, Italy. Besides losing mechanical cohesion, the blue tesserae in question had completely lost their color owing to light scattering caused by their internal fractures. Another possible use is in sealing fine cracks in deteriorated siliceous stone. It is stressed that the use of a relatively new product should always be subject to great caution, at least for a few years, because the results of laboratory tests can never entirely replace the direct experience gained by observing aging under natural conditions.

ICCROM(04398602) and A.A.

30-S1107.
Von Reventlow, Victor.
The treatment of gilded objects with rabbit-skin glue size as consolidating adhesive.
In book. *Gilded wood: conservation and history,* Bigelow, Deborah; and Hutchins, Catherine E., Editors (1991), pp. 269-275, [Eng. w. Eng. summary]. 5 notes.

Discusses the use of rabbit-skin glue as an adhesive for gesso consolidation with specific methods developed by the author for treatments using this collagen on various types of gesso, and the thought processes behind the methods.

A.A.

30-S1108.
Suardi, G.
Il Castello di Malpaga: problemi di conservazione e di consolidamento degli intonaci affrescati del cortile.
(The Malpaga Castle: conservation and consolidation problems of painted plasters of the courtyard.)
In book. *Superfici dell'architettura: le finiture: atti del convegno di studi, Bressanone, 20-29 giugno 1990,* Biscontin, Guido; and Volpin, Stefano, Editors (1991?), pp. 447-456, [Ita. w. Eng. + Ita. summaries]. 2 photos., 6 figs., 1 graph, refs.

Unsuitable environmental conditions caused decay, i.e., lack of adhesion and decohesion, in painted plasters from the 15th and 16th centuries in a castle near Bergamo, Italy. The plasters were divided into three different ages with different composition. The consolidation involved the use of acrylic resin to restore the decohesions and acrylic resin in water emulsion to restore the adhesion between the plaster and the wall.

G.A. and R.B.

30-S1109.
Durand, Roseline.
La consolidation des couches picturales pulvérulentes des Bonader, oeuvres murales suédoises peintes sur papier.
(The consolidation of powdery paint layers of *Bonaders*, Swedish mural works painted on paper.)
Conservation, restauration des biens culturels: revue de l'ARAAFU, **4,** pp. 16-21, (1992), [Fre. w. Fre. summary]. figs., refs.

Bonaders are decorative mural paintings painted on textile or paper and illustrate biblical themes. They appeared in Swedish folk art starting in 1690. As they are created out of materials of mediocre quality, their state of preservation is usually poor. The main problem is the disintegration of the powdery paint layer. Presents a way of permanently fixing the paint layer onto its support. Describes the experimental equipment needed to test the various consolidants: gelatin, vinyl products, acrylics, and cellulose ethers. The control tests are based on changes in the visual aspect after application of the consolidants on paper samples. Experiments with artificial aging by natural light were also conducted. The following conclusions were drawn. The same consolidant can give varying results depending on the color to which it is applied. The best application technique is fine repeated vaporization. The experiments on samples led to the selection of two cellulose ethers: hydroxypropylcellulose (S) and methyl cellulose (T). Methyl cellulose applied on *bonaders* gave the best results. C.C.

30-S1110.
Gayo, M.D.; Parra, E.; and Carrassón, A.
Technical examination and consolidation of the paint layer on a Mudéjar coffered ceiling in the Convent of Santa Fe, Toledo.

In book. *Conservation of the Iberian and Latin American cultural heritage: preprints of the contributions to the IIC Madrid Congress, 9-12 September 1992*, Hodges, H.W.M.; Mills, John S.; and Smith, Perry, Editors (1992), pp. 54-56, [Eng. w. Eng. summary]. 7 figs., 6 refs.

Before commencing the conservation treatment of a 15th-century coffered ceiling in the convent of Santa Fe, Toledo, the painting materials were analyzed. Elemental analysis of the pigments was carried out by x-ray fluorescence (XRF) spectrometry. Cross sections were made of the samples for optical microscopy. The binding media and the varnish were identified by gas chromatography, by analyzing the fatty acids, terpenes, and amino acids. Once the painting had been studied, consolidation treatment was applied using different materials according to the solubility of the paint layers. Animal glue was mainly used, and Paraloid B-72 to a lesser extent, as a preliminary to the structural reinforcement of the support. A.A.

30-S1111.
Guillemard, Denis; and Renard, Alain.
Les peintures ethnographiques: question de pulvérulence.
(Ethnographic paintings: the question of powdering.)

The conservator, no. 16, pp. 18-22, (1992), [Fre. w. Eng. summary]. 4 photos., refs.

The realization that the state of a material has changed lies at the heart of all conservation initiatives. Such recognition is based on earlier references to such alterations or on the use of similar objects which originate from the same or another culture as models. It is essential to recognize what can affect analysis because this, in turn, can influence decisions on the treatment of objects. The powdering of heavily pigmented surfaces of ethnographic paintings is sometimes perceived as a negative change or an inherent fault in an object, even though it represents a conscious choice of technique by artists from non-Western civilizations. Preventive conservation and the search for suitable solutions promotes the conservation of such paintings because they take into account the key causes of change, i.e., housekeeping and climate. A.A.

30-S1112.
Höring, Franz.
Bemalte Wandbehänge als Restaurierproblem.
(The restoration of painted tapestry and its problems.)

Restauratorenblätter, **13**, pp. 109-115, (1992), [Ger. w. Eng. summary]. 15 ill., 8 refs.

Although many painted tapestries from the Baroque period have been preserved (it was once a popular form of interior decoration both in the secular and ecclesiastical sector), the subject has been sparsely documented in Austrian art history. On the basis of restorations, it is possible to study technological characteristics such as the type and structure of the fabric, the dye, the technique of painting, the methods of application, the processes of aging, etc. Four significant examples from three Austrian provinces are presented and used to explain and justify the different measures employed for restoration. A.A. and M.K.

Treatment

30-S1113.
Johnson, Colin.
Party straws and Egyptian coffins.

Affl: British Museum. Department of Conservation, London, UK.

Conservation news (United Kingdom Institute for Conservation of Historic and Artistic Works), **49**, p. 13, (1992), [Eng.]. 1 photo.

Straws were used as a counterweight during the process of readhesion of applied surfaces that were lifting from ancient Egyptian artifacts. A 6% Vinamul 3252 poly(vinyl acetate) polyethylene copolymer in distilled water was applied using white spirit as a wetting agent to relax flaking surfaces. Straws were flexed, positioned, and weighted (with separation strips of polyethylene foam if necessary) to apply the appropriate tension.
Al.B.

30-S1114.
Kaltenegger, Uta.
Konservierungsprobleme an Gouachemalereien (1941-1943) von Charlotte Salomon.
(Problems of conservation encountered with gouache paintings by Charlotte Salomon (1941-43).)

Zeitschrift für Kunsttechnologie und Konservierung, **6**, no. 2, pp. 360-366, (1992), [Ger.].

During Charlotte Salomon's exile in southern France, 1941-43, she wrote and painted an autobiographical "song play" depicting her difficult life with 169 gouache paintings. The water-based paint has shown a tendency to crack and then detach entirely from the paper. This article deals with the efforts by the Stichting Kollektief Restauratieratelier Amsterdam to develop techniques to stabilize the paintings, restore them to their original state when possible, and to preserve them from further deterioration. The techniques (using a vacuum table) are described in detail. They also may prove useful in preserving paintings in books and for conserving ethnographic objects.
E.M.B.

30-S1115.
Van Strydonck, Mark J.Y.; Van Der Borg, Klaas; and De Jong, Arie F.M.
Dating Precolumbian museum objects.

Affl: Institut Royal du Patrimoine Artistique, Brussels, Belgium.

Radiocarbon, **34**, no. 3, pp. 928-933, (1992), [Eng. w. Eng. summary]. figs., tables, refs.

Reports radiocarbon dating of some pre-Columbian artifacts. Both conventional beta counting and accelerator mass spectrometry (AMS) were used to date textiles, bamboo from weaving looms, a feather carpet, and straw from a clay mask. Discusses the particular problems in sample pretreatment, especially when modern synthetic polymers have been used as consolidants.
A.A.

30-S1116.
Ballantyne, Ann; and Hulbert, Anna.
19th and early 20th century restorations of English Mediaeval wall paintings: problems and solutions.

In book. *Les anciennes restaurations en peinture murale*, (1993), pp. 143-151, [Eng.]. 14 refs.

Most English wall paintings were done in a secco technique involving an oil medium or oil varnish, sometimes applied as glazes over a size underpainting. This is called the cole technique, and occasionally involves gilding. They were covered in limewash at the Reformation and rediscovered in the 19th century. Outlines the problems encountered when trying to consolidate loose flakes of limewash, powdery paint, and crumbling plaster with wax and wax-resin mixtures that prevented evaporation from ancient walls. The removal of wax has become a major problem faced by wall paintings conservators in England today. Methylene chloride is no longer recommended. The advent of the Wolbers' gels brought new hope. Describes the process of lime stippling or the alternative, barium hydroxide injections. A technique designed by David Perry for transferring frescoes is explained.
M.B.

30-S1117.
Bourgain, Jean-Yves; and Callède, Bernard.
Les fresques du Primatice dans la salle de bal du château de Fontainebleau: l'héritage: essai de dérestauration. (Frescoes by Il Primaticcio in the ballroom of the Castle of Fontainebleau: the legacy, a derestoration attempt.)

In book. *Les anciennes restaurations en peinture murale*, (1993), pp. 201-235, [Fre.]. 16 photos., drawings, axonometric elevation.

The ballroom in the main castle of Francis I, built over several years starting in 1527, is described as to its structure, monumental size, over 50 frescoes, ceiling, loggias, and roof. The paintings, in early Mannerist style, mythological in the content the Court's scholars dictated, have undergone numerous restorations starting very early in their existence. A basic 1972 document on the restoration of the Francis I gallery in the same castle is referenced here as providing a wealth of technical information on the wall paintings executed by the same artists and the restorations they underwent until 1963. Such a study has not yet been completed for this ballroom, but a step-by-step report on the execution and emergency consolidation of a single painting is given. *Vieillard et jeune homme* (Old and Young Man) (120 x 165 cm) by Il Primaticcio (1504-70) has been heavily restored in the heterogeneous way that characterizes all interventions in this castle. Stratigraphic examinations and physicochemical analyses of 23 small samples taken by the Laboratoire de Recherche des Monuments Historiques allowed the determination of the presence of three different painting techniques. The original material is cautiously characterized; damage detected included heavy fungus infestation (treated with a solution of Streptomycine and nitrate of econazole) due to water infiltration and unfortunate previous interventions. All are detailed, as are the derestoration and rerestoration work carried out.
M.B.

30-S1118.
Costanzi Cobau, Andreina.
In situ consolidation of a Roman fresco near Ein Yael, Jerusalem.

Affl: Centro di conservazione archeologica, Rome, Italy.

In book. *ICOM Committee for Conservation tenth triennial meeting, Washington, DC, 22-27 August 1993: preprints*, Bridgland, Janet, Editor (1993), pp. 536-540, [Eng. w. Eng. summary]. ill., bibliog.

In the spring of 1990, the Department of Antiquities of Israel carried out an in situ conservation intervention on a Roman fresco from a villa near Ein Yael, located in the vicinity of Jerusalem. The intervention was carried out according to the following principles: in situ consolidation of the fresco; use of products compatible with the original components; application of techniques similar to the ancient ones; use of local products and equipment; roofing and protection against water as preventive measures; and a maintenance program. In the spring of 1992, an examination of the structure confirmed the highly effective intervention.
A.A.

30-S1119.
Dangas, Isabelle M.; Brunet, Jacques L.; and Vidal, Pierre M.
Interventions: nettoyage des parois, tests de consolidation au Salon Noir de la grotte préhistorique de Niaux (France). (Interventions: cleaning of walls, consolidation tests in the Black Room of the prehistoric cave of Niaux, France.)

In book. *ICOM Committee for Conservation tenth triennial meeting, Washington, DC, 22-27 August 1993: preprints*, Bridgland, Janet, Editor (1993), pp. 842-847, [Fre. w. Fre. summary]. 6 b&w ill., refs.

The decorated walls of the Black Room of the cave of Niaux showed spotting, and the presence of worm-shaped heaps of dirt due to trickling water washing off pigments, dust, and clay deposits, with subsequent obliteration of the prehistoric drawings, posing a serious threat to their conservation. The walls were cleaned. In addition, it became necessary to submit consolidants and refixing products such as synthetic resins and

Treatment

Paraloid B-72 to various tests, i.e., conditions of application, dilution, solvents, etc.
A.A. and M.B.(transl.)

30-S1120.
Hansen, Eric F.; Lowinger, Rosa; and Sadoff, Eileen.
Consolidation of porous paint in a vapor-saturated atmosphere: a technique for minimizing changes in the appearance of powdering, matte paint.

Journal of the American Institute for Conservation, 32, no. 1, pp. 1-14, (1993), [Eng. w. Eng. summary]. 10 figs., 3 tables, 17 refs.

When resins are applied for consolidation of a matte paint surface, the colors may darken because of increased surface gloss, the result of the formation of a film over the surface to be protected. Darkening may also occur when resin fills the void space in the powdering paint. A technique is described for consolidating matte, low-gloss, powdery surfaces with minimal if not negligible darkening of the colors. The technique outlined involves the application of a stable thermoplastic resin solution in an atmosphere containing a very high concentration of the solvent used to dissolve the resin, thus slowing solvent evaporation and allowing the resin to penetrate the paint layer and surround the exposed pigment particles. In addition to retaining the matte appearance of the object, "tide lines" may be prevented and adhesion of the pigment may be improved. A.A.

30-S1121.
Hansen, Eric F.; Bishop, Mitchell Hearns; and Walston, Sue.
An interdisciplinary bibliographic approach to a complex conservation problem: the consolidation of matte paint.

Affl: Getty Conservation Institute, Marina del Rey, CA, USA.

In book. *ICOM Committee for Conservation tenth triennial meeting, Washington, DC, 22-27 August 1993: preprints,* Bridgland, Janet, Editor (1993), pp. 189-194, [Eng. w. Eng. summary]. refs.

Describes a literature survey, occasioned by a research project into the problems of consolidating matte, friable paint, with an emphasis on ethnographic objects. Available bibliographies and databases, such as the Bib-

liographic database of the Conservation Information Network (BCIN), Chemical Abstracts (CAS), and Rubber and Plastics Research Association (RAPRA), provided few references. Although these few references were initially located, isolating the problem's physical nature and understanding its interdisciplinary aspects aided in identifying and compiling a wide variety of literature of direct relevance to the problem and useful to the conservator in designing treatment strategies. Annotated references to this literature have been gathered into a topical supplement to *Art and Archaeology Technical Abstracts* (AATA), to be published 1994 [the present publication]. The organization, sources, and unique aspects of this bibliography are described here, as is the research methodology used to assemble the references. A.A.

30-S1122.
Petersen, K.; Heyn, Ch.; and Krumbein, W.E.
Degradation of synthetic consolidants used in mural painting restoration by microorganisms.

Affl: Carl von Ossietzky Universität, ICBM, Geomicrobiology, Oldenburg, Germany.

In book. *Les anciennes restaurations en peinture murale,* (1993), pp. 47-58, [Eng. w. Eng. summary].

For centuries, traditional organic fixatives, especially those based on proteins, such as casein and animal glue, oil, or even plant gums, were used in the preparation as well as restoration of wall paintings. Synthetic consolidants have come into use within the last 30 years. By experience, every restorer knows that most of the natural polymers used for consolidation can easily be degraded by microorganisms under conditions of high humidity. One of the reasons for introducing synthetic consolidants in the restoration of mural paintings was that those materials were expected to be more resistant to microbial attack. Degradation of mural paintings that had been restored by synthetic consolidants could, however, be detected by the naked eye in many cases and was more closely investigated by means of scanning electron microscopy (SEM). Microbial attack frequently occurred from beneath the material applied on the surface of the paintings.

The increasing number of objects treated with, e.g., derivatives of cellulose, poly(vinyl alcohol), poly(vinyl acetate), and even acrylate methylacrylate copolymers, led to the investigation of the possibility of biodeterioration of synthetic consolidants. In the case of most Medieval, as well as modern wall paintings from different climatic regions (north Germany to Brazil), it could be shown that the microflora, enriched from the restored objects and involved in the biodeterioration of the original paintings, were able to live on and to destroy those synthetic materials that had been applied to the specific objects during former restorations. A.A.

30-S1123.
Petukhova, Tatyana; and Bonadies, Stephen D.
Sturgeon glue for painting consolidation in Russia.

Journal of the American Institute for Conservation, **32**, no. 1, pp. 23-31, (1993), [Eng. w. Eng. summary]. 10 figs., 3 refs., bibliog.

Sturgeon glue, prepared from the inner membrane of the air bladder of the fish, has long been used by Russian conservators as a consolidant and adhesive. It has recently become more accessible to Western conservators. It has greater tack and lower viscosity than comparable mammalian products like gelatin and rabbit-skin glue. The consolidation of badly tented paint on a 16th-century panel painting is described. Translated and adapted sections from the standard text of Russian conservators illustrate current techniques in Russia. (See also AATA 28-1942.) A.A.

30-S1124.
Pfister, Paul.
Annäherung an die Gemäldeoberfläche der modernen Malerei.
(An approach to the study of modern paintings surfaces.)

Restauro, **99**, no. 5, pp. 338-341, (1993), [Ger. w. Eng. summary]. 8 ill., 7 refs.

Impressionist painters intended to give an exact representation of light in their paintings, by means of the art materials available to them at the time. Recommends gaining a thorough understanding of the surface qualities of these paintings prior to attempting any restoration treatment, and in particular, to be aware of the fact that they seldom used varnish. The fluid qualities of Impressionist paintings have also been lost due to relinings, varnishings, and restorations. A reconstruction of the assumed gloss-matte surface relationships is recorded in the example *Berthe Morisot en deuil* by Manet, based on the binding medium component of the oil paint. Natural resins and beeswax are recommended for the treatment of the surface. The use of synthetic resins is strongly discouraged, in opposition to views expressed in *Art in the Making, Impressionism*, a 1990 National Gallery of London publication. A.A.

30-S1125.
Piqué, Francesca; Tintori, Leonetto; and Borsook, Eve.
Wall painting conservation in Tuscany before the Florentine flood of 1966.

Affl: Courtauld Institute of Art, London, UK.

In book. *Les anciennes restaurations en peinture murale*, (1993), pp. 91-103, [Eng. w. Eng. summary]. 5 figs., bibliog.

The 1966 flood in Florence caused conservators, scientists, and art historians from all over the world to collaborate to tackle the task of conserving and restoring damaged wall paintings. This was a rare occurrence in the 1950-68 time span. Conservator Leonetto Tintori carried out three collaborative projects described here: murals by Giotto in the Bardi and Peruzzi Chapels of the Santa Croce, Florence, and in the Scrovegni Chapel, Padua. The discussion of these case studies is based on contemporary records. The conservation problems are set out, the cleaning, consolidation, and fixing materials and techniques are indicated, and a discussion concludes the description of the interventions.

A.A. and M.B.

Treatment

See also:

Collecting wooden ethnographic carvings in the tropics, **30-S354.**

Les pastels [Pastels], **30-S369.**

The cleaning of Color Field paintings, **30-S282.**

The use of wax and wax-resin preservatives on English Medieval wall paintings: rationale and consequences, **30-S388.**

Colouring technique and repair methods for wooden cultural properties, **30-S303.**

Conservation of wall paintings, **30-S366.**

Ajanta murals: their composition and technique and preservation, **30-S232.**

Los nuevos materiales en el arte contemporáneo [New materials in contemporary art], **30-S448.**

Produits, faits, modes en peinture murale: évolution et répartition des produits de restauration utilisés dans les peintures murales de 1850 à 1992: un premier tri concernant France, Espagne, Angleterre et Pologne [Products, facts, modes in mural painting: evolution and distribution of restoration products used in mural paintings from 1850 to 1992: a first sorting concerning France, Spain, England, and Poland], **30-S511.**

Conservation of mural paintings, **S522.**

Fixatifs pour le pastel [Fixatives for pastels], **30-S708.**

Conservation of contemporary art, **30-S736.**

Appendix I
Author Index

Göpfrich, Jutta, S1068.
Górzyńska, Małgorzata, S432, S485.
Götz, Stephan, S500.
Gowers, Harold J., S909, S921, S937.
Grabowski, Jozef, S240.
Graf, Roy, S312.
Grange, B., S847.
Grant, Campbell, S513.
Grattan, David, S1069.
Green, Robert E., Jr., S880.
Greenland, Melville, S1014.
Greig, Thelma F., S515.
Grillini, G.C., S493.
Grote, R.-J., S1070.
Guilford, C., S591, S611.
Guillemard, Denis, S1039, S1111.
Guinand, Jeanne-Laurence, S1071.
Guineau, Bernard, S369.
Gunn, Michael, S333.
Gunther, Erna, S266.
Gupta, C.B., S1072.
Haastrup, Ulla, S302.
Hadert, Hans, S155.
Hall, Robert F., S729.
Halpine, Susana M., S669.
Hamburg, Herman R., S799.
Hamel, Paul B., S287.
Hamelin, Bernard, S922.
Hamilton, Augustus, S18.
Hammer, Ivo, S1098.
Hamsik, Mojmir, S353.
Haner, Paul, S971.
Hanna, Seamus B., S1051, S1052, S1099.
Hansen, Eric F., S1084, S1085, S1120, S1121.
Hanson, Jim, S309.
Harding, R.H., S735.
Hare, Clive H., S867.
Harren, R.E., S826.
Harrington, John Peabody, S33, S58, S62.
Harris, B.L., S714.
Harrison, Vernon George Wentworth, S711.
Hartmann, Gayle H., S305.
Hatchfield, Pamela, S1053.
Havaux, Cecilia Rangel, S1054.
Hawley, Florence May, S46, S524.
Hay, T.K., S781.
Hayek, Erich W.H., S655, S665.
Heath, Diana, S1086.
Heble, Milind, S871.
Hebrard, Michel, S1100.
Hediger, H., S853.
Hegedus, Charles R., S854.

Heifkant, J.A., S855.
Heilman, William R., S532.
Heinonen, Markku, S650.
Heizer, Robert Fleming, S101.
Hemmendinger, Henry, S761.
Henderson, J., S1064.
Hendy, Philip, S241.
Hepper, F. Nigel, S463.
Hermans, Johan, S436.
Hermerén, Karin, S1087.
Heron, Carl, S654.
Herring, Bernd, S643.
Hesler, K.K., S848.
Hess, Manfred, S799.
Hey, Margaret, S530.
Heylen, J., S547.
Heyn, Ch., S1122.
Higuchi, Seiji, S928, S945, S955, S964, S972, S1022, S1024, S1040, S1075.
Hill, Jo, S684, S685.
Hill, William H., S845.
Himmelheber, Hans, S208, S211.
Hinch, Ralph, S598.
Hiraharu, T., S858.
Hird, M.J., S780.
Hittmair, E., S949.
Hodge, Frederick Webb, S25.
Hodge, Walter H., S98, S177.
Hodges, Henry W.M., S215.
Hofer, H., S829.
Hofmann, Christa, S1067.
Holloway, Patricia S., S464.
Holmes, Tommy, S334.
Holsworth, D.D., S749.
Holsworth, R.M., S866, S879.
Holtzen, D.A., S833.
Hook, John W. III, S826, S845.
Hopwood, Walter, S630.
Höring, Franz, S1112.
Horsin-Déon, Simon, S4.
Horton-James, David, S1045, S1062, S1101.
Hours, Madeleine, S753.
Howard, Helen, S388, S514.
Howatt-Krahn, A., S417.
Howlett, D.R., S452.
Howlett, S.G., S452.
Hudson, Travis, S344, S345.
Huff, Ralph H., S279.
Hughes, Sylvia, S465.
Huisman, H.F., S827, S855, S857.
Hulbert, Anna, S1116.
Humecki, Howard, S598.
Humphrey, B.J., S1005.
Hunt, Valerie Reich, S501.

Hutchens, Alma R., S490.
Hyder, William D., S519.
Hyman, David S., S553.
I'ons, Anne, S997.
Idiceanu, Dorina, S439.
Immerwahr, Sara A., S466.
Indictor, Norman, S644.
Innes, Jocasta, S400, S467.
Isaacs, Jennifer, S401.
Isaacs, M.D.J., S589.
Ito, Nobuo, S973.
Ivanova, A.V., S919, S920, S938.
Iwasaki, Tomokichi, S893, S929.
Iyengar, J.R., S604.
Jackson, G., S219.
Jacobsen, E.A., S701.
Jaeschke, Helena F., S1088.
Jaeschke, Richard L., S1064, S1088.
Jägers, Elisabeth, S1068.
James, D.M., S722.
Jarvis, G.W.P., S912.
Jenkins, Katharine D., S216.
Jettmar, W., S762.
Jirat-Wasiutynkski, Vojtech, S317.
Jirat-Wasiutynski, Thea, S317, S468.
Johnson, Colin, S1113.
Johnson, Meryl, S554.
Johnston, Ruth M., S744, S748, S750, S754, S761, S763.
Johnston-Feller, Ruth M., S790, S841.
Jolly, David, S195.
Jones, Elizabeth H., S832.
Jones, Peter Lloyd, S533.
Jordis, Ulrich, S655.
Joyce, Sarah, S1041.
Joyce, T.A., S28.
Judd, D.B., S713.
Jun-Feng Song, S873.
Kaempf, G., S800.
Kahn, Rahim Bux, S126.
Kaltenegger, Uta, S1114.
Kannan, M.V.K., S868.
Kaplan, Lawrence, S228, S455.
Karreman, M.F.S., S435.
Karsten, Erich, S402.
Kashiwagi, K. Maresuke, S571.
Katon, J.E., S648.
Katsuhiko, Masuda, S945.
Keck, Caroline, S736.
Keene, Suzanne, S1031.
Kenjo, Toshiko, S930.
Kenndler, Ernst, S656, S670.
Kieslich, Tanya, S679.
Kimmelman, Michael, S418.

Kindl, Silvia, S1102.
Kirshore, R., S907.
Kléber, Robert, S539, S544.
Klumpp, E., S690.
Knauss, Carl J., S861, S871.
Kochummen, K.M., S630.
Kockaert, Leopold, S346, S981.
Koller, Manfred, S301, S901, S916.
Königfeld, P., S1073.
Koob, Stephen P., S988.
Kooijman, Simon, S209, S267.
Kopf, C.W., S99.
Krauss, Beatrice H., S288, S335, S515.
Krenmayr, Peter, S655, S665.
Kronstein, Max, S110, S122.
Kropp, B., S681.
Krumbein, W.E., S1122.
Kuiper, Luitsen, S926.
Kummer, W., S1070.
Kunz, Noel, S810.
Kupka, Karel, S224.
Kurtze, D.A., S878.
Labi, Kwame Amoah, S516.
Lagercrantz, Sture, S242.
Laiderman, D.D., S712.
Laing, D.K., S589.
Lal, B.B., S143, S232, S931.
Lalli, C., S631.
Laman, Karl Edward, S162, S242.
Lambourne, Ronald, S849.
Landrey, Gregory, S635.
Landry, James M., S664.
Lang, Patricia L., S648.
Langenheim, Jean H., S233.
Lanterna, Giancarlo, S678.
Laroque, Claude, S369, S1013.
Larsen, Mogens, S302.
Larson, George P., S730.
Larson, John, S1006, S469.
Latner, J., S210.
Lato, M., S583.
Laure, Pierre, S1089.
Laurie, Arthur Pillans, S15, S29, S127, S196.
Lausmann, M., S1073.
Lavalle, Denis, S470.
Lavallée, Pierre, S128.
Lawrence, J.F., S604.
Lawrie, Leslie Gordon, S129.
Lee, D.J.V., S318, S935, S950, S967, S1023, S1055, S1056.
Lee, John, S354, S998.
Lee, Nicholas J., S1051, S1052.
Leechman, Douglas, S54, S75.

Author Index

Rufini, S., S583.
Russell, John, S304.
Russell, L.W., S613.
Rutherford, D.J., S851.
Sadoff, Eileen T., S1085, S1120.
Sakurai, Takakage, S891, S892, S893.
Sampathkumaran, P.S., S868.
Sander, Jochen, S521.
Sandner, Ingo, S1092.
Santos Ramos, Juan, S1061.
Sanz Crusado, Laura Jack, S1083.
Sapia, G.M., S583.
Sathyanarayana, M.N., S868.
Saunders, T.E., S777.
Sauter, Fritz, S655.
Savko, Michel, S962.
Scarzella, Paolo, S421.
Schaake, R.C.F., S855, S857.
Schafer, Edward R., S181.
Schafer, H., S840.
Schaffer, Erika, S924, S934.
Schaller, E.J., S757.
Schere, G.A., S717.
Schery, Robert W., S159.
Schießl, Ulrich, S322, S323, S339, S1011, S1077.
Schleicher, Barbara, S1078.
Schmidt, H., S1091.
Schmidt, R.N., S758.
Schmidt-Beiwl, Karin, S670.
Schmitzer, Werner, S1012, S976.
Schnell, Raymond, S106.
Scholz, H.A., S163.
Schott, Franz Leonhard, S1059.
Schramm, Hans-Peter, S622, S643.
Schreiber, Hiltigund, S314.
Schultes, Richard E., S341.
Schulz, H., S681.
Schwartz, Catherine, S369.
Scott, David A., S519.
Scott, Louis, S582.
Sease, Catherine, S1044.
Seeger, Inez Wolf, S231.
Segal, R., S66.
Serck-Dewaide, Myriam, S957.
Sève, Robert, S885.
Seymour, Raymond B., S340.
Shackley, Myra, S608.
Shafey, H.M., S813.
Shedrinsky, Alexander M., S638, S644.
Sheinina, E.G., S936.
Shelley, Marjorie, S442.
Shepard, Anna O., S107, S580.
Shibata, Yuji, S119.

Shida, Tsukasa, S674.
Shoeib, A.S., S649.
Silbergeld, Jerome, S427.
Sillans, Roger, S202.
Silver, Constance S., S977, S995.
Simpson, Colin, S149.
Simpson, L.A., S798, S851.
Sinkai, Tetuo, S659, S674.
Sino, D., S676.
Siqueiros, David Alfaro, S381.
Sirois, Jane, S473.
Sivasamban, M.A., S868.
Skálová, Zuzana, S479.
Skans, Bengt, S628, S651.
Skerry, B.S., S882.
Skirius, Christine, S592.
Skolnik, Herman, S480.
Slifko, Phillip M., S861, S871.
Small, Sophie, S1100.
Smith, Alistair, S386.
Smith, C. Earle, S228.
Smith, D.T., S819.
Smith, F., S531.
Smith, H.H., S36, S43, S56, S61.
Smith, Harlan I., S44, S48.
Smith, Leslie Melville, S1060.
Smith, Monica, S1015.
Smith, N.D.P., S739.
Smith, Ray, S407.
Smith, Watson, S160.
Society for Economic Botany, S424.
Sonoda, Naoko, S660.
Souza, Luiz, S679.
Sparkman, Philip Steadman, S26.
Spurrell, F.C.J., S16.
Stachelberger, Herbert, S612.
Stanziola, Ralph, S763.
Stavisky, B.J., S520.
Steedman, Elsie Viault, S45.
Steinberg, Arthur, S657.
Stephen, Alexander M., S11, S12, S70.
Stern, E. Marianne, S497.
Stevens, Phillip, S978.
Stevenson, Matilda Coxe, S24, S27.
Stieg, Fred B. Jr., S716, S719, S723, S724, S733, S740, S743, S755, S765, S773, S774, S822, S836.
Stipkovich, Walter, S871.
Stodulski, Leon P., S497.
Stoebner, A., S753.
Stoll, Anna, S521.
Stolow, Nathan, S248, S538, S832.
Stoppelaëre, Alexandre, S115.
Storch, Paul S., S1058.

274

Appendix II
Audiovisual Title Index

Appendix III

Source Directory for for Volume 30, Number 3

The following directory of sources cited in Volume 30, Number 3 is comprised of three sections: 1) Periodical Publishers; 2) Monograph Publishers; and 3) Audiovisual Material Distributors. Footnotes refer to further information that may be available from other abstracting services. Other possible methods for acquiring the sources cited are suggested at the end of this directory. The relevant AATA Volume 30, Number 3 abstracts are included for each title listed herein.

Note: Some sources are not regularly abstracted for AATA. Publication may be located by consulting the following additional abstracts publications:

[1]Chemical Abstracts
[2]Forest Products Abstracts
[3]International Repertory for the Literature of Art
[4]Textile Technology Digest

[5]British Archaeological Abstracts
[6]Bibliography of the History of Art
[7]International Centre for the Study of the Restoration and Conservation of Cultural Property

Document delivery may be available through:

CAS (Chemical Abstracts Service)
P.O. Box 3012
Columbus, OH 43210, USA

InfoQuest
1803 Research Boulevard, Suite 600
Rockville, MD 20850, USA

Infomation on Demand
P. O. Box 9550
Berkeley, CA 94709, USA

Periodical Publishers

Acta archaeologica Academiae Scientiarum Hungaricae
Akademiai Kiado, Publishing House of the
Hungarian Academy of Sciences
P.O. Box 24
V. Alkotmany u. 21
1363 Budapest, Hungary
[ISSN 0001-5210]
Abstracts: S170

Acta Universitatis Nicolai Copernici
Uniwersytet Mikołaja Kopernika w
Toruniu
ul. Fosa Staromiejska 3
87-110 Toruń, Poland
[ISSN 0860-1232]
Abstracts: S486

Actes (Congrès des Sociétés de philosophie de langue française)
Éditions de la baconnière
19 av. du Collège
C.P. 185
2017 Boudry, Switzerland
Abstracts: S115

Adhäsion
Heinrich Vogel Fachzeitschriften GmbH
Neumarkter Str. 18
Postfach 802020
8000 Munich, 80 Germany
[ISSN 0001-8198]
Abstracts: S769

Advances in archaeological method and theory
Academic Press, Inc.
1250 Sixth Ave.
San Diego, CA 92101 USA
[ISSN 0162-8003]
Abstracts: S406

Advances in organic coatings science and technology series
Technomic Publishing Company, Inc.
851 New Holland Ave.
Box 3535
Lancaster, PA 17604 USA
[ISSN 0271-1885]
Abstracts: S857

African arts
University of California, Los Angeles.
African Studies Center
405 Hilgard Ave.
Los Angeles, CA 90024 USA
[ISSN 0001-9933]
Abstracts: S291, S292, S444

African studies bulletin
African Studies Association
Emory University
Credit Union Bldg.
Atlanta, GA 30322 USA
[ISSN 0568-1537]
Abstracts: S195

AIAA journal
American Insitute of Aeronautics and
Astronautics
370 L'Enfant Promenade S.W.
Washington, DC 20024 USA
[ISSN 0001-1452]
Abstracts: S813

American anthropologist
American Anthropological Association
1703 New Hampshire Ave. NW
Washington, DC 20009 USA
[ISSN 0002-7294]
Abstracts: S11, S46

American antiquity: a quarterly review of American archaeology
Society for American Archaeology
808 17th St. NW
Suite 200
Washington, DC 20006 USA
[ISSN 0002-7316]
Abstracts: S189, S190, S197, S198, S385, S566, S568, S590, S605

American artist
American Artist Magazine
1515 Broadway
New York, NY 10036 USA
[ISSN 0002-7375]
Abstracts: S275, S985

American laboratory
International Scientific
Communications, Inc.
30 Controls Dr. ·
Box 870
Shelton, CT 06484-0870 USA
[ISSN 0044-7749]
Abstracts: S610

The American naturalist
University of Chicago Press. Journals
Division
5720 S. Woodlawn Ave.
P.O. Box 37005
Chicago, IL 60637 USA
[ISSN 0003-0147]
Abstracts: S7

American Orchid Society bulletin
American Orchid Society
6000 Olive Ave.
West Palm Beach, FL 33405 USA
[ISSN 0003-0252]
Abstracts: S193

American paint & coatings journal
American Paint Journal Co.
2911 Washington Ave.
Saint Louis, MO 63103 USA
[ISSN 0098-5430]
Abstracts: S860

American paint journal
American Paint Journal Co.
2911 Washington Ave.
Saint Louis, MO 63103 USA
[ISSN 0003-0317]
Abstracts: S110, S122, S706, S723

Analyst
Royal Society of Chemistry (Great Britain)
Blackhorse Rd.
Letchworth, SG6 1HN UK
[ISSN 0003-2654]
Abstracts: S35, S654

Analytical chemistry[1]
American Chemical Society
1155 16th Street NW
Washington, DC 20036 USA
[ISSN 0003-2700]
Abstracts: S527, S588, S655, S673, S856

*Ancient India: bulletin of the
Archaeological Survey of India*
Archaeological Survey of India
Government of India
New Delhi, 110011 India
Abstracts: S894, S895

*Annales (Laboratoire de recherche des
musées de France)*
Réunion des musées nationaux (France)
10 rue de Lille
75007 Paris, France
[ISSN 0373-8027]
Abstracts: S567

*Annual report (United States. Bureau of
American Ethnology)*
United States Government Printing Office
Washington, DC 20402-9325 USA
[ISSN 0097-269X]
**Abstracts: S8, S9, S13, S14, S17, S22,
S24, S27, S32, S34, S41, S45, S53,
S55, S57**

*Anthropological papers of the University
of Alaska*
University of Alaska, Fairbanks.
Department of Anthropology
310 Eielson Bldg.
Fairbanks, AK 99775 USA
[ISSN 0041-9354]
Abstracts: S180

Anthropos
Editions Saint-Paul
Perolles 42
1700 Fribourg, Switzerland
[ISSN 0257-9774]
Abstracts: S158

Antiques
Brant Publications
575 Broadway
5th floor
New York, NY 10012 USA
[ISSN 0003-5939]
Abstracts: S140

Source Directory

Antiquity
Oxford University Press. Oxford Journals
Pinkhill House
Southfield Rd.
Eynsham, OX8 1JJ UK
[ISSN 0003-598X]
Abstracts: S523

Applied optics
American Institute of Physics
335 E. 45th St.
New York, NY 10017 USA
[ISSN 0003-6935]
Abstracts: S873

Applied polymer symposia
Wiley-Interscience
605 Third Ave.
New York, NY 10016 USA
[ISSN 0570-4898]
Abstracts: S766

*Applied scientific research. A.
Mechanics, heat, chemical engineering,
mathematical methods*
Kluwer Academic Publishers
Postbus 322
3300 AH Dordrecht, Netherlands
[ISSN 0003-6994]
Abstracts: S745

Arbeitsblätter für Restauratoren
Römisch-Germanisches Zentralmuseum
Ernst-Ludwig-Platz 2
6500 Mainz, Germany
[ISSN 0066-5738]
Abstracts: S976, S1097

The archaeological journal
Royal Archaeological Institute
96 New Walk
Leicester, LE1 6TD UK
[ISSN 0066-5983]
Abstracts: S16

Archaeology
Archaeological Institute of America
15 Park Row
New York, NY 10038 USA
[ISSN 0003-8113]
Abstracts: S390, S491

Archaeometry[1]
University of Oxford. Research Laboratory
for Archaeology and the History of Art
6 Keble Rd.
Oxford, OX1 3QJ UK
[ISSN 0003-813X]
Abstracts: S534, S653

Arkos
Tecniche Nuove S.p.A.
Via Ciro Menotti 14
20129 Milan, Italy
Abstracts: S1065

Ars orientalis
University of Michigan
Department of History of Art
Tappan Hall
Ann Arbor, MI 48109 USA
[ISSN 0571-1371]
Abstracts: S315

Art and auction
Art and Auction
250 West 57th St.
New York, NY 10019 USA
[ISSN 0197-1093]
Abstracts: S370

Art digest
Art Digest Co.
23 E. 26th St.
New York, NY 10010 USA
[ISSN 0277-9021]
**Abstracts: S134, S145, S146, S147,
S148, S166**

Artibus Asiae
Artibus Asiae Publishers
Via Baraggie 47
6612 Ascona, Switzerland
[ISSN 0004-3648]
Abstracts: S49, S143

The artifact
El Paso Archaeological Society
Box 4345
El Paso, TX 79914 USA
[ISSN 0004-3680]
Abstracts: S236, S249

ARTnews
ARTnews Associates
48 W. 38th St.
New York, NY 10018 USA
[ISSN 0004-3273]
Abstracts: S154

Arts
Art Digest Co.
23 E. 26th St.
New York, NY 10010 USA
[ISSN 0733-5466]
Abstracts: S171

Arts magazine
Art Digest Co.
23 E. 26th St.
New York, NY 10010 USA
[ISSN 0004-4059]
Abstracts: S317

Artscanada
Society for Art Publications
3 Church St.
Toronto, ONT M5E 1M2 Canada
[ISSN 0004-4113]
Abstracts: S248

Bantu studies: a journal devoted to the scientific study of Bantu, Hottentot, and Bushman
Witwatersrand University Press
Private Bag, Wits
2050 Johannesburg, South Africa
Abstracts: S66

Beiträge zur Erhaltung von Kunstwerken
Restoratoren Fachverband e.V.i.G.
Greifenhagener Str. 8
1058 Berlin, Germany
Abstracts: S993

Berliner Beiträge zur Archäometrie
Staatliche Museen Preussischer
Kulturbesitz
Schloßstr. 1a
1000 Berlin, 19 Germany
[ISSN 0344-5089]
Abstracts: S642

Bijutsu kenkyu = The journal of art studies
Japan Publications Trading Co. Ltd.
Box 5030

Tokyo International
Tokyo, 100-31 Japan
[ISSN 0021-907X]
Abstracts: S119, S893

Bollettino d'arte[6]
Ufficio centrale per i beni ambientali,
architettonici, archeologici, artistici e storici
Via di San Michele 22
00153 Rome, Italy
[ISSN 0391-9854]
Abstracts: S395, S1033

Bollettino dell'Istituto Centrale del Restauro
Istituto Centrale del Restauro
Piazza S. Francesco di Paola 9
00184 Rome, Italy
[ISSN 0021-244X]
Abstracts: S139, S157, S235, S903

The Book & Paper Group annual
American Institute for Conservation of
Historic and Artistic Works. Book and
Paper Group
1400 16th St. NW
Suite 340
Washington, DC 20036 USA
[ISSN 0887-8978]
Abstracts: S1010, S1029, S1076

Boston Museum bulletin
Museum of Fine Arts, Boston
465 Huntington Ave.
Boston, MA 02115 USA
Abstracts: S244

Bukkyo geijutsu
Japan Publications Trading Co. Ltd.
Box 5030
Tokyo International
Tokyo, 100-31 Japan
[ISSN 0004-2889]
Abstracts: S183, S271, S272

Bulletin (Institut Royal du Patrimoine Artistique) = Bulletin (Koninklijk Instituut voor het Kunstpatrimonium)
Institut Royal du Patrimoine Artistique
1 parc du Cinquantenaire
1040 Brussels, Belgium
[ISSN 0085-1892]
Abstracts: S535, S537, S539, S569, S906, S962, S981

Bulletin (Museum and Picture Gallery, Baroda (India))
Museum and Picture Gallery, Baroda (India)
Baroda, 390005 India
Abstracts: S911

Bulletin (Société d'Archéologie Copte)
Société d'archéologie copte
222 rue Ramses
Cairo, Egypt
[ISSN 0068-5291]
Abstracts: S479

Bulletin—The St. Louis Art Museum
St. Louis Art Museum
Forest Park
Saint Louis, MO 63110 USA
[ISSN 0009-7691]
Abstracts: S285

Bulletin du Laboratoire du Musée du Louvre
Musée du Louvre. Laboratoire de recherche des musées de France
Palais de Louvre
75041 Paris, France
[ISSN 0553-2566]
Abstracts: S545

Bulletin of the American Group (International Institute for Conservation of Historic and Artistic Works)
American Institute for Conservation of Historic and Artistic Works
1717 K Street, N.W.
Suite 301
Washington, DC 20006 USA
[ISSN 0535-0867]
Abstracts: S746

Bulletin of the Chemical Society of Japan
Nippon Kagakkai
5, 1-chome Kanda-Surugadai
Chiyodo-ku
Tokyo, 101 Japan
[ISSN 0009-2673]
Abstracts: S571

Bulletin of the Public Museum of the City of Milwaukee
Milwaukee Public Museum
800 W. Wells St.
Milwaukee, WI 53233 USA
Abstracts: S36, S43, S56, S61

Bulletin: The Museum of Far Eastern Antiquities (Östasiatiska museet) Stockholm
Ostasiatiska museet
Skeppsholmen
Box 16381
103 27 Stockholm, Sweden
[ISSN 0081-5961]
Abstracts: S222

Canadian geographical journal
Royal Canadian Geographical Society
39 McArthur Ave.
Vanier, Ontario K1L 8L7 Canada
[ISSN 0315-1824]
Abstracts: S95

Chemistry of natural compounds
Plenum Publishing Corp.
233 Spring St.
New York, NY 10013 USA
[ISSN 0009-3130]
Abstracts: S570

Chimie des peintures
Etudes et réalisations de la couleur
68, rue Jean-Jaurès
92800 Puteaux, France
[ISSN 0009-434X]
Abstracts: S103, S708

Chronica botanica
Ronald Press
c/o John Wiley & Sons
605 Third Ave.
New York, NY 10158-0012 USA
Abstracts: S88

Ciba review
Ciba-Geigy Ltd.
4002 Basel, Switzerland
Abstracts: S121

Coatings and plastics preprints
American Chemical Society
1155 16th Street NW
Washington, DC 20036 USA
[ISSN 0099-0701]
Abstracts: S760, S788

*Colloid and polymer science =
Kolloid-Zeitschrift & Zietschrift für
Polymere*
Dr. Dietrich Steinkopff Verlag
Saalbaustr. 12
Postfach 11 14 42
6100 Darmstadt, 11 Germany
[ISSN 0303-402X]
Abstracts: S693, S702

Colloids and surfaces
Elsevier Science Publishers B.V.
Postbus 211
1000 AE Amsterdam, Netherlands
[ISSN 0166-6622]
Abstracts: S815

Color engineering
Chromatic Communications Enterprises
P.O. Box 30127
Walnut Creek, CA 94598 USA
[ISSN 0010-1478]
Abstracts: S230, S754

Color research and application
John Wiley & Sons, Inc.
605 Third Ave.
New York, NY 10158-0012 USA
[ISSN 0361-2317]
Abstracts: S885

*COMA: bulletin of the Conference of
Museum Anthropologists*
Conference of Museum Anthropologists
Fortitude Valley, Queensland, Australia
[ISSN 0158-734X]
Abstracts: S333

*Conservation news (United Kingdom
Institute for Conservation of Historic and
Artistic Works)*
United Kingdom Institute for Conservation
37 Upper Addison Gardens
Holland Park
London, W14 8AJ UK
[ISSN 0309-2224]
Abstracts: S1113

*Conservation of cultural property
in India*
Indian Association for the Study of
Conservation of Cultural Property
c/o National Museum Institute
Janpath
New Delhi, 110 001 India
[ISSN 0376-7965]
**Abstracts: S644, S907, S1001, S1026,
S1072**

Conservation restauration
Fédération nationale des artistes
restaurateurs des oeuvres d'art
18, Square des Moulineaux
92100 Boulogne-Billancourt, France
[ISSN 0765-5428]
Abstracts: S398, S1016

*Conservation, restauration des biens
culturels: revue de l'ARAAFU*
Association des restaurateurs d'art et
d'archéologie de formation universitaire
3, rue Michelet
75006 Paris, France
Abstracts: S488, S1109

The conservator
United Kingdom Institute for Conservation
37 Upper Addison Gardens
Holland Park
London, W14 8AJ UK
[ISSN 0140-0096]
**Abstracts: S373, S514, S967, S1074,
S1111**

*Contributions from the United States
National Herbarium*
Smithsonian Institution Press
955 L'Enfant Plaza
Suite 2100
Washington, DC 20560 USA
[ISSN 0097-1618]
Abstracts: S21

Current anthropology
University of Chicago Press. Journals
Division
5720 S. Woodlawn Ave.
P.O. Box 37005
Chicago, IL 60637 USA
[ISSN 0011-3204]
Abstracts: S325

Current science
Current Science Association
C.V. Raman Ave.
P.O. Box 8001
Sadashivanager
Bangalore, 560 080 India
[ISSN 0011-3891]
Abstracts: S522

Defazet-aktuell
Wissenschaftliche Verlagsgesellschaft mbH
Postfach 10 10 61
7000 9 Stuttgart, Germany
[ISSN 0366-8975]
Abstracts: S771

Denkmalpflege in Baden-Württemberg
Landesdenkmalamt Baden-Württemberg
Mörikestr. 12
7000 Stuttgart, 1 Germany
[ISSN 0340-2495]
Abstracts: S339

Deutsche Farben-Zeitschrift
Wissenschaftliche Verlagsgesellschaft
Stuttgart, Germany
[ISSN 0341-065X]
Abstracts: S551

Drawing[6]
Drawing Society
15 Penn Plaza
Box 66
415 Seventh Ave.
New York, NY 10001-2050 USA
[ISSN 0191-6963]
Abstracts: S310, S311, S460, S468

Du
Conzett & Huber Zeitschriften AG
8036 Zurich, Switzerland
Abstracts: S192

Dyestuffs
Allied Chemical and Dye Corporation.
National Aniline Division
New York, NY, USA
[ISSN 0095-845X]
Abstracts: S744

Eastern art
College Art Association of America
275 Seventh Ave.
5th floor
New York, NY 10011-6708 USA
Abstracts: S52

Economic botany[2]
New York Botanical Garden. Scientific
Publications Department
Bronx, NY 10458-5126 USA
[ISSN 0013-0001]
**Abstracts: S228, S263, S392, S426,
S429, S453, S455, S464, S482, S502,
S518**

Eingereicht für News Letters
Fraunhofer-Institut für Silicatforschung
Neunerplatz 2
8700 Würzburg, Germany
Abstracts: S1091

Ethnographic conservation newsletter
ICOM Committee for Conservation.
Working Group on Ethnographic Materials
c/o Todd Howatt-Krahn
123 W. 14th Ave.
Suite C
Vancouver, BC V5Y 1W8 Canada
Abstracts: S1041, S1046

The eye
The Eye
143 Golf Links
New Delhi, 110003 India
Abstracts: S495

Farbe + Lack
Curt R. Vincentz Verlag
Schiffgraben 41-43
Postfach 6247
3000 Hanover, Germany
[ISSN 0014-7699]
**Abstracts: S257, S814, S839, S847,
S850, S859, S870**

Farben, Lacke, Anstrichstoffe
Wissenschaftliche Verlagsgesellschaft mbH
Postfach 10 10 61
7000 9 Stuttgart, Germany
Abstracts: S130, S136

Farben-Zeitung
Curt R. Vincentz Verlag
Schiffgraben 41-43
Postfach 6247
3000 Hanover, Germany
Abstracts: S690, S691, S692, S697, S700, S889

Fiber producer
W.R.C. Smith Publishing Co.
1760 Peach Tree Rd. N.W.
Atlanta, GA 30357 USA
[ISSN 0361-4921]
Abstracts: S801

Field Museum news
Field Museum of Natural History
Roosevelt Road at Lake Shore Dr.
Chicago, IL 60605-2496 USA
Abstracts: S92

Fine woodworking
Taunton Press, Inc.
63 S. Main St.
Box 5506
Newtown, CT 06470-5506 USA
[ISSN 0361-3453]
Abstracts: S348

Forensic science international
Elsevier Science Publishing Co., Inc.
P.O. Box 882
Madison Sq. Station
New York, NY 10159 USA
[ISSN 0379-0738]
Abstracts: S589, S602, S609, S613, S618, S620

Fresenius' journal of analytical chemistry
Springer-Verlag GmbH & Co. KG
Heidelberger Platz 3
1000 Berlin, 33 Germany
[ISSN 0937-0633]
Abstracts: S656, S665, S670, S681

The geological curator
Geological Curators Group
c/o Geological Society of London
Burlington House
London, W1V 0JU UK
[ISSN 0144-5294]
Abstracts: S1031

The Getty Conservation Institute newsletter
Getty Conservation Institute
4503 Glencoe Ave.
Marina del Rey, CA 90292-6537 USA
Abstracts: S1079

Graphis
Graphis Press
Dufourstr. 107
8008 Zurich, Switzerland
[ISSN 0017-3452]
Abstracts: S179, S188

Harvard journal of Asiatic studies
Harvard-Yenching Institute
2 Divinity Ave.
Cambridge, MA 02138 USA
[ISSN 0073-0548]
Abstracts: S73

Harvard magazine[6]
Harvard Magazine, Inc.
7 Ware St.
Cambridge, MA 02138 USA
[ISSN 0095-2427]
Abstracts: S410

Hesperia
American School of
Classical Studies at Athens
54 Souidias St.
106-76 Athens, Greece
[ISSN 0018-098X]
Abstracts: S104

Holz-Zentralblatt
DRW-Verlag Weinbrenner-KG
Fasanenweg 18
7022 Leinfelden-Echterdingen, Germany
[ISSN 0018-3792]
Abstracts: S204, S205

Holzforschung[2]
Walter de Gruyter und Co.
Genthiner Str. 13
1000 Berlin, 30 Germany
[ISSN 0018-3830]
Abstracts: S650

Hozon kagaku
Bunka-cho Tokyo Kokuritsu Bunkazai
Kenkyujo Hozon Kagakubu
13-27 Ueno Koen
Taito-ku
Tokyo, 110 Japan
[ISSN 0287-0606]
**Abstracts: S928, S929, S930, S932,
S933, S939, S940, S941, S945, S955,
S964, S1022, S1024, S1040, S1075**

Hyperfine interactions[1]
J.C. Baltzer AG. Scientific Publishing
Company
Wettsteinplatz 10
4058 Basel, Switzerland
[ISSN 0304-3843]
Abstracts: S663

ICA newsletter
Intermuseum Conservation Association
Intermuseum Laboratory
Allen Art Building
Oberlin College
Oberlin, OH 44074 USA
[ISSN 0018-876X]
Abstracts: S324, S1009

ICCM bulletin
Australian Institute for the Conservation
of Cultural Material
GPO Box 1638
Canberra, ACT 2601 Australia
[ISSN 0313-5381]
**Abstracts: S308, S312, S380, S595,
S944, S959, S960, S974, S997, S1042**

ICOMOS information
Edizioni scientifiche italiane
Via Chiatamone 7
80121 Naples, Italy
Abstracts: S1048

Indian archives
National Archives of India/
India Janpath
New Delhi 110001, India
[ISSN 0367-7435]
Abstracts: S896

Indian leaflet series
Denver Art Museum
Department of Indian Art
Publications Department
100 W. 14th Ave. Parkway
Denver, CO 80204 USA
Abstracts: S59

L'industria della vernice
Edizioni Ariminum S.r.l.
Via Negroli 51
20133 Milan, Italy
[ISSN 0019-7564]
Abstracts: S141

Industrial and engineering chemistry
American Chemical Society
1155 16th Street NW
Washington, DC 20036 USA
[ISSN 0019-7866]
**Abstracts: S163, S688, S689, S698,
S701, S710, S714, S717**

*Informes y trabajos del Instituto de
Conservacion y Restauracion de Obras
de Arte, Arqueologia y Etnologia*
Instituto de Conservación y Restauración
de Bienes Culturales (Spain)
Calle El Greco, 4
Ciudad Universitaria
28040 Madrid, Spain
Abstracts: S548

JCT: Journal of coatings technology
Federation of Societies for Coatings
Technology
1315 South Walnut St.
Suite 830
Philadelphia, PA 19107 USA
[ISSN 0361-8773]
**Abstracts: S489, S615, S786, S787,
S790, S797, S800, S811, S818, S819,
S822, S827, S828, S830, S831, S833,
S837, S838, S841, S846, S848, S852,
S854, S861, S864, S871, S872, S875,
S876, S877, S879, S882, S883, S884,
S886**

Journal de la Société des africanistes
La Société des africanistes
Musée de l'Homme
Place du Trocadero
75116 Paris, France
[ISSN 0037-9166]
Abstracts: S106

Journal of American folklore
American Anthropological Association
1703 New Hampshire Ave. NW
Washington, DC 20009 USA
[ISSN 0021-8715]
Abstracts: S12

Journal of analytical and applied pyrolysis[1]
Elsevier Science Publishers B.V.
Postbus 211
1000 AE Amsterdam, Netherlands
[ISSN 0165-2370]
Abstracts: S636, S662, S678

Journal of anthropological research
University of New Mexico. Department of Anthropology
Albuquerque, NM 87131 USA
[ISSN 0091-7710]
Abstracts: S361

Journal of applied physics
American Institute of Physics
335 E. 45th St.
New York, NY 10017 USA
[ISSN 0021-8979]
Abstracts: S878

Journal of applied polymer science
John Wiley & Sons, Inc.
605 Third Ave.
New York, NY 10158-0012 USA
[ISSN 0021-8995]
Abstracts: S834, S858

Journal of archaeological science
Academic Press Ltd.
24-28 Oval Rd.
London, NW1 7DX UK
[ISSN 0305-4403]
Abstracts: S608

Journal of California and Great Basin anthropology
California State University, Bakersfield.
Department of Sociology-Anthropology
9001 Stockdale Hwy.
Bakersfield, CA 93311 USA
[ISSN 0191-3557]
Abstracts: S481

Journal of chemical education[1]
American Chemical Society. Division of Chemical Education
20th and Northampton
Easton, PA 18042 USA
[ISSN 0021-9584]
Abstracts: S105, S109

Journal of chromatography[1]
Elsevier Science Publishers B.V.
Postbus 211
1000 AE Amsterdam, Netherlands
[ISSN 0021-9673]
Abstracts: S536, S577, S583, S604

The journal of Egyptian archaeology
Egypt Exploration Society
3 Doughty Mews
London, WCIN 2PG UK
[ISSN 0307-5133]
Abstracts: S1064

Journal of ethnobiology
Society of Ethnobiology
c/o Catherine S. Fowler
Department of Anthropology
University of Nevada
Reno, NV 89557 USA
[ISSN 0278-0771]
Abstracts: S349

Journal of field archaeology
Boston University
745 Commonwealth Ave.
Boston, MA 02215 USA
[ISSN 0093-4690]
Abstracts: S1058

Journal of forensic sciences
American Society for Testing and Materials
1916 Race St.
Philadelphia, PA 19103 USA
[ISSN 0022-1198]
Abstracts: S532

The journal of industrial and
engineering chemistry
American Chemical Society
1155 16th Street NW
Washington, DC 20036 USA
[ISSN 0095-9014]
Abstracts: S686

Journal of New World archaeology
University of California, Los Angeles.
Institute of Archaeology
405 Hilgard Ave.
Los Angeles, CA 90024-1510 USA
[ISSN 0147-9024]
Abstracts: S371

Journal of paint technology
Federation of Societies for Coatings
Technology
1315 South Walnut St.
Suite 830
Philadelphia, PA 19107 USA
[ISSN 0022-3352]
**Abstracts: S265, S279, S750, S755,
S757, S762, S768, S770, S775, S780,
S784**

Journal of protective coatings & linings
Journal of Protective Coatings & Linings
24 South 18th St.
Pittsburgh, PA 15203 USA
[ISSN 8755-1985]
Abstracts: S867

Journal of the American Institute for
Conservation
American Institute for Conservation of
Historic and Artistic Works
1717 K Street, N.W.
Suite 301
Washington, DC 20006 USA
[ISSN 0197-1360]
**Abstracts: S326, S387, S646, S671,
S675, S792, S982, S1066, S1120, S1123**

Journal of the American Oriental
Society
American Oriental Society
University of Michigan
Harlan Hatcher Graduate Library
Ann Arbor, MI 48109-1205 USA
[ISSN 0003-0279]
Abstracts: S181

Journal of the Arnold Arboretum
Harvard University. Arnold Arboretum
Cambridge, MA 02138 USA
[ISSN 0004-2625]
Abstracts: S233

Journal of the International Institute for
Conservation-Canadian Group: J. IIC-CG
IIC Canadian Group
PO Box 9195
Ottawa, Ontario K1G 3T9 Canada
[ISSN 0381-0402]
Abstracts: S606

Journal of the New York Botanical
Garden
New York Botanical Garden. Scientific
Publications Department
Bronx, NY 10458-5126 USA
[ISSN 0885-4165]
Abstracts: S98

Journal of the Oil and Colour Chemists'
Association
Oil and Colour Chemists' Association
Priory House
967 Harrow Rd.
Wembley, HA0 2SF UK
[ISSN 0030-1337]
**Abstracts: S126, S619, S722, S737,
S739, S741, S751, S756, S765, S778,
S808, S863, S868, S881**

Journal of the Optical Society of
America
Optical Society of America
1816 Jefferson Pl. NW
Washington, DC 20036 USA
[ISSN 0030-3941]
Abstracts: S705, S735, S738

Journal of the science of food and
agriculture
Elsevier Applied Science Publishers Ltd.
Crown House
Linton Road
Barking, IG11 8JU UK
[ISSN 0022-5124]
Abstracts: S676

Journal of the Walters Art Gallery
Walters Art Gallery
600 N. Charles St.
Baltimore, MD 21201 USA
[ISSN 0083-7156]
Abstracts: S890, S910

Journal of the Washington Academy of Sciences
Washington Academy of Sciences
2100 Foxhall Rd. N.W.
No. COLE
Washington, DC 20007-1199 USA
[ISSN 0043-0439]
Abstracts: S118

Journal of thermal analysis[1]
Akademiai Kiado, Publishing House of the
Hungarian Academy of Sciences
P.O. Box 24
V. Alkotmany u. 21
1363 Budapest, Hungary
[ISSN 0368-4466]
Abstracts: S634

Journal: a contemporary art magazine
Los Angeles Institute of
Contemporary Art
Los Angeles, CA USA
Abstracts: S337

Kalori: journal of the Museums Association of Australia
Royal South Australian Society of Arts
Institute Bldg.
North Terr.
Adelaide, South Australia 5000 Australia
[ISSN 0047-312X]
Abstracts: S908

Kermes
Nardini
Via Ammirato 37
50136 Florence, Italy
[ISSN 88-404-3953-6]
Abstracts: S440, S492

Khudozhestvennoe nasledie: Khranenie, issledovanie, restavratsiia
Izd-vo Iskusstvo
Sobinovskij per.3
103009 Moscow, Russia
Abstracts: S601

The kiva
Arizona Archaeological and Historical
Society
Arizona State Museum
University of Arizona
Tucson, AZ 85721 USA
[ISSN 0023-1940]
Abstracts: S217, S218, S259

Kobunkazai no kagaku
Kobunkazai Kagaku Kenkyukai
c/o Tokyo Kokuritsu
Bunkazai Kenkyusho
13-27 Ueno Koen, Taito-ku
Tokyo, 110 Japan
[ISSN 0368-6272]
Abstracts: S150, S151, S659, S674, S891, S892

Kolloid Zeitschrift
Darmstadt, Germany
[ISSN 0368-6590]
Abstracts: S696

A Magyar Mernok- es Epitesz-Egylet kozlonye
Magyar Mernok- es Epitesz-Egylet
Budapest, Hungary
Abstracts: S100

Maltechnik
Verlag Georg D.W. Callwey
Streitfeldstr. 35
Postfach 800409
8000 Munich, 80 Germany
Abstracts: S173, S718, S899, S915, S916

Maltechnik-Restauro
Verlag Georg D.W. Callwey
Streitfeldstr. 35
Postfach 800409
8000 Munich, 80 Germany
[ISSN 0025-1445]
Abstracts: S321, S323, S358, S628, S949, S966, S969, S1011, S1038

Man
Royal Anthropological Institute of Great
Britain and Ireland
50 Fitzroy St.
London, W1P 5HS UK
[ISSN 0025-1496]
Abstracts: S28, S38

Source Directory

Die Mappe; Deutsche Maler- und
Lackierer-Zeitschrift
Verlag Georg D.W. Callwey
Streitfeldstr. 35
Postfach 800409
8000 Munich, 80 Germany
[ISSN 0025-2697]
Abstracts: S789

MASCA journal
University of Pennsylvania. Museum
Applied Science Center for Archaeology
University Museum
33rd & Spruce Streets
Philadelphia, PA 19104 USA
[ISSN 0198-0106]
Abstracts: S316

Masterkey
Southwest Museum
Box 128
Highland Park Station
Los Angeles, CA 90042 USA
Abstracts: S68, S69, S256

Materiali e strutture
L'Erma di Bretschneider
Via Cassiodoro, 19
00193 Rome, Italy
Abstracts: S1106

Materials performance
National Association of Corrosion
Engineers
Box 218340
Houston, TX 77218 USA
[ISSN 0094-1492]
Abstracts: S812

Materialy konserwatorskie
Poland
Abstracts: S925

Materiały zachodniopomorskie
(Muzeum Narodowe)
Muzeum Narodowe w Szczecinie
Staromlynska 27
70-561 Szczecin, Poland
[ISSN 0076-5236]
Abstracts: S207

Meddelelser om konservering
Nordisk Konservatorforbund
Nationalmuseets Farvekonservering
2800 Brede, Denmark
[ISSN 0106-469X]
Abstracts: S651

Mededelingen van de Koninklijke
Vlaamse Academie voor
Wetenschappen, Letteren en Schone
Kunsten van België, Klasse der
Wetenschappen
Standaard Uitgevery N.V.
Belgielei 147A
2018 Antwerp, Belgium
[ISSN 0369-285X]
Abstracts: S90

Mededelingenblad (IIC Nederland)
IIC Nederland
Prinses Irenelaan 8
1182 BJ Amsterdam, Netherlands
Abstracts: S435

Mediaeval Scandinavia
Odense University Press
Campusvej 55
5230 Odense, M Denmark
[ISSN 0076-5864]
Abstracts: S420

Memoirs of the Archaeological Survey
of India
Archaeological Survey of India
Government of India
New Delhi, 110011 India
Abstracts: S232

The microscope
Microscope Publications
2820 S. Michigan Ave.
Chicago, IL 60616-3292 USA
[ISSN 0026-282X]
Abstracts: S555, S592, S593, S598, S661

Mikrochemie vereinigt mit
Mikrochimica acta
Springer-Verlag
Mölkerbastei 5
Postfach 367
1011 Vienna, Austria
[ISSN 0369-2795]
Abstracts: S526

292

Mikrochimica acta
Springer-Verlag
Mölkerbastei 5
Postfach 367
1011 Vienna, Austria
[ISSN 0344-838X]
Abstracts: S550

Minutes of meeting: UKG-IIC
International Institute for Conservation of
Historic and Artistic Works
6 Buckingham St.
London, WC2N 6BA UK
Abstracts: S912

*A Miskolci Herman Ottó Muzeum
közleményei*
Hermann Otto Muzeum
Felszabaditok ut. 28
3529 Miskolc, Hungary
[ISSN 0544-4233]
Abstracts: S1000

Missouri Botanical Garden bulletin
Missouri Botanical Garden
Box 299
Saint Louis, MO 63166-0299 USA
[ISSN 0026-6507]
Abstracts: S71, S72

*Mitteilungen (Deutscher
Restauratoren-Verband)*
Geschäftsstelle bayerisches Landesamt für
Denkmalpflege
Postfach 10 02 03
8000 Munich, 1 Germany
[ISSN 0176-8875]
Abstracts: S322

*Mouseion: bulletin de l'Office
international des musées*
Presses Universitaires de France
17 rue Soufflot
75005 Paris, France
Abstracts: S887, S888

Museum
Unesco
7-9 Place de Fontenoy
75007 Paris, France
[ISSN 0027-3996]
Abstracts: S241

Museum Alliance quarterly
Natural History Museum of
Los Angeles County.
Section of Ornithology
900 Exposition Blvd.
Los Angeles, CA 90007 USA
Abstracts: S251

*Museum news (American Association
of Museums)*
American Association of Museums
1225 Eye St. NW
Suite 200
Washington, DC 20005 USA
[ISSN 0027-4089]
Abstracts: S736

*The museums journal (Museums
Association)*
Museums Association
34 Bloomsbury Way
London, WC1A 2SF UK
[ISSN 0027-416X]
Abstracts: S950

Muzei i pametnitsi na kulturata
Foreign Trade Co. "Hemus"
7 Levsky St.
1000 Sofia, Bulgaria
[ISSN 0324-1793]
Abstracts: S948

Müzeumi mütargyvédelem
Központi Muzemi Igazgatóság (Hungary)
PO Box 58
1450 Budapest, Hungary
[ISSN 0139-4398]
Abstracts: S975

National Gallery technical bulletin[6]
National Gallery Publications
Trafalgar Square
London, WC2N 5DN UK
[ISSN 0140-7430]
**Abstracts: S386, S423, S578, S581,
S587, S594, S607, S617**

National geographic
National Geographic Society (U.S.)
17th and M Streets NW
Washington, DC 20036 USA
[ISSN 0027-9358]
Abstracts: S168

Nationalmuseets arbejdsmark
Nationalmuseet (Denmark)
Konserveringsanstalt 2
2800 Brede, Denmark
[ISSN 0084-9308]
Abstracts: S302

Nature
Macmillan Journals Ltd.
4 Little Essex St.
London, WC2R 3LF UK
[ISSN 0028-0836]
Abstracts: S84, S433

Natuurwetenschappelijk tijdschrift
Natuur- en Geneeskundige Vennootschap
Krijgslaan 281 S.8
9000 Ghent, Belgium
[ISSN 0070-1748]
Abstracts: S525

New scientist
IPC Magazines Ltd.
Commonwealth House
1-19 New Oxford St.
London, WC1 1NG UK
[ISSN 0262-4079]
Abstracts: S458, S465, S476

The New York Times
New York Times
Subscription Dept.
6th floor
229 W. 43rd St.
New York, NY 10036 USA
[ISSN 0362-4331]
Abstracts: S304, S418

*Newsletter (Australian Institute of
Aboriginal Studies)*
Australian Institute of Aboriginal and
Torres Strait Islander Studies
P.O. Box 553
Canberra, ACT 2601 Australia
[ISSN 0004-9344]
Abstracts: S603

*Newsletter (Canadian Conservation
Institute) = Bulletin (Institut canadien de
conservation)*
Canadian Conservation Institute
1030 Innes Rd.
Ottawa, Ontario K1A 0C8 Canada
Abstracts: S1069

*Newsletter (Western Association for Art
Conservation)*
Western Association for Art Conservation
Elizabeth C. Welsh, Newsletter Editor
1213 W. San Miguel Ave.
Phoenix, AZ 85013 USA
[ISSN 1052-0066]
Abstracts: S1084

Nigeria
Ministry of Culture and Social Welfare
(Nigeria)
P.M.B. 12524
Lagos, Nigeria
[ISSN 0029-0033]
Abstracts: S80

Nihon kagaku zasshi
Nippon Kagakkai
5, 1-chome Kanda-Surugadai
Chiyodo-ku
Tokyo, 101 Japan
[ISSN 0369-5387]
Abstracts: S138

*Nouvelles de l'ARSAG et du Groupe
documents graphiques du Comité de
conservation de l'ICOM*
Association pour la recherche scientifique
sur les arts graphiques
36 rue Geoffroy Saint-Hilaire
75005 Paris, France
[ISSN 0765-0248]
Abstracts: S1043

Oceania
University of Sydney
Sydney, NSW 2006 Australia
[ISSN 0029-8077]
Abstracts: S306

Ochrona zabytków
Poland. Ministerstwo Kultury i Sztuki
Generalny Konserwator Zabytkow
Osrodek Dokumentacji Zabytkow
ul. Brzozowa 35
00-258 Warsaw, Poland
[ISSN 0029-8427]
Abstracts: S264, S968

Official digest (Federation of Paint and Varnish Production Clubs)
Federation of Paint and Varnish Production Clubs
c/o Federation of Societies for Coatings Technology
1315 South Walnut St.
Suite 830
Philadelphia, PA 19107 USA
[ISSN 0097-2827]
Abstracts: S712, S715, S716, S719, S720, S724, S725, S726, S727, S728, S729, S730, S731, S732, S733, S734

Official digest (Federation of Societies for Paint Technology)
Federation of Societies for Coatings Technology
1315 South Walnut St.
Suite 830
Philadelphia, PA 19107 USA
[ISSN 0097-2835]
Abstracts: S740, S743, S747, S749

OPD restauro: quaderni dell'Opificio delle pietre dure e Laboratori di restauro di Firenze
OpusLibri
Via della Torretta 16
50137 Florence, Italy
Abstracts: S631

Organic coatings and plastics chemistry: preprints of papers presented at the meeting of the American Chemical Society
American Chemical Society
1155 16th Street NW
Washington, DC 20036 USA
[ISSN 0161-214X]
Abstracts: S804

Organic coatings science and technology
Marcel Dekker, Inc.
270 Madison Ave.
New York, NY 10016 USA
[ISSN 0883-2676]
Abstracts: S826

Pacific Coast Archaeological Society quarterly
Pacific Coast Archaeological Society
P.O. Box 10926
Costa Mesa, CA 92627 USA
[ISSN 0552-7252]
Abstracts: S273

PACT
European Study Group on Physical, Chemical and Mathematical Techniques Applied to Archaeology
c/o Tony Hackens, ed.
28-a Av. Leopold
1330 Rixensart, Belgium
[ISSN 0257-8727]
Abstracts: S625

Paint and varnish production manager
New York, USA
Abstracts: S694, S695, S699

Paint manufacture
Morgan-Grampian
40 Beresford St.
London, SE18 6BQ UK
[ISSN 0030-9508]
Abstracts: S153

Paint technology
Sawell Publications Ltd.
127 Stanstead Rd.
London, SE23 1JE UK
[ISSN 0030-9524]
Abstracts: S210, S213, S709

Paintindia
Colour Publications Pvt. Ltd.
126-A Dhuruwadi
Off Dr. Nariman Rd.
Bombay, 400 025 India
[ISSN 0556-4409]
Abstracts: S340

El Palacio
Museum of New Mexico
P.O. Box 2087
Santa Fe, NM 87504 USA
[ISSN 0031-0158]
Abstracts: S120, S142

Pamatkova pece
Státní ústav památkové pece a ochrany
pirody
Valdstejnske nam. 1
118 01 Prague, 1 Czech Republic
Abstracts: S914

The paper conservator: journal of the
Institute of Paper Conservation
Institute of Paper Conservation
P.O. Box 17
London, WC1N 2PE UK
[ISSN 0309-4227]
Abstracts: S405, S1032

Papers of the Michigan Academy of
Science, Arts, and Letters
Michigan Academy of Science, Arts, and
Letters
400 Fourth St.
Ann Arbor, MI 48109-4816 USA
[ISSN 0096-2694]
Abstracts: S60, S102

Partisan review
Partisan Review, Inc.
236 Bay State Rd.
Boston, MA 02215 USA
[ISSN 0031-2525]
Abstracts: S125

Pátina
Escuela de Conservación y Restauración
de Bienes Culturales
Calle Guillermo Rolland n. 2
28013 Madrid, Spain
Abstracts: S1061

Peintures, pigments, vernis
Société de productions documentaires
Paris, France
[ISSN 0031-4102]
Abstracts: S113, S114, S124, S133,
S169, S178, S191, S199, S200, S201,
S225

Philosophical transactions of the Royal
Society of London
Royal Society of London
6 Carlton House Terrace
London, SW1 5AG UK
[ISSN 0370-2316]
Abstracts: S1

Pitture e vernici
Editrice Sapil
Via N. Battaglia 10
20127 Milan, Italy
[ISSN 0048-4245]
Abstracts: S820, S825, S835

Polymeric materials science and
engineering: proceedings of the ACS
Division of Polymeric Materials Science
and Engineering⁴
American Chemical Society
1155 16th Street NW
Washington, DC 20036 USA
[ISSN 0743-0515]
Abstracts: S862, S865, S866

Polymers paint colour journal
Fuel and Metallurgical Journals
Publications Ltd.
Queensway House
2 Queensway
Redhill, RH1 1QS UK
[ISSN 0370-1158]
Abstracts: S639, S823, S851, S869

Possibilities, an occasional review
Wittenborn, Schultz
New York, USA
Abstracts: S112

Powder technology
Elsevier Sequoia SA
Box 564
1001 Lausanne, Switzerland
[ISSN 0032-5910]
Abstracts: S764, S777

Der Präparator
Verband Deutscher Präparatoren e.V.
Postfach 25 02 60
4630 Bochum, Germany
[ISSN 0032-6542]
Abstracts: S901

Proceedings (American Society for
Testing and Materials)
American Society for Testing and
Materials
1916 Race St.
Philadelphia, PA 19103 USA
[ISSN 0066-0515]
Abstracts: S687

*Proceedings and transactions of the
Royal Society of Canada = Délibérations
et mémoires de la Société royale du
Canada*
Royal Society of Canada
P.O. Box 9734
Ottawa, Ontario K1G 5J4 Canada
[ISSN 0316-4616]
Abstracts: S54

*Proceedings of the Indian Academy of
Sciences*
Indian Academy of Sciences
C.V. Raman Ave.
P.B. no. 8005
Bangalore, 560 080 India
Abstracts: S85, S86, S87

Proceedings of the Japan Academy
Nihon Gakushiin
7-32 Ueno Koen
Taito-ku
Tokyo, 110 Japan
[ISSN 0021-4280]
Abstracts: S167

Progress in organic coatings
Elsevier Science Publishers B.V.
Postbus 211
1000 AE Amsterdam, Netherlands
[ISSN 0300-9440]
**Abstracts: S773, S776, S779, S781,
S798, S809, S816, S842, S843, S855**

Radiocarbon[1]
University of Arizona. Department of
Geosciences
c/o Austin Long
Tucson, AZ 85721 USA
[ISSN 0033-8222]
Abstracts: S1115

*Rendiconti dell'Accademia di
archeologia lettere e belle arti*
Società nazionale di scienze, lettere e arti
a Napoli
Via Mezzocannone 8
80100 Naples, Italy
Abstracts: S185, S186, S203

Resin review
Rohm and Haas. Resinous Products
Division
Independence Mall West
Philadelphia, PA 19105 USA
[ISSN 0034-5571]
Abstracts: S845

Restaurator
Munksgaard International Publishers Ltd.
35 Nørre Søgade
P.O. Box 2148
1016 Copenhagen, Denmark
[ISSN 0034-5806]
Abstracts: S980, S991

Restauratorenblätter
IIC Österreichische Sektion
Arsenal, Objekt 15/4
1030 Vienna, Austria
[ISSN 0232-2609]
Abstracts: S504, S1025, S1112

Restauro
Verlag Georg D.W. Callwey
Streitfeldstr. 35
Postfach 800409
8000 Munich, 80 Germany
[ISSN 0933-4017]
Abstracts: S521, S1059, S1067, S1124

Revista colombiana de folclor
Instituto Colombiano de Antropología
Calle 8, No. 8-87
Apdo. Aéreo 407
Bogotá, Colombia
Abstracts: S212

*Revista muzeelor si monumentelor:
Muzee*
Consiliul Culturii şi Educatiei Socialiste
Calea Victoriei 174
Bucharest, Romania
[ISSN 0035-0206]
**Abstracts: S439, S1008, S1019, S1020,
S1021**

*Revue d'archéométrie: bulletin de
liaison du Groupe des méthodes
physiques et chimiques de l'archéologie*
Groupe des méthodes physiques et
chimiques de l'archéologie (France)
c/o L. Langouet
Université de Rennes
35042 Rennes, France
[ISSN 0399-1237]
Abstracts: S342, S343

Rock art research
Archaeological Publications
P.O. Box 216
Caulfield South, Victoria 3162 Australia
[ISSN 0813-0426]
Abstracts: S499

*Rocznik muzeum narodowego w
Warszawie*
Muzeum Narodowe w Warszawa
ul. Jerozolimskie 3
00 495 Warsaw, Poland
[ISSN 0509-6936]
Abstracts: S917

Sborník restaurátorských prací
Státní restaurátorské ateliéry
Pohořelec 22
Malá Strana
118 01 Prague, 1 Czech Republic
Abstracts: S647

*Sborník Vysoké školy
chemicko-technologické v Praze.
Polymery: chemie, vlastnosti a
zpracování*
Statni pedagogicke nakladatelstvi
Ostrovni 30
113 01 Prague, 1 Czech Republic
[ISSN 0139-908X]
Abstracts: S599

Science
American Association for the
Advancement of Science
1333 H St. NW
Washington, DC 20005 USA
[ISSN 0036-8075]
Abstracts: S40, S528, S543, S582, S721

*Science and technology for cultural
heritage*
CNR—Comitato Nazionale per la Scienza
e la Tecnologia dei Beni Culturali
Piazzale A. Moro 7
00185 Rome, Italy
or
Giardini Editori e Stampatori in Pisa
Via delle Sorgenti 23
56010 Agnano Pisano, Italy
Abstracts: S668

Science progress
Blackwell Scientific Publications
Osney Mead
Oxford, OX2 OEL UK
[ISSN 0036-8504]
Abstracts: S135

Seifen, Öle, Fette, Wachse
Verlag für chemische Industrie H.
Ziolkowsky KG
Beethovenstr. 16
8900 Augsburg, 1 Germany
[ISSN 0173-5500]
Abstracts: S152

Soobshcheniia
Moscow. Vsesoiuznaia tsentral'naia
nauchno-issledovatel'skaia laboratoriia po
konservatsii i restavratsii muzeinykh
khudozhestvennykh tsennostei
Moscow, Russia
[ISSN 0579-9716]
Abstracts: S938

South African archaeological bulletin
South African Archaeological Society
P.O. Box 15700
8018 Vlaeberg, South Africa
[ISSN 0038-1969]
Abstracts: S161

Speculum; a journal of Medieval studies
Mediaeval Academy of America
1430 Massachusetts Ave.
Cambridge, MA 02138 USA
[ISSN 0038-7134]
Abstracts: S117

Studies in conservation
International Institute for Conservation of
Historic and Artistic Works
6 Buckingham St.
London, WC2N 6BA UK
[ISSN 0039-3630]
**Abstracts: S184, S255, S290, S294,
S359, S519, S530, S533, S541, S542,
S544, S546, S547, S552, S554, S561,
S562, S563, S565, S579, S657, S660,
S667, S669, S677, S844, S898, S905,
S909, S934, S935, S965, S1005, S1023,
S1101**

Studies in museology
Maharaja Sayajirao University of Baroda.
Department of Museology
Sayaji Park
Baroda, 390002 India
[ISSN 0081-8259]
Abstracts: S902, S904

Tappi journal[4]
Technical Association of the Pulp and
Paper Industry
Technology Park Atlanta
Box 105113
Atlanta, GA 30348-5113 USA
[ISSN 0734-1415]
Abstracts: S767, S791, S795, S803

*Technical studies in the field of the fine
arts*
Fogg Art Museum
32 Quincy St.
Harvard University
Cambridge, MA 02138 USA
[ISSN 0096-9346]
**Abstracts: S75, S76, S77, S78, S81,
S703, S704**

Technika
Országos Műszaki Információs
Központ és Könyvtár
PB 452, VIII
Szentkirályi u. 21
1372 Budapest, Hungary
Abstracts: S97

*Transactions of the Ethnological Society
of London*
Ethnological Society of London
London, UK
Abstracts: S6

Travaux de peinture
Société de productions documentaires
Paris, France
Abstracts: S165

Umĕni
Academia, Publishing House of the
Czechoslovak Academy of Sciences
Vodickova 40
112 29 Prague, 1 Czech Republic
[ISSN 0049-5123]
Abstracts: S353

Verfkroniek
Vereniging van Verf- en
Drukinktfabrikanten (Netherlands)
Schuttersveld 10
Postbus 248
2300 Leiden, Netherlands
[ISSN 0042-3904]
Abstracts: S137

*Veröffentlichungen des Museums für
Indische Kunst*
Otto Harrassowitz
Taunusstr. 14
6200 Wiesbaden, 1 Germany
Abstracts: S298

*Vestnik Moskovskogo Universiteta.
Seriia VI: Biologiia, pochvovedenie*
Izdatel'stvo Moskovskogo Universiteta
ul. Gercena 5/7
Moscow, 103009 Russia
[ISSN 0579-9422]
Abstracts: S289

The Wall Street journal
Dow Jones & Co., Inc.
200 Liberty St.
New York, NY 10007 USA
[ISSN 0193-2241]
Abstracts: S375

Wallaceana
University of Malaya. Department of
Zoology
Lembah Pantai
59100 Kuala Lumpur, Malaysia
Abstracts: S391

*Warasan Samnakngan Khana
Kammakan Wichai hang Chat = Journal
of the National Research Council of
Thailand*
Samnakngan Khana Kammakan Wichai
hang Chat (Thailand)
196 Phahonyothin Rd.
Chatuchak
Bangkok, Thailand
[ISSN 0028-0011]
Abstracts: S477

*Wiener Berichte über Naturwissenschaft
in der Kunst*
Hochschule für Angewandte Kunst
(Vienna, Austria)
Oskar Kokoschka-Platz 2
1011 Vienna, Austria
**Abstracts: S612, S622, S637, S638,
S1047**

The Wisconsin archaeologist
Wisconsin Archeological Society
P.O. Box 1292
Milwaukee, WI 53201 USA
[ISSN 0043-6364]
Abstracts: S47, S91

Yakugaku zasshi
Pharmaceutical Society of Japan
Nihon Yakugakkai, 12-15
Shibuya 2-chome
Shibuya-ku
Tokyo, 150 Japan
[ISSN 0031-6903]
Abstracts: S560

Zabytkoznawstwo i konserwatorstwo
Uniwersytet Mikołaja Kopernika w
Toruniu
ul. Fosa Staromiejska 3
87-110 Toruń, Poland
[ISSN 0563-9506]
Abstracts: S432

*Zeitschrift für Kunsttechnologie und
Konservierung*
Wernersche Verlagsgesellschaft mbH
Liebfrauenring 17-19
Postfach 2233
6520 Worms, Germany
[ISSN 0931-7198]
**Abstracts: S430, S496, S503, S672,
S1077, S1114**

Monograph Publishers

*Aboriginal antiquities in Australia: their
nature and preservation*
(1970)
Australian Institute of Aboriginal and
Torres Strait Islander Studies
P.O. Box 553
Canberra, ACT 2601 Australia
Abstracts: S253, S913.

*Aboriginal use of bitumen by the
California Indians*
(1943)
California State Printing Office
Sacramento, CA USA
Abstracts: S101

*Abstracts and preprints: international
conference on the conservation of
library and archive materials and the
graphic arts*
(1980)
Institute of Paper Conservation
P.O. Box 17
London, WC1N 2PE UK
or
Society of Archivists
Information House
20-24 Old St.
London, EC1V 9AP UK
[ISBN 0-90288-604-5; 0-9507268-0-X]
Abstracts: S978

*Adam in ochre: inside aboriginal
Australia*
(1951)
Angus & Robertson Pty Ltd.
P.O. Box 290
North Ryde, NSW 2113 Australia
Abstracts: S149

*Adhesives and consolidants: preprints of
the contributions to the Paris Congress,
2-8 September 1984*
(1984)
International Institute for Conservation of
Historic and Artistic Works
6 Buckingham St.
London, WC2N 6BA UK
Abstracts: S367, S372, S1014

El Adobe: Simposio Internacional y Curso-taller sobre Conservación del Adobe: informe final y ponencias principales: Lima-Curso (Peru) 10-22 sept. 1983
(1983)
International Centre for the Study of the Preservation and the Restoration of Cultural Property
13 via di San Michele
00153 Rome, Italy
Abstracts: S351

Aegean painting in the Bronze Age
(1990)
Pennsylvania State University Press
820 N. University Dr.
Suite C
Barbara Bldg.
University Park, PA 16802 USA
[ISBN 0-271-00628-5]
Abstracts: S466

African textiles: looms, weaving and design
(1979)
British Museum Publications Ltd.
46 Bloomsbury St.
London, WC1B 3QQ UK
[ISBN 0-7141-1552-5]
Abstracts: S313

AFTPV, 15th Congress, Cannes, 1983
(1983)
Verlag Chemie GmbH
Pappelallee 3
Postfach 1260
Weinheim, Germany
Abstracts: S821

American artists in their New York studios: conversations about the creation of contemporary art
(1992)
Harvard University Art Museums. Center for Conservation and Technical Studies
32 Quincy St.
Cambridge, MA 02138-3883 USA
or
Daco-Verlag Günter Bläse, Verlag Hanfstaengl Nachfolger
Richard-Wagner-Str. 10
70184 Stuttgart, Germany
[ISBN 3-87135-006-0]
Abstracts: S500

American Indian painting of the Southwest and Plains areas
(1968)
University of New Mexico Press
1720 Lomas Blvd. N.E.
Albuquerque, NM 87131-1591 USA
Abstracts: S239

American painting to 1776: a reappraisal
(1971)
University Press of Virginia
P.O. Box 3608
University Station
Charlottesville, VA 22903 USA
[ISBN 0-8139-0378-5]
Abstracts: S258

American pastels in the Metropolitan Museum of Art
(1989)
Metropolitan Museum of Art
1000 Fifth Ave.
New York, NY 10028-0198 USA
or
Harry N. Abrams, Inc.
100 Fifth Ave.
New York, NY 10011 USA
[ISBN 0-87099-547-2; 0-8109-1895-1 (Abrams); 0-87099-548-0 (pbk.)]
Abstracts: S442

Analyse et conservation des documents graphiques et sonores: travaux du Centre de recherches sur la conservation des documents graphiques, 1982-1983
(1984)
Editions du CNRS
15 Quai Anatole
75007 Paris, France
[ISBN 2-222-03419-1]
Abstracts: S369, S1004, S1013

Anasazi and Pueblo painting
(1991)
University of New Mexico Press
1720 Lomas Blvd. N.E.
Albuquerque, NM 87131-1591 USA
[ISBN 0-8263-1236-5]
Abstracts: S487

Les anciennes restaurations en peinture murale
(1993)
International Institute for Conservation of Historic and Artistic Works. Section française
29 rue de Paris
77420 Champs-sur-Marne, France
Abstracts: S511, S1116, S1117, S1122, S1125

Ancient binding media, varnishes and adhesives[7]
(1985)
International Centre for the Study of the Preservation and the Restoration of Cultural Property
13 via di San Michele
00153 Rome, Italy
Abstracts: S377

Ancient Egyptian materials & industries
(1934 and 1962)
Edward Arnold Publishers Ltd.
41 Bedford Sq.
London, WC1B 3DQ UK
Abstracts: S63

Andrea Mantegna
(1992)
Thames & Hudson Ltd.
30 Bloomsbury St.
London, WC1B 3QP United Kingdom
or
Gruppo Editoriale Electa S.p.A.
Via Trentacoste 7
20129 Milan, Italy
[ISBN 0-500-97400-4]
Abstracts: S505

Annaes do XX Congresso internacional de americanistas, realizado no Rio de Janeiro, de 20 a 30 de agosto de 1922
(1924)
Imprensa nacional
Rio de Janeiro, Brazil
Abstracts: S37

Annual report for 1926: National Museum of Canada
(1928)
National Museums of Canada
Ottawa, Canada
Abstracts S44

Application of science in examination of works of art: proceedings of the seminar, 7-9 September 1983
(1985)
Museum of Fine Arts, Boston
465 Huntington Ave.
Boston, MA 02115 USA
[ISBN 0-87846-255-4]
Abstracts: S621

Application of science in examination of works of art: proceedings of the seminar, September 7-16, 1965
(1965)
Museum of Fine Arts, Boston
465 Huntington Ave.
Boston, MA 02115 USA
[ISBN 0-87846-071-3]
Abstracts: S220, S538, S748

Applied polymer science
(1985)
American Chemical Society
1155 16th St., NW
Washington, DC 20036 USA
[ISBN 0-8412-0891-3]
Abstracts: S836

Archaeological chemistry III
(1984)
American Chemical Society
Division of History of Chemistry
1155 16th St., NW
Washington, DC 20036 USA
[ISBN 0-8412-767-4]
Abstracts: S616

Archaeological chemistry IV
(1989)
American Chemical Society
1155 16th Street NW
Washington, DC 20036 USA
[ISBN 0-8412-1449-2]
Abstracts: S648

Archaeometry: further Australasian studies
(1987)
Australian National University.
Research School of Pacific Studies.
Department of Prehistory
G.P.O. Box 4
Canberra, A.C.T. 2601 Australia
[ISBN 0-7315-0040-7]
Abstracts: S632

Architecture et décors peints: Amiens, Octobre 1989[7]
(1990)
Direction du patrimoine (France)
3, rue de Valois
75042 CEDEX 01 Paris, France
Abstracts: S450, S456, S457, S470, S472, S474, S478, S1089

The art of fresco painting as practised by the old Italian and Spanish masters, with a preliminary inquiry into the nature of the colours used in fresco painting, with observations and notes[7]
(1952)
A. Tiranti
London, UK
Abstracts: S156

Artifacts: an introduction to early materials and technology
(1964)
John Baker Publishers Ltd.
c/o A.&C. Black Ltd.
35 Bedford Row
London, WC1R 4JH UK
Abstracts: S215

Artigianato e tecnica nella società dell'alto Medioevo occidentale, 2-8 aprile 1970
(1971)
Presso la sede del Centro italiano di studi sull'alto Medioevo
Palazzo Ancalani
Piazza della Libertà 12
06049 Spoleto, Italy
Abstracts: S261

The artist's handbook
(1987)
Alfred A. Knopf, Inc.
201 E. 50th St.
New York, NY 10022 USA
[ISBN 0-394-55585-6]
Abstracts: S407

The artist's handbook of materials and techniques
(1938)
Dial Press
c/o Doulbeday & Co.
501 Franklin Ave.
Garden City, NY 11530 USA
Abstracts: S83

Artists' pigments: a handbook of their history and characteristics[7]
(1986)
National Gallery of Art
4th St. and Constitution Ave. N.W.
Washington, DC 20565 USA
or
Cambridge University Press
Edinburgh House
Shaftesbury Rd.
Cambridge, CB2 2RU UK
[ISBN 0-521-30374-5]
Abstracts: S623

Assemblage of spirits: idea and image in New Ireland
(1987)
George Braziller, Inc.
60 Madison Ave.
Suite 1001
New York, NY 10010 USA
or
Minneapolis Institute of Arts
2400 Third Ave. South
Minneapolis, MN 55404 USA
[ISBN 0-8076-1187-5]
Abstracts: S403

Atlas of rock-forming minerals in thin section
(1980)
Halstead Press
605 Third Ave.
New York, NY 10158 USA
or
John Wiley & Sons, Inc.
605 Third Ave.
New York, NY 10158-0012 USA
[ISBN 0-470-26921-9]
Abstracts: S591

Atlas of sedimentary rocks under the microscope[7]
(1984)
Halstead Press
605 Third Ave.
New York, NY 10158 USA
or
John Wiley & Sons, Inc.
605 Third Ave.
New York, NY 10158-0012 USA
[ISBN 0-470-27476-X]
Abstracts: S611

Barnett Newman: selected writings and interviews
(1990)
Alfred A. Knopf, Inc.
201 E. 50th St.
New York, NY 10022 USA
[ISBN 0-394-58038-9]
Abstracts: S475

The beginnings of Netherlandish canvas painting, 1400-1530
(1989)
Cambridge University Press
Edinburgh House
Shaftesbury Rd.
Cambridge, CB2 2RU UK
[ISBN 0-521-34259-7]
Abstracts: S445

A bibliography of African art
(1965)
International African Institute
Lionel Robbins Bldg.
10 Portugal St.
London, WC2A 2HD UK
Abstracts: S223

A bibliography of dyeing and textile printing comprising a list of books from the 16th century to the present time (1946)
(1949)
Chapman and Hall Ltd.
11 New Fetter Lane
London, EC4P 4EE UK
Abstracts: S129

Biodeterioration 5: papers presented at the fifth international biodeterioration symposium, Aberdeen, September 1981
(1983)
Wiley & Sons Ltd.
Baffins Lane
Chichester, PO19 1UD UK
[ISBN 0-471-10296-2]
Abstracts: S354, S998

Bush food: Aboriginal food and herbal medicine
(1987)
Weldons Pty Ltd
43 Victoria St.
McMahons Point, NSW 2060 Australia
[ISBN 0-949708-33-X]
Abstracts: S401

Caractérisation, datation, technique de la peinture antique: IIIe rencontres internationales d'archéologie et d'histoire d'Antibes
(1983)
Association pour la promotion et la diffusion des connaissances archéologiques
B.P. 37
06562 Valbonne, France
[ISBN 2-90410-02-X]
Abstracts: S352

Case studies in the conservation of stone and wall paintings: preprints of the contributions to the Bologna Congress, 21-26 September 1986
(1986)
International Institute for Conservation of Historic and Artistic Works
6 Buckingham St.
London, WC2N 6BA UK
Abstracts: S388

The chemistry of plant gums and
mucilages and some related
polysaccharides
(1959)
Van Nostrand Reinhold Company, Inc.
115 Fifth Ave.
New York, NY 10003 USA
Abstracts: S531

Cherokee plants and their uses: a 400
year history
(1975)
Herald Publishing Co.
Sylva, NC USA
Abstracts: S287

Chinese painting colors: studies of their
preparation and application in
traditional and modern times
(1988)
Hong Kong University Press
139, Pokfulam Road
Hong Kong, Hong Kong
or
University of Washington Press
P.O.Box 50096
Seattle, WA 98145-5096 USA
[ISBN 962-209-222-5; 0-295-96356-5]
Abstracts: S427

Chinigchinich: a revised and annotated
version of Alfred Robinson's translation
of Father Geronimo Boscana's historical
account of the belief, usages, customs
and extravagancies of the Indians of this
mission of San Juan Capistrano called
the Acagchemem Tribe
(1933)
Fine Arts Press
Santa Ana, California, USA
Abstracts: S58

Classification of black pottery pigments
and paint areas
(1938)
University of New Mexico Press
1720 Lomas Blvd. N.E.
Albuquerque, NM 87131-1591 USA
Abstracts: S524

The cleaning of Color Field paintings
(1974)
Museum of Fine Arts
Box 6826
1001 Bissonnet
Houston, TX 77265 USA
Abstracts: S282

Cleaning, retouching and coatings:
technology and practice for easel
paintings and polychrome sculpture:
preprints of the contributions to the
Brussels Congress, 3-7 September 1990
(1990)
International Institute for Conservation of
Historic and Artistic Works
6 Buckingham St.
London, WC2N 6BA UK
Abstracts: S469

Color in business, science, and industry
(1952)
John Wiley & Sons, Inc.
605 Third Ave.
New York, NY 10158-0012 USA
Abstracts: S713

Colorantes naturales de México
(1988)
Industrias Resistol, S.A.
Mexico City, Mexico
[ISBN 968-6318-00-3]
Abstracts: S412

I colori pompeiani[7]
(1967)
De Luca Editore
Via S. Anna 11
00186 Rome, Italy
Abstracts: S229

Como se pinta un mural
(1985)
Editorial Arte y Literatura
Palacio del Segundo Cabo
O'Reilly No. 4
Habana Vieja
Havana, Cuba
Abstracts: S381

*La conservación en zonas
arqueológicas: tres decadas de trabajo*
(1991)
Instituto Nacional de Antropología e
Historia. Escuela Nacional de
Conservación, Restauración y Museografía
"Manuel del Castillo Negrete"
Cordoba 45
Col. Roma
06700 Mexico City, Mexico
Abstracts: S1095

*Conservation and restoration of pictorial
art*
(1976)
Butterworth & Co.
Borough Green
Sevenoaks, TN15 8PH UK
[ISBN 0-408-70712-7]
**Abstracts: S293, S572, S573, S574,
S575, S576, S943**

*Conservation concerns: a guide for
collectors and curators*
(1992)
Smithsonian Institution Press
955 L'Enfant Plaza
Suite 2100
Washington, DC 20560 USA
or
Cooper-Hewitt Museum
2 East 91st St.
New York, NY 10128 USA
[ISBN 1-56098-174-1 (pbk.)]
Abstracts: S501

*De la conservation et de la restauration
des tableaux: éléments de l'art du
restaurateur: historique de la partie
mécanique de la peinture, depuis sa
renaissance jusqu'a nos jours:
classification de toutes les écoles:
recherches et notices sur quelques
grands maîtres*
(1851)
Chez Hector Bossange
Paris, France
Abstracts: S4

*Conservation in the tropics: proceedings
of the Asia-Pacific Seminar on
Conservation of Cultural Property, 7-16
February 1972: held at the Central
Conservation Laboratory, National
Museum, New Delhi*
(1974)
International Centre for the Study of the
Preservation and the Restoration of
Cultural Property
13 via di San Michele
00153 Rome, Italy
Abstracts: S927, S931

*A conservation manual for the field
archaeologist*
(1987)
University of California, Los Angeles.
Institute of Archaeology
405 Hilgard Ave.
Los Angeles, CA 90024-1510 USA
[ISBN 0-917956-59-1]
Abstracts: S1044

*Conservation of ancient Egyptian
materials: preprints of the conference
organised by the United Kingdom
Institute for Conservation, Archaeology
Section, held at Bristol, 15-16 December
1988*
(1988)
United Kingdom Institute for Conservation
37 Upper Addison Gardens
Holland Park
London, W14 8AJ UK
[ISBN 1-871656-02-8]
Abstracts: S1053

*Conservation of manuscripts and
paintings of Southeast Asia*
(1984)
Butterworth & Co.
Borough Green
Sevenoaks, TN15 8PH UK
[ISBN 0-408-10671-9]
Abstracts: S1002

Conservation of metals: problems in the treatment of metal-organic and metal-inorganic composite objects: international restorer seminar, Veszprém, Hungary, 1-10 July 1989
(1990)
Központi Muzeumi Igazgatóság
P.O. Box 58
Budapest, Hungary
[ISBN 963-555-770-1]
Abstracts: S1086, S1093

Conservation of paintings and the graphic arts: preprints of contributions to the Lisbon Congress, 9-14 October 1972
(1972)
International Institute for Conservation of Historic and Artistic Works
6 Buckingham St.
London, WC2N 6BA UK
Abstracts: S558, S920

Conservation of the Iberian and Latin American cultural heritage: preprints of the contributions to the IIC Madrid Congress, 9-12 September 1992
(1992)
International Institute for Conservation of Historic and Artistic Works
6 Buckingham St.
London, WC2N 6BA UK
Abstracts: S1110

Conservation of wall paintings
(1984)
Butterworth & Co.
Borough Green
Sevenoaks, TN15 8PH UK
[ISBN 0-408-10812-6]
Abstracts: S366

The conservation of wall paintings: proceedings of a symposium organized by the Courtauld Institute of Art and the Getty Conservation Institute, London, 13-16 July 1987
(1991)
Getty Conservation Institute
4503 Glencoe Ave.
Marina del Rey, CA 90292-6537 USA
[ISBN 0-89236-162-X]
Abstracts: S1098, S1099, S1104, S1105

Conservation of wall paintings: the international scene
(1986)
Council for the Care of Churches
83 London Wall
London, EC2M 5NA UK
Abstracts: S1028, S1030, S1034

Conservation of wood in painting and the decorative arts
(1978)
International Institute for Conservation of Historic and Artistic Works
6 Buckingham St.
London, WC2N 6BA UK
Abstracts: S957

Conservation on archaeological excavations: with particular reference to the Mediterranean area
(1984)
International Centre for the Study of the Preservation and the Restoration of Cultural Property
13 via di San Michele
00153 Rome, Italy
Abstracts: S1007

Conservation, restoration of leather and wood: training of restorers: sixth international restorer seminar, Veszprém, Hungary, 1987
(1988)
Központi Muzeumi Igazgatóság
P.O. Box 58
Budapest, Hungary
[ISBN 963-7108-01-7]
Abstracts: S1049

Conservation today: papers presented at the UKIC 30th Anniversary Conference, 1988
(1988)
United Kingdom Institute for Conservation
37 Upper Addison Gardens
Holland Park
London, W14 8AJ UK
[ISBN 1-87165-601-X]
Abstracts: S1051

Conservation within historic buildings: preprints of the contributions to the Vienna Congress, 7-13 September 1980
(1980)
International Institute for Conservation of Historic and Artistic Works
6 Buckingham St.
London, WC2N 6BA UK
Abstracts: S973

Conservazione delle opere d'arte su carta e pergamena: atti del convegno Torgiano, 14-16 aprile 1988
(1990)
Volumnia Editrice
via Baldeschi 2
Perugia, Italy
Abstracts: S1081

Contemporary African arts and crafts: on-site working with art forms and processes
(1974)
Unwin Hyman Ltd.
29 W. 35th St.
New York, NY 10001-2291 USA
[ISBN 0-04-730029-9]
Abstracts: S281

The craft of old-master drawings
(1957)
University of Wisconsin Press
114 N. Murray St.
Madison, WI 53715 USA
[ISBN 0-299-01421-5]
Abstracts: S182

The culture of the Luiseño Indians
(1908-1910)
University Press of Berkeley
Berkeley, CA USA
Abstracts: S26

Daigoji goju no to no hekiga
(1959)
Yoshikawa Kobunkan
Tokyo, Japan
Abstracts: S194

Dawn of art: painting and sculpture of Australian aborigines
(1965)
Penguin Books, Inc.
40 W. 23rd St.
New York, NY 10010 USA
Abstracts: S224

Degas pastels
(1988)
National Gallery of Canada
380 Sussex Dr.
P.O. Box 427
Station A
Ottawa, ONT KIN 9N4 Canada
[ISBN 0-88884-547-2]
Abstracts: S419

The deterioration and conservation of painted glass: a critical bibliography[7]
(1982)
Oxford University Press
Walton St.
Oxford, OX2 6DP UK
[ISBN 0-19-726017-9]
Abstracts: S994

A dictionary of the economic products of the Malay Peninsula
(1935)
"Published on behalf of the governments of the Straits Settlements and Federated Malay States by the Crown agents for the colonies."
London, England
Abstracts: S65

Documentation bois. VII: conservation du bois et traitement des surfaces. Tome 2: traitement des surfaces[7]
(1960)
Lignum (Union suisse en faveur du bois)
Falkenstr. 26
Zurich, Switzerland
Abstracts: S897

Domestic implements, arts, and manufactures
(1904)
G.A. Vaughn, Government Printer
Brisbane, Queensland Australia
or
Queensland. Department of Public Lands
Brisbane, Queensland Australia
Abstracts: S23

Dreamings: the art of aboriginal Australia
(1988)
George Braziller, Inc.
60 Madison Ave.
Suite 1001
New York, NY 10010 USA
[ISBN 0-8076-1201-4]
Abstracts: S425

Early advances in conservation
(1988)
British Museum
Great Russell St.
London, WC1B 3DG UK
[ISBN 0-86159-0651]
Abstracts: S1052, S1055

Early Medieval wall painting and painted sculpture in England: based on the proceedings of a symposium at the Courtauld Institute of Art, February 1985
(1990)
British Archaeological Reports
5 Centremead
Osney Mead
Oxford, OX2 0DQ UK
[ISBN 0-86054-719-1]
Abstracts: S459, S1090

The economic botany of the Kiowa Indians as it relates to the history of the tribe
(1981)
AMS Press
56 E. 13th St.
New York, NY 10003-4686 USA
[ISBN 0-404-15740-8]
Abstracts: S341

Egyptian paintings of the Middle Kingdom
(1968)
Unwin Hyman Ltd.
29 W. 35th St.
New York, NY 10001-2291 USA
[ISBN 0-04-709007-3]
Abstracts: S245

Entwicklung und Werkstoffe der Tafelmalerei
(1928)
Elmar Sändig
Postfach 7
Walluf
65392 Nendeln, Liechtenstein
[ISBN 3-500-29540-1]
Abstracts: S42

Entwicklung und Werkstoffe der Wandmalerei vom Altertum bis zur Neuzeit
(1970)
Elmar Sändig
Postfach 7
Walluf
65392 Nendeln, Liechtenstein
Abstracts: S252

Ethnoart: Africa, Oceania, and the Americas: a bibliography of theses and dissertations
(1988)
Garland Publishing
717 Fifth Ave.
Suite 2500
New York, NY 10022-8102 USA
[ISBN 0-8240-7545-5]
Abstracts: S411

The ethnobotany of pre-Columbian Peru
(1962)
Aldine Publishing
Chicago, IL USA
Abstracts: S206

The ethnobotany of the California Indians: a compendium of the plants, their users, and their uses
(1972)
University of Northern Colorado. Museum of Anthropology
Greeley, CO 80639 USA
Abstracts: S269

Ethnobotany of the Hawaiians
(1975)
University of Hawaii Press
2840 Kolowalu St.
Honolulu, HI 96822 USA
Abstracts: S288

The ethnobotany of the island Caribs of
Dominica
(1957)
Istituto Botanico dell'Università di Firenze
Piazza San Marco 4
50121 Florence, Italy
Abstracts: S177

The ethnobotany of the Maya
(1931)
Tulane University.
Middle American Research Institute
New Orleans, LA 70118 USA
Abstracts: S51

Ethnobotany of the Nitinaht Indians of
Vancouver Island
(1983)
Royal British Columbia Museum
675 Belleville St.
Victoria, BC V8V 1X4 Canada
[ISBN 0-7718-8375-7]
Abstracts: S356

Ethnobotany of the Ramah Navaho
(1973)
Kraus Reprint and Periodicals
Route 100
Milwood, NY 10546 USA
Abstracts: S277

Ethnobotany of the Tewa Indians
(1916)
United States Government Printing Office
Washington, DC 20402-9325 USA
Abstracts: S33

Ethnological studies among the
northwest-central Queensland
Aborigines
(1897)
E. Gregory, Government Printer
Brisbane, Queensland Australia
Abstracts: S19

Ethnology of Futuna
(1936)
Bernice Pauahi Bishop Museum
1525 Bernice St.
P.O. Box 19000-A
Honolulu, HI 96817-0916 USA
Abstracts: S67

Ethnology of Uvea (Wallis Island)
(1937)
Bernice Pauahi Bishop Museum
1525 Bernice St.
P.O. Box 19000-A
Honolulu, HI 96817-0916 USA
Abstracts: S74

Every man his own house-painter and
colourman: the whole forming a
complete system for the amelioration of
the noxious quality of common paint: a
number of invaluable inventions,
discoveries and improvements...and a
variety of other particulars that relate to
house painting in general
(1829)
I.F. Setchel
London, England
Abstracts: S2

Examination and conservation of wall
paintings of Sheesh Mahal, Nagaur: a
programme under National Project on
Wall Paintings
(1989)
INTACH Conservation Centre
HIG-44
Aliganj Scheme
Lucknow, 226 020 India
Abstracts: S428

Excavations at Kaminaljuyu, Guatemala
(1946)
Carnegie Institution of Washington
1530 P St., NW
Washington, DC 20005 USA
Abstracts: S107

La fabbrica dei colori: pigmenti e
coloranti nella pittura e nella tintoria
(1986)
Il Bagatto
Piazza dei Sanniti 30
Rome, 00185 Italy
[ISBN 88-7755-050-3]
Abstracts: S394, S396, S397

Facciate dipinte: conservazione e restauro: atti del convegno di studi, Genova, 15-17 aprile 1982
(1984)
SAGEP
Piazza Merani 1
16145 Genoa, Italy
[ISBN 88-7058-101-2]
Abstracts: S365

Facts about processes, pigments and vehicles: a manual for art students[7]
(1895)
Macmillan Publishers Ltd.
4 Little Essex St.
London, WC2R 3LF UK
Abstracts: S15

Fifth international restorer seminar = Fünftes internationales Seminar für Restauratoren: Veszprém, Hungary, 29.6-9.7, 1985
Központi Muzeumi Igazgatóság
P.O. Box 58
Budapest, Hungary
[ISBN 963-016-864-2 (pbk.: v.2)]
Abstracts: S1027

Food: its search, capture, and preparation
(1901)
G.A. Vaughn, Government Printer
Brisbane, Queensland Australia
or
Queensland. Home Secretary's Department
Brisbane, Queensland Australia
Abstracts: S20

Fourth international restorer seminar: Veszprém, Hungary, 2-10 July 1983 = Viertes internationales Seminar für Restauratoren = Quatriéme cours international pour restaurateurs
(1984)
Központi Muzemi Igazgatóság (Hungary)
PO Box 58
1450 Budapest, Hungary
[ISBN 963-01-3811-5 (pbk.)]
Abstracts: S363, S1003

Fresco painting: modern methods and techniques for painting in fresco and secco
(1947)
American Artists Group
New York, NY, USA
Abstracts: S111

Gathering the desert
(1985)
University of Arizona Press
1230 N. Park Ave., #102
Tucson, AZ 85719 USA
[ISBN 0-8165-0935-2]
Abstracts: S378

Gilded wood: conservation and history
(1991)
Sound View Press
170 Boston Post Rd.
Suite 150
Madison, CT 06443 USA
[ISBN 0-932087-21-3]
Abstracts: S874, S1100, S1107

Gloss: its definition and measurement
(1949)
Chemical Publishing Co., Inc.
80 Eighth Ave.
New York, NY 10011 USA
Abstracts: S711

Graining: ancient and modern
(1937)
Frederick J. Drake & Co.
Chicago, IL USA
Abstracts: S79

Greek and Roman methods of painting: some comments on the statements made by Pliny and Vitruvius about wall and panel painting[7]
(1910)
Cambridge University Press
Edinburgh House
Shaftesbury Rd.
Cambridge, CB2 2RU UK
Abstracts: S29

Handbook of American Indians north of Mexico
(1907 and 1910)
United States Government Printing Office
Washington, DC 20402-9325 USA
Abstracts: S25

Handbook of Indian foods and fibers of arid America
(1986)
University of California Press
2120 Berkeley Way
Berkeley, CA 94720 USA
[ISBN 0-520-05436-9]
Abstracts: S389

Handbook of South American Indians. Volume 6: physical anthropology, linguistics and cultural geography of South American Indians
(1950)
United States Government Printing Office
Washington, DC 20402-9325 USA
Abstracts: S132

Handbook of West African art
(1954)
Milwaukee Public Museum
800 W. Wells St.
Milwaukee, WI 53233 USA
Abstracts: S164

Hawaiian antiquities (Moolelo Hawaii)
(1951)
Bernice Pauahi Bishop Museum
1525 Bernice St.
P.O. Box 19000-A
Honolulu, HI 96817-0916 USA
[ISBN 0-910240-15-9]
Abstracts: S144

The Hawaiian canoe
(1981)
Editions Limited
P.O. Box 869
Hanalei, HI 96714 USA
Abstracts: S334

Hawaiian life of the pre-European period
(1940)
Southworth-Anthoensen Press
Portland, Maine, USA
Abstracts: S89

Hawaiian sculpture
(1988)
University of Hawaii Press
2840 Kolowalu St.
Honolulu, HI 96822 USA
[ISBN 0-8248-1069-4]
Abstracts: S415

Herbs, spices, and medicinal plants: recent advances in botany, horticulture, and pharmacology
(1985)
Oryx Press
4041 N. Central Ave.
Suite 700
Phoenix, AZ 85012-3397 USA
[ISBN 0-89774-143-9]
Abstracts: S379

Hess' paint film defects, their causes and cure
(1979)
Chapman and Hall Ltd.
11 New Fetter Lane
London, EC4P 4EE UK
[ISBN 0-412-13880-8]
Abstracts: S799

Historische Malmaterialien und ihre Identifizierung
(1988)
VEB deutscher Verlag der Wissenschaften
Johannes-Dieckmann-Str. 10
Berlin, Germany
or
Akademische Druck- und Verlagsanstalt
Auersperggasse 12
Graz, Austria
[ISBN 3-326-00202-5 (Germany) and 3-201-01459-1 (Austria)]
Abstracts: S643

Hopi dyes
(1978)
Museum of Northern Arizona Press
Route 4
Box 720
Flagstaff, AZ 86001 USA
[ISBN 0-89734-000-0]
Abstracts: S300

Source Directory

Hopi journal of Alexander M. Stephen
(1936)
Columbia University Press
562 W. 113th St.
New York, NY 10025 USA
Abstracts: S70

*How Indians use wild plants for food,
medicine, and crafts*
(1974)
Dover Publications, Inc.
180 Varick St. NY
10014 USA
[ISBN 0-486-23019-8]
Abstracts: S278

*ICOM Committee for Conservation,
eighth triennial meeting, Sydney,
Australia, 6-11 September, 1987:
preprints*
(1987)
ICOM Committee for Conservation
1 rue Miollis
75732 Paris, France
[ISBN 0-89236-094-1]
Abstracts: S399, S1045

*ICOM Committee for Conservation, fifth
triennial meeting, Zagreb, 1-8 October
1978: preprints*
(1978)
ICOM Committee for Conservation
1 rue Miollis
75732 Paris, France
Abstracts: S301, S796, S951, S954, S958

*ICOM Committee for Conservation,
fourth triennial meeting, Venice, 13-18
October 1975: preprints*
(1975)
ICOM Committee for Conservation
1 rue Miollis
75732 Paris, France
**Abstracts: S284, S564, S782, S783,
S936, S937, S942**

*ICOM Committee for Conservation,
ninth triennial meeting, Dresden,
German Democratic Republic, 26-31
August 1990: preprints*
(1990)
ICOM Committee for Conservation
1 rue Miollis
Paris, France
[ISBN 0-89236-185-9]
Abstracts: S652, S1085, S1092

*ICOM Committee for Conservation,
seventh triennial meeting, Copenhagen,
10-14 September 1984: preprints*
(1984)
ICOM Committee for Conservation
1 rue Miollis
75732 Paris, France
or
J. Paul Getty Trust
401 Wilshire Blvd.
Suite 900
Los Angeles, CA 90401-1455 USA
Abstracts: S360, S1012

*ICOM Committee for Conservation, sixth
triennial meeting, Ottawa, 21-25
September 1981: preprints*
(1981)
ICOM Committee for Conservation
1 rue Miollis
75732 Paris, France
**Abstracts: S97, S331, S338, S596, S597,
S600, S986, S987**

*ICOM Committee for Conservation tenth
triennial meeting, Washington, DC,
22-27 August 1993: preprints*
(1993)
ICOM Committee for Conservation
1 rue Miollis
75732 Paris, France
[ISBN 0-935868-65-8]
**Abstracts: S508, S509, S510, S512,
S516, S517, S520, S680, S1118, S1119,
S1121**

Source Directory

In situ archaeological conservation:
proceedings of meetings, 6-13 April
1986, Mexico
(1987)
Instituto Nacional de Antropología e
Historia (Mexico)
Córdoba 47
Col Roma
06700 Mexico City, Mexico
or
Getty Conservation Institute
4503 Glencoe Ave.
Marina del Rey, CA 90292-6537 USA
[ISBN 0-941103-03-X]
Abstracts: S1035, S1037

Indian herbalogy of North America: the
definitive guide to native medicinal
plants and their uses
(1991)
Shambhala Publications
Horticultural Hall
300 Massachusetts Ave.
Boston, 02115 United States
or
Random House
201 E. 50th St.
New York, NY 10022 USA
[ISBN 0-87773-639-1]
Abstracts: S490

Indian life on the northwest coast of
North America, as seen by the early
explorers and fur traders during the last
decades of the 18th century
(1972)
University of Chicago Press
5801 S. Ellis Ave.
4th floor
Chicago, IL 60637 USA
[ISBN 0-226-31088-4]
Abstracts: S266

Indian rawhide: an American folk art
(1974)
University of Oklahoma Press
1005 Asp Ave.
Norman, OK 73019-0445 USA
[ISBN 0-8061-1136-4]
Abstracts: S280

Indian uses of native plants
(1987)
Mendocino County Historical Society
P.O. Box 922
Mendocino, CA 95460 USA
Abstracts: S404

The Institute of Paper Conservation:
conference papers, Manchester, 1992
(1992)
Institute of Paper Conservation
P.O. Box 17
London, WC1N 2PE UK
[ISBN 0-9507268-3-4]
Abstracts: S498

Interior wall decoration: practical
working methods for plain and
decorative finishes, new and standard
treatments
(1924)
Frederick J. Drake & Co.
Chicago, IL USA
Abstracts: S39

International symposium on the
conservation and restoration of cultural
property: conservation and restoration
of mural paintings II: 18-21 November
1985, Tokyo, Japan
(1985)
Bunka-cho Tokyo Kokuritsu Bunkazai
Kenkyujo Hozon Kagakubu
13-27 Ueno Koen
Taito-ku
Tokyo, 110 Japan
Abstracts: S383

International symposium on the
conservation and restoration of cultural
property: conservation of Far Eastern art
objects: 26-29 November 1979, Tokyo,
Japan
(1980)
Bunka-cho Tokyo Kokuritsu Bunkazai
Kenkyujo Hozon Kagakubu
13-27 Ueno Koen
Taito-ku
Tokyo, 110 Japan
Abstracts: S972

*International symposium on the
conservation and restoration of cultural
property: conservation of wood: 24-28
November 1977, Tokyo, Nara, and
Kyoto, Japan*
(1978)
Bunka-cho Tokyo Kokuritsu Bunkazai
Kenkyujo Hozon Kagakubu
13-27 Ueno Koen
Taito-ku
Tokyo, 110 Japan
Abstracts: S303, S961

*Internationale Leder- und
Pergamenttagung = International leather
and parchment symposium, vom 8. Mai
bis 12. Mai 1989*[7]
(1989)
Deutsches Ledermuseum
Frankfurter Str. 86
6050 Offenbach-am-Main, Germany
Abstracts: S1068

*Investigación, conservación y
restauración de la técnica pictorica al
pastel*
(1988)
Instituto Nacional de Antropología e
Historia. Escuela Nacional de
Conservación, Restauración y Museografía
"Manuel del Castillo Negrete"
Cordoba 45
Col. Roma
06700 Mexico City, Mexico
Abstracts: S1054

*Johann Georg Rudolphi: 1633-1693.
Vol. 1*
(1979)
Ferdinand Schöningh GmbH Verlag
Postfach 2540
33055 Paderborn, Germany
[ISBN 3-506-76175-7]
Abstracts: S584

*The journals of Captain James Cook on
his voyages of discovery*
(1988)
Kraus Reprint and Periodicals
Route 100
Milwood, NY 10546 USA
[ISBN 0-8115-3861-3]
Abstracts: S414

*Journées sur la conservation,
restauration des biens culturels:
recherches et techniques actuelles:
Paris, 15-16 octobre 1987*
(1987)
Association des restaurateurs d'art et
d'archéologie de formation universitaire
3 rue Michelet
75006 Paris, France
Abstracts: S1039

*Ka hana kapa: the making of bark-cloth
in Hawaii*
(1911)
Bishop Museum Press
P.O. Box 19000-A
Honolulu, HI 96817-0916 USA
Abstracts: S31

*Kiva mural decorations at Awatovi and
Kawaika-a, with a survey of other wall
paintings in the Pueblo Southwest*[7]
(1952)
Peabody Museum of Archaeology and
Ethnology
Harvard University
11 Divinity Ave.
Cambridge, MA 02138 USA
Abstracts: S160

The Kongo I
(1953)
Victor Pettersons Bokindustri
Aktiebolag
Stockholm, Sweden
Abstracts: S162

The Kongo IV
(1968)
Berlingska Boktryckeriet
Lund, Sweden
Abstracts: S242

Kunststoffe in der Konservierung und Restaurierung von Kulturgütern: Seminar 28-30 November 1985 in Bern = Produits synthétiques pour la conservation et la restauration des oeuvres d'art: séminaire 28-30 novembre 1985 à Berne
(1987)
Paul Haupt AG Verlag
Falkenplatz 14
3001 Bern, Switzerland
[ISBN 3-258-03655-1]
Abstracts: S1036

Lā'au Hawai'i: traditional Hawaiian uses of plants
(1992)
Bishop Museum Press
P.O. Box 19000-A
Honolulu, HI 96817-0916 USA
[ISBN 0-930897-62-5]
Abstracts: S494

Lackrohstoff-Tabellen
(1987)
Curt R. Vincentz Verlag
Schiffgraben 41-43
Postfach 6247
3000 Hanover, Germany
[ISBN 3-87870-340-6]
Abstracts: S402

Lecciones barrocas: pinturas sobre la vida de la Virgen de la Ermita de Egipto
(1990)
Banco de República
Carrera 7 #14-78
Bogotá, Colombia
Abstracts: S461

Legno e restauro: ricerche e restauri su architetture e manufatti lignei
(1989)
Messaggerie toscane
Florence, Italy
Abstracts: S1078

Library and archives conservation: the Boston Athenaeum's 1971 seminar on the application of chemical and physical methods to the conservation of library and archival materials, 17-21 May 1971, Topsfield, Massachusetts
(1972)
Boston Athenaeum Library
10 1/2 Beacon St.
Boston, MA 02108-3777 USA
Abstracts: S922

Light: its interaction with art and antiquities
(1980)
Plenum Publishing Corp.
233 Spring St.
New York, NY 10013 USA
[ISBN 0-306-40416-8]
Abstracts: S805

Ludowe malarstwo na szkle
(1968)
Zaklad Narodowy im. Ossolinskich.
Wydawnictwo Polskeij Akademii Nauk
Rynek 9
Wrocław, 50-106 Poland
Abstracts: S240

Manuale del pittore restauratore[7]
(1866)
Successori Le Monnier
Florence, Italy
Abstracts: S5

Maori art
(1896)
Harmer Johnson Books Ltd.
38 E. 64th St.
New York, NY 10021 USA
Abstracts: S18

Maria van Bourgondie: de tragiek van een vorstin
(1982)
Drukkery Uitgevery Herman Cools
Kasteeldreef 66-1
2750 Beveren, Belgium
Abstracts: S346

Mark Rothko's Harvard murals
(1988)
Harvard University Art Museums. Center
for Conservation and Technical Studies
32 Quincy St.
Cambridge, MA 02138-3883 USA
[ISBN 0-916724-69-7]
Abstracts: S413

Material culture notes
(1969)
Denver Art Museum Dept. of Indian Art
100 W. 14th Ave. Parkway
Denver, CO 80204 USA
Abstracts: S247

Material culture of the Blackfoot Indians
(1910)
American Museum of Natural History
Central Park W. at 79th St.
New York, NY 10024-5192 USA
Abstracts: S30

*The material culture of the peoples of
the Gwembe Valley*
(1968)
Praeger Publishers
1 Madison Ave.
11th Flr.
New York, NY 10010-5300 USA
Abstracts: S243

*The materials and techniques of
Medieval painting[7]*
(1956)
Dover Publications, Inc.
180 Varick St.
New York, NY 10014 USA
[ISBN 0-486-20327-1]
Abstracts: S172

Materials issues in art and archaeology
(1988)
Materials Research Society
9800 McKnight Rd.
Suite 327
Pittsburgh, PA 15237 USA
[ISBN 0-931837-93-6]
Abstracts: S645

*Materials issues in art and archaeology
III: symposium held 27 April-1 May
1992, San Francisco*
Materials Research Society
9800 McKnight Rd.
Suite 327
Pittsburgh, PA 15237 USA
[ISBN 1-55899-162-X]
Abstracts: S497, S880

*Materiały i techniki malarskie w
średniowiecznych malowidłach
ściennych w domu dawnego Bractwa
Kupieckiego przy ulicy Żeglarskiej 5 w
Toruniu*
(1991)
Uniwersytet Mikołaja Kopernika w
Toruniu
ul. Fosa Staromiejska 3
87-110 Toruń, Poland
[ISBN 83-231-0117-5]
Abstracts: S485

*Memória d'activitats del Centre de
Conservació Restauració de Bens
Culturals Mobles de la Generalitat de
Catalunya: 1982-1988[7]*
(1988)
Generalitat de Catalunya. Departament de
Cultura
Placa Sant Jaume, s-n
08002 Barcelona, Spain
Abstracts: S1063

*Methods in scientific examination of
works of art: infrared microspectroscopy*
(1991)
Getty Conservation Institute
4503 Glencoe Ave.
Marina del Rey, CA 90292-6537 USA
Abstracts: S664

Le métier du peintre[7]
(1990)
Dessain & Tolra
10 rue de la Pepinière
75008 Paris, France
[ISBN 2-249-27795-8]
Abstracts: S462

The mining of gems and ornamental
stones by American Indians
(1941)
United States Government Printing Office
Washington, DC 20402-9325 USA
Abstracts: S93

Modern art: the restoration and
techniques of modern paper and paints:
proceedings of a conference jointly
organised by UKIC and the Museum of
London, 22 May 1989[7]
(1989)
United Kingdom Institute for Conservation
37 Upper Addison Gardens
Holland Park
London, W14 8AJ UK
[ISBN 1-87-1656-04-4]
Abstracts: S434, S436, S437

Mohave tatooing and face-painting
(1947)
Southwest Museum
Box 128
Highland Park Station
Los Angeles, CA 90042 USA
Abstracts: S116

The museum conservation of
ethnographic objects
(1988)
National Museum of Ethnology
Senri Expo Park
565 Osaka, Japan
Abstracts: S1062

The mystic warriors of the Plains
(1972)
Doubleday & Co.
P.O. Box 5071
Des Plaines, IL 60017-5071 USA
[ISBN 0-385-04741-X]
Abstracts: S268

National Museum, Ottawa: annual
report for 1927
(1929)
National Museum (Canada)
Ottawa, ONT Canada
Abstracts: S48

Natural resins
(1938)
American Gum Importers Association
360 Furman St.
Brooklyn, NY USA
Abstracts: S82

Navajo native dyes: their preparation
and use
(1978 and 1940)
Filter Press
P.O. Box 5
Palmer Lake, CO 80133 USA
[ISBN 0-910584-57-5 (paper); 0-910584-49-4
(cloth)]
Abstracts: S299

Neues Rezeptbuch für die Farben- und
Lackindustrie
(1952)
Curt R. Vincentz Verlag
Schiffgraben 41-43
Postfach 6247
3000 Hanover, Germany
Abstracts: S155

New approaches to southern African
rock art
(1983)
South African Archaeological Society
P.O. Box 15700
8018 Vlaeberg, South Africa
[ISBN 0-620-05489-1]
Abstracts: S355

New directions in the study of plants
and people: research contributions from
the Institute of Economic Botany
(1990)
New York Botanical Garden
Scientific Publications Department
Bronx, NY 10458-5126
[ISBN 0-89327-347-3]
Abstracts: S451, S484

A new original version of Boscana's historical account of the San Juan Capistrano Indians of Southern California
(1934)
Smithsonian Institution
National History Bldg., Rm. C222B
10th and Constitution Ave. NW
Washington, DC 20560 USA
Abstracts: S62

Notes from a ceramic laboratory
(1977)
Carnegie Institution of Washington
1530 P St., NW
Washington, DC 20005 USA
Abstracts: S580

Notes on the technique of Indian polychrome wooden sculpture
(1969)
National Museum. Conservation Laboratory
New Delhi, 110 011 India
Abstracts: S246

L'ocre et son industrie en Puisaye, géologie et histoire
(1968)
Association d'études et de recherches du Vieux Toucy
Toucy, France
Abstracts: S238

Ocres: ocres et ocriers du pays d'Apt
(1986)
Edisud
La Calade
Route Nationale 7
13090 Aix-en-Provence, France
[ISBN 2-85744-253-X]
Abstracts: S384

On picture varnishes and their solvents[7]
(1985)
National Gallery of Art
4th St. and Constitution Ave. N.W.
Washington, DC 20565 USA
[ISBN 0-89468-084-6]
Abstracts: S832

The organic chemistry of museum objects[7]
(1987)
Butterworth & Co.
Borough Green
Sevenoaks, TN15 8PH UK
[ISBN 0-408-11810-5]
Abstracts: S633

Organic coatings: their origin and development: proceedings of the international symposium on the history of organic coatings, held 11-15 September 1989, Miami Beach, Florida, USA
(1990)
Elsevier Science Publishing Co., Inc.
P.O. Box 882
Madison Sq. Station
New York, NY 10159 USA
[ISBN 0-444-01520-5]
Abstracts: S454, S480

Original treatises on the arts of painting
(1967)
Dover Publications, Inc.
180 Varick St.
New York, NY 10014 USA
Abstracts: S234

Ornamented bark-cloth in Indonesia
(1963)
N.V. Boekhandel En Drukkery V.H.
E.J. Brill
Postbus 9000
2300PA Leiden, Netherlands
Abstracts: S209

Paint and surface coatings: theory and practice
(1987)
Halstead Press
605 Third Ave.
New York, NY 10158 USA
[ISBN 0-470-20809-0]
Abstracts: S849

Paint flow and pigment dispersion: a rheological approach to coatings and ink technology
(1979)
Wiley-Interscience
605 Third Ave.
New York, NY 10016 USA
[ISBN 0-471-03272-7]
Abstracts: S802

Paint magic: the home decorator's guide to painted finishes[7]
(1987)
Pantheon Books
201 E. 50th St.
New York, NY 10022 USA
[ISBN 0-394-75434-4]
Abstracts: S400

The painter's craft: an introduction to artists' materials
(1948)
Van Nostrand Reinhold Company Inc.
115 Fifth Ave.
New York, NY 10003 USA
Abstracts: S123

The painter's methods and materials
(1960 and 1967)
Seeley Service & Co.
London, UK
or
Dover Publications, Inc.
180 Varick St.
New York, NY 10014 USA
Abstracts: S196

Painters painting: a candid history of the modern art scene, 1940-1970
(1984)
Abbeville Press
488 Madison Avenue
New York, NY 10022 USA
[ISBN 0-89659-418-1]
Abstracts: S362

The painters' encyclopaedia
(1887)
M.T. Richardson
New York, USA
Abstracts: S10

Painting materials: a short encyclopaedia[7]
(1966)
Dover Publications, Inc.
180 Varick St.
New York, NY 10014 USA
[ISBN 0-486-21597-0]
Abstracts: S227

The palm, tree of life: biology, utilization, and conservation: proceedings of a symposium at the 1986 annual meeting of the Society for Economic Botany held at the New York Botanical Garden, Bronx, New York, 13-14 June 1986[2]
(1988)
New York Botanical Garden. Scientific Publications Department
Bronx, NY 10458-5126 USA
[ISBN 0-89327-326-0]
Abstracts: S424

Papers presented at the art conservation training programs conference: 2-4 May 1984, Center for Conservation and Technical Studies, Harvard University Art Museums, Cambridge, Massachusetts
(1984)
Harvard University Art Museums
Center for Conservation and
Technical Studies
32 Quincy St.
Cambridge, MA 02138-3883 USA
Abstracts: S368

Papers presented at the sixteenth annual art conservation training programs conference: 26-28 April 1990, University of Delaware/Winterthur Museum Art Conservation Department
(1991)
University of Delaware. Art Conservation Program
303 Old College
Newark, DE 19716 USA
Abstracts: S1102

*Papers presented by trainees at the
fifteenth annual art conservation
training programs conference: 28 April
1989, Center for Conservation and
Technical Studies, Harvard University
Art Museums, Cambridge,
Massachusetts*
(1990)
Harvard University Art Museums
Center for Conservation and
Technical Studies
32 Quincy St.
Cambridge, MA 02138-3883 USA
Abstracts: S449

*The particle atlas: an encyclopedia of
techniques for small particle
identification*
(1979)
Ann Arbor Science Publishers
Ann Arbor, MI USA
[ISBN 0-250-40008-1]
Abstracts: S585, S586

*Pastels: from the 16th to the 20th
century*
(1984)
Rizzoli International Publications
300 Park Ave. S.
New York, NY 10010 USA
or
Skira International Corp.
381 Park Ave. S.
New York, NY 10016 USA
[ISBN 0-8478-0533-6]
Abstracts: S364

*Patterns of paradise: the styles and
significance of bark cloth around the
world*
(1980)
Field Museum of Natural History
Roosevelt Road at Lake Shore Dr.
Chicago, IL 60605-2496 USA
[ISBN 0-914868-05-5]
Abstracts: S319

*People of the desert and sea:
ethnobotany of the Seri Indians*
(1985)
University of Arizona Press
1230 N. Park Ave., #102
Tucson, AZ 85719 USA
[ISBN 0-8165-0818-6]
Abstracts: S376

*Pharaoh's flowers: the botanical
treasures of Tutankhamun*
(1990)
Her Majesty's Stationary Office
H.M.S.O. Publication Centre
P.O. Box 276
London, SW8 5DT UK
[ISBN 0-11-250040-4]
Abstracts: S463

*Physica en schilderkunst, inleiding tot
de studie van physische verschijnselen
toegepast op schilderkunst en
schildertechniek*
(1943)
A. Manteau, n.v.
Brussels, Belgium
Abstracts: S707

Physiochemical hydrodynamics
(1962)
Prentice-Hall
Rte. 9W
Englewood Cliffs, NJ 07632 USA
Abstracts: S742

Pigment handbook. Volume 3
(1973)
Wiley-Interscience
605 Third Ave.
New York, NY 10016 USA
[ISBN 0-471-67123-1 (v.1)]
Abstracts: S772, S774

*Le pitture murali: tecniche, problemi,
conservazione[7]*
(1990)
Centro Di della Edifimi S.r.l.
1 Costa Scarpuccia
50125 Florence, Italy
[ISBN 88-7038-196X]
Abstracts: S1080

Les plantes utiles au Gabon: essai d'inventaire et de concordance des noms vernaculaires et scientifiques des plantes spontanées et introduites: description des espèces, propriétés, utilisations économiques, ethnographiques et artistiques
(1961)
Editions Lechevalier
120 Bl. St. Germain
75280 Cedex 06 Paris, France
Abstracts: S202

Plants for man
(1952)
Prentice-Hall
Rte. 9W
Englewood Cliffs, NJ 07632 USA
Abstracts: S159

Plants for people
(1990)
Oxford University Press, Inc.
200 Madison Ave.
New York, NY 10016 USA
[ISBN 0-19-520840-4]
Abstracts: S471

Plants in British Columbia Indian technology
(1992)
Royal British Columbia Museum
675 Belleville St.
Victoria, BC V8V 1X4 Canada
Abstracts: S506

Plants in Hawaiian culture
(1993)
University of Hawaii Press
2840 Kolowalu St.
Honolulu, HI 96822 USA
[ISBN 0-8248-1225-5]
Abstracts: S515

Polarized light microscopy
(1984)
McCrone Research Institute
2820 S. Michigan Ave.
Chicago, IL 60616-3292 USA
[ISBN 0-250-40262-9]
Abstracts: S614

Pompeiana: raccolta di studi per il secondo centenario degli scavi di Pompei
(1950)
G. Macchiaroli
Naples, Italy
Abstracts: S131

Il Prato della Valle e le opere in pietra calcarea collocate all'aperto
(1990)
Libreria Progetto
Via Marzolo 28
Padua, Italy
Abstracts: S1082

Precolumbian cements: a study of the calcareous cements in pre-Hispanic meso-American building construction
(1970)
Johns Hopkins University Press
701 W. 40th St.
Suite 275
Baltimore, MD 21211 USA
Abstracts: S553

Prehistoric and Roman studies: commemorating the opening of the Department of Prehistoric and Romano-British Antiquities
(1971)
British Museum
Great Russell St.
London, WC1B 3DG UK
Abstracts: S262

Preprints of papers presented at the eighth annual meeting, San Francisco, California, 22-25 May 1980
(1980)
American Institute for Conservation of Historic and Artistic Works
1717 K Street, N.W.
Suite 301
Washington, DC 20006 USA
Abstracts: S971, S979

Preprints of papers presented at the eleventh annual meeting, Baltimore, Maryland, 25-29 May 1983
(1983)
American Institute for Conservation of Historic and Artistic Works
1717 K Street, N.W.
Suite 301
Washington, DC 20006 USA
Abstracts: S999

Preprints of papers presented at the fifteenth annual meeting, Vancouver, British Columbia, Canada, 20-24 May 1987
(1987)
American Institute for Conservation of Historic and Artistic Works
1717 K St., NW
Suite 301
Washington, DC 20006 USA
Abstracts: S635

Preprints of papers presented at the fourteenth annual meeting: Chicago, Illinois, 21-25 May 1986
(1986)
American Institute for Conservation of Historic and Artistic Works
1717 K St., NW
Suite 301
Washington, DC 20006 USA
Abstracts: S393, S627

Preprints of papers presented at the ninth annual meeting, Philadelphia, 27-31 May 1981
(1981)
American Institute for Conservation of Historic and Artistic Works
1717 K Street, N.W.
Suite 301
Washington, DC 20006 USA
Abstracts: S336, S810, S988, S990

Preprints of papers presented at the seventh annual meeting: Toronto, Canada, 30-31 May and 1 June 1979
(1979)
American Institute for Conservation of Historic and Artistic Works
1717 K St., NW
Suite 301
Washington, DC 20006 USA
Abstracts: S309, S963

Preprints of papers presented at the sixteenth annual meeting, New Orleans, Louisiana, 1-5 June 1988
(1988)
American Institute for Conservation of Historic and Artistic Works
1717 K St., NW
Suite 301
Washington, DC 20006 USA
Abstracts: S409

Preprints of papers presented at the sixth annual meeting of the American Institute for Conservation of Historic and Artistic Works, Fort Worth, Texas, 1-4 June 1978
(1978)
American Institute for Conservation of Historic and Artistic Works
1717 K St., NW
Suite 301
Washington, DC 20006 USA
Abstracts: S952

Preprints: ICOM Committee for Conservation, sixth triennial meeting, Ottawa, 21-25 September 1981
See *ICOM Committee for Conservation*

Preservation and conservation: principles and practices: proceedings of the North American international regional conference, Williamsburg, Virginia, and Philadelphia, Pennsylvania, 10-16 September 1972
(1976)
Preservation Press
1785 Massachusetts Ave., NW
Washington, DC 20036 USA
[ISBN 0-89133-029-1]
Abstracts: S947

Primitive art: pre-Columbian, North American Indian, African, Oceanic
(1979)
Harry N. Abrams, Inc.
100 Fifth Ave.
New York, NY 10011 USA
[ISBN 0-8109-1459-X]
Abstracts: S307

Proceedings of the eighth international conference in organic coatings science and technology, Athens, Greece, 12-16 July 1982
(1984)
Marcel Dekker, Inc.
270 Madison Ave.
New York, NY 10016 USA
[ISSN 0271-1885]
Abstracts: S824

Proceedings of the fourth symposium on thermophysical properties sponsored by the Standing Committee on Thermophysical Properties, Heat Transfer Division, of the American Society of Mechanical Engineers
(1968)
American Society of Mechanical Engineers
345 E. 47th St.
New York, NY 10017 USA
[ISSN 0082-0989; 0586-3104]
Abstracts: S758

Proceedings of the national seminar on the conservation of cultural material, Perth, 1973
(1976)
Australian Institute for the Conservation of Cultural Material
GPO Box 1638
Canberra, ACT 2601 Australia
[ISBN 0-9597371-0-3]
Abstracts: S946

Proceedings of the Symposium on Sandalwood in the Pacific: April 9-11, 1990, Honolulu, Hawaii
(1990)
United States Department of Agriculture
Pacific Southwest Research Station
P.O. Box 245
Berkeley, CA 94701 USA
Abstracts: S1006

Proceedings of the twenty-fourth international archaeometry symposium
(1986)
Smithsonian Institution Press
955 L'Enfant Plaza
Suite 2100
Washington, DC 20560 USA
Abstracts: S624

Protective and decorative coatings: paints, varnishes, lacquers, and inks
(1941 and 1946)
Wiley & Sons Ltd.
Baffins Lane
Chichester, PO19 1UD UK
or
Chapman and Hall Ltd.
11 New Fetter Lane
London, EC4P 4EE UK
Abstracts: S94

Quex Museum House and Gardens
(1990)
Powell-Cotton Museum
Quex Park
Birchington, CT7 0BH UK
or
Jarrold Colour Publications
Barrack St.
Norwich, NR3 1TR UK
[ISBN 0-9513915-1-8]
Abstracts: S452

Recent advances in conservation: contributions to the IIC Rome Conference, 1961
Butterworth & Co.
Borough Green
Sevenoaks, TN15 8PH UK
Abstracts: S900

Recent advances in the conservation and analysis of artifacts: Jubilee Conservation Conference papers
(1987)
Summer Schools Press
Institute of Archaeology
31-34 Gordon Square
London, WC1H OPY UK
[ISBN 0-9512423-0-3 (pbk.)]
Abstracts: S629, S630

Report on the collecting visit to the
Wosera-Abelam of Sarakim village, and
a note on conservation requirements
(1980)
British Museum
Great Russell St.
London, WC1B 3DG UK
Abstracts: S318

Restaurierung von Kulturdenkmalen:
Beispiele aus der niedersächsischen
Denkmalpflege
(1989)
C.W. Niemeyer GmbH & Co. KG
Osterstr. 19
3250 Hameln, 1 Germany
[ISBN 3-87585-152-8]
Abstracts: S438, S1070, S1073

Il restauro delle opere d'arte moderne e
contemporane
(1991)
Nardini
Via Ammirato 37
50136 Florence, Italy
[ISBN 88-404-4010-0]
Abstracts: S1094

Restoration of Indian art: some case
studies. Volume I
(1988)
INTACH Conservation Centre
HIG-44
Aliganj Scheme
Lucknow, 226 020 India
Abstracts: S1057

Restoration of paintings
(1973)
Van Dishoeck
Bussum, Netherlands
or
Unieboek B.V.
Postbus 97
3390 DB Houten, Netherlands
[ISBN 90-228-4292-4]
Abstracts: S926

Rock art conservation in Australia
(1988)
Australian Government Publishing Service
P.O. Box 7
Planetarium Station
New York, NY 10024 USA
[ISBN 0-644-07197-4]
Abstracts: S422

The rock paintings of the Chumash: a
study of a California Indian culture
(1993)
Santa Barbara Museum of Natural History
2559 Puesta del Sol Rd.
Santa Barbara, CA 93105 USA
Abstracts: S513

Russian icons
(1963)
Marboro Books
1 Pond Rd.
Rockleigh, NJ 07647 USA
Abstracts: S214

Samoan material culture
(1930)
Bernice Pauahi Bishop Museum
1525 Bernice St.
P.O. Box 19000-A
Honolulu, HI 96817-0916 USA
Abstracts: S50

Scandinavian painted decor
(1990)
Rizzoli International Publications
300 Park Ave. S.
New York, NY 10010 USA
[ISBN 0-8478-1235-9]
Abstracts: S467

Schutz und Pflege von Baudenkmälern
in der Bundesrepublik Deutschland: ein
Handbuch
(1980)
W. Kohlhammer GmbH
Hessbrühlstr. 69
Postfach 800430
70504 Stuttgart, Germany
[ISBN 3-17-004987-9]
Abstracts: S806

Science, technology, and European cultural heritage: proceedings of the European symposium, Bologna, Italy, 13-16 June 1989[7]
(1991)
Butterworth-Heinemann Publishers
P.O. Box 63
Westbury House
Bury St.
Guildford, GU2 5BH UK
[ISBN 0-7506-0237-6]
Abstracts: S1096, S1103

Scientific methodologies applied to works of art: proceedings of the symposium, Florence, Italy, 2-5 May 1984
(1986)
Montedison
Foro Buonaparte
Milan, Italy
Abstracts: S626

Le scienze, le istituzioni, gli operatori alla soglia degli anni '90
(1988)
Libreria Progetto
Via Marzolo 28
Padua, Italy
Abstracts: S421

The search for the Tassili frescoes: the story of the prehistoric rock paintings of the Sahara
(1959)
E.P. Dutton
2 Park Ave.
New York, NY 10016 USA
Abstracts: S187

Society of Automotive Engineers: international automotive engineering congress, Detroit, Michigan, 13-17 January 1969
(1969)
Society of Automotive Engineers
2 Pennsylvania Plaza
New York, NY 10001 USA
Abstracts: S763

Some plants used by the Yuki Indians of Round Valley, northern California
(1957)
Southwest Museum
Box 128
Highland Park Station
Los Angeles, CA 90042 USA
Abstracts: S176

Special report on picture varnish
(1958)
Carnegie-Mellon University. Mellon Institute
4400 Fifth Ave.
Pittsburgh, PA 15213 USA
Abstracts: S529

Spectacular vernacular: the adobe tradition[7]
(1989)
Aperture Foundation
20 E. 23rd St.
New York, NY 10010 USA
[ISBN 0-89381-391-5]
Abstracts: S431

Spot tests in inorganic analysis
(1972)
Elsevier Science Publishing Co., Inc.
P.O. Box 882
Madison Sq. Station
New York, NY 10159 USA
[ISBN 0-444-40929-7]
Abstracts: S556

Spot tests in organic analysis
(1966)
Elsevier Science Publishers B.V.
Postbus 211
1000 AE Amsterdam, Netherlands
[ISBN 0-444-40209-8]
Abstracts: S540

The student's Cennini: a handbook for tempera painters
(1942)
Dolphin Press
Brighton, UK
Abstracts: S96

Superfici dell'architettura: le finiture: atti del convegno di studi, Bressanone, 20-29 giugno 1990
(1991?)
Libreria Progetto
Via Marzolo 28
Padua, Italy
Abstracts: S493, S1108

Symposium '86: the care and preservation of ethnological materials: proceedings = L'entretien et la sauvegarde de matériaux ethnologiques: actes
(1988)
Canadian Conservation Institute
1030 Innes Rd.
Ottawa, Ontario K1A 0C8 Canada
[ISBN 0-660-12624-9]
Abstracts: S416, S417, S640, S641, S1050, S1056, S1060

Symposium '91: saving the 20th century: the degradation and conservation of modern materials: abstracts = Sauvegarder le XXe siècle: la dégradation et la conservation des matériaux modernes: résumés
(1991)
Canadian Conservation Institute
1030 Innes Rd.
Ottawa, ONT K1A OC8 Canada
Abstracts: S666

Systematic research collections in anthropology: an irreplaceable national resource: a report of a conference sponsored by the Council for Museum Anthropology
(1977)
Peabody Museum of Archaeology and Ethnology
Harvard University
11 Divinity Ave.
Cambridge, MA 02138 USA
Abstracts: S297

Tagungs-Bericht: Internationale Farbtagung Color = Proceedings: international colour meeting, Stockholm, 1969
(1969)
Musterschmidt GmbH Verlag
Vogelsangstr. 7
Zurich, Switzerland
Abstracts: S759, S761

Tapa in Polynesia
(1972)
Bernice Pauahi Bishop Museum
1525 Bernice St.
P.O. Box 19000-A
Honolulu, HI 96817-0916 USA
[ISBN 0-910240-13-2]
Abstracts: S267

Tapa, washi and western handmade paper: papers prepared for a symposium held at the Honolulu Academy of Arts, 4-11 June 1980
(1981)
Honolulu Academy of Arts
900 S. Beretania St.
Honolulu, HI 96814 USA
Abstracts: S335

Technique and personality
(1963)
New York Graphic Society Books
34 Beacon St.
Boston, MA 02108 USA
Abstracts: S208, S211

La technique de la peinture pompéienne[7]
(1957)
Edizioni tecniche
Via San Siro 27
20149 Milan, Italy
Abstracts: S174

The technique of the great painters[7]
(1949)
Carroll and Nicholson
London, UK
Abstracts: S127

*Les techniques du dessin: leur
évolution dans les différentes écoles
de l'Europe[7]*
(1949)
Van Oest
Paris, France
Abstracts: S128

Techniques of modern artists
(1983)
Macdonald & Co. Ltd.
Headway House
66-73 Shoe Lane
London, EC4P 4AB UK
[ISBN 0-356-09802-8]
Abstracts: S350

*Technologie industrielle, conservation,
restauration du patrimoine culturel:
colloque AFTPV/SFIIC, Nice, 19-22
September 1989*
(1989)
EREC
68 rue Jean Jaures
92800 Puteaux, France
[ISBN 2-905519-12-6]
Abstracts: S1071

The technology of natural resins
(1942)
Wiley & Sons Ltd.
Baffins Lane
Chichester, PO19 1UD UK
or
Chapman and Hall Ltd.
11 New Fetter Lane
London, EC4P 4EE UK
Abstracts: S99

*Le tecniche, la conservazione, il restauro
delle pitture murali[7]*
(1935)
Società anonima tipografica
"Leonardo da Vinci"
Città di Castello, Italy
Abstracts: S64

Testament to the Bushmen
(1985)
Penguin Books, Inc.
40 W. 23rd St.
New York, NY 10010 USA
[ISBN 0-14-007579-8]
Abstracts: S382

*Thin layer chromatography: an aid
for the analysis of binding materials
and natural dyestuffs from works of art*
(1972)
International Council of Museums
ICOM Secretariat
1 rue Miollis
75732 Paris, CEDEX 15 France
Abstracts: S559

*Third Pan-African Congress on
Prehistory, Livingstone, 1955*
(1957)
Chatto & Windus
The Hogarth Press
30 Bedford Sq.
London, WC1B 3SG UK
Abstracts: S175

*Thompson ethnobotany:
knowledge and usage of plants by
the Thompson Indians of British
Columbia*
(1990)
Royal British Columbia Museum
675 Belleville St.
Victoria, BC V8V 1X4 Canada
[ISBN 0-7718-8916-X]
Abstracts: S483

*The traditional artist in African
societies*
(1973)
Indiana University Press
601 N. Morton St.
Bloomington, IN 47404-3797 USA
[ISBN 0-253-39901-7]
Abstracts: S274, S276

Treatise on coatings
(1967)
Marcel Dekker, Inc.
270 Madison Ave.
New York, NY 10016 USA
[ISBN 0-8247-1474-1 (v.2); 0-8247-
1475-X (v.3)]
Abstracts: S752

Ucuncu uluslararasi kerpic koruma sempozyumu: 29 Eylul-4 Ekim 1980, Ankara = Third international symposium on mudbrick (adobe) preservation: 29 September-4 October 1980, Ankara
(1980)
International Council of Museums
ICOM Secretariat
1 rue Miollis
75732 Paris, CEDEX 15 France
or
International Council of
Monuments and Sites
Hotel Saint Aignan
75, rue du Temple
75003 Paris, France
Abstracts: S970

Useful plants of Ghana: West African uses of wild and cultivated plants²
(1990)
Intermediate Technology Publications Ltd.
103-105 Southampton Row
London, WC1B 4HH UK
[ISBN 1-85339-080-1]
Abstracts: S447

Useful plants of Malawi
(1964)
Malawi Government Printer
Zomba, Malawi
Abstracts: S219

The useful plants of west tropical Africa
(1985)
Royal Botanic Gardens (Kew)
Richmond, TW9 3AB UK
[ISBN 0-947643-01-X]
Abstracts: S374

VIII Congrés de Conservació de Béns Culturals: València, 20, 21, 22 i 23 de setembre de 1990 = Congreso de Conservación de Bienes Culturales: Valencia, 20, 21, 22 y 23 de setiembre de 1990
(1990)
Generalidad Valenciana
Avda. Campanar 32
46015 Valencia, Spain
[ISBN 84-7890-179-5]
Abstracts: S448, S658, S1083

VIth international congress on deterioration and conservation of stone: Torun, 12-14.09.1988. Supplement: list of participants = VIe congrès international sur l'alteration et la conservation de la pierre: Torun, 12-14.09.1988
(1989)
Uniwersytet Mikołaja Kopernika
w Toruniu
ul. Fosa Staromiejska 3
Toruń, Poland
Abstracts: S649

Voices of German Expressionism
(1970)
Prentice-Hall
Rte. 9W
Englewood Cliffs, NJ 07632 USA
[ISBN 0-13-943712-6]
Abstracts: S254

Volkstümliche Malerei auf Holz: Kleister- und Kasein-Techniken
(1979)
Oberösterreichischer Landesverlag
Landstr. 41
4020 Linz, Austria
Abstracts: S314

Vollständige Anweisung zur Restauration der Gemälde in Oel-, Wachs-, Tempera-, Wasser-, Miniatur-, und Pastellfarben: nebst Belehrungen über die Bereitung der vorzüglichsten Firnisse für Gemälde, Basreliefs und Gypsstatuen, getrocknete Insecten und Pflanzen, Kupferstiche und Landkarten, sowie über das Reinigen, Bleichen, Aufziehen und Einrahmen der Kupferstiche, Steinabdrücke und Holzschnitte; für Kunstliebhaber, Maler, Bronzierer, Tapezirer etc.⁷
(1834 and Circa s, AD)
Bauverlag GmbH
Postfach 1460
6200 Wiesbaden, Germany
[ISBN 3-7625-2671-0]
Abstracts: S3

Wallpaper in America: from the 17th century to World War I
(1980)
W.W. Norton & Co., Inc.
500 Fifth Ave.
New York, NY 10110 USA
[ISBN 0-393-01448-7]
Abstracts: S320

Wash and gouache: a study of the development of the materials of watercolor[7]
(1977)
Harvard University Art Museums. Center for Conservation and Technical Studies
32 Quincy St.
Cambridge, MA 02138-3883 USA
[ISBN 0-916724-06-9]
Abstracts: S296

Windows on the dreaming: Aboriginal paintings in the Australian National Gallery
(1989)
Australian National Gallery
P.O. Box 1150
Canberra, ACT 2601 Australia
or
Ellsyd Press
137-139 Regent St.
Chippendale, NSW 2008 Australia
[ISBN 0-908197-96-9]
Abstracts: S443

Wooden ritual artifacts from Chaco Canyon, New Mexico: the Chetro Ketl collection
(1978)
University of Arizona Press
1230 N. Park Ave., #102
Tucson, AZ 85719 USA
[ISBN 0-8165-0576-4]
Abstracts: S305

Wow-Ipits: eight Asmat woodcarvers of New Guinea
(1967)
Mouton & Cie, Editions
7 rue Dupuytren
75006 Paris, France
Abstracts: S231

XVII. FATIPEC-Kongress: Vorprogramm: Lugano, Schweiz, 23.- 28.9.1984 = XVIIème Congrès FATIPEC: programme préliminaire: Lugano, Suisse, 23.-28.9.1984 = XVIIth FATIPEC Congress: preliminary programme: Lugano, Switzerland, 23.- 28.9.1984
(1984)
Schweizerische Vereinigung der Lack- und Farben-Chemiker
Zurich, Switzerland
Abstracts: S829

XXXV Congreso Internacional de Americanistas, Mexico, 1962: actas y memorias
(1964)
Editorial Libros de México
Mexico City, Mexico
Abstracts: S216

Yves Klein, 1928-1962: a retrospective
Rice University. Institute for the Arts
Menil Foundation
Houston, TX 77006 USA
or
The Arts Publisher, Inc.
113 E. 61st St.
New York, NY 77006 USA
Abstracts: 347

14e congrès FATIPEC = 14 FATIPEC Kongress = 14th FATIPEC congress: recent progress in the production, processing and properties of varnishes and paints, Budapest, Hungary, 4-9 June 1978
(1978)
Fédération d'associations de techniciens des industries des peintures, vernis, emaux et encres d'imprimerie de l'Europe continentale
Maison de la Chimie
28 rue Saint Dominique
Paris, France
Abstracts: S794

*18 FATIPEC Kongress: die
wissenschaftliche und technische
Entwicklung in der Farben, Lack und
Druckfarbenindustrie an der Schwelle
des 21. Jahrhunderts = 18th FATIPEC
congress: the scientific and technical
developments in the coatings and
printing ink industries on the doorway
of the 21st century = 18ème congrès
FATIPEC: les développements
scientifiques et techniques dans
l'industrie des peintures, vernis et
encres d'inprimerie au seuil du 21ème
siecle, Venice, Italy, 22-26 September
1986*
(1986)
Fédération d'associations de techniciens
des industries des peintures, vernis,
emaux et encres d'imprimerie de
l'Europe continentale
Maison de la Chimie
28 rue Saint Dominique
Paris, France
Abstracts: S840

*19 FATIPEC Kongress: Gegenwart und
Zukunft von Wissenschaft und Technik
der Anstriche und ihrer Komponenten =
19th FATIPEC congress: presence and
future in science and technology of
coatings and their components = 19ème
congrès FATIPEC: la science et la
technologie des peintures et de leurs
composants à l'heure actuelle et à
l'avenir, Aachen, Germany, 1988*
(1988)
Fédération d'associations de techniciens
des industries des peintures, vernis,
emaux et encres d'imprimerie de
l'Europe continentale
Maison de la Chimie
28 rue Saint Dominique
Paris, France
Abstracts: S853

*1976 TAPPI coating conference, 15-18
May, Atlanta, Georgia: papers*
(1977)
Technical Association of the Pulp
and Paper Industry
Technology Park Atlanta
Box 105113
Atlanta, GA 30348-5113 USA
Abstracts: S793

*1980 coating conference: proceedings of
the Technical Association of the Pulp
and Paper Industry*
(1980)
Technical Association of the Pulp
and Paper Industry
Technology Park Atlanta
Box 105113
Atlanta, GA 30348-5113 USA
Abstracts: S807

331

Audiovisual Material Distributors

Australian Film Commission/CA
875 N. Gower St.
Hollywood, CA 90038 USA

Australian Information Service
636 Fifth Ave.
New York, NY 10020 USA

Australian Museum
6-8 College St.
Sydney, NSW 2000 Australia

Boston University
African Studies Center
2161 Massachusetts Ave.
Boston, MA 02215 USA

Film Australia
P.O. Box 46
Eton Rd.
Lindfield, NSW 2070 Australia

RM Associates/NY
250 W. 57th St.
Suite 1005/6
New York, NY 10019 USA

Sydney Filmmakers Co-operative
P.O. Box 217
Kings Cross, NSW 2011 Australia

Tasmanian Film Corp.
6 McLaren St.
North Sydney, NSW 2060 Australia

University of California, Los Angeles.
Instructional Media Library
Film and Television Archive
1438 Melnitz Hall
405 Hilgard Ave.
Los Angeles, CA 90024 USA

Appendix IV
Subject Index

The present index is an alphabetical listing of AATA's terms. There are two types of index entries. The first type of entry is one in which the alphabetical primary term is the most important concept for the abstract indexed. This entry consists of: 1) the alphabetized primary term (bold type); 2) the original title, if the original language is English, or the title translated into English, if the original language is not English; 3) the abbreviation for the name of the original language (italicized in parentheses); 4) additional secondary terms that have been used in indexing the abstract (bold italic type lower case); and 5) the AATA abstract number for this volume. Examples of this type of entry are illustrated below:

The second type of index entry consists of: 1) the alphabetized term (bold type); 2) the primary term for that abstract (bold italic type); 3) the original title, if the original language is English, or the title translated into English; 4) the original language; and 5) the AATA abstract number for this volume. This type of entry is illustrated for three abstracts in this volume below:

Note that in the second entry type, where more than one title appears under the primary index term, that term is not repeated.

abalone shell
Native American—American Indian painting of the Southwest and Plains areas *(Eng)* S239

Abelam
Consolidation techniques for "yam masks": a practical investigation paper presented to the National Museum Act and the Museum of

Cultural History at the University of California at Los Angeles as an advanced internship research project *(Eng) Acryloid B-72; gelatin; masks; paint; rattan; yam masks* S996
red pigment—Report on the collecting visit to the Wosera-Abelam of Sarakim village, and a note on conservation requirements *(Eng)* S318

Ablebond 342-1
stained glass—Field applications of stained glass conservation techniques *(Eng)* S1013

abrasion
leather—The examination of use marks on some Magdalenian end scrapers *(Eng)* S262
watercolors—The structure of watercolor films with a high PVC *(Ita)* S820

absolute dating
rock paintings—Perspectives and potentials for absolute dating prehistoric rock paintings *(Eng)* S523

absorption
latex paint—Latex paints: CPVC, formulation, and optimization *(Eng)* S784
paint—The pigment-binder relationship as a fundamental property of paint *(Eng)* S709
pigment—Predicting the oil absorption and the critical pigment volume concentration of multicomponent pigment systems *(Eng)* S732
—The relationship of pigment packing patterns and CPVC to film characteristics and hiding power *(Eng)* S733
pigment volume concentration—C.P.V.C. of a pigment mixture as a function of vehicle type *(Eng)* S747
—Coating formulation and development using critical pigment volume concentration prediction and statistical design *(Eng)* S854
—CPVC, critical pigment volume concentration: an overview *(Eng)* S883
—Density method for determining the CPVC of flat latex paints *(Eng)* S822
—The determination of CPVC by the oil absorption test method *(Eng)* S723
—Determination of CPVC of latex paints using hiding power data *(Eng)* S788
—Oil absorption and critical pigment volume concentration (CPVC) *(Eng)* S712
—Pigment volume concentration and an interpretation of the oil absorption of pigments *(Eng)* S827
—Single pigment paints *(Eng)* S786
—Vehicle CPVC *(Eng)* S775
reflectance—The use of differential spectral analysis in the study of museum objects *(Eng)* S744

Abstract art
Some structural solutions to the question of preventive conservation care for a major travelling exhibition, "The Crisis of Abstraction in Canada: The 1950s." *(Eng) Canada; preventive conservation* S508
Baumeister, Willi (1889-1955)—Studies of the painting techniques of Willi Baumeister *(Ger)* S496

Abydos reliefs (Egypt)
Techniques of decoration in the Hall of Barques in the Temple of Sethos I at Abydos

(Eng) cleaning; consolidation; Egyptian; ethylenediaminetetraacetic acid; mural paintings; Paraloid B-72; pigment S1064

Acacia campylacantha
Africa—The useful arts of Africa: their methods and materials *(Eng)* S251

accelerated aging
fixatives—Determination of the influence of Rowney's "Perfix" fixative on the properties of paper *(Pol)* S925
Fourier transform infrared spectroscopy—Analysis of aged paint binders by FTIR spectroscopy *(Eng)* S657
synthetic materials—Natural and accelerated aging of synthetic products compared with that of natural products *(Fre)* S1036
wood—Investigation into methods and materials for the adhesion of flaking paint on ethnographic objects: a progress report *(Eng)* S1045

accelerator mass spectrometry
pre-Columbian—Dating precolumbian museum objects *(Eng)* S1115

acetic acid
miniatures (paintings)—Conservation of miniatures *(Eng)* S270

acetone
cleavage—A case of paint cleavage *(Eng)* S703
mural paintings—Ajanta murals: their composition and technique and preservation *(Eng)* S232
Nagoya Castle (Nagoya, Japan)—Study on the repair technique of polychrome paintings drawn on sliding screens in the Nagoya Castle *(Jpn)* S945
paper—Conservation of some non-book material in National Library, Calcutta *(Eng)* S1026
reattaching—Reattaching color layers on a wooden wall and documenting the distribution of damages *(Jpn)* S1024
tempera—Examination and treatment of a tempera on canvas from the 16th century: the *Emmaus Pilgrims* from the Fine Arts Museum of Brussels *(Fre)* S981

acidity
textiles—Technical study and conservation of an old painted textile (Simhasana) *(Eng)* S902

Acoma
The Acoma Indians *(Eng) chimney soot; copper ore; egg; Kachina masks; milk; Native American; pigment; pitch (tar); red pigment; USA (New Mexico—Acoma); yellow* S57

Acronal 300D
acrylic resin—A preliminary evaluation of acrylic emulsions for the adhesion of flaking paint on ethnographic objects *(Eng)* S1046
adhesives—Adhesives for impregnation of painting on canvas *(Swe)* S1087

Acronal 500D
adhesives—Adhesives for impregnation of painting on canvas *(Swe)* S1087

Acropolis of Lero (Côte d'Azur, France)
hematite—Physico-chemical and colorimetric study of haemitite reds and purples, with ref-

erence to the mural paintings of the Acropolis of Lero, or "histories of ochre" *(Fre)* S352
mural paintings—Physico-chemical study of the painting layers of the Roman mural paintings from the Acropolis of Lero *(Fre)* S342
acrylic resin
Consolidation with acrylic colloidal dispersions *(Eng) brittleness; consolidation; organic materials; poly(vinyl acetate); viscosity; water* S988
—The identification and characterization of acrylic emulsion paint media *(Eng) binding media; chromatography; emulsion; Fourier transform infrared spectroscopy; microscopy; modern art; Museum of Modern Art (New York City, NY, USA); paint; paintings (objects); pyrolysis gas chromatography; staining (analysis); standards* S666
—Modern day artists colours *(Eng) alkyd resin; artists' materials; egg tempera; oil; paint; tempera; watercolors* S437
—A preliminary evaluation of acrylic emulsions for the adhesion of flaking paint on ethnographic objects *(Eng) Acronal 300D; adhesion; ethnographic conservation; flaking; Neocryl B700; paint; Paraloid B-72; Primal AC22; Primal AC235; resin* S1046
—A study of acrylic dispersions used in the treatment of paintings *(Eng) adhesives; aging; Lascaux 360 HV; Lascaux 498HV; painting (technique); paintings (objects); peeling; Plextol B500; Rhoplex AC33; Rhoplex AC34; solubility; yellowing* S1066
adhesives—Adhesives for impregnation of painting on canvas *(Swe)* S1087
—The evaluation of some adhesive systems utilized in the consolidation of paintings. The kinetics of consolidation (II) *(Rum)* S1020
artists' materials—The artist's handbook of materials and techniques *(Eng)* S83
ceilings—Conservation treatments with reference to color paintings on the ceiling of the main hall, National Treasure, of Toshodaiji Temple, Nara *(Jpn)* S941
chalk—Observations about conservation techniques regarding the consolidation of waterbound chalk paint layers *(Ger)* S1077
Daiju-ji Temple (Japan)—Preservative treatment on the *Shoheki-ga* at the Daiju-ji *(Jpn)* S955
fixatives—Fixing agent for chalking color on wood and its laboratory evaluation *(Jpn + Eng)* S1040
fluorescence microscopy—Ultraviolet fluorescence microscopy of paint cross sections: cycloheptaamylose-dansyl chloride complex as a protein-selective stain *(Eng)* S671
historic buildings—Conservation within historic buildings in Japan *(Eng)* S973
illuminations—Practice and practical possibilities in the conservation of Medieval miniatures *(Ger)* S969
Melanesian—Conservation of powdering pigment layers on Melanesian objects: choice of a fixative *(Fre)* S1039
mural paintings—Products, facts, modes in mural painting: evolution and distribution of restoration products used in mural paintings from 1850 to 1992: a first sorting concerning France, Spain, England, and Poland *(Fre)* S511

—Some problems on the preservation of wall paintings using synthetic resins *(Jpn)* S892
—Three Bodhisattvas: the conservation of a fifteenth century Chinese wall painting in the British Museum collection *(Eng)* S1051
Nagoya Castle (Nagoya, Japan)—Study on the repair technique of polychrome paintings drawn on sliding screens in the Nagoya Castle *(Jpn)* S945
Osakihachiman shrine (Japan)—Conservation treatment of the painting on wooden walls in the oratory of Osakihachiman Shrine *(Jpn)* S964
painting (technique)—Trial data on painting materials—mediums, adhesives, and film substances *(Eng)* S77
panel paintings—Preservative treatment on paint layer of screen and wall panel paintings *(Jpn)* S929
—Treatment on sliding screen and wall panel paintings to prevent exfoliation with synthetic resins *(Jpn)* S928
pest control—A historical survey of the materials used for pest control and consolidation in wood *(Ger)* S1010
plaster—The Malpaga Castle: conservation and consolidation problems of painted plasters of the courtyard *(Ita)* S1108
Plexigum P24—A study of Plexigum P24 used as a fixative for flaking paint traces *(Fre)* S1043
Plextol B500—Evaluation of the stability, appearance and performance of resins for the adhesion of flaking paint on ethnographic objects *(Eng)* S1101
synthetic resin—Restoration with synthetic resins in Japan *(Ger)* S966
tablets—Preservative treatment of the *Funa-Ema* (votive tablets of boats), important folklore materials at Arakawa Shrine and Hakusanhime Shrine *(Jpn)* S932
vinyl acetate—Very high binding vinyl acetate based dispersions *(Eng)* S869
votive tablets—Cleaning treatment on votive tablet in traditional way *(Jpn)* S939
wood—Studies on fixing treatments of color paintings on the ceiling of Sanmon Gate, National Treasure, Tofuku-ji Temple *(Jpn)* S940

Acrylic Resin Sol
historic buildings—Conservation within historic buildings in Japan *(Eng)* S973

acrylic silane
mural paintings—Conservation of central Asian wall painting fragments from the Stein Collection in the British Museum *(Eng)* S1099

Acryloid B-72 *see also* **Paraloid B-72**
Abelam—Consolidation techniques for "yam masks": a practical investigation paper presented to the National Museum Act and the Museum of Cultural History at the University of California at Los Angeles as an advanced internship research project *(Eng)* S996
consolidation—A consolidation treatment for powdery matte paint *(Eng)* S979
Iran—Friable pigments and ceramic surfaces: a case study from SW Iran *(Eng)* S1058

—The problem of conservation of very large canvases painted in glue medium *(Pol)* S968
calcimine—Interior wall decoration: practical working methods for plain and decorative finishes, new and standard treatments *(Eng)* S39
—The painters' encyclopaedia *(Eng)* S10
China—Chinese painting colors: studies of their preparation and application in traditional and modern times *(Eng)* S427
Chumash—Volume V: Manufacturing processes, metrology, and trade *(Eng)* S345
consolidants—Degradation of synthetic consolidants used in mural painting restoration by microorganisms *(Eng)* S1122
consolidation—Consolidation of delaminating paintings *(Eng)* S951
Cook, James (1728-1779)—The journals of Captain James Cook on his voyages of discovery *(Eng)* S414
cracking—Crack mechanisms in gilding *(Eng)* S874
Egypt—Ancient Egyptian materials and industries *(Eng)* S63
fixing—Theoretical approach to refixing *(Fre)* S1017
gas chromatography mass spectrometry—GC/MS and chemometrics in archaeometry: investigation of glue on Copper-Age arrowheads *(Eng)* S665
—Rapid identification of binding media in paintings using simultaneous pyrolysis methylation gas chromatography *(Eng)* S668
illuminations—Some tests on the use of wax for fixing flaking paint on illuminated parchment *(Eng)* S898
isinglass—Potential applications of isinglass adhesive for paper conservation *(Eng)* S1076
Luiseño—The culture of the Luiseño Indians *(Eng)* S26
Medieval—Medieval surface techniques, II *(Eng)* S122
mural paintings—The examination of mural paintings *(Dut)* S525
—Microchemical analysis of the wall paintings of St. Baafsabtei in Ghent (about 1175) *(Dut)* S90
—Restoration of ancient monumental painting in cult buildings *(Eng)* S284
—The structure of the 17th-century mural paintings in the S. George Orthodox church at Veliko Turnovo (Bulgaria) *(Pol)* S264
—The technique of the paintings at Sitabhinji *(Eng)* S143
—The techniques, conservation, and restoration of mural paintings *(Ita)* S64
—The wall paintings in the Bagh caves: an investigation into their methods *(Eng)* S87
Native American—Handbook of American Indians north of Mexico *(Eng)* S25
—A new original version of Boscana's historical account of the San Juan Capistrano Indians of Southern California *(Eng)* S62
organic chemistry—The organic chemistry of museum objects *(Eng)* S633
painting (technique)—Original treatises on the arts of painting *(Eng + Lat)* S234
—Painting materials: a short encyclopaedia *(Eng)* S227

—Trial data on painting materials—mediums, adhesives, and film substances *(Eng)* S77
—Trial data on painting materials—mediums, adhesives, and film substances (continued) *(Eng)* S78
paintings (objects)—Analysis of paint media, varnishes and adhesives *(Eng)* S625
panel paintings—Basic experiments concerning deterioration of glue and discoloration of pigments, and discussion on the actual condition of wall panel paintings on the basis of their results *(Jpn)* S930
—Present state of screen and panel paintings in Kyoto *(Jpn)* S933
—Preservative treatment on paint layer of screen and wall panel paintings *(Jpn)* S929
pigment—Domestic implements, arts, and manufactures *(Eng)* S23
—Ethnology of the Ungava District, Hudson Bay Territory *(Eng)* S14
—Studies on the ancient pigments in Japan *(Eng)* S52
Plains Indians—The mystic warriors of the Plains *(Eng)* S268
plants—The use of wild plants in tropical South America *(Eng)* S132
Polynesian—Breadfruit *(Eng)* S92
polysaccharides—Polysaccharides as part of a color layer and methods for their identification *(Cze)* S647
protein—Identification of protein containing binding media and adhesives in works of art by amino acid analysis *(Jpn)* S659
pyrolysis gas chromatography—Forensic applications of pyrolysis capillary gas chromatography *(Eng)* S609
pyrolysis mass spectrometry—Pyrolysis-mass spectrometry of natural gums, resins, and waxes and its use for detecting such materials in ancient Egyptian mummy cases (cartonnages) *(Eng)* S636
rabbit-skin glue—The treatment of gilded objects with rabbit-skin glue size as consolidating adhesive *(Eng)* S1107
screens (furniture)—Restoration of a Japanese screen *(Ger)* S949
Seri—People of the desert and sea: ethnobotany of the Seri Indians *(Eng)* S376
shadow puppets—The restoration of shadow puppets *(Ger)* S976
stone—The consequences of previous adhesives and consolidants used for stone conservation at the British Museum *(Eng)* S1052
tempera—Tempera adhesives in the history of art *(Ger)* S97
textiles—The link between the treatments for paintings and the treatments for painted textiles *(Eng)* S363
—Technical study and conservation of an old painted textile (Simhasana) *(Eng)* S902
thin layer chromatography—Methods in scientific examination of works of art. Volume 1: thin-layer chromatography course book *(Eng)* S684
—Thin layer chromatography: an aid for the analysis of binding materials and natural dyestuffs from works of art *(Eng)* S559

Turkistan—The materials in the wall paintings from Kizil in Chinese Turkestan *(Eng)* S81
USA (New Mexico)—The materials and methods of some religious paintings of early 19th century New Mexico *(Eng)* S142
Vuillard, Edouard (1868-1940)—History, analysis and treatment of "La salle à manger au château de Clayes," 1938, by Edouard Vuillard *(Eng)* S1009
—The special problems and treatment of a painting executed in hot glue medium, "The Public Garden" by Edouard Vuillard *(Eng)* S999
wallpaper—Wallpaper in America: from the 17th century to World War I *(Eng)* S320
whitewash—Decorative painters and house painting at Massachusetts Bay, 1630-1725 *(Eng)* S258
wood—Investigation into methods and materials for the adhesion of flaking paint on ethnographic objects: a progress report *(Eng)* S1045

adobe
1981 report on the development of methods for the conservation of Pueblo Indian mural paintings in the American Southwest *(Eng)* *mural paintings; Native American; plaster; Pueblo; stacco; strappo; USA (Southwest); walls* S995
—The conservation of adobe walls decorated with mural paintings and reliefs in Peru *(Eng)* *lime; mural paintings; Peru; polystyrene; rain; relief; wind* S958
—Experiments on preservation of adobe structures and restoration of gypsum plaster paintings in Uzbekistan *(Eng)* *Asia, Central; consolidation; gypsum; monomers; plaster; polymers; Uzbekistan; walls* S983
—Spectacular vernacular: the adobe tradition *(Eng)* *Afghanistan; Africa, West; architecture; climate; deserts; mud; Near East; USA (Southwest)* S431
—Treatment of adobe friezes in Peru *(Eng)* *consolidation; ethyl silicate; fixing; friezes (ornamental bands); paint; Paraloid B-72; Peru; Primal AC34* S970
mural paintings—A survey of the painted mud *Viharas* of Sri Lanka *(Eng)* S351
Pueblo—The state of preservation of Pueblo Indian mural paintings in the American Southwest: findings of a condition study carried out in 1978-1979, and a proposed pilot project to test materials and methods for conservation *(Eng)* S977
Tamberma—Architecture of the Tamberma (Togo) *(Eng)* S332
Temple of the Paintings (Bonampak Site, Chiapas, Mexico)—Conservation and restoration of the murals of the Temple of the Paintings in Bonampak, Chiapas *(Eng)* S1037

adsorption
pigment volume concentration—Pigment volume concentration, pigment surface concentration, packing density, and gloss of paints *(Ger)* S850
viscosity—Microscopic examination of pigment/vehicle interaction during film formation *(Eng)* S762

Aegean
Bronze Age—Aegean painting in the Bronze Age *(Eng)* S466
Afghanistan
adobe—Spectacular vernacular: the adobe tradition *(Eng)* S431
Africa
Bibliography and the arts of Africa *(Eng)* *bibliographies* S195
—A bibliography of African art *(Eng)* *bibliographies; rock art* S223
—Contemporary African arts and crafts: on-site working with art forms and processes *(Eng)* *artists' materials; carving; paintings (objects)* S281
—The material culture of the peoples of the Gwembe Valley *(Eng)* *castor oil; graphite; ocher; plants; Trichilia roka oil; Zambia* S243
—Personality and technique of African sculptors *(Eng)* *carvings; coatings; coloring; cracking; palm oil; resin; soot; wood* S208
—Quex Museum House and Gardens *(Eng)* *Asia; motion pictures* S452
—The useful arts of Africa: their methods and materials *(Eng)* *Acacia campylacantha; colorants; dye; folk art; gum; pigment; plants* S251
consolidation—Consolidation of loose paint on ethnographic wooden objects *(Ger)* S901
dye—African textiles: looms, weaving and design *(Eng)* S313
material culture—Ethnoart: Africa, Oceania, and the Americas: a bibliography of theses and dissertations *(Eng)* S411
painting (technique)—Pigments and paints in primitive exotic techniques *(Fre)* S201
primitive art—Primitive art: pre-Columbian, North American Indian, African, Oceanic *(Eng)* S307
red pigment—African red pigments *(Eng)* S641
rock paintings—Petroglyphs and pictographs on the British Columbia coast *(Eng)* S95

Africa, southern
rock art—Testament to the Bushmen *(Eng)* S382

Africa, West
Handbook of West African art *(Eng)* *camwood; castor oil; masks; metal; palm oil; patina; sculpture; soot; wood* S164
adobe—Spectacular vernacular: the adobe tradition *(Eng)* S431
plants—The useful plants of west tropical Africa *(Eng)* S374
wood—Plants for religious use from the forest region of West Africa *(Fre)* S106

aging
acrylic resin—A study of acrylic dispersions used in the treatment of paintings *(Eng)* S1066
binding media—Contributions to the analysis of binders, adhesives and ancient varnishes *(Fre)* S547
Fourier transform infrared spectroscopy—Analysis of aged paint binders by FTIR spectroscopy *(Eng)* S657
gelatin—IR-spectroscopic analysis of aged gelatins *(Eng)* S596

organic materials—Some problems in analysis of aged organic materials in art works and artefacts *(Eng)* S595
Osakihachiman shrine (Japan)—Conservation treatment of the painting on wooden walls in the oratory of Osakihachiman Shrine *(Jpn)* S964
paintings (objects)—Restoration of paintings *(Eng)* S926
pastels (visual works)—An investigation into the use of several substances as fixatives for works of art in pastel *(Eng)* S953
pyrolysis gas chromatography—Examination through pyrolysis gas chromatography of binders used in painting *(Eng)* S626
synthetic materials—Natural and accelerated aging of synthetic products compared with that of natural products *(Fre)* S1036

Agora (Athens, Greece)
pigment—Ancient Greek pigments *(Eng)* S105
—Ancient Greek pigments from the Agora *(Eng)* S104

air pollution
historic buildings—Conservation within historic buildings in Japan *(Eng)* S973
illuminations—The conservation of a Petrarch manuscript *(Eng)* S910

Ajanta Caves (India)
frescoes—Fresco paintings of Ajanta *(Eng)* S126
mural paintings—Ajanta and Ellora wall paintings. Scientific research as an aid to their conservation *(Eng)* S569
—Ajanta murals: their composition and technique and preservation *(Eng)* S232

Akan
The theory and practice of conservation among the Akans of Ghana *(Eng) blackening; Ghana; rituals; stools* S516

albumen
verre eglomise—Eglomise: technique and conservation *(Ger)* S1059

alcohol
adhesives—The evaluation of some adhesive systems utilized in the consolidation of paintings. The kinetics of consolidation (II) *(Rum)* S1020
Apache—Plants used by the White Mountain Apache Indians of Arizona *(Eng)* S47
artificial ultramarine blue—A technical note on IKB (International Klein Blue) *(Eng)* S347
cleavage—A case of paint cleavage *(Eng)* S703
mural paintings—Ajanta murals: their composition and technique and preservation *(Eng)* S232
pastels (visual works)—The material side *(Eng)* S145
reattaching—Reattaching color layers on a wooden wall and documenting the distribution of damages *(Jpn)* S1024
varnish—Factors affecting the appearance of picture varnish *(Eng)* S721
verre eglomise—Proposal for the consolidation of the painted surface on reverse painted glass *(Eng)* S1003

Yoruba—Gelede: a Yoruba masquerade *(Eng)* S250

alder
icons—The technique of icon painting *(Eng)* S214
Nitinaht—Ethnobotany of the Nitinaht Indians of Vancouver Island *(Eng)* S356

Algeria (Tassili n'Ajjer)
frescoes—The Tassili frescoes *(Eng)* S188
rock paintings—The search for the Tassili frescoes: the story of the prehistoric rock paintings of the Sahara *(Eng)* S187

aliphatic hydrocarbons
encaustic wax—The cleaning and consolidation of Egyptian encaustic mummy portraits *(Eng)* S1088

alizarin madder
paint—Physicochemical alterations to the paint layer. 1. Results of a survey of various laboratories: apparent alterations of the paint layer and their probable causes. 2. Experimental study by the Musée du Louvre laboratory on madder varnish *(Fre)* S753

alkoxysilane
majolica—Experiments on the consolidation of glazes on majolica and glass tesserae from mosaics *(Ita)* S1106

alkyd resin
acrylic resin—Modern day artists colours *(Eng)* S437
illuminations—Practice and practical possibilities in the conservation of Medieval miniatures *(Ger)* S969
opacity—On the wet and dry opacity of paints *(Eng)* S722
pigment volume concentration—Pigment volume concentration and its effect on the corrosion resistance properties of organic paint films *(Eng)* S882
pyrolysis gas chromatography—Forensic applications of pyrolysis capillary gas chromatography *(Eng)* S609

alkymul
latex paint—The effect of extenders on the optical properties of air drying alkymul and styrene-butadiene latex paints *(Eng)* S728

Allongé, Auguste (1833-1898)
charcoal—Tonal drawing and the use of charcoal in nineteenth century France *(Eng)* S468

altarpieces
Herlin Cathedral (Germany)—The scientific examination of the polychromed sculpture in the Herlin altarpiece *(Eng)* S552
transferring—Transfer of paintings: at any price? *(Ger)* S916
wax—The preservation of wood sculpture: the wax immersion method *(Eng)* S890

alum
China—Chinese painting colors: studies of their preparation and application in traditional and modern times. *(Eng)* S427
dye—Aboriginal paints and dyes in Canada *(Eng)* S54

—Colors for textiles: ancient and modern *(Eng)* S109

panel paintings—Present state of screen and panel paintings in Kyoto *(Jpn)* S933

aluminum

extenders—Relative flatting efficiency of extenders and effect of these extenders on sheen uniformity, color uniformity, suction spotting, and enamel hold-out in solvent systems *(Eng)* S731

latex paint—The effect of extenders on the optical properties of air drying alkymul and styrene-butadiene latex paints *(Eng)* S728

paint—The comparisons of two-component extender systems in emulsion paint *(Eng)* S730

pigment volume concentration—Particle packing analysis of coatings above the critical pigment volume concentration *(Eng)* S818

aluminum oxide see **corundum**

Alyawara

Australian Aboriginal—An Alyawara day: flour, spinifex gum, and shifting perspectives *(Eng)* S361

—An Alyawara day: making men's knives and beyond *(Eng)* S385

Amazonian

resin—Resin classification by the Ka'apor Indians *(Eng)* S451

amber

balsam—The history of naval stores in coatings *(Eng)* S480

painting (technique)—Original treatises on the arts of painting *(Eng + Lat)* S234

pyrolysis gas chromatography—The use of pyrolysis gas chromatography (PyGC) in the identification of oils and resins found in art and archaeology *(Eng)* S644

American Colonial

Structural painting in early America *(Eng) manufacturing; paint* S489

house paint—House paints in Colonial America: their materials, manufacture and application. Part III *(Eng)* S230

—Problems in the restoration and preservation of old house paints *(Eng)* S947

American Society for Testing and Materials (USA)

The colourful twentieth century *(Eng) emulsion; manufacturing; paint; patents; pigment; standards* S434

Americas

ethnobotany—Bibliography of American archaeological plant remains (II) *(Eng)* S455

material culture—Ethnoart: Africa, Oceania, and the Americas: a bibliography of theses and dissertations *(Eng)* S411

amino acid

gas chromatography—Identification of proteinaceous binding media of easel paintings by gas chromatography of the amino acid derivatives after catalytic hydrolysis by a protonated carbon exchanger *(Eng)* S670

illuminations—The development of techniques of identification for pigments and bind-

ers used in the paint layer of manuscript illuminations *(Fre)* S546

mural paintings—On the technology of Central Asian wall paintings: the problem of binding media *(Eng)* S563

organic materials—A study of organic components of paints and grounds in Central Asian and Crimean wall paintings *(Eng)* S564

panel paintings—Basic experiments concerning deterioration of glue and discoloration of pigments, and discussion on the actual condition of wall panel paintings on the basis of their results *(Jpn)* S930

protein—The characterization of proteinaceous binders in art objects *(Eng)* S617

—Identification of protein containing binding media and adhesives in works of art by amino acid analysis *(Jpn)* S659

thin layer chromatography—Analysis of proteinaceous media by thin layer chromatography *(Rus)* S601

—A note on the thin-layer chromatography of media in paintings *(Eng)* S677

Tura, Cosimo (1430?-1495)—Amino acid analysis of proteinaceous media from Cosimo Tura's "The Annunciation with Saint Francis and Saint Louis of Toulouse." *(Eng)* S669

ammonia

mural paintings—Ajanta murals: their composition and technique and preservation *(Eng)* S232

screens (furniture)—Restoration of a Japanese screen *(Ger)* S949

textiles—Technical study and conservation of an old painted textile (Simhasana) *(Eng)* S902

ammonium carbonate

mural paintings—In review: an assessment of Florentine methods of wall painting conservation based on the use of mineral treatments *(Eng)* S1104

AMS see **accelerator mass spectrometry**

Anacardiaceae

A most useful plant family, the Anacardiaceae *(Eng) Asia; colorants; ethnobotany; gum; lacquer; mango; plants; poison oak* S71

Anang

The carver in Anang society *(Eng) carving; Nigeria; paint; palm oil; plants; wood* S276

Anasazi

Anasazi and Pueblo painting *(Eng) mural paintings; painting (technique); pigment; Pueblo; rock art* S487

—A simple method for distinguishing between organic and inorganic paints on black-on-white Anasazi pottery *(Eng) ceramics; hydrochloric acid; iron oxide; paint; potassium ferrocyanide* S568

wood—Wooden ritual artifacts from Chaco Canyon, New Mexico: the Chetro Ketl collection *(Eng)* S305

anatto

pigment—Ethnology of Futuna *(Eng)* S67

plants—On the history and migration of textile and tinctorial plants in reference to ethnology *(Eng)* S6

antelope
antelope
Native American—Indian rawhide: an American folk art *(Eng)* S280

anthropology
Systematic research collections in anthropology: an irreplaceable national resource. A report of a conference sponsored by the Council for Museum Anthropology *(Eng) ethnobotany; ethnographic conservation* S297
bark paintings—Narritjin in Canberra *(Eng)* S330
paint—Worldwide history of paint *(Eng)* S454

antimonite
house paint—Topical observations on the use of forgotten pigments used for painting rooms in Lower Saxony *(Ger)* S438

antimony
Romano-British—An analysis of paints used in Roman Britain *(Eng)* S210

Apache
Plants used by the White Mountain Apache Indians of Arizona *(Eng) alcohol; brewing; colorants; food; gourd; green pigment; Native American; plant materials; USA (Arizona)* S47
mining—The mining of gems and ornamental stones by American Indians *(Eng)* S93

apparel *see* **costume**

Appian, Adolphe (1818-1898)
charcoal—Tonal drawing and the use of charcoal in nineteenth century France *(Eng)* S468

aragonite
calcium carbonate—Calcium carbonate whites *(Eng)* S561

Araldite SV427
wood—The restoration of the wooden statue of Our Lady in the parish church of Cercina *(Ita)* S1078

archaeological conservation
adhesives—Some adhesives and consolidants used in conservation *(Eng)* S1031
excavations—Conservation of excavated intonaco, stucco, and mosaics *(Eng)* S1007
field archaeology—A conservation manual for the field archaeologist *(Eng)* S1044

archaeological sites
Asia, Southeast—The identification of insular Southeast Asian resins and other plant exudates for archaeological and ethnological application *(Eng)* S630
Bronze Age—Aegean painting in the Bronze Age *(Eng)* S466
ethnobotany—Bibliography of American archaeological plant remains *(Eng)* S228

archaeology
ethnobotany—Bibliography of American archaeological plant remains (II) *(Eng)* S455
mural paintings—Parallel progress in restoration and archaeology: discovery and restoration of monumental painting and sculpture on a loess ground *(Eng)* S520
primitive art—Primitive art: pre-Columbian, North American Indian, African, Oceanic *(Eng)* S307

archil
red pigment—Reds *(Ita)* S397

architectural elements
house paint—Microchemical analysis of old housepaints with a case study of Monticello *(Eng)* S661
Pueblo—The state of preservation of Pueblo Indian mural paintings in the American Southwest: findings of a condition study carried out in 1978-1979, and a proposed pilot project to test materials and methods for conservation *(Eng)* S977

architecture
The color of architectural surfaces *(Ita) color; paint* S365
—Painted surfaces in architecture: Amiens, October 1989 *(Fre) France; paint; polychromy* S450
adobe—Spectacular vernacular: the adobe tradition *(Eng)* S431
house paint—Historic finishes analysis *(Eng)* S441
plasterwork—The restoration of facade plasterwork in Italy *(Fre)* S472
pueblos (housing complexes)—A study of Pueblo architecture: Tusayan and Cibola *(Eng)* S9
Roman—Colorings and renderings in the ancient world *(Eng)* S395
Spain (Catalonia)—Architecture and decorated surfaces in Catalonia *(Fre)* S456

archival collections
decoration—Investigations and preliminary probes *(Fre)* S1089

Argentina (Cordoba)
rock paintings—On the nature of the colouring matter employed in primitive and rock-paintings *(Eng)* S38

arrowheads
gas chromatography mass spectrometry—GC/MS and chemometrics in archaeometry: investigation of glue on Copper-Age arrowheads *(Eng)* S665

arrowroot
bark cloth—Samoan material culture *(Eng)* S50

arsenic
Romano-British—An analysis of paints used in Roman Britain *(Eng)* S210

Art Institute of Chicago (Chicago, IL, USA)
Degas, Hilaire Germain Edgar (1834-1917)—Edgar Degas in the collection of the Art Institute of Chicago: examination of selected pastels *(Eng)* S1029

artificial ultramarine blue
A technical note on IKB (International Klein Blue) *(Eng) alcohol; ethyl acetate; ethyl alcohol; International Klein Blue; Klein, Yves (1928–1962); pigment; poly(vinyl acetate); ultramarine blue* S347
synthetic organic pigment—An early 20th-century pigment collection: the pigment collection in the Missiemuseum at Steyl-Tegelen *(Dut)* S435

342

dye—Rosewood, dragon's blood and lac *(Eng)* S181

manuscripts—Care and conservation of palm-leaf and paper illustrated manuscripts *(Eng)* S992

paint—Worldwide history of paint *(Eng)* S454

painting (technique)—Pigments and paints in primitive exotic techniques *(Fre)* S201

palm leaf—Problems of preservation of palm-leaf manuscripts *(Eng)* S331

plants—The ocean-going *noni*, or Indian mulberry (*Morinda citrifolia, Rubiaceae*) and some of its "colorful" relatives *(Eng)* S502

resin—Natural resins for the paint and varnish industry *(Eng)* S94

shadow puppets—The restoration of shadow puppets *(Ger)* S976

Asia, Central
adobe—Experiments on preservation of adobe structures and restoration of gypsum plaster paintings in Uzbekistan *(Eng)* S983

loess—The effect of the treatment with polybutyl methacrylate solutions on physical and mechanical properties of loess plaster *(Eng)* S954

mural paintings—Conservation of Central Asian wall painting fragments from the Stein Collection in the British Museum *(Eng)* S1099
—Conservation of mural paintings in Central Asia which have been damaged by salt efflorescence *(Eng)* S888
—On the technology of Central Asian wall paintings: the problem of binding media *(Eng)* S563
—Parallel progress in restoration and archaeology: discovery and restoration of monumental painting and sculpture on a loess ground *(Eng)* S520
—A study of organic components of ancient middle Asian and Crimean wall paintings *(Rus)* S289

organic materials—A study of organic components of paints and grounds in Central Asian and Crimean wall paintings *(Eng)* S564

polysaccharides—An investigation and identification of polysaccharides isolated from archaeological specimens *(Eng)* S570

textiles—Preservation of a textile and a miniature painting *(Eng)* S895

Asia, East
textiles—When textiles are paintings *(Eng)* S1060

Asia, Southeast
Conservation of manuscripts and paintings of Southeast Asia *(Eng) adhesives; bark; birch; gum; manuscripts; paintings (objects); palm leaf; paper; storage; tamarind seed; thankas* S1002
—The identification of insular Southeast Asian resins and other plant exudates for archaeological and ethnological application *(Eng) adhesives; archaeological sites; Fourier transform infrared spectroscopy; gum; infrared spectrometry; latex; Malaysia; plant materials; resin* S630

Asia, Western *see* **Near East**

Asmat
New Guinea—Wow-Ipits: eight Asmat wood-carvers of New Guinea *(Eng)* S231

asphaltum
bitumen—Prehistoric use of bitumen in Southern California *(Eng)* S256

house paint—House paints in Colonial America: their materials, manufacture and application. Part III *(Eng)* S230

Assyrian
fresco painting (technique)—Colors and painting in antiquity *(Fre)* S133

atacamite
Egypt—The entourage of an Egyptian governor *(Eng)* S244

mural paintings—Pigments and techniques of the early Medieval wall paintings of eastern Turkistan *(Ger)* S298

atomic absorption spectrometry
paint—Method to follow the degradation by natural weathering of emulsion paint films *(Ger)* S829

attapulgite
Maya blue—Examination and identification of Maya blue *(Fre)* S544
—Maya blue *(Spa)* S548
—Maya blue: a clay-organic pigment? *(Eng)* S543
—Maya blue: an updated record *(Eng)* S580
—Maya blue: further perspectives and the possible use of indigo as the colorant *(Eng)* S605

Mayan—The Maya mural paintings of Bonampak, materials analysis *(Fre)* S539

Auckland Museum (New Zealand)
Maori—Conservation considerations on four Maori carvings at Auckland Museum, New Zealand *(Eng)* S359
—Maori carvings in Auckland Museum, New Zealand. Ethical considerations in their restoration *(Eng)* S360

auripigment *see* **orpiment**

Australia
Australian Aboriginal—Ancient artists painted with human blood *(Eng)* S458

fatty acid—Fatty acid composition of 20 lesser-known Western Australian seed oils *(Eng)* S676

Oceania—Pigment consolidation on six Pacific artifacts: a CCI internship report *(Eng)* S984

paint—Worldwide history of paint *(Eng)* S454

Papua New Guinea—Ethnographic collections: case studies in the conservation of moisture-sensitive and fragile materials *(Eng)* S1062

plants—The ocean-going *noni*, or Indian mulberry (*Morinda citrifolia, Rubiaceae*) and some of its "colorful" relatives *(Eng)* S502

resin—Natural resins for the paint and varnish industry *(Eng)* S94

rock art—Rock art conservation in Australia *(Eng)* S422

rock paintings—Petroglyphs and pictographs on the British Columbia coast *(Eng)* S95

sand paintings—A calendar of dreamings *(Eng)* S295

wood—Conservation of polychrome wood sculpture at the Australian War Memorial *(Eng)* S944

Australia (New South Wales)
rock paintings—Two painted and engraved sandstone sites in Australia *(Eng)* S294

Australia (Queensland)
Australian Aboriginal—Ethnological studies among the northwest-central Queensland Aborigines *(Eng)* S19
—Food: its search, capture, and preparation *(Eng)* S20
rock art—Seeing red in Queensland *(Eng)* S433

Australia (Queensland— Laura)
Australian Aboriginal—Painting with plants: investigating fibres in Aboriginal rock paintings at Laura, north Queensland *(Eng)* S499

Australia (South Australia)
Australian Aboriginal—Walkabout *(Eng)* S108

Australia (Western Australia)
pigment—Two aboriginal rock pigments from Western Australia: their properties, use and durability *(Eng)* S290

Australia (Western Australia— Kimberley)
honey—Honey in the life of the Aboriginals of the Kimberleys *(Eng)* S306

Australia, central
Australian Aboriginal—An Alyawara day. making men's knives and beyond *(Eng)* S385

Australian Aboriginal
Aboriginal antiquities in Australia: their nature and preservation *(Eng)* S253
—Aboriginal art *(Eng)* artists' materials; carving; painting (technique) S446
—Adam in ochre: inside Aboriginal Australia *(Eng) bamboo juice; binding media; blood; ocher; rock art* S149
—An Alyawara day: flour, spinifex gum, and shifting perspectives *(Eng) adhesives; Alyawara; gum; spinifex* S361
—An Alyawara day: making men's knives and beyond *(Eng) Alyawara; Australia, central; knives; tools* S385
—Ancient artists painted with human blood *(Eng) Australia; blood; dating; painting (technique); rock paintings* S458
—Australian Aboriginal bark paintings: an ICOM report *(Eng) Bedacryl 122X; binding media; Calaton CB; charcoal; flattening; fumigation; insecticide; iron oxide; manganese; methyl bromide; Papua New Guinea; Paraloid B-72; pentachlorophenol* S918
—Bark paintings: techniques and conservation *(Eng) beeswax; charcoal; clay; egg; gum; gypsum; honey; manganese; ocher; painting (technique); pigment; poly(vinyl acetate)* S443
—Bush food: Aboriginal food and herbal medicine *(Eng) adhesives; food; medicine; paint; starch* S401
—Conservation of the Australian Museum's collection of Aboriginal bark paintings *(Eng) Australian Museum (Sydney, Australia); bark paintings; cleaning; color; epoxy; mounting; Munsell system* S959

—Dawn of art: painting and sculpture of Australian Aborigines *(Eng) bark paintings; charcoal black; clay; fixatives; magnesium oxide; ocher; pigment; sap; shells; water* S224
—Dreamings: the art of Aboriginal Australia *(Eng) bark paintings; symbolism* S408
—Ethnological studies among the northwest-central Queensland Aborigines *(Eng) Australia (Queensland); blood; feather; food; ocher; pigment; resin; white clay* S19
—Food: its search, capture, and preparation *(Eng) Australia (Queensland); clay; cooking; ethnobotany; food; pigment* S20
—An identification method for fat and/or oil binding media used on Australian Aboriginal objects *(Eng) binding media; fat; oil; organic materials; staining (analysis)* S680
—Methods and materials used in Australian Aboriginal art *(Eng) artists' materials; bark; binding media; brushes; painting (technique); pigment; poly(vinyl acetate); resin; sap* S380
—Painting with plants: investigating fibres in Aboriginal rock paintings at Laura, north Queensland *(Eng) Australia (Queensland— Laura); binding media; brushes; paint; plants; rock paintings* S499
—Pigment analysis for the authentication of the aboriginal paintings at Bunjils Cave, western Victoria *(Eng) authenticity; Bunjils Cave (Black Range, Victoria, Australia); electron microscopy; emission spectrometry; granite; infrared spectrometry; pigment; rock paintings; scanning electron microscopy; x-ray diffraction; x-ray fluorescence* S632
—The preservation and conservation of Aboriginal and Pacific cultural material in Australian Museums *(Eng) Australian Museum (Sydney, Australia); conservation; Oceania* S960
—Various approaches to the conservation and restoration of Aboriginal artifacts made from bark *(Eng) bark; paintings (objects); storage; wood* S974
—Walkabout *(Eng) Australia (South Australia); cave paintings* S108
—White clay and ochre *(Eng) cave paintings; clay; ocher* S237
bark paintings—Conservation of Aboriginal bark paintings and artifacts *(Eng)* S908
—Conservation of Australian Aboriginal bark paintings with a note on the restoration of a New Ireland wood carving *(Eng)* S905
—My country, Djarrakpi *(Eng)* S327
—Narritjin at Djarrakpi: Part 1 *(Eng)* S328
—Narritjin at Djarrakpi: Part 2 *(Eng)* S329
—Narritjin in Canberra *(Eng)* S330
honey—Honey in the life of the Aboriginals of the Kimberleys *(Eng)* S306
Pech Merle Cave (France)—Spitting images: replicating the spotted horses *(Eng)* S491
pigment—Two aboriginal rock pigments from Western Australia: their properties, use and durability *(Eng)* S290
rock art—Pictures of the dreaming: Aboriginal rock art of Australia *(Eng)* S390
—The recording of rock art: an illustrated paper presented to the Canadian Conservation Institute trainees and to the Course in the Conservation of Historic Monuments and Sites,

Australian Aboriginal

Restoration Services Division, Engineering and Architecture Branch, D.I.N.A. *(Eng)* S283
—Rock art conservation in Australia *(Eng)* S422
—Seeing red in Queensland *(Eng)* S433
rock paintings—Museum conservation of anthropological material *(Eng)* S913
—Two painted and engraved sandstone sites in Australia *(Eng)* S294
sand paintings—A calendar of dreamings *(Eng)* S295

Australian Museum (Sydney, Australia)
Australian Aboriginal—Conservation of the Australian Museum's collection of Aboriginal bark paintings *(Eng)* S959
—The preservation and conservation of Aboriginal and Pacific cultural material in Australian Museums *(Eng)* S960
Plextol B500—Evaluation of the stability, appearance and performance of resins for the adhesion of flaking paint on ethnographic objects *(Eng)* S1101

Austria
tapestries—The restoration of painted tapestry and its problems *(Ger)* S1112

Austria (Lambach)
frescoes—The conservation in situ of the Romanesque wall paintings of Lambach *(Eng)* S1098

Austria (Tyrol)
fresco painting (technique)—Tyrolean fresco: an attempt to reconstruct and modify the technique *(Pol)* S486

Austria (Upper Austria)
wood—The folk art tradition in painting on wood: paste and casein techniques *(Ger)* S314

Austria (Vienna)
mural paintings—Monumentales pastell—a forgotten invention in wall painting techniques about 1900 *(Eng)* S301

Austrian National Library
gouache—Conservation of costume designs for Broadway musicals, 1900-1925: from the drama collection, Austrian National Library, Vienna *(Ger)* S1067
microscopy—Microanalytical examination of works of art: two examples of the examination of paint layers *(Ger)* S612

authenticity
Australian Aboriginal—Pigment analysis for the authentication of the aboriginal paintings at Bunjils Cave, western Victoria *(Eng)* S632
Shroud of Turin—Microscopical study of the Turin "Shroud." *(Eng)* S637

Aztec
Pre-Hispanic Aztec colorists *(Eng) cochineal; colorants; pre-Columbian* S120
Náhuatl—A review of sources for the study of Náhuatl plant classification *(Eng)* S484

azurite
blue pigment—Blues *(Ita)* S394
—Identification of materials of paintings: I. Azurite and blue verditer *(Eng)* S541

ceramics—Technological notes on the pottery, pigments, and stuccoes from the excavations at Kaminaljuyu, Guatemala *(Eng)* S107
Herlin Cathedral (Germany)—The scientific examination of the polychromed sculpture in the Herlin altarpiece *(Eng)* S552
Horyuji Temple (Japan)—Coloring materals of the murals in the Main Hall of the Horyuji Temple compared with those of the ornamented tombs *(Jpn)* S271
house paint—House paints in Colonial America: their materials, manufacture and application. Part III *(Eng)* S230
Japan—Pigments used in Japanese paintings *(Eng)* S405
mural paintings—Chemical studies on ancient painting materials *(Jpn)* S150
—Chemical studies on ancient pigments in Japan *(Eng)* S138
—Chemical studies on the pigments of ancient ornamented tombs in Japan *(Jpn)* S151
—Chemical study on the coloring materials of the murals of the Taka-matsuzuka Tomb in Nara Prefecture *(Jpn)* S272
—Materials and painting techniques of the wall paintings of the main nave of S. Mary's Church in Toruń *(Pol)* S432
—Materials and techniques of medieval wall paintings from the former House of Merchants' Fraternity at 5 Żeglarska Street in Toruń *(Pol)* S485
—Pigments and techniques of the early Medieval wall paintings of eastern Turkistan *(Ger)* S298
—Pigments used in the paintings of "Hoodo." *(Jpn)* S183
Native American—What did they use for paint? *(Eng)* S236
Netherlandish—The beginnings of Netherlandish canvas painting, 1400-1530 *(Eng)* S445
paint—Physicochemical alterations to the paint layer. 1. Results of a survey of various laboratories: apparent alterations of the paint layer and their probable causes. 2. Experimental study by the Musée du Louvre laboratory on madder varnish *(Fre)* S753
panel paintings—Basic experiments concerning deterioration of glue and discoloration of pigments, and discussion on the actual condition of wall panel paintings on the basis of their results *(Jpn)* S930
pigment—The chemical studies on the pigments used in the Main Hall and pagoda of Hōryūji temple (Nara, Japan) *(Jpn)* S119
—Technical studies on the pigments used in ancient paintings of Japan *(Eng)* S167
Pueblo—Two summers' work in Pueblo ruins *(Eng)* S22
rock art—The ancients knew their paints *(Eng)* S249
Rudolphi, Johann Georg (1633-1693)—Johann Georg Rudolphi (1633-1693). Volume 1 *(Ger)* S584

backfilling
excavations—Conservation of excavated intonaco, stucco, and mosaics *(Eng)* S1007

bacteria
coatings—Water thinnable coatings, a symposium *(Eng)* S726

bacteria (Leptothrix ochracea)
Native American—Chinigchinich: a revised and annotated version of Alfred Robinson's translation of Father Geronimo Boscana's historical account of the belief, usages, customs and extravagancies of the Indians of this mission of San Juan Capistrano called the Acagchemem Tribe *(Eng)* S58

balsam
The history of naval stores in coatings *(Eng)* *amber; coatings; copal; manufacturing; paint; resin; rosin; turpentine* S480
gas chromatography—Gas chromatographic identification of a resinous deposit from a 6th century storage jar and its possible identification *(Eng)* S608
pine tar—Analysis of Finnish pine tar and tar from the wreck of frigate St. Nikolai *(Eng)* S650
pyrolysis gas chromatography—Analysis of natural resins by pyrolysis gas chromatography. II. Identification of natural resins by pyrograms *(Jpn)* S560

bamboo
pre-Columbian—Dating precolumbian museum objects *(Eng)* S1115

bamboo juice
Australian Aboriginal—Adam in ochre: inside Aboriginal Australia *(Eng)* S149

banana
canoes—The Hawaiian canoe *(Eng)* S334

banana yucca
ethnobotany—Ethnobotany of the Zuñi Indians *(Eng)* S27

Banks, Joseph (1743-1820)
plant materials—Sir Joseph's buried treasure *(Eng)* S476

banners
The conservation of the United Tin Plate Workers' Society Banner of 1821 *(Eng)* *cleaning; paint; poultice* S1074
paintings (objects)—Written sources about painted textiles *(Ger)* S504
textiles—The link between the treatments for paintings and the treatments for painted textiles *(Eng)* S363

Bantu
Bushman paint—A possible base for "Bushman" paint *(Eng)* S66

barium hydroxide
frescoes—19th and early 20th century restorations of English Mediaeval wall paintings: problems and solutions *(Eng)* S1116
mural paintings—In review: an assessment of Florentine methods of wall painting conservation based on the use of mineral treatments *(Eng)* S1104
—Products, facts, modes in mural painting: evolution and distribution of restoration products used in mural paintings from 1850 to

1992: a first sorting concerning France, Spain, England, and Poland *(Fre)* S511
—Wall paintings: technique, problems, conservation *(Ita)* S1080
stabilizers—Identification of stabilizing agents *(Eng)* S527

barium metaborate
pigment volume concentration—Pigment volume concentration and its effect on the corrosion resistance properties of organic paint films *(Eng)* S882

barium sulfate
The influence of variations of barium sulfate extender particle size on the hiding power of titanium dioxide paints *(Eng)* *distemper; linseed oil; paint; pigment; titanium dioxide* S706
frescoes—The consolidation of friable frescoes *(Eng)* S1015
latex paint—The effect of extenders on the optical properties of air drying alkymul and styrene-butadiene latex paints *(Eng)* S728
paint—The comparisons of two-component extender systems in emulsion paint *(Eng)* S730
pigment—Artists' pigments: a handbook of their history and characteristics *(Eng)* S623
—Some experiments and observations on the colours used in painting by the ancients *(Eng)* S1
pigment volume concentration—Pigment volume concentration and its effect on the corrosion resistance properties of organic paint films *(Eng)* S882
synthetic organic pigment—An early 20th-century pigment collection: the pigment collection in the Missiemuseum at Steyl-Tegelen *(Dut)* S435

barium yellow
India—Notes on the technique of Indian polychrome wooden sculpture *(Eng)* S246
—A study of Indian polychrome wooden sculpture *(Eng)* S255
pigment—Artists' pigments: a handbook of their history and characteristics *(Eng)* S623
yellow pigment—Yellows *(Ita)* S396

bark
Asia, Southeast—Conservation of manuscripts and paintings of Southeast Asia *(Eng)* S1002
Australian Aboriginal—Methods and materials used in Australian Aboriginal art *(Eng)* S380
—Various approaches to the conservation and restoration of Aboriginal artifacts made from bark *(Eng)* S974
canoes—The Hawaiian canoe *(Eng)* S334
ceramics—Two Kongo potters *(Eng)* S291
consolidation—A consolidation treatment for powdery matte paint *(Eng)* S979
dye—Aboriginal paints and dyes in Canada *(Eng)* S54
—The Kongo IV *(Eng)* S242
manuscripts—Birch-bark (bhurjapatra) and clay-coated manuscripts in the Gilgit Collection: their repair and preservation *(Eng)* S896
Mesoamerican—Ancient Mesoamerican mortars, plasters, and stuccos. The use of bark extracts in lime plasters *(Eng)* S197

Nitinaht—Ethnobotany of the Nitinaht Indians of Vancouver Island *(Eng)* S356
ocher—Friable ochre surfaces: further research into the problems of colour changes associated with synthetic resin consolidation *(Eng)* S997
Seri blue—Seri blue *(Eng)* S217
Sundi—The Kongo I *(Eng)* S162
wood—Identification of archaeological and recent wood tar pitches using gas chromatography/mass spectrometry and pattern recognition *(Eng)* S655

bark cloth *see also* **tapa**
The analysis and identification of oils in Hawaiian oiled tapa *(Eng) chromatography; drying oil; gas chromatography mass spectrometry; Hawaiian; kukui nut oil; oil; tapa* S629
—Ka hana kapa: the making of bark-cloth in Hawaii *(Eng) colorants; dye; Oceania; USA (Hawaii)* S31
—Patterns of paradise: the styles and significance of bark cloth around the world *(Eng) colorants; South America; USA (Hawaii)* S319
—Samoan material culture *(Eng) adhesives; arrowroot; breadfruit; brushes; dyeing; fausonga; painting (technique); Samoa; turmeric* S50
—Tapa in Polynesia *(Eng) adhesives; colorants; dye; plant materials; Polynesian; tapa* S267
—The technical aspects of ornamented barkcloth *(Eng) betel; carmine; coloring; green paint; Indonesia; Kalamaya (Homolomena alba); kudu tree (Morinda citrifolia); lime; paint; Peristrophe tinctoria; purple paint; root; water; wood* S209
Cook, James (1728-1779)—The journals of Captain James Cook on his voyages of discovery *(Eng)* S414
dye—Ethnology of Uvea (Wallis Island) *(Eng)* S74
tapa—Ancient Hawaiian tapa dyes for coloring paper *(Eng)* S335
—Hawaiian life of the pre-European period *(Eng)* S89
Tlingit—The conservation of a Tlingit blanket *(Eng)* S909
USA (Hawaii)—Hawaiian antiquities (Moolelo Hawaii) *(Eng)* S144

bark juice
pigment—Studies on the ancient pigments in Japan *(Eng)* S52

bark paintings
Conservation of Aboriginal bark paintings and artifacts *(Eng) Australian Aboriginal; fixing; flattening; retouching* S908
—Conservation of Australian Aboriginal bark paintings with a note on the restoration of a New Ireland wood carving *(Eng) Australian Aboriginal; beeswax; carvings; egg yolk; fixing; flattening; gloss; heat; honey; kaolin; Papua New Guinea (New Ireland); pentachlorophenol; poly(vinyl acetate); termite; toluene; vacuum tables; wax; wood; xylene* S905
—My country, Djarrakpi *(Eng) Australian Aboriginal; bark paintings; Maymuru, Narritjin (d. 1981); painting (technique)* S327

—Narritjin at Djarrakpi: Part 1 *(Eng) Australian Aboriginal; bark paintings; Maymuru, Narritjin (d. 1981); painting (technique)* S328
—Narritjin at Djarrakpi: Part 2 *(Eng) Australian Aboriginal; bark paintings; Maymuru, Narritjin (d. 1981); painting (technique)* S329
—Narritjin in Canberra *(Eng) anthropology; Australian Aboriginal; bark paintings; Maymuru, Narritjin (d. 1981); painting (technique)* S330
Australian Aboriginal—Australian Aboriginal bark paintings: an ICOM report *(Eng)* S918
—Bark paintings: techniques and conservation *(Eng)* S443
—Conservation of the Australian Museum's collection of Aboriginal bark paintings *(Eng)* S959
—Dawn of art: painting and sculpture of Australian Aborigines *(Eng)* S224
—Dreamings: the art of Aboriginal Australia *(Eng)* S408
ocher—Friable ochre surfaces: further research into the problems of colour changes associated with synthetic resin consolidation *(Eng)* S997
rock paintings—Museum conservation of anthropological material *(Eng)* S913

Baroque
Rudolphi, Johann Georg (1633-1693)—Johann Georg Rudolphi (1633-1693). Volume 1 *(Ger)* S584
tapestries—The restoration of painted tapestry and its problems *(Ger)* S1112

barrels
pine tar—Analysis of Finnish pine tar and tar from the wreck of frigate St. Nikolai *(Eng)* S650

basalt
ceramics—Technological notes on the pottery, pigments, and stuccoes from the excavations at Kaminaljuyu, Guatemala *(Eng)* S107

Baumeister, Willi (1889-1955)
Studies of the painting techniques of Willi Baumeister *(Ger) Abstract art; artists' materials; canvas; cardboard; frame construction; Germany; modern art; oil; oil paint; paint; sand* S496

Bedacryl 122X
Australian Aboriginal—Australian Aboriginal bark paintings: an ICOM report *(Eng)* S918
human head—The conservation of a preserved human head *(Eng)* S935

bee plant (Cleome serrulata)
black pigment—Ceramic pigments of the Indians of the Southwest *(Eng)* S40

beech
panel paintings—Wings from a quadriptych with the legend of St. John the Baptist: general problems and conservation treatment *(Pol)* S917

beer
house paint—Every man his own housepainter and colourman: the whole forming a complete system for the amelioration of the noxious quality of common paint: a number of invaluable inventions, discoveries and im-

provements...and a variety of other particulars that relate to house painting in general (*Eng*) S2

polysaccharides—Polysaccharides as part of a color layer and methods for their identification (*Cze*) S647

beeswax
adhesives—Adhesives for impregnation of painting on canvas (*Swe*) S1087
Australian Aboriginal—Bark paintings: techniques and conservation (*Eng*) S443
bark paintings—Conservation of Australian Aboriginal bark paintings with a note on the restoration of a New Ireland wood carving (*Eng*) S905
binding media—Artificial samples of paint binders. Oils, resins, waxes, glues, egg, prepared in binary mixtures: analytical characteristics and properties (*Ita*) S631
coatings—Development and growth of resins for the coating industry (*Eng*) S340
Egypt—Ancient Egyptian materials and industries (*Eng*) S63
honey—Honey in the life of the Aboriginals of the Kimberleys (*Eng*) S306
illuminations—Practice and practical possibilities in the conservation of Medieval miniatures (*Ger*) S969
—Some tests on the use of wax for fixing flaking paint on illuminated parchment (*Eng*) S898
mural paintings—A study of organic components of ancient middle Asian and Crimean wall paintings (*Rus*) S289
organic materials—A study of organic components of paints and grounds in Central Asian and Crimean wall paintings (*Eng*) S564
panel paintings—Wings from a quadriptych with the legend of St. John the Baptist: general problems and the treatment of conservation (*Pol*) S917
pigment—Analysis of the material and technique of ancient mural paintings (*Eng*) S220
Sudan (Mirgissa)—Physico-chemistry at the service of archaeology: examination of a series of samples from excavations done in Sudan (*Fre*) S545
verre eglomise—Eglomise: technique and conservation (*Ger*) S1059
wax—The preservation of wood sculpture: the wax immersion method (*Eng*) S890

Belgium (Bruges)
mural paintings—Structure, composition, and technique of the paintings (*Dut*) S346

Belgium (Brussels)
polychromy—Disinfestation and consolidation of polychromed wood at the Institut Royal du Patrimoine Artistique, Brussels (*Eng*) S957
tempera—Examination and treatment of a tempera on canvas from the 16th century: the *Emmaus Pilgrims* from the Fine Arts Museum of Brussels (*Fre*) S981

Belgium (Ghent)
mural paintings—Microchemical analysis of the wall paintings of St. Baafsabtei in Ghent (about 1175) (*Dut*) S90

Belgium (Watervliet)
triptychs—Material description, state of conservation, and treatment (*Dut*) S906

Bella Coola
Materia medica of the Bella Coola and neighbouring tribes of British Columbia (*Eng*) Canada (*British Columbia*); Douglas fir; fir; gum; oil; shark oil; water; wax S48

benzyl cellulose
illuminations—Practice and practical possibilities in the conservation of Medieval miniatures (*Ger*) S969

Berry ocher
ocher—French ocher from Berry (*Fre*) S124

beta counting
pre-Columbian—Dating precolumbian museum objects (*Eng*) S1115

betel
bark cloth—The technical aspects of ornamented bark-cloth (*Eng*) S209

Beva
consolidation—Consolidation of delaminating paintings (*Eng*) S951

Beva 371
adhesives—Adhesives for impregnation of painting on canvas (*Swe*) S1087
—The evaluation of some adhesive systems utilized in the consolidation of paintings. The kinetics of consolidation (III) (*Rum*) S1021
ocher—Friable ochre surfaces: further research into the problems of colour changes associated with synthetic resin consolidation (*Eng*) S997

bibliographies
An interdisciplinary bibliographic approach to a complex conservation problem: the consolidation of matte paint (*Eng*) conservation; consolidation; databases S1121
Africa—Bibliography and the arts of Africa (*Eng*) S195
—A bibliography of African art (*Eng*) S223
databases—Introduction to TINCL: a database system for art technological sources (*Eng*) S672
ethnobotany—Bibliography of American archaeological plant remains (*Eng*) S228
—Bibliography of American archaeological plant remains (II) (*Eng*) S455
illuminations—Practice and practical possibilities in the conservation of Medieval miniatures (*Ger*) S969
India—One hundred references to Indian painting (*Eng*) S49
material culture—Ethnoart: Africa, Oceania, and the Americas: a bibliography of theses and dissertations (*Eng*) S411
mural paintings—Wall paintings: technique, problems, conservation (*Ita*) S1080
New Guinea—Pilot study: survey of the literature relating to the material culture of the New Guinea Highlands (*Eng*) S308
pastels (crayons)—The manufacture of pastels (*Fre*) S103
—Pastel, a technique of yesterday and today (*Eng*) S364
pastels (visual works)—Analysis and conservation of graphic and sound documents: work

by the Centre de Recherches sur la Conservation des Documents Graphiques, 1982-1983 *(Fre)* S1004
—Pastels *(Fre)* S369
pigment—Bibliography on the pigments of painting *(Ger)* S642
verre eglomise—The deterioration and conservation of painted glass: a critical bibliography *(Eng)* S994

binding media
Analyses of paint media *(Eng) fatty acid; gas chromatography; linseed oil; National Gallery (London, England); paintings (objects); walnut oil* S587
—Analysis of binding media and adhesives in Buddhist wooden statues *(Jpn) adhesives; animal glue; Buddhist; chromatography; fish glue; gel electrophoresis; high performance liquid chromatography; organic materials; protein; sculpture; wood* S674
—Artificial samples of paint binders. Oils, resins, waxes, glues, egg, prepared in binary mixtures: analytical characteristics and properties *(Ita) animal glue; beeswax; casein; egg yolk; flour paste; gum arabic; linseed oil; mastic; organic materials; paint; resin; shellac* S631
—Binding media and pigments in the literature of antiquity *(Ger) history of technology; paint; pigment; vehicle (material)* S257
—Binding media identification in painted ethnographic objects *(Eng) adhesives; animal glue; blood; casein; egg; ethnographic conservation; gum; organic materials; paint; sugar; vegetable oil* S675
—Contributions to the analysis of binders, adhesives and ancient varnishes *(Fre) adhesives; aging; gas chromatography; infrared absorption; oil; polysaccharides; protein; resin; solubility; spectrometry; tar; thin layer chromatography; varnish; wax* S547
—Directory of natural organic binding media *(Ger) microchemistry; organic materials; paintings (objects)* S643
—The identification of paint media: an introduction *(Eng) paint* S574
—The importance of binders *(Fre) casein; emulsion; gelatin; gluten; gum; megilp; rubber; silicate; water* S225
—Methods used for the identification of binding media in Italian paintings of the 15th and 16th centuries *(Eng) chromatography; copper resinate; egg tempera; egg yolk; green pigment; Italy; malachite (pigment); microscopy; tempera; thin layer chromatography; underpainting* S554
—Perspectives on the chemistry of old paint binders *(Fre) gas chromatography; infrared spectrometry; paint; resin; sandarac; spectrometry; terpene* S535
—The problem of conservation of very large canvases painted in glue medium *(Pol) adhesives; canvas; ceilings; cleaning; frame construction; gluten; Poland (Stegna); polychromy; retouching* S968
—The problem of the binding medium particularly in wall painting *(Eng) animal glue; drying oil; egg white; egg yolk; milk; mural paintings* S534

acrylic resin—The identification and characterization of acrylic emulsion paint media *(Eng)* S666
adhesives—Ancient binding media, varnishes and adhesives *(Eng)* S377
artists' materials—The artist's handbook *(Eng)* S407
—The artist's handbook of materials and techniques *(Eng)* S83
—The painter's craft *(Fre)* S462
Australian Aboriginal—Adam in ochre: inside Aboriginal Australia *(Eng)* S149
—Australian Aboriginal bark paintings: an ICOM report *(Eng)* S918
—An identification method for fat and/or oil binding media used on Australian Aboriginal objects *(Eng)* S680
—Methods and materials used in Australian Aboriginal art *(Eng)* S380
—Painting with plants: investigating fibres in Aboriginal rock paintings at Laura, north Queensland *(Eng)* S499
Bronze Age—Aegean painting in the Bronze Age *(Eng)* S466
China—Chinese painting colors: studies of their preparation and application in traditional and modern times *(Eng)* S427
coatings—Mechanical properties of clay coating films containing styrene-butadiene copolymers *(Eng)* S834
—Paint and surface coatings: theory and practice *(Eng)* S849
—Pigment-polymer interaction and technological properties of pigmented coatings and plastics *(Eng)* S800
—Review of literature relating the effect of binder on coating gloss *(Eng)* S767
Czechoslovakia (Prague)—Technical parallels between panel and wall painting of the 14th century *(Cze)* S353
de Kooning, Willem (b. 1904)—De Kooning: "I see the canvas and I begin." *(Eng)* S304
differential scanning calorimetry—Investigation of paint media by differential scanning calorimetry (DSC) *(Eng)* S667
—Preliminary investigations of the binding media of paintings by differential thermal analysis *(Eng)* S634
Egypt—What do we know about the paints of the old Egyptians? *(Eng)* S137
Egypt (Saqqara)—Identification of medium used in polychrome reliefs in ancient Egyptian limestone tomb dating from the nineteenth dynasty /1350-1200 B.C./ at Saqqara *(Eng)* S649
encaustic painting—The technology, examination and conservation of the Fayum portraits in the Petrie Museum *(Eng)* S965
fatty acid—The gas chromatographic examination of paint media. Part I. Fatty acid composition and identification of dried oil films *(Eng)* S542
fluorescence microscopy—Ultraviolet fluorescence microscopy of paint cross sections: cycloheptaamylose-dansyl chloride complex as a protein-selective stain *(Eng)* S671
Fourier transform infrared spectroscopy—Analysis of aged paint binders by FTIR spectroscopy *(Eng)* S657

—Micro spectroscopy FTIR reflectance examination of paint binders on ground chalk (Eng) S681
frescoes—Artistic frescoes (Eng) S100
gas chromatography—Analyses of paint media (Eng) S578
—The application of gas chromatography in the investigation of works of art (Eng) S538
—Contribution to the study of aged proteinaceous media (Eng) S572
—The gas chromatographic examination of paint media. Some examples of medium identification in paintings by fatty acid analysis (Eng) S573
—The gas-chromatographic examination of paint media. Part II. Some examples of medium identification in paintings by fatty acid analysis (Eng) S558
—Identification of proteinaceous binding media of easel paintings by gas chromatography of the amino acid derivatives after catalytic hydrolysis by a protonated carbon exchanger (Eng) S670
—Organic analysis in the arts: some further paint medium analyses (Eng) S581
—Organic analysis in the examination of museum objects (Eng) S621
gas chromatography mass spectrometry—Rapid identification of binding media in paintings using simultaneous pyrolysis methylation gas chromatography (Eng) S668
Herlin Cathedral (Germany)—The scientific examination of the polychromed sculpture in the Herlin altarpiece (Eng) S552
illumination (decoration)—The technique of old writings and miniatures (Eng) S293
illuminations—The development of techniques of identification for pigments and binders used in the paint layer of manuscript illuminations (Fre) S546
Kachina masks—Zuni Katcinas (Eng) S53
lacquer—Lists of raw materials for lacquer (Ger) S402
latex paint—History of water-thinned paints (Eng) S163
—Scanning laser acoustic microscopy of latex paint films (Eng) S837
mass spectrometry—Application of mass spectrometric techniques to the differentiation of paint media (Eng) S576
—Organic mass spectrometry of art materials: work in progress (Eng) S607
mechanical properties—Influence of pigmentation on the mechanical properties of paint films (Eng) S779
Medieval—The materials and techniques of Medieval painting (Eng) S172
microscopy—Microanalytical examination of works of art: two examples of the examination of paint layers (Ger) S612
—The use of direct reactive fluorescent dyes for the characterization of binding media in cross sectional examinations (Eng) S635
miniatures (paintings)—Conservation of miniatures (Eng) S270
Montagnais—A Naskapi painted skin shirt (Eng) S247

mural paintings—Ajanta murals: their composition and technique and preservation (Eng) S232
—The earliest known paints (Eng) S153
—Materials and techniques of Medieval wall paintings from the former House of Merchants' Fraternity at 5 Żeglarska Street in Toruń (Pol) S485
—Microchemical analysis of the wall paintings of St. Baafsabtei in Ghent (about 1175) (Dut) S90
—On the technology of Central Asian wall paintings: the problem of binding media (Eng) S563
—The Pallava paintings at Conjeevaram: an investigation into the methods (Eng) S85
—The structure of the 17th-century mural paintings in the S. George Orthodox church at Veliko Turnovo (Bulgaria) (Pol) S264
—The technique of the paintings at Sitabhinji (Eng) S143
—The wall paintings in the Bagh caves: an investigation into their methods (Eng) S87
Nagoya Castle (Nagoya, Japan)—Study on the repair technique of polychrome paintings drawn on sliding screens in the Nagoya Castle (Jpn) S945
Native American—American Indian painting of the Southwest and Plains areas (Eng) S239
—Analysis of paints used by Canadian native cultures: a project at the Canadian Conservation Institute (Eng) S640
—CCI Native Materials Project: final report (Eng) S473
—Handbook of American Indians north of Mexico (Eng) S25
—Indian rawhide: an American folk art (Eng) S280
—What did they use for paint? (Eng) S236
organic chemistry—The organic chemistry of museum objects (Eng) S633
organic materials—Some problems in analysis of aged organic materials in art works and artefacts (Eng) S595
paint—Physicochemical alterations to the paint layer. 1. Results of a survey of various laboratories: apparent alterations of the paint layer and their probable causes. 2. Experimental study by the Musée du Louvre laboratory on madder varnish (Fre) S753
—Materials toward a history of housepaints: the materials and craft of the housepainter in 18th century America (Eng) S221
painting (technique)—Physics and painting: introduction to the study of physical phenomena applied to painting and painting techniques (Dut) S707
paintings (objects)—Analysis of paint media, varnishes and adhesives (Eng) S625
palm—The palm, tree of life: biology, utilization, and conservation. Proceedings of a symposium at the 1986 annual meeting of the Society for Economic Botany held at the New York Botanical Garden, Bronx, New York, 13-14 June 1986 (Eng) S424
paper chromatography—The analysis of paint media by paper chromatography (Eng) S530

pictographs—On the pictographs of the North American Indians *(Eng)* S8

pigment—Pigments and paints in classical antiquity *(Fre)* S200

pigment volume concentration—Critical pigment volume concentration of emulsion based paints *(Eng)* S757

—Critical pigment volume relationships *(Eng)* S710

—Density method for determining the CPVC of flat latex paints *(Eng)* S822

polysaccharides—The detection of polysaccharides in the constituent materials of works of art *(Fre)* S537

prehistoric—Pigments and paints in prehistoric antiquity *(Fre)* S191

protein—The characterization of proteinaceous binders in art objects *(Eng)* S617

—Identification of protein containing binding media and adhesives in works of art by amino acid analysis *(Jpn)* S659

—Notes on the identification of proteins in paint binders *(Fre)* S567

—Some observations on methods for identifying proteins in paint media *(Eng)* S533

pyrolysis—An improved pyrolytic technique for the quantitative characterization of the media of works of art *(Eng)* S575

pyrolysis gas chromatography—Application of pyrolysis gas chromatography on some of Van Meegeren's faked Vermeers and Pieter de Hooghs *(Eng)* S565

—Examination through pyrolysis gas chromatography of binders used in painting *(Eng)* S626

—Identification of synthetic materials in modern paintings. 1: varnishes and polymer binders *(Fre)* S660

red pigment—Report on the collecting visit to the Wosera-Abelam of Sarakim village, and a note on conservation requirements *(Eng)* S318

rock art—The ancients knew their paints *(Eng)* S249

—The prehistoric artist of Southern Matabeleland; his materials and technique as a basis for dating *(Eng)* S175

—The recording of rock art: an illustrated paper presented to the Canadian Conservation Institute trainees and to the Course in the Conservation of Historic Monuments and Sites, Restoration Services Division, Engineering and Architecture Branch, D.I.N.A. *(Eng)* S283

—Rock art conservation in Australia *(Eng)* S422

rock paintings—Paints of the Khoisan rock artists *(Eng)* S355

—Petroglyphs and pictographs on the British Columbia coast *(Eng)* S95

—Technique of the painting process in the rock-cut temples at Badami *(Eng)* S86

Scandinavia—Scandinavian painted decor *(Eng)* S467

Seri—People of the desert and sea: ethnobotany of the Seri Indians *(Eng)* S376

Shroud of Turin—Light microscopical study of the Turin Shroud. II *(Eng)* S593

tempera—Tempera adhesives in the history of art *(Ger)* S97

thin layer chromatography—High performance thin-layer chromatography for the identification of binding media: techniques and applications *(Eng)* S682

—Methods in scientific examination of works of art. Volume 1: thin-layer chromatography course book *(Eng)* S684

—Methods in scientific examination of works of art. Volume 3: thin-layer chromatography reference materials binder *(Eng)* S683

—The methods of identifying organic binders in paint layers *(Slo)* S599

Tura, Cosimo (1430?-1495)—Amino acid analysis of proteinaceous media from Cosimo Tura's "The Annunciation with Saint Francis and Saint Louis of Toulouse." *(Eng)* S669

vinyl acetate—Very high binding vinyl acetate based dispersions *(Eng)* S869

Vuillard, Edouard (1868-1940)—The special problems and treatment of a painting executed in hot glue medium, "The Public Garden by Edouard Vuillard" *(Eng)* S999

Wayang—Restoration of Indonesian Wayang-figures in the National Ethnographical Museum of Dresden *(Ger)* S1049

biodeterioration

consolidants—Degradation of synthetic consolidants used in mural painting restoration by microorganisms *(Eng)* S1122

mural paintings—Wall paintings: technique, problems, conservation *(Ita)* S1080

Thailand—Conservation of wall paintings in Thailand *(Eng)* S927

biotite

mural paintings—The technique of the paintings at Sitabhinji *(Eng)* S143

birch

Asia, Southeast—Conservation of manuscripts and paintings of Southeast Asia *(Eng)* S1002

gas chromatography mass spectrometry—GC/MS and chemometrics in archaeometry: investigation of glue on Copper-Age arrowheads *(Eng)* S665

icons—The technique of icon painting *(Eng)* S214

manuscripts—Birch-bark (bhurjapatra) and clay-coated manuscripts in the Gilgit Collection: their repair and preservation *(Eng)* S896

wood—Identification of archaeological and recent wood tar pitches using gas chromatography/mass spectrometry and pattern recognition *(Eng)* S655

bistre

drawing (technique)—The craft of old-master drawings *(Eng)* S182

bitumen

Aboriginal use of bitumen by the California Indians *(Eng) Chumash; tar; USA (California)* S101

—Prehistoric use of bitumen in Southern California *(Eng) asphaltum; Chumash; Native American; steatite; tar* S256

dye—Keresan Indian color terms *(Eng)* S102

Luiseño—The culture of the Luiseño Indians *(Eng)* S26

Mexico—Colors and paint at the time of the pre-Cortés Mexican civilizations *(Fre)* S169

bituminous material
organic chemistry—The organic chemistry of museum objects *(Eng)* S633

black ink
illumination (decoration)—The technique of old writings and miniatures *(Eng)* S293
—Writing technique and illumination of ancient Serbian manuscripts *(Fre)* S338

black manganite
prehistoric—Pigments and paints in prehistoric antiquity *(Fre)* S191

black pigment
Ceramic pigments of the Indians of the Southwest *(Eng)* *bee plant (Cleome serrulata); ceramics; glaze; Native American; ocher; pitch (tar); red ocher; USA (Southwest)* S40
—Classification of black pottery pigments and paint areas *(Eng)* *carbon black; ceramics; classifying; iron oxide; manganese; paint; pigment; soot; USA (Southwest)* S524
—Prehistoric pottery pigments in the Southwest *(Eng)* *ceramics; colorants; Native American; pigment; plant materials; USA (Southwest)* S46
ceramics—Technological notes on the pottery, pigments, and stuccoes from the excavations at Kaminaljuyu, Guatemala *(Eng)* S107
Chippewa—Some Chippewa uses of plants *(Eng)* S60
dye—Ethnology of Uvea (Wallis Island) *(Eng)* S74
frescoes—Fresco paintings of Ajanta *(Eng)* S126
Kachina masks—Zuni Katcinas *(Eng)* S53
mining—The mining of gems and ornamental stones by American Indians *(Eng)* S93
Mojave—Mohave tatooing and face-painting *(Eng)* S116
mural paintings—Microchemical analysis of the wall paintings of St. Baafsabtei in Ghent (about 1175) *(Dut)* S90
—The Pallava paintings at Conjeevaram: an investigation into the methods *(Eng)* S85
pictographs—On the pictographs of the North American Indians *(Eng)* S8
pigment—Oracle-bone color pigments *(Eng)* S73
prehistoric—Pigments and paints in prehistoric antiquity *(Fre)* S191

blackening
Akan—The theory and practice of conservation among the Akans of Ghana *(Eng)* S516

Blackfoot
The Blackfoot tipi *(Eng)* *hide; Native American; pigment; tepees* S68
—Material culture of the Blackfoot Indians *(Eng)* *fat; leather; Native American; pigment; quillwork; rawhide; tanning* S30
—Painted tipis and picture-writing of the Blackfoot Indians *(Eng)* *bone marrow; buffalo; charcoal black; fat; gallstones; Native American; pigment; tepees; water; yellow pigment* S69

blanching
house paint—Problems in the restoration and preservation of old house paints *(Eng)* S947

blankets
Tlingit—The conservation of a Tlingit blanket *(Eng)* S909

bleaching
illuminations—The conservation of a Petrarch manuscript *(Eng)* S910
paint—Physicochemical alterations to the paint layer. 1. Results of a survey of various laboratories: apparent alterations of the paint layer and their probable causes. 2. Experimental study by the Musée du Louvre laboratory on madder *(Fre)* S753
textiles—Technical study and conservation of an old painted textile (Simhasana) *(Eng)* S902
verre eglomise—Eglomise: technique and conservation *(Ger)* S1059
wood—Wood documentation. VII: wood conservation and surface treatment. Volume 2: surface treatment *(Fre)* S897

blistering
panel paintings—Wings from a quadriptych with the legend of St. John the Baptist: general problems and the treatment of conservation *(Pol)* S917
wood—Wood documentation. VII: wood conservation and surface treatment. Volume 2: surface treatment *(Fre)* S897

blood
Australian Aboriginal—Adam in ochre: inside Aboriginal Australia *(Eng)* S149
—Ancient artists painted with human blood *(Eng)* S458
—Ethnological studies among the northwest-central Queensland Aborigines *(Eng)* S19
binding media—Binding media identification in painted ethnographic objects *(Eng)* S675
coatings—Development and growth of resins for the coating industry *(Eng)* S340
Egyptian—Notes on Egyptian colours *(Eng)* S16
microscopy—Microscopical study of the Turin "Shroud," IV *(Eng)* S627
mural paintings—The earliest known paints *(Eng)* S153
—Materials and techniques of Medieval wall paintings from the former House of Merchants' Fraternity at 5 Żeglarska Street in Toruń *(Pol)* S485
Native American—What did they use for paint? *(Eng)* S236
paint—Materials toward a history of house-paints: the materials and craft of the house-painter in 18th century America *(Eng)* S221
pictographs—On the pictographs of the North American Indians *(Eng)* S8
pigment—Domestic implements, arts, and manufactures *(Eng)* S23
—Oracle-bone color pigments *(Eng)* S73
ritual objects—Eshu-Elegba: the Yoruba trickster god *(Eng)* S292
rock art—The ancients knew their paints *(Eng)* S249
—The recording of rock art: an illustrated paper presented to the Canadian Conservation

353

Institute trainees and to the Course in the Conservation of Historic Monuments and Sites, Restoration Services Division, Engineering and Architecture Branch, D.I.N.A. *(Eng)* S283
rock paintings—Perspectives and potentials for absolute dating prehistoric rock paintings *(Eng)* S523
Rwanda—Colors and drawings in Rwanda *(Fre)* S158
Shroud of Turin—Light microscopical study of the Turin Shroud. I *(Eng)* S592
—Microscopical study of the Turin Shroud. III *(Eng)* S598
tools—Potential applications of the organic residues on ancient tools *(Eng)* S624

bloodroot
Chippewa—Plants used by the Chippewa *(Eng)* S91
—Some Chippewa uses of plants *(Eng)* S60

blue dye
blue pigment—Blues *(Ita)* S394
Yoruba—Yoruba pattern dyeing *(Eng)* S80

blue frit
pigment—Ancient Greek pigments from the Agora *(Eng)* S104

blue ink
ink—The inks of ancient and modern Egypt *(Eng)* S35

blue paint
Pueblo—Two summers' work in Pueblo ruins *(Eng)* S22

blue pigment
Blues *(Ita) azurite; blue dye; blue verditer; cerulean blue; cobalt blue; dye; Egyptian blue; litmus; logwood; Maya blue; pigment; Prussian blue; smalt; woad* S394
—Blues for the chemist *(Eng) France (Auxerre); indigo; lapis lazuli; manuscripts; pigment; Raman spectroscopy* S465
—Identification of materials of paintings: I. Azurite and blue verditer *(Eng) azurite; blue verditer; copper carbonate; emission spectrometry; pigment; spectrometry; spot tests* S541
frescoes—Fresco paintings of Ajanta *(Eng)* S126
Maori—Maori art *(Eng)* S18
Maya blue—Maya blue: a new perspective *(Eng)* S590
—Maya blue: further perspectives and the possible use of indigo as the colorant *(Eng)* S605
—Maya blue: how the Mayas could have made the pigment *(Eng)* S645
mural paintings—Pigments used in the paintings of "Hoodo." *(Jpn)* S183
—The wall paintings in the Bagh caves: an investigation into their methods *(Eng)* S87
Romano-British—An analysis of paints used in Roman Britain *(Eng)* S210
Rudolphi, Johann Georg (1633-1693)—Johann Georg Rudolphi (1633-1693). Volume 1 *(Ger)* S584
Seri blue—Seri blue—an explanation *(Eng)* S218
USA (New Mexico— Isleta)—Isleta, New Mexico *(Eng)* S55

blue verditer
blue pigment—Blues *(Ita)* S394
—Identification of materials of paintings: I. Azurite and blue verditer *(Eng)* S541
house paint—House paints in Colonial America: their materials, manufacture and application. Part III *(Eng)* S230

blue green pigment
dye—Keresan Indian color terms *(Eng)* S102

Blum, Robert Frederick (1857-1903)
pastels (crayons)—American pastels of the late nineteenth & early twentieth centuries: materials and techniques *(Eng)* S442

body painting
Chippewa—Some Chippewa uses of plants *(Eng)* S60
Igbo—Uli painting and Igbo world view *(Eng)* S444
Kwakiutl—Plants in British Columbia Indian technology *(Eng)* S506
Mexico (Baja California)—Face and body painting in Baja California: a summary *(Eng)* S273
plants—The use of wild plants in tropical South America *(Eng)* S132

bogs
skin—Lipids from samples of skin from seven Dutch bog bodies: preliminary report *(Eng)* S653

Bolivia
masks—Chiriquano masks: polychrome wood (treatment and inquiry) *(Eng)* S1041

bone
animal glue—Manufacturing and analyzing ancient animal glues *(Swe)* S651
folk art—Care of folk art: the decorative surface *(Eng)* S501
Mexico (Baja California)—Face and body painting in Baja California: a summary *(Eng)* S273
Native American—Indian rawhide: an American folk art *(Eng)* S280
Plains Indians—The mystic warriors of the Plains *(Eng)* S268
Tibet—Preservation of two ancient objects *(Eng)* S894

bone marrow
Blackfoot—Painted tipis and picture-writing of the Blackfoot Indians *(Eng)* S69

bookbindings
parchment—Conservation and restoration of manuscripts and bindings on parchment *(Eng)* S980

books
Parylene—The application of Parylene conformal coating to archival and artifact conservation *(Eng)* S1005

boots
The examination, treatment and analysis of a pair of boots from the Aleutian Islands including a note about possible pesticide contamination *(Eng) hair; pesticides; pigment; seals; USA (Alaska—Aleutian Islands)* S387

boric acid
thin layer chromatography—Improved thin-layer chromatographic method for sugar separations *(Eng)* S583

botany
Gabon—The useful plants of Gabon: an inventory and concordance of popular and scientific names of native and nonnative plants. Description of species, properties, and economic, ethnographic, and artistic uses *(Fre)* S202
Náhuatl—A review of sources for the study of Náhuatl plant classification *(Eng)* S484
Native American—Some plants used by the Yuki Indians of Round Valley, northern California *(Eng)* S176
orchid—Orchids of economic use *(Eng)* S193
plant materials—The Botanical Museum of Harvard University has recently received the Economic Herbarium of Oakes Ames *(Eng)* S88
—Sir Joseph's buried treasure *(Eng)* S476
plants—Plants for man *(Eng)* S159

Bouts, Dirck, the elder (ca. 1415–1475)
The techniques of Dieric Bouts: two paintings contrasted *(Eng)* *linen; oak; panel paintings; pigment; tempera* S386

bowls
Chumash—Volume IV: Ceremonial paraphernalia, games, and amusements *(Eng)* S344

Brazil
plants—A study of plant-based colorants used by the Indians of Brazil and the plants from which they are derived *(Por)* S37
resin—Resin classification by the Ka'apor Indians *(Eng)* S451

Brazil (Minas Gerais)
rock paintings—Mossbauer study of rock paintings from Minas Gerais (Brazil) *(Eng)* S663

brazilwood
dyewood—Dyewoods, their composition and use. Part 1: Description of the most important dyewoods *(Ger)* S204

bread
mummies—Probing the mysteries of ancient Egypt; chemical analysis of a Roman period Egyptian mummy *(Eng)* S673

breadfruit
bark cloth—Samoan material culture *(Eng)* S50
Polynesian—Breadfruit *(Eng)* S92

brewing
Apache—Plants used by the White Mountain Apache Indians of Arizona *(Eng)* S47

brightness
opacity—Factors determining the brightness and opacity of white paints *(Eng)* S689
optical properties—Optical properties and theory of color of pigments and paints *(Eng)* S687
pigment—Color characteristics of artists' pigments *(Eng)* S705
pigment volume concentration—The effect on pigment volume concentration on the lightness or darkness of porous paints *(Eng)* S810

bristles
brushmarks—The physics of brushmarks *(Eng)* S739

British Museum (London, England)
carvings—Collecting wooden ethnographic carvings in the tropics *(Eng)* S998
Maori—Some early examples of the conservation of Maori wood carvings in the collections of the British Museum *(Eng)* S1055
mural paintings—Conservation of central Asian wall painting fragments from the Stein Collection in the British Museum *(Eng)* S1099
—Three Bodhisattvas: the conservation of a fifteenth century Chinese wall painting in the British Museum collection *(Eng)* S1051
stone—The consequences of previous adhesives and consolidants used for stone conservation at the British Museum *(Eng)* S1052

brittleness
acrylic resin—Consolidation with acrylic colloidal dispersions *(Eng)* S988
varnish—Special report on picture varnish *(Eng)* S529

Bronze Age
Aegean painting in the Bronze Age *(Eng)* *Aegean; archaeological sites; binding media; Minoan; mural paintings; pigment* S466

brown ink
illumination (decoration)—The technique of old writings and miniatures *(Eng)* S293

brown pigment
rock art—Seeing red in Queensland *(Eng)* S433

brushes
Australian Aboriginal—Methods and materials used in Australian Aboriginal art *(Eng)* S300
—Painting with plants: investigating fibres in Aboriginal rock paintings at Laura, north Queensland *(Eng)* S499
bark cloth—Samoan material culture *(Eng)* S50
Chumash—The rock paintings of the Chumash: a study of a California Indian culture *(Eng)* S513
—Volume V: Manufacturing processes, metrology, and trade *(Eng)* S345
copper carbonate—The mamzrauti: a Tusayan ceremony *(Eng)* S11
dye—Aboriginal paints and dyes in Canada *(Eng)* S54
Egypt—Egyptian paintings of the Middle Kingdom *(Eng)* S245
Mexico—Colors and paint at the time of the pre-Cortés Mexican civilizations *(Fre)* S169
Native American—America's first painters *(Eng)* S168
—American Indian painting of the Southwest and Plains areas *(Eng)* S239
—Indian rawhide: an American folk art *(Eng)* S280
—Native paints in the Canadian West Coast *(Eng)* S75
Papua New Guinea—Technique and personality *(Eng)* S211

pigment—The T'u-lu colour-container of the Shang-Chou period *(Eng)* S222
Plains Indians—The mystic warriors of the Plains *(Eng)* S268
red pigment—Report on the collecting visit to the Wosera-Abelam of Sarakim village, and a note on conservation requirements *(Eng)* S318
rock art—Testament to the Bushmen *(Eng)* S382

brushmarks
The physics of brushmarks *(Eng)* **bristles** S739

Buddhist
adhesives—Re-attaching a thick color layer of polychrome sculpture. Conservation of a seated figure of Rev. Tenkai *(Jpn)* S1075
binding media—Analysis of binding media and adhesives in Buddhist wooden statues *(Jpn)* S674
metal—The conservation of painted and polychromed metal work. Two case studies from the V & A Museum *(Eng)* S1086
mural paintings—Conservation of Central Asian wall painting fragments from the Stein Collection in the British Museum *(Eng)* S1099
protein—Identification of protein containing binding media and adhesives in works of art by amino acid analysis *(Jpn)* S659

buffalo
Blackfoot—Painted tipis and picture-writing of the Blackfoot Indians *(Eng)* S69

building materials
Conservation applied to historic preservation *(Eng)* *climate control; historic preservation; house paint; paint; USA (Delaware—Wilmington); Winterthur Museum (Delaware, USA)* S449
Egypt—Ancient Egyptian materials and industries *(Eng)* S63
palm—The palm, tree of life: biology, utilization, and conservation. Proceedings of a symposium at the 1986 annual meeting of the Society for Economic Botany held at the New York Botanical Garden, Bronx, New York, 13-14 June 1986 *(Eng)* S424

buildings see also **historic buildings; construction; also names of specific buildings**
The surface finishing of Renaissance facades in Ferrara, Italy: scientific studies *(Ita) calcite; facades; gypsum; Italy (Ferrara); limestone; pigment; plaster; Renaissance; stucco* S493
house paint—Microchemical analysis of old housepaints with a case study of Monticello *(Eng)* S661
mural paintings—Conservation of English Medieval wallpaintings over the century *(Eng)* S1028
—Reproduction of colored patterns in temples and shrines *(Eng)* S383
—Study and conservation of quadratura decoration on the vaults of 17th-century French buildings *(Fre)* S470
pueblos (housing complexes)—A study of Pueblo architecture: Tusayan and Cibola *(Eng)* S9

Roman—Colorings and renderings in the ancient world *(Ita)* S395
Thailand—Conservation of wall paintings in Thailand *(Eng)* S927

Bulgaria (Melnik)
icons—Restoration and conservation of an icon from Melnik *(Bul)* S948

Bulgaria (Veliko Turnovo)
mural paintings—The structure of the 17th-century mural paintings in the S. George Orthodox church at Veliko Turnovo (Bulgaria) *(Pol)* S264

Bundi
miniatures (paintings)—Application of traditional Indian techniques in the treatment of a Bundi miniature *(Eng)* S324

Bunjils Cave (Black Range, Victoria, Australia)
Australian Aboriginal—Pigment analysis for the authentication of the aboriginal paintings at Bunjils Cave, western Victoria *(Eng)* S632

Bureau of American Ethnology
Native American—The formation of ethnographic collections: the Smithsonian Institution in the American Southwest *(Eng)* S406

burlap
Miró, Joan (1893-1983)—Joan Miro: comment and interview *(Eng)* S125

burnt sienna
mural paintings—Microchemical analysis of the wall paintings of St. Baafsabtei in Ghent (about 1175) *(Dut)* S90
pyrolysis gas chromatography—Examination through pyrolysis gas chromatography of binders used in painting *(Eng)* S626

burnt umber
icons—Restoration and conservation of an icon from Melnik *(Bul)* S948

Bushman paint
A possible base for "Bushman" paint *(Eng) Bantu; concretions; drying oil; Khoi Khoi; limonite; paint; red ocher; San; sandstone; tallow; water* S66

Bushongo
red pigment—Note on the pigment blocks of the Bushongo, Kasai District, Belgian Congo *(Eng)* S28

Butvar B98
carvings—Collecting wooden ethnographic carvings in the tropics *(Eng)* S354

butyl alcohol
mural paintings—Ajanta murals: their composition and technique and preservation *(Eng)* S232

Byzantine
A monument of Byzantine wall painting: the method of construction *(Fre) charcoal; lime putty; mural painting (technique); painting (technique); plaster; putty* S184
Fourier transform infrared spectroscopy—Applications of infrared microspectroscopy to art historical questions about Medieval manuscripts *(Eng)* S648

gas chromatography—Gas chromatographic identification of a resinous deposit from a 6th century storage jar and its possible identification *(Eng)* S608
kohl—Analysis of materials contained in mid-4th to early 7th-century A.D. Palestinian kohl tubes *(Eng)* S497
miniatures (paintings)—Conservation methods for miniature paintings on parchment: treatment of the paint layer *(Eng)* S943
panel paintings—Methods of egg-tempera panel painting conservation employed in the State Hermitage *(Eng)* S986
parchment—The conservation methods for miniature-painting on parchment *(Eng)* S920

cactus
Native American—Indian rawhide: an American folk art *(Eng)* S280
plants—The ethnobotany of pre-Columbian Peru *(Eng)* S206

cadmium yellow
pigment—Artists' pigments: a handbook of their history and characteristics *(Eng)* S623
yellow pigment—Yellows *(Ita)* S396

Calaton CB
Australian Aboriginal—Australian Aboriginal bark paintings: an ICOM report *(Eng)* S918

calcimine
Interior wall decoration: practical working methods for plain and decorative finishes, new and standard treatments *(Eng)* adhesives; casein; pigment; plaster; whiting; zinc S39
—The painters' encyclopaedia *(Eng)* adhesives; artists' materials; pigment; water; zinc white S10

calcite
buildings—The surface finishing of Renaissance facades in Ferrara, Italy: scientific studies *(Ita)* S493
calcium carbonate—Calcium carbonate whites *(Eng)* S561
cement—Precolumbian cements: a study of the calcareous cements in pre-Hispanic meso-American building construction *(Eng)* S553
ceramics—Technological notes on the pottery, pigments, and stuccoes from the excavations at Kaminaljuyu, Guatemala *(Eng)* S107
Chowa—Rhodesian engravers, painters and pigment miners of the fifth millennium B.C. *(Eng)* S161
mural paintings—The investigation of pigments and paint layer structures of mural paintings at Maitepnimit Temple *(Eng)* S477

calcium
dye—Colors for textiles: ancient and modern *(Eng)* S109
opaque white pigment—Opaque white pigments in coatings *(Eng)* S836
paint—Method to follow the degradation by natural weathering of emulsion paint films *(Ger)* S829

calcium carbonate
Calcium carbonate whites *(Eng)* aragonite; calcite; coral; lime white; onyx; oyster shell white; precipitated chalk; white pigment S561

—Optical properties of calcium carbonate in paper coatings *(Eng)* coatings; optical properties; paper; pigment volume concentration; poly(vinyl chloride); rheology; scattering; viscosity S807
chalk—Observations about conservation techniques regarding the consolidation of water-bound chalk paint layers *(Ger)* S1077
coatings—Mechanical properties of clay coating films containing styrene-butadiene copolymers *(Eng)* S834
—Note: on the cohesion of clay and $CaCO_3$ coatings *(Eng)* S858
—Plastic pigments in paper coatings: the effect of particle size on porosity and optical properties *(Eng)* S803
Egypt—The entourage of an Egyptian governor *(Eng)* S244
extenders—Relative flatting efficiency of extenders and effect of these extenders on sheen uniformity, color uniformity, suction spotting, and enamel hold-out in solvent systems *(Eng)* S731
fixing—Theoretical approach to refixing *(Fre)* S1017
frescoes—The consolidation of friable frescoes *(Eng)* S1015
mural paintings—Chemical studies on ancient painting materials *(Jpn)* S150
—Mural paintings in the Fraugde church on Funen *(Dan)* S302
—The structure of the 17th-century mural paintings in the S. George Orthodox church at Veliko Turnovo (Bulgaria) *(Pol)* S264
—Structure, composition, and technique of the paintings *(Dut)* S346
paint—The comparisons of two-component extender systems in emulsion paint *(Eng)* S730
pigment—Ancient Greek pigments from the Agora *(Eng)* S104
—Technical studies on the pigments used in ancient paintings of Japan *(Eng)* S167
pigment volume concentration—Effect of particle size distribution of pigment and pigment volume concentration on flat wall paint properties (solvent type) *(Eng)* S729
—Pigment volume concentration and its effect on the corrosion resistance properties of organic paint films *(Eng)* S882
Tomb of Nefertari (Thebes, Egypt)—Chemical analyses of pigments and media used in the mural paintings of the tomb of Nefertari *(Spa)* S658

calcium caseinate
adhesives—The evaluation of some adhesive systems utilized in the consolidation of paintings. The kinetics of consolidation (II) *(Rum)* S1020

calcium chloride
stabilizers—Identification of stabilizing agents *(Eng)* S527

calcium soap
pigment—Analysis of the material and technique of ancient mural paintings *(Eng)* S220

calcium sulfate

calcium sulfate *see also* **gypsum**
mural paintings—Ajanta and Ellora wall paintings. Scientific research as an aid to their conservation *(Eng)* S569
Velazquez, Diego Rodriguez de Silva (1599-1660)—The technique of Velasquez in the painting *The Drinkers* at the Picture Gallery of Naples *(Eng)* S139

caliatour wood
dyewood—Dyewoods, their composition and use. Part 1: Description of the most important dyewoods *(Ger)* S204

calligraphy
adhesives—Natural adhesives in East Asian paintings *(Eng)* S372

calorimetry
differential scanning calorimetry—Investigation of paint media by differential scanning calorimetry (DSC) *(Eng)* S667

camwood
Africa, West—Handbook of West African art *(Eng)* S164
dyewood—Dyewoods, their composition and use. Part 1: Description of the most important dyewoods *(Ger)* S204
Sundi—The Kongo I *(Eng)* S162
wood—Plants for religious use from the forest region of West Africa *(Fre)* S106

Canada
Abstract art—Some structural solutions to the question of preventive conservation care for a major travelling exhibition, "The Crisis of Abstraction in Canada: The 1950s." *(Eng)* S508
dye—Aboriginal paints and dyes in Canada *(Eng)* S54
Native American—Analysis of paints used by Canadian native cultures: a project at the Canadian Conservation Institute *(Eng)* S640

Canada (British Columbia)
Bella Coola—Materia medica of the Bella Coola and neighbouring tribes of British Columbia *(Eng)* S48
conifers—Ethnobotany of coniferous trees in Thompson and Lillooet Interior Salish of British Columbia *(Eng + Fre)* S426
Kwakiutl—Field research in the conservation of ethnographical collections: an ecological approach applied to polychrome monumental sculpture *(Eng)* S417
—Plants in British Columbia Indian technology *(Eng)* S506
rock paintings—Petroglyphs and pictographs on the British Columbia coast *(Eng)* S95
Thompson—Ethnobotany of the Thompson Indians of British Columbia, based on field notes by James A. Teit *(Eng)* S45
—Thompson ethnobotany: knowledge and usage of plants by the Thompson Indians of British Columbia *(Eng)* S483

Canada (British Columbia— Kitwanga)
totem poles—Restoration of totem poles in British Columbia *(Eng)* S44

Canada (British Columbia— Queen Charlotte Islands)
Native American—Indian life on the northwest coast of North America, as seen by the early explorers and fur traders during the last decades of the 18th century *(Eng)* S266

Canada (British Columbia— Vancouver Island)
Nitinaht—Ethnobotany of the Nitinaht Indians of Vancouver Island *(Eng)* S356
Salish—The ethnobotany of the Coast Salish Indians of Vancouver Island *(Eng)* S263

Canada (West Coast)
Native American—Native paints in the Canadian West Coast *(Eng)* S75

Canadian Conservation Institute (Ottawa, Ontario, Canada)
Native American—CCI Native Materials Project: final report *(Eng)* S473

candlenut oil (Aleurites moluccana)
pigment—Domestic implements, arts, and manufactures *(Eng)* S23

candlenut soot
dye—Ethnology of Uvea (Wallis Island) *(Eng)* S74

canoes
The Hawaiian canoe *(Eng) banana; bark; kukui; paint; ti (plant); USA (Hawaii); waterproofing* S334
Chumash—Volume IV: Ceremonial paraphernalia, games, and amusements *(Eng)* S344
Cook, James (1728-1779)—The journals of Captain James Cook on his voyages of discovery *(Eng)* S414
Maori—The examination, analysis and conservation of a Maori model canoe *(Eng)* S373

canvas
adhesives—Adhesives for impregnation of painting on canvas *(Swe)* S1087
—The evaluation of some adhesive systems utilized in the consolidation of paintings. The kinetics of consolidation (III) *(Rum)* S1021
—The treatment of cracks in canvas paintings with synthetic adhesives: procedures and possible combinations with the lining process *(Eng)* S1092
Baumeister, Willi (1889-1955)—Studies of the painting techniques of Willi Baumeister *(Ger)* S496
binding media—The problem of conservation of very large canvases painted in glue medium *(Pol)* S968
de Kooning, Willem (b. 1904)—De Kooning: "I see the canvas and I begin." *(Eng)* S304
fixing—Theoretical approach to refixing *(Fre)* S1017
icons—Restoration and conservation of an icon from Melnik *(Bul)* S948
—The technique of icon painting *(Eng)* S214
Netherlandish—The beginnings of Netherlandish canvas painting, 1400-1530 *(Eng)* S445
paintings (objects)—Manual of the painter restorer *(Ita)* S5
—Written sources about painted textiles *(Ger)* S504

358

carmine

house paint—House paints in Colonial America: their materials, manufacture and application. Part III *(Eng)* S230
pigment—Artists' pigments: a handbook of their history and characteristics *(Eng)* S623
red pigment—Reds *(Ita)* S397
carpets
pre-Columbian—Dating precolumbian museum objects *(Eng)* S1115
Carriera, Rosalba (1675-1757)
Rosalba Carriera and the early history of pastel painting *(Eng) chalk; Italy (Venice); pastels (visual works)* S498
cartoons
pastels (visual works)—A portrait of Master Sahl (1683-1753). Particularities of a pastel restoration *(Ger)* S993
carving
Africa—Contemporary African arts and crafts: on-site working with art forms and processes *(Eng)* S281
Anang—The carver in Anang society *(Eng)* S276
Australian Aboriginal—Aboriginal art *(Eng)* S446
India—Notes on the technique of Indian polychrome wooden sculpture *(Eng)* S246
—A study of Indian polychrome wooden sculpture *(Eng)* S255
rock art—The recording of rock art: an illustrated paper presented to the Canadian Conservation Institute trainees and to the Course in the Conservation of Historic Monuments and Sites, Restoration Services Division, Engineering and Architecture Branch, D.I.N.A. *(Eng)* S283
wood—Plants for religious use from the forest region of West Africa *(Fre)* S106
Yoruba—Gelede: a Yoruba masquerade *(Eng)* S250
carvings
Collecting wooden ethnographic carvings in the tropics *(Eng) Butvar B98; ethylene oxide; kaolin; ocher; paint; Papua New Guinea; Paraloid B-72; wood; xylene* S354
Africa—Personality and technique of African sculptors *(Eng)* S208
bark paintings—Conservation of Australian Aboriginal bark paintings with a note on the restoration of a New Ireland wood carving *(Eng)* S905
consolidation—Consolidation of loose paint on ethnographic wooden objects *(Ger)* S901
Hawaiian—Hawaiian sculpture *(Eng)* S415
Maori—Conservation considerations on four Maori carvings at Auckland Museum, New Zealand *(Eng)* S359
—Maori carvings in Auckland Museum, New Zealand. Ethical considerations in their restoration *(Eng)* S360
—Some early examples of the conservation of Maori wood carvings in the collections of the British Museum *(Eng)* S1055
masks—Restoration of a New-Ireland ceremonial mask and a double wood carving of Oceania *(Hun)* S975

Papua New Guinea (Wosera-Abelam)—The removal and conservation of the painted bark (palm leaf petiole) panels and carved figures from a Papua New Guinea "Haus Tambaran" *(Eng)* S1056
wood—Case studies in the treatment of polychrome wood sculptures at the Victoria and Albert Museum *(Eng)* S1006
Yoruba—A Yoruba master carver: Duga of Meko *(Eng)* S274
Casa Sandalia (Spain)
mural paintings—The legacy of the Tía Sandalia: consolidation, removal, and mounting of the work in the future Ethnographic Museum of Villacañas (Toledo) *(Spa)* S1083
Cascol
adhesives—Adhesives for impregnation of painting on canvas *(Swe)* S1087
casein
On the material side: recent trends in painting mediums *(Eng) milk; oil; paint* S134
—Studio talk: improvement in tubed casein. Interview with Ted Davis *(Eng) distilled water; lactic acid; lime; milk; oil; Tuffilm varnish; varnish* S171
adhesives—The evaluation of some adhesive systems utilized in the consolidation of paintings. The kinetics of consolidation (II) *(Rum)* S1020
binding media—Artificial samples of paint binders. Oils, resins, waxes, glues, egg, prepared in binary mixtures: analytical characteristics and properties *(Ita)* S631
—Binding media identification in painted ethnographic objects *(Eng)* S675
—The importance of binders *(Fre)* S225
calcimine—Interior wall decoration: practical working methods for plain and decorative finishes, new and standard treatments *(Eng)* S39
coatings—Review of literature relating the effect of binder on coating gloss *(Eng)* S767
consolidation—Consolidation of delaminating paintings *(Eng)* S951
fluorescence microscopy—Ultraviolet fluorescence microscopy of paint cross sections: cycloheptaamylose-dansyl chloride complex as a protein-selective stain *(Eng)* S671
frescoes—Artistic frescoes *(Eng)* S100
gas chromatography—Contribution to the study of aged proteinaceous media *(Eng)* S572
—Identification of proteinaceous media of easel paintings by gas chromatography of the amino acid derivatives after catalytic hydrolysis by a protonated carbon exchanger *(Eng)* S670
gas chromatography mass spectrometry—Rapid identification of binding media in paintings using simultaneous pyrolysis methylation gas chromatography *(Eng)* S668
glaze—On the material side. Glazes and glazing—Part 2 *(Eng)* S148
historic buildings—Defects of color dyes on historic buildings' renderings *(Cze)* S914
latex paint—History of water-thinned paints *(Eng)* S163
Mexico—Colors and paint at the time of the pre-Cortés Mexican civilizations *(Fre)* S169

360

cellulose
mural paintings—Ajanta murals: their composition and technique and preservation *(Eng)* S232
thin layer chromatography—Separation of carbohydrates by thin-layer chromatography *(Eng)* S550

cellulose acetate
clay—Restoration of a relief in painted clay *(Fre)* S887
manuscripts—A clay-coated manuscript in the Gilgit collection *(Eng)* S907
mural paintings—Conservation of mural paintings in Central Asia which have been damaged by salt efflorescence *(Eng)* S888
paper—Conservation of some non-book material in National Library, Calcutta *(Eng)* S1026
polymers—Consolidation of the pictorial layer of illuminations with pure synthetic polymers *(Fre)* S989
Vuillard, Edouard (1868-1940)—A technical and stylistic analysis of detrempe painting on cardboard by Edouard Vuillard *(Eng)* S1014

cellulose ether
The use of cellulose ethers in the treatment of Egyptian polychromed wood *(Eng) cleaning; Egyptian; flaking; paint; polychromy; wood* S1053
consolidants—The consolidation of powdery paint layers of *Bonaders*, Swedish mural works painted on paper *(Fre)* S1109
Melanesian—Conservation of powdering pigment layers on Melanesian objects: choice of a fixative *(Fre)* S1039

cellulose nitrate
lacquer—Glossiness of nitrocellulose lacquer coatings *(Eng)* S715
mural paintings—Products, facts, modes in mural painting: evolution and distribution of restoration products used in mural paintings from 1850 to 1992: a first sorting concerning France, Spain, England, and Poland *(Fre)* S511
stone—The consequences of previous adhesives and consolidants used for stone conservation at the British Museum *(Eng)* S1052

cement
Precolumbian cements: a study of the calcareous cements in pre-Hispanic meso-American building construction *(Eng) calcite; Central America; gypsum; hardeners; hydraulic; lime; limestone; Mayan; Mexico; mortar* S553
latex paint—History of water-thinned paints *(Eng)* S163
mural paintings—Conservation of English Medieval wallpaintings over the century *(Eng)* S1028
—How to paint a mural *(Spa)* S381
stone—The consequences of previous adhesives and consolidants used for stone conservation at the British Museum *(Eng)* S1052

Cennini, Cennino Drea (b. ca. 1370)
Netherlandish—The beginnings of Netherlandish canvas painting, 1400-1530 *(Eng)* S445

Central America *see also* **Mesoamerican**
cement—Precolumbian cements: a study of the calcareous cements in pre-Hispanic meso-American building construction *(Eng)* S553
Maya blue—Maya blue *(Spa)* S548
paint—Worldwide history of paint *(Eng)* S454

Central Research Laboratory (Amsterdam, Netherlands)
databases—Introduction to TINCL: a database system for art technological sources *(Eng)* S672

ceramics
Technological notes on the pottery, pigments, and stuccoes from the excavations at Kaminaljuyu, Guatemala *(Eng) ash (residue); azurite; basalt; black pigment; calcite; carbon black; charcoal black; cinnabar; copper; Guatemala (Kaminaljuyu); hematite; lime; malachite; pigment; plaster; secco; stucco; yellow ocher* S107
—Two Kongo potters *(Eng) bark; colorants; mwindu (Bridelia scleroneura); Zaire* S291
Anasazi—A simple method for distinguishing between organic and inorganic paints on black-on-white Anasazi pottery *(Eng)* S568
black pigment—Ceramic pigments of the Indians of the Southwest *(Eng)* S40
—Classification of black pottery pigments and paint areas *(Eng)* S524
—Prehistoric pottery pigments in the Southwest *(Eng)* S46
Iran—Friable pigments and ceramic surfaces: a case study from SW Iran *(Eng)* S1058
plants—The ethnobotany of pre-Columbian Peru *(Eng)* S206
Shipibo—Restoration of Shipibo pottery *(Eng)* S1050

cereal
Sudan (Mirgissa)—Physico-chemistry at the service of archaeology: examination of a series of samples from excavations done in Sudan *(Fre)* S545

cerulean blue
blue pigment—Blues *(Ita)* S394

chalk
Observations about conservation techniques regarding the consolidation of water-bound chalk paint layers *(Ger) acrylic resin; calcium carbonate; consolidation; darkening; ethyl methacrylate; gloss; gypsum; iron oxide; paint; pigment; poly(vinyl acetate); poly(vinyl alcohol); resin; solubility; solvents; wood* S1077
Carriera, Rosalba (1675-1757)—Rosalba Carriera and the early history of pastel painting *(Eng)* S498
contemporary art—Interview with Joel Shapiro *(Eng)* S460
delamination—Detection of delaminations in art objects using air-coupled ultrasound *(Eng)* S880
drawing (technique)—The craft of old-master drawings *(Eng)* S182
drawings—Charcoal, chalk and pastel drawings: special problems for collectors, Part 1 *(Eng)* S310
—Charcoal, chalk and pastel drawings: special problems for collectors, Part 2 *(Eng)* S311

—Techniques and subsequent deterioration of drawings *(Eng)* S312
Fourier transform infrared spectroscopy—Micro spectroscopy FTIR reflectance examination of paint binders on ground chalk *(Eng)* S681
fresco painting (technique)—Survey of fresco painting *(Ger)* S130
house paint—House paints in Colonial America: their materials, manufacture and application. Part III *(Eng)* S230
India—A study of Indian polychrome wooden sculpture *(Eng)* S255
mural paintings—Analysis of pigments and plaster of the paintings in the Sheesh Mahal, Nagaur *(Eng)* S428
—Materials and painting techniques of the wall paintings of the main nave of S. Mary's Church in Toruń *(Pol)* S432
—Materials and techniques of Medieval wall paintings from the former House of Merchants' Fraternity at 5 Żeglarska Street in Toruń *(Pol)* S485
—Restoration of ancient monumental painting in cult buildings *(Eng)* S284
Nagoya Castle (Nagoya, Japan)—Study on the repair technique of polychrome paintings drawn on sliding screens in the Nagoya Castle *(Jpn)* S945
New Guinea—Wow-Ipits: eight Asmat woodcarvers of New Guinea *(Eng)* S231
paint—Artists' paints and their manufacture, and the products *(Ger)* S152
panel paintings—Present state of screen and panel paintings in Kyoto *(Jpn)* S933
pastels (visual works)—History, technology and conservation of dry media *(Eng)* S1018
—A sculpture and a pastel by Edgar Degas *(Eng)* S285
pigment—Ancient Greek pigments from the Agora *(Eng)* S104
—The T'u-lu colour-container of the Shang-Chou period *(Eng)* S222
prehistoric—Pigments and paints in prehistoric antiquity *(Fre)* S191
rock art—The ancients knew their paints *(Eng)* S249
—The recording of rock art: an illustrated paper presented to the Canadian Conservation Institute trainees and to the Course in the Conservation of Historic Monuments and Sites, Restoration Services Division, Engineering and Architecture Branch, D.I.N.A. *(Eng)* S283
screens (doors)—Treatment on painting of sliding screens and wall panels to prevent exfoliation in Japan *(Eng)* S972
Sundi—The Kongo I *(Eng)* S162
synthetic organic pigment—An early 20th-century pigment collection: the pigment collection in the Missiemuseum at Steyl-Tegelen *(Dut)* S435

chalking
 cracking—Defects with old paint surfaces: occurrence, causes and remedies *(Ger)* S789
 glaze—Optics of paint films: glazes and chalking *(Eng)* S748

charcoal
Tonal drawing and the use of charcoal in nineteenth century France *(Eng) Allongé, Auguste (1833-1898); Appian, Adolphe (1818-1898); Courbet, Gustave (1819-1877); drawings; fixing; France; Lalanne, Maxime (1826-1886); mounting; paper; Redon, Odilon (1840-1916); Robert, Karl* S468
—The uses of charcoal in drawing *(Eng) drawings* S317
Australian Aboriginal—Australian Aboriginal bark paintings: an ICOM report *(Eng)* S918
—Bark paintings: techniques and conservation *(Eng)* S443
Byzantine—A monument of Byzantine wall painting: the method of construction *(Fre)* S184
carboxymethylcellulose—The use of carboxymethylcellulose in the restoration of easel paintings *(Rum)* S1008
Chumash—A study of some Californian Indian rock art pigments *(Eng)* S519
contemporary art—Interview with Joel Shapiro *(Eng)* S460
drawing (technique)—The craft of old-master drawings *(Eng)* S182
—Drawing techniques: their evolution in different European schools *(Fre)* S128
drawings—Charcoal, chalk and pastel drawings: special problems for collectors, Part 1 *(Eng)* S310
—Charcoal, chalk and pastel drawings: special problems for collectors, Part 2 *(Eng)* S311
—Techniques and subsequent deterioration of drawings *(Eng)* S312
fixatives—Determination of the influence of Rowney's "Perfix" fixative on the properties of paper *(Pol)* S925
—Experimental studies on fixatives for powdery traces *(Fre)* S1012
Mojave—Mohave tatooing and face-painting *(Eng)* S116
mural paintings—The earliest known paints *(Eng)* S153
—Mural paintings in the Fraugde church on Funen *(Dan)* S302
Native American—What did they use for paint? *(Eng)* S236
Nitinaht—Ethnobotany of the Nitinaht Indians of Vancouver Island *(Eng)* S356
Papua New Guinea (New Ireland)—Assemblage of spirits: idea and image in New Ireland *(Eng)* S403
pastels (visual works)—History, technology and conservation of dry media *(Eng)* S1018
Pech Merle Cave (France)—Spitting images: replicating the spotted horses *(Eng)* S491
pictographs—On the pictographs of the North American Indians *(Eng)* S8
pigment—The T'u-lu colour-container of the Shang-Chou period *(Eng)* S222
rock art—The ancients knew their paints *(Eng)* S249
rock paintings—Perspectives and potentials for absolute dating prehistoric rock paintings *(Eng)* S523
textiles—Technical study and conservation of an old painted textile (Simhasana) *(Eng)* S902

Tlingit—The conservation of a Tlingit blanket *(Eng)* S909

charcoal black
Australian Aboriginal—Dawn of art: painting and sculpture of Australian Aborigines *(Eng)* S224
Blackfoot—Painted tipis and picture-writing of the Blackfoot Indians *(Eng)* S69
ceramics—Technological notes on the pottery, pigments, and stuccoes from the excavations at Kaminaljuyu, Guatemala *(Eng)* S107
dye—Aboriginal paints and dyes in Canada *(Eng)* S54
Egypt—The entourage of an Egyptian governor *(Eng)* S244
mural paintings—Ajanta murals: their composition and technique and preservation *(Eng)* S232
—Chemical studies on the pigments of ancient ornamented tombs in Japan *(Jpn)* S151
—Microchemical analysis of the wall paintings of St. Baafsabtei in Ghent (about 1175) *(Dut)* S90
—Structure, composition, and technique of the paintings *(Dut)* S346
pastels (visual works)—Analysis and conservation of graphic and sound documents: work by the Centre de Recherches sur la Conservation des Documents Graphiques, 1982-1983 *(Fre)* S1004
pigment—Technical studies on the pigments used in ancient paintings of Japan *(Eng)* S167
rock art—The recording of rock art: an illustrated paper presented to the Canadian Conservation Institute trainees and to the Course in the Conservation of Historic Monuments and Sites, Restoration Services Division, Engineering and Architecture Branch, D.I.N.A. *(Eng)* S283
Sundi—The Kongo I *(Eng)* S162

chateaux
mural paintings—The Château of Oiron and its decorated surfaces *(Fre)* S457

chemical composition
forensic science—Developments in paint analysis for forensic purposes *(Eng)* S639

chemical properties
coatings—Effect of certain physical and chemical properties of titanium dioxides on the optical properties of coatings *(Eng)* S821
history of technology—Chemistry of painting surfaces from earliest time to unfathomable future *(Eng)* S279
painting (technique)—Painting materials: a short encyclopaedia *(Eng)* S227

Cherokee
Cherokee plants and their uses: a 400 year history *(Eng) dye; Native American; plants* S287
—An early Cherokee ethnobotanical note *(Eng) colorants; ethnobotany; Native American; USA (Georgia)* S118

chests
The cleaning, conservation, and restoration of a Matyo chest *(Hun) cleaning; fungi; furniture; Hungary; insects; paint; pigment; wood* S1000

Chetro Ketl site
wood—Wooden ritual artifacts from Chaco Canyon, New Mexico: the Chetro Ketl collection *(Eng)* S305

chiaroscuro
drawing (technique)—The craft of old-master drawings *(Eng)* S182

chilicothe (Marah macrocarpus)
Luiseño—The culture of the Luiseño Indians *(Eng)* S26
Native American—Chinigchinich: a revised and annotated version of Alfred Robinson's translation of Father Geronimo Boscana's historical account of the belief, usages, customs and extravagancies of the Indians of this mission of San Juan Capistrano called the Acagchemem Tribe *(Eng)* S58

chimney soot
Acoma—The Acoma Indians *(Eng)* S57

China
Chinese painting colors: studies of their preparation and application in traditional and modern times *(Eng) adhesives; alum; binding media; gardenia seeds; gamboge (pigment); indigo; painting (technique); pigment; plants; size (material)* S427
—Scientific study of the decoration of four wooden funerary boxes from China *(Fre) funerary containers; pigment; polychromy; wood* S510
adhesives—Natural adhesives in East Asian paintings *(Eng)* S372
mural paintings—Pigments used in the paintings of "Hoodo." *(Jpn)* S183

Chinese
clay—Restoration of a relief in painted clay *(Fre)* S887
dye—Rosewood, dragon's blood and lac *(Eng)* S181
mural paintings—Three Bodhisattvas: the conservation of a fifteenth century Chinese wall painting in the British Museum collection *(Eng)* S1051
pigment—The T'u-lu colour-container of the Shang-Chou period *(Eng)* S222
shadow puppets—Restoration of Chinese and Indonesian shadow puppets *(Eng)* S1011
wood—Case studies in the treatment of polychrome wood sculptures at the Victoria and Albert Museum *(Eng)* S1006

Chinese ink
Horyuji Temple (Japan)—Coloring materals of the murals in the Main Hall of the Horyuji Temple compared with those of the ornamented tombs *(Jpn)* S271
mural paintings—Pigments used in the paintings of "Hoodo." *(Jpn)* S183

Chippewa
How Indians use wild plants for food, medicine, and crafts *(Eng) dye; Native American; plants* S278
—Plants used by the Chippewa *(Eng) bloodroot; colorants; dye; Native American* S91

chromatography

—Some Chippewa uses of plants *(Eng) black pigment; bloodroot; body painting; grease; Native American; pigment* S60
—Uses of plants by the Chippewa Indians *(Eng) colorants; dye; ethnobotany; Native American; plants* S41

chloramine T.
textiles—Technical study and conservation of an old painted textile (Simhasana) *(Eng)* S902

chloride
opaque white pigment—Opaque white pigments in coatings *(Eng)* S836
poly(vinyl chloride)—Measurement of optical constants of sublimed pigmented layers and calculation of color of pigmented polyvinyl chloride films *(Ger)* S853

chlorine
radioactivity—Radiochemical investigation of ionic penetration into paint films *(Eng)* S778

chlorite
mural paintings—Chemical studies on the pigments of ancient ornamented tombs in Japan *(Jpn)* S151

chloroform
infrared absorption—Dammar and mastic infrared analysis *(Eng)* S528

Chola
mural paintings—The mural paintings in the Brihadisvara Temple at Tanjore: an investigation into the method *(Eng)* S76

Chowa
Rhodesian engravers, painters and pigment miners of the fifth millennium B.C. *(Eng) calcite; carbonate rock; copper; manganese dioxide; minerals; mining; ocher; pigment; pyrolusite; rhodochrosite; rhodonite; silicate; Zimbabwe* S161

chromate
pigment volume concentration—Coating formulation and development using critical pigment volume concentration prediction and statistical design *(Eng)* S854
—Pigment volume concentration and its effect on the corrosion resistance properties of organic paint films *(Eng)* S882
synthetic organic pigment—An early 20th-century pigment collection: the pigment collection in the Missiemuseum at Steyl-Tegelen *(Dut)* S435

chromatography
The chromatographic analysis of ethnographic resins *(Eng) gas chromatography; liquid chromatography; organic materials; resin; thin layer chromatography; wax* S603
acrylic resin—The identification and characterization of acrylic emulsion paint media *(Eng)* S666
animal glue—Manufacturing and analyzing ancient animal glues *(Swe)* S651
—The significance of fat in animal glue for painting purposes *(Ger)* S628
bark cloth—The analysis and identification of oils in Hawaiian oiled tapa *(Eng)* S629

binding media—Analysis of binding media and adhesives in Buddhist wooden statues *(Jpn)* S674
—Methods used for the identification of binding media in Italian paintings of the 15th and 16th centuries *(Eng)* S554
fatty acid—Fatty acid composition of 20 lesser-known Western Australian seed oils *(Eng)* S676
—The gas chromatographic examination of paint media. Part I. Fatty acid composition and identification of dried oil films *(Eng)* S542
forensic science—Developments in paint analysis for forensic purposes *(Eng)* S639
gas chromatography—Analysis of organic residues of archaeological origin by high-temperature gas chromatography and gas chromatography-mass spectrometry *(Eng)* S654
—The application of gas chromatography in the investigation of works of art *(Eng)* S538
—Contribution to the study of aged proteinaceous media *(Eng)* S572
—Identification of proteinaceous binding media of easel paintings by gas chromatography of the amino acid derivatives after catalytic hydrolysis by a protonated carbon exchanger *(Eng)* S670
gas chromatography mass spectrometry—Rapid identification of binding media in paintings using simultaneous pyrolysis methylation gas chromatography *(Eng)* S668
illumination (decoration)—Writing technique and illumination of ancient Serbian manuscripts *(Fre)* S338
illuminations—The development of techniques of identification for pigments and binders used in the paint layer of manuscript illuminations *(Fre)* S546
ink—Gas chromatographic mass spectrometric analysis of tannin hydrolysates from the ink of ancient manuscripts (XIth to XVIth century) *(Eng)* S577
mural paintings—Chemical study on the coloring materials of the murals of the Taka-matsuzuka Tomb in Nara Prefecture *(Jpn)* S272
paintings (objects)—Analysis of paint media, varnishes and adhesives *(Eng)* S625
paper chromatography—The analysis of paint media by paper chromatography *(Eng)* S530
Peru—An analytical study of pre-Inca pigments, dyes and fibers *(Eng)* S571
plants—Analytical procedures *(Eng)* S531
—Plant gums as painting mediums in the light of old treatises, their properties, and their identification in ancient polychromy *(Pol)* S207
polysaccharides—The detection of polysaccharides in the constituent materials of works of art *(Fre)* S537
—Polysaccharides as part of a color layer and methods for their identification *(Cze)* S647
protein—Identification of protein containing binding media and adhesives in works of art by amino acid analysis *(Jpn)* S659
pyrolysis gas chromatography—Examination through pyrolysis gas chromatography of binders used in painting *(Eng)* S626

365

—The identification of dammar, mastic, sandarac and copals by pyrolysis gas chromatography *(Eng)* S638
—Identification of natural gums in works of art using pyrolysis-gas chromatography *(Eng)* S652
—Identification of synthetic materials in modern paintings. 1: varnishes and polymer binders *(Fre)* S660
—Pyrolysis gas chromatographic mass spectrometric identification of intractable materials *(Eng)* S588
—The use of pyrolysis gas chromatography (PyGC) in the identification of oils and resins found in art and archaeology *(Eng)* S644
resin—Natural resins of art and archaeology. Their sources, chemistry, and identification *(Eng)* S579
tempera—An improved method for the thin-layer chromatography of media in tempera paintings *(Eng)* S562
thin layer chromatography—Forensic examination of wax seals by thin-layer chromatography *(Eng)* S602
—Methods in scientific examination of works of art. Volume 1: thin-layer chromatography course book *(Eng)* S684
—Methods in scientific examination of works of art. Volume 2: thin-layer chromatography protocols *(Eng)* S685
—Methods in scientific examination of works of art. Volume 3: thin-layer chromatography reference materials binder *(Eng)* S683
—A note on the thin-layer chromatography of media in paintings *(Eng)* S677
—Separation of carbohydrates by thin-layer chromatography *(Eng)* S550
—Thin-layer chromatography of resin acid methyl esters *(Eng)* S536
Tura, Cosimo (1430?-1495)—Amino acid analysis of proteinaceous media from Cosimo Tura's "The Annunciation with Saint Francis and Saint Louis of Toulouse." *(Eng)* S669
varnish—Special report on picture varnish *(Eng)* S529
wax—Characterization of commercial waxes by high-temperature gas chromatography *(Eng)* S604

chrome yellow
India—Notes on the technique of Indian polychrome wooden sculpture *(Eng)* S246
—A study of Indian polychrome wooden sculpture *(Eng)* S255
pigment—Artists' pigments: a handbook of their history and characteristics *(Eng)* S623
yellow pigment—Yellows *(Ita)* S396

chromium
Romano-British—An analysis of paints used in Roman Britain *(Eng)* S210

chrysocolla
On the colors of the ancients: chrysocolla *(Ita) color; green pigment; Medieval* S185
mural paintings—Pigments and techniques of the early Medieval wall paintings of eastern Turkistan *(Ger)* S298

Chumash
Ethnobotany of Chumash Indians, California, based on collections by John P. Harrington *(Eng) ethnobotany; plants; USA (California)* S482
—The rock paintings of the Chumash: a study of a California Indian culture *(Eng) brushes; egg; fat; milkweed; ocher; oil; rock paintings; USA (California)* S513
—A study of some Californian Indian rock art pigments *(Eng) charcoal; gypsum; Native American; ocher; oyster shell white; pigment; rock art; USA (California)* S519
—Volume IV: Ceremonial paraphernalia, games, and amusements *(Eng) bowls; canoes; ritual objects; rock art; wood* S344
—Volume V: Manufacturing processes, metrology, and trade *(Eng) adhesives; brushes; manufacturing; pigment; pine tar; red pigment; tar* S345
bitumen—Aboriginal use of bitumen by the California Indians *(Eng)* S101
—Prehistoric use of bitumen in Southern California *(Eng)* S256
pictographs—On the pictographs of the North American Indians *(Eng)* S8

Church of Lourps (Longueville, France)
mural paintings—The Church of Lourps in Longueville: restoration of the decorated surfaces *(Fre)* S474

churches
Scandinavia—Scandinavian painted decor *(Eng)* S467
Spain (Catalonia)—Architecture and decorated surfaces in Catalonia *(Fre)* S456

cinder
masks—Chiriquano masks: polychrome wood (treatment and inquiry) *(Eng)* S1041

cinnabar *see also* **vermilion**
ceilings—Conservation treatments with reference to color paintings on the ceiling of the main hall, National Treasure, of Toshodaiji Temple, Nara *(Jpn)* S941
ceramics—Technological notes on the pottery, pigments, and stuccoes from the excavations at Kaminaljuyu, Guatemala *(Eng)* S107
house paint—House paints in Colonial America: their materials, manufacture and application. Part III *(Eng)* S230
India—Notes on the technique of Indian polychrome wooden sculpture *(Eng)* S246
Japan—Pigments used in Japanese paintings *(Eng)* S405
mural paintings—Analysis of pigments and plaster of the paintings in the Sheesh Mahal, Nagaur *(Eng)* S428
—Chemical studies on ancient painting materials *(Jpn)* S150
—Chemical studies on ancient pigments in Japan *(Eng)* S138
—Chemical studies on the pigments of ancient ornamented tombs in Japan *(Jpn)* S151
—The investigation of pigments and paint layer structures of mural paintings at Maitepnimit Temple *(Eng)* S477

—Pigments and techniques of the early Medieval wall paintings of eastern Turkistan *(Ger)* S298
panel paintings—Wings from a quadriptych with the legend of St. John the Baptist: general problems and conservation treatment *(Pol)* S917
pictographs—On the pictographs of the North American Indians *(Eng)* S8
pigment—Ancient Greek pigments from the Agora *(Eng)* S104
—Oracle-bone color pigments *(Eng)* S73
red pigment—Red pigments of antiquity *(Fre)* S114
USA (New Mexico)—The materials and methods of some religious paintings of early 19th century New Mexico *(Eng)* S142

citronella oil
paper—Conservation of some non-book material in National Library, Calcutta *(Eng)* S1026

classifying
adhesives—Note on the classification of choice of adhesives *(Eng)* S1001
black pigment—Classification of black pottery pigments and paint areas *(Eng)* S524
resin—Resin classification among the Semelai of Tasek Bera, Pahang, Malaysia *(Eng)* S392
—Resin classification by the Ka'apor Indians *(Eng)* S451

clay
Restoration of a relief in painted clay *(Fre)* cellulose acetate; Chinese; consolidation; impregnation; plaster of Paris; poly(vinyl acetate); polychromy; relief; sawdust; sculpture; silk paper S887
Australian Aboriginal—Bark paintings: techniques and conservation *(Eng)* S443
—Dawn of art: painting and sculpture of Australian Aborigines *(Eng)* S224
—Food: its search, capture, and preparation *(Eng)* S20
—White clay and ochre *(Eng)* S237
ceilings—Conservation treatments with reference to color paintings on the ceiling of the main hall, National Treasure, of Toshodaiji Temple, Nara *(Jpn)* S941
coatings—Mechanical properties of clay coating films containing styrene-butadiene copolymers *(Eng)* S834
—Note: on the cohesion of clay and $CaCO_3$ coatings *(Eng)* S858
—Optical properties and structure of clay-latex coatings *(Eng)* S791
Horyuji Temple (Japan)—Coloring materals of the murals in the Main Hall of the Horyuji Temple compared with those of the ornamented tombs *(Jpn)* S271
human head—The conservation of a preserved human head *(Eng)* S935
iron oxide—Infrared study of the yellow and red iron oxide pigments *(Ger)* S551
manuscripts—Birch-bark (bhurjapatra) and clay-coated manuscripts in the Gilgit Collection: their repair and preservation *(Eng)* S896
—A clay-coated manuscript in the Gilgit collection *(Eng)* S907

Maya blue—Maya blue: how the Mayas could have made the pigment *(Eng)* S645
mural paintings—Physico-chemical study of the painting layers of the Roman mural paintings from the Acropolis of Lero *(Fre)* S342
Native American—What did they use for paint? *(Eng)* S236
Papua New Guinea—Technique and personality *(Eng)* S211
prehistoric—Pigments and paints in prehistoric antiquity *(Fre)* S191
pueblos (housing complexes)—A study of Pueblo architecture: Tusayan and Cibola *(Eng)* S9
rock art—The ancients knew their paints *(Eng)* S249
—The recording of rock art: an illustrated paper presented to the Canadian Conservation Institute trainees and to the Course in the Conservation of Historic Monuments and Sites, Restoration Services Division, Engineering and Architecture Branch, D.I.N.A. *(Eng)* S283
Seri blue—Seri blue *(Eng)* S217
—Seri blue—an explanation *(Eng)* S218
Sudan (Mirgissa)—Physico-chemistry at the service of archaeology: examination of a series of samples from excavations done in Sudan *(Fre)* S545
Tibet—Preservation of two ancient objects *(Eng)* S894

cleaning
Abydos reliefs (Egypt)—Techniques of decoration in the Hall of Barques in the Temple of Sethos I at Abydos *(Eng)* S1064
Australian Aboriginal—Conservation of the Australian Museum's collection of Aboriginal bark paintings *(Eng)* S959
banners—The conservation of the United Tin Plate Workers' Society Banner of 1821 *(Eng)* S1074
binding media—The problem of conservation of very large canvases painted in glue medium *(Pol)* S968
caves—Interventions: cleaning of walls, consolidation tests in the Black Room of the prehistoric cave of Niaux, France *(Fre)* S1119
cellulose ether—The use of cellulose ethers in the treatment of Egyptian polychromed wood *(Eng)* S1053
chests—The cleaning, conservation, and restoration of a Matyo chest *(Hun)* S1000
color field—The cleaning of Color Field paintings *(Eng)* S282
encaustic painting—The technology, examination and conservation of the Fayum portraits in the Petrie Museum *(Eng)* S965
encaustic wax—The cleaning and consolidation of Egyptian encaustic mummy portraits *(Eng)* S1088
human head—The conservation of a preserved human head *(Eng)* S935
latmul—The conservation of an orator's stool from Papua New Guinea *(Eng)* S1042
Iran—Friable pigments and ceramic surfaces: a case study from SW Iran *(Eng)* S1058
mural paintings—Conservation of central Asian wall painting fragments from the Stein Collection in the British Museum *(Eng)* S1099

367

—Conservation of wall paintings *(Eng)* S366
—Indian murals: techniques and conservation *(Eng)* S931
—Restoration of ancient monumental painting in cult buildings *(Eng)* S284
—Specific problems concerning the restoration of wall paintings at Humor *(Eng)* S1034
—Three Bodhisattvas: the conservation of a fifteenth century Chinese wall painting in the British Museum collection *(Eng)* S1051
—Wall painting conservation in Tuscany before the Florentine flood of 1966 *(Eng)* S1125
painting (technique)—Technical examination and conservation of an Indian painting *(Eng)* S904
paintings (objects)—Manual of the painter restorer *(Ita)* S5
Papua New Guinea—An ethnographic collecting expedition to Papua New Guinea: field conservation and laboratory treatment *(Eng)* S967
poly(butyl methacrylate)—New possibilities of polybutyl methacrylate as a consolidating agent for glue painting on loess plaster *(Eng)* S936
poly(vinyl alcohol)—The fixing of mural paintings with polyvinyl alcohol (Mowiol N-70-98): a restorer's experience *(Fre)* S962
rock paintings—Museum conservation of anthropological material *(Eng)* S913
shields (armor)—The conservation of some carved wooden war shields from the Tifalmin Valley, Papua New Guinea *(Eng)* S950
stone—The conservation of the Winchester Anglo-Saxon fragment *(Eng)* S1090
tempera—Examination and treatment of a tempera on canvas from the 16th century: the *Emmaus Pilgrims* from the Fine Arts Museum of Brussels *(Fre)* S981
—Problems in restoring a tempera on 19th-century paper: decoration by Ponga for the balcony of the Olympic Theatre of Piove di Sacco *(Ita)* S1081
Temple of the Paintings (Bonampak Site, Chiapas, Mexico)—Conservation and restoration of the murals of the Temple of the Paintings in Bonampak, Chiapas *(Eng)* S1037
terracotta—The treatment and examination of painted surfaces on eighteenth-century terracotta sculptures *(Eng)* S469
textiles—Painted textiles *(Eng)* S963
—Technical study and conservation of an old painted textile (Simhasana) *(Eng)* S902
Thompson—Thompson ethnobotany: knowledge and usage of plants by the Thompson Indians of British Columbia *(Eng)* S483
Tibet—Preservation of two ancient objects *(Eng)* S894
turmeric—Some conservation problems encountered with turmeric on ethnographic objects *(Eng)* S1023
verre eglomise—The deterioration and conservation of painted glass: a critical bibliography *(Eng)* S994
votive tablets—Cleaning treatment on votive tablet in traditional way *(Jpn)* S939
Vuillard, Edouard (1868-1940)—The special problems and treatment of a painting executed

in hot glue medium, "The Public Garden" by Edouard Vuillard *(Eng)* S999
wood—Conservation of polychrome wood sculpture at the Australian War Memorial *(Eng)* S944

cleavage
A case of paint cleavage *(Eng)* *acetone; alcohol; consolidation; diacetone alcohol; Italian; paint; resin; vapor; wax* S703
—A trial index of laminal disruption *(Eng)* *coatings; enamel; lacquer; marquetry* S792
consolidation—Consolidation of delaminating paintings *(Eng)* S951
Vuillard, Edouard (1868-1940)—The special problems and treatment of a painting executed in hot glue medium, "The Public Garden" by Edouard Vuillard *(Eng)* S999

climate *see also* **tropical climate**
adobe—Spectacular vernacular: the adobe tradition *(Eng)* S431
plaster—The Malpaga Castle: conservation and consolidation problems of painted plasters of the courtyard *(Ita)* S1108
reattaching—Reattaching color layers on a wooden wall and documenting the distribution of damages *(Jpn)* S1024
wallpaper—Wallpaper on walls: problems of climate and substrate *(Eng)* S982

climate control
building materials—Conservation applied to historic preservation *(Eng)* S449
frescoes—The conservation in situ of the Romanesque wall paintings of Lambach *(Eng)* S1098
Papua New Guinea—Ethnographic collections: case studies in the conservation of moisture-sensitive and fragile materials *(Eng)* S1062

coal
mural paintings—Restoration of ancient monumental painting in cult buildings *(Eng)* S284

coal tar
pigment—The history of artists' pigments *(Eng)* S135

coatings *see also* **finishes**
Anatomy of paint *(Eng)* *gloss; opacity; paint* S867
—Coloristics of grey coatings *(Eng)* *carbon black; coloring; poly(vinyl chloride); white pigment* S840
—Combining mixture and independent variables for coatings research *(Eng)* *pigment volume concentration; poly(vinyl chloride)* S848
—The contributions of pigments and extenders to organic coatings *(Eng)* *extenders; optical properties; pigment* S734
—Development and growth of resins for the coating industry *(Eng)* *beeswax; blood; egg white; gelatin; gum arabic; resin; vinyl* S340
—Development of a predictive model for the changes in roughness that occur during the painting process *(Eng)* *viscosity* S884
—Effect of certain physical and chemical properties of titanium dioxides on the optical properties of coatings *(Eng)* *chemical properties; emulsion; opacity; optical properties; paint;*

color

collage
contemporary art—Modern art: the restoration and techniques of modern paper and paints. Proceedings of a conference jointly organised by UKIC and the Museum of London, 22 May 1989 *(Eng)* S436

collagen
gas chromatography—Identification of proteinaceous binding media of easel paintings by gas chromatography of the amino acid derivatives after catalytic hydrolysis by a protonated carbon exchanger *(Eng)* S670
microscopy—Microscopical study of the Turin "Shroud," IV *(Eng)* S627
mummies—Probing the mysteries of ancient Egypt; chemical analysis of a Roman period Egyptian mummy *(Eng)* S426
rabbit-skin glue—The treatment of gilded objects with rabbit-skin glue size as consolidating adhesive *(Eng)* S1107
Shroud of Turin—Microscopical study of the Turin "Shroud." *(Eng)* S637

Colombia
varnish—Varnish of Pasto, a Colombian craft of aboriginal origin *(Spa)* S212

Colombia (Bogotá)
Inca—Mopa-mopa or Pasto varnish: the frames of the Church of Egypt, in Bogotá *(Spa)* S461

color see also **names of specific colors**
Angular color measurement on automotive materials *(Eng) colorimetry* S763
—Color and appearance characterization for the coatings industry *(Eng) coatings; colorimetry; light* S830
—Goniophotometric analysis of colored surface *(Eng) paint; reflected light* S759
—A goniospectrophotometer for color measurements *(Eng) colorimetry* S761
—Pigment volume concentration effects in color prediction and practice *(Eng) pigment volume concentration; poly(vinyl chloride); titanium dioxide* S797
architecture—The color of architectural surfaces *(Ita)* S365
artists' materials—The artist's handbook *(Eng)* S407
—The painter's craft *(Fre)* S462
Australian Aboriginal—Conservation of the Australian Museum's collection of Aboriginal bark paintings *(Eng)* S959
carboxymethylcellulose—The use of carboxymethylcellulose in the restoration of easel paintings *(Rum)* S1008
ceilings—Conservation treatments with reference to color paintings on the ceiling of the main hall, National Treasure, of Toshodaiji Temple, Nara *(Jpn)* S941
chrysocolla—On the colors of the ancients: chrysocolla *(Ita)* S185
colorimetry—Colorimetric measurements on small paint fragments using microspectrophotometry *(Eng)* S589
consolidation—Consolidation of loose paint on ethnographic wooden objects *(Ger)* S901

contemporary art—Modern art: the restoration and techniques of modern paper and paints. Proceedings of a conference jointly organised by UKIC and the Museum of London, 22 May 1989 *(Eng)* S436
Daiju-ji Temple (Japan)—Preservative treatment on the *Shoheki-ga* at the Daiju-ji *(Jpn)* S955
dye—Navajo native dyes: their preparation and use *(Eng)* S299
Egypt—The entourage of an Egyptian governor *(Eng)* S244
Egyptian—Notes on Egyptian colours *(Eng)* S16
flat paint—The effect of pigmentation on modern flat wall paints *(Eng)* S716
forensic science—Developments in paint analysis for forensic purposes *(Eng)* S639
frescoes—The frescoes of Tavant (France) *(Eng)* S179
Hopi—Hopi dyes *(Eng)* S300
illuminations—Some details on the technique and of the restoration of two illuminated 13th century manuscripts from Western Europe *(Fre)* S942
masks—Chiriquano masks: polychrome wood (treatment and inquiry) *(Eng)* S1041
Melanesian—Conservation of powdering pigment layers on Melanesian objects: choice of a fixative *(Fre)* S1039
metamerism—Geometric metamerism *(Eng)* S754
mineral pigment—Earth pigments and their colors *(Ita)* S309
mural paintings—The analysis of pigments from ancient mural paintings. The state of the problem and a bibliography *(Fre)* S343
—The Church of Lourps in Longueville: restoration of the decorated surfaces *(Fre)* S474
—Monumentales pastell—a forgotten invention in wall painting techniques about 1900 *(Eng)* S301
—Mural paintings in the Fraugde church on Funen *(Dan)* S302
—Some problems on the preservation of wall paintings using synthetic resins *(Jpn)* S892
ocher—Friable ochre surfaces: further research into the problems of colour changes associated with synthetic resin consolidation *(Eng)* S997
paint—Objective predictors of paint appeal *(Eng)* S831
paintings (objects)—Written sources about painted textiles *(Ger)* S504
Papua New Guinea—Technique and personality *(Eng)* S211
pastels (visual works)—On the technical study of thirty pastel works on paper by Jean-François Millet *(Eng)* S368
—Pastels *(Fre)* S369
—A sculpture and a pastel by Edgar Degas *(Eng)* S285
pictographs—On the pictographs of the North American Indians *(Eng)* S8
pigment—Color characteristics of artists' pigments *(Eng)* S705
—Some experiments and observations on the colours used in painting by the ancients *(Eng)* S1

371

Copper Age
gas chromatography mass spectrometry—GC/MS and chemometrics in archaeometry: investigation of glue on Copper-Age arrowheads *(Eng)* S665

copper alloy
metal—Examples of conservation of painted metal objects *(Eng)* S1093

copper carbonate
The mamzrauti: a Tusayan ceremony *(Eng) brushes; green pigment; Hopi; pigment; shale; yucca* S11
blue pigment—Identification of materials of paintings: I. Azurite and blue verditer *(Eng)* S541
dye—Aboriginal paints and dyes in Canada *(Eng)* S54
Native American—Handbook of American Indians north of Mexico *(Eng)* S25
pigment—Archaeological expedition to Arizona in 1895 *(Eng)* S17
Pueblo—Two summers' work in Pueblo ruins *(Eng)* S22

copper chloride
mural paintings—Mural paintings in the Fraugde church on Funen *(Dan)* S302

copper foil
stained glass—Field applications of stained glass conservation techniques *(Eng)* S1013

copper ore
Acoma—The Acoma Indians *(Eng)* S57

copper plate
Rudolphi, Johann Georg (1633-1693)—Johann Georg Rudolphi (1633-1693). Volume 1 *(Ger)* S584

copper resinate
binding media—Methods used for the identification of binding media in Italian paintings of the 15th and 16th centuries *(Eng)* S554

copper sulfite
dye—Keresan Indian color terms *(Eng)* S102

Coptic (Christian sect)
icons—Conservation problems in Egypt: some remarks on the technology of postmediaeval Coptic icons *(Eng)* S479

coral
calcium carbonate—Calcium carbonate whites *(Eng)* S561

corn fungus
Kachina masks—Zuni Katcinas *(Eng)* S53

corn pollen
Kachina masks—Zuni Katcinas *(Eng)* S53

cornstarch
graining—Graining: ancient and modern *(Eng)* S79

corrosion
pigment volume concentration—Pigment volume concentration and its effect on the corrosion resistance properties of organic paint films *(Eng)* S882
stained glass—A new fixation method for paint layer conservation *(Eng)* S1091

corundum
paint—Physicochemical alterations to the paint layer. 1. Results of a survey of various laboratories: apparent alterations of the paint layer and their probable causes. 2. Experimental study by the Musée du Louvre laboratory on madder varnish *(Fre)* S753

cosmetics
kohl—Analysis of materials contained in mid-4th to early 7th-century A.D. Palestinian kohl tubes *(Eng)* S497

costume
gouache—Conservation of costume designs for Broadway musicals, 1900-1925: from the drama collection, Austrian National Library, Vienna *(Ger)* S1067
Irian Jaya—A support system for flexible palm spathe objects *(Eng)* S517

cotton
Neuen Wilden—The "fast" paintings of the Neuen Wilden *(Ger)* S358
textiles—Technical study and conservation of an old painted textile (Simhasana) *(Eng)* S902

Courbet, Gustave (1819-1877)
charcoal—Tonal drawing and the use of charcoal in nineteenth century France *(Eng)* S468

cracking
Crack mechanisms in gilding *(Eng) adhesives; drying; gesso; gilding; mechanical properties; shrinkage; wood* S874
—Cracking on paintings *(Ger) additives; paintings (objects); panels; softwood; varnish; wood* S718
—Defects with old paint surfaces: occurrence, causes and remedies *(Ger) flaking; paint; resin* S789
adhesives—The treatment of cracks in canvas paintings with synthetic adhesives: procedures and possible combinations with the lining process *(Eng)* S1092
Africa—Personality and technique of African sculptors *(Eng)* S208
coatings—Studies of film formation in latex coatings *(Eng)* S804
contemporary art—Conservation of contemporary art *(Eng)* S736
illuminations—The conservation of a Petrarch manuscript *(Eng)* S910
majolica—Experiments on the consolidation of glazes on majolica and glass tesserae from mosaics *(Ita)* S1106
mechanical properties—Mechanical properties of weathered paint films *(Eng)* S851
painting (technique)—Physics and painting: introduction to the study of physical phenomena applied to painting and painting techniques *(Dut)* S707
panel paintings—Basic experiments concerning deterioration of glue and discoloration of pigments, and discussion on the actual condition of wall panel paintings on the basis of their results *(Jpn)* S930
—Present state of screen and panel paintings in Kyoto *(Jpn)* S933
Tibet—Preservation of two ancient objects *(Eng)* S894

crackle
Vuillard, Edouard (1868-1940)—A technical and stylistic analysis of detrempe painting on cardboard by Edouard Vuillard *(Eng)* S1014

craquelure
Craquelures *(Fre)* **pigment** S817

crayons
drawing (technique)—The craft of old-master drawings *(Eng)* S182
fixatives—Determination of the influence of Rowney's "Perfix" fixative on the properties of paper *(Pol)* S925

creosote
Notes on creosote lac scale insect resin as a mastic and sealant in the Southwestern Great Basin *(Eng)* **insects; mastic; Native American; resin; sealing compounds; USA (Great Basin); wax** S481
Mojave—Mohave tatooing and face-painting *(Eng)* S116
plants—Gathering the desert *(Eng)* S378
Seri—People of the desert and sea: ethnobotany of the Seri Indians *(Eng)* S376

cross sections
encaustic painting—The technology, examination and conservation of the Fayum portraits in the Petrie Museum *(Eng)* S965
fluorescence microscopy—Ultraviolet fluorescence microscopy of paint cross sections: cycloheptaamylose-dansyl chloride complex as a protein-selective stain *(Eng)* S671
infrared spectrometry—Methods in scientific examination of works of art: infrared microspectroscopy *(Eng)* S664
microscopy—The use of direct reactive fluorescent dyes for the characterization of binding media in cross sectional examinations *(Eng)* S635
polyester—Embedding paint cross section samples in polyester resins: problems and solutions *(Eng)* S679
reference materials—Second report on reference materials incorporating special reports by members of the working group: ICOM Committee for Conservation, Madrid, 2-7 October, 1972 *(Eng)* S557

crystallography
Romano-British—An analysis of paints used in Roman Britain *(Eng)* S213

cultivation
turmeric—Advances in the agronomy and production of turmeric in India *(Eng)* S379

cumengeite
mural paintings—The investigation of pigments and paint layer structures of mural paintings at Maitepnimit Temple *(Eng)* S477

cuprous oxide
red pigment—Red pigments of antiquity *(Fre)* S114

Curcuma longa
Carib—Plants used by the Dominica Caribs *(Eng)* S98
Polynesian—Traditional use of *Curcuma longa* (Zingiberaceae) in Rotuma *(Eng)* S518

cypress
adhesives—Re-attaching a thick color layer of polychrome sculpture. Conservation of a seated figure of Rev. Tenkai *(Jpn)* S1075
fixatives—Fixing agent for chalking color on wood and its laboratory evaluation *(Jpn + Eng)* S1040
icons—The technique of icon painting *(Eng)* S214

Czechoslovakia (Prague)
Technical parallels between panel and wall painting of the 14th century *(Cze)* **binding media; Emaus Monastery (Czechoslovakia); gilding; Medieval; mural paintings; ocher; panel paintings; pigment; Saint Vitus Cathedral (Prague, Czechoslovakia); underdrawing** S353

Daiju-ji Temple (Japan)
Preservative treatment on the *Shoheki-ga* at the Daiju-ji *(Jpn)* **acrylic resin; adhesion; color; flaking; mural paintings; paintings (objects); paper; peeling; pigment; poly(vinyl alcohol); screens (doors); Tamechika, Reizei (1823-1864)** S955

dammar
illuminations—Practice and practical possibilities in the conservation of Medieval miniatures *(Ger)* S969
—Some tests on the use of wax for fixing flaking paint on illuminated parchment *(Eng)* S898
infrared absorption—Dammar and mastic infrared analysis *(Eng)* S528
mural paintings—Ajanta murals: their composition and technique and preservation *(Eng)* S232
pyrolysis gas chromatography—The identification of dammar, mastic, sandarac and copals by pyrolysis gas chromatography *(Eng)* S638
varnish—Factors affecting the appearance of picture varnish *(Eng)* S721
—The influence of light on the gloss of matt varnishes *(Eng)* S782
verre eglomise—Eglomise: technique and conservation *(Ger)* S1059

darkening
chalk—Observations about conservation techniques regarding the consolidation of waterbound chalk paint layers *(Ger)* S1077
consolidation—Consolidation of porous paint in a vapor-saturated atmosphere: a technique for minimizing changes in the appearance of powdering, matte paint *(Eng)* S1120
—Investigations into techniques for the consolidation of high pigment volume concentration paint at the Getty Conservation Institute *(Eng)* S1084
illuminations—The conservation of a Petrarch manuscript *(Eng)* S910
pastels (visual works)—Analysis and conservation of graphic and sound documents: work by the Centre de Recherches sur la Conservation des Documents Graphiques, 1982-1983 *(Fre)* S1004
—Pastels *(Fre)* S369
wood—Investigation into methods and materials for the adhesion of flaking paint on ethnographic objects: a progress report *(Eng)* S1045

darkness
pigment volume concentration—The effect on pigment volume concentration on the lightness or darkness of porous paints *(Eng)* S810

databases
Introduction to TINCL: a database system for art technological sources *(Eng) artists' materials; bibliographies; Central Research Laboratory (Amsterdam, Netherlands); history of technology* S672
bibliographies—An interdisciplinary bibliographic approach to a complex conservation problem: the consolidation of matte paint *(Eng)* S1121
mural paintings—Products, facts, modes in mural painting: evolution and distribution of restoration products used in mural paintings from 1850 to 1992: a first sorting concerning France, Spain, England, and Poland *(Fre)* S511
Native American—CCI Native Materials Project: final report *(Eng)* S473

datil
ethnobotany—Ethnobotany of the Zuñi Indians *(Eng)* S27

dating *see also* **types of dating, e.g., dendrochronology, radiocarbon dating**
Australian Aboriginal—Ancient artists painted with human blood *(Eng)* S458
frescoes—The conservation in situ of the Romanesque wall paintings of Lambach *(Eng)* S1098
pre-Columbian—Dating precolumbian museum objects *(Eng)* S1115
rock paintings—Perspectives and potentials for absolute dating prehistoric rock paintings *(Eng)* S523
tools—Potential applications of the organic residues on ancient tools *(Eng)* S624

Davies, Arthur Bowen (1862-1928)
pastels (crayons)—American pastels of the late nineteenth & early twentieth centuries: materials and techniques *(Eng)* S442

Davy, Humphry (1778-1829)
pigment—Some experiments and observations on the colours used in painting by the ancients *(Eng)* S1

de Kooning, Willem (b. 1904)
De Kooning: "I see the canvas and I begin." *(Eng) artists' materials; binding media; canvas; kerosene; mayonnaise; oil paint; paint; safflower oil* S304

deacidification
gouache—Conservation of costume designs for Broadway musicals, 1900-1925: from the drama collection, Austrian National Library, Vienna *(Ger)* S1067
—Restoration of three miniature paintings with a problem of colour change *(Eng)* S1057
paper—Conservation of some non-book material in National Library, Calcutta *(Eng)* S1026
textiles—Technical study and conservation of an old painted textile (Simhasana) *(Eng)* S902

decoration
Investigations and preliminary probes *(Fre) archival collections; France; historic buildings; polychromy* S1089
mural paintings—The Church of Lourps in Longueville: restoration of the decorated surfaces *(Fre)* S474
—The paintings on walls and ceilings in the cabinets of the gallery building at Hannover-Herrenhausen *(Ger)* S1070
—Reproduction of colored patterns in temples and shrines *(Eng)* S383
—The restoration of 18th-century decorative wall paintings imitating wallhangings in Hungary *(Ger)* S321
—Study and conservation of quadratura decoration on the vaults of 17th-century French buildings *(Fre)* S470
—A survey of the painted mud *Viharas* of Sri Lanka *(Eng)* S351
painting (technique)—The confirmation of literary sources on art technology through scientific examination *(Ger)* S323
plasterwork—The restoration of facade plasterwork in Italy *(Fre)* S472
polychromy—Problems of the interpretation of historical sources and their confirmation by the results of technical analysis on works of art, shown on the example of painted sculptures from the 18th century in southern Germany *(Ger)* S322
pueblos (housing complexes)—A study of Pueblo architecture: Tusayan and Cibola *(Eng)* S9
tempera—Problems in restoring a tempera on 19th-century paper: decoration by Ponga for the balcony of the Olympic Theatre of Piove di Sacco *(Ita)* S1081

deer
Mojave—Mohave tatooing and face-painting *(Eng)* S116
Native American—Indian rawhide: an American folk art *(Eng)* S280
rock paintings—Petroglyphs and pictographs on the British Columbia coast *(Eng)* S95

Degas, Hilaire Germain Edgar (1834-1917)
Edgar Degas in the collection of the Art Institute of Chicago: examination of selected pastels *(Eng) Art Institute of Chicago (Chicago, IL, USA); pastels (visual works)* S1029
pastels (visual works)—Degas pastel research project: a progress report *(Eng)* S393
—Degas pastels *(Eng)* S419
—A sculpture and a pastel by Edgar Degas *(Eng)* S285

delamination
Detection of delaminations in art objects using air-coupled ultrasound *(Eng) animal glue; chalk; gesso; hide; ultrasound* S880
adhesion—A quantitative method for determining the adhesion of coatings to plastics *(Eng)* S881
Rothko, Mark (1903-1970)—Mark Rothko's Harvard murals *(Eng)* S413

Vuillard, Edouard (1868-1940)—The distemper technique of Edouard Vuillard *(Eng)* S275
—History, analysis and treatment of "La salle à manger au château de Clayes," 1938, by Edouard Vuillard *(Eng)* S1009
—A technical and stylistic analysis of detrempe painting on cardboard by Edouard Vuillard *(Eng)* S1014

distilled water
casein—Studio talk: improvement in tubed casein. Interview with Ted Davis *(Eng)* S171

Dix, Otto (1891-1969)
Studies on the painting technique of Otto Dix during the period 1933-1969 *(Ger) drawings; pigment; tempera* S430

dolomite
opacity—On the wet and dry opacity of paints *(Eng)* S722

Dominica
The ethnobotany of the island Caribs of Dominica *(Eng) dye; ethnobotany; oil; pigment; tannin; turmeric* S177
Carib—Plants used by the Dominica Caribs *(Eng)* S98

Douglas fir
Bella Coola—Materia medica of the Bella Coola and neighbouring tribes of British Columbia *(Eng)* S48

dragon's blood
dye—Rosewood, dragon's blood and lac *(Eng)* S181
pyrolysis gas chromatography—Analysis of natural resins by pyrolysis gas chromatography. II. Identification of natural resins by pyrograms *(Jpn)* S560
red pigment—Reds *(Ita)* S397

drawing (technique)
The craft of old-master drawings *(Eng) bistre; carbon black; chalk; charcoal; chiaroscuro; crayons; graphite; ink; iron gall ink; pastels (visual works); sepia; washes* S182
—Drawing techniques: their evolution in different European schools *(Fre) charcoal; colorants; European; paper; pastels (visual works); watercolors* S128
artists' materials—The artist's handbook *(Eng)* S407

drawings
Charcoal, chalk and pastel drawings: special problems for collectors, Part 1 *(Eng) chalk; charcoal; pastels (crayons)* S310
—Charcoal, chalk and pastel drawings: special problems for collectors, Part 2 *(Eng) chalk; charcoal; pastels (crayons)* S311
—Techniques and subsequent deterioration of drawings *(Eng) chalk; charcoal; graphite; ink; metal points; watercolors* S312
artists' materials—The painter's craft *(Fre)* S462
caves—Interventions: cleaning of walls, consolidation tests in the Black Room of the prehistoric cave of Niaux, France *(Fre)* S1119
charcoal—Tonal drawing and the use of charcoal in nineteenth century France *(Eng)* S468
—The uses of charcoal in drawing *(Eng)* S317

Dix, Otto (1891-1969)—Studies on the painting technique of Otto Dix during the period 1933-1969 *(Ger)* S430
fixatives—Determination of the influence of Rowney's "Perfix" fixative on the properties of paper *(Pol)* S925
—Experimental studies on fixatives for powdery traces *(Fre)* S1012
gouache—Conservation of costume designs for Broadway musicals, 1900-1925: from the drama collection, Austrian National Library, Vienna *(Ger)* S1067
pastels (visual works)—History, technology and conservation of dry media *(Eng)* S1018
—A portrait of Master Sahl (1683-1753). Particularities of a pastel restoration *(Ger)* S993
—A sculpture and a pastel by Edgar Degas *(Eng)* S285
Ruscha, Edward Joseph (b. 1937)—Pastel, juice and gunpowder: the Pico iconography of Ed Ruscha *(Eng)* S337
Rwanda—Colors and drawings in Rwanda *(Fre)* S158

drying
cracking—Crack mechanisms in gilding *(Eng)* S874
gloss—Gloss of paint films and the mechanism of pigment involvement *(Eng)* S872
latex paint—Changes in hiding during latex film formation. Part II. Particle size and pigment packing effects *(Eng)* S871
polymers—The mechanism of polymer migration in porous stones *(Eng)* S1047
Tibet—Preservation of two ancient objects *(Eng)* S894

drying oil
bark cloth—The analysis and identification of oils in Hawaiian oiled tapa *(Eng)* S629
binding media—The problem of the binding medium particularly in wall painting *(Eng)* S534
Bushman paint—A possible base for "Bushman" paint *(Eng)* S66
consolidation—Consolidation of delaminating paintings *(Eng)* S951
fat—Aje or Ni-in (the fat of a scale insect): painting medium and unguent *(Eng)* S216
fatty acid—The gas chromatographic examination of paint media. Part I. Fatty acid composition and identification of dried oil films *(Eng)* S542
fixing—Theoretical approach to refixing *(Fre)* S1017
gas chromatography—The application of gas chromatography in the investigation of works of art *(Eng)* S538
ground (material)—The ground in pictures *(Eng)* S241
linseed oil—Critical pigment volume concentration in linseed oil films *(Eng)* S760
painting (technique)—Greek and Roman methods of painting: some comments on the statements made by Pliny and Vitruvius about wall and panel painting *(Eng)* S29
paintings (objects)—Analysis of paint media, varnishes and adhesives *(Eng)* S625

dye

Ojibwa—Ethnobotany of the Ojibwa Indians *(Eng)* S56
organic chemistry—The organic chemistry of museum objects *(Eng)* S633
painting (technique)—Artifacts: an introduction to early materials and technology *(Eng)* S215
Peru—An analytical study of pre-Inca pigments, dyes and fibers *(Eng)* S571
—Peruvian natural dye plants *(Eng)* S429
pigment—Domestic implements, arts, and manufactures *(Eng)* S23
—Ethnology of Futuna *(Eng)* S67
plants—The ocean-going *noni*, or Indian mulberry *(Morinda citrifolia, Rubiaceae)* and some of its "colorful" relatives *(Eng)* S502
—On the history and migration of textile and tinctorial plants in reference to ethnology *(Eng)* S6
—Plants for man *(Eng)* S159
—Plants used by the Indians of Mendocino County, California *(Eng)* S21
—Plants used by the Indians of the United States *(Eng)* S7
—The useful plants of west tropical Africa *(Eng)* S374
Potawatomi—Ethnobotany of the forest Potawatomi Indians *(Eng)* S61
red ocher—Red ochre and human evolution: a case for discussion *(Eng)* S325
ritual objects—Eshu-Elegba: the Yoruba trickster god *(Eng)* S292
Seri—People of the desert and sea: ethnobotany of the Seri Indians *(Eng)* S376
shadow puppets—Restoration of Chinese and Indonesian shadow puppets *(Eng)* S1011
tapa—Ancient Hawaiian tapa dyes for coloring paper *(Eng)* S335
—Hawaiian life of the pre-European period *(Eng)* S89
tapestries—The restoration of painted tapestry and its problems *(Ger)* S1112
thin layer chromatography—Analysis of thin-layer chromatograms of paint pigments and dyes by direct microspectrophotometry *(Eng)* S620
—Thin layer chromatography: an aid for the analysis of binding materials and natural dyestuffs from works of art *(Eng)* S559
Thompson—Ethnobotany of the Thompson Indians of British Columbia, based on field notes by James A. Teit *(Eng)* S45
—Thompson ethnobotany: knowledge and usage of plants by the Thompson Indians of British Columbia *(Eng)* S483
turmeric—Some conservation problems encountered with turmeric on ethnographic objects *(Eng)* S1023
x-ray diffraction—Nondestructive infrared and x-ray diffraction analyses of paints and plastics *(Eng)* S532
yellow pigment—Yellow pigments used in antiquity *(Fre)* S113
Yoruba—Yoruba pattern dyeing *(Eng)* S80

dyeing
A bibliography of dyeing and textile printing comprising a list of books from the 16th century to the present time (1946) *(Eng) France;*

Germany; Great Britain; India; printing; Russia; USA S129
bark cloth—Samoan material culture *(Eng)* S50
Native American—Indian life on the northwest coast of North America, as seen by the early explorers and fur traders during the last decades of the 18th century *(Eng)* S266
painting (technique)—Original treatises on the arts of painting *(Eng + Lat)* S234

dyewood
Dyewoods, their composition and use. Part 1: Description of the most important dyewoods *(Ger) brazilwood; caliatour wood; camwood; dye; fisetin; logwood; Narra; redwood; sapponwood; sibukai; wood; yellow wood dye* S204
—Dyewoods, their composition and use. Part 2: Wood dyes and their fields of application *(Ger) dye; fisetin; logwood; redwood dye; synthetic dye; wood; yellow wood dye* S205

eagle feather
Native American—American Indian painting of the Southwest and Plains areas *(Eng)* S239

Early American *see* American Colonial

earthquakes
ceilings—The restoration of the wooden painted ceiling in the "Confraternità del Rosario," SS. Filippo and Giacomo Church, Ospedaletto d'Alpinolo *(Ita)* S1096

easel paintings
carboxymethylcellulose—The use of carboxymethylcellulose in the restoration of easel paintings *(Rum)* S1008
gas chromatography—Identification of proteinaceous binding media of easel paintings by gas chromatography of the amino acid derivatives after catalytic hydrolysis by a protonated carbon exchanger *(Eng)* S670
oil paintings—Development and materials of easel painting *(Ger)* S42

ebony
Egypt—The entourage of an Egyptian governor *(Eng)* S244

Edo period
reattaching—Reattaching thick color layer of polychrome wooden sculpture *(Jpn)* S1022

EDTA *see* ethylenediaminetetraacetic acid

egg
Acoma—The Acoma Indians *(Eng)* S57
Australian Aboriginal—Bark paintings: techniques and conservation *(Eng)* S443
binding media—Binding media identification in painted ethnographic objects *(Eng)* S675
Chumash—The rock paintings of the Chumash: a study of a California Indian culture *(Eng)* S513
gas chromatography—Identification of proteinaceous binding media of easel paintings by gas chromatography of the amino acid derivatives after catalytic hydrolysis by a protonated carbon exchanger *(Eng)* S670
mass spectrometry—Organic mass spectrometry of art materials: work in progress *(Eng)* S607

Ellora Site (India)
mural paintings—Ajanta and Ellora wall paintings. Scientific research as an aid to their conservation *(Eng)* S569

Elu
dye—Colors for textiles: ancient and modern *(Eng)* S109
Yoruba—Yoruba pattern dyeing *(Eng)* S80

Elvacite 2044
wood—The restoration of the wooden statue of Our Lady in the parish church of Cercina *(Ita)* S1078

Elvamide 8061
Plexigum P24—A study of Plexigum P24 used as a fixative for flaking paint traces *(Fre)* S1043

Emaus Monastery (Czechoslovakia)
Czechoslovakia (Prague)—Technical parallels between panel and wall painting of the 14th century *(Cze)* S353

embalming
mummies—Probing the mysteries of ancient Egypt; chemical analysis of a Roman period Egyptian mummy *(Eng)* S673

embedding
polyester—Embedding paint cross section samples in polyester resins: problems and solutions *(Eng)* S679

emerald green
forgeries—The technical investigation and conservation treatment of an alleged Ming Dynasty wall painting *(Eng)* S956

emission spectrometry
Australian Aboriginal—Pigment analysis for the authentication of the aboriginal paintings at Bunjils Cave, western Victoria *(Eng)* S632
blue pigment—Identification of materials of paintings: I. Azurite and blue verditer *(Eng)* S541

emulsion
acrylic resin—The identification and characterization of acrylic emulsion paint media *(Eng)* S666
American Society for Testing and Materials (USA)—The colourful twentieth century *(Eng)* S434
binding media—The importance of binders *(Fre)* S225
coatings—Effect of certain physical and chemical properties of titanium dioxides on the optical properties of coatings *(Eng)* S821
—Water thinnable coatings, a symposium *(Eng)* S726
ground (material)—The ground in pictures *(Eng)* S241
latex paint—History of water-thinned paints *(Eng)* S163
Nagoya Castle (Nagoya, Japan)—Study on the repair technique of polychrome paintings drawn on sliding screens in the Nagoya Castle *(Jpn)* S945
Neuen Wilden—The "fast" paintings of the Neuen Wilden *(Ger)* S358
oil paintings—The technique of the great painters *(Eng)* S127

opacity—Latex paint opacity: a complex effect *(Eng)* S765
paint—The comparisons of two-component extender systems in emulsion paint *(Eng)* S730
—Method to follow the degradation by natural weathering of emulsion paint films *(Ger)* S829
—The painter's methods and materials *(Eng)* S196
panel paintings—Methods of egg-tempera panel painting conservation employed in the State Hermitage *(Eng)* S986
pigment volume concentration—Influence of pigments on properties of emulsion paints *(Ger)* S870
—Statistical model for emulsion paint above the critical PVC *(Eng)* S833
varnish—On picture varnishes and their solvents *(Eng)* S832
watercolors—The structure of watercolor films with a high PVC *(Ita)* S820
wood—Investigation into methods and materials for the adhesion of flaking paint on ethnographic objects: a progress report *(Eng)* S1045
—Studies on fixing treatments of color paintings on the ceiling of Sanmon Gate, National Treasure, Tofuku-ji Temple *(Jpn)* S940

enamel
cleavage—A trial index of laminal disruption *(Eng)* S792
contemporary art—Interview with Joel Shapiro *(Eng)* S460
extenders—Relative flatting efficiency of extenders and effect of these extenders on sheen uniformity, color uniformity, suction spotting, and enamel hold-out in solvent systems *(Eng)* S731
—Size and shape properties of representative white hiding and extender pigments *(Eng)* S727
finishes—Fundamentals of formulation of interior architectural finishes *(Eng)* S724
flat paint—The effect of pigmentation on modern flat wall paints *(Eng)* S716
icons—The technique of icon painting *(Eng)* S214
latex paint—The effect of extenders on the optical properties of air drying alkymul and styrene-butadiene latex paints *(Eng)* S728
paint—The comparisons of two-component extender systems in emulsion paint *(Eng)* S730

encapsulation
Parylene—The application of Parylene conformal coating to archival and artifact conservation *(Eng)* S1005

encaustic painting
The technology, examination and conservation of the Fayum portraits in the Petrie Museum *(Eng) binding media; cleaning; cross sections; Egypt (Faiyûm Oasis); pigment; portraits; priming; samples; stabilizing; wood* S965
history of conservation—Complete guide for the restoration of oil, wax, tempera, watercolor, miniature, and pastel paintings, together with instructions for preparing excellent varnishes for paintings, bas-reliefs and plaster casts, dried insects and plants, prints and maps, as well as the cleaning, bleaching,

mounting, and framing of copper engravings, lithographs, and woodcuts; for the art lover, painter, bronzer, decorator, etc. *(Ger)* S3
pigment—Pigments and paints in classical antiquity *(Fre)* S200

encaustic wax
The cleaning and consolidation of Egyptian encaustic mummy portraits *(Eng) aliphatic hydrocarbons; cleaning; Egypt (Hawara); excavations; heat; mummies; paint; paper; Paraloid B-72; poly(ethylene glycol); portraits; Roman; scalpel; soap; softening; solubility; solvents; water; wax; wood* S1088

England
frescoes—19th and early 20th century restorations of English Mediaeval wall paintings: problems and solutions *(Eng)* S1116
mural paintings—Conservation of English Medieval wallpaintings over the century *(Eng)* S1028
—Early Medieval wall painting and painted sculpture in England: based on the proceedings of a symposium at the Courtauld Institute of Art, February 1985 *(Eng)* S459
—Products, facts, modes in mural painting: evolution and distribution of restoration products used in mural paintings from 1850 to 1992: a first sorting concerning France, Spain, England, and Poland *(Fre)* S511
—The use of wax and wax-resin preservatives on English Medieval wall paintings: rationale and consequences *(Eng)* S388

England (St. Albans)
mural paintings—Workshop practices and identification of hands: Gothic wall paintings at St Albans *(Eng)* S514

England (Winchester)
stone—The conservation of the Winchester Anglo-Saxon fragment *(Eng)* S1090

enzymes
screens (doors)—Treatment on painting of sliding screens and wall panels to prevent exfoliation in Japan *(Eng)* S972

epoxy
Australian Aboriginal—Conservation of the Australian Museum's collection of Aboriginal bark paintings *(Eng)* S959
stained glass—Field applications of stained glass conservation techniques *(Eng)* S1013
wood—Consolidation of deteriorated wooden artifacts *(Eng)* S961

epoxy resin
adhesives—The evaluation of some adhesive systems utilized in the consolidation of paintings. The kinetics of consolidation (III) *(Rum)* S1021
consolidation—A review of problems encountered in the consolidation of paint on ethnographic wood objects and potential remedies *(Eng)* S1085
synthetic resin—Restoration with synthetic resins in Japan *(Ger)* S966

erosion
titanium dioxide—The durability of paint films containing titanium dioxide—contraction, erosion and clear layer theories *(Eng)* S809

Eskimo
Ethnological results of the Point Barrow expedition *(Eng) green pigment; painting; pigment; red ocher; saliva; wood* S13
—A Western Eskimo ethnobotany *(Eng) ethnobotany; plants* S180

esters
gas chromatography—Analysis of organic residues of archaeological origin by high-temperature gas chromatography and gas chromatography-mass spectrometry *(Eng)* S654

ethnobotany
Bibliography of American archaeological plant remains *(Eng) archaeological sites; bibliographies; Paleolithic; plant materials; USA* S228
—Bibliography of American archaeological plant remains (II) *(Eng) Americas; archaeology; bibliographies; plants* S455
—Ethnobotany of the Fort Yukon Region, Alaska *(Eng) Gwich'in; medicine; plants; USA (Alaska—Fort Yukon)* S464
—Ethnobotany of the Tewa Indians *(Eng) pigment; yucca* S33
—Ethnobotany of the Zuñi Indians *(Eng) banana yucca; datil; dye; fruit; mastication; Native American; ocher; yellow; yucca; Zuni* S27
—Harold L. Lyon Arboretum lecture no. 5 *(Eng) fiber; Hawaiian; plants* S288
—An introductory study of the arts, crafts, and customs of the Guiana Indians *(Eng) French Guiana; gum; Guyana; Native American; oil; pigment; rubber; Surinam; wax* S34
—Plants for people *(Eng) colorants; plants* S471
—Uses of plants by the Indians of the Missouri River region *(Eng) colorants; dye; Missouri River; Native American* S32
Anacardiaceae—A most useful plant family, the Anacardiaceae *(Eng)* S71
anthropology—Systematic research collections in anthropology: an irreplaceable national resource. A report of a conference sponsored by the Council for Museum Anthropology *(Eng)* S297
Australian Aboriginal—Food: its search, capture, and preparation *(Eng)* S20
Cherokee—An early Cherokee ethnobotanical note *(Eng)* S118
Chippewa—Uses of plants by the Chippewa Indians *(Eng)* S41
Chumash—Ethnobotany of Chumash Indians, California, based on collections by John P. Harrington *(Eng)* S482
conifers—Ethnobotany of coniferous trees in Thompson and Lillooet Interior Salish of British Columbia *(Eng + Fre)* S426
Dominica—The ethnobotany of the island Caribs of Dominica *(Eng)* S177
Eskimo—A Western Eskimo ethnobotany *(Eng)* S180
Kiowa—The economic botany of the Kiowa Indians as it relates to the history of the tribe *(Eng)* S341

pigment—Exposure evaluation: quantification of changes in appearance of pigmented materials *(Eng)* S790
reflectance—The use of differential spectral analysis in the study of museum objects *(Eng)* S744
rock art—The recording of rock art: an illustrated paper presented to the Canadian Conservation Institute trainees and to the Course in the Conservation of Historic Monuments and Sites, Restoration Services Division, Engineering and Architecture Branch, D.I.N.A. *(Eng)* S283
Rothko, Mark (1903-1970)—Mark Rothko's Harvard murals *(Eng)* S413
—Mark Rothko's Harvard murals are irreparably faded by sun *(Eng)* S418
Vuillard, Edouard (1868-1940)—History, analysis and treatment of "La salle à manger au château de Clayes," 1938, by Edouard Vuillard *(Eng)* S1009

faience
majolica—Experiments on the consolidation of glazes on majolica and glass tesserae from mosaics *(Ita)* S1106

fast atom bombardment
mummies—Probing the mysteries of ancient Egypt: chemical analysis of a Roman period Egyptian mummy *(Eng)* S673

fat *see also* **varieties of animal fat, e.g., deer fat, iguana fat, etc.**
Aje or Ni-in (the fat of a scale insect): painting medium and unguent *(Eng)* **colorants; drying oil; insects; linseed oil; Llaveia axin** S216
animal glue—The significance of fat in animal glue for painting purposes *(Ger)* S628
Australian Aboriginal—An identification method for fat and/or oil binding media used on Australian Aboriginal objects *(Eng)* S680
Blackfoot—Material culture of the Blackfoot Indians *(Eng)* S30
—Painted tipis and picture-writing of the Blackfoot Indians *(Eng)* S69
Chumash—The rock paintings of the Chumash: a study of a California Indian culture *(Eng)* S513
Egypt—Ancient Egyptian materials and industries *(Eng)* S63
gas chromatography—Gas chromatographic identification of a resinous deposit from a 6th century storage jar and its possible identification *(Eng)* S608
—Organic analysis in the examination of museum objects *(Eng)* S621
Mexico (Baja California)—Face and body painting in Baja California: a summary *(Eng)* S273
Mojave—Mohave tatooing and face-painting *(Eng)* S116
mural paintings—The earliest known paints *(Eng)* S153
—Materials and techniques of Medieval wall paintings from the former House of Merchants' Fraternity at 5 Żeglarska Street in Toruń *(Pol)* S485
Native American—American Indian painting of the Southwest and Plains areas *(Eng)* S239

—What did they use for paint? *(Eng)* S236
organic chemistry—The organic chemistry of museum objects *(Eng)* S633
pigment—Domestic implements, arts, and manufactures *(Eng)* S23
plants—Plants for man *(Eng)* S159
prehistoric—Pigments and paints in prehistoric antiquity *(Fre)* S191
rock art—The ancients knew their paints *(Eng)* S249
—The prehistoric artist of Southern Matabeleland; his materials and technique as a basis for dating *(Eng)* S175
—The recording of rock art: an illustrated paper presented to the Canadian Conservation Institute trainees and to the Course in the Conservation of Historic Monuments and Sites, Restoration Services Division, Engineering and Architecture Branch, D.I.N.A. *(Eng)* S283
Thompson—Ethnobotany of the Thompson Indians of British Columbia, based on field notes by James A. Teit *(Eng)* S45

fatty acid
Fatty acid composition of 20 lesser-known Western Australian seed oils *(Eng) Australia; chromatography; gas chromatography; liquid chromatography; oil; plant materials; thin layer chromatography* S676
—The gas chromatographic examination of paint media. Part I. Fatty acid composition and identification of dried oil films *(Eng) binding media; chromatography; drying oil; gas chromatography; triglycerides* S542
animal glue—Manufacturing and analyzing ancient animal glues *(Swe)* S651
—The significance of fat in animal glue for painting purposes *(Ger)* S628
binding media—Analyses of paint media *(Eng)* S587
dye—Colors for textiles: ancient and modern *(Eng)* S109
gas chromatography—Analysis of organic residues of archaeological origin by high-temperature gas chromatography and gas chromatography-mass spectrometry *(Eng)* S654
—The gas chromatographic examination of paint media. Some examples of medium identification in paintings by fatty acid analysis *(Eng)* S573
—The gas-chromatographic examination of paint media. Part II. Some examples of medium identification in paintings by fatty acid analysis *(Eng)* S558
gas chromatography mass spectrometry—Rapid identification of binding media in paintings using simultaneous pyrolysis methylation gas chromatography *(Eng)* S668
paintings (objects)—Analysis of paint media, varnishes and adhesives *(Eng)* S625
pyrolysis gas chromatography—The potential of pyrolysis-gas chromatography/mass spectrometry in the recognition of ancient painting media *(Eng)* S678
thin layer chromatography—Thin-layer chromatography of resin acid methyl esters *(Eng)* S536

fausonga

bark cloth—Samoan material culture *(Eng)* S50

feather
Australian Aboriginal—Ethnological studies among the northwest-central Queensland Aborigines *(Eng)* S19
Egypt—Ancient Egyptian materials and industries *(Eng)* S63
Hopi—Hopi journal of Alexander M. Stephen *(Eng)* S70
Irian Jaya—A support system for flexible palm spathe objects *(Eng)* S517
pre-Columbian—Dating precolumbian museum objects *(Eng)* S1115
tools—Potential applications of the organic residues on ancient tools *(Eng)* S624

fern
New Guinea—Wow-Ipits: eight Asmat woodcarvers of New Guinea *(Eng)* S231

fiber *see also* **synthetic fiber**
An instrumental technique for assessing the transparency of melt-spun fibers *(Eng) transparency* S801
Cook, James (1728-1779)—The journals of Captain James Cook on his voyages of discovery *(Eng)* S414
ethnobotany—Harold L. Lyon Arboretum lecture no. 5 *(Eng)* S288
forgeries—The technical investigation and conservation treatment of an alleged Ming Dynasty wall painting *(Eng)* S956
human head—The conservation of a preserved human head *(Eng)* S935
microscopy—Microscopical study of the Turin "Shroud," IV *(Eng)* S627
mummies—Probing the mysteries of ancient Egypt: chemical analysis of a Roman period Egyptian mummy *(Eng)* S673
organic chemistry—The organic chemistry of museum objects *(Eng)* S633
textiles—Technical study and conservation of an old painted textile (Simhasana) *(Eng)* S902
Vuillard, Edouard (1868-1940)—History, analysis and treatment of "La salle à manger au château de Clayes," 1938, by Edouard Vuillard *(Eng)* S1009

field archaeology
A conservation manual for the field archaeologist *(Eng) archaeological conservation; excavations; handling; in situ conservation; lifting; manuals; packing; storage* S1044

fig
house paint—House paints in Colonial America: their materials, manufacture and application. Part III *(Eng)* S230

fig tree juice
pigment—Facts about processes, pigments and vehicles: a manual for art students *(Eng)* S15

fillers
latex paint—CPVC as point of phase inversion in latex paints *(Eng)* S866
mural paintings—Restoration of ancient monumental painting in cult buildings *(Eng)* S284

Native American—CCI Native Materials Project: final report *(Eng)* S473
pigment volume concentration—CPVC as point of phase inversion in latex paints *(Eng)* S879
—Influence of pigments on properties of emulsion paints *(Ger)* S870
white pigment—White pigments in ancient painting *(Ita)* S203

filling
miniatures (paintings)—Application of traditional Indian techniques in the treatment of a Bundi miniature *(Eng)* S324
Tibet—Preservation of two ancient objects *(Eng)* S894
wood—Consolidation of deteriorated wooden artifacts *(Eng)* S961
—Wood documentation. VII: wood conservation and surface treatment. Volume 2: surface treatment *(Fre)* S897

filter paper
parchment—The conservation methods for miniature-painting on parchment *(Eng)* S920

finishes *see also* **coatings**
Coating formulation: its effects on the durability of exterior wood finishes *(Eng) coatings; pigment volume concentration; redwood; wood* S808
—Fundamentals of formulation of interior architectural finishes *(Eng) enamel; pigment; solvents* S724
Fourier transform infrared spectroscopy—Fourier transform infrared spectral analysis of natural resins used in furniture finishes *(Eng)* S646
house paint—Historic finishes analysis *(Eng)* S441
interior decoration—Paint magic: the home decorator's guide to painted finishes *(Eng)* S400
Maori—Maori carvings in Auckland museum, New Zealand. Ethical considerations in their restoration *(Eng)* S360
paint—The material side *(Eng)* S166
—Materials toward a history of housepaints: the materials and craft of the housepainter in 18th century America *(Eng)* S221
reflectance—Relation between surface roughness and specular reflectance at normal incidence *(Eng)* S738

finishing
Native American—Indian rawhide: an American folk art *(Eng)* S280
Poland—Folk painting on glass *(Pol)* S240
wood—Wood documentation. VII: wood conservation and surface treatment. Volume 2: surface treatment *(Fre)* S897

Finnish
pine tar—Analysis of Finnish pine tar and tar from the wreck of frigate St. Nikolai *(Eng)* S650

fir
Bella Coola—Materia medica of the Bella Coola and neighbouring tribes of British Columbia *(Eng)* S48

fire

Horyuji Temple (Japan)—Scientific treatments made on the main hall of the Hōryūji Monastery after the fire of 1949 *(Jpn)* S893
votive tablets—Cleaning treatment on votive tablet in traditional way *(Jpn)* S939

fisetin

dyewood—Dyewoods, their composition and use. Part 1: Description of the most important dyewoods *(Ger)* S204
—Dyewoods, their composition and use. Part 2: Wood dyes and their fields of application *(Ger)* S205

fish

Mexico (Baja California)—Face and body painting in Baja California: a summary *(Eng)* S273
Montagnais—A Naskapi painted skin shirt *(Eng)* S247

fish glue *see also* **sturgeon glue**

adhesives—The evaluation of some adhesive systems utilized in the consolidation of paintings. The kinetics of consolidation (II) *(Rum)* S1020
binding media—Analysis of binding media and adhesives in Buddhist wooden statues *(Jpn)* S674
isinglass—Potential applications of isinglass adhesive for paper conservation *(Eng)* S1076
Medieval Observations on a late Medieval painting medium *(Eng)* S117
painting (technique)—Greek and Roman methods of painting: some comments on the statements made by Pliny and Vitruvius about wall and panel painting *(Eng)* S29
prehistoric—Pigments and paints in prehistoric antiquity *(Fre)* S191

fixatives

Determination of the influence of Rowney's "Perfix" fixative on the properties of paper *(Pol)* *accelerated aging; charcoal; crayons; drawings; paper; pastels (visual works)* S925
—Experimental studies on fixatives for powdery traces *(Fre)* *coatings; paper; resin; synthetic resin* S987
—Fixatives for mural paintings *(Itu)* *consolidants; mural paintings* S903
—Fixing agent for chalking color on wood and its laboratory evaluation *(Jpn + Eng)* *acrylic resin; animal glue; cypress; fixing; hide; oyster shell white; Paraloid B-72; Primal AC34; weathering; wood; yellow ocher* S1040
—An investigation of several fixatives for pastel works *(Eng)* *paper; pastels (visual works); pigment* S1102
Australian Aboriginal—Dawn of art: painting and sculpture of Australian Aborigines *(Eng)* S224
consolidants—Degradation of synthetic consolidants used in mural painting restoration by microorganisms *(Eng)* S1122
contemporary art—American artists in their New York studios: conversations about the creation of contemporary art *(Eng)* S500
Melanesian—Conservation of powdering pigment layers on Melanesian objects: choice of a fixative *(Fre)* S1039

pastels (crayons)—American pastels of the late nineteenth & early twentieth centuries: materials and techniques *(Eng)* S442
pastels (visual works)—Degas pastels *(Eng)* S419
—Fixatives for pastels *(Fre)* S708
—An investigation into the use of several substances as fixatives for works of art in pastel *(Eng)* S953
—Investigation, conservation and restoration of the pastel painting technique *(Spa)* S1054
—The material side *(Eng)* S145
—Pastel fixatives *(Ger)* S899
Plexigum P24—A study of Plexigum P24 used as a fixative for flaking paint traces *(Fre)* S1043
rock paintings—Museum conservation of anthropological material *(Eng)* S913
triptychs—Material description, state of conservation, and treatment *(Dut)* S906

fixing

Theoretical approach to refixing *(Fre)* *adhesives; calcium carbonate; canvas; drying oil; humidity; matte; methacrylate; oil paint; pigment; poly(vinyl acetate); poly(vinyl alcohol); relative humidity; wood* S1017
adobe—Treatment of adobe friezes in Peru *(Eng)* S970
bark paintings—Conservation of Aboriginal bark paintings and artifacts *(Eng)* S908
—Conservation of Australian Aboriginal bark paintings with a note on the restoration of a New Ireland wood carving *(Eng)* S905
charcoal—Tonal drawing and the use of charcoal in nineteenth century France *(Eng)* S468
consolidants—The consolidation of powdery paint layers of *Bonaders*, Swedish mural works painted on paper *(Fre)* S1109
fixatives—Fixing agent for chalking color on wood and its laboratory evaluation *(Jpn + Eng)* S1040
illuminations—Practice and practical possibilities in the conservation of Medieval miniatures *(Ger)* S969
—Some details on the technique and of the restoration of two illuminated 13th century manuscripts from Western Europe *(Fre)* S942
—Some tests on the use of wax for fixing flaking paint on illuminated parchment *(Eng)* S898
leather—The behavior of colors on leather and parchment objects and the resulting problems of conservation *(Ger + Eng)* S1068
mural paintings—Ajanta murals: their composition and technique and preservation *(Eng)* S232
—Indian murals: techniques and conservation *(Eng)* S931
—Specific problems concerning the restoration of wall paintings at Humor *(Eng)* S1034
paper—Conservation of some non-book material in National Library, Calcutta *(Eng)* S1026
parchment—Conservation and restoration of manuscripts and bindings on parchment *(Eng)* S980
pastels (crayons)—Pastel, a technique of yesterday and today *(Eng)* S364
pastels (visual works)—Analysis and conservation of graphic and sound documents: work

by the Centre de Recherches sur la Conservation des Documents Graphiques, 1982-1983 *(Fre)* S1004
—Electrostatic stabilizing plate (E.S.P.): an alternative method for stabilizing the flaking tendencies of works of art in pastel *(Eng)* S952
—Fixing and flocking *(Eng)* S985
—Pastels *(Fre)* S369
poly(vinyl alcohol)—The fixing of mural paintings with polyvinyl alcohol (Mowiol N-70-98): a restorer's experience *(Fre)* S962
polymers—Consolidation of the pictorial layer of illuminations with pure synthetic polymers *(Fre)* S989
reattaching—Reattaching color layers on a wooden wall and documenting the distribution of damages *(Jpn)* S1024
screens (doors)—Treatment on painting of sliding screens and wall panels to prevent exfoliation in Japan *(Eng)* S972
shadow puppets—Restoration of Chinese and Indonesian shadow puppets *(Eng)* S1011
shields (armor)—Restoration of a ceremonial shield from the Solomon Islands *(Eng)* S1025
stained glass—A new fixation method for paint layer conservation *(Eng)* S1091
stucco—Stucco: a report on the methodology developed in Mexico *(Eng)* S1035
textiles—Technical study and conservation of an old painted textile (Simhasana) *(Eng)* S902
wood—Studies on fixing treatments of color paintings on the ceiling of Sanmon Gate, National Treasure, Tofuku-ji Temple *(Jpn)* S940

flags
Netherlandish—The beginnings of Netherlandish canvas painting, 1400-1530 *(Eng)* S445
textiles—The link between the treatments for paintings and the treatments for painted textiles *(Eng)* S363

flaking
acrylic resin—A preliminary evaluation of acrylic emulsions for the adhesion of flaking paint on ethnographic objects *(Eng)* S1046
cellulose ether—The use of cellulose ethers in the treatment of Egyptian polychromed wood *(Eng)* S1053
coffins—Party straws and Egyptian coffins *(Eng)* S1113
consolidation—Consolidation of delaminating paintings *(Eng)* S951
cracking—Defects with old paint surfaces: occurrence, causes and remedies *(Ger)* S789
Daiju-ji Temple (Japan)—Preservative treatment on the *Shoheki-ga* at the Daiju-ji *(Jpn)* S955
forgeries—The technical investigation and conservation treatment of an alleged Ming Dynasty wall painting *(Eng)* S956
historic buildings—Conservation within historic buildings in Japan *(Eng)* S973
—Defects of color dyes on historic buildings' renderings *(Cze)* S914
house paint—Historic finishes analysis *(Eng)* S441
illuminations—The conservation of a Petrarch manuscript *(Eng)* S910
—Practice and practical possibilities in the conservation of Medieval miniatures *(Ger)* S969

—Some details on the technique and of the restoration of two illuminated 13th century manuscripts from Western Europe *(Fre)* S942
—Some tests on the use of wax for fixing flaking paint on illuminated parchment *(Eng)* S898
leather—The examination of use marks on some Magdalenian end scrapers *(Eng)* S262
masks—Chiriquano masks: polychrome wood (treatment and inquiry) *(Eng)* S1041
—The examination and treatment of two wood funerary masks with Negroid features *(Eng)* S990
miniatures (paintings)—Conservation methods for miniature paintings on parchment: treatment of the paint layer *(Eng)* S943
mural paintings—Ajanta murals: their composition and technique and preservation *(Eng)* S232
—Application of synthetic resins to the preservation of antiques and art crafts *(Jpn)* S891
—Some problems on the preservation of wall paintings using synthetic resins *(Jpn)* S892
—Three Bodhisattvas: the conservation of a fifteenth century Chinese wall painting in the British Museum collection *(Eng)* S1051
Nagoya Castle (Nagoya, Japan)—Study on the repair technique of polychrome paintings drawn on sliding screens in the Nagoya Castle *(Jpn)* S945
Oceania—Pigment consolidation on six Pacific artifacts: a CCI internship report *(Eng)* S984
Osakihachiman shrine (Japan)—Conservation treatment of the painting on wooden walls in the oratory of Osakihachiman Shrine *(Jpn)* S964
panel paintings—Basic experiments concerning deterioration of glue and discoloration of pigments, and discussion on the actual condition of wall panel paintings on the basis of their results *(Jpn)* S930
—Present state of screen and panel paintings in Kyoto *(Jpn)* S933
—Preservative treatment on paint layer of screen and wall panel paintings *(Jpn)* S929
—Treatment on sliding screen and wall panel paintings to prevent exfoliation with synthetic resins *(Jpn)* S928
—Wings from a quadriptych with the legend of St. John the Baptist: general problems and the treatment of conservation *(Pol)* S917
paper—Conservation of some non-book material in National Library, Calcutta *(Eng)* S1026
parchment—The conservation methods for miniature-painting on parchment *(Eng)* S920
pastels (visual works)—Electrostatic stabilizing plate (E.S.P.): an alternative method for stabilizing the flaking tendencies of works of art in pastel *(Eng)* S952
Plextol B500—Evaluation of the stability, appearance and performance of resins for the adhesion of flaking paint on ethnographic objects *(Eng)* S1101
Pollock, Jackson (1912-1956)—My painting *(Eng)* S112
Rothko, Mark (1903-1970)—Mark Rothko's Harvard murals *(Eng)* S413

Fourier transform infrared spectroscopy

screens (doors)—Treatment on painting of sliding screens and wall panels to prevent exfoliation in Japan *(Eng)* S972
screens (furniture)—Restoration of a Japanese screen *(Ger)* S949
shields (armor)—The conservation of some carved wooden war shields from the Tifalmin Valley, Papua New Guinea *(Eng)* S950
synthetic resin—Restoration with synthetic resins in Japan *(Ger)* S966
tablets—Preservative treatment of the *Funa-Ema* (votive tablets of boats), important folklore materials at Arakawa Shrine and Hakusanhime Shrine *(Jpn)* S932
Thailand—Conservation of wall paintings in Thailand *(Eng)* S927
votive tablets—Cleaning treatment on votive tablet in traditional way *(Jpn)* S939
Vuillard, Edouard (1868-1940)—History, analysis and treatment of "La salle à manger au château de Clayes," 1938, by Edouard Vuillard *(Eng)* S1009
—A technical and stylistic analysis of detrempe painting on cardboard by Edouard Vuillard *(Eng)* S1014
wall hangings—The study and conservation of glue paintings on textile: 18th and 19th century painted wall hangings from southern Sweden *(Eng)* S512
wood—Investigation into methods and materials for the adhesion of flaking paint on ethnographic objects: a progress report *(Eng)* S1045
—Studies on fixing treatments of color paintings on the ceiling of Sanmon Gate, National Treasure, Tofuku-ji Temple *(Jpn)* S940

flat paint
The effect of pigmentation on modern flat wall paints *(Eng)* color; enamel; house paint; paint; physical properties; pigment volume concentration S716

flattening
Australian Aboriginal—Australian Aboriginal bark paintings: an ICOM report *(Eng)* S918
bark paintings—Conservation of Aboriginal bark paintings and artifacts *(Eng)* S908
—Conservation of Australian Aboriginal bark paintings with a note on the restoration of a New Ireland wood carving *(Eng)* S905

flax
manuscripts—A clay-coated manuscript in the Gilgit collection *(Eng)* S907
mummies—Probing the mysteries of ancient Egypt: chemical analysis of a Roman period Egyptian mummy *(Eng)* S673

flour paste
binding media—Artificial samples of paint binders. Oils, resins, waxes, glues, egg, prepared in binary mixtures: analytical characteristics and properties *(Ita)* S631
mural paintings—The examination of mural paintings *(Dut)* S525
protein—Identification of protein containing binding media and adhesives in works of art by amino acid analysis *(Jpn)* S659

fluorescence microscopy
Ultraviolet fluorescence microscopy of paint cross sections: cycloheptaamylose-dansyl chloride complex as a protein-selective stain *(Eng)* acrylic resin; animal glue; binding media; casein; cross sections; gelatin; linseed oil; microscopy; protein; tempera; ultraviolet S671

folk art
Care of folk art: the decorative surface *(Eng)* bone; glass; gold leaf; ivory; metal; paint; wood S273
Africa—The useful art of Africa: their methods and materials *(Eng)* S251
consolidants—The consolidation of powdery paint layers of *Bonaders*, Swedish mural works painted on paper *(Fre)* S1109
Native American—Indian rawhide: an American folk art *(Eng)* S280
wood—The folk art tradition in painting on wood: paste and casein techniques *(Ger)* S314

food
Apache—Plants used by the White Mountain Apache Indians of Arizona *(Eng)* S47
Australian Aboriginal—Bush food: Aboriginal food and herbal medicine *(Eng)* S401
—Ethnological studies among the northwest-central Queensland Aborigines *(Eng)* S19
—Food: its search, capture, and preparation *(Eng)* S20
stabilizers—Identification of stabilizing agents *(Eng)* S527

forensic science
Developments in paint analysis for forensic purposes *(Eng)* chemical composition; chromatography; color; electron microprobe; forensic science; gas chromatography; infrared spectrometry; paint; pigment; pyrolysis gas chromatography; pyrolysis mass spectrometry; resin; spectrometry; spectrophotometry; x-ray diffraction S639
—Forensic analysis of coatings *(Eng)* Fourier transform infrared spectroscopy; infrared spectrometry; neutron activation analysis; paint; pigment; pyrolysis gas chromatography S615

forgeries
The technical investigation and conservation treatment of an alleged Ming Dynasty wall painting *(Eng)* emerald green; ethyl alcohol; fiber; linen; microcrystalline wax; Ming; mud; mural paintings; poly(vinyl acetate); transferring; vapor; xylene S956
pyrolysis gas chromatography—Application of pyrolysis gas chromatography on some of Van Meegeren's faked Vermeers and Pieter de Hooghs *(Eng)* S565
wood—Case studies in the treatment of polychrome wood sculptures at the Victoria and Albert Museum *(Eng)* S1006

Fourier transform infrared spectroscopy
Analysis of aged paint binders by FTIR spectroscopy *(Eng)* accelerated aging; aging; binding media; egg yolk; inorganic pigment; linseed oil; oil; paintings (objects); pigment; Renaissance; spectrometry S657
—Applications of infrared microspectroscopy to art historical questions about Medieval

393

manuscripts *(Eng) animal glue; Byzantine; co-chineal; egg yolk; hide; kaolin; manuscripts; Medieval; protein; red pigment; spectrometry* S648
—Fourier transform infrared spectral analysis of natural resins used in furniture finishes *(Eng) coatings; finishes; furniture; organic materials; resin; spectrometry* S646
—Micro spectroscopy FTIR reflectance examination of paint binders on ground chalk *(Eng) binding media; chalk; organic materials; paint* S681
acrylic resin—The identification and characterization of acrylic emulsion paint media *(Eng)* S666
Asia, Southeast—The identification of insular Southeast Asian resins and other plant exudates for archaeological and ethnological application *(Eng)* S630
forensic science—Forensic analysis of coatings *(Eng)* S615
gas chromatography—Examination of the diterpenoic resin components of anatomical wax models from the eighteenth century by gas chromatography *(Eng)* S656

frame construction
artists' materials—The artist's handbook *(Eng)* S407
Baumeister, Willi (1889-1955)—Studies of the painting techniques of Willi Baumeister *(Ger)* S496
binding media—The problem of conservation of very large canvases painted in glue medium *(Pol)* S968

France
architecture—Painted surfaces in architecture: Amiens, October 1989 *(Fre)* S450
charcoal—Tonal drawing and the use of charcoal in nineteenth century France *(Eng)* S468
decoration—Investigations and preliminary probes *(Fre)* S1089
dyeing—A bibliography of dyeing and textile printing comprising a list of books from the 16th century to the present time (1946) *(Eng)* S129
frescoes—The frescoes of Tavant (France) *(Eng)* S179
illuminations—Some details on the technique and of the restoration of two illuminated 13th century manuscripts from Western Europe *(Fre)* S942
mural paintings—The conservation of wall-paintings in France *(Eng)* S1030
—Products, facts, modes in mural painting: evolution and distribution of restoration products used in mural paintings from 1850 to 1992: a first sorting concerning France, Spain, England, and Poland *(Fre)* S511
—Study and conservation of quadratura decoration on the vaults of 17th-century French buildings *(Fre)* S470
Paleolithic—Paleolithic pigments and processing *(Eng)* S357

France (Auxerre)
blue pigment—Blues for the chemist *(Eng)* S465

France (Deux-Sevres)
mural paintings—The Château of Oiron and its decorated surfaces *(Fre)* S457

France (Dordogne)
mural paintings—The earliest known paints *(Eng)* S153

France (Fontainebleau)
frescoes—Frescoes by Il Primaticcio in the ballroom of the Castle of Fontainebleau: the legacy, a derestoration attempt *(Fre)* S1117

France (Isère)
mural paintings—Ancient Collegiate Church of Saint Barnard de Romans: decorated surfaces of the choir and transept *(Fre)* S478

France (Longueville)
mural paintings—The Church of Lourps in Longueville: restoration of the decorated surfaces *(Fre)* S474

France (Niaux)
caves—Interventions: cleaning of walls, consolidation tests in the Black Room of the prehistoric cave of Niaux, France *(Fre)* S1119

France (Paris)
ocher—French ocher from Berry *(Fre)* S124

France (Provence— Apt)
ocher—Ochers and ocher workers and manufacturers around Apt, Provence, France *(Fre)* S384

France (Puisaye)
ocher—Ocher and ocher industry in the Puisaye region, geology and history *(Fre)* S238

France, southern
gouache—Problems of conservation encountered with gouache paintings by Charlotte Salomon (1941-1943) *(Ger)* S1114
Pech Merle Cave (France)—Spitting images: replicating the spotted horses *(Eng)* S491

Franseria dumosa
Seri blue—Seri blue *(Eng)* S217

French Guiana
ethnobotany—An introductory study of the arts, crafts, and customs of the Guiana Indians *(Eng)* S34

fresco painting (technique)
The art of fresco painting as practised by the old Italian and Spanish masters, with a preliminary inquiry into the nature of the colours used in fresco painting, with observations and notes *(Eng) Italy (Rome); Spain* S156
—Colors and painting in antiquity *(Fre) Assyrian; cave paintings; Egyptian; mural paintings; Mycenaean; wax* S133
—Fresco painting in antiquity *(Ita) Italy (Herculaneum); Italy (Pompeii)* S157
—Fresco painting: modern methods and techniques for painting in fresco and secco *(Eng) mortar; plaster; secco* S111
—Survey of fresco painting *(Ger) chalk; painting (technique); pigment* S130
—Tyrolean fresco: an attempt to reconstruct and modify the technique *(Pol) Austria (Tyrol); gypsum* S486

Bronze Age—Aegean painting in the Bronze Age *(Eng)* S466
painting (technique)—Original treatises on the arts of painting *(Eng + Lat)* S234
pigment—Facts about processes, pigments and vehicles: a manual for art students *(Eng)* S15
—The history of artists' pigments *(Eng)* S135

frescoes
19th and early 20th century restorations of English Mediaeval wall paintings: problems and solutions *(Eng) barium hydroxide; England; lime; Medieval; methylene chloride; mural paintings; oil varnish; paintings (objects); plaster; secco; transferring; varnish; walls; wax; whitewash* S1116
—Artistic frescoes *(Eng) binding media; casein; lime; mural paintings* S100
—The conservation in situ of the Romanesque wall paintings of Lambach *(Eng) Austria (Lambach); climate control; consolidation; dating; desalination; mural paintings; Romanesque; salt* S1098
—The consolidation of friable frescoes *(Eng) barium sulfate; calcium carbonate; consolidants; lime; methyl triethoxysilane; pigment; salt; sulfuric acid; tetra orthosilicate; yellow ocher* S1015
—Fresco paintings of Ajanta *(Eng) Ajanta Caves (India); black pigment; blue pigment; cave paintings; gypsum; India (Ajanta); lampblack; lapis lazuli; lime; ocher; plaster; sienna; umber* S126
—Frescoes by Il Primaticcio in the ballroom of the Castle of Fontainebleau: the legacy, a derestoration attempt *(Fre) France (Fontainebleau); Mannerist; mural paintings; painting (technique); Primaticcio, Francesco (1504-1570)* S1117
—The frescoes of Tavant (France) *(Eng) color; France; green earth; mural paintings; ocher; painting (technique); pigment; plaster; whitewash* S179
—In situ consolidation of a Roman fresco near Ein Yael, Jerusalem *(Eng) in situ conservation; Israel (Jerusalem); Roman* S1118
—The Tassili frescoes *(Eng) Algeria (Tassili n'Ajjer); colorants; iron oxide; rock paintings; Sahara Desert; yellow ocher* S188
contemporary art—Contemporary artists and their experimental use of historical methods and techniques *(Eng)* S286
history of technology—Chemistry of painting features from earliest time to unfathomable future *(Eng)* S279
latex paint—History of water-thinned paints *(Eng)* S163
Medieval—Pigments and paints in the Middle Ages *(Fre)* S199
mural paintings—Restoration of old paintings. With special emphasis on frescoes and murals (alone) in oil paint *(Ger)* S889
—Structure, composition, and technique of the paintings *(Dut)* S346
—Study and conservation of quadratura decoration on the vaults of 17th-century French buildings *(Fre)* S470
—Wall paintings: technique, problems, conservation *(Ita)* S1080

paintings (objects)—Manual of the painter restorer *(Ita)* S5
pigment—Pigments and paints in classical antiquity *(Fre)* S200
rock paintings—The search for the Tassili frescoes: the story of the prehistoric rock paintings of the Sahara *(Eng)* S187
Spain (Catalonia)—Architecture and decorated surfaces in Catalonia *(Fre)* S456

friezes (ornamental bands)
adobe—Treatment of adobe friezes in Peru *(Eng)* S970

fruit
ethnobotany—Ethnobotany of the Zuñi Indians *(Eng)* S27
Tamberma—Architecture of the Tamberma (Togo) *(Eng)* S332

fumigation
Australian Aboriginal—Australian Aboriginal bark paintings: an ICOM report *(Eng)* S918
carvings—Collecting wooden ethnographic carvings in the tropics *(Eng)* S998
panel paintings—Wings from a quadriptych with the legend of St. John the Baptist: general problems and the treatment of conservation *(Pol)* S917
Papua New Guinea—An ethnographic collecting expedition to Papua New Guinea: field conservation and laboratory treatment *(Eng)* S967

funerary containers
China—Scientific study of the decoration of four wooden funerary boxes from China *(Fre)* S510

fungi
chests—The cleaning, conservation, and restoration of a Matyo chest *(Hun)* S1000
coatings—Water thinnable coatings, a symposium *(Eng)* S726
Native American—Puffball usages among North American Indians *(Eng)* S349
pest control—A historical survey of the materials used for pest control and consolidation in wood *(Ger)* S1010
rock art—The recording of rock art: an illustrated paper presented to the Canadian Conservation Institute trainees and to the Course in the Conservation of Historic Monuments and Sites, Restoration Services Division, Engineering and Architecture Branch, D.I.N.A. *(Eng)* S283

funori
adhesives—Re-attaching a thick color layer of polychrome sculpture. Conservation of a seated figure of Rev. Tenkai *(Jpn)* S1075

furniture
chests—The cleaning, conservation, and restoration of a Matyo chest *(Hun)* S1000
Fourier transform infrared spectroscopy—Fourier transform infrared spectral analysis of natural resins used in furniture finishes *(Eng)* S646
wood—The folk art tradition in painting on wood: paste and casein techniques *(Ger)* S314

Gabon

Gabon
The useful plants of Gabon: an inventory and concordance of popular and scientific names of native and non-native plants: description of species, properties, and economic, ethnographic, and artistic uses *(Fre) botany; oil; pigment; plants; wood* S202

galena
house paint—Topical observations on the use of forgotten pigments used for painting rooms in Lower Saxony *(Ger)* S438

gallstones
Blackfoot—Painted tipis and picture-writing of the Blackfoot Indians *(Eng)* S69

gamboge (pigment)
China—Chinese painting colors: studies of their preparation and application in traditional and modern times. *(Eng)* S427
Japan—Pigments used in Japanese paintings *(Eng)* S405
mural paintings—The investigation of pigments and paint layer structures of mural paintings at Maitepnimit Temple *(Eng)* S477
—Reproduction of colored patterns in temples and shrines *(Eng)* S383
plant materials—A dictionary of the economic products of the Malay Peninsula *(Eng)* S65
pyrolysis gas chromatography—Analysis of natural resins by pyrolysis gas chromatography. II. Identification of natural resins by pyrograms *(Jpn)* S560
yellow pigment—Yellows *(Ita)* S396

gamma radiation
wood—Consolidation of deteriorated wooden artifacts *(Eng)* S961
—Consolidation of painted wooden artifacts: an ICOM report *(Eng)* S924

gardenia seeds
China—Chinese painting colors: studies of their preparation and application in traditional and modern times. *(Eng)* S427

gas chromatography
Analyses of paint media *(Eng) binding media; National Gallery (London, England); paintings (objects)* S578
—Analysis of organic residues of archaeological origin by high-temperature gas chromatography and gas chromatography-mass spectrometry *(Eng) chromatography; esters; fatty acid; gas chromatography mass spectrometry; lipids; mass spectrometry; organic materials* S654
—The application of gas chromatography in the investigation of works of art *(Eng) binding media; chromatography; drying oil* S538
—Contribution to the study of aged proteinaceous media *(Eng) animal materials; binding media; casein; chromatography; egg white; egg yolk; protein* S572
—Examination of the diterpenoic resin components of anatomical wax models from the eighteenth century by gas chromatography *(Eng) Fourier transform infrared spectroscopy; hardeners; mass spectrometry; plasticizers; resin; turpentine; wax* S656

—The gas chromatographic examination of paint media. Some examples of medium identification in paintings by fatty acid analysis *(Eng) binding media; fatty acid; paintings (objects)* S573
—Gas chromatographic identification of a resinous deposit from a 6th century storage jar and its possible identification *(Eng) balsam; Byzantine; fat; Israel (En Boqeq); oil; resin* S608
—The gas-chromatographic examination of paint media. Part II. Some examples of medium identification in paintings *(Eng) binding media; fatty acid; paintings (objects)* S558
—Identification of proteinaceous binding media of easel paintings by gas chromatography of the amino acid derivatives after catalytic hydrolysis by a protonated carbon exchanger *(Eng) amino acid; binding media; carbohydrates; casein; chromatography; collagen; easel paintings; egg; hydrolysis; mural paintings; paintings (objects); priming; protein* S670
—Organic analysis in the arts: some further paint medium analyses *(Eng) binding media; paint* S581
—Organic analysis in the examination of museum objects *(Eng) binding media; fat; mass spectrometry; oil; paint; protein; resin* S621
—A review, with illustrations, of methods applicable to the analysis of resin/oil varnish mixtures *(Eng) mass spectrometry; National Gallery (London, England); oil varnish; resin; varnish* S600
animal glue—Manufacturing and analyzing ancient animal glues *(Swe)* S651
binding media—Analyses of paint media *(Eng)* S587
—Contributions to the analysis of binders, adhesives and ancient varnishes *(Fre)* S547
—Perspectives on the chemistry of old paint binders *(Fre)* S535
chromatography—The chromatographic analysis of ethnographic resins *(Eng)* S603
fatty acid—Fatty acid composition of 20 lesser-known Western Australian seed oils *(Eng)* S676
—The gas chromatographic examination of paint media. Part I. Fatty acid composition and identification of dried oil films *(Eng)* S542
forensic science—Developments in paint analysis for forensic purposes *(Eng)* S639
gum—The analysis of exudate plant gums in their artistic applications: an interim report *(Eng)* S616
Herlin Cathedral (Germany)—The scientific examination of the polychromed sculpture in the Herlin altarpiece *(Eng)* S552
illuminations—The development of techniques of identification for pigments and binders used in the paint layer of manuscript illuminations *(Fre)* S546
infrared spectrometry—Instrumental analysis in the coatings industry *(Eng)* S619
ink—Gas chromatographic mass spectrometric analysis of tannin hydrolysates from the ink of ancient manuscripts (XIth to XVIth century) *(Eng)* S577

396

mass spectrometry—Organic mass spectrometry of art materials: work in progress *(Eng)* S607
Mudéjar—Technical examination and consolidation of the paint layer on a Mudéjar coffered ceiling in the Convent of Santa Fe, Toledo *(Eng)* S1110
paintings (objects)—Analysis of paint media, varnishes and adhesives *(Eng)* S625
polysaccharides—Polysaccharides as part of a color layer and methods for their identification *(Cze)* S647
protein—The characterization of proteinaceous binders in art objects *(Eng)* S617
pyrolysis gas chromatography—Application of pyrolysis gas chromatography on some of Van Meegeren's faked Vermeers and Pieter de Hooghs *(Eng)* S565
—Forensic applications of pyrolysis capillary gas chromatography *(Eng)* S609
—Pyrolysis gas chromatographic mass spectrometric identification of intractable materials *(Eng)* S588
resin—A comparison of pyrolysis mass spectrometry, pyrolysis gas chromatography and infra-red spectroscopy for the analysis of paint resins *(Eng)* S618
—Natural resins of art and archaeology. Their sources, chemistry, and identification *(Eng)* S579
Rudolphi, Johann Georg (1633-1693)—Johann Georg Rudolphi (1633-1693). Volume 1 *(Ger)* S584
skin—Lipids from samples of skin from seven Dutch bog bodies: preliminary report *(Eng)* S653
thin layer chromatography—Thin-layer chromatography of resin acid methyl esters *(Eng)* S536
Tomb of Nefertari (Thebes, Egypt)—Chemical analyses of pigments and media used in the mural paintings of the tomb of Nefertari *(Spa)* S658
wax—Characterization of commercial waxes by high-temperature gas chromatography *(Eng)* S604

gas chromatography mass spectrometry
GC/MS and chemometrics in archaeometry: investigation of glue on Copper-Age arrowheads *(Eng) adhesives; arrowheads; birch; Copper Age; wood* S665
—Rapid identification of binding media in paintings using simultaneous pyrolysis methylation gas chromatography *(Eng) adhesives; animal glue; binding media; casein; chromatography; egg yolk; fatty acid; glair; linseed oil; oil; organic materials; pyrolysis gas chromatography* S668
bark cloth—The analysis and identification of oils in Hawaiian oiled tapa *(Eng)* S629
gas chromatography—Analysis of organic residues of archaeological origin by high-temperature gas chromatography and gas chromatography-mass spectrometry *(Eng)* S654
pine tar—Analysis of Finnish pine tar and tar from the wreck of frigate St. Nikolai *(Eng)* S650

pyrolysis gas chromatography—Analytical pyrolysis as a tool for the characterization of organic substances in artistic and archaeological objects *(Eng)* S662
—The potential of pyrolysis-gas chromatography/mass spectrometry in the recognition of ancient painting media *(Eng)* S678
skin—Lipids from samples of skin from seven Dutch bog bodies: preliminary report *(Eng)* S653
wood—Identification of archaeological and recent wood tar pitches using gas chromatography/mass spectrometry and pattern recognition *(Eng)* S655

gauze
manuscripts—A clay-coated manuscript in the Gilgit collection *(Eng)* S907
paper—Conservation of some non-book material in National Library, Calcutta *(Eng)* S1026

gel
gloss—Gloss of paint films and the mechanism of pigment involvement *(Eng)* S872

gel electrophoresis
binding media—Analysis of binding media and adhesives in Buddhist wooden statues *(Jpn)* S674

gelatin
IR-spectroscopic analysis of aged gelatins *(Eng) aging; infrared spectrometry; solubility; spectrometry* S596
Abelam—Consolidation techniques for "yam masks": a practical investigation paper presented to the National Museum Act and the Museum of Cultural History at the University of California at Los Angeles as an advanced internship research project *(Eng)* S996
adhesives—Adhesives for impregnation of painting on canvas *(Swe)* S1087
—The evaluation of some adhesive systems utilized in the consolidation of paintings. The kinetics of consolidation (II) *(Rum)* S1020
binding media—The importance of binders *(Fre)* S225
coatings—Development and growth of resins for the coating industry *(Eng)* S340
consolidation—Consolidation of loose paint on ethnographic wooden objects *(Ger)* S901
Egypt—What do we know about the paints of the old Egyptians? *(Eng)* S137
fluorescence microscopy—Ultraviolet fluorescence microscopy of paint cross sections: cycloheptaamylose-dansyl chloride complex as a protein-selective stain *(Eng)* S671
glaze—On the material side. Glazes and glazing—Part 2 *(Eng)* S148
illuminations—Practice and practical possibilities in the conservation of Medieval miniatures *(Ger)* S969
Medieval—Medieval surface techniques, II *(Eng)* S122
mural paintings—Ajanta murals: their composition and technique and preservation *(Eng)* S232
—A study of organic components of ancient middle Asian and Crimean wall paintings *(Rus)* S289

Oceania—Pigment consolidation on six Pacific artifacts: a CCI internship report *(Eng)* S984
panel paintings—Wings from a quadriptych with the legend of St. John the Baptist: general problems and the treatment of conservation *(Pol)* S917
stabilizers—Identification of stabilizing agents *(Eng)* S527

gems
icons—The technique of icon painting *(Eng)* S214

German
wood—Case studies in the treatment of polychrome wood sculptures at the Victoria and Albert Museum *(Eng)* S1006

Germany
Baumeister, Willi (1889-1955)—Studies of the painting techniques of Willi Baumeister *(Ger)* S496
dyeing—A bibliography of dyeing and textile printing comprising a list of books from the 16th century to the present time (1946) *(Eng)* S129
Expressionist—Voices of German Expressionism *(Eng)* S254

Germany (Hildesheim)
Ottonian—The painted ceiling from the Romanesque period in the Protestant church of Saint Michael at Hildesheim *(Ger)* S1073

Germany (Rothenburg)
Herlin Cathedral (Germany)—The scientific examination of the polychromed sculpture in the Herlin altarpiece *(Eng)* S552

Germany (Saxony)
house paint—Topical observations on the use of forgotten pigments used for painting rooms in Lower Saxony *(Ger)* S438

Germany, southern
illuminations—Some details on the technique and of the restoration of two illuminated 13th century manuscripts from Western Europe *(Fre)* S942
painting (technique)—The confirmation of literary sources on art technology through scientific examination *(Ger)* S323
polychromy—Problems of the interpretation of historical sources and their confirmation by the results of technical analysis on works of art, shown on the example of painted sculptures from the 18th century in southern Germany *(Ger)* S322

gesso
artists' materials—Techniques of ancient painting: the preparation of the support *(Ita)* S440
cracking—Crack mechanisms in gilding *(Eng)* S874
delamination—Detection of delaminations in art objects using air-coupled ultrasound *(Eng)* S880
icons—The technique of icon painting *(Eng)* S214
India—A study of Indian polychrome wooden sculpture *(Eng)* S255

painting (technique)—Original treatises on the arts of painting *(Eng + Lat)* S234
rabbit-skin glue—The treatment of gilded objects with rabbit-skin glue size as consolidating adhesive *(Eng)* S1107
tempera—The material side: tempera painting—part 1 *(Eng)* S146
Velazquez, Diego Rodriguez de Silva (1599-1660)—The technique of Velasquez in the painting The Drinkers at the Picture Gallery of Naples *(Eng)* S139
wax—The preservation of wood sculpture: the wax immersion method *(Eng)* S890
wood—The restoration of the wooden statue of Our Lady in the parish church of Cercina *(Ita)* S1078

Getty Conservation Institute (Marina del Rey, CA, USA)
consolidation—Investigations into techniques for the consolidation of high pigment volume concentration paint at the Getty Conservation Institute *(Eng)* S1084
ethnographic conservation—Ethnographic conservation training at the GCI *(Eng)* S1079
infrared spectrometry—Methods in scientific examination of works of art: infrared microspectroscopy *(Eng)* S664

Ghana
Useful plants of Ghana: West African uses of wild and cultivated plants *(Eng) colorants; dye; plants* S447
Akan—The theory and practice of conservation among the Akans of Ghana *(Eng)* S516

gilding
cracking—Crack mechanisms in gilding *(Eng)* S874
Czechoslovakia (Prague)—Technical parallels between panel and wall painting of the 14th century *(Cze)* S353
egg tempera—The student's Cennini: a handbook for tempera painters *(Eng)* S96
Iceland—Likneskjusmid: fourteenth century instructions for painting from Iceland *(Eng)* S503
illuminations—Some details on the technique and of the restoration of two illuminated 13th century manuscripts from Western Europe *(Fre)* S942
mural paintings—Wall paintings: technique, problems, conservation *(Ita)* S1080
painting (technique)—Original treatises on the arts of painting *(Eng + Lat)* S234
poly(vinyl alcohol)—Experiments in the use of polyvinyl alcohol as a substitute for animal glues in the conservation of gilded wood *(Eng)* S1100
rabbit-skin glue—The treatment of gilded objects with rabbit-skin glue size as consolidating adhesive *(Eng)* S1107
screens (furniture)—Restoration of a Japanese screen *(Ger)* S949
votive tablets—Cleaning treatment on votive tablet in traditional way *(Jpn)* S939
Wayang—Restoration of Indonesian Wayang-figures in the National Ethnographical Museum of Dresden *(Ger)* S1049

wood—Colouring technique and repair methods for wooden cultural properties *(Eng)* S303

Giotto di Bondone (ca. 1266-1337)
mural paintings—Wall painting conservation in Tuscany before the Florentine flood of 1966 *(Eng)* S1125

Giovanni di Fiesole see **Angelico, Fra**

glair
fluorescence microscopy—Ultraviolet fluorescence microscopy of paint cross sections: cycloheptaamylose-dansyl chloride complex as a protein-selective stain *(Eng)* S671
gas chromatography mass spectrometry—Rapid identification of binding media in paintings using simultaneous pyrolysis methylation gas chromatography *(Eng)* S668
pyrolysis gas chromatography—The potential of pyrolysis-gas chromatography/mass spectrometry in the recognition of ancient painting media *(Eng)* S678

glass
The restoration of three paintings on glass *(Spa)* *paintings (objects); pigment; varnish; watercolors* S1061
adhesives—The evaluation of some adhesive systems utilized in the consolidation of paintings. The kinetics of consolidation (III) *(Rum)* S1021
folk art—Care of folk art: the decorative surface *(Eng)* S501
majolica—Experiments on the consolidation of glazes on majolica and glass tesserae from mosaics *(Ita)* S1106
Medieval—Pigments and paints in the Middle Ages *(Fre)* S199
painting (technique)—Original treatises on the arts of painting *(Eng + Lat)* S234
Poland—Folk painting on glass *(Pol)* S240
stained glass Field applications of stained glass conservation techniques *(Eng)* S1013
verre eglomise—The deterioration and conservation of painted glass: a critical bibliography *(Eng)* S994
—Églomise: technique and conservation *(Ger)* S1059
—Proposal for the consolidation of the painted surface on reverse painted glass *(Eng)* S1003

glass transition temperature
coatings—Mechanical properties of clay coating films containing styrene-butadiene copolymers *(Eng)* S834
mechanical properties—Influence of pigmentation on the mechanical properties of paint films *(Eng)* S779

glaze
On the material side. Glazes and glazing—Part 2 *(Eng)* *casein; consolidation; gelatin; shellac; tempera; water* S148
—Optics of paint films: glazes and chalking *(Eng)* *chalking; colorants; paint* S748
black pigment—Ceramic pigments of the Indians of the Southwest *(Eng)* S40
house paint—Problems in the restoration and preservation of old house paints *(Eng)* S947

majolica—Experiments on the consolidation of glazes on majolica and glass tesserae from mosaics *(Ita)* S1106
painting (technique)—Original treatises on the arts of painting *(Eng + Lat)* S234
reflectance—The use of differential spectral analysis in the study of museum objects *(Eng)* S744

gloss
Factors controlling gloss of paint films *(Eng)* *surface texture; titanium dioxide* S798
—Gloss of paint films and the mechanism of pigment involvement *(Eng)* *drying; gel; paint; pigment; rheology* S872
—Gloss: its definition and measurement *(Eng)* *scattering* S711
New aspects of gloss of paint film and its measurement *(Eng)* *paint; pigment; scattering* S776
—Problems connected with the concept of gloss *(Eng)* *light* S885
—Surface appearance (gloss, sheen, and flatness) *(Eng)* *pigment; reflectance* S772
bark paintings—Conservation of Australian Aboriginal bark paintings with a note on the restoration of a New Ireland wood carving *(Eng)* S905
chalk—Observations about conservation techniques regarding the consolidation of waterbound chalk paint layers *(Ger)* S1077
coatings—Anatomy of paint *(Eng)* S867
—Light scattering from glossy coatings on paper *(Eng)* S873
—Optical properties and structure of clay-latex coatings *(Eng)* S791
—Plastic pigments in paper coatings: the effect of particle size on porosity and optical properties *(Eng)* S803
—Review of literature relating the effect of binder on coating gloss *(Eng)* S767
colorants—Physics and psychophysics of colorant values *(Eng)* S713
consolidation—Investigations into techniques for the consolidation of high pigment volume concentration paint at the Getty Conservation Institute *(Eng)* S1084
lacquer—Glossiness of nitrocellulose lacquer coatings *(Eng)* S715
paint—Objective predictors of paint appeal *(Eng)* S831
pigment—Exposure evaluation: quantification of changes in appearance of pigmented materials *(Eng)* S790
—Gloss of paint films: II. Effects of pigment size *(Eng)* S886
pigment volume concentration—Coating formulation and development using critical pigment volume concentration prediction and statistical design *(Eng)* S854
—CPVC relationships. III. The real CPVC and its relationships to Young's modulus, magnetic moment, abrasive wear and gloss *(Eng)* S855
—Pigment volume concentration, pigment surface concentration, packing density, and gloss of paints *(Ger)* S850
polymers—Opaque polymers *(Eng)* S826

titanium dioxide—The durability of paint films containing titanium dioxide—contraction, erosion and clear layer theories *(Eng)* S809
varnish—The influence of light on the gloss of matt varnishes *(Eng)* S782
—The influence of varnishes on the appearance of paintings *(Eng)* S844

gluten
binding media—The importance of binders *(Fre)* S225
—The problem of conservation of very large canvases painted in glue medium *(Pol)* S968

glycerin
mural paintings—The examination of mural paintings *(Dut)* S525

goethite
prehistoric—Pigments and paints in prehistoric antiquity *(Fre)* S191
rock art—Seeing red in Queensland *(Eng)* S433
rock paintings—Mossbauer study of rock paintings from Minas Gerais (Brazil) *(Eng)* S663

gold
icons—Restoration and conservation of an icon from Melnik *(Bul)* S948
mural paintings—The investigation of pigments and paint layer structures of mural paintings at Maitepnimit Temple *(Eng)* S477
pigment—The pigments used in the wall paintings *(Jpn)* S194
screens (furniture)—Restoration of a Japanese screen *(Ger)* S949

gold (powdered)
yellow pigment—Yellow pigments used in antiquity *(Fre)* S113

gold leaf
folk art—Care of folk art: the decorative surface *(Eng)* S501
icons—The technique of icon painting *(Eng)* S214
mural paintings—Pigments and techniques of the early Medieval wall paintings of eastern Turkistan *(Ger)* S298
screens (furniture)—Restoration of a Japanese screen *(Ger)* S949
shadow puppets—The restoration of shadow puppets *(Ger)* S976

Gothic
mural paintings—Early Gothic wall paintings: an investigation of painting techniques and materials of 13th-century mural paintings in a Danish village church *(Eng)* S509

gouache
Conservation of costume designs for Broadway musicals, 1900-1925: from the drama collection, Austrian National Library, Vienna *(Ger) Austrian National Library; costume; deacidification; drawings; paint; paper* S1067
—Problems of conservation encountered with gouache paintings by Charlotte Salomon (1941-1943) *(Ger) France, southern; paintings (objects); paper; Salomon, Charlotte; vacuum tables* S1114

—Restoration of three miniature paintings with a problem of colour change *(Eng) deacidification; litharge; miniatures (paintings); paper* S1057
Miró, Joan (1893-1983)—Joan Miro: comment and interview *(Eng)* S125
paint—The material side *(Eng)* S166
paper—Paintings on paper: a dialogue in five case histories *(Eng)* S971
pastels (visual works)—Degas pastels *(Eng)* S419
rock paintings—The search for the Tassili frescoes: the story of the prehistoric rock paintings of the Sahara *(Eng)* S187
Vuillard, Edouard (1868-1940)—History, analysis and treatment of "La salle à manger au château de Clayes," 1938, by Edouard Vuillard *(Eng)* S1009
watercolors—Wash and gouache: a study of the development of the materials of watercolor *(Eng)* S296

gourd
Apache—Plants used by the White Mountain Apache Indians of Arizona *(Eng)* S47

graffiti
mural paintings—Wall paintings: technique, problems, conservation *(Ita)* S1080

graining
Graining: ancient and modern *(Eng) cornstarch; oil; whiting* S79
house paint—Every man his own housepainter and colourman: the whole forming a complete system for the amelioration of the noxious quality of common paint. A number of invaluable inventions, discoveries and improvements...and a variety of other particulars that relate to house painting in general *(Eng)* S2

granite
Australian Aboriginal—Pigment analysis for the authentication of the aboriginal paintings at Bunjils Cave, western Victoria *(Eng)* S632
mural paintings—The technique of the paintings at Sitabhinji *(Eng)* S143

graphite
Africa—The material culture of the peoples of the Gwembe Valley *(Eng)* S243
drawing (technique)—The craft of old-master drawings *(Eng)* S182
drawings—Techniques and subsequent deterioration of drawings *(Eng)* S312
Native American—What did they use for paint? *(Eng)* S236
pastels (visual works)—Analysis and conservation of graphic and sound documents: work by the Centre de Recherches sur la Conservation des Documents Graphiques, 1982-1983 *(Fre)* S1004
prehistoric—Pigments and paints in prehistoric antiquity *(Fre)* S191
rock art—The ancients knew their paints *(Eng)* S249

grass
latmul—The conservation of an orator's stool from Papua New Guinea *(Eng)* S1042

grave markers
Chumash—Volume IV: Ceremonial paraphernalia, games, and amusements *(Eng)* S344

grease
Chippewa—Some Chippewa uses of plants *(Eng)* S60
mural paintings—Ajanta murals: their composition and technique and preservation *(Eng)* S232
Native American—Handbook of American Indians north of Mexico *(Eng)* S25
rock art—The recording of rock art: an illustrated paper presented to the Canadian Conservation Institute trainees and to the Course in the Conservation of Historic Monuments and Sites, Restoration Services Division, Engineering and Architecture Branch, D.I.N.A. *(Eng)* S283

Great Britain *see also* **England**
dyeing—A bibliography of dyeing and textile printing comprising a list of books from the 16th century to the present time (1946) *(Eng)* S129
Romano-British—An analysis of paints used in Roman Britain *(Eng)* S210

Greece
parchment—The conservation methods for miniature-painting on parchment *(Eng)* S920

Greek
painting (technique)—Greek and Roman methods of painting: some comments on the statements made by Pliny and Vitruvius about wall and panel painting *(Eng)* S29
pigment—Pigments and paints in classical antiquity *(Fre)* S200
—Some experiments and observations on the colours used in painting by the ancients *(Eng)* S1
red pigment—Red pigments of antiquity *(Fre)* S114

green earth
frescoes—The frescoes of Tavant (France) *(Eng)* S179
Herlin Cathedral (Germany)—The scientific examination of the polychromed sculpture in the Herlin altarpiece *(Eng)* S552
icons—Restoration and conservation of an icon from Melnik *(Bul)* S948
India—Notes on the technique of Indian polychrome wooden sculpture *(Eng)* S246
mural paintings—The analysis of pigments from ancient mural paintings. The state of the problem and a bibliography *(Fre)* S343
—Conservation of mural paintings in Central Asia which have been damaged by salt efflorescence *(Eng)* S888
—Microchemical analysis of the wall paintings of St. Baafsabtei in Ghent (about 1175) *(Dut)* S90
—The structure of the 17th-century mural paintings in the S. George Orthodox church at Veliko Turnovo (Bulgaria) *(Pol)* S264
pigment—Artists' pigments: a handbook of their history and characteristics *(Eng)* S623

green ink
ink—The inks of ancient and modern Egypt *(Eng)* S35

green paint
bark cloth—The technical aspects of ornamented bark-cloth *(Eng)* S209
Pueblo—Two summers' work in Pueblo ruins *(Eng)* S22

green pigment
Apache—Plants used by the White Mountain Apache Indians of Arizona *(Eng)* S47
binding media—Methods used for the identification of binding media in Italian paintings of the 15th and 16th centuries *(Eng)* S554
chrysocolla—On the colors of the ancients: chrysocolla *(Ita)* S185
copper carbonate—The mamzrauti: a Tusayan ceremony *(Eng)* S11
Eskimo—Ethnological results of the Point Barrow expedition *(Eng)* S13
Native American—Some plants used by the Yuki Indians of Round Valley, northern California *(Eng)* S176
pigment—Archaeological expedition to Arizona in 1895 *(Eng)* S17
Zuni—The Zuni Indians, their mythology, esoteric fraternities, and ceremonies *(Eng)* S24

grinding
artists' materials—The painter's craft *(Fre)* S462

ground (material)
The ground in pictures *(Eng)* *drying oil; emulsion* S241
artists' materials—The painter's craft *(Fre)* S462

guaiacum
pyrolysis gas chromatography—Analysis of natural resins by pyrolysis gas chromatography. II. Identification of natural resins by pyrograms *(Jpn)* S560
Seri blue—Seri blue *(Eng)* S217
—Seri blue—an explanation *(Eng)* S218

guano
rock paintings—On the nature of the colouring matter employed in primitive and rock-paintings *(Eng)* S38

Guarani
resin—Resin classification by the Ka'apor Indians *(Eng)* S451

Guatemala (Kaminaljuyu)
ceramics—Technological notes on the pottery, pigments, and stuccoes from the excavations at Kaminaljuyu, Guatemala *(Eng)* S107

gum
The analysis of exudate plant gums in their artistic applications: an interim report *(Eng)* *gas chromatography; hydrolysis; liquid chromatography; plants* S616
Africa—The useful art of Africa: their methods and materials *(Eng)* S251
Anacardiaceae—A most useful plant family, the Anacardiaceae *(Eng)* S71
Asia, Southeast—Conservation of manuscripts and paintings of Southeast Asia *(Eng)* S1002

—The identification of insular Southeast Asian resins and other plant exudates for archaeological and ethnological application *(Eng)* S630
Australian Aboriginal—An Alyawara day: flour, spinifex gum, and shifting perspectives *(Eng)* S361
—Bark paintings: techniques and conservation *(Eng)* S443
Bella Coola—Materia medica of the Bella Coola and neighbouring tribes of British Columbia *(Eng)* S48
binding media—Binding media identification in painted ethnographic objects *(Eng)* S675
—The importance of binders *(Fre)* S225
dye—Colors for textiles: ancient and modern *(Eng)* S109
—Rosewood, dragon's blood and lac *(Eng)* S181
Egypt—Ancient Egyptian materials and industries *(Eng)* S63
Egypt (Saqqara)—Identification of medium used in polychrome reliefs in ancient Egyptian limestone tomb dating from the nineteenth dynasty /1350-1200 B.C./ at Saqqara *(Eng)* S649
ethnobotany—An introductory study of the arts, crafts, and customs of the Guiana Indians *(Eng)* S34
ink—The inks of ancient and modern Egypt *(Eng)* S35
Malawi—Useful plants of Malawi *(Eng)* S219
Medieval—Observations on a late Medieval painting medium *(Eng)* S117
Mexico—Colors and paint at the time of the pre-Cortés Mexican civilizations *(Fre)* S169
mural paintings—Ajanta murals: their composition and technique and preservation *(Eng)* S232
—The Pallava paintings at Conjeevaram: an investigation into the methods *(Eng)* S85
—A study of organic components of ancient middle Asian and Crimean wall paintings *(Rus)* S289
—The technique of the paintings at Sitabhinji *(Eng)* S143
—The techniques, conservation, and restoration of mural paintings *(Ita)* S64
Native American—American Indian painting of the Southwest and Plains areas *(Eng)* S239
—What did they use for paint? *(Eng)* S236
paintings (objects)—Analysis of paint media, varnishes and adhesives *(Eng)* S625
plant materials—A dictionary of the economic products of the Malay Peninsula *(Eng)* S65
plants—Analytical procedures *(Eng)* S531
—Plant gums as painting mediums in the light of old treatises, their properties, and their identification in ancient polychromy *(Pol)* S207
—Plants for man *(Eng)* S159
polysaccharides—The detection of polysaccharides in the constituent materials of works of art *(Fre)* S537
—An investigation and identification of polysaccharides isolated from archaeological specimens *(Eng)* S570
pyrolysis gas chromatography—Identification of natural gums in works of art

using pyrolysis-gas chromatography *(Eng)* S652
—Pyrolysis gas chromatographic mass spectrometric identification of intractable materials *(Eng)* S588
pyrolysis mass spectrometry—Pyrolysis-mass spectrometry of natural gums, resins, and waxes and its use for detecting such materials in ancient Egyptian mummy cases (cartonnages) *(Eng)* S636
rock art—The prehistoric artist of Southern Matabeleland; his materials and technique as a basis for dating *(Eng)* S175
—The recording of rock art: an illustrated paper presented to the Canadian Conservation Institute trainees and to the Course in the Conservation of Historic Monuments and Sites, Restoration Services Division, Engineering and Architecture Branch, D.I.N.A. *(Eng)* S283
rock paintings—The search for the Tassili frescoes: the story of the prehistoric rock paintings of the Sahara *(Eng)* S187
shields (armor)—Restoration of a ceremonial shield from the Solomon Islands *(Ger)* S1025
sumac—The use of the sumacs by the American Indian *(Eng)* S72
tempera—The material side: tempera painting—part 1 *(Eng)* S146
thin layer chromatography—Methods in scientific examination of works of art. Volume 3: thin-layer chromatography reference materials binder *(Eng)* S683
wax—The preservation of wood sculpture: the wax immersion method *(Eng)* S890
Yoruba—A Yoruba master carver: Duga of Meko *(Eng)* S274

gum arabic
binding media—Artificial samples of paint binders. Oils, resins, waxes, glues, egg, prepared in binary mixtures: analytical characteristics and properties *(Ita)* S631
ceilings—Restoration of painted ceilings in Oman: the Jabrin fortress *(Fre)* S1048
coatings—Development and growth of resins for the coating industry *(Eng)* S340
Egypt—What do we know about the paints of the old Egyptians? *(Eng)* S137
ink—Gas chromatographic mass spectrometric analysis of tannin hydrolysates from the ink of ancient manuscripts (XIth to XVIth century) *(Eng)* S577
mural paintings—The examination of mural paintings *(Dut)* S525
Netherlandish—The beginnings of Netherlandish canvas painting, 1400-1530 *(Eng)* S445
orchid—Orchids of economic use *(Eng)* S193
polysaccharides—Polysaccharides as part of a color layer and methods for their identification *(Cze)* S647
stabilizers—Identification of stabilizing agents *(Eng)* S527
Tomb of Nefertari (Thebes, Egypt)—Chemical analyses of pigments and media used in the mural paintings of the tomb of Nefertari *(Spa)* S658

heat

adhesives—The evaluation of some adhesive systems utilized in the consolidation of paintings. The kinetics of consolidation (I) *(Rum)* S1019
—The evaluation of some adhesive systems utilized in the consolidation of paintings. The kinetics of consolidation (II) *(Rum)* S1020
—The evaluation of some adhesive systems utilized in the consolidation of paintings. The kinetics of consolidation (III) *(Rum)* S1021
bark paintings—Conservation of Australian Aboriginal bark paintings with a note on the restoration of a New Ireland wood carving *(Eng)* S905
encaustic wax—The cleaning and consolidation of Egyptian encaustic mummy portraits *(Eng)* S1088
verre eglomise—Proposal for the consolidation of the painted surface on reverse painted glass *(Eng)* S1003
wood—Consolidation of painted wooden artifacts *(Eng)* S934

heating

mural paintings—Conservation of English Medieval wallpaintings over the century *(Eng)* S1028

hematite

Physico-chemical and colorimetric study of haemitite reds and purples, with reference to the mural paintings of the Acropolis of Lero, or "histories of ochre" *(Fre) Acropolis of Lero (Côte d'Azur, France); mural paintings; ocher; paint; pigment; red pigment; Roman* S352
ceramics—Technological notes on the pottery, pigments, and stuccoes from the excavations at Kaminaljuyu, Guatemala *(Eng)* S107
Horyuji Temple (Japan)—Coloring materals of the murals in the Main Hall of the Horyuji Temple compared with those of the ornamented tombs *(Jpn)* S271
house paint—Topical observations on the use of forgotten pigments used for painting rooms in Lower Saxony *(Ger)* S438
mural paintings—The investigation of pigments and paint layer structures of mural paintings at Maitepnimit Temple *(Eng)* S477
—Physico-chemical study of the painting layers of the Roman mural paintings from the Acropolis of Lero *(Fre)* S342
Native American—What did they use for paint? *(Eng)* S236
pigment—Archaeological expedition to Arizona in 1895 *(Eng)* S17
—The T'u-lu colour-container of the Shang-Chou period *(Eng)* S222
—Two aboriginal rock pigments from Western Australia: their properties, use and durability *(Eng)* S290
prehistoric—Pigments and paints in prehistoric antiquity *(Fre)* S191
rock art—The ancients knew their paints *(Eng)* S249
—Seeing red in Queensland *(Eng)* S433
rock paintings—Mossbauer study of rock paintings from Minas Gerais (Brazil) *(Eng)* S663

Shroud of Turin—Microscopical study of the Turin Shroud. III *(Eng)* S598
Tlingit—The conservation of a Tlingit blanket *(Eng)* S909

hemlock

Nitinaht—Ethnobotany of the Nitinaht Indians of Vancouver Island *(Eng)* S356

hemp

manuscripts—A clay-coated manuscript in the Gilgit collection *(Eng)* S907

Herlin Cathedral (Germany)

The scientific examination of the polychromed sculpture in the Herlin altarpiece *(Eng) altarpieces; azurite; binding media; carbon black; gas chromatography; Germany (Rothenburg); green earth; indigo; lead white; liquid chromatography; madder; matte; microscopy; paint; pigment; polychromy; red lead; relief; sculpture; spectrophotometry; thin layer chromatography; verdigris; vermilion* S552

hide

animal glue—Manufacturing and analyzing ancient animal glues *(Swe)* S651
—The significance of fat in animal glue for painting purposes *(Ger)* S628
Blackfoot—The Blackfoot tipi *(Eng)* S68
delamination—Detection of delaminations in art objects using air-coupled ultrasound *(Eng)* S880
fixatives—Fixing agent for chalking color on wood and its laboratory evaluation *(Jpn + Eng)* S1040
Fourier transform infrared spectroscopy—Applications of infrared microspectroscopy to art historical questions about Medieval manuscripts *(Eng)* S648
Montagnais—A Naskapi painted skin shirt *(Eng)* S247
Native American—Indian rawhide: an American folk art *(Eng)* S280
painting (technique)—Greek and Roman methods of painting: some comments on the statements made by Pliny and Vitruvius about wall and panel painting *(Eng)* S29
shadow puppets—The restoration of shadow puppets *(Ger)* S976

high performance liquid chromatography

binding media—Analysis of binding media and adhesives in Buddhist wooden statues *(Jpn)* S674
paintings (objects)—Analysis of paint media, varnishes and adhesives *(Eng)* S625
protein—Identification of protein containing binding media and adhesives in works of art by amino acid analysis *(Jpn)* S659
Tura, Cosimo (1430?-1495)—Amino acid analysis of proteinaceous media from Cosimo Tura's "The Annunciation with Saint Francis and Saint Louis of Toulouse." *(Eng)* S669

historic buildings

Conservation within historic buildings in Japan *(Eng) acrylic resin; Acrylic Resin Sol; air pollution; flaking; humidity; Japan (Kyoto); light; microorganisms; nitrogen oxide; paint; pollution; relative humidity; sulfur oxide* S973

—Hopi journal of Alexander M. Stephen *(Eng)* *feather; mineral pigment; pigment; saliva; seeds* S70

—The Na-ac-nai-ya: a Tusayan initiation ceremony *(Eng) melon; mortar; painting (technique); ritual objects; saliva; seeds; shale* S12

copper carbonate—The mamzrauti: a Tusayan ceremony *(Eng)* S11

Native American—Indian herbalogy of North America: the definitive guide to native medicinal plants and their uses *(Eng)* S490

pigment—Archaeological expedition to Arizona in 1895 *(Eng)* S17

pueblos (housing complexes)—A study of Pueblo architecture: Tusayan and Cibola *(Eng)* S9

Horyuji Temple (Japan)

Coloring materals of the murals in the Main Hall of the Horyuji Temple compared with those of the ornameled tombs *(Jpn) azurite; carbon black; Chinese ink; clay; hematite; iron oxide; lead; litharge; malachite; manganese; mural paintings; pigment; red lead; vermilion; white clay; yellow ocher* S271

—Scientific treatments made on the main hall of the Hōryūji Monastery after the fire of 1949 *(Jpn) fire; mud; mural paintings; pigment; steel; timber; urea-formaldehyde resin* S893

mural paintings—Application of synthetic resins to the preservation of antiques and art crafts *(Jpn)* S891

hot glue

Vuillard, Edouard (1868-1940)—The special problems and treatment of a painting executed in hot glue medium, The Public Garden by Edouard Vuillard *(Eng)* S999

hot spatula

shadow puppets—Restoration of Chinese and Indonesian shadow puppets *(Eng)* S1011

—The restoration of shadow puppets *(Ger)* S976

house paint

Every man his own house-painter and colourman: the whole forming a complete system for the amelioration of the noxious quality of common paint. A number of invaluable inventions, discoveries and improvements...and a variety of other particulars that relate to house painting in general *(Eng) beer; graining; pigment* S2

—Historic finishes analysis *(Eng) architecture; finishes; flaking; historic houses; house paint; Morse Libby Mansion (Portland, Maine, USA); paint; staining (finishing)* S441

—House paints in Colonial America: their materials, manufacture and application. Part III *(Eng) American Colonial; asphaltum; azurite; blue verditer; carmine; chalk; cinnabar; fig; indigo; lead; ocher; orpiment; paint; pigment; red lead; sienna; smalt; spruce; umber; vermilion* S230

—Kline paints a picture *(Eng) titanium; turpentine; zinc white* S154

—Microchemical analysis of old housepaints with a case study of Monticello *(Eng) architectural elements; buildings; coatings; historic buildings; Jefferson, Thomas (1743-1826); microscopy; Monticello (Virginia, USA); paint;*

polarized light microscopy; stereomicroscopy S661

—Problems in the restoration and preservation of old house paints *(Eng) adhesion; American Colonial; blanching; fading; glaze; historic buildings; inpainting; oil paint; reattaching; spectrophotometry; varnish; verdigris; yellowing* S947

—Topical observations on the use of forgotten pigments used for painting rooms in Lower Saxony *(Ger) antimonite; galena; Germany (Saxony); gypsum; hematite; historic buildings; ocher; paint; pyrite; rooms; vivianite* S438

building materials—Conservation applied to historic preservation *(Eng)* S449

facades—Conserving deteriorated exterior plaster coatings *(Ita)* S1065

flat paint—The effect of pigmentation on modern flat wall paints *(Eng)* S716

historic buildings—Defects of color dyes on historic buildings' renderings *(Cze)* S914

Scandinavia—Scandinavian painted decor *(Eng)* S467

houses

Tamberma—Architecture of the Tamberma (Togo) *(Eng)* S332

HPLC *see* **high performance liquid chromatography**

human head

The conservation of a preserved human head *(Eng) Bedacryl 122X; clay; cleaning; ethnography; fiber; Jivaro; Maori; New Zealand; paint; Papua New Guinea; skin; soluble nylon; xylene* S935

human remains

skin—Lipids from samples of skin from seven Dutch bog bodies: preliminary report *(Eng)* S653

humidity

coatings—Formulating for better control of internal stress *(Ita)* S835

consolidants—Degradation of synthetic consolidants used in mural painting restoration by microorganisms *(Eng)* S1122

fixing—Theoretical approach to refixing *(Fre)* S1017

historic buildings—Conservation within historic buildings in Japan *(Eng)* S973

illuminations—The conservation of a Petrarch manuscript *(Eng)* S910

mural paintings—Conservation of mural paintings in Central Asia which have been damaged by salt efflorescence *(Eng)* S888

—Indian murals: techniques and conservation *(Eng)* S931

—The paintings on walls and ceilings in the cabinets of the gallery building at Hannover-Herrenhausen *(Ger)* S1070

panel paintings—Basic experiments concerning deterioration of glue and discoloration of pigments, and discussion on the actual condition of wall panel paintings on the basis of their results *(Jpn)* S930

rock art—The recording of rock art: an illustrated paper presented to the Canadian Conservation Institute trainees and to the Course

in the Conservation of Historic Monuments and Sites, Restoration Services Division, Engineering and Architecture Branch, D.I.N.A. (Eng) S283
Romania—Specific forms of degradation and their causes in wood panel tempera paintings (Rum) S439
stone—The conservation of the Winchester Anglo-Saxon fragment (Eng) S1090
wood—Consolidation of painted wooden artifacts (Eng) S934

Hungary
chests—The cleaning, conservation, and restoration of a Matyo chest (Hun) S1000
mural paintings—The restoration of 18th-century decorative wall paintings imitating wallhangings in Hungary (Ger) S321

Hungary (Lovas)
red ocher—A paint mine from the early Upper Palaeolithic age near Lovas (Hungary, County Veszprém) (Eng) S170

huntite
pigment—Two aboriginal rock pigments from Western Australia: their properties, use and durability (Eng) S290
Tomb of Nefertari (Thebes, Egypt)—Chemical analyses of pigments and media used in the mural paintings of the tomb of Nefertari (Spa) S658

hydrated lime
rock paintings—On the nature of the colouring matter employed in primitive and rockpaintings (Eng) S38

hydraulic
cement—Precolumbian cements: a study of the calcareous cements in pre-Hispanic meso-American building construction (Eng) S553

hydrochloric acid
Anasazi—A simple method for distinguishing between organic and inorganic paints on black-on-white Anasazi pottery (Eng) S568
mural paintings—Ajanta murals: their composition and technique and preservation (Eng) S232

hydrogen peroxide
illuminations—The conservation of a Petrarch manuscript (Eng) S910

hydrogen sulfide
illuminations—The conservation of a Petrarch manuscript (Eng) S910

hydrolysis
gas chromatography—Identification of proteinaceous binding media of easel paintings by gas chromatography of the amino acid derivatives after catalytic hydrolysis by a protonated carbon exchanger (Eng) S670
gum—The analysis of exudate plant gums in their artistic applications: an interim report (Eng) S616
illuminations—The development of techniques of identification for pigments and binders used in the paint layer of manuscript illuminations (Fre) S546
ink—Gas chromatographic mass spectrometric analysis of tannin hydrolysates from the ink of

ancient manuscripts (XIth to XVIth century) (Eng) S577
plants—Analytical procedures (Eng) S531
polysaccharides—Polysaccharides as part of a color layer and methods for their identification (Cze) S647
protein—The characterization of proteinaceous binders in art objects (Eng) S617

hydroxypropylcellulose
consolidants—The consolidation of powdery paint layers of Bonaders, Swedish mural works painted on paper (Fre) S1109
shields (armor)—Restoration of a ceremonial shield from the Solomon Islands (Ger) S1025

hymenaea courbaril
resin—Preliminary investigations of Hymenaea courbaril as a resin producer (Eng) S233

Iatmul
The conservation of an orator's stool from Papua New Guinea (Eng) cleaning; consolidation; grass; hair; Papua New Guinea; reattaching; ritual objects; wood S1042

Iceland
Likneskjusmid: fourteenth century instructions for painting from Iceland (Eng) gilding; Medieval; Norway; painting (technique); pine; resin; wood S503

icons
Conservation problems in Egypt: some remarks on the technology of postmediaeval Coptic icons (Eng) Coptic (Christian sect); Egypt; tempera S479
—Restoration and conservation of an icon from Melnik (Bul) Bulgaria (Melnik); burnt umber; canvas; egg tempera; gold; green earth; indigo; ivory; lead white; linen; pigment; red ocher; silver; tempera; vermilion; wood S948
—The technique of icon painting (Eng) alder; birch; canvas; cypress; egg yolk; enamel; gems; gesso; gold leaf; lead white; lime; Medieval; oak; ocher; priming; Russia; tempera; Ukraine (Kiev); vermilion; wood S214
isinglass—Potential applications of isinglass adhesive for paper conservation (Eng) S1076

Igbo
Uli painting and Igbo world view (Eng) mural paintings; Nigeria; rituals S444

iguana
pigment—Domestic implements, arts, and manufactures (Eng) S23

illumination (decoration)
The technique of old writings and miniatures (Eng) binding media; black ink; brown ink; illuminations; ink; pigment S293
—Writing technique and illumination of ancient Serbian manuscripts (Fre) black ink; chromatography; illuminations; ink; manuscripts; pigment; Serbia S338

illuminations
The conservation of a Petrarch manuscript (Eng) air pollution; bleaching; cracking; darkening; flaking; humidity; hydrogen peroxide; hydrogen sulfide; lead carbonate; lead sulfide; lead white; manuscripts; vellum S910

illuminations

—The development of techniques of identification for pigments and binders used in the paint layer of manuscript illuminations *(Fre) amino acid; binding media; chromatography; gas chromatography; hydrolysis; manuscripts; minerals; pigment; spectrophotometry; sugar; thin layer chromatography* S546
—Practice and practical possibilities in the conservation of Medieval miniatures *(Ger) acrylic resin; alkyd resin; beeswax; benzyl cellulose; bibliographies; carboxymethylcellulose; dammar; ethyl cellulose; fixing; flaking; gelatin; Medieval; methyl cellulose; mineral wax; parchment; poly(vinyl acetate)* S969
—Some details on the technique and of the restoration of two illuminated 13th century manuscripts from Western Europe *(Fre) color; fixing; flaking; France; Germany, southern; gilding; manuscripts; parchment; pigment; psalters; radiography; vinyl acetate* S942
—Some tests on the use of wax for fixing flaking paint on illuminated parchment *(Eng) adhesives; beeswax; dammar; fixing; flaking; microcrystalline wax; paint; parchment; wax* S898
illumination (decoration)—The technique of old writings and miniatures *(Eng)* S293
—Writing technique and illumination of ancient Serbian manuscripts *(Fre)* S338
parchment—Conservation methods for Medieval miniatures on parchment *(Eng)* S919
—The conservation methods for miniature-painting on parchment *(Eng)* S920
—Diagnosis and therapy in parchment and miniature restoration *(Ger)* S991
polymers—Consolidation of the pictorial layer of illuminations with pure synthetic polymers *(Fre)* S989
—The use of synthetic polymers for the consolidation of Medieval miniatures on parchment *(Rus)* S938

impregnation
adhesives—Adhesives for impregnation of painting on canvas *(Swe)* S1087
clay—Restoration of a relief in painted clay *(Fre)* S887
consolidants—Considerations concerning criteria for the selection of consolidant and the relative methodology of application *(Ita)* S1082
consolidation—New methods for the consolidation of fragile objects *(Eng)* S900
poly(butyl methacrylate)—New possibilities of polybutyl methacrylate as a consolidating agent for glue painting on loess plaster *(Eng)* S936
synthetic resin—Restoration with synthetic resins in Japan *(Ger)* S966
Tibet—Preservation of two ancient objects *(Eng)* S894
wood—Consolidation of painted wooden artifacts *(Eng)* S934
—Consolidation of painted wooden artifacts: an ICOM report *(Eng)* S924

Impressionist
An approach to the study of modern paintings surfaces *(Ger) artists' materials; matte* S1124

pastels (visual works)—A sculpture and a pastel by Edgar Degas *(Eng)* S285

in situ conservation
field archaeology—A conservation manual for the field archaeologist *(Eng)* S1044
frescoes—In situ consolidation of a Roman fresco near Ein Yael, Jerusalem *(Eng)* S1118
Papua New Guinea—An ethnographic collecting expedition to Papua New Guinea: field conservation and laboratory treatment *(Eng)* S967

Inca
Mopa-mopa or pasto varnish: the frames of the Church of Egypt, in Bogotá *(Bogotá); mopa-mopa tree (Eleagia utilis); paint; plant materials; resin; varnish; wood* S461
Peru—An analytical study of pre-Inca pigments, dyes and fibers *(Eng)* S571

India
The first painting on earth *(Eng) history of technology; painting (technique)* S495
—Notes on the technique of Indian polychrome wooden sculpture *(Eng) barium yellow; carbon black; carving; chrome yellow; cinnabar; green earth; indigo; kaolin; malachite (pigment); ocher; pigment; polychromy; sculpture; strontium yellow; wood* S246
—One hundred references to Indian painting *(Eng) bibliographies; mural paintings; painting (technique); panel paintings; textiles* S49
—A study of Indian polychrome wooden sculpture *(Eng) barium yellow; carving; chalk; chrome yellow; dye; gesso; kaolin; malachite; pigment; polychromy; red lead; red ocher; shellac; strontium yellow; varnish; wood; yellow ocher* S255
dyeing—A bibliography of dyeing and textile printing comprising a list of books from the 16th century to the present time (1946) *(Eng)* S129
manuscripts—A clay-coated manuscript in the Gilgit collection *(Eng)* S907
miniatures (paintings)—Application of traditional Indian techniques in the treatment of a Bundi miniature *(Eng)* S324
—The conservation of Indian and Moghul miniatures *(Eng)* S978
mural paintings—Ajanta and Ellora wall paintings. Scientific research as an aid to their conservation *(Eng)* S569
—Conservation of mural paintings *(Eng)* S522
—Indian murals: techniques and conservation *(Eng)* S931
—Technique of the painting process in the Kailasanatha and Vaikunthaperumal temples at Kanchipuram *(Eng)* S84
organic materials—A study of organic components of paints and grounds in Central Asian and Crimean wall paintings *(Eng)* S564
painting (technique)—Technical examination and conservation of an Indian painting *(Eng)* S904
turmeric—Advances in the agronomy and production of turmeric in India *(Eng)* S379

408

binding media—Contributions to the analysis of binders, adhesives and ancient varnishes *(Fre)* S547
iron oxide—Infrared study of the yellow and red iron oxide pigments *(Ger)* S551
Maya blue—Examination and identification of Maya blue *(Fre)* S544
paintings (objects)—Analysis of paint media, varnishes and adhesives *(Eng)* S625
polysaccharides—The detection of polysaccharides in the constituent materials of works of art *(Fre)* S537
Sudan (Mirgissa)—Physico-chemistry at the service of archaeology: examination of a series of samples from excavations done in Sudan *(Fre)* S545

infrared photography
pigment—The pigments used in the wall paintings *(Jpn)* S194
reference materials—Second report on reference materials incorporating special reports by members of the working group: ICOM Committee for Conservation, Madrid, 2-7 October, 1972 *(Eng)* S557

infrared spectrometry
Instrumental analysis in the coatings industry *(Eng)* gas chromatography; paint; pyrolysis; solvents S619
—Methods in scientific examination of works of art: infrared microspectroscopy *(Eng)* cross sections; Getty Conservation Institute (Marina del Rey, CA, USA); resin; samples; spectrometry S664
Asia, Southeast—The identification of insular Southeast Asian resins and other plant exudates for archaeological and ethnological application *(Eng)* S630
Australian Aboriginal—Pigment analysis for the authentication of the aboriginal paintings at Bunjils Cave, western Victoria *(Eng)* S632
binding media—Perspectives on the chemistry of old paint binders *(Fre)* S535
forensic science—Developments in paint analysis for forensic purposes *(Eng)* S639
—Forensic analysis of coatings *(Eng)* S615
gelatin—IR-spectroscopic analysis of aged gelatins *(Eng)* S596
Mayan—The Maya mural paintings of Bonampak, materials analysis *(Fre)* S539
mural paintings—A study of organic components of ancient middle Asian and Crimean wall paintings *(Rus)* S289
polysaccharides—An investigation and identification of polysaccharides isolated from archaeological specimens *(Eng)* S570
—Polysaccharides as part of a color layer and methods for their identification *(Cze)* S647
resin—A comparison of pyrolysis mass spectrometry, pyrolysis gas chromatography and infra-red spectroscopy for the analysis of paint resins *(Eng)* S618
thin layer chromatography—The methods of identifying organic binders in paint layers *(Slo)* S599
varnish—Special report on picture varnish *(Eng)* S529

x-ray diffraction—Nondestructive infrared and x-ray diffraction analyses of paints and plastics *(Eng)* S532

ink
Gas chromatographic mass spectrometric analysis of tannin hydrolysates from the ink of ancient manuscripts (XIth to XVIth century) *(Eng)* chromatography; gas chromatography; gum arabic; hydrolysis; iron gall ink; manuscripts; mass spectrometry; parchment; tannin S577
—The inks of ancient and modern Egypt *(Eng)* blue ink; copper; Egypt; green ink; gum; iron oxide S35
drawing (technique)—The craft of old-master drawings *(Eng)* S182
drawings—Techniques and subsequent deterioration of drawings *(Eng)* S312
fixatives—Experimental studies on fixatives for powdery traces *(Fre)* S1012
illumination (decoration)—The technique of old writings and miniatures *(Eng)* S293
—Writing technique and illumination of ancient Serbian manuscripts *(Fre)* S338
mural paintings—Pigments used in the paintings of "Hoodo." *(Jpn)* S183
painting (technique)—Original treatises on the arts of painting *(Eng + Lat)* S234
paper—Conservation of some non-book material in National Library, Calcutta *(Eng)* S1026
pigment—Paint flow and pigment dispersion: a rheological approach to coatings and ink technology *(Eng)* S802
plants—The useful plants of west tropical Africa *(Eng)* S374
Plexigum P24—A study of Plexigum P24 used as a fixative for flaking paint traces *(Fre)* S1043
wallpaper—Wallpaper in America: from the 17th century to World War I *(Eng)* S320

inorganic gel
stained glass—A new fixation method for paint layer conservation *(Eng)* S1091

inorganic materials
light—Light: its interaction with art and antiquities *(Eng)* S805
spot tests—Spot tests in inorganic analysis *(Eng)* S556

inorganic pigment *see also* **mineral pigment**
adhesives—Natural adhesives in East Asian paintings *(Eng)* S372
ceilings—Restoration of painted ceilings in Oman: the Jabrin fortress *(Fre)* S1048
coatings—Pigment-polymer interaction and technological properties of pigmented coatings and plastics *(Eng)* S800
—Plastic pigments in paper coatings: the effect of particle size on porosity and optical properties *(Eng)* S803
Fourier transform infrared spectroscopy—Analysis of aged paint binders by FTIR spectroscopy *(Eng)* S657
mineral pigment—Earth pigments and their colors *(Ita)* S421
mural paintings—The investigation of pigments and paint layer structures of mural paintings at Maitepnimit Temple *(Eng)* S477

iron oxide

pigment—The pigments used in the wall
paintings *(Jpn)* S194
—Role of pigments *(Eng)* S768
radioactivity—Radiochemical investigation of
ionic penetration into paint films *(Eng)* S778
red pigment—African red pigments *(Eng)*
S641
—Red pigments of antiquity *(Fre)* S114
rock art—The ancients knew their paints *(Eng)*
S249
Shroud of Turin—Light microscopical study
of the Turin Shroud. I *(Eng)* S592
—Microscopical study of the Turin Shroud. III
(Eng) S598

iron oxide red
mural paintings—The earliest known paints
(Eng) S153

iron phosphate
Maori—Maori art *(Eng)* S18

isinglass
Potential applications of isinglass adhesive for
paper conservation *(Eng) adhesives; fish glue;
icons; paper; Russia* S1076
extenders—Relative flatting efficiency of ex-
tenders and effect of these extenders on sheen
uniformity, color uniformity, suction spotting,
and enamel hold-out in solvent systems *(Eng)*
S731
protein—Identification of protein containing
binding media and adhesives in works of art
by amino acid analysis *(Jpn)* S659
verre eglomise—Eglomise: technique and
conservation *(Ger)* S1059

isocyanates
synthetic resin—Restoration with synthetic
resins in Japan *(Ger)* S966

isopropanol
tempera—Examination and treatment of a
tempera on canvas from the 16th century: the
Emmaus Pilgrims from the Fine Arts Museum
of Brussels *(Fre)* S981
textiles—Technical study and conservation of
an old painted textile (Simhasana) *(Eng)* S902

Israel (En Boqeq)
gas chromatography—Gas chromatographic
identification of a resinous deposit from a 6th
century storage jar and its possible identifica-
tion *(Eng)* S608

Israel (Jerusalem)
frescoes—In situ consolidation of a Roman
fresco near Ein Yael, Jerusalem *(Eng)* S1118

Italian
binding media—Analyses of paint media
(Eng) S594
cleavage—A case of paint cleavage *(Eng)* S703
panel paintings—Methods of egg-tempera
panel painting conservation employed in the
State Hermitage *(Eng)* S986
tempera—Ancient surface technology *(Eng)*
S110

Italy
binding media—Methods used for the identi-
fication of binding media in Italian paintings
of the 15th and 16th centuries *(Eng)* S554

ceilings—The restoration of the wooden
painted ceiling in the "Confraternità del Rosa-
rio," SS. Filippo and Giacomo Church, Ospeda-
letto d'Alpinolo *(Ita)* S1096
majolica—Experiments on the consolidation of
glazes on majolica and glass tesserae from mo-
saics *(Ita)* S1106
mural paintings—Wall painting conservation
in Tuscany before the Florentine flood of 1966
(Eng) S1125
—Wall paintings: technique, problems, conser-
vation *(Ita)* S1080
plasterwork—The restoration of facade plas-
terwork in Italy *(Fre)* S472
protein—Notes on the identification of pro-
teins in paint binders *(Fre)* S567
Roman—Colorings and renderings in the an-
cient world *(Ita)* S395

Italy (Campania)
mural paintings—Destruction and restoration
of Campanian mural paintings in the eigh-
teenth and nineteenth centuries *(Eng)* S1105

Italy (Cercina)
wood—The restoration of the wooden statue
of Our Lady in the parish church of Cercina
(Ita) S1078

Italy (Ferrara)
buildings—The surface finishing of Renais-
sance facades in Ferrara, Italy: scientific studies
(Ita) S493

Italy (Florence)
Angelico, Fra (ca. 1400-1455)—Restoration
of a miniature by Fra Angelico in Florence
(Fre) S1016
mural paintings—In review: an assessment of
Florentine methods of wall painting conserva-
tion based on the use of mineral treatments
(Eng) S1104

Italy (Herculaneum)
fresco painting (technique)—Fresco painting
(Ita) S157
mural paintings—Mural painting technique of
Herculaneum *(Ita)* S186

Italy (Naples)
Velazquez, Diego Rodriguez de Silva (1599-
1660)—The technique of Velasquez in the
painting *The Drinkers* at the Picture Gallery of
Naples *(Eng)* S139

Italy (Piedmont)
mineral pigment—Earth pigments and their
colors *(Ita)* S421

Italy (Piove di Sacco)
tempera—Problems in restoring a tempera on
19th-century paper: decoration by Ponga for
the balcony of the Olympic Theatre of Piove di
Sacco *(Ita)* S1081

Italy (Pompeii)
The technique of antique Pompeian wall paint-
ing *(Ita) lime; mural paintings* S131
fresco painting (technique)—Fresco painting
(Ita) S157
mural paintings—Mural painting technique of
Herculaneum *(Ita)* S186
pigment—Analysis of the material and tech-
nique of ancient mural paintings *(Eng)* S220

412

Italy (Rome)

fresco painting (technique)—The art of
fresco painting as practised by the old Italian
and Spanish masters, with a preliminary in-
quiry into the nature of the colours used in
fresco painting, with observations and notes
(Eng) S156
historic buildings—Inspection of the state of
the art: materials commonly available on the
market and employed for renderings and paint
(Ita) S1033

Italy (Venice)

Carriera, Rosalba (1675-1757)—Rosalba Car-
riera and the early history of pastel painting
(Eng) S498

ivory

folk art—Care of folk art: the decorative sur-
face *(Eng)* S501
icons—Restoration and conservation of an
icon from Melnik *(Bul)* S948

jade

Mexico—Colors and paint at the time of the
pre-Cortés Mexican civilizations *(Fre)* S169
pigment—The T'u-lu colour-container of the
Shang-Chou period *(Eng)* S222

Japan

Pigments used in Japanese paintings *(Eng)*
*azurite; cinnabar; gamboge (pigment); indigo;
iron oxide; lead white; malachite (pigment);
obsidian; oyster shell white; paintings (ob-
jects); pigment; red lead; vermilion; yellow
ocher* S405
—Pigments used on Japanese paintings from
the protohistoric period through the 17th cen-
tury *(Eng) lacquer; leather; oil; pigment;
Shosoin (Nara, Japan); tempera; wood* S315
adhesives—Natural adhesives in East Asian
paintings *(Eng)* S372
—Re-attaching a thick color layer of poly-
chrome sculpture. Conservation of a seated
figure of Rev. Tenkai *(Jpn)* S1075
animal glue—"Nikawa": traditional produc-
tion of animal glue in Japan *(Eng)* S367
mural paintings—Chemical studies on ancient
painting materials *(Jpn)* S150
—Chemical studies on ancient paintings in Ja-
pan *(Eng)* S138
—Chemical studies on the pigments of ancient
ornamented tombs in Japan *(Jpn)* S151
—Reproduction of colored patterns in temples
and shrines *(Eng)* S383
panel paintings—Preservative treatment on
paint layer of screen and wall panel paintings
(Jpn) S929
pigment—Studies on the ancient pigments in
Japan *(Eng)* S52
—Technical studies on the pigments used in
ancient paintings of Japan *(Eng)* S167
screens (doors)—Treatment on painting of
sliding screens and wall panels to prevent ex-
foliation in Japan *(Eng)* S972
synthetic resin—Restoration with synthetic
resins in Japan *(Ger)* S966
tablets—Preservative treatment of the *Funa-
Ema* (votive tablets of boats), important folk-
lore materials at Arakawa Shrine and Haku-
sanhime Shrine *(Jpn)* S932

wood—Colouring technique and repair meth-
ods for wooden cultural properties *(Eng)* S303

Japan (Kyoto)

historic buildings—Conservation within his-
toric buildings in Japan *(Eng)* S973
mural paintings—Pigments used in the paint-
ings of "Hoodo." *(Jpn)* S183
panel paintings—Present state of screen and
panel paintings in Kyoto *(Jpn)* S933

Japan (Nara)

pigment—The chemical studies on the pig-
ments used in the Main Hall and pagoda of
Hōryūji temple (Nara, Japan) *(Jpn)* S119

Japan (Tokyo)

reattaching—Reattaching thick color layer of
polychrome wooden sculpture *(Jpn)* S1022
votive tablets—Cleaning treatment on votive
tablet in traditional way *(Jpn)* S939

Japanese

painting (technique)—Pigments and paints in
primitive exotic techniques *(Fre)* S201
screens (furniture)—Restoration of a Japanese
screen *(Ger)* S949

Japanese paper

carboxymethylcellulose—The use of car-
boxymethylcellulose in the restoration of easel
paintings *(Rum)* S1008
panel paintings—Basic experiments concern-
ing deterioration of glue and discoloration of
pigments, and discussion on the actual condi-
tion of wall panel paintings on the basis of
their results *(Jpn)* S930
pastels (visual works)—Removing severe dis-
tortions in a pastel on canvas *(Eng)* S1032
reattaching—Reattaching color layers on a
wooden wall and documenting the distribution
of damages *(Jpn)* S1024
tempera—Problems in restoring a tempera on
19th-century paper: decoration by Ponga for
the balcony of the Olympic Theatre of Piove di
Sacco *(Ita)* S1081
votive tablets—Cleaning treatment on votive
tablet in traditional way *(Jpn)* S939

Jefferson, Thomas (1743-1826)

house paint—Microchemical analysis of old
housepaints with a case study of Monticello
(Eng) S661

Jelling Man

The Jelling Man and other paintings from the
Viking age *(Eng) egg tempera; oil paint; pig-
ment; Scandinavia; sculpture; shrinkage; Vi-
king; wood* S420

Jivaro

human head—The conservation of a pre-
served human head *(Eng)* S935

Johns, Jasper (b. 1930)

contemporary art—Painters painting: a can-
did history of the modern art scene, 1940-1970
(Eng) S362

Jokoji temple (Katsushika, Tokyo, Japan)

reattaching—Reattaching thick color layer of
polychrome wooden sculpture *(Jpn)* S1022

Ka'apor
resin—Resin classification by the Ka'apor Indians *(Eng)* S451

Kachina masks
Zuni Katcinas *(Eng) binding media; black pigment; colorants; corn fungus; corn pollen; pollen; saliva; yellow pigment; yucca; Zuni* S53
Acoma—The Acoma Indians *(Eng)* S57

Kalamaya (Homalomena alba)
bark cloth—The technical aspects of ornamented bark-cloth *(Eng)* S209

kaolin
bark paintings—Conservation of Australian Aboriginal bark paintings with a note on the restoration of a New Ireland wood carving *(Eng)* S905
carvings—Collecting wooden ethnographic carvings in the tropics *(Eng)* S354
Fourier transform infrared spectroscopy—Applications of infrared microspectroscopy to art historical questions about Medieval manuscripts *(Eng)* S648
India—Notes on the technique of Indian polychrome wooden sculpture *(Eng)* S246
—A study of Indian polychrome wooden sculpture *(Eng)* S255
Native American—What did they use for paint? *(Eng)* S236
pigment—Archaeological expedition to Arizona in 1895 *(Eng)* S17
—The pigments used in the wall paintings *(Jpn)* S194
Pueblo—Two summers' work in Pueblo ruins *(Eng)* S22
rock art—The ancients knew their paints *(Eng)* S249
Sudan (Mirgissa)—Physico-chemistry at the service of archaeology: examination of a series of samples from excavations done in Sudan *(Fre)* S545

kauri
Maori—Maori art *(Eng)* S18

kerosene
de Kooning, Willem (b. 1904)—De Kooning: "I see the canvas and I begin." *(Eng)* S304

ketone resin
Melanesian—Conservation of powdering pigment layers on Melanesian objects: choice of a fixative *(Fre)* S1039

Kew Gardens (London, England)
plant materials—Sir Joseph's buried treasure *(Eng)* S476

Khoi Khoi
Bushman paint—A possible base for "Bushman" paint *(Eng)* S66

Khoisan
rock paintings—Paints of the Khoisan rock artists *(Eng)* S355

kinetics
adhesives—The evaluation of some adhesive systems utilized in the consolidation of paintings. The kinetics of consolidation (I) *(Rum)* S1019

—The evaluation of some adhesive systems utilized in the consolidation of paintings. The kinetics of consolidation (II) *(Rum)* S1020
—The evaluation of some adhesive systems utilized in the consolidation of paintings. The kinetics of consolidation (III) *(Rum)* S1021

Kiowa
The economic botany of the Kiowa Indians as it relates to the history of the tribe *(Eng) dye; ethnobotany; Native American; plants; tannin; USA (Oklahoma)* S341

Kirchner, Ernst Ludwig (1880-1938)
Expressionist—Voices of German Expressionism *(Eng)* S254

kiva
Seri blue—Seri blue *(Eng)* S217
—Seri blue—an explanation *(Eng)* S218

Klein, Yves (1928-1962)
artificial ultramarine blue—A technical note on IKB (International Klein Blue) *(Eng)* S347

Klucel GF
adhesives—Adhesives for impregnation of painting on canvas *(Swe)* S1087

knives
Australian Aboriginal—An Alyawara day: making men's knives and beyond *(Eng)* S385

kohl
Analysis of materials contained in mid-4th to early 7th-century A.D. Palestinian kohl tubes *(Eng) Byzantine; cosmetics; paint; Palestinian; Roman* S497

koka
dye—Ethnology of Uvea (Wallis Island) *(Eng)* S74

kokowai
Maori—Maori art *(Eng)* S18

Korea
adhesives—Natural adhesives in East Asian paintings *(Eng)* S372

Kuba
patina—The study of patina *(Fre)* S416

kudu tree (Morinda citrifolia)
bark cloth—The technical aspects of ornamented bark-cloth *(Eng)* S209

kukui
canoes—The Hawaiian canoe *(Eng)* S334

kukui nut oil
bark cloth—The analysis and identification of oils in Hawaiian oiled tapa *(Eng)* S629

Kwakiutl
Field research in the conservation of ethnographical collections: an ecological approach applied to polychrome monumental sculpture *(Eng) Canada (British Columbia); Native American; paint; reproductions; sculpture; totem poles; wood* S417
—Plants in British Columbia Indian technology *(Eng) body painting; Canada (British Columbia); pigment; plant materials; red pigment* S506
Native American—CCI Native Materials Project: final report *(Eng)* S473

lac
dye—Rosewood, dragon's blood and lac *(Eng)* S181

lacquer
Glossiness of nitrocellulose lacquer coatings *(Eng) cellulose nitrate; coatings; gloss* S715
—Lists of raw materials for lacquer *(Ger) additives; binding media; Europe; manufacturing; paint; plasticizers; solvents* S402
Anacardiaceae—A most useful plant family, the Anacardiaceae *(Eng)* S71
cleavage—A trial index of laminal disruption *(Eng)* S792
Japan—Pigments used on Japanese paintings from the protohistoric period through the 17th century *(Eng)* S315
mass spectrometry—Organic mass spectrometry of art materials: work in progress *(Eng)* S607
organic chemistry—The organic chemistry of museum objects *(Eng)* S633
Osakihachiman shrine (Japan)—Conservation treatment of the painting on wooden walls in the oratory of Osakihachiman Shrine *(Jpn)* S964
painting (technique)—Pigments and paints in primitive exotic techniques *(Fre)* S201
pigment volume concentration—Determination of the CPVC by measuring the internal stress in paint films *(Ger)* S859
plants—The use of wild plants in tropical South America *(Eng)* S132
resin—The technology of natural resins *(Eng)* S99
varnish—New book of recipes for the paint and varnish industry *(Ger)* S155
—Varnish of Pasto, a Colombian craft of aboriginal origin *(Spa)* S212

lactic acid
casein—Studio talk: improvement in tubed casein. Interview with Ted Davis *(Eng)* S171

Lalanne, Maxime (1827-1886)
charcoal—Tonal drawing and the use of charcoal in nineteenth century France *(Eng)* S468

lampblack
frescoes—Fresco paintings of Ajanta *(Eng)* S126
pigment—Studies on the ancient pigments in Japan *(Eng)* S52

lamps
stained glass—Field applications of stained glass conservation techniques *(Eng)* S1013

lapis lazuli *see also* **ultramarine blue**
blue pigment—Blues for the chemist *(Eng)* S465
frescoes—Fresco paintings of Ajanta *(Eng)* S126
Mexico—Colors and paint at the time of the pre-Cortés Mexican civilizations *(Fre)* S169
mural paintings—Conservation of mural paintings in Central Asia which have been damaged by salt efflorescence *(Eng)* S888
—Microchemical analysis of the wall paintings of St. Baafsabtei in Ghent (about 1175) *(Dut)* S90

—Mural paintings in the Fraugde church on Funen *(Dan)* S302
—Pigments and techniques of the early Medieval wall paintings of eastern Turkistan *(Ger)* S298
—The wall paintings in the Bagh caves: an investigation into their methods *(Eng)* S87
prehistoric—Pigments and paints in prehistoric antiquity *(Fre)* S191

Lascaux 360 HV
acrylic resin—A study of acrylic dispersions used in the treatment of paintings *(Eng)* S1066

Lascaux 498 HV
acrylic resin—A study of acrylic dispersions used in the treatment of paintings *(Eng)* S1066

laser
latex paint—Scanning laser acoustic microscopy of latex paint films *(Eng)* S837

latex
Asia, Southeast—The identification of insular Southeast Asian resins and other plant exudates for archaeological and ethnological application *(Eng)* S630
plants—Plants for man *(Eng)* S159

latex paint
Changes in hiding during latex film formation *(Eng) coatings; extenders; pigment volume concentration; poly(vinyl chloride); porosity; reflectance* S861
—Changes in hiding during latex film formation. Part II. Particle size and pigment packing effects *(Eng) drying; extenders; pigment volume concentration; poly(vinyl chloride); porosity; reflectance* S871
—CPVC as point of phase inversion in latex paints *(Eng) coatings; fillers; pigment volume concentration; polymers* S866
—The effect of extenders on the optical properties of air drying alkymul and styrene-butadiene latex paints *(Eng) alkymul; aluminum; barium sulfate; enamel; extenders; mica; optical properties; poly(vinyl chloride); silicate; styrene; styrene-butadiene* S728
—Effect of pigmentation on internal stress in latex coatings *(Eng) pigment volume concentration* S828
—History of water-thinned paints *(Eng) binding media; casein; cement; Egyptian; emulsion; frescoes; Medieval; milk; mud; mural paintings; paint; polymers; portland cement; resin; vinyl* S163
—Latex paints: CPVC, formulation, and optimization *(Eng) absorption; pigment; pigment volume concentration* S784
—Scanning laser acoustic microscopy of latex paint films *(Eng) binding media; coatings; laser; microscopy; pigment volume concentration* S837
adhesion—Adhesion of latex paint: Part 1 *(Eng)* S787
coatings—Mechanical properties of clay coating films containing styrene-butadiene copolymers *(Eng)* S834
—Optical properties and structure of clay-latex coatings *(Eng)* S791
—Studies of film formation in latex coatings *(Eng)* S804

lime

Rudolphi, Johann Georg (1633-1693)—Johann Georg Rudolphi (1633-1693). Volume 1 *(Ger)* S584

lead-tin yellow
Rudolphi, Johann Georg (1633-1693)—Johann Georg Rudolphi (1633-1693). Volume 1 *(Ger)* S584

leather
The behavior of colors on leather and parchment objects and the resulting problems of conservation *(Ger + Eng) fixing; lining; paint; parchment; poly(vinyl acetate); shadow puppets* S1068
—The examination of use marks on some Magdalenian end scrapers *(Eng) abrasion; flaking; Magdalenian; ocher; tools; use marks* S262
Blackfoot—Material culture of the Blackfoot Indians *(Eng)* S30
Japan—Pigments used on Japanese paintings from the protohistoric period through the 17th century *(Eng)* S315
pigment Ethnology of the Ungava District, Hudson Bay Territory *(Eng)* S14

leveling
Levelling of paints *(Eng) coatings; lead; paint* S742
—On surface levelling in viscous liquids and gels *(Eng) lead; viscosity* S745

lichens
rock art—The recording of rock art: an illustrated paper presented to the Canadian Conservation Institute trainees and to the Course in the Conservation of Historic Monuments and Sites, Restoration Services Division, Engineering and Architecture Branch, D.I.N.A. *(Eng)* S283

lifting
field archaeology—A conservation manual for the field archaeologist *(Eng)* S1044

light
Light: its interaction with art and antiquities *(Eng) art; coatings; dye; inorganic materials; organic materials* S805
coatings—Light reflectance of spherical pigments in paper coatings *(Eng)* S795
—Optical properties and structure of clay-latex coatings *(Eng)* S791
—Plastic pigments in paper coatings: the effect of particle size on porosity and optical properties *(Eng)* S803
color—Color and appearance characterization for the coatings industry *(Eng)* S830
contemporary art—Conservation of the contemporary *(Eng)* S248
gloss—Problems connected with the concept of gloss *(Eng)* S885
historic buildings—Conservation within historic buildings in Japan *(Eng)* S973
paint—Physicochemical alterations to the paint layer. 1. Results of a survey of various laboratories: apparent alterations of the paint layer and their probable causes. 2. Experimental study by the Musée du Louvre laboratory on madder varnish *(Fre)* S753

pigment—Optics of light-scattering films: study of effects of pigment size and concentration *(Eng)* S735

light microscopy
microscopy—Microscopical study of the Turin "Shroud," IV *(Eng)* S627
Shroud of Turin—Light microscopical study of the Turin Shroud. I *(Eng)* S592
—Light microscopical study of the Turin Shroud. II *(Eng)* S593

lightfastness
opacity—Measurements of the fading of pigments in relation to opacity *(Eng)* S756

lighting
paint—The material side *(Eng)* S166

lignin
pine tar—Analysis of Finnish pine tar and tar from the wreck of frigate St. Nikolai *(Eng)* S650

Lillooet
conifers—Ethnobotany of coniferous trees in Thompson and Lillooet Interior Salish of British Columbia *(Eng + Fre)* S426

lime
adobe—The conservation of adobe walls decorated with mural paintings and reliefs in Peru *(Eng)* S958
bark cloth—The technical aspects of ornamented bark-cloth *(Eng)* S209
casein—Studio talk: improvement in tubed casein. Interview with Ted Davis *(Eng)* S171
cement—Precolumbian cements: a study of the calcareous cements in pre-Hispanic meso-American building construction *(Eng)* S553
ceramics—Technological notes on the pottery, pigments, and stuccoes from the excavations at Kaminaljuyu, Guatemala *(Eng)* S107
frescoes 19th and early 20th century restorations of English Mediaeval wall paintings: problems and solutions *(Eng)* S1116
—Artistic frescoes *(Eng)* S100
—The consolidation of friable frescoes *(Eng)* S1015
—Fresco paintings of Ajanta *(Eng)* S126
historic buildings—Defects of color dyes on historic buildings' renderings *(Cze)* S914
icons—The technique of icon painting *(Eng)* S214
Italy (Pompeii)—The technique of antique Pompeian wall painting *(Ita)* S131
Medieval—Observations on a late Medieval painting medium *(Eng)* S117
Mesoamerican—Ancient Mesoamerican mortars, plasters, and stuccos. The use of bark extracts in lime plasters *(Eng)* S197
mortar—Ancient Mesoamerican mortars, plasters, and stuccos: Las Flores, Tampico *(Eng)* S189
—Ancient Mesoamerican mortars, plasters, and stuccos: Palenque, Chiapas *(Eng)* S190
mural paintings—Ajanta murals: their composition and technique and preservation *(Eng)* S232
—Analysis of pigments and plaster of the paintings in the Sheesh Mahal, Nagaur *(Eng)* S428

lime

—Chemical study on the coloring materials of the murals of the Taka-matsuzuka Tomb in Nara Prefecture *(Jpn)* S272
—How to paint a mural *(Spa)* S381
—Indian murals: techniques and conservation *(Eng)* S931
—Materials and techniques of Medieval wall paintings from the former House of Merchants' Fraternity at 5 Żeglarska Street in Toruń *(Pol)* S485
—Mural painting technique of Herculaneum *(Ita)* S186
—Mural paintings in the Fraugde church on Funen *(Dan)* S302
—The Pallava paintings at Conjeevaram: an investigation into the methods *(Eng)* S85
—Products, facts, modes in mural painting: evolution and distribution of restoration products used in mural paintings from 1850 to 1992. A first sorting concerning France, Spain, England, and Poland *(Fre)* S511
—Structure, composition, and technique of the paintings *(Dut)* S346
—The technique of the paintings at Sitabhinji *(Eng)* S143
—The techniques, conservation, and restoration of mural paintings *(Ita)* S64
Papua New Guinea (New Ireland)—Assemblage of spirits: idea and image in New Ireland *(Eng)* S403
pigment—Ethnology of Futuna *(Eng)* S67
plaster—Conservation in archaeological areas: three decades of work *(Spa)* S1095
plasterwork—The restoration of facade plasterwork in Italy *(Fre)* S472
protein—Identification of protein containing binding media and adhesives in works of art by amino acid analysis *(Jpn)* S659
Puuc—Ancient Mesoamerican mortars, plasters, and stuccos: the Puuc Area *(Eng)* S198
stucco—Stucco: a report on the methodology developed in Mexico *(Eng)* S1035

lime putty
Byzantine—A monument of Byzantine wall painting: the method of construction *(Fre)* S184

lime white
calcium carbonate—Calcium carbonate whites *(Eng)* S561
mural paintings—Unfinished wall paintings in Egyptian tombs and temples *(Ger)* S192

limestone
buildings—The surface finishing of Renaissance facades in Ferrara, Italy: scientific studies *(Ita)* S493
cement—Precolumbian cements: a study of the calcareous cements in pre-Hispanic meso-American building construction *(Eng)* S553
consolidants—Considerations concerning criteria for the selection of consolidant and the relative methodology of application *(Ita)* S1082
mural paintings—The earliest known paints *(Eng)* S153
—The structure of the 17th-century mural paintings in the S. George Orthodox church at Veliko Turnovo (Bulgaria) *(Pol)* S264
Paleolithic—Paleolithic pigments and processing *(Eng)* S357

pigment volume concentration—Effect of particle size distribution of pigment and pigment volume concentration on flat wall paint properties (solvent type) *(Eng)* S729
polymers—The mechanism of polymer migration in porous stones *(Eng)* S1047
sedimentary rock—Atlas of sedimentary rocks under the microscope *(Eng)* S611

limewater
stone—The conservation of the Winchester Anglo-Saxon fragment *(Eng)* S1090

limonite
Bushman paint—A possible base for "Bushman" paint *(Eng)* S66
mining—The mining of gems and ornamental stones by American Indians *(Eng)* S93
Native American—What did they use for paint? *(Eng)* S236
prehistoric—Pigments and paints in prehistoric antiquity *(Fre)* S191
rock art—The ancients knew their paints *(Eng)* S249

linen
Bouts, Dirck, the elder (ca. 1415-1475)—The techniques of Dieric Bouts: two paintings contrasted *(Eng)* S386
forgeries—The technical investigation and conservation treatment of an alleged Ming Dynasty wall painting *(Eng)* S956
icons—Restoration and conservation of an icon from Melnik *(Bul)* S948
masks—The conservation of a Ptolemaic mummy mask *(Ger)* S1097
Netherlandish—The beginnings of Netherlandish canvas painting, 1400-1530 *(Eng)* S445
Shroud of Turin—Light microscopical study of the Turin Shroud. I *(Eng)* S592
—Light microscopical study of the Turin Shroud. II *(Eng)* S593
tuchlein paintings—The technique of a Tüchlein by Quinten Massys *(Eng)* S423

lining
adhesives—The treatment of cracks in canvas paintings with synthetic adhesives: procedures and possible combinations with the lining process *(Eng)* S1092
leather—The behavior of colors on leather and parchment objects and the resulting problems of conservation *(Ger + Eng)* S1068
Neuen Wilden—The "fast" paintings of the Neuen Wilden *(Ger)* S358
paintings (objects)—Manual of the painter restorer *(Ita)* S5
pastels (visual works)—Removing severe distortions in a pastel on canvas *(Eng)* S1032

linoxyn
mural paintings—The examination of mural paintings *(Dut)* S525

linseed oil
Critical pigment volume concentration in linseed oil films *(Eng) drying oil; pigment volume concentration* S760
barium sulfate—The influence of variations of barium sulfate extender particle size on the hiding power of titanium dioxide paints *(Eng)* S706

418

binding media—Analyses of paint media *(Eng)* S587
—Artificial samples of paint binders. Oils, resins, waxes, glues, egg, prepared in binary mixtures: analytical characteristics and properties *(Ita)* S631
differential scanning calorimetry—Preliminary investigations of the binding media of paintings by differential thermal analysis *(Eng)* S634
fat—Aje or Ni-in (the fat of a scale insect): painting medium and unguent *(Eng)* S216
fluorescence microscopy—Ultraviolet fluorescence microscopy of paint cross sections: cycloheptaamylose-dansyl chloride complex as a protein-selective stain *(Eng)* S671
Fourier transform infrared spectroscopy—Analysis of aged paint binders by FTIR spectroscopy *(Eng)* S657
gas chromatography mass spectrometry—Rapid identification of binding media in paintings using simultaneous pyrolysis methylation gas chromatography *(Eng)* S668
paint—The relationship between oil content, particle size and particle shape *(Eng)* S699
porosity—Porosity of paint films *(Eng)* S714
pyrolysis gas chromatography—Examination through pyrolysis gas chromatography of binders used in painting *(Eng)* S626
—The potential of pyrolysis-gas chromatography/mass spectrometry in the recognition of ancient painting media *(Eng)* S678
tempera—The material side: tempera painting—part 1 *(Eng)* S146
viscosity—Further experiments on the importance of the critical point *(Eng)* S694

lipids
gas chromatography—Analysis of organic residues of archaeological origin by high-temperature gas chromatography and gas chromatography-mass spectrometry *(Eng)* S654

liquid chromatography
chromatography—The chromatographic analysis of ethnographic resins *(Eng)* S603
fatty acid—Fatty acid composition of 20 lesser-known Western Australian seed oils *(Eng)* S676
gum—The analysis of exudate plant gums in their artistic applications: an interim report *(Eng)* S616
Herlin Cathedral (Germany)—The scientific examination of the polychromed sculpture in the Herlin altarpiece *(Eng)* S552
paintings (objects)—Analysis of paint media, varnishes and adhesives *(Eng)* S625

litharge
gouache—Restoration of three miniature paintings with a problem of colour change *(Eng)* S1057
Horyuji Temple (Japan)—Coloring materals of the murals in the Main Hall of the Horyuji Temple compared with those of the ornamented tombs *(Jpn)* S271
mural paintings—Chemical studies on ancient painting materials *(Jpn)* S150
—Chemical studies on ancient pigments in Japan *(Eng)* S138

—Pigments used in the paintings of "Hoodo." *(Jpn)* S183
pigment—The pigments used in the wall paintings *(Jpn)* S194
—Technical studies on the pigments used in ancient paintings of Japan *(Eng)* S167
yellow pigment—Yellow pigments used in antiquity *(Fre)* S113

lithopone
synthetic organic pigment—An early 20th-century pigment collection: the pigment collection in the Missiemuseum at Steyl-Tegelen *(Dut)* S435

litmus
blue pigment—Blues *(Ita)* S394
red pigment—Reds *(Ita)* S397

Llaveia axin
fat—Aje or Ni-in (the fat of a scale insect): painting medium and unguent *(Eng)* S216

loa
dye—Ethnology of Uvea (Wallis Island) *(Eng)* S74

loess
The effect of the treatment with polybutyl methacrylate solutions on physical and mechanical properties of loess plaster *(Eng) Asia, Central; mural paintings; plaster; poly(butyl methacrylate)* S954
poly(butyl methacrylate)—New possibilities of polybutyl methacrylate as a consolidating agent for glue painting on loess plaster *(Eng)* S936

logwood
blue pigment—Blues *(Ita)* S394
dye—Colors for textiles: ancient and modern *(Eng)* S109
dyewood—Dyewoods, their composition and use. Part 1: Description of the most important dyewoods *(Ger)* S204
—Dyewoods, their composition and use. Part 2: Wood dyes and their fields of application *(Ger)* S205
Peru—An analytical study of pre-Inca pigments, dyes and fibers *(Eng)* S571

loom weaving
dye—African textiles: looms, weaving and design *(Eng)* S313

looms
pre-Columbian—Dating precolumbian museum objects *(Eng)* S1115

Luba
patina—The study of patina *(Fre)* S416

Lucite 44
varnish—Factors affecting the appearance of picture varnish *(Eng)* S721

Luiseño
The culture of the Luiseño Indians *(Eng) adhesives; bitumen; chilicothe (Marah macrocarpus); dye; iron oxide; Native American; pitch (tar); red paint; rock art; turpentine* S26
Native American—The ethnobotany of the California Indians: a compendium of the plants, their users, and their uses *(Eng)* S269

419

stucco—Restoration and display of Egyptian stucco mummy masks from the period of the Roman Empire *(Eng)* S1027
Yoruba—Gelede: a Yoruba masquerade *(Eng)* S250

masonry
historic buildings—Defects of color dyes on historic buildings' renderings *(Cze)* S914
pueblos (housing complexes)—A study of Pueblo architecture: Tusayan and Cibola *(Eng)* S9

mass spectrometry
Application of mass spectrometric techniques to the differentiation of paint media *(Eng) binding media; paint* S576
—Organic mass spectrometry of art materials: work in progress *(Eng) binding media; egg; gas chromatography; lacquer; oil; paint; resin; varnish* S607
gas chromatography—Analysis of organic residues of archaeological origin by high-temperature gas chromatography and gas chromatography-mass spectrometry *(Eng)* S654
—Examination of the diterpenoic resin components of anatomical wax models from the eighteenth century by gas chromatography *(Eng)* S656
—Organic analysis in the examination of museum objects *(Eng)* S621
—A review, with illustrations, of methods applicable to the analysis of resin/oil varnish mixtures *(Eng)* S600
ink—Gas chromatographic mass spectrometric analysis of tannin hydrolysates from the ink of ancient manuscripts (XIth to XVIth century) *(Eng)* S577
mummies—Probing the mysteries of ancient Egypt; chemical analysis of a Roman period Egyptian mummy *(Eng)* S673
paintings (objects)—Analysis of paint media, varnishes and adhesives *(Eng)* S625
pyrolysis gas chromatography—Pyrolysis gas chromatographic mass spectrometric identification of intractable materials *(Eng)* S588
pyrolysis mass spectrometry—Pyrolysis-mass spectrometry of natural gums, resins, and waxes and its use for detecting such materials in ancient Egyptian mummy cases (cartonnages) *(Eng)* S636
resin—A comparison of pyrolysis mass spectrometry, pyrolysis gas chromatography and infra-red spectroscopy for the analysis of paint resins *(Eng)* S618
thin layer chromatography—Thin-layer chromatography of resin acid methyl esters *(Eng)* S536

mass treatment
polychromy—Disinfestation and consolidation of polychromed wood at the Institut Royal du Patrimoine Artistique, Brussels *(Eng)* S957

massicot
mural paintings—Pigments and techniques of the early Medieval wall paintings of eastern Turkistan *(Ger)* S298
yellow pigment—Yellow pigments used in antiquity *(Fre)* S113

Massys, Quentin (1465/66-1530)
tuchlein paintings—The technique of a Tüchlein by Quinten Massys *(Eng)* S423

masters theses
material culture—Ethnoart: Africa, Oceania, and the Americas: a bibliography of theses and dissertations *(Eng)* S411

mastic
binding media—Artificial samples of paint binders. Oils, resins, waxes, glues, egg, prepared in binary mixtures: analytical characteristics and properties *(Ita)* S631
creosote—Notes on creosote lac scale insect resin as a mastic and sealant in the Southwestern Great Basin *(Eng)* S481
infrared absorption—Dammar and mastic infrared analysis *(Eng)* S528
Medieval—Observations on a late Medieval painting medium *(Eng)* S117
pyrolysis gas chromatography—The identification of dammar, mastic, sandarac and copals by pyrolysis gas chromatography *(Eng)* S638
Rudolphi, Johann Georg (1633-1693)—Johann Georg Rudolphi (1633-1693). Volume 1 *(Ger)* S584
varnish—Factors affecting the appearance of picture varnish *(Eng)* S721
wood—The restoration of the wooden statue of Our Lady in the parish church of Cercina *(Ita)* S1078

mastication
ethnobotany—Ethnobotany of the Zuñi Indians *(Eng)* S27

material culture
Ethnoart: Africa, Oceania, and the Americas: a bibliography of theses and dissertations *(Eng) Africa; Americas; bibliographies; dissertations; ethnography; masters theses; Oceania* S411
Africa—Quex Museum House and Gardens *(Eng)* S452
New Guinea—Pilot study: survey of the literature relating to the material culture of the New Guinea Highlands *(Eng)* S308

matte
animal glue—Searching for a solution to the problem of altered mat paintings; a new product is needed *(Fre)* S1071
contemporary art—American artists in their New York studios: conversations about the creation of contemporary art *(Eng)* S500
fixing—Theoretical approach to refixing *(Fre)* S1017
Herlin Cathedral (Germany)—The scientific examination of the polychromed sculpture in the Herlin altarpiece *(Eng)* S552
Impressionist—An approach to the study of modern paintings surfaces *(Ger)* S1124
Maori—Conservation considerations on four Maori carvings at Auckland Museum, New Zealand *(Eng)* S359
—Maori carvings in Auckland museum, New Zealand. Ethical considerations in their restoration *(Eng)* S360
Netherlandish—The beginnings of Netherlandish canvas painting, 1400-1530 *(Eng)* S445

matte

optical properties—Some theoretical points
of view on the optical properties of matter:
attempt at defining "matness" (Fre) S783
pastels (visual works)—Maranyl as a fixative
for pastel (Eng) S922
varnish—The influence of light on the gloss of
matte varnishes (Eng) S782
Vuillard, Edouard (1868-1940)—History,
analysis and treatment of "La salle à manger
au château de Clayes," 1938, by Edouard Vuil-
lard (Eng) S1009
wallpaper—Wallpaper in America: from the
17th century to World War I (Eng) S320

mauve
Carib—Plants used by the Dominica Caribs
(Eng) S98

Maya blue
Examination and identification of Maya blue
(Fre) attapulgite; dye; electron diffraction; elec-
tron microscopy; indigo; infrared absorption;
optical microscopy; spectrophotometry; x-ray
diffraction S544
—Maya blue (Spa) attapulgite; Central Amer-
-ica; indigo; Mayan; Mexico; paintings (objects)
S548
—Maya blue: a clay-organic pigment? (Eng)
attapulgite; dye; indigo; Mayan; Mexico (Yu-
catán); sepiolite S543
—Maya blue: a new perspective (Eng) blue
pigment; indigo; Mayan; minerals; montmoril-
lonite; palygorskite; pigment S590
—Maya blue: an updated record (Eng) atta-
pulgite; dye; indigo; Mayan; Mexico; mont-
morillonite S580
—Maya blue: further perspectives and the pos-
sible use of indigo as the colorant (Eng) atta-
pulgite; blue pigment; indigo; Mayan; mont-
morillonite S605
—Maya blue: how the Mayas could have made
the pigment (Eng) blue pigment; clay; indigo;
Mayan; microscopy; palygorskite; pigment
S645
blue pigment—Blues (Ita) S394
Mayan—The Maya mural paintings of Bonam-
pak, materials analysis (Fre) S539

Mayan
The ethnobotany of the Maya (Eng) dye; ethno-
botany; plants; resin S51
—The Maya mural paintings of Bonampak,
materials analysis (Fre) attapulgite; indigo; in-
frared spectrometry; Maya blue; mural paint-
ings; paint; pigment; polysaccharides; protein;
red ocher; Temple of the Paintings (Bonampak
Site, Chiapas, Mexico); thin layer chromatog-
raphy; yellow ocher S539
cement—Precolumbian cements: a study of
the calcareous cements in pre-Hispanic meso-
American building construction (Eng) S553
Maya blue—Maya blue (Spa) S548
—Maya blue: a clay-organic pigment? (Eng)
S543
—Maya blue: a new perspective (Eng) S590
—Maya blue: an updated record (Eng) S580
—Maya blue: further perspectives and the pos-
sible use of indigo as the colorant (Eng) S605
—Maya blue: how the Mayas could have made
the pigment (Eng) S645

Temple of the Paintings (Bonampak Site,
Chiapas, Mexico)—Conservation and restora-
tion of the murals of the Temple of the Paint-
ings in Bonampak, Chiapas (Eng) S1037

Maymuru, Narritjin (d. 1981)
bark paintings—My country, Djarrakpi (Eng)
S327
—Narritjin at Djarrakpi: Part 1 (Eng) S328
—Narritjin at Djarrakpi: Part 2 (Eng) S329
—Narritjin in Canberra (Eng) S330

mayonnaise
de Kooning, Willem (b. 1904)—De Kooning:
"I see the canvas and I begin." (Eng) S304

mechanical properties
Influence of pigmentation on the mechanical
properties of paint films (Eng) binding media;
glass transition temperature; pigment volume
concentration; poly(vinyl chloride); polymers
S779
—Mechanical properties of weathered paint
films (Eng) cracking; paint; pigment volume
concentration; primer; staining (finishing);
weathering; wood S851
coatings—Mechanical properties of clay coat-
ing films containing styrene-butadiene copoly-
mers (Eng) S834
—Note: on the cohesion of clay and $CaCO_3$
coatings (Eng) S858
—Optical properties and structure of clay-latex
coatings (Eng) S791
cracking—Crack mechanisms in gilding (Eng)
S874

mechanical strength
coatings—Mechanical properties of clay coat-
ing films containing styrene-butadiene copoly-
mers (Eng) S834
—Note: on the cohesion of clay and $CaCO_3$
coatings (Eng) S858
viscosity—Microscopic examination of pig-
ment/vehicle interaction during film formation
(Eng) S762

medicine
Australian Aboriginal—Bush food: Aborigi-
nal food and herbal medicine (Eng) S401
ethnobotany—Ethnobotany of the Fort Yukon
Region, Alaska (Eng) S464
Native American—Indian herbalogy of North
America: the definitive guide to native medici-
nal plants and their uses (Eng) S490
Thompson—Thompson ethnobotany: knowl-
edge and usage of plants by the Thompson
Indians of British Columbia (Eng) S483

Medieval
The materials and techniques of Medieval
painting (Eng) binding media; metal; painting
(technique); pigment; vellum; woodwork S172
—Medieval surface techniques, II (Eng) adhe-
sives; egg white; gelatin; oil paint; stained
glass S122
—Observations on a late Medieval painting
medium (Eng) ash (residue); egg tempera; fish
glue; gum; lime; mastic; sodium hydroxide;
tempera; wax; wood S117
—Pigments and paints in the Middle Ages
(Fre) artists' materials; frescoes; glass; poly-
chromy; stained glass S199

metal

conservation—Conservation of interior decoration and furniture of monuments *(Ger)* S806
folk art—Care of folk art: the decorative surface *(Eng)* S501
history of technology—Chemistry of painting surfaces from earliest time to unfathomable future *(Eng)* S279
Medieval—The materials and techniques of Medieval painting *(Eng)* S172
physical properties—Physical study of two-coat paint systems *(Eng)* S701
pigment volume concentration—Effect of ageing of alkyd-TiO$_2$ paints on adhesion to mild steel: role of pigment volume concentration *(Eng)* S868
synthetic resin—Restoration with synthetic resins in Japan *(Ger)* S966

metal leaf
artists' materials—Techniques of ancient painting: the preparation of the support *(Ita)* S440

metal points
drawings—Techniques and subsequent deterioration of drawings *(Eng)* S312
pastels (visual works)—History, technology and conservation of dry media *(Eng)* S1018

metallic paint
Romano-British—An analysis of paints used in Roman Britain *(Eng)* S210

metallic pigment
Mesoamerican—Short methods for the identification of pigments *(Eng)* S566

metamerism
Geometric metamerism *(Eng) color; pigment* S754

methacrylate
fixing—Theoretical approach to refixing *(Fre)* S1017
mural paintings—Ajanta murals: their composition and technique and preservation *(Eng)* S232
—Application of synthetic resins to the preservation of antiques and art crafts *(Jpn)* S891
polymers—The mechanism of polymer migration in porous stones *(Eng)* S1047
wood—Consolidation of painted wooden artifacts: an ICOM report *(Eng)* S924

methyl alcohol
mural paintings—Ajanta murals: their composition and technique and preservation *(Eng)* S232

methyl bromide
Australian Aboriginal—Australian Aboriginal bark paintings: an ICOM report *(Eng)* S918
polychromy—Disinfestation and consolidation of polychromed wood at the Institut Royal du Patrimoine Artistique, Brussels *(Eng)* S957

methyl cellulose
consolidants—The consolidation of powdery paint layers of *Bonaders*, Swedish mural works painted on paper *(Fre)* S1109
illuminations—Practice and practical possibilities in the conservation of Medieval miniatures *(Ger)* S969

mural paintings—Ajanta murals: their composition and technique and preservation *(Eng)* S232
polymers—Consolidation of the pictorial layer of illuminations with pure synthetic polymers *(Fre)* S989

methyl ester
thin layer chromatography—Thin-layer chromatography of resin acid methyl esters *(Eng)* S536

methyl ethyl ketone
mural paintings—Ajanta murals: their composition and technique and preservation *(Eng)* S232

methyl isobutyl ketone
pigment volume concentration—Critical pigment volume concentration of paints. Its measurement and some relationships *(Eng)* S857

methyl methacrylate
textiles—Preservation of a textile and a miniature painting *(Eng)* S895

methyl triethoxysilane
frescoes—The consolidation of friable frescoes *(Eng)* S1015

methylene chloride
frescoes—19th and early 20th century restorations of English Mediaeval wall paintings: problems and solutions *(Eng)* S1116

Mexico
Colors and paint at the time of the pre-Cortés Mexican civilizations *(Fre) bitumen; brushes; casein; cochineal; gum; hair; jade; lapis lazuli; malachite; milk; mosaics; mother of pearl; ocher; polychromy; purple pigment; pyrite; turquoise; water* S169
cement—Precolumbian cements: a study of the calcareous cements in pre-Hispanic meso-American building construction *(Eng)* S553
dye—Natural dyes of Mexico *(Spa)* S412
Maya blue—Maya blue *(Spa)* S548
—Maya blue: an updated record *(Eng)* S580
Mesoamerican—Ancient Mesoamerican mortars, plasters, and stuccos. The use of bark extracts in lime plasters *(Eng)* S197
mural paintings—How to paint a mural *(Spa)* S381
Nahuatl—A review of sources for the study of Náhuatl plant classification *(Eng)* S484
pastels (visual works)—Investigation, conservation and restoration of the pastel painting technique *(Spa)* S1054
pigment—Painted Mexican furniture and trinkets *(Fre)* S178
plants—Plants used by the Indians of the United States *(Eng)* S7
plaster—Conservation in archaeological areas: three decades of work *(Spa)* S1095
stucco—Stucco: a report on the methodology developed in Mexico *(Eng)* S1035
sumac—The use of the sumacs by the American Indian *(Eng)* S72

Mexico (Baja California)
Face and body painting in Baja California: a summary *(Eng) body painting; bone; fat; fish;*

Native American; pigment; pumpkin seed oil; white pigment S273

Mexico (Chiapas)
Temple of the Paintings (Bonampak Site, Chiapas, Mexico)—Conservation and restoration of the murals of the Temple of the Paintings in Bonampak, Chiapas *(Eng)* S1037

Mexico (Chiapas— Palenque)
mortar—Ancient Mesoamerican mortars, plasters, and stuccos: Palenque, Chiapas *(Eng)* S190

Mexico (Tampico— Las Flores)
mortar—Ancient Mesoamerican mortars, plasters, and stuccos: Las Flores, Tampico *(Eng)* S189

Mexico (Yucatán)
Maya blue—Maya blue: a clay-organic pigment? *(Eng)* S543

mica
latex paint—The effect of extenders on the optical properties of air drying alkymul and styrene-butadiene latex paints *(Eng)* S728
paper—Conservation of some non-book material in National Library, Calcutta *(Eng)* S1026

microchemistry
binding media—Directory of natural organic binding media *(Ger)* S643
elemental analysis—Microscopic methods for research on paintings *(Ger)* S526
mural paintings—The examination of mural paintings *(Dut)* S525

microcrystalline wax
forgeries—The technical investigation and conservation treatment of an alleged Ming Dynasty wall painting *(Eng)* S956
illuminations—Some tests on the use of wax for fixing flaking paint on illuminated parchment *(Eng)* S898

microorganisms
historic buildings—Conservation within historic buildings in Japan *(Eng)* S973

microscopy see also **optical microscopy**
Application of particle study in art and archaeology *(Eng) pigment; polarized light microscopy; stereomicroscopy* S585
—Dispersion staining *(Eng) dispersion staining; staining (analysis)* S610
—Microanalytical examination of works of art: two examples of the examination of paint layers *(Ger) Austrian National Library; binding media; electron microscopy; paint; papyrus; pigment; scanning electron microscopy; spectrometry* S612
—The microscopical identification of artists' pigments *(Eng) pigment* S606
—Microscopical study of the Turin "Shroud," IV *(Eng) blood; collagen; fiber; iron oxide; light microscopy; Shroud of Turin; vermilion* S627
—The particle atlas: an encyclopedia of techniques for small particle identification *(Eng) electron microscopy; optical microscopy; polarized light microscopy; scanning electron microscopy; transmission electron microscopy* S586
—Ultramicrominiaturization of microchemical tests *(Eng) relative humidity; samples* S555

—The use of direct reactive fluorescent dyes for the characterization of binding media in cross sectional examinations *(Eng) binding media; cross sections; paint; reactive dye; varnish* S635
acrylic resin—The identification and characterization of acrylic emulsion paint media *(Eng)* S666
binding media—Methods used for the identification of binding media in Italian paintings of the 15th and 16th centuries *(Eng)* S554
fluorescence microscopy—Ultraviolet fluorescence microscopy of paint cross sections: cycloheptaamylose-dansyl chloride complex as a protein-selective stain *(Eng)* S671
Herlin Cathedral (Germany)—The scientific examination of the polychromed sculpture in the Herlin altarpiece *(Eng)* S552
house paint—Microchemical analysis of old housepaints with a case study of Monticello *(Eng)* S661
latex paint—Scanning laser acoustic microscopy of latex paint films *(Eng)* S837
Maya blue—Maya blue: how the Mayas could have made the pigment *(Eng)* S645
pigment—Artists' pigments: a handbook of their history and characteristics *(Eng)* S623
polarized light microscopy—Polarized light microscopy *(Eng)* S614
red pigment—African red pigments *(Eng)* S641
sedimentary rock—Atlas of sedimentary rocks under the microscope *(Eng)* S611
Shroud of Turin—Light microscopical study of the Turin Shroud. I *(Eng)* S592
—Microscopical study of the Turin "Shroud." *(Eng)* S637

Middle East see **Near East**

Middle Kingdom
Egypt—Egyptian paintings of the Middle Kingdom *(Eng)* S245
—The entourage of an Egyptian governor *(Eng)* S244

migration
polymers—The mechanism of polymer migration in porous stones *(Eng)* S1047

mildew
mural paintings—Ajanta murals: their composition and technique and preservation *(Eng)* S232

milk
Acoma—The Acoma Indians *(Eng)* S57
binding media—The problem of the binding medium particularly in wall painting *(Eng)* S534
casein—On the material side: recent trends in painting mediums *(Eng)* S134
—Studio talk: improvement in tubed casein. Interview with Ted Davis *(Eng)* S171
latex paint—History of water-thinned paints *(Eng)* S163
Mexico—Colors and paint at the time of the pre-Cortés Mexican civilizations *(Fre)* S169
mural paintings—The earliest known paints *(Eng)* S153

Native American—America's first painters *(Eng)* S168
—American Indian painting of the Southwest and Plains areas *(Eng)* S239
—What did they use for paint? *(Eng)* S236
paint—Materials toward a history of house-paints: the materials and craft of the house-painter in 18th century America *(Eng)* S221
rock art—The ancients knew their paints *(Eng)* S249
rock paintings—The search for the Tassili frescoes: the story of the prehistoric rock paintings of the Sahara *(Eng)* S187

milkweed
Chumash—The rock paintings of the Chumash: a study of a California Indian culture *(Eng)* S513
Native American—The ethnobotany of the California Indians: a compendium of the plants, their users, and their uses *(Eng)* S269

Millet, Jean François (1814-1875)
pastels (visual works)—On the technical study of thirty pastel works on paper by Jean-François Millet *(Eng)* S368

mineral dye
Native American—Colors in Indian arts: their sources and uses *(Eng)* S59

mineral pigment see also **inorganic pigment**
Earth pigments and their colors *(Ita) color; inorganic pigment; Italy (Piedmont); manufacturing; ocher; paint; pigment; sienna; umber* S421
Hopi—Hopi journal of Alexander M. Stephen *(Eng)* S70
Native American—Analysis of paints used by Canadian native cultures: a project at the Canadian Conservation Institute *(Eng)* S640
pigment—Studies on the ancient pigments in Japan *(Eng)* S52
red pigment—Report on the collecting visit to the Wosera-Abelam of Sarakim village, and a note on conservation requirements *(Eng)* S318
USA (New Mexico— Isleta)—Isleta, New Mexico *(Eng)* S55

mineral wax
illuminations—Practice and practical possibilities in the conservation of Medieval miniatures *(Ger)* S969

minerals
Atlas of rock-forming minerals in thin section *(Eng) manuals; photomicrography; thin sections* S591
Chowa—Rhodesian engravers, painters and pigment miners of the fifth millennium B.C. *(Eng)* S161
dye—Natural dyes of Mexico *(Spa)* S412
illuminations—The development of techniques of identification for pigments and binders used in the paint layer of manuscript illuminations *(Fre)* S546
iron oxide—Infrared study of the yellow and red iron oxide pigments *(Ger)* S551
Maya blue—Maya blue: a new perspective *(Eng)* S590
miniatures (paintings)—Nolite manuscripta cruciare sed conservate potis. Considerations

on the preservation of Medieval miniatures *(Ger)* S1038
mural paintings—In review: an assessment of Florentine methods of wall painting conservation based on the use of mineral treatments *(Eng)* S1104
Native American—Indian uses of native plants *(Eng)* S404
Paleolithic—Paleolithic pigments and processing *(Eng)* S357
prehistoric—Pigments and paints in prehistoric antiquity *(Fre)* S191
red ocher—Red ochre and human evolution: a case for discussion *(Eng)* S325
spot tests—Spot tests in inorganic analysis *(Eng)* S556
Sudan (Mirgissa)—Physico-chemistry at the service of archaeology: examination of a series of samples from excavations done in Sudan *(Fre)* S545
yellow pigment—Yellows *(Ita)* S396

Ming
forgeries—The technical investigation and conservation treatment of an alleged Ming Dynasty wall painting *(Eng)* S956
mural paintings—Conservation of Central Asian wall painting fragments from the Stein Collection in the British Museum *(Eng)* S1099

miniatures (paintings)
Application of traditional Indian techniques in the treatment of a Bundi miniature *(Eng) Bundi; filling; India; inpainting* S324
—Conservation methods for miniature paintings on parchment: treatment of the paint layer *(Eng) Byzantine; flaking; paintings (objects); parchment* S943
—The conservation of Indian and Moghul miniatures *(Eng) coatings; India; Mughal* S978
—Conservation of miniatures *(Eng) acetic acid; binding media; malachite; parchment; ultraviolet; verdigris* S270
—Nolite manuscripta cruciare sed conservate potis. Considerations on the preservation of Medieval miniatures *(Ger) Medieval; minerals; paintings (objects); pigment* S1038
Angelico, Fra (ca. 1400-1455)—Restoration of a miniature by Fra Angelico in Florence *(Fre)* S1016
gouache—Restoration of three miniature paintings with a problem of colour change *(Eng)* S1057
history of conservation—Complete guide for the restoration of oil, wax, tempera, watercolor, miniature, and pastel paintings, together with instructions for preparing excellent varnishes for paintings, bas-reliefs and plaster casts, dried insects and plants, prints and maps, as well as the cleaning, bleaching, mounting, and framing of copper engravings, lithographs, and woodcuts; for the art lover, painter, bronzer, decorator, etc. *(Ger)* S3
ox blood—Ox-blood: a color binding media and a color name *(Ger)* S339
textiles—Preservation of a textile and a miniature painting *(Eng)* S895

watercolors—Conservation of Indian miniature paintings in the Baroda Museum *(Eng)* S911

mining
The mining of gems and ornamental stones by American Indians *(Eng) Apache; black pigment; gypsum; limonite; Native American; ocher; pigment; quartz; rock art; Yuma* S93
Chowa—Rhodesian engravers, painters and pigment miners of the fifth millennium B.C. *(Eng)* S161

minium
mural paintings—The investigation of pigments and paint layer structures of mural paintings at Maitepnimit Temple *(Eng)* S477
panel paintings—Wings from a quadriptych with the legend of St. John the Baptist: general problems and the treatment of conservation *(Pol)* S917

Minoan
Bronze Age—Aegean painting in the Bronze Age *(Eng)* S466

Miró, Joan (1893-1983)
Joan Miro: comment and interview *(Eng) burlap; gouache; painting (technique); primitivism; Spain (Barcelona); USA (New York)* S125

Missouri River
ethnobotany—Uses of plants by the Indians of the Missouri River region *(Eng)* S32

MMA see **methyl methacrylate**

moa
Maori—Maori art *(Eng)* S18

models (representations)
Maori—The examination, analysis and conservation of a Maori model canoe *(Eng)* S373

modern art
Twentieth century painting *(Eng) contemporary art; Expressionist; painting (technique)* S507
acrylic resin—The identification and characterization of acrylic emulsion paint media *(Eng)* S666
Baumeister, Willi (1889-1955)—Studies of the painting techniques of Willi Baumeister *(Ger)* S496
contemporary art—Modern Art: the restoration and techniques of modern paper and paints. Proceedings of a conference jointly organised by UKIC and the Museum of London, 22 May 1989 *(Eng)* S436
—The restoration of modern and contemporary works of art *(Ita)* S1094

modulus of elasticity
coatings—The effects of density fluctuations in organic coatings *(Eng)* S878
pigment volume concentration—Critical pigment volume concentration of paints. Its measurement and some relationships *(Eng)* S857

Mojave
Mohave tatooing and face-painting *(Eng) black pigment; charcoal; creosote; deer; fat; Native American; pumpkin; red pigment; wax; white pigment* S116

mold (fungus)
carvings—Collecting wooden ethnographic carvings in the tropics *(Eng)* S998
mural paintings—Conservation of mural paintings in Central Asia which have been damaged by salt efflorescence *(Eng)* S888

molding
synthetic resin—Restoration with synthetic resins in Japan *(Ger)* S966

molecular weight
viscosity—Microscopic examination of pigment/vehicle interaction during film formation *(Eng)* S762

monasteries
mural paintings—Conservation of Central Asian wall painting fragments from the Stein Collection in the British Museum *(Eng)* S1099

monomers
adobe—Experiments on preservation of adobe structures and restoration of gypsum plaster paintings in Uzbekistan *(Eng)* S983

Montagnais
A Naskapi painted skin shirt *(Eng) binding media; caribou; fish; hide; Native American; paint; pigment; skin; water* S247

Monticello (Virginia, USA)
house paint—Microchemical analysis of old housepaints with a case study of Monticello *(Eng)* S661

montmorillonite
Maya blue—Maya blue: a new perspective *(Eng)* S590
—Maya blue: an updated record *(Eng)* S580
—Maya blue: further perspectives and the possible use of indigo as the colorant *(Eng)* S605

mopa-mopa tree (Eleagia utilis)
Inca—Mopa-mopa or pasto varnish: the frames of the Church of Egypt, in Bogotá *(Spa)* S461
varnish—Varnish of Pasto, a Colombian craft of aboriginal origin *(Spa)* S212

mordant
dye—Navajo native dyes: their preparation and use *(Eng)* S299
Native American—Indian uses of native plants *(Eng)* S404
plants—The useful plants of west tropical Africa *(Eng)* S374
Thompson—Ethnobotany of the Thompson Indians of British Columbia, based on field notes by James A. Teit *(Eng)* S45
wood—Wood documentation. VII: wood conservation and surface treatment. Volume 2: surface treatment *(Fre)* S897

Morinda spp.
plants—The ocean-going *noni*, or Indian mulberry (*Morinda citrifolia, Rubiaceae*) and some of its ''colorful'' relatives *(Eng)* S502

Morse Libby Mansion (Portland, Maine, USA)
house paint—Historic finishes analysis *(Eng)* S441

mortar
Ancient Mesoamerican mortars, plasters, and stuccos: Las Flores, Tampico *(Eng) consolidation; lime; Mesoamerican; Mexico (Tampico— Las Flores); plaster; stucco* S189
—Ancient Mesoamerican mortars, plasters, and stuccos: Palenque, Chiapas *(Eng) consolidation; lime; Mesoamerican; Mexico (Chiapas— Palenque); plaster; stucco* S190
cement—Precolumbian cements: a study of the calcareous cements in pre-Hispanic meso-American building construction *(Eng)* S553
fresco painting (technique)—Fresco painting: modern methods and techniques for painting in fresco and secco *(Eng)* S111
historic buildings—Defects of color dyes on historic buildings' renderings *(Cze)* S914
—Inspection of the state of the art: materials commonly available on the market and employed for renderings and paint *(Ita)* S1033
Hopi—The Na-ac-nai-ya: a Tusayan initiation ceremony *(Eng)* S12
Mesoamerican—Ancient Mesoamerican mortars, plasters, and stuccos. The use of bark extracts in lime plasters *(Eng)* S197
mural paintings—Materials and painting techniques of the wall paintings of the main nave of S. Mary's Church in Toruń *(Pol)* S432
—Mural paintings in the Fraugde church on Funen *(Dan)* S302
—Products, facts, modes in mural painting: evolution and distribution of restoration products used in mural paintings from 1850 to 1992. A first sorting concerning France, Spain, England, and Poland *(Fre)* S511
Puuc—Ancient Mesoamerican mortars, plasters, and stuccos: the Puuc Area *(Eng)* S198
stone—The consequences of previous adhesives and consolidants used for stone conservation at the British Museum *(Eng)* S1052
—The conservation of the Winchester Anglo-Saxon fragment *(Eng)* S1090

mosaics
excavations—Conservation of excavated intonaco, stucco, and mosaics *(Eng)* S1007
majolica—Experiments on the consolidation of glazes on majolica and glass tesserae from mosaics *(Ita)* S1106
Mexico—Colors and paint at the time of the pre-Cortés Mexican civilizations *(Fre)* S169
shields (armor)—Restoration of a ceremonial shield from the Solomon Islands *(Ger)* S1025

Mossbauer spectroscopy
rock paintings—Mossbauer study of rock paintings from Minas Gerais (Brazil) *(Eng)* S663

mother of pearl
Mexico—Colors and paint at the time of the pre-Cortés Mexican civilizations *(Fre)* S169
shields (armor)—Restoration of a ceremonial shield from the Solomon Islands *(Ger)* S1025

motion pictures
Africa—Quex Museum House and Gardens *(Eng)* S452

mounting
Australian Aboriginal—Conservation of the Australian Museum's collection of Aboriginal bark paintings *(Eng)* S959
charcoal—Tonal drawing and the use of charcoal in nineteenth century France *(Eng)* S468
honey—Honey in the life of the Aboriginals of the Kimberleys *(Eng)* S306
Irian Jaya—A support system for flexible palm spathe objects *(Eng)* S517
masks—The conservation of a Ptolemaic mummy mask *(Ger)* S1097
mural paintings—Conservation of Central Asian wall painting fragments from the Stein Collection in the British Museum *(Eng)* S1099
panel paintings—Preservative treatment on paint layer of screen and wall panel paintings *(Jpn)* S929
pastels (visual works)—A portrait of Master Sahl (1683-1753). Particularities of a pastel restoration *(Ger)* S993
—Removing severe distortions in a pastel on canvas *(Eng)* S1032
textiles—Preservation of a textile and a miniature painting *(Eng)* S895

Mowilith 50
adhesives—Adhesives for impregnation of painting on canvas *(Swe)* S1087

Mowiol VP 3:83
adhesives—Adhesives for impregnation of painting on canvas *(Swe)* S1087

MTEOS *see* **methyl triethoxysilane**

mucilage
adhesives—Natural adhesives in East Asian paintings *(Eng)* S372
paintings (objects)—Analysis of paint media, varnishes and adhesives *(Eng)* S625
plants—Analytical procedures *(Eng)* S531
—The useful plants of west tropical Africa *(Eng)* S374

mud
adobe—Spectacular vernacular: the adobe tradition *(Eng)* S431
forgeries—The technical investigation and conservation treatment of an alleged Ming Dynasty wall painting *(Eng)* S956
Horyuji Temple (Japan)—Scientific treatments made on the main hall of the Hōryūji Monastery after the fire of 1949 *(Jpn)* S893
latex paint—History of water-thinned paints *(Eng)* S163
mural paintings—Conservation of mural paintings in Central Asia which have been damaged by salt efflorescence *(Eng)* S888

Mudejar
Technical examination and consolidation of the paint layer on a Mudéjar coffered ceiling in the Convent of Santa Fe, Toledo *(Eng) animal glue; ceilings; consolidation; gas chromatography; optical microscopy; Paraloid B-72; pigment; Spain (Toledo); spectrometry; x-ray fluorescence* S1110

Mughal
miniatures (paintings)—The conservation of Indian and Moghul miniatures *(Eng)* S978

mummies
Probing the mysteries of ancient Egypt: chemical analysis of a Roman period Egyptian mummy *(Eng) bread; collagen; diet; Egypt; embalming; fast atom bombardment; fiber; flax; mass spectrometry; onion; pine tar; pitch (tar); ramie; resin; Roman; scanning electron microscopy;* S673
encaustic wax—The cleaning and consolidation of Egyptian encaustic mummy portraits *(Eng)* S1088
masks—The conservation of a Ptolemaic mummy mask *(Ger)* S1097

mummy cases
pyrolysis mass spectrometry—Pyrolysis-mass spectrometry of natural gums, resins, and waxes and its use for detecting such materials in ancient Egyptian mummy cases (cartonnages) *(Eng)* S636

mungyene tree
Sundi—The Kongo I *(Eng)* S162

Munsell system
Australian Aboriginal—Conservation of the Australian Museum's collection of Aboriginal bark paintings *(Eng)* S959

mural painting (technique)
Byzantine—A monument of Byzantine wall painting: the method of construction *(Fre)* S184

mural paintings
Ajanta and Ellora wall paintings. Scientific research as an aid to their conservation *(Eng) Ajanta Caves (India); calcium sulfate; caves; Ellora Site (India); India; paint; pigment; plaster; stone; temples* S569
—Ajanta murals: their composition and technique and preservation *(Eng) acetone; Ajanta Caves (India); alcohol; ammonia; binding media; butyl alcohol; casein; cellulose; charcoal black; dammar; diacetone alcohol; ethyl alcohol; ethylene glycol; fixing; flaking; gelatin; grease; gum; hydrochloric acid; India (Ajanta); lime; methacrylate; methyl alcohol; methyl cellulose; methyl ethyl ketone; mildew; naphtha; peeling; pigment; plaster of Paris; poly(vinyl acetate); salt; shellac; sodium hydroxide; soot; tempera; toluene; turpentine; varnish* S232
—Analysis of pigments and plaster of the paintings in the Sheesh Mahal, Nagaur *(Eng) chalk; cinnabar; India (Nagaur); indigo; lime; malachite; orpiment; pigment; plaster; red lead; red ocher; red pigment; sandstone; Sheesh Mahal (Nagaur, India); zinc white* S428
—The analysis of pigments from ancient mural paintings. The state of the problem and a bibliography *(Fre) color; Egyptian blue; green earth; ocher; pigment* S343
—Ancient Collegiate Church of Saint Barnard de Romans: decorated surfaces of the choir and transept *(Fre) France (Isére); Medieval; paintings (objects); plasterwork; resin; Saint Bernard de Romans Church (Isére, France)* S478
—Application of synthetic resins to the preservation of antiques and art crafts *(Jpn) flaking; Horyuji Temple (Japan); methacrylate; poly(vi-*

nyl alcohol); silk; ureaformaldehyde resin; wood S891
—The Château of Oiron and its decorated surfaces *(Fre) ceilings; chateaux; France (Deux-Sevres); painting (technique); paneling; Renaissance; woodwork* S457
—Chemical studies on ancient painting materials *(Jpn) azurite; calcium carbonate; cinnabar; Japan; lead white; litharge; malachite; Muromachi; red lead; temples; white pigment; yellow ocher* S150
—Chemical studies on ancient pigments in Japan *(Eng) azurite; carbon black; cinnabar; Japan; lead white; litharge; malachite; red lead; red ocher; white pigment; yellow ocher* S138
—Chemical studies on the pigments of ancient ornamented tombs in Japan *(Jpn) azurite; charcoal black; chlorite; cinnabar; Japan; malachite; manganese; ocher; pigment; pyrolusite; tombs* S151
—Chemical study on the coloring materials of the murals of the Taka-matsuzuka Tomb in Nara Prefecture *(Jpn) iron oxide; lime; malachite; mercury; ocher; plaster; red lead; red pigment; Taka-matsuzuka Tomb (Nara, Japan); vermilion* S272
—The Church of Lourps in Longueville: restoration of the decorated surfaces *(Fre) Church of Lourps (Longueville, France); color; decoration; France (Longueville); paint* S474
—Conservation of Central Asian wall painting fragments from the Stein Collection in the British Museum *(Eng) acrylic silane; Asia, Central; British Museum (London, England); Buddhist; cleaning; Ming; monasteries; mounting; Raccanello E 55050; Stein, Aurel (1862-1943); temples* S1099
—Conservation of English Medieval wallpaintings over the century *(Eng) buildings; cement; England; heating; Medieval; varnish; wax* S1028
—Conservation of mural paintings *(Eng) India* S522
—Conservation of mural paintings in Central Asia which have been damaged by salt efflorescence *(Eng) Asia, Central; blacking; carbolic acid; cellulose acetate; green earth; humidity; lapis lazuli; malachite (pigment); mold (fungus); mud; ocher; paper pulp; plaster; salt; thymene; toluene; vinyl acetate* S888
—Conservation of wall paintings *(Eng) cleaning; consolidation; history of technology; pigment* S366
—The conservation of wallpaintings in France *(Eng) conservation; France* S1030
—A contribution on the history of materials *(Ger) artists' materials; Roman* S173
—Destruction and restoration of Campanian mural paintings in the eighteenth and nineteenth centuries *(Eng) excavations; gypsum; Italy (Campania); paintings (objects); transferring; varnish* S1105
—Development and materials of wall paintings from antiquity to recent times *(Ger) history of technology* S252
—The earliest known paints *(Eng) binding media; blood; charcoal; fat; France (Dordogne);*

iron oxide red; limestone; milk; ocher; Spain (Altamira) S153
—Early Gothic wall paintings: an investigation of painting techniques and materials of 13th-century mural paintings in a Danish village church *(Eng) Denmark; Gothic; paintings (objects); pigment* S509
—Early Medieval wall painting and painted sculpture in England: based on the proceedings of a symposium at the Courtauld Institute of Art, February 1985 *(Eng) England; Medieval; painting (technique); Romanesque; sculpture* S459
—The examination of mural paintings *(Dut) adhesives; casein; dye; egg white; flour paste; glycerin; gum arabic; linoxyn; microchemistry; resin; starch; wax* S525
—How to paint a mural *(Spa) cement; coatings; ethyl silicate; lime; Mexico; vinyl acetate* S381
—In review: an assessment of Florentine methods of wall painting conservation based on the use of mineral treatments *(Eng) ammonium carbonate; barium hydroxide; Italy (Florence); minerals; paintings (objects); sulfation* S1104
—Indian murals: techniques and conservation *(Eng) cleaning; fixing; humidity; India; lime; plaster; poly(vinyl acetate); tempera* S931
—The investigation of pigments and paint layer structures of mural paintings at Maitepnimit Temple *(Eng) calcite; cinnabar; cumengeite; gamboge (pigment); gold; gypsum; hematite; indigo; inorganic pigment; lead white; Maitepnimit Temple; malachite; minium; tempera; Thailand* S477
—The legacy of the Tía Sandalia: consolidation, removal, and mounting of the work in the future Ethnographic Museum of Villacañas (Toledo) *(Spa) Casa Sandalia (Spain); Ethnographic Museum (Toledo, Spain); paintings (objects); relief; sculpture; Spain (Toledo); transferring* S1083
—Materials and painting techniques of the wall paintings of the main nave of S. Mary's Church in Toruń *(Pol) azurite; carbon black; chalk; malachite; mortar; ocher; paintings (objects); Poland (Torún); red lead; red ocher; Saint Mary's Church (Toruń, Poland); umber; whitewash* S432
—Materials and techniques of Medieval wall paintings from the former House of Merchants' Fraternity at 5 Żeglarska Street in Toruń *(Pol) azurite; binding media; blood; carbon black; chalk; egg yolk; fat; iron oxide; lime; malachite; Medieval; ocher; paintings (objects); pigment; plaster; Poland (Torún); red lead; vermilion; yellow ocher* S485
—Microchemical analysis of the wall paintings of St. Baafsabtei in Ghent (about 1175) *(Dut) adhesives; Belgium (Ghent); binding media; black pigment; burnt sienna; casein; charcoal black; green earth; lapis lazuli; ocher; pigment; red ocher; silicate; wood; yellow ocher* S90
—Monumentales pastell—a forgotten invention in wall painting techniques about 1900 *(Eng) Austria (Vienna); casein; color; painting (technique); pastels (crayons); plaster* S301

—Mural painting technique of Herculaneum *(Ita) Italy (Herculaneum); Italy (Pompeii); lime; Roman* S186
—The mural paintings in the Brihadisvara Temple at Tanjore: an investigation into the method *(Eng) Chola; India (Tanjore); pigment* S76
—Mural paintings in the Fraugde church on Funen *(Dan) calcium carbonate; charcoal; color; copper chloride; Denmark; lapis lazuli; lime; mortar; ocher; protein; Romanesque* S302
—On the technology of Central Asian wall paintings: the problem of binding media *(Eng) amino acid; Asia, Central; binding media* S563
—The paintings on walls and ceilings in the cabinets of the gallery building at Hannover-Herrenhausen *(Ger) casein; ceilings; consolidation; decoration; Hannover-Herrenhausen castle; humidity; polymers* S1070
—The Pallava paintings at Conjeevaram: an investigation into the methods *(Eng) binding media; black pigment; gum; India (Conjeevaram); lime; pigment; plaster* S85
—Parallel progress in restoration and archaeology: discovery and restoration of monumental painting and sculpture on a loess ground *(Eng) archaeology; Asia, Central; paintings (objects)* S520
—Physico-chemical study of the painting layers of the Roman mural paintings from the Acropolis of Lero *(Fre) Acropolis of Lero (Côte d'Azur, France); clay; electron microprobe; hematite; ocher; painting (technique); pigment; red ocher; Roman; x-ray diffraction* S342
—Pigments and techniques of the early Medieval wall paintings of eastern Turkistan *(Ger) anhydrite; atacamite; azurite; carbon black; chrysocolla; cinnabar; gold leaf; gypsum; indigo; lapis lazuli; lead white; malachite; massicot; Medieval; orpiment; pigment; red ocher; Turkistan; vermilion; yellow ocher* S298
—Pigments used in the paintings of "Hoodo." *(Jpn) azurite; blue pigment; China; Chinese ink; indigo; ink; Japan (Kyoto); lead; litharge; malachite; ocher; pigment; red lead; red ocher; vermilion; yellow ocher* S183
—Preliminary studies for the conservation of the Rothko Chapel paintings: an investigative approach *(Eng) artists' materials; paintings (objects); Rothko Chapel (Houston, TX, USA); Rothko, Mark (1903-1970)* S336
—Products, facts, modes in mural painting: evolution and distribution of restoration products used in mural paintings from 1850 to 1992. A first sorting concerning France, Spain, England, and Poland *(Fre) acrylic resin; barium hydroxide; casein; cellulose nitrate; databases; England; France; lime; mortar; paintings (objects); Poland; poly(vinyl acetate); poly(vinyl alcohol); resin; Spain; wax* S511
—Proposals on the technique of Roman mural paintings *(Ita) Roman* S235
—Reproduction of colored patterns in temples and shrines *(Eng) buildings; caves; decoration; gamboge (pigment); indigo; Japan; malachite; oyster shell white; paint; pigment; reproductions; shrines; temples; wood; yellow ocher* S383

—The restoration of 18th-century decorative wall paintings imitating wallhangings in Hungary *(Ger) decoration; Hungary; secco; wall hangings* S321

—Restoration of ancient monumental painting in cult buildings *(Eng) adhesives; chalk; cleaning; coal; fillers; ocher; pigment; plaster; salt; tempera* S284

—Restoration of old paintings. With special emphasis on frescoes and murals (alone) in oil paint *(Ger) frescoes; oil paint; painting (technique)* S889

—Some problems on the preservation of wall paintings using synthetic resins *(Jpn) acrylic resin; color; flaking; Nijo Castle (Kyoto, Japan); Ryozenji Temple (Nara, Japan)* S892

—Specific problems concerning the restoration of wall paintings at Humor *(Eng) cleaning; fixing; Romania (Humor)* S1034

—The structure of the 17th-century mural paintings in the S. George Orthodox church at Veliko Turnovo (Bulgaria) *(Pol) adhesives; animal glue; binding media; Bulgaria (Veliko Turnovo); calcium carbonate; carbon black; egg yolk; green earth; limestone; malachite; ocher; plaster; red lead; vermilion* S264

—Structure, composition, and technique of the paintings *(Dut) Belgium (Bruges); calcium carbonate; charcoal black; frescoes; lime; ocher; painting (technique); pigment; red ocher; Saint Donatian Church (Bruges, Belgium); St. John's white; tempera; yellow ocher* S346

—Study and conservation of quadratura decoration on the vaults of 17th-century French buildings *(Fre) buildings; decoration; France; frescoes; vaults (structural elements)* S470

—A study of organic components of ancient middle Asian and Crimean wall paintings *(Rus) Asia, Central; beeswax; gelatin; gum; infrared spectrometry; sugar; Ukraine (Crimea)* S289

—A survey of the painted mud *Viharas* of Sri Lanka *(Eng) adobe; decoration; painting (technique); Sri Lanka; walls* S351

—Technique and conservation of mural paintings: report on the meeting held in Washington and New York, 17-25 September 1965 *(Fre) history of technology; paint; plasterwork* S226

—Technique of the painting process in the Kailasanatha and Vaikunthaperumal temples at Kanchipuram *(Eng) India; pigment; plasterwork* S84

—The technique of the paintings at Sitabhinji *(Eng) adhesives; binding media; biotite; granite; gum; India (Sitabhinji); lime; ocher; red ocher; yellow ocher* S143

—The techniques, conservation, and restoration of mural paintings *(Ita) adhesives; gum; lime; oil; resin; sgraffito; strappo; tempera; wax* S64

—Three Bodhisattvas: the conservation of a fifteenth century Chinese wall painting in the British Museum collection *(Eng) acrylic resin; British Museum (London, England); Chinese; cleaning; flaking; transferring* S1051

—Unfinished wall paintings in Egyptian tombs and temples *(Ger) Egypt; Egyptian blue; lime*

white; malachite (pigment); ocher; pigment; plaster; red pigment; resin; soot; tombs* S192

—The use of wax and wax-resin preservatives on English Medieval wall paintings: rationale and consequences *(Eng) England; history of conservation; Medieval; resin; wax* S388

—Wall painting conservation in Tuscany before the Florentine flood of 1966 *(Eng) cleaning; consolidation; Giotto di Bondone (ca. 1266-1337); history of conservation; Italy; Santa Croce Cathedral (Florence, Italy); Scrovegni Chapel (Padua, Italy)* S1125

—The wall paintings in the Bagh caves: an investigation into their methods *(Eng) adhesives; binding media; blue pigment; India (Bagh caves); lapis lazuli; pigment; plaster; tempera* S87

—Wall paintings: technique, problems, conservation *(Ita) barium hydroxide; bibliographies; biodeterioration; conservation; frescoes; gilding; graffiti; Italy; paintings (objects); photogrammetry; plaster* S1080

—Workshop practices and identification of hands: Gothic wall paintings at St Albans *(Eng) England (St. Albans); Medieval; paintings (objects); polychromy* S514

Abydos reliefs (Egypt)—Techniques of decoration in the Hall of Barques in the Temple of Sethos I at Abydos *(Eng)* S1064

adobe—1981 report on the development of methods for the conservation of Pueblo Indian mural paintings in the American Southwest *(Eng)* S995

—The conservation of adobe walls decorated with mural paintings and reliefs in Peru *(Eng)* S958

Anasazi—Anasazi and Pueblo painting *(Eng)* S487

artists' materials—The artist's handbook of materials and techniques *(Eng)* S83

binding media—The problem of the binding medium particularly in wall painting *(Eng)* S534

Bronze Age—Aegean painting in the Bronze Age *(Eng)* S466

consolidants—The consolidation of powdery paint layers of *Bonaders*, Swedish mural works painted on paper *(Fre)* S1109

—Degradation of synthetic consolidants used in mural painting restoration by microorganisms *(Fre)* S1122

Czechoslovakia (Prague)—Technical parallels between panel and wall painting of the 14th century *(Cze)* S353

Daiju-ji Temple (Japan)—Preservative treatment on the *Shoheki-ga* at the Daiju-ji *(Jpn)* S955

Egypt (Thebes)—Introduction to Theban painting *(Fre)* S115

fixatives—Fixatives for mural paintings *(Ita)* S903

forgeries—The technical investigation and conservation treatment of an alleged Ming Dynasty wall painting *(Eng)* S956

fresco painting (technique)—Colors and painting in antiquity *(Fre)* S133

frescoes—19th and early 20th century restorations of English Mediaeval wall paintings: problems and solutions *(Eng)* S1116

—Artistic frescoes *(Eng)* S100
—The conservation in situ of the Romanesque wall paintings of Lambach *(Eng)* S1098
—Frescoes by Il Primaticcio in the ballroom of the Castle of Fontainebleau: the legacy, a derestoration attempt *(Fre)* S1117
—The frescoes of Tavant (France) *(Eng)* S179
gas chromatography—Identification of proteinaceous binding media of easel paintings by gas chromatography of the amino acid derivatives after catalytic hydrolysis by a protonated carbon exchanger *(Eng)* S670
hematite—Physico-chemical and colorimetric study of haemitite reds and purples, with reference to the mural paintings of the Acropolis of Lero, or "histories of ochre" *(Fre)* S352
Horyuji Temple (Japan)—Coloring materals of the murals in the Main Hall of the Horyuji Temple compared with those of the ornamented tombs *(Jpn)* S271
—Scientific treatments made on the main hall of the Hōryūji Monastery after the fire of 1949 *(Jpn)* S893
Igbo—Uli painting and Igbo world view *(Eng)* S444
India—One hundred references to Indian painting *(Eng)* S49
Italy (Pompeii)—The technique of antique Pompeian wall painting *(Ita)* S131
latex paint—History of water-thinned paints *(Eng)* S163
loess—The effect of the treatment with polybutyl methacrylate solutions on physical and mechanical properties of loess plaster *(Eng)* S954
Mayan—The Maya mural paintings of Bonampak, materials analysis *(Fre)* S539
Mesoamerican—Short methods for the identification of pigments *(Eng)* S566
Native American—What did they use for paint? *(Eng)* S236
organic materials—A study of organic components of paints and grounds in Central Asian and Crimean wall paintings *(Eng)* S564
Ottonian—The painted ceiling from the Romanesque period in the Protestant church of Saint Michael at Hildesheim *(Ger)* S1073
ox blood—Ox-blood: a color binding media and a color name *(Ger)* S339
painting (technique)—Greek and Roman methods of painting: some comments on the statements made by Pliny and Vitruvius about wall and panel painting *(Eng)* S29
pigment—Analysis of the material and technique of ancient mural paintings *(Eng)* S220
—Pigments and paints in classical antiquity *(Fre)* S200
—The pigments used in the wall paintings *(Jpn)* S194
—Technical studies on the pigments used in ancient paintings of Japan *(Eng)* S167
plasterwork—The restoration of facade plasterwork in Italy *(Fre)* S472
poly(butyl methacrylate)—New possibilities of polybutyl methacrylate as a consolidating agent for glue painting on loess plaster *(Eng)* S936

poly(vinyl acetate)—Polyvinyl acetate in the conservation of the wall paintings *(Eng)* S1103
poly(vinyl alcohol)—The fixing of mural paintings with polyvinyl alcohol (Mowiol N-70-98): a restorer's experience *(Fre)* S962
Pueblo—Kiva mural decorations at Awatovi and Kawaika-a, with a survey of other wall paintings in the Pueblo Southwest *(Eng)* S160
—The state of preservation of Pueblo mural paintings in the American Southwest: findings of a condition study carried out in 1978-1979, and a proposed pilot project to test materials and methods for conservation *(Eng)* S977
reattaching—Reattaching color layers on a wooden wall and documenting the distribution of damages *(Jpn)* S1024
rock art—The ancients knew their paints *(Eng)* S249
rock paintings—Technique of the painting process in the rock-cut temples at Badami *(Eng)* S86
Romano-British—An analysis of paints used in Roman Britain *(Eng)* S213
Spain (Catalonia)—Architecture and decorated surfaces in Catalonia *(Fre)* S456
Temple of the Paintings (Bonampak Site, Chiapas, Mexico)—Conservation and restoration of the murals of the Temple of the Paintings in Bonampak, Chiapas *(Eng)* S1037
Thailand—Conservation of wall paintings in Thailand *(Eng)* S927
Tomb of Nefertari (Thebes, Egypt)—Chemical analyses of pigments and media used in the mural paintings of the tomb of Nefertari *(Spa)* S658
transferring—Transfer of paintings: at any price? *(Ger)* S916
Turkistan—The materials in the wall paintings from Kizil in Chinese Turkestan *(Eng)* S81
USA (New Mexico)—The materials and methods of some religious paintings of early 19th century New Mexico *(Eng)* S142

Muromachi
mural paintings—Chemical studies on ancient painting materials *(Jpn)* S150
wood—Studies on fixing treatments of color paintings on the ceiling of Sanmon Gate, National Treasure, Tofuku-ji Temple *(Jpn)* S940

Museum of Modern Art (New York City, NY, USA)
acrylic resin—The identification and characterization of acrylic emulsion paint media *(Eng)* S666

musical instruments
patina—The study of patina *(Fre)* S416

mwindu (Bridelia scleroneura)
ceramics—Two Kongo potters *(Eng)* S291

Mycenaean
fresco painting (technique)—Colors and painting in antiquity *(Fre)* S133

myrrh
Egypt—What do we know about the paints of the old Egyptians? *(Eng)* S137

NAA see **neutron activation analysis**

Nagoya Castle (Nagoya, Japan)
Study on the repair technique of polychrome paintings drawn on sliding screens in the Nagoya Castle *(Jpn) acetone; acrylic resin; binding media; chalk; emulsion; flaking; paintings (objects); pigment; polychromy; screens (doors)* S945

Nahuatl
A review of sources for the study of Náhuatl plant classification *(Eng) Aztec; botany; ethnobotany; Mesoamerican; Mexico; plants* S484

naphtha
mural paintings—Ajanta murals: their composition and technique and preservation *(Eng)* S232
resin—The technology of natural resins *(Eng)* S99

Naples yellow
pigment—Artists' pigments: a handbook of their history and characteristics *(Eng)* S623
yellow pigment—Yellows *(Ita)* S396

Narra
dyewood—Dyewoods, their composition and use. Part 1: Description of the most important dyewoods *(Ger)* S204

Naskapi
Native American—CCI Native Materials Project: final report *(Eng)* S473

National Gallery (London, England)
binding media—Analyses of paint media *(Eng)* S587
gas chromatography—Analyses of paint media *(Eng)* S578
—A review, with illustrations, of methods applicable to the analysis of resin/oil varnish mixtures *(Eng)* S600

National Gallery of Canada (Ottawa, Ontario, Canada)
pastels (visual works)—Degas pastel research project: a progress report *(Eng)* S393

National Museum of Denmark (Brede, Denmark)
metal—Examples of conservation of painted metal objects *(Eng)* S1093

Native American see also **specific nations, e.g., Haida, Inuit, Thompson**
America's first painters *(Eng) brushes; casein; milk; pigment; tempera; USA (New Mexico— Santa Fe)* S168
—American Indian painting of the Southwest and Plains areas *(Eng) abalone shell; binding media; brushes; carbonate rock; copper; eagle feather; egg; fat; gum; milk; oil paint; painting (technique); pigment; saliva; seeds; turquoise* S239
—Analysis of paints used by Canadian native cultures: a project at the Canadian Conservation Institute *(Eng) binding media; Canada; inorganic pigment; mineral pigment; organic materials; paint; pigment; synthetic organic pigment; vegetable pigment* S640
—CCI Native Materials Project: final report *(Eng) binding media; Canadian Conservation*

Institute *(Ottawa, Ontario, Canada); databases; extenders; fillers; Haida; Kwakiutl; Naskapi; Northwest Coast Indians; pigment; Plains Indians; samples; Tsimshian* S473
—Chinigchinich: a revised and annotated version of Alfred Robinson's translation of Father Geronimo Boscana's historical account of the belief, usages, customs and extravagancies of the Indians of this mission of San Juan Capistrano called the Acagchemem Tribe *(Eng) bacteria (Leptothrix ochracea); chilicothe (Marah macrocarpus); iron oxide; pigment; pitch (tar); red ocher; red pigment; rock art; seeds; turpentine; USA (California— San Juan Capistrano)* S58
—Colors in Indian arts: their sources and uses *(Eng) aniline dye; dye; mineral dye; North America; vegetable dye* S59
—The ethnobotany of the California Indians: a compendium of the plants, their users, and their uses *(Eng) ethnobotany; Luiseño; milkweed; paint; plants; sap; USA (California)* S269
—The formation of ethnographic collections: the Smithsonian Institution in the American Southwest *(Eng) Smithsonian Institute (Washington, DC, USA); USA (Southwest)* S406
—Handbook of American Indians north of Mexico *(Eng) adhesives; binding media; copper carbonate; dye; grease; iron oxide; oil; organic materials; pigment; saliva; seeds; USA (Pacific Northwest); water* S25
—Handbook of Indian foods and fibers of arid America *(Eng) deserts; dye; insecticide; plants; USA (Southwest)* S389
—Indian herbalogy of North America: the definitive guide to native medicinal plants and their uses *(Eng) dye; Hopi; medicine; North America; plants* S490
—Indian life on the northwest coast of North America, as seen by the early explorers and fur traders during the last decades of the 18th century *(Eng) Canada (British Columbia— Queen Charlotte Islands); dyeing; ocher* S266
—Indian rawhide: an American folk art *(Eng) antelope; binding media; bone; brushes; cactus; deer; finishing; folk art; hide; masks; pigment; rawhide; resin* S280
—Indian uses of native plants *(Eng) dye; minerals; mordant; paint; pigment; plants; red pigment* S404
—The Indians of the Redwood Belt of California: an ethnobotanical approach to culture area *(Eng) plants; redwood; USA (California)* S260
—Native paints in the Canadian West Coast *(Eng) brushes; Canada (West Coast); dye; salmon egg* S75
—A new original version of Boscana's historical account of the San Juan Capistrano Indians of Southern California *(Eng) adhesives; lead white; pigment; USA (California— San Juan Capistrano); white pigment* S62
—Puffball usages among North American Indians *(Eng) fungi; North America; pigment; puff balls* S349
—Seri use of mesquite, *Prospis glandulosa* variety *torreyana (Eng) dye; mesquite; paint* S259

—Some plants used by the Yuki Indians of Round Valley, northern California *(Eng)* botany; dye; green pigment; USA (California) S176
—What did they use for paint? *(Eng) adhesion; azurite; binding media; blood; carbon black; casein; charcoal; clay; diatomaceous earth; egg; fat; graphite; gum; hematite; iron oxide; kaolin; limonite; malachite; manganese; milk; mural paintings; ocher; pigment; prehistoric; rock art; serpentine; vegetable oil* S236
Acoma—The Acoma Indians *(Eng)* S57
adobe—1981 report on the development of methods for the conservation of Pueblo Indian mural paintings in the American Southwest *(Eng)* S995
Apache—Plants used by the White Mountain Apache Indians of Arizona *(Eng)* S47
bitumen—Prehistoric use of bitumen in Southern California *(Eng)* S256
black pigment—Ceramic pigments of the Indians of the Southwest *(Eng)* S40
—Prehistoric pottery pigments in the Southwest *(Eng)* S46
Blackfoot—The Blackfoot tipi *(Eng)* S68
—Material culture of the Blackfoot Indians *(Eng)* S30
—Painted tipis and picture-writing of the Blackfoot Indians *(Eng)* S69
Cherokee—Cherokee plants and their uses: a 400 year history *(Eng)* S287
—An early Cherokee ethnobotanical note *(Eng)* S118
Chippewa—How Indians use wild plants for food, medicine, and crafts *(Eng)* S278
—Plants used by the Chippewa *(Eng)* S91
—Some Chippewa uses of plants *(Eng)* S60
—Uses of plants by the Chippewa Indians *(Eng)* S41
Chumash—A study of some Californian Indian rock art pigments *(Eng)* S519
conifers—Ethnobotany of coniferous trees in Thompson and Lillooet Interior Salish of British Columbia *(Eng + Fre)* S426
creosote—Notes on creosote lac scale insect resin as a mastic and sealant in the Southwestern Great Basin *(Eng)* S481
dye—Aboriginal paints and dyes in Canada *(Eng)* S54
—Keresan Indian color terms *(Eng)* S102
—Navajo native dyes: their preparation and use *(Eng)* S299
ethnobotany—Ethnobotany of the Zuñi Indians *(Eng)* S27
—An introductory study of the arts, crafts, and customs of the Guiana Indians *(Eng)* S34
—Uses of plants by the Indians of the Missouri River region *(Eng)* S32
Hopi—Hopi dyes *(Eng)* S300
Kiowa—The economic botany of the Kiowa Indians as it relates to the history of the tribe *(Eng)* S341
Kwakiutl—Field research in the conservation of ethnographical collections: an ecological approach applied to polychrome monumental sculpture *(Eng)* S417
Luiseño—The culture of the Luiseño Indians *(Eng)* S26

Meskwaki—Ethnobotany of the Meskwaki Indians *(Eng)* S43
Mexico (Baja California)—Face and body painting in Baja California: a summary *(Eng)* S273
mining—The mining of gems and ornamental stones by American Indians *(Eng)* S93
Mojave—Mohave tatooing and face-painting *(Eng)* S116
Montagnais—A Naskapi painted skin shirt *(Eng)* S247
Nitinaht—Ethnobotany of the Nitinaht Indians of Vancouver Island *(Eng)* S356
Ojibwa—Ethnobotany of the Ojibwa Indians *(Eng)* S56
pictographs—On the pictographs of the North American Indians *(Eng)* S8
pigment—Ethnology of the Ungava District, Hudson Bay Territory *(Eng)* S14
plants—Gathering the desert *(Eng)* S378
—Plants used by the Indians of Mendocino County, California *(Eng)* S21
—Plants used by the Indians of the United States *(Eng)* S7
—A study of plant-based colorants used by the Indians of Brazil and the plants from which they are derived *(Por)* S37
—The use of wild plants in tropical South America *(Eng)* S132
Potawatomi—Ethnobotany of the forest Potawatomi Indians *(Eng)* S61
primitive art—Primitive art: pre-Columbian, North American Indian, African, Oceanic *(Eng)* S307
Pueblo—Kiva mural decorations at Awatovi and Kawaika-a, with a survey of other wall paintings in the Pueblo Southwest *(Eng)* S160
—The state of preservation of Pueblo Indian mural paintings in the American Southwest: findings of a condition study carried out in 1978-1979, and a proposed pilot project to test materials and methods for conservation *(Eng)* S977
—Two summers' work in Pueblo ruins *(Eng)* S22
rock art—The ancients knew their paints *(Eng)* S249
rock paintings—Petroglyphs and pictographs on the British Columbia coast *(Eng)* S95
Salish—The ethnobotany of the Coast Salish Indians of Vancouver Island *(Eng)* S263
Seri—People of the desert and sea: ethnobotany of the Seri Indians *(Eng)* S376
Seri blue—Seri blue *(Eng)* S217
—Seri blue—an explanation *(Eng)* S218
sumac—The use of the sumacs by the American Indian *(Eng)* S72
totem poles—The conservation of a Tlingit totem pole *(Eng)* S309
—Restoration of totem poles in British Columbia *(Eng)* S44
USA (New Mexico)—The materials and methods of some religious paintings of early 19th century New Mexico *(Eng)* S142
USA (New Mexico)— Isleta—Isleta, New Mexico *(Eng)* S55
Zuni—The Zuni Indians, their mythology, esoteric fraternities, and ceremonies *(Eng)* S24

natural history specimens
Parylene—Parylene at CCI = L'emploi du parylène à l'ICC *(Eng + Fre)* S1069

Navajo
Ethnobotany of the Ramah Navaho *(Eng) colorants; dye; ethnobotany; plants; resin* S277
dye—Navajo native dyes: their preparation and use *(Eng)* S299
sand paintings—Conservation of a Navajo sand-painting *(Eng)* S912

Near East
adobe—Spectacular vernacular: the adobe tradition *(Eng)* S431

Neocryl B700
acrylic resin—A preliminary evaluation of acrylic emulsions for the adhesion of flaking paint on ethnographic objects *(Eng)* S1046

Netherlandish
The beginnings of Netherlandish canvas painting, 1400-1530 *(Eng) azurite; canvas; Cennini, Cennino Drea (b. ca. 1370; flags; gum arabic; linen; matte; painting (technique); pigment; size (material); tempera; textiles; Tuchlein paintings* S445
Tuchlein paintings—The technique of a Tüchlein by Quinten Massys *(Eng)* S423

Netherlands
skin—Lipids from samples of skin from seven Dutch bog bodies: preliminary report *(Eng)* S653
tuchlein paintings—A Tuchlein from the Van der Goes legacy: identification, technique, and restoration *(Ger)* S521

Neuen Wilden
The "fast" paintings of the Neuen Wilden *(Ger) contemporary art; cotton; emulsion; lining; paint; peeling* S358

neutron activation analysis
forensic science—Forensic analysis of coatings *(Eng)* S615

New Guinea
Pilot study: survey of the literature relating to the material culture of the New Guinea Highlands *(Eng) artists' materials; bibliographies; ethnography; material culture* S308
—Wow-Ipits: eight Asmat woodcarvers of New Guinea *(Eng) Asmat; chalk; colorants; fern; mangrove; ocher; pigment; plant materials; sap; tau; wood* S231

New York School
contemporary art—Ephemeral paintings on "permanent view": the accelerated ageing of Mark Rothko's paintings *(Eng)* S399

New Zealand
human head—The conservation of a preserved human head *(Eng)* S935
Maori—Conservation considerations on four Maori carvings at Auckland Museum, New Zealand *(Eng)* S359
—Maori art *(Eng)* S18
—Maori carvings in Auckland museum, New Zealand. Ethical considerations in their restoration *(Eng)* S360

Newman, Barnett (1905-1970)
Barnett Newman: selected writings and interviews *(Eng) contemporary art; paint* S475

nickel
Romano-British—An analysis of paints used in Roman Britain *(Eng)* S210

Nigeria
Ethnobotanical studies from central Nigeria *(Eng) ethnobotany; plants* S453
Anang—The carver in Anang society *(Eng)* S276
Igbo—Uli painting and Igbo world view *(Eng)* S444
Yoruba—Gelede: a Yoruba masquerade *(Eng)* S250

Nijo Castle (Kyoto, Japan)
mural paintings Some problems on the preservation of wall paintings using synthetic resins *(Jpn)* S892

Nitinaht
Ethnobotany of the Nitinaht Indians of Vancouver Island *(Eng) alder; bark; Canada (British Columbia)—Vancouver Island); charcoal; colorants; dye; ethnobotany; hemlock; Native American; paint; pigment; plants; wood* S356

nitrogen oxide
historic buildings—Conservation within historic buildings in Japan *(Eng)* S973

North America
consolidation—A review of problems encountered in the consolidation of paint on ethnographic wood objects and potential remedies *(Eng)* S1085
Native American—Colors in Indian arts: their sources and uses *(Eng)* S59
—Indian herbalogy of North America: the definitive guide to native medicinal plants and their uses *(Eng)* S490
—Puffball usages among North American Indians *(Eng)* S349
rock paintings—Petroglyphs and pictographs on the British Columbia coast *(Eng)* S95

Northwest Coast Indians
Native American—CCI Native Materials Project: final report *(Eng)* S473

Norway
Iceland—Likneskjusmid: fourteenth century instructions for painting from Iceland *(Eng)* S503

nuclear magnetic resonance (testing)
coatings—Mechanical properties of clay coating films containing styrene-butadiene copolymers *(Eng)* S834

oak
Bouts, Dirck, the elder (ca. 1415-1475)— The techniques of Dieric Bouts: two paintings contrasted *(Eng)* S386
icons—The technique of icon painting *(Eng)* S214

obsidian
Japan—Pigments used in Japanese paintings *(Eng)* S405

—Materials and painting techniques of the wall paintings of the main nave of S. Mary's Church in Toruń *(Pol)* S432

—Materials and techniques of Medieval wall paintings from the former House of Merchants' Fraternity at 5 Żeglarska Street in Toruń *(Pol)* S485

—Microchemical analysis of the wall paintings of St. Baafsabtei in Ghent (about 1175) *(Dut)* S90

—Mural paintings in the Fraugde church on Funen *(Dan)* S302

—Physico-chemical study of the painting layers of the Roman mural paintings from the Acropolis of Lero *(Fre)* S342

—Pigments used in the paintings of "Hoodo." *(Jpn)* S183

—Restoration of ancient monumental painting in cult buildings *(Eng)* S284

—The structure of the 17th-century mural paintings in the S. George Orthodox church at Veliko Turnovo (Bulgaria) *(Pol)* S264

—Structure, composition, and technique of the paintings *(Dut)* S346

—The technique of the paintings at Sitabhinji *(Eng)* S143

—Unfinished wall paintings in Egyptian tombs and temples *(Ger)* S192

Native American—Indian life on the northwest coast of North America, as seen by the early explorers and fur traders during the last decades of the 18th century *(Eng)* S266

—What did they use for paint? *(Eng)* S236

New Guinea—Wow-Ipits: eight Asmat woodcarvers of New Guinea *(Eng)* S231

panel paintings—Present state of screen and panel paintings in Kyoto *(Jpn)* S933

pigment—Archaeological expedition to Arizona in 1895 *(Eng)* S17

—Painted Mexican furniture and trinkets *(Fre)* S178

—The pigments used in the wall paintings *(Jpn)* S194

—Technical studies on the pigments used in ancient paintings of Japan *(Eng)* S167

Poland—Folk painting on glass *(Pol)* S240

prehistoric—Pigments and paints in prehistoric antiquity *(Fre)* S191

rock art—The ancients knew their paints *(Eng)* S249

—The recording of rock art: an illustrated paper presented to the Canadian Conservation Institute trainees and to the Course in the Conservation of Historic Monuments and Sites, Restoration Services Division, Engineering and Architecture Branch, D.I.N.A. *(Eng)* S283

rock paintings—Petroglyphs and pictographs on the British Columbia coast *(Eng)* S95

—The search for the Tassili frescoes: the story of the prehistoric rock paintings of the Sahara *(Eng)* S187

Romano-British—An analysis of paints used in Roman Britain *(Eng)* S210

Rudolphi, Johann Georg (1633-1693)—Johann Georg Rudolphi (1633-1693). Volume 1 *(Ger)* S584

screens (furniture)—Restoration of a Japanese screen *(Ger)* S949

oil

acrylic resin—Modern day artists colours *(Eng)* S437

artists' materials—Techniques of ancient painting: the preparation of the support *(Ita)* S440

Australian Aboriginal—An identification method for fat and/or oil binding media used on Australian Aboriginal objects *(Eng)* S680

bark cloth—The analysis and identification of oils in Hawaiian oiled tapa *(Eng)* S629

Baumeister, Willi (1889-1955)—Studies of the painting techniques of Willi Baumeister *(Ger)* S496

Bella Coola—Materia medica of the Bella Coola and neighbouring tribes of British Columbia *(Eng)* S48

binding media—Contributions to the analysis of binders, adhesives and ancient varnishes *(Fre)* S547

casein—On the material side: recent trends in painting mediums *(Eng)* S134

—Studio talk: improvement in tubed casein. Interview with Ted Davis *(Eng)* S171

Chumash—The rock paintings of the Chumash: a study of a California Indian culture *(Eng)* S513

Dominica—The ethnobotany of the island Caribs of Dominica *(Eng)* S177

Egypt—Ancient Egyptian materials and industries *(Eng)* S63

ethnobotany—An introductory study of the arts, crafts, and customs of the Guiana Indians *(Eng)* S34

fatty acid—Fatty acid composition of 20 lesser-known Western Australian seed oils *(Eng)* S676

Fourier transform infrared spectroscopy—Analysis of aged paint binders by FTIR spectroscopy *(Eng)* S657

Gabon—The useful plants of Gabon: an inventory and concordance of popular and scientific names of native and nonnative plants. Description of species, properties, and economic, ethnographic, and artistic uses *(Fre)* S202

gas chromatography—Gas chromatographic identification of a resinous deposit from a 6th century storage jar and its possible identification *(Eng)* S608

—Organic analysis in the examination of museum objects *(Eng)* S621

gas chromatography mass spectrometry—Rapid identification of binding media in paintings using simultaneous pyrolysis methylation gas chromatography *(Eng)* S668

graining—Graining: ancient and modern *(Eng)* S79

Japan—Pigments used on Japanese paintings from the protohistoric period through the 17th century *(Eng)* S315

Malawi—Useful plants of Malawi *(Eng)* S219

mass spectrometry—Organic mass spectrometry of art materials: work in progress *(Eng)* S607

mural paintings—The techniques, conservation, and restoration of mural paintings *(Ita)* S64

Native American—Handbook of American Indians north of Mexico *(Eng)* S25
organic materials—Some problems in analysis of aged organic materials in art works and artefacts *(Eng)* S595
paint—Oil requirements and structure of paints *(Eng)* S695
—On the influence of grain size of pigment parts on oil requirement *(Ger)* S697
—The painter's methods and materials *(Eng)* S196
—Pigment and oil *(Ger)* S690
—The pigment-binder relationship as a fundamental property of paints *(Eng)* S709
painting (technique)—Greek and Roman methods of painting: some comments on the statements made by Pliny and Vitruvius about wall and panel painting *(Eng)* S29
—Trial data on painting materials—mediums, adhesives, and film substances *(Eng)* S77
palm—The palm, tree of life: biology, utilization, and conservation. Proceedings of a symposium at the 1986 annual meeting of the Society for Economic Botany held at the New York Botanical Garden, Bronx, New York, 13-14 June 1986 *(Eng)* S424
paper—Paintings on paper: a dialogue in five case histories *(Eng)* S971
pigment—Predicting the oil absorption and the critical pigment volume concentration of multicomponent pigment systems *(Eng)* S732
pigment volume concentration—The determination of CPVC by the oil absorption test method *(Eng)* S723
—Pigment volume concentration and an interpretation of the oil absorption of pigments *(Eng)* S827
plant materials—Pharaoh's flowers: the botanical treasures of Tutankhamun *(Eng)* S463
plants—Plants for man *(Eng)* S159
—The use of wild plants in tropical South America *(Eng)* S132
pyrolysis gas chromatography—The use of pyrolysis gas chromatography (PyGC) in the identification of oils and resins found in art and archaeology *(Eng)* S644
resin—Contribution to the study of natural resins in the art *(Eng)* S597
rock art—The ancients knew their paints *(Eng)* S249
thin layer chromatography—The methods of identifying organic binders in paint layers *(Slo)* S599
Vuillard, Edouard (1868-1940)—The distemper technique of Edouard Vuillard *(Eng)* S275

oil paint
Oil content as a determinant of the properties of oil paints and coatings *(Ger) coatings; paint; viscosity* S693
artists' materials—The artist's handbook of materials and techniques *(Eng)* S83
Baumeister, Willi (1889-1955)—Studies of the painting techniques of Willi Baumeister *(Ger)* S496
carboxymethylcellulose—The use of carboxymethylcellulose in the restoration of easel paintings *(Rum)* S1008

de Kooning, Willem (b. 1904)—De Kooning: "I see the canvas and I begin." *(Eng)* S304
Expressionist—Voices of German Expressionism *(Eng)* S254
fixing—Theoretical approach to refixing *(Fre)* S1017
house paint—Problems in the restoration and preservation of old house paints *(Eng)* S947
Jelling Man—The Jelling Man and other paintings from the Viking age *(Eng)* S420
Medieval—Medieval surface techniques, II *(Eng)* S122
mural paintings—Restoration of old paintings. With special emphasis on frescoes and murals (alone) in oil paint *(Ger)* S889
Native American—American Indian painting of the Southwest and Plains areas *(Eng)* S239
paint—Artists' paints and their manufacture, and the products *(Ger)* S152
—Rapid determination of the critical oil requirement. 1 *(Ger)* S700
—The relationship between oil content, particle size and particle shape *(Eng)* S699
painting (technique)—The painter's craft: an introduction to artists' materials *(Eng)* S123
pigment—The history of artists' pigments *(Eng)* S135
pigment volume concentration—Vehicle CPVC *(Eng)* S775
viscosity—Further experiments on the importance of the critical point *(Eng)* S694
—On oil-paint viscosity as an expression of paint structure *(Eng)* S702
—On the viscosity of oil paints *(Ger)* S696
—On the viscosity of oil paints, the turboviscosimeter, and the critical oil content *(Ger)* S692
Yoruba—A Yoruba master carver: Duga of Meko *(Eng)* S274

oil paintings
Development and materials of easel painting *(Ger) artists' materials; easel paintings* S42
—On the material side *(Eng) tempera; water* S147
—The technique of the great painters *(Eng) emulsion; pigment; tempera; varnish* S127
binding media—Analyses of paint media *(Eng)* S594
history of conservation—Complete guide for the restoration of oil, wax, tempera, watercolor, miniature, and pastel paintings, together with instructions for preparing excellent varnishes for paintings, bas-reliefs and plaster casts, dried insects and plants, prints and maps, as well as the cleaning, bleaching, mounting, and framing of copper engravings, lithographs, and woodcuts; for the art lover, painter, bronzer, decorator, etc. *(Ger)* S3
paintings (objects)—Manual of the painter restorer *(Ita)* S5

oil varnish
frescoes—19th and early 20th century restorations of English Mediaeval wall paintings: problems and solutions *(Eng)* S1116
gas chromatography—A review, with illustrations, of methods applicable to the analysis of resin/oil varnish mixtures *(Eng)* S600

organic materials
Some problems in analysis of aged organic materials in art works and artefacts *(Eng) aging; binding media; oil; protein; resin; wax* S595
—A study of organic components of paints and grounds in Central Asian and Crimean wall paintings *(Eng) amino acid; Asia, Central; beeswax; India; Medieval; mural paintings; polysaccharides; Ukraine (Crimea)* S564
acrylic resin—Consolidation with acrylic colloidal dispersions *(Eng)* S988
artists' materials—The artist's handbook of materials and techniques *(Eng)* S83
Australian Aboriginal—An identification method for fat and/or oil binding media used on Australian Aboriginal objects *(Eng)* S680
binding media—Analysis of binding media and adhesives in Buddhist wooden statues *(Jpn)* S674
—Artificial samples of paint binders. Oils, resins, waxes, glues, egg, prepared in binary mixtures: analytical characteristics and properties *(Ita)* S631
—Binding media identification in painted ethnographic objects *(Eng)* S675
—Directory of natural organic binding media *(Ger)* S83
chromatography—The chromatographic analysis of ethnographic resins *(Eng)* S603
coatings—Formulating for better control of internal stress *(Ita)* S835
—Reduced pigment volume concentration as an important parameter in interpreting and predicting the properties of organic coatings *(Eng)* S781
differential scanning calorimetry—Preliminary investigations of the binding media of paintings by differential thermal analysis *(Eng)* S634
extenders—Extenders *(Eng)* S165
Fourier transform infrared spectroscopy—Fourier transform infrared spectral analysis of natural resins used in furniture finishes *(Eng)* S646
—Micro spectroscopy FTIR reflectance examination of paint binders on ground chalk *(Eng)* S681
gas chromatography—Analysis of organic residues of archaeological origin by high-temperature gas chromatography and gas chromatography-mass spectrometry *(Eng)* S654
gas chromatography mass spectrometry—Rapid identification of binding media in paintings using simultaneous pyrolysis methylation gas chromatography *(Eng)* S668
light—Light: its interaction with art and antiquities *(Eng)* S805
Native American—Analysis of paints used by Canadian native cultures: a project at the Canadian Conservation Institute *(Eng)* S640
—Handbook of American Indians north of Mexico *(Eng)* S25
opacity—Measurements of the fading of pigments in relation to opacity *(Eng)* S756
organic chemistry—The organic chemistry of museum objects *(Eng)* S633
paintings (objects)—Analysis of paint media, varnishes and adhesives *(Eng)* S625

pigment—Studies on the ancient pigments in Japan *(Eng)* S52
pigment volume concentration—Research on the relationship between luster and pigment volume concentration *(Ger)* S771
protein—Some observations on methods for identifying proteins in paint media *(Eng)* S533
pyrolysis gas chromatography—Analytical pyrolysis as a tool for the characterization of organic substances in artistic and archaeological objects *(Eng)* S662
—The potential of pyrolysis-gas chromatography/mass spectrometry in the recognition of ancient painting media *(Eng)* S678
pyrolysis mass spectrometry—Pyrolysis-mass spectrometry of natural gums, resins, and waxes and its use for detecting such materials in ancient Egyptian mummy cases (cartonnages) *(Eng)* S636
spot tests—Spot tests in organic analysis *(Eng)* S540
Sudan (Mirgissa)—Physico-chemistry at the service of archaeology: examination of a series of samples from excavations done in Sudan *(Fre)* S545
synthetic organic pigment—An early 20th-century pigment collection: the pigment collection in the Missiemuseum at Steyl-Tegelen *(Dut)* S435
thin layer chromatography—The methods of identifying organic binders in paint layers *(Slo)* S599
tools—Potential applications of the organic residues on ancient tools *(Eng)* S624
viscosity—Microscopic examination of pigment/vehicle interaction during film formation *(Eng)* S762

Oriental lacquer *see* **urushi**

Orozco, José Clemente (1883-1949)
contemporary art—Contemporary artists and their experimental use of historical methods and techniques *(Eng)* S286

orpiment
house paint—House paints in Colonial America: their materials, manufacture and application. Part III *(Eng)* S230
mural paintings—Analysis of pigments and plaster of the paintings in the Sheesh Mahal, Nagaur *(Eng)* S428
—Pigments and techniques of the early Medieval wall paintings of eastern Turkistan *(Ger)* S298
yellow pigment—Yellow pigments used in antiquity *(Fre)* S113
—Yellows *(Ita)* S396

Osakihachiman shrine (Japan)
Conservation treatment of the painting on wooden walls in the oratory of Osakihachiman Shrine *(Jpn) acrylic resin; aging; flaking; lacquer; poly(vinyl alcohol); urushi; walls; wood* S964

Ottonian
The painted ceiling from the Romanesque period in the Protestant church of Saint Michael at Hildesheim *(Ger) animal glue; ceilings; Ger-*

many (Hildesheim); mural paintings; Paraloid B-72; Romanesque S1073

overpainting
Maori—Maori carvings in Auckland museum, New Zealand. Ethical considerations in their restoration *(Eng)* S360
masks—Restoration of a New-Ireland ceremonial mask and a double wood carving of Oceania *(Hun)* S975

ox blood
Ox-blood: a color binding media and a color name *(Ger) miniatures (paintings); mural paintings; paintings (objects); panel paintings* S339

ox gall
shadow puppets—Restoration of Chinese and Indonesian shadow puppets *(Eng)* S1011

oxidation
paint—Physicochemical alterations to the paint layer. 1. Results of a survey of various laboratories: apparent alterations of the paint layer and their probable causes. 2. Experimental study by the Musée du Louvre laboratory on madder varnish *(Fre)* S753

oyster shell white
adhesives—Re-attaching a thick color layer of polychrome sculpture. Conservation of a seated figure of Rev. Tenkai *(Jpn)* S1075
calcium carbonate—Calcium carbonate whites *(Eng)* S561
Chumash—A study of some Californian Indian rock art pigments *(Eng)* S519
fixatives—Fixing agent for chalking color on wood and its laboratory evaluation *(Jpn + Eng)* S1040
Japan—Pigments used in Japanese paintings *(Eng)* S405
mural paintings—Reproduction of colored patterns in temples and shrines *(Eng)* S383
reattaching—Reattaching thick color layer of polychrome wooden sculpture *(Jpn)* S1022

Pacific Area see **Oceania**

packing
coatings—Note: on the cohesion of clay and CaCO₃ coatings *(Eng)* S858
field archaeology—A conservation manual for the field archaeologist *(Eng)* S1044
paint—The pigment-binder relationship as a fundamental property of paints *(Eng)* S709
pigment volume concentration—Effect of particle size distribution of pigment and pigment volume concentration on flat wall paint properties (solvent type) *(Eng)* S729

paint
paint—Physicochemical alterations to the paint layer. 1. Results of a survey of various laboratories: apparent alterations of the paint layer and their probable causes. 2. Experimental study by the Musée du Louvre laboratory on madder varnish *(Fre) alizarin madder; azurite; binding media; bleaching; corundum; fading; lead white; light; madder; oxidation; pigment; ultraviolet; varnish* S753

—Artists' paints and their manufacture, and the products *(Ger) chalk; oil paint; pastels (crayons)* S152
—Classes of simple paint structure *(Eng) artists' materials* S704
—The comparisons of two-component extender systems in emulsion paint *(Eng) aluminum; barium sulfate; calcium carbonate; emulsion; enamel; extenders; latex paint; magnesium silicate; poly(vinyl chloride); silica; styrene; viscosity* S730
—Failure envelopes of paint films as related to pigmentation and swelling: technical translation *(Eng) pigment volume concentration; poly(vinyl chloride)* S785
—The material side *(Eng) casein; coatings; finishes; gouache; lighting; tempera; turpentine; watercolors* S166
—Materials toward a history of housepaints: the materials and craft of the housepainter in 18th century America *(Eng) binding media; blood; casein; finishes; milk; pigment* S221
—A method of hiding power determination and its application as an aid to paint formulation *(Eng) opacity; pigment volume concentration; reflectance; zinc sulfide* S737
—Method to follow the degradation by natural weathering of emulsion paint films *(Ger) atomic absorption spectrometry; calcium; emulsion; pigment volume concentration; spectrometry; water; weathering* S829
—Objective predictors of paint appeal *(Eng) color; gloss* S831
—Oil requirements and structure of paints *(Eng) oil; pigment* S695
—On the influence of grain size of pigment parts on oil requirement *(Ger) oil; pigment* S697
—The painter's methods and materials *(Eng) artists' materials; emulsion; history of technology; oil; tempera; varnish; watercolors* S196
—Pigment and oil *(Ger) oil; pigment* S690
—The pigment-binder relationship as a fundamental property of paints *(Eng) absorption; oil; packing; pigment* S709
—The problems of treating ethnographical specimens decorated with applied surface paint *(Eng) ethnographic conservation* S921
—Rapid determination of the critical oil requirement. 1 *(Ger) oil paint* S700
—The relationship between oil content, particle size and particle shape *(Eng) linseed oil; oil paint; oil varnish; pigment; varnish; viscosity* S699
—Scientific examination of artistic and decorative colorants *(Eng) colorants; history of technology; lead white; manufacturing; USA (Pennsylvania— Philadelphia); vermilion* S265
—Scientific preparation and application of paint *(Eng) pigment* S686
—Translation of Häufige Anstrichmängel und Anstrichschäden *(Eng) varnish* S799
—Worldwide history of paint *(Eng) anthropology; Asia; Australia; Central America; Egypt; Europe; history of technology* S454
Abelam—Consolidation techniques for "yam masks": a practical investigation paper presented to the National Museum Act and the

—Forensic analysis of coatings *(Eng)* S615
Fourier transform infrared spectroscopy—Micro spectroscopy FTIR reflectance examination of paint binders on ground chalk *(Eng)* S681
gas chromatography—Organic analysis in the arts: some further paint medium analyses *(Eng)* S581
—Organic analysis in the examination of museum objects *(Eng)* S621
glaze—Optics of paint films: glazes and chalking *(Eng)* S748
gloss—Gloss of paint films and the mechanism of pigment involvement *(Eng)* S872
—New aspects of gloss of paint film and its measurement *(Eng)* S776
gouache—Conservation of costume designs for Broadway musicals, 1900-1925: from the drama collection, Austrian National Library, Vienna *(Ger)* S1067
Hawaiian—Hawaiian sculpture *(Eng)* S415
hematite—Physico-chemical and colorimetric study of haemitite reds and purples, with reference to the mural paintings of the Acropolis of Lero, or "histories of ochre" *(Fre)* S352
Herlin Cathedral (Germany)—The scientific examination of the polychromed sculpture in the Herlin altarpiece *(Eng)* S552
historic buildings—Conservation within historic buildings in Japan *(Eng)* S973
—Defects of color dyes on historic buildings' renderings *(Cze)* S914
—Inspection of the state of the art: materials commonly available on the market and employed for renderings and paint *(Ita)* S1033
history of technology—Chemistry of painting surfaces from earliest time to unfathomable future *(Eng)* S279
house paint—Historic finishes analysis *(Eng)* S441
—House paints in Colonial America: their materials, manufacture and application. Part III *(Eng)* S230
—Microchemical analysis of old housepaints with a case study of Monticello *(Eng)* S661
—Topical observations on the use of forgotten pigments used for painting rooms in Lower Saxony *(Ger)* S438
human head—The conservation of a preserved human head *(Eng)* S935
illuminations—Some tests on the use of wax for fixing flaking paint on illuminated parchment *(Eng)* S898
Inca—Mopa-mopa or pasto varnish: the frames of the Church of Egypt, in Bogotá *(Spa)* S461
infrared spectrometry—Instrumental analysis in the coatings industry *(Eng)* S619
interior decoration—Paint magic: the home decorator's guide to painted finishes *(Eng)* S400
kohl—Analysis of materials contained in mid-4th to early 7th-century A.D. Palestinian kohl tubes *(Eng)* S497
Kwakiutl—Field research in the conservation of ethnographical collections: an ecological approach applied to polychrome monumental sculpture *(Eng)* S417

lacquer—Lists of raw materials for lacquer *(Ger)* S402
latex paint—History of water-thinned paints *(Eng)* S163
leather—The behavior of colors on leather and parchment objects and the resulting problems of conservation *(Ger + Eng)* S1068
leveling—Levelling of paints *(Eng)* S742
Mantegna, Andrea (1431-1506)—Mantegna's paintings in distemper *(Eng)* S505
Maori—The examination, analysis and conservation of a Maori model canoe *(Eng)* S373
mass spectrometry—Application of mass spectrometric techniques to the differentiation of paint media *(Eng)* S576
—Organic mass spectrometry of art materials: work in progress *(Eng)* S607
Mayan—The Maya mural paintings of Bonampak, materials analysis *(Fre)* S539
mechanical properties—Mechanical properties of weathered paint films *(Eng)* S851
metal—The conservation of painted and polychromed metal work. Two case studies from the V & A Museum *(Eng)* S1086
—Examples of conservation of painted metal objects *(Eng)* S1093
microscopy—Microanalytical examination of works of art: two examples of the examination of paint layers *(Ger)* S612
—The use of direct reactive fluorescent dyes for the characterization of binding media in cross sectional examinations *(Eng)* S635
mineral pigment—Earth pigments and their colors *(Ita)* S421
Montagnais—A Naskapi painted skin shirt *(Eng)* S247
mural paintings—Ajanta and Ellora wall paintings. Scientific research as an aid to their conservation *(Eng)* S569
—The Church of Lourps in Longueville: restoration of the decorated surfaces *(Fre)* S474
—Reproduction of colored patterns in temples and shrines *(Eng)* S383
—Technique and conservation of mural paintings: report on the meeting held in Washington and New York, 17-25 September 1965 *(Fre)* S226
Native American—Analysis of paints used by Canadian native cultures: a project at the Canadian Conservation Institute *(Eng)* S640
—The ethnobotany of the California Indians: a compendium of the plants, their users, and their uses *(Eng)* S269
—Indian uses of native plants *(Eng)* S404
—Seri uses of mesquite, *Prospis glandulosa* variety *torreyana* *(Eng)* S259
Neuen Wilden—The "fast" paintings of the Neuen Wilden *(Ger)* S358
Newman, Barnett (1905-1970)—Barnett Newman: selected writings and interviews *(Eng)* S475
Nitinaht—Ethnobotany of the Nitinaht Indians of Vancouver Island *(Eng)* S356
oil paint—Oil content as a determinant of the properties of oil paints and coatings *(Ger)* S693
opacity—Factors determining the brightness and opacity of white paints *(Eng)* S689

—Latex paint opacity: a complex effect *(Eng)* S765
—On the wet and dry opacity of paints *(Eng)* S722
optical properties—Optical properties and theory of color of pigments and paints *(Eng)* S687
—Prediction of optical properties of paints from theory (with special reference to microvoid paints) *(Eng)* S770
—Some theoretical points of view on the optical properties of matter: attempt at defining "matness." *(Fre)* S783
organic chemistry—The organic chemistry of museum objects *(Eng)* S633
paper—Conservation of some non-book material in National Library, Calcutta *(Eng)* S1026
paper chromatography—The analysis of paint media by paper chromatography *(Eng)* S530
Papua New Guinea (New Ireland)—Assemblage of spirits: idea and image in New Ireland *(Eng)* S403
parameter—Particle size as a formulating parameter *(Eng)* S755
parchment—The conservation methods for miniature-painting on parchment *(Eng)* S920
pest control—A historical survey of the materials used for pest control and consolidation in wood *(Ger)* S1010
physical properties—Physical study of two-coat paint systems *(Eng)* S701
pigment—Exposure evaluation: quantification of changes in appearance of pigmented materials *(Eng)* S790
—Studies of the effects of particle size distribution on the packing efficiency of particles *(Eng)* S777
pigment volume concentration—Application of the statistical method in testing paints for durability *(Eng)* S688
—Color and CPVC *(Eng)* S719
—Critical pigment volume concentration of emulsion based paints *(Eng)* S757
—Critical pigment volume concentration of paints. Its measurement and some relationships *(Eng)* S857
—Critical pigment volume relationships *(Eng)* S710
—The determination of CPVC by the oil absorption test method *(Eng)* S723
—Determination of the CPVC by measuring the internal stress in paint films *(Ger)* S859
—Effect of particle size distribution of pigment and pigment volume concentration on flat wall paint properties (solvent type) *(Eng)* S729
—Influence of pigments on properties of emulsion paints *(Ger)* S870
—The influence of PVC on paint properties *(Eng)* S773
—New additive helps cut the cost of hiding *(Eng)* S823
—Physical chemistry of paint coatings *(Eng)* S720
—Single pigment paints *(Eng)* S786
—Statistical model for emulsion paint above the critical PVC *(Eng)* S833

Plains Indians—The mystic warriors of the Plains *(Eng)* S268
plants—Plants used by the Indians of Mendocino County, California *(Eng)* S21
plaster—The Malpaga Castle: conservation and consolidation problems of painted plasters of the courtyard *(Ita)* S1108
Plexigum P24—A study of Plexigum P24 used as a fixative for flaking paint traces *(Fre)* S1043
Plextol B500—Evaluation of the stability, appearance and performance of resins for the adhesion of flaking paint on ethnographic objects *(Eng)* S1101
polyester—Embedding paint cross section samples in polyester resins: problems and solutions *(Eng)* S679
polymers—The use of synthetic polymers for the consolidation of Medieval miniatures on parchment *(Rus)* S938
porosity—Porosity of paint films *(Eng)* S714
prehistoric—Pigments and paints in prehistoric antiquity *(Fre)* S191
protein—The characterization of proteinaceous binders in art objects *(Eng)* S617
—Notes on the identification of proteins in paint binders *(Fre)* S567
—Some observations on methods for identifying proteins in paint media *(Eng)* S533
pyrolysis—An improved pyrolytic technique for the quantitative characterization of the media of works of art *(Eng)* S575
pyrolysis gas chromatography—Forensic applications of pyrolysis capillary gas chromatography *(Eng)* S609
—Pyrolysis gas chromatographic mass spectrometric identification of intractable materials *(Eng)* S588
reattaching—Reattaching thick color layer of polychrome wooden sculpture *(Jpn)* S1022
red pigment—Report on the collecting visit to the Wosera-Abelam of Sarakim village, and a note on conservation requirements *(Eng)* S318
resin—A comparison of pyrolysis mass spectrometry, pyrolysis gas chromatography and infra-red spectroscopy for the analysis of paint resins *(Eng)* S618
—Natural resins *(Eng)* S82
ritual objects—Eshu-Elegba: the Yoruba trickster god *(Eng)* S292
rock art—The ancients knew their paints *(Eng)* S249
—Dating and context of rock engravings in South Africa *(Eng)* S582
—Rock art conservation in Australia *(Eng)* S422
—Testament to the Bushmen *(Eng)* S382
rock paintings—Paints of the Khoisan rock artists *(Eng)* S355
Romano-British—An analysis of paints used in Roman Britain *(Eng)* S210, S213
Scandinavia—Scandinavian painted decor *(Eng)* S467
screens (furniture)—Restoration of a Japanese screen *(Ger)* S949
shadow puppets—Restoration of Chinese and Indonesian shadow puppets *(Eng)* S1011

—The restoration of shadow puppets *(Ger)* S976
spectrophotometry—The use of microspectrophotometry for the identification of pigments in small paint samples *(Eng)* S613
stained glass—Field applications of stained glass conservation techniques *(Eng)* S1013
synthetic resin—Restoration with synthetic resins in Japan *(Ger)* S966
terracotta—The treatment and examination of painted surfaces on eighteenth-century terracotta sculptures *(Eng)* S469
thin layer chromatography—High performance thin-layer chromatography for the identification of binding media: techniques and applications *(Eng)* S682
Thompson—Thompson ethnobotany: knowledge and usage of plants by the Thompson Indians of British Columbia *(Eng)* S483
Tura, Cosimo (1430?-1495)—Amino acid analysis of proteinaceous media from Cosimo Tura's "The Annunciation with Saint Francis and Saint Louis of Toulouse." *(Eng)* S669
varnish—New book of recipes for the paint and varnish industry *(Ger)* S155
viscosity—Further experiments on the importance of the critical point *(Eng)* S694
—On oil-paint viscosity as an expression of paint structure *(Eng)* S702
—On the viscosity of oil paints *(Ger)* S696
—On the viscosity of oil paints, the turboviscosimeter, and the critical oil content *(Ger)* S692
—On the viscosity of paints used for coatings *(Ger)* S691
—Paint viscosity and ultimate pigment volume concentration *(Eng)* S717
votive tablets—Cleaning treatment on votive tablet in traditional way *(Jpn)* S939
Vuillard, Edouard (1868-1940)—History, analysis and treatment of "La salle à manger au château de Clayes," 1938, by Edouard Vuillard *(Eng)* S1009
wood—Conservation of polychrome wood sculpture at the Australian War Memorial *(Eng)* S944
—Consolidation of painted wooden artifacts *(Eng)* S934
—Consolidation of painted wooden artifacts: an ICOM report *(Eng)* S924
—Investigation into methods and materials for the adhesion of flaking paint on ethnographic objects: a progress report *(Eng)* S1045
—Studies on fixing treatments of color paintings on the ceiling of Sanmon Gate, National Treasure, Tofuku-ji Temple *(Jpn)* S940
—Wood documentation. VII: wood conservation and surface treatment. Volume 2: surface treatment *(Fre)* S897
—Wooden ritual artifacts from Chaco Canyon, New Mexico: the Chetro Ketl collection *(Eng)* S305
x-ray diffraction—Nondestructive infrared and x-ray diffraction analyses of paints and plastics *(Eng)* S532

painting (technique)
Artifacts: an introduction to early materials and technology *(Eng) colorants; dye; history of technology* S215

—The confirmation of literary sources on art technology through scientific examination *(Ger) artists' materials; decoration; history of technology* S323
—Greek and Roman methods of painting: some comments on the statements made by Pliny and Vitruvius about wall and panel painting *(Eng) animal glue; drying oil; egg; fish glue; Greek; hide; mural paintings; oil; panel paintings; pigment; resin; Roman; varnish* S29
—Original treatises on the arts of painting *(Eng + Lat) adhesives; amber; artists' materials; dyeing; fresco painting (technique); gesso; gilding; glass; glaze; history of technology; ink; rust; stucco; tempering; varnish; wood* S234
—The painter's craft: an introduction to artists' materials *(Eng) oil paint; pigment; tempera* S123
—Painting materials: a short encyclopaedia *(Eng) adhesives; chemical properties; manuals; physical properties; pigment; solvents; thinners* S227
—Painting techniques *(Ita) history of technology; Medieval* S261
—Physics and painting: introduction to the study of physical phenomena applied to painting and painting techniques *(Dut) binding media; cracking; panel paintings; pigment; varnish; yellowing* S707
—Pigments and paints in primitive exotic techniques *(Fre) Africa; Asia; history of technology; Japanese; lacquer; Oceania; pigment; wood* S201
—Technical examination and conservation of an Indian painting *(Eng) cleaning; India;* S904
—Trial data on painting materials—mediums, adhesives, and film substances *(Eng) acrylic resin; adhesives; artists' materials; oil; pigment* S77
—Trial data on painting materials—mediums, adhesives, and film substances (continued) *(Eng) adhesives* S78
acrylic resin—A study of acrylic dispersions used in the treatment of paintings *(Eng)* S1066
Anasazi—Anasazi and Pueblo painting *(Eng)* S487
artists' materials—The artist's handbook *(Eng)* S407
—Techniques of ancient painting: the preparation of the support *(Ita)* S440
Australian Aboriginal—Aboriginal art *(Eng)* S446
—Ancient artists painted with human blood *(Eng)* S458
—Bark paintings: techniques and conservation *(Eng)* S443
—Dreamings: the art of Aboriginal Australia *(Eng)* S425
—Methods and materials used in Australian Aboriginal art *(Eng)* S380
bark cloth—Samoan material culture *(Eng)* S50
bark paintings—My country, Djarrakpi *(Eng)* S327
—Narritjin at Djarrakpi: Part 1 *(Eng)* S328
—Narritjin at Djarrakpi: Part 2 *(Eng)* S329
—Narritjin in Canberra *(Eng)* S330

painting (technique)

Bronze Age—Aegean painting in the Bronze Age *(Eng)* S466
Byzantine—A monument of Byzantine wall painting: the method of construction *(Fre)* S184
China—Chinese painting colors: studies of their preparation and application in traditional and modern times. *(Eng)* S427
Chumash—Volume IV: Ceremonial paraphernalia, games, and amusements *(Eng)* S344
contemporary art—Interview with Joel Shapiro *(Eng)* S460
—Painters painting: a candid history of the modern art scene, 1940-1970 *(Eng)* S362
—Techniques of modern artists *(Eng)* S350
dye—African textiles: looms, weaving and design *(Eng)* S313
Egypt—Study of painting techniques in ancient Egypt *(Ita)* S492
Eskimo—Ethnological results of the Point Barrow expedition *(Eng)* S13
fresco painting (technique)—Survey of fresco painting *(Ger)* S130
frescoes—Frescoes by Il Primaticcio in the ballroom of the Castle of Fontainebleau: the legacy, a derestoration attempt *(Fre)* S1117
—The frescoes of Tavant (France) *(Eng)* S179
history of conservation—Restoration between yesterday and tomorrow *(Ger)* S915
Hopi—The Na-ac-nai-ya: a Tusayan initiation ceremony *(Eng)* S12
Iceland—Likneskjusmid: fourteenth century instructions for painting from Iceland *(Eng)* S503
Igbo—Uli painting and Igbo world view *(Eng)* S444
India—The first painting on earth *(Eng)* S495
—One hundred references to Indian painting *(Eng)* S49
iron oxide—Infrared study of the yellow and red iron oxide pigments *(Ger)* S551
Kwakiutl—Plants in British Columbia Indian technology *(Eng)* S506
Medieval—The materials and techniques of Medieval painting *(Eng)* S172
Miró, Joan (1893-1983)—Joan Miro: comment and interview *(Eng)* S125
modern art—Twentieth century painting *(Eng)* S507
mural paintings—The Château of Oiron and its decorated surfaces *(Fre)* S457
—Early Medieval wall painting and painted sculpture in England: based on the proceedings of a symposium at the Courtauld Institute of Art, February 1985 *(Eng)* S459
—Monumentales pastell—a forgotten invention in wall painting techniques about 1900 *(Eng)* S301
—Physico-chemical study of the painting layers of the Roman mural paintings from the Acropolis of Lero *(Fre)* S342
—Restoration of old paintings. With special emphasis on frescoes and murals (alone) in oil paint *(Ger)* S889
—Structure, composition, and technique of the paintings *(Dut)* S346
—A survey of the painted mud *Viharas* of Sri Lanka *(Eng)* S351

Native American—American Indian painting of the Southwest and Plains areas *(Eng)* S239
Netherlandish—The beginnings of Netherlandish canvas painting, 1400-1530 *(Eng)* S445
Papua New Guinea—Technique and personality *(Eng)* S211
pastels (visual works)—Investigation, conservation and restoration of the pastel painting technique *(Spa)* S1054
pigment—Some experiments and observations on the colours used in painting by the ancients *(Eng)* S1
Poland—Folk painting on glass *(Pol)* S240
polychromy—Problems of the interpretation of historical sources and their confirmation by the results of technical analysis on works of art, shown on the example of painted sculptures from the 18th century in southern Germany *(Ger)* S322
Pompeiian Style—Pompeian painting technique *(Fre)* S174
reattaching—Reattaching color layers on a wooden wall and documenting the distribution of damages *(Jpn)* S1024
red ocher—A paint mine from the early upper Palaeolithic age near Lovas (Hungary, County Veszprém) *(Eng)* S170
red pigment—Reds *(Ita)* S397
rock paintings—The search for the Tassili frescoes: the story of the prehistoric rock paintings of the Sahara *(Eng)* S187
Roman—Colorings and renderings in the ancient world *(Ita)* S395
sand paintings—A calendar of dreamings *(Eng)* S295
textiles—Painted textiles *(Eng)* S963
tuchlein paintings—The technique of a *Tüchlein* by Quinten Massys *(Eng)* S423
Vuillard, Edouard (1868-1940)—The distemper technique of Edouard Vuillard *(Eng)* S275
—A technical and stylistic analysis of detrempe painting on cardboard by Edouard Vuillard *(Eng)* S1014
watercolors—Early American water color painting *(Eng)* S140
white pigment—White pigments in ancient painting *(Ita)* S203
whitewash—Decorative painters and house painting at Massachusetts Bay, 1630-1725 *(Eng)* S258
wood—The folk art tradition in painting on wood: paste and casein techniques *(Ger)* S314

paintings (objects) *see also* **dioramas; easel paintings; miniatures (paintings); mural paintings; oil paintings; panel paintings; tempera paintings**
Analysis of paint media, varnishes and adhesives *(Eng) adhesives; binding media; chromatography; drying oil; fatty acid; gas chromatography; gum; high performance liquid chromatography; infrared absorption; liquid chromatography; mass spectrometry; mucilage; organic materials; protein; pyrolysis gas chromatography; resin; spectrometry; staining (analysis); sugar; thin layer chromatography; varnish; wax* S625
—Centre for the Conservation and Restoration of Movable Cultural Property of Catalonia: a

record of achievements, 1982-1988 *(Cat) conservation centers; Spain (Catalonia)* S1063
—Manual of the painter restorer *(Ita) canvas; cleaning; consolidation; frescoes; history of conservation; lining; oil paintings; pigment; tempera* S5
—Restoration of paintings *(Eng) aging; conservation; manuals; training* S926
—Written sources about painted textiles *(Ger) banners; canvas; color; textiles* S504
Abstract art—Some structural solutions to the question of preventive conservation care for a major travelling exhibition, "The Crisis of Abstraction in Canada: The 1950s." *(Eng)* S508
acrylic resin—The identification and characterization of acrylic emulsion paint media *(Eng)* S666
—A study of acrylic dispersions used in the treatment of paintings *(Eng)* S1066
adhesives—Adhesives for impregnation of painting on canvas *(Swe)* S1087
—The evaluation of some adhesive systems utilized in the consolidation of paintings. The kinetics of consolidation (I) *(Rum)* S1019
—The evaluation of some adhesive systems utilized in the consolidation of paintings. The kinetics of consolidation (II) *(Rum)* S1020
—The evaluation of some adhesive systems utilized in the consolidation of paintings. The kinetics of consolidation (III) *(Rum)* S1021
—Natural adhesives in East Asian paintings *(Eng)* S372
—The treatment of cracks in canvas paintings with synthetic adhesives: procedures and possible combinations with the lining process *(Eng)* S1092
Africa—Contemporary African arts and crafts: on-site working with art forms and processes *(Eng)* S281
animal glue—Searching for a solution to the problem of altered mat paintings: a new product is needed *(Fre)* S1071
—The significance of fat in animal glue for painting purposes *(Ger)* S628
artists' materials—The painter's craft *(Fre)* S462
Asia, Southeast—Conservation of manuscripts and paintings of Southeast Asia *(Eng)* S1002
Australian Aboriginal—Various approaches to the conservation and restoration of Aboriginal artifacts made from bark *(Eng)* S974
binding media—Analyses of paint media *(Eng)* S587
—Directory of natural organic binding media *(Ger)* S643
Bouts, Dirck, the elder (ca. 1415-1475)—The techniques of Dieric Bouts: two paintings contrasted *(Eng)* S386
ceilings—Conservation treatments with reference to color paintings on the ceiling of the main hall, National Treasure, of Toshodaiji Temple, Nara *(Jpn)* S941
Chumash—The rock paintings of the Chumash: a study of a California Indian culture *(Eng)* S513
color field—The cleaning of Color Field paintings *(Eng)* S282

consolidation—Consolidation of delaminating paintings *(Eng)* S951
contemporary art—The conservation of contemporary paintings *(Eng)* S370
—Conservation of the contemporary *(Eng)* S248
—Contemporary artists and their experimental use of historical methods and techniques *(Eng)* S286
—Ephemeral paintings on "permanent view": the accelerated ageing of Mark Rothko's paintings *(Eng)* S399
—New materials in contemporary art *(Spa)* S448
—Notes on the causes of premature aging of contemporary paintings *(Fre)* S398
—The restoration of modern and contemporary works of art *(Ita)* S1094
—Why modern art may never become old masterpieces *(Eng)* S375
cracking—Cracking on paintings *(Ger)* S718
Daiju-ji Temple (Japan)—Preservative treatment on the *Shoheki-ga* at the Daiju-ji *(Jpn)* S955
differential scanning calorimetry—Preliminary investigations of the binding media of paintings by differential thermal analysis *(Eng)* S634
Dix, Otto (1891-1969)—Studies on the painting technique of Otto Dix during the period 1933-1969 *(Ger)* S430
Egypt—Egyptian paintings of the Middle Kingdom *(Eng)* S245
Expressionist—Voices of German Expressionism *(Eng)* S254
Fourier transform infrared spectroscopy—Analysis of aged paint binders by FTIR spectroscopy *(Eng)* S657
frescoes—19th and early 20th century restorations of English Mediaeval wall paintings: problems and solutions *(Eng)* S1116
gas chromatography—Analyses of paint media *(Eng)* S578
—The gas chromatographic examination of paint media. Some examples of medium identification in paintings by fatty acid analysis *(Eng)* S573
—The gas-chromatographic examination of paint media. Part II. Some examples of medium identification in paintings by fatty acid analysis *(Eng)* S558
—Identification of proteinaceous binding media of easel paintings by gas chromatography of the amino acid derivatives after catalytic hydrolysis by a protonated carbon exchanger *(Eng)* S670
glass—The restoration of three paintings on glass *(Spa)* S1061
gouache—Problems of conservation encountered with gouache paintings by Charlotte Salomon (1941-1943) *(Ger)* S1114
Impressionist—An approach to the study of modern paintings surfaces *(Ger)* S1124
India (Thanjavur)—Technique, deterioration and restoration of Thanjavur paintings *(Eng)* S1072
Japan—Pigments used in Japanese paintings *(Eng)* S405

Mantegna, Andrea (1431-1506)—Mantegna's paintings in distemper *(Eng)* S505
manuscripts—Care and conservation of palm-leaf and paper illustrated manuscripts *(Eng)* S992
Maya blue—Maya blue *(Spa)* S548
miniatures (paintings)—Conservation methods for miniature paintings on parchment: treatment of the paint layer *(Eng)* S943
—Nolite manuscripta cruciare sed conservate potis. Considerations on the preservation of Medieval miniatures *(Ger)* S1038
mural paintings—Ancient Collegiate Church of Saint Barnard de Romans: decorated surfaces of the choir and transept *(Fre)* S478
—Destruction and restoration of Campanian mural paintings in the eighteenth and nineteenth centuries *(Eng)* S1105
—Early Gothic wall paintings: an investigation of painting techniques and materials of 13th-century mural paintings in a Danish village church *(Eng)* S509
—In review: an assessment of Florentine methods of wall painting conservation based on the use of mineral treatments *(Eng)* S1104
—The legacy of the Tía Sandalia: consolidation, removal, and mounting of the work in the future Ethnographic Museum of Villacañas (Toledo) *(Spa)* S1083
—Materials and painting techniques of the wall paintings of the main nave of S. Mary's Church in Toruń *(Pol)* S432
—Materials and techniques of Medieval wall paintings from the former House of Merchants' Fraternity at 5 Żeglarska Street in Toruń *(Pol)* S485
—Parallel progress in restoration and archaeology: discovery and restoration of monumental painting and sculpture on a loess ground *(Eng)* S520
—Preliminary studies for the conservation of the Rothko Chapel paintings: an investigative approach *(Eng)* S336
—Products, facts, modes in mural painting: evolution and distribution of restoration products used in mural paintings from 1850 to 1992. A first sorting concerning France, Spain, England, and Poland *(Fre)* S511
—Wall paintings: technique, problems, conservation *(Ita)* S1080
—Workshop practices and identification of hands: Gothic wall paintings at St Albans *(Eng)* S514
Nagoya Castle (Nagoya, Japan)—Study on the repair technique of polychrome paintings drawn on sliding screens in the Nagoya Castle *(Jpn)* S945
ocher—Friable ochre surfaces: further research into the problems of colour changes associated with synthetic resin consolidation *(Eng)* S997
ox blood—Ox-blood: a color binding media and a color name *(Ger)* S339
panel paintings—Wings from a quadriptych with the legend of St. John the Baptist: general problems and the treatment of conservation *(Pol)* S917
paper—Conservation of some non-book material in National Library, Calcutta *(Eng)* S1026

—Paintings on paper: a dialogue in five case histories *(Eng)* S971
pastels (visual works)—History, technology and conservation of dry media *(Eng)* S1018
—Removing severe distortions in a pastel on canvas *(Eng)* S1032
pigment—Bibliography on the pigments of painting *(Ger)* S642
—Paintings and pigments: I. The traditional palette *(Eng)* S316
—Pigments and paints in classical antiquity *(Fre)* S200
poly(vinyl acetate)—Polyvinyl acetate in the conservation of the wall paintings *(Eng)* S1103
polysaccharides—An investigation and identification of polysaccharides isolated from archaeological specimens *(Eng)* S570
preventive conservation—Ethnographic paintings: the question of powdering *(Fre)* S1111
pyrolysis gas chromatography—Examination through pyrolysis gas chromatography of binders used in painting *(Eng)* S626
—Identification of synthetic materials in modern paintings. 1: varnishes and polymer binders *(Fre)* S660
—The potential of pyrolysis-gas chromatography/mass spectrometry in the recognition of ancient painting media *(Eng)* S678
reference materials—Second report on reference materials incorporating special reports by members of the working group: ICOM Committee for Conservation, Madrid, 2-7 October, 1972 *(Eng)* S557
rock art—Testament to the Bushmen *(Eng)* S382
rock paintings—Perspectives and potentials for absolute dating prehistoric rock paintings *(Eng)* S523
Romania—Specific forms of degradation and their causes in wood panel tempera paintings *(Rum)* S439
Rothko, Mark (1903-1970)—Damaged goods *(Eng)* S410
—Mark Rothko's Harvard murals *(Eng)* S413
—Mark Rothko's Harvard murals are irreparably faded by sun *(Eng)* S418
Ruscha, Edward Joseph (b. 1937)—Pastel, juice and gunpowder: the Pico iconography of Ed Ruscha *(Eng)* S337
Spain (Catalonia)—Architecture and decorated surfaces in Catalonia *(Fre)* S456
stabilizers—Identification of stabilizing agents *(Eng)* S527
tapestries—The restoration of painted tapestry and its problems *(Ger)* S1112
textiles—The link between the treatments for paintings and the treatments for painted textiles *(Eng)* S363
—Technical study and conservation of an old painted textile (Simhasana) *(Eng)* S902
thin layer chromatography—A note on the thin-layer chromatography of media in paintings *(Eng)* S677
—Thin layer chromatography: an aid for the analysis of binding materials and natural dyestuffs from works of art *(Eng)* S559

transferring—Transfer of paintings: at any price? *(Ger)* S916

tuchlein paintings—A Tuchlein from the Van der Goes legacy: identification, technique, and restoration *(Ger)* S521

ultramicroanalysis—Ultramicroanalysis: an effective method for substantial investigation of works of art *(Ger)* S622

varnish—The influence of varnishes on the appearance of paintings *(Eng)* S844

—Old master paintings: a study of the varnish problem *(Eng)* S856

Vuillard, Edouard (1868-1940)—The special problems and treatment of a painting executed in hot glue medium, The Public Garden by Edouard Vuillard *(Eng)* S999

wall hangings—The study and conservation of glue paintings on textile: 18th and 19th century painted wall hangings from southern Sweden *(Eng)* S512

Palaeolithic *see* **Paleolithic**

Paleolithic
Paleolithic pigments and processing *(Eng) caves; France; limestone; minerals; pigment; red pigment; rock paintings* S357

ethnobotany—Bibliography of American archaeological plant remains *(Eng)* S228

red ocher—A paint mine from the early upper Palaeolithic age near Lovas (Hungary, County Veszprém) *(Eng)* S170

Palestinian
kohl—Analysis of materials contained in mid-4th to early 7th-century A.D. Palestinian kohl tubes *(Eng)* S497

palm
The palm, tree of life: biology, utilization, and conservation. Proceedings of a symposium at the 1986 annual meeting of the Society for Economic Botany held at the New York Botanical Garden, Bronx, New York, 13-14 June 1986 *(Eng) binding media; building materials; oil; palm oil; plant materials; resin* S424

palm leaf
Problems of preservation of palm-leaf manuscripts *(Eng) Asia; manuscripts* S331

Asia, Southeast—Conservation of manuscripts and paintings of Southeast Asia *(Eng)* S1002

manuscripts—Care and conservation of palm-leaf and paper illustrated manuscripts *(Eng)* S992

paper—Conservation of some non-book material in National Library, Calcutta *(Eng)* S1026

Papua New Guinea (Wosera-Abelam)—The removal and conservation of the painted bark (palm leaf petiole) panels and carved figures from a Papua New Guinea "Haus Tambaran" *(Eng)* S1056

palm oil
Africa—Personality and technique of African sculptors *(Eng)* S208

Africa, West—Handbook of West African art *(Eng)* S164

Anang—The carver in Anang society *(Eng)* S276

palm—The palm, tree of life: biology, utilization, and conservation: proceedings of a symposium at the 1986 annual meeting of the Society for Economic Botany held at the New York Botanical Garden, Bronx, New York, 13-14 June 1986 *(Eng)* S424

red pigment—Note on the pigment blocks of the Bushongo, Kasai District, Belgian Congo *(Eng)* S28

ritual objects—Eshu-Elegba: the Yoruba trickster god *(Eng)* S292

palm spathes
Irian Jaya—A support system for flexible palm spathe objects *(Eng)* S517

Papua New Guinea—Technique and personality *(Eng)* S211

palygorskite
Maya blue—Maya blue: a new perspective *(Eng)* S590

—Maya blue: how the Mayas could have made the pigment *(Eng)* S645

panel paintings *see also* **triptychs**
Basic experiments concerning deterioration of glue and discoloration of pigments, and discussion on the actual condition of wall panel paintings on the basis of their results *(Jpn) adhesion; adhesives; amino acid; azurite; cracking; desiccators; discoloration; flaking; humidity; Japanese paper; malachite; paper; pigment; protein; relative humidity; ultraviolet; zeolite* S930

—Methods of egg-tempera panel painting conservation employed in the State Hermitage *(Eng) Byzantine; egg tempera; emulsion; Italian; resin; Russia; stabilizing; sturgeon glue; synthetic resin* S986

—Present state of screen and panel paintings in Kyoto *(Jpn) adhesives; alum; chalk; cracking; flaking; Japan (Kyoto); malachite; ocher; temples; vermilion; wood* S933

—Preservative treatment on paint layer of screen and wall panel paintings *(Jpn) acrylic resin; adhesives; flaking; Japan; mounting; pigment; plastics; poly(vinyl alcohol); screens (doors)* S929

—Treatment on sliding screen and wall panel paintings to prevent exfoliation with synthetic resins *(Jpn) acrylic resin; flaking; screens (doors); synthetic resin* S928

—Wings from a quadriptych with the legend of St. John the Baptist: general problems and the treatment of conservation *(Pol) beech; beeswax; blistering; carbon black; cinnabar; flaking; fumigation; gelatin; gypsum; indigo; iron oxide; minium; paintings (objects); panels; pigment; silver leaf; Spanish School; vinyl acetate; wood; yellow ocher* S917

Bouts, Dirck, the elder (ca. 1415-1475)—The techniques of Dieric Bouts: two paintings contrasted *(Eng)* S386

Czechoslovakia (Prague)—Technical parallels between panel and wall painting of the 14th century *(Cze)* S353

India—One hundred references to Indian painting *(Eng)* S49

ox blood—Ox-blood: a color binding media and a color name *(Ger)* S339

painting (technique)—Greek and Roman methods of painting: some comments on the statements made by Pliny and Vitruvius about wall and panel painting *(Eng)* S29
—Physics and painting: introduction to the study of physical phenomena applied to painting and painting techniques *(Dut)* S707
Romania—Specific forms of degradation and their causes in wood panel tempera paintings *(Rum)* S439
sturgeon glue—Sturgeon glue for painting consolidation in Russia *(Eng)* S1123
triptychs—Material description, state of conservation, and treatment *(Dut)* S906

paneling
mural paintings—The Château of Oiron and its decorated surfaces *(Fre)* S457

panels
artists' materials—Techniques of ancient painting: the preparation of the support *(Ita)* S440
ceilings—The restoration of the wooden painted ceiling in the "Confraternità del Rosario," SS. Filippo and Giacomo Church, Ospedaletto d'Alpinolo *(Ita)* S1096
cracking—Cracking on paintings *(Ger)* S718
panel paintings—Wings from a quadriptych with the legend of St. John the Baptist: general problems and the treatment of conservation *(Pol)* S917
screens (doors)—Treatment on painting of sliding screens and wall panels to prevent exfoliation in Japan *(Eng)* S972
screens (furniture)—Restoration of a Japanese screen *(Ger)* S949
wax—The preservation of wood sculpture: the wax immersion method *(Eng)* S890

paper
Conservation of some non-book material in National Library, Calcutta *(Eng)* acetone; carboxymethylcellulose; cellulose acetate; citronella oil; consolidation; deacidification; fixing; flaking; gauze; ink; mica; paint; paintings (objects); palm leaf; poly(methyl acrylate); poly(vinyl acetate) S1026
—Paintings on paper: a dialogue in five case histories *(Eng)* gouache; oil; paintings (objects) S971
Asia, Southeast—Conservation of manuscripts and paintings of Southeast Asia *(Eng)* S1002
calcium carbonate—Optical properties of calcium carbonate in paper coatings *(Eng)* S807
carboxymethylcellulose—The use of carboxymethylcellulose in the restoration of easel paintings *(Rum)* S1008
charcoal—Tonal drawing and the use of charcoal in nineteenth century France *(Eng)* S468
coatings—Light scattering from glossy coatings on paper *(Eng)* S873
consolidants—The consolidation of powdery paint layers of *Bonaders*, Swedish mural works painted on paper *(Fre)* S1109
contemporary art—Modern art: the restoration and techniques of modern paper and paints. Proceedings of a conference jointly or-

ganised by UKIC and the Museum of London, 22 May 1989 *(Eng)* S436
Daiju-ji Temple (Japan)—Preservative treatment on the *Shoheki-ga* at the Daiju-ji *(Jpn)* S955
drawing (technique)—Drawing techniques: their evolution in different European schools *(Fre)* S128
encaustic wax—The cleaning and consolidation of Egyptian encaustic mummy portraits *(Eng)* S1088
fixatives—Determination of the influence of Rowney's "Perfix" fixative on the properties of paper *(Pol)* S925
—Experimental studies on fixatives for powdery traces *(Fre)* S987
—An investigation of several fixatives for pastel works *(Eng)* S1102
gouache—Conservation of costume designs for Broadway musicals, 1900-1925: from the drama collection, Austrian National Library, Vienna *(Ger)* S1067
—Problems of conservation encountered with gouache paintings by Charlotte Salomon (1941-1943) *(Ger)* S1114
—Restoration of three miniature paintings with a problem of colour change *(Eng)* S1057
isinglass—Potential applications of isinglass adhesive for paper conservation *(Eng)* S1076
manuscripts—Care and conservation of palm-leaf and paper illustrated manuscripts *(Eng)* S992
organic chemistry—The organic chemistry of museum objects *(Eng)* S633
panel paintings—Basic experiments concerning deterioration of glue and discoloration of pigments, and discussion on the actual condition of wall panel paintings on the basis of their results *(Jpn)* S930
Parylene—The application of Parylene conformal coating to archival and artifact conservation *(Eng)* S1005
pastels (visual works)—Analysis and conservation of graphic and sound documents: work by the Centre de Recherches sur la Conservation des Documents Graphiques, 1982-1983 *(Fre)* S1004
—An investigation into the use of several substances as fixatives for works of art in pastel *(Eng)* S953
—On the technical study of thirty pastel works on paper by Jean-François Millet *(Eng)* S368
Plexigum P24—A study of Plexigum P24 used as a fixative for flaking paint traces *(Fre)* S1043
reference materials—Second report on reference materials incorporating special reports by members of the working group: ICOM Committee for Conservation, Madrid, 2-7 October, 1972 *(Eng)* S557
screens (doors)—Treatment on painting of sliding screens and wall panels to prevent exfoliation in Japan *(Eng)* S972
tablets—Preservative treatment of the *Funa-Ema* (votive tablets of boats), important folklore materials at Arakawa Shrine and Hakusanhime Shrine *(Jpn)* S932
tempera—Problems in restoring a tempera on 19th-century paper: decoration by Ponga for

the balcony of the Olympic Theatre of Piove di Sacco *(Ita)* S1081
Vuillard, Edouard (1868-1940)—History, analysis and treatment of "La salle à manger au château de Clayes," 1938, by Edouard Vuillard *(Eng)* S1009
wallpaper—Wallpaper in America: from the 17th century to World War I *(Eng)* S320
—Wallpaper on walls: problems of climate and substrate *(Eng)* S982
wood—Studies on fixing treatments of color paintings on the ceiling of Sanmon Gate, National Treasure, Tofuku-ji Temple *(Jpn)* S940

paper chromatography
The analysis of paint media by paper chromatography *(Eng) binding media; chromatography; paint* S530
plants—Analytical procedures *(Eng)* S531
rock art—Dating and context of rock engravings in South Africa *(Eng)* S582
thin layer chromatography—Thin-layer chromatography of resin acid methyl esters *(Eng)* S536
varnish—Special report on picture varnish *(Eng)* S529

paper pulp
mural paintings—Conservation of mural paintings in Central Asia which have been damaged by salt efflorescence *(Eng)* S888

Papua New Guinea
An ethnographic collecting expedition to Papua New Guinea: field conservation and laboratory treatment *(Eng) cleaning; consolidation; ethnography; fumigation; in situ conservation; specimens; storage* S967
—Ethnographic collections: case studies in the conservation of moisture-sensitive and fragile materials *(Eng) Australia; climate control; consolidation; ethnographic conservation; traveling exhibitions* S1062
—Technique and personality *(Eng) brushes; clay; color; painting (technique); palm spathes; pigment; sago palm; sap; shell; stone* S211
Australian Aboriginal—Australian Aboriginal bark paintings: an ICOM report *(Eng)* S918
carvings—Collecting wooden ethnographic carvings in the tropics *(Eng)* S354
human head—The conservation of a preserved human head *(Eng)* S935
Iatmul—The conservation of an orator's stool from Papua New Guinea *(Eng)* S1042

Papua New Guinea (New Ireland)
Assemblage of spirits: idea and image in New Ireland *(Eng) artists' materials; charcoal; lime; paint; pigment; plants; polychromy; wood* S403
bark paintings—Conservation of Australian Aboriginal bark paintings with a note on the restoration of a New Ireland wood carving *(Eng)* S905
Malanggan—The material composition of Malanggans—a preliminary approach toward a non-destructive analysis *(Eng)* S333
masks—Restoration of a New-Ireland ceremonial mask and a double wood carving of Oceania *(Hun)* S975

Papua New Guinea (Tifalmin Valley)
shields (armor)—The conservation of some carved wooden war shields from the Tifalmin Valley, Papua New Guinea *(Eng)* S950

Papua New Guinea (Wosera-Abelam)
The removal and conservation of the painted bark (palm leaf petiole) panels and carved figures from a Papua New Guinea "Haus Tambaran" *(Eng) carvings; palm leaf; ritual objects* S1056

papyrus
microscopy—Microanalytical examination of works of art: two examples of the examination of paint layers *(Ger)* S612

paraffin
pigment volume concentration—Particle packing analysis of coatings above the critical pigment volume concentration *(Eng)* S818
resin—Contribution to the study of natural resins in the art *(Eng)* S597

Paraloid B-72 *see also* **Acryloid B-72**
Abydos reliefs (Egypt)—Techniques of decoration in the Hall of Barques in the Temple of Sethos I at Abydos *(Eng)* S1064
acrylic resin—A preliminary evaluation of acrylic emulsions for the adhesion of flaking paint on ethnographic objects *(Eng)* S1046
adhesives—Adhesives for impregnation of painting on canvas *(Swe)* S1087
adobe—Treatment of adobe friezes in Peru *(Eng)* S970
animal glue—Searching for a solution to the problem of altered mat paintings: a new product is needed *(Fre)* S1071
Australian Aboriginal—Australian Aboriginal bark paintings: an ICOM report *(Eng)* S918
carvings—Collecting wooden ethnographic carvings in the tropics *(Eng)* S354
ceilings—The restoration of the wooden painted ceiling in the "Confraternità del Rosario," SS. Filippo and Giacomo Church, Ospedaletto d'Alpinolo *(Ita)* S1096
encaustic wax—The cleaning and consolidation of Egyptian encaustic mummy portraits *(Eng)* S1088
fixatives—Fixing agent for chalking color on wood and its laboratory evaluation *(Jpn + Eng)* S1040
Melanesian—Conservation of powdering pigment layers on Melanesian objects: choice of a fixative *(Fre)* S1039
Mudejar—Technical examination and consolidation of the paint layer on a Mudéjar coffered ceiling in the Convent of Santa Fe, Toledo *(Eng)* S1110
ocher—Friable ochre surfaces: further research into the problems of colour changes associated with synthetic resin consolidation *(Eng)* S997
Ottonian—The painted ceiling from the Romanesque period in the Protestant church of Saint Michael at Hildesheim *(Ger)* S1073
polychromy—Disinfestation and consolidation of polychromed wood at the Institut Royal du Patrimoine Artistique, Brussels *(Eng)* S957
polymers—The mechanism of polymer migration in porous stones *(Eng)* S1047

reattaching—Reattaching color layers on a wooden wall and documenting the distribution of damages *(Jpn)* S1024
—Reattaching thick color layer of polychrome wooden sculpture *(Jpn)* S1022
stucco—Restoration and display of Egyptian stucco mummy masks from the period of the Roman Empire *(Eng)* S1027
synthetic materials—Natural and accelerated aging of synthetic products compared with that of natural products *(Fre)* S1036
verre eglomise—Eglomise: technique and conservation *(Ger)* S1059
—Proposal for the consolidation of the painted surface on reverse painted glass *(Eng)* S1003

parameter
Particle size as a formulating parameter *(Eng) paint; pigment volume concentration; porosity; viscosity* S755

parchment
Conservation and restoration of manuscripts and bindings on parchment *(Eng) bookbindings; fixing; manuscripts* S980
—Conservation methods for Medieval miniatures on parchment *(Eng) consolidation; illuminations; Medieval; pigment* S919
—The conservation methods for miniature-painting on parchment *(Eng) adhesion; Byzantine; filter paper; flaking; Greece; illuminations; paint;* S920
—Diagnosis and therapy in parchment and miniature restoration *(Ger) history of conservation; illuminations; manuscripts; Medieval; Switzerland (St. Gall)* S991
Angelico, Fra (ca. 1400-1455)—Restoration of a miniature by Fra Angelico in Florence *(Fre)* S1016
illuminations—Practice and practical possibilities in the conservation of Medieval miniatures *(Ger)* S969
—Some details on the technique and of the restoration of two illuminated 13th century manuscripts from Western Europe *(Fre)* S942
—Some tests on the use of wax for fixing flaking paint on illuminated parchment *(Eng)* S898
ink—Gas chromatographic mass spectrometric analysis of tannin hydrolysates from the ink of ancient manuscripts (XIth to XVIth century) *(Eng)* S577
leather—The behavior of colors on leather and parchment objects and the resulting problems of conservation *(Ger + Eng)* S1068
miniatures (paintings)—Conservation methods for miniature paintings on parchment: treatment of the paint layer *(Eng)* S943
—Conservation of miniatures *(Eng)* S270
polymers—Consolidation of the pictorial layer of illuminations with pure synthetic polymers *(Fre)* S989
—The use of synthetic polymers for the consolidation of Medieval miniatures on parchment *(Rus)* S938
shadow puppets—Restoration of Chinese and Indonesian shadow puppets *(Eng)* S1011
—The restoration of shadow puppets *(Ger)* S976

Wayang—Restoration of Indonesian Wayang-figures in the National Ethnographical Museum of Dresden *(Ger)* S1049

parinarium nut
shields (armor)—Restoration of a ceremonial shield from the Solomon Islands *(Ger)* S1025

Parylene
The application of Parylene conformal coating to archival and artifact conservation *(Eng) books; coatings; encapsulation; paper* S1005
—Parylene at CCI = L'emploi du parylène à l'ICC *(Eng + Fre) natural history specimens* S1069

pastels (crayons)
American pastels of the late nineteenth & early twentieth centuries: materials and techniques *(Eng) Blum, Robert Frederick (1857-1903); Cassat, Mary (1845-1926); Davies, Arthur Bowen (1862-1928); fixatives; pastels (crayons); pigment; Shinn, Everett (1876-1953); Twachtman, John Henry (1853-1902); Whistler, James Abbott McNeill (1834-1903)* S442
—The manufacture of pastels *(Fre) bibliographies* S103
—Pastel, a technique of yesterday and today *(Eng) bibliographies; fixing; manufacturing* S364
drawings—Charcoal, chalk and pastel drawings: special problems for collectors, Part 1 *(Eng)* S310
—Charcoal, chalk and pastel drawings: special problems for collectors, Part 2 *(Eng)* S311
mural paintings—Monumentales pastell—a forgotten invention in wall painting techniques about 1900 *(Eng)* S301
paint—Artists' paints and their manufacture, and the products *(Ger)* S152
pastels (visual works)—Investigation, conservation and restoration of the pastel painting technique *(Spa)* S1054

pastels (visual works)
Analysis and conservation of graphic and sound documents: work by the Centre de Recherches sur la Conservation des Documents Graphiques, 1982-1983 *(Fre) bibliographies; carbon black; charcoal black; darkening; ethyl alcohol; ethylene oxide; fixing; graphite; paper; Plexisol; synthetic resin; water* S1004
—Degas pastel research project: a progress report *(Eng) Degas, Hilaire Germain Edgar (1834-1917); National Gallery of Canada (Ottawa, Ontario, Canada)* S393
—Degas pastels *(Eng) Degas, Hilaire Germain Edgar (1834-1917); fixatives; gouache; hatching* S419
—Electrostatic stabilizing plate (E.S.P.): an alternative method for stabilizing the flaking tendencies of works of art in pastel *(Eng) fixing; flaking* S952
—Fixatives for pastels *(Fre) fixatives; optics; plastics; resin* S708
—Fixing and flocking *(Eng) fixing; Venice turpentine* S985
—History, technology and conservation of dry media *(Eng) chalk; charcoal; drawings; metal points; paintings (objects); pencils; pigment* S1018

—An investigation into the use of several substances as fixatives for works of art in pastel *(Eng) aging; fixatives; paper; samples; ultraviolet* S953
—Investigation, conservation and restoration of the pastel painting technique *(Spa) artists' materials; fixatives; Mexico; painting (technique); pastels (crayons)* S1054
—Maranyl as a fixative for pastel *(Eng) matte; pigment* S922
—The material side *(Eng) alcohol; casein; copal; fixatives; resin; vinyl butyral* S145
—On the technical study of thirty pastel works on paper by Jean-François Millet *(Eng) color; manuals; Millet, Jean François (1814-1875); paper; pentimenti; pigment* S368
—Pastel fixatives *(Ger) fixatives* S899
—Pastels *(Fre) bibliographies; color; darkening; ethylene oxide; fixing; pigment; resin* S369
—A portrait of Master Sahl (1683-1753). Particularities of a pastel restoration *(Ger) cartoons; drawings; mounting* S993
—Removing severe distortions in a pastel on canvas *(Eng) canvas; Japanese paper; lining; mounting; painting (objects); vacuum; Vigée-Lebrun, Marie Anne Élisabeth (1755-1842); wheat starch paste* S1032
—A sculpture and a pastel by Edgar Degas *(Eng) chalk; color; Degas, Hilaire Germain Edgar (1834-1917); drawings; Impressionist; wax* S285
artists' materials—The artist's handbook of materials and techniques *(Eng)* S83
Carriera, Rosalba (1675-1757)—Rosalba Carriera and the early history of pastel painting *(Eng)* S498
Degas, Hilaire Germain Edgar (1834-1917)—Edgar Degas in the collection of the Art Institute of Chicago: examination of selected pastels *(Eng)* S1029
drawing (technique)—The craft of old-master drawings *(Eng)* S182
—Drawing techniques: their evolution in different European schools *(Fre)* S128
fixatives—Determination of the influence of Rowney's "Perfix" fixative on the properties of paper *(Pol)* S925
—An investigation of several fixatives for pastel works *(Eng)* S1102
history of conservation—Complete guide for the restoration of oil, wax, tempera, watercolor, miniature, and pastel paintings, together with instructions for preparing excellent varnishes for paintings, bas-reliefs and plaster casts, dried insects and plants, prints and maps, as well as the cleaning, bleaching, mounting, and framing of copper engravings, lithographs, and woodcuts; for the art lover, painter, bronzer, decorator, etc. *(Ger)* S3
Vuillard, Edouard (1868-1940)—History, analysis and treatment of "La salle à manger au château de Clayes," 1938, by Edouard Vuillard *(Eng)* S1009

patents
American Society for Testing and Materials (USA)—The colourful twentieth century *(Eng)* S434

patina
The study of patina *(Fre) Kuba; Luba; musical instruments; sculpture; Tabwa; wood; Zaire* S416
Africa, West—Handbook of West African art *(Eng)* S164
pyrolysis gas chromatography—Analytical pyrolysis as a tool for the characterization of organic substances in artistic and archaeological objects *(Eng)* S662

pattern recognition
wood—Identification of archaeological and recent wood tar pitches using gas chromatography/mass spectrometry and pattern recognition *(Eng)* S655

peat
skin—Lipids from samples of skin from seven Dutch bog bodies: preliminary report *(Eng)* S653

Pech Merle Cave (France)
Spitting images: replicating the spotted horses *(Eng) Australian Aboriginal; charcoal; France, southern; pigment; red ocher; saliva* S491

pectin
plants—Plants for man *(Eng)* S159

peeling
acrylic resin—A study of acrylic dispersions used in the treatment of paintings *(Eng)* S1066
consolidation—Consolidation of loose paint on ethnographic wooden objects *(Ger)* S901
Daiju-ji Temple (Japan)—Preservative treatment on the *Shoheki-ga* at the Daiju-ji *(Jpn)* S955
mural paintings—Ajanta murals: their composition and technique and preservation *(Eng)* S232
Neuen Wilden—The "fast" paintings of the Neuen Wilden *(Ger)* S358
tempera—Problems in restoring a tempera on 19th-century paper: decoration by Ponga for the balcony of the Olympic Theatre of Piove di Sacco *(Ita)* S1081
wood—Studies on fixing treatments of color paintings on the ceiling of Sanmon Gate, National Treasure, Tofuku-ji Temple *(Jpn)* S940

pencils
pastels (visual works)—History, technology and conservation of dry media *(Eng)* S1018

pentachlorophenol
Australian Aboriginal—Australian Aboriginal bark paintings: an ICOM report *(Eng)* S918
bark paintings—Conservation of Australian Aboriginal bark paintings with a note on the restoration of a New Ireland wood carving *(Eng)* S905
polychromy—Disinfestation and consolidation of polychromed wood at the Institut Royal du Patrimoine Artistique, Brussels *(Eng)* S957

pentimenti
pastels (visual works)—On the technical study of thirty pastel works on paper by Jean-François Millet *(Eng)* S368

Pepto-Bismol
Ruscha, Edward Joseph (b. 1937)—Pastel, juice and gunpowder: the Pico iconography of Ed Ruscha *(Eng)* S337

Peristrophe tinctoria
bark cloth—The technical aspects of ornamented bark-cloth (Eng) S209

Peru
An analytical study of pre-Inca pigments, dyes and fibers (Eng) chromatography; cochineal; dye; Inca; indigo; iron oxide; logwood; pigment; spectrometry; vermilion S571
—Peruvian natural dye plants (Eng) dye; plant materials; textiles S429
adobe—The conservation of adobe walls decorated with mural paintings and reliefs in Peru (Eng) S958
—Treatment of adobe friezes in Peru (Eng) S970
plants—The ethnobotany of pre-Columbian Peru (Eng) S206
pyrolysis gas chromatography—Analysis of natural resins by pyrolysis gas chromatography. II. Identification of natural resins by pyrograms (Jpn) S560
textiles—When textiles are paintings (Eng) S1060

pest control
A historical survey of the materials used for pest control and consolidation in wood (Ger) acrylic resin; consolidation; fungi; paint; reversibility; wood S1010

pesticides
boots—The examination, treatment and analysis of a pair of boots from the Aleutian Islands including a note about possible pesticide contamination (Eng) S387

petroglyphs see also **rock paintings**
rock art—Chemical and micromorphological analysis of rock art pigments from the western Great Basin (Eng) S371
—Dating and context of rock engravings in South Africa (Eng) S582

pH
Plextol B500—Evaluation of the stability, appearance and performance of resins for the adhesion of flaking paint on ethnographic objects (Eng) S1101

phosphate
Maori—Maori art (Eng) S18

photogrammetry
mural paintings—Wall paintings: technique, problems, conservation (Ita) S1080
pigment volume concentration—Determination of the brightening power in relation to the pigment volume concentration (PVC) of white pigments. A reasonable quick method (Ger) S814

photomicrography
linseed oil—Critical pigment volume concentration in linseed oil films (Eng) S766
minerals—Atlas of rock-forming minerals in thin section (Eng) S591
polarized light microscopy—Polarized light microscopy (Eng) S614

physical properties see also **chemical properties; mechanical properties; optical properties**
Physical study of two-coat paint systems (Eng) metal; paint; tensile strength S701
adhesives—Some adhesives and consolidants used in conservation (Eng) S1031
consolidation—A review of problems encountered in the consolidation of paint on ethnographic wood objects and potential remedies (Eng) S1085
flat paint—The effect of pigmentation on modern flat wall paints (Eng) S716
painting (technique)—Painting materials: a short encyclopaedia (Eng) S227
pigment volume concentration—Critical pigment volume concentration (CPVC) as a transition point in the properties of coatings (Eng) S876

picea see **spruce**

Picramnia pentandra
Carib—Plants used by the Dominica Caribs (Eng) S98

pictographs
On the pictographs of the North American Indians (Eng) binding media; black pigment; blood; charcoal; Chumash; cinnabar; color; Inuit; Native American; pigment; rock art; USA (California—Santa Barbara) S8

pigment
Analysis of the material and technique of ancient mural paintings (Eng) beeswax; calcium soap; Italy (Pompeii); mural paintings S220
—Ancient Greek pigments (Eng) Agora (Athens, Greece) S105
—Ancient Greek pigments from the Agora (Eng) Agora (Athens, Greece); blue frit; calcium carbonate; chalk; cinnabar; lead carbonate; lead white; mercury sulfide; red ocher; silicate; sulfide; yellow ocher S104
—Archaeological expedition to Arizona in 1895 (Eng) copper carbonate; green pigment; hematite; Hopi; kaolin; ocher; red ocher; ritual objects; Sityatki site; USA (Arizona) S17
—Artists' pigments: a handbook of their history and characteristics (Eng) barium sulfate; barium yellow; cadmium yellow; carmine; chrome yellow; cobalt yellow; green earth; Indian yellow; manuals; microscopy; Naples yellow; red lead; standards; vermilion; zinc white S623
—Bibliography on the pigments of painting (Ger) bibliographies; paintings (objects) S642
—The chemical studies on the pigments used in the Main Hall and pagoda of Hōryūji temple (Nara, Japan) (Jpn) azurite; Japan (Nara); lead white; malachite; red lead; red ocher; yellow ocher S119
—Color characteristics of artists' pigments (Eng) brightness; color; conservation S705
—Domestic implements, arts, and manufactures (Eng) adhesives; animal glue; blood; candlenut oil (Aleurites moluccana); dye; fat; honey; iguana; saliva; vegetable glue S23
—Ethnology of Futuna (Eng) anatto; dye; lime; turmeric; white pigment S67

—Painted tipis and picture-writing of the Blackfoot Indians *(Eng)* S69
blue pigment—Blues *(Ita)* S394
—Blues for the chemist *(Eng)* S465
—Identification of materials of paintings: I. Azurite and blue verditer *(Eng)* S541
boots—The examination, treatment and analysis of a pair of boots from the Aleutian Islands including a note about possible pesticide contamination *(Eng)* S387
Bouts, Dirck, the elder (ca. 1415-1475)—The techniques of Dieric Bouts: two paintings contrasted *(Eng)* S386
Bronze Age—Aegean painting in the Bronze Age *(Eng)* S466
buildings—The surface finishing of Renaissance facades in Ferrara, Italy: scientific studies *(Ita)* S493
calcimine—Interior wall decoration: practical working methods for plain and decorative finishes, new and standard treatments *(Eng)* S39
—The painters' encyclopaedia *(Eng)* S10
ceilings—Conservation treatments with reference to color paintings on the ceiling of the main hall, National Treasure, of Toshodaiji Temple, Nara *(Jpn)* S941
—Restoration of painted ceilings in Oman: the Jabrin fortress *(Fre)* S1048
ceramics—Technological notes on the pottery, pigments, and stuccoes from the excavations at Kaminaljuyu, Guatemala *(Eng)* S107
chalk—Observations about conservation techniques regarding the consolidation of waterbound chalk paint layers *(Ger)* S1077
chests—The cleaning, conservation, and restoration of a Matyo chest *(Hun)* S1000
China—Chinese painting colors: studies of their preparation and application in traditional and modern times. *(Eng)* S427
—Scientific study of the decoration of four wooden funerary boxes from China *(Fre)* S510
Chippewa—Some Chippewa uses of plants *(Eng)* S60
Chowa—Rhodesian engravers, painters and pigment miners of the fifth millennium B.C. *(Eng)* S161
Chumash—A study of some Californian Indian rock art pigments *(Eng)* S519
—Volume V: Manufacturing processes, metrology, and trade *(Eng)* S345
coatings—The contributions of pigments and extenders to organic coatings *(Eng)* S734
—Formulating for better control of internal stress *(Ita)* S835
—Light reflectance of spherical pigments in paper coatings *(Eng)* S795
—Plastic pigments in paper coatings: the effect of particle size on porosity and optical properties *(Eng)* S803
color field—The cleaning of Color Field paintings *(Eng)* S282
consolidation—Consolidation of loose paint on ethnographic wooden objects *(Ger)* S901
—Consolidation of porous paint in a vapor-saturated atmosphere: a technique for minimizing changes in the appearance of powdering, matte paint *(Eng)* S1120

contemporary art—American artists in their New York studios: conversations about the creation of contemporary art *(Eng)* S500
—Modern art: the restoration and techniques of modern paper and paints. Proceedings of a conference jointly organised by UKIC and the Museum of London, 22 May 1989 *(Eng)* S436
—Notes on the causes of premature aging of contemporary paintings *(Fre)* S398
—Why modern art may never become old masterpieces *(Eng)* S375
copper carbonate—The mamzrauti: a Tusayan ceremony *(Eng)* S11
craquelure—Craquelures *(Fre)* S817
Czechoslovakia (Prague)—Technical parallels between panel and wall painting of the 14th century *(Cze)* S353
Daiju-ji Temple (Japan)—Preservative treatment on the *Shoheki-ga* at the Daiju-ji *(Jpn)* S955
differential scanning calorimetry—Investigation of paint media by differential scanning calorimetry (DSC) *(Eng)* S667
Dix, Otto (1891-1969)—Studies on the painting technique of Otto Dix during the period 1933-1969 *(Ger)* S430
Dominica—The ethnobotany of the island Caribs of Dominica *(Eng)* S177
durability—Fundamental studies of paints. Paint durability as affected by the colloidal properties of the liquid paint *(Eng)* S698
dye—Aboriginal paints and dyes in Canada *(Eng)* S54
—Colors for textiles: ancient and modern *(Eng)* S109
—Keresan Indian color terms *(Eng)* S102
—The Kongo IV *(Eng)* S242
Egypt—Egyptian paintings of the Middle Kingdom *(Eng)* S245
—The entourage of an Egyptian governor *(Eng)* S244
—What do we know about the paints of the old Egyptians? *(Eng)* S137
encaustic painting—The technology, examination and conservation of the Fayum portraits in the Petrie Museum *(Eng)* S965
Eskimo—Ethnological results of the Point Barrow expedition *(Eng)* S13
ethnobotany—Ethnobotany of the Tewa Indians *(Eng)* S33
—An introductory study of the arts, crafts, and customs of the Guiana Indians *(Eng)* S34
extenders—Size and shape properties of representative white hiding and extender pigments *(Eng)* S727
finishes—Fundamentals of formulation of interior architectural finishes *(Eng)* S724
fixatives—Experimental studies on fixatives for powdery traces *(Fre)* S1012
—An investigation of several fixatives for pastel works *(Eng)* S1102
fixing—Theoretical approach to refixing *(Fre)* S1017
forensic science—Developments in paint analysis for forensic purposes *(Eng)* S639
—Forensic analysis of coatings *(Eng)* S615
Fourier transform infrared spectroscopy—Analysis of aged paint binders by FTIR spectroscopy *(Eng)* S657

459

—Materials and techniques of Medieval wall paintings from the former House of Merchants' Fraternity at 5 Żeglarska Street in Toruń *(Pol)* S485
—Microchemical analysis of the wall paintings of St. Baafsabtei in Ghent (about 1175) *(Dut)* S90
—The mural paintings in the Brihadisvara Temple at Tanjore: an investigation into the method *(Eng)* S76
—The Pallava paintings at Conjeevaram: an investigation into the methods *(Eng)* S85
—Physico-chemical study of the painting layers of the Roman mural paintings from the Acropolis of Lero *(Fre)* S342
—Pigments and techniques of the early Medieval wall paintings of eastern Turkistan *(Ger)* S298
—Pigments used in the paintings of "Hoodo." *(Jpn)* S183
—Reproduction of colored patterns in temples and shrines *(Eng)* S383
—Restoration of ancient monumental painting in cult buildings *(Eng)* S284
—Structure, composition, and technique of the paintings *(Dut)* S346
—Technique of the painting process in the Kailasanatha and Vaikunthaperumal temples at Kanchipuram *(Eng)* S84
—Unfinished wall paintings in Egyptian tombs and temples *(Ger)* S192
—The wall paintings in the Bagh caves: an investigation into their methods *(Eng)* S87
Nagoya Castle (Nagoya, Japan)—Study on the repair technique of polychrome paintings drawn on sliding screens in the Nagoya Castle *(Jpn)* S945
Native American—America's first painters *(Eng)* S168
—American Indian painting of the Southwest and Plains areas *(Eng)* S239
—Analysis of paints used by Canadian native cultures: a project at the Canadian Conservation Institute *(Eng)* S640
—CCI Native Materials Project: final report *(Eng)* S473
—Chinigchinich: a revised and annotated version of Alfred Robinson's translation of Father Geronimo Boscana's historical account of the belief, usages, customs and extravagances of the Indians of this mission of San Juan Capistrano called the Acagchemem Tribe *(Eng)* S58
—Handbook of American Indians north of Mexico *(Eng)* S25
—Indian rawhide: an American folk art *(Eng)* S280
—Indian uses of native plants *(Eng)* S404
—A new original version of Boscana's historical account of the San Juan Capistrano Indians of Southern California *(Eng)* S62
—Puffball usages among North American Indians *(Eng)* S349
—What did they use for paint? *(Eng)* S236
Netherlandish—The beginnings of Netherlandish canvas painting, 1400-1530 *(Eng)* S445
New Guinea—Wow-Ipits: eight Asmat woodcarvers of New Guinea *(Eng)* S231

Nitinaht—Ethnobotany of the Nitinaht Indians of Vancouver Island *(Eng)* S356
Oceania—Pigment consolidation on six Pacific artifacts: a CCI internship report *(Eng)* S984
ocher—Friable ochre surfaces: further research into the problems of colour changes associated with synthetic resin consolidation *(Eng)* S997
oil paintings—The technique of the great painters *(Eng)* S127
Ojibwa—Ethnobotany of the Ojibwa Indians *(Eng)* S56
opacity—Measurements of the fading of pigments in relation to opacity *(Eng)* S756
optical properties—Optical properties and theory of color of pigments and paints *(Eng)* S687
paint—Physicochemical alterations to the paint layer. 1. Results of a survey of various laboratories: apparent alterations of the paint layer and their probable causes. 2. Experimental study by the Musée du Louvre laboratory on madder varnish *(Fre)* S753
—Materials toward a history of housepaints: the materials and craft of the housepainter in 18th century America *(Eng)* S221
—Oil requirements and structure of paints *(Eng)* S695
—On the influence of grain size of pigment parts on oil requirement *(Ger)* S697
—Pigment and oil *(Ger)* S690
—The pigment-binder relationship as a fundamental property of paints *(Eng)* S709
—The relationship between oil content, particle size and particle shape *(Eng)* S699
—Scientific preparation and application of paint *(Eng)* S686
painting (technique)—Greek and Roman methods of painting: some comments on the statements made by Pliny and Vitruvius about wall and panel painting *(Eng)* S29
—The painter's craft: an introduction to artists' materials *(Eng)* S123
—Painting materials: a short encyclopaedia *(Eng)* S227
—Physics and painting: introduction to the study of physical phenomena applied to painting and painting techniques *(Dut)* S707
—Pigments and paints in primitive exotic techniques *(Fre)* S201
—Trial data on painting materials—mediums, adhesives, and film substances *(Eng)* S77
paintings (objects)—Manual of the painter restorer *(Ita)* S5
Paleolithic—Paleolithic pigments and processing *(Eng)* S357
panel paintings—Basic experiments concerning deterioration of glue and discoloration of pigments, and discussion on the actual condition of wall panel paintings on the basis of their results *(Jpn)* S930
—Preservative treatment on paint layer of screen and wall panel paintings *(Jpn)* S929
—Wings from a quadriptych with the legend of St. John the Baptist: general problems and the treatment of conservation *(Pol)* S917
Papua New Guinea—Technique and personality *(Eng)* S211

pigment

thin layer chromatography—Analysis of thin-layer chromatograms of paint pigments and dyes by direct microspectrophotometry *(Eng)* S620
Thompson—Ethnobotany of the Thompson Indians of British Columbia, based on field notes by James A. Teit *(Eng)* S45
titanium dioxide—Back to basics: opacity and titanium dioxide pigments *(Eng)* S863
Tlingit—The conservation of a Tlingit blanket *(Eng)* S909
Tomb of Nefertari (Thebes, Egypt)—Chemical analyses of pigments and media used in the mural paintings of the tomb of Nefertari *(Spa)* S658
totem poles—The conservation of a Tlingit totem pole *(Eng)* S309
Turkistan—The materials in the wall paintings from Kizil in Chinese Turkestan *(Eng)* S81
turmeric—Some conservation problems encountered with turmeric on ethnographic objects *(Eng)* S1023
ultramicroanalysis—Ultramicroanalysis: an effective method for substantial investigation of works of art *(Ger)* S622
USA (New Mexico)—The materials and methods of some religious paintings of early 19th century New Mexico *(Eng)* S142
USA (New Mexico— Isleta)—Isleta, New Mexico *(Eng)* S55
varnish—The origins of pigment and varnish techniques *(Eng)* S141
viscosity—Further experiments on the importance of the critical point *(Eng)* S694
—Microscopic examination of pigment/vehicle interaction during film formation *(Eng)* S762
—On oil-paint viscosity as an expression of paint structure *(Eng)* S702
Vuillard, Edouard (1868-1940)—The distemper technique of Edouard Vuillard *(Eng)* S275
wallpaper—Colors and other materials of historic wallpaper *(Eng)* S326
—Wallpaper in America: from the 17th century to World War I *(Eng)* S320
watercolors—Wash and gouache: a study of the development of the materials of watercolor *(Eng)* S296
white pigment—White pigments in ancient painting *(Ita)* S203
whitewash—Decorative painters and house painting at Massachusetts Bay, 1630-1725 *(Eng)* S258
wood—Colouring technique and repair methods for wooden cultural properties *(Eng)* S303
—The folk art tradition in painting on wood: paste and casein techniques *(Ger)* S314
—Wooden ritual artifacts from Chaco Canyon, New Mexico: the Chetro Ketl collection *(Eng)* S305
x-ray diffraction—Nondestructive infrared and x-ray diffraction analyses of paints and plastics *(Eng)* S532
yellow pigment—Yellow pigments used in antiquity *(Fre)* S113
Yoruba—A Yoruba master carver: Duga of Meko *(Eng)* S274
Zuni—The Zuni Indians, their mythology, esoteric fraternities, and ceremonies *(Eng)* S24

pigment volume concentration
Application of the statistical method in testing paints for durability *(Eng) durability; paint* S688
—C.P.V.C. of a pigment mixture as a function of vehicle type *(Eng) absorption; vehicle (material)* S747
—Characterization of pigment volume concentration effects in latex paints *(Eng) latex paint; staining (analysis)* S819
—Coating formulation and development using critical pigment volume concentration prediction and statistical design *(Eng) absorption; chromate; coatings; gloss; polyurethane foam; resin; silica; titanium dioxide white; zinc yellow* S854
—Color and CPVC *(Eng) color; paint* S719
—CPVC as point of phase inversion in latex paints *(Eng) fillers; latex paint; polymers; porosity* S879
—CPVC relationships. III. The real CPVC and its relationships to Young's modulus, magnetic moment, abrasive wear and gloss *(Eng) coatings; gloss; mercury; porosimetry; porosity* S855
—CPVC, critical pigment volume concentration: an overview *(Eng) absorption* S883
—Critical look at CPVC performance and application properties *(Eng) coatings; latex paint; resin* S862
—Critical look at CPVC performance and applications properties *(Eng) coatings; latex paint* S875
—Critical pigment volume concentration (CPVC) as a transition point in the properties of coatings *(Eng) coatings; physical properties; poly(vinyl chloride); polymers* S876
—Critical pigment volume concentration and chalking in paints *(Eng) colorants; porosity* S746
—Critical pigment volume concentration and its effects in latex coatings *(Eng) coatings; latex paint* S824
—Critical pigment volume concentration in latex coatings *(Eng) coatings; latex paint* S816
—Critical pigment volume concentration of emulsion based paints *(Eng) binding media; paint; tensile strength* S757
—Critical pigment volume concentration of paints. Its measurement and some relationships *(Eng) coatings; methyl isobutyl ketone; modulus of elasticity; paint; polyurethane foam; solvents; viscosity* S857
—Critical pigment volume relationships *(Eng) binding media; paint* S710
—Density method for determining the CPVC of flat latex paints *(Eng) absorption; binding media; latex paint; poly(vinyl chloride); porosity* S822
—The determination of CPVC by the oil absorption test method *(Eng) absorption; oil; paint* S723
—Determination of CPVC of latex paints using hiding power data *(Eng) absorption; latex paint; pigment; poly(vinyl chloride); titanium dioxide* S788
—Determination of critical pigment volume concentration by measurement of the density

462

pigment volume concentration

durability—The science of durability of organic coatings: a foreword *(Eng)* S843
fading—Reflections on the phenomenon of fading *(Eng)* S841
finishes—Coating formulation: its effects on the durability of exterior wood finishes *(Eng)* S808
flat paint—The effect of pigmentation on modern flat wall paints *(Eng)* S716
latex paint—Changes in hiding during latex film formation *(Eng)* S861
—Changes in hiding during latex film formation. Part II. Particle size and pigment packing effects *(Eng)* S871
—CPVC as point of phase inversion in latex paints *(Eng)* S866
—Effect of pigmentation on internal stress in latex coatings *(Eng)* S828
—Latex paints: CPVC, formulation, and optimization *(Eng)* S784
—Scanning laser acoustic microscopy of latex paint films *(Eng)* S837
linseed oil—Critical pigment volume concentration in linseed oil films *(Eng)* S760
mechanical properties—Influence of pigmentation on the mechanical properties of paint films *(Eng)* S779
—Mechanical properties of weathered paint films *(Eng)* S851
opacity—Measurements of the fading of pigments in relation to opacity *(Eng)* S756
—On the wet and dry opacity of paints *(Eng)* S722
opaque white pigment—Opaque white pigments in coatings *(Eng)* S836
paint—Failure envelopes of paint films as related to pigmentation and swelling: technical translation *(Eng)* S785
—A method of hiding power determination and its application as an aid to paint formulation *(Eng)* S737
—Method to follow the degradation by natural weathering of emulsion paint films *(Ger)* S829
parameter—Particle size as a formulating parameter *(Eng)* S755
pigment—Pigment/binder geometry *(Eng)* S774
—Predicting the oil absorption and the critical pigment volume concentration of multicomponent pigment systems *(Eng)* S732
—The relationship of pigment packing patterns and CPVC to film characteristics and hiding power *(Eng)* S733
—Role of pigments *(Eng)* S768
polymers—Opaque polymers in paints with high pigment volume concentration *(Eng)* S847
—Use of small polymeric microvoids in formulating high PVC paints *(Eng)* S846
porosity—Porosity of paint films *(Eng)* S714
—The production and control of high dry hiding *(Eng)* S740
radioactivity—Radiochemical investigation of ionic penetration into paint films *(Eng)* S778
reflectance—Application of Mie scatter theory to the reflectance of paint-type coatings *(Eng)* S758
—Experimental study on spectral reflective properties of a painted layer *(Eng)* S813

scattering—Effect of particle crowding on scattering power of TiO₂ pigments *(Eng)* S780
tensile strength—Ultimate tensile properties of paint films *(Eng)* S752
titanium dioxide—The durability of paint films containing titanium dioxide—contraction, erosion and clear layer theories *(Eng)* S809
viscosity—Paint viscosity and ultimate pigment volume concentration *(Eng)* S717
watercolors—The structure of watercolor films with a high PVC *(Ita)* S820
white pigment—The Louisville Paint and Varnish Production Club, Fourth Technical Symposium. The effect of physical characteristics of white and extender pigments on paint film properties *(Eng)* S725

pine
Iceland—Likneskjusmid: fourteenth century instructions for painting from Iceland *(Eng)* S503

pine resin
Maori—Maori art *(Eng)* S18

pine tar
Analysis of Finnish pine tar and tar from the wreck of frigate St. Nikolai *(Eng) balsam; barrels; Finnish; gas chromatography mass spectrometry; lignin; resin; rope; Russia; shipwrecks; spectrometry; tar; wood* S650
Chumash—Volume V: Manufacturing processes, metrology, and trade *(Eng)* S345
mummies—Probing the mysteries of ancient Egypt; chemical analysis of a Roman period Egyptian mummy *(Eng)* S673

pistachio
sumac—The use of the sumacs by the American Indian *(Eng)* S72

pitch (tar)
Acoma—The Acoma Indians *(Eng)* S57
black pigment—Ceramic pigments of the Indians of the Southwest *(Eng)* S40
Chumash—Volume V: Manufacturing processes, metrology, and trade *(Eng)* S345
conifers—Ethnobotany of coniferous trees in Thompson and Lillooet Interior Salish of British Columbia *(Eng + Fre)* S426
Luiseño—The culture of the Luiseño Indians *(Eng)* S26
mummies—Probing the mysteries of ancient Egypt; chemical analysis of a Roman period Egyptian mummy *(Eng)* S673
Native American—Chinigchinich: a revised and annotated version of Alfred Robinson's translation of Father Geronimo Boscana's historical account of the belief, usages, customs and extravagancies of the Indians of this mission of San Juan Capistrano called the Acagchemem Tribe *(Eng)* S58
Thompson—Thompson ethnobotany: knowledge and usage of plants by the Thompson Indians of British Columbia *(Eng)* S483
wood—Identification of archaeological and recent wood tar pitches using gas chromatography/mass spectrometry and pattern recognition *(Eng)* S655

mechanical properties of loess plaster *(Eng)* S954
Mesoamerican—Ancient Mesoamerican mortars, plasters, and stuccos. The use of bark extracts in lime plasters *(Eng)* S197
mortar—Ancient Mesoamerican mortars, plasters, and stuccos: Las Flores, Tampico *(Eng)* S189
—Ancient Mesoamerican mortars, plasters, and stuccos: Palenque, Chiapas *(Eng)* S190
mural paintings—Ajanta and Ellora wall paintings. Scientific research as an aid to their conservation *(Eng)* S569
—Analysis of pigments and plaster of the paintings in the Sheesh Mahal, Nagaur *(Eng)* S428
—Chemical study on the coloring materials of the murals of the Taka-matsuzuka Tomb in Nara Prefecture *(Jpn)* S272
—Conservation of mural paintings in Central Asia which have been damaged by salt efflorescence *(Eng)* S888
—Indian murals: techniques and conservation *(Eng)* S931
—Materials and techniques of Medieval wall paintings from the former House of Merchants' Fraternity at 5 Żeglarska Street in Toruń *(Pol)* S485
—Monumentales pastell—a forgotten invention in wall painting techniques about 1900 *(Eng)* S301
—The Pallava paintings at Conjeevaram: an investigation into the methods *(Eng)* S85
—Restoration of ancient monumental painting in cult buildings *(Eng)* S284
—The structure of the 17th-century mural paintings in the S. George Orthodox church at Veliko Turnovo (Bulgaria) *(Pol)* S264
—Unfinished wall paintings in Egyptian tombs and temples *(Ger)* S192
—The wall paintings in the Bagh caves: an investigation into their methods *(Eng)* S87
—Wall paintings: technique, problems, conservation *(Ita)* S1080
poly(butyl methacrylate)—New possibilities of polybutyl methacrylate as a consolidating agent for glue painting on loess plaster *(Eng)* S936
pueblos (housing complexes)—A study of Pueblo architecture: Tusayan and Cibola *(Eng)* S9
Puuc—Ancient Mesoamerican mortars, plasters, and stuccos: the Puuc Area *(Eng)* S198
Romano-British—An analysis of paints used in Roman Britain *(Eng)* S210, S213
Thailand—Conservation of wall paintings in Thailand *(Eng)* S927
wallpaper—Wallpaper on walls: problems of climate and substrate *(Eng)* S982

plaster of Paris
clay—Restoration of a relief in painted clay *(Fre)* S887
mural paintings—Ajanta murals: their composition and technique and preservation *(Eng)* S232
stone—The consequences of previous adhesives and consolidants used for stone conservation at the British Museum *(Eng)* S1052

plastering
Tamberma—Architecture of the Tamberma (Togo) *(Eng)* S332
plasterwork
The restoration of facade plasterwork in Italy *(Fre) architecture; color; decoration; facades; Italy; lime; mural paintings; polychromy; stucco* S472
mural paintings—Ancient Collegiate Church of Saint Barnard de Romans: decorated surfaces of the choir and transept *(Fre)* S478
—Technique and conservation of mural paintings: report on the meeting held in Washington and New York, 17-25 September 1965 *(Fre)* S226
—Technique of the painting process in the Kailasanatha and Vaikunthaperumal temples at Kanchipuram *(Eng)* S84
rock paintings—Technique of the painting process in the rock-cut temples at Badami *(Eng)* S86
white pigment—White pigments in ancient painting *(Ita)* S203

plasticizers
gas chromatography—Examination of the diterpenoic resin components of anatomical wax models from the eighteenth century by gas chromatography *(Eng)* S656
lacquer—Lists of raw materials for lacquer *(Ger)* S402
tensile strength—Ultimate tensile properties of paint films *(Eng)* S752

plastics *see also* **polymers**
adhesion—A quantitative method for determining the adhesion of coatings to plastics *(Eng)* S881
coatings—Pigment-polymer interaction and technological properties of pigmented coatings and plastics *(Eng)* S800
—Plastic pigments in paper coatings: the effect of particle size on porosity and optical properties *(Eng)* S803
—Properties of high solid systems: ACS talks examine physical and optical characteristics *(Eng)* S860
contemporary art—Conservation of the contemporary *(Eng)* S248
extenders—Extenders *(Eng)* S165
opaque white pigment—Opaque white pigments in coatings *(Eng)* S836
panel paintings—Preservative treatment on paint layer of screen and wall panel paintings *(Jpn)* S929
pastels (visual works)—Fixatives for pastels *(Fre)* S708
wood—Studies on fixing treatments of color paintings on the ceiling of Sanmon Gate, National Treasure, Tofuku-ji Temple *(Jpn)* S940
x-ray diffraction—Nondestructive infrared and x-ray diffraction analyses of paints and plastics *(Eng)* S532

Plexigum P24
A study of Plexigum P24 used as a fixative for flaking paint traces *(Fre) acrylic resin; Elvamide 8061; fixatives; ink; paint; paper; pigment; Plexisol P550; poly(butyl methacrylate); vapor* S1043

Plexisol
pastels (visual works)—Analysis and conservation of graphic and sound documents: work by the Centre de Recherches sur la Conservation des Documents Graphiques, 1982-1983 *(Fre)* S1004

Plexisol P550
adhesives—Adhesives for impregnation of painting on canvas *(Swe)* S1087
Plexigum P24—A study of Plexigum P24 used as a fixative for flaking paint traces *(Fre)* S1043
verre eglomise—Eglomise: technique and conservation *(Ger)* S1059

Plextol B500
Evaluation of the stability, appearance and performance of resins for the adhesion of flaking paint on ethnographic objects *(Eng) acrylic resin; adhesion; Australian Museum (Sydney, Australia); ethnographic conservation; flaking; paint; pH; resin; solubility; tensile strength* S1101
acrylic resin—A study of acrylic dispersions used in the treatment of paintings *(Eng)* S1066

poison oak
Anacardiaceae—A most useful plant family, the Anacardiaceae *(Eng)* S71
sumac—The use of the sumacs by the American Indian *(Eng)* S72

Poland
Folk painting on glass *(Pol) coloring; finishing; glass; ocher; woodcuts* S240
mural paintings—Products, facts, modes in mural painting: evolution and distribution of restoration products used in mural paintings from 1850 to 1992. A first sorting concerning France, Spain, England, and Poland *(Fre)* S511
poly(vinyl acetate)—Polyvinyl acetate in the conservation of the wall paintings *(Eng)* S1103

Poland (Stegna)
binding media—The problem of conservation of very large canvases painted in glue medium *(Pol)* S968

Poland (Torún)
mural paintings—Materials and painting techniques of the wall paintings of the main nave of S. Mary's Church in Toruń *(Pol)* S432
—Materials and techniques of Medieval wall paintings from the former House of Merchants' Fraternity at 5 Żeglarska Street in Toruń *(Pol)* S485

polarized light microscopy
Polarized light microscopy *(Eng) color; manuals; microscopy; optics; photomicrography; staining (analysis)* S614
house paint—Microchemical analysis of old housepaints with a case study of Monticello *(Eng)* S661
microscopy—Application of particle study in art and archaeology *(Eng)* S585
—The particle atlas: an encyclopedia of techniques for small particle identification *(Eng)* S586
red pigment—African red pigments *(Eng)* S641

Shroud of Turin—Microscopical study of the Turin "Shroud." *(Eng)* S637

pollen
Kachina masks—Zuni Katcinas *(Eng)* S53

Pollock, Jackson (1912-1956)
My painting *(Eng) adhesion; flaking* S112

pollution *see also* **air pollution**
historic buildings—Conservation within historic buildings in Japan *(Eng)* S973

poly(butyl methacrylate)
New possibilities of polybutyl methacrylate as a consolidating agent for glue painting on loess plaster *(Eng) cleaning; impregnation; loess; mural paintings; optical properties; plaster; Russia; solvents; xylene* S936
loess—The effect of the treatment with polybutyl methacrylate solutions on physical and mechanical properties of loess plaster *(Eng)* S954
Plexigum P24—A study of Plexigum P24 used as a fixative for flaking paint traces *(Fre)* S1043
stucco—Restoration and display of Egyptian stucco mummy masks from the period of the Roman Empire *(Eng)* S1027

poly(ethylene glycol)
encaustic wax—The cleaning and consolidation of Egyptian encaustic mummy portraits *(Eng)* S1088
stone—The consequences of previous adhesives and consolidants used for stone conservation at the British Museum *(Eng)* S1052

poly(methyl acrylate)
paper—Conservation of some non-book material in National Library, Calcutta *(Eng)* S1026

poly(methyl methacrylate)
watercolors—Conservation of Indian miniature paintings in the Baroda Museum *(Eng)* S911

poly(vinyl acetate)
Polyvinyl acetate in the conservation of the wall paintings *(Eng) mural paintings; paintings (objects); Poland; resin* S1103
acrylic resin—Consolidation with acrylic colloidal dispersions *(Eng)* S988
adhesives—The evaluation of some adhesive systems utilized in the consolidation of paintings. The kinetics of consolidation (II) *(Rum)* S1020
artificial ultramarine blue—A technical note on IKB (International Klein Blue) *(Eng)* S347
Australian Aboriginal—Bark paintings: techniques and conservation *(Eng)* S443
—Methods and materials used in Australian Aboriginal art *(Eng)* S380
bark paintings—Conservation of Australian Aboriginal bark paintings with a note on the restoration of a New Ireland wood carving *(Eng)* S905
ceilings—Conservation treatments with reference to color paintings on the ceiling of the main hall, National Treasure, of Toshodaiji Temple, Nara *(Jpn)* S941

extenders—Influence of fine particle size extenders on the optical properties of latex paints *(Eng)* S838
latex paint—Changes in hiding during latex film formation *(Eng)* S861
—Changes in hiding during latex film formation. Part II. Particle size and pigment packing effects *(Eng)* S871
—The effect of extenders on the optical properties of air drying alkymul and styrene-butadiene latex paints *(Eng)* S728
linseed oil—Critical pigment volume concentration in linseed oil films *(Eng)* S766
mechanical properties—Influence of pigmentation on the mechanical properties of paint films *(Eng)* S779
paint—The comparisons of two-component extender systems in emulsion paint *(Eng)* S730
—Failure envelopes of paint films as related to pigmentation and swelling: technical translation *(Eng)* S785
pigment—Role of pigments *(Eng)* S768
pigment volume concentration—Critical pigment volume concentration (CPVC) as a transition point in the properties of coatings *(Eng)* S876
—Density method for determining the CPVC of flat latex paints *(Eng)* S822
—Determination of CPVC of latex paints using hiding power data *(Eng)* S788
—Determination of the brightening power in relation to the pigment volume concentration (PVC) of white pigments. A reasonable quick method *(Ger)* S814
—Effect of ageing of alkyd-TiO$_2$ paints on adhesion to mild steel: role of pigment volume concentration *(Eng)* S868
—Effect of particle size distribution of pigment and pigment volume concentration on flat wall paint properties (solvent type) *(Eng)* S729
—Effect of pigment volume concentration and film thickness on the optical properties of surface coatings *(Eng)* S751
—The effect on pigment volume concentration on the lightness or darkness of porous paints *(Eng)* S810
—Formulating high-PVC paints with opaque polymer additives *(Eng)* S845
—The influence of PVC on paint properties *(Eng)* S773
—New additive helps cut the cost of hiding *(Eng)* S823
—Paint coating pigment volume concentration *(Eng)* S812
—Particle packing analysis of coatings above the critical pigment volume concentration *(Eng)* S818
—Pigment volume concentration and an interpretation of the oil absorption of pigments *(Eng)* S827
—Pigment volume concentration and its effect on the corrosion resistance properties of organic paint films *(Eng)* S882
—Pigment volume concentration, pigment surface concentration, packing density, and gloss of paints *(Ger)* S850
—Re-examination of the CPVC as a transition point in the properties of coatings *(Eng)* S865

—Review of methods of CPVC determination *(Eng)* S877
—Single pigment paints *(Eng)* S786
—Statistical model for emulsion paint above the critical PVC *(Eng)* S833
polymers—Use of small polymeric microvoids in formulating high PVC paints *(Eng)* S846
radioactivity—Radiochemical investigation of ionic penetration into paint films *(Eng)* S778
scattering—Effect of particle crowding on scattering power of TiO$_2$ pigments *(Eng)* S780
vinyl acetate—Very high binding vinyl acetate based dispersions *(Eng)* S869
watercolors—The structure of watercolor films with a high PVC *(Ita)* S820

polychromy
Disinfestation and consolidation of polychromed wood at the Institut Royal du Patrimoine Artistique, Brussels *(Eng) Belgium (Brussels); consolidation; insects; mass treatment; methyl bromide; Paraloid B-72; pentachlorophenol; sculpture; wood; Xylamon* S957
—Problems of the interpretation of historical sources and their confirmation by the results of technical analysis on works of art, shown on the example of painted sculptures from the 18th century in southern Germany *(Ger) decoration; Germany, southern; painting (technique); sculpture; wood* S322
adhesives—Re-attaching a thick color layer of polychrome sculpture. Conservation of a seated figure of Rev. Tenkai *(Jpn)* S1075
architecture—Painted surfaces in architecture: Amiens, October 1989 *(Fre)* S450
artists' materials—Techniques of ancient painting: the preparation of the support *(Ita)* S440
binding media—The problem of conservation of very large canvases painted in glue medium *(Pol)* S968
cellulose ether—The use of cellulose ethers in the treatment of Egyptian polychromed wood *(Eng)* S1053
China—Scientific study of the decoration of four wooden funerary boxes from China *(Fre)* S510
clay—Restoration of a relief in painted clay *(Fre)* S887
decoration—Investigations and preliminary probes *(Fre)* S1089
Egypt (Saqqara)—Identification of medium used in polychrome reliefs in ancient Egyptian limestone tomb dating from the nineteenth dynasty /1350-1200 B.C./ at Saqqara *(Eng)* S649
Herlin Cathedral (Germany)—The scientific examination of the polychromed sculpture in the Herlin altarpiece *(Eng)* S552
India—Notes on the technique of Indian polychrome wooden sculpture *(Eng)* S246
—A study of Indian polychrome wooden sculpture *(Eng)* S255
masks—Chiriquano masks: polychrome wood (treatment and inquiry) *(Eng)* S1041
Medieval—Pigments and paints in the Middle Ages *(Fre)* S199

metal—The conservation of painted and polychromed metal work. Two case studies from the V & A Museum *(Eng)* S1086
—Examples of conservation of painted metal objects *(Eng)* S1093
Mexico—Colors and paint at the time of the pre-Cortés Mexican civilizations *(Fre)* S169
mural paintings—Workshop practices and identification of hands: Gothic wall paintings at St Albans *(Eng)* S514
Nagoya Castle (Nagoya, Japan)—Study on the repair technique of polychrome paintings drawn on sliding screens in the Nagoya Castle *(Jpn)* S945
Papua New Guinea (New Ireland)—Assemblage of spirits: idea and image in New Ireland *(Eng)* S403
plants—Plant gums as painting mediums in the light of old treatises, their properties, and their identification in ancient polychromy *(Pol)* S207
plasterwork—The restoration of facade plasterwork in Italy *(Fre)* S472
reattaching—Reattaching thick color layer of polychrome wooden sculpture *(Jpn)* S1022
stucco—Stucco: a report on the methodology developed in Mexico *(Eng)* S1035
terracotta—The treatment and examination of painted surfaces on eighteenth-century terracotta sculptures *(Eng)* S469
wax—The preservation of wood sculpture: the wax immersion method *(Eng)* S890
Wayang—Restoration of Indonesian Wayang-figures in the National Ethnographical Museum of Dresden *(Ger)* S1049
wood—Case studies in the treatment of polychrome wood sculptures at the Victoria and Albert Museum *(Eng)* S1006
—Colouring technique and repair methods for wooden cultural properties *(Eng)* S303
—Conservation of polychrome wood sculpture at the Australian War Memorial *(Eng)* S944
—Consolidation of deteriorated wooden artifacts *(Eng)* S961
—The restoration of the wooden statue of Our Lady in the parish church of Cercina *(Ita)* S1078

polyester
Embedding paint cross section samples in polyester resins: problems and solutions *(Eng) cross sections; embedding; paint; resin; samples* S679
stone—The consequences of previous adhesives and consolidants used for stone conservation at the British Museum *(Eng)* S1052

polyethylene
coffins—Party straws and Egyptian coffins *(Eng)* S1113

polymerization
wood—Consolidation of deteriorated wooden artifacts *(Eng)* S961
—Consolidation of painted wooden artifacts *(Eng)* S934
—Consolidation of painted wooden artifacts: an ICOM report *(Eng)* S924

polymers *see also* **plastics**
Consolidation of the pictorial layer of illuminations with pure synthetic polymers *(Fre) cellulose acetate; consolidation; fixing; illuminations; methyl cellulose; parchment; solvents* S989
—The mechanism of polymer migration in porous stones *(Eng) drying; limestone; methacrylate; migration; Paraloid B-72; resin; sandstone; solvents; viscosity* S1047
—Opaque polymers *(Eng) coatings; gloss; scattering; titanium dioxide* S826
—Opaque polymers in paints with high pigment volume concentration *(Eng) pigment volume concentration; porosity* S847
—Use of small polymeric microvoids in formulating high PVC paints *(Eng) coatings; pigment volume concentration; poly(vinyl chloride); titanium dioxide* S846
—The use of synthetic polymers for the consolidation of Medieval miniatures on parchment *(Rus) consolidation; illuminations; Medieval; paint; parchment; synthetic materials* S938
adhesion—Adhesion of latex paint: Part 1 *(Eng)* S787
adobe—Experiments on preservation of adobe structures and restoration of gypsum plaster paintings in Uzbekistan *(Eng)* S983
coatings—Mechanical properties of clay coating films containing styrene-butadiene copolymers *(Eng)* S834
—Properties of high solid systems: ACS talks examine physical and optical characteristics *(Eng)* S860
consolidants—Degradation of synthetic consolidants used in mural painting restoration by microorganisms *(Eng)* S1122
durability—The science of durability of organic coatings: a foreword *(Eng)* S843
latex paint—CPVC as point of phase inversion in latex paints *(Eng)* S866
—History of water-thinned paints *(Eng)* S163
mechanical properties—Influence of pigmentation on the mechanical properties of paint films *(Eng)* S779
mural paintings—The paintings on walls and ceilings in the cabinets of the gallery building at Hannover-Herrenhausen *(Ger)* S1070
pigment volume concentration—CPVC as point of phase inversion in latex paints *(Eng)* S879
—Critical pigment volume concentration (CPVC) as a transition point in the properties of coatings *(Eng)* S876
plaster—Conservation in archaeological areas: three decades of work *(Spa)* S1095
polysaccharides—An investigation and identification of polysaccharides isolated from archaeological specimens *(Eng)* S570
pyrolysis gas chromatography—Forensic applications of pyrolysis capillary gas chromatography *(Eng)* S609
—Identification of synthetic materials in modern paintings. 1: varnishes and polymer binders *(Fre)* S660
—Pyrolysis gas chromatographic mass spectrometric identification of intractable materials *(Eng)* S588

synthetic materials—Natural and accelerated aging of synthetic products compared with that of natural products *(Fre)* S1036
varnish—On picture varnishes and their solvents *(Eng)* S832
vinyl acetate—Very high binding vinyl acetate based dispersions *(Eng)* S869

Polynesian
Breadfruit *(Eng) adhesives; breadfruit* S92
—Traditional use of *Curcuma longa* (Zingiberaceae) in Rotuma *(Eng) Curcuma longa; plant materials; rituals* S518
bark cloth—Tapa in Polynesia *(Eng)* S267
Cook, James (1728-1779)—The journals of Captain James Cook on his voyages of discovery *(Eng)* S414
plants—The ocean-going *noni*, or Indian mulberry (*Morinda citrifolia, Rubiaceae*) and some of its "colorful" relatives *(Eng)* S502

polypeptides
thin layer chromatography—The methods of identifying organic binders in paint layers *(Slo)* S599

polysaccharides
The detection of polysaccharides in the constituent materials of works of art *(Fre) binding media; carbohydrates; chromatography; gum; infrared absorption; protein; spectrometry; sugar; thin layer chromatography* S537
—An investigation and identification of polysaccharides isolated from archaeological specimens *(Eng) Asia, Central; gum; infrared spectrometry; paintings (objects); plants; polymers* S570
—Polysaccharides as part of a color layer and methods for their identification *(Eng) adhesives; beer; chromatography; gas chromatography; gum arabic; honey; hydrolysis; infrared spectrometry; plant materials; starch; thin layer chromatography* S647
binding media—Contributions to the analysis of binders, adhesives and ancient varnishes *(Fre)* S547
Mayan—The Maya mural paintings of Bonampak, materials analysis *(Fre)* S539
organic materials—A study of organic components of paints and grounds in Central Asian and Crimean wall paintings *(Eng)* S564
plants—Analytical procedures *(Eng)* S531
thin layer chromatography—The methods of identifying organic binders in paint layers *(Slo)* S599

polysiloxane
majolica—Experiments on the consolidation of glazes on majolica and glass tesserae from mosaics *(Ita)* S1106

polystyrene
adobe—The conservation of adobe walls decorated with mural paintings and reliefs in Peru *(Eng)* S958
pigment—Viscosity, packing density and optical properties of pigment blends *(Eng)* S815

polyurethane foam
Irian Jaya—A support system for flexible palm spathe objects *(Eng)* S517

pigment volume concentration—Coating formulation and development using critical pigment volume concentration prediction and statistical design *(Eng)* S854
—Critical pigment volume concentration of paints. Its measurement and some relationships *(Eng)* S857
pyrolysis gas chromatography—Forensic applications of pyrolysis capillary gas chromatography *(Eng)* S609

Pompeiian Style
Pompeian colors *(Eng) color; pigment; Roman* S229
—Pompeian painting technique *(Fre) painting (technique); Vitruvian tinctorium* S174

Ponga, Giuseppe
tempera—Problems in restoring a tempera on 19th-century paper: decoration by Ponga for the balcony of the Olympic Theatre of Piove di Sacco *(Ita)* S1081

poppy-seed oil
binding media—Analyses of paint media *(Eng)* S594

porosimetry
pigment volume concentration—CPVC relationships. III. The real CPVC and its relationships to Young's modulus, magnetic moment, abrasive wear and gloss *(Eng)* S855
—Pigment volume concentration and an interpretation of the oil absorption of pigments *(Eng)* S827

porosity
Porosity of paint films *(Eng) linseed oil; paint; pigment volume concentration; vapor* S714
—The production and control of high dry hiding *(Eng) pigment volume concentration; reflectance* S740
coatings—The influence of pore volume and particle size of micronized silica gel on the matting performance in clear coatings *(Eng)* S794
—Optical properties and structure of clay-latex coatings *(Eng)* S791
—Plastic pigments in paper coatings: the effect of particle size on porosity and optical properties *(Eng)* S803
extenders—Size and shape properties of representative white hiding and extender pigments *(Eng)* S727
latex paint—Changes in hiding during latex film formation *(Eng)* S861
—Changes in hiding during latex film formation. Part II. Particle size and pigment packing effects *(Eng)* S871
opacity—Latex paint opacity: a complex effect *(Eng)* S765
parameter—Particle size as a formulating parameter *(Eng)* S755
pigment—Pigment/binder geometry *(Eng)* S774
—The relationship of pigment packing patterns and CPVC to film characteristics and hiding power *(Eng)* S733
—Viscosity, packing density and optical properties of pigment blends *(Eng)* S815

Tura, Cosimo (1430?-1495)—Amino acid analysis of proteinaceous media from Cosimo Tura's "The Annunciation with Saint Francis and Saint Louis of Toulouse." *(Eng)* S669
USA (New Mexico)—The materials and methods of some religious paintings of early 19th century New Mexico *(Eng)* S142

Prussian blue
blue pigment—Blues *(Ita)* S394
Pueblo—Two summers' work in Pueblo ruins *(Eng)* S22
USA (New Mexico)—The materials and methods of some religious paintings of early 19th century New Mexico *(Eng)* S142

psalters
illuminations—Some details on the technique and of the restoration of two illuminated 13th century manuscripts from Western Europe *(Fre)* S942

Ptolemaic
masks—The conservation of a Ptolemaic mummy mask *(Ger)* S1097

Pueblo
Kiva mural decorations at Awatovi and Kawaika-a, with a survey of other wall paintings in the Pueblo Southwest *(Eng) mural paintings; Native American; USA (Southwest)* S160
—The state of preservation of Pueblo Indian mural paintings in the American Southwest: findings of a condition study carried out in 1978-1979, and a proposed pilot project to test materials and methods for conservation *(Eng) adobe; architectural elements; mural paintings; Native American; USA (Southwest)* S977
—Two summers' work in Pueblo ruins *(Eng) azurite; blue paint; copper carbonate; green paint; kaolin; Native American; pigment; Prussian blue; red paint; sesquioxide; USA (Colorado); white paint* S22
adobe—1981 report on the development of methods for the conservation of Pueblo Indian mural paintings in the American Southwest *(Eng)* S995
Anasazi—Anasazi and Pueblo painting *(Eng)* S487
dye—Navajo native dyes: their preparation and use *(Eng)* S299

pueblos (housing complexes)
A study of Pueblo architecture: Tusayan and Cibola *(Eng) architecture; buildings; clay; decoration; gypsum; Hopi; masonry; plaster; whitewash; Zuni* S9

puff balls
Native American—Puffball usages among North American Indians *(Eng)* S349

pumpkin
Mojave—Mohave tatooing and face-painting *(Eng)* S116

pumpkin seed oil
Mexico (Baja California)—Face and body painting in Baja California: a summary *(Eng)* S273

puppets
shadow puppets—The conservation of Javanese shadow puppets *(Eng)* S937
—Restoration of Chinese and Indonesian shadow puppets *(Eng)* S1011

purple dye
dye—Ethnology of Uvea (Wallis Island) *(Eng)* S74

purple paint
bark cloth—The technical aspects of ornamented bark-cloth *(Eng)* S209

purple pigment
hematite—Physico-chemical and colorimetric study of haemitite reds and purples, with reference to the mural paintings of the Acropolis of Lero, or "histories of ochre" *(Fre)* S352
Mexico—Colors and paint at the time of the pre-Cortés Mexican civilizations *(Fre)* S169
pigment—Painted Mexican furniture and trinkets *(Fre)* S178

Vuillard, Edouard (1868-1940)—History, analysis and treatment of "La salle à manger au château de Clayes," 1938, by Edouard Vuillard *(Eng)* S1009

putty
Byzantine—A monument of Byzantine wall painting: the method of construction *(Fre)* S184
extenders—Extenders *(Eng)* S165
wood—The restoration of the wooden statue of Our Lady in the parish church of Corcina *(Ita)* S1078

Puuc
Ancient Mesoamerican mortars, plasters, and stuccos: the Puuc Area *(Eng) lime; Mesoamerican; mortar; plaster; stucco* S198

pyrite
house paint—Topical observations on the use of forgotten pigments used for painting rooms in Lower Saxony *(Ger)* S438
Mexico—Colors and paint at the time of the pre-Cortés Mexican civilizations *(Fre)* S169

pyrolusite
Chowa—Rhodesian engravers, painters and pigment miners of the fifth millennium B.C. *(Eng)* S161
mural paintings—Chemical studies on the pigments of ancient ornamented tombs in Japan *(Eng)* S151
prehistoric—Pigments and paints in prehistoric antiquity *(Fre)* S191

pyrolysis
An improved pyrolytic technique for the quantitative characterization of the media of works of art *(Eng) binding media; paint; quantitative analysis* S575
infrared spectrometry—Instrumental analysis in the coatings industry *(Eng)* S619

pyrolysis gas chromatography
Analysis of natural resins by pyrolysis gas chromatography. II. Identification of natural resins by pyrograms *(Jpn) balsam; copal; dragon's blood; elemi; gamboge (pigment); guaiacum; Peru; resin; rosin* S560
—Analytical pyrolysis as a tool for the characterization of organic substances in artistic and

archaeological objects *(Eng) gas chromatography mass spectrometry; organic materials; patina; vegetable oil* S662
—Application of pyrolysis gas chromatography on some of Van Meegeren's faked Vermeers and Pieter de Hooghs *(Eng) binding media; forgeries; gas chromatography; resin; Van Meegeren studio* S565
—Examination through pyrolysis gas chromatography of binders used in painting *(Eng) aging; binding media; burnt sienna; chromatography; lead white; linseed oil; paintings (objects)* S626
—Forensic applications of pyrolysis capillary gas chromatography *(Eng) adhesives; alkyd resin; gas chromatography; paint; polymers; polyurethane foam; rubber* S609
—The identification of dammar, mastic, sandarac and copals by pyrolysis gas chromatography *(Eng) chromatography; copal; dammar; mastic; resin; sandarac* S638
—Identification of natural gums in works of art using pyrolysis-gas chromatography *(Eng) chromatography; gum; plant materials* S652
—Identification of synthetic materials in modern paintings. 1: varnishes and polymer binders *(Fre) binding media; chromatography; paintings (objects); polymers; synthetic materials; varnish* S660
—The potential of pyrolysis-gas chromatography/mass spectrometry in the recognition of ancient painting media *(Eng) animal glue; casein; egg yolk; fatty acid; gas chromatography mass spectrometry; linseed oil; organic materials; paintings (objects); protein* S678
—Pyrolysis gas chromatographic mass spectrometric identification of intractable materials *(Eng) carbon black; chromatography; gas chromatography; gum; mass spectrometry; paint; polymers; resin* S588
—The use of pyrolysis gas chromatography (PyGC) in the identification of oils and resins found in art and archaeology *(Eng) amber; chromatography; drying oil; oil; resin* S644
acrylic resin—The identification and characterization of acrylic emulsion paint media *(Eng)* S666
forensic science—Developments in paint analysis for forensic purposes *(Eng)* S639
—Forensic analysis of coatings *(Eng)* S615
gas chromatography mass spectrometry—Rapid identification of binding media in paintings using simultaneous pyrolysis methylation gas chromatography *(Eng)* S668
paintings (objects)—Analysis of paint media, varnishes and adhesives *(Eng)* S625
resin—A comparison of pyrolysis mass spectrometry, pyrolysis gas chromatography and infra-red spectroscopy for the analysis of paint resins *(Eng)* S618
wood—Conservation of polychrome wood sculpture at the Australian War Memorial *(Eng)* S944

pyrolysis mass spectrometry
Pyrolysis-mass spectrometry of natural gums, resins, and waxes and its use for detecting such materials in ancient Egyptian mummy cases (cartonnages) *(Eng) adhesives; Egypt;*

gum; mass spectrometry; mummy cases; organic materials; resin; rosin; spectrometry; wax S636
forensic science—Developments in paint analysis for forensic purposes *(Eng)* S639

quantitative analysis
pyrolysis—An improved pyrolytic technique for the quantitative characterization of the media of works of art *(Eng)* S575
reflectance—The use of differential spectral analysis in the study of museum objects *(Eng)* S744

quartz
mining—The mining of gems and ornamental stones by American Indians *(Eng)* S93
Rudolphi, Johann Georg (1633-1693)—Johann Georg Rudolphi (1633-1693). Volume 1 *(Ger)* S584

Quercus *see* oak

quillwork
Blackfoot—Material culture of the Blackfoot Indians *(Eng)* S30

rabbit-skin glue
The treatment of gilded objects with rabbit-skin glue size as consolidating adhesive *(Eng) adhesives; collagen; gesso; gilding* S1107
fluorescence microscopy—Ultraviolet fluorescence microscopy of paint cross sections: cycloheptaamylose-dansyl chloride complex as a protein-selective stain *(Eng)* S671
poly(vinyl alcohol)—Experiments in the use of polyvinyl alcohol as a substitute for animal glues in the conservation of gilded wood *(Eng)* S1100
wood—The restoration of the wooden statue of Our Lady in the parish church of Cercina *(Ita)* S1078

Raccanello E 55050
mural paintings—Conservation of Central Asian wall painting fragments from the Stein Collection in the British Museum *(Eng)* S1099

radioactivity
Radiochemical investigation of ionic penetration into paint films *(Eng) chlorine; coatings; iron oxide; pigment volume concentration; poly(vinyl chloride); strontium* S778

radiocarbon dating
pre-Columbian—Dating precolumbian museum objects *(Eng)* S1115
Shroud of Turin—Microscopical study of the Turin Shroud. III *(Eng)* S598
tools—Potential applications of the organic residues on ancient tools *(Eng)* S624

radiography
illuminations—Some details on the technique and of the restoration of two illuminated 13th century manuscripts from Western Europe *(Fre)* S942
reference materials—Second report on reference materials incorporating special reports by members of the working group: ICOM Committee for Conservation, Madrid, 2-7 October, 1972 *(Eng)* S557

red ocher

A paint mine from the early upper Palaeolithic age near Lovas (Hungary, County Veszprém) *(Eng) Hungary (Lovas); lead; painting (technique); Paleolithic* S170
—Red ochre and human evolution: a case for discussion *(Eng) colorants; dye; minerals* S325
black pigment—Ceramic pigments of the Indians of the Southwest *(Eng)* S40
Bushman paint—A possible base for "Bushman" paint *(Eng)* S66
Chumash—A study of some Californian Indian rock art pigments *(Eng)* S519
Eskimo—Ethnological results of the Point Barrow expedition *(Eng)* S13
icons—Restoration and conservation of an icon from Melnik *(Bul)* S948
India—A study of Indian polychrome wooden sculpture *(Eng)* S255
Mayan—The Maya mural paintings of Bonampak, materials analysis *(Fre)* S539
mural paintings—Analysis of pigments and plaster of the paintings in the Sheesh Mahal, Nagaur *(Eng)* S428
—Chemical studies on ancient pigments in Japan *(Eng)* S138
—Materials and painting techniques of the wall paintings of the main nave of S. Mary's Church in Toruń *(Pol)* S432
—Microchemical analysis of the wall paintings of St. Baafsabtei in Ghent (about 1175) *(Dut)* S90
—Physico-chemical study of the painting layers of the Roman mural paintings from the Acropolis of Lero *(Fre)* S342
—Pigments and techniques of the early Medieval wall paintings of eastern Turkistan *(Ger)* S298
—Pigments used in the paintings of "Hoodo." *(Jpn)* S183
—Structure, composition, and technique of the paintings *(Dut)* S346
—The technique of the paintings at Sitabhinji *(Eng)* S143
Native American—Chinigchinich: a revised and annotated version of Alfred Robinson's translation of Father Geronimo Boscana's historical account of the belief, usages, customs and extravagancies of the Indians of this mission of San Juan Capistrano called the Acagchemem Tribe *(Eng)* S58
ocher—Ocher and ocher industry in the Puisaye region, geology and history *(Fre)* S238
Papua New Guinea (New Ireland)—Assemblage of spirits: idea and image in New Ireland *(Eng)* S403
Pech Merle Cave (France)—Spitting images: replicating the spotted horses *(Eng)* S491
pigment—Ancient Greek pigments from the Agora *(Eng)* S104
—Archaeological expedition to Arizona in 1895 *(Eng)* S17
—The chemical studies on the pigments used in the Main Hall and pagoda of Hōryūji temple (Nara, Japan) *(Jpn)* S119
—Two aboriginal rock pigments from Western Australia: their properties, use and durability *(Eng)* S290

red pigment—Reds *(Ita)* S397
Shroud of Turin—Microscopical study of the Turin "Shroud." *(Eng)* S637
Sudan (Mirgissa)—Physico-chemistry at the service of archaeology: examination of a series of samples from excavations done in Sudan *(Fre)* S545
textiles—Technical study and conservation of an old painted textile (Simhasana) *(Eng)* S902
Tlingit—The conservation of a Tlingit blanket *(Eng)* S909

red paint
Luiseño—The culture of the Luiseño Indians *(Eng)* S26
Pueblo—Two summers' work in Pueblo ruins *(Eng)* S22

red pigment
African red pigments *(Eng) Africa; electron microscopy; iron oxide; microscopy; pigment; plant materials; polarized light microscopy; scanning electron microscopy* S641
—Note on the pigment blocks of the Bushongo, Kasai District, Belgian Congo *(Eng) Bushongo; palm oil; pigment; water; wood; Zaire (Kasai)* S28
—Red pigments of antiquity *(Fre) cinnabar; copper; cuprous oxide; Greek; iron oxide; lead; pigment; realgar; red lead; Roman* S114
—Reds *(Ita) archil; carmine; dragon's blood; litmus; madder; painting (technique); realgar; red lake; red lead; red ocher; sapponwood; vermilion* S397
—Report on the collecting visit to the Wosera-Abelam of Sarakim village, and a note on conservation requirements *(Eng) Abelam; binding media; brushes; inorganic pigment; mineral pigment; paint; pigment; timber* S318
Acoma—The Acoma Indians *(Eng)* S57
Chumash—Volume V: Manufacturing processes, metrology, and trade *(Eng)* S345
dye—Keresan Indian color terms *(Eng)* S102
Fourier transform infrared spectroscopy—Applications of infrared microspectroscopy to art historical questions about Medieval manuscripts *(Eng)* S648
hematite—Physico-chemical and colorimetric study of haematite reds and purples, with reference to the mural paintings of the Acropolis of Lero, or "histories of ochre" *(Fre)* S352
Kwakiutl—Plants in British Columbia Indian technology *(Eng)* S506
Maori—Maori art *(Eng)* S18
Mojave—Mohave tatooing and face-painting *(Eng)* S116
mural paintings—Analysis of pigments and plaster of the paintings in the Sheesh Mahal, Nagaur *(Eng)* S428
—Chemical study on the coloring materials of the murals of the Taka-matsuzuka Tomb in Nara Prefecture *(Jpn)* S272
—Unfinished wall paintings in Egyptian tombs and temples *(Ger)* S192
Native American—Chinigchinich: a revised and annotated version of Alfred Robinson's translation of Father Geronimo Boscana's historical account of the belief, usages, customs and extravagancies of the Indians of this mis-

478

sion of San Juan Capistrano called the Acagchemem Tribe *(Eng)* S58
—Indian uses of native plants *(Eng)* S404
Paleolithic—Paleolithic pigments and processing *(Eng)* S357
pigment—Oracle-bone color pigments *(Eng)* S73
—Two aboriginal rock pigments from Western Australia: their properties, use and durability *(Eng)* S290
rock paintings—Petroglyphs and pictographs on the British Columbia coast *(Eng)* S95
Shroud of Turin—Microscopical study of the Turin Shroud. III *(Eng)* S598
USA (New Mexico— Isleta)—Isleta, New Mexico *(Eng)* S55
Vuillard, Edouard (1868-1940)—History, analysis and treatment of "La salle à manger au château de Clayes," 1938, by Edouard Vuillard *(Eng)* S1009

Redon, Odilon (1840-1916)
charcoal—Tonal drawing and the use of charcoal in nineteenth century France *(Eng)* S468

redwood
dyewood—Dyewoods, their composition and use. Part 1: Description of the most important dyewoods *(Ger)* S204
finishes—Coating formulation: its effects on the durability of exterior wood finishes *(Eng)* S808
Native American—The Indians of the Redwood Belt of California: an ethnobotanical approach to culture area *(Eng)* S260

redwood dye
dyewood—Dyewoods, their composition and use. Part 2: Wood dyes and their fields of application *(Ger)* S205

reference materials
Preliminary report on reference materials: ICOM Committee for Conservation, Amsterdam, 15-19 September, 1969 *(Eng) conservation laboratories; pigment; samples; standards* S549
—Second report on reference materials incorporating special reports by members of the working group: ICOM Committee for Conservation, Madrid, 2-7 October, 1972 *(Eng) cross sections; infrared photography; paintings (objects); paper; radiography; samples; standards; textiles* S557

reflectance
Application of Mie scatter theory to the reflectance of paint-type coatings *(Eng) coatings; optical properties; pigment volume concentration* S758
—Experimental study on spectral reflective properties of a painted layer *(Eng) carbon black; pigment volume concentration; scattering; titanium dioxide; zinc white* S813
—Relation between surface roughness and specular reflectance at normal incidence *(Eng) finishes; ultraviolet* S738
—The use of differential spectral analysis in the study of museum objects *(Eng) absorption; fading; glaze; pigment; quantitative analysis; varnish* S744

coatings—Light reflectance of spherical pigments in paper coatings *(Eng)* S795
colorimetry—Colorimetric measurements on small paint fragments using microspectrophotometry *(Eng)* S589
gloss—Surface appearance (gloss, sheen, and flatness) *(Eng)* S772
latex paint—Changes in hiding during latex film formation *(Eng)* S861
—Changes in hiding during latex film formation. Part II. Particle size and pigment packing effects *(Eng)* S871
opacity—Measurements of the fading of pigments in relation to opacity *(Eng)* S756
paint—A method of hiding power determination and its application as an aid to paint formulation *(Eng)* S737
pigment—Exposure evaluation: quantification of changes in appearance of pigmented materials *(Eng)* S790
pigment volume concentration—Effect of particle size distribution of pigment and pigment volume concentration on flat wall paint properties (solvent type) *(Eng)* S729
—Effect of pigment volume concentration and film thickness on the optical properties of surface coatings *(Eng)* S751
porosity—The production and control of high dry hiding *(Eng)* S740
scattering—Effect of particle crowding on scattering power of TiO_2 pigments *(Eng)* S780

reflected light
color—Goniophotometric analysis of colored surface *(Eng)* S759

relative humidity
fixing—Theoretical approach to refixing *(Fre)* S1017
historic buildings—Conservation within historic buildings in Japan *(Eng)* S973
microscopy—Ultramicrominiaturization of microchemical tests *(Eng)* S555
panel paintings—Basic experiments concerning deterioration of glue and discoloration of pigments, and discussion on the actual condition of wall panel paintings on the basis of their results *(Jpn)* S930
wallpaper—Wallpaper on walls: problems of climate and substrate *(Eng)* S982

relief
adobe—The conservation of adobe walls decorated with mural paintings and reliefs in Peru *(Eng)* S958
clay—Restoration of a relief in painted clay *(Fre)* S887
Egypt (Saqqara)—Identification of medium used in polychrome reliefs in ancient Egyptian limestone tomb dating from the nineteenth dynasty /1350-1200 B.C./ at Saqqara *(Eng)* S649
Herlin Cathedral (Germany)—The scientific examination of the polychromed sculpture in the Herlin altarpiece *(Eng)* S552
mural paintings—The legacy of the Tía Sandalia: consolidation, removal, and mounting of the work in the future Ethnographic Museum of Villacañas (Toledo) *(Spa)* S1083

479

Shipibo—Restoration of Shipibo pottery *(Eng)* S1050
stained glass—Field applications of stained glass conservation techniques *(Eng)* S1013
Sundi—The Kongo I *(Eng)* S162
tempera—The material side: tempera painting—part 1 *(Eng)* S146
thin layer chromatography—High performance thin-layer chromatography for the identification of binding media: techniques and applications *(Eng)* S682
—Methods in scientific examination of works of art. Volume 1: thin-layer chromatography course book *(Eng)* S684
—Methods in scientific examination of works of art. Volume 2: thin-layer chromatography protocols *(Eng)* S685
—Methods in scientific examination of works of art. Volume 3: thin-layer chromatography reference materials binder *(Eng)* S683
—The methods of identifying organic binders in paint layers *(Slo)* S599
—Thin layer chromatography: an aid for the analysis of binding materials and natural dyestuffs from works of art *(Eng)* S559
—Thin-layer chromatography of resin acid methyl esters *(Eng)* S536
Thompson—Thompson ethnobotany: knowledge and usage of plants by the Thompson Indians of British Columbia *(Eng)* S483
USA (New Mexico)—The materials and methods of some religious paintings of early 19th century New Mexico *(Eng)* S142
varnish—Factors affecting the appearance of picture varnish *(Eng)* S721
—The influence of light on the gloss of matt varnishes *(Eng)* S782
—The influence of varnishes on the appearance of paintings *(Eng)* S844
—New book of recipes for the paint and varnish industry *(Ger)* S155
—On picture varnishes and their solvents *(Eng)* S832
—Special report on picture varnish *(Eng)* S529
—Varnish of Pasto, a Colombian craft of aboriginal origin *(Spa)* S212
wood—Investigation into methods and materials for the adhesion of flaking paint on ethnographic objects: a progress report *(Eng)* S1045

retouching
bark paintings—Conservation of Aboriginal bark paintings and artifacts *(Eng)* S908
binding media—The problem of conservation of very large canvases painted in glue medium *(Pol)* S968
ceilings—The restoration of the wooden painted ceiling in the "Confraternità del Rosario," SS. Filippo and Giacomo Church, Ospedaletto d'Alpinolo *(Ita)* S1096
masks—The examination and treatment of two wood funerary masks with Negroid features *(Eng)* S990
shields (armor)—Restoration of a ceremonial shield from the Solomon Islands *(Ger)* S1025
wood—The restoration of the wooden statue of Our Lady in the parish church of Cercina *(Ita)* S1078

reversibility
pest control—A historical survey of the materials used for pest control and consolidation in wood *(Ger)* S1010

rheology
calcium carbonate—Optical properties of calcium carbonate in paper coatings *(Eng)* S807
coatings—Paint and surface coatings: theory and practice *(Eng)* S849
gloss—Gloss of paint films and the mechanism of pigment involvement *(Eng)* S872

rhodochrosite
Chowa—Rhodesian engravers, painters and pigment miners of the fifth millennium B.C. *(Eng)* S161

rhodonite
Chowa—Rhodesian engravers, painters and pigment miners of the fifth millennium B.C. *(Eng)* S161

Rhodopas
animal glue—Searching for a solution to the problem of altered mat paintings: a new product is needed *(Fre)* S1071

Rhoplex AC 33
acrylic resin—A study of acrylic dispersions used in the treatment of paintings *(Eng)* S1066

Rhoplex AC 34
acrylic resin—A study of acrylic dispersions used in the treatment of paintings *(Eng)* S1066

ritual objects
Eshu-Elegba: the Yoruba trickster god *(Eng) blood; dye; paint; palm oil; plants; Yoruba* S292
Chumash—Volume IV: Ceremonial paraphernalia, games, and amusements *(Eng)* S344
Hopi—The Na-ac-nai-ya: a Tusayan initiation ceremony *(Eng)* S12
Iatmul—The conservation of an orator's stool from Papua New Guinea *(Eng)* S1042
Papua New Guinea (Wosera-Abelam)—The removal and conservation of the painted bark (palm leaf petiole) panels and carved figures from a Papua New Guinea "Haus Tambaran" *(Eng)* S1056
pigment—Archaeological expedition to Arizona in 1895 *(Eng)* S17

rituals
Akan—The theory and practice of conservation among the Akans of Ghana *(Eng)* S516
Igbo—Uli painting and Igbo world view *(Eng)* S444
Polynesian—Traditional use of *Curcuma longa* (Zingiberaceae) in Rotuma *(Eng)* S518
rock art—Pictures of the dreaming: Aboriginal rock art of Australia *(Eng)* S390
Yoruba—Gelede: a Yoruba masquerade *(Eng)* S250

Robert, Karl
charcoal—Tonal drawing and the use of charcoal in nineteenth century France *(Eng)* S468

rock art
The ancients knew their paints *(Eng) azurite; binding media; blood; carbon black; chalk; charcoal; clay; egg; fat; graphite; gypsum; he-*

Roman

hematite—Physico-chemical and colorimetric study of haemitite reds and purples, with reference to the mural paintings of the Acropolis of Lero, or "histories of ochre" *(Fre)* S352
kohl—Analysis of materials contained in mid-4th to early 7th-century A.D. Palestinian kohl tubes *(Eng)* S497
mummies—Probing the mysteries of ancient Egypt: chemical analysis of a Roman period Egyptian mummy *(Eng)* S673
mural paintings—A contribution on the history of materials *(Ger)* S173
—Mural painting technique of Herculaneum *(Ita)* S186
—Physico-chemical study of the painting layers of the Roman mural paintings from the Acropolis of Lero *(Fre)* S342
—Proposals on the technique of Roman mural paintings *(Ita)* S235
ocher—French ocher from Berry *(Fre)* S124
painting (technique)—Greek and Roman methods of painting: some comments on the statements made by Pliny and Vitruvius about wall and panel painting *(Eng)* S29
pigment—Pigments and paints in classical antiquity *(Fre)* S200
—Some experiments and observations on the colours used in painting by the ancients *(Eng)* S1
Pompeiian Style—Pompeian colors *(Eng)* S229
red pigment—Red pigments of antiquity *(Fre)* S114
Romano-British—An analysis of paints used in Roman Britain *(Eng)* S210
stucco—Restoration and display of Egyptian stucco mummy masks from the period of the Roman Empire *(Eng)* S1027

Romanesque
frescoes—The conservation in situ of the Romanesque wall paintings of Lambach *(Eng)* S1098
mural paintings—Early Medieval wall painting and painted sculpture in England: based on the proceedings of a symposium at the Courtauld Institute of Art, February 1985 *(Eng)* S459
—Mural paintings in the Fraugde church on Funen *(Dan)* S302
Ottonian—The painted ceiling from the Romanesque period in the Protestant church of Saint Michael at Hildesheim *(Ger)* S1073

Romania
Specific forms of degradation and their causes in wood panel tempera paintings *(Rum)* handling; humidity; paintings (objects); panel paintings; tempera; wood S439

Romania (Humor)
mural paintings—Specific problems concerning the restoration of wall paintings at Humor *(Eng)* S1034

Romano-British
An analysis of paints used in Roman Britain *(Eng)* antimony; arsenic; blue pigment; chromium; copper; Great Britain; lead sulfide; magnesium; manganese; nickel; ocher; paint; pig-

ment; plaster; potassium; Roman; sand; silica; sulfide; turquoise S210
—An analysis of paints used in Roman Britain *(Eng)* crystallography; Egyptian blue; mural paintings; paint; pigment; plaster; turquoise; x-ray diffraction S213

rooms
house paint—Topical observations on the use of forgotten pigments used for painting rooms in Lower Saxony *(Ger)* S438

root
bark cloth—The technical aspects of ornamented bark-cloth *(Eng)* S209

rope
pine tar—Analysis of Finnish pine tar and tar from the wreck of frigate St. Nikolai *(Eng)* S650

rosewood
dye—Rosewood, dragon's blood and lac *(Eng)* S181

rosin
balsam—The history of naval stores in coatings *(Eng)* S480
pigment—Studies on the ancient pigments in Japan *(Eng)* S52
pyrolysis gas chromatography—Analysis of natural resins by pyrolysis gas chromatography. II. Identification of natural resins by pyrograms *(Jpn)* S560
pyrolysis mass spectrometry—Pyrolysis-mass spectrometry of natural gums, resins, and waxes and its use for detecting such materials in ancient Egyptian mummy cases (cartonnages) *(Eng)* S636
resin—The technology of natural resins *(Eng)* S99

Rothko Chapel (Houston, TX, USA)
mural paintings—Preliminary studies for the conservation of the Rothko Chapel paintings: an investigative approach *(Eng)* S336

Rothko, Mark (1903-1970)
Damaged goods *(Eng)* contemporary art; Harvard Murals; paintings (objects); pigment S410
—Mark Rothko's Harvard murals *(Eng)* artists' materials; delamination; fading; flaking; Harvard Murals; paintings (objects) S413
—Mark Rothko's Harvard murals are irreparably faded by sun *(Eng)* fading; Harvard Murals; paintings (objects) S418
contemporary art—Ephemeral paintings on "permanent view": the accelerated ageing of Mark Rothko's paintings *(Eng)* S399
mural paintings—Preliminary studies for the conservation of the Rothko Chapel paintings: an investigative approach *(Eng)* S336

rubber
binding media—The importance of binders *(Fre)* S225
ethnobotany—An introductory study of the arts, crafts, and customs of the Guiana Indians *(Eng)* S34
extenders—Extenders *(Eng)* S165
plants—The use of wild plants in tropical South America *(Eng)* S132

Salomon, Charlotte
gouache—Problems of conservation encountered with gouache paintings by Charlotte Salomon (1941-1943) *(Ger)* S1114

salt
frescoes—The conservation in situ of the Romanesque wall paintings of Lambach *(Eng)* S1098
—The consolidation of friable frescoes *(Eng)* S1015
mural paintings—Ajanta murals: their composition and technique and preservation *(Eng)* S232
—Conservation of mural paintings in Central Asia which have been damaged by salt efflorescence *(Eng)* S888
—Restoration of ancient monumental painting in cult buildings *(Eng)* S284
rock art—The recording of rock art: an illustrated paper presented to the Canadian Conservation Institute trainees and to the Course in the Conservation of Historic Monuments and Sites, Restoration Services Division, Engineering and Architecture Branch, D.I.N.A. *(Eng)* S283

Samoa
bark cloth—Samoan material culture *(Eng)* S50

samples
encaustic painting—The technology, examination and conservation of the Fayum portraits in the Petrie Museum *(Eng)* S965
infrared spectrometry—Methods in scientific examination of works of art: infrared microspectroscopy *(Eng)* S664
microscopy—Ultramicrominiaturization of microchemical tests *(Eng)* S555
Native American—CCI Native Materials Project: final report *(Eng)* S473
pastels (visual works)—An investigation into the use of several substances as fixatives for works of art in pastel *(Eng)* S953
polyester—Embedding paint cross section samples in polyester resins: problems and solutions *(Eng)* S679
reference materials—Preliminary report on reference materials: ICOM Committee for Conservation, Amsterdam, 15-19 September, 1969 *(Eng)* S549
—Second report on reference materials incorporating special reports by members of the working group: ICOM Committee for Conservation, Madrid, 2-7 October, 1972 *(Eng)* S557
thin layer chromatography—Methods in scientific examination of works of art. Volume 2: thin-layer chromatography protocols *(Eng)* S685

San
Bushman paint—A possible base for "Bushman" paint *(Eng)* S66

sand
Baumeister, Willi (1889-1955)—Studies of the painting techniques of Willi Baumeister *(Ger)* S496
Romano-British—An analysis of paints used in Roman Britain *(Eng)* S210

sand paintings
A calendar of dreamings *(Eng) Australia; Australian Aboriginal; painting (technique); plants* S295
—Conservation of a Navajo sand-painting *(Eng) Navajo; poly(vinyl acetate)* S912

sandalwood
dye—Rosewood, dragon's blood and lac *(Eng)* S181

sandarac
binding media—Perspectives on the chemistry of old paint binders *(Fre)* S535
Egypt—What do we know about the paints of the old Egyptians? *(Eng)* S137
pyrolysis gas chromatography—The identification of dammar, mastic, sandarac and copals by pyrolysis gas chromatography *(Eng)* S638

sandstone
Bushman paint—A possible base for "Bushman" paint *(Eng)* S66
mural paintings—Analysis of pigments and plaster of the paintings in the Sheesh Mahal, Nagaur *(Eng)* S428
polymers—The mechanism of polymer migration in porous stones *(Eng)* S1047
rock paintings—Two painted and engraved sandstone sites in Australia *(Eng)* S294
sedimentary rock—Atlas of sedimentary rocks under the microscope *(Eng)* S611

Santa Croce cathedral (Florence, Italy)
mural paintings—Wall painting conservation in Tuscany before the Florentine flood of 1966 *(Eng)* S1125

sap
Australian Aboriginal—Dawn of art: painting and sculpture of Australian Aborigines *(Eng)* S224
—Methods and materials used in Australian Aboriginal art *(Eng)* S380
Native American—The ethnobotany of the California Indians: a compendium of the plants, their users, and their uses *(Eng)* S269
New Guinea—Wow-Ipits: eight Asmat woodcarvers of New Guinea *(Eng)* S231
Papua New Guinea—Technique and personality *(Eng)* S211
resin—Resin classification by the Ka'apor Indians *(Eng)* S451
Seri blue—Seri blue *(Eng)* S217
sumac—The use of the sumacs by the American Indian *(Eng)* S72

sapponwood
dyewood—Dyewoods, their composition and use. Part 1: Description of the most important dyewoods *(Ger)* S204
red pigment—Reds *(Ita)* S397

sawdust
clay—Restoration of a relief in painted clay *(Fre)* S887

scalpel
encaustic wax—The cleaning and consolidation of Egyptian encaustic mummy portraits *(Eng)* S1088

—Maori carvings in Auckland museum, New Zealand. Ethical considerations in their restoration *(Eng)* S360
metal—The conservation of painted and polychromed metal work. Two case studies from the V & A Museum *(Eng)* S1086
mural paintings—Early Medieval wall painting and painted sculpture in England: based on the proceedings of a symposium at the Courtauld Institute of Art, February 1985 *(Eng)* S459
—The legacy of the Tía Sandalia: consolidation, removal, and mounting of the work in the future Ethnographic Museum of Villacañas (Toledo) *(Spa)* S1083
patina—The study of patina *(Fre)* S416
polychromy—Disinfestation and consolidation of polychromed wood at the Institut Royal du Patrimoine Artistique, Brussels *(Eng)* S957
—Problems of the interpretation of historical sources and their confirmation by the results of technical analysis on works of art, shown on the example of painted sculptures from the 18th century in southern Germany *(Ger)* S322
reattaching—Reattaching thick color layer of polychrome wooden sculpture *(Jpn)* S1022
terracotta—The treatment and examination of painted surfaces on eighteenth-century terracotta sculptures *(Eng)* S469
wax—The preservation of wood sculpture: the wax immersion method *(Eng)* S890
Wayang—Restoration of Indonesian Wayang-figures in the National Ethnographical Museum of Dresden *(Ger)* S1049
wood—Case studies in the treatment of polychrome wood sculptures at the Victoria and Albert Museum *(Eng)* S1006
—Colouring technique and repair methods for wooden cultural properties *(Eng)* S303
—Conservation of polychrome wood sculpture at the Australian War Memorial *(Eng)* S944

sealing compounds
creosote—Notes on creosote lac scale insect resin as a mastic and sealant in the Southwestern Great Basin *(Eng)* S481

seals
boots—The examination, treatment and analysis of a pair of boots from the Aleutian Islands including a note about possible pesticide contamination *(Eng)* S387

seaweed
adhesives—Natural adhesives in East Asian paintings *(Eng)* S372
screens (doors)—Treatment on painting of sliding screens and wall panels to prevent exfoliation in Japan *(Eng)* S972

secco
ceramics—Technological notes on the pottery, pigments, and stuccoes from the excavations at Kaminaljuyu, Guatemala *(Eng)* S107
fresco painting (technique)—Fresco painting: modern methods and techniques for painting in fresco and secco *(Eng)* S111
frescoes—19th and early 20th century restorations of English Mediaeval wall paintings: problems and solutions *(Eng)* S1116

mural paintings—The restoration of 18th-century decorative wall paintings imitating wall-hangings in Hungary *(Ger)* S321

sedimentary rock
Atlas of sedimentary rocks under the microscope *(Eng) carbonate rock; limestone; microscopy; sandstone; staining (analysis); stone; thin sections* S611

seeds
fatty acid—Fatty acid composition of 20 lesser-known Western Australian seed oils *(Eng)* S676
Hopi—Hopi journal of Alexander M. Stephen *(Eng)* S70
—The Na-ac-nai-ya: a Tusayan initiation ceremony *(Eng)* S12
Kachina masks—Zuni Katcinas *(Eng)* S53
Native American—American Indian painting of the Southwest and Plains areas *(Eng)* S239
—Chinigchinich: a revised and annotated version of Alfred Robinson's translation of Father Geronimo Boscana's historical account of the belief, usages, customs and extravagancies of the Indians of this mission of San Juan Capistrano called the Acagchemem Tribe *(Eng)* S58
—Handbook of American Indians north of Mexico *(Eng)* S25

Semelai
resin—The exploitation of resinous products in a lowland Malayan forest *(Eng)* S391
—Resin classification among the Semelai of Tasek Bera, Pahang, Malaysia *(Eng)* S392

sepia
drawing (technique)—The craft of old-master drawings *(Eng)* S182

sepiolite
Maya blue—Maya blue: a clay-organic pigment? *(Eng)* S543

Serbia
illumination (decoration)—Writing technique and illumination of ancient Serbian manuscripts *(Fre)* S338

Seri
People of the desert and sea: ethnobotany of the Seri Indians *(Eng) adhesives; binding media; colorants; creosote; dye; ethnobotany; Native American; plants* S376

Seri blue
Seri blue *(Eng) bark; clay; Franseria dumosa; guaicum; kiva; Native American; sap* S217
—Seri blue—an explanation *(Eng) blue pigment; clay; guaicum; kiva; Native American; resin; staining (finishing); x-ray diffraction* S218

serpentine
Native American—What did they use for paint? *(Eng)* S236

sesquioxide (iron)
Pueblo—Two summers' work in Pueblo ruins *(Eng)* S22

sgraffito
mural paintings—The techniques, conservation, and restoration of mural paintings *(Ita)* S64

shadow puppets
The conservation of Javanese shadow puppets *(Eng) Indonesia (Java); puppets; skin; storage* S937
—Restoration of Chinese and Indonesian shadow puppets *(Eng) Chinese; coatings; dye; egg white; fixing; hot spatula; Indonesian; ox gall; paint; parchment; puppets; size (material); starch; sugar; tempera* S1011
—The restoration of shadow puppets *(Ger) adhesives; Asia; color; egg white; gold leaf; hide; hot spatula; paint; parchment* S976
leather—The behavior of colors on leather and parchment objects and the resulting problems of conservation *(Ger + Eng)* S1068

shale
copper carbonate—The mamzrauti: a Tusayan ceremony *(Eng)* S11
Hopi—The Na-ac-nai-ya: a Tusayan initiation ceremony *(Eng)* S12

Shang
pigment—The T'u-lu colour-container of the Shang-Chou period *(Eng)* S222

Shapiro, Joel (act. 20th century)
contemporary art—Interview with Joel Shapiro *(Eng)* S460

shark oil
Bella Coola—Materia medica of the Bella Coola and neighbouring tribes of British Columbia *(Eng)* S48

shea butter
Tamberma—Architecture of the Tamberma (Togo) *(Eng)* S332

Sheesh Mahal (Nagaur, India)
mural paintings—Analysis of pigments and plaster of the paintings in the Sheesh Mahal, Nagaur *(Eng)* S428

shell
Maori—Some early examples of the conservation of Maori wood carvings in the collections of the British Museum *(Eng)* S1055
Papua New Guinea—Technique and personality *(Eng)* S211

shellac
binding media—Artificial samples of paint binders. Oils, resins, waxes, glues, egg, prepared in binary mixtures: analytical characteristics and properties *(Ita)* S631
glaze—On the material side. Glazes and glazing—Part 2 *(Eng)* S148
India—A study of Indian polychrome wooden sculpture *(Eng)* S255
Maori—Some early examples of the conservation of Maori wood carvings in the collections of the British Museum *(Eng)* S1055
mural paintings—Ajanta murals: their composition and technique and preservation *(Eng)* S232
resin—The technology of natural resins *(Eng)* S99
Shipibo—Restoration of Shipibo pottery *(Eng)* S1050
stone—The consequences of previous adhesives and consolidants used for stone conservation at the British Museum *(Eng)* S1052

shells
Australian Aboriginal—Dawn of art: painting and sculpture of Australian Aborigines *(Eng)* S224

shields (armor)
The conservation of some carved wooden war shields from the Tifalmin Valley, Papua New Guinea *(Eng) cleaning; consolidation; flaking; Papua New Guinea (Tifalmin Valley); pigment; poly(vinyl acetate); wood* S950
—Restoration of a ceremonial shield from the Solomon Islands *(Ger) Elastosil A33; fixing; gum; hydroxypropylcellulose; mosaics; mother of pearl; Oceania; parinarium nut; pigment; poly(vinyl acetate); protein; retouching; Solomon Islands* S1025

Shinn, Everett (1876-1953)
pastels (crayons)—American pastels of the late nineteenth & early twentieth centuries: materials and techniques *(Eng)* S442

Shipibo
Restoration of Shipibo pottery *(Eng) ceramics; inpainting; resin; shellac* S1050

shipwrecks
pine tar—Analysis of Finnish pine tar and tar from the wreck of frigate St. Nikolai *(Eng)* S650

Shosoin (Nara, Japan)
Japan—Pigments used on Japanese paintings from the protohistoric period through the 17th century *(Eng)* S315

shrines
mural paintings—Reproduction of colored patterns in temples and shrines *(Eng)* S383

shrinkage
cracking—Crack mechanisms in gilding *(Eng)* S874
Jelling Man—The Jelling Man and other paintings from the Viking age *(Eng)* S420

Shroud of Turin
Light microscopical study of the Turin Shroud. I *(Eng) blood; iron oxide; light microscopy; linen; microscopy; pigment* S592
—Light microscopical study of the Turin Shroud. II *(Eng) binding media; light microscopy; linen; tempera* S593
—Microscopical study of the Turin "Shroud." *(Eng) authenticity; collagen; electron microprobe; microscopy; polarized light microscopy; red ocher; vermilion* S637
—Microscopical study of the Turin Shroud. III *(Eng) blood; electron microprobe; hematite; iron oxide; pigment; radiocarbon dating; red pigment; vermilion; yellow pigment* S598
microscopy—Microscopical study of the Turin "Shroud," IV *(Eng)* S627

sibukau
dyewood—Dyewoods, their composition and use. Part 1: Description of the most important dyewoods *(Ger)* S204

sienna
frescoes—Fresco paintings of Ajanta *(Eng)* S126

snail
Mexico—Colors and paint at the time of the pre-Cortés Mexican civilizations *(Fre)* S169
pigment—Painted Mexican furniture and trinkets *(Fre)* S178

soap
encaustic wax—The cleaning and consolidation of Egyptian encaustic mummy portraits *(Eng)* S1088
extenders—Size and shape properties of representative white hiding and extender pigments *(Eng)* S727

Society of Dyers and Colorists (CIE) (Bradford, England)
colorimetry—Colorimetric measurements on small paint fragments using microspectrophotometry *(Eng)* S589

sodium hydroxide
Medieval—Observations on a late Medieval painting medium *(Eng)* S117
mural paintings—Ajanta murals: their composition and technique and preservation *(Eng)* S232
stabilizers—Identification of stabilizing agents *(Eng)* S527

softwood
cracking—Cracking on paintings *(Ger)* S718
history of technology—Chemistry of painting surfaces from earliest time to unfathomable future *(Eng)* S279
Vuillard, Edouard (1868-1940)—History, analysis and treatment of "La salle à manger au château de Clayes," 1938, by Edouard Vuillard *(Eng)* S1009

sol-gel
stained glass—A new fixation method for paint layer conservation *(Eng)* S1091

Solomon Islands
shields (armor) Restoration of a ceremonial shield from the Solomon Islands *(Ger)* S1025

solubility
acrylic resin—A study of acrylic dispersions used in the treatment of paintings *(Eng)* S1066
binding media—Contributions to the analysis of binders, adhesives and ancient varnishes *(Fre)* S547
chalk—Observations about conservation techniques regarding the consolidation of waterbound chalk paint layers *(Ger)* S1077
encaustic wax—The cleaning and consolidation of Egyptian encaustic mummy portraits *(Eng)* S1088
gelatin—IR-spectroscopic analysis of aged gelatins *(Eng)* S596
pigment—Paint flow and pigment dispersion: a rheological approach to coatings and ink technology *(Eng)* S802
Plextol B500—Evaluation of the stability, appearance and performance of resins for the adhesion of flaking paint on ethnographic objects *(Eng)* S1101
totem poles—The conservation of a Tlingit totem pole *(Eng)* S309

soluble nylon
human head—The conservation of a preserved human head *(Eng)* S935
stone—The consequences of previous adhesives and consolidants used for stone conservation at the British Museum *(Eng)* S1052
—The conservation of the Winchester Anglo-Saxon fragment *(Eng)* S1090
Thailand—Conservation of wall paintings in Thailand *(Eng)* S927
Tlingit—The conservation of a Tlingit blanket *(Eng)* S909

soluble salts
excavations—Conservation of excavated intonaco, stucco, and mosaics *(Eng)* S1007

solvents
adhesives—Adhesives for impregnation of painting on canvas *(Swe)* S1087
—The evaluation of some adhesive systems utilized in the consolidation of paintings. The kinetics of consolidation (I) *(Rum)* S1019
—The evaluation of some adhesive systems utilized in the consolidation of paintings. The kinetics of consolidation (II) *(Rum)* S1020
—The evaluation of some adhesive systems utilized in the consolidation of paintings. The kinetics of consolidation (III) *(Rum)* S1021
artists' materials—The artist's handbook of materials and techniques *(Eng)* S83
—The painter's craft *(Fre)* S462
chalk—Observations about conservation techniques regarding the consolidation of waterbound chalk paint layers *(Ger)* S1077
coatings—Formulating for better control of internal stress *(Ita)* S835
encaustic wax—The cleaning and consolidation of Egyptian encaustic mummy portraits *(Eng)* S1088
finishes—Fundamentals of formulation of interior architectural finishes *(Eng)* S724
infrared spectrometry Instrumental analysis in the coatings industry *(Eng)* S619
lacquer—Lists of raw materials for lacquer *(Ger)* S402
ocher—Friable ochre surfaces: further research into the problems of colour changes associated with synthetic resin consolidation *(Eng)* S997
painting (technique)—Painting materials: a short encyclopaedia *(Eng)* S227
pigment volume concentration—Critical pigment volume concentration of paints. Its measurement and some relationships *(Eng)* S857
poly(butyl methacrylate)—New possibilities of polybutyl methacrylate as a consolidating agent for glue painting on loess plaster *(Eng)* S936
polymers—Consolidation of the pictorial layer of illuminations with pure synthetic polymers *(Fre)* S989
—The mechanism of polymer migration in porous stones *(Eng)* S1047
resin—The technology of natural resins *(Eng)* S99
tempera—Examination and treatment of a tempera on canvas from the 16th century: the

Emmaus Pilgrims from the Fine Arts Museum of Brussels *(Fre)* S981
thin layer chromatography—Improved thin-layer chromatographic method for sugar separations *(Eng)* S583
—Separation of carbohydrates by thin-layer chromatography *(Eng)* S550
varnish—On picture varnishes and their solvents *(Eng)* S832
Vuillard, Edouard (1868-1940)—History, analysis and treatment of "La salle à manger au château de Clayes," 1938, by Edouard Vuillard *(Eng)* S1009

soot
Africa—Personality and technique of African sculptors *(Eng)* S208
Africa, West—Handbook of West African art *(Eng)* S164
black pigment—Classification of black pottery pigments and paint areas *(Eng)* S249
dye—Ethnology of Uvea (Wallis Island) *(Eng)* S74
Maori—Maori art *(Eng)* S18
mural paintings—Ajanta murals: their composition and technique and preservation *(Eng)* S232
—Unfinished wall paintings in Egyptian tombs and temples *(Ger)* S192
prehistoric—Pigments and paints in prehistoric antiquity *(Fre)* S191
rock art—The ancients knew their paints *(Eng)* S249
Rwanda—Colors and drawings in Rwanda *(Fre)* S158

Sotatsu (act. 17th century)
screens (furniture)—Restoration of a Japanese screen *(Ger)* S949

South Africa
rock art—Dating and context of rock engravings in South Africa *(Eng)* S582

South America
bark cloth—Patterns of paradise: the styles and significance of bark cloth around the world *(Eng)* S319
dye—Colors for textiles: ancient and modern *(Eng)* S109
plants—The use of wild plants in tropical South America *(Eng)* S132
resin—Preliminary investigations of Hymenaea courbaril as a resin producer *(Eng)* S233

Spain
fresco painting (technique)—The art of fresco painting as practised by the old Italian and Spanish masters, with a preliminary inquiry into the nature of the colours used in fresco painting, with observations and notes *(Eng)* S156
mural paintings—Products, facts, modes in mural painting: evolution and distribution of restoration products used in mural paintings from 1850 to 1992. A first sorting concerning France, Spain, England, and Poland *(Fre)* S511

Spain (Altamira)
mural paintings—The earliest known paints *(Eng)* S153

Spain (Barcelona)
Miró, Joan (1893-1983)—Joan Miro: comment and interview *(Eng)* S125

Spain (Catalonia)
Architecture and decorated surfaces in Catalonia *(Fre) architecture; churches; frescoes; mural paintings; stucco* S456
paintings (objects)—Centre for the Conservation and Restoration of Movable Cultural Property of Catalonia: a record of achievements, 1982-1988 *(Cat)* S1063

Spain (Toledo)
Mudéjar—Technical examination and consolidation of the paint layer on a Mudéjar coffered ceiling in the Convent of Santa Fe, Toledo *(Eng)* S1110
mural paintings—The legacy of the Tía Sandalia: consolidation, removal, and mounting of the work in the future Ethnographic Museum of Villacañas (Toledo) *(Spa)* S1083

Spanish
plants—Gathering the desert *(Eng)* S378

Spanish School
panel paintings—Wings from a quadriptych with the legend of St. John the Baptist: general problems and the treatment of conservation *(Pol)* S917

specimens
Papua New Guinea—An ethnographic collecting expedition to Papua New Guinea: field conservation and laboratory treatment *(Eng)* S967

spectrometry
binding media—Contributions to the analysis of binders, adhesives and ancient varnishes *(Fre)* S547
—Perspectives on the chemistry of old paint binders *(Fre)* S535
blue pigment—Identification of materials of paintings: I. Azurite and blue verditer *(Eng)* S541
forensic science—Developments in paint analysis for forensic purposes *(Eng)* S639
Fourier transform infrared spectroscopy—Analysis of aged paint binders by FTIR spectroscopy *(Eng)* S657
—Applications of infrared microspectroscopy to art historical questions about Medieval manuscripts *(Eng)* S648
—Fourier transform infrared spectral analysis of natural resins used in furniture finishes *(Eng)* S646
gelatin—IR-spectroscopic analysis of aged gelatins *(Eng)* S596
infrared spectrometry—Methods in scientific examination of works of art: infrared microspectroscopy *(Eng)* S664
iron oxide—Infrared study of the yellow and red iron oxide pigments *(Ger)* S551
microscopy—Microanalytical examination of works of art: two examples of the examination of paint layers *(Ger)* S612
Mudéjar—Technical examination and consolidation of the paint layer on a Mudéjar coffered ceiling in the Convent of Santa Fe, Toledo *(Eng)* S1110

paint—Method to follow the degradation by natural weathering of emulsion paint films *(Ger)* S829

paintings (objects)—Analysis of paint media, varnishes and adhesives *(Eng)* S625

Peru—An analytical study of pre-Inca pigments, dyes and fibers *(Eng)* S571

pine tar—Analysis of Finnish pine tar and tar from the wreck of frigate St. Nikolai *(Eng)* S650

polysaccharides—The detection of polysaccharides in the constituent materials of works of art *(Fre)* S537

pyrolysis mass spectrometry—Pyrolysis-mass spectrometry of natural gums, resins, and waxes and its use for detecting such materials in ancient Egyptian mummy cases (cartonnages) *(Eng)* S636

Sudan (Mirgissa)—Physico-chemistry at the service of archaeology: examination of a series of samples from excavations done in Sudan *(Fre)* S545

wood—Identification of archaeological and recent wood tar pitches using gas chromatography/mass spectrometry and pattern recognition *(Eng)* S655

x-ray diffraction—Nondestructive infrared and x-ray diffraction analyses of paints and plastics *(Eng)* S532

spectrophotometry
Spectrophotometry for the analysis and description of color *(Eng) color* S750
—The use of microspectrophotometry for the identification of pigments in small paint samples *(Eng) paint; pigment* S613

colorimetry—Colorimetric measurements on small paint fragments using microspectrophotometry *(Eng)* S589

forensic science—Developments in paint analysis for forensic purposes *(Eng)* S639

Herlin Cathedral (Germany) The scientific examination of the polychromed sculpture in the Herlin altarpiece *(Eng)* S552

house paint—Problems in the restoration and preservation of old house paints *(Eng)* S947

illuminations—The development of techniques of identification for pigments and binders used in the paint layer of manuscript illuminations *(Fre)* S546

Maya blue—Examination and identification of Maya blue *(Fre)* S544

thin layer chromatography—Analysis of thin-layer chromatograms of paint pigments and dyes by direct microspectrophotometry *(Eng)* S620

spinifex
Australian Aboriginal—An Alyawara day: flour, spinifex gum, and shifting perspectives *(Eng)* S361

Egyptian—Notes on Egyptian colours *(Eng)* S16

spot tests
Spot tests in inorganic analysis *(Eng) inorganic materials; manuals; minerals* S556
—Spot tests in organic analysis *(Eng) organic materials* S540

blue pigment—Identification of materials of paintings: I. Azurite and blue verditer *(Eng)* S541

spruce
house paint—House paints in Colonial America: their materials, manufacture and application. Part III *(Eng)* S230

Sri Lanka
mural paintings—A survey of the painted mud *Viharas* of Sri Lanka *(Eng)* S351

St. John's white
mural paintings—Structure, composition, and technique of the paintings *(Dut)* S346

stabilizers
Identification of stabilizing agents *(Eng) barium hydroxide; calcium chloride; gum arabic; lead acetate; paintings (objects); sodium hydroxide; starch; thickening; tragacanth* S527

varnish—Old master paintings: a study of the varnish problem *(Eng)* S856

stabilizing
consolidation—Consolidation of loose paint on ethnographic wooden objects *(Ger)* S901

encaustic painting—The technology, examination and conservation of the Fayum portraits in the Petrie Museum *(Eng)* S965

panel paintings—Methods of egg-tempera panel painting conservation employed in the State Hermitage *(Eng)* 3986

synthetic resin—Restoration with synthetic resins in Japan *(Ger)* S966

stacco
adobe—1981 report on the development of methods for the conservation of Pueblo Indian mural paintings in the American Southwest *(Eng)* S995

stained glass
Field applications of stained glass conservation techniques *(Eng) Abelebond 342-1; adhesion; copper foil; epoxy; glass; lamps; paint; resin; silane; Union Carbide A-1100; USA (New York); windows* S1013
—A new fixation method for paint layer conservation *(Eng) coatings; consolidation; corrosion; fixing; inorganic gel; sol-gel; windows* S1091

conservation—Conservation of interior decoration and furniture of monuments *(Ger)* S806

Medieval—Medieval surface techniques, II *(Eng)* S122
—Pigments and paints in the Middle Ages *(Fre)* S199

staining (analysis)
acrylic resin—The identification and characterization of acrylic emulsion paint media *(Eng)* S666

Australian Aboriginal—An identification method for fat and/or oil binding media used on Australian Aboriginal objects *(Eng)* S680

fluorescence microscopy—Ultraviolet fluorescence microscopy of paint cross sections: cycloheptaamylose-dansyl chloride complex as a protein-selective stain *(Eng)* S671

microscopy—Dispersion staining *(Eng)* S610

—The use of direct reactive fluorescent dyes for the characterization of binding media in cross sectional examinations *(Eng)* S635
paintings (objects)—Analysis of paint media, varnishes and adhesives *(Eng)* S625
pigment volume concentration—Characterization of pigment volume concentration effects in latex paints *(Eng)* S819
polarized light microscopy—Polarized light microscopy *(Eng)* S614
sedimentary rock—Atlas of sedimentary rocks under the microscope *(Eng)* S611

staining (finishing)
house paint—Historic finishes analysis *(Eng)* S441
mechanical properties—Mechanical properties of weathered paint films *(Eng)* S851
plants—The useful plants of west tropical Africa *(Eng)* S374
Seri blue—Seri blue—an explanation *(Eng)* S218
Tamberma—Architecture of the Tamberma (Togo) *(Eng)* S332
Thompson—Ethnobotany of the Thompson Indians of British Columbia, based on field notes by James A. Teit *(Eng)* S45
—Thompson ethnobotany: knowledge and usage of plants by the Thompson Indians of British Columbia *(Eng)* S483
wood—The folk art tradition in painting on wood: paste and casein techniques *(Ger)* S314
—Wood documentation. VII: wood conservation and surface treatment. Volume 2: surface treatment *(Fre)* S897

standards
acrylic resin—The identification and characterization of acrylic emulsion paint media *(Eng)* S666
American Society for Testing and Materials (USA)—The colourful twentieth century *(Eng)* S434
pigment—Artists' pigments: a handbook of their history and characteristics *(Eng)* S623
reference materials—Preliminary report on reference materials: ICOM Committee for Conservation, Amsterdam, 15-19 September, 1969 *(Eng)* S549
—Second report on reference materials incorporating special reports by members of the working group: ICOM Committee for Conservation, Madrid, 2-7 October, 1972 *(Eng)* S557
thin layer chromatography—Methods in scientific examination of works of art. Volume 2: thin-layer chromatography protocols *(Eng)* S685

starch
Australian Aboriginal—Bush food: Aboriginal food and herbal medicine *(Eng)* S401
Egypt—Ancient Egyptian materials and industries *(Eng)* S63
mural paintings—The examination of mural paintings *(Dut)* S525
polysaccharides—Polysaccharides as part of a color layer and methods for their identification *(Cze)* S647
shadow puppets—Restoration of Chinese and Indonesian shadow puppets *(Eng)* S1011

stabilizers—Identification of stabilizing agents *(Eng)* S527
tempera—Examination and treatment of a tempera on canvas from the 16th century: the *Emmaus Pilgrims* from the Fine Arts Museum of Brussels *(Fre)* S981
thin layer chromatography—Separation of carbohydrates by thin-layer chromatography *(Eng)* S550
Vuillard, Edouard (1868-1940)—History, analysis and treatment of "La salle à manger au château de Clayes," 1938, by Edouard Vuillard *(Eng)* S1009

steatite
bitumen—Prehistoric use of bitumen in Southern California *(Eng)* S256

steel
Horyuji Temple (Japan)—Scientific treatments made on the main hall of the Hōryūji Monastery after the fire of 1949 *(Jpn)* S893
pigment—Role of pigments *(Eng)* S768
pigment volume concentration—Effect of ageing of alkyd-TiO$_2$ paints on adhesion to mild steel: role of pigment volume concentration *(Eng)* S868
—Pigment volume concentration and its effect on the corrosion resistance properties of organic paint films *(Eng)* S882

Stein, Aurel (1862-1943)
mural paintings—Conservation of Central Asian wall painting fragments from the Stein Collection in the British Museum *(Eng)* S1099

Stella, Frank (b. 1936)
contemporary art—Painters painting: a candid history of the modern art scene, 1940-1970 *(Eng)* S362

stereomicroscopy
house paint—Microchemical analysis of old housepaints with a case study of Monticello *(Eng)* S661
microscopy—Application of particle study in art and archaeology *(Eng)* S585

stone *see also* **types of stone, e.g., limestone, marble, etc.**
The consequences of previous adhesives and consolidants used for stone conservation at the British Museum *(Eng)* *adhesives; British Museum (London, England); cellulose nitrate; cement; consolidants; history of conservation; mortar; plaster of Paris; poly(ethylene glycol); polyester; shellac; soluble nylon; vinyl acetate* S1052
—The conservation of the Winchester Anglo-Saxon fragment *(Eng)* *Anglo-Saxon; cleaning; England (Winchester); history of conservation; humidity; limewater; mortar; soluble nylon; sulfur dioxide; Winchester Cathedral (England)* S1090
majolica—Experiments on the consolidation of glazes on majolica and glass tesserae from mosaics *(Ita)* S1106
mural paintings—Ajanta and Ellora wall paintings. Scientific research as an aid to their conservation *(Eng)* S569
Papua New Guinea—Technique and personality *(Eng)* S211

sedimentary rock—Atlas of sedimentary rocks under the microscope *(Eng)* S611
synthetic resin—Restoration with synthetic resins in Japan *(Ger)* S966

stools
Akan—The theory and practice of conservation among the Akans of Ghana *(Eng)* S516

storage
Asia, Southeast—Conservation of manuscripts and paintings of Southeast Asia *(Eng)* S1002
Australian Aboriginal—Various approaches to the conservation and restoration of Aboriginal artifacts made from bark *(Eng)* S974
drawings—Charcoal, chalk and pastel drawings: special problems for collectors, Part 1 *(Eng)* S310
field archaeology—A conservation manual for the field archaeologist *(Eng)* S1044
manuscripts—Care and conservation of palm-leaf and paper illustrated manuscripts *(Eng)* S992
masks—The examination and treatment of two wood funerary masks with Negroid features *(Eng)* S990
Papua New Guinea—An ethnographic collecting expedition to Papua New Guinea: field conservation and laboratory treatment *(Eng)* S967
shadow puppets—The conservation of Javanese shadow puppets *(Eng)* S957
turmeric—Some conservation problems encountered with turmeric on ethnographic objects *(Eng)* S1023

strappo
adobe—1981 report on the development of methods for the conservation of Pueblo Indian mural paintings in the American Southwest *(Eng)* S995
mural paintings—The techniques, conservation, and restoration of mural paintings *(Ita)* S64

straw
coffins—Party straws and Egyptian coffins *(Eng)* S1113

strawberry
Thompson—Ethnobotany of the Thompson Indians of British Columbia, based on field notes by James A. Teit *(Eng)* S45

strontium
radioactivity—Radiochemical investigation of ionic penetration into paint films *(Eng)* S778

strontium yellow
India—Notes on the technique of Indian polychrome wooden sculpture *(Eng)* S246
—A study of Indian polychrome wooden sculpture *(Eng)* S255
synthetic organic pigment—An early 20th-century pigment collection: the pigment collection in the Missiemuseum at Steyl-Tegelen *(Dut)* S435

stucco
Restoration and display of Egyptian stucco mummy masks from the period of the Roman Empire *(Eng)* Egypt *(Faiyûm Oasis); masks;*

Paraloid B-72; pigment; poly(butyl methacrylate); Roman; toluene S1027
—Stucco: a report on the methodology developed in Mexico *(Eng) consolidation; fixing; lime; Mexico; polychromy; tropical climate* S1035
buildings—The surface finishing of Renaissance facades in Ferrara, Italy: scientific studies *(Ita)* S493
ceramics—Technological notes on the pottery, pigments, and stuccoes from the excavations at Kaminaljuyu, Guatemala *(Eng)* S107
conservation—Conservation of interior decoration and furniture of monuments *(Ger)* S806
excavations—Conservation of excavated intonaco, stucco, and mosaics *(Eng)* S1007
masks—The conservation of a Ptolemaic mummy mask *(Ger)* S1097
Mesoamerican—Ancient Mesoamerican mortars, plasters, and stuccos. The use of bark extracts in lime plasters *(Eng)* S197
mortar—Ancient Mesoamerican mortars, plasters, and stuccos: Las Flores, Tampico *(Eng)* S189
—Ancient Mesoamerican mortars, plasters, and stuccos: Palenque, Chiapas *(Eng)* S190
painting (technique)—Original treatises on the arts of painting *(Eng + Lat)* S234
plaster—Conservation in archaeological areas: three decades of work *(Spa)* S1095
plasterwork—The restoration of facade plasterwork in Italy *(Fre)* S472
Puuc—Ancient Mesoamerican mortars, plasters, and stuccos: the Puuc Area *(Eng)* S198
Spain (Catalonia)—Architecture and decorated surfaces in Catalonia *(Fre)* S456

sturgeon glue *see also* **fish glue**
Sturgeon glue for painting consolidation in Russia *(Eng) panel paintings; Russia; viscosity* S1123
adhesives—Adhesives for impregnation of painting on canvas *(Swe)* S1087
panel paintings—Methods of egg-tempera panel painting conservation employed in the State Hermitage *(Eng)* S986

styrene
latex paint—The effect of extenders on the optical properties of air drying alkymul and styrene-butadiene latex paints *(Eng)* S728
paint—The comparisons of two-component extender systems in emulsion paint *(Eng)* S730
vinyl acetate—Very high binding vinyl acetate based dispersions *(Eng)* S869

styrene-butadiene
latex paint—The effect of extenders on the optical properties of air drying alkymul and styrene-butadiene latex paints *(Eng)* S728

sucker roe (Catastomus)
pigment—Ethnology of the Ungava District, Hudson Bay Territory *(Eng)* S14

Sudan (Mirgissa)
Physico-chemistry at the service of archaeology: examination of a series of samples from excavations done in Sudan *(Fre) beeswax; cereal; clay; honey; infrared absorption; kaolin;*

minerals; organic materials; protein; spectrometry; sulfur; thin layer chromatography S545

sugar
binding media—Binding media identification in painted ethnographic objects *(Eng)* S675
illuminations—The development of techniques of identification for pigments and binders used in the paint layer of manuscript illuminations *(Fre)* S546
mural paintings—A study of organic components of ancient middle Asian and Crimean wall paintings *(Rus)* S289
organic chemistry—The organic chemistry of museum objects *(Eng)* S633
paintings (objects)—Analysis of paint media, varnishes and adhesives *(Eng)* S625
polysaccharides—The detection of polysaccharides in the constituent materials of works of art *(Fre)* S537
shadow puppets—Restoration of Chinese and Indonesian shadow puppets *(Eng)* S1011
thin layer chromatography—Improved thin-layer chromatographic method for sugar separations *(Eng)* S583
—Separation of carbohydrates by thin-layer chromatography *(Eng)* S550

sulfation
mural paintings—In review: an assessment of Florentine methods of wall painting conservation based on the use of mineral treatments *(Eng)* S1104

sulfide
pigment—Ancient Greek pigments from the Agora *(Eng)* S104
—Painted Mexican furniture and trinkets *(Fre)* S178
Romano-British—An analysis of paints used in Roman Britain *(Eng)* S210

sulfur
dye—Colors for textiles: ancient and modern *(Eng)* S109
Sudan (Mirgissa)—Physico-chemistry at the service of archaeology: examination of a series of samples from excavations done in Sudan *(Fre)* S545
yellow pigment—Yellow pigments used in antiquity *(Fre)* S113

sulfur dioxide
stone—The conservation of the Winchester Anglo-Saxon fragment *(Eng)* S1090

sulfur oxide
historic buildings—Conservation within historic buildings in Japan *(Eng)* S973

sulfuric acid
frescoes—The consolidation of friable frescoes *(Eng)* S1015

sumac
The use of the sumacs by the American Indian *(Eng) colorants; gum; Mexico; Native American; pistachio; poison oak; sap; wood* S72

sun-dried brick *see* **adobe**

Sundi
The Kongo I *(Eng) bark; camwood; chalk; charcoal black; colorants; mungyene tree; resin; Zaire* S162

support (material)
artists' materials—The painter's craft *(Fre)* S462

surface texture
gloss—Factors controlling gloss of paint films *(Eng)* S798

Surinam
ethnobotany—An introductory study of the arts, crafts, and customs of the Guiana Indians *(Eng)* S34

Sweden
consolidants—The consolidation of powdery paint layers of *Bonaders,* Swedish mural works painted on paper *(Fre)* S1109
wall hangings—The study and conservation of glue paintings on textile: 18th and 19th century painted wall hangings from southern Sweden *(Eng)* S512

Switzerland (St. Gall)
parchment—Diagnosis and therapy in parchment and miniature restoration *(Ger)* S991

symbolism
Australian Aboriginal—Dreamings: the art of Aboriginal Australia *(Eng)* S408

synthetic dye
dyewood—Dyewoods, their composition and use. Part 2: Wood dyes and their fields of application *(Ger)* S205

synthetic materials
Natural and accelerated aging of synthetic products compared with that of natural products *(Fre) accelerated aging; aging; Paraloid B-72; polymers* S1036
polymers—The use of synthetic polymers for the consolidation of Medieval miniatures on parchment *(Rus)* S938
pyrolysis gas chromatography—Identification of synthetic materials in modern paintings. 1: varnishes and polymer binders *(Fre)* S660

synthetic organic pigment
An early 20th-century pigment collection: the pigment collection in the Missiemuseum at Steyl-Tegelen *(Dut) artificial ultramarine blue; barium sulfate; chalk; chromate; cobalt green; dioramas; Indian yellow; lead chromate; lithopone; organic materials; pigment; strontium yellow; yellow ocher; zinc white* S435
artists' materials—The artist's handbook of materials and techniques *(Eng)* S83
Native American—Analysis of paints used by Canadian native cultures: a project at the Canadian Conservation Institute *(Eng)* S640

synthetic resin
Restoration with synthetic resins in Japan *(Ger) acrylic resin; adhesion; consolidation; epoxy resin; ethyl silicate; excavations; flaking; impregnation; isocyanates; Japan; metal; mold-*

(Fre) acetone; Belgium (Brussels); canvas; cleaning; isopropanol; pigment; solvents; starch; varnish S981
—An improved method for the thin-layer chromatography of media in tempera paintings *(Eng) chromatography; protein; thin layer chromatography; ultraviolet* S562
—The material side: tempera painting—part 1 *(Eng) casein; egg; gesso; gum; linseed oil; resin* S146
—Problems in restoring a tempera on 19th-century paper: decoration by Ponga for the balcony of the Olympic Theatre of Piove di Sacco *(Ita) cleaning; color; decoration; ethyl alcohol; Italy (Piove di Sacco); Japanese paper; paper; peeling; Ponga, Giuseppe* S1081
—Tempera adhesives in the history of art *(Ger) adhesives; binding media* S97
—Tempera paints *(Ger) varnish* S136
acrylic resin—Modern day artists colours *(Eng)* S437
Angelico, Fra (ca. 1400-1455)—Restoration of a miniature by Fra Angelico in Florence *(Fre)* S1016
artists' materials—The artist's handbook of materials and techniques *(Eng)* S83
binding media—Methods used for the identification of binding media in Italian paintings of the 15th and 16th centuries *(Eng)* S554
Bouts, Dirck, the elder (ca. 1415-1475)—The techniques of Dieric Bouts: two paintings contrasted *(Eng)* S386
Dix, Otto (1891-1969)—Studies on the painting technique of Otto Dix during the period 1933-1969 *(Ger)* S430
Egypt—Study of painting techniques in ancient Egypt *(Ita)* S492
fluorescence microscopy—Ultraviolet fluorescence microscopy of paint cross sections: cycloheptaamylose-dansyl chloride complex as a protein-selective stain *(Eng)* S671
glaze—On the material side. Glazes and glazing—Part 2 *(Eng)* S148
history of conservation—Complete guide for the restoration of oil, wax, tempera, watercolor, miniature, and pastel paintings, together with instructions for preparing excellent varnishes for paintings, bas-reliefs and plaster casts, dried insects and plants, prints and maps, as well as the cleaning, bleaching, mounting, and framing of copper engravings, lithographs, and woodcuts; for the art lover, painter, bronzer, decorator, etc. *(Ger)* S3
icons—Conservation problems in Egypt: some remarks on the technology of postmediaeval Coptic icons *(Eng)* S479
—Restoration and conservation of an icon from Melnik *(Bul)* S948
—The technique of icon painting *(Eng)* S214
Japan—Pigments used on Japanese paintings from the protohistoric period through the 17th century *(Eng)* S315
Medieval—Observations on a late Medieval painting medium *(Eng)* S117
mural paintings—Ajanta murals: their composition and technique and preservation *(Eng)* S232

—Indian murals: techniques and conservation *(Eng)* S931
—The investigation of pigments and paint layer structures of mural paintings at Maitepnimit Temple *(Eng)* S477
—Restoration of ancient monumental painting in cult buildings *(Eng)* S284
—Structure, composition, and technique of the paintings *(Dut)* S346
—The techniques, conservation, and restoration of mural paintings *(Ita)* S64
—The wall paintings in the Bagh caves: an investigation into their methods *(Eng)* S87
Native American—America's first painters *(Eng)* S168
Netherlandish—The beginnings of Netherlandish canvas painting, 1400-1530 *(Eng)* S445
oil paintings—On the material side *(Eng)* S147
—The technique of the great painters *(Eng)* S127
paint—The material side *(Eng)* S166
—The painter's methods and materials *(Eng)* S196
painting (technique)—The painter's craft: an introduction to artists' materials *(Eng)* S123
paintings (objects)—Manual of the painter restorer *(Ita)* S5
pigment—The history of artists' pigments *(Eng)* S135
Romania—Specific forms of degradation and their causes in wood panel tempera paintings *(Rum)* S439
Rudolphi, Johann Georg (1633-1693)—Johann Georg Rudolphi (1633-1693). Volume 1 *(Ger)* S584
shadow puppets—Restoration of Chinese and Indonesian shadow puppets *(Eng)* S1011
Shroud of Turin—Light microscopical study of the Turin Shroud. II *(Eng)* S593
Thailand—Conservation of wall paintings in Thailand *(Eng)* S927
USA (New Mexico)—The materials and methods of some religious paintings of early 19th century New Mexico *(Eng)* S142
Velazquez, Diego Rodriguez de Silva (1599-1660)—The technique of Velasquez in the painting *The Drinkers* at the Picture Gallery of Naples *(Eng)* S139
wood—The folk art tradition in painting on wood: paste and casein techniques *(Ger)* S314
—The restoration of the wooden statue of Our Lady in the parish church of Cercina *(Ita)* S1078

tempering
painting (technique)—Original treatises on the arts of painting *(Eng + Lat)* S234

Temple of the Paintings (Bonampak Site, Chiapas, Mexico)
Conservation and restoration of the murals of the Temple of the Paintings in Bonampak, Chiapas *(Eng) adobe; cleaning; consolidation; Mayan; Mexico (Chiapas); mural paintings* S1037
Mayan—The Maya mural paintings of Bonampak, materials analysis *(Fre)* S539

temples
mural paintings—Ajanta and Ellora wall paintings. Scientific research as an aid to their conservation *(Eng)* S569
—Chemical studies on ancient painting materials *(Jpn)* S150
—Conservation of Central Asian wall painting fragments from the Stein Collection in the British Museum *(Eng)* S1099
—Reproduction of colored patterns in temples and shrines *(Eng)* S383
panel paintings—Present state of screen and panel paintings in Kyoto *(Jpn)* S933

tensile strength
Ultimate tensile properties of paint films *(Eng) coatings; pigment volume concentration; plasticizers; weathering* S752
coatings—Mechanical properties of clay coating films containing styrene-butadiene copolymers *(Eng)* S834
physical properties—Physical study of two-coat paint systems *(Eng)* S701
pigment volume concentration—Critical pigment volume concentration of emulsion based paints *(Eng)* S757
—Determination of critical pigment volume concentration by measurement of the density of dry paint films *(Eng)* S749
—Effect of ageing of alkyd-TiO$_2$ paints on adhesion to mild steel: role of pigment volume concentration *(Eng)* S868
Plextol B500—Evaluation of the stability, appearance and performance of resins for the adhesion of flaking paint on ethnographic objects *(Eng)* S1101

tepees
Blackfoot—The Blackfoot tipi *(Eng)* S68
—Painted tipis and picture-writing of the Blackfoot Indians *(Eng)* S69

termite
bark paintings—Conservation of Australian Aboriginal bark paintings with a note on the restoration of a New Ireland wood carving *(Eng)* S905

terpene
binding media Perspectives on the chemistry of old paint binders *(Fre)* S535

terracotta
The treatment and examination of painted surfaces of eighteenth-century terracotta sculptures *(Eng) cleaning; Europe; paint; polychromy; sculpture* S469
conservation—Conservation of interior decoration and furniture of monuments *(Ger)* S806

tetraethyl orthosilicate
frescoes—The consolidation of friable frescoes *(Eng)* S1015

Tewa
ethnobotany—Ethnobotany of the Tewa Indians *(Eng)* S33

textiles *see also* **specific types of textiles, e.g., cotton, silk**
The link between the treatments for paintings and the treatments for painted textiles *(Eng)*

adhesives; banners; consolidants; flags; paintings (objects) S363
—Painted textiles *(Eng) cleaning; consolidants; painting (technique)* S963
—Preservation of a textile and a miniature painting *(Eng) Asia, Central; methyl methacrylate; miniatures (paintings); mounting; silk; wheat starch paste* S895
—Technical study and conservation of an old painted textile (Simhasana) *(Eng) acidity; adhesives; ammonia; bleaching; carbon tetrachloride; charcoal; chloramine T; cleaning; cotton; deacidification; fiber; fixing; indigo; isopropanol; malachite (pigment); paintings (objects); red ocher; vermilion; wheat starch paste; yellow ocher; zinc white* S902
—When textiles are paintings *(Eng) Asia, East; Oceania; Peru; pigment; silk; tapa* S1060
dye—African textiles: looms, weaving and design *(Eng)* S313
Hopi—Hopi dyes *(Eng)* S300
India—One hundred references to Indian painting *(Eng)* S49
Malawi—Useful plants of Malawi *(Eng)* S219
Netherlandish—The beginnings of Netherlandish canvas painting, 1400-1530 *(Eng)* S445
paintings (objects)—Written sources about painted textiles *(Ger)* S504
Peru—Peruvian natural dye plants *(Eng)* S429
plants—The ethnobotany of pre-Columbian Peru *(Eng)* S206
pre-Columbian—Dating precolumbian museum objects *(Eng)* S1115
reference materials—Second report on reference materials incorporating special reports by members of the working group: ICOM Committee for Conservation, Madrid, 2-7 October, 1972 *(Eng)* S557
tapestries—The restoration of painted tapestry and its problems *(Ger)* S1112

Thailand
Conservation of wall paintings in Thailand *(Eng) biodeterioration; buildings; consolidation; flaking; mural paintings; plaster; rainwater; soluble nylon; tempera; tropical climate; vandalism* S927
mural paintings—The investigation of pigments and paint layer structures of mural paintings at Maitepnimit Temple *(Eng)* S477

thankas
Asia, Southeast—Conservation of manuscripts and paintings of Southeast Asia *(Eng)* S1002

thermoplastic
coatings—Internal stress in pigmented thermoplastic coatings *(Eng)* S811

thermoplastic resin
consolidation—Consolidation of porous paint in a vapor-saturated atmosphere: a technique for minimizing changes in the appearance of powdering, matte paint *(Eng)* S1120
Iran—Friable pigments and ceramic surfaces: a case study from SW Iran *(Eng)* S1058

thermosetting
adhesives—The evaluation of some adhesive systems utilized in the consolidation of paint-

ings. The kinetics of consolidation (I) *(Rum)* S1019 —The evaluation of some adhesive systems utilized in the consolidation of paintings. The kinetics of consolidation (III) *(Rum)* S1021

thin layer chromatography
Analysis of proteinaceous media by thin layer chromatography *(Rus) amino acid; protein* S601
—Analysis of thin-layer chromatograms of paint pigments and dyes by direct microspectrophotometry *(Eng) dye; pigment; spectrophotometry* S620
—Forensic examination of wax seals by thin-layer chromatography *(Eng) chromatography; seals; wax* S602
—High performance thin-layer chromatography for the identification of binding media: techniques and applications *(Eng) binding media; carbohydrates; paint; protein; resin; wax* S682
—Improved thin-layer chromatographic method for sugar separations *(Eng) boric acid; silica gel; solvents; sugar* S583
—Methods in scientific examination of works of art. Volume 1: thin-layer chromatography course book *(Eng) adhesives; binding media; carbohydrates; chromatography; coatings; protein; resin* S684
—Methods in scientific examination of works of art. Volume 2: thin-layer chromatography protocols *(Eng) carbohydrates; chromatography; protein; resin; samples; standards; wax* S685
—Methods in scientific examination of works of art. Volume 3: thin-layer chromatography reference materials binder *(Eng) binding media; chromatography; gum; protein; resin; wax* S683
—The methods of identifying organic binders in paint layers *(Slo) binding media; infrared spectrometry; oil; organic materials; polypeptides; polysaccharides; resin; wax* S599
—A note on the thin-layer chromatography of media in paintings *(Eng) amino acid; chromatography; paintings (objects); ultraviolet* S677
—Separation of carbohydrates by thin-layer chromatography *(Eng) carbohydrates; cellulose; chromatography; solvents; starch; sugar* S550
—Thin layer chromatography: an aid for the analysis of binding materials and natural dyestuffs from works of art *(Eng) adhesives; dye; paintings (objects); resin; varnish* S559
—Thin-layer chromatography of resin acid methyl esters *(Eng) chromatography; fatty acid; gas chromatography; mass spectrometry; methyl ester; paper chromatography; resin; silica gel; silver nitrate; triglycerides* S536
binding media—Contributions to the analysis of binders, adhesives and ancient varnishes *(Fre)* S547
—Methods used for the identification of binding media in Italian paintings of the 15th and 16th centuries *(Eng)* S554
chromatography—The chromatographic analysis of ethnographic resins *(Eng)* S603

fatty acid—Fatty acid composition of 20 lesser-known Western Australian seed oils *(Eng)* S676
Herlin Cathedral (Germany)—The scientific examination of the polychromed sculpture in the Herlin altarpiece *(Eng)* S552
illuminations—The development of techniques of identification for pigments and binders used in the paint layer of manuscript illuminations *(Fre)* S546
Mayan—The Maya mural paintings of Bonampak, materials analysis *(Fre)* S539
paintings (objects)—Analysis of paint media, varnishes and adhesives *(Eng)* S625
polysaccharides—The detection of polysaccharides in the constituent materials of works of art *(Fre)* S537
—Polysaccharides as part of a color layer and methods for their identification *(Cze)* S647
skin—Lipids from samples of skin from seven Dutch bog bodies: preliminary report *(Eng)* S653
Sudan (Mirgissa)—Physico-chemistry at the service of archaeology: examination of a series of samples from excavations done in Sudan *(Fre)* S545
tempera—An improved method for the thin-layer chromatography of media in tempera paintings *(Eng)* S562

thin sections
minerals—Atlas of rock-forming minerals in thin section *(Eng)* S591
sedimentary rock—Atlas of sedimentary rocks under the microscope *(Eng)* S611

thinners
artists' materials—The painter's craft *(Fre)* S462
painting (technique)—Painting materials: a short encyclopaedia *(Eng)* S227

Thompson
Ethnobotany of the Thompson Indians of British Columbia, based on field notes by James A. Teit *(Eng) Canada (British Columbia); colorants; dye; ethnobotany; fat; pigment; staining (finishing); strawberry* S45
—Thompson ethnobotany: knowledge and usage of plants by the Thompson Indians of British Columbia *(Eng) Canada (British Columbia); cleaning; dye; ethnobotany; medicine; paint; pitch (tar); plants; resin; staining (finishing)* S483
conifers—Ethnobotany of coniferous trees in Thompson and Lillooet Interior Salish of British Columbia *(Eng + Fre)* S426

thymene
mural paintings—Conservation of mural paintings in Central Asia which have been damaged by salt efflorescence *(Eng)* S888

ti (plant)
canoes—The Hawaiian canoe *(Eng)* S334

Tibet
Preservation of two ancient objects *(Eng) bone; clay; cleaning; cracking; drying; excavations; filling; impregnation; vacuum* S894

500

ley of the Kings (Egypt); varnish; white pigment S658

tombs
Egypt (Saqqara)—Identification of medium used in polychrome reliefs in ancient Egyptian limestone tomb dating from the nineteenth dynasty /1350-1200 B.C./ at Saqqara *(Eng)* S649
mural paintings—Chemical studies on the pigments of ancient ornamented tombs in Japan *(Jpn)* S151
—Unfinished wall paintings in Egyptian tombs and temples *(Ger)* S192
pigment—Technical studies on the pigments used in ancient paintings of Japan *(Eng)* S167

tools
Potential applications of the organic residues on ancient tools *(Eng) animal materials; blood; dating; feather; hair; organic materials; plant materials; radiocarbon dating; radioimmuno assay* S624
Australian Aboriginal—An Alyawara day: making men's knives and beyond *(Eng)* S385
Hawaiian—Hawaiian sculpture *(Eng)* S415
leather—The examination of use marks on some Magdalenian end scrapers *(Eng)* S262

Toshodaiji Temple (Nara, Japan)
ceilings—Conservation treatments with reference to color paintings on the ceiling of the main hall, National Treasure, of Toshodaiji Temple, Nara *(Jpn)* S941

totem poles
The conservation of a Tlingit totem pole *(Eng) Native American; pigment; solubility* S309
—Restoration of totem poles in British Columbia *(Eng) Canada (British Columbia—Kitwanga); colorants; Native American* S44
Kwakiutl—Field research in the conservation of ethnographical collections: an ecological approach applied to polychrome monumental sculpture *(Eng)* S417

toxicity
artists' materials—The painter's craft *(Fre)* S462
plants—Plants used by the Indians of Mendocino County, California *(Eng)* S21

tragacanth
consolidation—Consolidation of loose paint on ethnographic wooden objects *(Ger)* S901
stabilizers—Identification of stabilizing agents *(Eng)* S527

training
ethnographic conservation—Ethnographic conservation training at the GCI *(Eng)* S1079
paintings (objects)—Restoration of paintings *(Eng)* S926

transferring
Transfer of paintings: at any price? *(Ger) altarpieces; canvas; mural paintings; paintings (objects); wood* S916
forgeries—The technical investigation and conservation treatment of an alleged Ming Dynasty wall painting *(Eng)* S956
frescoes—19th and early 20th century restorations of English Mediaeval wall paintings: problems and solutions *(Eng)* S1116

mural paintings—Destruction and restoration of Campanian mural paintings in the eighteenth and nineteenth centuries *(Eng)* S1105
—The legacy of the Tía Sandalia: consolidation, removal, and mounting of the work in the future Ethnographic Museum of Villacañas (Toledo) *(Spa)* S1083
—Three Bodhisattvas: the conservation of a fifteenth century Chinese wall painting in the British Museum collection *(Eng)* S1051

transmission electron microscopy
microscopy—The particle atlas: an encyclopedia of techniques for small particle identification *(Eng)* S586

transparency
fiber—An instrumental technique for assessing the transparency of melt-spun fibers *(Eng)* S801

traveling exhibitions
Papua New Guinea—Ethnographic collections: case studies in the conservation of moisture-sensitive and fragile materials *(Eng)* S1062

Trichilia roka oil
Africa—The material culture of the peoples of the Gwembe Valley *(Eng)* S243

triglycerides
fatty acid—The gas chromatographic examination of paint media. Part I. Fatty acid composition and identification of dried oil films *(Eng)* S542
thin layer chromatography—Thin-layer chromatography of resin acid methyl esters *(Eng)* S536

triptychs
Material description, state of conservation, and treatment *(Dut) animal glue; Belgium (Watervliet); consolidation; fixatives; panel paintings; reattaching; wax-resin; wood* S906

tropical climate
plants—The useful plants of west tropical Africa *(Eng)* S374
resin—The exploitation of resinous products in a lowland Malayan forest *(Eng)* S391
—Resin classification among the Semelai of Tasek Bera, Pahang, Malaysia *(Eng)* S392
stucco—Stucco: a report on the methodology developed in Mexico *(Eng)* S1035
Thailand—Conservation of wall paintings in Thailand *(Eng)* S927

Tsimshian
dye—Aboriginal paints and dyes in Canada *(Eng)* S54
Native American—CCI Native Materials Project: final report *(Eng)* S473

Tuchlein paintings
The technique of a *Tüchlein* by Quinten Massys *(Eng) animal glue; linen; Massys, Quentin (1465/66-1530); Netherlandish; painting (technique); underdrawing* S423
—A Tuchlein from the Van der Goes legacy: identification, technique, and restoration *(Ger) Netherlands; paintings (objects)* S521
Bouts, Dirck, the elder (ca. 1415-1475)—The techniques of Dieric Bouts: two paintings contrasted *(Eng)* S386

Netherlandish—The beginnings of Netherlandish canvas painting, 1400-1530 *(Eng)* S445

Tuffilm varnish
casein—Studio talk: improvement in tubed casein: interview with Ted Davis *(Eng)* S171

Tura, Cosimo (1430?-1495)
Amino acid analysis of proteinaceous media from Cosimo Tura's "The Annunciation with Saint Francis and Saint Louis of Toulouse." *(Eng) amino acid; animal glue; binding media; chromatography; egg tempera; egg yolk; high performance liquid chromatography; paint; protein* S669

Turkistan
The materials in the wall paintings from Kizil in Chinese Turkestan *(Eng) adhesives; gypsum; mural paintings; pigment* S81
mural paintings—Pigments and techniques of the early Medieval wall paintings of eastern Turkistan *(Ger)* S298

turmeric
Advances in the agronomy and production of turmeric in India *(Eng) colorants; cultivation; India* S379
—Some conservation problems encountered with turmeric on ethnographic objects *(Eng) cleaning; consolidation; dye; ethnographic conservation; pigment; storage* S1023
bark cloth—Samoan material culture *(Eng)* S50
Carib—Plants used by the Dominica Caribs *(Eng)* S98
Dominica—The ethnobotany of the island Caribs of Dominica *(Eng)* S177
dye—Ethnology of Uvea (Wallis Island) *(Eng)* S74
pigment—Ethnology of Futuna *(Eng)* S67
plants—On the history and migration of textile and tinctorial plants in reference to ethnology *(Eng)* S6
yellow pigment—Yellows *(Ita)* S396

turpentine
balsam—The history of naval stores in coatings *(Eng)* S480
gas chromatography—Examination of the diterpenoic resin components of anatomical wax models from the eighteenth century by gas chromatography *(Eng)* S656
house paint—Kline paints a picture *(Eng)* S154
Luiseño—The culture of the Luiseño Indians *(Eng)* S26
mural paintings—Ajanta murals: their composition and technique and preservation *(Eng)* S232
Native American—Chinigchinich: a revised and annotated version of Alfred Robinson's translation of Father Geronimo Boscana's historical account of the belief, usages, customs and extravagancies of the Indians of this mission of San Juan Capistrano called the Acagchemem Tribe *(Eng)* S58
paint—The material side *(Eng)* S166
verre eglomise—Eglomise: technique and conservation *(Ger)* S1059

wood—The restoration of the wooden statue of Our Lady in the parish church of Cercina *(Ita)* S1078

turquoise
Mexico—Colors and paint at the time of the pre-Cortés Mexican civilizations *(Fre)* S169
Native American—American Indian painting of the Southwest and Plains areas *(Eng)* S239
Romano-British—An analysis of paints used in Roman Britain *(Eng)* S210, S213

Tutankhamun's tomb
plant materials—Pharaoh's flowers: the botanical treasures of Tutankhamun *(Eng)* S463

Twachtman, John Henry (1853-1902)
pastels (crayons)—American pastels of the late nineteenth & early twentieth centuries: materials and techniques *(Eng)* S442

Tyrian purple
dye—Colors for textiles: ancient and modern *(Eng)* S109
pigment—Painted Mexican furniture and trinkets *(Fre)* S178
—Some experiments and observations on the colours used in painting by the ancients *(Eng)* S1

Ukraine (Crimea)
mural paintings—A study of organic components of ancient middle Asian and Crimean wall paintings *(Rus)* S289
organic materials—A study of organic components of paints and grounds in Central Asian and Crimean wall paintings *(Eng)* S564

Ukraine (Kiev)
icons—The technique of icon painting *(Eng)* S214

ultramarine blue *see also* **artificial ultramarine blue; lapis lazuli**
artificial ultramarine blue—A technical note on IKB (International Klein Blue) *(Eng)* S347

ultramicroanalysis
Ultramicroanalysis: an effective method for substantial investigation of works of art *(Ger) paintings (objects); pigment; Raffaello Sanzio (1483-1520)* S622

ultrasound
delamination—Detection of delaminations in art objects using air-coupled ultrasound *(Eng)* S880

ultraviolet
fluorescence microscopy—Ultraviolet fluorescence microscopy of paint cross sections: cycloheptaamylose-dansyl chloride complex as a protein-selective stain *(Eng)* S671
miniatures (paintings)—Conservation of miniatures *(Eng)* S270
paint—Physicochemical alterations to the paint layer. 1. Results of a survey of various laboratories: apparent alterations of the paint layer and their probable causes. 2. Experimental study by the Musée du Louvre laboratory on madder varnish *(Fre)* S753
panel paintings—Basic experiments concerning deterioration of glue and discoloration of pigments, and discussion on the actual condi-

—The relationship between oil content, particle size and particle shape *(Eng)* S699
—Translation of Häufige Anstrichmängel und Anstrichschäden *(Eng)* S799
painting (technique)—Greek and Roman methods of painting: some comments on the statements made by Pliny and Vitruvius about wall and panel painting *(Eng)* S29
—Original treatises on the arts of painting *(Eng + Lat)* S234
—Physics and painting: introduction to the study of physical phenomena applied to painting and painting techniques *(Dut)* S707
paintings (objects)—Analysis of paint media, varnishes and adhesives *(Eng)* S625
pyrolysis gas chromatography—Identification of synthetic materials in modern paintings. 1: varnishes and polymer binders *(Fre)* S660
reflectance—The use of differential spectral analysis in the study of museum objects *(Eng)* S744
resin—Natural resins for the paint and varnish industry *(Eng)* S94
—The technology of natural resins *(Eng)* S99
tempera—Examination and treatment of a tempera on canvas from the 16th century: the *Emmaus Pilgrims* from the Fine Arts Museum of Brussels *(Fre)* S981
—Tempera paints *(Ger)* S136
thin layer chromatography—Thin layer chromatography: an aid for the analysis of binding materials and natural dyestuffs from works of art *(Eng)* S559
Tomb of Nefertari (Thebes, Egypt)—Chemical analyses of pigments and media used in the mural paintings of the tomb of Nefertari *(Spa)* S658
white pigment—The Louisville Paint and Varnish Production Club, Fourth Technical Symposium. The effect of physical characteristics of white and extender pigments on paint film properties *(Eng)* S725
wood—The restoration of the wooden statue of Our Lady in the parish church of Cercina *(Ita)* S1078

vaults (structural elements)
mural paintings—Study and conservation of quadratura decoration on the vaults of 17th-century French buildings *(Fre)* S470

vegetable dye
Native American—Colors in Indian arts: their sources and uses *(Eng)* S59
yellow pigment—Yellow pigments used in antiquity *(Fre)* S113

vegetable glue
pigment—Domestic implements, arts, and manufactures *(Eng)* S23

vegetable materials
Ruscha, Edward Joseph (b. 1937)—Pastel, juice and gunpowder: the Pico iconography of Ed Ruscha *(Eng)* S337

vegetable oil
binding media—Binding media identification in painted ethnographic objects *(Eng)* S675

Native American—What did they use for paint? *(Eng)* S236
pyrolysis gas chromatography—Analytical pyrolysis as a tool for the characterization of organic substances in artistic and archaeological objects *(Eng)* S662

vegetable pigment
Native American—Analysis of paints used by Canadian native cultures: a project at the Canadian Conservation Institute *(Eng)* S640

vehicle (material)
binding media—Binding media and pigments in the literature of antiquity *(Ger)* S257
pigment—Exposure evaluation: quantification of changes in appearance of pigmented materials *(Eng)* S790
pigment volume concentration—C.P.V.C. of a pigment mixture as a function of vehicle type *(Eng)* S747

Velazquez, Diego Rodriguez de Silva (1599-1660)
The technique of Velasquez in the painting *The Drinkers* at the Picture Gallery of Naples *(Eng)* animal glue; calcium sulfate; gesso; Italy *(Naples)*; tempera S139

vellum
illuminations—The conservation of a Petrarch manuscript *(Eng)* S910
Medieval—The materials and techniques of Medieval painting *(Eng)* S172

veneer
wood—The folk art tradition in painting on wood: paste and casein techniques *(Ger)* S314

Venice turpentine
pastels (visual works)—Fixing and flocking *(Eng)* S985

verdigris
Herlin Cathedral (Germany)—The scientific examination of the polychromed sculpture in the Herlin altarpiece *(Eng)* S552
house paint—Problems in the restoration and preservation of old house paints *(Eng)* S947
miniatures (paintings)—Conservation of miniatures *(Eng)* S270

vermilion
Herlin Cathedral (Germany)—The scientific examination of the polychromed sculpture in the Herlin altarpiece *(Eng)* S552
Horyuji Temple (Japan)—Coloring materals of the murals in the Main Hall of the Horyuji Temple compared with those of the ornamented tombs *(Jpn)* S271
house paint—House paints in Colonial America: their materials, manufacture and application. Part III *(Eng)* S230
icons—Restoration and conservation of an icon from Melnik *(Bul)* S948
—The technique of icon painting *(Eng)* S214
Japan—Pigments used in Japanese paintings *(Eng)* S405
microscopy—Microscopical study of the Turin "Shroud," IV *(Eng)* S627
mural paintings—Chemical study on the coloring materials of the murals of the Taka-matsuzuka Tomb in Nara Prefecture *(Jpn)* S272

—Materials and techniques of Medieval wall paintings from the former House of Merchants' Fraternity at 5 Żeglarska Street in Toruń *(Pol)* S485
—Pigments and techniques of the early Medieval wall paintings of eastern Turkistan *(Ger)* S298
—Pigments used in the paintings of "Hoodo." *(Jpn)* S183
—The structure of the 17th-century mural paintings in the S. George Orthodox church at Veliko Turnovo (Bulgaria) *(Pol)* S264
paint—Scientific examination of artistic and decorative colorants *(Eng)* S265
panel paintings—Present state of screen and panel paintings in Kyoto *(Jpn)* S933
Peru—An analytical study of pre-Inca pigments, dyes and fibers *(Eng)* S571
pigment—Artists' pigments: a handbook of their history and characteristics *(Eng)* S623
—Painted Mexican furniture and trinkets *(Fre)* S178
—The pigments used in the wall paintings *(Jpn)* S194
—Technical studies on the pigments used in ancient paintings of Japan *(Eng)* S167
red pigment—Reds *(Ita)* S397
Shroud of Turin—Microscopical study of the Turin "Shroud." *(Eng)* S637
—Microscopical study of the Turin Shroud. III *(Eng)* S598
textiles—Technical study and conservation of an old painted textile (Simhasana) *(Eng)* S902
USA (New Mexico)—The materials and methods of some religious paintings of early 19th century New Mexico *(Eng)* S142

verre eglomise

The deterioration and conservation of painted glass: a critical bibliography *(Eng) bibliographies; cleaning; glass; manufacturing; Medieval; weathering* S994
—Eglomise: technique and conservation *(Ger) albumen; beeswax; bleaching; dammar; glass; isinglass; Paraloid B-72; Plexisol P550; poly(vinyl acetate); turpentine* S1059
—Proposal for the consolidation of the painted surface on reverse painted glass *(Eng) alcohol; consolidation; glass; heat; Paraloid B-72; poly(vinyl alcohol); vacuum tables* S1003

Victoria and Albert Museum (London, England)

metal—The conservation of painted and polychromed metal work. Two case studies from the V & A Museum *(Eng)* S1086
wood—Case studies in the treatment of polychrome wood sculptures at the Victoria and Albert Museum *(Eng)* S1006

Vigée-Lebrun, Marie Anne Élisabeth (1755-1842)

pastels (visual works)—Removing severe distortions in a pastel on canvas *(Eng)* S1032

Viking

Jelling Man—The Jelling Man and other paintings from the Viking age *(Eng)* S420

vinyl

coatings—Development and growth of resins for the coating industry *(Eng)* S340
latex paint—History of water-thinned paints *(Eng)* S163
Melanesian—Conservation of powdering pigment layers on Melanesian objects: choice of a fixative *(Fre)* S1039

vinyl acetate

Very high binding vinyl acetate based dispersions *(Eng) acrylic resin; binding media; dispersions; poly(vinyl chloride); polymers; styrene* S869
illuminations—Some details on the technique and of the restoration of two illuminated 13th century manuscripts from Western Europe *(Fre)* S942
mural paintings—Conservation of mural paintings in Central Asia which have been damaged by salt efflorescence *(Eng)* S888
—How to paint a mural *(Spa)* S381
panel paintings—Wings from a quadriptych with the legend of St. John the Baptist: general problems and the treatment of conservation *(Pol)* S917
stone—The consequences of previous adhesives and consolidants used for stone conservation at the British Museum *(Eng)* S1052

vinyl butyral

pastels (visual works)—The material side *(Eng)* S145

viscosity

Further experiments on the importance of the critical point *(Eng) durability; linseed oil; oil paint; paint; pigment* S694
—Microscopic examination of pigment/vehicle interaction during film formation *(Eng) adsorption; convection; mechanical strength; molecular weight; organic materials; pigment; weathering* S762
—On oil-paint viscosity as an expression of paint structure *(Eng) coatings; oil paint; paint; pigment* S702
—On the viscosity of oil paints *(Ger) oil paint; paint* S696
—On the viscosity of oil paints, the turboviscosimeter, and the critical oil content *(Ger) coatings; oil paint; paint* S692
—On the viscosity of paints used for coatings *(Ger) coatings; paint* S691
—Paint viscosity and ultimate pigment volume concentration *(Eng) paint; pigment volume concentration* S717
acrylic resin—Consolidation with acrylic colloidal dispersions *(Eng)* S988
calcium carbonate—Optical properties of calcium carbonate in paper coatings *(Eng)* S807
coatings—Development of a predictive model for the changes in roughness that occur during the painting process *(Eng)* S884
consolidation—Consolidation of delaminating paintings *(Eng)* S951
leveling—On surface levelling in viscous liquids and gels *(Eng)* S745
Melanesian—Conservation of powdering pigment layers on Melanesian objects: choice of a fixative *(Fre)* S1039

oil paint—Oil content as a determinant of the properties of oil paints and coatings *(Ger)* S693
paint—The comparisons of two-component extender systems in emulsion paint *(Eng)* S730
—The relationship between oil content, particle size and particle shape *(Eng)* S699
parameter—Particle size as a formulating parameter *(Eng)* S755
pigment—Paint flow and pigment dispersion: a rheological approach to coatings and ink technology *(Eng)* S802
—Pigment/binder geometry *(Eng)* S774
—The relationship of pigment packing patterns and CPVC to film characteristics and hiding power *(Eng)* S733
—Viscosity, packing density and optical properties of pigment blends *(Eng)* S815
pigment volume concentration—Critical pigment volume concentration of paints. Its measurement and some relationships *(Eng)* S857
—The influence of PVC on paint properties *(Eng)* S773
polymers—The mechanism of polymer migration in porous stones *(Eng)* S1047
sturgeon glue—Sturgeon glue for painting consolidation in Russia *(Eng)* S1123
varnish—Factors affecting the appearance of picture varnish *(Eng)* S721
—On picture varnishes and their solvents *(Eng)* S832
—Special report on picture varnish *(Eng)* S529

Vitruvian tinctorium
Pompeian Style—Pompeian painting technique *(Fre)* S174

vivianite
house paint—Topical observations on the use of forgotten pigments used for painting rooms in Lower Saxony *(Ger)* S438
Maori—Maori art *(Eng)* S18

votive tablets
Cleaning treatment on votive tablet in traditional way *(Jpn)* acrylic resin; cleaning; fire; flaking; gilding; Japan (Tokyo); Japanese paper; paint S939

Vuillard, Edouard (1868-1940)
The distemper technique of Edouard Vuillard *(Eng)* distemper; oil; painting (technique); pigment S275
—History, analysis and treatment of "La salle à manger au château de Clayes," 1938, by Edouard Vuillard *(Eng)* adhesives; canvas; fading; fiber; flaking; gouache; matte; paint; paper; pastels (visual works); purple pigment; red pigment; softwood; solvents; starch; wood S1009
—The special problems and treatment of a painting executed in hot glue medium, "The Public Garden" by Edouard Vuillard *(Eng)* adhesives; binding media; cleaning; cleavage; consolidation; hot glue; paintings (objects); poly(vinyl acetate); USA (Washington); water S999
—A technical and stylistic analysis of detrempe painting on cardboard by Edouard Vuillard *(Eng)* cardboard; cellulose acetate;

crackle; distemper; flaking; painting (technique) S1014
contemporary art—Contemporary artists and their experimental use of historical methods and techniques *(Eng)* S286

wall hangings
The study and conservation of glue paintings on textile: 18th and 19th century painted wall hangings from southern Sweden *(Eng)* flaking; paintings (objects); Sweden S512
mural paintings—The restoration of 18th-century decorative wall paintings imitating wall-hangings in Hungary *(Ger)* S321

wallpaper
Colors and other materials of historic wallpaper *(Eng)* color; pigment S326
—Wallpaper in America: from the 17th century to World War I *(Eng)* adhesives; ink; manufacturing; matte; paper; pigment; size (material); USA; whiting S320
—Wallpaper on walls: problems of climate and substrate *(Eng)* climate; condensation; consolidation; historic buildings; paper; plaster; relative humidity; walls; wood S982

walls
adobe—1981 report on the development of methods for the conservation of Pueblo Indian mural paintings in the American Southwest *(Eng)* S995
—Experiments on preservation of adobe structures and restoration of gypsum plaster paintings in Uzbekistan *(Eng)* S983
frescoes—19th and early 20th century restorations of English Mediaeval wall paintings: problems and solutions *(Eng)* S1116
mural paintings—A survey of the painted mud Viharas of Sri Lanka *(Eng)* S351
Osakihachiman shrine (Japan)—Conservation treatment of the painting on wooden walls in the oratory of Osakihachiman Shrine *(Jpn)* S964
wallpaper—Wallpaper on walls: problems of climate and substrate *(Eng)* S982

walnut oil
binding media—Analyses of paint media *(Eng)* S587
Rudolphi, Johann Georg (1633-1693)—Johann Georg Rudolphi (1633-1693). Volume 1 *(Ger)* S584

washes
drawing (technique)—The craft of old-master drawings *(Eng)* S182

water
acrylic resin—Consolidation with acrylic colloidal dispersions *(Eng)* S988
Australian Aboriginal—Dawn of art: painting and sculpture of Australian Aborigines *(Eng)* S224
bark cloth—The technical aspects of ornamented bark-cloth *(Eng)* S209
Bella Coola—Materia medica of the Bella Coola and neighbouring tribes of British Columbia *(Eng)* S48
binding media—The importance of binders *(Fre)* S225

Blackfoot—Painted tipis and picture-writing of the Blackfoot Indians *(Eng)* S69
Bushman paint—A possible base for "Bushman" paint *(Eng)* S66
calcimine—The painters' encyclopaedia *(Eng)* S10
coatings—Water thinnable coatings, a symposium *(Eng)* S726
dye—The Kongo IV *(Eng)* S242
encaustic wax—The cleaning and consolidation of Egyptian encaustic mummy portraits *(Eng)* S1088
glaze—On the material side. Glazes and glazing—Part 2 *(Eng)* S148
Mexico—Colors and paint at the time of the pre-Cortés Mexican civilizations *(Fre)* S169
Montagnais—A Naskapi painted skin shirt *(Eng)* S247
Native American—Handbook of American Indians north of Mexico *(Eng)* S25
oil paintings—On the material side *(Eng)* S147
paint—Method to follow the degradation by natural weathering of emulsion paint films *(Ger)* S829
pastels (visual works)—Analysis and conservation of graphic and sound documents: work by the Centre de Recherches sur la Conservation des Documents Graphiques, 1982-1983 *(Fre)* S1004
pigment—The T'u-lu colour-container of the Shang-Chou period *(Eng)* S222
red pigment—Note on the pigment blocks of the Bushongo, Kasai District, Belgian Congo *(Eng)* S28
rock art—The ancients knew their paints *(Eng)* S249
—The prehistoric artist of Southern Matabeleland; his materials and technique as a basis for dating *(Eng)* S175
rock paintings—The search for the Tassili frescoes: the story of the prehistoric rock paintings of the Sahara *(Eng)* S187
Vuillard, Edouard (1868-1940)—The special problems and treatment of a painting executed in hot glue medium, "The Public Garden" by Edouard Vuillard *(Eng)* S999

watercolors
Conservation of Indian miniature paintings in the Baroda Museum *(Eng)* *artists' materials; India; miniatures (paintings); poly(methyl methacrylate); toluene* S911
—Early American water color painting *(Eng)* *painting (technique); USA* S140
—The structure of watercolor films with a high PVC *(Ita)* *abrasion; emulsion; pigment volume concentration; poly(vinyl chloride)* S820
—Wash and gouache: a study of the development of the materials of watercolor *(Eng)* *artists' materials; gouache; pigment* S296
acrylic resin—Modern day artists colours *(Eng)* S437
artists' materials—The artist's handbook of materials and techniques *(Eng)* S83
drawing (technique)—Drawing techniques: their evolution in different European schools *(Fre)* S128
drawings—Techniques and subsequent deterioration of drawings *(Eng)* S312

glass—The restoration of three paintings on glass *(Spa)* S1061
history of conservation—Complete guide for the restoration of oil, wax, tempera, watercolor, miniature, and pastel paintings, together with instructions for preparing excellent varnishes for paintings, bas-reliefs and plaster casts, dried insects and plants, prints and maps, as well as the cleaning, bleaching, mounting, and framing of copper engravings, lithographs, and woodcuts; for the art lover, painter, bronzer, decorator, etc. *(Ger)* S3
paint—The material side *(Eng)* S166
—The painter's methods and materials *(Eng)* S196
pigment—Facts about processes, pigments and vehicles: a manual for art students *(Eng)* S15
screens (furniture)—Restoration of a Japanese screen *(Ger)* S949

waterproofing
canoes—The Hawaiian canoe *(Eng)* S334
consolidants—Considerations concerning criteria for the selection of consolidant and the relative methodology of application *(Ita)* S1082

wax *see also* **beeswax; mineral wax**
Characterization of commercial waxes by high-temperature gas chromatography *(Eng)* *chromatography; gas chromatography* S604
—The preservation of wood sculpture: the wax immersion method *(Eng)* *altarpieces; beeswax; elemi; gesso; gum; insects; panels; polychromy; sculpture; wood* S890
animal glue—Searching for a solution to the problem of altered mat paintings: a new product is needed *(Fre)* S1071
bark paintings—Conservation of Australian Aboriginal bark paintings with a note on the restoration of a New Ireland wood carving *(Eng)* S905
Bella Coola—Materia medica of the Bella Coola and neighbouring tribes of British Columbia *(Eng)* S48
binding media—Contributions to the analysis of binders, adhesives and ancient varnishes *(Fre)* S547
chromatography—The chromatographic analysis of ethnographic resins *(Eng)* S603
cleavage—A case of paint cleavage *(Eng)* S703
conservation—Conservation of interior decoration and furniture of monuments *(Ger)* S806
creosote—Notes on creosote lac scale insect resin as a mastic and sealant in the Southwestern Great Basin *(Eng)* S481
Egypt—Study of painting techniques in ancient Egypt *(Ita)* S492
encaustic wax—The cleaning and consolidation of Egyptian encaustic mummy portraits *(Eng)* S1088
ethnobotany—An introductory study of the arts, crafts, and customs of the Guiana Indians *(Eng)* S34
Expressionist—Voices of German Expressionism *(Eng)* S254
fresco painting (technique)—Colors and painting in antiquity *(Fre)* S133

frescoes—19th and early 20th century restorations of English Mediaeval wall paintings: problems and solutions *(Eng)* S1116
gas chromatography—Examination of the diterpenoic resin components of anatomical wax models from the eighteenth century by gas chromatography *(Eng)* S656
illuminations—Some tests on the use of wax for fixing flaking paint on illuminated parchment *(Eng)* S898
Medieval—Observations on a late Medieval painting medium *(Eng)* S117
Mojave—Mohave tatooing and face-painting *(Eng)* S116
mural paintings—Conservation of English Medieval wallpaintings over the century *(Eng)* S1028
—The examination of mural paintings *(Dut)* S525
—Products, facts, modes in mural painting: evolution and distribution of restoration products used in mural paintings from 1850 to 1992. A first sorting concerning France, Spain, England, and Poland *(Fre)* S511
—The techniques, conservation, and restoration of mural paintings *(Ita)* S64
—The use of wax and wax-resin preservatives on English Medieval wall paintings: rationale and consequences *(Eng)* S388
organic materials—Some problems in analysis of aged organic materials in art works and artefacts *(Eng)* S595
paintings (objects)—Analysis of paint media, varnishes and adhesives *(Eng)* S625
. *pastels (visual works)*—A sculpture and a pastel by Edgar Degas *(Eng)* S285
plants—Plants for man *(Eng)* S159
pyrolysis mass spectrometry—Pyrolysis-mass spectrometry of natural gums, resins, and waxes and its use for detecting such materials in ancient Egyptian mummy cases (cartonnages) *(Eng)* S636
resin—Contribution to the study of natural resins in the art *(Eng)* S597
tempera—Ancient surface technology *(Eng)* S110
thin layer chromatography—Forensic examination of wax seals by thin-layer chromatography *(Eng)* S602
—High performance thin-layer chromatography for the identification of binding media: techniques and applications *(Eng)* S682
—Methods in scientific examination of works of art. Volume 2: thin-layer chromatography protocols *(Eng)* S685
—Methods in scientific examination of works of art. Volume 3: thin-layer chromatography reference materials binder *(Eng)* S683
—The methods of identifying organic binders in paint layers *(Slo)* S599
varnish—The influence of light on the gloss of matt varnishes *(Eng)* S782

wax-resin
cleavage—A case of paint cleavage *(Eng)* S703
triptychs—Material description, state of conservation, and treatment *(Dut)* S906

Wayang
Restoration of Indonesian Wayang-figures in the National Ethnographical Museum of Dresden *(Ger) binding media; gilding; Indonesia; parchment; polychromy; sculpture* S1049

weathering
coatings—Pigment-polymer interaction and technological properties of pigmented coatings and plastics *(Eng)* S800
fixatives—Fixing agent for chalking color on wood and its laboratory evaluation *(Jpn + Eng)* S1040
mechanical properties—Mechanical properties of weathered paint films *(Eng)* S851
paint—Method to follow the degradation by natural weathering of emulsion paint films *(Ger)* S829
tensile strength—Ultimate tensile properties of paint films *(Eng)* S752
titanium dioxide—The durability of paint films containing titanium dioxide—contraction, erosion and clear layer theories *(Eng)* S809
verre eglomise—The deterioration and conservation of painted glass: a critical bibliography *(Eng)* S994
viscosity—Microscopic examination of pigment/vehicle interaction during film formation *(Eng)* S762

weaving
dye—African textiles: looms, weaving and design *(Eng)* S313

wheat starch paste
adhesives—Natural adhesives in East Asian paintings *(Eng)* S372
pastels (visual works)—Removing severe distortions in a pastel on canvas *(Eng)* S1032
textiles—Preservation of a textile and a miniature painting *(Eng)* S895
—Technical study and conservation of an old painted textile (Simhasana) *(Eng)* S902

Whistler, James Abbott McNeill (1834-1903)
pastels (crayons)—American pastels of the late nineteenth & early twentieth centuries: materials and techniques *(Eng)* S442

white clay
Australian Aboriginal—Ethnological studies among the northwest-central Queensland Aborigines *(Eng)* S19
ceilings—Conservation treatments with reference to color paintings on the ceiling of the main hall, National Treasure, of Toshodaiji Temple, Nara *(Jpn)* S941
Horyuji Temple (Japan)—Coloring materals of the murals in the Main Hall of the Horyuji Temple compared with those of the ornamented tombs *(Jpn)* S271

white paint
Pueblo—Two summers' work in Pueblo ruins *(Eng)* S22

white pigment
The Louisville Paint and Varnish Production Club, Fourth Technical Symposium. The effect of physical characteristics of white and extender pigments on paint film properties *(Eng) pigment volume concentration; varnish* S725

—White pigments in ancient painting *(Ita) fillers; painting (technique); pigment; plasterwork* S203

calcium carbonate—Calcium carbonate whites *(Eng)* S561

coatings—Coloristics of grey coatings *(Eng)* S840

Mexico (Baja California)—Face and body painting in Baja California: a summary *(Eng)* S273

Mojave—Mohave tatooing and face-painting *(Eng)* S116

mural paintings—Chemical studies on ancient painting materials *(Jpn)* S150

—Chemical studies on ancient pigments in Japan *(Eng)* S138

Native American—A new original version of Boscana's historical account of the San Juan Capistrano Indians of Southern California *(Eng)* S62

pigment—Ethnology of Futuna *(Eng)* S67

—Two aboriginal rock pigments from Western Australia: their properties, use and durability *(Eng)* S290

pigment volume concentration—Determination of the brightening power in relation to the pigment volume concentration (PVC) of white pigments. A reasonable quick method *(Ger)* S814

—Effect of pigment volume concentration and film thickness on the optical properties of surface coatings *(Eng)* S751

Tomb of Nefertari (Thebes, Egypt)—Chemical analyses of pigments and media used in the mural paintings of the tomb of Nefertari *(Spa)* S658

whitewash
Decorative painters and house painting at Massachusetts Bay, 1630-1725 *(Eng) adhesives; egg white; painting (technique); pigment; USA (New England)* S258

frescoes—19th and early 20th century restorations of English Mediaeval wall paintings: problems and solutions *(Eng)* S1116

—The frescoes of Tavant (France) *(Eng)* S179

mural paintings—Materials and painting techniques of the wall paintings of the main nave of S. Mary's Church in Toruń *(Pol)* S432

pueblos (housing complexes)—A study of Pueblo architecture: Tusayan and Cibola *(Eng)* S9

whiting
calcimine—Interior wall decoration: practical working methods for plain and decorative finishes, new and standard treatments *(Eng)* S39

graining—Graining: ancient and modern *(Eng)* S79

wallpaper—Wallpaper in America: from the 17th century to World War I *(Eng)* S320

Winchester Cathedral (England)
stone—The conservation of the Winchester Anglo-Saxon fragment *(Eng)* S1090

wind
adobe—The conservation of adobe walls decorated with mural paintings and reliefs in Peru *(Eng)* S958

windows
stained glass—Field applications of stained glass conservation techniques *(Eng)* S1013

—A new fixation method for paint layer conservation *(Eng)* S1091

Winterthur Museum (Delaware, USA)
building materials—Conservation applied to historic preservation *(Eng)* S449

woad
blue pigment—Blues *(Ita)* S394

plants—On the history and migration of textile and tinctorial plants in reference to ethnology *(Eng)* S6

wood
Case studies in the treatment of polychrome wood sculptures at the Victoria and Albert Museum *(Eng) carvings; Chinese; forgeries; German; polychromy; sculpture; Victoria and Albert Museum (London, England)* S1006

—Colouring technique and repair methods for wooden cultural properties *(Eng) coatings; color; gilding; Japan; pigment; polychromy; sculpture* S303

—Conservation of polychrome wood sculpture at the Australian War Memorial *(Eng) Australia; cleaning; consolidation; European; paint; poly(vinyl acetate); polychromy; pyrolysis gas chromatography; sculpture* S944

—Consolidation of deteriorated wooden artifacts *(Eng) consolidation; epoxy; filling; gamma radiation; polychromy; polymerization* S961

—Consolidation of painted wooden artifacts *(Eng) discoloration; heat; humidity; impregnation; paint; polymerization; vacuum chambers* S934

—Consolidation of painted wooden artifacts: an ICOM report *(Eng) consolidation; gamma radiation; impregnation; methacrylate; paint; polymerization* S924

—Ethnographical wooden objects *(Eng) color; synthetic resin* S923

—The folk art tradition in painting on wood: paste and casein techniques *(Ger) Austria (Upper Austria); folk art; furniture; painting (technique); pigment; staining (finishing); tempera; veneer* S314

—Identification of archaeological and recent wood tar pitches using gas chromatography/mass spectrometry and pattern recognition *(Eng) bark; birch; gas chromatography mass spectrometry; pattern recognition; pitch (tar); spectrometry; wood tar* S655

—Investigation into methods and materials for the adhesion of flaking paint on ethnographic objects: a progress report *(Eng) accelerated aging; adhesives; darkening; dispersions; emulsion; ethnographic conservation; flaking; Oceania; paint; reattaching; resin* S1045

—Plants for religious use from the forest region of West Africa *(Fre) Africa, West; camwood; carving; colorants; iroko* S106

—The restoration of the wooden statue of Our Lady in the parish church of Cercina *(Ita) Araldite SV427; Elvacite 2044; gesso; Italy (Cercina); mastic; polychromy; Primal AC33;*

putty; rabbit-skin glue; retouching; tempera; turpentine; varnish; Xylamon S1078
—Studies on fixing treatments of color paintings on the ceiling of Sanmon Gate, National Treasure, Tofuku-ji Temple *(Jpn)* acrylic resin; ceilings; color; emulsion; fixing; flaking; Muromachi; paint; paper; peeling; plastics; Primal AC3444; Tofuku-ji Temple (Kyoto, Japan) S940
—Wood documentation. VII: wood conservation and surface treatment. Volume 2: surface treatment *(Fre)* bleaching; blistering; filling; finishing; mordant; paint; staining (finishing) S897
—Wooden ritual artifacts from Chaco Canyon, New Mexico: the Chetro Ketl collection *(Eng)* Anasazi; Chetro Ketl site; dendrochronology; paint; pigment; USA (New Mexico) S305
adhesives—The evaluation of some adhesive systems utilized in the consolidation of paintings. The kinetics of consolidation (III) *(Rum)* S1021
Africa—Personality and technique of African sculptors *(Eng)* S208
Africa, West—Handbook of West African art *(Eng)* S164
Anang—The carver in Anang society *(Eng)* S276
artists' materials—Techniques of ancient painting: the preparation of the support *(Ita)* S440
Australian Aboriginal—Various approaches to the conservation and restoration of Aboriginal artifacts made from bark *(Eng)* S974
bark cloth—The technical aspects of ornamented bark-cloth *(Eng)* S209
bark paintings—Conservation of Australian Aboriginal bark paintings with a note on the restoration of a New Ireland wood carving *(Eng)* S905
binding media—Analysis of binding media and adhesives in Buddhist wooden statues *(Jpn)* S674
carvings—Collecting wooden ethnographic carvings in the tropics *(Eng)* S354
ceilings—Restoration of painted ceilings in Oman: the Jabrin fortress *(Fre)* S1048
—The restoration of the wooden painted ceiling in the "Confraternità del Rosario," SS. Filippo and Giacomo Church, Ospedaletto d'Alpinolo *(Ita)* S1096
cellulose ether—The use of cellulose ethers in the treatment of Egyptian polychromed wood *(Eng)* S1053
chalk—Observations about conservation techniques regarding the consolidation of waterbound chalk paint layers *(Ger)* S1077
chests—The cleaning, conservation, and restoration of a Matyo chest *(Hun)* S1000
China—Scientific study of the decoration of four wooden funerary boxes from China *(Fre)* S510
Chumash—Volume IV: Ceremonial paraphernalia, games, and amusements *(Eng)* S344
conifers—Ethnobotany of coniferous trees in Thompson and Lillooet Interior Salish of British Columbia *(Eng + Fre)* S426
conservation—Conservation of interior decoration and furniture of monuments *(Ger)* S806

consolidation—Consolidation of loose paint on ethnographic wooden objects *(Ger)* S901
—A consolidation treatment for powdery matte paint *(Eng)* S979
—A review of problems encountered in the consolidation of paint on ethnographic wood objects and potential remedies *(Eng)* S1085
cracking—Crack mechanisms in gilding *(Eng)* S874
—Cracking on paintings *(Ger)* S718
dye—Rosewood, dragon's blood and lac *(Eng)* S181
dyewood—Dyewoods, their composition and use. Part 1: Description of the most important dyewoods *(Ger)* S204
—Dyewoods, their composition and use. Part 2: Red dyes and their fields of application *(Ger)* S205
Egypt—Egyptian paintings of the Middle Kingdom *(Eng)* S245
—The entourage of an Egyptian governor *(Eng)* S244
encaustic painting—The technology, examination and conservation of the Fayum portraits in the Petrie Museum *(Eng)* S965
encaustic wax—The cleaning and consolidation of Egyptian encaustic mummy portraits *(Eng)* S1088
Eskimo—Ethnological results of the Point Barrow expedition *(Eng)* S13
finishes—Coating formulation: its effects on the durability of exterior wood finishes *(Eng)* S808
fixatives—Fixing agent for chalking color on wood and its laboratory evaluation *(Jpn + Eng)* S1040
fixing—Theoretical approach to refixing *(Fre)* S1017
folk art—Care of folk art: the decorative surface *(Eng)* S501
Gabon—The useful plants of Gabon: an inventory and concordance of popular and scientific names of native and nonnative plants. Description of species, properties, and economic, ethnographic, and artistic uses *(Fre)* S202
gas chromatography mass spectrometry—GC/MS and chemometrics in archaeometry: investigation of glue on Copper-Age arrowheads *(Eng)* S665
Hawaiian—Hawaiian sculpture *(Eng)* S415
history of technology—Chemistry of painting surfaces from earliest time to unfathomable future *(Eng)* S279
Iatmul—The conservation of an orator's stool from Papua New Guinea *(Eng)* S1042
Iceland—Likneskjusmid: fourteenth century instructions for painting from Iceland *(Eng)* S503
icons—Restoration and conservation of an icon from Melnik *(Bul)* S948
—The technique of icon painting *(Eng)* S214
Inca—Mopa-mopa or pasto varnish: the frames of the Church of Egypt, in Bogotá *(Spa)* S461
India—Notes on the technique of Indian polychrome wooden sculpture *(Eng)* S246
—A study of Indian polychrome wooden sculpture *(Eng)* S255

wood

Japan—Pigments used on Japanese paintings from the protohistoric period through the 17th century *(Eng)* S315
Jelling Man—The Jelling Man and other paintings from the Viking age *(Eng)* S420
Kwakiutl—Field research in the conservation of ethnographical collections: an ecological approach applied to polychrome monumental sculpture *(Eng)* S417
Maori—Conservation considerations on four Maori carvings at Auckland Museum, New Zealand *(Eng)* S359
—Maori carvings in Auckland museum, New Zealand. Ethical considerations in their restoration *(Eng)* S360
—Some early examples of the conservation of Maori wood carvings in the collections of the British Museum *(Eng)* S1055
masks—Chiriquano masks: polychrome wood (treatment and inquiry) *(Eng)* S1041
—The examination and treatment of two wood funerary masks with Negroid features *(Eng)* S990
mechanical properties—Mechanical properties of weathered paint films *(Eng)* S851
Medieval—Observations on a late Medieval painting medium *(Eng)* S117
Mesoamerican—Ancient Mesoamerican mortars, plasters, and stuccos. The use of bark extracts in lime plasters *(Eng)* S197
mural paintings—Application of synthetic resins to the preservation of antiques and art crafts *(Jpn)* S891
—Microchemical analysis of the wall paintings of St. Baafsabtei in Ghent (about 1175) *(Dut)* S90
—Reproduction of colored patterns in temples and shrines *(Eng)* S383
New Guinea—Wow-Ipits: eight Asmat woodcarvers of New Guinea *(Eng)* S231
Nitinaht—Ethnobotany of the Nitinaht Indians of Vancouver Island *(Eng)* S356
ocher—Friable ochre surfaces: further research into the problems of colour changes associated with synthetic resin consolidation *(Eng)* S997
organic chemistry—The organic chemistry of museum objects *(Eng)* S633
Osakihachiman shrine (Japan)—Conservation treatment of the painting on wooden walls in the oratory of Osakihachiman Shrine *(Jpn)* S964
painting (technique)—Original treatises on the arts of painting *(Eng + Lat)* S234
—Pigments and paints in primitive exotic techniques *(Fre)* S201
panel paintings—Present state of screen and panel paintings in Kyoto *(Jpn)* S933
—Wings from a quadriptych with the legend of St. John the Baptist: general problems and conservation treatment *(Pol)* S917
Papua New Guinea (New Ireland)—Assemblage of spirits: idea and image in New Ireland *(Eng)* S403
patina—The study of patina *(Fre)* S416
pest control—A historical survey of the materials used for pest control and consolidation in wood *(Ger)* S1010

pine tar—Analysis of Finnish pine tar and tar from the wreck of frigate St. Nikolai *(Eng)* S650
plant materials—Pharaoh's flowers: the botanical treasures of Tutankhamun *(Eng)* S463
plants—The ocean-going *noni*, or Indian mulberry (*Morinda citrifolia, Rubiaceae*) and some of its "colorful" relatives *(Eng)* S502
poly(vinyl alcohol)—Experiments in the use of polyvinyl alcohol as a substitute for animal glues in the conservation of gilded wood *(Eng)* S1100
polychromy—Disinfestation and consolidation of polychromed wood at the Institut Royal du Patrimoine Artistique, Brussels *(Eng)* S957
—Problems of the interpretation of historical sources and their confirmation by the results of technical analysis on works of art, shown on the example of painted sculptures from the 18th century in southern Germany *(Ger)* S322
reattaching—Reattaching color layers on a wooden wall and documenting the distribution of damages *(Jpn)* S1024
—Reattaching thick color layer of polychrome wooden sculpture *(Jpn)* S1022
red pigment—Note on the pigment blocks of the Bushongo, Kasai District, Belgian Congo *(Eng)* S28
resin—The exploitation of resinous products in a lowland Malayan forest *(Eng)* S391
Romania—Specific forms of degradation and their causes in wood panel tempera paintings *(Rum)* S439
shields (armor)—The conservation of some carved wooden war shields from the Tifalmin Valley, Papua New Guinea *(Eng)* S950
sumac—The use of the sumacs by the American Indian *(Eng)* S72
synthetic resin—Restoration with synthetic resins in Japan *(Ger)* S966
tablets—Preservative treatment of the *Funa-Ema* (votive tablets of boats), important folklore materials at Arakawa Shrine and Hakusanhime Shrine *(Jpn)* S932
transferring—Transfer of paintings: at any price? *(Ger)* S916
triptychs—Material description, state of conservation, and treatment *(Dut)* S906
varnish—Varnish of Pasto, a Colombian craft of aboriginal origin *(Spa)* S212
Vuillard, Edouard (1868-1940)—History, analysis and treatment of the "La salle à manger au château de Clayes," 1938, by Edouard Vuillard *(Eng)* S1009
wallpaper—Wallpaper on walls: problems of climate and substrate *(Eng)* S982
wax—The preservation of wood sculpture: the wax immersion method *(Eng)* S890
Yoruba—A Yoruba master carver: Duga of Meko *(Eng)* S274

wood flour
extenders—Extenders *(Eng)* S165

wood tar
wood—Identification of archaeological and recent wood tar pitches using gas chromatography/mass spectrometry and pattern recognition *(Eng)* S655

514

woodcuts
Poland—Folk painting on glass *(Pol)* S240

woodwork
Medieval—The materials and techniques of Medieval painting *(Eng)* S172
mural paintings—The Château of Oiron and its decorated surfaces *(Fre)* S457

woodworms
ceilings—The restoration of the wooden painted ceiling in the "Confraternità del Rosario," SS. Filippo and Giacomo Church, Ospedaletto d'Alpinolo *(Ita)* S1096

wool
dye—Navajo native dyes: their preparation and use *(Eng)* S299

World Heritage Museum (Illinois, USA)
mummies—Probing the mysteries of ancient Egypt; chemical analysis of a Roman period Egyptian mummy *(Eng)* S673

x-ray diffraction
Nondestructive infrared and x-ray diffraction analyses of paints and plastics *(Eng) dye; infrared spectrometry; paint; pigment; plastics; spectrometry* S532
Australian Aboriginal—Pigment analysis for the authentication of the aboriginal paintings at Bunjils Cave, western Victoria *(Eng)* S632
forensic science—Developments in paint analysis for forensic purposes *(Eng)* S639
Iran—Friable pigments and ceramic surfaces: a case study from SW Iran *(Eng)* S1058
Maya blue Examination and identification of Maya blue *(Fre)* S544
mural paintings—Physico-chemical study of the painting layers of the Roman mural paintings from the Acropolis of Lero *(Fre)* S342
rock paintings—Mossbauer study of rock paintings from Minas Gerais (Brazil) *(Eng)* S663
Romano-British—An analysis of paints used in Roman Britain *(Eng)* S213
Seri blue—Seri blue—an explanation *(Eng)* S218

x-ray fluorescence
Australian Aboriginal—Pigment analysis for the authentication of the aboriginal paintings at Bunjils Cave, western Victoria *(Eng)* S632
Mudejar—Technical examination and consolidation of the paint layer on a Mudéjar coffered ceiling in the Convent of Santa Fe, Toledo *(Eng)* S1110

Xia
pigment—The T'u-lu colour-container of the Shang-Chou period *(Eng)* S222

XRD *see* **x-ray diffraction**

XRF *see* **x-ray fluorescence**

Xylamon
ceilings—The restoration of the wooden painted ceiling in the "Confraternità del Rosario," SS. Filippo and Giacomo Church, Ospedaletto d'Alpinolo *(Ita)* S1096
polychromy—Disinfestation and consolidation of polychromed wood at the Institut Royal du Patrimoine Artistique, Brussels *(Eng)* S957

wood—The restoration of the wooden statue of Our Lady in the parish church of Cercina *(Ita)* S1078

xylene
bark paintings—Conservation of Australian Aboriginal bark paintings with a note on the restoration of a New Ireland wood carving *(Eng)* S905
carvings—Collecting wooden ethnographic carvings in the tropics *(Eng)* S354
forgeries—The technical investigation and conservation treatment of an alleged Ming Dynasty wall painting *(Eng)* S956
human head—The conservation of a preserved human head *(Eng)* S935
poly(butyl methacrylate)—New possibilities of polybutyl methacrylate as a consolidating agent for glue painting on loess plaster *(Eng)* S936
reattaching—Reattaching color layers on a wooden wall and documenting the distribution of damages *(Jpn)* S1024

yam masks
Abelam—Consolidation techniques for "yam masks": a practical investigation paper presented to the National Museum Act and the Museum of Cultural History at the University of California at Los Angeles as an advanced internship research project *(Eng)* S996

yellow
Acoma—The Acoma Indians *(Eng)* S57
Carib—Plants used by the Dominica Caribs *(Eng)* S98
dye—Aboriginal paints and dyes in Canada *(Eng)* S54
ethnobotany—Ethnobotany of the Zuñi Indians *(Eng)* S27

yellow arsenic sulfide
pigment—Painted Mexican furniture and trinkets *(Fre)* S178

yellow lead oxide
yellow pigment—Yellows *(Ita)* S396

yellow ocher
ceilings—Conservation treatments with reference to color paintings on the ceiling of the main hall, National Treasure, of Toshodaiji Temple, Nara *(Jpn)* S941
ceramics—Technological notes on the pottery, pigments, and stuccoes from the excavations at Kaminaljuyu, Guatemala *(Eng)* S107
Chumash—A study of some Californian Indian rock art pigments *(Eng)* S519
fixatives—Fixing agent for chalking color on wood and its laboratory evaluation *(Jpn + Eng)* S1040
frescoes—The consolidation of friable frescoes *(Eng)* S1015
—The Tassili frescoes *(Eng)* S188
Horyuji Temple (Japan)—Coloring materals of the murals in the Main Hall of the Horyuji Temple compared with those of the ornamented tombs *(Jpn)* S271
India—A study of Indian polychrome wooden sculpture *(Eng)* S255
Japan—Pigments used in Japanese paintings *(Eng)* S405

Mayan—The Maya mural paintings of Bonampak, materials analysis *(Fre)* S539
mural paintings—Chemical studies on ancient painting materials *(Jpn)* S150
—Chemical studies on ancient pigments in Japan *(Eng)* S138
—Materials and techniques of Medieval wall paintings from the former House of Merchants' Fraternity at 5 Żeglarska Street in Toruń *(Pol)* S485
—Microchemical analysis of the wall paintings of St. Baafsabtei in Ghent (about 1175) *(Dut)* S90
—Pigments and techniques of the early Medieval wall paintings of eastern Turkistan *(Ger)* S298
—Pigments used in the paintings of "Hoodo." *(Jpn)* S183
—Reproduction of colored patterns in temples and shrines *(Eng)* S383
—Structure, composition, and technique of the paintings *(Dut)* S346
—The technique of the paintings at Sitabhinji *(Eng)* S143
ocher—Ocher and ocher industry in the Puisaye region, geology and history *(Fre)* S238
panel paintings—Wings from a quadriptych with the legend of St. John the Baptist: general problems and the treatment of conservation *(Pol)* S917
pigment—Ancient Greek pigments from the Agora *(Eng)* S104
—The chemical studies on the pigments used in the Main Hall and pagoda of Hōryūji temple (Nara, Japan) *(Jpn)* S119
synthetic organic pigment—An early 20th-century pigment collection: the pigment collection in the Missiemuseum at Steyl-Tegelen *(Dut)* S435
textiles—Technical study and conservation of an old painted textile (Simhasana) *(Eng)* S902
yellow pigment—Yellow pigments used in antiquity *(Fre)* S113
—Yellows *(Ita)* S396

yellow pigment
Yellow pigments used in antiquity *(Fre) dye; gold (powdered); litharge; massicot; orpiment; pigment; silver; sulfur; vegetable dye; yellow ocher* S113
—Yellows *(Ita) barium yellow; cadmium yellow; chrome yellow; cobalt yellow; gamboge (pigment); history of technology; Indian yellow; mars yellow; minerals; Naples yellow; orpiment; saffron; turmeric; yellow lead oxide; yellow ocher; zinc yellow* S396
Blackfoot—Painted tipis and picture-writing of the Blackfoot Indians *(Eng)* S69
Kachina masks—Zuni Katcinas *(Eng)* S53
Maori—Maori art *(Eng)* S18
rock art—Seeing red in Queensland *(Eng)* S433
Shroud of Turin—Microscopical study of the Turin Shroud. III *(Eng)* S598

yellow wood dye
dyewood—Dyewoods, their composition and use. Part 1: Description of the most important dyewoods *(Ger)* S204

—Dyewoods, their composition and use. Part 2: Wood dyes and their fields of application *(Ger)* S205

yellowing
acrylic resin—A study of acrylic dispersions used in the treatment of paintings *(Eng)* S1066
house paint—Problems in the restoration and preservation of old house paints *(Eng)* S947
painting (technique)—Physics and painting: introduction to the study of physical phenomena applied to painting and painting techniques *(Dut)* S707
pigment—Exposure evaluation: quantification of changes in appearance of pigmented materials *(Eng)* S790

Yoruba
Gelede: a Yoruba masquerade *(Eng) alcohol; carving; masks; Nigeria; rituals* S250
—A Yoruba master carver: Duga of Meko *(Eng) artists' materials; carvings; gum; oil paint; pigment; wood* S274
—Yoruba pattern dyeing *(Eng) blue dye; dye; Elu; indigo* S80
ritual objects—Eshu-Elegba: the Yoruba trickster god *(Eng)* S292

yucca
copper carbonate—The mamzrauti: a Tusayan ceremony *(Eng)* S11
ethnobotany—Ethnobotany of the Tewa Indians *(Eng)* S33
—Ethnobotany of the Zuñi Indians *(Eng)* S27
Kachina masks—Zuni Katcinas *(Eng)* S53

Yuma
mining—The mining of gems and ornamental stones by American Indians *(Eng)* S93

Zaire
ceramics—Two Kongo potters *(Eng)* S291
patina—The study of patina *(Fre)* S416
Sundi—The Kongo I *(Eng)* S162

Zaire (Kasai)
red pigment—Note on the pigment blocks of the Bushongo, Kasai District, Belgian Congo *(Eng)* S28

Zambia
Africa—The material culture of the peoples of the Gwembe Valley *(Eng)* S243

zeolite
panel paintings—Basic experiments concerning deterioration of glue and discoloration of pigments, and discussion on the actual condition of wall panel paintings on the basis of their results *(Jpn)* S930

Zimbabwe
Chowa—Rhodesian engravers, painters and pigment miners of the fifth millennium B.C. *(Eng)* S161

zinc
calcimine—Interior wall decoration: practical working methods for plain and decorative finishes, new and standard treatments *(Eng)* S39

zinc sulfide
paint—A method of hiding power determination and its application as an aid to paint formulation *(Eng)* S737

zinc white
 calcimine—The painters' encyclopaedia *(Eng)* S10
 extenders—Size and shape properties of representative white hiding and extender pigments *(Eng)* S727
 house paint—Kline paints a picture *(Eng)* S154
 mural paintings—Analysis of pigments and plaster of the paintings in the Sheesh Mahal, Nagaur *(Eng)* S428
 pigment—Artists' pigments: a handbook of their history and characteristics *(Eng)* S623
 —Role of pigments *(Eng)* S768
 pigment volume concentration—Particle packing analysis of coatings above the critical pigment volume concentration *(Eng)* S818
 reflectance—Experimental study on spectral reflective properties of a painted layer *(Eng)* S813
 synthetic organic pigment—An early 20th-century pigment collection: the pigment collection in the Missiemuseum at Steyl-Tegelen *(Dut)* S435

 textiles—Technical study and conservation of an old painted textile (Simhasana) *(Eng)* S902
zinc yellow
 pigment volume concentration—Coating formulation and development using critical pigment volume concentration prediction and statistical design *(Eng)* S854
 —Pigment volume concentration and its effect on the corrosion resistance properties of organic paint films *(Eng)* S882
 yellow pigment—Yellows *(Ita)* S396
Zuni
 The Zuni Indians, their mythology, esoteric fraternities, and ceremonies *(Eng) green pigment; Native American; pigment* S24
 ethnobotany—Ethnobotany of the Zuñi Indians *(Eng)* S27
 Kachina masks—Zuni Katcinas *(Eng)* S53
 pueblos (housing complexes)—A study of Pueblo architecture: Tusayan and Cibola *(Eng)* S9

Appendix V
Glossary

The majority of definitions were adopted for this work from the sources listed below. The numerical note that follows each definition indicates its source. (The authors' contributions are designated "A").

[1] *Paint/Coatings Dictionary* (1978) compiled by Definitions Committee of the Federation of Societies for Coatings Technology (Philadelphia: The Federation).

[2] 'Glossary' in *Pigment Handbook* (1973) ed. Temple C. Patton, Vol. III. 503-512 (New York: Wiley).

[3] Buck, Richard D. 'Inspecting and Describing the Condition of Art Objects' in *Museum Registration Methods* (1979) (Washington, D.C.: American Association of Museums).

[4] 'Relevant Adhesive Terminology' in *Adhesives and Consolidants, IIC, Preprints of the Contributions to the Paris Congress, 2-8 September 1984* eds. N.S. Brommelle, E.M. Pye, P. Smith, and G. Thomson (London: International Institute for Conservation of Historic and Artistic Works).

[5] D.W. Carr and M. Leonard *Looking at Paintings: A Guide to Technical Terms* 1992 (Malibu: J. Paul Getty Museum in association with British Museum Publications).

[6] *Art & Architecture Thesaurus* (1990) Published on behalf of The Getty Art History Information Program (New York: Oxford University Press).

abrasion Wearing away of a surface in service by action such as rubbing, scraping, or erosion. [1]

abrasion resistance The ability of a coating to resist being worn away and to maintain its original appearance and structure as when subjected to rubbing, scraping, or erosion. [1]

absolute reflectance Reflectance measured relative to the perfect diffuser. [1]

absorption a) The process by which a liquid is drawn into and tends to fill permeable pores in a porous solid body. b) The process by which light or other electromagnetic radiation is converted into heat or other radiation differing in wavelength from the original absorption when incident on or passing through a material. [2]

absorption coefficient Absorption of radiant energy for a unit concentration through a unit pathlength for a specified wavelength and angle of incidence and viewing. [1]

acacia gum Water-soluble gum obtained from trees of the acacia species, as an exudation from incisions in the bark. It is water-soluble and is used as an adhesive, thickening agent and for transparent paints. [1]

accelerated aging Any set of conditions designed to produce in a short time the results obtained under normal conditions of aging. In accelerated aging test, the usual factors considered are heat, light, or oxygen, either separately or combined. [1]

accelerated weathering Tests designed to simulate, but at the same time to intensify and accelerate, the destructive action of natural outdoor weathering on coatings films. The tests involve exposure to artificially produced components of natural weather, e.g., light, heat, cold, water vapor, rain, etc., which are arranged and repeated in a given cycle. There is no universally accepted test, and different investigators use different cycles. [1]

519

accretion *(also called incrustation)* An accumulation of extraneous material on the surface of an object that alters the original design. [3]

achromatic Literally, color free; having no hue. [2]

acrylic A general term used to describe a fairly large family of polymers and copolymers where at least one principal structural unit is derived from acrylic or methacrylic acids or their esters. Note: Polymers of this class find outlets as constituents of many types of solvent-borne adhesives and emulsion adhesives, particularly where resistance to plasticizer migration is required. [4]

additive Any substance added in small quantities to another substance, usually to improve properties. [1]

adhere To cause two surfaces to be held together by adhesion. [1]

adherend A body that is, or is intended to be, held to another body by an adhesive. [4]

adhesion State in which two surfaces are held together by interfacial forces which may consist of valence forces or interlocking action, or both. [1]

adhesion, mechanical Adhesion between surfaces in which the adhesive holds the parts together by interlocking action. [1]

adhesive Substance capable of holding materials together by surface attachment. Note: Adhesive is the general term and includes among others cement, glue, mucilage, and paste. All of these terms are loosely used interchangeably. Various descriptive adjectives are applied to the term, 'adhesive,' to indicate certain characteristics as follows: Physical form—liquid adhesive, tape adhesive; Chemical type—silicate adhesive, resin adhesive; Materials bonded—paper adhesive, metal-plastic adhesive, can label adhesive; and Conditions of use—hot-setting adhesive. [1]

adhesive film Synthetic resin adhesive, usually of the thermosetting type, in the form of a thin dry film of resin, used under heat and pressure as an interleaf in the production of laminated materials (particularly plywood and densified wood) [1]

adsorbent Substance offering a suitable active surface, upon which other substances may be adsorbed. [1]

adsorption The property exhibited by a solid to condense upon its surface a thin layer of a gas or liquid with which it is in contact. [2]

aggregate Aggregates are formed by the cementation of individual particles, probably by chemical forces during the manufacture of the material or its dispersal in the vehicle before sampling. [2]

aging Storage of paints, varnishes, etc., under defined conditions of temperature, relative humidity, etc., in suitable containers, or of dry films of these materials, for the purpose of subsequent tests. [1]

albumin Water-soluble protein derived from egg whites or animal blood, which is used in coatings and adhesives [1].

alkyd resin A synthetic resin made from polyhydric alcohols and polybasic acids; generally modified with resins, fatty acids, or fatty oils. [2]

alligatoring A type of crazing or surface cracking of a definite pattern, as indicated by name. The effect is often caused during weather aging. [1]

amorphous silica SiO_2. A naturally occurring or synthetically produced pigment, characterized by the absence of pronounced crystalline structure, and which has no sharp peaks in its x-ray diffraction pattern. It may contain water of hydration or be an anhydrous type. It is used as an extender pigment, flatting agent, and as a desiccant in metal flake and metal powder coatings. [1]

angle of contact Associated with the phenomenon of wetting. When a drop of liquid contacts a solid surface it can remain exactly spherical, in which case no wetting occurs; or it can spread out to a perfectly flat film, and in that latter case complete wetting occurs. The angle of contact is the angle between the tangent to the periphery of the drop at the point of contact with the solid, and the surface of the solid. When the drop spreads to a perfectly flat film, the angle of contact is zero. When it remains exactly spherical, the area of contact is a point only, and the angle of contact is 180~. [1]

angle of incidence Angle between the axis of an impinging light beam and the perpendicular to the object surface. [1]

angle of reflection Angle between the axis of a reflected light beam and the perpendicular to the object surface. [1]

angle of viewing Angle between the axis of a detected light beam and the perpendicular to the object surface. [1]

animal fats Include such products as lard, bone fat, tallow and butter fat. They are semi-solid at ordinary air temperature, and consist chiefly of the glycerides of oleic and stearic acids. [1]

animal oils Normally restricted to the animal foot oils and lard oil, and quite distinct from the fish oils. Neatsfoot oil is typical of the foot oils. The animal oils are characterized by the almost complete absence of acids more unsaturated than oleic acid, and by the presence of cholesterol. The presence of this latter compound enables them to be distinguished from the nondrying vegetable oils. [1]

animal waxes Obtained from a great variety of sources and have little in common, except absence of glycerides. [1]

anti-oxidant a substance (also called an inhibitor) which is effective in preventing oxidation by molecular oxygen. [A]

apparent density Mass per volume of loose, dry pigment (or powder) including the air voids between the particles. Usually expressed as lbs/cubic foot or g/cm3. [1]

appearance Manifestation of the nature of objects and materials through visual attributes such as size, shape, color, texture, glossiness, transparency, opacity, etc. [1]

archival Used broadly to describe materials, such as paper or mat board, or processing methods that are expected to allow items to be stored for extended periods of time without loss of quality. [6]

architectural coatings Coatings intended for on-site application to interior or exterior surfaces of residential, commercial, institutional, or industrial buildings—as opposed to industrial coatings. They are protective and decorative finishes applied at ambient temperatures. [1]

average particle size A value of the size attribute (usually diameter) that is taken to be the best single value that is representative of the whole size distribution for the purpose involved. [2]

base coat 1) All plaster applied before the finish coat; may be a single coat or a scratch coat and a brown coat. 2) The first coat applied to a surface, as paint; a prime coat. 3) An initial coat applied to a wood surface before staining or otherwise finishing it. [1]

beeswax Mixture of crude cerotic acid and myricin separated from honey. It is a soft natural wax, with a mp of 63 ~C, an acid value usually below 20, a saponification value of 90-95, and a very low iodine value of 6 13. [4]

binder Non-volatile portion of the liquid vehicle of a coating. It binds or cements the pigment particles together and the paint film as a whole to the material to which it is applied. [1]

blanching Irregular, obtrusive, pale, or milky areas in paint or varnish; not a superficial defect like bloom, but a scattering of light from microporosities or granulation in aged films. [3]

bleeding The diffusion of coloring or other matter through a coating from a substrate; also the spreading or running of a pigment color by the action of a solvent such as water or alcohol. [2]

bloom A visible exudation of efflorescence on a surface (can be caused by lubricant, plasticizer, etc.). [2]

body To thicken an adhesive. [4]

bond (noun) An attachment between adherends achieved by an adhesive. [4]

bond (verb) To attach adherends by an adhesive. Note: the use of 'glue' is deprecated. [4]

bond strength The force necessary to bring an adhesive joint to the point of failure, with failure occurring in or near the plane of the bond-line. [4]

breaking force The force necessary to bring an adhesive joint to the point of failure, irrespective of mode of failure. [4]

brightness (of a color) Intensity, strength, or vividness, usually relative to some other color with which it is compared. [2]

brightness (photometric) Luminance. The luminous intensity of any surface in a given di-

rection per unit of projected area of the surface as viewed from that direction. [2]

brittle Easily broken when bent rapidly or scratched as with a knife blade or the finger nail; the opposite of tough. [1]

brittleness Tendency to crack or snap when subjected to deformation. [1]

brush The basic tool used to apply not only paint but varnishes and metal leaf as well. Brushes are made from a wide variety of materials and come in a nearly infinite array of shapes and sizes. In ancient times, brushes may have been made from tufts of animal hair tied in small bundles to a reed handle. Cennino Cennini, writing in the 15th century, described delicate brushes made from miniver fur and mounted on quill handles, as well as larger brushes made from hog hairs and attached to wooden sticks. In the 19th century, metal ferrules were introduced as a means of holding the brush hairs together. The size and shape of the ferrule were dictated by the desired size (wide or narrow) and shape (flat or round) of the brush. In modern times, brushes of the highest quality are most frequently made with sable hair. Coarser animal hairs are still used to make bristle brushes, and a number of synthetic fibers have been introduced. [5]

buckled cleavage (or buckling) One type of laminal disruption in which loosened layers take a conformation of gable like ridges. These ridges may combine parallel and perpendicular disruption and may be caused by compressive forces underneath the laminae. They are recognized by contour and by sonancy. [5]

carboxymethyl cellulose (CMC) The common name for a cellulose ether of glycolic acid. It is usually marketed as a water-soluble sodium salt, more properly called sodium carboxymethyl cellulose. In the early literature, it is sometimes called cellulose glycolate or cellulose glycolic acid. [1]

casein An adhesive made from the curd of soured skim milk. Although casein powder mixed with limewater has been used as a binder for pigments since ancient times, only scattered references to the use of casein in old master paintings can be found. During the 19th century, casein colors gained some popularity and were commercially manufactured. The surface of a casein painting has a dull matte sheen. Casein is

considered to be a difficult medium that presents problems in handling and correction (primarily because of its quick- drying nature); it also forms an extremely brittle film that does not age well. [5]

cast film A film made by depositing a layer of plastic, either molten, in solution, or in a dispersion, onto a surface, solidifying and removing the film from the surface. [1]

cellulose esters products of the esterification of certain of the hydroxyl groups of the cellulose macromolecule with organic or mineral acids: cellulose esters are soluble in organic solvents such as esters or ketones, and thus form the basis of some solvent-borne adhesives. Note: Examples of cellulose esters are cellulose acetate, cellulose acetobutyrate, cellulose acetopropionate, cellulose nitrate. [4]

cellulose ethers products of the etherification of certain of the hydroxyl groups of the cellulose macromolecule: the ethers are soluble in, or solubilized by, water and simple alcohols and find use as the basis of water-soluble adhesives for paper and as thickening agents in water-borne adhesives. Note: Examples of cellulose ethers are carboxymethyl cellulose, ethyl cellulose, methyl cellulose. [4]

chalk 1) Soft naturally-occurring form of calcium carbonate. The whiter varieties are powdered, washed, and dried. The product is known as whiting; the finer varieties as Paris white. 2) The product of chalking. [4]

chalking A phenomenon manifested in paint films by the presence of loose removable powder, evolved from the film itself, at or just beneath the surface (detected by rubbing the film); dry, chalk-like appearance or deposit on the surface of a plastic; condition of a glossy surface that has lost its natural gloss and become powdery. [3]

checking That phenomenon manifested in paint films by slight breaks in the film that do not penetrate to the underlying surface. The break should be called a crack if the underlying surface is visible. Where precision is necessary in evaluating a paint film, checking may be described as visible (as seen with the naked eye) or as microscopic (as observed under a magnification of 10 diameters). [1]

cleavage A parallel disruption occurring as separation between or in any of the laminae of a stratified construction, so called because it runs parallel to the surface. When marked, it is visible as an elevation of contour and audible as having a sonancy (the faint sound emitted upon contact) different from that of coherent structures in the same artifact. [3]

coalescence a) The fusion of dispersed particles of an emulsion. b) The fusion of two adhesive films when brought together. [4]

coat Paint, varnish, or lacquer applied to a surface in a single application (one layer) to form a properly distributed film when dry. A coating system usually consists of a number of coats separately applied in a predetermined order at suitable intervals to allow for drying or curing. It is possible with certain types of material to build up coating systems of adequate thickness and opacity by a more or less continuous process of application, e.g., wet- on-wet spraying. In this case, no part of the system can be defined as a separate coat in the above sense. [1]

cohesion The state in which the particles of a single substance are held together by the primary or secondary valence forces. [4]

cohesive failure Failure within a body of the adhesive, i.e., not at the interface. [4]

collagen The natural protein of skin, bone, and connective tissue from which gelatine and animal glue are obtained. [4]

color One aspect of appearance; a stimulus based on visual response to light, and consisting of the three dimensions of hue, saturation, and lightness. [1]

colorant A substance that is used to modify the color of an object (confusion arises when it is called a color). [3]

color difference Magnitude and character of the difference between two colors under specified conditions. [1]

colorimeter Instrument used to measure light reflected or transmitted by a specimen. Two general types of colorimeters are commonly used: 1) for measuring concentrations of colored materials for analytical purposes, and 2) for measuring quantities which can be correlated with a psychophysical description of color. Generally, the

second type should properly be referred to as a tristimulus colorimeter. [1]

color match Pair of colors exhibiting no perceptible difference when observed under specified conditions. The quality of an attempted match is described by the closeness to this ideal match. [1]

color measurement Physical measurement of light radiated, transmitted, or reflected by a specimen under specified conditions, and mathematically transformed into standardized colorimetric terms which can be correlated with visual evaluations of colors relative to one another. Although the term 'color measurement' is normally used, color itself cannot be measured. [1]

color notation Orderly system of numbers, letters, or a combination of both, which serves to describe the relationship of colors in three-dimensional space. Thus, three dimensions must be included; for example, hue, value, and chroma of the Munsell System. Single dimensional notations, such as a yellowness scale, can be used only if the other two dimensions are fixed or described; two-dimensional notations can be used only if the third is fixed or described. [1]

compatibility Ability of two or more substances mixed with each other to form a stable homogeneous mixture.[1]

concentration 1) Amount of a substance expressed in relationship to the whole. 2) Act or process of increasing the amount of a given substance in relationship to the whole. [1]

congeal To change from a liquid or soft state to a solid or rigid state. [1]

consolidate To strengthen or to impart resiliency to paint that has poor cohesive or adhesive properties through the introduction of a consolidant. [1]

crack A fracture or fissure in any surface, especially a paint film. No loss is implied. [3]

craquelure A pattern of cracks that develops on the surface of a painting as a result of the natural drying and aging of the paint film. The use of different types of paint media and painting supports will result in varying types of craquelure. Tempera paintings, for example, will develop a characteristically delicate craquelure, which in some cases may be so fine as to be

nearly invisible to the naked eye. Oil paintings, on the other hand, tend to develop a more prominent network of drying cracks; the pattern will vary according to the type of support used, as well as the type of environmental conditions to which the painting has been exposed. If significant amounts of resins or other complex materials are mixed with paint, large, disfiguring dry cracks may develop, imparting a texture to the surface of the painting that resembles reptile skin (hence the term alligator cracks). A circular pattern of impact cracks can develop in a canvas painting as the result of a foreign object striking the surface or the reverse of the painting. Craquelure is considered a natural and, to some extent, desirable phenomenon. Drying cracks do not necessarily indicate that the paint has loosened from the support. Although the visual prominence of excessive crackle patterns can be minimized with retouching, the presence of most craquelure should simply be accepted. [4]

craze, crazing A defect appearing as fine cracks at the surface of a material. [3]

critical pigment volume concentration (CPVC) That level of pigmentation, PVC value (q.v.) in the dry paint, where just sufficient binder is present to fill the voids between the pigment particles. At this level, a sharp break occurs in film properties such as scrub resistance, hiding, corrosion resistance, ease of stain removal, etc. Different requirements for each product would dictate different PVC or CPVC ratios. Ceiling paints, for instance, are not required to be very washable and can be formulated at or above CPVC, whereas gloss paints and many exterior formulations are designed well below their CPVC, where CPVC has no significance. CPVC has significance only in flat paints. [1]

crosslinking Applied to polymer molecules, the setting up of chemical links between the molecular chains to form a three dimensional or network polymer generally by covalent bonding. [1]

cupped cleavage or cupping A type of laminal disruption in which flakes of paint are created with paint surfaces bent concavely into the shape of cups. [3]

cure To change the properties of a system into a final, more stable, usable condition by the use of heat, radiation, or reaction with chemical additives. [2]

cure temperature The specified temperature for curing an adhesive. [4]

cure time The period of time necessary for an adhesive to cure under the specified conditions. [4]

dammar resin Resin obtained from species of Shorea, Hopea, Balnocarpus, and which is soluble in certain organic solvents. Note: Dammar resin is used as a tackifier and modifier of pressure-sensitive adhesives. [4]

degradation Change in characteristics or quality of the original substance through chemical breakdown or physical wear. [1]

delaminate To separate existing layers [1]

density Mass per unit volume: preferably expressed as g/cm3. [2]

dent, dig, gouge, chip A defect in the surface, caused by a blow. A dent is a simple concavity; a dig implies that some material has been displaced; a gouge, that material has been scooped out; a chip, that material has been broken away. [3]

deterioration A permanent impairment of the physical properties. [1]

diffused light Nondirectional light. [1]

discoloration Staining. Also changing or darkening in color from the standard or original. [1]

dispersed Finely divided or colloidal in nature. [1]

dispersion A heterogeneous system in which finely divided (particulate) solid matter is distributed in a liquid or solid. [2]

distemper Heavily pigmented, matte drying composition, capable of being thinned with water, in which the binding medium consists essentially of either glue or casein or similar sizing material. [1]

distinctness-of-image gloss The sharpness with which image outlines are reflected by the surface of an object. [1]

dry A film is considered dry when it feels firm to the finger, using moderate pressure. [1]

dry brush Technique in which paint or ink is applied sparingly with a semidry brush. [1]

drying 1) Process of change of coatings from the liquid to the solid state, due to evaporation of the solvent, physico-chemical reactions of the binding medium, or a combination of these causes; 2) Process of removing moisture from pigments. It is carried out either in a current of hot air or in a vacuum. [1]

dullness 1) Lack of luster or gloss. 2) Colors of low chroma or saturation. [1]

dye Colorant which does not scatter light, but which absorbs certain wavelengths and transmits others. Dyes are generally organic in nature and generally soluble in water or some other solvent system; or they may exist in such a finely dispersed state that they do not scatter light and behave as though they were in solution. The dividing line between a dye and a pigment may, therefore, be indefinite and dependent on the particular total system involved. [1]

efflorescence A white powdery deposit on the surface of a specimen, usually caused by the precipitation or crystallization of soluble salts that have migrated to the surface. [2]

eggshell 1) Gloss lying between semigloss and flat. Generally thought to be between 20 and 35 as determined with a 60~ glossmeter. 2) An off white color. [1]

elasticity The property of the material by which it tends to return to its original dimensions after the removal of a stress. [4]

embrittlement A perceptible decline of firm, pliant, and supple organic material toward an amorphous or even pulverized state; easily observed in fabrics, paper, and leather. [3]

emulsion A mixture of two materials that do not naturally mix (such as oil and water). In order to create a paint medium, an emulsifying agent is introduced to a mixture of resin (or oil) and water, thus allowing tiny droplets of the resinous material to remain suspended in the water. When the water evaporates, the resinous material left behind forms the now non-water-soluble film of paint. Egg yolks are naturally occurring emulsions. Emulsions of egg and oil may have been used as painting media as early as the 16th century. In the 20th century, synthetic polymer emulsions of man-made resins and water

have been introduced as alternatives to oil paints. [5]

emulsion adhesive A stable dispersion of a polymeric adhesive in a liquid continuous phase. [4]

emulsion paint Paint, the vehicle of which is an emulsion of binder in water. The binder may be oil, oleoresinous varnish, resin or other emulsifiable binder. Not to be confused with a latex paint in which the vehicle is a latex. [1]

enamel Topcoat which is characterized by its ability to form a smooth surface; originally associated with a high gloss, but may also include lower degrees of gloss, i.e., flat enamels. [1]

encaustic A wax-based paint. Encaustic paintings are created by mixing pigment with molten wax (such as beeswax) and applying the mixture to a support while still hot. After the colors have been completely applied, the entire picture is heated slightly in order to fuse the paint layers together. Encaustic is most commonly associated with Egyptian portraits on mummy cases of the second to fourth centuries AD; these are known as Fayum portraits because of their common occurrence in the Fayum district of upper Egypt. The extreme stability of the encaustic medium has allowed Fayum portraits to remain exceptionally well preserved, possessing an astonishing clarity. Encaustic was rarely used again as a paint medium until the early 20th century, when some artists developed an interest in the fact that encaustic could be used to create thick, vibrant impasto with an Epoxide Resin: A synthetic resin containing epoxide groups; also called "epoxy resin." Note: This is a class of thermosetting resin that may be used in adhesives for structural purposes especially when cross-linked with a hardener or catalyst such as, for example, amines or anhydrides. [4]

epoxy resins Crosslinking resins based on the reactivity of the epoxide group. One common type is the resin made from epichlorhydrin and bisphenol A. Aliphatic polyols such as glycerol may be used instead of the aromatic bisphenol A or bisphenol F. [1]

erosion 1) Wearing away of the top coating of a painted surface, e.g., by chalking (q.v.) or by the abrasive action of windborne particles of grit, which may result in exposure of the under-

Glossary

lying surface; 2) Phenomenon manifested in paint films by the wearing away of the finish to expose the substrate or undercoat. The degree of failure is dependent on the amount of substrate or undercoat visible. Erosion occurs as the result of chalking (q.v.) or by the abrasive action of windborne particles of grit. [1]

essential oils Volatile oils or essences derived from vegetation and characterized by distinctive odors and a substantial measure of resistance to hydrolysis. Chemically, essential oils are often principally terpenes. Some essential oils are nearly pure single compounds. Some contain resins in solution and are then called oleoresins or balsams. [1]

evaporation rate A measure of the length of time required for a given amount of a substance to evaporate, compared with the time required for an equal amount of ethyl ether or butyl acetate (rated at 100) to evaporate. [1]

evaporation rate, final Time interval for complete evaporation of all solvent. [1]

evaporation rate, initial Time interval during which low boiling solvent evaporates completely. [1]

exposure tests Tests which are conducted to evaluate the durability of a coating or film. They include exposure to ultraviolet light, moisture, cold, heat, salt water, mildew, etc. They can be generated either naturally or artificially. [1]

extender (pigment) A specific group of achromatic pigments of low refractive index (between 1.45 and 1.70) incorporated into a vehicle system whose refractive index is in a range of 1.5 to 1.6. Consequently, they do not contribute significantly to the hiding power of paint. They are used in paint to: reduce cost, achieve durability, alter appearance (e.g., decrease in gloss), control rheology and influence other desirable properties. If used at sufficiently high concentration, an extender may contribute dry hiding and increase reflectance. [1]

fading Subjective term used to describe the lightening of the color of a pigmented paint following exposure to the effects of light, heat, time, temperature, chemicals, etc. The observed fading may result from deterioration of the pigment, from deterioration of the vehicle, or from a decrease in gloss. A separation of the vehicle from the pigment particle in the interior of the

film, with the subsequent introduction of microvoids which scatter light, may also be interpreted visually as fading. [1]

filler 1) Pigmented composition used for filling fine cracks and indentations to obtain a smooth, even surface preparatory to painting. 2) Synonymous with extender. 3) A relatively nonadhesive substance added to an adhesive to improve its working properties, permanence, strength, and other qualities. [1]

film 1) A layer of one or more coats of paints or varnish covering an object or surface. 2) Any supported or unsupported thin continuous covering or coating. [1]

fineness When applied to pigments, it describes the particle size. When it is used in connection with the dispersion of pigments, it means the degree of dispersion of the pigment agglomerates. [1]

finish 1) Final coat in a painting system; 2) Sometimes refers to the entire coating system: the texture, color, and smoothness of a surface, and other properties affecting appearance. [1]

flake *(also called island)* A portion of a lamina isolated and bound by fissures. Flakes may have profiles (sections) that are flat, rimmed, convex, or concave. [3]

flaking That phenomenon manifested in paint films by the actual detachment of pieces of the film itself either from its substrate or from paint previously applied. Flaking (scaling) is generally preceded by cracking or checking or blistering and is the result of loss of adhesion, usually due to stress-strain factors coming into play. [1]

flat enamel Pigmented coating of low specular gloss, which has the leveling characteristics of a gloss enamel. Enamel has the connotation of both gloss and flow. [1]

flat lacquer A lacquer having the appearance of having been rubbed after it has dried. [1]

flat paint (finish) Paint which dries to a surface which scatters the light falling on it, so as to be substantially free from gloss or sheen. [1]

flatting agent A material added to paints, varnishes, and other coating materials to reduce the gloss of the dried film. [2]

flatting pigment Any finely divided particle added to a paint formulation in order to de-

crease the gloss of the dried film. It may be an extender-type (low refractive index) or a hiding pigment, and it is generally non-chromatic (neutral near-white), although not necessarily so. The reduction in gloss comes about from surface-light scattering which occurs when light strikes the pigments protruding at the surface. [1]

flood To apply sufficient quantity of consolidant solution to damaged area of paint to ensure complete penetration with minimum number of applications. [A]

fresco Method of painting in which pigments mixed only with water are applied to a freshly laid surface of lime plaster. The painted surface is rendered durable by the pigment absorbing calcium hydroxide from the wet plaster, which is converted into insoluble calcium carbonate as the surface dries. The term is sometimes used incorrectly to denote any form of mural painting. [1]

fresnel reflection Phenomenon of reflection at the surface or interface where media or materials of different refractive indices join. Fresnel laws state that the angle of reflection is equal and opposite to the incident angle, and that the magnitude of the reflection depends on the angle of the incident light, on the relative refractive indices, and on the polarization of the incident light. When the surfaces are smooth and planar, specular (mirrorlike) reflection occurs, which is subjectively referred to as specular gloss. When the surfaces are rough, the reflectance at the air-material interface is diffuse, and the surface is observed to be matte-like. [1]

gel 1) A semisolid material, somewhat elastic, composed of matter in a colloidal state that does not dissolve; remains suspended in a solvent. 2) Semisolid system consisting of a network of solid aggregates in which liquid is held. 3) Initial jellylike solid phase that develops during the formation of a resin from a liquid. 4) Irreversible, massive increase in the resistance to flow of an oil, vehicle, or coating (clear or pigmented); characterized by a semi (jelly-like) or fully rigid condition. In use, it may refer to a near-rigid state in which a very limited flow may be detected. [1]

gelatin The soluble protein derived from collagen. [4]

gelation The process of forming a gel. Note: Adhesives can be classified by mode of gelation.

a) Gel formation by loss of volatile constituents by evaporation or diffusion: i) loss of organic solvent, e.g., rubber solution; ii) loss of water, e.g., starch, animal glue, rubber latex, sodium silicate, poly(vinylacetate), etc. b) Gel formation by cooling, e.g., animal glue. c) Gel formation by condensation polymerization, e.g., urea formaldehyde, phenol formaldehyde. d) Gel formation by addition polymerization, induced by heat, catalyst and/or light, e.g., various polyesters. [4]

geometric metamerism Phenomenon exhibited by a pair of colors which appear to be a color match at one angle of illumination and viewing but which are no longer a match when the angle of illumination or viewing is changed. [1]

gesso In the strictest sense, the Italian word gesso refers to a mixture of calcium sulphate (a white powder commonly known as gypsum) and rabbit-skin glue that is applied in liquid form as a primer to the surface of a painting support. In broader usage, the term has come to refer to many types of similar white preparatory layers, including those made from chalk (calcium carbonate), as well as modern synthetic adhesives. The gesso layer smooths out the irregularities in the support; it is usually applied in many thin layers and sanded and polished between applications. The final smooth surface provides an optimum base for painting in a variety of media. [5]

glaze A transparent layer of darker paint that is applied over an opaque layer of lighter paint. Glazes may also be applied on top of one another as a means of creating a sense of depth and translucency. Although glazes can theoretically be made with all paint media, they are most commonly associated with oil paintings. The rich, translucent nature of oil paint, which can be mixed with resins in order to facilitate the handling and transparency of the paint, lends itself to glazing techniques. [5]

gloss Subjective term used to describe the relative amount and nature of mirror-like (specular) reflection. Different types of gloss are frequently arbitrarily differentiated, such as sheen, distinctness-of-image gloss, etc. Trade practice recognizes the following stages, in increasing order of gloss: Flat (or matte) -practically free from sheen, even when viewed from oblique angles (usually less than 15 on 85~ meter); Eggshell—usually 20-35 on 60~ meter; Semigloss—usually 35-70 on

60~ meter; Full gloss—smooth and almost mirrorlike surface when viewed from all angles, usually above 70 on 60~ meter. [1]

glossmeter An instrument for measuring the degree of gloss in relative terms. Such instruments measure the light reflected at a selected specular angle, such as 20~ (from the perpendicular), 45~, 60~, 75~, or 85~. Results obtained are very dependent on the instrument design, calibration technique used, types of samples, etc. In essence, a glossmeter is an abridged goniophotometer (q.v.). [1]

glue (noun) e.g. animal glue, fish glue. An impure protein obtained by hydrolysis of collagenous materials such as skin, bone and connective tissue by various methods; also an adhesive prepared from this substance by heating with water. Note: Through general use, the term 'glue' is often synonymous with 'adhesive' but this is strongly deprecated. [4]

goniochromatism The phenomenon where the color of a material changes as the angle of illumination and/or viewing is changed. [1]

goniometachromatism The phenomenon where the colors of two goniochromatic materials match exactly at one set of illumination-viewing angles but no longer appear to match if either the illumination or viewing angles, or both, are changed. Such pairs of samples are also called geometric metamers. [1] Goniophotometer An instrument used to measure the amount of light reflected as a function of the viewing angle when the incident angle is kept constant. Generally, the incident angle may be changed. [1]

goniospectrophotometer An instrument used to measure a spectrophotometric curve at various angles of incidence and reflectance. The angles of incidence and reflectance may be changed. On goniochromatic samples, the results obtained are dependent on the angles of incidence and reflectance, and on samples exhibiting specular reflectance (glossy materials), the results are also dependent on the total subtended angle of viewing relative to the specular angle. [1]

gouache An opaque, matte, water-based paint made from gum arabic and a chalk-like filler. The term gouache can refer both to the paint medium as well as to the technique of using watercolors (which are also made from gum arabic) in an opaque fashion. [5]

ground The material applied to a support in order to prepare it for painting. The term can be synonymous with the word priming. Different types of grounds can be loosely associated with different periods and schools of painting. In Northern European Renaissance painting, for example, grounds were traditionally made from mixtures of chalk (calcium carbonate) and rabbit-skin glue; in Italy during the same period, gypsum (calcium sulphate) was used. Venetian painters of the Renaissance favored red grounds; this practice eventually led to the wide use of a variety of ground colors, including dark earth tones, blacks, and even rich grays created by scraping paint residues from a palette and mixing them with other ground materials. Grounds of lead white and oil were popular during the late 18th and 19th centuries. [5]

gum A water-soluble vegetable resin or its solutions in water or alcohol or a solution of dextrine in water. [4]

gum arabic The dried exudation from the stem and branches of Acacia senegal and other species of Acacia. High-purity varieties are known as 'gum acacia.'' [4]

gum tragacanth The dried mucilaginous exudation from Astragalus gummifer and other species of Astragalus (Leguminosae), and which is partly soluble in water. Note: Gum tragacanth is used as a modifier and stabilizer in water- (or occasionally alcohol-) borne adhesives. [4]

haze Subjective term to describe small amounts of light scattering. When applied to transparent materials, it generally applies to the percentage of transmitted light which is scattered relative to that which is transmitted. When applied to glossy reflecting materials, it generally refers to the slight scattering from the surface which decreases the distinctness-of-image gloss (20~ gloss). [1]

heat-activated adhesive A dry coating of adhesive that is rendered tacky by application of heat. [4]

heat activation/reactivation The provision or restoration of the bonding properties of a dried adhesive film. [4]

heat-sealing adhesive A thermoplastic adhesive already present in a thin layer on the adherends which, by the application of heat and pressure, forms the bond. [4]

heat-sealing adhesive film A heat-activated adhesive in film form. Note: The film may be a coating on an adherend. The term is commonly used in the packaging industry. [4]

hiding, complete The state of uniform application of paint at such a thickness that, when dry, the substrate is no longer affecting the color, i.e., a thickness such that increasing the thickness even slightly does not change the perceived color. Complete hiding is frequently judged by application of a uniform film over a white and black substrate such as a Morest Chart. It is sometimes defined as the state when a contrast ratio of 0.98 is obtained (although this is seldom complete hiding as judged visually). Visual complete hiding is not necessarily spectrophotometric complete hiding (q.v.). [1]

hiding, incomplete The state of application of a coating at such a thickness that the color of the substrate has an effect on the color which the coating would exhibit if it were applied at complete hiding. Increasing the thickness of the coating thus changes the perceived color. The relative degree of incomplete hiding is frequently described by the contrast ratio. [1]

hiding power The ability of a paint or paint material to hide or obscure a surface to which it is uniformly applied. [2]

hue Chromatic color (white, gray, and black colors possess no hue). [2]

index of refraction The numerical expression of the ratio of the velocity of light in a vacuum to the velocity of a light in a given substance. [2]

interference color Color which appears in thin films illuminated with composite light as the result of the reinforcement of some colors (wavelengths) and weakening or elimination of others, depending on the phase differences and amplitudes of the light waves involved. The color produced depends on the angle of incidence, thickness of the film, and the refractive index. Interference color also appears when light strikes narrow slits, the principle of the diffraction grating. [1]

irridescence Color produced from light interference phenomenon. [1]

jelly glue A prepared adhesive consisting of a gelled solution of animal glue in water, with or without additives such as plasticizers, fillers, etc. It is melted for use. [4]

kaolin China clay; a variety of clay containing a major percentage of kaolinite. [2]

lacuna A void in the integument of an artifact where design material has been lost. [3]

latex adhesive A stable dispersion of elastomeric polymer in a water continuous phase. [4]

latex paint A paint containing a stable aqueous dispersion of synthetic resin, produced by emulsion polymerization, as the principal constituent of the binder. Modifying resins may also be present. [1]

leveling 1) The measure of the ability of a coating to flow out after application so as to obliterate any surface irregularities such as brush marks, orange peel, peaks, or craters which have been produced by the mechanical process of applying or coating. 2) The property of a freshly spread aqueous polish to dry to a uniform and streak-free appearance. [1]

lifting Separation of the paint layer from the substrate often resulting in distortion or loss of paint.

lightness 1) Achromatic dimension necessary to describe the three dimensionality of color, the others being hue and saturation. Sometimes the lightness dimension is called "brightness." In the Munsell Color Order System, the lightness dimension is called "value." 2) Perception by which white objects are distinguished from gray and light objects from dark ones. [1]

loss of gloss A paint defect in which a dried film of paint loses gloss, usually over a period of several weeks. [1]

masstone 1) A pigment-vehicle mixture which contains a single pigment only. 2) Occasionally, this term is used more loosely to describe a pigment-vehicle mixture which contains no white pigment. [1]

matte finish A coating which display no gloss when observed at any angle; a perfectly diffusely reflecting surface. In practice, such perfect surfaces are extremely difficult to prepare. Hence, the term is applied to finishes which closely approach this ideal. Matte is also spelled 'mat'. [1]

mechanical adhesion Adhesion between surfaces due to the interlocking of a solid adhesive with the asperities of the surfaces or subsequent

Glossary

solidification of a liquid adhesive absorbed by porous substrates. [4]

medium In paints or enamels, the continuous phase in which the pigment is dispersed; thus, in the liquid paint in the can, it is synonymous with vehicle, and in the dry film it is synonymous with binder. [1]

metamerism A phenomenon exhibited by a pair of colors which match under one or more sets of conditions, be they real or calculated. Metamerism should not be confused with 'flair' or color constancy, which terms apply to the apparent color change exhibited by a single color when the spectral distribution of the light source is changed or when the angle of illumination or viewing is changed. [1]

mucilage A solution of gum in water. [4]

mudcracking Paint film defect characterized by a broken network of cracks in the film. [1]

multi-part adhesive An adhesive that is packed as two or more separate reactive components that are either mixed before use or applied separately to the adherends. [4]

multiple-layer adhesive A film adhesive, usually supported with a different adhesive composition on each side, designed to bond dissimilar materials. [4]

ocher (yellow, golden, red) There are two types of ocher: 1) synthetic, and 2) natural (a naturally occurring yellow-brown hydrated iron oxide). Synthetic ocher possesses little advantage over the natural earth pigments, the difference being the method of manufacture. Natural ocher is found in France, Italy, Spain, Africa, Great Britain, and the United States. [1]

oil The general term that describes a drying oil used as a paint medium. Oil commonly implies the use of linseed oil, but it can also refer to several other drying oils: walnut oil, for example, which was used in early Italian painting, or poppyseed oil, which was a favorite of French 18th-century painters. Drying oils are different from nondrying oils (such as olive oil or sunflower oil) because of their unique ability to form solid films upon prolonged exposure to air. The rich, luminous nature and appearance of oils led to their use as paint media. The use of oils as binders for pigments in paintings can be traced back to the fifth and sixth centuries. (Prior to this time, ancient references to oils only discussed

their use in association with cooking, cosmetics, or medicines.) In the early Renaissance, oils were used in combination with other paint media, particularly in transparent glazes on egg-tempera paintings. During the 15th century, the techniques of oil painting were developed and refined (particularly in Northern Europe, by artists such as the van Eycks), and by the beginning of the 16th century oil had become the predominant painting medium. [5]

oil paint 1) Paint that contains drying oil as the sole film forming ingredient. 2) A paint that contains drying oil, oil varnish, or oil-modified resin as the basic vehicle ingredient. 3) Commonly (but technically incorrect), any paint soluble in organic solvents (deprecated). [1]

one-part adhesive An adhesive, sometimes prepared from several ingredients, that is packed in a single container and ready for use but which may require the addition of water. [4]

one-way-stick adhesive An adhesive that is applied to only one of the adherends; also called "single-spread adhesive." [4]

opacity A general term to describe the degree to which a material obscures a substrate, as opposed to transparency which is the degree to which a material does not obscure a substrate. Opacity is sometimes described in terms of the contrast ratio. [1]

paint 1) Verb. To apply a thin layer of a coating to a substrate by brush, spray, roller, immersion, or any other suitable means. 2) Noun. Any pigmented liquid, liquefiable, or mastic composition designed for application to a substrate in a thin layer which is converted to an opaque solid film after application. Used for protection, decoration or identification, or to serve some functional purpose such as the filling or concealing of surface irregularities, the modification of light and heat radiation characteristics, etc. [1]

panel A wooden support used for a painting. Wood panels were among the earliest types of painting supports; wall paintings (the predominant form of painted decoration in ancient times) were permanent, stationary artworks, whereas use of a wood panel allowed for portability of the work of art. Wood planks could be joined together to create a support of any size or shape. Nearly all types of wood have been used at one time or another as painting supports. A few broad generalizations can be drawn regarding

the popularity of certain types of woods during particular periods. It is generally acknowledged, for example, that Italian painters of the Renaissance used poplar, whereas Northern European painters favored oak. However, the use of such diverse woods as fir, chestnut, walnut, or lindenwood, or such exotic woods as mahogany, was not unusual. [5]

paste adhesive An adhesive in paste form. [4]

pastel 1) Light tint; masstone to which white has been added. 2) Soft delicate hue. 3) In art, a picture made with a crayon of pigment with some binding medium such as gum. [1]

peel strength The force necessary to bring an adhesive joint to failure and/or maintain a specified rate of failure by means of a stress applied in the peeling mode. [4]

pigment The coloring agent that is mixed with a binding medium to form paint. Pigments were originally made from clays (which could be baked or ground into fine powders, such as yellow ocher), ground minerals (such as lapis lazuli, which, when ground into a powder, produces the pigment known as ultramarine blue), and naturally occurring by products (such as candle soot, used to make lampblack). Synthetic pigments (which are man- made) can also be traced back to ancient times: Egyptian blue, for example, was manufactured from a combination of copper, calcium, and sand (silica). In modern times, less expensive synthetic substitutes have replaced most naturally occurring pigments. The advent of scientific examination techniques has enabled conservation scientists to identify nearly all of the pigments used in the history of painting; this has led to the discovery that different pigments were used at different points in time. As a result, pigment identification can often be used to support or refute opinions concerning the date and origin of a particular painting. [5]

pigment volume concentration (PVC) The ratio of pigment volume to the volume of pigment plus the volume of binder. [A]

polymer 1) Substance, the molecules of which consist of one or more structural units repeated any number of times; vinyl resins are examples of true polymers. The name is also frequently applied to large molecules produced by any chemical process, e.g., condensation in which water or other products are produced; alkyd resins are examples of these. Homopolymer- Poly-

mer of which the molecules consist of one kind of structural unit repeated any number of times; polyvinyl chloride and polyvinyl acetate are examples. Copolymer- Polymer of which the molecule consists of more than one kind of structural unit derived from more than one monomer; polyvinyl chloride-acetate, or polyvinyl acetate-acrylic copolymers are examples. 2) A substance consisting of molecules characterized by the repetition (neglecting ends, branch junctions, and other minor irregularities) of one or more types of monomeric units. [1]

polymerization adhesive An adhesive that sets by polymerization in the assembly. [4]

poly(vinyl acetate) (PVAc) A range of thermoplastic materials in either emulsion or resinous form produced by the polymerization of vinyl acetate as the sole or principal monomer. Note: Polyvinyl acetate is used as a versatile adhesive for porous materials, particularly for wood and paper, and for general packaging work. [4]

poly(vinyl alcohol) (PVAl) A thermoplastic material produced by the hydrolysis of polyvinyl acetate. Commercial polyvinyl alcohol usually contains some residual acetate groups. Note: The uses of polyvinyl alcohol are as follows: a) as a water-soluble adhesive for porous materials and for use in contact with food; b) as an additive in other adhesives to improve adhesion and as a stabilizer, etc.; c) as a heat-seal or moisture reactivation adhesive. [4]

poly(vinyl butyral) A thermoplastic polymer made from polyvinyl alcohol and butyraldehyde. Note: The main uses of polyvinyl butyral are as follows: a) as a constituent of two-polymer systems which provide high-strength structural adhesives; b) as a main component of certain hot-melt adhesives used in particular for laminated safety glass and packaging applications. [4]

porosity Presence of numerous small voids in a material. [1]

pressure-sensitive adhesive An adhesive that produces a permanently tacky film to which a second adherend readily adheres after the brief application of pressure; also called 'self-adhesive' but this term is deprecated. [4]

reflectance, diffuse Reflectance over a wide range of angles. In popular usage, the diffuse

reflectance is all of the reflected radiant energy except that of the specular angle. [1]

reflectance, specular Reflectance of a beam of radiant energy at an angle equal but opposite to the incident angle; the mirror-like reflectance. The magnitude of the specular reflectance on glossy materials depends on the angle and on the difference in refractive indices between two media at a surface and may be calculated from the Fresnel Law. [2]

resin a) A solid, semi-solid or liquid, usually organic, material that has an indefinite and often high molecular mass and, when solid, usually has a softening or melting range and gives a conchoidal fracture. Note: Bitumens, pitches, gums, and waxes are excluded by convention. b) A polymeric material, commonly uncompounded, used in the plastics industry. [4]

reversibility Where mechanical and chemical treatments can be removed and the object restored to its original state. [A]

saturation The attribute of color perception that expresses the degree of departure from the gray of the same lightness. All grays have zero saturation. [1]

scattering Diffusion or redirection of radiant energy encountering particles of different refractive index; scattering occurs at any such interface, at the surface, or inside a medium containing particles. [1]

sealer A composition to prevent excessive absorption of finish coats into porous surfaces (also to prevent bleeding). [2]

sealing The application of a material to the surface of an adherend, prior to that of the adhesive, in order to reduce the absorbency of the adherend; also called 'sizing." [4]

self-curing adhesive A one-part adhesive that cures, after application, under specified conditions. [4]

semigloss A gloss range between high gloss and eggshell, approximately 35 to 70 on the 60~ gloss scale. [1]

separate application adhesive An adhesive consisting of two parts, one part being applied to one adherend and the other part to the second adherend. The parts react when the two are brought together to form a joint. [4]

setting The process by which an adhesive increases its cohesive strength by chemical or physical action, e.g., polymerization, oxidation, gelation, hydration cooling, or evaporation of volatile constituents. [4]

setting time The time interval between the commencement of a setting process, e.g., the application of heat and/or pressure to an assembled joint, and the development of the desired level of bond strength. [4]

sheen An attribute of object mode of appearance which is similar to luster; gloss with poor distinctness-of-image reflectance. Frequently, in the paint industry, sheen is used synonomously with 'low-angle sheen,' a characteristic where a material appears to be matte when illuminated and viewed near to the perpendicular, but appears to be glossy when illuminated and viewed at an angle near to the grazing angle, such as 85~ off the perpendicular. Sheen is therefore frequently evaluated in terms of gloss measurements made on a 75~ or 85~ gloss meter. [1]

size In its broadest sense, the term applies to any material used as a primer to seal an absorbent surface. Sizes traditionally are dilute solutions of water-based glues; canvas, for example, can be coated with a thin size of gelatin in order to prevent oils or resins from subsequent ground or paint layers from soaking through to the threads of the fabric. Sizing can also be used to stiffen a surface or to produce a smooth finish; gesso grounds were often sized as part of the final preparation of their surfaces. [5]

slurry A suspension of solids in water. [2]

solvent-activated adhesive A dry adhesive, pre-applied to an adherend, that rendered tacky just prior to use by application of a solvent. [4]

solvent-activation/reactivation The use of solvent to provide or restore the binding properties of a dried adhesive film. [4]

solvent adhesive A solvent or dilute solution of a polymer that dissolves the surfaces of the adherends, and which bonds as the solvent evaporates [4]

spectrogoniophotometer Goniophotometer used to measure the geometric distribution of reflected or transmitted flux at individual wavelengths. [1]

spectrophotometer Photometric device for the measurement of spectral transmittance, spectral reflectance, or relative spectral emittance. Spectrophotometers are normally equipped with dispersion optics (prism or grating) to give a continuous spectral curve. [1]

spectrophotometer, abridged Photometric device for measuring the transmittance, reflectance, or relative emittance at discrete wavelengths. The particular discrete wavelengths may be selected by the choice of a series of narrow bandpass filters (such as interference filters), or masks, etc. No continuous spectral curve can be obtained from such an instrument. [1]

spectrophotometric curve A curve measured on a spectrophotometer; hence a graph of relative reflectance or transmittance (or absorption) as the ordinate, plotted versus wavelength or frequency as the abscissa. The most common curves in the visible region use wavelength units of nanometers, with the short wavelength units at the left of the scale. [1]

specular gloss The degree to which a surface simulates a mirror in its capacity to reflect incident light. [2]

specular reflectance excluded (SCE) Measurement of reflectance made in such a way that the specular reflectance is excluded from the measurement; diffuse reflectance. The exclusion may be accomplished by using 0~ (perpendicular) incidence on the samples, thereby reflecting the specular component of the reflectance back into the instrument, by use of black absorbers or light traps at the specular angle when the incident angle is not perpendicular, or in directional measurements by measuring at an angle different from the specular angle. [1]

specular reflectance included (SCI) Measurement of the total reflectance from a surface, including the diffuse and specular reflectances. [1]

spraying 1) Method of application in which the coating material is broken up into a fine mist, which is directed onto the surface to be coated. The atomization process is usually, but not necessarily, effected by a compressed air jet. [1]

stability The quality of being not likely to give way, deteriorate, decomposed or otherwise change [6]

stabilizer An additive to an adhesive intended to prevent or slow down undesirable effects such as excessive reactivity, absorption by adherends, coagulation. [4]

starch A white, odorless, granular complex carbohydrate from a variety of plant sources (including wheat and rice) that is used as an adhesive in conservation

substrate 1) Any surface to which a coating or printing ink is applied. 2) The nonpainted material to which the first coat was applied; sometimes referred to as the original substrate. [1]

surface tension Property arising from molecular forces of the surface film of all liquids which tend to alter the contained volume of liquid into a form of minimum superficial area. Note: Surface tension is numerically equal to the force acting normal to an imaginary line of unit length in a surface. It is also numerically equal to the work required to enlarge the surface by unit area. The usual unit of measurement is dynes per cm (newtons per cm in SI units). [1]

surfactants Contracted from surface active agents, these are additives which reduce surface tension and may form micelles and thereby improve wetting (wetting agents); help disperse pigments (dispersants, q.v.); inhibit foam (defoamers, q.v.); or emulsify (emulsifiers, q.v.). Conventionally, they are classified as to their charge; anionic (negative); cationic (positive); nonionic (no charge) or amphoteric (both positive or negative). [1]

tempera A water-based paint medium that, upon drying, produces an opaque surface with a soft sheen. Egg tempera is made primarily from egg yolk (although egg white can be added), and glue tempera (sometimes called distemper or, if painted on very fine linen, Tchlein is made from animal glue. Egg-tempera techniques were fully developed during the early Italian Renaissance. Although egg was eventually replaced by oil as the predominant painting medium, interest in the use of egg tempera revived during the 19th century and has continued to this day. The medium produces a hard, durable, and somewhat lustrous surface. Egg tempera dries very quickly and cannot be brushed uniformly over broad areas; as a result, egg-tempera pictures are painted with repeated brushstrokes, visible as many small hatches on the finished surface. Glue tempera also dries to a matte surface but is more

Glossary

fragile than egg tempera. It can be brushed on in small strokes, in a fashion similar to egg tempera, but glue tempera lends itself to the covering of broader areas as well. [5]

tensile strength The force necessary to bring an adhesive joint to the point of failure by means of an essentially uniform stress at right angles to the bond-line. [4]

thermoplastic (adjective) Having the property of being softened by heat and hardened by cooling; these phenomena are repeatable. Many thermoplastic materials become thermosetting by appropriate treatment to induce crosslinking, e.g., by addition of a suitable chemical crosslinking agent or by irradiation. [4]

thermosetting Having the property of undergoing a chemical reaction by the action of heat, catalysts, ultraviolet light, etc., leading to a relatively infusible state. Note: Thermosetting resins, when cured, are generally insoluble. [4]

tint A colored product produced by the mixture of white pigment in predominating amount with a nonwhite colorant or pigment. The tint of a colorant is much lighter and much less saturated than the colorant itself. [2]

tristimulus colorimeter Instrument used to measure quantities which can be used to obtain an approximation of tristimulus values. They are normally equipped with three (or four) special filters to obtain R, G, B values which must then be normalized to CIE magnitude. They were designed and are properly used only for measuring the color difference between two similar, non-metameric samples. [2]

tristimulus values The amounts of the three stimuli required to match a color (usually designated X, Y, and Z). [2]

undertone The color of a thin layer of pigment/vehicle mixture applied on a white background (but not obscuring it). [2]

varnish A coating applied to the surface of a painting. The varnish layer plays a dual role: it has a profound effect upon the final appearance of the painting and also serves as a protective coating for the paint surface. The variety of varnishing materials is as diverse as the choices of paint media and techniques throughout the history of painting. The benefits of using a clear resin as a final coating for a surface were realized during antiquity; waxes, for example, have been found on the surfaces of ancient wall paintings and must have been chosen because they produce a uniform, luminescent sheen on the surface. By the early Renaissance, a variety of materials had been developed for use as painting varnishes, ranging from egg white to sandarac resin (obtained from North African pine trees). Tree resins (such as mastic and dammar), fossil resins (such as copal), and insect excretions (such as shellac) eventually became the types of materials most frequently chosen for use as varnishes. Complicated oil/resin mixtures (made with such drying oils as linseed oil) were also developed as varnishes, although such mixtures are considered undesirable because of their tendency over time to become very discolored and virtually insoluble (making them extremely difficult to remove). Many of these natural materials are still in use today by artists and restorers; numerous synthetic varnishing materials have also been developed that provide a wide array of surface characteristic. Although varnishes are traditionally clear, they can be toned or altered with the addition of pigments and other materials. Varnishes also tend to darken and discolor with time, necessitating their removal and replacement. This cleaning process is made technically possible as a result of the difference in solubility between the soft, easily dissolved varnish and the harder medium of the aged paint film. Many of the recently introduced synthetic varnishes have the added advantage of remaining stable and unchanged in appearance over time. Additives for natural varnishing materials have also been developed to prevent discoloration, thus reducing the need for frequent removal and replacement of varnishes. On a microscopic level, a varnish coating fills in the tiny gaps and spaces in the upper layer of a paint film, providing a uniform surface for the reflection of light. As a result, the pigments within the painting become deeper, or more saturated, in appearance. Variable aspects of varnishes, such as level of gloss and thickness of coating, are controlled by the artist or restorer. Some paintings (such as Dutch 17th-century landscapes) will require highly saturated, rich surfaces, while others (such as Italian egg-tempera paintings) will require a soft matte sheen. Many paintings are best left without any sort of varnish coating. The Impressionists preferred to leave their paintings unvarnished, as they believed that a resinous coating interfered with the freshness and spontaneity of the paint surface. During the 20th cen-